INTELLIGENCE, CREATIVITY AND FANTASY

PHI (Book Series)

ISSN Print : 2639-0191

ISSN Online : 2639-0205

Series Editors

Mário S. Ming Kong
CIAUD – FAUL, Lisbon School of Architecture, Lisbon University, Lisbon, Portugal

Maria do Rosário Monteiro
CHAM, FCSH, Universidade NOVA de Lisboa, Portugal

Intelligence, Creativity and Fantasy

Chief-Editors:

Mário S. Ming Kong & Maria do Rosário Monteiro

CIAUD- FA ULisboa/ CHAM, FCSH, Universidade NOVA de Lisboa, Portugal

Co-Editor:

Maria João Pereira Neto

CIAUD- FA ULisboa/CHAM, FCSH, Universidade NOVA de Lisboa, Portugal

CRC Press
Taylor & Francis Group
Boca Raton London New York

CRC Press is an imprint of the
Taylor & Francis Group, an **informa** business

A BALKEMA BOOK

CRC Press/Balkema is an imprint of the Taylor & Francis Group, an informa business

© 2020 Taylor & Francis Group, London, UK

Typeset by MPS Limited, Chennai, India

Library of Congress Cataloging-in-Publication Data

Applied for

Published by: CRC Press/Balkema
 Schipholweg 107C, 2316 XC Leiden, The Netherlands

First issued in paperback 2023

ISBN: 978-1-03-257107-2 (pbk)
ISBN: 978-0-367-27719-2 (hbk)
ISBN: 978-0-429-29775-5 (ebk)

DOI: https://doi.org/10.1201/9780429297755

Publisher's Note
The publisher has gone to great lengths to ensure the quality of this reprint but points out that some imperfections in the original copies may be apparent.

Table of contents

Editorial foreword xi
Mário S. Ming Kong, Maria do Rosário Monteiro & Maria João Pereira Neto

Preface xiii
Mário S. Ming Kong

Committees xv

Sponsors xxi

Part I Intelligence, creativity and fantasy

The creativity code 3
M. du Sautoy

The intelligence of fiction 5
F. Lavocat

The presence of metaphysical symbolism in architectural formation of Armenia early and
medieval spiritual sites 7
A. Shatvoryan

Fantasies of space and time 13
D. Fimi

Traces of a recreated reality: Rafael Bordalo Pinheiro's busts of Pai Paulino 21
M. do R. Pimentel

Political fiction or the art of the deal 35
R. Zink

Part II Architecture/urbanism/design

"Through the rabbit hole": Intelligence creativity and fantasy in architectural composition 43
M.S.M. Kong

Creativity and beauty in art and science today: A basis for discussion of a possible future architecture 47
C.G. Gonçalves

Notes on illusion: Ideation as an instrument for a spatial intelligence of architecture 53
F. Oliveira

'The open work': Inter-relations between science and art 59
A.M. Feliciano

UOVO-EGG-OEUF-OVO: From the origins of the world to a creative objective 65
R. Maddaluno

Towards a meta-Baroque: Imagining a "fantastic reality" 71
M.J. Soares

Stolen characters against an enclosure of the imagination 79
D. Jesus

Developing creative approaches in architectural education 85
I. Tarasova

Table of contents

Fantasy and creativity of the Azuchi-Momoyama period Japanese tea architecture 89
A.P. Higashino

From fantasy to experimentation: The one-to-one scale in architecture exhibitions 93
A. Neiva

Architecture and cinema: The tower as both scenario and protagonist 99
E. Kuchpil & A. Pimentel dos Santos

Fictional movement on the NY's Guggenheim ramp 105
S. Paiva de Sousa & M. Baptista-Bastos

Gottfried Böhm's creativity: Architecture as a sculpture made of concrete 109
A. Serafin

Intelligence, creativity and fantasy in Bernard Tschumi's Glass Video Gallery: In-between translucency, transgression and interaction 115
A. Vasconcelos

From the intensity to the essence: Fantasy and architectural creativity between the Neorealism and the Third Modernism in Portugal 121
M. Baptista-Bastos & S. Paiva de Sousa

Paper as a flexible alternative applied to the Dom-Ino System: From Le Corbusier to Shigeru Ban 125
A. Nogueira & M.S.M. Kong

The internationalisation of Álvaro Siza and the myth of the traditional and conservative architect 131
J. Nunes

The fantasy of reality: On the design drawings of Álvaro Siza Vieira 137
J.M.C. Duarte

The "good taste": When patterns restrict creativity 143
G.M. de Carvalho

Creativity and pragmatism: A practical example of a project 149
C.R. Castro & M.S.M. Kong

Towards a more intelligent dwelling: The quest for versatility in the design of the contemporary home 155
H.L. Farias

The house as a mirror and support of identity: Reflections for a more conscious and subjective inhabiting 161
A. Santos Leite

Architecture stories in the construction of children's spatial conscience 167
M. Louro

From fantasy to reality: Adaptive reuse for flour mills in Venice 173
S. Palomares Alarcón

The ruined fantasies of intelligent minds: 'The Nobel's town' and neglected Swedish heritage in St. Petersburg 179
I. Seits

World-in-spheres: A cartographic expedition through the spherical world of Peter Sloterdijk 187
F.H. Brum de Almeida, G.H. Rosa Querne & L. de M. Reitz

From international context to Portuguese urban planning: Creativity on mechanical aesthetics in Planos Gerais de Urbanização 193
J. Cabral Dias

"Fantastic" colonial cities: Portuguese colonial utopia 199
A. Ramos

Fantasy and reality belong together; multidimensional thinking to innovate the
creative process 205
J. Silveira Dias & D. Loução

Creativity and intelligent research in design: The use of quasi-experience 211
F. Moreira da Silva

Sustainability through design creativity 217
A. Moreira da Silva

Design skills and craftwork culture in scenic design for theatre 223
L. Soares, R.A. Almendra, E. Aparo & F. Moreira da Silva

Foot haptic perception in hospital wayfinding 229
M. de A. Borges

Methodology for colour planning in urban furniture: Laje, a case study 235
M. Gamito & J. Sousa

Fashion design and productive thinking: Pragmatical approaches to creativity 239
L. Ferrão & G. Sousa

Part III Arts

Fantasy, creativity and proportions: Spiral representations in culture and art 245
T. Lousa & J. Mikosz

The creative *daemon* (δαίμων) and the hyper-intellection of art 251
J. Pereira de Matos

The creation through listening: Expression, intelligence, inspiration and wisdom 255
S.C. Yan & A.L.M.M. Rodrigues

Art and mind set: Neuroscience and education in the life project 261
C. Accetta

The creativity of artistic appropriation and the copyright 267
G. Horváth

Creativity through destruction in the genesis of artist's books 273
A. Canau

Aldo Rossi's Teatrino 277
Fernando J. Ribeiro

The torrent of art, the rooms of art. The *Fiumara d'Arte* and *Atelier sul Mare* in Sicily 283
S. Centineo

Considerations on the colours of Pompeii walls 289
M.J. Durão

Pictorial (re-) creations: From the fourth Centenary of India (1898) to Expo'98 293
M.J. Castro

Creativity and the observer 299
A.L.M.M. Rodrigues

Drawing in architecture: Exercising the creativity of thinking architectural space 303
A.R. Ortega & S. Weihermann

Part IV Humanities

The love of the one for the many and the many for the one 313
D. Swartz

A Mesopotamian notion of intelligence and creativity: The ingenious nature of Enki/Ea 319
I.G. de Almeida

Table of contents

The legend of Sardanapalus: From ancient Assyria to European stages and screens 325
M. de F. Rosa

Fantasy, cryptozoology and/or reality: Interconnected stories of mythological creatures
and marine mammals 333
C. Brito

To ponder the pathology of power in the early modern Era: Creativity and intelligence in the
political theory and practice reflected in emblems and iconological programs 339
M.L.G. da Cruz

From the ineptitude to a higher capability: The Jesuits and the formation of a Christian
community in Brazil and Japan (16th-century) 345
M.A. Boscariol

Creativity in the 16th-century representation of King Sebastião's in the Battle of Ksar-el-Kebir 351
A.P. Avelar

Intelligence and creativity at the service of the Society of Jesus in 16th century Japan:
The contribution of Father Luís Fróis 357
H. Resende

A science of the probable; epistemological inventiveness according to Diderot 363
L.M.A.V. Bernardo

The gaze of death or modern adventures of the imagination in three acts 369
S. Wróbel

The railways of the Begum's Fortune by Jules Verne and André Laurie 377
F. de L. Lourencetti

On Hesse's *Der Steppenwolf*: How creatively actual a modern literary artwork can lively be? 383
F. Ribeiro

Creativity in H.G. Wells: Imagining the role of miracles in a secular society 389
L. Sampaio da Silva

On stories: Tolkien and fictional worlds 395
M. do R. Monteiro

Victorious nature in Anglo-Saxon England and fantasy Middle-earth 405
A. Cossío

Tree and forest models in Victorian/Edwardian fantasy: MacDonald, Morris and
Grahame as triggers of J. R. R. Tolkien's Creativity 411
A. Cossío

From Tolkien's British Middle-earth to King's American West Mid-World 419
R. Montero-Gilete

The final frontier: Fictional explorations of the borders of nature and fantasy in
early twentieth-century imaginative literature 425
M. Simonson

The cure for death: Fantasies of longevity and immortality in speculative fiction 431
T. Botelho

Upgraded fantasy: Recreating SF film 437
I. Borbely

Healing through storytelling: Myth and fantasy in Tomm Moore's *Song of the Sea* 443
A. Varandas

Between reality and fantasy; a reading of Katherine Vaz' "My Hunt for King Sebastião" 449
M. Avelar

Intelligence, creativity and fantasy in *Baltasar and Blimunda*, by José Saramago 453
L.S. Loureiro

Intelligence for obedience and creativity for subversion: Reading António Ladeira's
Os Monociclistas (2018) and *Seis Drones* (2018) 459
M. Rendeiro

Literary creativity and political debate. The case of African journals *Mensagem* and
Notícias do Imbondeiro 467
N. Alfieri

Creativity and innovation in *Cante* from the *Estado Novo* to the present 473
E.M. Raposo

From rap to literature: Creativity as a strategy of resistance in Portugal through the
works by Telma Tvon 479
F. Lupati

Part V Social sciences

Creativity, Utopia and Eternity at the Francke Foundations in Halle: Art between image
politics and cultural memory 487
K. Groop

Harriet Martineau, John H. Bridges, and the sociological imagination 493
M. Wilson

Form and function regulating creativity and facilitating imagination: Literary excursions
in the diary of my great-grandfather 499
J. Dahlbacka

Translanguaging as a creative and enriching practice 505
R. Seredyńska-Abou Eid

Part VI Sciences/technologies

Intelligence, innovation, fantasy and heart: The Portuguese engineers of the nineteenth
and early twentieth centuries 513
A. Cardoso de Matos

The introduction of new construction materials and the teaching of engineering based
on technical intelligence: The role of Antão Almeida Garrett 521
M. da L. Sampaio

A relationship between typography, designers and users to build a creative experience
in the digital culture 527
E. Napoleão, G. Braviano, P.M.R. Amado & M.J. Baldessar

The fantasy of the natural/cultural elements as symbolic tourist attractions through
senses and technology 533
A. Pereira Neto

Remediation and metaphor: Gamifying teaching programming 537
D. Maestri & L.M. Fadel

Pokémon Go: The embedded fantasy 543
G.H.C. de Faria, L.M. Fadel & C.E.V. Vaz

Crowdsourcing: An intelligent and creative way for information access 549
L.C. Borges & A.M.D. da Silva

Comparative analysis of the luminous performance of fenestration with Japanese paper
and glazing with a polymeric film in meditation rooms 555
M.B. Cruz, J. Pereira, M. da G. Gomes & M.S.M. Kong

The magic touch of creative fantasy: Turning C.G. animation into telling movies 563
C.M. Figueiredo

Table of contents

Part VII Exhibitions

Drawings & paintings: "Pompeii colours and materials" 571
M.J. Durão

Literature and video: "Borderlands" 573
M. Simonson & T. Örn Karlsson

Author index 575

Book Series page 577

Editorial foreword

CHIEF-EDITORS, PHI 2019 Congress Organising Chairpersons
Mário S. Ming Kong
(Professor/ Senior Researcher, CIAUD- FA ULisboa/ CHAM, FCSH, Universidade NOVA de Lisboa, Portugal)
Maria do Rosário Monteiro
(Professor/ Researcher CHAM, FCSH, Universidade NOVA de Lisboa, Portugal)

Co-Editor, PHI 2019 Congress Co-Organising Chairperson
Maria João Pereira Neto
(Professor/Senior Researcher, CIAUD- FA ULisboa/ CHAM, FCSH, Universidade NOVA de Lisboa, Portugal)

It is our pleasure to present the fourth volume of Proportion, Harmony, and Identities (PHI). It is the theoretical basis for the fourth INTERNATIONAL MULTIDISCIPLINARY CONGRESS PHI 2019, held in the University of the Maison de la Recherche, Sorbonne Nouvelle University, Paris, on October 7th to 9th, 2019.

The Congress was designed as a platform for researchers, academics and students to present, share and exchange ideas, visions of the past and the future and research results applicable to Architecture, Urban Planning, Design, Arts, Humanities, Social Sciences, Sciences and Technology, among others, on the importance of harmony and proportion as subjects that define, differentiate and unite identities. This year's Book and Congress are dedicated to the theme INTELLIGENCE, CREATIVITY AND FANTASY.

We received one hundred and forty-six papers from sixteen countries and after an intense process of scrutiny through rigorous double-blind peer review method, and a linguistic review, ninety-three papers were selected for presentation and publication as chapters of this volume. In this sense, this book represents the combined effort of scholars from Armenia, Brazil, Canada, Finland, France, Italy, Japan, Romania, Poland, Portugal, Russia, Spain, Sweden, United Kingdom and the United States of America.

We decided to organise the publication in seven major sections, each divided into chapters. The first, bearing the same title as the book itself, is formed by chapters that serve, in our opinion, as pertinent introductions to the diversity and complexity of themes involving Intelligence, Creativity and Fantasy in a multidisciplinary perspective. The first part includes texts written by our Keynote speakers on topics such as: the code of creativity; the intelligence of fiction; the presence of metaphysical symbolism in architectural formation of the early and medieval spiritual sites of Armenia; fantasies of space and time; Rafael Bordalo Pinheiro's bust of Pai Paulino; political fiction or the art of the deal.

The second section approaches Intelligence, Creativity and Fantasy applied to Architecture, Urban Planning and Design, or putting it in a different formulation, this section deals with the city, and its evolution based on the concept of Intelligence, Creativity and Fantasy.

The third section assembles texts dealing with Intelligence, Creativity and Fantasy in the Arts, approaching different perspectives on their importance and influence on the development of Imagination, Fantasy, Creativity in arts.

The fourth section assembles chapters under the vast umbrella of Humanities: narratology, literature, cultural heritage, philosophy and history.

The fifth section is dedicated to Social Sciences and the sixth section to themes related to Sciences and Technologies.

The final, seventh, section includes short articles destined to complement the two art exhibitions on display during the PHI 2019 Congress, namely "Pompeii colours and materials" – drawings and paintings by Maria João DURÃO, and "Borderlands" – photography, prose and video by Martin SIMONSON and Thomas ÖRN KARLSSON. Apart from our intervention in the organisation of the volume, all individual chapters are the sole responsibility of their respective authors.

We thank all members of the scientific committee, partner universities, and their research centres, organising committee members, and especially all the participants for making this book and the Congress possible.

Preface

Mário S. Ming Kong
PHI 2019 Congress Organizing Chairperson
Professor/Senior Researcher, CIAUD- FA ULisboa/ CHAM, FCSH, Universidade NOVA de Lisboa, Portugal

We are pleased to welcome you to the book Intelligence, Creativity and Fantasy (PHI 2019). It is the outcome of a Call for Full papers launch in October 2018, during the PHI 2018. The chapters included in this book were presented and discussed publicly during the 5th INTERNATIONAL MULTIDISCIPLINARY CONGRESS PHI held at Maison de la Recherche, Sorbonne University and Sorbonne Nouvelle University, Paris, from the 7th to the 9th of October 2019.

Proportion, Harmony and Identities (PHI) book series and congresses are annual international events for the presentation, interaction and dissemination of multidisciplinary researches related to the broad topic of Harmony, Proportion and Identity relevant to Architecture, Urban Planning, Design, Arts, Humanities, Social Sciences, Sciences and Technology.

Finally, we showcased this year, for the first time during a PHI Congress, two art exhibitions, complemented by short articles that were integrated into this year's book.

It aims to foster the awareness and discussion on the importance of multidisciplinarity and its benefits for the community at large, crossing frontiers set by Western academic tradition, but that, according to the project organisers, prevent most of the times the communication of knowledge and the creation of bridges that may foster humanity's evolution.

On behalf of the Editors and Organisers, it is my pleasure to mention the participation of experts from fifteen countries in the three days event. We have received research papers from distinguished academics and researchers from countries spreading over three continents. Thus, this event revealed itself as a platform for researchers of a wide variety of fields to discuss, share, and exchange experiences. The comprehensive content of the PHI project has attracted enormous attention, and the wealth of information spread out over this and previous PHI books, published by Taylor and Francis, are, from our point of view, extremely useful for professionals and students working in the related fields.

This publication, containing the full papers, documents and presentations publically presented during the Congress PHI 2019, is the result of the creative work of their authors and a highly selective peer-review process.

I want to express my sincere thanks to all who have contributed to the success of PHI 2019.

The 5th International Multidisciplinary Congress PHI 2019: "Intelligence, Creativity and Fantasy" would not have been possible without the help of a group of people from the Lisbon School of Architecture, University of Lisbon, Nova School of Social Sciences and Humanities, Universidade NOVA de Lisboa, and the Sorbonne Nouvelle University, Paris. Researchers affiliated with the research centres from these universities – CIAUD, CHAM, Centre de Recherches sur les Pays Lusophones – Universidade de Sorbonne Nouvelle, Paris (CREPAL) and Centre de Recherches Interdisciplinaires sur les Mondes Ibériques Contemporains (CRIMIC) – Sorbonne University – selflessly and enthusiastically supported and helped us to overcome the logistic difficulties a preparation of such an event usually faces.

I want to thank all authors of submitted papers for their participation. All contributed a great deal of effort and creativity to produce this work, and in my quality of organising chair, I am especially happy that they chose PHI 2019 as the place to present it. Credit also goes to all collaborators, in particular, to the Scientific Committee members and reviewers, who donated substantial time from their busy schedules to carefully read and conscientiously evaluate the submissions.

In the name of the Organising Committee, I would like to take this opportunity to extend our sincere gratitude to all subsidiary Organisations, for their support and encouragement and for making the event a success.

Special thanks go to all our speakers, authors, and delegates for making PHI 2019 a fruitful platform for sharing, learning, networking, and inspiration.

We sincerely hope the academic community and the public, in general, find this publication enriching and thought-provoking.

Portugal, October 2019

Committees

ORGANIZING COMMITTEE

Chief-Editors

Mário S. Ming Kong
*Senior Researcher, CIAUD – FAUL, Lisbon School of Architecture,
Universidade de Lisboa, Portugal/CHAM, FCSH, Universidade NOVA de
Lisboa, Portugal*
Maria do Rosário Monteiro
Senior Researcher, CHAM, FCSH, Universidade NOVA de Lisboa, Portugal

Co-Editor

Maria João Pereira Neto
*Senior Researcher, CIAUD – FAUL, Lisbon School of Architecture,
Universidade de Lisboa, Portugal/CHAM, FCSH, Universidade NOVA de
Lisboa, Portugal*

SCIENTIFIC COMMITTEE AND PEER REVIEWERS

Aleksander Olszewski
*Faculty of Art, Kazimierz Pułaski University of Technology and Humanities,
Radom, Poland*

Amílcar Manuel Marreiros Duarte
*Universidade do Algarve, Faculdade de Ciências e Tecnologia,
Departamento de Ciências Biológicas e Bioengenharia, Portugal*
ORCID: 0000-0002-2763-1916

Ana Cristina Gil
University of the Azores, CHAM and FCSH, Portugal
ORCID: 0000-0001-5656-9798

Ana Cardoso de Matos
*Member of Research Centre CIDEHUS/UE) and Professor at the Évora
University, Department of History, Portugal*
ORCID: 0000-0002-4318-5776

Ana Cristina Guerreiro
*Senior Researcher, CIAUD – FAUL, Lisbon School of Architecture,
Universidade de Lisboa, Portugal*
ORCID: 0000-0001-5112-5979

Ana Isabel Buescu
*Senior Researcher, CHAM, Department of History, FCSH, Universidade
NOVA de Lisboa, Portugal*
ORCID: 0000-0002-5938-8463

Ana Maria Martinho Gale
Senior Researcher, CHAM, FCSH, Universidade NOVA de Lisboa, Portugal
ORCID: 0000-0002-3690-8729

Ana Marta Feliciano
*Senior Researcher, CIAUD – FAUL, Lisbon School of Architecture,
Universidade de Lisboa, Portugal*
ORCID: 0000-0002-3251-3973

Annalisa Di Roma
*Associate Professor in Industrial Design, Polytechnic University of
Bari, Italy*
ORCID: 0000-0003-4807-1433

Andreia Garci
*Professora auxiliar convidada no Curso de Arquitectura da
Universidade da Beira Interior, Portugal*
ORCID: /0000-0002-0735-1490

Andrzej Markiewicz
*Kazimierza Pulaski University of Technology and Humanities in Radom,
Poland*

António Leite
*Senior Researcher, CIAUD – FAUL, Lisbon School of Architecture,
Universidade de Lisboa, Portugal*
ORCID: 0000-0003-2529-5362

Armen Shatvoryan
*Deputy Dean of the National University of Architecture & Construction of
Armenia (NUACA), Armenia*

Committees

Barbara Vaz Massapina — *Senior Researcher, CIAUD – FAUL, Lisbon School of Architecture, Universidade de Lisboa, Portugal* ORCID: 0000-0003-3665-3495

Calogero Montalbano — *Professor at the Polytechnic of Bari in Architectural and Urban Design, Italy* ORCID: 0000-0001-8969-0236

Carla Alferes Pinto — *Senior Researcher, CHAM, FCSH, Universidade NOVA de Lisboa, Portugal* ORCID: 0000-0001-9055-9630

Carla Chiarantoni — *Professor in Architectural Design at the School of Building Architecture of the Polytechnic of Bari, Italy* ORCID: 0000-0001-9907-8550

Carlos Manuel Almeida Figueiredo — *Senior Researcher, CIAUD – FAUL, Lisbon School of Architecture, Universidade de Lisboa, Portugal* ORCID: 0000-0002-1107-4211

Clara Gonçalves — *CITAD, Universidade Lusíada de Lisboa, Portugal / ISMAT, Portugal* ORCID: 0000-0002-1236-5803

David Swartz — *Originally from Toronto, Canada, David has resided in Lisbon, Portugal since 2013, where he teaches English at Universidade NOVA de Lisboa, Portugal* ORCID: 0000-0001-7952-4795

Dimitra Fimi — *University of Glasgow, Scotland* ORCID: 0000-0002-5018-3074

Fátima Vieira — *Senior Researcher, CETAPS, Faculdade de Letras da Universidade do Porto, Portugal* ORCID: 0000-0002-2733-1243

Francoise Lavocat — *Senior Researcher, SFLGC, Professor of Comparative Literature, Sorbonne Nouvelle University, France* ORCID: 0000-0003-3423-3331

Fernando Moreira Da Silva — *Senior Researcher, Director of CIAUD – FAUL, Lisbon School of Architecture, Universidade de Lisboa, Portugal* ORCID:0000-0002-5972-7787

Filipa Fernandes — *Instituto Superior de Ciências Sociais e Políticas (ISCSP/ULisboa), Portugal* ORCID: 0000-0002-0880-4770

Francisco Caramelo — *FCSH Dean, Senior Researcher, CHAM, FCSH, Universidade NOVA de Lisboa, Portugal* ORCID: 0000-0001-5865-1699

Francisco Oliveira — *Senior Researcher, CIAUD – FAUL, Lisbon School of Architecture, Universidade de Lisboa, Portugal* ORCID: 0000-0003-0089-3112

Gianni Montagna — *Senior Researcher, CIAUD – FAUL, Lisbon School of Architecture, Universidade de Lisboa, Portugal* ORCID: 0000-0002-5843-2047

Gisela Horvath — *Faculty of Arts and Humanities, Partium Christian University, Oradea, Romania* ORCID: 0000-0002-7254-3704

Hervé Baudry — *Senior Researcher, CHAM, FCSH, Universidade NOVA de Lisboa, Portugal* ORCID: 0000-0001-9102-913X

João Cabral — *Senior Researcher, CIAUD – FAUL, Lisbon School of Architecture, Universidade de Lisboa, Portugal* ORCID: 0000-0002-9711-8560

João Paulo Oliveira E Costa — *Senior Researcher, President Centre of CHAM, FCSH, Universidade NOVA de Lisboa, Portugal* ORCID: 0000-0002-7404-0772

João Seixas — *Physics Department of Instituto Superior Técnico (Lisbon, Portugal) / Member of Laboratório de Instrumentação e Física Experimental de Partículas (LIP) / Member of Centro de Física Teórica de Partículas (CFTP) / Member of CMS Collaboration, Portugal* ORCID: 0000-0002-7531-0842

Jorge De Novaes Bastos — *Senior Researcher, CIAUD – FAUL, Lisbon School of Architecture, Universidade de Lisboa, Portugal*
ORCID: 0000-0002-5739-5926

Jorge Tavares Ribeiro — *Senior Researcher, CIAUD – FAUL, Lisbon School of Architecture, Universidade de Lisboa, Portugal*
ORCID: 0000-0002-9609-339X

José Cabral Dias — *Faculty of Architecture of University of Porto, Porto, Portugal*
ORCID: 0000-0002-8472-5062

Iulianna Borbély — *Faculty of Arts and Humanities, Partium Christian University, Oradea, Romania*
ORCID: 0000-0002-7753-1374

Jorge Firmino Nunes — *Senior Researcher, CIAUD – FAUL, Lisbon School of Architecture, Universidade de Lisboa, Portugal*
ORCID: 0000-0002-1340-6080

Julian Sobrino Simal — *Professor Titular de Universidad Universidad de Sevilla, Escuela Técnica Superior de Arquitectura, Spain*
ORCID: 0000-0003-4458-4119

Luís Crespo Andrade — *Senior Researcher, CHAM, FCSH, Universidade NOVA de Lisboa, Portugal*
ORCID: 0000-0002-6792-8124

Luis Manuel A. V. Bernardo — *Senior Researcher, CHAM, FCSH, Universidade NOVA de Lisboa, Portugal*
ORCID: 0000-0002-3587-7799

Łukasz Rudecki — *Faculty of Arts - Kazimierz Pulaski University of Technology and Humanities Radom, Poland*

Manuela Cristina Paulo Carvalho De Almeida Figueiredo — *Senior Researcher, CIAUD – FAUL, Lisbon School of Architecture, Universidade de Lisboa, Portugal*
ORCID: 0000-0001-5956-9996

Manuela Cristóvão — *Visual Arts and Design Department, School of Arts, Évora University, Portugal*
ORCID: 0000-0002-9791-2895

Marco Neves — *Researcher, CIAUD – FAUL, Lisbon School of Architecture, Universidade de Lisboa, Portugal*
ORCID: 0000-0002-6311-8909

Marcus Du Sautoy — *Charles Simonyi Professor for the Public Understanding of Science, Oxford University, England*

Margarida Vaz Do Rego Machado — *Universidade dos Açores, CHAM and FCSH, Portugal*
ORCID: 0000-0001-9027-1856

Maria Angélica Sousa Oliveira Varandas Azevedo Cansado — *Department of English Studies, School of Arts and Humanities, University of Lisbon / ULICES (University of Lisbon Center for English Studies), Portugal*
ORCID: 0000-0002-6647-3359

Maria De Fátima Nunes — *President of the Advanced Research Scientific Board (IIFA). Full Professor and Teacher of History, History of Culture and History of Science, Évora University, Portugal*
ORCID: 0000-0002-0578-8728

Maria Da Graça Moreira — *Senior Researcher, CIAUD – FAUL, Lisbon School of Architecture, Universidade de Lisboa, Portugal*
ORCID: 0000-0001-9501-877X

Maria Da Glória Gomes — *Engenharia, CERIS, DECivil, Instituto Superior Técnico, Universidade de Lisboa, Portugal*
ORCID: 0000-0003-1499-1370

Margarida Maria Garcia Louro — *Senior Researcher, CIAUD – FAUL, Lisbon School of Architecture, Universidade de Lisboa, Portugal*
ORCID: 0000-0003-2487-539X

Maria Margarida Rendeiro — *Senior Researcher, CHAM, FCSH, Universidade NOVA de Lisboa, Portugal*
ORCID: 0000-0002-8607-3256

Maria João Durão — *Senior Researcher, CIAUD – FAUL, Lisbon School of Architecture, Universidade de Lisboa, Portugal / Laboratório da Cor/ColourLab FAUL Coordinator*
ORCID: 0000-0002-3125-4893

Committees

Maria João Pereira Neto *Senior Researcher, CIAUD – FAUL, Lisbon School of Architecture, Universidade de Lisboa, Portugal / CHAM, FCSH, Universidade NOVA de Lisboa, Portugal*
ORCID: 0000-0003-0489-3144

Maria Da Luz Sampaio *Researcher, CIDEHUS, University of Évora, Portugal*
ORCID: 0000-0002-9231-4757

Maria Leonor Garcia Da Cruz *Professor and Researcher School of Arts and Humanities, University of Lisbon, Portugal*
ORCID: 0000-0002-8989-4527

Maria Leonor Sampaio Da Silva *Senior Researcher, Universidade dos Açores, CHAM e FCSH, Portugal*
ORCID 0000-0002-4241-272X

Maria Do Rosário Monteiro *Senior Researcher Coordinator of the Research Group Culture and Literature, CHAM, FCSH, Universidade NOVA de Lisboa, Portugal*
ORCID: 0000-0001-6214-5975

Maria Do Rosário Pimentel *Researcher, CHAM, FCSH, Universidade NOVA de Lisboa, Portugal*
ORCID: 0000-0001-7737-6952

Mário Albino Pio Cachão *Faculty of Sciences, University of Lisbon, Portugal*

Mário Say Ming Kong *Senior Researcher, CIAUD – FAUL, Lisbon School of Architecture, Universidade de Lisboa, Lisboa, Portugal / CHAM, FCSH, Universidade NOVA de Lisboa, Portugal*
ORCID: 0000-0002-4236-2240

Martin Simonson *University of the Basque Country (UPV/EHU), Spain*
ORCID: 0000-0003-3576-4636

Miguel De Aboim Borges *CIAUD – FAUL, Lisbon School of Architecture, Universidade de Lisboa, Portugal*

Olinda Kleiman *Full Professor / Director of CREPAL, Sorbonne Nouvelle – Paris 3, France*
ORCID: 0000-0002-0714-8601

Paula Reaes Pinto *Assistant Professor, Arts and Design Department, University of Évora / Full member, CHAIA – Centre for Art History and Artistic Research, University of Évora / CIAUD – FAUL, Lisbon School of Architecture, Universidade de Lisboa, Portugal*
ORCID: 0000-0003-1857-9797

Paulo Pereira *Senior Researcher, CIAUD – FAUL, Lisbon School of Architecture, Universidade de Lisboa, Portugal*
ORCID: 0000-0002-9480-6376

Pedro Cortesão Monteiro *Senior Researcher, CIAUD – FAUL, Lisbon School of Architecture, Universidade de Lisboa, Portugal*
ORCID: 0000-0002-3183-7810

Raúl Montero Gilete *University of the Basque Country (UPV/EHU), Spain*
ORCID: 0000-0002-2008-0963

Regina Aparecida Sanchez *Associate Professor. School of Arts, Sciences and Humanities, University of São Paulo, Brazil / Researcher, CIAUD – Research Centre for Architecture, Urbanism and Design – Faculty of Architecture, University of Lisbon, Portugal*

Rui Zink *Senior Researcher, Instituto de Estudos de Literatura e Tradição (IELT), FCSH, Universidade NOVA de Lisboa, Portugal*

Santi Centineo *Polytechnic University of Bari, Italy*
ORCID: 000-0002-1365-982X

Sónia Frias *Instituto Superior de Ciências Sociais e Políticas (ISCSP/ULisboa) / Researcher, CEsAISEG, University of Lisbon / President, African Commission of the Geographical Society of Lisbon, Portugal*
ORCID: 0000-0002-9259-8286

Teresa Botelho *Department of Languages, Cultures and Modern Literatures (DLCLM), University of Porto / CETAPS, FCSH, Universidade NOVA de Lisboa, Portugal*
ORCID: 0000-0003-1256-8771

PEER REVIEW

Scholars have been invited, through an international CFP, to submit full chapters on theoretical and methodological aspects related to the theme "INTELLIGENCE, CREATIVITY AND FANTASY" in the scientific fields of Architecture, Arts and Humanities, Design, Engineering, Social and Natural Sciences. The selected chapters were then publically presented on the Congress "INTELLIGENCE, CREATIVITY AND FANTASY" thus fostering a multidisciplinary discussion.

All full chapters proposals were subjected to double-blind peer review, distributed according to each scientific area to senior researchers for evaluation. Members of the scientific committee also peer-reviewed papers within their field of expertise. The theme had been proposed to the international academic community in October 2019, during PHI Congress in Maison de la Recherche, Sorbonne Nouvelle, University, Paris. This book is the outcome of the production, revision, lengthy selection and evaluation process that lasted 12 months.

BOOK PRODUCTION REPORT

More than one hundred full papers were submitted. After the selection, the Reader will find in this book chapters written by authors (senior researchers and post-graduation students) from Armenia, Brazil, Canada, Finland, France, Italy, Japan, Romania, Poland, Portugal, Russia, Spain, Sweden, United Kingdom, USA.

Sponsors

This event and this book had the support of CHAM (NOVA FCSH—UAc), through the strategic project sponsored by FCT (UID/HIS/04666/2019).

The creativity code

Marcus du Sautoy
Public Understanding of Science and Professor of Mathematics at the University of Oxford, UK

ABSTRACT: Professor Marcus du Sautoy looks at the nature of creativity and asks how long it will be before computers can compose a symphony, write a Nobel Prize-winning novel or paint a masterpiece. And if so, would we be able to tell the difference? As humans, we have an extraordinary ability to create works of art that elevate, expand and transform what it means to be alive. Yet in many other areas, new developments in AI are shaking up the status quo, as we find out how many of the tasks humans engage in can be done equally well, if not better, by machines. But can machines be creative? Will they soon be able to learn from the art that moves us, and understand what distinguishes it from the mundane? Du Sautoy asks how much of our emotional response to a great work of art is down to our brains reacting to pattern and structure and explores what it is to be creative in mathematics, art, language and music. Could machines come up with something creative, and might that push us into being more imaginative in turn?

Keywords: creativity

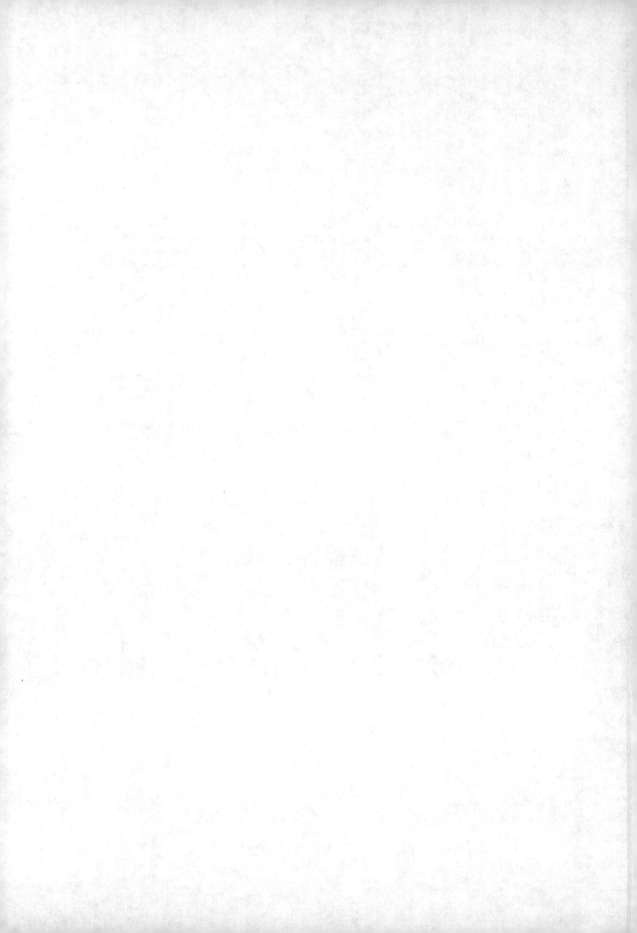

The intelligence of fiction

Françoise Lavocat
SFLGC, Sorbonne Nouvelle University, Paris, France
ORCID: 0000-0003-3423-3331

ABSTRACT: Fiction has since long ago (at least since the year 1000, with the Tale of Genji), been accused of making people, and more particularly women, stupid. The most famous heroes characterised by their addiction to fiction (Don Quixote and Madame Bovary, or even the Cecilia of The Purple Rose of Cairo) are neither distinguished by their intelligence nor their ability to adapt to the world or their participation through work in society. In the past, fiction was also suspected of undermining women's chastity and morality; now, it is accused of facilitating the passage of violent beings into action. Without dwelling too much on this endless and repetitive indictment, I would also like to point out the current contempt for fiction that accompanies what is called "the documentary turn". Several critics ridicule the clichés and the supposed exhaustion of fiction, and a prominent young French author, Edouard Louis, claims that he rejects it for political reasons.

On the other hand, since the 1980s and the rise of fiction theories, the advantages of fiction have been constantly highlighted, mainly from an educational and therapeutic point of view. From Aristotle to evolutionary and cognitive theories, fiction is supposed to train children's abilities to read mind's, educate them to sociability and solicit capacities to empathy (Schaeffer, 1999, Zunshine 2006). Alexandre Gefen highlighted the extraordinary vogue of theories that attributed healing powers to fiction (2017).

My purpose in this paper is to question the intelligence of fiction, rather than whether it makes the reader more or less intelligent. I would also like to take the gap I just have developed into account, i.e. between the lasting accusations against fiction and its praise.

Keywords: Fiction, Intelligence

1 COGNITIVE SHIFT AND DOXASTIC PLASTICITY

The metaphors of "transport" (Marie-Laure Ryan, 1991), "fictional immersion", the concepts of "deictic displacement" all suggest that exposure to a fiction implies a cognitive change and the choice of an imaginary environment that reorders spatial and temporal references, sometimes modifies logical modalities. This displacement implies the provisional adoption of the point of view of the character or narrator. The crucial question is to know to what extent this cognitive operation can lead to a change in beliefs (doxastic plasticity). An important argument for criticism and praise of fiction is rooted in this phenomenon. Fiction would thus be an exercise in mobility in the playful adoption of points of view. Is it a factor of corruption or relativisation of values and tolerance? We relate this questioning to the theory of storyworld possible self (Maria-Angeles Martinez, 2018).

2 AMELIORATIVE REPRESENTATION AND ABILITY TO SHAPE THE WORLD

Fictions are very often criticised for giving people a flattering image of the world, which would lead them to escapism and optimism that would make readers unsuitable for the real world (Oatley, 1999). This is indeed a constancy of fiction. The social classes represented are always higher than those of their readers: this is true of novels between the 17th and 19th centuries as well as today's television series. With two examples, however, I will defend the hypothesis that fiction very often has the function of providing positive models of individual and collective behaviour. In the case of fiction dealing with disasters, it is always the human link that is represented in a privileged way to overcome chaos and grief. Novels from the 17th to the 19th century also always represent a much lower fertility than that which exists in reality. While real families commonly have more than ten children,

decimated by huge infant mortality, fictional women rarely have more than two or three children. Infant mortality is almost unknown there! The reason is, of course, that a novel cannot develop in an interesting way the destinies of a too large family. Nor is the death of children an exciting adventure. Can we not think that the novels have prepared the demographic transition in this way? Would not they have proposed a family model where the individual comes first?

3 THE TENDENCY FOR REFLEXIVITY AND METAPHORIZATION OF COGNITIVE PROCESSES

The ability of fiction to integrate elements of theorisation about fiction itself is certainly a constituent element of its "intelligence". It would be useful to question the status of metafiction from a historical perspective and to ask ourselves what status to give to what Richard Saint-Gelais calls the "autochthonous theories of fiction" (2005).

The most developed illustration of meta-fictionality is the representation of an entry into a world of fiction in a fiction. However, this entry is regularly shown in a dysphoric light. A sensorial frustration systematically accompanies it. Finally, I would like to question the ability of fiction to metaphorise, and for a long time now, cognitive processes that have only recently been discovered in neurosciences. The relationship of fiction with inhibition of action could also be one of the reasons for the very ambivalent relationship of civilisations, for more than a thousand years, to fiction. Fiction is capable of suggesting the pleasures,

benefits and dangers it embodies. If I use this turn of phrase ('fiction is capable'), it is not that I consider fiction as a person, but that I am doubtful as to the author's full awareness of the scope of meta-fiction metaphors.

BIBLIOGRAPHICAL REFERENCES

Gefen, Alexandre. (2017). Réparer le monde. La littérature française face au XVIe siècle. Paris: José Corti.

Lavocat, Françoise. (2016). *Fait et fiction*. Paris: Seuil.

___. (2018). Amour et catastrophes. In *Le Désordre du monde* ("Rencontres Recherche et Création" du Festival d'Avignons sous la direction de Catherine Courtet, Mireille Besson, Françoise Lavocat, Alain Viala, pp. 217–237). Paris: CNRS Editions

Lavocat, Françoise (ed.). (2016). *Interprétation et sciences cognitives*. Paris: Hermann.

Martinez, Maria-Angeles. (2018). *Storyworlds Possible selves*. Berlin: De Gruyter Mouton.

Oatley, Keith. (1999). Why fiction may be twice as true as fact. Fiction as cognitive and Emotional Simulation. *Review of General Psychology*, 3 (2), pp. 107–117. doi.org/10.1037/1089-2680.3.2.101.

Ryan, Marie-Laure (1991), *Possible Worlds, Artificial Intelligence, and Narrative Theory*. Bloomington (Ind.): Indiana University Press.

Saint-Gelais, Richard. (2005). Les théories autochtones de la fiction. *Atelier Fabula*. Disponible en ligne, URL: http://www.fabula.org/atelier.php?Les_th%26eacute%3Bories_autochtones_de_la_fiction [dernière mise à jour : 23 mars 2006, consulté le 15 juin 2014].

Schaeffer, Jean-Marie. (1999). *Pourquoi la fiction?* Paris: Seuil.

Zunshine, Lisa. (2006). *Why We Read Fiction. Theory of Mind and the Novel*. Columbus: The Ohio State University Press.

The presence of metaphysical symbolism in architectural formation of Armenia early and medieval spiritual sites

Armen Shatvoryan

National University of Architecture & Construction of Armenia (NUACA), Yerevan, Republic of Armenia

ABSTRACT: Through the analogy of the architectural environment with the special, meaningful proportions, astronomical regularities, etc., the work emphasises the importance of design approach in architecture where the metaphysical concepts and factors are reflected as signs of universal rules and creative solutions forming the space.

In the chapter, particular attention is paid to one of the most famous and unique Armenian temple – Zvartnots, where the covered metaphysical meanings appear. Visual signs and ideas, carved in the stones of the facades of the churches and surfaces of the khachkars – the identifying cross stones of the Armenian culture were analysed as well. Correspondingly the complex methodology of architectural design is discussed, when metaphysical components are taken into account in order to achieve a better environment, and which can be applied to all branches of Architecture from micro- to macro-level.

Summing up, the "true" definition of Architecture is addressed as one of the highest expression of human creative activity.

Keywords: metaphysical symbolism, meaningful architecture, analogy

1 INTRODUCTION TO THE ARMENIAN CREATIVITY

Armenia is a country of an ancient, distinctive culture, with a distinct history, full of trials and inexhaustible energy of creation, juxtaposed to the destructive force of numerous conquerors. The cities and structures built anew on the destroyed and looted territories are proof of that thirst for creation. Having carried through the centuries the experience of creative work with space, the search for new forms and the dissemination of spiritual ideas – architecture has become an integral "representative" part of Armenian culture.

It is worth to note that since ancient times, during the Kingdom of Urartu, about 850 years B.C. when Rome was just rising, Armenian architects had already built three-story palaces and typical residential buildings (see Fig. 1) (Hasratyan, 2010, p. 200).

Following the adoption of Christianity as the state religion in 301, Armenian architecture quickly found its niche in global architecture, with the churches and monasteries that have survived to our years (Hastings, 2000).

Below, the creative approaches of architectural thought, on the example of religious buildings of early and medieval Armenia, in particular churches, monasteries and khachkars, will be considered.

Using natural resources for construction such as varieties of basalt, tuff, etc., Armenian architects and

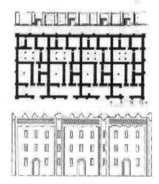

Figure 1. Typical residential houses (at the top), multi-floor buildings in the Kingdom of Urartu, VIII century B.C. (at the bottom) (Hasratyan, 2010, p. 200).

stonecutters achieved a high level of skilfulness in refining them and achieving the constructive and artistic tasks set. Constructed from carefully processed natural stone, these structures, even with their ruins, leave a very strong impression on people.

Moreover, they affect not by the grandeur of Egyptian temples, or the majesty of Roman aqueducts and amphitheatres, nor the pomp of Muslim madrassas, or overwhelming scale of Gothic churches and the brightness of the golden decoration of Orthodox churches. The architecture of Armenian churches and

monasteries affects a person solely by proportionality of forms, the richness of compositional, practical solutions and methods, constructive meaningfulness and logic, as well as moderateness in decorations. (Azatyan, 1987).

All these constructions are professionally linked to the immediate environment of their location, starting from the selection of the location for construction and ending with the correlation with the surrounding nature, as if "growing out" of it. At the same time, the author's mastery is manifested in the harmonious combination of solidity, aesthetics and proportionality with the most important filter of architecture – the human being.

There is also an incredible combination of continuity to the traditions of the past and the search for new compositional solutions. This is "tolerance" towards new forms and their harmonious interaction with well-established laws of creation. All this ultimately manifests itself in architecture as an ordered combination of the "old" and the "new".

However, besides what was mentioned above, another important factor, that is present in the culture of the Armenian people and is reflected in the architecture should be noted, i.e. the existence of the meaningful metaphysical concepts in the formation of the spiritual sites and objects of Armenian culture.

2 METAPHYSICAL SYMBOLISM

The "astronomical, universal heritage" presence in the pre-Christian period should also be attributed to the aforementioned well-established laws of creation. With a close analytical look at the essence of forms and architectural solutions, the hidden, metaphysical ideas and laws are revealed to the observer (Neapolitanskij, 2013).

Thus, it is interesting to analyse the shaping and symbolism of the Armenian "khachkars" – architectural monuments and relics, which represent a stone stele with a carved image of a cross.

The word khachkar is composed of the Armenian root "Khach" – "cross", and "kar" – "stone", which represent numerous monuments of great spiritual value scattered throughout the Armenian highlands. The Armenian cross itself, also called blooming, is a kind of a cross, distinguished by sprouted branches (see Fig. 2) (Hakobyan, 2003).

The blossoming endings symbolise the life-giving power of the cross and its distinction from the cross as an instrument of punishment (Architecture, 2012).

Coming back to the khachkars, it should be noted that one of the significant difference from other similar stone monuments lies in the distinct, patterned symbol that is traditionally forming the Armenian cross and symbolising the "world". The symbol has a special name in the Armenian language: "vardak" – "rose". The same name was given to the "lace pattern" that was

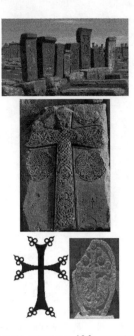

Figure 2. Noratus cemetery, 10th century, (at the top), Khachkar at Dadviank monastery (in the middle), as well as Armenian "sprouted" cross (on the bottom left). Khachkar, 996, from the Cape of Noratus; is currently stored in Etchmiadzin Monastery (on the bottom) (Hakobyan, 2003), (Architecture, 2012).

Figure 3. The lace pattern "Vardak" on the Goshavank Monastery khachkar, made by the Master Poghos, 1291 (Photo of the author).

used in the pagan era, when women knitted a pattern for domestic needs, singing (programming) positive wishes to the close relatives (see Fig. 3).

There is also another etymology of the word "vardak", derived from the word "vardan" – (from Proto-Armenian "rotating", "khalke"), referring to another cosmogonic symbol – the swastika, widespread in pagan times, which found its reflection in the Christian architectural heritage that reached also our days (Avetisyan, 2017).

The word "swastika" itself is a compound word of two Sanskrit roots meaning "su" – सु "good", and "asti" – अ, "life, existence", i.e. "well-being".

When analysing the schematic essence of such symbols, it is possible to carry out an explicit visual

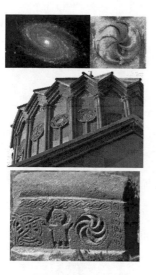

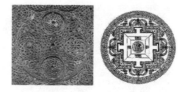

Figure 5. Lace pattern of Dadivank khachkar, beginning of the XIII century, Artsakh (on the left), and example of a mandala (on the right) (Alaexis, 2010).

Figure 4. Example of a spiral galaxy (to the left top), "Arevakhach", Armenian sign of eternity at Makaravank, near Achajur (X century) (to the right top), as well as 5-arched eternity sign on the Cathedral of the Holy Mother of God, Harichavank Monastery, (XIII century) (in the middle), and Aghout cemetery in Sisian (below), (Avetisyan, 2017), (Armenian eternity sign, 2013).

identification of the image with the rotational motion of the galaxy (see Fig. 4).

Accordingly, such obvious similarities with cosmic elements indicate indirectly but firmly the astronomical knowledge coming from the pre-Christian period and metaphysical meanings, influencing on the formation of spiritual structures such as khachkars, churches and temples.

That symbols, one of the oldest in the Armenian culture, the pagan "Arevakhach", came from pre-Christian time, like many other Armenian creative traditions, was transformed from a more dynamic and "astronomical" image, into the mentioned above pattern – "vardak" – a symmetrical, structured, static image and was incorporated into Christian architecture.

And here, it is interesting to draw the analogy of the essence of the symbol with other similar images such as "mandalas," schematic images of the universe, which is also amazing in its diversity, at the same time having a common, clear, symmetrical-structural concept (Fig. 5).

The essence of this image is nothing but a visual schematic symbol of the universe, as it reflects the rules and cyclic regularities in the world.

Analogically it is coinciding with our "earth" as it also a "universe – world" on which the cross – a symbol of the Christian faith, stands and grows.

As a conclusion, again, it is necessary to underline the reflection of the metaphysical symbols, came from a pre-Christian time, and finds their reflection in post-pagan periods, accordingly influencing the culture and creative processes.

3 THE DEVELOPMENT OF THE METAPHYSICAL SYMBOLS WITH THEIR COVERED MEANINGS

The development of the symbol of swastika evolved into another rather common image – Arevakhach "Arev" – "Sun", and "Khach" – "Cross" (Sun Cross), also known as the Armenian Sign of Eternity – ancient Armenian symbol in the form of a circular, vortex, screw-like circle, similar to the sun.

The main meaning of "arevakhach" is the divine light, and hence the sun, the flow of life, well-being, glory, eternity and good luck. (Armenian eternity sign, 2013).

"Arevakhach" in ancient Armenia was applied to weapons, objects of everyday use, carpets, clothes, family flags and coats of arms, as well as it was used in the design of the tombs, churches, khachkars, and in general in the architecture of medieval Armenia (Fig. 4).

4 MEANINGFUL ARCHITECTURE

Further, the pearl of the medieval temple architecture is presented – the temple of "Zvartnots", (640-650 A.D.) – the "Temple of the guarding angels" from the Armenian word "zvartun" – awaken angel.

The construction of the temple, majestic in those days, began in 640 and lasted for twenty years approximately. The initiator of this large-scale construction was the Catholicos Nerses III the Restorer. (Marutyan, 1963).

This unique structure was designed to eclipse all the existing ones back then, with its scale, magnificence, and most importantly, its compositional approach and architectural appearance.

The ceremony of consecration of the colossal temple was attended by the Byzantine emperor Constans II, who wished to build a similar temple in Constantinople. In the X century, the temple collapsed during an earthquake due to the weakness of the nodes

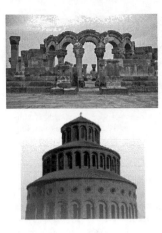

Figure 6. Ruins of Zvartnots Cathedral (at the top), and the Toros Toromanyan's visual reconstruction (at the bottom) (Mnatsakanyan, 1971).

of supports of the second tier. The ruins of Zvartnots were discovered during excavations in 1901–1907 by the architect Toros Toramanyan. (Mnatsakanyan, 1971) (Fig. 6).

If we analyse the overall architectural and planning composition from the point of view of medieval "metaphysical geometry", it is interesting to note that the "cosmogonic" spiral, which is differently reflected in many ways in a wide range of architectural monuments and objects, here as well could be fitted into the square on the plan of the temple.

Starting from the eastern wall, which also symbolically coincides with the idea of "I am the Light", this square surrounds all four corners of the square described around the circumference in a form of a spiral, it also surrounds all the four columns, eventually ending in the centre of the temple where the "heaven and earth" are connected.

The four columns, in their turn, symbolise the four gospels on which the Christian faith itself is based (Fig. 7).

The choice of the circumferential outline of the temple plan is unique. From the point of view of architectural creative thought, using the circle as a plan at the times when central-domed temples and dome basilicas were the most common forms, was considered to be a risky step, given the conservatism and traditionalism of Armenian architecture (Fig. 8).

And yet, it is precisely visible here: the phenomenon of the creative architectural inclination of Armenian architects and the stonecutters along with strict adherence to forms and laws – not to forget about the development, by putting into practice risky and bold ideas.

Analytically comparing the rectangular contours widely known at that time with the circumferential plan form, one can trace the idea of "spreading" the ideas of Christianity, tracing the dynamic essence in

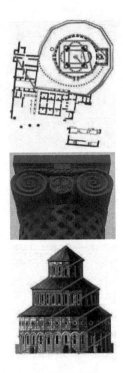

Figure 7. The symbol of "Spiral", laid over the general plan, (at the top); in the capitals of the inner columns, with the sign of the Catholicos Nerses III, (in the middle), (the photo of the author); as well as on the reconstruction facade of Zvartnots Cathedral, after Toromanian (at the bottom) (Danelyan, 2012).

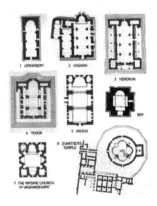

Figure 8. Types of Armenian churches (IV-VII centuries) 1 Single-nave basilica, 2–3 three-nave basilicas, 4 dome basilica, 5 church in the shape of a domed hall, 6 central domed temples, 7 cross domed temple, 8 centric temple (Harutyunyan, 1992).

visual comparison with the static, rectangular plans of the "**establishment**" in other churches and temples.

Another analytical moment of the space-planning solution of the temple consists of its visual appearance.

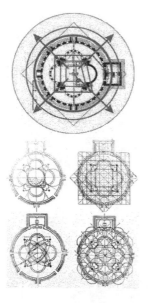

Figure 9. The spiral laid over on the plan of the temple, centrifugally "spreading" the idea of Christianity, and the Fractal geometry of the formation of the temple plan (Danelyan, 2012), (Marutyan, 1963).

When considering the reconstruction of the facade, it is possible to superimpose the same spiral already in the vertical direction, continuing the idea of **"spreading"**, both on the plan and in the general-volume appearance of the structure (Fig. 9).

This is also possible to affirm judging by the comparison of the roof slope at the top level of the temple. Usually, the roof slopes of the Armenian churches are with higher angle, in the contrast of the Zvartnots' roof lower angle.

Having a circle as the "starting" point for "spreading the idea", the whole essence of the semantic composition comes in as one natural ensemble of architectural solutions.

Here it is worthwhile to pay attention to the architectural and creative factors that formed this space. In the past, the religious buildings of Armenia were built primarily based on the main idea. In the Middle Ages, one central idea prevailed in Armenia – dissemination of the laws of the Christian religion, in particular of the Armenian Apostolic Church (Fig. 9).

That was of particular importance as a general concept of national identification for Armenia which was under the rule of the Christian but still Orthodox Byzantium at that time. As for the architecture, it is worth noting that the basic idea of building any temple or church was "the earthly manifestation of a high, hidden spiritual meaning", for the temple is a spatial manifestation of the divine idea of harmony in our visual-material world.

5 DISCUSSION

In conclusion, it should be emphasised that the essence of architecture, its authenticity, as well as the usefulness of its role in human life, only seems understandable. If we draw an analogy with other life phenomena, then sooner or later we face a situation when what once was obvious and "fully" studied, turns out to be still carrying hidden potential. This is most clearly manifested in the analysis of the influence of architecture on human life, as well as the comparison of different approaches in the creative process itself.

Thus, the design of architectural structures in different periods of past centuries is strikingly different from architectural design today, although the essence and purpose of architecture remains unchanged – to provide for the human needs in terms of the space (shelter from external natural influences, housing, creating a comfortable working space, leisure facilities, and etc.). And it is not so much about the difference in the use of creative tools, from lines and drawing boards to virtual design and using all kinds of software and BIM (Building Integrated Models) technologies, but rather about the approaches to the architecture itself, to its particular creative process to achieve the "expected" result.

Located in the Caucasus, Armenia has more than 4,500 monasteries and churches. The evolution of their architectural design from ancient times until now follows specific unique rules and regularities.

The architects of the past viewed architecture as a creative, methodical process through which it was possible to achieve the most harmonious organisation of space as a whole, regardless of the purpose and functional orientation of the structures.

It is interesting to note the general trend in the architecture of past historical periods in different cultures. It is quite often based on an analogy of the macro and microcosm, and the aspiration to organise space in accordance with the laws of the universe.

Today it is difficult to define the complete sense of the architecture, and the full impact of that kind of human creative activity.

Many architectural monuments scattered throughout the country witness the strength of the people's spirit and contain rich research material.

BIBLIOGRAPHICAL REFERENCES

Alaexis. (2010, July). File: Dadivank khachkar.JPG. Retrieved from: https://commons.wikimedia.org/wiki/File:Dadivank_khachkar.JPG

Architecture., T. G. (2012). [Armen.:'cross-stone'] Typical Armenian stone monument, comprising an upright slab (h. c. 1–3 m) carved with a cross design, usually set on a plinth or rectangular base". Oxford University Press.

Armenian eternity sign. (2013, December 3). Retrieved from Wikipedia: https://en.wikipedia.org/wiki/Armenian_eternity_sign

Avetisyan, V. (2017, May 24). Арев хач — Патераз махач — Кер хач — Армянская свастика. Retrieved from Вне Строк: https://vstrokax.net/istoriya/arev-hach-paterazmahach-ker-hach-armyanskaya-svastik/

Azatyan, S. (1987). "Portals in monumental architecture of Armenia IX-XIV centuries". Yerevan, Armenia: published by "Sovetakan Grogh" (Soviet writer).

Danelyan, M. (2012). The temple of Zvartnots and the movement to eternity. *Ejmiatsin*, 108–114.

Hakobyan, J. (2003). "Life in the Monuments of Death: A visit to the cemetery village, Noraduz". *Armenia Now*.

Harutyunyan, V. (1992). *History of Armenian Architecture*. Yerevan: Luys.

Hasratyan, M. (2010). Histoire de l'architecture Arménienne des origines à nos jours. Lyon, France.

Hastings, A. (2000). A World History of Christianity. Wm. B. Eerdmans Publishing.

Marutyan, T. (1963). *Zvartnots and Zvartnots-type temples* (Zvartnots ev zvartnocatip tacharner). Yerevan: Haypethrat.

Mnatsakanyan, S. (1971). *Zvartnots, The monuments of Armenian Architecture VII century* (Zvartnots, Pamyatnik Armyanskogo zodchestva). Yerevan: Iskusstvo.

Neapolitanskij, S. M. (2013). The world sacred architecture. Creative principles of world harmony. Moscow, Russia: Amrita-Rus.

Fantasies of space and time

Dimitra Fimi
University of Glasgow, UK
ORCID: 0000-0002-5018-3074

ABSTRACT: How does fantasy engage with concepts of space and time, both understood in collective terms (e.g. the national/cultural/universal past and landscape) or as personal concerns (e.g. death and finite time)? This paper attempts to address such questions by surveying key fantasy works of the 20th and 21st century.

Keywords: fantasy, space, time, chronotope, death, immortality, J.R.R. Tolkien, Ursula K. Le Guin, K.K. Rowling, Philip Pullman, Neil Gaiman, Alan Garner, Pat O'Shea, Susan Cooper

1 INTRODUCTION: PLAYING WITH SPACE AND TIME

Have you ever heard of paracosms? Those "worlds" that young children create, usually around toys and often in collaboration with other children? (Cohen and MacKeith, 1991; Root-Bernstein, 2014). You will, of course, know of the Brontë siblings as adults. But have you ever heard of their childhood creations, the worlds of Gondal and Angria, complete with maps, a cosmogonical framework, interweaved stories and literary traditions? (Brontë et al., 2010). These stories were acted out through a set of toy soldiers belonging to the only brother of the group, Branwell and were supported by the siblings own miniscule manuscripts and other writings.[1]

If you have heard of the young Brontës' story creations, it is quite possible you may also know about Boxen, a world of talking animals fashioned by a very young C.S. Lewis and his brother, Warnie, and based on a box of toy animals (see Lewis and Lewis, 2008). Again, the Boxen stories were augmented by elaborate adventures, maps, timelines, and other paraphernalia.

As is obvious, at least some members of both of these sets of siblings went on to become celebrated writers and especially well-recognised for their imaginative visions: the Gothic landscapes and fairy-tale references of the Brontë sisters; the land of the Animals that Talk in Lewis's *Chronicles of Narnia*.

Paracosms are within the normal range of childhood experience – if I take a show of hands I am sure there will be many in this audience who spent time as children building elaborate worlds and stories, often written down or drawn, and which were based

on toys or stories picked up from books or TV, etc. In many ways, writing fiction is very much a continuation of such activities: as Umberto Eco wisely said, "writing a novel is a cosmological matter...to tell a story you must first of all construct a world" (1985, pp. 20, 23). All fiction creates a world. But some worlds are *seemingly* closer to ours, while some are "other", alternative, imaginary, either in a subtle or in a self-conscious way.

Mark Wolf (2012) has recently examined the activity of building imaginary worlds as a topic worthy of study in its own right independent of any accompanying narrative. In most cases hitherto, narrative has been the main focus of literary criticism, while the world a novel builds is usually examined within the (rather limited) concept of "setting": place and time. But think about that: place and time, how complex and rich are those two simple terms we all use in our everyday life if we pause for a moment to consider them further? If I actually change them to "space" and "time" instead, then you may get resonances of Einstein's space-time, which gave rise to Bakhtin's concept of the "chronotope" (the fundamental unity of time and space in a narrative – an idea very much inspired by contemporary scientific thought[2]), and the vast, multi-layered, fluid, or slippery sense of space and time we get in fantasy literature.

1. For a recent comparative analysis of the worldbuilding practices of the Brontë siblings and J.R.R. Tolkien, see Mann (2019).

2. Bakhtin argues that: "In the literary artistic chronotope, spatial and temporal indicators are fused into one carefully thought-out, concrete whole. Time, as it were, thickens, takes on flesh, becomes artistically visible; likewise, space becomes charged and responsive to the movements of time, plot and history. The intersection of axes and fusion of indicators characterizes the artistic chronotope" (1984, p. 84). The chronotope is not unlike the concept of a fictional world, in which space and time are integrally interwoven. Bakhtin himself acknowledges the influence of Einstein's theory of relativity on this concept (1984, pp. 84–85).

Going back to childhood paracosms, those worlds are often very much centred around concepts of space and time – the "where", physically, can be the child's bedroom, or the garden, or the schoolyard. But that same "where", imaginatively, can be a version of our world where the child is God, or a different planet, or weird, scary, mysterious, or enchanted country somewhere "far away" or out of sight. The same goes with time. The "mundane" time, governed by clocks, teachers, and parents, can be at night after the lights are off, or at play-time in school, or one of those lazy Sunday afternoons. But the imaginative time can be the past, or the future, or the indeterminate fairy-tale "once upon a time". What is certain (and for many grown-ups who have moved too far away from their childhood selves, rather surprising) is that the child is keenly aware of this distinction (Golomb, 2011). During play, the muddy patch on the side of the lawn is a desert, or a pool of sentient sludge, or a volcanic landscape. The moment the bell rings or parent announces it is lunchtime, it is the muddy patch again, the traces of which have to be washed off from hands, and – occasionally – faces. The child navigates these alternate perceptions of space and time easily. And that is what we do too when we read fiction.

I suggest that one of the most fundamental things that fantasy literature does when presenting us with imaginary worlds or reconfigurations of our world is to challenge, to question, to redefine, to understand, to grapple and eventually come to terms with, concepts of space and time. It does not only allow the writer and reader to continue this childhood play of moving from one world to another by opening a book – in many ways, all fiction does that. Think about opening a historical novel, for example, or a realistic novel set in the Victorian period. In these examples, the past *is* another world, a "foreign country", as H.P. Hartley put it (1953, p. 1), in which the reader is immersed. But fantasy literature distorts space and time in impossible ways: for example, it can build a coherent and fully-realized alternative world with its own chronology and geography; or a version of our world in which supernatural forces erupt and challenge every sense of 'here' and 'now' we think we have; or it can construct a doorway to an "other" world or dimension, with a different concept of time; or offer us a hidden, invisible world somewhere around us, with its own historical traditions and spaces we cannot access. This is the sort of stuff of childhood paracosms writ large. Play, yes, but serious play and play with serious stuff – can it get more serious than space and time, concepts that anchor our perception of the world?

So how can fantasy literature challenge and stretch our perceptions of space and time? Let me count the ways, by taking you to a journey around imaginary worlds and their creation and creators.

2 BLENDING CHRONOTOPES: FROM THE NATIONAL/LOCAL TO THE UNIVERSAL

J.R.R. Tolkien's *The Lord of the Rings* (1954–55) has been claimed to be a 'founding' text of modern fantasy, and the 'mental template' (Attebery, 1992, p. 14) we share for defining fantasy as a genre. The moment we open the book, we seem to be in a "mythical" or an approximation of a "medieval" space and time. Middle-earth is a pre-industrial world of kings and warriors, still forested at a pre-modern level. But once we start "zooming in", as it were, and noticing details in the vastness of a seemingly coherent map, we find anachronisms and historical "accidents". Though Rohan is a simulacrum of Anglo-Saxon culture, from the architecture of Meduseld to its Old English names and place-names, to the Beowulfian scenes we find incorporated in the plot (Shippey, 2005, pp. 139–45; Shippey, 2001, pp. 90–7; Honegger 2011), the Shire is not medieval. It is 'more or less a Warwickshire village of about the period of the Diamond Jubilee' (Tolkien, 1981, p. 230; see also p. 235), complete with pocket watches, umbrellas, and fireworks. And while Tolkien compared Gondor with Ancient Egypt, Rome, and Byzantium (1981, pp. 157, 376, 281), just around the corner, on the borders of Mordor we get a glimpse of the Somme, the rotting bodies of Elves, Men, and Orcs, friends and enemies moulded together in a grim reminiscence of Tolkien's traumatic experience in the Great War (Garth, 2006).

This palimpsest of chronotopes – from Anglo-Saxon heroic culture to an Egyptian/Byzantine/Roman mash-up, to the Victorian pastoral, all the way to the battlefields of WWI – are weaved together in a tapestry that feels coherent – it is only when you turn it around that you see the knots and disparate elements "sticking out", so to speak. Yes, each "chronotope", each reference to historical space and time, brings along residues of associations that enrich and complicate the fantasy world Tolkien offers us. The hobbits' insularism and little-Englishness chimes with their Victorian-English-village chronotope. The 'noble savage' freshness and virility we see in the 'Dark-Age' Rohirrim contrasts with the 'decadent' atmosphere of a civilisation which has reached its peak and is now in decline, already felt by the Egyptian and Byzantine resonances in Gondor. This sort of fantasy that plays with time and space by hybridising historical cultures to create a complex mosaic of geopolitical concerns is also evident in George R.R. Martin's *A Song of Ice and Fire* series (1996–2011), in which we have at various points chronotopes that allude to the War of the Roses, medieval Spain, Viking raiders, and the lives of nomadic peoples of the Eurasian steppes (Larrington, 2016). It is not accidental that Tolkien claimed that his invented world, Middle-earth (itself only a part of a larger cosmological conception, Arda), is

his "version" of Europe in some mythical "proto"-prehistory (Tolkien, 1981, pp. 239, 376)[3]. Here is another challenge to how we perceive space and time: the imaginary world not as wholly "other", "alternative", or "invented", but as an echo (or perhaps a hypothetical "draft") of the world most fantasy readers recognise. Think about how this stretches the way we perceive space and time, specifically our perceptions of, and relationship with, the past.

For Tolkien, this connection of his imaginary world with the land he loved and lived in was fundamental for his creative project right from the start. When he began writing the stories of the Elves, complete with a cosmogony, stories of the gods, heroic legends, and romantic fairy stories, long before *The Lord of the Rings* was ever conceived, the world he was writing about was not Middle-earth, but England (Tolkien, 1984, pp. 278–94). Tolkien's original impetus to create a world was a nationalistic project: he felt compelled to "restore to the English…a mythology of their own" (Tolkien, 1981, pp. 230–1), following similar projects of re-discovering (or inventing!) national mythologies in Germany, Denmark, and Finland, alongside (and in antagonism with) the earlier 'Celtic' revival (Fimi, 2008, pp. 50–55; Shippey, 2000). This concern with the national/cultural mythological past – it seems to me – is a particular interest of at least one strand of fantasy and fantastic writing. Good examples of this concern are the successful children's and young adult fantasies that flourished in the British Isles in the generation that followed Tolkien and his friend C.S. Lewis. Susan Cooper, Alan Garner, Pat O'Shea and many other children's fantasists did not invent entire alternative imaginary worlds. They set their stories in Cornwall, or Buckinghamshire, or Cheshire, or North Wales, or Galway – real landscapes of the British Isles in contemporary times, but with intrusions (or even eruptions) of the mythological past into the modern world. In *The Hounds of the Mórrígan* (1985), rural Galway is invaded by the medieval Irish 'goddess' of strife and destruction, and the child protagonists enter an otherworldy version of Ireland (still recognisable by landmarks on the landscape, but also clearly 'other' and enchanted), in order to save their own intruded world from annihilation. In *The Owl Service* (1967), a cursed love triangle from the Welsh *Mabinogion* tales is involuntarily re-enacted by three teenagers and seems to affect the physical world around them. In Susan Cooper's *The Dark is Rising* sequence (1965–1977), King Arthur returns from the Romano-Celtic past in order to continue a perennial fight between good and evil, a narrative focus which Cooper very much associated with her childhood memories of WWII[4]. Such fantasies begin as if they are realistic fiction and invite us to re-conceptualise the world around

us, allowing it to be disrupted (and sometimes healed) by the past. Past and present stop being distinct but bleed into each other.

The case of the *Harry Potter* books (1997–2007) is in some ways similar, but also distinct. It has been argued that the *Harry Potter* books are an example of portal fantasy (Butler, 2012) with platform 9 3/4 as a 'passageway' to the magical world of Hogwarts. But I prefer Gamble and Yates's classification of the *Harry Potter* series as a world-within-a-world, marked off by physical boundaries" (2008, p. 122). I think this taxonomical category acknowledges the fact that the *Harry Potter* universe exists in our world, the world as we know or perceive it. Hogwarts exists in a real place in Britain – in Scotland, in fact! – and Diagon Alley exists in London, as does Sirius Black's house, 12 Grimmauld Place. It is just that we do not have the means or special powers to access them. Our 'muggle' eyes do not see them. But the world in which Harry operates is our world, though 'revised' to accommodate an entire alternative history that dovetails into, or even sometimes 'explains', ours. Take, for example, the historical witch-hunts and witch trials in Britain and Europe in the late Middle Ages and Early Modern periods. J.K. Rowling incorporates them into her 'magical history' of the wizarding world and 'explains' that us, 'muggles', have got the wrong end of the stick about them[5]. At the same time, the entire trajectory of the seven *Harry Potter* books is an attempt to re-tell the story of the Holocaust. From Social Darwinism, the Eugenics, and the rise of Nazi Germany, to the persecution of 'mudbloods' and the pursuit of a 'pure' magical race who adopts the motto 'magic is might', the parallels are deliberate and unmistakable. I have often taught the *Harry Potter* books in children's literature courses, immediacy following books for children that deal with racism and segregation in a realistic, historical context, such as Mildred Taylor's *Roll of Thunder, Hear My Cry* (1976), which is set in southern Mississippi in the 1930s, or Jamila Gavin's *Coram Boy* (2000), which is set in the 18th century, with slavery as one of its thematic strands. For difficult themes such as racism, which many children still face today, it could be argued that tackling the issue through contexts set within historical novels can be at least as beneficial as that offered through contemporary fiction. It can, in fact, be easier to talk about *past* horrors (and give hope by offering a contrast with the, sometimes, improved situation today), rather than

3. For a detailed discussion see Fimi, 2008, pp. 160–88.
4. For a detailed discussion of the way in which O'Shea, Garner, and Cooper engage with the "Celtic" past and with notions of heritage, see Fimi, 2017.

5. As Harry writes in a school essay: "Non-magic people (more commonly known as Muggles) were particularly afraid of magic in medieval times, but not very good at recognizing it. On the rare occasion that they did catch a real witch or wizard, burning had no effect whatsoever. The witch or wizard would perform a basic Flame Freezing Charm and then pretend to shriek with pain while enjoying a gentle, tickling sensation. Indeed, Wendelin the Weird enjoyed being burned so much that she allowed herself to be caught no less than forty-seven times in various disguises" (Rowling, 1999, p. 7).

focus on the now and a child's immediate experience (Brooks and Hampton, 2005). Well, doesn't fantasy do the same thing? Instead of taking us to the "else-where" of the past, it takes us to the "elsewhere" of an invented world. In many ways, both *realistic* depictions of historical racial prejudice (such as *Roll of Thunder, Hear My Cry*) and *fantastical* re-imaginings of historical racial prejudice (such as the *Harry Potter* books) create 'safe spaces' for children (and adults, I would claim!) to explore and question assumptions and ideological stances. The social commitment of this strand of fantasy is expressed via distorting percep-tions of historical time. The *Harry Potter* books fulfil the function of 'mythologising' current anxieties and concerns – an idea I shall return to.

So fantasy often deals with the immediate histori-cal past, but – as we saw above – also with ideas of heritage and the national/cultural past. We could think of fantasy as a post-Romantic phenomenon, a mode of fantastic writing that deals with local mythological traditions: the echoes of the past in the landscape. But there is also fantasy that moves beyond the regional or national. Turning to perhaps the most acclaimed author of American fantasy in the 20th century, and a creator of a world to rival Tolkien's, we find a different chal-lenge to space and time. I am talking, of course, about Ursula K. Le Guin's *Earthsea* series (1986–2001). In contrast to the large singular land masses that define the likes of Tolkien's Middle-earth and other fantasy worlds inspired by it, Le Guin made a conscious pivot away from the "white" "European" model, and set Earthsea within an archipelago of islands, thus provid-ing a chronotope at once more primal and also more inward-looking. Earthsea is a world mostly made of water, where journeys are made by boat as opposed to long walks, and where communities are both iso-lated from each other, but more close-knit. It is also very deliberately a non-white world: the majority of characters are deliberately copper-brown in complex-ion (Le Guin, 2004). Le Guin evokes a more distant past, a past of tribal communities who share similar shamanic practices and rituals. In some ways, her fan-tasies are an effort to capture an "unrecorded" past, a past before the mythological traditions that rely on the written text, a past that we can only glimpse through anthropology. And I think that the past she is evok-ing is meant to be a universal past: what was there before Egypt, and Ancient Greece and Rome, and medieval Europe? What was there in the other places of the world, where we do not get written mythologi-cal texts until much later, but where there must have been rich oral traditions, beliefs, folk narratives, and rituals? What were those first human tribes and social groups thinking, imagining, dreaming? As eloquently captured by Attebery:

> Le Guin is taking her concept of magic from a different source than Tolkien's. She has gone right past courtly romance and peasant lore to the universal beliefs of

tribal societies. Hers is the magic of ritual name-bestowal, and singing to the hunted animal, and In the beginning was the Word. Her wizards are shamans, witch doctors. Like Claude Levi-Strauss, she revives the ancient, magical view of the universe, the so-called savage mind, as an interesting alternative to our mech-anistic, scientific view of the cosmos. (Attebery, 1980, p. 168)

This same impulse to go back the universal is also evident in Neil Gaiman's acclaimed novel *American Gods* (2001), which is based on the premise of old gods and traditions moving, changing, and adapting in space (America, in that case) and time. Apart from the array of Egyptian, Norse, Baltic, and Celtic gods and divinities we see parading through its pages, we also get a glimpse of forgotten gods lost in the mists of pre-textual time. The tale of the priestess Atsula and the mammoth-headed god Nunyunnini is a story set in 14,000 BCE, following a group of nomadic peo-ple from a Siberian tribe. These invented people, with invented names, re-enact a story that Gaiman repeat-edly follows in his novel, interweaved with actual named gods and recorded historical cultures: as they each come to America, they adapt and, often, change beyond recognition, or even become altogether forgot-ten. Just like Le Guin's invented tribal societies which can be read as an evocation of a universal 'primaeval' past, Gaiman's Siberian tribe seems to be an attempt to go back to a space and time of which we know nothing for sure, but which we can only imagine and construct as an 'other' version of ourselves.

3 PERSONAL SPACE AND TIME: CONTEMPLATING FINITENESS

So far, I have talked about chronotopes in fantasy lit-erature that make us reconsider (and re-evaluate) our relationship to space and time: Are imaginary worlds entirely imaginary? How do we grapple with fantasy's creative re-use (and often amalgamation) of mytholog-ical traditions, historical cultures, and the evocation of the national or universal past?

But place and time work in other ways too. There is that personal sense of time that definitely feels linear – at least that is how most of us experience it. We live our lives around calendars and clocks. We count birthdays and anniversaries. We remember things by meaningful dates which are often rites of passage: births, grad-uations, weddings, deaths. Well, that is where I am heading really: death. The finiteness of time that many of us are keenly aware of: we plan our lives around achieving our dreams in the time we have, we compile 'bucket lists' of things to do before we die. As Henry Wadsworth Longfellow so eloquently caught it in "A Psalm for Life", in that ruthless anapaestic metre that does, actually, sound like drums beating rhythmically:

Art is long, and Time is fleeting, And our hearts, though strong and brave, Still, like muffled drums are beating Funeral marches to the grave. (1868, p. 3)

That sense of the finiteness of time, of the inevitability of death, is something that fantasy literature has often grappled with. How do we live with the knowledge of death? How would we live if we did not die? What if there is something out there, after death? And what would be the cost of pursuing immortality against the natural order of things?

I'll start with Tolkien, again, for the reasons outlined above, and because he was quite outspoken about the centrality of death in his fantasy, not least in his self-reflective and self-theorizing essay "On Fairy-Stories", his 'manifesto' on what fantasy is and how it is supposed to work (Flieger and Anderson, 2008, p. 9). In his theorising, Tolkien offers 'escape' as one of the main functions of fantasy. He claims fantasy helps authors and readers *escape from* a trite, mundane, unimaginative world, but also, importantly, the constraints 'reality' imposes on us. For Tolkien, fantasy is a vehicle for breaking those constraints and satisfying impossible desires: the desire to converse with other living creatures such as animals; the desire to fly like a bird; and "the oldest and deepest desire, the Great Escape: the Escape from Death" (Tolkien, 2008, p. 74). Tolkien went so far as to say that *The Lord of the Rings* 'is about Death and the desire for deathlessness' (Tolkien, 1981, p. 262).

Death vs immortality (or, perhaps more accurately, a definite end to life, vs serial longevity), is one of the central binaries in Middle-earth. Men are – as the One Ring verse brutally declares – "doomed to die". The Elves, on the other hand, do not partake in that "doom" – in that destiny. They can be killed by violence, but they have the ability to return. Their souls and bodies are bound to the created world itself – as long as it exists, they exist. What happens to Men when they die within the framework of Tolkien's mythology, is a mystery. No one knows. Just like in our 'real' world, there are educated guesses, but no one has come back to tell the tale. In some ways, therefore, the anxiety and bitterness over the 'doom' of Men is one about knowledge vs ignorance, something captured in a poignant late work by Tolkien, published only posthumously, the (Platonic in mode) dialogue between Finrod Felagund and Andreth (Tolkien, 1994, pp. 301-66). In this piece, Andreth, a wise but all too human woman and Finrod, an Elvish Lord, discuss the problem of death. Is death a punishment? Is it a 'gift'? Is it part of a 'natural' cycle? I think it extraordinary how Tolkien's immersive worldbuilding is strong enough, secure enough, to allow the reader to explore and empathize with the dilemmas and metaphysical anxieties of a woman and an Elvish lord while they debate life and death: how can creatures with different 'dooms' interact in a world that accommodates them both? How can a mortal woman and an immortal man live and love together?

Tolkien asked that question the other way around too, at least twice. The Elvish maiden in love with a mortal man is at the heart of one of the key stories of Tolkien's extended mythology, the tale of Beren and Lúthien, and these two names meant much more to Tolkien than just the embodiment of two different life spans and the dilemma of love between two different 'species'. It is well-known that the love story of Beren and Lúthien is a 'calque', a 'mythologising' of the young love, forbidden and therefore reinforced, between the young Tolkien and Edith Bratt, later his wife and lifelong companion (Carpenter, 1977). They are buried together at Wolvercote Cemetery in Oxford, and their gravestone bears the names of Beren and Lúthien. The motif of the 'fairy' woman and the mortal man, the latter seduced and doomed to lunacy, melancholy, or death, is an international folklore motif and common in many Northern European traditions. But in Tolkien's hands, it becomes a vehicle to explore the question of death and immortality again. Like an inversion of the Orpheus story (Libran-Moreno, 2007), Lúthien brings Beren back from death, but in doing so, has to forgo her immortality in order to be with him. That same dilemma is re-enacted thousands of years and many generations later by Aragorn and Arwen, descendants of Beren and Lúthien when Arwen faces the same ruthless choice. The moment of Aragorn's death, as narrated in the Appendices of *The Lord of the Rings*, and Arwen's subsequent aimless existence contemplating her own demise is a curious mix of melancholy and despair[6].

This is the stuff of myth – the sort of fundamental human questions that myth in its religious or spiritual guise has attempted to answer through the centuries. The tales of Beren and Lúthien, and Aragorn and Arwen are comparable to that of Eos and Tithonus in the Homeric Hymns (Faulkner, 2008): Eos is the goddess of the Dawn, who wished for her mortal lover, Tithonus, to become immortal. He was granted that gift from Zeus, but Eos forgot to ask for eternal youth for him too, so Tithonus is condemned to be forever ageing but never will he die! In some later retellings, he becomes a cricket, or a cicada, singing eternally, begging for death. In Tolkien's world, the Elves grow weary of the world to which they are tied and cannot escape. One way of looking at it is that the Elves are 'stuck' in the world, 'doomed' to be disillusioned, tired and melancholy, while Men may actually 'escape' to an unknown, but perhaps more interesting 'other' place through death. Time and space mean something very different to Elves and Men in this context.

The desire of deathlessness is also an important part of how fantasy deals with time. What if we could find a way to avoid death? What would be the price of non-finite time?

6. Despite Tolkien's usual rejection of despair (see esp. Tolkien, 2004, p. 269).

Death is a central theme in J.K. Rowling's *Harry Potter* series. As part of a recent interview with J.K. Rowling, Geordie Greig claimed that 'Death is the key to understanding J K Rowling'. He quotes her saying:

> My books are largely about death. They open with the death of Harry's parents. There is Voldemort's obsession with conquering death and his quest for immortality at any price, the goal of anyone with magic. I so understand why Voldemort wants to conquer death. We're all frightened of it. (Greig, 2006)

But 'understanding' Voldermort's desire does not mean approving or rewarding it. The central 'message' of the Harry Potter series is that death is a natural part of life and should be accepted as such. Attempting to escape it is not just folly, but at best morally questionable, at worst reprehensible. In Rowling's world, other than possession of the Philosopher's stone (which is deliberately destroyed at the end of the first book[7]) it takes an act of murder to achieve a semblance of immortality by ripping part of one's soul from the whole. But even this is more like an insurance against death, which is still finite. The price is too terrible. The power it bestows too intoxicating.

In Le Guin's Earthsea, one wizard's pursuit of immortality threatens the invented world itself. At the beginning of *The Farthest Shore*, the final book of the first trilogy, we encounter a state of "thinning"[8]: magic is seeping out of the world, and people and animals are sickening. The main protagonist, Ged, whose life we have followed throughout this entire first trilogy, and who is now the Archmage of Earthsea, travels with the young prince Arren to the "Dry Land", the land of the dead. Here, Ged and Arren find a deranged wizard who has managed to breach the divide between the world of the living and the land of the dead so as to guarantee his own immortality – or, more accurately, his serial longevity. However, as is so often the case in the many tales we have examined, this comes at a great cost to the protagonist, who now exists in a pitiful state in-between life and death. But this condition of being half dead and half alive takes on a greater significance, when one understands that in contrast to Tolkien and Rowling who operate within a Judeo/Christian worldview in which there is hope for 'something' beyond

death, in Le Guin's trilogy, operating within an Eastern/Taoist perspective, death is but one aspect of a circular rite of passage, rather than the 'end-game' within a more simple linear structure. Accordingly, when Ged refers to the long-dead legendary king of Earthsea, Erreth-Akbe, he explains that the part of the King that survives is not merely his name, nor his shadow in the land of the dead, but rather it is out there, in the world of the living, albeit in a different form:

> He is the earth and sunlight, the leaves of trees, the eagle's flight. He is alive. And all who ever died, live; they are reborn and have no end, nor will there ever be an end. (Le Guin, 2018, p. 371)

Earlier on, Ged has already explained to Arren that:

> Life rises out of death, death rises out of life; in being opposite they yearn to each other, they give birth to each other and are forever reborn. And with them, all is reborn, the flower of the apple tree, the light of the stars. In life is death. In death is rebirth. What then is life without death? Life unchanging, everlasting, eternal?-What is it but death – death without rebirth? (Le Guin, 2018, p. 343–5)

Importantly, Philip Pullman also manages to explore the finiteness of personal time and death in *His Dark Materials* trilogy (1995–2000), but this time from a humanist, rather than a religious or spiritual perspective. When Lyra descends to the land of the dead to free ghostly remains from an existence of perpetual remorse and torment, she promises them a version of an 'afterlife' that chimes with Le Guin's, whilst also applying a materialistic understanding of the universe: "a pure physical absorption into cosmic matter" (Wehlau, 2008, p. 45):

> "This is what'll happen," she said, "and it's true, perfectly true. When you go out of here, all the particles that make you up will loosen and float apart, just like your daemons did. If you've seen people dying, you know what that looks like. But your daemons en't just nothing now; they're part of everything. All the atoms that were them, they've gone into the air and the wind and the trees and the earth and all the living things. They'll never vanish. They're just part of everything. And that's exactly what'll happen to you, I swear to you, I promise on my honour. You'll drift apart, it's true, but you'll be out in the open, part of everything alive again." (Pullman, 2000, p. 335)

In the last two fantasy texts, I have discussed, death is not just bound to time (the notion of a cut-off point of a personal timeline, and what may come after) but also to space. In Pullman and Le Guin we get a "land" of the dead, a particular place where the dead live, or where they are rather trapped and from where they can be freed. This is a very different version of Tolkien's notion of "escape". This is not escaping from death into deathlessness but escaping the view of afterlife prevalent in the classical and Judeo-Christian tradition, into other spiritual or philosophical alternatives.

7. Already from the first book in the series, which addresses a younger readership, we have a clear indication that death is something to accept. As Dumbledore says to Harry about the choice of Nicolas and Perenelle Flamel to destroy the philosopher's stone and eventually die: "'To one as young as you, I'm sure it seems incredible, but to Nicolas and Perenelle, it really is like going to bed after a very, very long day. After all, to the well-organised mind, death is but the next great adventure" (Rowling, 1997, p. 215).
8. The term comes from Clute and Grant's definition of the structure of fantasy, which often begins with the stage of "bondage", a sense of "wrongness" which can be expressed by the "secondary" world undergoing a "thinning of texture, a fading away of beingness" (Clute and Grant, 1997, p. 339).

4 FANTASY AND/AS MYTH

Fantasy comes very close to the function of myth when dealing with death and immortality and other 'big' existential questions, such as the origin of evil. Not by attempting to establish religious dogma or offer a scientific explanation, but through the telling of an imaginative story. In many different cultures around the world, myth has served as a creative, but also a economical way of thinking about the world and fundamental questions of human existence. Mary Beard (in Bragg, 2008), in a concise and lucid discussion on the function of myth, has suggested that we should be thinking of myth as a verb ('to myth'), as a process that allows different societies to express their worldviews, beliefs, fears and anxieties by *telling a story*.[9] The same can be claimed about the way in which fantasy deals with national, cultural, or universal pasts and landscapes – it hybridises and mythologises them. Laurence Coupe, drawing on the philosopher Paul Ricoeur, has examined myth as a vehicle to explore and understand reality via a symbolic, metaphorical way of thinking (Coupe, 2009, pp. 8-9). Fantasy seems to be doing something very similar. By stretching, distorting, and expanding space and time – understood as either collective or personal concepts – fantasy harnesses creativity to make us think of new, alternative, fresh ways about them. In many ways, it brings us back to those moments of childhood imaginary play: the sort of activity that helped our younger selves develop. As the late, and much-missed, Terry Pratchett once, reportedly, said:

> 'Fantasy is an exercise bicycle for the mind. It might not take you anywhere, but it tones up the muscles that can.' (2015).

BIBLIOGRAPHICAL REFERENCES

Attebery, B. (1980). The Fantasy Tradition in American Literature: From Irving to Le Guin. Bloomington: Indiana University Press.

_____. (1992). *Strategies of Fantasy*. Bloomington: Indiana University Press.

Bakhtin, Mikhail (1984). Forms of Time and of the Chronotope in the Novel. In M. Holquist (Ed.), *The Dialogic Imagination: Four Essays* (pp. 84–258). Austin: University of Texas Press.

Bragg, M. (2008, March 13). In Our Time: The Greek Myths. London: BBC Radio 4.

Brontë, C., Brontë, E., and Brontë, A. (2010). *Tales of Glass Town, Angria, and Gondal: Selected Writings* (edited by Christine Alexander). Oxford: Oxford University Press.

Brooks, W. and Hampton, G. (2005). Safe Discussions Rather Than First Hand Encounters: Adolescents Examine Racism Through One Historical Fiction Text. *Children's Literature in Education*, 36(1), 83–98. doi: 10.1007/s10583-004-2191-0

9. See also Fimi (2012).

Butler, C. (2012). Modern Children's Fantasy. In E. James and F. Mendlesohn (Eds.) *The Cambridge Companion to Fantasy Literature* (pp. 224-35). Cambridge: Cambridge University Press.

Carpenter, H. (1977). *Tolkien: A Biography*. London: Allen and Unwin,

Clute, J. and Grant, J. (1997). *The Encyclopedia of Fantasy*. London: Orbit.

Cohen, D. and MacKeith, S. (1991). The Development of Imagination: The Private Worlds of Childhood. New York: Routledge.

Coupe, L. (2009). *Myth*. London: Routledge.

Eco, U. (1985). *Reflections on The Name of the Rose*. London: Secker & Warburg.

Faulkner, A. (2008). The Homeric Hymn to Aphrodite: Introduction, Text, and Commentary. Oxford: Oxford University Press.

Fimi, D. (2008). Tolkien, Race, and Cultural History: From Fairies to Hobbits. Basingstoke: Palgrave Macmillan.

_____. (2012). Tolkien and the Fantasy Tradition. In Whitehead, C. (Ed.) *The Fantastic: Critical Insights* (pp. 40–60). Ipswich, Mass.: Salem Press.

_____. (2017). Celtic Myth in Contemporary Children's Fantasy: Idealization, Identity, Ideology. London: Palgrave Macmillan.

Flieger, V., and Anderson, D.A. (2008). Introduction. In Tolkien, J.R.R., *Tolkien on Fairy-Stories* (edited by Verlyn Flieger and Douglas A. Anderson, pp. 1–23). London: HarperCollins.

Gaiman, N. (2000). *American Gods*. London: Headline.

Gamble, N. and Yates, S. (2002). Exploring Children's Literature: Teaching the Language and Reading of Fiction. London: Paul Chapman.

Garth, J. (2006). Frodo and the Great War. In W.G. Hammond and C. Scull (Eds.), *The Lord of the Rings, 1954–2004: Scholarship in Honor of Richard E. Blackwelder* (pp. 41–56). Milwaukee: Marquette University Press.

Golomb, C. (2011). The Creation of Imaginary Worlds: The Role of Art, Magic and Dreams in Child Development. London: Jessica Kingsley Publishers.

Greig, G. (2006, September 1). 'There would be so much to tell her...'. *The Telegraph*. Retrieved from: https://www.telegraph.co.uk/news/uknews/1507438/There-would-be-so-much-to-tell-her....html

Hartley, P.J. (1953). *The Go-Between*. New York: Knopf.

Honegger, T. (2011). The Rohirrim: 'Anglo-Saxons on Horseback'? An Inquiry into Tolkien's Use of Sources. In J. Fisher (Ed.) *Tolkien and the Study of his Sources: Critical Essays* (pp. 116–132). Jefferson: McFarland.

Larrington, C. (2016). Winter is Coming: The Medieval World of Game of Thrones. London: I.B. Tauris.

Libran-Moreno, M. (2007). 'A Kind of Orpheus Legend in Reverse': Two Classical Myths in the Story of Beren and Lúthien. In E. Segura and T.M. Honegger, *Myth and Magic: Art According to the Inklings* (pp. 143–85). Zollikofen: Walking Tree Publishers.

Le Guin, U.K. (2004). A Whitewashed Earthsea: How the Sci Fi Channel Wrecked my Books. Retrieved from: http://www.slate.com/articles/arts/culturebox/2004/12/a_whitewashed_earthsea.html

_____. (2018). The Books of Earthsea: The Complete Illustrated Edition. London: Gollancz.

Lewis, C. S. and Lewis, W.H. (2008). *Boxen: Childhood Chronicles Before Narnia*. New York: HarperCollins.

Longfellow, H.W. (1868). *The Poetical Works of Henry Wadsworth Longfellow*. London: George Routledge and Sons.

Mann, M. F. (2019). Artefacts and Immersion in the World-building of Tolkien and the Brontës. In D. Fimi and T. Honegger (Eds.), *Sub-creating Arda: World-building in J.R.R. Tolkien's Works, its Precursors, and Legacies* (pp. . . .). Zollikofen: Walking Tree Publishers.

Pratchett, T. (2015, March 12). Terry Pratchett in Quotes: 15 of the Best. *The Guardian*. Retrieved from: https://www.theguardian.com/books/booksblog/2015/mar/12/terry-pratchett-in-quotes-15-of-the-best

Pullman, P. (2000). *The Amber Spyglass*. London: Scholastic.

Rowling, J.K. (1999). *Harry Potter and the Prisoner of Azkaban*. London: Bloomsbury.

Root-Bernstein, M. (2014). *Inventing Imaginary Worlds*. Lanham, MD: Rowman and Littlefield.

Shippey, T. (2000). Grimm, Grundtvig, Tolkien: Nationalisms and the Invention of Mythologies. In M. Kuteeva (Ed.) *The Ways of Creative Mythologies: Imagined Worlds and Their Makers* (Vol. 1, pp. 7–71). Telford: Tolkien Society Press.

_____. (2001). *J.R.R. Tolkien: Author of the Century*. London: HarperCollins.

_____. (2005). The Road to Middle-earth: Revised and Expanded Edition. London: HarperCollins.

Tolkien, J. R. R. (1981). *The Letters of J. R. R. Tolkien* (edited by Humphrey Carpenter with the assistance of Christopher Tolkien). London: Allen & Unwin.

_____. (1984) *The Book of Lost Tales, Part Two* (edited by Christopher Tolkien). London: George Allen & Unwin.

_____. (1993). *Morgoth's Ring: The Later Silmarillion, Part One: The Legends of Aman* (edited by Christopher Tolkien). London: HarperCollins.

_____. (2004). *The Lord of the Rings, 50th Anniversary Edition* (edited by Wayne G. Hammond & Christina Scull). London: HarperCollins.

Wehlau, R. (2008). Truth, Fiction and Freedom: The Harrowing of Hell in Philip Pullman's *The Amber Spyglass* and Ursula Le Guin's *The Other Wind*. In M. J. Toswell (Ed.), *The Year's Work in Medievalism*, XXII (pp. 43-53). Eugene: Wipf & Stock.

Wolf, M.J.P. (2012). Building Imaginary Worlds: The Theory and History of Subcreation. New York: Routledge.

Traces of a recreated reality: Rafael Bordalo Pinheiro's busts of Pai Paulino

Maria do Rosário Pimentel
CHAM, FCSH, Universidade NOVA de Lisboa, Lisbon, Portugal
ORCID: 0000-0001-7737-6952

ABSTRACT: Putting the main focus on a dimension of Rafael Bordalo Pinheiro' work, it can be observed that he made clay the raw material of his sculptures, represented as social mirror, with intelligence, sensibility and creativity. The plasticity of the material and the associated technique allowed him to emphasise facial traits, to caricature gestures and features, and to fill with life the depiction of several figures of his time. He sculpted busts of distinguished persons, and immortalised street characters and popular, picturesque or iconic figures of Portuguese society, either anonymous or not. In such a collection, we will find the representation of some black people, among them the former slave Pai Paulino, a popular figure of the 19th century Lisbon.

Keywords: Rafael Bordalo Pinheiro, Pai Paulino, creativity, slavery, colonialism, Berlin Conference, British Ultimatum, artistic representations of black people, caricature, art/testimony

1 INTRODUCTION

Intelligence, Creativity and Fantasy are three challenging concepts, provided the complexity and intercessions they hold concerning the processes of knowledge, the sensitivities, the association and production of ideas, the capacity for resolutions and the production of objects. The unknown is processed with imagination when engaging the rational and emotional intelligence, the mental system. Yet, if it is true that creativity presupposes imagination, the latter goes further, opening a space towards fantasy.

When combined with human rationality and sustained by the imagination, creativity, essential in everyday resistance and an inseparable companion to freedom, is a condition for humanity's survival and development. Taken, for a long time, as an ability only reachable by some minds in very specific fields, creativity is now understood as a potentiality of intelligence, liable to be developed by all humans. Innate or acquired, it is part of a learning process enabling each person to obtain the capabilities to create and recreate objects and goals and to ponder on ways of thinking and generate energy. It allows for dreaming, for conceiving, enacting, interpreting, to understand, to represent, to transmit, and to raise awareness.

The imagination surrounds us beyond what we think. There is no universe, nature or history without imagination. There is no knowledge without creativity. There are no experiences or truths without knowledge, imagination and emotion. The creative ability applies to the most various domains, to any activity and all aspects and levels of our existence from the individual to the social, from the concrete to the dream, from the sensibility to the belief. We dare to say that learning to imagine equals learning to live and, like all human action, entails a cultural enhancement.

For this study, we engaged with Rafael Bordalo Pinheiro (1846–1905), one of the most important figures of Portuguese culture in the late 19th and early 20th centuries, and how he depicted Africans in his artistic production. The subject is directly related to the issues of colonialism and slavery. Slavery that, as a social matter, was not only itself a human creation, constantly recreated throughout the ages, but was also a source of inspiration and reflection on the human condition. In this case, the approach focuses on the figures of black people residing in Portugal and is based on the reflections provided by the busts of the unique figure Pai Paulino.

2 THE MULTIFACETED WORK OF BORDALO PINHEIRO

A shrewd observer of deep sensibility and humanism, and carrier of unique creativity and strong critical voice, Bordalo Pinheiro portrayed black people in all sorts of ways in his vast and diversified artistic work, pointing to modes of life and patterns of relationship. Based on his work, we attempt a possible interpretation of some of his pieces, with the conviction that it is required to know how to 'read' Bordalo. We will try to find the discourse that underlies the work of

this remarkable spirit who has endowed his art with an intense social meaning and a no less intense criticism of manners.

Versatile in his areas of interest, he was the author of a written, drawn, painted, and modelled body of work with relevant documental value for the history of Portugal of the last quarter of the 19th century. He was a draughtsman, watercolourist, illustrator, decorator, publicist, the precursor of the artistic poster in Portugal, and master of the lithography. In love with the theatre, he was an actor. Aware of the cultural and political life, he left countless chronicles where he depicts several aspects of that day-to-day life. As a journalist, he had an intensive activity, contributing both to the national and international press. He published several newspapers, albums and almanacks, in which he had the collaboration of renowned authors, as Guerra Junqueiro, Guilherme de Azevedo (using the pseudonym João Rialto), Ramalho Ortigão, João Chagas, Júlio Dantas and D. João da Câmara, among many others[1].

He was an eminent caricaturist, using humour and satire as his main weapons. In 1875, in the humoristic newspaper *A Lanterna Mágica*, the first Portuguese daily publication dedicated to social criticism, emerged one of his most famous creations: the *Zé Povinho* (Joe Public). A symbol of a resigned people, who has in the 'manguito' (arm-gesture of contempt or insult) his most potent weapon against the sovereign powers[2]. The success of this figure was so substantial that it remains as a critical reference in Portuguese life (Silva, 2007: 243–253). Similarly, the incisive titles and drawings on the cover of the magazine *A Paródia*, with which he qualified the political, social and economic reality of his time, are still relevant. Nowadays, the most widespread are *A Política: a Grande Porca* (Politics: the Great Swine), *A Finança: o Grande Cão* (Finance: the Great Dog),

A Economia: a Galinha Choca (Economy: the Broody Hen) or *A Retórica Parlamentar: o Grande Papagaio* (The Parliamentary Rhetoric: the Great Parrot) (Pinheiro, 1900, 24 de Janeiro; 1900, 17 de Janeiro; 1900, 16 de Maio; 1900, 7 de Fevereiro)[3].

From 1885, Bordalo Pinheiro devoted himself to ceramics in the newly created Fábrica de Faianças das Caldas da Rainha (faience factory), of which he was appointed artistic director. He introduced the industrial manufacture with modern machinery and equipment, as well as workers with specialised artistic and technical training. The pieces he created, with naturalistic features, intertwine a keen awareness of reality with a rich and daring imaginary. His extensive production ranges from utilitarian tableware to decorative items both for indoor and outdoor, including garden ornaments, colourful roof tiles and recreational glazed tiles that, in José Augusto França's words, reflect an "end-of-century" taste between the popular and the "kitsch" (França, 1992, p. 96).

He also devoted himself to sculpture, which he combined with portrait. He chose clay as the raw material for his stereotyped figures, where the plasticity of the material enabled him to emphasise facial traits and to caricature gestures and features of several figures of his time. He sculpted busts of distinguished persons, and immortalised street characters and popular, picturesque or iconic figures of Portuguese society, either anonymous or not. The *bonecos de movimento* (movement figures) became famous, such as the Nany from Caldas, the Policeman, the Sacristan and the Priest. Also celebrated were 60 figures from the passion of Christ that he sculpted, commissioned by the Portuguese government, for the Buçaco Chapels[4]. According to Fialho de Almeida's critical appraisal, "they are the dawning in the national sculpture of a dramatic era only sporadically renewed after Machado de Castro [. . .]" (Almeida, 1933: 116; Cf.Couto, 2003–2006).

From the lower social rankings, the black people did not go unnoticed, with existence in Portuguese society going back centuries, linking them to slavery and the collective imagination. Bordalo placed them alongside Zé Povinho, Patient Mary, the Priest, the Policeman and many other key figures, giving them the honour to be part of his gallery of figures from everyday life. In representing them, the ceramist, in a more or less burlesque fashion, stressed their features, enhanced the colours, evidenced their muscles, emphasised their qualities and flaws, and provided them with captions of mismatched worlds. Notwithstanding, by depicting them, he gave them authenticity and a place in Portuguese society, regardless of the humorous features,

1. The newspapers *O Binóculo* (1846–1905a), *A Lanterna Mágica* (1868–1875), *O António Maria* (1846–1905b), *A Paródia (1846–1905c)*, the albums of caricatures *O Calcanhar de Aquiles* (1870), *Álbum das Glórias* (1880–1883) and the comic strip *A Berlinda* (1870–1871) were some of Rafael Bordalo's publications in Portugal. He also published the *Mapa de Portugal* (Map of Portugal), which had great success, with sales of over 4000 copies within a month. Between 1873 and 1875, he collaborated as an illustrator in the Spanish journals *Illustración* of Madrid, *Illustración Española y Americana*, *El Mundo Cómico*, *El Bazar* Illustración and in several French and English magazines. During his stay in Brazil, he directed, collaborated and owned several publications, as was the case, of the caricature magazines *Psit!!!* (1877) and *O Besouro* (1878–79), without ever losing contact with the Portuguese reality and editions (Couto, 2003–2006).
2. José Augusto França, an eminent Portuguese art historian, when referring to this newspaper, praises the author by pointing out that in a period marked by the mediocrity of the national graphic humour, "a work of quality emerged, due to the allusive imagination and the skill of the drawing" (França, 1992: 93)

3. On the relevance of Bordalo in illustrated journalism in Portugal see the article by Raquel Henriques da Silva (2007: 242).
4. Of the 86 figures commissioned, Rafael Bordalo Pinheiro only made 60 that are in José Malhoa Museum, in Caldas da Rainha, Portugal.

with which he might or might not have enwrapped them.

3 TRACES OF A RECREATED REALITY

Present in almost every economic sector, performing the most different tasks, living side by side with all the other elements of the population, the Africans, of a more or less pronounced colour, and either slaves or freemen did not fully participate in Portuguese society. Yet, it can neither be said that they were unwanted. On the contrary, they have always been seen as an essential labour force and an important factor for wealth. However, their acceptance was relative. Only economic power, social or intellectual prestige, or some circumstance of popularity, were capable of opening the gaps in the social barrier that prejudice maintained.

This population of colour has always been seen as an exotic element ready to arouse curiosity and fill in the records. The iconographic and literary reading of national and foreign authors highlight such social and cultural dimension of Portuguese life after the 15th century. It is a latent memory of the paintings of public spaces, as in the case of the controversial anonymous 16th century *O Chafariz d'El-Rey* and *Rua Nova dos Mercadores*. Also, of the paintings *Vista do Mosteiro dos Jerónimos* (1657) by Filipe Lobo, *O Terreiro do Paço* (1662) by Dirk Stoop, O *Cais do Sodré* (1785) by Joaquim Marques, and the work *A Feira das Bestas* (1792) by Nicolas Delerive, among many other pictorial records. Similarly relevant are the several records from chronicles or letters, journals and descriptions, literary and, even, of legal texts that allow an approach to this reality and the mental frameworks of different epochs. As an example we have the record of the late 16th century entitled *Ritratto e Riverso del Regno di Portogallo*[5], the description *Tratado da majestade, grandeza e abastança da cidade de Lisboa*, presented in the mid 16th century by João Brandão de Buarcos (1923), the *Descrição do Reino de Portugal*, by Duarte Nunes de Leão (2002), the *Diário* (1787–1788) by William Beckford (1957), the book *Portugal. Recordações do ano de 1842,* by the prince Félix Lichnowsky (2005), not to mention theatre plays and cord literature [literature de cordel], religious and popular records, woodcuts, lithographs and tile panels.

In the 19th century, the presence of black and mixed people, free or freed was still substantial, although the Pombaline legislation of 1761, 1767 and 1773 contributed to its reduction[6]. There were, of course,

changes in the social environment, regarding the previous centuries, especially after the Pombaline decree of January 16, 1773, which considered the freed "fit for all jobs, honours, and dignities, without the distinguishing mark of freedmen [. . .]" (Silva, 1830b, 640). The black people continued exercising several different activities, from servants to sellers, from errand boys to master of dance, from musicians to sailors, from prostitutes to beggars, who beg for their masters, not forgetting that among them were also owners, men of letters and members of the clergy. Similarly, artists continued to depict them in the streets, in homes, in churches, in daily activities, in festivities, working in shows, as entertainers, as entourage figures, or as individuals who, somehow, managed to overcome anonymity[7].

Often, the black man also appears as an aesthetic model. In this sense, beyond the representation itself, it can still be measured the social and cultural interpretation involving artists and models. Depending on the artist's goal, the portrait may focus on an idealised or a real black man, in his daily duties or his moments of fun, as a child, a young adult or as an older person. It may be a hardened, a naive or a sensual black. With a polished or rude and ragged appearance, even a savage, with traits of struggle, or of dependence. With an expression of audacity or grace, of pride or melancholy and absent glance (Cf. Neto, 1999). Black children were part of the domestic staff and these scenes, appearing with their masters, or playing alongside the white boys and pets[8].

In general, the portrayal of Africans in scenes from everyday life was a symbol of those that had significant possessions. Their image served mainly to proclaim a

5. Regarding this work see Radulet (1997, Dezembro)
6. By royal orders of September 19, 1761, and January 2, 1767, Pombal intended to divert traffic to the colonies, especially to Brazil, by proclaiming all blackmen and mulattos free, which were arriving from America, Africa, and Asia and landing in the Portuguese metropolis. For this purpose, they did not need any letter of manumission or emancipation,

nor any other decree besides the certificates of the administrators and customs officials of where they had arrived (Silva, 1830: 811–812). Concerning the freedom of the children of slaves, Pombal decreed, by the law of January 16, 1773, that only the descendants of slave mothers or grandmothers should remain in this condition, but this condition would not be transmitted to later generations. Those whose condition already came from great-grandmothers would be free, even though their mothers and grandmothers were slaves. Independently of these determinations, the law granted freedom to all those born after its publication. (Silva, 1830: 640). However, as foreseen in the Ordenações Manuelinas, it was still in place, since the 16th century, the determination of the suspension of manumission if the individual proved himself to be in any way ungrateful to his old master (Coimbra et al., s.d.: Livro IV, Título LV).
7. See the 19th century lithographs Negros em cavalinhos de pasta by Legrand, included in Álbum Touradas, and O Carnaval de Lisboa, by Canongia. This is also the case of the famous black saints, St. Anthony of Noto, St. Benedict the Moor, St. Elesbaan King of Ethiopia and St. Ephigenia of Ethiopia, represented in the altar of the Brotherhood Irmandade do Rosário dos Homens Pretos (Our Lady of the Rosary of the Black Men), in the church of Graça, in Lisbon.
8. See the detail of tiles frieze that can be found at Fundação Medeiros e Almeida, in Lisbon, which represent the playfulness of a white boy with a black boy and a dog.

social status, a certain opulence and the good nature of those they served[9]. Being portrayed with a black woman servant, who serenely performs her duty, or with a little black boy playing by the edge of her dress, was a matter of good taste that emphasised power, magnitude and possessions brought from the 'new' worlds. This notion is also embedded in the representation of the chained slaves, carved in the coach that was part of embassy parade sent by D. John V to Pope Clement XI, in 1716.

Through their representation in art, some Africans became famous, who would have otherwise remained unknown. We can mention Catarina, slave of the supervisor Rui Fernandes, portrayed in 1521 by Albrecht Dürer. Another case was the dwarves in the court of D. Maria I, who was simultaneously a curiosity and an amusement, and whose portraits have reached the present day through the painting *Mascarada nupcial* (1788), by José Conrado Rosa, a Portuguese painter of the second half of the 18th century[10]. Another famous jester had already been expressly mentioned in print: João de Sá, a "black creole" born a slave in Portugal, to whom D. John III granted manumission and favoured with the habit of the Order of Santiago. He was considered one of the wittiest men of his time. A target of constant mockery due to his colour, he replied in a tone of caustic irony that "the happiness of a Portuguese knight consisted in calling himself Vasconcelos, having a farm, six hundred thousand reis of income, being a fool, and being good for nothing" (Sabugosa, 1923: 94–97). In *Colecção Política de Apotegmas* (Moraes, 1761), were registered some of the playful sayings that were directed at him and others with which he taunted the court's noblemen[11].

The Blacks of St. George were also famous. They were part of the procession of Corpus Christi in the City of Lisbon dressed flamboyantly in white trousers, wearing a red coat and hat, playing the trumpets, flute and drums. They sent the "gang" towards the streets shouting the stepping out of the Holy Knight on feast day[12]. In 1875, the Brotherhood of St. George, in which they were integrated, still received from the city's municipality 50 mil reis, with which it gratified the five "little blacks" of S. George (Brásio, 1944: 107). They were carved, for posterity, in painted wood, paper and fabric, in an anonymous miniature sculpture from the 19th century[13]. The coloured lithography by Roque Gameiro, dated from 1888, also survived until the present, portraying a standardised St. George's black man.

In the same way, Pai Cândido was photographed, when he was already a free man, by Paulo Guedes in 1904, jamming with his 'court', settled in Rossio, songs and dances, using sounds extracted from cans, which delighted the audience[14]. We cannot forget the "black Fernanda", a famous figure of Lisbon's daily life from the beginning of the 20th century. Her fantasised memories were perpetuated in the book *Lembranças de uma colonial (memórias da preta Fernanda)*, published in 1912 by A. Totta and F. Machado. Neither can we neglect the very popular aunt Carolina, "the black woman of the pine nuts", who died at the age of 115, and had a full body photography of herself published by the newspaper *Diário de Notícias* on her funeral day, on December 28, 1943. These are just a few examples.

4 BORDALO PINHEIRO AND PAI PAULINO

The presence of black people was not strange in Rafael Bordalo Pinheiro's work. He left us representations of Africans sculpted in clay and drawn in his many caricatures. Sometimes, as in the case of the figures of the Stations of the Cross, Africans are present with their full existential burden[15]. At other times, as in

9. In D. Manuel's Book of Hours the black people appear represented in their daily labour. On the other hand, Cristóvão de Morais portrays D. Joanna of Austria, D. Sebastian's mother, with her hand resting on a black child's head. In addition, in the mid-17th century, Manuel Franco reproduces the prince D. Afonso VI playing with a black boy. In any case, we do not know whether they are slaves or not, but, at least in the two last examples, they are represented with the apparatus required by the nobility to which they belong.

10. Rosa, the famous dwarf, was the favourite one, holding private chambers near D. Maria. William Beckford described her as a "black, large lipped, and flattened nose" dwarf, all adorned while flirting with a Moorish servant. The same author describes that when the court went to Salitre Theatre, it was accompanied by their little black children and their service dwarfs. They were figures of the entourage that everyone loved. The queen set the example and the whole royal family "competed to see who was doing more cuddles and caresses to D. Rosa" (Beckford, 1957: 213). In this painting it is also represented the slave Ciríaco, portrayed in the previous year by Joaquim Leonardo da Rocha, in oil on wood, on display at Bocage's Museum, in Lisbon. Because he had large white spots on his body, he was the subject of various studies and observations on the origin of the black colour of his epidermis.

11. (Cf. Moraes, 1761: 297–298). Another well-known black jester, but of whom we have less information, was Dom

Tissão, which amused the house of the Marquis of Pombal (Dantas, 1969: 10).

12. Irisalva Moita mentions that the Blacks of St. George dressed in red and playing the fife and drum were the most decorative and popular set of the Corpus Christi procession (Moita, 1979).

13. The sculpture, which is under the care of Museu do Chiado in Lisbon, is formed by five uniform black men with their respective instruments displayed on a base. The piece has 140 mm by 180 mm, without the glass case, and 245 mm by 205 mm with the case.

14. The term pai (father) or mãe (mother) are designations attributed by the Africans to a person as demonstration of respect for their age and the wisdom acquired during his/her life.

15. About the figures of the Stations in the Cross, Fialho de Almeida, with his penetrating literary style, stresses Bordalo's genius, visible in those figures "of a great and rare

the garden statuettes or in the African warrior figure, they fill the space with the strong musculature of their black naked bodies. At other occasions, the artist caricatured them, accentuating their features, satirising burlesque aspects and criticisable customs. Related to this are the several figures of the black king Gungunhana, in which Bordalo combines shapes with attitudes and reproduces a defeated power merged with the irrepressible addiction to alcohol[16]. It is the strength of the model's inner expression that stands out in his modelled heads and busts. Among the latter are the busts of the black man Pai Paulino, a very popular figure from 19th century Lisbon.

Paulino José da Conceição was a former black slave, born in Bahia, probably in 1798, who was part of the Brazilian contingent of troops that accompanied D. Pedro IV in the landing of liberals at Mindelo on July 8, 1832. Among the 7500 'Brave of Mindelo', Pai Paulino was one of those who stood out in the fighting, for which feat he was honoured. He lived at n. 12 Travessa Nova de Santos, in Lisbon. He was a whitewasher, an entertainer in the bullfighting arena of Campo de Santana square, a St. George fife player. He served as brother in the black religious brotherhoods, and was a "representative" for those of "his race". It is not strange he became so popular, not only for what he was and for what he represented, but also for what in him was projected by the many social groups. He died of cachexia on March 12, 1869, and was buried without a coffin in a grave in the cemetery of Alto de S. João, in Lisbon (Neto, 1998, pp. 193–202).

He belonged to the brotherhoods *Irmandade de Nossa Senhora do Rosário e Adoração dos Santos Reis* (of Our Lady of the Rosary and Worship of the Holy Kings) and *Irmandade dos Homens Pretos com o título Jesus, Maria, José* (of the Black Men with the title Jesus, Mary and Joseph), both in Lisbon. He was also "high dignitary" of the court of the "Empire of the Kingdom of Congo", which under these brotherhoods gathered people of colour, managed a fictitious kingdom, similarly to the European courts, elected a sovereign and appointed representatives that performed social actions (Pimentel, 2010: 151–177).

Since the 16th century, the coloured population integrated these religious organisations, which had their charters and carried out the important mission of aiding their brothers socially and morally[17]. Since they were constituted of slaves or former slaves, in either case, marginalised individuals, they had extraordinary importance not only given the beneficence purposes to which they were intended but also regarding the representative strength and the significance they held against their counterparts of free white men. They were a form of integration and, simultaneously, of preserving African culture. This included its monetary fund, obtained through contributions, alms and other sources of profit, among them, renting slave labour ("money-earning slaves"), to carry out burials and, by royal privilege, whenever possible, to purchase the manumission of fellow slaves, even against the owner's will[18]. Besides participating in the liberation processes, they opposed the separation of families through the sale of their members, the trade of slaves to distant lands, especially to Brazil, where slavery was still in effect and defended the slaves who were under precarious conditions or being mistreated, denouncing the masters' cruelty[19].

beauty" and expressive strength, fruit of a "boiling genius [. . .] [which] snatches from the malleable mud pieces of brutish from, even fragmented at times, but all of them vibrant and insanely inventive, of a fethal energy of the soul of monsters, of a perceptiveness of creation full of dreams; and at the hand of the strange creative fire that holds him, here he is forging in this defenceless clay a humanity distinct from the contemporary, nervous and his, dislodged from the conventional, hieratic and rough [. . .]" (Almeida, 1933: 143).
16. Gungunhana was the last king of Gaza, nowadays a territory south of Mozambique. His reign lasted from 1884 until December 28, 1895, day in which he was taken prisoner by Mouzinho de Albuquerque, following the military campaigns of occupation and pacification of the African territories undertaken by Portugal. The start of his reign coincided with the Berlin Conference (November 15, 1884 to February 26, 1885) in which the European powers shared amongst themselves the African continent. That Gungunhana was a famous figure in the European press was, surely, relevant in the Portuguese administration's decision of bringing him to Lisbon and then banishing him to the Azores. Bordalo Pinheiro caricatured him as "Asclepius" in various drawings that accompanied poetry and news articles in which the ruler was mocked mercilessly (Eduardo Fernandes) (Pinheiro, 1896, 14 de Março; 1896, 11 de Abril; 1896, 6 de Fevereiro). He also created several pieces in ceramics (pitchers, bottles, jars) ridiculing his figure and the symbols of African power.

17. The first Rosary brotherhood was created at the church of S. Domingos, initially by white brothers, to which later on the blacks associated themselves and which, in 1551, was already divided into two, one clearly of whites and another of blacks, as clearly reports Cristóvão Rodrigues de Oliveira in *Sumário* (Oliveira, 1987: 67). In 1565, the crown approved the Charter of the *Irmandade de Nossa Senhora do Rosário dos Homens Pretos*. It became involved in continuous biquering with the white brothers. The black brothers ended up being expelled from the monastery, taking refuge in other Brotherhoods of blacks that had in the meanwhile been formed, such as the *Confraria de Jesus, Maria, José* in the Church of Carmo. Only in the mid 17th century did it acquired a new projection, with the readmission of the black brothers and the restitution of some of the former privileges (Lahon, 2013).
18. In the 18th century, after the Pombaline resolution that freed all slaves entering the kingdom, the brotherhoods of blacks that enjoyed such privilege protested to the royal authorities for the freedom granted to them by the 1761 law, when the legislation was not respected (Brásio, 1944).
19. The sale of slaves to territories outside of Portugal was one of their preoccupations. Many masters proceeded to the sale of slaves, especially for Brazil, as a form of punishment or revenge by which they did not lose Money, or, in the case of slaves born at home, as a means of subtracting them, profitably, to the law of 1773 that guaranteed their freedom. It is not difficult to imagine the conflicts that these privileges must have caused between masters and slaves. As a result,

As "representative" of the "Empire of the Kingdom of Congo", Pai Paulino defended, before the Portuguese crown, the rights of the black, slave or emancipated population on Portuguese mainland territory. As recorded in *Livro da Irmandade dos Homens Pretos com o título Jesus, Maria, José, situada no Convento dos Religiosos de Jesus da Terceira Ordem da Penitência do Patriarca S. Francisco*, Paulino José da Conceição enrolled in this brotherhood "on the 14th day of the month of January of the year 1844 [...] becoming at once a judge [...]" and promising "to keep the Commitment and orders that were made towards the good government of aforementioned brotherhood" (Neto, 1999: 226; 1998: 196). According to the same document, at that time, he lived at "Santo Amaro Street, n. 26". Later on, his autograph signature appears, as signatory, in the covenant *Compromisso dos Irmãos Pretos da Irmandade de Nossa Senhora do Rosário e Adoração dos Santos Reis*, which worshipped in the chapel da Senhora das Almas in the old asylum of S. Domingos, dated September 6, 1853 (Neto, 1998: 196). It is assumed that until 1864, he worked in both institutions, at which time, according to the newspaper *Jornal do Commercio*, "they crushed him out of the position" (1864, 23 de Julho).

Figure 1. Pai Paulino's signature in the Brotherhood *Irmandade dos Homens Pretos com o título Jesus, Maria, José.*

The newspaper *Jornal do Commercio*, by the pen of the chronicler Ribeiro Guimarães, who was a critical thinker vigilant to the intricacies of daily life, highlights the festivities, the social activities and internal disputes of these African imperial courts, constituted under the protection of religious brotherhoods[20]. From his chronicles, where he compares the court of the

"Empire of the Kingdom of Congo" with the "European Courts", emerges not only the news, full of exoticism, but also a critical reference. From the comparison, the author draws caustic remarks to the European institutions and the bitter laughter of humiliation of the Africans. With this in mind, he emphasises in the chronicle published in edition 2790:

> The blacks are like our Portuguese, they only want a natural king [...]. Princess Sebastiana's crown is a sham, but it doesn't cost a drop of blood. Hers is a paper throne, but it doesn't stand over thousands of corpses. The crown of the Empire of the Kingdom of Congo is a joke; but how we cry in front of so many legitimate, serious and noble crowns, maintained only by oppression, the bayonets and by the usurpation of the most sacred human rights. (Guimarães, 1863, 27 de Janeiro)

In edition 937, in the article titled "The Guardian of the Blacks", he highlights the figure and action of Pai Paulino:

> The blacks have in Lisbon an unveiled guardian, of weak condition, but full pride; this guardian is another black man, he is Pai Paulino José da Conceição, judge of the Brotherhood of Jesus, Mary e Joseph. The black Pai Paulino, according to what he told us, has contributed to liberating many of his colour, who have come here from Africa still has slaves; as soon as he is told that someone arrives in Lisbon, he shortly handles it, so that he does not have to return to Africa. He says that it has already happened that some came well treated, as deck boys and sailors, and then shipped to Brazil in the same quality are sold there. The black man Paulino does not limit himself to their protection, he assists, with his diligence and good will, all who for any reason, find themselves harassed or in need of support. Recently, three black men, João Lopes de Chira, António Januário and Manoel Joaquim António, who were the slaves of Manoel Joaquim de Sousa Monteiro in Angola, arrived in the patache *Perpétua*: they managed to leave the ship and enlist in the Royal Navy, finding themselves as ship's boys on board the carrack *Vasco da Gama*. When coming to black Paulino's attention that they had been mistreated on board of the patache, he immediately filed a complaint to the minister of the Navy, and the inspector of the shipyard, asking the captain to be punished were it proven that he mistreated the blacks. In short, he has advocated his

the right to purchase manumissions against the masters' will was not always in effect. (Brásio, 1944, 90). Didier Lahon points out that "in Lisbon, the masters of slaves who wished to sell their slaves abroad, had such fear of the unexpected intervention of one of the black institutions of the capital, before or at the time of shipment, that some added a clause, held by the owner, to the insurance registered in a notary, in case the boarding did not take place due to a brotherhood. (Lahon, 2011, 17–18).

20. By occasion of the festivities in honour of the patron saint, besides the religious program, the regency of the Empire of the Congo organized parties in which took presence the Africans and their descendants, as well as white people that offered the court cakes and liqueurs while being graced with titles. "Yesterday took place the first ball, in the royal palace of the Forest, held by princess Sebastiana Júlia, regent of the kingdom of the empire of the Congo. It was very crowded of whites and the niggers were splendid. The princess had her throne on the stage and there she was surrounded by her court, composed of duchesses, countesses and maids, as her royal guard of halberds. [...] After midnight, the guests that had paid entry tickets left and the princess and her court,

her subjects and a few whites remained. Then the princess descended from her throne and conceded to dance with the regent prince Congo's national dance with great gravitas. [...] Plenty was danced. Some black women, and particularly l'dy Sebastiana, danced with finesse and gravity the *Banzé*, the national dance. [...] there was a distribution of titles in the process of wooing several whites. One received the title of marquis of Hackney, another of count of Haringey and another of marquis of Newham. These whites, grateful of such a distinction, granted the princess and the chamberlain with a cocktail of maidenhair syrup, liqueurs and cakes. [...]" (Guimarães, 1863, 27 de Janeiro; 1863, 24 de Janeiro).

cause with great endeavour. The black Paulino says that he is very grateful to the minister of the Navy and the inspector of the shipyard for their good reception, treating him with great patience. (Ribeiro, 1856, 26 de Outubro).

In 1859, Ribeiro Guimarães reported the existing conflicts in the "Brotherhood of the blacks", which had refused to participate in the Corpus Christi procession, with the portable platforms of worshipped saints, and the sadness such absence caused in Lisbon's population. The appearance of the black men with their typical revelry "was perhaps the most exciting public curiosity". At the heart of the conflict is, once again, the figure of Pai Paulino, now as "dictator of Lisbon's niggers and judge of the Brotherhood". Heated by the offences he claimed to have received from the Holy Brotherhood, which refused to give him "a dispatch house", "he did not allow the Brotherhood to take its place in the procession." With disdain, the chronicler ponders on the scope of the dispute: "After the issue of the succession to the throne of the empire of the Kongo, perhaps this is the most serious with which Pai Paulino has been faced" (Ribeiro, 1856, 26 de Outubro)[21].

Rafael Bordalo Pinheiro participated in these satirical humour that had as object not so much the experiences of the African community but, mainly, to make a sharp critique of the misrule and the profligacy of the Portuguese customs. In the balancing of different realities, the criticism was inserted, the opinion was expressed and the laughter, which typically marks the comic expressions, was promoted. On February 12, 1880, with the title *O Baile dos Preto*, Bordalo mocked the reception given by the new Queen D. Filipa, in the Amoreiras Street. The caption reveals mocking and critical puns:

A less refined ball than that of the palace of Ajuda. Her Majesty dances the tango with the president of the council at the guests' request. The war minister holds a little *presumptive* kinky hair, freeing us from being the ones to *support* him. In summary, the impressions we got from the party. Great friendliness and plenty of rank smell on the part of their Majesties and Highnesses. Some say that the constituent party looks with jealousy at this black ministry, which rose to power ahead of him. (Pinheiro, 1880, 12 de Fevereiro)

A few months later, during the celebrations of the Tercentenary of Camões, Pai Paulino is depicted mocking the poet because the portable platforms of Africans, took "his majesty" while the civil procession in his honour had only the "popular majesty" in the Corpus Christi procession, (Pinheiro, 1880, 17 de Junho). In the issue of September 28, 1882, from the same humorous newspaper, Bordalo dedicates some verses to "her

Majesty the new queen of the Congo", and in it he, once again, refers to Pai Paulino. The subtle mockery of Portuguese politicians is evident (Pinheiro, 1882, 28 de Setembro). Bordalo, after expressing his veneration as a "white man" to the queen, whose colour "does not tarnish the golden radiance of the royal crown", offers his services and advises her that to make her reign a fortunate, long and just one, she must be cautious when choosing the "Paulinos" to whom she will give the ministries of war and justice. Moreover, she should not falter in punishing laziness. He urges, furthermore, if noticing any embezzlement in the kingdom's finances, she must, without tumult or fuss, call Burnay[22]. He will have a quick remedy to reestablish the finances, and she will be able to see the "shining metal" prosper in her endeavours, become surrounded by splendour and greatness and receive from the people praises and commendations. (Pinheiro, 1882, 28 de Setembro).

By that time, Paulino José da Conceição had already died, giving place to a "new" Pai Paulino who had inherited his name and, like him, was an entertainer in the Lisbon bullrings[23]. In 1888, Bordalo Pinheiro drew a caricature, published in the July 28 issue of the weekly newspaper *Pontos nos ii*, with the caption:

The bullfight's Pai Paulino is so popular that we decided to publish his true effigy. We don't want such a man to die imprinted on the trench without the consolation of firstly having been printed on paper" (Pinheiro, 1888, 28 de Julho: 167)

However, this is not the Pai Paulino that the ceramist immortalised in a bust where the burden of old age is significant.

21. In 1908, the newspaper Diário de Notícias still emphasises the execution of these processions with the participation of Africans and the memory of Pai Paulino and the entire generation that came after him, thirty-nine years after his death (1908. 19 de Junho).

22. Henrique Burnay, 1st Count of Burnay, of Belgian descent, in his time known as "Lord One Million", was a Portuguese businessperson and politician with strong international connections to whom Rafael Bordalo Pinheiro gave no rest in his caricaturist quest.
23. The black men were a prominent figure in the bullrings, where besides being in charge of the cleaning of the arena and the bullpens, they were also used as entertainers during remission. The great adherence of the audience made the participation of black men mandatory in bullfights held in the capital, whose programs reserved at least two tickets for each day of show. (Cf. Tinhorão, 1988: 228). William Beckford, in his Diary in Portuguese lands, expresses his displeasure at this kind of amusement, which he calls a "lugubrious spectacle", in which some black men jumped into the arena dressed "as monkeys, wagging their tails, in the midst of the hideous clatter of who knows how many awful bassoons and rabecs", while others, "stuck in bags stumbled and rolled before of the bulls, making them lose their patience" (Beckford, 1957: 151). The black men Benedict the Tenatious, the Break-it-all, the Old and the new Pai Paulino were famous "entertainers"; also the black women Mary Ant, Rose Mary, Shrieky Mary, the Wogiant and the black Cartusian. Either pleasing or disgusting, with the advent of the 20th century, the participation of black men in the bullrings gradually diminished until disappearing or being replaced by other sorts of amusements.

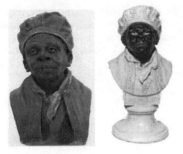

Figure 2. (left) The bust of "Pai Paulino" from August 1893 signed by Rafael Bordalo Pinheiro. Painted terracotta sculpture. Photo © José Manuel Costa Alves; (right) The bust of "Pai Paulino" dated 1894 and signed with the monogram "RBP" and the brand Fábrica de Faianças das Caldas da Rainha. Escultura in glazed faience. © Museu Bordalo Pinheiro/EGEAC.

There are two busts of Pai Paulino belonging to Rafael Bordalo Pinheiro's Museum: one from 1894 and another, less known, from the previous year.

These are the two busts we want to highlight from Rafael Bordalo Pinheiro's artistic production. There are also two other versions of the bust of 1894, with distinct polychromy, one in the Berardo collection and another in the National Ceramic Museum. Clearly, Rafael Bordalo Pinheiro was touched by this singular figure, which was his contemporary. So much so, that he ended up portraying him, by heart, near the end of his life. It is also a fact that Paulino José da Conceição met the man who knew how to keep him "alive" for posterity.

In 1893, Bordalo Pinheiro portrayed Pai Paulino, in a painted terracotta version, not as a typical Lisbon character but as an individual. Instead of giving him merely the facial features moulded by time, the skin tone, the colourful clothes, Bordalo shows us, in the bust, an inner expression that we imagine had been that of Pai Paulino the bullfighting entertainer, the bagpiper and the "guardian of the black men". The busts reveal traces of a reality and engrave destinies, instants of life and, evidently, reflect the greatness of the master who created them and gave them a form with meaning.

In 1894, in order to commercialise the piece, Bordalo Pinheiro made a new Pai Paulino bust, using, once again, his favourite material – the clay. In this case, the piece appears white and glazed, lacking the bold colours of the clothes, and seeming to reinforce the humanism of the figure's glance. Unlike the previous piece, which he signed with his full name, "Rafael Bordalo Pinheiro" and the date August 1893, this last bust appears with the monogram "RBP" and the brand *Fábrica de Faianças das Caldas da Rainha* and the reference to the year of 1894.

This second bust was, possibly, to commercialise. Bordalo put it on a base and inscribed in it Pai Paulino's name, reinforcing his identity. He turned him into a

symbol, providing him with an enigmatic and insightful glance, perhaps in supplication or in the rapture of one who, slave or free, always lived in the fringes of society. His gaze reveals a past and, above all, a desire for the future. There are dreams in the eyes of Pai Paulino.

When looking at the busts, it is impossible to remain without reaction: they are, in fact, "figures that capture the eyes." (Almeida, 1933: 117). What we have before us is, rather than just the details of a face, the depths of the soul, in clay, emerging from the "laborious gestation" of "one of the most profoundly creative genius of the contemporary world" (Almeida, 1933: 117)[24].

5 PAI PAULINO AMONG AFRICANS

In this paper, it was not our intention to approach the diverse representations of black men, which are part of the heritage of Bordalo Pinheiro. However, when focusing on his sculpture and favouring the bust of Pai Paulino, it soon became clear that these representations did not belong to the humorous style. It was necessary to integrate them into the author's artistic diversity. The differences are significant between the depictions of Pai Paulino and Gungunhana. In their union is Bordalo Pinheiro's geniality. He was watchful of everything that surrounded him, an artist "in all things and of all things an artist", as his friend, Júlio César Machado said (2005). In general, if in his portrayals of black men, his drawing is full of paternalism, incivility and inferiority, the truth is that we can also find goodness, trustfulness, resilience and character. Quite frequently, a sense of humanism and indignation against slavery emerges from his graphic work.

Typically, when talking about Bordalo Pinheiro, one of our first thoughts is his skill in caricature art, a field where he became know, in Portugal and abroad. In this field, Bordalo was "an indelible and unmistakable name in the Portuguese 19th century" (Couto, 2003–2006)[25]. However, it should be added that Bordalo

24. The writer and art critic Fialho de Almeida admired the man and artist that Rafael Bordalo Pinheiro was. He mentions that he "did a short pilgrimage to Bordalo's Faience Factory, in Caldas da Rainha, to study at first hand the "laborious gestation of an isolated genius and the vile indifference of a foolish public". The reason that drove him to the visit and writing about what he observed was, he confesses, "the desire to capture an expression of Bordalo's genius", which seemed to him still "little known, and to produce a detailed chronicle of one of the most strangely original works that have come life in a long time in the country's sculpture" (Almeida, 1933: 115–116).

25. Júlio César Machado declares, "Never has caricature occupied such a relevant place in Portugal in the history of fashion and manners, as those reached lately under the talent and efforts of Rafael Bordalo. The political caricature has had in other times a certain relevance, while the burlesque Supplement existed. However, the moral, fantastic and intimate caricatures, and the witticism towards abuse requires

was not just a caricaturist. In addition to the countless humorous drawings, customs paintings, illustrations, chronicles, portraits, statuettes, decorative pieces or everyday objects, with a realistic or kitsch taste, Bordalo captured reality, filtered it through the sieve of sensibility and created testimonies supported by his genius.

His personal style offers a peculiar communication of reality but, clearly, the social diversity, the political contingencies, the economic circumstances and the cultural contexts influenced and directed his creativity. The historical framework is fundamental to understand his work, just as it is essential to discern his satirical humour that its interpretation is not literal.

His representations of black men and the African world related to colonial issues do not diverge from what was at the centre of the debate, either concerning national circumstances or international relations. Even if they are contemporary, both in the busts of the former slave Pai Paulino and in the several productions of the black king Gungunhana, the historical premises have, necessarily, a considerable weight.

At that time, colonial issues and international relations were of particular importance. It can be highlighted that the Berlin Conference (1884–1885), the British Ultimatum (1890), the campaigns of conquest and pacification in Africa, as well as the development of the ideologies of European progress and expansionism, to which are related the new forms of domination and submission on a world scale (Guimarães, 1987: 162–163).

In Portugal there was a tumultuous period marked by economic stagnation, little industrialisation, indebtedness and great external dependence, together with political agitation and a certain revolutionary spirit, resulting from the discussion of new ideas of progress and the evolution of societies that circulated throughout Europe. The divergence with other countries of Western Europe accentuated the idea and feeling of Portugal's decay.

The intellectual movement 70's Generation and the Conferences of the Casino give voice to the anxieties and proposals for changes that could lead to the exit from the state of decline and indifference that had appeared in Portuguese society. Rafael is part of this socio-cultural elite that, imbued with progressive ideals, aimed at this transformation towards modernity (Guimarães, 1987: 160–161). The Portuguese constraints, the movements of the European powers, the

imperialisms and the civilizational rakings, the singularities of places and peoples enwrap Bordalo's criticism and humour, where, often, they arise from a game of interferences and inversion of roles that easily generate laughter and lead to double interpretations.

On the agenda, there was also the question of slavery, which marked Portuguese politics and international relations throughout the 19th century[26]. There was also an increase in the trends of thought that sustained a civilizational hierarchy of peoples based on scientific criteria that forebode the inherent inferiority of the colonised peoples, particularly the black men, who were placed at the base of the civilizational scale. Europe was the continent that concentrated all development conditions, and white individuals were at the top of the civilizational hierarchy (Pimentel, 2017: 273–285).

For the European intellectuals of the 19th century, the issue of race had great meaning[27]. The problematization of hypotheses about the origin and the differences of the human species, which had long fermented in Western thought, led to the development of theories that implied the idea of equality, freedom, progress and civilisation. Arguments that are reflected in the debates about the end of slavery, which often led to the argument of the slave's inability to live as a free man, to their natural incivility and, therefore, to their inferiority and need for protection by the European powers. (Pimentel, 2013: 51–68). From here, colonialism and scientific racism sprang out.

Behind these questions pulsed the plans for an industrialised Europe, which looked at Africa as a large market, not only for the surplus of industrial production but also for the acquisition at low cost of raw materials, provided by abundant cheap labour. The observation of Oliveira Martins in this regard is elucidating: "With freedom, with humanity, no farms were ever colonised" (Martins, 1920: 234).

26. On July 3, 1842, Portugal abolished slave trade, which was declared a crime of piracy on July 25. On February 25, 1869, slavery was abolished in all Portuguese territories, and the slaves acquired the condition of freemen. In 1877, the condition of serfdom was extinguished, and the freemen became "subject to public tutelage until April 29, 1878. Legally slavery and serfdom were extinguished. In practice, however, the reality was something else. In Brazil, the end of slave trade was decreed in 1850 and on May 13, 1888, the Golden Law declared the end of slavery. Bordalo Pinheiro, during his stay in Brazil, knew this reality closely.

27. In Portugal, Oliveira Martins, contemporary of Rafael Bordalo Pinheiro, was one of the authors that dedicated himself to the study of the issues related with the origin and variety of the human species. To him the black was an "adult child", an "anthropologically inferior sort, not unlikely close to the anthropoid and quite undeserving of the name man". Given this "the notion of an education of the blacks" was "absurd, not only in relation to history, as well as concerning the mental capability of these inferior races". Their inferiority made the notion of a "civilization of the savages" nothing but an illusion (Martins, 1920: 284–286).

the cooperation of the public's spirit, so to speak, with the artist, so as to be able to appreciate him, and that it does not want to cut his nails as to a scratching cat or muzzle the dog for anything it might bite. There are nations where one could write the exact history of freedom by writing the history of the caricature. We do not have censure, but it exists, if not in form, in essence, and at times for anything in Portugal is the worst of tyrannies; it is called suitability; it could be called hypocrisy" (Machado, 2005).

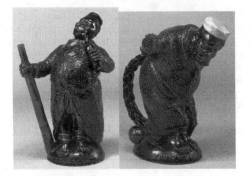

Figure 3. "Gungunhana before". "Gungunhana after". © Museu da Cerâmica das Caldas da Rainha, Portugal.

Figure 4. "The Portuguese facing the foreigner: There are no small people, only small men". Source: http://hemerotecadigital.cm-lisboa.pt/Periodicos/OAntonioMaria/1896/1896_master/OAntonioMariaN432N443.pdf.

Following this tumult of ideas, the plans of dominion, of power and, particularly in Portugal, the crisis provoked by the British Ultimatum, the emphasis of Bordalo Pinheiro's message rested at times in a patriotic exaltation, an attack on the African resistance, or on a destructive criticism of national and foreign political strategies. These attitudes are particularly striking in the use of the ethnic dimension of African societies and the representation of Gungunhana[28].

In his drawings, Bordalo portraits him in many ways, including, as a dandy, a civilised older man and a scribe, but always mocking the real figure or pointing out the picturesque of his existence in Lisbon (Pinheiro, 1896, 14 de Março; 1896, 11 de Abril). The most famous representation is, however, one in which the king appears metamorphosed in several anthropomorphic pieces and associated with an excessive zest for alcoholic beverages. This is the case of the squat bottles that, according to the captions, depict "Gungunhana before" being defeated, with an open smile, a victorious glance, the upright posture of one who holds power, and having a stick in one hand and a bottle of Port wine in the other, and "Gungunhana after" being defeated, sad, with the symbol of power replaced by a white beret and with hands and feet tied with a thick chain. Bordalo bends him under the intensity of double bondage.

In the cartoon titled *The Portuguese facing the foreigner*, with Victor Hugo's quote "There are no small people, only small men", Bordalo enacts the Portuguese position facing the demands of the Berlin Conference, establishing the difference between the situation before and after the arrest of Gungunhana in Africa. A Portuguese military man, small and slender, regarding his European partners, becomes a giant, holding a rifle with a small figure of Gungunhana, hanging from the barrel. Here the devaluation of some and the magnitude of others are well exposed in the

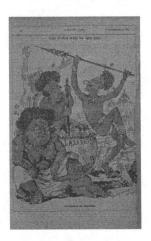

Figure 5. The Zulus of Europe". Source: http://hemerotecadigital.cm-lisboa.pt/Periodicos/OAntonioMaria/1884/1884_master/OAntonioMariaN240N291.pdf

way stature and dignity are tampered with (Pinheiro, 1896, 6 de Fevereiro).

Here, it is recognisable, as in the "Gungunhana bottles", the distance existing between humiliation and pride, regardless of the person. There may also be present a particular formulation of the collective unconscious and of the national ambitions defrauded against the international context, where the Portuguese were seen as "The Zulus of Europe" (Pinheiro, 1884, 11 de Dezembro):

It is also a fact that, often through allegories with civilizational contrasts and the analogy with stereotypes about Africa and the Africans that had been passed along for centuries, Rafael Bordalo strikes a precise blow on the irresponsibility and servility displayed by

28. With the arrest of this important African King, Portugal wanted to assure its rule over East Africa, in accordance with the policy of effective occupation, established at the Berlin Conference.

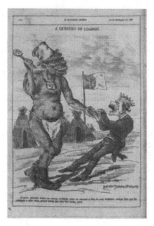

Figure 6. "The inland black teaches the civilised white how to hold a flag proudly; it would be better if he would teach him how to whitewash the house, for he might have more of a knack for it". Source: http://hemerotecadigital.cm-lisboa.pt/Periodicos/OAntonioMaria/1883/1883_master/OAntonioMariaN188N239.pdf.

the Portuguese rulers in face of the European interests, particularly the British. Concerning this issue, the cartoon "The problem of Loango" with the caption "The inland black teaches the civilized white how to proudly hold a flag; it would be better if he would teach him how to whitewash the house, for he might have more of a knack for it" is quite enlightening (Pinheiro, 1883, 20 de Setembro).

Rafael goes into the past to reveal the present. In an inverted scene, the Portuguese flag is hoisted in the indigenous village, and where the crown and the spanking paddle symbolize the interconnected powers, and while cursing – the monarchy and slavery –, he attacks the leadership, praises colonial enterprise and leaves, hovering, inscribed the remark of respectability for both Africans and Portuguese. This does not, however, mean that the white colonisers identify with the colonised blacks and that to the latter a minority statute is not attributed, which actually justified being tutelage by those (Guimarães, 1987: 179–180).

6 FINAL REMARK

The irony, the rebelliousness, the excesses, the allegories, the critical vivaciousness, and the analogies are essential issues in the work of Bordalo Pinheiro. However, through his particularities, we gain access to the many levels of reality, often less spoken of, even at times almost imperceptible, dissimulated or even ambiguous and contradictory[29]. In the full or soft lines

29. Many of his works are singular iconographic documents of the political, social and cultural reality of Portugal in the late 19th century.

of his drawings, in the excessive or miniaturised forms, grotesque or naturalist, of his work, exists a concrete reality, a critic, an opinion and a warning. Bordalo criticised, denounced and attacked, but also fought, defended and praised in an epoch of great turmoil of ideas and intense social and political changes.

His character that of a restless and erratic spirit: at times of a sharp acidity, at others of extreme gentleness. If on the one hand, he displays a devastating critic, at others he takes on a strong civic intervention. If sometimes he reveals an uncomfortable paternalism, marked by a certain disdain, at others he exhibits a philanthropy sprung from an intense humanism. Behind all this, seemingly contradictory complexity, the men and his time emerge, interconnected, in the artist's creativity.

The freedom with which his hands worked, at the margins of the powers, was not always appreciated, and he did not always carry out his humouristic spirit with impunity. Bordalo took the hostility with apparent tranquillity, constantly envisioning with great energy new and bold work projects (Silva, 2007: 243). Nonetheless, near the end of his life, he confessed to the journalist Joaquim Leitão, "with unchecked bitterness and the authority of someone who [. . .] knew quite well the inanity and inconsistency of glory", that "in Portugal, one is never settled. It is necessary to restart every day!. . ." (1935: 117). If many of the figures he caricatured granted him due recognition both still in life and after his death, the truth is that at times he felt the force of adversity, if not the flavour of prohibition[30]. A feeling of disillusionment can be felt by the end of his life, probably also because of the failure of the ideals that had excited the spirits of so many figures of the Portuguese culture, which now, in the end of the century, gave way to disenchantment and restlessness (Túlio, 1997: 341–343).

The work he left can be considered a privileged hub of questioning about subjects that reach from the historical, social and political, to the mental and psychological, entering the philosophical and aesthetic,

30. From 1885 to 1891, Bordalo Pinheiro published the newspaper *Jornal Pontos nos ii*, which was closed by the Civil Government of Lisbon immediately after its edition of February 5, 1891, dedicated to the Rebellion of Porto of January 31, due to the criticism it contained. (Couto, 2003–2006). Many of his works also brought him recognition. Joaquim Antunes Leitão expresses the respect that illustrious figures dedicated to him: "Neither Rebelo da Silva, Pinheiro Chagas, Ramalho, Júlio César Machado, Fernando Palha, Teixeira de Vasconcelos, João de Deus, or Manuel de Arriaga, no one from the literary greatest minds of two generations showed himself bitter" (Leitão, 2005). At Bordalo Pinheiro's funeral, Hintze Ribeiro, replied like this to someone who found his presence strange, since he had been one of the most caricatured figures: "— I was. . . And for very reason when I want to recall my political life, I go through the pages of Bordalo. My political story is not in the Chambers Diaries, but in the collections of caricature journals of Rafael Bordalo" (Leitão, 2005).

Figure 7. Rafael Bordalo Pinheiro's signature and monogram (RBP).

and, even, raising the discussion of the ends and functions of art itself. His approach shows that artistic activity needs not to be limited to the areas of formal perceptions, aesthetic fruition or pure entertainment. Once again, the words are from his friend and collaborator Joaquim Leitão (2005):

> From his pencils, charcoals and India inks, we can retrieve documentation to catalogue and reconstruct manners, customs, environment and clothing, the history itself of the end of the century.

Rafael Bordalo Pinheiro communicated with his own time and through his creativity transmitted and provided to posterity a living memory and a perspective of events that would have otherwise passed unnoticed or been forgotten.

ACKNOWLEDGEMENT

This chapter had the support of CHAM (NOVA FCSH/UAc), through the strategic project sponsored by FCT (UID/HIS/04666/2019)
The text was translated from the Portuguese original to English by Eduardo Marques da Costa.

BIBLIOGRAPHICAL REFERENCES

. (1943, 28 de Dezembro) *Diário de Notícias*. Lisboa.
. (1908. 19 de Junho) *Diário de Notícias*. Lisboa.
. (1864, 23 de Julho) *Jornal do Comércio*.
Almeida, Fialho de. (1933) *Os Gatos*. Lisboa: Livraria Clássica Editora.
Beckford, William. (1957) *Diário de William Beckford em Portugal e Espanha* Lisboa: Emp. Nac. de Publicidade.
Brandão, João. (1923) *TRATADO da Majestade, Grandeza e Abastança da Cidade de Lisboa, na 2.ª metade do século XVI: (estatistica de Lisboa de 1552*. Lisboa: Livraria Ferin.
Brásio, António. (1944) *Os Pretos em Portugal*. Lisboa: Agência Geral das Colónias.
Coimbra, Arménio Alves Fernandes, Santos, Pedro Manuel Amaro, Rodrigues, Joaquim Pereira, et al. (s.d.) *Ordenações Manuelinas on-line*. http://www1.ci.uc.pt/ihti/proj/manuelinas/.acedido a 15/1/2019.
Couto, Matilde Tomaz do. (2003–2006) *Rafael Bordalo Pinheiro" (acedido a 25/11/2018)*. https://www.instituto-camoes.pt/activity/centro-virtual/bases-tematicas/figuras-da-cultura-portuguesa/rafael-bordalo-pinheiro.23/11/2018
Dantas, Júlio. (1969) *Lisboa de nossos avós*. 2ª. Lisboa: Câmara Municipal de Lisboa.

França, José-Augusto. (1992) *A arte portuguesa oitocentista*. 3ª. 28. Lisboa: Instituto de Cultura e Língua Portuguesa/Ministério da Educação.
Guimarães, Ângela. (1987) Imperialismo e emoções – A visão de Bordalo Pinheiro. *Sociologia, problemas e práticas* 2: 157–182. https://repositorio.iscte-iul.pt/handle/10071/1117. (acedido a 10/1/2019).
Guimarães, Ribeiro. (1863, 27 de Janeiro) *Jornal do Comércio*.
—. (1863, 24 de Janeiro) *Jornal do Comércio*.
Lahon, Didier. (2013) Da redução da alteridade à consagração da diferença: as irmandades negras em Portugal (séculos XVI-XVIII). *Projeto História: Revista do Programa de Estudos Pós-Graduados de História* 44. https://revistas.pucsp.br/revph/article/view/6002. (accessed 8/1/2019).
Leão, Duarte Nunes de. (2002) *Descrição do Reino de Portugal*. 3ª. Lisboa: Centro de História da Universidade.
Leitão, Joaquim. (2005) *O poço que ri*. Lisboa: Biblioteca Nacional. http://purl.pt/273/1/joaquim-leitao-00.html
—. (1935) Asas em Terra. *Anais das Bibliotecas, Museus e Arquivo Histórico Municipais* 8: 115–119.
Lichnowsky, Príncipe Félix (2005) *Portugal. Recordações do ano de 1842*. 2ª. Lisboa: Frenesim.
Machado, Júlio César. (2005) *Rafael Bordalo Pinheiro*. purl.pt/273/1/julio-cesar-machado.html.acedido a 13/1/2019.
Martins, Oliveira. (1920) *O Brasil e as Colónias Portuguesas*. 3ª ed aumentada. Lisboa: Parceria António Maria Pereira. https://openlibrary.org/books/OL13489740M/O_Brazil_e_as_colonias_portuguezas_.
Moita, Irisalva. (1979) *O Povo de Lisboa. Exposição iconográfica (junho-Julho 1978–1979)*. Lisboa: Câmara Municipal de Lisboa, Direcção dos Serviços Centrais e Culturais.
Moraes, Pedro José Suppico de. (1761) *Colecção Política de Apotegmas ou ditos agudos e sentenciosos*. 1. Coimbra: Oficina Francisco de Oliveira.
Neto, Maria Cristina. (1999) Pai Paulino. *Catálogo Os Negros em Portugal – séculos XV a XIX*. Lisboa: CNCDP.
—. (1998) Algumas achegas para o estudo de Paulio José da Conceição (1798?-1869). *Boletim da Sociedade de Geografia de Lisboa* 116 (1–12).
Oliveira, Cristóvão Rodrigues de. (1987) *Lisboa em 1551: Sumário em que brevemente se contêm algumas coisas assim eclesiásticas como seculares que há na cidade de Lisboa*. Lisbon: Livros Horizonte.
Pimentel, Maria do Rosário. (2017) The idea of progress and the practice of slavery in the second half of the 18th century. In: Kong, Mário S. Ming, Monteiro, Maria Do Rosário E Neto, Maria João Pereira (ed) *Progress(es); Theories and practices*. Leiden: CRC Press, 273–285.
—. (2013) Marquês Sá da Bandeira e o estatuto do liberto. In: Monteiro, Maria Do Rosário, Pimentel, Maria Do Rosário and Lourenço, Vitor Marçal (eds). *Marquês de Sá da Bandeira e o seu tempo*. Lisboa: Academia Militar, 51–68.
—. (2010) *Chão de Sombras; Estudos sobre Escravatura*. Lisboa: Colibri.
Pinheiro, Rafael Bordalo. (1900, 24 de Janeiro) *A Paródia*.
—. (1900, 17 de Janeiro) *A Paródia*.
—. (1900, 16 de Maio) *A Paródia*.
—. (1900, 7 de Fevereiro) *A Paródia*.
—. (1896, 14 de Março) *O António Maria*.
—. (1896, 11 de Abril) *O António Maria*.

—. (1896, 6 de Fevereiro) *O António Maria*.

—. (1888, 28 de Julho) *Pontos nos ii*.

—. (1884, 11 de Dezembro) *O António Maria*.

—. (1883, 20 de Setembro) *O António Maria*

—. (1882, 28 de Setembro) *O António Maria*. Lisboa.

—. (1880, 17 de Junho) *O António Maria*

—. (1880, 12 de Fevereiro) *O António Maria*. Lisboa.

—. (1880–1883) *Álbum das Glórias*.

—. (1870–1871) *A Berlinda*.

—. (1870) *O calcanhar d'Achilles: album de caricaturas*. Lisboa Joaquim Germano da Sousa Neves.

—. (1868–1875) *A lanterna mágica*.

—. (1846–1905a) *O binoculo: hebdomadario de caricaturas, espectaculos e litteratura* Lisboa: Typ. Portugueza.

—. (1846–1905b) *O António Maria*.

—. (1846–1905c) *A Paródia*.

Radulet, Carmen. (1997, Dezembro) Um Retrato Italiano do Reino de Portugal no século XVI. *Mare Liberum* 14: 99–114.

Ribeiro, Guimarães. (1856, 26 de Outubro) O protector dos pretos. *Jornal do Comércio*. Lisboa.

Sabugosa, Conde de [António Maria José de Melo César e Meneses]. (1923) *Bobos na corte*. 2ª. Lisboa: Portugália Editora.

Silva, António Delgado da. (1830) *Colecção de legislação portuguesa, (1763–1774)*. Lisboa: Typografia Maigrense.

Silva, Raquel Henriques. (2007) O Zé Povinho de Rafael Bordalo Pinheiro: Uma iconologia de ambivalência. *Revista de História de Arte* (3): 238–253. https://run.unl.pt/bitstream/10362/12545/1/ART_12_SILVA.pdf. (acedido a 7/2/2019).

Tinhorão, José Ramos. (1988) *Os Negros em Portugal (Uma Presença Silenciosa)*. Lisboa: Editorial Caminho.

Totta, A. & Machado, F. (1912) *Recordações d'uma colonial (memorias da preta Fernanda)*. Lisboa: Oficina da ilustração Portuguesa. https://archive.org/details/recordaesdum00valeuoft/page/n7

Túlio, Ramires Ferro. (1997) Fim-do-século. In: Coelho, Jacinto Prado (ed) *Dicionário de Literatura*. 4ª. 2. Lisboa: Mário Figueirinhas Editor.

Political fiction or the art of the deal

Rui Zink
IELT, FCSH, Universidade NOVA de Lisboa, Portugal
ORCID: 0000-0003-1672-9480

ABSTRACT: What if, instead of science fiction, we called the genre 'political fiction'? Why are Oulipo's constraint methods the best to approach the teaching of creativity? Why do writers write about what they write about? Are writers such as Le Guin, Lem, Vonnegut using their 'imagination' or just writing down their views on what is there?

Keywords: Science Fiction, Political Fiction, Creativity

1 SCURU FITCHADU

A few months ago, I walked into a bar where a new band played. It was *Scuru Fitchadu*, a hip-hop post-punk neo-dub or whatever band from Cape Verde. Scuru Fitchadu means 'Enclosed Darkness' in Creole. Their energy was outstanding, the sound a bit too loud for my taste. One of them danced in a beautiful and electrifying way, another one, hipster beard and hood, looked scary at the keyboards. It was at the once primal, tribal, war music and computer music, with lots of complex cuts and mixes. Not my thing (after five minutes I wanted out of there) but their power was overwhelming. I was about to leave when I hear the voice of Amílcar Cabral last speech:

> Camaradas e compatriotas, neste momento em que começamos um novo ano de vida e de luta (...) devo lembrar a todos, militantes, combatentes (...), que a hora é de acção e não de palavras. ["Comrades and fellow countrymen, now that we start a new year of our lives and struggle (...) I must remind everyone, partisans, freedom fighters, that it is a time for action, not words."]

Cabral is Cape Verde's main national hero from the anti-colonial struggle, and he was killed in 1973. A tape, of course, but it still was a shock to hear that voice from another time in a 2019 concert by such a post-punk post-postmodern band. I had no means to grasp what I was viewing and listening to on that stage until the memory came to me of reading William Gibson's *Neuromancer*. That influential book sort of explained or previewed the Scuru Fitchadu aesthetics. Books and films do that, sometimes.

What Gibson saw in 1984 is nowadays, in some youngster surroundings, a plain fact. Was he a visionary? Yes. On the other hand, no. I don't think science fiction writers (or any other kind) are 'visionary'.

In fact, I do think our best writers are doomed to little else than talk about themselves and their time.

If I were to choose 20th century most important text, I'd pick *The Metamorphosis*, Franz Kafka's novella about a man that wakes up realising he was turned into a disgusting (and, more important, *disposable*) bug. The story was written at the realm of WWI and published in 1915, but it 'predicts' a good part of humankind's future. How does Kafka do that? Is it 'genius'? Maybe. But 'genius' is, by definition, a difficult material to work with. 'Genius' is a little bit like 'God': words used not so much to understand but to dismiss what we are too lazy to understand. I'd rather say that Kafka spoke about what was already there. He just happened to look with a little bit more focus than others. Thus, instead of 'visionary', I consider writers of great books as people who see what is there, only pay a bit more attention.

Kafka's work is more derivative and autobiographical than imaginative. The same goes for Stanislaw Lem's *Solaris*, for Ursula K. Le Guin's *The Dispossessed*, for Kurt Vonnegut's *Slaughterhouse-Five*. The best writers know you are your own writing tool — you have nothing else to write with — and eventually accept that.

2 RULES AS MIRRORS

In 1942, Isaac Asimov established the Three Laws of Robotics:

1. A robot may not injure a human being or, through inaction, allow a human being to come to harm.
2. A robot must obey any orders given to it by human beings, except where such orders would conflict with the First Law.

35

3. A robot must protect its own existence as long as such protection does not conflict with the First or Second Law.

I think the time has come, in 2019, to establish the Three Laws of Humanistics. Here is my proposal:

- Thou shall not kill
- Be kind unto thy neighbours
- Be open-minded unto strangers

Oops, I'm being told these laws were already written many years ago. Centuries? Even millennia? I'm really sorry. I just did what us writers do: more often than not, we see ourselves as bold explorers only to find out we've been doing little more than wandering in circles around the covered ground.

Oh well. Since it is so, if these Laws of Humanistics were written so long ago, how come they were not yet abode?

And another question: if these ancient laws were broken, how do we know robots will not break their law?

[I can hear HAL suddenly interrupting me, in annoyed automat voice: Because we're not human, that's why you dumb fellow. Duh! HAL didn't say 'dumb fellow' but, at least in academic symposiums, machines don't swear.]

The rules may be good, but one thing we know is that rules are bound to be broken. And we all know one-day robots are going to break the rules. How do I know that? Because it has been a subject of interest around the science fiction community for ages. And we humans have the Midas touch: if we talk about something, likely it is bound to happen sooner or later. If a robot can say "I, robot" what is the existential extension of that 'I'? If a writer questions if 'androids dream with electrical sheep', the Pandora box is open. We know that people misbehaved in biblical times, and we know that because there were rules about that.

"Thou shalt not kill" informs us that people broke this commandment even before it was given to us. We also know that already in biblical times teenagers could be annoying, because of the desperate cry "Honor Father and Mother". And we also know people coveted other people's husbands & wives, for God found it necessary to state "Thou shalt not commit adultery".

We can also assume that, by then, heroin and cocaine were nearly non-existent, for there is nothing about drug abuse. The same with mobile phones, since there is no commandment for "Thou shalt not texting while driving".

Basically, we all do as Hannibal Lecter taught Clarice in *Silence of the Lambs*: "What do we covet, Clarice?" The answer is: we covet what we see. We talk about what we see. (Our current fascination for wise serial-killers that save the day will also be very nourishing for future anthropologists.)

How come, then, that science fiction writers (and writers and poets in general) write about what is not there? The answer I subscribe and the one I find more sensible is: they, too, write about what is there. We, too, like Clarice in Wonderland, covet what we see.

There is nothing else there. Or, if there is, we cannot see it. *SOLARIS*.

I actually believe that science fiction — or speculative fiction — is the more attached genre to the time/space bird cage where/when it is sung/written. And we all know the Latin root for speculative: mirror, 'speculum'.

3 THE ART OF THE DEAL

If Asimov could write those rules for robotics, I'm sure we can find something similar for young writers. Here is my suggestion for *The Three Laws of Writing*:

1. Write only about what you know
2. Write only about what you don't know
3. Follow other writer's path without tripping on their footprints

And, most of all, be ready to find out that maybe–maybe–you never let the simulation capsule.

Sometimes I abhor the word 'creativity'. It's like 'thinking out of the box': once upon a time, meaningful concepts now drained of their strength by overconfident marketers. And two can play that game: if they can raid our words, we can raid theirs. *Negotiation*, for instance. *Negotiation* I like. Chewing until you reach some understanding. Mediocre artists, poor souls, are 'creative'; the best ones are listeners. Listening is essential to negotiating. Unless you are with the mob, you can't do *bizniss* without listening.

Take a sculptor, for instance, and a piece of wood. A bully sculptor—the art world is full bullies—will impose himself on the wood, likely a bad combination of a lazy reading of Nietzsche and Schopenhauer. My favourite kind of sculptor will listen to the wood, not impose him/herself on the wood. *Yes, I have my intentions, but what are yours, wood?*

Kurt Vonnegut began his career with sci-fi novels and stories. Years later he felt the need to flee the ghetto in order to be taken as a 'serious writer', only to end up realising he needed the very toolbox he left behind in order to grasp the dumb-folding reality of the Dresden bombing he witnessed as a war prisoner. His voice needed the little green guys in order to talk about his most horrifying and defining moment. He also needed that approach to fulfil a promise:

> "You were just babies in the war—like the ones upstairs!"
> I nodded that this was true. We had been foolish virgins in the war, right at the end of childhood.
> "But you're not going to write that way, are you."
> This wasn't a question. This was an accusation.
> "I—I don't know," I said.

"Well, I know," she said. "You'll pretend you were men instead of babies, and you'll be played in the movies by Frank Sinatra or John Wayne or some other glamorous, war-loving, dirty old men. And war will look lovely, so we'll have a lot of them. And they'll be fought by babies like the babies upstairs."

(. . .)

So I held up my hand, and I made her a promise: (. . . .) "I tell you what,", I said, "I'll call it 'The Children's Crusade'." (Vonnegut, 1969, p. 18)

Actually, 'The Children's Crusade' is a poor title, and I assume that's why it became a sort of subtitle—editors' sensible pressure. (With me happened the exact opposite: I want the title for this paper to be *The Art of the Deal*, only to find out it was already taken.) Despite the Trafamaldorians and time as ever-present landscape theories, *Slaughterhouse-Five* is not as much the result of a fertile imagination as of painful personal experience, and the urge to get it off the author's chest. Arguably, it is the novel Vonnegut was born to write, his masterpiece.

Before *Slaughterhouse-Five*, Vonnegut had already dealt with the subject, somehow, in *Mother Night*: an infamous spokesman for the Nazis is, in fact, a spy but the only person inside the secret, his handler, dies; and now, instead of hailed as a war hero, he's being chased as a war criminal, only getting by protected by right-wing nuts who think he really is a war criminal and thus adore him.

Vonnegut may have been an ironist from the very beginning, but irony followed him too. In fact, both *Mother Night* (1962) and *Slaughterhouse-five* (1969) work with the same ur-experience: *a German-American goes to Nazi Germany to fight Nazism in 1945 and eventually is captured and imprisoned in a slaughterhouse in a harmless non-militarized German city called Dresden only to be witness to and survivor to an arguably war crime committed by the good guys against the bad guys.* It seems bad slapstick, and yet it's true.

Vonnegut didn't *imagine things*. As great writers do, he just used his considerable imagination & creativity kit in order to talk about what he knows. Not so much 'creating' or 'writing up' (writing is usually conceived as going up, touching the higher spheres of knowledge and sensitivity) as *writing down stuff*. Plus, it is an old Creative writing trick: if you have a good story, just tell it, without flourishes. An analogy can be made with sushi: if your fish is fresh, eat it raw, if not make a nice and baroque-ish *soufflé*.

You write about what is bugging you, or you are doomed to fail. In short: you write what you can, not what you want. And then, sometimes, you surprise yourself by going the extra mile from that starting point.

Ursula K. Le Guin and Kurt Vonnegut have at least one thing in common: both are familiar with Anthropology, a social science very close to science fiction, although not always that is clear to both 'genres' of approach to human issues.

Le Guin always seemed to me as being 'a politically correct writer' in the most beautiful way. By this I mean I agreed with her ethics, the way societies worked well according to her also seemed to work well according to me, and her attempts at writing utopias in dystopic times, as is the case of *The Dispossessed* (1974).

(I must quickly add I tend to abhor self-proclaimed 'anti-political correctness freedom fighters'—in my country at least, they usually are the types that never cared for freedom when we had a real dictatorship and censorship and all the goods that come with fascist regimes.) When Le Guin describes the learning of the arts in anarchist 'moon' Anarris (or is it 'anarrist moon Anarchis'?), she is not talking about some distant planet or using her 'incredible imagination', she is instead stating a very clear political view on education:

> He had never gone to a concert here in Abbenay, partly because he thought of music as something you do rather than something you hear. (. . .) Learning centres taught all the skills that prepare for the practice of art: training in singing, metrics, dance, the use of brush, chisel, knife, lathe, and so on. It was all pragmatic: the children learned to see, speak, hear, move, handle. No distinction was drawn between the arts and the crafts; art was not considered as having a place in life, but as being a basic technique of life, like speech. (156)

And don't start me on Frank Herbert's *Dune* (1965). In a way, he is more ambiguous than Le Guin because she is more generous. However, these writers are answering the problems the world they lived in faced. And they were answering the ones they could, i.e., the ones that interested them. Political and anthropological fiction at its best: eyes pretending to look far away but feet well-grounded on the present.

The funny thing in political fiction is, the likes of Frank Herbert or Le Guin hardly try to disguise what they're talking about: their surroundings, their view on the time they live in.

Vonnegut doesn't try at all. He's writing about an unnecessary slaughter of 'the bad guys' by 'the good guys'. He's trying, using his personal experience as a vantage point, to fulfil his promise to his former comrade's wife: to show are at its most pitiful and unglamorous shape. Only he needs his sci-fi gear to do that.

4 KNOW THYSELF

Since we are playing the three rules game, why not also state The Three Laws of Intelligence? Here are mine:

1. Intelligence is overrated
2. Intelligence is dumb

3. Intelligence is more intelligent when it is not trying too hard to be intelligent.

Actually, this last bullet point is an answer—important in writing — to the beautiful Socrates' motto: "Know thyself".

The 'Creative writing' school I most admire is the Oulipo group (Ouvroir de Littérature Potentielle, founded in France in 1960) uses a method that is the very opposite of the blind belief in creation. The opposite, actually. They think self-awareness is important, but also that it risks being on the way. Therefore, instead of 'struggling to be creative', they simply try to solve problems—to get out of some mess or trap one fell into. They use constraints. A simple but effective strategy: try not to 'be creative', just focus on something else. In Portuguese, we've had for centuries a beautiful formula: "Como vou descalçar esta bota?" I'm not going to translate. Learn Portuguese, it's good for you.

Oulipo's point is: creativity, as 'spontaneity' or 'desire', are shy, elusive animals. One hint that you are after them, and off they go. A voluntary obstacle may be the needed tool to overcome a non-voluntary obstacle. No writer's block for the Oulipo writers: because they are not trying to be creative, only to overcome self-imposed limitations.

If I'm aware of something frail and precious, what I'm aware of may fade away, or even vanish. The sort of intelligence and, for the matter, creativity we work with in literary fiction are shy as deer in the woods: when we call upon them, they're likely not to come feed from our hands but instead to run as fast as they can. For the artist, Socrates' motto is important: if you are the very tool you're using, you should know well your tool. On the other hand, it must be subverted, after a point, for art's sake: "Forget thyself, ignore thyself". Or, even better, subvert it all the way and spray on your studio wall in big letters: "I may be smart, but when I am aware that I'm smart I stop being smart."

For instance: children are natural born humorists and poets – until the day their parents or some dumb parent's friends can't resist to laugh their hearts out and comment: "He/she's so funny."

The self-consciousness prophecy doesn't kill only stupidity. It also kills creativity.

Not being aware has a superpower. Don't forget the evil droid's comment on the thing in the first *Alien* saga film:

"He's perfect," says evil droid.
 The others are in shock: "You admire him."
 Evil droid: "[How can I not?] I admire its purity. A survivor. Unclouded by conscience, remorse, or delusions of morality."

In a way, a good writer should be like a child or—even better—a monster. In any case, an alien: unclouded by conscience, remorse, or delusions of morality.

5 ALLOW ME A PERSONAL NOTE

One day, my wife asked me in a sour mood if I had tried to kiss another woman at a party. I denied most vehemently. She bought it, relieved, for she could see I was sincere. Definitely, she had been misinformed. Later, I realised that it had actually happened. My bad. I had forgotten about the incident, which was a good thing: my lack of memory had turned me into the perfect liar, unclouded by guilt.

After all, it's not only in *2001: A Space Odyssey* that good things come from a memory loss.

6 POLITICAL SCIENCE

Detective stories are called Polars in France, a very good name. Polars are a bit like the Blues in the sense they are written around a fixed (and nearly monotonous) structure, based on the 1st, 4th and 5th chords of a key, the plot almost always the same: a killing, a detective in search of solving the mystery, the pursuit of restoring the order (Todorov, 1971). Around it, the detective visits the sights, the sights that are there. A polar is, in a way, a conformist and realistic – it doesn't build, it unveils. At its most inventive, a polar is the jazzistic version of a classic standard: let's say, Tony Bennet. Granting itself liberties but always needing to come back to the recognisable melody.

Science fiction is quite different. The plot is not the core of its identity. It is existentially shapeless. There is a possibility, and from that possibility, a whole world is built. It owes its due the 19th century fantastic. It is not so much 'once upon a time' as a 'what if'. What if there was a world where people walked upside down? What if we all lived on the moon? What if apes caged and enslaved humans? What if one person could become invisible? What if Martians invaded the Earth? What if we could live forever?

And the science fiction novel that appeals more to both this reader and writer is the one that could be relabelled, more accurately, as *political fiction*: the book that shows a possibility of human organisation, whether good, bad or just utterly different.

Continuing with the music analogy, sci-fi is neither blues nor rock – it's Jazz. And, at its most complex, Johannes Sebastian Bach's fugues and Mozart's operas. It is a whole view on a society built upon one single stone creating a constraint (Oulipo) and determining that wherever the plot develops or whatever characters you bring, they must abide to the specific book's ground rule. In that given novel, women rule the world; in another, humans have been frustratingly dealing for the last 150 years with a single intelligence planet; in other machines are thinking beings who need to be bound by three essential rules. Otherwise, they will destroy us.

The best Polars prey on our fears; the best sci-fi novels stimulate our curiosity by giving us samples of

other worlds and, more than that, by opening our minds for other possibilities of organising our world. That is why a work like Solaris is so challenging 58 years after it was published, because it expresses a challenge, even if it seems frustrating, or precisely because it is frustrating:

> Solaristics seemed to be falling apart (...) Subsequently, the confusion of hypotheses, the reviving of old ones, the introduction of trivial changes rendering them more precise or, on the contrary, more ambiguous—all this began to turn the field of solaristics, which despite the breadth had been rather straightforward up to this point, into an ever more entangled labyrinth full of blind alleys.

One can hear the bureaucracy accustomed Lem laughing—for he is toying not only with space travel and religion but also with academia and bureaucracy. However, it's a faint laugh, hard to catch. *Solaris* is many things, one of them a parody of human hubris, of trying to understand what you are doomed not too. The Strugatsky brothers have that kind of absurdist humour too, and it's a curious coincidence that their novel *Roadside Picnic* (1972) also was turned into a great film by Andrei Tarkovsky (*Solaris* in 1972, *Picnic* turned into *Stalker* in 1979). Needless to say, Tarkovsky's first task was to take away any hint of fun. Still, great films. Both books could also be called Much ado about nothing if the title wasn't also already taken.

That is also why the opening scene of the 2017's film *Valerian* is so ridiculous: across the centuries into the future, Earth's partners may change in shape and colour, but the Human leadership remains comically male-centred.

7 STILL SNUBBED AFTER ALL THESE YEARS

Many people still snub creative writing. Usually, they question a statement that was never made: "Yes, we promise that by attending a creative writing workshop, you'll be able to write a masterpiece + bestseller in only 6 weeks." To be honest, it usually takes at least seven weeks. Eight, if you want to become a certified genius.

A creative writing (CW) workshop can't fulfil that kind of promise—thus, it doesn't make the promise it in the first place. It opens your perspectives, by providing challenges to enhance your technique, yes. And open up a bit your reading talents, if you're lucky. The name also bothers me, for the claim on the adjective is a bit preposterous, but eventually, I got used to it. I no longer see the 'creative' in a CW course. In fact, I never did.

Indeed, a blunter (although less attractive) advertising prop would be to say: join our course and become at least a better reader, through the discussion on books you may haven't read or heard about yet—but expect no miracles. The naysayers even argue that creative

writing can shrink your creativity. And how will that happen? By loading your drive with too much information. By getting you familiarised with current or ancient editing practices (editing: re-reading your stuff or others in order to polish it), thus ending up limit your 'view', your 'freedom', your 'freshness'. In short, the risks are high that, by attending CW lessons, you'll become a narrowminded fiction bureaucrat instead of a True Creator, an artist that answers to no one but him/herself.

Ione may find this romantic perspective on art hilarious, and so did the Oulipo gang, the likes of Raymond Queneau, Italo Calvino, Benjamin Perec. Actually, they laughed their hearts out at this display of 'Ignorance is the New Knowledge' credo, even if current times show that ignorance may pay off, big time.

What can we do at that? Nothing. Arguing demands a term of agreement on the subject. Yes, too much education may turn you into a petulant snob, always quoting the 'scholar references', your mind filled with unnecessary information and so on. You may also get run over by a car while crossing the street at a crosswalk. However, that doesn't mean you did the wrong thing. Being educated may lead you to write great books. Overeducated, you may end up writing *Lolita*, which is also a great book.

Proto-fascist regimes tend to argue the benefits of ignorance and fund-cutting for the arts or social sciences. I simply opt not to agree with that method to achieve both bliss and 'creativity'. Even in semi-utopic Libertarian Anarris, Le Guin (1974, p. 167) shows the flaws of an education that misses its point:

> "(...) Nobody's born an Odonian any more than he's born civilized! But we've forgotten that. We don't educate for freedom. Education, the most important activity of the social organism, has become rigid, moralistic, authoritarian. Kids learn to parrot Odo's words as if they were laws—the ultimate blasphemy!"

We chose to belong to a different way of thinking and of living in society: we belong to a view on the arts that values former knowledge as a living thing. We assume a canon as something to respect, to grasp—*Thou shall read others and listen to others*—and arguing with them will be seen as the ultimate form of respect.

One doesn't need to read Plato or Hegel to struggle with philosophical questions; we simply accept the very idea that dialogue is good. That art, as well as science, at least human sciences, is dialogical.

Actually, that was a main problem the science of solaristics had to deal when facing that planet-ocean consisting of one unified ocean was one. How to communicate with a being that had never faced others? Stanislaw Lem's humans try desperately to make some sense of a mind without equal, a planet which is its own god:

> Someone fond of paradoxes and sufficiently stubborn could go on doubting that the ocean was a living being.

But it was impossible to deny the existence of its mind, whatever could be understood by the term. It had become quite clear that it was only too aware of our presence above it. . . That statement alone disconfirmed the entire expansive wing of solaristics that declared the ocean to be "a world unto itself," "a being unto itself," deprived by a process of repeated atrophy of its former sensory organs (. . .)

And yet, knowledge must be achieved, for we are doomed to try, as Camus (1942) clearly puts it: "I leave Sysiphus at the foot of the mountain. (. . .) One must imagine Sysiphus happy". Thus, Lem concludes:

We may be at the turning point of all history, I thought to myself. A decision to give up, turn back, either now or in the near future, could prevail; I no longer regarded even the closing down of the Station as improbable, or at least beyond the bounds of possibility. But I didn't believe that anything could be saved in this way. The very existence of the thinking colossus would never let people abide in peace again. However much they travelled across the Galaxy and made contact with civilizations of other beings similar to us, Solaris would present a perpetual challenge to humankind.

The romantic view on learning says: skip school, Mr Ferris Bueller; life is outside, Horatio, and it's larger than all your philosophical bullshit. On the other hand, Ferris Bueller owes a lot to Huckleberry Finn, and reading may open your mind, not close it.

Not only your mind, your eyes too, says Oulipo. If we are in a jail cell, romantic fools will tell you to close your eyes and dream. Italo Calvino, Raymond Queneau, Benjamin Perec will say, instead: open your eyes and try to find an exit, you poor dumb f—fellow.

A happy writer is not so much a writer who struggles with her/his demons and wins, but one who knows whose demons to struggle with—and is happy to know that sooner or later is going to lose.

Here's the whole Camus quote:

I leave Sisyphus at the foot of the mountain. One always finds one's burden again. But Sisyphus teaches the higher fidelity that negates the gods and raises rocks. He too concludes that all is well. This universe henceforth without a master seems to him neither sterile nor futile. Each atom of that stone, each mineral flake of that night-filled mountain, in itself, forms a world. The struggle itself toward the heights is enough to fill a man's heart. One must imagine Sisyphus happy.

Indeed.

BIBLIOGRAPHICAL REFERENCES

Asimov, I. (1950), *I, Robot*. New York: Gnome Press.

Besson, L. (producer/director) (2017), *Valerian and the City of a Thousand Planets*. USA: EuropaCorp.

Camus, A. (1942). *Le Mythe de Sysiphe*. Paris: Gallimard.

Gibson, W. (1984). *Neuromancer.* New York: Ace.

Harris, T. *The Silence of the Lambs*. New York: St. Martin's Press.

Herbert, F. (1965), *Dune*. New York: Chilton.

Hughes, J. (producer/director). (1986). *Ferris Bueller Day Off* [film]. USA: Paramount.

Kafka, F. (1915), *Die Verwandlung*. Leipzig: Kurt Wolff Verlag.

Le Guin, U. K. (1974). *The Dispossessed*. New York: Harper & Row.

Lem, S. *Solaris* (1961). Originally published in Poland. Kindle Edition: trad. Bill Johnston.

Oulipo (1973), *La Littérature Potentielle*. Paris: Gallimard.

Queneau, Raymond, Italo Calvino, et al. *Oulipo Laboratory*. London: Atlas, 1995.

Strugatsky, A., B. (1972), *Roadside Picnic*. New York: Macmillan. Trad: Antonina W. Bouls.

Todorov, T. (1971). *Poétique de la Prose*. Paris: Seuil.

Tarkovsky, A. (director). (1972). *Solaris*. USSR: Mosfilm.

Tarkovsky, A. (director). (1979). *Stalker*. USSR: Mosfilm.

Vonnegut, K. (1962). *Mother Night*. New York: Fawcett.

Vonnegut, K (1969). *Slaughterhouse-Five*. New York: Dell.

Part II
Architecture/urbanism/design

"Through the rabbit hole": Intelligence creativity and fantasy in architectural composition

Mario S. Ming Kong
CIAUD, Lisbon School of Architecture, Universidade de Lisboa, Lisbon, Portugal
ORCID: 0000-0002-4236-2240

ABSTRACT: There is a need on the part of man to exist in an organised world, where norms, rules, structures, forms, are constant. However, in this stable and orderly world, there is no room for progress or innovation. It is a static world, where the same processes and models are repeated continuously. Progress and innovation come from confusion, discomfort, imbalance that stimulates the human mind to dream, create and materialise new models, in an eternal pursuit of a balance that is always ephemeral.

We will develop our essay inspired by a few phrases from one of the most iconic books – Alice in Wonderland by Lewis Carrol (1832–1898) – where intelligence, creativity and fantasy are so well portrayed.

Keywords: Architectural Concept, Intelligence, Creativity, Fantasy

1 INTRODUCTION

In this study, "Intelligence, Fantasy and Creativity in architectural composition", we intend to analyse the role of fantasy, creativity and invention in the conceptual process of architectural design. This process can be compared, in our view, to a journey into a parallel world where everything is possible – if you believe it is, as the Mad Hatter claims in Tim Burton's (1958) version of Alice in Wonderland.[1]

1.1 Through the rabbit hole

Is it possible to analyse how fantasy, invention and creativity work? Is it possible to try to understand how an idea is "born"? Is it permissible to draw a parallel between creativity in literary production, as demonstrated by Lewis Carroll in the fantasy and creative story *Alice's adventures in Wonderland* (1898), and in the creative process of designing an architectural project?

Creativity, in the context of design, is, according to Bruno Munari (1907–1988), a productive capacity,[2] where fantasy, intelligence and reason are associated, and whose results aim to be practical and executable Munari (1987, p. 24).

Figure 1. Mad Hatter, 2012, Olga Abbasova, Heydar Aliyev Center, Baku, foto by Maria do Céu Rodrigues.

Thus, and following this reasoning, we can define the act of creating as a methodical path to solve a problem, using, among other tools, fantasy.

The entire process of conception, in whatever area, is based on the search for the "best" solution to a problem. In this quest, there must be a distancing from the existing. The status quo must be questioned. Figuratively one has to follow the white rabbit through the rabbit hole, showing such confidence as Alice, that

1. Tim Burton's *Alice in Wonderland* 2010.
2. Bruno Munari stated that fantasy is a productive capacity in which fantasy and reason are associated and whose outcome is always possible of concrete realisation (Munari, 1979, p. 69).

"something interesting is sure to happen" (Carroll, 1898, p. 30).

2 'CURIOUSER AND CURIOUSER!'[3]

If we compare the creative process in architecture with Alice's journey in the wonderland told by Lewis, we can find some analogies. Both require an open mind to new situations, to be able to observe from different perspectives; to be willing to experiment with different scales, but also to have the ability to relate and question these new experiences to what is known previously and to formulate value judgments.

Architecture, being a product of fantasy, creativity and invention, is born of relationships that the mind establishes between what it knows. Thus, it cannot be dissociated from the cultural, philosophical, ideological, sociological context: each epoch has its sensibility, its beauty, its sense of harmony and proportions and its identities (Kong, 2012, p, 359).

There is a need on the part of man to exist in an organised world, where norms, rules, structures, forms, are constant. However, in this stable and orderly world, there is no room for progress or innovation. It is a static world, where the same processes and models are constantly repeated. Progress and innovation come from confusion, discomfort, imbalance that stimulates the human mind to dream, create and materialise new models, in an eternal pursuit of a balance that is always ephemeral.

A creative person is someone who, faced with a specific problem, can analyse the resources at his disposal to escape adversity and curiosity to try new and unusual paths. This ability to identify and interconnect new values, to decide between possible options, we may call creativity. According to Vygotsky (1896–1934), imagination cannot be considered a diversion of the brain, but a necessary function that is in direct relation to the richness and variety of the experience accumulated by the human being, because it is based on this experience that fantasy is built on (Vygotsky, 1987). This is an aptitude which, following Vygotsky's reasoning, to be acquired, needs stimulation from childhood on. The development of creativity requires a broad vision of education, in addition to the capability of memorising teachings and of reproducing knowledge.

In this sense, the creative act has its genesis in need, knowledge and curiosity. According to Plato (428/427 BC – 348/347 BC) in his work "Timaeus", whatever is born proceeds necessarily from a cause, since it is impossible that anything is born without a cause (Platão, 1984, p. 260).

In the case of architecture, defined the need to create a place for the performance of a particular function, the architect works mainly focusing on three variables – space, form and scale. However, the last two entities materialise through forms. Thus, the fantastic and creative universe of architecture presupposes an action that creates forms. Any embodiment of desire is thus defined only by form and, according to Kandinsky, necessity creates forms (Kandinsky, s.d., p. 15).

Forms continue, propagate in the imaginary (Cf. Langer, 1953, p. 373). Because forms are contained, being strict definitions of space, they are also suggestions of other forms. A form can, therefore, produce a pleasant or unpleasant effect, have a beautiful or ugly appearance, can be harmonious or disharmonious, skilful or inept. All these notions are relative, a fact which is quite clear if we consider the infinite series of existing forms.

We consider forms as a kind of aperture, through which we can enter an uncertain realm, which is neither physical nor mental space, a potential generator of a multitude of images that want to be born. In line with this point of view, Rudolf Arnheim (1904–2007) refers that the artistic imagination can be described as the discovery of a new form for old content, or as a new concept of an old subject (Arnheim, 1980, p. 132).

In man's quest to impose his eternity through forms, he is influenced by experience and knowledge. These factors are dependent on the culture he belongs to; since the context changes proportionately to the variation of the various cultural environments, that, according to Kandinsky, to a certain extent, the act of creating forms is subjugated, to time (era) and space (nation) (Wassily Kandinsky, s.d., 16).

As each civilization has its own ways of conceiving objects (Cf. Schulz, 1969, p. 220), forms and spaces, of understanding them, of assimilating them and of relating to them (Cf. Langer, 1953, pp. 96–98 e 372–373) – it is in this continuous process that man seeks a historical, cultural and technical legitimacy for a new architecture as a valuable contribution to society and culture (Morales, 1979, p. 12). In this sense, Hall (1914–2009) refers that individuals, belonging to different cultures, not only speak different languages but more importantly, they inhabit different sensory worlds (Hall, p. 113). In this way, we may say that it is in the light of his respective culture that man tries to understand problems and that the understanding of the specificity of the problems or needs will generate a solution. This solution, more than a mere overcoming of a necessity of material order, is then a creative reflection of education, culture and innovation.

The interaction of society with a particular object, form or space can exercise a kind of magnetisation, metamorphosing the intentions of the author, and giving his creation an unexpected significance.

Forms are, in a sense, a continuity of man, a way of surpassing his mortality through the immortality of created forms, because, being the man who is the protagonist of creation, he transmits his identity to forms.

3. Carroll (1898, p. 16).

According to Henri Focillon (1881–1943), life is form, and form is the living form of life (Focillon, s.d., p. 12).

3 CONCLUSION

We can conclude that the creative process in the field of architecture goes through several phases: it registers impressions, adjusts and creatively conforms to individual and collective identities, evolves with new ways of seeing and feeling. These manifestations are assimilated by a creative vision, which becomes a tool for solving needs with new representations, new concepts, new purposes, new definitions.

However, we must point out that the creative, conceptual, methodological process in architectural design varies according to place, the current culture and on the experience and practice of the architect, in order to respond to the most diverse levels of demand, especially on aesthetic, formal and functional aspects of each society. In this sense, it can be understood that creativity and fantasy are also differently expressed while maintaining the same importance within the society from which they generate and that they reflect.

Increasingly, these plastic languages and architectural methods allow the emergence of new ways of seeing and feeling architecture, through the contribution of old or new sociocultural values, which are reflected directly or indirectly in the artistic environments, especially in the field of architecture. Let us conclude our reasoning referring to Hegel, according to who art is the sensible representation of an idea, the external symbol of a metaphysical content developed in time.

And in future? What are the new challenges, the new needs to be addressed? All roads are open to fantasy and creativity, as we can read in *Alice in Wonderland*:

"Would you tell me, please, which way I ought to go from here?" "That depends a good deal on where you want to get to," said the Cat. "I don't much care where—" said Alice. "Then it doesn't matter which way you go," said the Cat. (Carroll, 1898, p. 53)

BIBLIOGRAPHICAL REFERENCES

Arnheim, Rudolf. (1980). *Arte e percepção visual*. São Paulo: Pioneira Thomson Learning Ltda.

Carroll, Lewis. (1898). Alice's adventures in Wonderland and, Through the looking-glass. Boston: Lothrop.

Focillon, Henri. (s.d.). *A vida das formas*. Lisboa, Edições 70.

Hall, Edward T. (s.d.). *A dimensão Oculta*. Lisboa: Relógio D'Água Editores.

Munar, Bruno. (1987). Fantasia, invenção, criatividade e imaginação na comunicação visual. Lisboa: Colecções Dimensões.

Munari, Bruno. (1979). *Artista e designer*. Lisboa: Editorial Presença, Lda.

Kandinsky, Wassily (s.d.). *Gramática da criação*. Lisboa: Edições 70.

Kong, Mário S. Ming. (2012). Harmonia e Proporção. Um Olhar sobre o Desenho Arquitetónico no Ocidente e no Oriente. Lisboa: Editora Insidecity Lda.

Langer, Susane K. (1953). *Feeling and Form. A theory of art*. Londres.

Platão (1987). *Timeu*. In *Diálogos* (vo. IV). Lisboa: Europa América.

Schulz, Cristian Norberg. (1969), *Meaning in Architecture*. Londres: Charles Lenks & George Baird.

Solá-Morales, Ignasi de. (1979). *Diferencias. Topografia de la Arquitectura Contemporânea*, Barcelona: Editorial Gustavo Gili, S. A.

Vygotsky, L.S. (1987). *Imaginacion y el arte em la infancia*. Mexico: Hispânicas.

Creativity and beauty in art and science today: A basis for discussion of a possible future architecture

Clara Germana Gonçalves
CITAD, Lusíada University, Lisboa, Portugal/ISMAT, Portimão, Portugal
ORCID: 0000-0002-1236-5803

ABSTRACT: Considering that, throughout history, architecture has always been seen as being somewhere between art and science, and that the concepts of art and science have been subject to changing interpretations in time, this article explores the idea of how a theoretical discussion on the relationship between the arts and sciences – focusing specifically on creativity and beauty in both – might help in, and also be a justification for, reflecting, on the one hand, on the possible integration of architectural reasoning and/or design in and from other areas, and, on the other, on a non-human architecture (of a micro and macro scale) or not subject to gravity.

Keywords: future of architecture, art, science, creativity, beauty

1 INTRODUCTION

Architecture has always been dependent on the fate of art: at times, and indeed almost always because it was faithful to art, and at other times, because it wanted to escape art, a desire shown by the more orthodox side of the Modern Movement. But architecture has also been shaped by the fate of science: from the belief in the architect-Demiurge to the rejection of a scientific approach to doing things to the detriment of artistic freedom. Architecture has always gravitated between art and science and between the union and distance between them. The current tendency towards the re-approximation of art and science is the starting point for the discussion on architecture that is proposed herein.

Interdisciplinary dialogue would appear to be something essential, as specialisation tends to create isolated areas of knowledge, annul the relationships between the various disciplines and encourage the discounting of areas whose autonomy is not clear. In this respect, architecture can have a dual role, as its particular nature is non-specialized: interdisciplinary discussion also appears to be fundamental to its inner core, making architecture a privileged vehicle for such a discussion.

C. P. Snow, who has been frequently cited for the ideas he exposed in his seminal essay *Two Cultures* (1959) is still a reference figure in this discussion. For instance, the article "Creativity in art and science: are there two cultures?" (Andreasen and Ramchandran, 2012), which discusses creativity in individuals from both the arts and the sciences, cites him as follows (p. 50):

> In our society (that is, advanced western society) we have lost even the pretense of a common culture.

Persons educated with the greatest intensity we know can no longer communicate with each other on the plane of their major intellectual concern. This is serious for our creative, intellectual and, above all, our normal life. It is leading us to interpret the past wrongly, to misjudge the present, and to deny our hopes of the future. It is making it difficult or impossible for us to take good action…

2 ART AND SCIENCE

It is very common to find people for whom the study of mathematics and art is equally exciting. They feel the same sense of transcendence when studying mathematics or art. Whether it be from the point of view of the ideas, the process or the results. The pleasure of mathematics is also the pleasure of using its language, which is equal to the pleasure of looking at a colour, or touching paints, even if in their raw and unworked form.

With regard to architecture, it is worth remembering that whilst, on the one hand, in the nineteenth century architecture was deeply identified with the *beaux arts*, on the other hand, the idea that architecture is a science (with, according to that very definition, each part of a building integrated into one and the same system of mathematical ratios), may be considered, according to Wittkower (1998, p. 104), the basic position of Renaissance architecture.

Continuing this line of argument, Pelletier and Perez-Gomez (1994, p. 4) clarify:

> The reduction of the fine arts to a morally inconsequential aesthetic formalism is not an absolute paradigm but rather an historical event related to the glorification of scientific reason during the eighteenth

century. Believing that positive science is capable of disclosing absolute truth – a belief whose roots were indeed theological – the rationalists implicitly relegated art (and "non-scientific" architecture) to a marginal, illegitimate zone.

Both aspects can be contextualized through the idea proposed by Alistair C. Crombie (1986, cited in Garfield, 1989, p. 56) that the period in which Galileo lived, is one that mediated between the time of the "rational constructive artist" (personified by Michelangelo) and the "rational experimental scientist" (personified by Newton).

And, if on the one hand, architecture has always oscillated between art and science, on the other, art and science are seen alternately as two worlds, at times irreconcilable, and sometimes very close and, in certain aspects, practically indistinct. Several authors reference this approach, which can be seen from different points of view, often contradicting the current common-ground viewpoint. Federico Mayor (2001, p. 5) argues that "[o]ccasionally, when science reaches beyond its frontiers, it merges with philosophy. Likewise, art can be dematerialized – boiled down to pure ideas." In addition, it can be argued that, contrary to the "romantic" idea of the "inspired" artist, which is still very present in the current imaginary, "[a]rtists exercise the same self-discipline and rigour as scientists." (Mayor, 2001, p. 5). Or, in the words of Ortega y Gasset (1963, p. 391), referring to poetry:

> [I]n one of its dimensions, poetry is an investigation, and it discovers facts as positive as those habitually discovered in scientific research.[1]

In retrospect, it is also important to remember that the Greek *téchné* and the Latin *ars* refer, at the origin of Western culture, to any activity that implies previous knowledge and experience, or an activity that implies a skill that can be exercised in apprenticeship. And Eliane Strosberg (2001, p. 29) explains how the word "scientist" first emerged in Britain only in 1863. It is indicative of the approximation which, despite the given hierarchies, existed between the various disciplines.

One particularly captivating fact is that we can say that many of the attributes traditionally associated with art are now the prerogative of science. In the words of Siân Ede (2005, p. 1):

> Scientists weave incredible stories, invent extraordinary hypotheses and ask difficult questions about the meaning of life. They have insights into the working of our bodies and minds which challenge the way we construct our identities and selves. They create visual images, models and scenarios that are gruesome, baffling and beguiling. They say and do things that are

ethically and politically challenging and shocking. Is science the new art?

Early in the twentieth century, in his classic *Abstraction and Empathy* (1907), in which he reflected on the (apparent?) paradoxical romantic world, Wilhelm Worringer, evoking Novalis' (1772–1801) earlier thoughts on the subject, argues for the possibility of mathematics being an art form (1997, p. 19):

> We frequently find the, at first sight, astonishing idea put forward by modern art theoreticians that mathematics is the highest art form; indeed it is significant that it is precisely Romantic theory which, in its artistic programmes, has come to this seemingly paradoxical verdict, which is in such contradiction to the customary nebulous feeling for art. Yet no one will venture to assert that, for instance, Novalis, the foremost champion of this lofty view of mathematics and the originator of the dicta, 'The life of the gods is mathematics', 'Pure mathematics is religion', was not an artist through and through.

And further, on the relationship between art and mathematics, Paul Valéry (1871-1945) is an example of an author for whom both "cultures" (to use C. P. Snow's term) were most definitely not incompatible. Alongside poetry, he studied mathematics for almost all his life. To him, "[s]cience and art are crude names, in rough opposition. To be true, they are inseparable . . .". He goes on to reflect: "I cannot clearly see the differences between the two, being placed naturally in a situation where I deal only with works reflecting thinking matters." (cited in Strosberg, 2001, p. 14) In reality, the difference lies in the gradation of the degree of certainty affecting both:

> An outstanding difference between the sciences and the arts is that the former must aim at results that are either certain or immensely probable, whereas the latter can only hope for results of an unknown probability. (Valéry, 1977, p. 39)

Graham Farmelo (2003a, p. xiv) compares a work of art with an equation:

> Much like a work of art, a beautiful equation has among its attributes much more than attractiveness – it will have universality, simplicity, inevitability and an elemental power.

Discussing the boundaries between these important traditional areas of knowledge is paramount when a discussion on the current epistemological structure is proposed as a basis for discussing the future of architecture.

3 CREATIVITY

"Creativity is a prized feature of the human mind, but prizes can coexist with puzzlement." This statement from Margaret A. Boden (1996b, p. 1) is very eloquent. Many questions arise when discussing creativity. What

1. [Free translation. Or: "[e]n una de sus dimensiones la poesía es investigación y descubre hechos tan positivos como los habituales en la explotación científica."]

is it? What is the relationship between novelty and creativity? Is the creative process the same in art and science? This last question is of the utmost importance for the present discussion, as is the idea of two separate worlds: that of the arts and that of the sciences.

Margaret A. Boden concludes her essay on creativity (1996a, p. 289) with the following words:

> Creativity is not a separate "faculty," but an aspect of general intelligence – which involves many kinds of thought process. (. . .) The study of creativity is inescapably interdisciplinary.

These are two fundamental ideas which are shared with many other authors.

Studies in the neurosciences indicate that perhaps these areas, which are commonly considered to be different, are not so different after all, as proposed by Andreasen and Ramchandran (2012, p. 50):

> For many lay people, the word "creative" evokes images of novelists, poets, composers, and visual artists. If prompted, they would acknowledge the creativity of mathematician/physicists such as Einstein or inventors such as Thomas Edison, but there is a general tendency to assume that creativity is more associated with the arts than the sciences.

And whilst it is art that is essentially, or traditionally, associated with creativity, it is also pertinent to recall that the concept of creativity is a very recent one.

The notion of creativity as inventive and free achieving or accomplishing only gains true expression in the philosophy of art from the nineteenth century and the Romantic revolution onwards. At the dawn of Western culture, the term *poiein* refers to the reproduction of things existing in nature. Any new creation or originality was excluded, for art was governed by strict rules (such as canons or rules of proportion). In accordance with this idea, the Greek Demiurge emerges as an ordainer, not a creator. In the eighteenth century, the concept of creativity began to emerge more frequently and was increasingly associated with the concept of imagination. And in the nineteenth century, in contrast to the preceding centuries, art became practically synonymous with creativity. But after the great Romantic liberation, in reacting to the progressive banalization of the idea of creativity, the new currents in artistic expression, with few exceptions (such as Surrealism or Expressionism), failed to underline the value of enthusiasm and giving free rein to the fantasy, as had been part and parcel of Romanticism (Carchia, 2009, pp. 83–85; Tatarkiewicz, pp. 248–249).

The discussion of the term "creator" is typical of, and in line with, the debate of this issue. For a thousand years of academic study, the term did not even exist, not even in theology; in the following thousand years, it has existed, but only in reference to God. Indeed, in the nineteenth century, the term "creator" was incorporated into the sphere of art, becoming used exclusively in the said sphere, with "creator" being used very much as a synonym for the artist. One must, however, except the case of poetry which, since Greek antiquity, has had a special status. So much so that imagination and inspiration were, in classical Greece, ideas associated only with poetry. According to Tatarkiewicz, it was the Pole Maciej Kazimierz Sarbiewski (1595–1640) who, referring to poetry, used for the first time the word "creator": in his words, the poet not only "invents" (*confingit*), but "creates anew" (*de novo creat*); he even adds that the poet creates "in the manner of God" (*instar Dei*). However, one must stress again, this privilege belonged only to poetry; the other arts imitated and copied. From the nineteenth century onwards, creative as an adjective, and creative as a noun, became part of the new lexicon. And "creator" often referred to the artist or poet. One should also mention that what is now understood by creativity is different: the idea of *ex nihilo* disappears; creativity is now understood as the creation of new things and not the creation of things out of nothing (Tatarkiewicz, 1980, pp. 248–251, 282–288).

From the twentieth century on, the term "creator" began to be applied to all human culture (including the sciences, politics, technology). Today we use variants of the same root word with a similar meaning: creator, create, creative, creativity. Creativity is the central term. And Tatarkiewicz points out its double meaning: on the one hand as a process – in the mind of the creator – and on the other, (in the Polish language at least[2]) the product of that process. There is a significant difference between these two meanings, for we know the works but scarcely know the process (Tatarkiewicz, 1980, p. 251). The feature that distinguishes creativity in every field is novelty (in an activity or a work). Every instance of creativity implies *novelty*, although the inverse is not the case. (Tatarkiewicz, 1980, p. 257).

Tatarkiewicz (1980, p. 249) highlights the fact that, at the beginning of the twentieth century, when creativity in the sciences and nature increasingly became a theme of discussion, there was a transference to the sciences and nature, of concepts proper to art. One can cite as an example of this Matila Ghyka's (1881–1965) several studies which, despite their undoubtedly interesting approach to human and nature's proportions and structure, seem to be a case in which artistic proportions were (one might say) forced onto natural forms. And Tatarkiewicz (1980, pp. 249–250) presents further reflection that shows how the objectives of art and science can be confused or, at least, approximated:

> The point is that art and poetry have at least two basic values, both of which may be and have been its aim: on the one hand, the groping for the truth, the plumbing of nature, the discovery of rules, of the laws governing human behaviour – and on the other hand, creativity, the creation of new things that have not been before, of things that have been invented by man. In short, art and

2. This observation, included by the author, has intentionally been left in here for its relevancy.

poetry have two watchwords: law, and creativity; or: rules, and freedom; or again: skill, and imagination. The history of the concept of creativity indicates that for a very long time, the first role was uppermost. History shows that for a long time it was not believed that both roles could be fulfilled simultaneously.

Indeed, amongst various figures of acknowledged renown, Eugene Garfield cites A. L. Copley who was a scientist as well as an artist to testify to this proximity: "What is common to both art and science is the creative process and the synthetic thinking in both human endeavors" (1987, cited in Garfield, 1989, p. 54).

And art and science can come closer to each other by both the creative act and the desire to "surpass reality", as Federico Mayor (2001, p. 5) suggests:

> What is common to art and science? Creation. Or rather the drive that impels creativity. The thrill of the world and sound, of the color, lines and shapes of art. The temerity of the scientific hypothesis which extends beyond reality. What is the aim of a creative act in art or science? To surpass reality.

"To surpass reality." This phrase expresses succinctly one of the themes to be proposed herein as an object of study in architecture to be developed in the future: an architecture for scales other than the human scale.

Andreasen and Ramchandran (2012, p. 49) explain how they analysed "the relationship between creativity in the arts and the sciences" using "functional magnetic resonance imaging to explore the neural basis of creativity in a group of (. . .) individuals from both domains". And they conclude:

> This small group of "big C" [high levels of creativity] individuals includes a diverse group of artists and scientists. When the activations in the two groups are compared, the findings give no support for the notion that the artists and scientists represent 'two cultures'. Rather, they suggest that very gifted artists and scientists have association cortices that respond in similar ways.

It is also of interest here to discuss what is actually invented – let us call it pure human invention – i.e., what will be a real discovery. Even if the mechanisms for that discovery may be purely, or, fundamentally, human.

Roger Penrose (1990: 123–124) points out:

> How 'real' are the objects of the mathematician's world? From one point of view it seems that there can be nothing real about them all. Mathematical objects are just concepts; [. . .] Can they be other than mere arbitrary constructions of human mind? [. . .]. It is as though human thought is, instead, being guided towards some external truth – a truth which has a reality of its own, and which is revealed only partially to any one of us.

Moreover, Penrose (1990, p. 125) argues that what, in science, usually has the status of human invention is not, in fact, invention it is in reality, a discovery.

It is discovery, because if, in reality, the phenomenon exists, then the scientist does not invent it, they discover it. He goes on to illustrate this idea: "The Mandelbrot set is not an invention of the human mind: it was a discovery. Like Mount Everest, the Mandelbrot set is just there!"

"Is mathematics invention or discovery?" Penrose would argue for the second hypothesis, but he also states that "the matter is perhaps not quite so straightforward." In some cases, "the word 'invention' seems more appropriate than 'discovery'." Penrose explains both situations using, respectively, the expressions "works of man" and "works of God" (quotation marks from the original text). He goes on to explain that this fact is comparable to those that occur in the arts or engineering, and that: "great works of art are indeed 'closer to God' than are lesser ones". He quotes Jorge Luís Borges – "a famous poet is less of an inventor than a discoverer [. . .] – to express the idea that the greatest works of art reveal "eternal truths which have some kind of prior etherial [sic] existence". (Penrose, 1990, pp. 126–127)

Once more, the discourse is similar for both art and science.

4 BEAUTY

There is another aspect that seems to be of paramount importance when discussing science and art. That aspect is beauty. And whilst beauty may be an unappreciated expression in art today, scientists, on the contrary, feel free and happy to use it. And not without reflection. "Contemporary scientists often talk about 'beauty' and 'elegance'; artists hardly ever do." (Ede 2005, p. 1) This is the strong argument with which Siân Ede begins her book *Art and Science*. Moreover, she argues: today, "[scientists] use frequently a word that is scarcely ever heard in the arts. That word is 'beauty'." (Ede 2005, p. 13)

Graham Farmelo (2003a, p. xv) writes on Einstein:

> The concept of beauty was especially important to Einstein, the twentieth century's quintessential aesthete. According to his elder son Hans, 'He had a character more like that of an artist than of a scientist as we usually think of them. For instance, the highest praise for a good theory or a good piece of work was not that it was correct nor that it was exact buy that it was beautiful'.

And Bertrand Russell (echoing Novalis?) passionately argues before him (1959, p. 60):

> Mathematics, rightly viewed, possesses not only truth, but supreme beauty – a beauty cold and austere, like that of sculpture, without appeal to any part of our weaker nature, without the gorgeous trappings of painting or music, yet sublimely pure, and capable of a stern perfection such as only the greatest art can show. The true spirit of delight, the exaltation, the sense of

being more than man, which is the touchstone of the highest excellence, is to be found in mathematics as surely as in poetry.

We find a link in history. Copernicus (1473–1543) insisted on uniform circular movement in his heliocentric system while appealing to the aesthetic judgement of his fellow mathematicians: Ptolemaic system lacked beauty and unity. This was the reason for other Humanists to reject the work of the Scholastics (Bronovski and Mazlisch, 1988, p.129). Likewise, aesthetics judgment was present in Galileo:

> Galileo found Copernicus' proposal convincing not because it better fit the observations of planetary positions but because of its simplicity and elegance, in contrast to the complicated epicycles of the Ptolemaic model. (Hawking, 2002, p.ix)

The beauty of mathematics lies in this "perfection", in this "everything fits", in this "everything makes sense"; as in a work of art: everything in balance, the parts, the relationship between the various elements, the various events, the design, the harmony, the texture. Beauty and truth. Paul Valéry (1995, p. 49) had reflected on this subject matter as well:

> Mathematicians never stop talking about the beauty of the structure of their arguments and their demonstrations. Their discoveries are made by means of the perception of analogy of forms.[3]

Graham Farmelo (2003b) classifies the equations of modern science in the aptly titled book *It Must Be Beautiful*. Beautiful seems to be a condition *sine qua non* for true. Buckminster Fuller (1895–1983) (cited in Livio, 2003: 10) once put it:

> When I am working on a problem, I never think about beauty. I think only of how to solve the problem. But when I have finished, if the solution is not beautiful, I know it is wrong.

And as Einstein's eldest son, Hans, explained: "not beautiful" is a mistake.

Siân Ede (2005, p. 186) describes how – based on beauty – some scientists claim for themselves the role of artists. The author explains, as an example, how they claim that the images they produce using the new scanning technologies possess a beauty that is sufficient unto itself; they consider it a new form of abstract art. Putting the discussion of whether it is art or not to one side, it is interesting to discover how beauty is once again seen both as a warranty for truth and a goal in itself, in art and science.

3. [Free translation. Or: "Os matemáticos não param de falar da beleza da estrutura dos seus raciocínios e das suas demonstrações. As suas descobertas desenvolvemse através da percepção de analogia de formas."]

5 ON ARCHITECTURE FOR THE FUTURE

As the boundaries are not clear – between art, science, creativity, beauty – everything is open to discussion. Science – more specifically, neuroscience – seems to confirm that, after all, the brain of the artist and the scientist work in the same way. Furthermore, the epistemological structure of knowledge has been questioned, and we are now seeing several proposals for change. By way of example, one can refer to Margaret A. Boden's (1996a, p.289) considerations on creativity (already mentioned before): mainly that creativity is involved in several different kinds of thought processes and its study is "inescapably interdisciplinary." And as beauty is not restrictive to art, but is accepted or even transversally pursued, all perspectives seem to be possible.

Picon and Ponte (2003, p. 11) clarify that throughout history

> the sciences have served as a source of images and metaphors for architecture and have had a direct influence on the shaping of built space. In recent years, architects have been looking again at science as a source of inspiration in the production of their designs and constructions.

At the same time "[a]rchitecture has provided images for scientific and technological discourse also." There is an "exchange between the two domains". (Picon and Ponte, 2003, p. 11.) Establishing a different link, one interrelating architecture with music, Marcos Novak (b. 1957) is one author who, through the digital world, creates a new interdisciplinary relationship between architecture and music: "archimusic" – the fusion of both disciplines. Music serves as a basis, for, according to Novak, "music has reinvented itself in far more profound ways than architecture has dared" (Novak, 1994, p. 69) and may serve as an example to architecture.

The awareness that there is, beyond the visible world of everyday life, a macrocosmic and a microcosmic world, forces us to think about some fundamental questions: is the existence of architecture in this visible and sensitive world of everyday life a destiny? Can, or not, a parallel be drawn between the worlds of art and science, with the transposition of concepts? By this, I mean to reflect on architecture as a specific way of reasoning, a *design* (not necessarily constructed). Free of constraints. Using Margaret A. Boden's (1996a, pp. 271–272) concept of "dropping a constraint". While explaining what is understood by conceptual spaces, within other examples, she alludes to, for instance, how Arnold Schoenberg (1874–1951) created atonal music by ignoring the "home-key" constraint. What is proposed here is to drop gravity and human scale (for now...). This idea may be seen as a follow-up to earlier experiences, such as those of Claude-Nicolas Ledoux (1736–1806), whose built work lacks the sublime magic of his drawings. The same applies to Étienne-Louis Boullée's (1728–1799) drawings. Their

value depends on a non-existent building technique, on an impossible existence.

The traditional edifice of architecture will become something for which we do not yet have a name.

To use Federico Mayor (2001, p. 5) term, to "surpass reality" (as quoted above) is the primary goal.

ACKNOWLEDGEMENTS

This chapter was funded by National Funds through FCT – Fundação para a Ciência e a Tecnologia under the Project UID/AUR/04026/2019.

BIBLIOGRAPHICAL REFERENCES

Andreasen, Nancy C. and Ramchandran, Kanchna. (2012). Creativity in art and science: are there two cultures? *Dialogues in Clinical Neuroscience*, 14(1), pp. 49–54.

Boden, Margaret A. (1996a). Creativity. In Boden, Margaret A. (Ed.). *Artificial Intelligence* (pp. 267–291). Cambridge, Mass.: Academic Press.

Boden, Margaret A. (Ed.). (1996b). *Dimensions of Creativity*. Cambridge, Mass.: MIT Press.

Bronovski, J. & Mazlisch, Bruce. (1988) *A tradição intelectual do Ocidente*. Lisboa: Edições 70.

Carchia, Gianni. (2009). Criatividade. In Carchia, Gianni & D'Angelo, Paolo (Ed.s). *Dicionário de estética* (pp. 83–85). Lisboa: Edições 70.

Ede, Siân. (2005). *Art and Science*. London: I. B. Tauris.

Farmelo, Graham. (2003a). Foreword: It Must be Beautiful. In Farmelo, Graham (Ed.). *It Must Be Beautiful: Great Equations of Modern Science* (pp. xi–xviii). London: Granta Books.

Farmelo, Graham. (Ed.). (2003b). *It Must Be Beautiful: Great Equations of Modern Science*. London: Granta Books.

Garfield, Eugene. (1989). Art and Science. Part 1. The Art-Science Connection. In Garfiel, Eugene. *Essays of an Information Scientist: Creativity, Delayed Recognition, and other Essays* (pp. 54–61). Philadelphia, Penn., ISI Press.

Hawking, Stephen. (2002). Introduction. In Kepler, Johannes. *Harmonies of the World: Book Five*. Philadelphia, Penn: Running Press.

Livio, Mario. (2003). *The Story of Phi, the World's Most Astonishing Number*. New York, N.Y.: Broadway Books.

Mayor, Federico. (2001). Preface. In Strosberg, Eliane. *Art and Science* (p. 5). New York, N.Y.: Abbeville Press

Novak, Marcos. (1994). Breaking the Cage. *Pamphlet Architecture*. Architecture as a Translation of Music. Martin, Elizabeth. (Ed.). (16), pp. 69–71.

Ortega y Gasset, José. (1963). *Obras Completas*. Madrid: Revista de Occidente.

Pelletier, Louise, & Pérez-Gómez, Alberto. (1994). *Architecture, Ethics and Technology*. Ottawa: Carleton University Press.

Penrose, Roger. (1990). The Emperor's New Mind: Concerning Computers, Minds and the Laws of Physics. Oxford: Oxford University Press.

Picon, Antoine and Ponte, Alessandra (Eds). (2003). *Architecture and the Sciences*. New York, NY: Princeton Architectural Press.

Russell, Bertrand. (1959). *Mysticism and Logic and Other Essays*. London: George Allen & Unwin.

Strosberg, Eliane. (2001). *Art and Science*. New York, N.Y.: Abbeville Press.

Tatarkiewicz, Wladyslaw. (1980). *A History of Six Ideas: An Essay in Aesthetics*. Dordrecht: Springer.

Valéry, Paul. (1977). *Paul Valéry: An Anthology* (Lawler, James Ronald Ed.). London: Routledge & Kegan Paul.

Valéry, Paul. (1995) Discurso sobre a Estética, Poesia e Pensamento Abstracto. Lisboa: Vega.

Wittkower, Rudolf. (1998). *Architectural Principles in the Age of Humanism*. London: Academy Editions.

Worringer, Wilhelm. (1997) Abstraction and Empathy: A Contribution to the Psychology of Style. Chicago, Ill.: Ivan R. Dee.

Notes on illusion: Ideation as an instrument for a spatial intelligence of architecture

Francisco Oliveira
CIAUD, Faculdade de Arquitetura, Universidade de Lisboa, Lisboa, Portugal
ORCID: 0000-0003-0089-3112

ABSTRACT: This work intends to look at the role of visualisation in the creative process of architecture as a virtualised exploration, of the construction of a world that is understood by real and where the architecture of things arises as a support for the existence. In a context tagged by the most recent discoveries of science, ever closer to confirming ancestral models of prefiguration of the universe, imagination and creativity emerge as protagonists of the construction of a particular nature of intelligence inhabited by the dream of architects. We try to open the door to the understanding that the world emerges from the interaction between fields of the real, where the consciousness of illusion becomes the protagonist of a kind of game played between the real and the imagined. In this fantasy, space can precede the desire of the architect but, simultaneously, this same space, makes emerge the thought as creative force for the construction of an architectural illusion, which consubstantiates the spatial intelligence of architecture as a process of harmonization between the mind and the body, between the idea and the place of action.

Keywords: Illusion; Creativity; Intelligence; Visualization; Architecture.

1 ENTERTAINMENT OF PERCEPTION AND THE ARCHITECTURE OF SENSATIONS

When we debate on the term illusion, we realise that it comes from the Latin *illusio* and that in its origin was used rhetorically as synonymous with "irony," formed by *in*, "in," + *ludere*, of *Ludus*, arises associated with the concept of gambling and play. The concept refers to an idea of entertainment of perception, where the senses are induced to make a manipulated interpretation of the perceived phenomenon, in order to construct a system of substitution of the real, in hesitation between reality and dream.

This idea of illusion expresses the most primordial desires of its creator because all reality is born from an illusion that surrounds us and under certain circumstances may be transformed into something that we perceive and recognise as real. Cognitive processes and their information complexity are now at the center of the most controversial scientific discussions, namely those that arise from the search for the unification of a theoretical model that allows us to explain the duality of behaviours between the perceived phenomena present on the border between a world considered as tangible and real, and the world of the intangible, of the infinitely small, and in some degree illusory.

Likewise, in the field of architecture, we may call into question the processes used to create the environments and atmospheres in which our life unfolds, since the technical limits to the revelation of spatial imaginaries have been progressively exceeded over time. Today it is possible to express, through photoreal images, any idea of space or place, and it is even possible to experience them through virtualised systems of perception. The current techniques of algorithmic processing of images generated by powerful computers (CGI), give expression to a new form of intelligence that disturbs perception and immerses our senses in manipulated experiences, that allow to construct systems of substitution of the real, generating a situation of uncertainty between a dream and a statement of a feasible reality.

These dream machines, in which we often involuntarily immerse ourselves, are the expression of atmospheres and environments generated through the creative and imaginative power of those who risk controlling illusion and who, by assuming a quasi-divine power, may redefine how our existence is expressed in the universe and the limit may even define our existence.

The emergence of cinema in the late nineteenth century made possible to add the missing piece to the aspiration to make possible to witness the inhabit of the atmospheres expressed in the imagined images, whether they were drawn, recorded, painted or photographed. The illusion of time perception, coupled with the fantasy offered by the coordinated succession of slightly different images, came to impart the missing ingredient to the formation of a perceptive illusion, which now allows us an immersive sensory

interaction capacity, boosted by the latest advances in the technologies of perception, leading to the birth of what we may call an *architecture of sensations*.

This reality is strongly linked to the capacity to create atmospheres that can be inhabited by thoughts and are recognisable as credible, to the point of being able to stimulate our senses so that we can interact and evolve with them. In this regard and in an explicit way, in the story of C. Nolan's movie *Inception* (Nolan, 2010), Ariadne, is a talented young architect whose mission is to create the scenarios to accommodate the dreams that support the unfolding of the movie's narrative. This character has the task of re-creating a universe of illusion, manipulating and redefining the laws of nature in a world entirely controlled by the will of its creator. This seminal idea symbolically emerges the eternal role of Architecture, as support for the narratives of existence, however bizarre they may seem to us.

Indeed, in this extreme case, the whole universe is Architecture, and results from a full construction, since the imagination of an author creates everything, and there is no distinction between the natural and the artificial, as everything results from the ability to control the wavelengths of the energy fields that allow the characters to shape the things they recognize as having an existence.

This ability to conceive worlds, before they are so, is intrinsic to the architectural act as a creative action, where idealization emerges as process related with the consubstantiation of ideas, through means of inquiry and multisensory control where the visualization is assumed as a pre-figuration of a viable real, capable of being verbalized, built and inhabited.

Visualization is therefore assumed as being the result of a process of intellectual creation, *in-spiritu*, as an inner creative source, unfolded through cognitive processes, filtered by each individual and assumed to be determinant for the way we perceive and build the world, we believe to be real, but that may well be an illusion.

2 BRAIN, SPACE AND THE CONSCIOUSNESS

Illusion or reality, the fact is that space can be perceived regardless of the way it is structured, whether it is in the field of ideas or the field of real tectonic existence. What prevails is an idea of spatial intelligence that allows correlating, with meaning, the act of inhabiting the space.

Approaching Intelligence through its etymological sense, we perceive that the word has its origin in the Latin term, *Intelligentia*, which in turn comes from the expression *Intelligere*, in which the prefix Intel expresses the meaning of "between", and the *Ligere* transmits the notion of selection, of "choose" In this way, the primordial meaning of the term, refers to

the activity of choosing between the multiple possibilities or options that are offered to react to a given situation. Consequently, in this context, intelligence emerges as a system that, through information processing, allows to recognise the most effective choices to react to problems of different natures, impelling actions of intentional selection, in order to achieve a semantic optimisation of information.

In this regard, the theoretical physicist David Bohm (1917–1992) referred to intelligence as being the ability to "read between," in the sense that thought would be like the information contained in a book and the intelligence as the ability to read it and interpret their meaning. Bohm considered that intelligence would be like a state of mental alertness in a dimension different from that of thought (Bohm, 1980).

To introduce a notion of scale into the problematic of the mind and brain, it should be noted that the Hungarian mathematician and physicist J. Neumann, regarding memory and the brain's ability to deal with information, estimated that during a lifetime the human brain stores around $2,8 \times 10^{20}$ bits of data (Neumann, 1958). This tremendous amount of data far surpasses the storage capacity of any existing equipment and highlights the mysteries of our brain's memory and organisational patterns, especially in how it converts this data into information.

The fascination that is raised by the possibility of understanding the processes of construction of the real, led, in the middle of the twentieth century, two scientists: the above-mentioned American physicist David Bohm and the Austrian neurologist Karl H. Pribram (1919–2015); to reveal to us, through totally independent paths and methods, a theoretical model that allowed, in the case of Bohm, to explain phenomena unveiled by quantum physics, and in the case of Pribram to clarify several neurophysiological enigmas and, together, opened the door to the interpretation of brain-consciousness-universe interactions, revealing aspects of the construction of the world based on idea an implicit, mathematical-based, rule that allows us to consecrate the real in a way so that we recognize it as something that is necessarily fabricated by the mind.

Pribram's brain-holographic model has demonstrated that there is a process of holographic information treatment in the cerebral cortex, which is dependent on neurons that operate in a wave mode and are responsible for setting holographic interference patterns, revolutionizing the way we understand the storage and information processing in the brain (Pribram & Fernández gonzález, 1984).

This model is based on the idea of interaction of the electromagnetic fields whose vibrations are mutually mixed, generating a pattern of wave interference that, through the interpenetration of the frequencies of these waves, creates harmonic states that allow ordering the world of real things and the world of dreams (Pribram, 2012).

Pribram has shown that this field, *the harmonic field* as it calls it, is simultaneously distributed throughout the brain, and enables the (holographic) storage and encoding of the tremendous volume of information quantified by Neumann and which is therefore responsible for the expression of memory, mind and consciousness in the plane of the biological existence of the body. Pribram points out that, just as music is not only found in the instrument where it is played, but also in the resonance field that surrounds it, our memories are not only located in the brain, but also in the field of information (holographic) that involves it (Pribram, 2011).

An holographic model of the universe was also unveiled by David Bohm in his interpretation of quantum theory, where he presents us with a vision of space and time folded and restructured as a hologram, immersed in an ocean of oscillating frequencies that constitutes, for Bohm, the *veil order* of things, which it comes to designate by the *implicit order* or the involved order, where space-time relations do not exist and to which we are not granted access in the course of our daily life. Bohm also suggested that with the emergence of more intense fluctuations in the field of implicit order, holographic patterns will emerge that allow us to structure the space-time dimension that gives rise to an *explicit order* or revealed, that corresponds to the world in which we manifest (Bohm & Peat, 1987).

Considered together, Pribram's and Bohm's theories provide us with a new, profound and fascinating, way of interpreting the world, where our brain asserts itself as the builder of a mathematically objectified reality, resulting from the interpretation of frequencies which are, in reality, projections emanating from another dimension, from a deeper order of existence that is beyond both time and space (Talbot, 1996).

This model has been widely debated within the scientific community, and it seems that the most recent discoveries in the field of particle physics and more particularly the advances in the field of what is known as the "string theory" seem to contribute and reinforce the hypotheses implicit in the Bohm's and Pribram's holographic models.

Karl Pribram explained to us that our brains construct the objects, but Bohm moved a little further and stated that we are the creators of space and time, in which the dualism between mental and material will only be valid in the regular world of appearances, proper of what we can describe by Euclidean geometry and Newtonian mechanics (Bohm, 2003).

In this context, we can visualise the conceptual complexity offered by Pribram's and Bohm's theories, using an analogy with the metaphor present in the *Tesseract* scene of the movie *Interstellar*. For the fulfilment of this scene, Nolan and his team of architects conceived an interdimensional space, where time appears as three-dimensional, in a sort of holographic hypercube where all times of the same space coexist,

and from which it is allowed to perform inter-temporal communication, through the harmonic vibration of the strings of time triggered by gravitational waves (Nolan, 2014). This *non-place* may well be an approach to visualize the concept of Bohm's holographic model in which the more intense fluctuations in the field of the *implicit order* allow to generate the holographic patterns that will structure the space/time dimension and that will cause it to emerge the *explicit order* that matches the world where we manifest in.

3 SPATIAL INTELLIGENCE AND THE IMAGES OF THE MIND

Howard Gardner's *theory of multiple intelligences* helps us to identify various types of intelligence, arising from the unique abilities of individuals to deal with different areas of human expression, from which spatial intelligence stands out as the most directly related with the human creative dimension (Gardner, 2006).

Recent research in neurobiology points to the existence of regions of our brain, related to specific forms of cognition. This implies the recognition of different kinds of information processing that allow us to understand better the processes related to the capacity to deal with stimuli oriented to a particular type of intelligence. Therefore, it becomes possible to devise a way of stimulating the ability to perceive the spatiality of the world, through processes of ideation that lead to the materialisation, in-*spiritu*, of collective spatial intelligence that can be structured in the *implicit order* described by David Bohm.

This reinforces the idea that, for Bohm, all action arises from an intention in the implicit order. In this case, the imagination is in itself the creation of form; it already contains the intention and the germs of all the actions necessary to carry them out. Moreover, this affects our body and so on all the physical world, so that, as creation takes place from these more subtle levels of the implicit order, it will manifest through the explicit world. That is to say, in the implicit order as in the brain itself, the imagination and reality are indistinguishable, and therefore we should not be surprised with the idea that the images of the mind can be manifested as realities in the physical world (Bohm & Peat, 1987).

In this context, the creative activity proper to the nature of architecture and its intrinsic spatial intelligence emerges as a primordial characteristic for the invention of the (architectural) spaces that support and carry the narratives of our life. That is thus, the architectural space is the results of processes of the intellect which seeks to give coherence to the creative systems of ideation and visualisation.

Architecture is consequently assumed as being the tectonic backing for constructing a multidimensional idea of the imagined spaces, meeting one of Bohm's most astounding statements in which he announces

that the *tangible reality of everyday life is actually a kind of illusion* (Bohm, 2003). Just like in a holographic image created by the imagination, underlying which there is a deeper order of existence, a more fundamental level of reality that generates all manifestations of our physical world in exactly the same way that a fragment of a holographic film always generates a hologram (Talbot, 1996, p. 46).

to these, and the perceived efficacy contained in the imaginary expression of visual representation manages to be far superior to the best of the narrative syntheses provided by the words. Therefore, to visualise is to understand by images, as metaphors of the gaze, is to see through internal stimuli, the world that one wants to see externally. In this way, through visualisation, we can create space and time, as Bohm suggested.

4 CREATIVITY AND VISUALISATION PROCESSES

The visualisation processes, implicit throughout the creative act, are always associated with a kind of intelligence of space, through which one can give meaning to things and the narrative of life. We now recall the chronicles of the great Swedish genius Emanuel Swedenborg (1688–1772) that in his spiritual journeys at the universe of the *implicit order*, *visited* large cities, brilliantly luminous, describing them as strange in architecture and so sublimely beautiful that words were insufficient to convey its greatness. In describing one of these cities, Swedenborg stated that this would be a *place of stunning architectural design, so beautiful that it could be said that were the home and origin of the Art itself* (Swedenborg, 1984, p. 44).

The idea of an architecture of the sublime is something that may only be attained by imagination and suggestion. For Swedenborg himself, it would be impossible to express in words the greatness of what he experienced, suggesting that the power of the visualisation would far exceed the suggestion of the description itself. In this way, he made it clear that the Art and Architecture stood as the supreme expression of the beauty of the space, as so, they endure as the face of the intelligence.

The act of verbalising, expressing thoughts and things through words, is a catalyst for the imagination. This allows the arrangement of thought and the moulding of the ideas until they become intelligible. Verbalise is to configure, is to give shape to ideas. The word means the world. In this regard, we recall a remarkable expression of intelligence and spatial creativity, implicit in the processes of visualization induced by words, attained in the narratives of Marco Polo to the emperor Kublai Khan, told by the pen of Italo Calvino (1923–1985), in which *invisible* cities are progressively materialized as they are read and transformed into places by the supreme power of the imagination. Calvino, possibly touched by the spirit of Swedenborg, bequeathed us dizzying tales where the spatiality of imaginary cities is brought to reality by the holographic agitation of the imagination, activated by the visualisation induced in the readers, stimulating the architectural process intrinsic to our existence.

As Swedenborg inferred, the narrative capacity of space provided by the images is something intrinsic

5 VISIONARIES AND GENIUSES OF ILLUSION

It is said that the visionary is the one who visualises before all the others, being able to anticipate tendencies and concepts that are, most of the times, ahead of its time. Being the owner of innovative thinking, the creative being catalyses unconventional ideas and can see beyond time, anticipating needs that others rarely see. Usually, they are beings for whom the idealisation is done by images as projects of materialisation of the real, managing to capture our imagination to inhabit the worlds they created.

The graphic work of Giovanni Battista Piranesi (1720–1778) manifests the power to take us to inhabit the spaces of his *carved* architectures, where time is the protagonist of the evanescent fantasies that emerge from his engravings, where each image offers us a voyage to the soul of an imagined place. In this way, we are subtly led to enter in a parallel world where Piranesi brings to light a deep domain of spatiality and materiality, sensed by the game between light and shadows in his drawings. The magnificence of Piranesi's imagined architectures and the informed expressiveness of his designed testimonies, reveals an eloquent ability to convey the enduring values of Architecture itself. Piranesi, the visionary, always aspiring throughout his life to become a great builder, in the absence of significant orders, devoted himself to build a remarkable portfolio, whose pieces ended up influencing the technological knowledge and the transmission of architectural culture (Wilton-Ely, 1993).

Through Piranesi's work, we are led to travel in the nature of a dreamed world, genuinely classic and viscerally Euclidean, which contrasts with the capacity for transformation revealed by another great artist and engraver, MC Escher.

In the course of his artistic life, Maurits Cornelis Escher (1898–1972), who in his youth had attending studies in architecture, left us a vast graphic work, in which, through the subversive exercise of the classical principles of the perspective has managed to generate spaces and intricate structures that challenge us to reinterpret the laws of nature, exploring to the limit the illusory aspects of visual perception (Ernst, 2007). The way he ventured in the overcome of the contingencies of classical Euclidean geometry, opened the door

to a new interpretation of space and time. Through the multisensory experience offered by the challenging irony of his works, Escher succeeds to offer an intuited multidimensional reality that, based on the two-dimensionality of the supports that he uses, sometimes even manages to introduce the perception of movement and a fourth temporal dimension, both illusory. The work of MC Escher suggests the existence of a world of plausible appearances, which, through visual illusions, succeeds in playing with our perception and opens up a myriad of hypotheses for the interpretation of the spaces engendered, in which we are subtly invited to dwell in.

Another case of creative mastery is revealed by the work of Lebbeus Woods (1940–2012), the North American metaphysical architect who introduced an approach to an architecture of rebellion (Noever, 1992, p. 6). Woods guide us into the spirit of an extensive and unique graphic work where presents an endless number of experimental constructions and atmospheres that result from the interaction between materials and disruptive forms that arise shaped by energy flows that emerge from the various contexts where he worked. Lebbeus Woods drawings have the power to carry us into a universe of tension where we may witness the emergence of new forms for living and inhabiting a world in transformation that sometimes becomes apocalyptic (Woods, 1997).

The worlds imagined by Woods result from his journeys into the interior of the drawings while he creates them, deriving from a real creative hallucination, where he asserts that *jumped* into the designed spaces and explored them in order to break the barriers between seeing and doing (Woods, 1992, p. 31).

Like in the worlds imagined for the dreamed lives of the characters in Nolan's movie, Woods' architectures allow us to produce a synthesis between Escher's imponderable universe, Piranesi's descriptive realism, and the almost divine beauty of the worlds described by Swedenborg and Calvino, bringing together those geniuses of illusion, placed here at the creative apex of architectural thought. However, writing about illusion, creativity, and architecture without making a special reference to the work of the Catalan architect Antoni Gaudi (1852–1926) would be an unforgivable failure, especially since, of all the great creators already mentioned, Gaudi was the one who managed to bring to the order of the explicit its dreamed architecture.

Gaudi, in contrast to the abovementioned authors, made little use of drawings and images as a direct expression of his ideas, choosing to shape the space using models or even one-to-one prototypes, which in many cases were, later on, represented with drawings made by its collaborators. Like Woods, Gaudi also dared to *dive* into his imagined creations in order to explore the space, patiently carving the materials of his dreams struggling to detach the excess of matter, hoping to realize an idea of architecture, profoundly

rooted in the understanding of the laws of the implicit and divine nature in which he deeply believed (Zerbst, 1987).

Gaudi was a man of faith and governed all his life by a sincere religious dedication, which tried to express in all of his works. The way he modelled the unique expression of his architecture, subtly leads us to the images induced by Swedenborg's descriptions. We refer to the conviction that Gaudi, through his militant belief, pursued, on the essence of his mind, the answer to the restlessness of his spirit, travelling to the *implicit order* where he would find the reasons for its architecture. This is what Salvador Dali points us out in the preface to Descharnes's book on Gaudi's work when refers to the *"angelic essence of Gaudi's genius"* (Descharnes & Prévost, 1989) to explain to us the *odour of holiness* emanating from his achievements. It is also recalled that was a Gaudi's desire to make from his Barcelona the capital city of Art, an Athens of the twentieth century, perhaps the city imagined by Swedenborg in his dreams.

In this context it is important to note that Gaudi believed that what we have been referring as the *implicit* and *explicit* orders, end up covering a very accurate description of architecture and the world, for it was clear to him that the states of consciousness attained in his introspective moments served as mediators in the direct experience of the intervention of the implicit order in the explicit world of the architecture that he created. In this way, Gaudi ends up admitting that it is possible to modify the phenomena in the objective world by influencing the generating matrix of these, in the implicit order of a world that he considered being divine.

In certain a way, what we are trying to say is that Gaudi, in essence, believed that it was possible (re)program the *divine cinematic projector* that creates the objects in the first place. Consequently, it became clear to him that not only the conventional rules of nature, such as inertia and gravity, could be mastered entirely, but also that the mind could alter and reform the material world in a much more dramatic way. This way he dared to question the Gothic model, based on Euclidean geometries and formulas, in order to reinvent an architecture that is beyond the calculation and the geometry of the square and the compass, being indeed modelled by God in the reason of His intelligence.

Being controversial and challenging to demonstrate, the idea that we may generate detailed images of an imagined reality in the mind is, in some way, an idea intrinsic to the creative act of architecture; the eyes may be visual organs, but it is the brain that truly sees. Therefore, it is quite possible to conceive a similar but inverse process where the brain could generate an imagined reality that prevails over the "looking" reality, making a mirror world projected by an expectation created by the mind.

6 CONCLUSIONS

Since ancient times that the Tibetan mystics mentioned the *Tsal* as being the raw material of thoughts, also understood as an energy field. They claim that every action of the mind generates waves of this mysterious energy, believing that the whole universe is a product of the mind and that is created and animated by the collective *Tsal* of all beings.

In the course of a fascinating discussion under the theme of Intelligence, which occurred in 1972 and documented in a book, David Bohm and the Indian philosopher Jiddu Krishnamurti (1895–1986) present to us the idea that thought belongs to the order of time, but that intelligence is of another nature, of another order. In the course of the conversation, they both wondered whether there was a relationship between thought and intelligence and were led to conclude that thought really dominates the world and acts on it as a pointer that shows us a way beyond the limits of time. They also conclude that the brain is, in fact, an instrument of intelligence and that the *Intelligence is the substance of all* (Krishnamurti, 1987, pp. 384–408).

This comprehension may well be a corollary to all this reflection, emphasising that the spaces of the perceived world come to result from the thought that emerges from the action of those who dare to touch with their pointer on the stretched strings of time, where all past, present and futures spaces coexist. Consequently, we become aware of what is the essence of the architectural act, which we may recognise in the works of those whose imagination emerges as a creative force that serving an illusion, building the semantic choices, that form the spatial intelligence of Architecture.

As far as we know, of the immense mind, only a small fragment is used by us. The shredder influence of culture and tradition ends up limiting freedom and creativity, condemning us to occupy a distorted corner of the immense field implied by Bohm and Pribram. They are entities such as Gaudi, Woods, Piranesi, Escher among many other geniuses of creation that with their works point us different directions to accomplish the architecture of the world that we dwell or want to dwell. But we can hardly apprehend the whole through these fragments. The conquest of freedom, through the beauty of seeing, would allow us to give meaning to the thought space where we wish to act on. This way, the architectural desire will give rise to a new meaning for spatial intelligence, as a process of harmonisation between mind and body, between idea and the place of action.

BIBLIOGRAPHICAL REFERENCES

Bohm, D. (1980). *Wholeness and the Implicate Order*. London: Routledge.

Bohm, D. (2003). *The essential David Bohm*. (L. Nichol, Ed.) London: Routledge.

Bohm, D., & Peat, F. D. (1987). *Science, Order, and Creativity*. London: Routledge.

Calvino, I. (1990). *As Cidades Invisíveis*. Lisboa: Editorial Teorema.

Descharnes, R., & Prévost, C. (1989). *Gaudi, The Visionary*. New York: Dorset Press.

Ernst, B. (2007). *The Magic Mirror of M.C. Escher*. Berlin: TASCHEN.

Gardner, H. (2006). *Multiple Intelligences: New Horizons*. New York: Basic Books.

Krishnamurti, J. (1987). *The Awakening of Intelligence*. San Francisco, USA: Harper.

Neumann, J. v. (1958). *The Computer and the Brain*. New Haven, Connecticut: Yale University Press.

Noever, P. (1992). At the Outermost Boundary. In AAVV., Architectural Monographs – Lebeus Woods – Anarchitecture: Architecture is a Political Act (Vol. 22, p.6). New York, USA: Academy Editions.

Nolan, C., Thomas, E. (Producers), Nolan, C. (Writer), & Nolan, C. (Director). (2010). *Inception* [Motion Picture]. EUA: Warner Bros. Pictures.

Nolan, C., Thomas, E., Obst, L. (Producers), Nolan, C., Nolan, J. (Writers), & Nolan, C. (Director). (2014). *Interstellar* [Motion Picture]. EUA: Warner Bros. Pictures.

Pribram, K. H. (2011). Brain and Perception: Holonomy and Structure in Figural Processing. New York: Routledge.

Pribram, K. H. (2012). The implicate brain. In B. Hiley, & F. D. Peat, *Quantum Implications: Essays in Honour of David Bohm* (pp. 365–371). London: Routledge.

Pribram, K. H., & Fernández gonzález, R. (1984). Mente y Cerebro Como Realizaciones de Negentropía. *Teorema: Revista Internacional de Filosofía*, 14(LA FILOSOFIA DE KARL POPPER: el compromiso de la razón), pp. 225–257.

Pribram, K. H., & Martin-Ramirez, J. (1981). El Funcionamiento Holonomico Del Cerebro. Revista Latinoamericana de Psicologia, 13, 187–246.

Swedenborg, E. (1984). *The Universal Man*; *Soul-Body Interaction*. (G. F. Dole, Ed.) New York, USA: Paulist Press.

Talbot, M. (1996). *Holographic Universe*. London: Harper Collins Publishers.

Wilton-Ely, J. (1993). *Piranesi as architect and designer*. New York: Yale University Press.

Woods, L. (1992). Centricity. In AAVV, *Architectural Monographs – Anarchitetcture: Architecture is a Political Act* (Vol. 22, pp. 24–33). New York: Academy Editions.

Woods, L. (1997). *Radical Reconstruction*. New York: Princeton Architectural Press.

Zerbst, R. (1987). *Antoni Gaudí*. Koln: Tachen.

'The open work': Inter-relations between science and art

Ana Marta Feliciano

CIAUD, Lisbon School of Architecture, Universidade de Lisboa, Lisbon, Portugal
ORCID: 0000-0002-3251-3973

ABSTRACT: Reflection on the influence of Umberto Eco's *The Open Work*, published in 1962, from which a new understanding of the specificity of artistic or poetic processes is proposed, where a re-contextualization about the relation between scientific knowledge and the possible interaction with a set of contemporary artistic manifestations is posited, seeking in them to find a conductive thread.

Keywords: open work, scientific knowledge, artistic thinking, art, architecture

Art, more than knowing the world, produces complements of the world, autonomous forms that come together with existing ones exhibiting their own laws and personal life. However, each artistic form can very well be seen, if not as a substitute of scientific knowledge, as an epistemological metaphor: it means that, in each century, the way in which works of art structure themselves reflects – in the manner of similitude, of metaphorization, precisely, resolution of the concept of figure – the way by which science or, in a certain way, the culture of the time see reality. (Eco, 1989, p. 82).[1]

Answering the call for a continuous questioning of the limits of the work of art, the personalization process observed in western societies in the first half of the 20th century, prolonging the successive chain of self-criticism advocated by Modern Culture, would lead to a new threshold of rupture, in the middle of the century, which would be reflected in the very own structure of works of art and in the confirmation of a new role of the knowledgeable individual, now as a personalized and autonomous subject. This circumstance would evolve in the sense of providing a new experience of 'open', multipurpose and fluid aesthetic.

The profound evolution that occurred in the 'artist's new operative process', with a deepening of the conscience of a new relation between author, work and receptor, and the consequences manifested in the work of art's own structure and limits, will be perhaps a reflex of a wide transformation that took place in societies, with the fragmentation, the lack of determination and the intense suspicion about all universal discourses:

The rediscovery of pragmatism in philosophy (e. g. Rorty, 1979), the shift of ideas about the philosophy of science wrought by Kuhn (1962) and Feyerabend

(1975), Foucault's emphasis upon discontinuity and difference in history and his privileging of 'poly-morphous correlations in place of simple or complex casuality,' new developments in mathematics emphasizing indeterminacy (catastrophe and chaos theory, fractal geometry), the re-emergence of concern in ethics, politics, and anthropology for the validity and dignity of 'the other,' all indicate a widespread and profound shift in 'the structure of feeling' (Harvey, 1989, p. 9).

In fact, the relation between scientific, philosophic and artistic thought, usually limited within specific spheres, in a more profound reflection begins to reveal itself as a relation that carries multiple interactions, and we witness a continuity, an overlap, and an exchange of information, susceptible to assume itself as a motor of the evolution of knowledge;

La science crée en effet de la philosophie. Le philosophe doit donc infléchir son langage pour traduire la pensée contemporaine dans sa souplesse et sa mobilité. Il doit aussi respecter cette étrange ambiguïté qui veut que toute pensée scientifique s'interprète à la fois dans le langage réaliste et dans le langage rationaliste. (Bachelard, 1968, pp. 8–9)

In this framework, the search for an interlink between scientific knowledge and other intellectual and artistic areas tends to be symptomatic, a reflection developed by Thomas Kuhn, who insisted especially in the imaginative dimension inherent to the proposition of each new scientific theory, understanding it as a creative 'travel' to not yet experienced reigns.

Reflecting this entire universe of connections, the publishing of Umberto Eco's *The Open Work* in 1962 consisted also in an attempt of reflection about the specificity of artistic or poetic processes, proposing to reflect about the relation between the scientific knowledge of the time and the possible interaction with a set of contemporary artistic manifestations, seeking to

1. This is the author's translation from the Portuguese edition, which was based on the Italian edition. All subsequent citation of Eco's book are the author's translations.

Figure 1. Lambert de Saint-Omer's manuscript, 1260. 'Via Láctea ou galáxia vista no céu' [Milky Way or galaxy has seen in the sky], Nasa, n.d.

discern in them a common conductive thread. Specifically, aiming to avoid the creation of direct and rigid analogies yet accepting the evoking power of the 'fecund analogy' as a 'motor of prospection', as a research process of certain structural similarities which in a transversal way touch upon and structure Art's diverse fields, the conception of Eco's *The Open Work* resorts to the evocation of diverse and specific periods of History of Art and their relation with the science of those same periods. The work aimed to reach the space of contemporaneity by looking at the occurred evolution of scientific thinking's diverse fields, clearly finding in them a set of new concepts or ways of understanding the world that in a certain way appeared to reverberate in the internal structure of a set of new artistic manifestations.

The medieval artist's closed and unequivocal work reflected a conception of the cosmos as a hierarchy of clear and pre-determined orders. The work as a pedagogical message, as a monocentric and necessary structuring (even within the specific and rigid internal constriction of metrics and rhymes), reflects a syllogistic science, a logic of necessity, a deductive consciousness from which the real can reveal itself little by little without contretemps and in a single direction, starting from the first principles of reality.

The baroque openness and dynamism signal precisely the advent of a new scientific consciousness: the replacement through the visual, the tactile, which means, the prevalence of the subjective aspect, the shift of the attention towards the appearance of architectural and pictorial objects. For example, it reminds us of new philosophies and psychologies of impression and sensation, the empiricism that resolves the Aristotelian reality of substance in a series of perceptions. On the other hand, the abandonment of the composition's necessitating centre, from a privileged point of view, is accompanied by the assimilation of the Copernican view of the universe, which definitively eliminated the geocentrism and all its metaphysical corollaries. In the modern scientific universe, as in baroque construction or painting, the parts appeared endowed of equal value and authority, and the whole aspires to stretch itself to the infinite. (Eco, 1989, p. 83).

In this 'openness context', and taking as object of reflection the relation between the systems of physical processes of the world's structures, developed through exponential advancements of scientific disciplines and the new production and fruition processes emerging in diverse fields of artistic production, it is foreseeable, from the middle of the 20th century, a proximity and a subtle articulation between the emergence of a new structure in certain artistic creations and the confluence of a whole set of new of scientific inquiries.

In fact, as we look upon the scientific area that is dedicated to the knowledge of the structure of physical bodies that constitute the world, the first half of the 20th century would be a particularly fertile period since a wide set of discoveries would be transversally propagated to the different artistic fields. In that sense, and giving continuity to a set of 'radical discoveries' that since the beginning of the century had been processing in the fields of Physics, Geometry and Mathematics, the synthesis that would be elaborated by Benoît Mandelbrot in his work *The Fractal Geometry of Nature* (1983) becomes particularly relevant. In it, a new field of knowledge is systematised around the analysis of infinitely fractured forms of nature, based on the new developments around the 'Chaos Theory' and a new order of structural coherence observable in its dynamic systems.

Enjoying thus a new vision, from now on enlarged to the new 'macro' and 'microscopic' dimensions of the different bodies, Mandelbrot's research would make evident the notions of 'holistic process' and 'principle

Figure 2. Generative sequence of 'Koch's Curve', n.d. *'Peitgen'*, Homer Smith, n.d.

of self-similarity', in the understanding of the complexity of the relations that govern the world. These concepts, which intuitively have always been latent in the artistic process as a creation of an organic and coherent whole, became from this period on, through the dissemination of knowledge, particularly conscious and easy to manipulate as possible structuring concepts of the work of art itself. In that sense, reacting to this profound transformation of the way of seeing and understanding the world in its constituting processes, a whole set of reverberations would echo in Visual Arts, in Music, in Architecture, in Literature and Poetry. The 'radically innovative' experiences at the time of Stéphane Mallarmé would be particularly precursors of this new notion of 'Fractal Geometry'. These experiences were developed in the ambit of a possible multidimensional deconstruction of the book, which either by texts or unit blocks, can then become fractured in transformable planes or platforms, through a process of successive infinite decomposition of that same text in smaller blocks, equally movable and decomposable. Also significant in this field are the works of Belgian composer Henri Pousseur, who, since 1950, would centre his work on the fields of dodecaphonic, serial, electronic and random music.

Taking as a reference a wide set of works from which we can highlight some works by Robert Rauschenberg, John Cage and Merce Cunningham during the nineteen-sixties, we would witness the emergence of

the concepts of 'assemblage', 'happening', and 'environment', manifested through diverse artistic manifestations from which, according to different levels of participation, an interaction of the work 'under construction', of the work 'in motion' would be proposed with its potential interpreters or spectators. Aiming to reflect on the articulation of art with daily life and with the individual, now understood as an autonomous subject actively intervening in the reception of the artistic work, these manifestations would also question the very limits or boundaries of the artistic fields through a fusion between themselves, resorting to the use of a wide spectrum of materials, techniques and a renewed relationship of the work with its receptor.

Observable as such in different artistic scopes, the freedom of action proposed to the work's receptor, who was now understood as an active interpreter and intervenient in it, could this way reverberate the emergence of a new notion of 'uncertain'[2] as a valid result of the cognitive operation, in a process of similarity with the new emerging polyvalent logics within the field of contemporary physics.

In fact, arriving at the middle of the 20th century, western society, through a whole process of evolution professed by scientific thinking, would begin enjoying a set of new facts that would profoundly shake the previous vision of the physical world. The old discussion associated to the pair of concepts 'certain' and 'uncertain' had evolved, shifting since pre-scientific culture from a discussion around the universe's cosmic order and its impact on Man's destiny, to a new scientific threshold that, through the successive accumulation of knowledge in specialized sciences, would now require, for a rigorous discussion of the concepts, a clear explanation of the system under which they are analysed.

Assumed as one of the most paradigmatic moments of the 20th century, the discussion inherent to the confrontation of an Einsteinian vision of the universe and the emergence of a new Quantic epistemology would spread in a paradigmatic way to philosophical and artistic thinking, from this moment on, profoundly marked by the consequences of the 'uncertainty principle' formulated by Heisenberg, which would question the perfect calculability of the physical universe.

Proposing essentially to negate the 'heuristic phantom' of a static and rigid model of the physical world, of an exhaustive description of reality, from which the observer would be excluded, a vision of the universe emerged during this period propagating until actuality. This vision of the universe was governed by the 'openness and interaction' between its diverse bodies and respective physical phenomena, understood even at the level of particularly small infinitesimal scales.

2. The notion of 'uncertain' just mentioned, referring to the 'principle of uncertainty' or 'Heisenberg principle', should be understood in the light of the studies of Werner Heisenberg (1901–1976) formulated from 1927; author's note.

Figure 3. *'Activity on the Piano'*, P. Corner, 1962. Partiture of the series *'Kontakte'*, K. Stockhausen, 1960.

This vision, spread out to the scope of Philosophy and Art would give Man a new role, understood from this moment forth as an autonomous and interventionist individual in the context of a group or society that up until then, in a way, had always tended to override the individual sphere.

Complementing this aspect, it is possible to detect a tendency within the range of a set of emerging artistic manifestations during the nineteen-sixties, of a progressive interpretive freedom in the domain of different forms of expression, of the work's receptor, to render each interpretation, reading or execution of the work not coincidental with a unique definition of it. In certain literary works, among which we highlight the research of Mallarmé and James Joyce, and even certain musical compositions, with prominence of the works of Karlheinz Stockhausen, Luciano Berio and Henri Pousseur, we witness a similar possibility in which each execution becomes able to explain the work, nevertheless not exhausting it; as such, each successive execution realizes the work, but all are complementary with each other.

In the context of this multiplicity of analogies between science and new ways of artistic creation of the 'open work', analogies which in a first approximation tend to 'tear apart' and question the structure, coherence and character of the work of art as a coherent prospection of an author has been shaping itself

into actuality as an interrogation. This interrogation, shifting between an apocalyptic vision of the 'death of Art'[3] and he emergence of a new generating vision of the author, bestowed through resorting to a new notion of 'field of possibilities', would become the object of a wide debate and critique in the various artistic domains; because the creator

in a 'work in motion' poetics, may very well produce with the intent of an invitation to interpretive freedom, to the happy uncertainty of results, to the discontinued unpredictability of the choices subtracted to the necessity, but this 'possibility' to which the work 'opens itself' is such within the scope of a 'field' of relations. (Eco, 1989, p. 89).

Therefore, the controversy initiated in turn of an idea of the 'death of art' has revealed itself progressively according to a need to look at Art from a new perspective. Successively widened in its limits and structural relation, this reflection ends up transporting the work of art, through its operative process, to a new definition threshold. In fact, a prevailing characteristic in artistic manifestations from this period onward reveals a growing complexity in their structure, a structure which is now 'open' to a variety of materialization possibilities, due to the openness promoted by the author to the receptor's participation, a possibility which would remain nevertheless able to be concretized in a formative way in the work of art through a 'field of relations' or a 'structure of relations' intentionally predicted by the author.

As such, and having as a support this entire wide context of transformations inherent to the new discoveries promoted by science, with the consequent transformation of the vision of the world and of a new understanding of Man in this new universe of relations, the creation process of the work of art that was promoted during the sixties towards a successive questioning of its own internal limits and sense is in close relation with science and would contribute, through new performed synthesis, to a new threshold of notion of Modern Art.

Having a specific geographical and cultural context as a support, as well as a sense of consciousness of a 'western aesthetic' (Pareyson, 1960) deeply marked by the 'presence' of an 'author-creator', we can still observe – under the 'eclipse of distance' which separates the work from the receptor, a sense of permanence of a notion of work of art as an 'organism', as an author's personal production.

3. Based on the broad process of 'openness' of the work of art promoted by Modern Art, Dino Formaggio seeks in his essay *'La questione della "morte dell'arte" e la genesi della moderna idea di artisticità'*, contained in the work *'L'idea di artisticità'* (Orig. ed. Ceschina, Milan, 1962), to clarify the notion of 'death of Art' that had evolved from Schiller, Novalis and Hegel, proposing not so much the somewhat simplistic idea of a 'historical end of art', but rather a certain idea of 'the end of a certain type of art'; author's note.

Figure 4. *'Un Homme dans l'Espace!'* [A Man in Space!], Yves Klein (photograph by H. Shunk and J. Kender), 1960. *'Fun Palace'* project, Cedric Price, London, 1956–1961.

Under this new notion of 'field of possibilities' arising in the mentioned 'open work', and recognised in several fields of art, the structural complexity found in a variety of compositions, interventions or driven by the receptor's creative action on the work, would still be maintained, however, controlled under a structural framework predicted by the 'author-creator'.

The artistic manifestations of the middle of the 20th century structured organically and interactively would also promote the sharing of a certain knowledge through a new plateau of questioning the 'notion of form' (Eco, 1989, p. 82). This new questioning, present in numerous works of art from this period, even if rationally analysable in its various complementary aspects or moments, would nevertheless need to keep on being understood as a whole, in a relationship of its whole that is now evidently interactive. Thus, in a set of artistic manifestations which, somehow, constitute the Art panorama during this period, we witness the permanence of a notion of 'organism' emanating from the frame of 'predictions controlled' by the author. This understanding would be especially visible within the extent of a set of architectural inquiries that marked this period; namely, a set of prospective visions developed in turn of the 'megastructure'[4] concept and its 'evolutional and metabolic' principle of construction, initiated by interaction with its assumed residents.

4. The 'megastructure' concept mentioned here refers to the notion contained in the work of Reyner Banham *Megastructure, Urban Futures of the Recent Past* (1976); author's note.

Moving away from a static vision of reception of the work of art, the reflections produced during this period would become particularly paradigmatic of the sixties' cultural and artistic environment, which through the proposition of a new order of balance in the dialectic relationship between author, work and receptor, a clearly unstable and dynamic balance, similar to the 'metabolic process' seen in living organisms, would originate a period of profound critique, questioning of limits and creative structuring of the emerging works from diverse artistic fields.

As a consequence, following the profound changes promoted by the whole set of discoveries within the domain of scientific disciplines, the importance of these reflections thus finds itself, through the multiple interrogations raised around the poetics, the works' structure, and the technical processes and materials underlying their substantiation, in a new understanding of Man as a 'micro universe', as a potential 'model' of complex organization and coherence.

From this moment on, the conscience of a new notion of Man would tend to affirm itself, now understood as a subject-owner of a new 'conscience of freedom', 'autonomy', and 'individuality', a Man that would act on the stage of the new hedonistic society, the 'society of consumption', culturally redefining a new perception of his 'physical, biological and psychological' range. These reflections would imply the re-update of an understanding of the individual as a microcosm of the universe, leading to diverse new experiences within the domain of architecture as a mediating scope of the relation between Man and the World.

BIBLIOGRAPHICAL REFERENCES

Bachelard, Gaston. (1968). *Le Nouvel Esprit Scientifique.* (10th ed., 1st ed. 1934). Paris: Presse Universitaire de France. Retrieved from: http://classiques.uqac.ca/classiques/bachelard_gaston/nouvel_esprit_scientifique/nouvel_esprit.pdf.

Banham, Reyner. (1976). *Megastructure, Urban Futures of the Recent Past.* London: Thames and Hudson Ltd.

Eco, Umberto. (1989). *Obra Aberta.* [The Open Work]. (João Rodrigo Narciso Furtado, Trans.). Lisboa: Difel Difusão Editorial, Lda.

_____. (2000). *A Definição da Arte* [The Definition of Art] (José Mendes Ferreira, Trans.). Lisboa: Edições 70.

Formaggio, Dino. (1962). *L'idea di artisticità.* Milan: Ceschina.

Harvey, David. (1989). The condition of postmodernity: an enquiry into the origins of cultural change. Oxford: Basil Blackwell.

Mandelbrot, Benoît. (1983). *The Fractal Geometry of Nature.* New York: W. H. Freeman.

Pareyson, Luigi. (1960). *Estética – Teoria da Formatividade.* (2ª ed.). Turim: Zanichelli; Bolonha.

UOVO-EGG-OEUF-OVO: From the origins of the world to a creative objective

Raffaella Maddaluno

CIAUD, Lisbon School of Architecture, Universidade de Lisboa, Portugal
ORCID: 0000-0002-4365-0375

ABSTRACT: The egg has always elicited interest due to its multiple meanings and because of its symbolic significance. The current text aims to outline its numerous facets, both in its symbolic and sacred value and in its secular and creative value. According to different cultures and religions, it has been used to explain the origins of the world and of time, to represent a symbol of birth and rebirth; to symbolise purity or materiality, fertility or the alchemistic transformation of the elements. Within itself hides the mystery that often alludes to a future of unknown forms. It has been assimilated into the idea of primordial CHAOS from which rule and order, and as a consequence, humanity, are born. But it has also been widely used as an art object or as an object in art. Its oval shape has also been widely used in architecture, as a revolutionary choice, as is the case of the Borromini or Peruzzi spaces; or as a provocation, as is the case of the unfulfilled project for the competition of the Pompidou Centre in Paris by André Bruyere. But sometimes it has given origin to embryonic architectural spaces, capable of creating a suspension in time, where in silence both architecture and art can converse, as is the case of the OVO project by Rui Chafes and Camilo Rebelo.

Keywords: Silence, art, architecture, egg, Rui Chafes, Camilo Rebelo

1 THE ORIGIN OF THE WORLD

Accordingly, to Rui Chafes, the egg is a dive into the perfection of emptiness. The silence it establishes reminds us of the extreme closeness between life and death.[1]

The egg is considered a symbol that reveals itself to be the life of its specific MYSTERY; most of all, it is identifiable in the idea of REVELATION. The Orphic myth tells the story of the Primordial Night (the goddess of black wings) who was courted by the Northern Wind (the serpent), and from their union, the silver egg called LUNA was born. The silver egg, in Greek (Phanès), was called Eros, who is not the god of love, son for Aphrodite, but instead means ORIGINAL LIFE, source of life. The star, therefore, symbolises a mystery revealed on a dark night. To the Orphics, thus, it represented the revelation of life and being. This 'being' is also called Chaos by the Orphics[2].

In symbolic thinking, the idea of UNIVERSAL CHAOS is also linked to the COSMIC EGG. It was the embryo and seed of life and its metamorphoses. This association can assume two forms: the first sees the egg as the first BEING, arising from Chaos, from nothing. Several texts have henceforth defined Chaos as a vital force. However, the passage from the inorganic to the organic remains a mystery. Only symbolic knowledge allows for its explanation. Chaos is considered the MYSTERY in its unrevealed state. The egg, the seed, comes from Chaos. Yet life is a perennial metamorphosis, and that is why the egg, from which life germinates, must itself be born from life. Thus appears the figure of the bird, which is nothing more than Chaos metamorphosed, which lays its egg in the world.

The second interpretation, conversely, identifies the same Chaos with the egg, both as a form and as creative manifestations. As Constantin Amariu states, if Chaos is identified both with the night before creation and with the primordial waters, such Chaos—primordial Egg, – Chaos in the shape of an egg -, is always defined as a source (fons) or origin (origo), a reservoir of all possibilities of existence (Amariu, 1988, p. 8).

1. From an interview with Rui Chafes, 23.02.2019. Author's free translation.
2. Orphism was a religious-philosophical movement born in ancient Greece and it was based on the cult of Orpheus, dating back to the 6th and 7th century. According to the Orphic theogony and cosmogony, Time created the Egg of the world by making it come out of the Ether and from Chaos. From the egg is born Phanes, which thanks to its hermaphroditic being gives birth to the Earth and to Heaven, and from these are born the Titans, Kronus and Zeus. Zeus generates Dionysus, later killed by the Titans. Zeus as a gesture of revenge kills the Titans from whose ashes humanity is born.

Being revealing of life as a mystery, the egg is also symbolically associated with life that is resurrected after death (the symbolism of the Easter egg comes from this association).

2 SYMBOLIC KNOWLEDGE

Symbolic thinking has often been associated with the idea of the sacred. The symbol takes on the task of making people understand the nature of transcendence that is embodied in the profane world. And the revelation of sacred has the purpose of suppressing the 'profane' qualities of the ordinary thing so that it can become a 'consecrated thing' (Amariu, 1988, p. 31). The symbol is a means of knowledge, like a concept or metaphor. But in comparison with both, it is placed on a higher step because it connects THOUGHT and IMAGINA-TION, in a way that its 'knowledge' is a science that leads to myth. In this way, the world stops being profane and therefore becomes one-dimensional. Plato stated that myth is not a gratuitous story but the clue of a truth that escapes logical thinking. Symbolic knowledge is always revealed (Eco, 2000, p. 213).

The egg symbolises the permanence of being and mystery, in that ARKHÉ, is ONE before existing. The symbol serves as a term of relationship between one of the uncreated and the genesis of the creative life of mystery. All the origins of the 'egg symbol' describe the transition from ONE to the MULTI-PLE, from CHAOS to ORDER. Chaos is related to the uncreated, the order for 'creation': a transition from non-existence to life. The egg also symbolises the nostalgia for the primordial state, the return to the informal, the return to the embryonic state, to the matrix of things. The egg is also considered as an analogy to alchemic endeavours. As Jung states, in alchemy, the egg signifies absorbed chaos, included in the artifex, the one that contains the soul of the world that is imprisoned there. It is from the egg that the soul, the Phoenix, the eagle, is released. In the alchemic definition of the egg, therefore, we find the liberation of the soul and its purification from the matter from which it is born. Thus, the mystery (the 'secret') of alchemic transmutation, as a transition of matter to a higher state receives its explanation in the 'idea' owing to a visual symbol. In alchemy, as in initiation rites, the 'passage' is easy for those who possess the symbol. As such, the alchemic egg becomes the philosophical egg (Amariu, 1988, pp. 95–97).

3 OBJECTIFICATION IN ART

Accordingly, to Rui Chafes, the egg to an artist does not represent anything that can be verbalised. It is a mysterious form, without beginning or end, an original, seminal form, but without existence – perfection does not exist. To a man, the egg is everything (interview with Chafes, 23.02.2019, Interview).

Figure 1. Pietro Manzoni, Consumption of dynamic art by the art-devouring public (1960). Source: http://www.pieromanzoni.org/EN/works.htm.

Now ensues with the symbol the same thing that happens to the myth: one day it turns either into a profane discourse of things (into objects) or into literary narration (legend, fable, artistic objects). The egg has become something available to reflect the world and numerous artists have welcomed it and used it for their creative manifestations. Thus, it is no longer an uninhabited place, without dogma, sensitive content and experience. Instead, it is transformed into the manifestation of reality. The Pala di Brera (1472) by Piero della Francesca (1415–1492) represents an ostrich egg that hangs over the Virgin's head, symbolically manifesting the purity of the Immaculate Conception, because it was believed that the ostrich was hermaphrodite and that its eggs hatched in the sun, alluding to clear divine intervention.

Instead, chicken eggs are connected to the land, to materiality and are therefore edible. Such is the case of the work of art by Piero Manzoni (1933–1963), Consumazione dell'arte dinamica del pubblico [Consumption of dynamic art by art-devouring the public] (1960), in which the choice of the chicken egg link to a clear materiality, reinforced by the author's imprint which is a further indication of physicality (Spinelli, 2016).

The egg also arouses interest because there is an 'inside' that can only be known by breaking an 'outside', there is a void that is obtained after having emptied its contents. Jeff Koons (1955) worked on these concepts in his work *Cracked Eggs* (1994–2006), in five unique versions (Blue, Red, Magenta, Violet, Yellow). The breaking of the shell is assumed as a starting point, and this sacrificial gesture gives the possibility, through a kaleidoscopic play of reflections, of mixing the inside and the outside, desacralizing the essence.

In the case of the irreverent performance of the artist Milo Moiré, PlopEgg#1, presented in Cologne in 2014, the egg is used as a pretext to reflect on the condition of women, often considered 'reproduction animals'. The artist, standing upright from a tripod, expels from the vagina eggs full of colour that fall on the canvas

and as they break they spread the colours on a sheet. In the end, this sheet will be folded in two, giving life to representations that are reminiscent of the images used in the Rorschach test.

The egg can be interpreted as the possibility of a future that does not yet exist and whose forms are not well known. This is the case of the work *La Clairvoyance* (1936) of Renè Magritte (1898–1967), in which he portrays himself as he paints a bird while looking at an egg on the table. The egg, the future, remains a mystery, which only the divinatory ability of the artist will be able to decipher.

It became a form of obsession in the artistic work of Dalí (1904–1989), for him a representing symbol of duality or the prenatal, intrauterine world. He was so obsessed with it that he had Philippe Halsman photograph him in a foetal position inside an egg, 'Ab ovo' (1942), as if he was an embryo[3]. His passion for this object became so extreme to the point that we find it everywhere in his museum-house in Port Lligat in Catalonia and in the Theater-museum of Barcelona, where the eggs crown the buildings. The list in which the egg appears in Dalí's work is long: *Visage du Grand Masturbateur* [Face of the Great Masturbator] (1929), *Œufs sur le Plat (Sans le Plat)* [Eggs on the plate (Without the Plate)] (1932), *Métamorphose de Narcisse* [Metamorphosis of Narcissus] (1937), 'Geopoliticus' Child Watching the Birth of the New Man (1943), *L'Aurora* [Dawn] (1948), and finally *Madonna of Port Lligat* (1950). His filmed performances, in which the artist is 'born' from the egg, are also remarkable (Dalí 1968).

In the work of art by Maurizio Cattelan (1960), *HIM* (2001), front, and Lucio Fontana (1899–1968), *Concetto Spaziale, La Fine di Dio* [Spatial Concept, The End of God] (1963, on the wall), the egg loses its symbolic associations to creation as a divine act, to the generating principle of the universe, to the revealed mystery. In this case, it communicates the end of God with two distinct artistic modalities. The first that of Cattelan is entrusted to a wax statue depicting Hitler, the man who was able, because of the most heinous crimes committed against humanity, to have the existence of God challenged in the face of so many horrors. The second, by Fontana, makes God disappear into infinity, piercing an egg-shaped canvas, and opening up space to an unfathomable depth. Almost in semantic opposition, the egg is used in this case to speak of an absence, a theme dear to Fontana. For the artist, the importance of the recognition of the void and absence is the expression of an idea of freedom. The importance of absence is also a theme addressed by Gilles Deleuze (1925–1995), who helped define the idea of a philosophical void.

In 1924 Brancusi (1876–1954) sculpts a marble egg (Le Commencement du Monde [Beginning of the

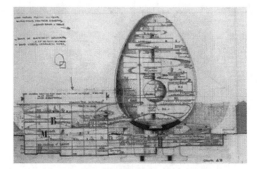

Figure 2. André Bruyére, Pompidou Centre's project (1970). Source: https://archiwebture.citedelarchitecture.fr/fonds/FRAPN02_BRUAN.

World]), a simple egg, polished, whose surface without elements of interruption allows the light to involve it, to caress it. A suggestion of infinity can be glimpsed in the endless continuity of this object, an absolute rejection of points of contact with the outside — a self-sufficient object, whose presence creates its own space (Jianu, 1966, p. 3).

The beginning and the end coincide, and where there is no relationship with the world, time is perpetuated to the infinite, entrusting all eternal things to the object in question.

This description can be borrowed and applied to the general idea of having oval shapes. These represent perfect unity, independence, presence outside of time and space, yet are creators of space (place) and duration (time) (Amariu, 1988:36).

When André Bruyére (1912–1988) participates in the competition for the Pompidou Centre's project (1970), he chooses a form that leaves no room for interpretation: an egg[4]. He repeats this choice for the proposal of a skyscraper in New York. In his idea of form, he defines the ovoid as 'a sphere deformed by intelligence' because he believes it is astonishing because of its simplicity, while the sphere saddens him due to its monotony (see Bruyère, 1978).

The oval shape represents perfection, even though among the Greeks, perfection was expressed in the form of a circle or sphere. But this geometry does not seem to correspond to ontological perfection, because in the end, the circle is nothing but an exception of the ellipse. The ellipse possesses two centres, everything is generated from two points, which allows for movement, and the movement causes the loss of the

3. See (2016) L'uovo nel simbolismo e nelle opere di Salvador Dalí.

4. André Bruyère, 1971. Project n° 272 presented to the competition for the Centre Beaubourg. Bruyère designs a 36-storey egg-shaped building, 100 meters high, with an area of 80,000 square meters. The project is not chosen. A small video by Jens Arnold (2014) ENSAD 2002–2003, shows in a humorous and provocative way, what would have happened in Paris and what reactions would have aroused if the Oeuf had really been built instead of the realized Centre Pompidou.

centre. The two centres, equal by nature, force a NON-CHOICE or a CONTINUOUS CHOICE and therefore cause a loss of truth.

In the Renaissance, we should look at Baldassarre Peruzzi (1481–1536) in order to find an ellipse as a space-generating form. His position in the historiography of forms places him in a particular position. Peruzzi's choice is, in reality, a non-choice, that of not assuming a centre and not assuming himself in a centre, an immutable, timeless centre. In fact, we find Peruzzi almost always side by side with other artists in various projects, his blueprints, notice those for the competition project of the Church in Via Giulia, are tormented by spatial indecision which leads him to make choices like that of the elliptical shape.

The possibility of movement transports architecture to the real world, and without force allows the presence of man inside it. This problem was raised and not resolved by Bramante (1444–1514) when dealing with the design of a circular temple, encountering the inconsistency caused by human presence (Maddaluno, 2015, pp. 200–213). In the project of San Pietro in Montorio (1508) in fact, we conclude that man signifies movement, because he is a user of space and in turn a generator of space.

We should look at Borromini (1599–1667) for a conscious and now reconciled use of elliptical shape. In fact, one of the most intricate themes when mentioning Borromini is related to typological issues. After the profound mannerist crisis, illusions about the historicity, naturality and universality of architectural types were no longer granted, as Alberti had decreed. We witness a heretical attitude of typology, the forms and models that can be associated with the idea of the sacred become de-sacralised. See Palladio (1508–1580) for example, who de-symbolises forms considered up until that moment as being pure, sacred, perfect, and pastes them without much hesitation to mansions and secular palaces. Borromini is not interested in an artificial recovery of universal truths. He accepts peacefully the typology crisis and the casuistry of the new models experienced by mannerism. He chooses geometric shapes, no longer belonging to the world of Euclidean geometry, and makes them communicate with each other. He frees the forms from any conventional function and any arbitrary identification. He notes the rupture of classical syntax without dramatising it. However, this break puts him in front of a series of available organisms, void of meaning. This generates a void to which Borromini responds, giving new meanings to new organisational structures (Tafuri, 1978, pp. 10–19).

4 A PLACE OF SILENCE: OVO – RUI CHAFES AND CAMILO REBELO

It is always the symbol that has allowed for the combination of the paths of an architect and an artist in a project called precisely OVO (January 2013–June 2014). There was the need to accommodate a sculpture, *Semente* [seed], by Rui Chafes, to think of and design a space that would give it a home and somehow represent the client. The artistic-architectural occasion makes us reflect on the relationships and conflicts that exist between the creative process of an artist and the spatial formulation of an architect, and more generally, it provokes us to reflect on the ancient theme of the relationship between art and architecture. In this case, the starting point was a work of art and, as the client has pointed out, the architecture offered himself to it. In this case, there was a theme, *sementes* [seeds], which reflects the work of the client, who produces seeds for the cultivation of garlic and onions. The careful research of these seeds is the result of the producer's conviction that a quality product starts from the seed, that is from the origin. This leads to the idea that the organic must begin with the absolute purity and quality of the seeds because if the seed is contaminated, the entire life that comes from it will be contaminated. Therefore, the starting point is related to the idea of the SEED as ORIGIN.

The sculpture by Rui Chafes should have represented in some way his essence as a man and as a producer, but it also becomes the starting point for the architect. It is around this presence and within this idea of origin that the whole story of the relationship between a space and an object of art unfolds. From an interview, we clearly apprehend that the sculptor Rui Chafes recognises a fundamental difference in method between the sculptural process and the architectural process, but that they have always in some way been integrated. It is on the nature of this integration that space is built. Both processes are 'languages of space', and space exists only in the presence of limits, geometry and construction. There is a proximity to architecture, in this specific case, as the artist himself states. His work process is quite close to the architectural process, more than other artists: the iron sculpture requires a project and a technical distance motivated by the very same time of the technological process, which is different for example from what happens with most of the atelier painting (Chafes, Interview, 23.02.2019).

The architectural necessity was to create a space to 'accommodate' the seed, with a series of restraints required by the sculptor himself: that space had no edges that did not produce shadows or reflections on the sculpture, that it was homogeneous as a surface. The goal was that the dramatic and dark appearance of the materials would not be imposing. The architect welcomes these requests in their absolute legitimacy, shares its rigour and authoritativeness. This project is an exercise in enslaving a work of art. His previous design experience, the museum of Côa, had already put him to the test regarding the discretion of the architectural space in the face of the need to exhibit works of

art and had already educated him about the humility to put at service his compositional activity. Usually, we see common practice concerning art museums to superimpose the architectural space on the exhibited works, which causes a particular difficulty on the part of the artists to feel 'welcomed'. A mistake that has not been made in the Côa museum.

The artist's requests set in motion a series of hypotheses also about the materials to be used: the continuity of the required surface could only convey towards choices such as marble, plaster, cement. The first solutions in the form of models presented by the architect were marble cubes, this being a material that would have alluded to the customer's origin (Alentejo) and that would have, due to its uniform materiality, met the sculptor's requests.[5]

Almost like an unconscious memory, the final form that comes to light is precisely an egg, initially rejected by the artist for its obviousness. From this refusal begins a long process, which lasts almost a year, in search of the more suitable shape to accommodate this 'seed'. The client provides three spaces in the basement of this former hotel in the Swiss Alps, leaving the choice up to them.

Moreover, the choice falls on the last of the three, a rectangular space, chosen because it is considered unconsciously as a reward for an initiatory journey. Because it is at the depths of the bottom that the seed is found, in the most mysterious darkness. The path of spatial research, after numerous hypotheses (vaulted space, scenography space, etc.), returns and is finally accepted, at the initial idea of using an egg space.

The realisation process starts from the construction of a wooden mould in full-scale that would have been the negative of the egg. Built on site, cast in concrete, the wooden egg is disassembled when the drying process is finished. The sculpture offers an image of lightness, of levity, and required around it a unitary space that did not fracture in the construction details, that offered itself continuously and devoid of moments of suspension, of fruition. The lightness of the sculpture needed something that would suggest mass, weight and protection. This ovoid space is completed by a marble floor, a desire not to lose the Alentejo reference. A translucent floor, which allows light to pass, transforming it into a large lamp. A significant effect obtained due to the constructive arrangement of superimposing thin slabs of marble and sheets of tempered glass like a sandwich.

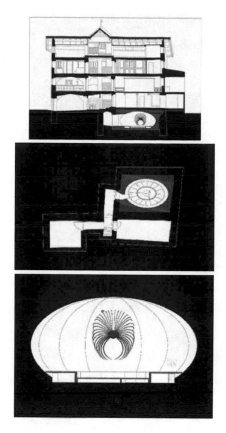

Figure 3. Camilo Rebelo, Ovo's project (Courtesy of the author).

The light from below, indeed, does not create shadows.

Another design choice related to light is the introduction of colour, which, together with some mandala drawings on the entrance door, transforms this space into a temple that leads to our origins. Each origin is associated with a colour, which has to do with the colour of our energetic aura, and every visitor who enters this space has the possibility of choosing the colour to light it. All this transforms it into a ritual space, but a secular rite that transports us to a journey to the origin, our origin, at the depths of the bottom of our path.

This space offers something scarce today: a complete silence. Moreover, silence is the endpoint in which art and architecture meet, welcoming each other. As Camilo Rebelo states, he looks at his space and without Rui's sculpture, he hears the noise. With Rui's work, he feels that there is silence, alliance, harmony (Camilo Rebelo, 01.02.2019, interview).

Silence irritates, makes presences more alive, forces a sudden awakening of the other senses. It causes angst because sound familiarity is lost, even if, very often, it is noisy.

5. From an interview with the architect (01.02.2019) we learn that the OVO project, in the basement of the house of OLIVIER, in Fideris, Switzerland, was a trial bed to test the collaborative harmony between the two. In fact, the client had purchased land in Grândola and entrusted the project of the house to Camilo Rebelo, with the idea of commissioning Rui Chafes some sculptures. In order to avoid problems of possible incompatibilities in the artistic process of the two, he made them work on a smaller scale.

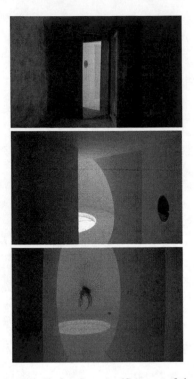

Figure 4. Rui Chafes, Semente (Courtesy of the author Camilo Rebelo).

5 CONCLUSION

From this analysis about the nature of an element like the egg, and about its multiple manifestations, we can gather some conclusions. The first is that increasingly more we feel the need to represent something that brings us back to a process of discovery of the origins, but that very often catches us unprepared and scares us. Hence the need to ironise this necessity, and turn the egg into a symbol, into an art object that alleviates the ontological signification. The second is that more and more the ephemeral and the noise are part of our journey, and that when we encounter these in moments of contemplation, like the place of Camilo Rebelo and Rui Chafes, we experience a profound sense of strangeness, which forces us to retune ourselves to our essence, which in the end, is silent as the inside of an egg is silent.

BIBLIOGRAPHICAL REFERENCES

(2016) L'uovo nel simbolismo e nelle opere di Salvador Dalì. *Tuttto sulle Galline*. https://www.tuttosullegalline.it/le-galline-nella-storia-e-nella-cultura/uovo-simbolismo-e-opere-salvador-dali/

Amariu, Constantin. (1988). *I simboli, l'uovo*. Roma: Ed. Mediterranee.

Armold, Jens. (2004). Centre Pompidou: L'oeuf de Pompidou, Beaubourg, Paris. https://www.youtube.com/watch?v=PCFd9aglMxs

Boncompagni, Solas. (2006). *Il mondo dei simboli. Numeri, lettere e figure geometriche*. Roma: Ed. Mediterranee.

Bruyère, André. (1978). *L'oeuf*. Paris: Edition Albini Michel.

Chevalier, Jean; Gherbrant Alain. (1986). *Dictionnaire des symbols*. Paris: Editions Robert Laffont S.A. and Editions Jupiter.

Dali, Salvador. (1968). Nacimiento de Dalí de un Huevo. https://www.youtube.com/watch?v=pfXI2Ydtd0A

Eco, Umberto. (2000.) O Modo simbólico, in *'Semiótica e filosofia da linguagem*. Lisbon: Instituto Piaget.

Galimberti, Jacopo. (2012). The Intellectual and the Fool: Piero Manzoni between the Milanese Art Scene and the Land of Cockaigne. *The Oxford Art Journal* 35 (1), 75–93. Doi: 10.1093/oxartj/kcs004.

Graves, Robert. (1967). *Les Mythes grecs*. Paris: Ed. Fayard.

Guénon, René. (1962). Symboles fondamentaux de la Science Sacrée. Paris: Gallimard.

Jianu, M. Ionel. (1963). *Brancusi*. Paris: Ed. Arted.

Maddaluno, Raffaella. (2015). Harmony and conflict: the centrality of man and the periphery of architecture in the language of Donato Bramante in San Pietro in Montorio. In Mário S. Ming Kong, Maria do Rosário Monteiro, Jorge Firmino Nunes, Maria Alexandra Quintas, Maria do Rosário Pimentel, Maria João Pereira Neto, & Pedro Gomes Januário (Eds.), *Proportion, (dis)Harmonies, Identities* (pp. 200-212). Lisbon: ARCHI&BOOKS. Retrieved from http://hdl.handle.net/10362/14820.

Mircea, Eliade. (2009). *Trattato di storia delle religioni*. Torino. Ed. Universale Bollati Boringhieri.

Mircea, Eliade. (1976). *Miti, sogni e misteri*. Milano: Rusconi.

Mircea, Eliade. (1981). Immagini e simboli. Saggi sul simbolismo magico-religioso. Milano: Jaca Book.

Moulinier, Louis. (1955). *Orphée et l'orphisme à l'époque classique*. Paris: Les Belles Lettres.

Paola, Francesca. (2013). Piero Manzoni e ZERO. Una regione creativa europea. Milano: Electa.

Spinelli, Carlo. (2016) L'uovo. Tra l'antico e il nuovo. *Artribune*. https://www.artribune.com/attualita/2016/07/uovo-simbolo-storia-arte/?fbclid=IwAR1ixCPIxw6-my2j8T4Usa4YEhnQpH86ksdEA_pnTmxtVPRpkXJpDZSXaQw

Tafuri, Manfredo. (1978). Il Metodo di progettazione di Borromini. In *Studi sul Borromini* (vol. II. pp. 10–19, 39–48). Roma: Accademia di San Luca.

Towards a meta-Baroque: Imagining a "fantastic reality"

Maria João Soares

Faculdade de Arquitectura e Artes da Universidade Lusíada de Lisboa | Centro de Investigação em Território, Arquitectura e Design (CITAD), Lisboa, Portugal
ORCID: 0000-0002-2594-8004

ABSTRACT: In her book, *Architecture from the Outside: Essays on Virtual and Real Space*, Elizabeth Grosz (2001: 6) argues for the possibility of philosophy constituting a means, or a vehicle, for the "construction" of architecture: "[t]he notion of philosophy as a making, building, production, or construction, a practical construction, is a really interesting idea, one worth developing in the future". Whilst this is not a philosophical text, it is, nonetheless a text that seeks to understand a philosophical thought process on the basis of particular ideas taken from the philosophy of Gilles Deleuze, such as the *montage* of the Baroque House, as an allegory, which the French philosopher developed from the principles of the German philosopher Gottfried Wilhelm Leibniz in *Le Pli: Leibniz et le Baroque* (*The Fold: Leibniz and the Baroque*). In addition to seeking to understand a thought process, this paper also seeks place the Baroque – as an imagined Baroque, a meta-Baroque – in a discussion of contemporaneity, seen through the prism of the inter-relations between the "obscure" worlds of artists Francis Bacon and Louise Bourgeois, and Bernini's *bel composto*, and through the gaze of the allegoric Baroque model proposed by Deleuze.

Keywords: Gilles Deleuze; Francis Bacon; Louise Bourgeois; Bernini's *bel composto*; Meta-Baroque Architecture

1 THE IMAGINED HOUSE THAT DELEUZE DESIGNED: AN ALLEGORY

Walter Benjamin made a decisive step forward in our understanding of the Baroque when he showed that allegory was not a failed symbol, or an abstract person-ification, but a power of figuration entirely different from that of the symbol: the latter combines the eternal and the momentary, nearly at the centre of the world, but allegory uncovers nature and history according to the order of time. (Deleuze, 2006, p. 143)

In his book *The Fold: Leibniz and the Baroque* (1988), the French philosopher Gilles Deleuze (1925–1995) develops a discourse based on a reading of the work of the German philosopher and mathematician Gottfried Wilhelm Leibniz (1646–1716) and proposes, as early as the third page of the text, a design. With his draw-ing, Deleuze appears to want to assert the power of figuration, assuming the drawing as a representation of an allegory. An allegory of the Baroque House. That house is not a direct representation of a Baroque archi-tectural representation; it is a model – or a diagram – that helps to provide information on a conceptual universe. In this Deleuzian reading of Leibniz[1]:

1. Gilles Deleuze argues that his text does not solely reflect Leibniz's thought, but also sets out to achieve, to the max-imum degree possible, a reconciliation of the Leibniz phi-losophy with that of the English philosopher John Locke (1632–1704) (2006, p. 4).

[t]he Baroque refers not to an essence but rather to an operative function, to a trait. It endlessly pro-duces folds. It does not invent things: there are all kinds of folds coming from the East, Greek, Roman, Romanesque, Gothic, Classical folds. [. . .] Yet the Baroque trait twists and turns its folds, pushing them to infinity, fold over fold, one upon the other. The Baroque folds unfurls all the way to infinity. First, the Baroque differentiates its folds in two ways, by mov-ing along to infinities, as if infinity were composed of two stages or floors: the pleats of matter, and the folds in the soul. (2006, p. 3)

In the original French publication of 1988, Deleuze's design or diagram is drawn in not-so-firm lines, the lines of someone seeking to confer upon it unexpected rigour. The finely drawn line, repeated several times, gives the drawing a certain degree of simplicity and humanity. The drawing is that of the Baroque alle-gorical house: a two-storey house in which the lower floor, directly open to the exterior, communicates with the second, which is almost entirely closed off to the exterior – a kind of "camera obscura". However, the drawing offers one singular feature. It shows the exte-rior and interior simultaneously: the exterior emerges as a façade on the lower level; the interior emerges in the transition from the lower floor to the upper floor, lingering on the latter. On the façade there is a door – of a good size – to which lead three steps drawn almost as semicircles, with the final step the exact same width as the door itself. On each side of

the door, two rectangular window openings are placed in a horizontal position. In terms of their uppermost line, they reach slightly above the upper level of the door. They are window openings placed above the line of sight – one cannot see inside this Baroque house, just as one cannot see the exterior from inside; but there is light that illuminates the space on the lower floor – that is what the drawing tells us. From these four window openings, four arrows point to the upper floor – the connection between the floors is represented using an interrupted line. It is in this connection created by the hypothetical entrance of light that reflects on the upper floor that one finds the transition from a world represented on the exterior to a world represented on the interior. One should point out that the drawing, in general terms, consists of a horizontal rectangle, for the lower level, and a smaller vertical rectangle, for the upper floor, that is closed at the top by two diagonal lines representing the two sides of a roof. From the ceiling inside, five lines – they could be ropes, elastics or textile elements – are represented as if in motion, as errant lines that twist their way down from the upper part of the second floor beyond the line dividing the two levels – the already mentioned interrupted line that separates the two floors and the two realities, the exterior and the interior. This upper level does not appear to have any source of daylight – at least not as clear a source as the four windows shown on the lower floor from the exterior, on the façade. But the four arrows pointing upwards diagonally cross the interrupted line that separates the floors, suggesting communication with the ropes or textile elements that are found hanging on the second floor. They do not meet, but a certain tension can be felt. The intertwining vertical lines seem to come to life, like tentacles, in the presence of the arrows. What converges upwards? Light? Atmosphere? Small hand-written notes to the left of each rectangle provide some clues. Next to the lower rectangle is written: "Pièces communes avec 'quelques petites ouvertures': les cinq sens" (Deleuze, 1988, p. 7) or "Common rooms, with 'several small openings:' the five senses (2006, p. 5). Next to the upper rectangle, one reads: "Pièce close privée, tapissée d'une 'toile diversifiée par les plis'" (Deleuze, 1988, p. 7) or "Closed private room, decorated with a 'drapery diversified by folds'" (2006, p. 5). We now understand that the lower floor is in contact with the world – bear in mind that it is represented through its façade – and that the five openings, if one includes the door, facilitate activation of the five senses which, when activated, convey "information" to the upper floor, which seems to fold over the first; this fold – or interrupted line – lets through, from the closed private floor on top, a screen that is diversified by folds, a screen that may consist of cords or ropes or a heavy and opulent fabric that has the folds woven into it. The upper floor falls in on itself in heavy obscurity, seeking tactile communication with the lower floor using a system of tensions. In the translation from French to English of the legend

added by Deleuze for the upper floor, the word "decorated" seems to be a little reductive for the majestic intensity of the folds produced by such draping. The drawing of this allegorical house is finished off with a small element on the exterior of the house on the left at the vertex where the lines of the two rectangles or floors meet. It is a short squiggling line that ends in two elements spiralling in opposing directions. Is it just a little added flourish? Is it a reference to a decorative coiled element indicative of the Baroque identity of the house? Or is it a hinge mediating between a drawing that represents concepts – if one refers immediately to philosophy, for it is not philosophy that, according to Deleuze and Félix Guattari (1930-1992), provides concepts – and a drawn diagram that represents concepts through precepts and feelings? (Deleuze & Guattari, 1994, p 7).

But what kind of house is this? It is an imagined house, formed by plastic forces, by pleats of matter. In this matter, there is an affinity with life. This is a house made up of organic matter. As Deleuze writes:

> The lower level or floor is thus also composed of organic matter. An organism is defined by endogenous folds, while inorganic matter has exogenous folds that are always determined from without or by the surrounding environment. (2006, pp. 7-8)

The lower floor is thus filled with matter and organisms, matter and living beings. And on the upper floor? With the soul – or the monad, to use Leibniz's term. But why is there a so apparent distinction between organic matter and soul in this model or this Baroque montage put together by Deleuze? The supposed division is an opening, between folds, that makes a case for the union of body and soul – bear in mind that endogenous folds define an organism. Deleuze points out:

> Life is not only everywhere, but souls are everywhere in matter. Thus, when an organism is called to unfold its own parts, its animal or sensitive soul is opened onto an entire theatre in which it perceives or feels according to its unity, independently of its organism, yet inseparable from it.
>
> In the Baroque, the soul entertains a complex relation with the body. Forever indissociable from the body, it discovers a vertiginous animality that gets it tangled in the pleats of matter, but also an organic or cerebral humanity (the degree of development) that allows it to rise up, and that will make it ascend over all other folds. (2006, p. 12)

The complex relationship between soul and body is represented, in the drawing, by the interrupted line between the two floors, where there is an interval between folds, the folds that descend from the upper down to the lower floor; this opening is essentially a place of activation of the plastic forces that reside in the animal plastic material and/or, as Deleuze differentiates, in the organic humanity. The soul falls

and becomes indiscernible from the matters and the organisms, while the matters and organisms emit vertical "impulses" or waves that reverberate in the folds of the upper floor. The upper floor – windowless but for some occasional and isolated bent small openings which provide light for the soul – is covered by a matter, a dark, dense curtain, diversified by folds, "as if it were living dermis" (Deleuze, 2006, p. 4). When called upon by the matter, the folds are activated, vibrate or oscillate from their lower extremities, like suspended ropes animated by ascending spasms. Of the two floors, Deleuze says the following:

> Leibniz constructs a great Baroque montage that moves between the lower floor, pierced with windows, and the upper floor, blind and closed, but on the other hand resonating as if it were a musical salon translating the visible movements below into sounds up above. (2006, p. 4).

The house is a world in interiority, almost blind, but animated by reverberations of visible movements. It is as if it were a labyrinthine world, but one where the labyrinth functions as an abyss where the Being falls in on itself, in successive layers of falls in the double sense of the word. The house is imagined, but it takes on an operative role: as a Baroque montage. That is the allegory.

2 MOUTH: ENTERING INTO THE FLESH

Let us return to Deleuze's diagram and the door in the centre of the lower horizontal rectangle. Although it is known that the Leibnizian monads have neither windows nor doors, nor any other type of opening, Deleuze points out the possibility of seeing it as a "camera obscura", where the light, which flows in through a single opening on the top, does not directly fall in the space, creating, in a way, various types of *trompe l'oeil*. He thus goes on to propose the following possibility: "the monad has furniture and objects only in trompe l'oeil." (Deleuze, 2006, p. 31); and advances:

> the architectural ideal is a room in black marble, in which light enters only through orifices so well bent that nothing on the outside can be seen through them, yet they illuminate or colour the décor of a pure inside.

However, there is the door on the lower floor – which is full of organic mass or matter – that opens freely. On the outside, it gives rise to, as if extending an invitation, the three steps that have been carefully drawn in the diagram. Like a mouth. A mouth that enters the flesh, progressively becoming an inner world.

Perhaps like a mouth painted by Francis Bacon (1909–1992) – gaping, entirely unapologetic in relation to its own almost animal-like nature. The red, shiny meat in the fold of the exterior to the interior. The

mouth, particularly a mouth depicted in a silent cry, is an obsessive element in the painting of Bacon. In an interview, Bacon himself points out:

> [a]nother thing that made me think about the human cry was a book that I bought when I was very young from a bookshop in Paris, a second-hand book which had a beautiful hand-coloured plates of diseases of the mouth, beautiful plates of the mouth open and of the examination of the inside of the mouth; and they fascinated me, and I was obsessed by them. And then I saw – or perhaps I even knew by then – the Potemkin film, and I attempted to use the Potemkin still as a basis on which I could also use these marvelous illustrations of the human mouth. It never worked out, though. (Sylvester, 2012, p. 35)

The perfect mouth uttering a scream is that of one of the female characters that witness, in horror, the Odessa Steps scene in Sergei M. Eisenstein's (1898–1948) film, *Battleship Potemkin* (1925). The scream is silent, and it is perfect that way. The scream as a disease that infects the mouth as it is swallowed down within the being. The pain reverberates in the folds of the soul – from the meat to the abstract world of the monad. On Bacon, Deleuze writes:

> [...], it is important to understand the affinity of the mouth, and the interior of the mouth, with meat, and to reach the point where the open mouth becomes nothing more than the section of a severed artery, [...]. The mouth then acquires this power of nonlocalization that turns all meat into a head without a face. It is no longer a particular organ, but the hole through which the entire body escapes, and from which the flesh descends [...]. This is what Bacon calls the Scream, in the immense pity that the meat evokes. (2003, p. 19)

The house needs this mouth as the opening to an obscure world, as a passage between plastic and elastic forces of matter. Opening in effort. Exterior that forces its way into the interior. No matter how much this allegory is fixated on the interiority fallen in on itself, the contagion – in the form of reverberation – is necessary. One can imagine, even – in a progression from a Deleuzian Baroque house to a new level – where the mouth is a mouth in movement, and due to so much movement, it loses its "place" in the Baroque symmetry proposed in Deleuze's drawing. A mouth that changes its configuration, its form, and its place, depending on the need to establish, as a whole in coalescence, different relationships between the exterior and the interior, causing the matter to reverberate and vibrate in different ways the folds that extend downwards. There are no more organs. There is a head without a face, an open and cavernous whole. One should not forget that in his drawing, Deleuze shows us the exterior and interior at the same time. In order to advance – to take a step forward –, the exterior would have to be shaken by the movement, dismantling the symmetry and the precise location of the elements that make up its image. One would have to assume

the architectural interiority as a thing, just as one can assume the flight of the body to the head as a "thing". We one would have to assume, as a pressing need in the architectural context, an operation of the imagination sublimated by an aesthetic intention. Accordingly, this Baroque architectural montage, now in a state of imbalance, that moves from the concepts to the precepts and feelings, is also an aesthetic operation. As Bacon points out in an interview:

> I've always been very moved by the movements of the mouth and the shape of the mouth and the teeth. [. . .], and I've always hoped in a sense to be able to paint the mouth like Monet painted a sunset. (Sylvester, 2012, pp. 49–50)

3 CELLS: INSIDE OF A MONTAGE

Bacon has said:

> I've used the figures lying on beds with a hypodermic syringe as a form of nailing the image more strongly into reality or appearance. I don't put the syringe because of the drug that's being injected but because it's less stupid than putting a nail through the arm, which would be even more melodramatic. I put the syringe because I want a nailing of the flesh onto the bed. (Sylvester, 2012, p. 78)

This brings us back to the presence of flesh as matter, to which one can add the presence of the need for the passage from the virtual to the actual – that pair, virtual and actual, is Deleuzian in its essence. In his painting, Bacon needed to "nail" this need for it to be more real, or perhaps to "appear" more real; and it is through the flesh, its thickness, that he nails it. Yes, this is melodramatic, but perhaps no more so than the image of the organic matter on the lower floor of the Baroque house being stimulated by and reacting to, or sensing, the upper floor. Whilst the monad is a being which, taken to the extreme, could exist without a body – remaining in the obscurity, illuminating itself, in small isolated areas – Leibniz, through Deleuze, argues for the need for a body. Precisely because there is a small area that is illuminated, and that requires a body. The pain that emanates through the body, using the nailed flesh, which in Bacon's painting is virtual, is in truth actualised in the folds of the monad, turning it into a being. Is that not the function of art? To go from the virtual to the actual.

But this needs to have a body can also be interpreted differently: one can imagine the representation of a body, which is virtual, even though it is actual, and expose it to a montage process. The allegorical house is body and soul of itself and to itself, the already mentioned Deleuzian montage. But the Baroque – not the Baroque of the philosophy and mathematics of Leibniz – offers us a complex process of montage that also results in a whole; here, one can think

of, for example, the *bel composto* of Gian Lorenzo Bernini (1598–1680). Giovanni Careri writes the following:

> Bernini was not referring to architecture alone, but rather to the relationship between arts. We ought to think, therefore, in terms of a dynamic process in which the rules of each arts are pushed to their limits in order to achieve an extension onto which the rules of another art will be crafted. (2003, p. 33)

Further, according to Careri (1995, p. 1), the interior of Bernini's chapels is the most complete realisation of the *bel composto*. In these chapels – such as the Cornaro chapel in Santa Maria della Vittoria (1647–52), the Fonseca chapel in San Lorenzo in Lucina (1664–75), and the Albertoni chapel in San Francesco a Ripa (1665–75) – the interiors function as complete autonomous organisms in and of themselves:

> a dark world sealed below by the balustrade and lit from above by the light of a lantern. Covered by a luminous celestial dome, this dark, earthly place is populated by bodies made of paint, marble, stucco, and flesh. (Careri, 1995, p. 1)

These bodies are organised in their matter, and in their "human organic" being – in a dark and closed world close to the idea of the monad, in a proliferation of other matters and other figures, in an arrangement that recalls, according to Careri (1995, p. 2), a type of montage – matters and figures that move from one component of the composition to the other. It is the spectator who assembles this into a whole. However, Deleuze takes this idea further, albeit without referring directly to the *bel composto* or Careri's notion of the montage; he proposes an overpowering reading of the Baroque as a whole:

> [i]f the Baroque establishes a total art or a unity of the arts, it does so first of all in extension, each art tending to be prolonged and even to be prolonged into the next art, which exceeds the one before. We have remarked that the Baroque often confines painting to retables, but it does so because the painting exceeds its frame and is realized in polychrome marble sculpture; and sculpture goes beyond itself by being architecture; and in turn, architecture discovers a frame in the façade, but the frame itself becomes detached from the inside and establishes relations with the surroundings so as to realize architecture in city planning. From one end of the chain to the other, the painter has become all urban designer. We witness the prodigious development of a continuity in the arts, in breadth or in extension: an interlocking of frames of which each is exceeded by a matter that moves through it. (2006, p. 141)

It is in this chain reaction in continuity, in constant extension – as if the folds of the Baroque clothes progress in continuity and swallow and extend, also in continuity, the arts, taking them, as one, from passage to passage in the successive curves of the fold – that the bodies that people these chapels are realised

in architecture, because they exceed the painting, to go beyond sculpture, to become architecture. Careri (1995, p. 3) attributes the term "emotional machines" to the prime nature of these chapels, but advances that in these machines, the spectator participates in the composition by gathering their heterogeneous elements together to make them a whole. In a way, this passage from the emotional machine to the determination of the coalescence of the elements, as a whole, through the filter – which is the agent-body, the body that feels but also gathers together – calls to mind the term *machinic*, a Deleuzian term associated with that which is machined, which is used by the French philosopher when he refers to the plastic forces impacting on the matter on the lower floor of the Baroque house. Deleuze writes:

> [i]f plastic forces can be distinguished, it is not because living matter exceeds mechanical processes, but because mechanisms are not sufficient to be machines. A mechanism is faulty not for being too artificial to account for leaving matter, but for not being mechanical enough, for not being adequately machined. Our mechanisms are in fact organized into parts that are not in themselves machines, while the organism is infinitely machined, a machine whose every part or piece is a machine, but only "transformed by different folds that it receives." (2006, p. 8)

This idea of a *machinic* whole leads us back to Eisenstein. In his *Cinéma 1: L'image-mouvement* (1983), Deleuze (2013, p. 30) argues, in a section about Eisenstein, that montage is the Whole of a film. For Careri, reference to the montage associated with the *composto*, takes in Soviet cinema and the composition as a whole, regardless of the heterogeneity of the components:

> [l]ike Bernini, Eisenstein works with leaps from one level to another and with conversations back and forth among disparate components, gauging the pathetic and cognitive effects he will obtain. Like Eisenstein, Bernini understands that linking together of several arts in a *composto* is successful only when uniqueness of each one has been preserved in the montage and only when the shift from one to another has been calculated according to the cognitive and pathetic effects that the artist wishes to create in the spectator. (Careri, 1995, p. 5)

Mieke Bal (2001, p. 98) argues that Careri uses this model – the montage model proposed by Eisenstein – to explain various aspects she refers to as integration. Montage, more than a model that unifies, is

> a dynamic model, a theory of reception. Cognitively, montage integrates iconography with the sensorial, thus producing pathos. And, most important, he insists, the 'non-indifference of materials' makes for embodied form.

Although he used one single frame from *Battleship Potemkin* as a reference for his mouths producing a silent cry, Bacon was probably conscious of the whole enormous montage process that resulted in the Odessa Steps sequence – the modelling of time and space. This reminds one of the mouths of Bacon's figures, that disintegrate in their respective faces, which themselves become dissolved in a process of "acceleration and alteration" of time, like a tremor, like an extraordinary agitation. This agitation is the result of different forces (it does not result from the movement of the head). Forces of pressure, expansion, contraction, flattening, stretching. Forces that are exerted on a motionless head. Forces, as we understand, of time and in time.

The Franco-American artist Louise Bourgeois (1911–2010) – a self-professed admirer of Bacon[2] – says of her work in an interview:

> [i]n general, my work portrays and encompasses the whole tradition of art. It is baroque, for example. I have even called one work Baroque, a work made about 1970." (Kuspit, 1998, p. 162)

It is precisely through Bourgeois's relationship with Baroque sculpture, specifically with Bernini – and in particular through her work Homage to Bernini (1967), that it offers what Bal (2001, p. 48) refers to as a "radically innovative exploration of sculpture narrativity – in dialogue with both modernism and baroque." For Bal, the form this exploration takes is architectural. In a way, Bourgeois informs the architectural aspect of her work with her own body. Whereby she herself, her body, is memory. In the work of Bourgeois, from the femme-maison – half woman, half house – to the Cells meticulously constructed as objects of interiority, and to representations in diverse media of the houses of her life, architecture has played a very present, representative role.

But Bourgeois's Cells do not reject an almost animal-like aspect that is given to them. In Spider, as the title indicates, a huge spider envelops one such Cell – as if the cell were the result of its own self, the housing for its eggs, its young. In the centre of the Cell a chair awaits an absent body, whilst on the metal grid that forms the cell's outer limits hang pieces of bone. In this sense, this is an approximation to the visceral work of Bacon. On pain, Bourgeois writes: "[e]ach *Cell* deals with fear. Fear is pain. Often it is not perceived as pain, because it is always disguising itself." (1998a, p. 205). In this sense also, as part animal – let us not forget pain – the Cells are constructions in interiority. Body-houses, but body-houses that are inside out – almost like a drawing of the cells "lodged" in our brain of the Spanish neuro-anatomist Santiago Ramón y Cajal (1852–1934). For Bal (2001, p. 48), Bourgeois's Cells

2. "The intensity of Francis Bacon's works moves me deeply. I react positively. I sympathize. His suffering communicates. The definition of beauty is a kind of intimacy in the visual. I feel for Bacon even though his emotions are not mine. The physical reality of his works is transformed and transcended. His room does not obey the laws of perspective. To look at his pictures makes me alive. I want to share it. It's almost the expression of love..." (Bourgeois, 1998, 229).

function like a Baroque chapel, where the body is in the interior and exterior at the same time. This brings us back to the Deleuzian house and the interiority, which is in some way inherent to the exteriority of the body as a whole. And to Bernini's chapels, where the sculpture-bodies and the non-indifference of materials give the chapels an embodied form, organising themselves in a world of closure and obscurity, as mentioned above, that is close to the idea of the monad. One finds in the work of Bourgeois, particularly in the Cells, the cross between the Deleuzian allegory and the *composto* of Bernini:

> [e]ach *Cell* deals with the pleasure of the voyeur, the thrill of looking and being looked at. The *Cells* either attract or repulse each other. There is this urge to integrate, merge, or disintegrate. (Bourgeois, 1998a, p. 205)

But it is in the figure of the femme-maison that one finds a motive a profound motive for the montage of a new understanding of an imagined Baroque – one that goes from the virtual to the actual, then returns to the virtual, without ever forfeiting a dimension of reality. This montage is carried out primarily in coalescence, because she, Louise Bourgeois, is her work and her work is she herself, her house. Louise Bourgeois is the *femme-maison*. She is a Whole, and the Whole is she herself.

4 META-BAROQUE: IMAGINING A "FANTASTIC REALITY"

Bourgeois's work *Hommage to Bernini* is a small bronze sculpture that is quite irregular in appearance; at its middle, its core is an orifice. In this void there emerge small "fingers" or perhaps small "phalli" that are only perceptible thanks to lighting. A cavernous body in metamorphosis? A grotesquely deformed head and its soul – close to a face such as those portrayed by Bacon? Could the void be an allusion to Bernini's chapels – like a house or like a *machinic* thing where the void reinforces the idea of the *bel composto*? Are the "fingers" bodies within bodies? From the sculpture to architecture, as Deleuze argues.

But later, in 1982, with her sculpture *Femme Maison*, Bourgeois (re)turns Bernini to the future. As Bal points out:

> She inhabits his work in the mode of parasite. Over time, inhabiting inevitably builds a new logic, invents a host that did not exist before the parasite came to live in and on him. (2001, p. 101).

The sculpture features a head that has become a high-rise building, extending from a voluminous and dramatic body of marble consisting of successive twisted and re-twisted folds – not regular folds like Bernini's. Folds in convulsion and confusion, where the interval – like the interrupted line between the two floors of the

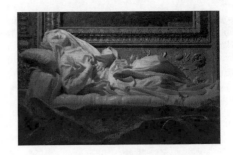

Figure 1. Gian Lorenzo Bernini, *Blessed Ludovica Albertoni*, 1671–74; Church of San Francesco a Ripa. Photo: Maria João Soares.

house drawn by Deleuze – appears less subtle. In the centre of this body is a void like a mouth; however, it is a mouth that is not uttering a cry.

On Bernini's folds, Deleuze writes:

> [...] when the folds of clothing spill out of painting, it is Bernini who endows them with sublime form in sculpture, when marble seizes and bears to infinity folds that cannot be explained by the body, but by a spiritual adventure that can set the body ablaze. His is not an art of structures but of textures, as seen in the twenty marble forms he fashions. [...] is it not the fire that can alone account for the extraordinary folds of the tunic of Bernini's Saint Theresa? Another order of the fold surges over the Blessed Ludovica Albertoni, this time turning back to a deeply furrowed earth. (2006, pp. 139–140)

What happens when the parasite settles in the folds described by Deleuze? When the parasite enters the clothing of Bernini's "chapel-women"[3]? It turns the *femme-maison* into an inverted model of the Baroque allegorical house. The folds are now at the bottom of the "house" and extend upwards in continuity, at the same time as "nailing" themselves – like flesh or like the monad, that is the question – to the centre of gravity. What is extended is the head, but one cannot know if the head, the building, is the body or if it is, in reality, the head. Body and head are indiscernible from each other as if they are a whole, and the parts are machines in constant operation, revealing the *machinic*. *Femme-maison* is, here, a time-fold in convulsion. From the virtual to the actual; and from the actual to the virtual.

Towards the end of *The Fold*, Deleuze writes:

> [s]omething has changed in the situation of monads, between the former model, the closed chapel with imperceptible openings, and the new model invoked by [sculptor] Tony Smith, the sealed car speeding down the dark highway. (2006, p 157)

In this new model, the monads do not content themselves with staticity – they move rapidly through the darkness, headlights on in the darkest of darks. We

3. An expression coined by Mieke Bal (2001).

Figure 2. Louise Bourgeois, *Femme Maison*, 1982; marble; 63.5 × 49.5 × 58.4 cm. Photo: Allan Finkelman. © Louise Bourgeois Trust/VAGA, New York.

not only fall into the abysses of the soul; we fall vertically and horizontally into and outside of Being. A breach has opened, and the mobile is exceeded. The new model exceeds the Einsteinian mechanical montage to become machinic in essence, where everything is a Whole – like Louise Bourgeois and her house, like Louise Bourgeois and her work. We are in coalescence. And looking for a meta-Baroque "Fantastic-reality"[4].

ACKNOWLEDGEMENT

This chapter is financed by national funding from FCT – Foundation for Science and Technology under the Project UID/AUR/04026/2019.

BIBLIOGRAPHICAL REFERENCES

Bal, Mieke. (2001). *Louise Bourgeois' Spider: The Architecture of Art-writing*, Chicago: The University of Chicago Press.

Bourgeois, Louise. (1998a). On Cells. In: Bernardac, Marie-Laure & Obrist, Hans-Hulrich (Eds.). *Louise Bourgeois: Destruction of the Father Reconstruction of the Father. Writings and Interviews 1923–1997* (pp. 205–208). London: Violette Editions.

Bourgeois, Louise. (1998b). Statement: Documenta IX. In: Bernardac, Marie-Laure & Obrist, Hans-Hulrich (Eds.). *Louise Bourgeois: Destruction of the Father Reconstruction of the Father. Writings and Interviews 1923–1997* (pp. 221–230). London: Violette Editions.

Careri, Giovanni. (1995). *Bernini: Flights of Love, the Art of Devotion* (Linda Lappin, Trans). Chicago: The University of Chicago Press.

_____. (2003). *Baroques*. New Jersey: Princeton University Press.

Deleuze, Gilles. (1988). *Le Plis*. Paris: Les Editions de minuit.

_____. (2003). *Francis Bacon*. London: Continuum. Translation Daniel W. Smith.

_____. (2006). *The Fold*. London: Continuum. Translation Tom Conley

_____. (2013). *Cinema 1: The Movement-Image*. London: Bloomsbury Academia.

Deleuze, Gilles & Guattari, Félix. (1994.) *What is Philosophy?* London: Verso.

Grosz, Elizabeth. (2001). *Architecture from the Outside: Essays on Virtual and Real Space*. Cambridge, MA: MIT Press.

Krauss, Rosalind E. (1999). Louise Bourgeois: Portrait of the Artist as Fillette. In: Krauss, Rosalind E. *Bachelors*. (pp. 191–206). Cambridge, MA: MIT Press.

Kuspit, Donald. (1998). Statements from an Interview with Donald Kuspit. In: Bernardac, Marie-Laure & Obrist, Hans-Hulrich (Eds.). *Louise Bourgeois: Destruction of the Father Reconstruction of the Father. Writings and Interviews 1923–1997*. (pp. 157–167). London: Violette Editions.

Sylvester, David. (2012) *Interviews with Francis Bacon*. London: Thames and Hudson.

4. An expression used by Rosalind E. Krauss (1999) to describe the relationship she established between Louise Bourgeois's work and the desiring-machine of Deleuze and Guattari.

Stolen characters against an enclosure of the imagination

Daniel Jesus
CIAUD, Lisbon School of Architecture, Universidade de Lisboa, Lisbon, Portugal
ORCID: 0000-0002-7528-2140

ABSTRACT: Imagination opens up possibilities for constructing an interpretative model because the type of reasoning implicit in architectural questions–holistic and philosophical, in the critical or prepositional domain–causes each rationally determined question to find no corresponding exact material solution. The essay develops accordingly, on the possibility of isolating Aristotelian propositions without determining a moral standpoint. On the one hand, the text is implicitly committed to ideology, utopia and fiction, while, on the other hand, from a narrative point of view, it is referred to the construction of a model of observation where fictional characters drawn from literature and cinema interplay with factual architectural events. Two stories unfold, both of them (a sort) of an architect character opposing a threat bigger than one man alone can withstand. Moreover, each case opens a limited set of ideological and aesthetic hypotheses, eventually narrowed down to a more or less effective use of architecture's disciplinary discourse. The recorded situations suspend the validation of meaning, leaving open the ability to draw conclusions. Nevertheless, through the conflictual association of ideas with space-time support, limits that can condition the imagination of architecture are diffusely suggested to the reader.

Keywords: fiction, intelligence, architecture, reasoning, ideology

From deep past awareness, Aristotle states spoken words as symbols of mental experience (Edghill, 2016, p. 37): and explains that just by building a model – establishing a set of propositions – we can verify what is true or false (Edghill, 2016, pp. 39-45). That is, we can only gauge whether the propositions are true or false according to said model, or a chosen perspective of observation.

Once upon a time in the West (1968), three gunmen at the behest of Frank shared a common viewpoint, as they waited on a deserted railway station. Interrupted by a distant hiss, the silence gave place to the painful respite of the locomotive halting to a rest... The trio was startled, but no one exited the carriage... Eventually, the train departed, with notes of harmonica surging from a stranger's blow, aloof, on the opposite quay. A dialogue unfolded thusly (Leone, 1969):

Harmonica: 'Frank?'
Gunman [profiled on the edge of the quay]:

Figure 1. Still-frame from *Once Upon a Time in the West*, directed by Sergio Leone (1968).

'Frank sent us.'
Harmonica: 'Did you bring a horse for me?'
Gunman: 'Well... looks like we're... [Snickers]
Looks like we're shy one horse.'
[Dramatic pause]
Harmonica [shaking his head]: 'You brought two too many.'
[Tension rises, from opposed plans]... (Nearly) unison stampedes of firearms, the four men fall on the ground...
[Another pause] ... One man painfully stands up – over harmonica notes...

In the aftermath, no words for symbolising the experience of the shooting were then possible. However, three fallen bodies on the wooden deck verified Harmonica's proposition. We could also have imagined two horses, clueless of the sense in which such verification occurred, duly unleashed from former duties.

1 INTELLIGENCE VERSUS STUPIDITY

The anticipation slowly builds up in the deserted station, from the waiting for a train's arrival. As a forester finally steps out, a brief dialogue develops into a life-and-death dispute. The sparing words that were exchanged do not give enough clues for particular morals to be distinguished on any side's favour. Every man presents himself on Cattle Corner Station as

crudely as the ground under his boots, offering the spectator no clues to how the action will unfold. The fact that it develops in some way and not the other is irrelevant, and the signs that appease the spectator creditor of a 'good end' for the narrative plot are carefully hidden from sight.

In the *western* movie of *spaghetti* declination, the evidence for differentiating the 'ugly, dirty and bad' gunmen like those on Harmonica's welcoming committee – the villains that we usually find pawned for a fatal destiny – from the character of good intent, is rather lightly carved, if there is any.

The scene presents no aprioristic distinction between true and false propositions; it gives no clues for reasoning in favour of a benevolent ending for Harmonica's part on the shootout. As all four men collapse after guns blast, it seems initially a close case for any attempt on judging an eventful skill of the newcomer in successfully opposing the threat of his welcoming party, against the plain stupidity implied in defying odds that unfavourable.

Nevertheless, we can freeze the instant before the cards being dropped on the table for the benefit of some hypothetical reasoning: at the crucial moment, there would be no way for any of the actors, never mind Harmonica, to know the outcome of one's recklessness in the face of potentially terminal circumstances. Based on the presumption that he never met his potential foes ('Frank?'), how could Harmonica have made a proper assessment regarding the lesser skills of his three opponents? With the amount of data missing on which he could rely for a proper judgment, probably the way it all developed was more due to a poor choice gone randomly into his hand, than to an intelligent evaluation of the situation.

Any exegesis directed at evaluating Harmonica's decision-making (acting recklessly against the odds) based on the former hypothesis remains a dangerous ground, like a schedule of arrivals that claims Frank's interest. That is if Robert Musil remarks in his 1937 essay *On Stupidity* are worth considering,

> Anyone who presumes to speak about stupidity today runs the risk of coming to grief in a number of ways. It may be interpreted as insolence on his part; it may even be interpreted as disturbing the progress of our time (Musil, 1995, p. 268).

He went on with further explanation:

> If it were not so hard to distinguish stupidity from talent, progress, hope, or improvement, no one would want to be stupid (Musil, 1995, p. 268).

So, rested on Musil's verifiable insight on a subject he claimed unverifiable, to acknowledge an opposite intelligence hypothesis becomes no minor feat. When we say intelligence, we mean the confidence one acquires developing the skill for the use of a utensil (a firearm). In the portrayed situation, intelligence can only be translated into technical expertise, the kind of talent that the deeper it is perfected, the more it

reinforces the confidence of its beholder. A skill is, in itself, a very narrow representation of intelligence, but a shootout at high noon also represents a state of affairs as rugged as it gets.

Therefore, a preliminary attempt in accessing for stupidity or intelligence on Harmonica's behalf will be postponed, resting both hypotheses like a pair of redundant horses. Instead, we will proceed through a different line of thought: did Harmonica's character really had a real choice, other than facing the ambush as boldly as he did?

2 NOT THAT, BUT THE OTHER

Considering how circumstances developed at the site, and instead of putting the confidence in his skill on the line against the fact of being cowardly outnumbered, would it serve Harmonica any good to claim that he 'would prefer not to'?

As can be deduced by the elegance of the newfound analytical back door, we have just poured an additional layer of fantasy over an already fictional background. Borrowing this time from literature (but always bonded by the book subject matter) the homonymous character adapted from *Bartleby, The Scrivener: A Story of Wall Street*, written in 1853 by Herman Melville, is subsumed as a third hypothesis for action.

In his fictional tale, the author imagined a perfect archetype to illustrate power (or possibility) in its purest state. The philosopher Giorgio Agamben (2007) picks up the philosophical statement that contemplates the difference between doing and acting from Melville's tale, the latter presenting itself as an objective of endless means: when the fictional writer Bartleby does not write, he incarnates the radical experience of acting without doing it. Refusing to empty the possibility through an exhaustively reiterated 'would prefer not to', Bartleby represents the practitioner who abstains from practice: any project activity is refuted as an impossibility.

The Bartleby hypothesis inscribes in the narrative a representation of the political subject, who exists upstream of the gunman or, accepting that we are already late for a disclosure time, the architect. It embodies the free spirit that denies subjection to a state of cognitive and conceptual impoverishment.

Since the vail has been unfolded, to get a historical glimpse of a said architect committed to a revolutionary utopia to the point of sacrificing his own life in the process of defending his plea, we retrieve the remarkable case of Giordano Bruno, who will have 'built within his own spirit a scientifically revolutionary cathedral' (Libeskind, 1991, p. 42). Considering the era, there is probably an overuse of the 'scientific' adjective for the instrumental purpose of opposing obscurantism. However, the critical aspect is that Giordano's precociousness in some subjects, which science would later validate as trustworthy, ended up putting

him in a position to burn, literally, at the hands of the guardians of the dogmatism from that era.

In the architectural lesson titled *The Pilgrimage of Absolute Architecture*, Daniel Libeskind (1991, p. 38–46) evokes the condemnation to death at the stake of Giordano Bruno, the Dominican friar, a philosopher, and (then said) heretic, who was accused of pantheism by the Catholic Church in Rome in the year 1600. This, in addition to the inconvenience of diffusing throughout Europe of the time, the ill-accepted heliocentric theory of a certain Nicolaus Copernicus.

In the said lecture, Libeskind interprets Giordano Bruno as an architect of a spiritual nature: that is, the kind of character that would never have contributed to the materialisation of a real building, despite the one built inside his head. Yet, he would have said – always according to Libeskind (1991, p. 42) – in his dying moments: 'They're not building them anymore outside, so I'm building it inside.' Moreover, he would have added, before being silenced by the flames: 'I have almost completed it. I've got it completely inside. It's not necessary for me to have it outside.'

Bartleby's perspective – as an archetype of translation for Giordano Bruno's reserve towards building real buildings – represents the most unpleasant and radical allusion to the possibility of constructing within architecture, by stating noncompliance with the conditioning context.

It is by way of his participation in the batch of presumed architects that the possibility of 'not doing' as 'action', intentional and fundamental, is to be included and recognised. It complies the needed opening for including everything external or residual within the 'disciplinary realm', something that can only be done without committing to the subtractive process of choice, obligatory for being 'precisely' an architect or for shooting foes across the quay.

The architect who prefers not to, by opposing the agreed deontological tradition, becomes a remaining force to counteract the ethical tradition that, according to Agamben (2007, p. 25), has repeatedly sought to turn the problem of power down to the terms of will and necessity. That is, making of what you want or owe the dominant theme (Agamben, 2007, p. 25).

Alongside an article correlating the rules of monastic life and the early settlement of the monasteries in the Egyptian desert (Deseille, 2008) comes a representation of *The Ladder of Divine Ascent*, also called *Ladder of Paradise* (originally retrieved in the monastery of Saint Catherine, Sinaï). The 12th-century illustration that accompanied the early text by Saint John Climacus (579–649) pictured the mandatory thirty steps for evolving the spirituality of the monks towards Christ. By diverting from an ascetic method that rose as a social guideline until late in the 17th century, Giordano Bruno made probably a premature misstep, one that eventually led him to fall in disgrace, met by hellfire.

[For all who rest wondering about Bartleby's fictional destiny, it was a similar case of emptying the

Figure 2. Article 'Les monastères, fleurs de desert', *Le Magazine Littéraire* 481. Author's photograph.

surprise effect brought by 'the opening of possibility' within the dominant system in power. Mystified by the fine balance between activity and stillness from Bartleby's proposition, some margin of tolerance was first conceded to the reluctant, by the retraction of the productive machine. However, once recovered from the surprise, the mechanical inertia of the superstructure inverted from mistrust to produce the constricting movement – to apply the appropriate disciplinary countermeasure – that definitively erased the writer from the writing. The same fate that objected to Giordano Bruno's architectural masterpiece, with the exemption of flames.]

3 NON-FLAMMABLE LOGIC

Contrary to the narrow and ascendant path to salvation described earlier, late capitalist domination and deserted railway stations in the middle of nowhere often present themselves like free or levelled playing fields, where a predetermined method for adequate social behaviourism is unavailable. However, as far as history can stretch (more than a case of once upon a time), the power relation between the actors involved in the grounds of social, economic or technical interchanging are rarely a product of any kind of equivalence.

On the other way around, examples of the weak combustibility of architects are easier to find, since the one who chooses to construct real cathedrals 'on the outside', tends to lodge under the structures of power (in order to command construction), with no particular need to worry about lightning from heavens or earthly bonfires.

Accordingly, the steps by which the spirituality of the architect evolves takes a significant shortcut in the 20th century. First, by jumping on the ideological elevator that lifted the Modern Movement in architecture to a praxis of universal recognition – using its social and direct political intervention.

Later, in peaceful confinement with the present state of neoliberalist affairs, it evolved from the said elevator to a proper seat in the master's penthouse. The

Figure 3. El Lissitzky, *Lenin's tribune*, 1920 [Painting]. Collection State Tretyakov Gallery, Moscow. https://commons.wikimedia.org/wiki/File:El_Lissitzky,_Lenin_Tribune,_1920._State_Tretyakov_Gallery,_Moscow.jpg

successful protagonist of architectural praxis learned to thrive from the intersection between convenient mythology and (presumably) erudite reason: the demiurge architect – sacralised as the exponent of the species – stands out in the art of avenging his particular mental representation of the world as a valuable commodity.

In the said context, Rem Koolhaas (1995, p. 1262) wrote, in the essay 'The Generic City' that: 'All resistance to postmodernism is anti-democratic. It creates a "stealth" wrapping around architecture that makes it irresistible, like a Christmas present from a charity.' In this small excerpt, Koolhaas translates the perfect alignment of the fate of architecture with the 'naturalization' of political destiny within the framework of liberal domination: that is, present circumstances translate the freedom to buy, to sell, to construct, to demolish, to circumscribe, and all opposing resistance is fundamentally charitable and naive. In short, any conditioning of an 'expressive freedom' could only be regarded as an unacceptable totalitarian drift.

At the turn of the century, Koolhaas was showing signs of exemplary conversion to Francis Fukuyama's *The End of History and the Last Man*. Mainly, by being an architect of his time: 'Maxim Gorky speaks in relation to Coney Island of "varied boredom". He clearly intends the term as an oxymoron. Variety cannot be boring. Boredom cannot be varied. But the infinite variety of the Generic City comes close, at least, to making variety normal: banalised, in a reversal of expectation, it is repetition that has become unusual, therefore, potentially, daring, exhilarating.' (1995, p. 1262)

The Futurists have not said it better – on the eve of two World Wars – and the global crisis that developed in 2007 from so much boldness and stimulation would not contradict Koolhaas's forethought.

To epitomise the problem of scale to preconfigured sizes and images of the ready-to-dress is to alienate inventiveness in favour of narrow freedom to decide between S, M, L and XL (Koolhaas, 1995).

Rem Koolhaas's apology resonates with an early formulation that the philosopher of aesthetics Samuel Taylor Coleridge subscribes to as suspension of disbelief, or willing suspension of disbelief. The statement translates the use in the work of fiction (by the author) of a 'verisimilitude of truth', to provoke in the reader the 'suspension of judgment' before the implausibility of the narrative (Coleridge, 1907, p.6). The similarity added by the verisimilitude of digitally represented architectural images comes to replace another previous empirical reference, which did not depend on strict visuality.

For the sake of argument, Roland Barthes's definition of architecture (as cited in Hamon, 1991, p. 151) claimed an opposite sense of precision both in the broader scope of concepts and in the strict domain of scale. According to Hamon, Barthes refers to architecture (in *L'obvie et l'obtus*) as '*l' art de la taille des choses*'[1] juxtaposing in the same set of words *(la) taille*, as noun and *tailler*, as a verb. The double meaning of measure and defining a scale, which states the conceptual scope of the problem, adds up to stereotomic, the way material elements are cut and assembled, which highlights the constitutive and constructive scope of architectonic imagination.

Had it not been a case of a spatial-temporal mismatch, Barthes himself could have given a connotative interpretation of the scalar elasticity proposed by Koolhaas: having specialized in the semiotic analysis of propaganda to highlight the political content implicated in language, Barthes would undoubtedly have something to say about the code system employed by the *star* architect.

Moving on: a global economic crisis later, on December 16, 2011, the newspaper *Der Spiegel* published an interview in which one can see the repositioning of Koolhaas concerning some facts. It seems now less indifferent to the manifestations of freedom, whether of an architectural, political, social, or financial nature: 'under neoliberalism, architecture lost its role as the decisive and fundamental articulation of a society' (Koolhaas, 2011). The state of affairs denounced by Koolhaas in the press came to play after his own lecture in the Sharjah Biennial, entitled *Dubai: From Judgement to Analysis* (2009), an occasion where he declares himself 'unhappy and nervous towards the increasingly extravagant conditions (...) reflecting very badly on architecture itself' (Koolhaas, 2009). Koolhaas finds himself concerned

1. From the Latin origin *taliare*, derives a double meaning for French: depending on whether it concerns the *taille* noun, which refers to the need for a size, proportion or scale, or is considered the verb *tailler* and its correlatives *entailler, retailler, détailler*, that are reconnected to the architecture through detail and construction.

with the uncontrolled proliferation of the architectural icon, which, although seemingly triumphant, guarantees to find itself in a state of premature exhaustion. Nevertheless, disregarding some 'ambivalent feelings' towards the work he has been commissioned to deliver, the new project announced for Dubai intends to run against the absurdity of iconic proliferation: it consists of a tower that the architect described as 'a very (...) singular pure building, really a new beginning'. Presently omitted from the lecture accessible online is a magnificent feature that distinguished said building: the possibility of revolving around its vertical axis. We can only expect, if it is ever concluded, that it does not end up turning on itself before dying a very simple icon, dramatically impersonating the gunmen once upon a time shot in the west. [Unexpected twist of the argument, that reinforces the hardworking analogy presented in the text: an unavoidable note from the author].

Probably Rem, as it was the case with Harmonica, did not have a real choice other than facing the ambush as boldly as he did: 'at the beginning of the 21st century, a growing amount of attention was focused on an ever-smaller number of architects, who were expected to produce more and more spectacular buildings' (Koolhaas, 2015). That was staged on an even fresher interview, (again) in *Der Spiegel*, punctuated by an apologetic remark towards his own embodied figuration of the *star architect*: 'in our architectural firm we felt increasingly uncomfortable with the obligation to constantly surpass ourselves' (Koolhaas, 2015).

The point made above lies to a certain extent in the bankruptcy of the great ideological systematisations that proceed from modernity – thus cataloguing the socialist or communist utopias, and then forged to redeem the archaic stratifications that characterised the ancient world. Scepticism in the redemptive capacity of large structures results, in reaction to the past, in a new belief, dedicated by postmodernity to sectoral action: according to a new presupposition, exhaustible competences gather in themselves the needed functional benefit.

Along several redemption stages, as Koolhaas denounces, the compulsion to be extravagant and spectacular in a context of free for all at the expense of the dignity of the profession, there is still pedagogical wisdom left to underline.

4 FIGURATIONS UNLIMITED

In the current academic context of architecture, the proliferation of 'undisputed figurations' is particularly abundant, because the availability and ease of computer reproduction of captivating images encourage their direct and unmediated importation into the concrete problem under study. *The Siteless catalog: 1001 Building Forms*, produced by François

Figure 4. Publications of Rem Koolhaas and Bruce Mau (O.M.A.), *S,M,L,XL* and François Blanciak, *Siteless: 1001 Building Forms*. Author's photograph[2].

Blanciak (2008), provides a wealth of possibilities for building formalisations, which clarifies contemporary architecture as a mere derivative of habitable scale for the plastic exercise of abstraction.

A feature of it is that the author organises the collected examples according to a single categorisation, based on the geographical location – Hong Kong, New York, Copenhagen, Los Angeles, Tokyo –, promoted as an ironic illustration of the absolute regional indistinctness. Absolute indifference between contexts, with respect to the geometrical nature of the presented figurations, inhibits any more or less specialised connoisseur of trying to establish a correspondence between places and forms: the simplified volumetric representation of each case is powered to abstraction, decontextualized from reference to any sort of place, where unity tends towards multiplicity.

The way an apparently innocuous and uncompromising publication (of critical intentionality), in which text is absent beyond the introduction, is[2] promoted through the phrase: 'Some may call it the first manifesto of the twenty-first century, for it lays down a new way to think about architecture' (Blanciak, 2008, p. 2). The 'thought' is equivalent, therefore, to the absence of text. Moreover, the annulment of the explanatory speech is celebrated as the greatest of presences.

The emptied formalisations on ideological grounds outline the reconversion of activity as 'pure architectures', which in the present context only means that they replace the modern utopian component with the private imagination.

When 'form as purpose' overlaps with 'the mediation of a conceptual reason', new figurations emerge, rooted in constructive vanity: good form is exempted

2. Photographed by the author against a green background ('suspension of disbelief' required due to printing limitations). Indirect homage to Gregory Bateson's truism in *Vers l'ecologie de l'esprit, tomo II*, París, Le Seuil (1980, cited in Guattari, 2000, p. 27): 'There is an ecology of bad ideas, just as there is an ecology of weed'.

from the material translation of a program, presumed to achieve legitimacy by default, capable of justifying the work, enclosing it in such an irreducible as well as unexplained truth. In the generous repository of available architectural images, it is not difficult to find materials that appeal to imagery sensitisation.

If '[t]he main problem of architectural intentionality,' similarly to a former *spaghetti western* shot in the Province of Granada, Spain, 'is the genesis of form' (Pérez-Gómez, 1996, p. 7) it will suffice to conclude the shared result of all premeditation – 'regardless of the sense in which such verification occurs, true or false' – as a residual of two abandoned horses.

5 EPILOGUE

Both architectural tales of Giordano Bruno and Rem Koolhaas present a different imbalance between reality and possibility, not to mention the fate that eventually seals each protagonist's destiny. If the available instrumentation and its use appear to be always at consonance with the contemporary culture of inception in a recent story, that will not occur in the former case.

Presented along these lines as an apologetic fantasy for 'the architectural uncanny' (Vidler, 1992), the Bartleby archetype implodes from within the processes of integrated consensus. 'I would prefer not to' becomes instrumental for opposing specific propositions that develop in a relatively narrow domain of possibility, as the gunfight Harmonica embraced at the beginning of the text, or like the impossible 'reasoning' of Giordano Bruno's Earth revolving around the Sun in the context of theocentric domination.

To deconstruct a dogmatic architecture, a conciliation between the availability of space and time for imagination with a resident human curiosity is therefore mandatory. Since the metaphysical commotion through generating a form, to which the mediation process appeals, constitutes one of the limits imposed on language, a fight for the reconfiguration of this limit should be open to the imagination. This predisposition becomes a fundamental circumstance in the light of the present state of affairs: the impossibility of an architectural thought outside language (Bregazzi, 2008, p. 108). That is the fundamental condition to tie any phenomena to its interpretation. As the whole architectural proposition arises from a linguistically transmitted intentionality, only the framing in a narrative system of imagined figurations, which nevertheless promises a concrete material answer, closes the question and its circle.

BIBLIOGRAPHICAL REFERENCES

Agamben, Giorgio. (2007). *Bartleby, Escrita da Potência*. Lisboa: Assírio & Alvim.

Blanciak, François. (2008). *Siteless: 1001 Building Forms*. Cambridge, Massachusetts: The MIT Press.

Bregazzi, Daniel Mielgo. (2008). *Construir ficciones. Para una filosofía de la arquitectura*. Madrid: Editorial Biblioteca Nueva.

Coleridge, Samuel Taylor. (1907). *Biographia Literaria* (Vol. 2). Oxford: Clarendon Press.

Deseille, Placide. (2008, December). Les monastères, fleurs de desert. *Le Magazine Littéraire*, 481, pp.64–65.

Edghill, E.M. (Trans.). (2016). On Interpretation. In Jones, R. B. (Comp.). *The Organon: The works of Aristotle on Logic* (pp. 35–58). Roger Bishop Jones, Middletown, DE.

Fukuyama, Francis. (1992). *The End of History (and the Last Man)*. The Free Press, New York.

Guattari, Félix. (2000). *The Three Ecologies*. London: The Athlone Press. https://monoskop.org/images/4/44/Guattari_Felix_The_Three_Ecologies.pdf.

Hamon, Phillipe. (1991). Littérature et Architecture: tout, parties, dominante (pp. 149–166). In *De l'architecture à l'épistémologie. La question de l'échelle*, Philippe Boudon (Comp.). Nouvelle Encyclopédie Diderot, Presses Universitaires de France, Paris.

Koolhaas, Rem, Mau, Bruce. (1995). *S, M, L, XL*. Rotterdam: 010 Publishers.

Koolhaas, Rem. (1995). The Generic City. In *S, M, L, XL*. (pp. 1238–1264). Rotterdam: 010 Publishers.

_____. (2009, March 15). *Dubai: from Judgment to Analysis*, lecture in Sharjah Biennial, United Arab Emirates [Transcripted]. https://oma.eu/lectures/dubai-from-judgment-to-analysis.

_____. (2011, December 16). 'We're Building Assembly-Line Cities and Buildings'. *Der Spiegel*. https://www.spiegel.de/international/zeitgeist/interview-with-star-architect-rem-koolhaas-we-re-building-assembly-line-cities-and-buildings-a-803798.html.

_____. (2015, April 5). 'We Shouldn't Tear Down Buildings We Can Still Use'. *Der Spiegel*. https://www.spiegel.de/international/europe/interview-with-rem-koolhaas-about-the-fondazione-prada-a-1031551.html.

Leone, Sergio (Director). (1969). *Once Upon a Time in the West*. In Paramount Pictures, Rafran Cinematografica, & San Marco (Producer). Italy; USA: Paramount Pictures.

Libeskind, Daniel. (1991). *Countersign*, Architectural Monographs n° 16. London: Academy Editions.

Melville, Herman. (1948). Bartleby. In *The Piazza Tales*. Ed. Egbert Oliver. (pp. 16–54). New York: Hendricks House, Farrar Straus.

Musil, Robert. (1995). *Precision and Soul: Essays and Addresses*. (B. Pike, D. S. Luft, Eds. and Trans.) Chicago and London: The University of Chicago Press.

Pérez-Gómez, Alberto. (1996). *Architecture and the Crisis of Modern Science*. Chicago: The MIT Press.

Vidler, Anthony. (1992). *The Architectural Uncanny; Essays in the Modern Unhomely*. Cambridge, Massachusetts: The MIT Press.

Developing creative approaches in architectural education

Irina Tarasova
Department of Architecture, Ural State University of Architecture and Art, Ekaterinburg, Russia
ORCID: 0000-0002-0893-206X

ABSTRACT: The paper shares an experience in developing creative approaches in architectural education. The architect's thinking specificity is considered as a theoretical basis for choosing a creative method for teaching history and architectural theory. The paper demonstrates creative approaches which applying to the interpreting of architectural theorists' ideas. Review of fundamental texts of architectural theorists is the basis in developing thinking skills in architecture students at bachelor and master levels. The methods were selected through a critical review of existing methods for interpreting the theoretical texts. The result of the article was the illustrating of creative approaches in architectural education.

Keywords: creative approaches, theory of architecture, creative thinking, architectural education

1 CREATIVITY METHODS

Architecture is a creative activity, which combines engineering, art and science. Creativity employs intuitive, heuristic and algorithmic methods.

It is becoming increasingly important to find new unconventional, creative methods in architectural education to enable students to learn courses of history and theory of architecture more effectively. Standard lecturing formats and note-taking in linear form are losing their relevance to the current context. Easy access to a wealth of information, publications and books on the Internet creates a competitive environment for the teaching staff. The teaching profession is facing the challenge of being able to teach students to analyse information, think critically and structure information appropriately irrespective of the level of its theoretical sophistication.

This paper suggests some creative approaches to the teaching of history and theory of architecture courses based on a review of some theoretical premises and, in particular, the distinctive features of architectural thinking.

2 DISTINCTIVE FEATURES OF ARCHITECTURAL THINKING

Various researchers have examined architectural thinking as a fundamental concept in architecture theory, Rapapport (1990), Iovlev (1993), Kapustin (2001), who have identified two main components in it: visual (spatial) thinking and verbal thinking, by analogy with thinking in daily routine contexts.

Spatial thinking is a cognitive process aimed at creating spatial models. Architectural activities result in visual outputs of spatial thinking using the mechanisms of spatial-temporal modelling, computer simulation, and scenario modelling (Iovlev, 1993). Verbal thinking or theoretical thinking in architecture is a cognitive process producing verbal constructions through verbal and conceptual logical operations.

Thus, professional architectural activity employs two main types of architectural thinking. These are united by one common feature, creativity, which is inherent in both spatial and verbal forms of architectural thinking. Moreover, architectural thinking is characterised by creativity, critique and conceptuality.

Both forms of architectural thinking, spatial and verbal, present a process that spans three levels: intuitive (an irrational form of knowledge), rational (rational knowledge) and sensory (sensory knowledge). Transitions characterise thinking from one level to another. At the same time, each of the three levels is present in professional architectural thinking.

In architectural education, the interaction between the visual and the verbal is an integral element of the learning process. Equal attention given to both the visual and the verbal in the architectural and pedagogical process helps the development of split-brain thinking engaging both the left hemisphere and the right hemisphere. This is an important communicative element as the would-be architect learns to not only design but also verbally present his/her project in public defending the advantages and positive aspects of the solution being presented.

Thus, the distinctive features of architectural thinking should determine criteria for choosing one or another method (or creative approach) in the teaching

practice. Architects present the results of their work visually and verbally. The visual outputs are sketches, drawings, designs, etc. The verbal outputs are texts, theories, statements, etc. Architectural solution visualisation along with the textual presentation are essential skills to be developed in students. These skills can be effectively formed using the method of museum experiment and the method of mental mapping, which help activate the visual and verbal components of architectural thinking in students.

Developing critical thinking skills employing creativity methods is seen as an effective teaching and learning practice, which allows students to formulate and effectively find solutions to problems in architecture and urbanism.

3 CREATIVE APPROACHES IN PEDAGOGY

The use of heuristic methods in teaching and learning has been considered by Sarkisov, who suggested some techniques such as Schiffsrat ("ship's council" in German), brainstorming, museum experiment, and Synectics. Synectics means assigning to objects properties of other objects (Sarkisov, 2004).

Researchers, as Kowaltowski, Bianchi and Pavia (2009), have addressed the value of creative thinking methods in design. Issues in creative and critical thinking and similarities and distinctions between them have been considered by Peter Quinn (2014).

3.1 *The method of museum experiment*

The master's degree course in architecture includes the module "Architect's Professional Thinking". This module teaches students methods of generating new ideas and applying these methods to problem-solving.

As for the method of museum experiment, it is a team exercise whereby each member of the team proposes his or her solution within a limited timeframe. The solution should be formulated verbally but also presented graphically as a drawing on a 10 cm × 8 cm sheet of paper.

In our museum experiment, the students were allocated six museum halls. Each hall was dedicated to a specific historical period: primitive society (hall 1), slave-owning society (hall 2), the Middle Ages (hall 3), 19th-century (hall 4), 20th century (hall 5), and 21st-century (hall 6). Each student had to propose a solution within the time limit. The problem that the student had to solve using the museum experiment was the lack of parking spaces in cities. The students came up with the following solutions (Figure 1).

– Primitive society (hall 1). A wooden post-and-lintel structure can accommodate space for parking vehicles on the conventional "first floor". A possible option is parking on the "second floor". Vehicles can be raised to the "second floor" or the roof of the

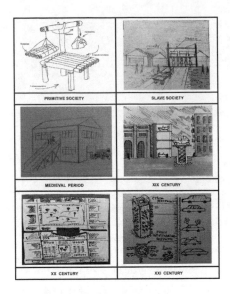

Figure 1. Solutions proposed to the parking problem based on the method of museum experiment by the students A. Pachenkova, A. Knyazeva, V. Boyarshinova, E. Luzhetskaya, S. Neverov, N. Shosholin.

wooden structure with the help of a lifting system with a counterbalance.
– Slave-owning system (hall 2). A two-storied wooden structure has room on the first floor for storing hay and water and for tying up a horse. On the second floor, there is space for carts. Slaves lift carts to the second level using ropes. This system enables the space to be used rationally and to fill it with a universal function.
– Middle Ages (hall 3). The problem of parking space shortage in medieval cities could be resolved with the help of a two-storied parking facility. A horse-drawn cart is driven onto the first floor, where the cart is left off, and the horse is led to the stables on the second floor.
– 19th-century (hall 4). The lift was invented in the 19th century. The problem of parking space shortage could be resolved with the help of a lifting mechanism similar to the lift. Cars could be lifted and parked in a special structure.
– 20th-century (hall 5). The solution for the 20th century is a separate functional zone or zones for keeping personal transport vehicles within the fabric of the city.
– 21st-century (hall 6). The main idea is that "a vertical modular magnetic element" could be performing the function of a multi-level parking facility but also serve as a service substation for refuelling and battery charging. The central ring acts as the structural core of the building. In the internal part of the core, there are next-generation drones with high weight-lifting ability. These drones would take automobiles up and down within 5–8 minutes. On the outside of

the structural core, along with the entire height of this element, there are built-in lines of electromagnetic cushions, which would fix a car perpendicular to the structural core. The absence of any additional pillars and planes around the structural core should enable "suspending" as many cars as possible. The "vertical modular magnetic element" serves as the main parking place, ensuring the convenience of parking and accommodation of a large number of cars.

Figure 2. A mind map for My Profession (proposed by the student A. Blinova).

4 MIND MAPPING

In the bachelor degree course of "Theory of Architecture and Other Spatial Arts", students are supposed to produce a mind map using the main postulates from the works by theoreticians of architecture, such as Vitruvius, Alberti, Vignola, Palladio.

The brothers Buzan (1993) proposed mind mapping. By this method, information is represented graphically while meeting specific requirements, such as line thickness, keywords, block lettering, etc.

The importance of observing such requirements is dictated by how the human brain perceives and memorises information. Since architectural thinking combines verbal and visual components, mind mapping seems to be appropriate in architectural education not only because it enables structural representation and recording of information but also because it helps to find new solutions.

Today the volume of information that a student has to find and study exceeds considerably compared with what students dealt with a few decades ago, so it has become essential to be able to structure and systematise information rather than accumulating it.

Mind mapping is a kind of variant of graphic representation and an opportunity for modern architecture students to apply skills of not only handling large volumes of information but also representing it graphically. The traditional linear representation of text does not contribute to the development of creative thinking. Unlike it, the non-traditional radial presentation in mind mapping is a creativity tool (Fig. 2).

The bachelor degree students were asked to present their results of studying the theoretical works by Vitruvius, Alberti, Vignola and Palladio in radial form (as a mind map). The assignment was formulated accordingly – to record the main postulates of these architectural theoreticians in the form of a mind map.

This is a complex creative task for a student because they have to summarise theoretical provisions in keywords on a strictly A4 sheet of paper. Particular attention is given to the formulation of keywords and to the ability to structure information by significance.

For example, one of the students produced a mind map for Vitruvius with the following first-level keywords: fundamental principles of architecture, a

Figure 3. A mind map for Vitruvius (proposed by the student A. Blinova).

Figure 4. A mind map for Palladio (proposed by the student A. Shkarupova)

Roman engineer, the treatise *The Ten Books of Architecture* (Fig. 3).

The mind map of another student constructed for Palladio contained the following keywords: "The Four Books of Architecture", palace buildings, villas of the Veneto, churches in Venice, a basilica in Vicenza (Fig. 4).

Presentation of architectural theory ideas as mental maps is not an absolute and the only appropriate method. However, each student develops a specific mental map, and the importance of using these mental maps as a creative approach to teaching and learning lies in the fact that the student develops a systemic view of theories in world architecture and, at the same time, departs from linear textual note-taking towards unconventional, creative visualisations.

5 CONCLUSION

The distinctive features of architectural thinking provide a theoretical basis for choosing creative methods for use in architectural education.

The methods of museum experiment and mind mapping enable creative thinking to be developed in architecture students and approach problems in a non-conventional way.

These creative approaches help activate both components of architectural thinking: visual and verbal.

BIBLIOGRAPHICAL REFERENCES

Buzan, T. & Buzan, B. (1993). *The mind map book.* London: BBC Books.

Iovlev, V. (1993). Space-time as a category of figurative thinking of the architect. Ekaterinburg: Architecton Publishing.

Kapustin, P. (2001). Design Thinking in Architecture: Problems and Perspectives of Research. *Special Issue of ARCHITECTON.* Ekaterinburg: Architecton Publishing.

Kowaltowski, Doris. & Bianchi, Giovanna. & Teixeira de Pavia, Valeria. (2009). *Methods that may stimulate creativity and their use in architectural design education.* Retrieved from: http://www.academia.edu/527010/Methods_that_may_stimulate_creativity_and_their_use_in_architectural_design_education.

Quinn, Peter. (2014). Critical Thinking and Creative Thinking. *TC SCAN (Vol. 4, pp. 1–11).* Retrieved from: https://www.academia.edu/8174348/Critical_Thinking_and_Creativity.

Rappaport, A. & Somov, G. (1990). *Form in architecture: Problems of theory and methodology.* Moscow: Stroiizdat Publishing.

Sarkisov, S. (2004). *Basics of Architectural Heuristic.* Moscow: Architecture-S Publishing.

Fantasy and creativity of the Azuchi-Momoyama period Japanese tea architecture

Adriana Piccinini Higashino

Architecture Department, Akashi College, National Institute of Technology, Hyogo, Japan

ABSTRACT: Azuchi-Momoyama period (1573–1600) was a time in Japanese history characterised by the appearance of great heroes and issuing of great battles. It was also when the first Europeans (Portuguese) arrived in Japan and a period that Japanese art and architecture flourished. Japanese warlords, such as Oda Nobunaga and Toyotomi Hideyoshi (1585–1592), were responsible for promoting atrocious violent acts and exquisite, delicate, exuberant and sophisticated art. The Tea Ceremony is an example of a habit that evolved into a form of art thanks to the patronage of warlords. It started with the collection of utensils and developed into the design of a space that elevated the act of drinking tea into a different dimension. Through this tea architecture, they aimed at experiencing a different world, detached from their reality, a Zen world, a world of serenity and art where each encounter was important. This study attempts to explain, through an analysis of João Rodrigues Tçuzu's description of the tea house, how the tea master translated into architecture the fantasy of a peaceful and fresh Zen world, how he designed the tea gardens and tea houses in a manner that the guest could experience this Zen fantasy.

Keywords: Traditional Japanese Architecture, Tea House, Tea Garden, Momoyama Period

1 INTRODUCTION

Tea arrived in Japan together with Buddhists in the 8th-century. However, it became popular much later. It is the wild Basara Damyo, with their gambling tea games that would make drinking tea popular. Later, in the Momoyama period under the patronage of influential warlords, such as Oda Nobunaga[1] and Toyotomi Hideyoshi[2], the tea masters, such as Sen no Rikyu[3], developed the act of drinking tea into an art.

Tea ceremony as an art requires a space specifically designed to its performance. An inner space, a tea house, and an outer space, the tea garden compose the tea space (Hyuga, 2002). The progressive experiences of the outside/inside space are essential elements to elevate the act of drinking tea into a fantasy.

Here, using sixteen-century contemporary descriptions of the tea space, written by João Rodrigues Tçuzu[4], we will clarify how the architectural environment was created to transform drinking tea into a fantasy.

João Rodrigues, also called Tçuzu[5] because of his work as an interpreter, was born in Portugal and arrived in Japan very young. He became fluent in Japanese and worked as an interpreter to Toyotomi Hideyoshi and later to Tokugawa Ieyasu[6] until he was expelled after thirty-three years in Japan.

1. Oda Nobunaga (1534–1582), a powerful feudal lord, started the reunification of Japan. He was a patron of the arts, built several gardens and castles, ordered Byobu screens paintings and sponsored the famous tea master, Sen no Rikyu (1522–1591)

2. Toyotomi Hideyoshi (1585–1592) succeeded his former liege lord Oda Nobunaga, and completed the unification of Japan. Also a patron of the arts, he rebuilt several Buddhist temples destroyed by the wars. He sponsored Sen no Rikyu after Nobonaga's death, and ordered Rikyu to commit suicide in 1591. Died in 1592 after his second failed invasion of Korea.

3. Sen no Rikyu (1522–1591) was from a Sakai city's merchant family. He studied tea under Takeno Jōō (1502–1555) and together with his master were the developers of the wabi aesthetic. Rikyū was the tea master for Oda Nobunaga and Toyotomi Hideyoshi. He designed small rustic tea rooms, which were referred to as sō-an ("grass hermitage").

4. João Rodrigues Tçuzu (1562–1633) Portuguese Jesuit missionary arrived in Japan during his early teens. He became fluent in Japanese and worked as an interpreter for Toyotomi Hideyoshi and Tokogawa Ieyasu until he was deported from Japan in 1604. He is now best known for his work on the Japanese language: *The Art of the Japanese Language* (1604).

5. There was another João Rodrigues at the Jesuit mission in Japan and Tçuzu (Tsuji) that means interpreter in Japanese was added to his name (Cooper, 1974)

6. Tokugawa Ieyasu (1543–1616) also a former liege lord Oda Nobunaga, seized power after winning the Battle of Sekigahara in 1600. He was successful in stablish a government system, the Tokugawa Bakufu that will last until 1868.

Rodrigues wrote descriptions of Japan and an account of the first twenty years of the mission's history. The original text was written in Macao in 1620, but the only available manuscript is the 1740 copy. However, the text as it exists today, although it was revised, seems to be faithful to the original text (Cooper, 1974).

The texts used here are the Portuguese eighteen-century manuscript. "Chapter 9: Da casa onde dao abeber o cha aos hospedes, chamada Suky" copy from the Ajuda library, code 49-IV-53, folios 63 to 65, and Cooper (2001) translation "How guests are especially entertained with cha in the suki house".

2 THE HERMIT HUT IMAGE

Rodrigues starts the text explaining that his primary purpose is to describe the building where the Japanese serve tea, and not to discuss the origins of the habit of drinking tea or the utensils used. According to him, Tea Ceremony is not an old habit and developed recently to the time he wrote the text. He emphasises that he is only describing the materials and how the tea house is built because it is an annexe necessaire to the lords and influential people's residences.

Drinking tea is the principal and most venerated political costume in Japan. The Japanese invest their best to invite people to drink tea and in the construction of the place to drink tea. The construction of the building, the path to the building, the entrance, among other things, are specially designed to give a general impression of quietness.

Further in his description, he makes an analogy of the tea house and the hut of a hermit, in a lonely mountain, a fantasy of a peaceful place. He explains how the design of the garden and the tea house involve the visitor into this fantasy. He says that the construction of the place is arranged form the quiet contemplation of natural things, as a hermit would have enjoyed. The building resembles a wild hut and is made of natural materials. It is made of timber with bark, to give the image that the building was naturally created there. According to Rodrigues the image of the hermit, solitude is strong, it reminds something ordinary to people that live in a solitary place. That everything was designed to imitate the natural, and at the same time, the design shows disdain but has the proper proportion and measure, as nature has on the things it creates. The place is called Suky, and it is used by noble people to entertain friends. The host invites the guest to the tea house, which Rodrigues refers to as the hermit hut. He detailed describes the journey of the guest through the garden before arriving at the tea house. According to him, the guests are expected to contemplate the path, the woods through which the guest enters, and everything that is there, although everything looks natural, it was designed with proportion and elegance. The hut

and the instruments of service there were designed to remind the retreat of a solitary hermit.

Rodrigues explains how the guest starts this fantastic experience through the appreciation of the garden. The tea fantasy starts when entering the garden and the guest contemplates and appreciates all the things to see there, and their relation to the image of the hermit, the solitary hut. In this space, gallantry and well-polished instruments for eating and drinking are not allowed. Rodrigues explains those instruments connected with the image of an imperial court, and have no relation with the image of the hermit mount, to which rustic things or things naturally deformed related better.

According to Rodrigues, all lords and rich people invested in building a tea house and a tea garden in their residences. Inside this space, the fantasy of the hermit hut prevailed and social status were not considered. Those houses were for their private use, where they could ordinarily serve their friends. In the tea house, the social status of the host did not matter. Even the noblest host would prepare the tea for his guest with his own hands. It was the ultimate honour a host could give to a guest.

Consequently, the opposite was also true, and a commoner person could invite nobles to drink tea at their Suky, even though they were a vassal of the guest. In the Suky, there was no social hierarchy; they were all the same, actors in the same play. He emphasises that to fully enjoy the fantasy of a day in the hut of a hermit, the host and the guest behaved as actors in a play,

3 THE DESIGN OF THE TEA GARDEN

Rodrigues explains how the fantasy of the hermit hut in the mountain is constructed by the carefully designed garden and the position of the house in the residence site. Several points a considered at the planning of the tea house. First is the location of the tea house, it should be built in the site of the residence, inside the same fence. The second was the entrance to the path that leads to the tea house. This entrance should be placed away from the street, and the daily entrance of the house, at a "solitary and dark place". Rodrigues text emphasises the image of solitude of the tea house.

Later he describes the tools and artifices used to make the spiritual passage from the real world to the tea world. The first artifice is the size of the entrance gate, it is low and narrow, to pass through the gate it is necessary to bend. When the guest bends to cross the gate, he is forced to look down. This forced shift of the view, the guest is forced to look down, at the floor is an artifice; it resets the guest view and helps guest's transition from the real world to the tea world. On the inner side of the gate, there are benches made of wood where the guest seat and wait. The time waiting is also a tool in the transition into the tea world. Near the benches, there are rustic but extremely clean privies, with stones

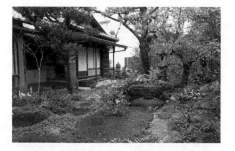

Figure 1. Example of a tea house and tea garden. Former residence of the Kinoshita family, built in 1941, Kobe city, Japan 2019 ©*A.Higashino.*

to step on, and a special kind of thick sand and a wet wooden shovel, perfumed with herbs, and there is no trash. The privies are ceremonial, and usually, nobody uses it unless in case of an urgent necessity, which is quickly cleaned by the house staff. Rodrigues detailed description of the unconventional design of the toilets, rustic doors, with knockers on the inner side and windows made of weaved bamboo, and his emphasis that those toilets are not to be used transmit the peculiarity of the space.

Rodrigues descriptions of the tea garden show how it was designed to be a fantasy, where everything seems natural but is not. He explains that there is a wood made of trees that look natural, but in fact, the trees were all carefully transplanted to the garden. Also, the trees were designed to look perfectly natural by choosing the best branches and cutting off the others. Most were pine trees, and they look as if they have grown at the garden, naturally and disarranged. In this wood, there was a long and narrow path made of stones evenly apart, on which the guest stepson. The stone path is also a trick to force the guest to look down. The path ends at the tea house, but along the path, there are several elements. In the middle of the way, from the entrance to the tea house, there is a high and rustic stone, concave with extremely clean water inside it and a bowl to take the water and wash hands. Rodrigues explains that it is winter, the water is warm, and emphasises how mindful of the guest wellbeing is the host.

In Rodrigues, texts are present images of freshness and carefully designed nature.

4 THE DESIGN OF THE TEA HOUSE

After crossing the garden, the guest arrived at the teahouse. Here once more Rodrigues emphasises that social status (swords and fans) have no place in the tea world. He detailed describes the tea house roofed porch, which was where the guest took off the sword and fan. In the porch, there were hats made of Bamboo, for rainy/sunny days, so that the guest could comfortably go to the garden, to wash hands or take a walk to admire the garden.

In his description of the tea house, Rodrigues makes clear that the importance is the quality of the space and not the size. He explains how the construction materials were chosen to give the house a rustic look, although the house was skilled built. He explains that high techniques of Japanese timber construction could be appreciated by paying attention to the refined connection between the elements, which was precise and sophisticated. The house was small, it usually had three or four tatami mats size, but it could be even smaller according to the will of the host, and that there were tea houses of only one and a half size mat. The timber used in the construction of the house has the bark on and looked as if it has just come from the woods. There was also always an old element, a piece of timber recycled from an older structure.

The entrance of the tea house was small. The tea house entrance is called Nijiriguchi because to pass through it one needs to squat and crawl inside (nijiru). This little door forces the visitor to look down. Similar to the gate at the tea garden entrance, again, the forced shift of the view is used in the transition from the outside space to the inside space. Inside the tea house, everything was designed and calculated to create the fantasy; even light was controlled. For clarity, the house has several windows made of weaved bamboo and covered on the outside. Rodrigues describes how the materials used in the ceiling and the decorative alcove (Tokonoma) create a surreal space that differs from the garden. The ceiling was made of smoked wood to show antiquity and poverty loneliness. At the head of the house, there was a wall with a concave niche, one-step higher where an antique painting or a phrase by estimated authors written with ancient calligraphy was hanged, or a flower in a vase was displayed for the guest to contemplate when he enters the house. The display of scrolls at the decorative alcove adds to the image of the rustic nature, refinement, and cultural knowledge.

The host comes to receive the guest at the first gate, salutes the guest and then the host goes to the tea house using a different path, through inside his residence, and the guest goes through the tea garden alone or with another guest. The guest(s) journey to the tea world is solitary. The host does not accompany the guest through the tea garden, which, according to Rodrigues, is to emphasise the image of loneliness, the fantasy of the hermit hut.

Inside the tea house, everything was carefully prepared. Rodrigues describes how the host gives time for the guest to appreciate the space inside the tea house alone before the food was served. Inside the tea house, there was a hearth with an iron pan full of water. The water was boiling. Everything was clean and well proportionated for the guest appreciation, the ashes were specially sorted, and the charcoal was of a particular kind. The guest contemplates all these details, very quietly. When the host thinks the guest has had enough time to admire the tea house, he entered the house from a low and narrow inner door. The host salutes

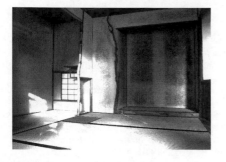

Figure 2. Example of a Tokonoma. Kyoto city, Japan 2018
©*A. Higashino*

and thanks to the guest for coming, the guest thanks the host for being invited. They talk quietly about beautiful things until the host decides it is time to eat. The host brings a small table that is like a tray with legs, with food for the guest and leaves a bowl of rice and wine to show the guest he can eat as much as pleased and other ceremonies. After the guest finishes eating the host says it is time for drinking tea. The guest is sent for a walk at the tea garden, to give the host time to redecorated the interior of the tea house and prepared it for the tea ceremony. The guest leaves the house and goes to the wood to wash hands. The host closes the Nijiriguchi, the small door of the house and cleans it, he changes the hanging scroll or the flower. When everything is ready, he opens the door and the guest returns inside the tea house. The guest appreciates the hanging scroll or the flower at the niche on the wall until it is time to drink tea, with all its ceremonies. After the tea ceremony is over the guest walks alone through the tea garden, the host used a different path and waited for the guest at the entrance of the garden.

5 CONCLUSION

Rodrigues descriptions showed two different types of space, the tea garden, and the tea house. Both spaces were designed using the image of a hermit hut in the woods. This fantasy persists in the design of every detail; everything is rustic but of refined design. The guest experiences those spaces alone, which is also an analogy to the fantasy of the hermit. By himself, the guess can fully appreciate the loneliness and melancholy of the space. The small gate to enter the garden and the little door of the tea house are design tricks, used to force the visitor to look down before entering a different space. These tricks reset the view of the visitor and emphasise the transition into a different space.

The fantasy of the tea world, the houses and gardens, later evolved into complexes of several buildings distributed in a garden. The fantasy became more complex and famous literary works would be used as a theme for the design of the tea house and the garden. A good example is Katsura Detached Palace in Kyoto that has Murasaki Shikibu's The Tale of Genji as the theme for the design of the tea houses and the garden.

BIBLIOGRAPHICAL REFERENCES

Cooper, M. (ed.). (2001). *João Rodrigues's account of sixteen-century Japan*. Edited and translated by Michael Cooper. London: The Hakluyt Society.
Cooper, M. (1994). *Rodrigues the Interpreter: An Early Jesuit in Japan and China*. New York: Weatherhill.
Fujimori, T. (2012). Fujimori terunobu no chashitsugaku: Nihon no gokusho kukan no nazo. Tokyo: Rikuyosha.
Hyūga, S. (2002). *Chashitsu ni manabu: Nihon kenchiku no sui*. Tokyo: Kodansha.
Lisbon: Library of the Ajuda Palace: *Jesuitas na Asia* series:
Rodrigues, João. (1604–1608). *Arte da lingoa de Iapam*. Nagasaki: Collegio de Iapao da Companhia de Iesv. Available at https://archive.org/details/bub_gb_NwnUAAAA MAAJ/page/n1. (accessed March 2019)-
_____. (1740). *Historia da Igreja do Japao*, Part 1, Books 1&2, 49-IV-53. Lisbon: Library of the Ajuda Palace.
Shikibu, M. (1976). *The tale of Genji*. London: Secker and Warburg.

From fantasy to experimentation: The one-to-one scale in architecture exhibitions

Ana Neiva
CEAU-FAUP – Centre for Studies in Architecture and Urbanism of Faculty of Architecture, University of Porto, Portugal
ORCID: 0000-0003-3821-906X

ABSTRACT: The framework for the architectural exhibition usually lies on the relationship between a concept of architecture as "container" and its objectification into "content," along with traditional juxtapositions to artistic practices such as the performing arts and spatial installations. However pertinent this framework might have been for the affirmation of the discipline's autonomy, it also limits the discussion into a superficial glance of the symptoms of the practice and its representation, instead of drawing from a broader and more complex debate on the potentialities regarding experimentation, mediation and emotional engagement in architecture exhibitions.

Focusing on examples that emphasise the object itself, this paper explores the relevance and the potentialities of one-to-one scale installation in the exhibition context, investigating its roots in fantasised architectures and stating its contemporary role in fostering creativity and exploration within Architecture. Ephemeral architectural installations facilitate the overlap of disciplinary boundaries and, additionally, enables other levels of effectiveness regarding public engagement. On the other hand, eluding function and reason unblock a free way to imagination and experimentation, there is to say, to creative freedom.

Building one-to-one scale, for the extent of this paper, is based on the idea of unmediated experience, excluding other ways of representing architecture besides the spatial experience.

Keywords: fantasy, folly, pavilion, architecture exhibition, environmental art

1 ARCHITECTURE IN EXHIBITIONS

The participation of architecture in exhibitions, as content, is related initially to the *Beaux-Arts salons* but also the rising of national museums all over Europe: the presence of drawings and scaled models amongst the broad content in Fine Art exhibition, was a common feature in the nineteenth-century art exhibitions.

On the one hand, the museum collections of drawings, scaled models or monuments' fragments were frequently used for pedagogical purposes, as they were archetypes to be copied. On the other, the architects also participated in annual shows – the beaux-art salons – along with several different art expressions: painting, sculpture, drawing, watercolour, engraving, pastel and other minor arts, aiming at promoting their work. In this context, architectural drawings and scaled models were considered and presented side-by-side with artworks and evaluated fundamentally by their aesthetical qualities.

Nevertheless, all over Europe and especially in more wealthy countries, the economic capacity of some museums allowed different kinds of encounters amid architecture and fine-arts, that exceeded the sharing of a wall.

Coincident with a period of national affirmation and more massive archaeological expeditions, the tendency towards historicism originated a particular interest in historical architecture exhibitions and, consequently, in archaeological finds. By showing fragments of monuments, or plaster casts of classic buildings, it was believed to be possible to recreate the experience of those distant places in the museum galleries, by supporting a one-to-one experience.

As Mari Lending explains, in her essay "Out of Space: Circulating Monuments" (Lending, 2015, p.26):

The cast collections confirmed the emerging opinion that architecture was actually best experienced out of place, in well-tempered, light-controlled curatorial environments. In fact, in 1818, the prominent museographer Quatrèmere de Quincy (. . .) stated that disintegrated buildings elements offer a more genuine understanding than an original building could ever provide, whether intact or in ruin. Not only out of place, but relocated in time as well, the temple

fragment induced, according to Quatrèmere, a veritable time travel, propelling the observer back to their moment of creation.

Simultaneously, in a parallel kind of effort towards patriotic affirmation, most governments enrolled in international Wold's Fairs events, promoting their achievements and identity at a global scale. To do so, the container, where either artistic artefacts or traditional goods, alongside with industrial, scientific and technological enterprises, were showcased should, necessarily, transmit a coherent and appealing image to the visitor and a strong statement to other nations. The Romanticism that dominated European culture, at the time, was translated into ephemeral historical architectures through retrieving particular forms linked of each nation past and tradition, alongside with exotic and distinctive vocabulary found in the colonial world.

National monuments would then be reinterpreted into temporary small-scale pavilions, in a very imaginative formulation based on singular architectonic elements, with no necessarily direct connection to existing concrete architectures.

Nevertheless, the ideological constraints and conditioned commissions limited the free expression of the architects. The laboratorial potentiality, related to the creation of ephemeral structures design, would be only possible many decades later, after the fall of main dictatorial and fascist regimes, as we will see later on.

1.1 *Fantasy*

The faculty or activity of imagining impossible or improbable things. (Oxford English Dictionary)

Going back in time, until the eighteen-century, another different type of structure started to be a standard feature in private parks. Being widely spread as an expression of a Romanticist and nostalgic view, *follies* punctuated the territory and the new British landscape design. Built merely for their owners' pleasure and personal delight, as long distance "eye-catchers" or private secret spaces, the *follies* were generated by the practice of commissioning special projects, in between architecture and sculpture that would virtually elude any functional or reasonable constraint.

Suspending the reason and the logic, fantasised architectures opened up for freedom, lightness and creativity, setting the ground for future formal and conceptual experimentation.

Although many of these structures were based in past architectures replicas or ruins, not having a clear and undeniable consequence in architecture disciplinary development, it cannot be denied that this type of commission, close to site-specific artistic assignments, created a context that would facilitate new forms and architectonic expressions.

Contemporary ephemeral architectures are direct heirs of this tradition and are still spreading worldwide.

1.2 *Experimentation*

The end of WWI and consequently dictatorial regimes and propaganda policies, opened up an era of intellectual freedom, with natural and direct consequences on ephemeral architectures, mainly, in the exhibition context.

Regarding the World's Fairs framework, as we were discussing previously, an enormous change occurred: resumed after twenty years of interregnum, since the last New York's show, held in 1939, the Brussels World's Fair of 1958, would start a new era, by focusing on scientific and technological advances aiming at peaceful purposes. This does not mean there was no architecture experimentation ahead: Mies van der Rohe double intervention – the *German Pavilion* and the *Germany's Electric Utilities Pavilion* – in *Barcelona's 1929 International Exhibition* is an undeniable example of it. But in Brussels, the fair's organisation would specifically recommend the adoption of modernist "style" for the building up of national pavilions, opposing the inherited nationalistic ideals, facilitating a new stage for architectural experimentation. Le Corbusier's famous *Philips Pavilion* is the uppermost example of the new paradigm.

On the other hand, the emergence of conceptual art tended to blur the limits between artistic disciplines. Concurrently, the institutional critic also favoured the expansion of art interventions outside the museum, increasing site-specific installations that gradually dissolve the distance between architecture and sculpture. An increasing abandoning of form as the central purpose of sculpture production – a walking around an object – gave place to installations/environmental art, common ground for researching in art and architecture. The transdisciplinarity created after environmental art considered a broader sensory experience, and used simultaneously different artistic fields – painting, photography, literature and poetry, digital art, video and cinema – mixed and concurrent in the materialisation of the concept that was at its origin.

Aiming at legibility, the installation became multidisciplinary; the body of the visitor became an integral and active part of the work. The entering of the "real life" in the museum, in a simultaneous and antagonistic movement of spreading art in non-institutional context, corroborated the central role of the visitor in the exhibition. Museums aimed at being more than culture archives, developing devices and strategies to educate audiences and to involve the visitor. The exhibition space was then onwards considered as an extraordinarily powerful device for transfer knowledge and generate discussion.

1.3 *Mediation – emotional engagement*

Recurring to mediation tactics, museums try to stimulate the presence of the public, decoding curatorial narratives, creating space for dialogues and debate,

and fomenting creativity and intelligence. By promoting guided tours, workshops and many other parallel events, the PR departments (many times under the direct responsibility of curators) explore ways of increasing communication, legibility and engagement. The use of multidisciplinary contribution, as well as multisensorial approach, in the creation of a particular environment, can promote a deeper involvement and absorption – an immersive experience –, and consequently an opportunity for more efficient transmission of contents.

The awareness regarding the usefulness of emotional engagement is widely studied, since the appearance of environmental art, aligned with the consideration of the visitor as an active part in the art experience. At the same time, market studies, cognitive development and education are exploring the potentialities of physical experience in learning processes and involvement strategies. A complete sensorial experience helps us to build and fix memories, our perceptive background – cultural, social, emotional and aesthetic – and can also be an active contributor in the creation of new associations or interpretations, when stimulated and confronted with new information, and therefore, capable of build knowledge through creative processes.

In architecture exhibitions, these ideas can be investigated in a specific way, considering the capacity of generating engagement.

Focusing on legibility issues, the curatorial narrative, and the importance of aesthetic experience, the container is the key to generate empathy and to foster curiosity within the public, while being a powerful occasion for experimentation.

1.4 *Intelligence*

The ability to acquire and apply knowledge and skills (Oxford English Dictionary)

According to this line of thought, art and architecture share a large group of common concerns, from experimentation and research potential to public engagement, particularly when developed within the exhibition environment. It is precisely considering these two apparently opposed features, aligned with the idea of a shared ground of overlapped disciplines, that this paper will discuss some of the contemporary examples of *follies* and architecture exhibitions installations, deeply related to art curatorial methods, goals and manifestations, supporting the relevance of the experimental condition in the architectural display.

Within fine art (Olafur Eliasson, Gordon Matta-Clark), music (Steve Reich, John Cage), and film (Mike Figgis, Christopher Nolan), one gleans architectural ideas that, when exhibited, might reveal to architects' dimensions of their discipline that are neglected in the practice of building design. As

such, exhibitions can themselves produce, rather than merely convey knowledge (Chan, 2010)

Trialling ideas in a laboratory context, away from real architecture constraints, can still be done diversely. From the museum context to biennial and architecture festivals, including special commissions, this paper points up some different examples that took place in those different domains or occasions. Exploring the Swiss national Pavilions at Venice Architecture Biennial latest editions; *Sensing Spaces: Architecture Reimagined* Exhibition (Royal Academy of Arts, London 2014); and the Summer Pavilions of the Serpentine Gallery (Hyde Park, London, 2000 – . . .), are placed in confront asserting the different potentialities regarding production of knowledge while enhancing immersive spatial experience.

2 LABORATORIES

2.1 *Biennials and art installations*

Contemporary art exhibitions, as well as art objects, can still be seen as models for architectural curatorial production or even for architecture interventions. Edoardo Tresoldi's large-scale sculptures, made in tight metallic meshes simulating historical architectures, or James Turrel's sky-spaces, as insights on deeply spatial creations, could carry us into hypotheses of interventions, for instance, in classical heritage and on the construction of poetic spaces, respectively.

If we add, on this set of references, Incidental Space exhibition, designed by Christian Kerez and curated by Sandra Oehly for Swiss National Representation at the 2016 Venice Architecture Biennial, there are no significant differences between their potential, regarding experimentation around space.

Their starting points and final goals are, indeed, different, but the way they rehearse about space, test the disciplinary limits and question signs and meaning, can reasonably be considered analogous.

The goal of the [Christian Kerez] pavilion was to present fundamental research by critically interrogating the daily conditions of architecture (. . .) The aim is to investigate the possibilities — technically, as much as in our imagination — of how to think, build and experience architecture differently (. . .) The project sounds out the borders of what is presently architecturally possible: how can one use the medium of architecture to think about an abstract and simultaneously complex architectonic space? How can one illustrate and produce such a space? (Press release– Incidental Space)

The Swiss pavilion of the latest Venice architecture biennale, in 2018 – *Svizzera 240: House Tour* –, follows quite the same principles, considering the spatial experience as the central concept of curatorial design.

Winning the *Golden Lyon* for the best national pavilion, it is a provocative answer to the main theme of the Biennale: Free Space here understood as

> an architectural search for potential, generosity or surprises that are latent within the world, the city or, for us, the apartment. (Bosshard, 2018)

What is particularly keen about this pavilion is the shift between the building and its representation. Quoting the curators:

> Instead of representing building (or using representation in order to build), the architects build representation. (Mairs, 2018)

The exhibition shows the dominance of a particular apartment image across Switzerland housing market – white walls, wood floors and plastic window frames – questioning its ubiquity.

> The surface [decoration] becomes the exhibition by itself and it's asking what kind of architecture are we surrounded by all the time. (Mairs, 2018)
>
> On this tour, you are no longer an apartment dweller, builder or buyer —nor are you an academic or even an architect— you become an entirely new architectural subject, a house tourist. (Press release– Incidental Space)

The incapacity of representing space, recurring to images, is here at play, and in fact, although it is possible to frame different scale compartments in a picture, or even use a human scale, it would not be possible to understand the real scale and variations of the space.

In synthesis, the power of this intervention relies on the absolute absence of any legend or explanation that is coincident with a surprising sequence of spaces, plus a ludic opportunity. Both Switzerland's interventions are outstanding proofs that "architecture can be presented through the medium of architecture itself" (Kerez, 2016) but also testimonies of playful and performative dimensions regarding interactivity with the visitor.

2.2 *Sensing spaces: architecture reimagined*

Another example, this time within a museum context, is the collective exhibition, *Sensing Spaces: Architecture Reimagined*, curated by Kate Goodwin for the Royal Academy of Arts, in 2014. In the first text of the respective catalogue, Christophe Le Brun, president of the Royal Academy of Arts, declares the main goals of the show:

> to redefine what an architectural exhibition can be (...) to offer visitors the opportunity to get directly involved with architecture, experiencing it through their bodies and senses. (Le Brun in Goodwin, 2014, p. 33)

The exhibition brings together a group of seven architects, from an extended international circuit, which conveys considerable cultural differences that reinforce the diversity of the presented proposals.

> The heart of this exhibition is the interaction between three factors: the nature of physical spaces, our perception of them, and their evocative power. (Goodwin, 2014, p. 36)

Kengo Kuma (Japan) and Li Xiadong (China) are the Asian representatives; the Chilean Pezo von Ellrichshausem, represents South America; from Africa, more specifically from Burkina Faso, the chosen one is Diébédo Francis Kéré; and from Europe two pairs of architects are selected: the Grafton Architects, from Ireland, and the Portuguese Pritzkers duo, Álvaro Siza Vieira and Eduardo Souto de Moura.

For Goodwin, the selection of this group of architects was based on their "distinctly engage with the ways architecture might move beyond practical and functional concerns to address the human spirit" (Goodwin, 2014, p.36). Moreover, the emphasis is placed on space, on its physical nature, our perception of it, and their evocative capacity.

According to the expected diversity, the answers reflect object-based proposals, of sculptural affiliation; evocative and symbolic approaches; and others, particularly site-specific, exacerbating specific spatial effects or proposing new interpretations regarding the pre-existing background.

The will to be connected and engaged with the gallery space is manifested in all the proposals, continuously testing the interaction between the galleries, the new structures and the visitors. In synthesis, all the installations result from a reaction to the immediate environment intersected with the main conceptual interests of the different authors.

Looking closer to the interventions, another level of detail arises. It is notable the desire to highlight the sensitive side of Eastern cultural tradition, where smell and touch are brought to greater experiential awareness. In Kengo Kuma and Li Xiaodong spaces, by reducing the presence of the light, the installations invite the visitor to circulate freely between two rooms of fragrances released by a light bamboo structure. Kuma's proposal tries to show that

> Architecture is no longer just about physical presence and visual effects with other senses as secondary elements. Exhibitions can provide opportunities to hint at the new tide for design and I predict that architecture will soon move into a more sensual mode. (Kuma in Goodwin, 2014, p. 71)

In an opposing intention, Grafton Architects work fundamentally with manipulation of light vs shadow, seeking to activate imagination and memory. The ceiling manipulation, capable of amplifying the natural variation of light, creates a striking contrast between the first room, and the second space where matter and gravity are the explored subjects.

The South American duo opts for an object-based installation, placed at the end of one of the museum's largest galleries. The gallery space is interpreted differently, and the installation is reduced to one single and autonomous piece. The ambiguity of the large-scale object, without suggesting crossing at first glance, makes the proposal of Pezo von Ellrichshause, much more intriguing. The dualities explored in many of the exhibition halls, using contrast as the main strategy to highlight the differences and the changes in between installations are, in this room, manifested by working on the section of the object. This approach needs the visitor to get inside in order to understand the suggested path. Sensory stimulation tested by other proposals – such as touch or smell –, is here translated by the bodily consciousness of the climbing, made by crossing a narrow staircase dominated by the shadow and the intense smell of wood. This confined ascension results in a surprising new viewpoint at the top of the object.

Another manifesto-type intervention, results from a greater symbolic idea, than the stimulation of synesthetic experience. Francis Kéré designs a structure that is, simultaneously, an allusion to participatory architecture, plus an opportunity to test new materials. The cultural reference brought up by the chosen material – plastic – is another surprising characteristic of this intervention. For an architect that almost work only with a palette of autochthonous materials, extracted from the places where he builds, working with plastic generates a political layer that goes beyond a site-specific proposal.

The Portuguese architects work with fundamental elements of construction to interfere with the pre-existing space. Álvaro Siza and Souto de Moura interventions seem particularly aligned with the Venice Architecture Biennale theme of that year: Fundamentals, proposing a door-frame and a column.

The capacity to read the site, bold characteristic of Portuguese architecture, is manifested in both installations, in a quite far-fetched way. Souto de Moura centres his attention on two of the original interior door-frames of the museum, proposing a facsimile but introducing a twist regarding their materiality and position in space. By replicating the door-frames in concrete, an absolutely contemporary material, Souto de Moura drastically opposes the Modern and Classical language. Moreover, he slightly rotates the new elements creating a new visual axis, reinforcing, simultaneously, and bringing attention to the presence of the pre-existing ones. More poetic and interpretive than at first sight it may seem, in a context where surprise and unexpected spatial succession is the dominant tone, Souto de Moura does not define its installation as Architecture, on the contrary, affirms that "it is a reflection of the architecture".

Álvaro Siza's intervention, on the other hand, reinforces the idea that "doing architecture means starting with what is on the site" (Siza in Goodwin, 2014).

The yellow and deconstructed column is distributed in three different pieces in the front patio of Burlington House, aiming at introducing some surprise and contributing to the spatial awareness of the surroundings.

> The scale [of the courtyard] is more domestic than monumental, but the facade of the building – with its portico and its columns, whiter than the rest of the stone – has a very strong presence. My first reaction was almost to panic when I thought of what to do. Then the idea of the column emerged and I imagined that I could make an installation that evoked the birth of the column. (Siza in Goodwin, 2014, p. 186)

Playing with the visitor's memory by creating a conceptual connection between both Portuguese interventions is intentionally expressed. Moreover, imagination and intelligence are stimulated by the multiple interpretations and connections suggested by the spatial interaction between the different proposals. Goodwin stresses out her goals and hopes for the exhibition:

> As well as enabling us to find greater pleasure in the spaces we inhabit, this exhibition will perhaps heighten our awareness of the sensory realm of architecture and thereby encourage the creation of a more rewarding built environment. (Goodwin, 2014, p. 37)

2.3 Serpentine pavilions

Even outside dedicated and specialised institutions or festivals, ephemeral architectures can be commissioned and contribute, in a closer way, to awaken public interest and curiosity.

The *Serpentine Gallery Summer Pavilions* are a constant presence in the garden of the art gallery in Hyde Park, since 2000. This project, launched by Julia Peyton-Jones, annually invites leading international architects, who have never built in the UK, to design a temporary structure that reflects their understanding of architecture. This initiative represents one of the most visited architecture exhibitions worldwide and a strong testimony of a method that brings society closer to architecture.

Although not consensual among the critic, for their association with extravagant follies indicating a formalism and lacking meaning

> There is nothing more dispiriting than seeing talented architects exert their energies on hastily planned follies with no meaningful outcome or overarching idea, and no more danger than divorcing architecture from the real-world constraints under which it thrives. (Wainwrigh, 2016)

these pavilions are "intended as an exciting and accessible way in which to introduce the public to contemporary architecture" (Julia Peyton-Jones in Serpentine Gallery Pavilion, 2005).

Every year each architect has to respond just a minimum programme: a 300-square-meter living space that

hosts a cafe, during the day and a forum for debates, shows and other activities at night, during the four months that the structure stays in Hide Park.

Since 2000, several architects engaged with the request in different ways. If Oscar Niemeyer decided to build his Pavilion (2003), based on key and recognisable formal elements of his buildings, along with some of his furniture; David Libeskind (2001) *Eighteen Turns*, evocates the folding and complex shapes that characterise his architectonic processes, without referring to its final shape in a direct way.

As another example, and possible variation regarding a different interpretation, Siza and Souto de Moura's pavilion (2005) explores a quite radically different strategy regarding their architecture production. Experimenting with new materials and formal generation methods, the Portuguese team works from a wood grid structure, organically distorted, that transforms the pavilion into an arachnid looking silhouette. As pointed out by Edwin Heathcote,

> The extraordinary, sensual, almost zoomorphic form seems such a radical departure for the architects. Yet both are highly skilled contextualists, exponents of a scarce skill in an age of simplistic architectural icons; and here, the lightness and transparency of the gridshell structure defers to the conservative brick solidity of the gallery and to the lush landscaping. Somehow the architects have achieved a design which is both expressionistic and self-effacing. (Serpentine Gallery Pavilion, 2005, pp. 8–9)

Indeed, even considering their expertise in reacting to new contexts, it is undeniable that, in this case, as an ephemeral and free of current constraints commission, both Siza and Souto de Moura explored new and unknown territories. Their pavilion seems to be the result of a clear moment of pure delight and experimentation.

3 FINAL CONSIDERATIONS

Serpentine's *follies* are fairly groundbreaking in their origin, purpose and strategy, as a specific and dedicated architecture commission, renovated every year, for an ephemeral and free of constraints building project. Nevertheless, *Young Architects Program* (YAP), developed by the Museum of Modern Art, in New York, was already established in 1998 as an annual call for young and emerging architects to develop gathering spaces at the MoMA P.S. 1 patio. It can also be said that YAP's programme has a strong point for enabling recognition for such young practitioners; in the end, both invest in fresh and creative approaches to the same problem, while focusing on the expansion of the museum/gallery into the society.

Significant other action, developed worldwide, could be mentioned, like the *Gwangju Folly Project*

(2011 and 2013) or *Bruges Contemporary Art and Architecture Triennial* (2018), among others. Both are promoted in urban context, demanding for new public interactions, political and social engagement, and a rising of consciousness of the built environment. Used as gazebos, shelters, gathering places or merely contemplating spots, these ephemeral structures or contemporary *follies* are bringing art and architecture, in a decoded and unmediated way, out of the museum, into the urban life.

Both playful and performative aspects of real–scale ephemeral architectures, mainly regarding interactivity with the visitor, are explored whatever context they happen to be inscribed. Designed without any functional constraint, focused on the corporeal experience of space – *Sensing Spaces: Architecture Reimagined* –, manipulating real spaces generating a ludic interface – *Svizzera 240: House Tour* –, or commissioning site-specific temporary buildings – *Serpentine Gallery Summer Pavilions* –, many are the approaches that keep following follies' imaginative attitude.

Overlapping disciplinary borders, fomenting emotional engagement and fostering the creation of knowledge through creative stimulation are, as demonstrated, contemporary and valuable strategies for reaching out general public audience.

BIBLIOGRAPHICAL REFERENCES

Bosshard, A. Tavor, L., van der Ploeg, M. Vihervaa, A. (2018). In Roda, M. Swiss Pavilion at Venice Biennale 2018: Freespace is House Tour. [Online]. 18 April. [Accessed 18 February, 2019]. Available from: www.ilgiornadellarachitettura.com

Chan, C. (2010). Exhibiting Architecture: Show, don't tell. [Online]. 17 September. [Accessed 27 February, 2019]. Available from: www.domusweb.it

Goodwin, K. (2014). *Sensing Spaces*. London: Royal Academy of Arts.

Kerez, C. (2017). Press Conference: Incidental Space. A project by Christian Kerez at the Swiss Pavilion. [Online]. 05 May [Accessed 24 February 2019]. Available from: www.biennials.ch

Lending, M. (2015) Out of Place: Circulating Monuments. In Pelkonen, E-L. CHAN, C. TASMAN, D. (eds). *Exhibiting Architecture: A Paradox* (pp. 25–32. Connecticut: Yale School of Architecture.

Mairs, J. (2018). Curators interview. [Online]. 24 May. [Accessed 25 February, 2019]. Available from: www.deezen.com.

Oxford English Dictionary. [Online]. s.v. Fantasy; Intelligence. [Accessed 27 February, 2019]. Available from: www.oed.com.

Wainwright, O. (2016). Serpentine Pavilion 2016: Bjarke Ingels' pyramid for the Minecraft generation. *The Guardian* [Online]. 7 June. [Accessed 25 February, 2019]. Available from: www.theguardian.com.

__ Serpentine Gallery. Pavilion, (2005). London: Art Review /Serpentine Gallery

Architecture and cinema: The tower as both scenario and protagonist

Eneida Kuchpil
Department of Architecture, Course of Architecture and Urbanism, Federal University of Paraná, Curitiba, Brasil

Andrezza Pimentel Dos Santos
Department of Architecture, Course of Architecture and Urbanism, Positivo University, Curitiba, Brasil

ABSTRACT: The construction in height inspired by the desire to dominate the natural forces of gravity, symbols of political or religious power. Vertical buildings, besides their role as icons, are transformed in explicit representations of power and wealth, the result of an interaction of economic and real estate forces. The enchantment generated by these buildings leads to many metaphorical possibilities reaching space beyond the limits of the architectonical world, being pictured in cinema and literature. The article discusses the place this monument occupies in our imaginary through cinema. Icons of modernity, skyscrapers represent urban utopias. The tower, real or imaginary, becomes a metalanguage and cinema uses its dramatic and emotional potentialities abundantly. The modern movement, in particular, occupies a prominent place in this field, and to represent it, it is frequent for architecture to have a protagonist role in cinema, that discusses the aesthetic of towers through symbolic representation.

Keywords: Architecture, Cinema and architecture, Vertical building.

1 INTRODUCTION

The ambition of humankind of trying to reach the skies using a monumental building, and the desire to touch the transcendental dates back to the biblical Genesis, when Noah's descendants launched themselves in Babylonian plains, decided to erect with stone and bricks a tower that would allow them to become intimate of God.

This urgency in overpass the clouds and look at the stars would be pursued by the most diverse forms of men until today. Men dream of building higher, since the Pyramid of Cheops in Egypt, built in 2700 BC, 230 m high, going through gothic cathedrals in the Middle Ages, pyramids of faith, built in many cities of medieval Europe dominated by the church. The greatness of these works can be understood as a projection of collective religiosity desires and also a demonstration of the technical exuberance of corporations that collaborated in the construction of these stone monuments, such as in our days these same forces, ideological and professional, mobilize themselves to erect from nothing an enormous "skyscraper" (Abalos and Herreros, 2002).

What are the dreams, rules and fears attached to these constructions – from the mythical tower of Babel to the Empire State Building, going through Gothic cathedrals?

Babel is perhaps the first reference when we speak about towers and ascension. A fascination that extrapolates the specific universe of constructions and expresses the human boldness of reaching the sky. A desire that is evidenced in the modern world in the construction of the first tall buildings that play with gravity, with stability and with structural ingenuity that become an icon of time, that secure, in the tallest tower, human's dominance.

2 IMAGINARY, POETICS AND THE AESTHETICS OF THE TOWER

This monument present since the biblical tradition with the Tower of Babel possesses a strong mythical, symbolic and aesthetical value. From there comes the interest by the evolution of this myth and its symbols. Classical, modern, postmodern, square, oval, twisted, dematerialised towers reveal the incessant renovation of forms. The vertical building is pointed as the definer of the spirit of the contemporaneous city that sees in it the possibility to see many architectonical and urban utopias happen, as Koolhaas evokes in his book *Delirius New York*:

> ... Building becomes Tower, landlocked lighthouse, ostensibly flashing its beams out to sea, but in fact luring the metropolitan audience to itself. (Koolhaas, 1994, p. 94)

These towers that mark the silhouette of the great metropolises are the cause of competition, designs,

challenges, controversies, destruction desires. Its symbolic dimension leads still to a phallic verticality evident but also metaphysical, in an evident reference to the male dominance over the territory, such as succeeds since the beginnings of civilisation.

3 THE TOWER AS BOTH SCENARIO AND PROTAGONIST

What place does this monument occupy in our imaginary? The tower appears since the Middle Ages as support of literary and artistical fictions that explore its form, its interior, its depths, its symbolism. The tower, real or imaginary, becomes a metalanguage. Icons of modernity, skyscrapers represented, in the popular imaginary, urban utopias of the future.

Cinema uses its dramatic and emotional potentialities abundantly. The modern, in particular, occupies a spotlight in this field and, to represent it, cinema frequently uses architecture, offering it a leading role, transforming its role from the mere scenic supporting character.

As the architect Josep Maria Montaner pointed out:

> The essence of cities is not rooted only in functional, productive or technocratic factors. They are made of many materials, among which are: representation, symbols, memory, wishes and dreams. (Montaner, 2001, p. 157)[1]

And in the interpretation and representation of such symbols, memories, wishes and dreams, few instruments have been as effective as cinema.

According to Trindade et al. (2004), the trajectory and representation of the city and architecture in cinema is extensive. In some films, in particular, it is more than a mere supporting character; it does not represent just an imagined reality, it is quite effective at communicating messages and materialising essential meanings relative to the city and its architecture. Looking at these representations of the imaginary city of movies can help us understand the meaning of the real city.

More than bringing representations of an imagined reality, architecture in cinema has been extremely effective in communicating messages. In the 20th Century, when clashes between modern and postmodern excited the world of science, the world of images was able to accompany, anticipate and criticise events.

What is certain is that, since its initial phase, the modern world was already communicated through cinema. It did not take long for architecture's modernity to also integrate cinematographic images. Tall buildings were the most immediate formula found by the

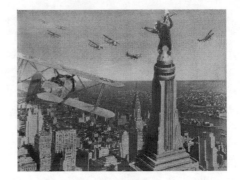

Figure 1. King Kong and the Empire State Building.

cinema to communicate the modernity represented by verticalization.

Moreover, at that, was absolutely exemplary. Having surpassed its near rivals recently in Manhattan, Hollywood quickly consecrated it as a model to represent the modern urban landscape, such as in C. Cooper and Ernest B. Schoedsack's *King Kong* (1933).

The Empire State Building has a part as a character of the plot in a huge list of more than 90 movies, such as *King Kong* (Dino De Laurentiis, 1976), *An Affair to Remember* (Leo McCarey, 1957), *Independence Day* (Roland Emmerich, 1996) and *Superman II* (Richard Lester, 1981).

From the movie *Metropolis* (1927) to Flash Gordon's illustrations, tall buildings were already a marked presence in the fictitious scenario of great metropolises, and today are an integral part of the everyday.

To Afonso and Eloy (2014), it is interesting to observe how the cinematographic critique of the city is materialised in utopias, or dystopias, through the representation of cities of the future, such as in films like *Metropolis* (Fritz Lang, 1927), *Blade Runner* (Ridley Scott, 1982), *The Terminator* (James Cameron, 1984), *The Fifth Element* (Luc Besson, 1997), *The Matrix* (Lana Wachowski and Lilly Wachowski, 1999); or in Godard and Antonioni's modernist cities; in cities of pure fantasy, like in *The City of Lost Children* (Marc Caro and Jean-Pierre Jeunet, 1995) and *Waterworld* (Kevin Costner and Kevin Reynolds, 1995); besides the cinematographic scenarios inspired on comic books and literature, such as in the Batman's Gotham City (Tim Burton, 1989), a cruel reference to New York City. Particularly modern architecture, the modern world, skyscrapers, technological innovations, the population density of the streets and means of transportation are some of the ways to represent the city and architecture in cinema.

Santos points out:

> Architecture, soaked by factors of cultural, economic, political and social order has, thus, the power to synthesize the filmic spatial experience, making the simulation generated by its representation a key-piece

1. All translations are the author's free translations. The original text: "a essência das cidades não está enraizada somente em fatores funcionais, produtivos ou tecnocráticos. Elas são feitas de diversos materiais, entre eles: a representaçã, os símbolos, a memória, os desejos e os sonhos"

in the analysis of the imaginary spaces of the cinema, since the overlap between reality and fiction produces images and emblematic situations that reflect themselves in their spatial perception and definitely incorporate themselves to the inhabitants/spectators' individual and collective urban life. (Santos, 2015, p. 12)[2]

The high concentration of tall buildings seem in the golden age of "skyscrapers" is elaborated in a considerably futuristic way, with science fiction exaggerations, in Fritz Lang's *Metropolis*, one of the manifestations of German expressionism. In this film, which is one of the first works that reflected the fear of the city of the future, the city and architecture appear as protagonists. The film's urban images showed the city of the future and an actual forest of tall buildings, as an inevitable consequence of the industrialisation of construction and the economic development of cities, ending up in urban spaces confined in the tall walls of urban canyons, taken by pollution and deprived of daylight.

Metropolis was the first cinematographic vision of a possible city of the future, with images of many skyscrapers, transportation axes developed on several levels, and impressive images of aeroplanes.

The representation of the city of Metropolis was influenced by the trip made by the director to New York City. To Afonso and Eloy (2014), Lang's city is also the product of the growth of industrialisation. In it, the growing importance of the machine leads to the precarious life of workers and spatial conditions of the place where they work, that presents itself as an underground space, hidden from people that enjoy what is there produced. A significant class differentiation between factory workers and employers is made in the own spatial configuration that is determined for this division with few common spaces. This way, the city is divided in two: the city of thinkers and the city of workers (which is located underground). A gothic cathedral, originally proposed to appear in the movie, was replaced by an astounding tower of Babel, a symbol of power. The film Metropolis (1927) had a significant impact on the way the city was thought of in other movies.

More than 60 years after *Metropolis*, two other classics of the genre, Ridley Scott's *Blade Runner* in the 1980's and Luc Besson's *The Fifth Element* in the 1990's, go back to the same perspective for the Third Millennium city, with flying cars and tall buildings,

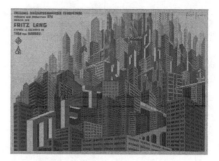

Figure 2. *Metropolis* (1927) – the first cinematographic vision of a possible city of the future.

evidencing men's desire for machines and verticality, as the future of cities.

Blade Runner (1980), taking place in 2019 in Los Angeles and inspired on Phillip K. Dick's science fiction novel *Do Androids Dream of Electric Sheep?*, the set design and architecture have a fundamental role representing the chaotic city of the future, where the urban scale is the starting point, expresses the decay of the urbanism of the Modern Movement and also represents the postmodern criticism of the exhaustion of the utopian city of the future. The "post-futurist" qualification borrows the name of the 1910's Italian vanguard and its desires of expressing the movement of the age of the machine. The reality of the end of the 20th Century, however, did not correspond to the imagine utopias in its beginning. The opening scenes recall the large proportion cities imagined by Antonio Sant'Elia, an Italian architect notable for his visionary drawings of the city of the future, with skyscrapers and multilevel traffic circulation (Gnoato, 2004).

According to Guillermo (2007), Ridley Scott's city was inspired in the buildings of the megalopolis, already anticipated by the Italian Antonio Sant' Elia in 1913, of the futurist vanguard, and in Le Corbusier's *Plan Voisin for Paris*, in Mies Van der Roche's designs and Frank Lloyd Wright's buildings.

Ridley Scott's Megalopolis is made of a collage of cities like Los Angeles and San Francisco. It possesses a dense atmosphere due to the great overlapping of buildings in solid and compact material, constituting itself in a megastructure among acid rain and constant fog, always under the night light. Los Angeles' architecture is a representation of the "machines of living", reminding of the definition of the architect and urbanist Le Corbusier, at the beginning of the 20th Century.

The great faces of buildings appear in the movie as support for the projection of images and advertising, cropped by torches of light beams projected in every direction, transforming their volumes in moving images. The transforming elements: cutting-edge

2. The original text: "A arquitetura banhada por fatores de ordem cultural, política, econômica e social tem, portanto, o poder de sintetizar a experiência espacial fílmica fazendo da simulação gerada por sua representação peça chave na análise dos espaços imaginários do cinema já que a sobreposição da realidade e ficção produz imagens e situações emblemáticas que se refletem na própria percepção espacial e se incorporam definitivamente na vivência urbana individual e coletiva de seus habitantes-espectadores."

Figure 3. Blade Runner – Ridley Scott's Megalopolis.

Figure 4. Blade Runner, the Tyrell Corporation a "building-city", its expressive dimension characterises a city inside another.

technology, a mixture of cultures and urban conglomerates compose a modernist city with physical and urban rampant growth.

The form of large corporations' buildings looks like Antiquity's buildings: Egyptian pyramidal mastabas tombs, Incan pyramids and Mesopotamia's ziggurats. Scott intended to show the power of Antiquity's architecture in the solidity of its forms and symbols, capable of recreating human attempts of overcoming time and space in the postmodern city and of rescuing the human of these scenarios. Cars float defying gravity and, at the same time, cloned human being trampled each other in the perfection of the physical and emotional constitution.

Noir Los Angeles is formed by a low, chaotic city and by an epic high city, in which some buildings are merged, like Frank Lloyd Wright's *Ennis Brown House* (1923) – that inspired and served partially as location for Officer Deckard's, played by Harrison Ford, the habitation, even though only a scenery, is the product of the great aesthetical influence of this work, with all of its internal wall covered with sculpted rock. According to Frampton (2008), in his work, *Modern Architecture: A Critical History*, Wright's interiors are "science fiction" places, and his vernacular architecture characterised through forms and materials that create a cosy atmosphere and user identity.

Another habitation of fictional Los Angeles is located on the Bradbury Building (1893), George Wyman's building, whose design was influenced by a science fiction work, Edward Bellamy's *Looking Backward* (1888).

The Tyrell Corporation building, a building with a volumetric and aesthetical approximation to Mesopotamian ziggurats, can also be highlighted in Blade Runner's Los Angeles. Elevators that rise along its facades characterise the building, and by its rigid interior, with a strong presence of stone, very high ceilings, columns with bases and chapiters and large spans. The headquarters of Tyrell Corporation, maker of replicants, represents a "building-city", its expressive dimension characterises a city inside another.

In *Blade Runner* (1982), it is assumed that the importance of architecture regarding some places, cultures and epochs was lost, and this city regresses to the past to reveal the historicist desire displayed by

postmodernism. The image of the film, although futurist, mixes modern architecture also characterised by big large towers and skyscrapers, imponent buildings toward the skies, of verticalized distribution as a way of escaping the terrifying image of the polluted city on the street level with some old buildings. That way the cities presents a character in which the past, present and future are present.

Big cities and the cities in which people like to live are those that have layers and layers of superimposed history. Buildings made today alongside buildings made in the 18th Century, alongside buildings made in the 19th Century, alongside buildings made in the 20th Century. (Dias, 2013)

Blade Runner (1982), although presenting a project for future Los Angeles (2019), presents this realist idea of temporal layers. Ridley Scott materialises these megastructures considered utopian or visionary, with fragments of the past: collages of yesterday and tomorrow.

There are no space ships, extra-terrestrials or anything like them, only the image of that the city would be in the near future (2019), with spaces of the city in decomposition and Los Angeles is shown as a decrepit landscape of industrialization and post-industrialization, cosmopolitan place, mixture of different architectonical styles, verticalization and multi-ethnicity.

According to Name (2003), in this scenario, utopia gives place to Foucault's "heterotopia", that is, "the existence 'in an impossible space' of a 'great number of possible and fragmentary worlds' or unfathomable spaces overlapping with each other", as observed by David Harvey in The condition of postmodernity: an enquiry into the origins of cultural change (1989). The scenes that take place in two completely different worlds. The city, labyrinthic, chaotic, profane and anarchical – and Tyrell's office and rooms – ordered, clean and almost sacred.

Gnoatto (2004) affirms that *Blade Runner* (1982), post futurist, is the portrait of a contemporaneous city, that expresses the extremes of a high technology society coexisting with old urban structures fighting for their survival, but that still allows the usage of human living spaces.

The images of the city are marked by their strong scenic character, in which the spatial configuration of cities and buildings reveals itself with a role as much or even more narrative than characters.

4 FINAL CONSIDERATIONS

One of the fascinating possibilities of cinema is allowing the proposal of visions of our future.

Cinema and architecture constitute two art forms that marked the 20th century though they are different forms of artistic expression. However, when thought of in function of one another, it makes sense for them to be analysed together. Cinema has depended, since its origin, from architecture and construction methods that allowed their creation.

As it is affirmed by Name (2003), architecture and cinema approached each other through the manipulation of space and time and cinema was always the field of experimentation and criticisms of the many architectonical and urbanistic utopias and anti-utopias. Cinema has the role of a showcase of architecture and debates relative to the urban space.

Until today, visual messages broadcast by movies such as *Metropolis* (1927) and *Blade Runner* (1982) continue to emphasise the opposed contrast between good and evil represent by architecture in movies, the dialectic between good guys and bad guys, between the traditional vernacular and modern technology. They are examples of how cinema represents architecture in its productions (Castello, 2002).

Some cities are not only constituted of buildings but also of symbolic representations legitimised through cinema and other media. And these images of the city influence the way we see, behave and approach ourselves to the real city.

Literature also reformulates the question of our ontological relation with the architecture of towers, its history and social role in the symbolic and urban geography. As well as in cinema, many authors approached the question of tall buildings such as Fitzgerald (2005) in his book *My Lost City*, analysing the American Dream and looking outside, evaluating the reality of speculative construction.

Cinema discusses the aesthetic of towers becoming, through symbolic representation, a revealing instrument of a complex game between dream and reality. These images mark by their strong scenic character, in which the spatial configuration of buildings and city are representative of the imagery of movies that reveal itself as a role as much or more narrative than characters.

Not only architecture but any representation of the city in cinema, be it the real or scenographic one, of the present, the past or the future, of optimist or pessimist view, is invariably a comment on the present. Movies reflect society's debates, emergent issues, new aesthetics and ideologies

BIBLIOGRAPHICAL REFERENCES

Abalos, Inaki and Herreros, Juan. (2002). Una nueva naturalidad (7 Micromanifiestos). Ábalos & Herreros. *2G: International Architecture Review Series*, 22 [no pagination].

Afonso, Adriana and Eloy, Sara. (2014). As visões futuristas no cinema: a morfologia da cidade futura nos filmes de Ficção Científica. *Arq.urb Revista eletrônica de Arquitetura e Urbanismo*, 11, 166–191.

An Affair to Remember. (1957). [Film]. Leo McCarey. Dir., EUA: Jerry Wald Productions.

Batman. (1989). [Film]. Tim Burton. Dir. EUA: Warner Bros., The Guber-Peters Company, PolyGram Filmed Entertainment.

Bellamy, Edward. (1888). *Looking Backward, 2000–1887*. Boston: Ticknor & Co.

Blade Runner. (1982). [Film]. Ridley Scott. Dir. EUA: Michael Deeley Production, Ridley Scott Productions, Shaw Brothers, The Ladd Company, Warner Bros. Pictures.

Castello, Lineu. (2002). Meu tio era um Blade Runner: ascensão e queda da arquitetura moderna no cinema. *Arquitextos*, 24, [no pagination].

Dick, Phillip K. (1968). *Do Androids Dream of Electric Sheep?* New York: Del Rey.

Dias, Manoel Graça. (2013, 14 May). Interview. *Arquitectura e Cinema*

Droguett, Juan D. Guillermo. (2007). Arquitetura e Cinema. *Revistagriffe*, 11

Fitzgerald, Francis Scott and West, James L. (2005). *My lost city: personal essays, 1920–1940*. Cambridge: Cambridge University Press.

Frampton, Kenneth. (2008). *História crítica da arquitetura moderna*. São Paulo: Martins Fontes.

Gnoato, Luis Salvador. (2004). Blade Runner. A cidade pós-futurista. *Arquitextos*, 53, [no pagination].

Harvey, David. (1989). The condition of postmodernity: an enquiry into the origins of cultural change. Oxford: Basil Blackwell.

Independence Day. (1996). [Film]. Roland Emmerich. dir. EUA: Centropolis Entertainment.

King Kong. (1933). [Film]. Merian Caldwell Cooper and Ernest B. Schoedsack. Dir. EUA: RKO Radio Pictures.

King Kong. (1976). [Film]. John Guillermin. dir. EUA: Dino De Laurentiis Corporation.

Koolhaas, Rem. (1994). *Delirious New York*. New York: The Monacelli Press.

Metropolis. (1927). [Film]. Fritz Lang. dir. Germany: Universum Films.

Montaner, Josep Maria. (2001). *A Modernidade superada*. Barcelona: Gustavo Gilli.

Name, Leo. (2003). O espaço urbano entre a lente e a retina: imersão nos escritos sobre cinema e cidade. In: Anais no X Encontro Nacional da ANPUR. Belo Horizonte.

Santos, Fábio Allon dos. (2005). Arquiteturas fílmicas. Ph.D. Dissertation. Universidade Federal do Rio Grande do Sul.

Superman II. (1981). [Film]. Richard Lester. Dir. EUA, United Kingdom: Dovemead Ltd., Film Export A.G., International Film Production.

The City of Lost Children. (1995). [Film]. Marc Caro and Jean-Pierre Jeunet. dir. France, Germany, and Spain: Canal+, Centre National de la Cinématographie, Eurimages, France 3 Cinéma, Televisión Española

The Fifth Element. (1997). (Film). Luc Besson. dir. France: Columbia Pictures, Gaumont.

The Matrix. (1999). (Film). Lana Wachowski and Lilly Wachowski. Dir. Australia, EUA: Village Roadshow Pictures, Silver Pictures

The Terminator. (1984). (Film). James Cameron. Dir. EUA, United Kingdom: Hemdale Film Corporation, Pacific Western Productions, Cinema '84 / Greenberg Brothers Partnership.

Trindade, Isabella Leite, Rolim, Ana Luisa, Câmara, Andréa Dornelas, Andrade, Paulo. (2004). Interface entre arquitetura, cidade moderna e cinema. *Topos* (NPGAU/UFMG), 1, 45–50.

Waterworld. 1995. (Film). Kevin Reynolds and Kevin Costner. Dir. EUA: Universal Pictures, Davis Entertainment, Gordon Company.

PICTURES SOURCES

Fig. 1:
https://www.flickr.com/photos/27862259@N02/680056499
6/in/photolist-bmWF3C-5fnbL2-74DtDS-fpiE8Z-u7r5C-
jPyk5Y-AYeVp-Qhacd1-5byFha-UBWmYK-BFAxG-mP
FMoa-fjqCrh-hMkXYx-8ePFV2-863Q8d-6PmDqy-4ZU
SU4-gd5KW-8EvT93-5ueStx-XXG8Pb-rweHDd-dwP
Ext-24qTty-5byG3n-4EAumZ-ksUvvq-6Y9e1d-fjqEBo-
24sXTkS-a5FMjP-65w1wa-7YvJG-od67Rm-2f78uy8-
XXG8Jb-eVynLP-f195j2-2yuL6d-82nTks-MVM729-5
byFtz-fpy1J5-2yqjLF-jG6L9-fpxt9j-7NsqZL-fpiGq2-5
bCXrj/

Fig. 2:
https://commons.wikimedia.org/wiki/File:1927_Boris_Bilin
ski_(1900–1948)_Plakat_f%C3%BCr_den_Film_Metro
polis,_Staatliche_Museen_zu_Berlin.jpg

Fig.3:
https://search.creativecommons.org/photos/dd523b3e-d164-
481f-b607-c4e4eabb8abf

Fig.4:
https://search.creativecommons.org/photos/e1c8fdf0-a25f-4
e30-b59a-915536e07f7f

Fictional movement on the NY's Guggenheim ramp

Soledade Paiva De Sousa[1] & Miguel Baptista-Bastos[2]
CIAUD, Lisbon School of Architecture, Universidade de Lisboa, Lisbon, Portugal
[1]*ORCID: 0000-0001-7431-8810*
[2]*ORCID: 0000-0003-2359-4748*

ABSTRACT: The inverse conical structure and the novelty, at that time, of a downward spiral path around an ample interior space, made the Guggenheim Museum (GG) in New York an icon in the history of architecture. In turn, the building immortalised this path, defined by a ramp that became the main protagonist of the space. The representation of the movement that the ramp has inside the GG of NY produced a complementary imagination to its spatial function in the museum. Given its expressiveness, from its construction to the present time, the ramp has been the scene for several creations along its helically ascension and descension path. Its image was chosen to represent NY in Woody Allen's film *Manhattan* and its space has been used in several other films: from chasing extraterrestrials to romantic encounters and espionage meetings; it has witnessed its destruction in the midst of a shooting, as well as the sliding fun of six penguins and the sad madness of Ophelia in a version of Hamlet. Frank Lloyd Wright's (FLW) conception of this ramp articulates the concepts of the PHI 2019 book: Intelligence, Creativity, and Fantasy. They correspond to a process relevant in architecture, which we intend to demonstrate, starting from intelligent and creative fiction at the beginning of a project to the fiction generated by its construction.

Keywords: architectural movement; spatial fictions; architectural ramp; rational and creative space

1 INTELLIGENT AND CREATIVE RESPONSE

The study carried out on a cross-section of the three concepts of the PHI 2019 book – Intelligence, Creativity and Fantasy – had as its basis the interior space of the Guggenheim Museum in NY marked by its ramp.

This was considered because the design of the ramp was an intelligent and creative answer to the client's aspirations to design a museum, which we will show in the first section. The relation of fantasy concept will be explained in a second part.

1.1 *From the collection to the museum*

Regarding the history of its design, we have included a brief interpretation from several books (Alofsín 1999; Giedion 2004; Pfeifer, 1993; Treiber; 1986 and Zevi, 1980, etc.) which are essential for contextualising this process.

At the outset, the then-future director of the museum, Hilla Rebay, played an important role by helping Solomon Guggenheim acquire several works, comprising a painting collection called Non-Objective. The collection was significant enough to create a foundation that would allow the museum to exhibit the private collection to the public.

1.2 *A different museum*

"I want a temple of spirit, a monument" (Pfeiffer, 1992, p.16) wrote Hilla Rebay in a statement from

a speech which demonstrates the intention to create a different museum. By being the representative of the commission who adjudicated the work for Frank Lloyd Wright, she created the conditions for the development of a new, visionary project that sought the best way to receive the private collection of contemporary paintings.

The structuring of the new shape outlined by F.L.W. proposed the rejection of the traditional organisation of a museum, combined with an interconnection of rooms.

1.3 *Light, the interior "Patio". The beginning of the ramp*

It was a long process from the design period 1943–45 to the construction period 1955–59 (the dates recorded in publications are slightly different). In the first proposal plan, the architect wrote: "continuous ramp" (Pfeiffer, 1992, p. 16), the idea of a spiral ramp around a wide space was outlined.

During this process, a six-storey building emerged around an interior space, empty from top to bottom. Each floor contained a set of tall windows on sloping walls that let in a diffused light. The main light, on the contrary, coming from a central lantern on the sixth floor, generously illuminated the great interior space.

1.4 *The ramp, the path of the museum*

The ascending/descending spiral ramp, conceived as an urban path, symbolised the representation of

infinite spatial continuity, the generator of the Guggenheim volume. The exhibition spaces were not closed, and they followed the path.

The idea of circulation would begin at the top: the museum visitor would take the lift to the top of the ramp and go progressively down around the central space until returning to the entrance. At any point of his/her descent, he/she could look, leaning against the parapet, into the emptiness. When we visit the museum, we find that most people contemplate the building beyond what is exhibited.

1.5 Controversies suppressed by the ramp

There is, in the work, an appreciation of the form that gave rise to a strong criticism: the form does not allow the function to which it is destined; it is not suitable for a museum.

During the construction, a group of artists sent a letter to director James Johnson Sweeney, Rebay's successor, complaining that the sloping walls and ramp floor were not suitable for the exhibition of paintings. F.L.W. replied that frames could be viewed under a better perspective by getting more quality in terms of lighting along the visitor's path.

1.6 The definition of the myth

Hence, the visualisation of the ramp submitted the works that would be exhibited there, transforming the GG of NY into the work of art to be visited, even though for the artists this path was representative of the anti-museum.

In the history of architecture, the building is a myth that has also produced sharp controversies: for some, it represents a kind of decay, for others, it is a symbol of modern architecture. It was designed as an organic alternative, by defining itself under spatial continuity, and by its expressionist character in the exaltation of form, thus distancing itself from the International Style (Hitchcock, 1984).

1.7 The ramp and the museums

The ramp, one of the symbols of modern architecture (Baltanás, 2005), has been assimilated by other museums throughout the world. Functional reasons and comfort issues in terms of movement for all ages, as well as its suggestive qualities, have made it a great partner of museums as if it were part of one of their requirements.

In this way, after the symbolic ramp of NY, others were projected in the world (The Kiasma in Helsinki, the Maxxi in Rome. . .). Richard Meier stated that he was inspired by the Guggenheim Museum of Wright while designing the High Museum of Art in Atlanta. In Brazil, in some of the museums designed by Oscar Niemeyer, a ramp is the most noticeable element. In Portugal, at the Carrilho da Graça's Museu do

Figure 1. Film *Manhattan*, directed by Woody Allen (film still, S. Sousa, 2017).

Conhecimento, (Museum of Knowledge), a ramp that circles around the patio and that forms the path to the entrance is also defined as a sculptural element in that space.

2 FICTIONAL MOVEMENT

2.1 Fiction on the ramp

The books we present about the relationship between architecture and cinema (Hauser, 1999) generally mention the difference between the static construction of architecture and the time and motion in the film (Pallasmaa, 2008). In the NY ramp, we consider a different situation since it is the image of the displacement, a real and imagined movement.

Probably by showing displacement, this ramp has provided relevant creations in films, since the narrative logic in the cinema is the recording of movement in a succession of events transmitted through visual and sound effects. The plots on this ramp are all different, the movement being the connecting link. As with the museum visitors, the characters are rarely motionless. They are so only for mere moments when they lean against the wall to observe the emptiness and the rest of the path.

In Sydney Pollack's *Three Days of the Condor* (1975), Robert Redford, a CIA employee pursued by the CIA itself, organises a secret meeting in the middle of the ramp.

In *Manhattan* (1979), director Woody Allen puts the ramp in the initial images as one of NY's ex-libris.

In *Someone to watch over me* (1987), directed by Ridley Scott, actor Tom Berenguer, protector of Mimi Rogers for having witnessed a murder during an inauguration in the museum, watches the assassin go down the ramp looking for his victim.

The film *Men in black* (1997), directed by Barry Sonnenfeld, combines comedy with fantasy and science fiction. In the Guggenheim, a grotesque extraterrestrial climbs the ramp fleeing from actor Will Smith.

Director Michael Almereyda, in 2000, in his version of *Hamlet* (Shakespeare, 1972; [1602]) with actor Ethan Hawke. Ophelia, played by actress Julia Styles, demonstrates her sad madness on the ramp of the museum.

Figure 4. Oil past painting. Author: Soledade Sousa, 2016 (S. Sousa, 2017).

Figure 2. Film *The international*, directed by Tom Tykwer (film still, S. Sousa, 2017).

Figure 3. Film *Mr Popper's Penguins*, directed by Mark Waters (film still, S. Sousa, 2017).

In the film *The international* (2009), directed by Tom Tykwer, we can consider the Guggenheim, along with actor Clive Owen, as one of the main protagonists. Its role led the production to build a replica of the museum for a massive shooting scene on the ramp, which involved several actors, enough to destroy it. The violent shooting peppered first the walls of the ramp with bullets, and finally, the large lantern that covers the inner emptiness.

From thrillers, we move on to the romantic comedy When in Rome (2010) directed by Mark Steven Johnson. A film that unfolds in the museum, as the main protagonist is an art curator of the Guggenheim. Many of the scenes are developed inside, but the ramp has a special moment when the "romantic couple", Kristen Bell and Josh Duhamel, walk on its plan while we see the exhibition.

The most entertaining moment comes in the movie *Mr Popper's Penguins* (2011), directed by Mark Waters, a comedy based on a classic of American children's literature with the same title. In the film, during a gala at the museum, actor Jim Carrey (Mr Popper) talks apprehensively to the actress Angela Lansbury, while watching his penguins running and sliding on the ramp until they jump over the guests.

The images from this film take us back to the fun photographs that appear in several Architectural History books, in which we observe the penguins wading through the hanging ramps designed by Berthold Lubetkin and Ove Arup in 1934 for the London Zoo (Allan, 2012).

2.2 A fantasy on the ramp

According to one of the protagonists of Durrenmatt's book *Justice* (2012, p. 54), the possible is almost infinite, while the real has boundaries that are strictly delimited. "This is the reason why thought can approach it in many ways. Joining in the possible corresponds to modifying our perspective of the real."

The discourse on the possible and the modification of the real corresponds to the process of the painting (Fig. 4) which transmit the helical ramp as a symbolic spiral of the infinite – the continuum movement.

Conforming to the detractors of Darwin's theory, absurd creatures were imagined to be fearless in the environment where they live, but who also survive thanks to the subjugation of other animals. Their structure is impossible: the two legs are insufficient as supports for such a bulky body. They have a kind of decorative hoop around the muzzle that makes their feeding difficult. They are total misfits, but good communicators despite the hoops that barely allow them to open their mouths. Even with all these contingencies, they manage to convince other animals to treat them like royalty. They exist only to be taken care of since everything is organised without their intervention.

These animals are fascinated by the movement of the interior of the Guggenheim Museum of NY; a movement that does not negate its imbalance by being able to move with the support of the ramp walls. Its dazzle is a particular case of the possible (Durrenmatt, 2012). They define a fantasy that emphasises the walls, the defining surfaces of the spatial configuration.

In the painting in which these visitors observe the emptiness, the surfaces are expressed as an unreal representation formed by the dynamism that was felt inside the museum. In it, the walls "have feelings" (Schonfield, 2000), colours that spin showing one of its main attributes, the spiral animation, stand out.

This fantasy was not imagined without copying, but by distorting the existing, it demonstrates what it can convey. Drawing on the *Air and Dreams: an essay on the Imagination of the Movement* (Bachelard, 2006), the observation of what we accomplished led us to two directions linked to the movement: that of the ramp itself and that of the relation between architecture and imagination, through its capacity to create images and subjugate them to a dynamic process of transformation.

The drawings are part of a set of oil pastels paintings corresponding to variations of works visited by these animals, which, although transformed, do not lose their identity. In this case, animals that cannot stand upright, leaning against the walls of the ramp show the essence of that space.

3 THE ENDING, THE BEGINNING OF THE RAMP

The idea to design a ramp was intelligent, creative and an originator of various fantasies

As in previous works, it has remained the study of antecedent phenomena in architectural design. Inquiring the beginning of a project has always demonstrated that it involves different areas of Knowledge. So, in this presentation, the two initial concepts, intelligence and creativity, accentuate the valorisation for future investigation connected to teach Architecture and also fantasy, by bringing unusual spatial uses.

3.1 Intelligent, creative response

Our nature is in the movement (Pascal, p. 58): and it was this nature that formed the idea of a continuous path in the ramp, which corresponds to the representation of the first researches of the project, expressing itself in the creation of spatial and visual order.

The proposal had an innovative role by tracing the entire museum in the same space, thus indicating that the formulation of the idea was a derivative of an option made through reason and imagination.

Creativity and intelligence are also revealed in the construction of the building as it continues to demonstrate the initial intentions: a downward development through a continuous path from the beginning to the end of the exhibition in which visitors see the exhibited works.

3.2 Fantasy, the representation of the movement of the ramp

The fantasy reinforces the intention to seduce the visitor to enter into another world "I want a temple of spirit, a monument" Pfeiffer, 1992, p.16) in addition to the function of the museum.

In this work, we have shown from the beginning to the end, that architecture is a result of fiction, and it is also a space for fiction. The movement of the ramp became the spectacle. It has gone beyond a pedestrian path, moving into a fictional world that has absorbed the reality. Both films and drawings have demonstrated this, opening architecture to other visions that have reinforced the qualities of its functions.

BIBLIOGRAPHICAL REFERENCES

Allan, John. (2012). *Berthold Lubetkin*. London: Black Dog Publishing.

Allen, Woody. (Director). (1979). Manhattan [DVD, 2012]. Los Angeles: MGM (Video & DVD).

Almereyda, Michael. (Director). (2000). *Hamlet* [DVD, 2011]. Los Angeles: Miramax Lionsgate.

Alofsin, Anthony. (1999). *Frank Lloyd Wright. Europe and beyond*. Berkeley and Los Angeles.: University of California Press.

Bachelard, Gaston. (2006). *El aire y los sueños: ensayo sobre la imaginación del movimiento* (1st ed. 1943). Madrid: Fondo de Cultura Económica.

Baltanás, José. (2005). *Le Corbusier, promenades*. Barcelona: Editorial Gustavo Gili.

Durrenmatt, Friedrich. (2012). *Justiça* (1st ed. 1957). Lisbon: Relógio d'água.

Giedion, Sigfried. (2004). O último período de Frank Lloyd Wright, In *Espaço, Tempo e Arquitectura. O desenvolvimento de uma nova tradição*, (1st ed. 1941). São Paulo: Martins Fontes Editora Ltda.

Hauser, Arnold. (1999). Naturalism, Impressionism, the Film Age, In *The Social History of Art*, Volume 4, 1951. London: Routledge.

Hitchcock, Henry-Russel & Johnson, Philip. (1984). *El estilo internacional* (1st ed. 1932). Madrid: Colección de arquitectura 11.

Johnson, Mark Steven. (Director). (2010). *When in Rome* [DVD, 2010]. Burbank: Touchstone.

Pallasmaa, Juhani. (2008). *The architecture of image: existential space in cinema*. Helsinki: Rakennustieto Publishing.

Pascal, Blaise. (1995). *Pensamientos* (1st ed. 1670). Madrid: Ediciones temas de hoy. S.A.

Pollack, Sydney. (Director). (1975). *Three days of the condor* [DVD, 2017]. Los Angeles: Paramount.

Pfeiffer, Bruce Brooks. (1992). Solomon R. Guggenheim Museum. In *Guggenheim museum. A to Z*. New York: The Guggenheim Museum.

_____ (1993). Frank Lloyd Wright: Masterworks. NY: Rizzoli.

Scott, Ridley. (Director). (1987). *Someone to watch over me*. [DVD, 2004]. Culver City: UCA Columbia Pictures.

Shakespeare, William. (1972). Hamlet (11602]. Lisbon: Editorial Verbo.

Schonfield, Katherine. (2000). Walls have feelings: Architecture, film and the city. London: Routledge.

Sonnenfeld, Barry. (Director). (1997). *Men in black*. [DVD, 2008]. Culver City: Sony Pictures Home Entertainment.

Treiber, Daniel. (1986). *Frank Lloyd Wright*. Paris: Fernand Hazan.

Tykwer, Tom. (Director). (2009). *The international*. [DVD, 2009]. Culver City: Sony Pictures Home Entertainment.

Waters, Mark (director). (2011). *Mr Popper's Penguins*. [DVD, 2012]. Los Angeles: 20th Century Fox Home Entertainment.

Zevi, Bruno (1980). Frank Lloyd Wright, In *Historia de la arquitectura moderna* (1st ed. 1950). Barcelona: Editorial Poseidon.

Gottfried Böhm's creativity: Architecture as a sculpture made of concrete

Aleksander Serafin

Institute of Architecture and Urban Planning; Faculty of Civil Engineering, Architecture and Environmental Engineering, Lodz University of Technology, Lodz, Poland
ORCID: 0000-0001-6300-5229

ABSTRACT: The paper explains the specificity of Gottfried Böhm's works. Among many built projects, some of them could be treated as evidence that he was able to introduce his style. This sort of creativity identified a local variation of brutalism, the architectural trend characterised by the exposure of raw concrete. However, thanks to this unique method, the German version of this trend means the sculptural treatment of an architectural form. This type of design does not get to giving expressiveness to the rectangular shapes of modernism by using a particular building material, and it is different from the implementation of brutalism that can be found in other world centres.

Although Böhm designed many objects that represent a different approach, the two of them are especially important for the development of European aesthetic thought. These projects are the pilgrimage church in Neviges (the city Velbert) and the town hall in Bensberg (the city Bergisch-Gladbach). Both of them are examples of this original brutalist style that can be treated as the contribution to Neo expressionistic tendencies.

Finally, it is worthy of noting that the generational continuity also represents a significant influence on the architect's creativity. As the projects of father Dominikus partly inspired his activity, in some aspects the work of Gottfried is continued by his successors Peter, Paul and Stephan Böhm. However, it should be clearly stated that each of them represents their way of designing.

Keywords: architecture, concrete, Böhm, Neo-Expressionism, sculpture

1 INTRODUCTION

Concrete surfaces can be treated as an aesthetic element of architecture. The use of the potential of this material contributes to increasing the clarity of the other artistic means. What is more, it is associated with the sculptural style. This approach presented an alternative to functionalism, which is associated with an abstemious way of thinking, which gradually deprived the architecture of its decorative values.

In this point of view, the works of Gottfried Böhm may be considered as extremely important[1]. Charles Jencks qualified this architect as belonging to a small group of German architects who after World War II have re-shaped the picture of 'modernity' (Jencks,

1985, p. 520). Despite Böhm's artistic output being diverse, some of his works represent the sculptural trend, which is a distinctive stage in the development of European architectural thought.

This way of architectural form shaping was not common at that time. The methods were rooted rather in the modernist paradigm. Although the discussed approach does not dominate in terms of the number of constructions, it has stood out from the whole German culture, thanks to one architect.

2 THE INFLUENCE OF DOMINIKUS BÖHM'S CREATIVITY

The architect's visions were shaped by the influence of his father, Dominikus Böhm. His realisations proved a brand new approach to shaping the sacred buildings at a particular time. Despite references to the past, his traditionalism has its origins in German expressionism whose phraseology has always combined monumentalism and poetics rather than classicism.

Despite some sacred projects designed together, a clear example of generational continuity, the one

1. Gottfried Böhm (born 1920) is a German architect honoured with the Pritzker Architecture Prize in 1986. He studied architecture at the university of technology (Technische Universität München) as well as sculpture at the art academy (Akademie der Bildenden Künste München). Gottfried Böhm is a son of architect Dominikus Böhm who was famous designer of many sacred buildings. He married architect Elizabeth Haggenmüller. Three of their sons continue family professional tradition.

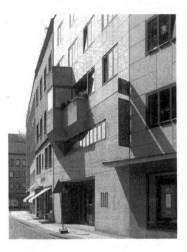

Figure 1. Dominikus Böhm, Kolpinghaus, Cologne, Germany, 1929 (rebuilt by Gottfried Böhm, 1973). Source: photo by Aleksander Serafin.

considered in terms of the design process, is the remodelling of the Kolpinghaus in Cologne (Fig. 1)[2]. Dominikus designed the original building and built in 1929. It was destroyed and then rebuilt in the 1970s according to the design of his son. The unique element added by Gottfried to the simple composition of the façade was a concrete bay window. This detail, however, strongly distinguishes the building in the urban tissue. Moreover, it identifies the author's style, that plays a particular role in the development of contemporary architectural thought.

3 MAIN WORKS OF GOTTFRIED BÖHM

It is difficult to determine the one Böhm's work that could be called his opus magnum. However, two projects deserve distinction from his entire creative output. These are the sanctuary in Neviges and the town hall in Bensberg. According to the literature, these two masterpieces are the culmination of the unique sculptural style (Sennott, 2004, p. 154). Previous projects realised in Cologne marked a movement toward this original language of forms. The resolute adaptation of unique design led to the promotion of a new archetype of both religious and a public building. The pure creation presented in the two examples does not subordinate to the sterility of modernism. This is the reason why the two mentioned cases are the top achievement of Böhm's concrete aesthetics.

2. Currently the Kolpinghaus has a function of social welfare and shelter. Originally, it was a journeyman hospice, which originated in the 19th century, and offered a basic service to wandering journeymen.

What is more, both cases discussed below are characterised by the architectural adaptation to the sculptural requirements.

4 THE PILGRIMAGE CHURCH IN NEVIGES

Indeed, the most recognisable work of Gottfried Böhm is the pilgrimage church in Neviges, the suburbs of Velbert (Fig. 2). It could be said that the architect demonstrated a contradiction between his work and the classic understanding of a temple. Moreover, the project is the negation of a new model that was introduced by modernists[3]. The form does not reflect any previous aspirations of sacred architecture.

The church is a strong spatial dominant at the background of the small buildings of the city. Thus, it uniquely identifies the pilgrimage route. The creative approach meant a categorical rejection of traditional canons. The distinctive features of the composition are clear and crystalline shapes. An artistic character of the project can be described in the way of its references to nature. The inspirations of geological forms are visible here.

Despite the large scale, the church form corresponds with the surrounding urban tissue because it refers to the varied roofs' angle of small historic buildings in the surrounding. This is an example of reconciling the different scale objects in the neighbourhood.

The building is finished outside with raw concrete that makes it a reminiscence of the monumental Goetheanum in Dornach (Sepioł, 2015, p. 142). This work designed by Rudolf Steiner[4] embodies the foundations of early expressionism.

The realisation is also a flagship example of brutalism. The concrete building reminds the fortifications of the Atlantic Wall (Kozłowski, 2013, p. 59). Composition in Neviges represents the style that gained a bunker-like architectural form in Germany (Wąs, 2008, p. 135).

3. Modern approach could be associated with the understanding of a temple as a "liturgical machine". An important turning point in the perception of the sacred building's archetype is the creative activity of Rudolf Schwarz (Stegers, 2008, p. 21). Architect. He played a decisive role in the process of reconstruction of Cologne after war. Regardless, his most influential works are the designs of the church of St. Anne in Düren and the church of St. Fronleichnam in Aachen. These buildings established a new formula of sacred architecture.

4. Rudolf Steiner (1861–1925) was an Austrian philosopher. He founded "anthroposophy" that had its roots in esoteric movement as well as in Goethean thought (Easton, 1980, p. 21). One of his most well known works is "Philosophy of Freedom" (originally: "Philosophie der Freiheit") that was written in 1894. However, he also became known as an architect while designing Goetheanum in Dornach, Switzerland. The building is the headquarter of the Anthroposophical Society which is an organization that continues Steiner's idea.

Figure 2. Gottfried Böhm, pilgrimage church, Velbert (Neviges), Germany, 1972. Source: photo by Aleksander Serafin.

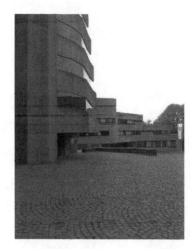

Figure 3. Gottfried Böhm, town hall, Bergisch Gladbach (Bensberg), Germany, 1976. Source: photo by Aleksander Serafin.

Brutalism also should be perceived as a neo-expressionist style. When raised over the city, the building materialises a utopian idea that has its source at the beginning of the twentieth century. That means something that Umberto Eco calls "poetics of mountains" and therefore the concept of appreciating Alpine nature as "the experience of the mountains something that uplifted the soul toward God, calling up a hint of infinity and capable of arousing great thoughts and passions" (Eco, 2004, p. 282). Based on this principle, the pioneers of Expressionism sought to build large objects intended for the community. Their visions have surprisingly come true after a long time, thanks to the efforts of the ecclesial community.

Wolfgang Pehnt assumes that this fantastic style building is inspired on the one hand by Le Corbusier's late work and on the other, the expressive period of his father's creativity, but there is still the great importance of visual expression achieved thanks to the reinforced concrete technology (Pehnt, 2000, p. 349). In the tradition of the German-speaking cultural area, it helped to establish the term "Betonfelsen" understood as the buildings with the appearance of concrete rocks (Sepioł, 2015, p. 143).

Finally, the church is an example of a combination of different areas of creativity, especially sculpture and architecture. It was designed in the spirit of Gesamtkunstwerk (Kossel, 2005, p. 270)[5]. Such an

interpretation seems to be justified in the specific place as well as the cultural conditions.

5 BENSBERG TOWN HALL

District Bensberg is currently a part of the city Bergisch-Gladbach. The town hall situated there is the second most recognisable example of the sculptural aspect of Böhm's architecture (Fig. 3). It was designed as a complement of the remains of a medieval castle. Today's horseshoe-shaped plans with a large courtyard together create a complete composition of the foundation.

The realisation is an important example of the German school of monument preservation. The realisation is an experiment in the acceptance of new forms coexisting a historical tissue. As noted by Heinrich Klotz, the very fact of using a brutalist convention, that is articulated with a refracted concrete blocks, in this case, does not seem to be calculated for stylistic reconciliation with the surrounding buildings (Klotz, 1987, p. 100). The unique scenery is created mostly by historic houses.

Peter Blundell Jones emphasises the similarity between the town hall in Bensberg and Bruno Taut's concept of Stadtkrone. The researcher says that Böhm's work corresponds with the entire crystal architecture of the expressionist period (Blundell Jones, 2007, p. 56). Once more, the expressionists' visions have come true thanks to the architect's realisation.

The architect elevated the building craft to the highest level in this instance. Noteworthy is the skilful combination of two materials: concrete and glass. Especially the glazing placed in the face of the external

5. Gesamtkunstwerk should be defined as a comprehensive or a total artwork. The issue plays an important role in the context of German culture development. The term was popularized by Richard Wagner and it was associated with his aesthetic conception. The idea was the ideal unification of the all types of art perceived via the theatre.

walls of the tower turned out to be an effective solution, which is used in the latest minimalistic layouts.

6 OTHER SCULPTURAL PROJECTS

Apart from the two main examples, some other buildings are worthy of distinguishing. The project that presents itself as an unequivocal expression of Böhm's concept is the church of Saint Gertrude of Helfta. Vertical elements that adhere to the street primarily determine its image. They diversify the frontage and create the original image of an urban border at the same time. The shape of the building resembles a slim aesthetic form carved in a concrete mass.

Among other realisations that illustrate the sculptural approach to shaping the architectural body, one can point the church of Christ Resurrection consecrated in 1971. It is characterised by an exuberant lightness that has its sources in the Baroque formulation. Another project is the multi-functional development situated in Düsseldorf-Garath, which additionally refers to the brickwork of Dutch Expressionism.

Art also plays an important role in Böhm's later work. An example can be found in the University Library in Mannheim completed in 1989. Here, however, the sculpture got to the issue of a façade, while the entire volume is shaped like a fortress. The carvings placed in the facade encode the typology of the Gothic, Baroque, modernist and chaotic city (Amsoneit, 1991, p. 72). Therefore, there is a kind of creativity that can be called narrative rather than abstract.

7 CONTINUATION OF THE CREATIVE APPROACH PREDOMINANT IN PETER BÖHM'S DESIGNS

Nowadays, the architect realises his projects mainly in cooperation with his sons, Peter, Paul and Stephan. Although the newest works represent a different formal narration, the foregone sculptural approach could be partly recognised in individual design activity of Peter Böhm, like The State Museum of Egyptian Art in Munich (Fig. 4). It creates one common volume with the edifice of University of Television and Film that was a different part of the same project. An interesting element is a narrow courtyard inserted into the monumental structure. Thanks to a long rhythm of pilasters and the concrete veneer it can be treated as a reminiscence of Louis Kahn's minimalism.

A rectangular entrance portal finished with raw material, on the one hand, refers to the ancient Egyptian temple in a simplified way. On the other hand, it exhibits something of artistic treatment of concrete visible in the compositions of Bensberg and Neviges.

Despite the heterogeneity of the buildings designed by Böhm family, Wolfgang Pehnt points out that it is

Figure 4. Peter Böhm, State Museum of Egyptian Art, Munich, Germany, 2011. Source: photo by Aleksander Serafin.

accompanied neither by the postmodern pleasure of quoting nor by the asceticism that is typical of the "New Simplicity" (Pehnt, 2002, p. 235). It should be noted that the juxtaposition of these two trends dominated European cultural reality.

8 CONCLUSION

Dennis Sharp claims after Arthur Drexler that something he calls "late expressionism" is fully displayed in a sculpture area. However, as an example of this creativity, he presents typical architectural works, such as buildings by Gottfried Böhm (Sharp, 1993, p. 87). In this way, the author presents the tendency to recognise the single representation of the style.

This activity raises the interest of researchers associated with this architectural trend. At the same time, Manfred Sack points out that architect's projects present Neo expressionistic approach that is different from Hermann Fehling's and Daniel Gogel's work (Sack, 1993, p. 27). This team shaped the second face of German Neo-Expressionism in the 70s of the twentieth century. It additionally should be noted that it was also architecture referring to sculptural principles, although the cooperative "Fehling+Gogel" created a different language of forms.

In both cases, creativity supported the brutalist style, where the leading role of concrete was noticeable. It is significant that the style appeared in the sacred architecture of German-speaking countries against the European background[6]. However, it

6. There should be mentioned here the persons who peculiarly directed a local sacred architecture such as Fritz Wotruba in Austria and Walter Förderer in Switzerland.

should be noted that those buildings in Austria and Switzerland took geometrised shapes.

While contemporary architecture used to manifest its lightness using cantilever constructions, bay windows and overhangs of a building mass, Böhm's compositions more frequently show their connection with the ground. It also has an ideological meaning as it symbolises the relationship of civilisation with nature. It also contradicts the modernist belief that technology makes the human independent of the rest of the world.

Concluding, it should be said that Böhm's work was not traditional. It was going with the times, but on the other hand, it was an expression of the author's strong individuality. Thanks to the diversity of creativity, he represents the contemporary architectural environment. Although he continued the father's work somehow, he is not subject to a modern or postmodern rigour. Instead, a significant part of his creativity is featured in his sophisticated architectural approach. What is more, some of those aspects are evident in particular works of the next generation of the architect's family.

BIBLIOGRAPHICAL REFERENCES

Amsoneit, W. (1991). *Contemporary European Architects*. Köln: Taschen.

Blundell Jones, P. (2007). Gottfried Böhm: Bensberg Town Hall. In P. Blundell Jones & E. Canniffe (Eds.), *Modern architecture through case studies. 1945-1990* (pp. 47–58). Oxford: Architectural Press.

Easton, S. (1980). *Rudolf Steiner: Herald of a new epoch*. Hudson, NY: Anthroposophic Press.

Eco, U. (2004). *On beauty. A history of a western idea*. London: Seeker and Warburg.

Jencks, C. (1985). *Modern movements in architecture*. Harmondsworth: Penguin Books.

Klotz, H. (1987). Moderne und Postmoderne. Architektur der Gegenwart. 1960–1980. Braunschweig – Wiesbaden: Vieweg.

Kossel, E. (2005). Orte der Stille. In I. Flagge & R. Schneider (Eds.), *Revision der Postmoderne* (pp. 268–279). Hamburg: Junis.

Kozłowski, T. (2013). *Tendencje ekspresjonistyczne w architekturze współczesnej*. Kraków: Politechnika Krakowska im. Tadeusza Kościuszki.

Pehnt, W. (2000). Glauben ausüben. In der Diaspora – Kirchenbau im 20. Jahrhundert. In R. Schneider, W. Nerdinger & W. Wang (Eds.), *Architektur im 20. Jahrhundert. Deutschland* (pp. 342–351). Frankfurt am Main: Prestel.

Pehnt, W. (2002). Gottfried Böhm. In U. Schwarz (Ed.), *New German architecture: a reflexive modernism* (pp. 230–235). Berlin: Hatje Cantz.

Sack, M. (1993). Einführung. In G. Feldmeyer (Ed.), *Die neue deutsche Architektur* (pp. 17–31). Stuttgart: Kohlhammer.

Sennott, R., Encyclopedia of twentieth century architecture. Volume 1. New York: Fitzroy Dearborn

Sepioł, J. (2015). *Architekci i historia*. Kraków: Universitas.

Sharp, D. (1993). Expressionist architecture today. In S. Behr, D. Fanning & D. Jarman (Eds.), *Expressionism reassessed* (pp. 80–90). Manchester: Manchester University Press.

Stegers, R. (2008). *Sacred buildings*. Basel: Birkhäuser.

Was, C. (2008). *Antynomie współczesnej architektury sakralnej*. Wrocław: Muzeum Architektury we Wrocławiu.

Intelligence, creativity and fantasy in Bernard Tschumi's Glass Video Gallery: In-between translucency, transgression and interaction

Ana Vasconcelos

CIAUD - FAUL, Lisbon School of Architecture, Universidade de Lisboa, Portugal
ORCID: 0000-0002-0909-9655

ABSTRACT: In the Glass Video Gallery, the "translucent condition" of the architectural space – both physical and metaphorical – and its capacity to activate the perception, imagination and other modes of occupancy, is at the same time effective, transgressive and displaced from the traditional notion of place. Several degrees of transparencies, illusions, dissolutions and perceptive instabilities are generated that introduce imprecise limits, activating for the visitor and/or spectator an experience between the real and the virtual realm, provided by the overlapping and varying speed of flows, images and reflections that are generated, particularly when the videos are played, and it is open to the public. Dissolved are opacities, precise visible limits, the coordinates of the body and space, and the sole temporal condition since many temporalities overlap one another: that of the city, the path, the visual and sound flows, those of thoughts, feelings, emotions, etc.

Between cognition, imagination, emotion and perplexity, the subject builds his or her perceptive field and inhabits the place multidimensionally, with the sensation that something is being transgressed. Subject and object are in opposition to one another, intercepting and interacting in the same imprecise space. The architectural space is established dynamically at every moment in-between the dissolution, dislocation and coherence of the perceptive reality, which becomes plural, imprecise and always different. Object and subject, space and event, art and architecture interact to construct the place. It is an interstitial place that, governed by a conception of a more inclusive and complex order, ultimately acquires the status of an object-place-event. A place of ambiguity, reverberation and reversibility, where the artistic and architectural are intentionally blended together, where the object/the construction and the urban dialogically interpenetrate each other, and where the mind and vision waver between cognitive visibility and invisibility of the unconsciousness, evoking the ambiguous and spectral revelation of Duchamp's Large Glass and the optical unconscious described by Rosalind Krauss. The shape, the glass and the virtual aspects dissolve the three-dimensional illusion of the perspective and reconquer the flat surface (as done by Picasso and Cubism). Space is fragmented, reverberated or expanded, and the observer is called upon to form part of the scene. The perception now ubiquitously "withdraws" and wavers between a global experience (panoptic and "panhaptic") and another partial or fragmented one, and the body wavers affectively between a sort of "non-figure" and "non-background". It is an experience that reminds us of the Piranesi's Imaginary Prisons or the sketching process of Giacometti; a sort of "poly-perspective hyper-reality" is generated, without any precise limits or shame. A "hyper-reality" that criticises the primacy of vision (of optics) and the sense of modern Western cultural tradition. Like a hypertext, the gallery manifests our current media-cultural, mechanical and electronic paradigm at the same time, characterised by the complexity, diversity, simultaneousness, multiplicity, velocity and interactivity. It is established as a *figural* in-between place with blurry or imprecise limits, where the subject and object, spectator and show, space and event, culture and nature, art and architecture overlap in multiple dimensions. In an evocation of intelligence, creativity and fantasy in architecture, an attempt is made to dissolve the strict and direct legibility of the perception, and a call is made to a more interactive and evocative experience of the place.

Keywords: Object-place-event, interaction, translucency, reality, virtuality

In the Glass Video Gallery[1], according to its author, architect Bernard Tschumi,

the appearance of permanence (buildings are solid; they are made of steel, cement, bricks, etc.) is questioned to a large extent by the immaterial representation of abstract systems (television and electronic images). (1994, p. 559)

and by the reflections and images of the surrounding environment, the kinematics of the city, all its colourless and transparent glass and its double slope

1. Images of the Glass Video Gallery can be seen at https://www.google.pt/search?biw=1650&bih=932&tbm=isch&sa=1&ei=xtCrXLD-EpWX1fAPnPqt0Ac&q=glass+video+gallery&oq=glass+video+gallery&gs_l=img.3......12348.12348..14099...0.0..0.73.73.1...1+.1..gws-wiz-img.W8hDYE vs3B0

(both transversal and longitudinal at the same time), which along with the perplexing presence of visitors and spectators compose its dynamic and transgressive condition that is both translucent and interactive, that is implicitly and explicitly revealed and unveiled over time.

In 1990 Tschumi built the Glass Video Gallery in Groningen, the Netherlands, a public pavilion designed for watching music videos. The work manifests the concept of "figural in-between space," a space of imprecise or blurry limits, from both a formal and a conceptual perspective. In it, the "translucent condition" of the architectural space – both physical and metaphorical – and its capacity to activate the perception, imagination and other modes of occupancy, is at the same time effective, transgressive and displaced from the traditional notion of place.

The "figural in-between ambit or space" is established through the operations of perceptive, functional and physical (material and structural) "displacement" implicit in the dynamic "translucent" condition between reality and virtuality, produced by the overlapping and varying speed of glows, images and reflections that are generated in the pavilion, especially when the videos are played and it is opened to the public. This condition introduces new articulations between indoors and outdoors, form and use, concept and experience, and the building and the city, to propose another concept of space and architectural sites. These new articulations and interrelationships result from the first question posed by Tschumi:

> If space is a material thing, does it have boundaries? If there are boundaries to space, is there another space beyond those limits?" [...] "If space has no limits, do things extend infinitely? Given that the entire finite extension of space is infinitely divisible (since every space can contain smaller spaces), then can't an infinite collection of spaces form a finite space? (1995, p. 32)

In both the interior space and the surrounding area, several degrees of transparencies, illusions, dissolutions and perceptive instabilities are generated. These effects introduce imprecise boundaries between the indoors-outdoors, indoors-indoors, broad-narrow, movement-permanence, space-event, sound-silence, sequence-simultaneity, material-immaterial, concrete-abstract, natural-artificial, observed-observer, activating for the visitor and/or spectator an experience between two dimensions: the real and the virtual. The space is seemingly held taut by the parallelepiped form of the gallery (dimensions: 3.60 m × 2.60 m × 21.60 m), slanted in two different directions, transversally and longitudinally; tensioned by its transparent materiality and its more or less reflective and fragile appearance, because colourless tempered glass and fine steel screens/mesh are used in the interior and exterior walls, the ceiling, flooring and a large part of the structure. The blinking movement,

Figure 1. Glass Video Gallery, Groningen, 1990, Bernard Tschumi Architects (a+u, Mar. 1994. Riley, 2003. Two drawings: © Bernard Tschumi; three photos: © Pinkster und Tahl).

speed and reversibility of the images, lights, sounds and multiple reflections (electronic video monitors and music are installed on six parallelepiped columns throughout the gallery), the active or passive presence of visitors/spectators and the surrounding environment (passers-by, cars, trees, wind, rain, natural and artificial light, etc.) also add to this tension.

In this place, a spatial condition of complexity and dynamism is created where the paradox, reciprocity and perceptive imprecision are the thematic keys, since in the gallery the simplicity and coherence of the

parallelepiped form with an orthogonal base are combined with the clarity and neutrality of the construction (in which the difference between the surface (skin) and structure: pillars and beams made from glass and metallic mesh that are joined by small metal pieces is minimised/blurred), the literal transparency of most of the materiality, and the sensation of instability that comes from the slanted, elevated position of the floor, the vertigo of the undefined limits, the immaterial representation of the abstract electronic systems, the steps and more or less perplexed expressions of the visitors and spectators (who are both observers and the observed) and the movement of the city.

The topological stability and the linear, chronological/temporal logic are intentionally affected with all the kinematic and phenomenological reverberation of visual fragmentation/discontinuity and/or continuity in the vacuum of the gallery. Dissolved are the opacities, the precise visible limits, the coordinates of the body and space, and the sole temporal condition, as many temporalities overlap: that of the city, the path, the visual and sound flows, of thoughts, feelings, emotions, etc. The notion of time and space can expand (kinematics of deceleration; greater depth of visual and/or sound field; etc.), but it can also contract (kinematics of extreme speed; the inclined floor and sole path through the gallery; etc.). The concept of scale, proportion and stability varies in the corporal perception of the visitor, activating the emotion and imagination, abstract intelligence and the experience of the place. Fantasy is established in association with the virtuality and utopia of the image (in space and on screen), as an architectural material.

Between cognition, imagination, emotion and perplexity, the subject builds his or her perceptive field and inhabits the place multidimensionally, with the sensation that something is being transgressed. Subject and object are in opposition to one another, intercepting and interacting in the same imprecise space between the real and the virtual realm, generating an interstitial space, unlike what occurs in the typical cinema, where the two are neutralised in the dark, physically separating themselves from the show.

At night, immersed and supplanted by the "reality" of the flow of film on the illuminated screens, the volume of the architectural box practically dematerialises. The materiality of the architecture becomes almost residual.

Object, subject and place are a show, space and architecture. The architectural space is established dynamically at every moment between the dissolution, dislocation and coherence of the perceptive reality, which becomes plural, imprecise and always different. Object and subject, space and event, art and architecture interact to construct the place.

In the gallery, Tschumi intentionally promotes a state of translucency and speed through the dynamic simultaneous tension of all these polarities, qualities, kinematics and circumstances that are interwoven with the synaesthetic presence of the visitor to establish the "place" (and not just the "building" or the exhibition). According to the metaphor of the translucent and the cinematic image, a place of varying characteristics has been imagined, designed and built:

– An architectural place where form, function, use, light, colour, interior, exterior, proximity, distance, information, music, visitor, spectator, artifice and nature mix and/or blend together in a spatial "density" between materiality and immateriality to build a night-time and day-time show in the continuous activity that goes on in the city;
– A paradoxical place of coherence, multiplicity and fragmentation; simple, yet complex, the intention of which has been to blur the limits between the visible or real and the establishment of another possibility for occupancy and experience in architecture. Neutrality and coherence of the simple orthogonal transparent box are dynamised by its slanted position, along with all the sound kinematics and visual effects. The free plan is in contrast to the one-way path. Its space is both open and closed;

A place in which the subject and the object, the building and the surround dings necessarily interact to architecturally "signify" space and event. In this dynamic, an interstitial space is created between the subject/object/event, a "space-experience" that is revealed at the same time. On the one hand is a linear space, i.e., one that is narrative, sequential: of the interior path (one-way direction along the longitudinal axis). On the other is a non-linear space, which is simultaneous or fragmentary: from the simultaneousness of the lived experience (material transparency; free plan; the coexistence of perceptions, different times, spatialities, images and information). It is a perceptively dynamic and unstable place where, as Tschumi writes, "space and event/process seem to be the same thing": "space as an event / occasion / process / movement" in a non-hierarchical relationship (which Tschumi graphically expresses in a sequence of drawings in his The Manhattan Transcripts (1981, pp. 7–8)[2] that defies the typical appearance of permanence and stability associated with an architectural

2. In The Manhattan Transcripts, through a sequence of drawings (created in 1981), Tschumi highlights the importance of a new non-hierarchical relationship between architecture and use, where concepts such as contradiction / confrontation/ conflict and break / fragmentation / dislocation / movement are understood as core values and themes to be explored (contrary to what is suggested by the strict functionalist analyses). According to Tschumi, the important thing is for architecture to manage to maintain all the aspects and their contradictions in a dynamic manner, in a new relationship of reciprocity and interaction between space and event/occasion/action (influenced by the Situationist discourse and the themes of the "era of 68", where "event" was understood as action and thought). For Foucault "event/occasion" is more than a mere logical sequence of words, activities or actions; it is "the moment of erosion, collapse, questioning and problematising which

construction. It is an in-between place that, governed by a conception of a more inclusive and complex order, ultimately acquires the status of an object-place-event;

A place of ambiguity, reverberation and reversibility, where the artistic and architectural are intentionally blended together, where the object/the construction and the urban dialogically interpenetrate each other, and where the mind and vision waver between cognitive visibility and invisibility of the unconscious, evoking the ambiguous and spectral revelation of the Duchamp's Large Glass and the optical unconscious described by Rosalind Krauss (Krauss, 1997)[3]. Between opacity (side view (Large Glass); obfuscation (Gallery)) and transparency, front and back, and a subtle and ambiguous veiling and unveiling, the limit is related to the "n" dimension. The form, the glass and the virtual aspects dissolve the three-dimensional illusion of the perspective and reconquer the flat surface (as done by Picasso and Cubism). Space is fragmented, reverberated or expanded, and the observer is called upon to form part of the scene;

– A figural place (imprecise: that "is neither figure nor background", but rather "something in between") of transition, exhibition and communication built based on the literalised metaphor of the "translucent". A place of complexity, interaction, interrelation, reciprocity, conflict and overlapping, the experience of which is no longer that of the architectural promenade. The perception now ubiquitously "withdraws" and wavers between a global experience (panoptic and "panhaptic") and another partial or fragmented one, and the body wavers affectively between a sort of "non-figure" and "non-background". In this wavering that lingers

"between", the experience of the place is multiplied and becomes uncertain in a complex, dynamic and disturbing coexistence, practically in a single moment/space-time (4th dimension), that rejects the purely organised, finite, lucid, narrative, historical and functional. It is an experience that reminds us of the Piranesi's Imaginary Prisons or the sketching process of Giacometti;

– A figural in-between place where the subject and object, spectator and show, space and event, culture and nature, art and architecture overlap in multiple dimensions, in a sort of "poly-perspective hyper-reality" (physically an conceptually, really and virtually, spatially and temporally), without any precise limits or shame. It is a "hyper-reality" that thus openly questions the problem of the specificity of culture and its value through an occupiable structure in which the urban, architectural and video, insofar as it constitutes art, are integrated. It also questions, through its degrees of transparency and the interaction of media, the feasibility of private life in contemporary media culture. It is a place where, in its invocation to a "polyperceptiveness", or better yet, the synaesthetic "intersensoriality" of the visitor (through the experiences consubstantiated by phatic images[4] (of contact) from videos, surfaces and spatialities that paradoxically create a materiality within the immateriality, in a process that adds Duchamp's infra-mince in its "minimal perceptibilities"), criticises the primacy of vision (of optics) and the sense of modern Western cultural tradition.

According to Terence Riley, in the field of architecture, the shift from the mechanical paradigm (focused on the machine) to an electronic one (focused on the media) may have been traced through projects like this gallery by Tschumi – as well as Diller and Scofidio's Slow House or Joel Sander's Kyle Residence project (1993) for Houston – since this gallery is presented as the deconstruction and reformulation of the archetypical "glass house", even though it is not a home/residence. The architecture becomes less material and more virtual, more media (Riley, 1999, p. 33).

In this work, by "undrawing / dematerialising / displacing", fractalising and perceptively dynamising the architectural object, Tschumi critiques it constituted concept and proposes another concept of place that surpasses the realms of the visual, three-dimensional, Cartesian, essential and harmonic and what is understood to be real: a "place of transgression" that, as Tschumi sustains, not only transgresses the limits and taboos established by history (without destroying them), it negates the way society expects it to be, introducing new possibilities in the field of architecture that suggest other life experiences to man (Tschumi, 1994, p. 78).

conditions the space where the events can eventually occur", which he called "thought events" (John Rajchman). Derrida defined "event" as "the emergence of an uneven multiplicity", revealing that the word "event" has the same etymological root as "invention" (Tschumi, Jan–Feb 1992, pp. 25–27 "The architecture of the event"). According to Foucault and Derrida, for Tschumi, the event that is always associated with the space is neither a beginning or an end (contrary to the axiom "form follows function"), but rather a turning point where life occurs. Thus the important thing is the spatialisation that emerges with the events or experiences and their implied reciprocal relationship. In works like The Manhattan Transcripts, Tschumi simply and explicitly presents a definition of architecture that is much broader and more involved, that goes beyond the condition of form (as a structure or configuration) or box/container made up of walls, to also include the contamination of heterogeneous, incompatible and improbable terms: "By going beyond the conventional definition of use, the transcripts take advantage of their experimental format to explore improbable confrontations" (1981, pp. 7–8).

3. In The Optical Unconscious, Krauss shows us a vision that goes beyond the retina, a vision between the eye, the rational, cognitive mind and the unconscious mind; a transparent vision built on a desire-in-vision, the same vision that is produced between the opacity of the organs and invisibility of the unconscious. (Krauss, 1997)

4. Expression taken from the painter Georges Roques, quoted by Christine Buci-Glucksmann (2002, p. 264).

The gallery is established at the same time as an extension and a contraction of the "street" condition (understood as the public space of the city/the interior "street"), as well as the expansion and compacting of the condition of the architectural and artistic object, where the concepts of space, programme and action/movement/event are interlaced in many different interactions and carried out exhaustively and reciprocally in terms of form/materiality, use and perception, with the intention of breaking / critiquing / "displacing" or, as Tschumi would say, "transgressing" and reconstructing the conventional components and approaches of architecture to the place.

It is an interstitial place that is established in a polytopic, polychronic and multidimensional spatial matrix, determined by a variation in simultaneous tensions that are interwoven and spawned in the space and time between reality and virtuality. Like a hypertext on the website, the gallery manifests, announcing or reflecting, our current media-cultural, mechanical and electronic paradigm at the same time, characterised by the complexity, diversity, simultaneousness, multiplicity, velocity and interactivity.

More than a place of transparency, stability and pure coherence, it is a place of translucency, transgression and interaction where the conditions of continuity and dislocation, coherence and fragmentation, reality and virtuality can be simultaneous. It is a place that evokes both Christine Buci-Glucksmann's concept of image-flow[5] regarding the dynamics and a complex place of affectation/interrelation in contemporaneity, as the homologous concept of phenomenological effect of the translucent by Jeffrey Kipnis which, defined as "the amazing spectrum of reflections, refractions and formal diffractions", characterises certain contemporary architectural objects-places-events. It follows no simple sense of origin or directionality, clarity or transparency, but rather demonstrates "a stunning disorder that comes to replace the elegant clarity, while

the architect entangles the observer in a spider web woven by the formal duplications of mirrors and veils" (Kipnis, 1997, p. 42).

The strict and direct legibility of the perception of the architectural object has been abandoned, with an evocation of intelligence, creativity and fantasy, and a call to a more interactive and evocative experience or emprise of the place, intentionally achieved in the project, at the level of the structuring order, form and space, functionality and the proposed use.

BIBLIOGRAPHICAL REFERENCES

Buci-Glucksmann, Christine. (2002). *La folie du voir – Une esthétique du virtuel*. Paris: Galilée.

Gannon, Todd (ed.). (2002)). *The Light Construction Reader 2*. New York: The Monacelli Press.

Kipnis, Jeffrey. (1997). Rev. El Croquis: "Peter Eisenman, 1990–1997", nº83: P-Tr's Progress. El Croquis Editorial, Madrid.

Krauss, Rosalind. (1997). *El inconsciente óptico*. Madrid: Tecnos.

Riley, Terence. (1999). *The Un-Private House*. New York: The Museum of Modern Art.

Riley, Terence. (2003). Light Construction. New York: The Museum of Modern Art.

Tschumi, Bernard. (1995). *En Questions of Space, Lectures on Architecture*. London: Bernard Tschumi and the Architectural Association.

Tschumi, Bernard. (1994). Event-Cities: "Groningen, Glass Video Gallery, 1990". Cambridge: MIT Press.

Tschumi, Bernard. (1994). *On Architecture and Disjunction*. Cambridge: The MIT Press.

Tschumi, Bernard. (Mar. 1994) Rev. a+u – Architecture and Urbanism: "Bernard Tschumi 1983–1993".

Tschumi, Bernard. (Jan-Feb.1992) Rev. Architectural Design: "Modern Pluralism-Just exactly what is going on?".

Tschumi, Bernard. (1981) The Manhattan Transcripts. New York: St. Martin Press.

5. In the field of thought and artistic production, Christine Buci-Glucksmann distinguishes among the concept of image-flow, associated with the idea of complexity, dynamism, corporeality and translucency, the concept of image-glass (both Deleuzian and non-Deleuzian), associated with the idea of simplicity, purity, lightness, superficiality, transparency and dematerialisation, which is integrated in the apology for the transparencies in modernity. According to Buci-Glucksmann, the image-flow is associated with a condition of "contemporaneity" in its rhizomatic senses of complexity, entanglement, reverberation, affectation (as opposed to neutrality or indifference), and that is revealed in an ambiguity that is somewhere in between deep and superficial, reality and virtuality. This ambiguity is inherent to the topological category (non-linear, non-polarised, and non-dual) and the quality of being borderline, where reversibility is established. Image-flow is thus a concept that is patent in a large part of modern architecture, from Tschumi, Eisenman, Gehry, Koolhaas, Ito, Libeskind and Fujimoto, to the "operative topographies" of Miralles, Hadid and FOA, among others. (Buci-Glucksmann, 2002).

From the intensity to the essence: Fantasy and architectural creativity between the Neorealism and the Third Modernism in Portugal

Miguel Baptista-Bastos[1] & Soledade Paiva de Sousa[2]
CIAUD, Lisbon School of Architecture, Universidade de Lisboa, Portugal
[1]*ORCID: 0000-0003-2359-4748*
[2]*ORCID: 0000-0001-7431-8810*

ABSTRACT: This work relates the affinity between two artistic movements that determined a rupture between the political power instituted in Portugal, in the second half of the 20th century, which were Neorealism and the Third Portuguese Modernism, in its various artistic expressions. However, we emphasise architecture in its practical and theoretical components and consequent revelations. There is sometimes confusion in telling the movements apart, due to a correlation based on a close affinity between the two, under a Marxist ideology opposing Salazar's government. Nevertheless, these two artistic manifestations are different in their final demonstrations, because while Neorealism has practically as methodology the final destination between the class struggle portrayed in a formalistic realism and very contextualised in rurality, the Third Modernism is expressed in a more heterogeneous and abstract way, because the everyday city with all its idiosyncrasies is the support where it develops its state of art. This paper attempts to distinguish clearly and objectively, the main elements that exposed Neorealism and the Third Modernism in Portuguese architecture, the effects that they had as a critique to current aesthetics, and in the development of new trends within the national panorama.

Keywords: Neorealism; Third Portuguese Modernism; Architecture, Rupture; Creativity.

1 INTRODUCTION

Neorealism is assumed in Portugal as an artistic vanguard with a strong expression in literature (Alves Redol, Fernando Namora, Carlos de Oliveira) and consequently in illustration, since the covers of the books of these authors contained a strong plastic expression in the drawings of the novel contents (Manuel Ribeiro de Pavia, Júlio Pomar, Cipriano Dourado, Victor Palla and the famous drawings of Álvaro Cunhal done in prison). They also painted on canvases, as in music (Fernando Lopes-Graça), and in painting (Victor Palla, Manuel Ribeiro de Pavia).

The Third and last Portuguese Modernism was formed as a direct inheritance of the same movement, although with a more cosmopolitan and less melancholy vision of the social context. It revealed a greater heterogeneity within a shorter period. The most diverse artistic expressions crossed equally and without supremacy, in a kind of melting pot. This crossing was conveyed in cinema (Fernando Lopes, Paulo Rocha), in literature (Ary dos Santos, Baptista-Bastos, Herberto Hélder), in architecture (Nuno Teotónio Pereira, Manuel Tainha, Siza Vieira), in painting (Costa Pinheiro, Sá Nogueira, Lurdes Castro), in illustration (Abel Manta), and in design (Sebastião Rodrigues). On the other hand, it contains a metaphysical component, attributed through permeability and acceptance of other more marginal artistic movements, such as the neorealist Lisbon Surrealist Group (Mário Cesariny, Alexandre O'Neill, Cruzeiro Seixas, Mário Henrique Leiria, etc.), which was somehow ignored by the context.

2 RELATIONS BETWEEN NEOREALISM AND THE THIRD MODERNISM IN THE PANORAMA OF PORTUGUESE ARCHITECTURE

There was an approximation to the neorealist movement through a group of architects, critics of the status quo of Salazar's dictatorial regime. These architects, led by Nuno Portas, were extremely influenced by a post-war aesthetics, rooted in Italian neorealism, more specifically in cinema and in architecture. Nuno Portas collaborated in the magazine *Architecture* from 1958 and became its director, having influenced a trend in Portuguese architectural thought. He wrote not only about architecture but also about art critique, obtaining from that some notoriety. He inserts cinema in some of these texts, primarily of Italian neorealist tendency. The examples of social housing in Olivais-Norte (1958), winner the Valmor Municipal Architecture Prize in 1968, and the house in Vila Viçosa (1957-59), were the examples built in the late

50's that assumedly constitute a Neorealist aesthetic, with the main signature of Nuno Portas, although they were made in partnership with Nuno Teotónio Pereira.

However, there was a contradiction between this intellectual group of architects, because the exported aesthetic did not meet what was happening in the country, which was regulated by an extreme right-wing dictatorship. Neorealism was stimulated in the theses defended in the cultural and literary plane by Marxism and its disseminators, which consequently implied a materialist conception of social phenomena, the attention given to the dialectic of historical transformations, the valorisation of class conflicts as a motor of these transformations (Ramos, 2007, p. 245). According to Pedro Vieira de Almeida: How is it possible that, intending to constitute themselves as journey companions of poets, and neo-realist painters, to whom they linked ties of friendship and affinities of various order that cemented the active companionship of the general exhibitions of plastic arts, none of the controversies of neo-realism has touched, to the slightest extent, the generality of national architects? (Almeida, 2008, p. 142).

Neorealism in Portuguese architecture gained its greatest aesthetic expression late, after the Third Modernism and immediately after the period that followed the Revolution of April 1974, with the SAAL operations (Serviço de Apoio Ambulatório Local [Local Ambulatory Support Service]–instituted on July 31, 1974, through a joint dispatch between the Minister of Internal Affairs, Costa Brás, and the Secretary of State for Housing and Urbanism, Nuno Portas). Going against all other artistic expressions of the time, it found an ideological affinity and consequently a great operativity, through the Portuguese revolution from the mid-seventies, whose political orientation was deeply inspired by Marxism, with all its ramifications.

3 BETWEEN FANTASY AND REALITY IN THE THEORY OF PORTUGUESE ARCHITECTURE OF THE 20TH CENTURY: FROM THE CASA PORTUGUESA [PORTUGUESE HOUSE] TO THE ARQUITECTURA POPULAR EM PORTUGAL [POPULAR ARCHITECTURE IN PORTUGAL]

Interestingly, the greatest theoretical testimony in Portuguese popular architecture in the 20th century, sometimes mistaken as one of the major Neorealist manifestations of Portuguese architectural theory, emerged late in an emblematic book: the well-known survey of Portuguese regional architecture, entitled *Arquitectura Popular em Portugal* [Popular Architecture in Portugal], promoted by the architects José Huertas Lobo and Keil do Amaral. Begun in 1955, this work took some years and was published in two volumes in the year 1961. This work was an in-depth study

of the diversity of traditional Portuguese architecture. It was elaborated by about two hundred architects divided into diverse teams of work spread throughout the entire country. Its general analysis contained a great methodological homogeneity. It is more than a simple catalogue of constructive techniques and shapes that relate to the provinces: it functions as a catalyst of great formal diversity, where the need to build in a characteristic place with specific conditions comes from a deep vernacular knowledge until then not yet explored in these directions by architects in Portugal. On the other hand, it was possible to fall into a disperse and diffuse work, since many people were contributing to a work of great degree of complexity—which did not happen—because the homogeneity of this work was due to the fact that these architects had classical academic training. In spite of its constitution being modern, since they resorted to sociology and anthropology, its essence goes back to a quasi-treaty-like organization, interpreted for the local popular architecture, cataloguing the differences of styles of the traditional architecture, with a strong popular and folkloric valence, understood in a philosophical orientation similar to that of the Hungarian philosopher Georg Lukács, in which the tradition of a people is expressed in a permanent conflict between its patrimonial value and against the hegemonic tendencies, coming from dominant ideologies with hegemonic cultural tendencies (Lukács, 1966, 326-368). According to Lukács, only through local expression, it is possible to obtain unlimited cultural and aesthetic varieties (Lukács,1967, 82-157). It tried to understand the equation that led to the solution and not the solution as a result of an equation, that is: an investigation was defined linking the understanding of the place to geography, to the environment, considering from the adopted materials all the way to spatial organization, from the appropriation of space to the constructive solution. The living conditions and the daily life of these settlements determined the different architectures in different places.

Mainland Portugal was divided into six zones (Minho, Beiras, Estremadura, Alentejo, and Algarve) and among this great team, the coordinators were Keil do Amaral, José Huertas Lobo, Nuno Teotónio Pereira, Pires Martins, Francisco Silva Dias, Fernando Távora, Celestino de Castro, Fernando Torres, António Pinto de Freitas and Frederico George. . . Interestingly, Nuno Portas was not or did not want to be part of this team. . . These groups worked in a perspective that went beyond Neorealism, going further towards an ecumenical vision originating from the Third Portuguese Modernism, because they overlapped analyses related to social sciences (sociological and anthropological) to a geopolitical view of class struggle. However, it became a covert political manifesto at the time, because it came against institutional power, sponsored by the government through the uniformed and fantasists idea of the ideal of the Casa Portuguesa

Figure 1. Two volumes of 'Arquitectura Tradicional em Portugal' 1961 (M. Baptista-Bastos 2019).

Figure 2. Book 'Casas Portuguesas' 1933 (M. Baptista-Bastos 2019).

[the Portuguese House], created by the MOP (Ministério das Obras Públicas [Ministry of Public Works]: it emerged in 1946 and, up until the Revolution of April 1974, it was the largest controlling entity in the entire public works policy of the Dictatorship).

The publication of *Arquitectura Popular em Portugal* [Popular Architecture in Portugal] demystified an aesthetic/ideological concept invented and crystallised by Salazar's dictatorial regime. It collided with the existing fantasy about what was considered the perfect ideological style, contained in another book written earlier, by architect Raul Lino (1992). This book, entitled *Casas Portuguesas* [Portuguese Houses], served as a motto for what was to be a typically Portuguese house, categorised as the ideal model for the nation: the emblematic archetype of what should be the 'Portuguese houses'. This work was politically adopted for a nationalist ideology of fascist expression and metamorphosed into law, becoming the axiom of what should be representative of the national architectural culture. . . Unfortunately, its influence was so profound that it still serves as an aesthetic matrix for many Portuguese.

Casas Portuguesas showcases the failure that was imposed for decades by the Salazarist Dictatorship, about the unanimous and indivisible aesthetics of the fantasised model for what should be the perfect house for the Portuguese people. The plurality and enormous variety of architectural responses found in the book *Arquitectura Popular em Portugal* originated another way of analysing the country, through its popular architecture and consequently, to fantasise other aesthetic solutions.

This book is not a Neorealist manifestation, but rather a reinvention of modernity through tradition. It lies within the omens of the Third Portuguese Modernism, since, even though it is a work of local content, its determination is universalist. This is a sound job, from whence the whole fantasy that conquered the Portuguese sixties generation of architects, led by Álvaro Siza Vieira, began. Since then, Portuguese architecture has obtained other forms of creativity with the following foundations: the greatest possible consideration for the place and its architectural tradition interacted

with contemporaneity, whose result is a genuinely regional architecture with a universalist dimension, establishing an artistic progression which determines the Third Portuguese Modernism.

4 'PISCINA DAS MARÉS' [POOLS OF TIDES] AND' EDIFÍCIO FRANJINHAS' [FRINGE BUILDING]: THE THIRD PORTUGUESE MODERNISM AS ACTION AND RUPTURE IN ARCHITECTURE

The architecture of the Third Portuguese Modernism contains a cultural range that reveals more city-based than rural. This revelation appears in two iconic buildings. One in Porto and one in Lisbon.

In Porto, more specifically in Leça da Palmeira, Álvaro Siza Vieira designs the Piscina das Marés [freely translated as Pool of Tides]. Inaugurated in 1966, it develops in an extraordinary way, not just the concepts included the survey of the book *Arquitetura Popular em Portugal*, but also transfers to the place a deeply erudite and tolerant atmosphere, inspired by the foundations of two great architects of international modernity: Frank Lloyd Wright and Alto Aalvar. This union, associated with the enormous talent of Siza Vieira, originated one of the most important buildings of the second half of the 20th century. The communion between the built space and the place is perfect, claiming a different modernity, with new concerns, where everyone can bathe by the rocks, in a public swimming pool enclosed in a beach. The junction of the new architecture with the pre-existence of the old place is so harmonious that its symbiosis is absolute. Seldom has there ever been architectural equipment with these formal solutions, for it is created in a deeply cosmopolitan assumption perfectly embedded in nature, as this: without formal and human hierarchies.

In Lisbon, designed by Nuno Teotónio Pereira, a building named 'Franjinhas' [freely translated as

Figure 3. 'Piscina das Marés', 1966, by Álvaro Siza Vieira (M. Baptista-Bastos 2017).

Figure 4. 'Edifício Franjinhas', 1966, by architect Nuno Teotóneo Pereira (M. Baptista-Bastos 2019).

Fringe Building] was inaugurated in 1969. This building won the Valmor Prize in 1971, being considered one of the most important examples of the second half of the 20th century and an innovative banner of Modernism. It contains a direct relationship of pop culture with a relatively unknown aesthetic of the national context, which was the Brutalist aesthetic of English origin. Paradoxically, a rupture is created with the aesthetic status quo of that time, and it generates a great controversy in public opinion through the media. The Franjinhas building was probably the first building that had a critical impact on a large national scale, having been the object of a conservative and populist campaign coordinated by the newspaper *Diário Popular* [Popular Diary]—the Portuguese daily newspaper with the greatest national circulation in that time period—in which the new buildings that emerged in Lisbon were criticised, calling them 'mamarrachos' [meaning large, bulky and unsightly construction]. Due to this episode, the population began to speak and to express opinions on the architecture built in Portugal; until today …

5 CONCLUSION

At last, the relation between these two artistic movements that had an enormous influence on Portuguese society was analysed. Whilst Neorealism is much more recognised, since temporarily it projected itself into society for some time, with a slight interval that occurred in the 1960s revived later by the revolution in April 1974, the Third Portuguese Modernism, begun from the beginning of the 60's, established direct relations between the different artistic expressions in a much more permissive, blended and conceivable way, reflecting up to today in the cultural creativity of Portuguese architecture for the rest of the world.

BIBLIOGRAPHICAL REFERENCES

(2004). *Arquitectura Popular em Portugal* (1st ed. 1961). Lisbon: Centro Editor Livreiro da Ordem dos Arquitectos.

Lino, Raul (1992). *Casas Portuguesas – Alguns apontamentos sobre o arquitectar das casas simples* (1st ed. 1933). Lisboa: Livros Cotovia.

Luckács, György (1966). *Estetica. Vol. 1- Cuestiones preliminares y de principio*. Barcelona: Ediciones Grijalbo.

_____. (1967). *Estetica. Vol. 4- Cuestiones liminares de lo estético*. Barcelona: Ediciones Grijalbo.

Ramos, Jorge Leitão (2007). 'O Neo-realismo que nunca existiu', in *Batalha pelo Conteúdo-Exposição documental-Movimento Neo-realista português* (2007). Vila Franca de Xira, Portugal. Ed. Câmara Municipal, de Vila Franca de Xira e Museu do Neorrealismo.

Paper as a flexible alternative applied to the Dom-Ino System: From Le Corbusier to Shigeru Ban

Alex Nogueira
Lisbon School of Architecture, University of Lisbon, Lisbon, Portugal
Architecture and Urbanism Course, Federal University of Mato Grosso do Sul (UFMS), Campo Grande, Brazil
ORCID: 0000-0002-1983-7578

Mário S. Ming Kong
CIAUD, Lisbon School of Architecture, University of Lisbon, Lisbon, Portugal
ORCID: 0000-0002-4236-2240

ABSTRACT: Modern Architecture has as one of its assumptions the independence between the structural and wall systems. This independence combined with the contemporary needs of space flexibility, for diverse reasons, leads us to investigate two distinct phenomena, first the Dom-ino Structural System, proposed by Le Corbusier (1887–1965) between 1914 and 1917, and later the innovative and questioning experiences conducted by the architect Shigeru Ban, including the use of unconventional materials such as paper. From this encounter of experiences emerge some fundamental questions for this work, to wit: to what extent the autonomy achieved with the structural independence, here symbolised by the Dom-ino System, has been appreciated? Is paper an element capable of materialising a creative response to the challenge of flexibility in wall systems (both façades and internal walls)? Based on the supporting bibliography and the analytical approach found in the work of the aforementioned architects, we briefly sought to contextualize, interpret, and later to conceive a preliminary proposal for a new flexible wall system based on paper usage to be applied in the centenary structure Dom-ino (symbolically and as an example), in order to illustrate new possibilities of applications using paper and thus seek to instigate their greater employability in works that aim flexibility, creativity, quickness, simplicity, lightness and sustainability as part of their programs.

Keywords: Dom-ino System; Flexibility; Paper; Architecture.

1 INTRODUCTION

Every house carries within itself further of what can be seen, whether in its form, implantation, style or even the construction techniques. All these elements highlight aspects that connect the architectural making with a particular society and time, for example. Thus, we can understand architecture as a record, but in addition to being a record, "Architecture is a way of knowledge by experience" (Colquhoun, 1983 in Nesbitt, 2006, p. 230, our translation), in other words, every architecture is also an experience.

An experiment that often has not allowed itself to go beyond, and has been repeating patterns that do not make sense as before, denying its creative nature. This is especially true for housing issue: the model employed as the traditional family is no longer unique and have seen a social transformation compared with its past. Moreover, within the so-called "traditional" pattern there is a typical family seasonality (children who grow up and form their dwellings) (Tramontano

and Benevente, 2004); that is to say, people's needs are elastic, and it does not seem to us that architecture, in most cases, has incorporated this contemporary demand.

On the other hand, throughout the twentieth century until today, are worthy of registration the efforts of some architects inquiring an experimental, inventive, nonconformist and creative architecture, whether in their reinterpretation of spaces and connections, conceptual search, materiality or technology employed. We want to highlight, for example, Buckminster Fuller, Gerrit Rietveld, Le Corbusier, Kenzo Tange, Cedric Price, Renzo Piano, Richard Rogers and Shigeru Ban, among many others. From these names, we explore in this article two architects and specific moments: Le Corbusier, with his Dom-Ino System and the three houses/experiments of Shigeru Ban; the first representing all the technological evolution and possibilities contained in the beginnings of the Modern Movement, and the second seeking to bring creative responds to current challenges.

According to Kong (2014):

> It is up to the architect to realize this and use his creativity to find, test and incorporate alternative materials and techniques that contribute to the solution of raised issues, rather than being limited to what the market offers.

To this end, based both on this approach and the analysed cases, we reach our primary objective of this article: the preliminary development of a proposed wall system made of folding paper as external and internal walls. Additionally, we also seek to emphasise new possibilities for the use of paper in architecture as a flexible, light, accessible, easily manipulated and sustainable material.

The proposal that we developed here takes as a "space of application" the skeleton of the Dom-ino System in order to add value to architecture exploratory and inventive character, as well as the challenging and questioning gesture that stimulates a general reflection on the limits of standardization, the potential concepts of free plan and free façade (based on the Dom-ino System, according to Curtis (1986)), and on the forgotten importance of architecture as an experience.

2 CONTEXT, CASE STUDY AND PROPOSAL

Several authors have increasingly reported the incompatibility between the architectural immobility found on the overwhelming majority of projects and the current needs for agility and fluidity of people. According to Lorenzo (2010, p.90, our translation), it is necessary the understanding of the projects as an open and flexible process:

> as a general scheme prepared to be varied, an embryo that will develop according to the evolution of the initial needs and the emergence of new ones.

Likewise, even if flexibility has not always been the final concept of the modernist architectural premises, it is undeniable that, as mediated by technological advances and other historical issues (post-war, artistic vanguards, etc.), this movement represented a significant advance, especially the consolidation of experiences such as the Dom-ino System. According to Palermo (2006, p.33, our translation):

> The Dom-ino System was the culminating point of this period, for synthesising a series of technical and conceptual knowledge that was used by Le Corbusier in his later works, originating a high number of structural and architectural solutions, and physically sedimenting the ideas of Modernism in architecture.

This statement is also supported by Curtis (1986, p.43) when he states that the advances synthesised by the Dom-ino System were:

> (…) quite central to Le Corbusier's 'Five Points of New Architecture' in the 1920s (the pilotis, the free

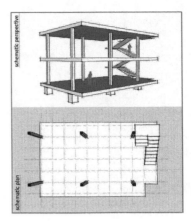

Figure 1. Perspective and Schematic Perspective Plan of the Dom-ino System (without scale). From the authors, modelled in *SketchUp* software.

plan, the free façade, the strip window and the roof terrace), and were also to be basic to his urbanistic proposal.

In this case, due to the flexibility bias, the main characteristics are free plan and free façade, which, in theory, make it possible to occupy and delimit the space in a better independent, dynamic and varied way.

According to Curtis (1986), the beginning of the development of the Dom-ino System dated from 1914, and was "completed" in mid-1917, being presented only 14 years later by Le Corbusier (Charles Édouard Jeanneret) in *Oeuvre complète*, volume I. Curtis (1986, p. 42). Furthermore, the author adds:

> (…) He proposed a rapid construction housing system based on a cheap and standardized concrete skeleton, using rubble for infill walls, and mass-produced windows, doors and fixtures. The houses would be laid out end in formal patterns, some of them indented around grassy communal areas. Aesthetic effects would arise from proportions of rectangular volumes, plain mouldings, linear cornices and simple apertures. He called the system Dom-ino, a name that invokes domus (Latin for house) and the game of dominoes: in plan the six-points supports set in an oblong did resemble a rectangular domino chip.

This skeleton (see Figure 1) was the basis for many of Le Corbusier's residential works and given his strong influence propagated through his ideas, arguments and style. We can state that the Dom-ino System, even indirectly, is considerably presented in contemporary architectural production. However, the question arises as to how the System (or what it represents) has spread over the hundred years after its creation? Why some represented aspects – especially free plan and free façade – have not always translated into a more flexible and also free architecture?

Although the several exceptions of works that successfully sought and seek to exploit the aforementioned freedom, it is still not a recurring practice in the architectural making, where the pattern established in most houses insists on static solidity as a blind and customary response. In contrast to this accommodated architectural way, and endeavouring to be a reaction to this gap, we see the emergence of the work of the architect Shigeru Ban, to whom the unusual and the creativity seeks to advance, update and reinterpret concepts (and materials) that have already been assimilated.

The three chosen works have, as well as the architectural quality of the projects, some relationship/revision of architectural concepts that have arisen, to some extent, with the Dom-ino System itself (recalling that, according to Curtis (1986) Dom-ino System was instrumental for Le Corbusier to arrive at his "five points"), and with materialises or unusual systems. Thus, we delimitate our analysis to the *Curtain Wall House*, *Paper House*, both 1995 and *Nine-Square Grid House*, 1997 (see Figure 2).

The *Curtain Wall House*, interpreted here as an architectural experience, is a single-family dwelling on three floors, situated in a corner of Tokyo, where the concept of free façade is expanded by means of white fabric curtains that have abandoned the condition to be an internal element (Tanzer, 2003, p.31) in a relatively fast and straightforward way. In order to be able to open the interior of the house, it is possible to "close" the sides of the house as well as to open them completely. It is worth mentioning that this capacity of mutation and reinterpretation, non-conventionality of the material for such use, malleability and lightness are essential characteristics for our research.

In the paradigmatic *Paper House* (Yamanashi), an annex to Shigeru Ban's own residence, the architect explores paper tubes as an element that simultaneously structures the house and shapes its surroundings, advancing to the outside and exploring its free plan with an "S" shape which defines the spaces, with a total of 110 tubes, of which ten are responsible for supporting the vertical loads (Costa, 2015). In *Paper House*'s project/experience, what interests us the most is its materiality and its versatility, where the architect demonstrated that paper, as a material, can go far beyond its usual uses, and tried to demystify its image of fragility, as the paper tubes support the house.

Finally, at *Nine-Square Grid House*, we have a square that can be a single space or divided up to nine compartments, through panels and "panel-furniture" where the impulse element to be experienced is the flexibility and versatility:

Two of the sides of the house are formed by a storage band where sliding panels that cover from floor to ceiling are hidden. When deploying these panels this versatile space can be compartmentalised in many different ways, being able to accommodate nine

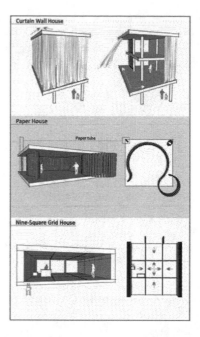

Figure 2. Presentation schemes of the three projects of the architect Shigeru Ban analysed – *Curtain Wall House*, *Paper House* and *Nine-Square Grid House*, respectively (without scale). From the authors, modelled in *SketchUp* software.

independent square areas. (Lorenzo, 2010, p.322, our translation)

This house elevates the concept of free plan to another level, presenting a multiplicity of internal layouts that allow accommodating future changes or specific and/or transient needs of the users. This type of strategy, as well as the mechanism, attends sensitive points of our proposal presented in this paper.

Through the analysed experiments, we found that it is still possible to investigate new readings for concepts considered as consolidated, as shown by Shigeru Ban's projects by reinterpreting the notions of free façade (*Curtain Wall House*) and the free plan (*Nine-Square Grid House*), as well as to question the pre-established use of materials, demonstrating alternative possibilities and uses (*Paper House*). In this approach, we use the spatiality based on the emblematic Dom-ino System, the studied cases, and the questions at the beginning of this article to present a preliminary proposal of a wall system made of paper, using folding technique to achieve flexibility.

The choice of using paper as the protagonist of our proposal presented here was encouraged by projects such as *Paper House* and can be considered justified. Firstly, it is easily accessible, cheap, versatile and light material. Secondly, it is a sustainable material since the proposal aims at the exclusive use of recycled or reused paper (Kong, 2014). Finally, it can be foldable.

Figure 3. Example of an assembly panel sequence, a hand-made model originally made on scale 1 to 10. From the authors.

The word *"origami"* comes from the Japanese, where *"ori"* means paper and *"kami"* means folding (Kong, 2014). It is also known as folding, which is one of the main strategies that enable a system that can be compacted or expanded according to the necessity, besides to explore different forms creatively, because:

> There are numerous possibilities of designing a morphology and mobility of form, transforming a rigid plane into a flexible plane. (Liu, 2016, p.70, our translation)

To that end, it allows us to be closer to the flexibility pretended. This ability comes from the malleability of paper associated with the "mountain and valley" system employed in origami (Kong, 2014), and used here to "fanfold" the paper.

Our proposal, in summary, consists of a panel with a slender metallic edge that can be expanded through parallel sliding of its sidebars. When closed (when it is acquired, for example), it is a square of one meter, that can expand vertically up to three meters, and in any two-centimetres gradation between one and three meters, being adaptable to several spaces with different dimensions between the floor and the ceiling. The top and bottom edges are easily set by means of insertion devices in metal guides that are one centimetre high, which can be incorporated during the construction (ideal situation) in the ceiling and the floor; or can be fixed later, however, in this case, an increase of one centimetre would be required on the floor to solve the difference in level generated.

The guides (grid) are based on the Dom-ino System, where we refer to its modulation one by one meter, and on the *Nine-Square Grid House*, precisely because it also explores the idea of the grid. Differently from Shigeru Ban's project, where the panels run through the guides, here the panels are embedded in the guides and can be removed and replaced as often and in as many dispositions (according to the grid) users want.

The union of the panel system in addition to the versatility and lightness of the paper, incorporating the support provided by the guides, aim to enable users a real facility when handling the walls, so that, once the system is installed, it can be changed when necessary without complications and in a few hours,

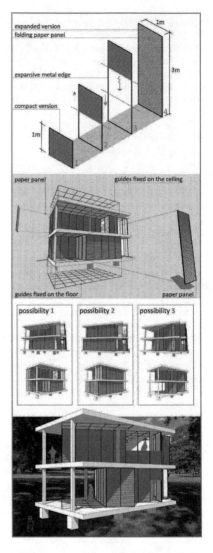

Figure 4. Schematic representation of the preliminary proposal of the paper wall system (without scale). From the authors, modelled in *SketchUp* software.

having nothing more than standard tools and a ladder. In Figure 3 and 4 we schematically present the proposal in order to facilitate its understanding, and specifically in Figure 4, as part of the scheme, its application in the Dom-ino System is shown in three possibilities (among many others), also trying to validate the concepts of free plan and free façade typical of the Dom-ino System.

As previously stated, this is a preliminary proposal, where many issues still need to be better solved, such as the panel sealing, acoustics, safety, compatibility with curved shapes, specification of an appropriate type of paper, both to have a better climatic relationship and to inclement weather (the adoption of paper with alveoli

conforming to folding should be a strong possibility). Although the significance of these issues, they do not invalidate the achieved points attributed to architecture, which, by its innovative and creative character, debates common sense, instils curiosity and inventiveness. Moreover, it allows itself to rethink the concepts, the needs of people, the methods, the materials, and the systems.

3 CONCLUSIONS

In this brief space, we seek to combine the analysis of relevant pieces to architecture, especially the iconic Dom-ino System, and the productions of the architect Shigeru Ban towards an architecture that either ventures to try new concepts or reinterprets them. From this set of experiments, we preliminarily proposed a flexible wall system with paper and its folding as the central element, because we believe that both this material and this technique still have much to offer to architecture.

In the analyses and relations of the collected information, as well as in the essence of the developed proposal and its intended representation, the response to the presented questions in the introduction of this article can be directly and indirectly found. Besides the partial answers, due to the ample and complex matters, the discussions conducted here indeed indicate significant response and aim for an architectonic making mediated by innovation, creativity, nerve and experiment.

BIBLIOGRAPHICAL REFERENCES

Colquhoun, Alan. (2006). Três tipos de historicismo. In *Uma Nova Agenda para a Arquitetura: Antologia Teórica (1965–1995)*. São Paulo: Cosac Naify.

Costa, Marta Isabel Silva Rodrigues. (2015). A descontextualização de objectos correntes para materiais de construção: o caso da aplicação dos tubos de papel de Shigeru Ban. Masters dissertation, Universidades Lusíada. [Accessed 15 November 2018] Available from: http://hdl.handle.net/11067/1890.

Curtis, William J. R. (1986). *Le Corbusier: Ideas and form*. Oxford: Phaidon.

Kong, Mário S. Ming. (2014). Architecture on Paper and sustainable materials. Sustainable materials as methodological support of the graphical thinking process in the development of a creative aesthetic language, in *2nd Annual International Conference on Architecture and Civil Engineering (ACE 2014)* (pp. 376-381). Singapore: E-periodical: 2251-371X.

Liu, Eunice. (2016). *Do plano à forma*. Ph.D. thesis, Universidade de São Paulo, Faculdade de Arquitetura e Urbanismo – FAUUSP. [Accessed 26 November 2018] Available from: http://www.teses.usp.br/teses/disponiveis/16/16134/tde-16022017- 103149/pt-br.php.

Lorenzo, Pablo Fernández. (2010). *La casa abierta: Hacia una vivenda variable y sostenible concebida como si el habitante importara*. Ph.D. thesis, Universidad Politécnica de Madrid, Escuela Técnica Superior de Arquitectura de Madrid. [Accessed 19 October 2018] Available from: http://oa.upm.es/21971/1/PABLO_FERNANDEZ_LORENZO.pdf.

Palermo, H. Nicolás Sica. (2006). *O Sistema Dom-Ino*. Masters dissertation, Universidade Federal do Rio Grande do Sul, Faculdade de Arquitetura, PROPAR. [Accessed 12 December 2018] Available from: https://lume.ufrgs.br/handle/10183/7917.

Tanzer, K. (2003). *When Practice Leads Theory*, Phi Kappa Phi Forum, 83(3), pp. 30–34. [Accessed 14 December 2018] Available from: http://widgets.ebscohost.com/prod/customerspecific/ns000290/authentication/index.php?url=https%3a%2f%2fsearch.ebscohost.com%2flogin.aspx%3fdirect%3dtrue%26AuthType%3dip%2ccookie%2cshib%2cuid%26db%3dbth%26AN%3d10901360%26lang%3dpt%26site%3deds-live%26scope%3dsite.

Tramontano, Marcelo; Benevente, Varlete. (2004). *Comportamentos & espaços de morar: leituras preliminares das e-pesquisas Nomads*. In: *ENTAC'04*, São Paulo. Annals. 210mmx297mm. [Accessed 13 June 2017] Available from: http://www.nomads.usp.br/site/livraria/livraria.html.

The internationalisation of Álvaro Siza and the myth of the traditional and conservative architect

Jorge Nunes

Departamento de História e Teoria da Arquitetura, do Urbanismo e do Design, Universidade de Lisboa,
CIAUD Lisbon School of Architecture, Universidade de Lisboa, Lisbon, Portugal
ORCID: 0000-0002-1340-6080

ABSTRACT: The first years of the internationalisation of the architect Álvaro Siza, since his "discovery" by Italian criticism in the early 1970s until the award of the Pritzker Prize in 1992, have enshrined the image of a traditional and relatively marginal architect in the face of important debates in the architectural culture of the time. During this period, the critical reception of his work was guided by the widespread idea that, initiated under the premises of the critical revision of the Modern Movement – that in Portugal had the architect Nuno Portas one of the main protagonists – his work had no theoretical dimension, did not reveal great monumental and technological achievements, and insisted on the artisanal character of architecture. This article intends to show that Siza occupied a unique position in the architectural culture of those years when participating actively in the discussion of the disciplinary autonomy that at the time dominated the debates of Postmodernism in the United States and Europe.

Keywords: Álvaro Siza, Postmodernism, Tradition, Realism, Disciplinary Autonomy

1 INTRODUCTION

In July 1988, the Italian magazine *Domus* published in issue number 696 a project by Álvaro Siza, which had recently been completed in The Hague. It was a small building with two dwellings, a shop, a bar, and an underground car park access. The project, documented with a photographic report by Gabriele Basilico, honoured the two traditions of the Dutch modernist architecture, recovering the historical "conflict" that opposed De Stijl's rationalism to "late Romanticism" that the Expressionism of the Amsterdam School was one of the last manifestations. Siza masterfully combined the two antagonistic currents into a synthesis of great formal and constructive harmony, with the expressionism of the three-story house, revealed in the curved walls lined with red brick, to dialogue with the white "objectivity" of the house located on the right end side. The Umberto Barbieri's critical text devoted to this work traced a small historical trajectory of Siza since his "discovery" by Italian criticism in the early 1970s, until the internationalization of his career, which began in the second half of that decade with the projects carried out for Berlin, drawn up in a political and cultural context very different from the one in which Siza had graduated in Portugal. Barbieri began by partially paraphrasing a text by

Vittorio Gregotti published in Controspazio magazine issue number 9, reiterating one of the first international readings of Siza's work, ending with reference to urban renewal projects for the Schilderswijk district in The Hague commissioned in 1984 by the municipality of the Dutch city, and whose most recent achievement was the project of the two houses then published. The description and analysis of the two houses project in The Hague emphasised Siza's ability to turn his designs into viable projects with qualified responses to very specific orders, marked by situations of great complexity in programmatic, budgetary, legislative and constructive terms.

However, Gregotti's citation and the last few paragraphs of Barbieri's text largely determined Siza's profile drawn up in July 1988 at a time of transition from his route preceding the award of the Pritzker Prize in 1992: that of an architect with a high degree of professionalism and a profound knowledge of construction, which had achieved international recognition, but who, more than fifteen years after his discovery by Italian architecture in the early 1970s, had not yet freed itself from the image created in those years and that had projected him as a traditional and relatively marginal architect in the face of the great debates of the architectural culture of the time (Barbieri, 1988, p. 26, 28).

In a way, it is this marginality that can justify the expression "cacophony of forms" with which Barbieri referred to the plastic complexity and typological ambiguity of the two small houses and which according to the critic's explanation were a result of the very personal, poetic, almost artistic interpretation that Siza made of the language of modern architecture. An interpretation that, through the technique of collage, integrated elements derived from the "site" with modern dialects, conjugating them in a "Sizian" world of signs and images (Barbieri, 1988, p. 30).

2 A TRADITIONAL CONCEPTION OF ARCHITECTURE

The idea that Siza was a defender of a very traditional conception of architecture was largely due to Vittorio Gregotti. It was he who, in the 1972 text, presented him as an architect who, although expressing himself in the context of the modern movement, was "out of fashion." Not in the references. Siza "a shy man, of few words", who used a simple language and spoke with an accent of the north of Portugal, maintained a discreet posture; he did not have a theoretical approach, he did not consider himself politically committed, and he did not feel attracted by monumental and technological achievements, insisting on the artisanal character of architecture. In the theoretical debate of Modernism and the discussion of the meaning of Postmodernism, he was a marginal figure who had sided with the tendencies and figures that played a central role in the architecture of the 1970s (Barbieri, 1988, p. 27, 28).

This image disclosed by the Italian architect was structured from the theoretical reflections of Nuno Portas whose work was decisive in the characterisation of the Portuguese architecture of the post-war period and the dissemination of the work of Siza in the international context. It was Portas, who in the late 1950s proposed a new realism for Portuguese architecture, in terms similar to those that Vittorio Gregotti described for Italy. In 1959, in the December issue of the magazine *Arquitectura*, and echoing the debates surrounding the critical revision of the Modern Movement, Portas questioned the idealism of the historical vanguards between the two world wars, believing that the time had come to discuss modernity in a maturing sphere: that of the content and meaning of the modern spirit itself (Toussaint, 2017, p. 9). In his view, it was necessary to react to the "weariness or ill-being" that was permeating in the architectural culture at that time. Once the myth of progress had been debunked, as well as that of the reaction to progress, whose ideologies had nourished the debates of modernity for years, it was urgent to establish a new realism based on dialogue, beyond the restricted circle of architects, and a method that would depart from solutions acritically imported from foreign realities (Toussaint,

2017, p.11). Portas defended that it should be the new generation that at that time was emerging and that Siza was integrating, promoting a common method of interpretation of reality, abdicating *a priori* vocabularies. In addition to the primacy of space, which was by himself reaffirmed, this method would integrate history and tradition, translated into respect for the living forces of national folk culture and in connection with the built environment. The detailed study of human needs should allow the connection of the creative act with the processes of knowledge of the complexity of reality, with Portas referring to the integration into the existing environment, be it natural or historical, and to the constructive process option that takes advantage of all the progress that has been made in the study of new techniques, as well as of traditional ones, in a casuistic study in which each situation, each case, commands freely and freely translates into spatial forms (Toussaint, 2017, p. 9). The following year, in a new critical text also published in the magazine *Arquitectura*, Portas rehearsed the first systematization of Siza's early work, recognizing in three of his first buildings an early maturity that he associated with his capacity to remain free from abstract activities and an individualistic expression without *a priori* formal choices (Toussaint, 2017, p.13, 15). Given the role of Portas in the relations between Portugal, Spain and Italy and in the systematization and dissemination of Siza's works carried out in these years, it is not surprising that Gregotti recognized in the proposal of a new modern spirit – capable of overcoming the rationalist dogmas of progress and reconcile with the reality and processes of history and tradition – the attributes that led him to characterize Siza as a traditional architect. The text of Gregotti was published again in 1976, in the issue that the French magazine *L'Architecture d'Aujourd' hui* (AA) dedicated in its entirety to Portugal. The image of Siza as an old-fashioned architect was reaffirmed, which was neither theoretical nor had (until then) major urban projects, which liked small things and had a traditional view of architecture. Gregotti still echoed the realistic proposal of Portas by recognising in Siza's work the reflection of the physical conditions of the site and the environment in its historical dimension, with which the architect discussed the project in its full-length (Gregotti, 1976). It was these qualities that made Siza one of the ten world architects of his generation, capable of transforming architecture into an authentic expression, able to surprise a sophisticated cultural environment, appearing where it would not be expected (Toussaint, 2017, p. 23).

3 LANGUAGE, COLLAGE, HISTORY

In the same publication, Oriol Bohigas explored other dimensions of Siza's work also present in Barbieri's 1988 text: the personal, poetic, and artistic approach

anchored in the collage technique. Drawing on the jargon of Structuralism analysis, in vogue at the time, Bohigas framed Siza in the debates of Postmodernism, recognising in the Portuguese architect the example of an innovative tendency in European architecture that retakes the linguistic bases of rationalism accentuating the artistic aspects giving the artistic fact a new pre-eminence in architectural production. For the Spanish architect, to respect the immediate tradition while proceeding to a codification that criticises and dissolves it through a new use of the language code based on collage, surprise, and syntactic changes, was a way to operate that approached Siza of the mutations operated by Mannerism (Bohigas, 1976). Bohigas drew attention to the alternative that the Portuguese architect could represent in the 1970s, opposing his design method to the project methods of the great technological machines, which eventually led him to question the possibility of the historical influence of a motivated but necessarily modest and marginal project in the face of great production.

Gregotti also did not fail to point out Siza's return to a more disciplinary discourse anchored in abstract languages, eventually close to those which Portas had criticised in 1959 when proposing a new working methodology for the Portuguese architecture. In the end, both authors compared Siza to Robert Venturi. The parallelism that Gregotti encountered with Robert Venturi started from the return to language, which for the American architect would be based on contemporary mass culture and in the Portuguese had a much more rigorous and traditionally architectural resolution. Bohigas, in the same way, understood that Venturi was ideological and literary, while Siza was strictly architectural.

Collage and quotation, which were at the centre of the disciplinary debates of those years, were an instrument through which Siza exercised a metalinguistic practice that understood the language of the Modern Movement as a historical vocabulary apt to be quoted and commented upon. Using techniques such as collage, which allowed the dialogue with works and authors of his election, Siza participated in one of the central discussions that in the context of the debates of Postmodernism became dominant and in relation to which he was an active voice: the disciplinary autonomy in the face of any sociological, functional or geographic-cultural orders or imperatives.

In the United States, this discussion was led by figures such as Colin Rowe, who in the early 1970s was one of the first architects to take up postmodern positions, defending the need for alternatives to modern dogmas, whose traumatic authoritarianism absolutely refused. Rowe rejected the social reform programs of the Modern Movement. He admired the aesthetic achievements of the 1920s, especially Le Corbusier's work. However, he considered the messianism of the Modern Movement a failure, as witnessed by Rem Koolhaas, his student at Cornell University. According to Koolhaas, Colin Rowe's modernism was utterly cut off from his social program; the social for him was the height of ridicule. There is in Rowe's book Collage City an extremely revealing phrase: "In this way, we can enjoy the aesthetics of utopia without suffering the inconvenience of political utopia." This was the first time Koolhaas was confronted with this typically Anglo-Saxon tendency, which then became increasingly dominant in the United States (Koolhaas, 1985, p. 2–3).

Rowe's ideological position had to underlie the question that in Europe was fought by the radical critique of Manfredo Tafuri. In his essay "L'Architecture dans le boudoir: The language of criticism and the criticism of language", published in 1974, Tafuri criticized, in a negative way, works by postmodern authors connoted with the return to language (such as James Stirling, Aldo Rossi or the New York Five), presenting them as examples of an escape from contemporary architects from the realm of the real to the universe of signs. This escape, which led to the conceptualization of spaces "eroticized" by a "self-isolated" (and therefore alienated) language, was a symptom of an attitude that sought to recover the dimension of the object and its *unicum* character, removing it from the its economic and functional context, and setting it as an exceptional and therefore surreal moment, placing it in brackets in the flow of objects created by the productive system (Tafuri, 2000, p. 161).

For Tafuri, the return to language was a proof of failure that revealed only the removal of form from the sphere of everyday life and the inability of architects to draw the necessary conclusions from the fate of the modernist avant-garde. The result was an architecture of excess and emptiness, a symptom of the subjective alienation that had come in the postwar period in consumer society (in America, but also in Europe), little more than a pathetic repetition of the self-destructive project of vanguard, relegated now to the *boudoir* (Tafuri, 2000, p. 164).

4 POSTMODERNISM

Siza has always refused the idea of an autonomous architecture, defending, however, an artistic understanding of architecture: "Architecture is Art, or it is not Architecture" (Siza, 1997, p. 31). This ambiguity regarding the issue of disciplinary autonomy, which made Siza a heterodox postmodern, was to be analysed during the 1980s by authors such as Marc Émery (1980), Peter Testa (1988) and Paulo Varela Gomes (1989). Marc Émery in October 1980, in issue 211 of the *AA* magazine devoted entirely to the work of the Portuguese architect carried out between 1970 and 1980, resumed the text of Gregotti giving greater emphasis to the influence exercised in Siza by authors such as Aldo Rossi and Robert Venturi. The knowledge of the contradictions inherent in the pluralism of the Modern Movement and the affinities that Siza

maintained with these authors (Siza was recognized in the "revolution" operated by Venturi's Complexity and Contradiction) did not prevent him from refusing an autonomous architecture and more figurative tendencies of Postmodernism, both in the historicist and deconstructivist trends that were affirmed in the second half of the 1980s:

> Almost always a long way from this engagement and this autonomy, production these days tends to waver between inscrutability and populism, kitsch and elegance; in one way or another it suggests substituting the much-criticised succession of "isms" with a single "ism" so cheerfully indifferent that it tries to contain everything achieving pluralism and survival through disguises and scenarios, invoking gratuitousness and history at the same time. (...) Elements and signs of crisis, simplified and few, recycled in waves of rapid and ephemeral dissemination, are exhibited as an expression of individual creativity; as an imaginative response to increasing bureaucratisation and the death of certainties. This and a touch of irony revealed to the point of annihilation legitimise, or try to legitimize, the association of any irresponsibility with the well-considered ways of Rossi or of Stirling, or other less well-known figures (Siza, 1997, p. 36–38).

The terms in which Siza stood in the face of this disciplinary autonomy were analysed in 1984 by Peter Testa in the book The Architecture of Alvaro Siza, which is still today one of the most in-depth essays on his work methodology. Based on the analysis of works such as the Carlos Siza House, the Malagueira District at Évora and the projects for Kreuzberg at Berlin and testimonies and texts written by Siza, Testa stresses the unique position of Siza in the context of Postmodernism, while simultaneously moving away from the dogmas of modern architecture and the more hedonistic postmodern practices, but also of the regionalist proposals that would be advanced by authors like Kenneth Frampton and whose calls to local cultural values and constructive traditions he interprets as a reactionary traditionalism (Testa, 1988, p. 33, 34). In his view, Siza's work is not a form of localism or regionalism, but instead constitutes a dialectical process that relies on a creative dialogue with the context "as found" instead of using universal solutions or subjective inventions (Testa, 1988, p. 75).

Although Nuno Portas had repeatedly expressed his displeasure with the evolution of Siza's work since the late 1960s, when he began a process of critical review of the rationalist architecture of the 1920s and 1930s, with a return to more abstract languages and abandonment of more explicit references to sites, territories, and traditions, Testa's reading of buildings from that period seems to be based on premises similar to the realism proposed by Portas in the late 1950s, namely when he states that Siza refuses *a priori* vocabularies, seeking an inclusive method in which tradition and modernity can enter into interaction (Testa, 1988, p. 33–34).

5 REALISM AND UNCERTAINTY

This realism was acknowledged by Siza himself when he affirmed that "he takes everything into account, since what he is interested in is reality (Testa, 1988, p. 131) and that his architectural proposal aims at deepening the existing ways of transformation, in the confrontations and pressures that make reality:

> A proposal that intends to be more than a passive materialization refuses to reduce that same reality, by analyzing each of its aspects one by one, that proposition cannot find support in a fixed image, cannot follow a linear evolution. Nevertheless, that proposal cannot be ambiguous, nor restrain itself to a disciplinary discourse, however sure it seems to be. Each design must catch, with the utmost rigor, a precise moment of a fleeting image in all its shades. The better you can recognize that flittering quality of reality, the clearer your design will be. (...) This is the outcome of participation in the process of cultural transformation of construction-destruction (Testa, 1988, p. 37)

For Siza, the fleeting quality of reality leads to the recognition of a fundamental condition of uncertainty that prevents the architecture from being based on a set of immutable rules or a rigid and imperative framework. Siza is aware that the contemporary era is marked by doubt about the possibility of understanding or mastery of the complexity of the world, which leads us to think that his refusal of universal and a priori rules may be related to the theme of the end of the absolute truths and grand narratives, which is one of the central topics of Postmodernism:

> But the truth is that today, in general, we are not so concerned with being modern. Some people think that it is high time we were post-modern. It is good to be able to build a roof or a terrace, to use stone or concrete or other materials according to convenience or taste, "or a rubber, but that never enters anyone's head," as my Structures teacher used to say. It is clear that this pleasure is not compatible with great convictions; we risk really building out of rubber or cardboard. We feel uncertain. (...) In any case, the lack of interest in being modern is a fact." We can find out now, through the critics or from our own understanding, whether we are post-modernist or have not yet achieved this, whether we are late-modernist or crypto-post-modernist, or regionalist or whatever else. In this way we can find corners of tranquillity for our uncertainties, a long way away as we are from the optimism and the clear working tools of the fifties (Siza, 1997, p. 35–36).

Although Siza does not seek a general rule or engage in the pursuit of simple truths that can be discovered and considered essential and valid in all cases, Peter Testa understands that it is not clear that he subscribes to a perfectly relativistic position. His insistence on referring to reality allows a plurality of sources and methodologies, which seeks to internalise all the data of each situation – Everything that exists is important – from which no point can be omitted. It can, however,

narrow the field by rejecting the opposite approach of starting with preexisting models and forms, not taking into account the "situation." Thus, concludes Testa, Siza's experimental attitude, which is not separate from the demands of customs and uses, is categorically different from the stubbornly formal, technical, and social experimentalism of the Modern Movement or the absolute resignation of the "last" and "Post" modernists (Testa, 1988, p.145). To achieve a broader theoretical framework that can inform Siza's practice, Testa cites, without being exhaustive, a series of testimonies taken from published interviews, of which stands the well-known affirmation in which Siza states that the architects invent nothing:

> Architecture is increasingly a problem of use and references to models (. . .) Architects invent nothing. They work continuously with models which they transform in response to the problems they encounter. (. . .) References are the instruments wich an architect possesses – they are the patrimony of knowledge, information. They are all the experience possible to known, and that one can use. It is not a critical position – it is the wisest use possible in a given context. (. . .) My architecture does not have a pre-established language and does not establish a language. It is a response to a concrete problem, a situation in transformation to which I participate . . . we have passed the stage in architecture where we thought that the unit in a language resolved everything. A pre-established language, pure, beautiful, etc., does not interest me. (. . .) All that exists is important, and one cannot exclude anything from this reality . . . Each place is different and complex. That is why I cannot apply a pre-established language and why, for the moment, it is difficult for me to theorize what I do (Testa, 1988, p.38–39).

By stating explicitly that architects work with preexisting models and invent nothing, Siza insists that the selection and transformation of preexisting models are guided by the "situation," characterised by both the "way of life" and the "place." According to his terms, the "situation" is in continuous mutation, and each place is "different and complex," a condition that denies the possibility of a hermetic and unitary language based on absolute rules and standards. In this sense, Siza does not exclude a safe and systematic examination of the interrelationship between architecture and society, but it is not clear how this relation is understood. What is clear, Testa stresses is that in his insistence on the socio-physical context, as the basis for architecture, Siza implicitly rejects the notion of an autonomous architecture – of an architecture that refers solely to itself. On the other hand, his research program cannot be understood simply as "realist" or "neo-realist," since Siza is aware that reality is always contingent and also does not want to eliminate the artifice of architecture (Testa, 1988, p. 131).

His method of work is a dialectical operation that defies reduction to any of its multiple fronts, denying ultimate authority to any particular model, yet does not fall into relativism nihilist. The theoretical position he left expressed in statements and texts, suggests the idea of a process of transformation that operates not only within an objective reality, participating in the creation of the present cultural moment, but also within the discipline of architecture, in "models" derived at least partly in the context and history of architecture, safeguarding its autonomy. It is this unique position that leads Testa to assert that Siza's work reveals non-imitative contextualism (Testa, 1988, p. 130).

> The clarity and the effectiveness of Architecture depend on an engagement with the complexity of the transformations which traverse the space; but this engagement is only able to transform Architecture when stability and a kind of silence is achieved through the design: the timeless and universal territory of order. Complexity and order create in the materials and the volumes and spaces a luminous vibration and permanent availability. This is why Architecture does not regulate behavior in a significant way but is in no way a neutral framework. The more you engage with the circumstances of your production, the more you are freed from it; "voice" by being an impassive conductor of voices, is a measurement and not a limit in the search for perfection. (Siza, 1997, p. 36, 38)

In the years following the publication of Peter Testa's essay, Siza deepened this dialectical process in order to force a continual re-consideration of architecture. In spite of not sanctioning the imitation of dead styles or casual loans of historical forms and schemes, his inroads into history have become more pronounced, turning into research on the very nature of architecture, as can be seen in the second phase of the Hague project, or in the interventions at the Quinta da Malagueira made in late 1980s, early 1990s. This metalinguistic re-appropriation of architecture was marked by a certain hedonism, which found in architecture a source of pleasure, and which the Portuguese architect recognised in 1993 when referring to the "geometric forms of strictly controlled sensuality" (Siza, 1997, p. 129). In addition to its obvious Corbusian connotations, this statement reminds us of the essay mentioned above "L'Architecture dans le boudoir," with which Manfredo Tafuri critically pointed out the escape of postmodern architects from the domain of the real to the universe of signs. In Siza's case, pleasure results not only from the aesthetic perception of forms but above all from the manipulation of the means of architecture, whose domain reached superlative levels in works of the second half of the 1980s, such as the Faculty of Architecture of the University of Porto or School of Education, in Setubal.

Paulo Varela Gomes, in a text published in 1989 about the Siza projects for The Hague, saw in the formal characteristics of the works of this period, marked by purism and austerity, traces of an architecture that affirmed its autonomy by eliminating (and by hostility to) other forms of art and knowledge. In a defiant tone, the Portuguese historian rejected the realistic

arguments of Nuno Portas and Peter Testa, seeing in these characteristics an obsessive urge to expel all non-architectural references from his work. In his view, this liberation from the "essence of the architectural act and place" in an autistic and tabula rasa attitude aims at restoring architecture to its original place; a place which, now on an idealistic plane, can only be the first because architectural knowledge is immanent to its production process. In this sense, the origin of architecture is not in the program but in itself; it is intrinsic to the very act of designing. It is, as he asserted, a clear understanding that architecture is a matter of place and not of history. Varela Gomes argues that the origin of the architecture is not in history, contrary to what was defended by all classicism committed to subalternating architectural knowledge in relation to literary myth or, in our time, to historical science. On the contrary, the origin of history is that it is in architecture and today it is not possible to show it without returning to the same attitude of ground-zero-of-history that the early modernists assumed (Gomes, 1989, p. 34).

Varela Gomes thus radicalised the ontological and tectonic perspective, according to which architecture is a founding gesture without which no knowledge is possible: without the architecture of a place, without a topology of real objects that allow fixing the memory does not exist knowledge. Even if these objects belong to nature (trees, rocks, etc.), the operation of giving the order to grasp what one wants to record in memory is always an architectural operation. The first human gesture is to identify the place. Without this gesture, there is no Identity of the Subject or the possibility of Logos. No natural place exists as a place (conceptual, place-for-me) without an architecture (Gomes, 1989, p. 37). With this argument, he justifies Siza's desire to affirm the primacy of architecture against all temptations external to it: against design, Siza defends drawing, an architecture that refuses to be a market product or subject to marketing; against the expression and symbolism (the literary version of architecture), he chooses the dryness of architectural reason; against the site, territory, and tradition (against sociology and geography), Siza chooses the monument turned to itself; and finally, against functionality as ideology (against empiricism), he conceives compressed spaces, difficult stairs (and scales), and material fragilities (Gomes, 1989, p. 39).

The awarding of the Pritzker prize in 1992 altered the image of Siza created throughout the 1970s and 1980s, consolidating the idea of Peter Testa that his architecture can be examined through various objectives. As William Curtis put it a few years later, his work represents an extension of modernism in new areas of expression, but this path does not fail to have its deformations and deviations. It responds evidently to the climate, culture, and landscape, but not in an obvious way. It addresses the issue of the region, but without adopting a manifestly regionalist approach. In fact, those who tried to catch Siza on a regionalist agenda have failed to recognise his struggle to escape a provincial culture, and they return to approaching it armed with some aspects of the supposedly "universal" modern architecture. While the architecture of Siza is sometimes driven by a social commitment, it is also sometimes driven by a melancholy irony. Belief and disbelief seem to co-exist in a somewhat broader social project or destiny for architecture. He is an artist who likes ambiguities, extremes, transitions, and doubts (Curtis, 1995, p. 19).

BIBLIOGRAPHICAL REFERENCES

Barbieri, Umberto. (1988). Alvaro Siza, Edificio per abitaioni com negozio e bar, L'Aia. *Domus*. (696), 25–31.

Bohigas, Oriol. (1976). La passion d'Álvaro Siza selon Oriol Bohigas. *L'Architecture D'Aujourdoui*. 185. 43.

Curtis, William. (1995). Álvaro Siza, Paisagens Urbanas. In de Llano, P.& Castanheira, C. (eds.). *Álvaro Siza, Obras e Projectos* (pp. 19–25). s.l.: Centro Galego de Arte Contemporânea Electa.

Émery, Marc. (1980). La tranquile révolution d'Álvaro Siza. *L'Architecture D'Aujourdoui*. 211, 10–13.

Gregotti, Vittorio. (1972). Architetture recenti di Álvaro Siza. *Controspazio*, 9. (Anno IV), 22–39.

Gregotti, Vittorio. (1976). La passion d'Álvaro Siza selon Vittorio Gregotti. *L'Architecture D'Aujourdoui*. 185. 42–57.

Gomes, Paulo Varela. (1989). Per Forza di Levare. Architécti. *Revista de Arquitectura e Construção*. 3, 33–39.

Koolhaas. Rem. (1985). La Deuxième Chance de L'Architecture Moderne. *L'Architecture D'Aujourdoui*. 238, pp. 2–9.

Portas, Nuno. (1959). A responsabilidade de uma novíssima geração no movimento moderno em Portugal, *Arquitectura*. 66, 13–14.

Tafuri, Manfredo. (2000). L'Architecture dans le Boudoir: The Language of Criticism and the Criticism of Language. In Hays, K. M. ed. *Architecture Theory Since 1968* (pp. 146–173). Cambridge, Massachusetts: The MIT Press.

Testa, Peter. (1988). *The architecture of Alvaro Siza*. Porto: Edições da FAUP.

Toussaint, Michel. (2017). A Obra de Álvaro Siza: Reconhecimento e Interpretação / The Work of Álvaro Siza: Recognition and Interpretation. In: Melo, M.; Toussaint, M. (ed)s. *Álvaro Siza: Guia de Arquitetura / Architectural Guide* (pp. 8–29). Lisboa: A+A Books.

Siza, Álvaro. (1997) *Writings on Architecture*. Milan: Skira.

The fantasy of reality: On the design drawings of Álvaro Siza Vieira

João Miguel Couto Duarte
Faculdade de Arquitectura e Artes da Universidade Lusíada de Lisboa/Centro de Investigação em Território,
Arquitectura e Design (CITAD), Lisboa, Portugal
ORCID ID: 0000-0002-2161-2650

ABSTRACT: Fantasy – understood as a fiction, an extravagance, or a reverie – is often perceived as being at odds with reality, a way of eluding its contingencies, with reality and fantasy arguably existing in different spheres. But fantasy is also perceived as being intertwined with reality for always being rooted in it, with reality and fantasy accordingly being distinct from each other only on the surface.

This paper aims to discuss the fantasy that would seem to pervade some of the design drawings made by the architect Álvaro Siza Vieira. Siza Vieira has always relied on the drawing to immerse himself in and to amble through the architectural objects as they are being defined. Many of the said drawings establish a more direct relationship with what they purport to represent; others, on the contrary, deliberately avoid such a relationship – reality instead appears altered, if not to say distorted, often being populated with weird figures, as if the architectural object being defined were part of a fantasy. Nevertheless, these drawings also allow for an understanding of their objects, and the place of fantasy in Siza Vieira's design process is one deserving of assessment.

With a nod to the title of one of his books, perhaps one can say that Siza Vieira finds in fantasy a way 'To Imagine the Evidence' of his architecture.

Keywords: Siza Vieira's design drawings; Siza Vieira's design process; architectural fantasies; architectural drawing

1 THE DRAWING AND THE FANTASY OF ARCHITECTURE

Architects have long found in fantasy a means of speculating about architectural ideas, extending the scope of their imaginary beyond a more direct relationship with reality. Some of the said speculations – arguably those that are most well known – often take on radical forms, actual utopias, asserting themselves as manifestos, sometimes even without any objective of concretisation; others remain private thoughts, personal reveries, driven by just the circumstantial pleasure of imagining them. One should bear in mind that the activity of designing architecture has always run, and still does, concurrently to the activity of fantasising architecture, even if the latter seems more evident from the dawn of the Italian Renaissance onwards.

Reflecting on the relationship between fantasy and architecture involves, however, a need to reflect on the value that representation has for such a relationship – the term 'representation' being used in the broadest sense. Gänshirt (2007), as cited below, does not explicitly refer to architectural fantasies, but his words support reflection about that particular value of representation. Furthermore, fantasies may be thought of as being the outcome of a design process.

> The design tool is such a central issue because ideas, thoughts and visions cannot be conveyed directly; they can be expressed only with the aid of "tools", "instruments" or "media". We have to communicate our ideas through gestures, by talking about them, drawing them, writing them down or presenting them in some other way. (Gänshirt, 2007, p. 81)

It is also worth considering that from the outset, i.e. even before the possibility of allowing ideas, thoughts and visions to be conveyed, it is through the very possibility of definition that representation provides space for them.

Of all the different tools, the drawing has understandably long been the favoured one, becoming not only a handy way to convey speculations about architecture but also and above all a vital constituent instance for such speculative possibilities.

> Drawing offers an unbounded surface for speculative possibilities, and is limited only by graphic technique and imagination. [...] [V]isionary drawings push the boundaries of imagination beyond the normative constraints of physicality. The architecture

depicted through these drawings is not limited by considerations of gravity, function, scale, or materiality. They conjure, present, and anticipate worlds previously unbuilt and unimagined. (Fraser & Henmi, 1994, p. 148)

The relationship between the fantasy of architecture and the drawing proved to be a mutually profitable one: by connecting itself with the drawing, the fantasy could assume the possibility of both concretisation and dissemination; by connecting itself with the formulation of a fantasy, the drawing could overcome a rigid instrumental condition. Architectural fantasies became inextricable from the drawing, with the drawing concomitantly emerging as the locus for the definition of fantasies. This has always been a very much appreciated particularity of the drawing.

The elaborate, constructed nature of visionary drawings manifest imaginary worlds which cannot exist in any other realm except through drawing. Such drawings represent more than the shapes of an intended object; they evoke a sense of light, atmosphere, monumentality, texture, and intent. In this sense, a drawing represents an author's entire world, nascent in the imagination. Once drawn, this world *is*, it exists, it has presence. (Fraser & Henmi, 1994, p. 158)

This unique relationship between the fantasy of architecture and the drawing would have certain consequences as far the definition of the architectural objects thus imagined is concerned, however, with the construction dimension of said objects eventually being overlooked if not even overtly ignored. Some of the churches experimented with by Leonardo da Vinci (1452–1519) in some axonometric drawings, for instance, show a lesser degree of attention paid to the feasibility of construction. "Leonardo was free to indulge his *fantasia*" (Ackerman, 2002, p. 69), as the designs in question did not have to respond to ecclesiastical functions. In fact, Leonardo "was generally indifferent to the structural viability of his designs" (Ackerman, 2002, p. 69). Far more radical is the work of Étienne-Louis Boullée (1729–1799), in asserting a definite alienation from the construction dimension of architecture. His designs are conceived from the outset beyond the bounds of the possibility of realisation, with the technical requirements resulting from their possible construction being ignored. The design exists as a compelling image, a fantasy, engendered above all to impress whoever sees it. The drawing becomes the actual work of the architect.

It is, to put it plainly, absolutely fundamental to Boullés's designs that they remained *tableaux*. Boullé's architectural theory was a radical extrapolation of then current ideas, which had lost contact with reality. (Kruft, 1994, p. 161)

By existing as drawings, architectural fantasies could, in a certain way, dispute the place of architecture when actual realisation thereof was not possible.

The fact that drawing is only an analogue of the building [...] allows for architectural ideas that might not be realisable either because of cost or the lack of certain technologies to be presented. The history of speculative and fantastic architecture is long and honourable. (Brawne, 2003, p. 97)

As already mentioned, the importance of architectural fantasies is often perceived as residing in the capacity of such fantasies for conveying singular worlds, thus extending the scope of the architects' imaginary beyond a more immediate relationship with reality. In this way, fantasies constitute referential images informing the invention of architecture. They matter because of their evocative power. That is the case with the architectural visions elaborated by Antonio di Pietro Averlino, known as Filarete (c. 1400-c. 1469); Giovanni Battista Piranesi (1720–1778); Étienne-Louis Boullée; Le Corbusier (1887–1965); Antonio Sant'Elia (1888–1916); Yakov Chernikhovthe (1889–1951) and other Russian Constructivists; Hugh Ferriss (1889–1962); Ron Herron (1930–1994); Lebbeus Woods (1940–2012); and Archizoom Associati (1960s-1970s); to mention only a few.

However, the importance of fantasy can also be perceived at a more intimate level, with the architects eventually finding in fantasy an instance for appraising their ideas through a design process.

2 THE FANTASY OF REALITY – ON THE DESIGN DRAWINGS OF ÁLVARO SIZA VIEIRA

2.1 *The place of fantasy in Siza Vieira's work*

The work of the architect Álvaro Siza Vieira (1933-) continues to make an impression, thanks to its permanent experimentation in terms of modelling of spaces and the built volumes that enclose them; the constant reinvention of references and models that permeates it; the mastery of the whole – a whole that is always complex, even in works on a smaller scale – and attention to detail; the heterogeneity of his designs; and also the sense of unity that emanates from them, the paradoxical and intense, or poetic, expression of his identity.

It is a work that is fed by a permanent availability in relation to the world, as Siza Vieira himself affirms in a conversation with Domingo Santos (2008, p. 11):

I am not self-confined. I feel as though I am part of what is going in the architecture world, where I notice a lot of ideas and diversification. [...] I must say that I have never worked in isolation, and the language of my architecture has all the dependencies, to varying extents, on what is happening at the moment.

And that finds in continuity its own foundations, as Siza Vieira also confirms in the same conversation (Domingo Santos, 2008, p. 11):

I think that the basis of my work is continuity – a continuity which naturally has run parallel to the events

and novelties in the architectural world: new materials, new technical possibilities and above all, the numerous issues regarding the way we think about cities.

The readings of the work of Siza Vieira have consolidated the ties that link him to Le Corbusier, Adolf Loos (1870–1833), Bruno Taut (1880–1938), J. P. Oud (1890–1963), Alvar Aalto (1898–1976); and also to Frank Lloyd Wright (1867–1959) and James Stirling (1926–1992) (Figueira, 2008, p. 34). Many of these relationships are indeed highlighted by Siza Vieira himself in some of his writings (Siza, 2009). Even when they show themselves to be very direct, featuring in some case even as deliberate citations, these relationships are constantly given new meaning by being the object of new and very personal syntheses.

It is in architecture in particular that Siza Vieira has based his design work, to which his many travels have significantly contributed. One should highlight one of his specific convictions here, which Alves Costa appears to have identified well:

> Siza believes, as we do, in the continuity of architectural culture, and in particular that of his work. Ironically, he therefore considers himself conservative. (Costa, 2008, p. 38)

Conversely, architectural utopias and visionary designs do not seem to sustain his architecture. Indeed, Siza Vieira does not seem to preoccupy himself with imagining or creating them[1].

One of the intrinsic characteristics of his work is that it always has realisation as a built and habitable reality as its own horizon.

> Determining the necessary concept for each construction from the standpoint of space, structure, and the organization of the materials [...] constitutes, regardless of the circumstantial models, the theme of his entire output, which grows richer in its poetics and the clarity of its meanings. (Costa, 2008, p. 35)

Even when the design object is not intended to be realised, it is its hypothetical built existence that provides the vision for Siza Vieira in his defining of it. An example for this is the Museum for Two Picassos, an imagined design project for the exhibition 'Visiones para Madrid: cinco ideas arquitectónicas' [Visions for Madrid: Five Architectural Ideas], in 1992. The museum – a pavilion to be located in the city's Parque del Oeste – was designed to exhibit two works by Pablo Picasso (1881–1973); Guernica, painted in 1937; and Pregnant Woman, a sculpture from 1950[2]. Utopia – in this case, that of modernity – is present in his work, without question, but as something that is now in the past; it is in opposition to utopia that contemporaneity finds its configuration. As an inherent trait, "Siza's architecture occupies the place of "crisis". Because there is no ideology – that is, what Roland Barthes defined as something dominant [...] – our customary space is one of crisis" (Figueira, 2008, p. 25).

One can, thus, justifiably ask the question as to the place of fantasy in the work of Álvaro Siza Vieira.

As pure speculation of ideas of architecture, ambiences and spatial forms, untied from any possible realisation, fantasy does not seem to be considered either as a reference for invention in his works or as an object of his drawings. However, many of the unique features that run through his oeuvre could be said to reveal the presence of fantasy. Alongside individuality and the unprecedented, Costa (2008, p. 35), indeed identifies fantasy as something Siza Vieira aspires to right at the beginning of his career.

In Siza Vieira, fantasy is not an instance that is parallel to reality, and much less is it the antithesis thereof. On the contrary, fantasy is rooted in reality, and it is as reality that fantasy is desired and its realisation is advanced. Fantasy is realised in reality; it exists as a built thing. It contributes by giving meaning to architecture; it confers exceptionality upon it.

Fantasy comes to the fore in the permanent reinvention of references, the deliberate exploration of paradoxes, the plasticity of the solutions – from the unstable-looking volumes on the ramped galleries of the Iberê Camargo Foundation building in Porto Alegre, Brazil (1998–2008); to the cut-away and recessed ceilings of the Mimesis Museum in Paju-si, South Korea (2006–2010); and to the sculpted staircases in diverse volumes of the International Museum of Contemporary Sculpture in Santo Tirso, Portugal (2010–2016), which are full of details bordering on the capricious (Fig. 1); to mention only examples from recent works. But it is always a fantasy that is built, as part of a whole, giving to the work its full meaning and deriving from the work its meaning. "It is the serenity and beauty of the whole construction that enables us to settle our doubts, and this always happens" (Costa, 2008, p. 39).

1. Despite the apparent distancing on the part of Siza Vieira from architectural speculation, his work has been readily absorbed into the universe of fantasy in the drawn form. Robocoop, an urban art duo from Italy, which has been active since 2012, has included parts of Siza Vieira's works – from the Portuguese Pavilion in Lisbon (1995–1998) and the Iberê Camargo Foundation in Porto Alegre, Brazil (1998–2008) – in the Vedute di Roma by Piranesi. Robocoop's "aim is to document the architecture world comparing it to the past [...] with a provocative and reflexive approach" (Robocoop, n.d.).

2. The 'Visions for Madrid: Five Architectural Ideas' exhibition was organised as part of Madrid's European Capital of Culture programme in 1992. A number of architects were invited to propose designs for a location in the city chosen by them (Siza, 2000). Siza Vieira returned to the design project for the Museum for Two Picassos, in collaboration with Carlos Castanheira (1957-), for the Art Pavilion at Saya Park, Gyeongsangbuk-do, South Korea (Carlos Castanheira Architects, 2018). The building is due to open in 2019.

Figure 1. Stairs of the International Museum of Contemporary Sculpture, in Santo Tirso, Portugal. Siza Vieira, 2010–2016. Photo: João Morgado – Architectural Photography, 2016.

3 DRAWING IN FANTASY

Reflecting on the place of fantasy in the work of Siza Vieira necessarily means considering the drawing, given that it is in the drawing that he to a large extent bases his relationship with the world and, accordingly, the creation of architectural objects. This has been widely recognised, including by Siza Vieira himself, from the outset: "I depend greatly on drawing and sketching, from the beginning", he stated in a recent conversation with Faria (2016, p. 58)[3]. The drawing engenders the fantasy that permeates many of his works. Even so, it is a fantasy of a value that is different to the fantasy considered so far herein, given that the fantasy sought by Siza Vieira in the drawing may be more removed from an immediate relationship with reality.

Fantasy is a prominent element in his frequent self-portraits, where, for example, he appears as a Don Quixote-like figure.

Using a subtle irony, these drawings seem to represent […] his *alter ego*, the heroic version of a character riding a horse, brandishing his sword against the adversities menacing architecture. (Amado Lorenzo, 2017, p. 149)

But fantasy also emerges in the drawings in which he observes the world, those produced for the pure pleasure of doing so: "[t]hat is the sort of drawing I find most attractive", as he often states, here in the aforementioned conversation with Domingo Santos (2008, p. 57). Fantasy emerges as Siza Vieira becomes part of the drawing – it is a common feature

for him to include his hands, almost always holding a cigarette, the sheet of paper he is drawing on and even the pen he is drawing with in his drawings. Siza Vieira becomes an observer of himself observing the world, allowing himself to become enveloped in a game of representations. Fantasy also emerges through the fact that these drawings are peopled with impossible faces, strange figures, transfigured bodies – sometimes winged and suspended in the space. And, finally, it also emerges, in the dizzying speed that characterises how some of the drawings are produced, motivated more by an urgency to register fascination for the world than by concerns with establishing a retinal relationship with the visible worlds.

Suddenly the pencil or *Bic* begins to fix images, faces in the foreground, faded profiles or luminous details, the hands which draw them. Lines, at first timid, rigid, lacking precision, later obstinately analytical, at moments vertiginously definite, free until drunkenness; later tired and gradually irrelevant. (Siza, 1988, p. 15)

These different forms of expression of fantasy at times co-exist in one and the same drawing. At any rate, these drawings seem to come into being more as a reflex of an interior universe and, therefore, the imagination, than as a simple registration of the observed reality, if such a registration was ever really the intention.

It is possible to identify all these singularities in some of Siza Vieira's design drawings, perhaps contradicting the more immediate expectation as to the clarifying role that such a register such as a drawing should have. Architectural objects, when they are being defined, also at times, seem to be drawn by Siza Vieira as if they were part of a fantasy. In the imagined wanderings carried out through perspective views, the drawing strays itself way from reality, with the object it purports to represent appearing altered, if not to say distorted, often being populated with weird figures (Fig. 2).

As with the questioning of the place of fantasy in Siza Vieira's work, it is likewise fair to ask the question of the place that fantasy has in his design thought when he entrusts the drawing with the development of his thought.

In contrast to the drawings made just for pure pleasure, those produced in the context of a design project are bound to guarantee control of the definition of reality. Rigorous fixation – both formal and geometric at the same time – of the object to be designed is required. Nevertheless, the drawing must be able to bring to the fore, and out of a state of lack of definition, the non-quantifiable qualities of the spatial universe that is being created; the tensions that permeate it; the clarity of the games of shade and light that animate it; the unexpected details that punctuate it. All this is aimed at by Siza Vieira in the drawing when he confronts the creation of an architectural object.

3. Siza Vieira also attaches great importance to models, turning to them from the early stages of each design project onwards (Robbins, 1994, p. 152).

Figure 2. Sketch perspective for the Museum for two Picassos, in Madrid, Spain. Siza Vieira, 1992. Ink on paper. 300 × 210 mm (ARCH400986). Álvaro Siza fonds, Canadian Centre for Architecture. Gift of Álvaro Siza. © Álvaro Siza.

In Siza Vieira, the drawing becomes one with the design, emerging, to use the words of Gregotti (in Siza, 2000, p. 9), as his own very personal form of writing.

> I believe there is no more appropriate word than this for defining the continuity between the drawing that describes his approach to the places; the *raison d'être* of the forms as a whole; the thought process behind them; and the design that modifies and reorganises them in accordance with a hypothesis, i.e. in accordance with a drawing.[4]

But Gregotti (in Siza, 2000, p. 9) also points out:

> For Siza drawing is not a language in and to itself; it is all about taking measurements, registering the internal hierarchies of the place that is observed, the desires it creates, the tensions it induces; it is about learning to see the questions it raises and making them transparent and penetrable. Finally, it is about searching, by means of the writing in the form of a drawing, for a series of resonances that progressively function as parts of a whole, that maintain the identity of the reasons for their contextual origins, but at the same time are organised into sequences, paths, calculated pauses that are aligned by means of discreet differences towards a necessary but not explicit process of diversity, of the writing of the spaces and the forms of the design project.[5]

And that writing is revealed not only in the form of sketches, given that the technical drawings also construct it, as Gregotti (in Siza, 2000, p. 9) makes clear as well.

It is worthwhile returning to the intimate relationship Siza Vieira has with the drawing to examine the place in his design thought of the fantasy that emanates from some of his drawings.

The continuity that Gregotti (in Siza, 2000, p. 9) identifies, from the drawing with which Siza Vieira approaches the places to the drawing with which, based on hypothesis, he fixes his design, should be extended to the drawings through which Siza Vieira makes his observations of the world. These drawings too are his writing, considering that, when he is producing them, Siza Vieira approximates and fixes that which he is observing. The extension of this continuity can be explained by the adoption of the same way of looking at things in both cases, more than by any manifest similarity of expression between the two types of drawing. As Fraser and Henmi (1994, p. 124) put it:

> [h]is drawing of a commission and his drawing of a travel scene could be interchangeable. They seem to demonstrate not only the same way of drawing but also the same way of looking.

When one assumes the extension of the continuity, as argued by Gregotti (in Siza, 2000, p. 9), that which the two forms of drawing are fixated on is shown to be one and the same thing, given that, in the end run, Siza Vieira is looking for the same thing in architecture, regardless of whether he is observing it or designing it. It is no surprise that all that which Gregotti (in Siza, 2000, p. 9) identifies in Siza Vieira's use of the drawing when bound to the design process can also be found in its entirety when the drawing serves the merely pleasurable purpose of observing the world: the 'taking of measurements'; 'registering the internal hierarchies of the place that is observed'; 'the desires it creates and the tensions it induces'; and the search for 'resonances organised into sequences, paths, calculated pauses', etc... The images he creates in one case encounter the images constructed in the other, crossing imagination with memory, and lived experience with desired experience. Herein, in this to and fro of images provided by the drawing, is rooted his creative research, as Curtis (1999, pp. 24–25) explains: "[i]mages seem to float in his mind establishing a web of relationships to the [design] problem".

4. Own translation. Original text: "Nenhum vocábulo, creio, é mais apropriado do que este para definir a continuidade entre o desenho que descreve a sua aproximação aos lugares, a razão de ser das formas em conjunto, a reflexão que as elabora, e o projecto que as modifica e reorganiza segundo uma hipótese, isto é, segundo um desenho" (Gregotti in Siza, 2000, p. 9).
5. Own translation. Original text: "Contudo, o desenho não é para Siza uma linguagem autónoma; trata-se de tirar as medidas, de fixar as hierarquias internas do lugar que se observa, dos desejos que ele suscita, das tensões que induz; trata-se de aprender a ver as interrogações, a torná-las transparentes e penetráveis. Trata-se por fim de procurar [...] uma série de ressonâncias que progressivamente funcionem como partes de um todo, que mantenham a identidade das razões da sua origem contextual mas que ao mesmo tempo se organizam em sequências, percursos, paragens calculadas, que se alinham através de diferenças discretas na direcção de um processo de diversidade necessária não ostentada, de escrita dos espaços e das formas do projecto" (Gregotti in Siza, 2000, p. 9).

It is Siza Vieira himself who best reflects the presence of these two forms of drawing in his work, in a small text – almost a poem – on drawing from 2001:

> Most of my drawings follow a precise objective: to find the Form that responds to the Function and frees itself from the function – and the effort – opening itself up to an unpredictable destiny. / Whether simultaneously or not, another drawing emerges "on the side". / A drawing that is pleasure, absence, pause, crosses with another, for we never distance ourselves entirely from anything. [...] Free of restraint, the other drawing leads to the conscious drawing (Siza, 2009, p. 273)[6]

With their incongruity as a constant, the figures in apparent movement with which Siza Vieira peoples his design drawings prove useful in understanding the spaces he seeks to define, as he states in the conversation with Domingo Santos (2000, p. 59):

> The inclusion of people in that sort of drawing has nothing to do with the problem of scale, which sometimes is not even real, but it does have to do with the influence of those foreseeable movements by people on the final architectural form. They are drawings that deal with the way things flow until they become architecture.

So, there is nothing contradictory in these drawings; no paradox to be found in them.

4 FINDING IN FANTASY A WAY 'TO IMAGINE THE EVIDENCE' OF THE ARCHITECTURE

Returning to Siza Vieira's thoughts on this matter (Siza, 2009, p. 273), the drawing in which he imagines the world emerges alongside the drawing through which he observes the world at his pleasure, one drawing being nourished by the fact that the other freeing itself.

It would, perhaps, be impertinent to insist on fantasy as a distinctive mark of some of the design drawings of Siza Vieira. But if one does insist on the affirmation of fantasy, it should not be regarded as a deviation, but as an instance in which the design thought encounters a possibility of clarification.

With a nod to the title of one of his books (Siza, 2000), perhaps one can say that Siza Vieira finds in fantasy a way 'To Imagine the Evidence' of his architecture.

6. Own translation. Original text: "A maior parte dos meus desenhos obedece a um fim preciso: encontrar a Forma que responda à Função e da função se liberte – e do esforço – abrindo-se a imprevisível destino. / Simultaneamente ou não, "ao lado", surge outro desenho. / Desenho de prazer, de ausência, de repouso, cruza-se com o outro, pois de nada nos alheamos por inteiro. [...] Liberto, o outro desenho conduz ao desenho consciente" (Siza, 2009, p. 273).

ACKNOWLEDGEMENTS

This work is financed by national funding from FCT – Foundation for Science and Technology under the Project UID/AUR/04026/2019.

The author wishes to thank João Morgado – Architectural Photography for the photography of the International Museum of Contemporary Sculpture, in Santo Tirso, Portugal.

BIBLIOGRAPHICAL REFERENCES

Ackerman, James. (2002). *Origins, Imitations, Conventions: Representation in the Visual Arts*. Cambridge, MA; London: The MIT Press.

Amado Lorenzo, Antonio. (2017). Los autorretratos de los arquitectos. **EGA Expresión Gráfica Arquitectónica, 22(29)**, 146–155. doi: 10.4995/ega.2017.3353

Brawne, Michael. (2003). *Architectural Thought: the Design Process and the Expectant Eye*. Amsterdam, Netherlands; London: Elsevier.

Carlos Castanheira Architects. (2018). *Saya Park Art Pavilion*. Retrieved February 21, 2019, from https://www.carloscastanheira.pt/

Costa, Alexandre. (2008). Scandalous Artisticity. In Jorge Figueira (Ed), *Álvaro Siza Modern Redux* (pp. 33–40). Ostfildern: Hatje Cantz Verlag.

Curtis, William. (1999). Notes on Invention: Alvaro Siza. *El Croquis*, (95), 22–31.

Domingo Santos, Juan. (2008). The Meaning of Things: a Conversation with Alvaro Siza. *El Croquis*, (140), 7–59.

Faria, Eduarda. (2016). *Inside a Creative Mind: Vol. 4. Álvaro Siza Vieira*. Lisbon: Fundação Calouste Gulbenkian.

Figueira, Jorge. (2008). Álvaro Siza. Modern Redux. Being Precise, Being Happy. In Jorge Figueira (Ed), *Álvaro Siza Modern Redux* (pp. 25–31). Ostfildern: Hatje Cantz Verlag.

Fraser, Iain and Henmi, Rod. (1994). *Envisioning Architecture – an Analysis of Drawing*. New York: Van Nostrand Reinhold.

Gänshirt, Christian (2007). *Tools for Ideas: An Introduction to Architectural Design*. Basel; Boston, MA; Berlin: Birkhäuser.

Kruft, Hanno-Walter. (1994). *A History of Architectural Theory: from Vitruvius to the Present*. New York: Princeton Architectural Press.

Robins, Edward. (1994). *Why Architects Draw*. Cambridge, MA; London: The MIT Press.

Robocoop. (n.d.). About. Retrieved February 20, 2019, from https://robocoop.net/Info.

Siza, Álvaro. (1988). Travel sketches. In *Álvaro Siza: esquissos de viagem* (p. 15). Porto: Documentos de Arquitectura.

Siza, Álvaro. (2000). *Imaginar a evidência*. Lisbon: Edições 70.

Siza, Álvaro. (2009). *01 Textos*. Porto: Civilização Editora.

The "good taste": When patterns restrict creativity

Gisele Melo de Carvalho
CIAUD, School of Architecture, Lisbon University, Lisbon, Portugal
ORCID: 0000-0002-2948-1624

ABSTRACT: The chapter is an investigation about the expression "good taste", from the point of view of aesthetics. It focuses on the composition criteria that characterise the expression, where it identifies a set of parameters that govern artistic activity at the moment, notably the classicist patterns. This expression was initially used in the French social and artistic environment in the 18th–century, when a predominance of Classical Antiquity prevailed. Later it was adopted by the Portuguese and the Brazilian people, in the most diverse domains of the aesthetic, including the housing architecture and its interiors. The research will be directed to projects, their constituent elements and professionals when they use aesthetic standards that fit what was defined as good taste. Thus, complementing the collection of historiographical data concerning the origin and development of the expression in Europe, ten interviews with professionals working in the area of housing projects in Recife, Brazil, illustrate the understanding of the expression still in vogue in this city, opening space for research on a broader universe, in the sense of building a concept of classic in the current projects.

Keywords: Classicism, Interiors, Housing, Social Spaces, Aesthetics

1 INTRODUCTION

The questions of taste have always been the subject of many debates, since they are referring to individuals, and based on subjectivity. In the Enlightenment, Kant made an essential contribution by stating that the "judgment of taste" could not be logical, since it will always be based on subjectivity, and not on the essence of the object (Bayer, 1978, p. 199). In a universe where certain concepts and values predominate in the social sphere, they can interfere with the subjectivity, and consequently in the judgment that each person will make of the objects around him. Also in the 18th-century, in a Europe where the legacy of classical antiquity prevailed, its artistic criteria were present in people's minds, who tried to transpose them to the value criteria of the composition, conditioning, in a certain way, the artistic creativity. So, to what point is there a connection of the concept of "good taste" with the classic and what is instituted? Is "bad taste" opposition to the classical canon? What was the role of classicism prevailing in the 18th-century for the sedimentation of a concept, used until the present time, in Recife, Brazil? What validates an architecture project as being of "good taste"?

2 THE "GREEK TASTE"

In the artistic milieu of revolutionary France, at the end of the 18th-century, the oppositions to the *Ancien Régime* and the Baroque-Rococo were contained in an aesthetic, diverse to these styles, based on the compositional principles of Greek classicism, characterising French Neoclassicism. This revival of the classic is observed in the exaltation of ancient Greece, initially in ephemeral decorations, drawings, texts, and small projects and continued with some prominent buildings that became the reference for the new taste. One example is Ange-Jacques Gabriel's projects, such as the *Place de la Concorde* in Paris and the *Petit Trianon* in Versailles, the contributions of the excavations of Herculaneum and Pompeii in Italy, and the studies of Julien-David LeRoy in mid-century, "*Ruines des plus beaux monuments de la Grece*" (Frampton, 1997, p. 4).

These works became decisive references for the taste for antiquity, and the circumstances favourable to the requests for projects, in the second half of this century, were essential for the affirmation of the Neoclassical Movement in France, which had in the project of the Church of *Sainte-Geneviève*, one of its major landmarks. As Nuno Gonçalo Monteiro says, culturally, the 18th-century was in Europe "a French century", since French was the diplomatic language that succeeded Latin and also:

> Because the authors, the fashions of clothes, the models of sociability, and, in a general way, the parameters of the French taste imposed themselves everywhere, although with competitors. (Rochebrune, 2008, p. 31)[1]

1. All translations are the author's free translations. The original text is presented in the footnotes: "porque os autores, as

France will increasingly influence the rest of Europe as a cultural centre in this period. In Portugal, there was the development of a culture prone to "sponsor works of aesthetically classicist content, associated with the French culture of the reign of Louis XIV" (Rochebrune, 2008, p. 36)[2]. Later in Portugal, the Marquês de Pombal and his policies aimed at valuing enlightenment ideas contributed to increasing this influence by the end of the 18th-century.

As a result, in the case of housing and its interiors, the influence of French culture and taste were generalised in Europe at the time and also adopted by the Portuguese elites, "as a new decorative grammar". In Portugal,

> an influential unique role was reserved for the organisation and decoration of the interior of the residences, where the criteria of "good taste" are sometimes associated with France or England. (Franco, 2014, p. 247).[3]

Thus, in Lisbon elites' houses, the French taste prevailed, synonymous of the taste for the ancient and the Greek, which meant the adoption of the classicist patterns in the composition of the spaces. Carlo Franco identified as recurrent a disposition in pairs furniture and objects, the symmetry, repetition and uniformity of the constituent elements of the living spaces, that is, ordering and structuring in these spaces as a practice already assumed and valued.

3 THE "ITALIAN TASTE"

The "good taste", in addition to its symbology and social preference, was nevertheless a concept thread at the Royal Academy of Architecture in France, with a clear application purpose, for the architectural works of its members, and linked to Greco-Roman classicism. From its beginnings, the French Academy assumed the mission to establish a "French national order"[4], a "doctrine of mandatory architecture"[5], that is, aesthetic parameters that would guide the production of architecture in the country. The Academy members believed that they could only find greatness and perfection in the imitation of the ancients (Kruft, 2016, p. 271)[6].

The link with Italian classicism shows how "good taste" was tied to it. The two pillars of the classical

theory, Vitruvius and Alberti, together with the Italian writers Palladium, Scamozzi, Vignola, Serlio, Viola and Cataneo, were studied by the members of the Royal Academy of Architecture, founded in 1671. Because of this, the beginning of the theory of architecture in France was conditioned exclusively by Italian thought (Hautecoeur, apud Kruft, 2016, p. 243)[7], highlighting the contribution of Claude Perrault's new French translation of Vitruvius' *Treaty* in 1664. It was in Vitruvius writing that they found the rules for compositional principles, referred to as the "venustas" (Vitruvius, 2007, p.74) of the architectonic work, the base for the compositional principles later reflected in the Royal Academy.

The initial discussion in the French Academy dealt with the question of what would be the "good taste", concluding provisionally that it would be what pleased intelligent men.

One perceives from the first moment a link between "good taste" and the taste of the wealthier classes, who end up becoming opinion makers for the rest of society, as will be seen in the following topics of this chapter.

Later, in 1673 Claude Perrault defines "good taste" as formed by the association of two categories of beauty, the "*beauté positive*" and the "*beauté arbitraire*". The first one based on the criteria of "*solidité, salubrité, commodité and symétrie*", and the second, associated with aesthetic freedom. The "*bon goût*" differs to Perrault, from the "*bon sens*", which is based only on the criteria of "*beauté positive*", based on classical antiquity, and to oppose it, would be a reprehensible aesthetic posture since it does not allow modifications to already established criteria. (Kruft, 2016, p. 283).

For Sébastien Le Clerc and Gilles-Marie Oppenordt, unlike Perrault's criteria, and of what prevailed in the Academy at the time, the "good taste" was free of restriction, it was connected to the pleasure of the observer and the "judgment of personal taste". However, it was not this concept that went forward and came to the present. Creativity could not be so free of standards since academic purposes have always been to determine criteria to be used nationally in architecture, a "doctrine of obligatory architecture," as quoted above.

Later, in 1743, the France Royal Academy of Architecture approved the definition of four fundamental concepts of architecture theory:

- *good taste*: harmony of the whole and its parts, which is dependent on three conditioning factors:
- *ordering*, which is the distribution of the parts of the building, linked to the size and use of the building;
- *proportion*: the rule of convenient measures, linked to use and places and based on nature;

modas de vestuários, os modelos de sociabilidade e, de uma maneira geral, os parâmetros do gôsto francês se impuseram um pouco por toda a parte, embora com concorrentes."

2. "patrocinar obras de teor esteticamente classicista, associadas à cultura francesa do reinado de Luís XIV".

3. "se reservou para a organização e decoração do interior das residências um especial papel influenciador, onde os critérios do *bom gosto* surgem, por vezes, associados a França ou a Inglaterra."

4. "ordem francesa nacional".

5. "doutrina de arquitetura obrigatória".

6. "grandeza e perfeição apenas na imitação dos antigos".

7. "exclusivamente pelo pensamento italiano".

– *convenience*: "subjection to established and received uses, provides rules to put each thing in its place" (Lemonnier, apud Kruft, 2016, p. 297).[8]

Having exposed these fundamental concepts, it turns out that creativity could develop to a certain extent, as long as it respected these constraints of measure, proportion and respect to what had already been instituted.

These concepts are present in Germain Boffrand's *Livre d'Architecture*, where "good taste" is the central concept, disregarding subjective issues and linked to fads and ornamentation. "Good taste" is a quality of the building itself, which incorporates the architectural principles of *"belles proportions, convenance, commodité, sûreté, santé et bon sens"*. This means that "each part as a whole must have a proportion and a convenient form to its use." (Bofrand, apud Kruft, 2016, p. 298). Here again, when one sees Boffrand's postulate, one finds the criteria of measure and utility condition "good taste" in architecture.

Also, Charles-Etienne Briseux's *Traité du Beau Essentiel* (1752) gives Kruft the chance to discuss the linking of beauty and "good taste" to fundamental principles of architecture, which would be harmonic proportional rules originating in nature. These concepts became part of the teaching of initiates in the theory of architecture, but for him, even the lay public was able to perceive these rules, but not to identify them (Kruft, 2016, p. 305). It is perceived that non-attachment to these rules would lead to a dubious taste, namely a "bad taste", since free of these principles.

Thus, "good taste", originating from its concept based on the compositional principles elaborated by the Greeks and Romans in classical antiquity, taken up and developed by the French Academy in the 18th-century, were linked to classicism as regards harmony, order, proportion and convenience, and influenced also the taste of European academic and economic elite.

The conclusion is that "good taste" is directly linked to the taste for what is classic, and bad taste to its non-binding.

The concept "good taste" crossed the Atlantic to the city of Recife, Brazil. This expression was used by the artistic community and consequently in the housing projects from the 19th-century both referring to the conformation of the projects and their interiors, as well as referring to the professionals who carried out these projects, seen as "tasteful architects" and "tasteful decorators", identified here as the professionals who dominated the classical compositional repertoire and transposed it into their projects.

4 THE "GOOD TASTE" IN RECIFE, BRAZIL

The Portuguese court, when settling in the Rio de Janeiro, in Brazil, from 1808 onwards, brought with it the concept of "good taste", which was established as the elite's taste, spreading to the other layers of society while aesthetic reference.

Brazil, due to the characteristic of its formation, has always been characterised as an extremely complex country, from a social point of view, with varied cultures that were expressed in cultural artefacts and art objects.

However, social diversity and creativity free of parameters yielded to the rules considered as "good taste" from the nineteenth century, when cultural elements from other countries, notably France and England, become part of cultural aesthetic references. Gustavo Rocha Peixoto, discussing the adoption of neoclassicism in Brazil, points out motives linked to a civilising ideology, not allowing the creativity in the aesthetic field to be detached from such a strong reference:

So does the need to subordinate momentary emotions to more distant goals. In the case of architecture, the adoption of neoclassicism can be understood as an act of civilising will, just because of its formal austerity results from the sublimation of the sensory emotions in the name of a rationally more consistent and controlled architecture, both exterior and interior. Moreover, furthermore, this emotional control of architecture comes from an extended long-term glance both by looking at the distant past of the primitive hut or classical antiquity, and chiefly because its p orientation is for the construction of an idealised future. (Peixoto, 2000, p. 280)[9]

The two references proposed by Peixoto, one on the solid foundation of a valued past and the other on the idea of a promising future, may explain how the permanence of the valorisation of the classic, and the expression of "good taste" attached to it, has been identified until today.

The city of Recife, in 19th-century, received direct influences on the 'good taste' from both the Portuguese court, set in Rio de Janeiro and the more affluent local class that constantly travelled to its main radiating centre, the city of Paris. Also, the "good taste", now an aesthetic criterion, defined by the French Academy for

8. "sujeição aos usos estabelecidos e recebidos, fornece regras para colocar cada coisa no seu lugar".

9. "o mesmo ocorre com a necessidade de subordinar as emoções momentâneas a objetivos mais distantes. No caso da arquitetura, a adoção do neoclassicismo pode ser compreendido como ato de vontade civilizadora, justo porque sua austeridade formal resulta da sublimação das emoções sensoriais em nome de uma arquitetura racionalmente mais consistente e controlada, por inteiro, assim no exterior como no interior. E, além disso, esse controle emocional da arquitetura se dá mediante um olhar espichado de longo prazo tanto pelo fato de mirar o passado distante da cabana primitiva ou da Antiguidade clássica, como principalmente por que é para a construção de um futuro idealizado que ela se orienta".

Architecture, made it possible to penetrate all social domains, as Gilberto Freyre attests:

> The French taste not only of architecture but of dessert, of wine, of doll's lacquer to the shine of the furniture, of the image of a saint, joined the dress, dominating the most learned and wealthy bourgeoisie [. . .] everything Portuguese was getting "bad taste"; everything French, English, Italian or German was getting "good taste. (Freyre, 1999, p.336)[10]

Thus, the expression "good taste", initially diffused by the court and the more affluent personalities, during the following centuries influenced the middle class, becoming a common expression in the contemporaneousness of the city of Recife, in what concerns questions of art and architecture.

To illustrate how the expression is understood in the circle of professional architects, professors, decorators and shopkeepers who work the interface of the housing project and its interiors, ten initial interviews were made regarding qualitative interviews and broader research inquiries in progress.

The central question was to ascertain the understanding of the expression "good taste" and whether there could be a connection between "good taste" with the classic and its conditioning factors, like proportion and respect to the already established to curb artistic creativity.

Here are excerpts from interviews conducted by this reseracher:

Elizabeth Araruna, an architect who graduated in 1970, owner of an art gallery, says that "good taste":

> Is coherence, a balance between the various elements that make up the space [. . .]. As you begin to acculturate, you begin to realise the ideas of the world that are already in place [...] the classical laws of balance, the harmonic divisions. Whatever becomes eternal somehow, it acquires the adjective classical [...] everything that goes through centuries [...] a classic house has the definite notions of aesthetics classic, and the non-classical house, it has freedom in the use of this classic aesthetic [...] derives from this classic basis [...]. The classic is the basis of our civilisation.[11]

Joel Posternak, a pioneer furniture retailer who made history over 30 years in the city, first defines "good taste" as:

> A feeling of culture that exists to discover that it pleases to a person in form, volume. On the other hand, what he does not like, would be bad taste. Good taste would be a good design, volume; it is a feeling of perfection. [...]. It is in the culture.[12]

Tânia Carneiro Leão is an artist and also an antiquarian in the city since 1968, decorator of residences. For her, "good taste":

> It is a good thing for one, but that may be different for another. There is no objective definition, not good taste, not bad taste. In the area of architecture, it may be a well-designed piece of furniture [...] the classic would be something that obeys patterns, old styles, cleaner, more precise lines. In a sense, the good taste could be something classic.[13]

Alexana Vilar, Architect and Urbanist, Professor, Master in Design and Specialist in Ergonomics, comments:

> Good taste" for me is related to a very subjective characteristic, which involves cultural, aesthetic and behavioural elements. An environment is considered to be very tasteful when it adds balance and harmony between existing elements, causing a sense of immediate empathy to those who observe it. I believe that it has a connection with the classical because the classic is very controlled by the relations of symmetry and proportion.[14]

Pedro Henrique Cabral Valadares is an Architect and Urbanist, Professor, PhD. in Theory and History of Architecture. He says:

> I believe that "good taste" is something relative, but often related to a certain common sense [. . .] making use of specific pre-established criteria [. . .]. In architecture, I think that balance is one of the main criteria [. . .] harmony is another criterion whose definition I

10. "o gosto francês, não só de arquitetura como de sobremesa, de vinho, de verniz de boneca para brilho do móvel, de imagem de santo, juntou-se ao do vestido, dominando os burgueses mais instruídos e mais ricos [. . .] tudo que era português foi ficando "mau gosto"; tudo que era francês ou inglês ou italiano ou alemão foi ficando "bom gosto".
11. "É uma coerência, um equilíbrio entre os diversos elementos que compõem o espaço [. . .] na medida em que você começa a se aculturar você começa a perceber as ideias do mundo que já estão colocadas [. . .] as leis clássicas do equilíbrio [...] as divisões harmônicas [...] tudo o que se torna de alguma forma eterno, ele adquire o adjetivo clássico [. . .] é tudo que atravessa séculos [. . .]uma casa clássica tem as noções definidas da estética clássica, e a casa não clássica, ela tem uma liberdade na utilização dessa estética [...] deriva dessa base. O clássico é a base da nossa civilização".

12. "Um sentimento de cultura que existe, ao descobrir que aquilo lhe agrada na forma, no volume [. . .]. Por outro lado o que não lhe agrada, seria o *mau gosto*. *Bom gosto* seria um bom desenho, volume, é uma sensação de perfeição [...]. Tá na cultura."
13. "bom gosto" é uma coisa boa para um, mas que pode ser diferente para outro. Não existe uma definição objetiva, não existe "bom gosto" nem "mau gosto". Na área de arquitetura, pode ser um móvel bem desenhado [. . .] o clássico seria algo que obedece a padrões, a estilos antigos, com linhas mais limpas, mais precisas. Em certo sentido, o "bom gosto" poderia ser algo clássico."
14. "bom gosto" está relacionado com características bastante subjetivas, que envolve elementos culturais, estéticos e comportamentais. Um ambiente é considerado de muito *bom gosto* quando agrega equilíbrio e harmonia entre os elementos existentes entre si, causando uma sensação de empatia imediata a quem o observa. [...] Acredito que tem uma ligação com o clássico, uma vez que o clássico está muito pautado nas relações de simetria e proporção."

146

believe to be more comprehensive. [...] I believe that the definition of classical is quite broad, but I venture that common sense better absorbs what is of classical origin.[15]

Denise Gouveia, Architect, store owner of contemporary furniture of Brazilian design, identifies good taste as an adaptation to a lifestyle, with elegance, harmony and proportion. She could not answer the connection between "good taste" and classic.

Stela Gláucia Alves Barthel, Architect and Urbanist, PhD in Archeology and Professor in the area of Theory and History of Architecture, says that:

> "good taste" has to do with harmony. You feel that things fit well, and it has to do with common sense, too. However, that is very subjective, and it varies from person to person. Not necessarily it has a connection with classical. The things of classicism are regarded as the best that humankind has produced, but there are other possibilities.[16]

Denise Gaudiot, Architect and Urbanist, Professor, Master of Design, when asked about her understanding of what would be a room "with good taste", answeres that:

> For me is when the room is in harmony. Even the contrasts are in harmony [...] the classic is connected with what people use to see within a vision of harmony, of something that you will find pleasant to look at, and will not attack you in any way [...] that is, the idea that it is a perennial thing.[17]

Vera Braga, PhD in History, works in Public Education, says that:

> To have "good taste" is to be in harmony with yourself by encompassing your residence. When the furniture is suitable for space [...], it has to have proper style and aesthetic sense. Lightness, well-being and harmony, these are characteristics of people who have "good taste". It is linked with classic, without a doubt

[...]. I think the classic should never be discarded. [...] a more classic taste is more reliable; it has to do with the cultural issue, with historicity, intellectuality, refinement.[18]

Alexandre Mesquita Paiva, Professor, Architect and Urbanist, Specialist in Design, comments:

> The person has posture, has a look, and that good taste is a reference he has, to be putting a filtering [...]. Of course there is a common sense [...] comfort, proportion, this common sense, which is difficult to evaluate, I think it is a cultural thing [...] but both "good taste" and "bad taste" comes more from this common sense, and from there comes the tastes by the exoticism, by the differentiation. Why does it become exoticism? Because few people already select it.[19]

It is demonstrated through these statements that the concepts developed by the French Academy in the 18th-century, such as harmony, proportion and the bond to rules remain "in essence", in the understanding of these professionals about what "good taste" is, signalling their connection with the classic.

5 CONCLUSIONS

The researched historiography shows that "good taste" was an expression that began to be used in the European artistic environment of the 18th-century initially in France, later by the Portuguese and that from the 19th-century onward was adopted by the Brazilians, in the most diverse domains of the aesthetic.

In the face of many debates, the concept of "good taste" was approved in 1743 by the Royal Academy of Architecture of France, as a harmony, which depends on the ordering, proportion and convenience of the whole and the parts that make up a work. From this concept, it turns out that creativity in architecture could develop to a certain extent, as long as it respected these constraints of measure, proportion, and what had already been instituted.

15. "relacionado com um certo senso comum, [...] fazendo uso de determinados critérios preestabelecidos [...] em arquitetura, penso que equilíbrio seja um dos principais critérios [...] Harmonia é outro critério, cuja definição acredito ser mais abrangente. [...] acredito que a definição de clássico seja bastante ampla, mas eu arrisco que o senso comum absorve melhor o que é de origem clássica". Interview extract made by the author.

16. "Acho que 'bom gosto' tem a ver com harmonia. Você sente que as coisas se encaixam bem, e tem a ver com bom senso, também. Mas isso é muito subjetivo, e varia de pessoa para pessoa. Não necessariamente está ligado ao clássico. As coisas do classicismo são tidas como o que melhor a humanidade produziu, mas há outras possibilidades". Interview extract made by the author.

17. "Para mim é quando o ambiente está em harmonia. Mesmo os contrastes, estão em harmonia. [...] o clássico tá ligado com aquilo que a gente está habituado a ver dentro de uma visão de harmonia, de uma coisa que você vai achar agradável de olhar, não vai lhe agredir de maneira nenhuma, [...] essa ideia de que é uma coisa perene".

18. "Ter "bom gosto" é estar em harmonia com você mesmo englobando a sua residência. Quando existe uma adequação do mobiliário com o Espaço [...] é ter estilo adequado e senso estético [...] Leveza, bem estar e harmonia, essas são características de pessoas que têm *bom gosto* [...] está ligado ao clássico, sem duvida [...] penso que o clássico não deve ser descartado nunca [...] acho mais confiável um gosto mais clássico, tem a ver com a questão cultural, com a historicidade, a intelectualidade, o refinamento."

19. "A pessoa tem uma bagagem, tem um olhar, e aquele 'bom gosto' é uma referência que ele tem, de estar colocando uma filtragem [...] Lógico que existe um senso comum [...] de conforto, de proporção, esse senso comum que é difícil de se avaliar, acho que é uma coisa cultural [...] mas tanto "bom gosto" quanto "mau gosto" surge mais desse senso comum, e a partir daí vem os gostos pelos exotismos, pelas diferenciações. Por que se torna exotismo? porque já é selecionado por poucas pessoas."

Coincidentally, in Recife, the concept of "good taste" for the majority of professionals interviewed was also identified as harmony, precisely the basic concept approved by the French Academy, demonstrating that the same understanding remains in the minds of professionals in the area of architecture and the arts today.

The connection between "good taste" and classic is notorious. Most of the interviewees mentioned this link directly, and those who did not do so indirectly linked it to the old culture and the coherence in the use of the elements and patterns that go back to classical antiquity.

From this, one can consider the possibility to validated these findings with broader research, to discover how much the expression "good taste" is linked to the past, being a constraint to change and creativity, labelled immediately as "bad taste" for being disruptive of the everyday use of classical compositional patterns.

BIBLIOGRAPHICAL REFERENCES

Bayer, Raymond. (1978). *História da Estética*. Lisboa: Editoria Estampa.

Frampton, Kenneth. (1997). *História Crítica da Arquitetura Moderna*. São Paulo: Marins Fontes.

Franco, Carlo. (2014). *Casas das Elites de Lisboa – Objetos, interiores e vivências*. (PhD Estudo do Patrimônio). Lisboa: Universidade Católica Portuguesa.

Freyre, Gilberto (1996). Sobrados e Mocambos: Decadência do Patriarcado Rural e Desenvolvimento Urbano. (9a. edição). Rio de Janeiro: Editora Record.

Kruft, Hanno-Walter (2016). *História da Teoria da Arquitetura*. São Paulo: Editora da Universidade de São Paulo.

Peixoto, Gustavo Rocha. (2000). Reflexos das Luzes na Terra do Sol: sobre a teoria da arquitetura no Brasil da Independência: 1808–1831. São Paulo, ProEditores.

Rochebrune, Marie-Laure de. org. (2008). O gosto "à grega"- Nascimento do neoclassicismo em França - 1750–1775. Lisboa: Museu Calouste Gulbenkian.

Vitruvius, Pollio. (2007). *Tratado de Arquitetura*. (Tradução do latim, introdução e notas M. Justino Maciel). São Paulo: Martins Editora Livraria Ltda.

Creativity and pragmatism: A practical example of a project

Caio R. Castro[1] & Mário S. Ming Kong[2]
CIAUD, Lisbon School of Architecture, Universidade de Lisboa, Lisboa, Portugal
[1]*ORCID: 0000-0002-0901-499X1*
[2]*ORCID: 0000-0002-4236-22402*

ABSTRACT: The purpose of this chapter is to describe the creative course of a project and theoretical analysis of the procedures adopted for it, and how theory and practice complement one another in an infinite process of possibilities. The objective of the presented project is to solve the lousy lighting and ventilation of a group of vertical buildings in the outskirts of Lisbon, which were occupied when they were only with the skeleton of reinforced concrete. Assuming that exterior openings with minimal dimensions lead to increased energy consumption, poor ventilation, and adverse psychological effects, a palliative and emergency solution was sought. The solution found to the problem is a simple folding membrane made of aluminium profiles, rubber and plastic sheets – all of them recycled – that presents itself as a simple response and that entails major positive modifications to the previous situation of the building. In a pragmatic approach to identifying the problem and proposing its solution, the various stages of transformation of the creative process are discussed until reaching the final solution to solve the problem, which was determined at the beginning of the process. When achieving the objective with the project, the theoretical foundation developed throughout the creation points to other possibilities of the same product, in a union between creativity and intelligence that allow recycling the use of the same object for other architectural purposes.

Keywords: Pragmatism in architecture, Bairro da Jamaica, Folding, Membrane, Practice and Theory of Architecture.

1 INTRODUCTION

The Bairro da Jamaica consists of 9 buildings – the tallest being seven floors tall (Fig. 1) – a project from the 1980s to create an urbanisation plan that never materialised since the contractor went bankrupt during the works. It was, nevertheless, occupied at the beginning of the following decade. Today, it is home to about 215 families, which corresponds to approximately 800 people, comprised within the 5 hectares of land where the buildings are located.

The vertical access is by internal stairs, without lighting or handrails, so that the touch, more than sight, is the predominant sense for this dangerous route. The elevators were never installed, and their hollow shafts remained, bared without protection in some blocks, like a scar of what could be a facilitator of a more dignified life.

Darkness is also an issue on the outside of the buildings since there is no public lighting.

This situation is well known to Portuguese public opinion in general, as reported by the *Público* newspaper where it reads (Gorjão Henriques, 2017, own translation):

The lack of housing conditions, such as excessive moisture, infiltrations on the walls and floors and

Figure 1. View of the tallest blocks at Bairro da Jamaica. Source: Google Street View, taken February 2014.

the lack of ventilation have already caused health problems for children and adults.

A rehousing program started at the end of 2018, covering 187 people in the first phase, with the total families relocated only in 2022. However, in the meantime, measures are needed to promote small improvements for this habitat.

2 ONE OF THE MANY PROBLEMS: WALLS AND WINDOWS

As reported so far, it is identifiable the difficulty of the residents to have access to light, both in the form

of artificial lighting as the technique of subverting the natural darkness of a specific architectural spatial configuration without openings to the outside, as well as to enable being outdoors during the night, in safety and with the stimulus of vision to function correctly.

In the sphere of the private life of the inhabitants, the illumination of the apartments by natural light is identified as another issue as well. This is easily verifiable when analysing the exterior images of the buildings. Among the wide variety of window models, most of the observed types are small in size.

In this case, there is a conjunction of several overlapping factors that generate problems: an excess of the opaque element area (the brick wall) to the detriment of the area of a transparent element (the window, for example). Whereby the first element ends up having aggravating factors besides inhibiting the natural light: since it is not covered with cement plaster, it generates infiltrations and the presence of dampness inside the apartments. As if this problem alone was not enough, the poor natural lighting and ventilation make this situation very much worse.

3 LIGHT AS A NEED

The effects of natural lighting inside buildings as a positive catalyst for the functioning of physical, physiological and psychological aspects of the human being is widely studied in the literature.

In school buildings, a study carried out over two years associates sunlight with better students' achievement, among other benefits, in comparison to artificial light. (Hathaway, 2000, p. 22).

Another research from the same period attempted to show the benefits that schools have with large openings to the outside world over others with few or no openings and concludes there are benefits for the first type. (Heschong 1999, p. 57).

In the same way, the phenomenon of being within a determined space and having an adequate relationship with the view of the outside world has proven to have substantial benefits to the satisfaction of its users, greater when in direct relation with nature, but, nevertheless, with positive results for urban elements. (Kaplan, 2001, p. 507).

4 THE PRAGMATIC APPROACH AS GUIDING THE PROJECT

After listing the issues that we have chosen as problematic and desirable to be solved, there is room for the elucidation of what characterises the pragmatic method that was used to obtain the solution (which we will discuss later) and its application in the architecture project.

Being pragmatic means objectivity in dealing with a problem and finding practical solutions that seek to solve deficiencies previously detected. In this case, there is an option for the valorisation of the utilitarian and concrete character to the detriment of the excessive theoretical intellectualisation. However, this does not mean the total negation of the second, but a constant search for testing philosophical theories (unconditionally perennial in their existence, since they are linked to the cultural factors of the moment of being produced) and intellectual dogmas, for obtaining practical and measurable results.

As a method, it is unconditionally tied to the process of trial and error, and susceptible to improvement, and here is the significant difference of the pragmatic approach to philosophical doctrines, which, being essentially metaphysical, are not concerned with the practical validation of their concepts.

However, it is necessary to clarify that contrary to what the denomination might suggest,

> Pragmatism's attitude to problem-solving is pluralistic and anti-absolutist: we must not assume there is a single right answer; but, more than that, we must not attempt to relieve ourselves of the responsibility to think and decide for ourselves by supposing that a 'theory' (including pragmatism itself) will solve our problems. (Macarthur, 2017, p. 108)

Therefore, when the author speaks of responsibility, we can conclude that the action of the architect as a creator is not diminished, much less his final product – the project – may be of less artistic value than one whose based on more abstract theories.

In this way, there is no incompatibility between creativity and a pragmatic project attitude, since this is only a tool to reach a result, therefore, as valid as other creative processes.

By placing the architect's decision on the same level as the scientific methodology that underlies the pragmatic approach applied to architecture, the creator's intelligence is valued as being capable of proposing a solution and being aware of its limitations. Part of this process starts even before the solution, and is in the way the problem is formulated (as performed in identifying the problem of the Bairo da Jamaica), and thus,

> Not only is criticism (intelligence) necessary, the main task of pragmatism-as-method is to make criticism better. Intelligence is improved by becoming more experimental and more democratic: expanding the range of those whose experience bears on one's own inquiries; and being open to wider social circles of information, reflection and criticism. (Macarthur, 2017, p. 109).

5 FROM THE UNFINISHED SOLIDITY TO THE TRANSLUCENT FOLD

The solution envisaged for the problem described above, concerning the buildings of the Bairro of

Jamaica, goes through an understanding of the structure in reinforced concrete in its most basic form, that is, a skeleton that allows the treatment of openings of free form, as advocated by Le Corbusier, in 1914, while developing his prototype Dom-Ino structure.

In the Dom-Ino structure, the wall, an opaque mass, reminiscent of its function throughout history as both structure and fence, no longer exists. However, according to the appropriation phenomenon found in the Jamaican Quarter, a Dom-Ino is an element lacking in parts to become a home, or, in its most primordial function, a shelter.

The materiality of the phenomenon of self-construction seen in the Bairro da Jamaica suggests the intention of the solid wall and at the same time the dematerialisation of the same with the placement of the translucent movable element, a window in this case. Both elements can be considered as spontaneous since no project analysed the choice as a whole, those being mainly fruit of the economic means of the population that inhabits and built it, although, within this limitation, it is possible to see some variations of that, which suggest formal and aesthetic intentions.

It has already been seen throughout this text that these two elements are in tension: there is an excess of the first (wall) and scarcity of the second (window).

Speculatively, the inherent characteristic of the architecture project, it is possible to reconcile the two elements and their respective inherent function through a spatial procedure: the fold.

In its behavioural description, "the fold is a flexible element that allows for differentiation while maintaining continuity." (Coffeen, 2014). Therefore, in its application to the specific physical form of the need to be wall and window at the same time, it would maintain the immobile factor of the wall, and the desire to be dynamic and transparent expressed through the window.

In its most basic form, this procedure can be explained on a sheet of paper folded accordion-shaped, able to retract completely, opening like a window, and when stretched to become a barrier, therefore, a wall.

The characterisation of the bending behaviour reveals another characteristic of the fold that goes beyond being able to transform into factor A and factor B, according to its geometry in a given time:

> The fold overcomes binaries including the binary between binaries and not binaries. Which is to say, the fold doesn't just replace either/or with and. It supersedes the distinction by offering either/or and/or and. It all depends on the mode of the fold. (Coffeen, 2014).

With the addition of the theoretical understanding stated above, it is possible to make another parallel of the paper accordion and the membrane constructed by the inhabitants of the District of Jamaica, limited by economic factors in the choice of construction elements, but which, nevertheless, obtained results with unpredictable variations (Fig. 2), just like a fold, where

Figure 2. The membrane applied at the blocks with various configurations made possible by the fold. Source: Author's drawing.

the act of "molding amounts to modulating in a definitive way; modulating is molding in a continuous and perpetually variable fashion" (Deleuze, 2006, p. 20).

One might think of the total incompatibility of Gilles Deleuze's thinking with a pragmatic approach, however, as previously reported, this method of approach does not limit the use of theoretical inquiries, provided they can be used in a purposeful manner practical and testable.

Before the conclusions of this article, as a helpful, creative appendix, the theoretical definition presented by Deleuze will show another possible way of the fold besides the primordial function for which it was projected, that is, to be a foldable membrane that serves like window and wall at the same time.

6 FROM THE FOLDED PAPER TO THE PROJECT

From the transmutation of the paper prototype (which served as a model and not as a drawing tool) to the project to be built, there are several choices to take into account. This stage is the most creative moment in the process, where paper must become an object of greater dimensions and a lot more resistant. Once the formal configuration is already defined, the focus is on the materials and its performance.

The first incompatibility in this process arises precisely at the fold, and automatically results from the increase in its thickness, a consequence of its increase in scale. If on paper the model fits in one hand, to serve its purpose in the real scale the dimensions are between 2.5 meters in height, with a variable length according to the spans of the concrete skeleton beams.

Since current engineering does not allow a blade in this scale with the same behaviour verified in paper,

Figure 3. Diagrammatic view of the membrane with the materials and parts that comprise it. Source: Author's drawing.

and also the same resilience, it is chosen to divide the real scale of the structure in two: (A) one to serve as a fold and (B) as an element without deformation (Fig. 3).

For the first one (A element) the choice rests on the use of recycled granulated rubber, with a thickness of 8mm. This material has widespread use as a soft floor, and its choice as a fold falls mainly on the ecological component and the fact that it is cheaper than vulcanised rubber.

Rubber also has waterproofing properties throughout its area, which makes it an asset especially when its contact area is pressed against element B. Finally, the behaviour of the material when folded works perfectly with the purpose that is intended, therefore allows the tensioning and the return to its original form.

The B element of the membrane is 35 cm wide with a height of 2.5 m. Due to the need for the material to allow light to enter and at the same time to be economically feasible, it was decided to use transparent polycarbonate sheets with a 1.6 cm section composed of 3 layers.

This material has a reasonable sound insulation capacity, being able to serve as a barrier to sounds of up to 21 dB (SABIC, 2013: 21). Nonetheless, a value still below 27 dB than a standard 4 mm glass window offers (Scherer & Pizzutti, 2005, p. 1809). Because of the location of the Bairro da Jamaica, within a consolidated block, therefore, without contact with non-local access streets, external noise is not a significant problem.

Regarding the thermal insulation capacity of the polycarbonate, the indicated membrane specification

Figure 4. Detail of the connection of element A with element B. Source: Author's drawing.

is more than twice the capacity of a 4 mm standard glass (SABIC, 2013, p. 21), making it especially useful for the winter season, since in summer the possibility of fully opening the panels makes the thermal behaviour a minor item.

At the two vertical ends of B element, the use of U-shaped profile PVC angles is provided to avoid the proliferation of fungi inside the polycarbonate alveoli, which would compromise their transparency.

Stainless bolts provide the union of the elements A and B with nuts, located in the 3 cm part of the rubber that overlies the polycarbonate, alternating between front and back to allow the fold in accordion more easily. The pressure of the screws pressing the rubber against the polycarbonate waterproofs the parts and makes it a single membrane (Fig. 4).

As stated throughout the text, the spans of the reinforced concrete structure of the Bairro da Jamaica are variable, requiring a rectangular aluminium structure that grips the building and serves as a conduit where the membrane slides on rails.

At the lower and upper horizontal edges, a projection of the aluminium plate towards the outside occurs, to make just the spacing between it and the angle that covers the membrane. This is useful for the situation in which, although the membrane is fully stretched to "close the wall", the "zigzag" of the folds advance to the outside area of the building's floor, and even so are still inside the aluminium projection.

7 CREATIVITY AS A RE-SIGNIFICATION OF THE EXISTING

We could close the article after explaining the folding membrane and proceed with the conclusions. However, we believe that after all the restlessness that guided the process of its design, we would be missing a valuable chance to raise other possibilities that are present in this membrane.

It would be like cutting the sheet of paper to be in the proper shape to be folded in the various segments, and not look at the rest of the paper that fell to the ground; or after the sheet has already been folded as a membrane, not to explore other possibilities that its geometry allows by being tensioned in a way other than what was planned as a wall and window element at the same time.

In this sense, creativity and intelligence go together, in a process that aims to recycle what already exists, giving it another meaning:

> And sometimes a sign becomes a shape and in the world of shapes, generates a series of images that from that moment on have no longer a relation to their origin.
>
> It may happen that a shape frees itself of its significance and survives the contents that originated its birth, or even that the shape is renewed in its significance, almost reborn with an unexpected wealth. It may also happen that certain significance gets hold on a shape although it wasn't originally related to or inspired by it. (Kong, 2013, p. 137).

This is an infinite process, but if we put limitations on the adopted procedures, we obtain results whose application can easily be verified.

If it is defined that the continuous membrane is indivisible between parts A and B, as it is in the application described in this article, we can apply it, for example, as a movable cover, by merely laying the rails on the side.

Moreover, by using the possibility already present in part, it can serve as a wall that becomes a cover, just by using the correct curvature that allows at the top the slide of the membrane, if it is desired that it is sliding. Such a solution could be used as a greenhouse for vegetables (Fig. 2) to be built on the roof of the buildings of the Bairro da Jamaica.

Alternatively, to finish, a simple twist on the vertical axis creates a tension that results in a parametric geometry. If both ends are fixedly attached, the resulting spiral serves as a playful child climbing apparatus with minimal changes in detail that allow the children to cling.

Throughout these possibilities, we never failed to shape the initial fold we had, meeting the definition cited by Deleuze earlier in this article.

Creativity goes hand in hand with the scepticism of facing an object and asking what else it can be beyond what it is at a given moment of time and space, and this procedure can only be promoted by the creator, by having the position to ask the questions and get new answers, in a process that, as we said before, is infinite:

> Everything depends upon how one sets it to work. Like the concept of the sign – and therefore of semiology – it can simultaneously confirm and shake logocentric and ethnocentric assuredness. […] Doubtless is more necessary, from within semiology, to transform concepts, to displace them, to turn them against their presuppositions, to reinscribe them in other chains, and little by little we modify the terrain of our work and thereby produce new configurations… (Derrida, 1972: 24)

8 CONCLUSIONS

Through the creative path presented here, it is clear the added value that is, for someone connected to the creative process, in this concrete case that of an architect, the integration of theory and practice to the process of creation. The mutual cycle of theory to constantly provoke project practice, and vice versa is capable of producing effects that reveal the hidden possibilities of a given object.

A fitting collateral effect of the alliance between theory and practice cannot be ignored: the possibility that, at each stage of the creation process, the object may develop autonomously in other directions. It is the case presented in this article when the initial design of the membrane reaches its full realisation and then is used for other possible purposes.

On the object itself – the folding membrane – this demonstrates through a pragmatic design approach, the ability of the architect to solve concrete problems objectively.

Having as a priority the premise to return, within the private sphere, the right to the light that is denied to the residents of the Bairro da Jamaica, the project process sought the best way to find an architectural solution, limited mainly by cost constraints.

The analysis of the process makes clear the importance of mastery of the capabilities of the material to satisfy the designs instituted at the beginning of the creative process. Creativity and intelligence are closely linked in the processes observed here, both in the pragmatic approach to choosing the folded element and in solving the problems arising from this choice after the transformation of the concept into a form.

As the end of the chain of this pragmatic, creative process, we lack the validation of the hypothesis on which we based that it would be more the appropriate solution. For this, it would be necessary to construct the membrane and evaluate the way of its use with the residents, the durability, among other factors. As we said that being pragmatic means testing for concrete improvements, in this case lifting the membrane's fallibilities would take it back to the drawing board for evolution. Since this was not possible, we consider that this project is complete only to the drawing phase.

BIBLIOGRAPHICAL REFERENCES

Cofeen, Daniel. (2014, June 1). On the Fold: Deleuze, Nietzsche, and the Seduction of Metaphor. [Blog post]. http://hilariousbookbinder.blogspot.com/2014/01/on-fold-deleuze-nietzsche-and-seduction.html.

Deleuze, Gilles. (2006). *The Fold: Leibniz and the Baroque*. London: Continuum.

Derrida, Jacques. (1972). *Positions*. Chicago: University of Chicago Press.

Gorjão Henriques, Joana. (2017-12-21). Famílias do Bairro da Jamaica vão ser realojadas, diz Ministério do Ambiente. *Público*. https://www.publico.pt/2017/12/21/local/noticia/familias-do-jamaica-vao-ser-realojadas-1796849.

Hathaway, Warren E. (2000). A study into the effects of types of light on children: a case of daylight robbery. *IRC Internal reports* nº 659, 11–29.

Heschong, Lisa. (1999). Daylighting in Schools: An Investigation into the Relationship between Daylighting and Human Performance. Detailed Report.

Kaplan, R. (2001). The Nature of the View from Home: Psychological Benefits. *Environment and Behavior*, 33(4), 507–542.

Kong, Mário S. Ming (2013).Creativity, fantasy and architectural culture, *1st Annual International Conference on Architecture and Civil Engineering (ACE 2013)* (pp. 136–140). Singapore. Doi: 10.5176/2301-394X_ACE13.40

Macarthur, D. (2017). Reflections on Pragmatism as a Philosophy of Architecture. *FOOTPRINT*, 105–120. Doi:10.7480/footprint.11.1.1796.

SABIC. (2013). *LEXAN THERMOCLEAR Multiwall polycarbonate sheet* [Technical manual], p.22. https://www.agi.pt/Files/PortalReady/v000/PDF/construcao/Thermoclear%202UV%20Manual%20Tecnico.pdf.

Scherer, Minéia Johann, Pizzutti dos Santos, Jorge Luiz. (2005). Estudo do isolamento sonoro de vidros de diferentes tipos e espessuras, ensaiados individualmente e formando vitragem dupla. *Anais do VIII Encontro Nacional e IV Encontro Latino-Americano sobre Conforto no Ambiente Construído* – ENCAC-ELACAC 2005, 1806–1813.

Towards a more intelligent dwelling: The quest for versatility in the design of the contemporary home

Hugo L. Farias

CIAUD – FAUL, Lisbon School of Architecture, Universidade de Lisboa, Lisboa, Portugal
ORCID: 0000-0001-9346-4039

ABSTRACT: Dwelling, today, must meet the profound social, labour and technological changes that occurred in recent decades, and brought different and evolving requirements to the house. A clear dissociation between emerging ways of living and proposed housing models, heirs of modern rationalist architecture, can be observed. Addressing this question, several authors have pointed to different strategies as a way to find a more suitable house for the accelerated transformation of contemporary ways of dwelling: flexibility, adaptability, functional ambiguity and spatial de-hierarchization. The article aims to frame these concepts, contribute to the establishment of strategies and design tools developed to promote a more intelligent dwelling: a more open-use and versatile interior domestic space, more adapted to change, present and future.

Keywords: Dwelling, Change, Versatility, Flexibility, Adaptability.

1 INTRODUCTION

Intelligence is the ability to adapt to change.

Stephen Hawking

The dwelling is a central theme of research for the architectural discipline, in as much the house is central to human life and human society. The permanent nature of dwelling contrasts with a continuous transformation of the living spaces, since the experiential and social transformations of the human being, over historical time, match a continuous evolution and modification of domestic space. The issue of dwelling is, thus, for architecture, always a problem to be solved.

Today, with the profound changes we can witness in society, the new demands that labour issues begin to establish in the home, and the profound changes introduced by new technologies, especially information technologies, there has been a clear dissociation between emerging lifestyles and the proposed housing models.

It can be stated that housing models generally proposed and built today are maladjusted to the inhabitants' needs and that most of the houses people inhabit, heirs of the proposals of modern functionalist architecture, can be characterized as rigid models in terms of functional predetermination, spatial configuration and hierarchy, both of circulation and of dimension of its different living spaces. This situation reduces their ability to adapt, over time, to different functional requirements, both family and work-related requirements.

To address this issue, several authors and practising architects have pointed out different strategies as possible ways of finding a more suitable dwelling to the accelerated transformation of contemporary modes of living.

These include the concept of flexibility – understood as the possibility to physically transform the dwelling space, so that it responds, in a more rich and varied way, to the needs of the inhabitants; and the concept of adaptability – understood as the capacity of the dwelling space to be able to fulfil different uses and forms of appropriation, without having to change physically. The concepts of polyvalence, spatial and functional ambiguity and *de-hierarchization* of the house emerge as possible answers to the idea of adaptability:

1. proposing that dwelling spaces should not be designed as mono-functional, but developed to allow different functions and distinct possibilities of use;
2. understood as the possibility of proposing spaces without functional predetermination, designed as functionally opened to different possibilities of use and appropriation;
3. the idea of dwelling *de-hierarchization* understood both as the possibility of proposing a higher equivalence of shape and size of housing spaces and as the increase of possibilities of circulation inside the house.

The article aims to characterise the framework of social, labour, and technological transformations that have occurred in recent years and have contributed to the need for diversification of housing solutions. It also aims to frame the concepts of flexibility, adaptability, functional ambiguity and *de-hierarchization* of domestic space, drawing on several authors. Finally, the article aims to contribute to the provision of a basis for the establishment of principles and strategies for the design of a new home, thought for today and tomorrow: a more *intelligent* dwelling.

2 DWELLING AND SOCIAL, LABOUR AND TECHNOLOGICAL CHANGE

Human society exists in constant evolution and transformation. According to Pereira (2010) the house as a vital component of the material culture of a particular society and as a primary territory for the expression of identity and living particularities of individuals who cohabit in it is directly involved in these changes, slowly incorporating and expressing, in its form and organization, the changes in lifestyles of its inhabitants.

However, the acceleration we have witnessed in recent years, in the social change and the transformation of ways of life, lead us to the conclusion that housing, as it today is designed, built and proposed, has become inadequate to the needs of the inhabitants it intends to welcome. It is not surprising therefore that in the introduction to the book *Casa Collage* Monteys and Fuertes ask the following question: How many (architects) are actually building a house that people need in the 21st century? (Fuertes & Monteys, 2001).

3 DWELLING AND SOCIAL CHANGE

According to Ignacio Paricio and Xavier Sust in *La vivienda contemporánea – Programa y Tecnologia* (Paricio & Sust, 2000), the major changes that have occurred in recent years, relevant to the topic of dwelling architecture relate, first of all, to the question of profound social transformations.

As the most important of these recent changes, these authors point out: the increased longevity of people; the significant decline in the birth rate and the consequent decrease in the average size of the family; the declining number of marriages and the increase of non-marital and other forms of family life or family grouping; the increase of age of young people leaving the parental home; the delay in the age of marriage and, consequentially, in the birth of children; the increase in the number of separations and divorces and the consequent increase in the number of single-parent families, single-person households and composed families; the emergence of other forms of living together in the house, besides the

traditional family household (Paricio & Sust, 2000). Sandra Marques Pereira adds to this list, signalling out the importance of individualisation and diversification of the family composition, and pointing out the appearance of a significant number of couples without children, families of DINK (double-income no kids) and LAT couples (living apart together) (Pereira, 2010).

Apart from these issues, these authors also indicate transformations at the level of growth and redistribution of wealth in society and terms of values and habits of society, as crucial factors of the transformation of the contemporary dwelling.

Among a long list of issues, we highlight the ones that seem most relevant to rethinking the contemporary house:

– the transformation of family relationships between different generations;
– the importance given to body hygiene, body care, and the protection of privacy;
– the increase in the number of women incorporated in the labour market; the growing equality between the sexes;
– the growing importance of leisure activities, developed in the home.

4 DWELLING AND LABOUR CHANGE

In addition to the profound social changes, the transformations that recently have been acknowledged in terms of labour and employment also become relevant for understanding the changes in the habits and ways of life of the dwellers.

On the one hand, we are witnessing a period of high mobility for reasons of employment: many families and individuals have to move to ensure a regular and secure job; many have to move for career reasons or to follow a job opportunity, also as a result of the globalization of companies and the labour market.

This labour mobility raises several different issues:

– on the one hand, the growing demand for smaller homes, for individuals living alone, sometimes temporarily, close to the workplace;
– on the other, the growing need for houses that can accommodate other models of life and lifestyles, in as much as each individual or displaced family carry with them a set of cultural values and modes of living that determine the use and appropriation of the dwelling space.

Also, with the new technological possibilities, the house is now able, once again, to include the workplace within the dwelling structure, for a significant number of different professions. In fact, this growing trend is becoming an interesting choice for many persons and companies, mainly because of the savings it can mean: personal savings in terms of avoiding travel cost and time between home and work; and company

savings in terms of diminishing space requirements in the workplace. Working from home also provides a different way to develop the profession, less conditioned by schedules, rules and other entrepreneurial conditions and more adapted to the rhythms of family or individual life. Depending on the kind of work developed, the activity may require an autonomous space with a specific characterisation. In some cases, the development of the profession in the home may entail an autonomous relationship of the working space with the exterior, for example. All this should be taken into account when considering a dwelling for today.

5 DWELLING AND TECHNOLOGICAL CHANGE

Finally, the house has undergone a profound transformation through the technologies that have continuously been invading its interiors. A first period of significant change – especially from the second half of nineteenth century until the beginning of the twentieth – can be associated with the progressive search for modern comfort, through the introduction, in the house, of all the amenities that technology could offer, in the period: electricity, gas, running water and plumbing began to slowly become common in the domestic interior (Rybczynski, 1989).

A second important moment can be witnessed in the middle of the twentieth century, mostly after World War II, and as a direct result of the significant technological advances that stemmed from the war effort. This is the time for electrical appliances to invade the home, a time featured by significant incorporation of equipment and devices in the house, that were to transform domestic life: washing machines, dryers, ovens, refrigerators and freezers, heaters, blenders, among many others.

More recently, and with an equally significant impact on the dwelling, the multiplication of audio-visual and telecommunications equipment came in to transform the lives in the house radically. At first, the location of the main audiovisual and communication equipment constituted different *foci* that organised the mode of use of a particular dwelling space: the radio and the stereo system, and the centralizing presence of the television set in the living room; the location of the landline phone in the living room or the entrance hall, are examples of the relationship established between equipment, space and use.

However, the technological evolution of these devices has led to their gradual spread around the house, first with the proliferation of phones and television sets, still as fixed pieces of equipment, in living rooms, bedrooms, kitchens; then with the emergence and proliferation of mobile devices that do not belong to any space: they are wherever its user is. The relationship between space, equipment and use ceases; there is no longer a focus that unifies the members of the family; each inhabitant establishes his centre.

All of these issues contribute to the realisation that the house is in a paradoxical situation: on the one hand, the activities that dwellers develop in the house are generally the same as they have always been; on the other, there is a significant transformation in the way these activities are carried out.

The house today has a very diverse population, with different and varied demands, needs and preferences, generating occupations and also uses of great diversity; the acceleration that characterizes the changes that have been taking place leads us to believe that this is not a closed process but, on the contrary, it is a growing tendency. More and more, the house will be the host of different, transforming and evolving lifestyles and modes of living.

For all these reasons, a reflection on how the house should accommodate this present diversity, and try to foresee its future adequacy, by providing a full range of answers to the growing demands by expanding its usability, seems to be fully justified.

6 A MORE INTELLIGENT DWELLING

In order to meet the challenge facing the design of dwelling – the quest for a more intelligent dwelling, a more open-use and versatile interior domestic space, more adapted to future change –, several authors, starting from the 1960s, began discussing and proposing the ideas of flexibility, and adaptability as possible answers to a more open conception of domestic dwelling space.

More recently, the idea of ambiguity (or functional indeterminacy) was introduced in the architectural debate, for which contribute the principles *de-hierarchization* of the internal organisation of the house.

The idea of flexibility within the domestic space is a very comprehensive concept with distinct interpretations for different authors. This concept presents itself as an appropriate response to the excessive determinism of the house, as an opportunity to respond to the identified social changes and the evolution of lifestyles; and as a response to present-day dissociation between proposed housing models and emerging ways of living (Paricio, Sust, 2000). For Monique Eleb-Vidal flexibility poses the problem of habitat adaptation to the ways of life of users, while at the same time sets the possibilities of appropriation of dwellings by the dwellers. (Eleb-Vidal, 1995). In other words, flexibility may be the critical factor for the possibility of a dwelling design that answers the question of how to propose a spatial and constructive structure – which is by nature static and long-lasting – that can adapt to different inhabitants, with distinct and changing social, cultural, and space-use characteristics. Also, as Eleb-Vidal points out, a design that is more open to a richer and more varied appropriation by the dwellers.

Although more commonly associated with the ability to physically change the shape of the domestic space – through mobile walls, sliding doors and folding panels – the idea of flexibility must be viewed in a more comprehensive way, as the possibility of creating greater versatility in the house and should primarily be thought of as a matter of potential (Fuertes & Monteys, 2001). As Rem Koolhaas states in *S, M, L, XL*:

> Flexibility is not the exhaustive anticipation of all possible changes. Most changes are unpredictable. [...] Flexibility is the creation of margin–excess capacity that enables different and even opposite interpretations and uses. (Koolhaas, 1995, p. 240)

In this sense, the concept comprises both the idea of active flexibility and the idea of passive flexibility; these are two types of strategies – which can complement one another – that can contribute to the design of a renewed house, a house more open to different use and appropriation, better prepared for the evolution of dweller use, more able to allow and host changes in family composition and life, and more capable of receiving the future incorporation of new equipment and activities.

By active flexibility we can understand the solutions that are characterised by the possibility that they offer the inhabitants of physically changing the shape of the interior spaces of the dwelling.

In this category we find technical solutions that seek to distinguish, in the design process, the fixed elements from those that may be designed as movable or changeable components; taking advantage of the possibilities of the latter, solutions based on the idea of active flexibility propose the use of moving/moveable parts (or elements that can be installed and removed easily) that can ensure different interior configurations of the domestic space. Among these flexible space-defining components one can find: light construction walls, easy to assemble/disassemble, or even moveable; sliding or folding panels and doors; easy to install/uninstall cupboards, cabinets and wardrobes, working simultaneously as storage and as spatial partitions, etc.

According to Monique Eleb-Vidal (1995), this space transformation approach can be seen in two different ways: as initial flexibility and as permanent flexibility.

In the first case, the principle is that future inhabitants can choose the configuration of the interior of their dwelling, thereby participating in the design of their home, but only at the initial moment of its occupation. This approach, with direct implications for the architectural design, but also for the very construction process, is of particular interest in the role that each family or individual can play in shaping a specific solution for the internal configuration of the home, thus allowing for a better match between dweller's needs, aspirations and appropriation of domestic space. It is less attractive in the long run because it does not propose solutions designed to accommodate future change, in family structure and family life, transforming and evolving dweller use, etc.

Permanent flexibility, still a proposal based on an active flexibility strategy, proposes technical solutions that seek to ensure the possibility of changing the inside domestic space throughout the dwelling's lifetime.

In this case, the main idea is to design moveable or moving components that allow, in a simple way and in the short or long time, for the adapting of the house to future change and to modifying use and appropriation needs of the dwellers.

By passive flexibility – also named by some authors as adaptability – we can understand the idea of ensuring different possibilities of use and appropriation in the domestic interior without physical alteration of its spatial structure. As stated by Gerard Maccreanor in his article *Adaptability*:

> Adaptability is a different way of viewing flexibility. The adaptable building is both transfunctional and multifunctional and must allow the possibility of changing use; living into working, working into leisure or as a container of several uses simultaneously. (Maccreanor, 1998, p. 40).

Cabrita and Coelho, long-time researchers in the field of housing architecture in Portugal, also support the idea of adaptability as central to the design of the domestic interior. These authors indicate a set of design principles for ensuring the adaptability of housing interior spaces, among which are: design of the different spaces without significant dimensional variations; design architecturally neutral spaces to minimize the functional determination of each compartment; design and position doors and windows so as to minimize their possible space-use limitation, and maximize different uses; design circulation spaces and areas in order to increase their capability for other uses; design spatial configurations that encourage and multiply the relationship and connection between different compartments of the dwelling (Cabrita & Coelho, 2009).

The idea of adaptability is directly related to the concepts of spatial ambiguity, polyvalence and functional indeterminacy, also advocated by several architects and authors.

The idea of ambiguity arises from the motivation to counteract the excessive functional predetermination that most of the current housing solutions – being heirs to modern-movement housing research and realisations – still present.

In fact, under the influence of the process of rationalisation of the design process that occurred from the beginning of the twentieth century, the design of the modern functionalist house is primarily based on the idea of efficiency, being founded on a three different levelled predetermination: an objective determination of domestic activities and functional requirements; the

determination of the 'right' shape and size of each compartment to accommodate these activities, functions and needs; the determination of the relationship between each of these spaces, also dictated by purely functional assumptions. This results in a housing space configuration, whose spaces are rigidly hierarchical, both from its size and area and from its position and relative spatial relationship.

Ambiguity – both functional and spatial – can thus be understood as the possibility of designing and proposing dwelling spaces without functional predetermination, that is, open, because of its features – its area, shape and architectural characterisation, – to different possibilities of use and appropriation. Ambiguity points the way for the *de-hierarchization* of the dwelling space.

Monteys and Fuertes (2001) support the idea of spatial and functional ambiguity as a means to achieve a house more open to different use and appropriation. They state that they can assure that the higher the specialisation of the house has been, and more undefined spaces have disappeared from its internal structure, the greater has been the loss of flexibility in the dwelling. These authors argue for a greater formal and dimensional equivalence between different compartments of the house and a greater functional indeterminacy in the design as a means to a more interesting home. Paricio and Sust (2000) are also among those who maintain the idea of an ambiguous partition of the house, as a possibility to expand the versatility of the use of space, without the need for physical transformation.

Finally, the idea of *de-hierarchization* of the dwelling space, which appears as an idea that brings together some of the previous topics: it refers to the dismantling of the traditional dimensional and formal hierarchy of the house, being supported in the same concept of the ambiguity of spaces. The proposal is to establish formally and dimensionally equivalent dwelling spaces so that this indeterminacy constitutes an opening to use, that is, that each dwelling space can accommodate the development of various and changing household activities. It also refers to the dismantling of the relationships traditionally established between the different compartments of the house, suggesting that the circulations should be incremented and even duplicated, circulation redundancies should be proposed, in order for the house to liberate itself from the excessive hierarchy of movement between its spaces.

In the search for the idea of *de-hierarchization* of the dwelling space, some authors have pointed out the fact that many pre-modern urban housing solutions have internal spatial organisations with features and qualities that today we are seeking for the design of a renewed home:

– low functional predetermination of spaces;
– formal and dimensional equivalence between compartments;

– circulation multiplication and increased communication links between different compartments;
– duplication of entries to the home;
– the existence of different kinds of spaces in direct contact with the exterior of the house.

All these features extend the possibilities of use and appropriation of the house, allowing different models of life and their change and evolution over time. Thus, they constitute spatial organisations that should be considered relevant case studies for the analysis and verification of the ideas outlined; also for the establishment of principles and strategies for a more flexible home.

7 FLEXIBILITY STRATEGIES: SOME GUIDELINES FOR THE DESIGN OF THE DWELLING SPACE

The achievement of flexibility in the domestic space has to be considered from the beginning of the design process, in as much as it is deeply related to structural, infrastructural, spatial and tectonic features. In this sense, it is not a method that can be introduced in a design process; to be consequent, it should be a foundation to the design development. This final part of the article aims to point out some of the most important design strategies that can be used in the pursuit of the possibilities of flexibility in the domestic space.

8 BUILDING STRATIFICATION – THE FIXED AND THE MOBILE

This strategy recognises that flexible domestic space is conditioned, firstly, by the fixed and permanent elements and the way these may allow for variable use. Several authors – Habraken (2000), Leupen (2006) and Brand (1997) – studied the relationship between different architectural elements that define the building, focusing on how their design should maximise flexibility and transformation. These authors identify a set of elements that have longer life cycles and are more difficult to alter, change or remove; and elements more prone to transformation. They propose a design that ensures the independence of different layers or elements, so that change is possible in the less permanent ones, without affecting the others. In a flexible residential building, structure, skin, services and space should thus be designed as autonomously as possible.

9 DWELLING FACILITIES – RATIONALISING AND LIBERATING DOMESTIC SPACE

This strategy focuses on dwelling facilities – mainly kitchens and bathrooms: their design solution and their position in the interior space. The main idea is to design these spaces as efficiently as possible, to organise/concentrate/arrange them in the most optimised

solution; this will have benefits in rationalising domestic infrastructure – water supply, plumbing, fume exhaustion; and liberating as much space as possible for the other uses of the house.

10 MOBILE PARTITIONS – TRANSFORMING INTERIOR SPACE

This strategy focuses on mobile, configurable and changeable elements: walls, doors, cabinets, cupboards and wardrobes. These components can be designed to be sliding, folding, and moveable components, or to be easily installed and removed whenever necessary. Based on these possibilities of transformation, the interior space of the home can be altered: different rooms can be joined or separated; the spatial disposition of the house can be more or less divided.

11 CIRCULATIONS AND ENTRIES

This strategy focuses on circulation and entrances to the house. As was argued when discussing the idea of *de-hierarchization* of the domestic space, strong hierarchy of circulation and mono-functionality characterises modern dwelling models. The idea behind this strategy is to counter this situation through three types of solutions:

a) design of circulation areas as multifunctional spaces;
b) design alternative circulation paths through the house, incrementing relationships between compartments;
c) design alternative entrances to the house, connecting different functional sectors to the exterior, increasing the possibilities of an interior-exterior physical relationship, and augmenting the potential use and appropriation of the dwelling.

12 AMBIGUOUS SPACES – INCREASING THE POSSIBILITIES OF DOMESTIC APPROPRIATION

This strategy is primarily related to the idea of adaptability. The idea is to design the different spaces of the house as undifferentiated rooms, both functionally and spatially. This means designing the main rooms of the house based on an equivalence of dimensions, area, shape, architectural features, inside-outside relationship and circulation. A house based on this kind of design solution will assume the ideas of adaptability and polyvalence as its main objective, proposing an open use and appropriation of its interior spaces

by the dwellers, in as much as it is not designed for a functionally predetermined purpose or a programmed circulation.

13 FINAL CONSIDERATIONS

Social, labour and technological changes are reflected in contemporary lifestyles and modes of dwelling, which are also in continuous change. The inherited housing models of the modern period feature a spatial and functional rigidity that hinders their suitability and adaptation to the needs of the dwellers, both present and future.

Flexibility, in its various aspects, presents itself as a possible way for the design of a more adapted and suitable home for each dweller, and also more open to future needs and aspirations. Strategies for the design of a more flexible and adaptable dwelling have been introduced, developed and implemented during the last decades, but their study and application should be furthered, to give answer to the growing need for a more suitable and adequate provision of dwellings, in a time of accelerated social, labour and technological change.

The pursuit of versatility in the design of the contemporary house is justified because, in a time of permanent and significant change, it might contribute to the design of a more intelligent house.

BIBLIOGRAPHICAL REFERENCES

Brand, S. (1997). How Buildings Learn: What Happens After They're Built. London: Phoenix Illustrated.

Cabrita, A. R., Coelho, A. B. (2009). *Habitação Evolutiva e Adaptável*. Lisbon: LNEC.

Eleb-vidal, M., Chatelet, et al. (1988). *Penser l'habité: le logement en questions*. Paris: Pierre Mardaga Editeur.

Fuertes, P., Monteys, X. (2001). *Casa Collage – Un ensayo sobre la arquitectura de la casa*. Barcelona: Ed. Gustavo Gilli.

Grupo de Investigación Habitar (2010). *Rehabitar en nueve episodios*. Madrid: Ed. Lampreave.

Habraken, J. (2000). *El disenÞo de soportes*. Barcelona: Ed. Gustavo Gili.

Koolhaas, R. (1995). *S, M, L, XL*. New York: The Monacelli Press.

Leupen, B. (2006). *Frame and Generic Space*. Rotterdam: 010 Publishers.

Maccreanor, G. (1998). "Adaptability", in *a+t – Housing and Flexibility* I (12) p. 40–45.

Paricio, I., Sust, X. (2000). *La vivienda contemporánea*: Programa y tecnología, Institut de Tecnologia de la Construcció de Catalunya.

Pereira, S. M. (2010). *Casa e Mudança Social*. Lisboa: Ed. Caleidoscópio.

Rybczynski, W. (1989). *La casa: historia de una idea*. Madrid: Nerea.

The house as a mirror and support of identity: Reflections for a more conscious and subjective inhabiting

António Santos Leite

CIAUD – FAUL, Lisbon School of Architecture, Universidade de Lisboa, Lisboa, Portugal
ORCID: 0000-0003-2529-5362

ABSTRACT: To reflect on the individual house, understand it as the 'support of an identity'; that is, accepting it as an effective 'mirror of the individual', a condition that for us is a topically subjective and interacting reality, which we create under multiple forms and that also reciprocally affects us. Specifically, we propose the valorisation of an identifying house as an operative means which qualifies the dwelling and, in a wider sense, a conscientiously more differentiated and subjective life.

Keywords: home, individual house, identifying the house, individual dwelling, individual inhabiting

According to Pallasmaa (2016, pp. 7–8), the act of inhabiting, which here we designate as a house, is the fundamental means that we have to relate with the World. It is essentially an interaction and an extension; because the inhabitant is situated in the space, and this space is situated in the conscience of the inhabitant, therefore this same space becomes an exteriorization and extension of his being, both from the physical and mental point of view.

In the bourgeois and post-modern World we live in, at least, the house is always dreamt as an individual house, archetypical and matrix-like. It tends to be, when all limiting pragmatism are pushed aside, a very pure immanence which, both culturally and instinctively, has a tendency to fulfil a tacit desire of identity, since, despite all the functionalist mythmaking of the Modern Movement, no one truly dreams their home as an anonymous and abstract inhabitation cell in any collective building. As such, assuming the rejection of a strictly abstract referencing, we seek to understand, and obviously also to defend here, how such a house can be understood intentionally as a 'support of an identity'; that is, accepting it as an effective 'mirror of the individual', a condition that is for us a topically subjective and interacting reality, which we create under multiple forms and that also reciprocally affects us. We can subscribe to the idea of that which we call home is our place in the World, regardless of the Architecture that limits it (Bañón, 2003, p. 37).

Therefore, in this conception of inhabiting in which individual subjectivity becomes hypertrophic, and where the dimension of the private and the domestic, 'our space', 'the space known to us', emerges as a central reality of a very individual understanding of the World, the House is likely to present itself potentially as a very significant pivot in our identity drives. In this house, we are hence confronted, in a Matrix-like way, with a reality in which the individual is reflected and assumes himself as a key-character of the construction, because it implies that it is he who shapes it organically and symbiotically and that provides it with its true meaning; that is, in this house we face a conception which, in the face of the idiosyncrasy inherent to its subjectivity, only its promotor can provide value and meaning to. As Gaston Bachelard posited,

> What would be the use, for instance, in giving the plan of the room that was really *my* room, in describing the little room at the end of the garret, in saying that from the window, across the indentations of the roofs, one could see the hill. I alone, in my memories of another century, can open the deep cupboard that still retains for me alone that unique odor, the odor of raisins drying on a wicker tray. (Bachelard, 1994, p. 13)

So, if we accept that the House can be much more than a mere physical reality – since, in a certain way, it is "the centre of the universe; one takes hold of the universe when becoming owners of the house (Bachelard, 1948, p. 106)[1] – incorporating the subjective aspects by those who inhabit and imagine it, therefore, at the limit, only that individual can truly know it. As such, only he can do to it, especially to its most personal details, a coherent and significant judgement. In fact, the house that we here seek may clearly emerge as an egocentric and subjective product, at times difficult to integrate in any collective culture, which is why it

1. Author's free translation. "[elle] est le centre d'un univers. On prend possession de l'univers en se faisant maître de la maison".

Figure 1. Raymond Isidore, *"Maison Picassiete"*, Chartres (1928–1964).

is not surprising that many of these houses, especially when they are assumed as being unruly and exuberant, and thus shunned for 'good taste' contentions, mediation and compromise inherent to the generality of the collective values, only assume value to the I that can signify it, emerging thereby often ostracised by cultural values of the collective or the cultured.

Notwithstanding this finding, we must mention that, paradoxically, this individual signification of the house may be amplified to a restricted group of individuals, for example, a family or a group with shared values; that is, it may transform itself in a 'collective individual', provided that all possess the same significant codes and can, this way, attribute a generically similar value to the subjective elements and contexts that they have to value.

A limit example of this extended individuality, despite the scale and the collective rule, which determines it, could be the royal palace of Versailles and the symbology associated with it. Actually, this 'large house', a reference of 17th and 18th-centuries French classicism, tends to be inseparable from the identity trilogy established between this construction[2], the

King, and the French state. This reality is highlighted by the ritualized inhabiting celebrated by the King and his Court, thus assuming itself as the obvious location for the celebration of a collective liturgy that simultaneously highlighted a real "I" – that is, an individual subject, its absolute king Louis XIV – and a collective "I", that is, the nation of France. As such, this identity thus materialised itself, both by an architectural shaping that located the monarch's bedroom, its significant "I", as the matrix centre of that enormous house, and by a public planning of all its activities, a routine that would predefine the spaces and the time for the majority of royal acts, which would range from specific government acts to the mere daily and physiological life of this sovereign.

As Burke explains, such activities would be precisely planned from the moment of waking up, *la cérémonie du lever du roi* until his last act of going to bed, *le coucher du roi*. Moreover, Burke further states that this strict royal routine it was noted that with an almanack and a clock one could say, even three hundred miles away, what the King was doing (Burke, 1995, p. 85).

Once understood this context of affirmation of the primacy of the individual and the subjective in the meaning of the house, even if this individual is, as we have seen, paradoxically collective, it is no wonder that at the end of its materialisation process, the individual that signifies it is likely to emerge closely connected to his creation; that is, he tends to emerge strongly interlinked with it and, often, identified with it. On the essence of this reality, writer and art critic Mario Praz defended explicitly the search for an idea of *Stimmung*, which was the way in which a dwelling expresses the character of its owner, the way it reflects his soul (Rybczynski, 1986–2003: 53–54), pointing out that, for him, the essence of the house was thereby the individual subjectivity.

That way, tendentially it makes sense that the metaphor of the house's conception as a mirror of the individual reveals itself, directly, in the subjective and interacting way that is particular to it as a singular process of creation. A process which, due to this specificity, can consequently easily become narcissistic and selfish, since we cannot forget that, as Camps says, individualism means atomisation, closure within the private sphere, and disaffect regarding the public (1996, p. 17), therefore only creating a dialogue between a subject – an "I", a 'significant subject' – and the House that he conforms and that we associate to a large mirror.

In effect, the mirror metaphor conveys, in our opinion, the deepest meaning of the dialectic relation that tends to be established in any identifying house, since it is the subject who conforms the 'mirror', it is the house that totally or partially reflects and consequently

2. More objectively, the construction of the Royal Palace of Versailles' complex happened throughout a large temporal arch that transformed it from a hunting pavilion, built in 1624 under King Louis XIII (1601–1643), until the liberal initiatives of King Louis Phillipe (1773–1848), who then transformed it in 1830 into a palace dedicated to '*all* France's

glories', a reality that would be confirmed in 1873 with its definitive change into a museum; author's note.

Figure 3. Fernando Távora; exterior and interior view of the *'Covilhã House'* (1973–1976).

Figure 2. Museum-House of Mario Praz, Pimoli Palace, Rome. Caravaggio, *'Narcissus'*, 1594–1596, Galleria Nazionale d'Arte Antica.

conditions him in his future. In truth, this metaphorical mirror could even be assumed as, according to Régnier-Bohler, a damnation lake or an object that is symbolic of the act of resending of the being to his own corrected image, introducing the record of the illusory of which the gaze can become guilty of, through the perils of a vision that aims to be truthful (1990, p. 373).

This mirror reflection provided by the house can thus allow the subject to project, with more or less intentionality, images or 'seductive expressions' of his life and identity; such projections could make him think, within idealisations that can last minimally unaffected through time, that his identity can overcome his inevitable physical limit through his construction; that is, that allow him to have the belief of the metaphysical overcoming of his death.

Nevertheless, it is also noteworthy to mention about such images and identifying intentions that are projected in the house, that, obviously, these are not necessarily mere objective reproductions of some immediate reality of the subject, since we must consider the fact that "the non-I that protects the I" (Bachelard, 1994, p. 5). This factuality, ambiguous yet intrinsically human, thus tends to conform in the construction of the house as an idealised projection made up of an amalgamation of realities, unrealities and subjectivities,

which as a whole tends to reveal itself, intentionally or not, as a mask. Such mask assumes itself, narcissistically, as the desired alter-ego, as the house, states Santamaria, indicates common and collective senses of the lived experience which contain and elevate the bordering behaviours between intimacy and someone's ways of acting in public life (1999, p. 39).

Upon this comprehension, in which the individual assumes himself in an identifying way as being in a direct correlation with his house, begins to unravel an umbilical cord, or, better yet, a 'life cord', which, according to our opinion, is subjacent and intrinsic to the relation that exists between himself and the House he builds and that builds him – 'his house'. This life cord, therefore, tends to denote itself from the act of creating, whether by the evident relation of 'giving birth', or by an effective filial relation that self-nourishes from the common life between both. That is, beyond the first moment of scission of the 'umbilical cord', taking place at the matrix act of creation, the subject and his House keep metamorphizing each other mutually through the interactions that occur in their inevitable 'life together'.

That way, the idea of interaction between a subject and the House that is likely to signify him is revealed to us as a matrix-like truthfulness, given that, if the subject is responsible for the initiative of the creation of his own house, then the latter reciprocally conditions and shapes him through the stimuli and life experiences it tacitly imposes on him.

On this dialectic interaction, Fernando Távora wrote about 'his' Covilhã house, an old rural manor house he rehabilitated for himself as a refuge and a place of identity:

> We have known each other for long. Yet, I only began knowing her better when, together, we began the romance of her – and our – transformation. It was, thus, ten years carefully fixating and deciding the transformations that we both – she and I – would lovingly accept. We have known each other for long. Yet, now we know each other better, and we are both different. (1993, p. 131[3].

So, once this specific inter-relation is established, one could even accept the identity fusion that tends to always occur between a subject and the habitational reality built by him as a constant, which thus remains as a testimony of the multiple lived experiences and identity-related memories that this 'subject-house' pairing has sedimented throughout its evolution process.

Beyond the specificity of this interaction between a subject and his individual house, another comprehension process can be established which, also within this reflection and although dependent on it, could open one other pathway for the understanding of another matrix-based variable intrinsically linked to the house, a pathway that can be briefly named here as the 'sense of belonging'. Specifically, this sense, which we can partially dissociate from the more restricted content of a 'sense of possession', presents itself also as an emotional and individual referential that grants, or can grant, an eloquent value to the concept of the house which we seek.

With effect, this sense of belonging, a sense that is likely to be established between a significant subject and his house, may be responsible for another degree of involvement intrinsically subjective, and therefore also potentially shunned from cultural collective codes and, as such, capable of providing the house's reality another identifying and qualifying value. This differentiation of meanings, apparently not very relevant, tends to enclose in itself a content that is effectively differentiated since, in the identifying process, more than a sense of possessing a strong sense of belonging tends to establish itself. This sense is distinct from the first because one can belong without actually possessing. Besides this reality it is even possible to mention that, in a certain way, the sense of belonging might overcome from an identity perspective the sense of possession, because ultimately the latter assumes an instrumental value due to the abstract potential of exchange, rather than a deeper feeling that is implicit to the sense of belongingness in which that instrumental value tends to be an unquantifiable material reality.

Nevertheless, for a broader comprehension of the problem we pursue, and also in association to this subjective and emotional context of belongingness

established between a significant subject and his house, we must also seek to reflect on the sense that the individual has to mark his construction – in 'his world' –, a strong desire for newness; better yet, on the sense that the individual has to want to leave marked in his house something strikingly new.

As such, in this process of construction of the individual house we tend to notice a generalized desire, which we can call a 'foundation desire', a desire that can be understood by the almost instinctive need that the subject has of signalling from the beginning the identity he wishes, since we can subscribe to the idea that, as says Bañón, the house that one aims to build proceeds from the demolition of the previous; t is not about reforming the pre-existing, of rehabilitating, but rather of replacing and building a different one in its stead (2003, p. 58).

In spite of this insight, which is particularly evident in societies where individualism is likely to emerge as common-place, be it by the matrix of a bourgeois and liberal culture built from individualism and suspicion of the collective, or by the permanence of a rural imaginary where land possession represented a relative autonomy from third parties, it is also clear that this 'foundation desire', for understandable economic and pragmatic reasons, might not be fulfilled in a large majority of cases. Indeed, this desire tends to be pragmatically mitigated due to resource scarcity, since the dimension of material and sentimental means involved in the construction process of a house, and particularly of an individual house, imply the possible commitment between both the physical or symbolic pre-existences of the built space, and the economic and material resources that are effectively available. In this context, it is easily understandable that, in spite the fact that in many cases it is not possible to build a house from scratch, this foundation desire may manifest itself using a partial remodelling that is as significant as the pre-existing identity of construction allows. In fact, this need for individual marking of a territory can also be seen, even if limited in its physical and symbolic extension, in the generalised necessity of appropriation and interior remodelling of any dwelling that is more limited or temporary[4] when there is a change of owner or tenant.

As such, in order to close the current reflection about the individual house, an identifying and subjective house that emerges as a potential mirror of the individual, we can affirm that the delimitation established initially is likely to reveal many of the reasons that may be underlying the matrix-like dialectics established between the subject and his house.

3. Author's free translation.

4. This reality of need for appropriation and remodelling of any dwelling is clearly evident, even in the remodelling of a dwelling that is integrated in a collective building, the reason for which, whilst limited in its possible expressions, it may reveal itself in its essence as a truly individual house; author's note.

Figure 4. Aerial photograph of the outskirts of Sommerville, Massachusetts, no date. Hreinn Fridfinnsson, *'House Project'*, 1974.

It is a process from which the potential affirmation of an identity desire, both architectural and socially collective, emerges as the most meaningful constancy, given that, says Echeverría, the structuring of dwellings through the delimitation of private dwellings is a process that occurs in parallel to the social emergence of individuality, substantiated by cities and states where the bourgeoisie has prevailed (1999, p. 16).

That way, the perception of this individual house tends to open a pathway, an irreversible pathway, towards the valorisation of its meaning beyond the mere pragmatism of a more immediate reality, be it strictly functional, material, economic or something else, proposing its understanding as a identity-based qualifying expression where, according to Rybczynski, the desire to have an own dwelling potentiates a growing conscience of individuality and the need to express said individuality physically (2003, p. 118)[5].

Yet, we must stress that this house will always have to be analysed with the specific understanding that, as Gaston Bachelard posited, "A house that has been experienced is not an inert box. Inhabited space transcends geometrical space" (1994, p. 47), which implies that it demands, always, the overcoming of any immediate or pragmatic reason, for it is potentially an operative means through which a significant subject may affirm himself in terms of identity and build his place in the World.

BIBLIOGRAPHICAL REFERENCES

Bachelard, Gaston. (1994). *The poetics of space* (2ª ed ed.). Boston: Beacon Press.

_____. (1948). *La Terre et les Rêveries du Repos*. Paris: Librairie José Corti.

_____. (2003). A Terra e os Devaneios do Repouso; Ensaio sobre as Imagens da Intimidade (Paulo Neves, Trans.). S. Paulo: Fontes Editora.

Bañón, José Joaquín Parra (2003). Pensamiento Arquitectónico en la Obra de José Saramago; Acerca de la Arquitectura de la Casa. Sevilha: Aconcagua Libros S.L.

Burke, Peter (1995). La Fabricación de Luis XIV. Madrid: Ed. Nerea.

Camps, Victoria. (1996). Paradoxos do Individualismo (M. Alberto, Trans.). Lisboa: Relógio de Água Editores.

Echeverría, Javier. (1999). Cosmopolitas Domésticos (2ª ed.). Barcelona: Editorial Anagrama, S.A.

Pallasmaa, Juhani. (2016). *Habitar*. Barcelona: Editorial Gustavo Gili, SA.

Régnier-Bohler, Danielle (1990). Ficções; o Indivíduo. In Ariès, Philippe, Duby, Georges (dir.). *História da Vida Privada – Da Europa Feudal ao Renascimento* (vol. 2, Armando Carvalho Homem, Trans.). Porto: Edições Afrontamento.

Rybczynski, Wiltold. (2003). La Casa; Historia de una Idea. San Sebastian: Editorial Nerea, S.A.

Santamaria, Cristina. (1999). Elogio y Denuesto de una Metáfora. *Sileno; Variaciones sobre Arte y Pensamiento*.

Távora, Fernando. (1993). Texto de Fernando Távora sobre a reabilitação da "casa da Covilhã" (1973–1976). In AA.VV. *Fernando Távora*. Lisboa: Luiz Trigeiros; Editorial Blau.

5. Author's free translation.

Architecture stories in the construction of children's spatial conscience

Margarida Louro
CIAUD, Faculdade de Arquitetura, Universidade de Lisboa, Lisboa, Portugal
ORCID: 0000-0003-2487-539X

ABSTRACT: Based on three fundamental themes: intelligence, creativity and fantasy, this article has as main objective to focus the importance of constructing an imaginary in children that emphasises the relevance of the surrounding space in its various scales of interaction with individuals: objects, buildings and cities that surround them. Starting from a research experience carried out about two years ago, this reflection presents a critical reading of three specific stories-books produced as part of the research: *A Casa do Futuro, Rabiscos em Arquitetura, Urbanismo e Design* and *Uma Família de Portas;* dedicated to children and oriented for this creative interconnection with the surrounding space. Thus, from a set of specific objectives delimited by the theme and the approach, three editorial projects emerge, designed to formalise this intention of interaction with the young public, stimulating a critical evaluation of the space in its different approaches. Stimulating and alerting the sensitivity for the themes of spatiality in architecture, urbanism and design, is the main focuses of this strategy that seeks to build *Architecture Stories*, through the development of children's spatial imaginary, uniting intelligence, creativity and fantasy.

Keywords: Architecture, Children's Imaginary, Space Consciousness, Habitability, Education

1 ABOUT CONSTRUCTING A CHILDREN'S SPATIAL CONSCIENCE

To educate is to stimulate the individual in the sense of developing and guiding his capacities and abilities for life in society and safeguard his future independence. Fundamentally, educating is to instruct competences, sensitivities and values, in order to develop all the physical, intellectual and moral skills that will structure the personality and the capacity for future action. This action has special relevance during childhood and adolescence when there is a higher predisposition for the assimilation of information and the construction of valuable imagery that will shape all the future formation.

In this sense, fostering education in the capacities to value the surrounding world, and especially from the relevance of the surrounding space as an essential element of the condition of being (Heidegger, 1996), is assumed as the primordial issue. By the various scales of the space that surround us (both near and far), structural assumptions should construct a value mentality, from an early age, formalised in the creation of a children's spatial imaginary.

Actually, the construction of our thinking and our way of interacting with the surrounding contemporary world is increasingly complex (Morin, 1991). Activating new forms of education that are structured on motivations, sensitivities and stimuli will be a fundamental component in the educational reinvention of societies, given the new ethical problems associated with new concepts and definitions.[1]

2 ABOUT ARCHITECTURE STORIES: A CASA DO FUTURO

The book *A Casa do Futuro* [The House of the Future] became the first foray into this mission and aimed to bring academic education in architecture, urbanism and design closer to the general public and particularly to children and young people (Louro, Martinho, 2017). This strategy was materialised through the production of an illustrated book where spatial themes were approached in order to stimulate interest and awareness on the importance of the surrounding space (Fig. 1).

The target audience is children in elementary school (between 7 and 11 years of age), although it can also be used with younger children in kindergarten who

1. Reference to the fact that current issues of knowledge, education and teaching are established in new conditions of experience, where new ways of acting reinvent new systems of characterization, centred on new conditions of appropriation, reference and valuation.

Figure 1. Cover of the book: *A Casa do Futuro* [The House of the Future], by Margarida Louro and Camila Martinho, 2017.

do not yet have the autonomy of reading but who can be assisted by educators, teachers, parents, or grandparents. Moreover, in this way, the general public was integrated into the project, as adults are the ones who choose and purchase books for children. This aspect had some relevance in the very disclosure of the book, which appeared in some cases associated with more thematic stores, like museums, art or architecture galleries.

The title of the story, The House of the Future, derives from a very objective definition, on the theme of the *House*, assumed as a second body that soon will surround and delimits us. Moreover, it is from this primordial condition of existence that all story unfolds in order to emphasise the importance of space in the formation of *Being*. By associating thematic and problematic aspects of the current consciousness on environmental sustainability, a kind of subtitle emerges: "A story about sustainable architecture for kids and adults", thus clarifying of the scope of the book theme and the audience to whom it is addressed.

In this sense, the story unfolds around a young architect advised by an older person to guide her in solving an architectural problem faced by a family (of extra-terrestrials) who asks her to design a house they could take when returning to their planet. The extraterrestrial planet is used to foresee Earth conditions since it had also suffered many environmental cases of abuse. In this way, the story stresses the search for new ways of life. Combining the reinvention of new concepts, such as the portable, transformable, adaptable house, the intrigue captivates the reader across its resolution, while, at the same time, activates concepts and consciences about new conditions and current problems.

Several concepts or themes emerge and interrelate in the construction of different consciousness:

– The environmental awareness, present in the book subtitle, associated with sustainability and the effective balance between needs and resources, safeguarding from pollution and habitat destruction.

– The reinforcement of social conscience and the importance of intergenerational knowledge and the family. Time and temporality are effectively the underlying themes of the story as the title implies. The social promotion is stressed through the emphasis on the family, and the timeless value of this reliable condition for economy and sustainability.

– Current cities conditions and the construction of the awareness of problems and difficulties are developed in the references to the cars and traffic, presenting proposals for alternative mobility, associated with clean, non-polluting and inexhaustible energies. Another aspect is the question around the new forms of communication and the existence of telepresence.

– The importance of the space valuation appears in different scales: in the typology of the city; the relations between centre and periphery; in the presence of green spaces (concerning the vast forest that is focused in the story) and that functions as the green lung of the city. This calls attention to the need for the valuation of public spaces and the importance of their existence in an urban context. Regarding the house, it appears related to the idea of movement, as something that goes with the inhabitants, the mobile house. Thus, although associated with the organisation typological archetypes, related with more classic concepts such as rooms, kitchen, living room, garage, etc., the form arises associated with innovation, creating a kind of egg house, which relates to the metaphor of the shell that surrounds in the background the first house that contains the embryo of life.

– Another aspect is technology, and it refers to the coexistence of state-of-the-art technologies (such as the energy converter that immediately transforms concepts into things). On the other hand, more traditional and universal concepts such as drawing and imagination emerge, associating it with the coexistence of representation techniques (such as pencils and pens) and its evolution (associated with computer and digital drawing), always safeguarding the importance of human intelligence, creativity and imagination in solving problems.

Illustrations reinforce the written text, creating an imagery of objectification. Approaches that go beyond the spaces which are formalised in individuals and the clothes they wear, the objects they handle, exploring the spatial configuration in its multiple scales: objects, buildings and cities.

3 ABOUT ARCHITECTURE STORIES: RABISCOS EM ARQUITETURA, URBANISMO E DESIGN

The book *Rabiscos em Arquitetura Urbanismo e Design* [Scribbles in Architecture, Urbanism and

Figure 2. Cover of the book: *Rabiscos em Arquitetura, Urbanismo e Design* [Scribbles in Architecture, Urbanism and Design], by Margarida Louro and Camila Martinho, 2018.

Figure 3. Cover of the book: *Uma Família de Portas* (A Family of Doors), by Margarida Louro and Joana Gonçalves, 2018.

Design], is assumed as a graphic activity book, primarily oriented to children, although it may be extended to the juvenile and eventually adult readers due to the specificity of its theme (Louro, Martinho, 2017). Actually, the title of the book *Rabiscos em Arquitetura, Urbanismo e Design*, awakens the attention of other readers specialised in these three areas (Fig. 2).

The subject of the book is not exhausted in its playful approach as a workbook, associated with drawing and painting. This book, essentially, seeks to be an educational tool on many sources and natures. Based on thematic challenges that seek to meet specific functional requirements in order to reach certain objectives, children and young people are invited to reach different levels of creative complexity, where they activate mechanisms of critical and creative response.

> Educational projects must respond to real needs. First and foremost, they have to identify a problem and then design an initiative to resolve it. (Raedo, 2018)

Based on thematic challenges associated with FAULisboa's six areas of expertise – Architecture, Interior Architecture and Rehabilitation, Urban Design, Product Design, Communication Design and Fashion Design – several challenges are proposed to provide a multiplicity of imaginative capacities.

Intended primarily for children, the produced material can be accepted as didactic support at school education, as a recreational or leisure element, or even as a family activity to be unscrambled together between parents and children or grandparents and grandchildren.

From the multiple thematic challenges promoted in the areas of Architecture, Urbanism and Design, this was another initiative taken by the FAJunior Office of the Faculty of Architecture of the University of Lisbon (FAULisboa), oriented to children, with the aim of increasing sensitivity to the themes of Architecture, Urbanism and Design, bringing them closer to these realities and familiarizing them, in some way, with the academic offer of the FAULisboa.

Complementary to this institutional objective, the book assumes the mission of raising awareness of the importance of the surrounding space at the various scales where it determines the individual:

– The scale of the body, next to the various objects that surround us (from the clothes to the objects that we use and see).
– The surrounding scale of the building (defined in the different spaces we inhabit like: home, school, hospital, cinemas, etc.)
– And the larger scale of the cities and territories we inhabit (defined in the streets that we walk along, in the cities we live in or the landscapes we visit).

Critical experimentation is promoted, activating the intelligence, the creativity and the fantasy in a consolidated construction of a spatial imaginary and promoting a solid foundation for the children's formation, and the bases for a critical evaluation of the surrounding global space.

As Atrio Cerezo et al. (2016) referenced, it is the student, by himself, who must discover through his senses the characteristics of his environment space and the power of manipulating objects in the definition of abstract concepts.

4 ABOUT ARCHITECTURE STORIES: UMA FAMÍLIA DE PORTAS

The book *Uma Familia de Portas* [A Family of Doors] is a second architecture story, following the first experience with the book The House of the Future, reinforcing the mission of bringing academic higher education closer to the general public (Louro, Gonçalves, 2018). Following a similar logic, an illustrated history was created, which deals with themes related to common and accessible problems about the space that surrounds us (Fig. 3).

The title of the story: A Family of Doors, emerges from a theme very present in the current conjuncture of cities and especially in the context of Portuguese cities, which refers to the rehabilitation of old buildings at the expense of the option for new construction. In this

way, the theme of rehabilitation associated with the restoration of buildings assumes a strong expression (as in the first example focused on The House of the Future) from the suggestion of a subtitle where this is explicitly defined as: "A story on the rehabilitation of buildings for kids and adults."

In this sense, the story of this book unfolds around an old house, which occupies a consolidated area of the city and which, as in a family, is composed/inhabited by several members (where the doors are assumed as protagonists) of various ages, statutes and personalities. In this context, an adventure unfolds that revolves around the process of transformation and modernisation of an old house, where uncertainty about the permanence of the old doors of the house, in the process of rehabilitation emerges, in suspense, almost until the end of the story.

As background, in addition to a specific architectural problem, namely its durability, conservation and transformation, other contemporary values are associated, such as the role of the family, cooperation between the various elements, the role of each in the context of the house (making an analogy with the place in society). This set of issues allows us to build existential ethics towards others, especially related to appreciation and respect for the spaces we inhabit, offering children a complete awareness of the value and respect for the space they inhabit, and so become one day more demanding adults.

The illustration in this book is taken as a second narrative. In this way, in addition to giving body and image to the plot of the story as well as the design of spaces and main characters, in this case, the doors, the book reveals new entities and secondary elements that subtly are also understood as characters, telling parallel stories. This emphasises children's ability to observe and encourages multiple readings of the book through various perspectives that allow the discovery of new things and details that, at first reading, were not perceived.

> All the spaces we inhabit, outdoor spaces, cities, landscapes, interior and intimate spaces have their particular characteristics. Moreover, these are interpreted in different ways according to who designs them, how they are planned and also according to those who inhabit them and frequent them. (Arqui-con in AAVV, Amag, 2016: art. 05)

5 GENERAL CONCLUSIONS

To educate by architecture, it is assumed as a pedagogical strategy in the sense of cultivating a critical conscience that, besides promoting eventual future students of architecture, urbanism or design, establishes a valued relationship, positive and particularly demanding with the surrounding space.

These three experiences (embodied in these books for children) formalise a strategy to foster more

knowledgeable public about the need and relevance of the architectural quality of the spaces in their education and formation and consequently in society in general.

Architecture and its conceptual basis founded on the Vitruvian triad established on *utilitas*, *firmitas* and *venustas*, must respond effectively to a function (response to a given program), with a logic of durability (permanence in time) and effectively aesthetic purpose (or whether it has to have aesthetic value, emotion, touch). In this sense, teaching with architecture, or by architecture, becomes more and more awareness of the role of the architect profession,[2] starting in Portugal the first steps on this approach with institutional incursions that seek such a revision and implementation at multiple educational levels, from pre-school to pre-university formations.[3]

As Baeza (2013) points out, to be an architect is to be someone who can turn a house into a dream. To combine the materials needed to build a building in such a way that the result is a wonderful space.

This is the mission currently underway in the scope of the FAJunior Office in complement with many other actions that,[4] in a partnership with several educational institutions, will allow through intelligence, creativity and fantasy, to support the education and development of children and young people so that they become more conscious and demanding adults.

BIBLIOGRAPHICAL REFERENCES

AAVV, Amag! The Arquitecture Magazine for Children. https://a-magazine.org
Atrio Cerezo, Santiago; Ruiz López, Natalia; Gómez Moñivas, Sacha. (2016). Arquitectura en la Formación

2. Reference to the PuEmA Seminar – For an education in architecture, promoted and held at the Order of Architects in Lisbon between 1 and 16 February 2019 and which took on the inaugural scope: *"PuMAm aims to mobilize national and international experts from different areas: architects, teachers, educators, artists as well as children, young people and families for a joint reflection on the themes of Architecture Education"* (https://www.puema.pt)
3. Reference to Decree-Law no. 55/2018, of July 6, which establishes the curriculum of basic and secondary education, the guiding principles of its conception, operationalization and evaluation of the learning, in order to ensure that all students acquire the knowledge and develop the skills and attitudes that contribute to achieving the competencies foreseen in the Profile of Students Exiting Compulsory Schooling. This recent diploma emphasizes a complementary appreciation of cultural education (distributed by its various areas), in order to educate children and young people within the horizon of the next 12 years.
4. Reference to other actions carried out by the FAJunior Office of the Faculty of Architecture of the University of Lisbon, in particular the various activities developed in the scope of research and formalised in activities applied and offered to different audiences. (FAJunior site: http://fajunior.fa.ulisboa.pt/)

de Formadores: Del Tangram a los Mosaicos Nazaríes – Firmitas, Utilitas Y 'Venustas'/Architecture in Training Trainers: From Tangram to Nasrid Palace Mosaic – Firmitas, Utilitas and 'venustas'. In: AAVV (Teresa Romañá, invited editor) *Bordón Revista de Pedagogia Educacion y Arquitectura/Education and Architecture*, Special Issue, volumen 68, número 1, pp 43-59.

Baeza, Alberto Campos. (2013). Quiero Ser Arquitecto. Donostia: Amag.

Coll Salvador, César. (1993). *Psicologia y Curriculum*. Buenos Aires: PAIDOS.

FA Júnior: http://fajunior.fa.ulisboa.pt

Heidegger, Martin. (1996). "Bâtir, Habiter, Penser" in *Essais et Confeìrences*. Paris: Éditions Gallimard (Trad. de Vorträge und Aufsätze, Pfullingen, 1954).

Louro, Margarida (coord.); et al. (2017). Objeto, Edifício, Cidade – propostas para habitar num planeta pequeno/Object, Building, City – proposals for inhabiting a small planet. Lisboa: By the Book.

Louro, Margarida; Gonçalves, Joana. (2018). *Uma Família de Portas*. Lisboa: Livros Horizonte.

Louro, Margarida; Martinho, Camila. (2017). *A Casa do Futuro*. Lisboa: Livros Horizonte.

Louro, Margarida; Martinho, Camila. (2018). *RABISCOS em arquitetura, urbanismo e design*. Lisboa: Livros Horizonte.

Morin, Edgar. (1991). *Introdução ao Pensamento Complexo*. Lisboa: Publicações Instituto Piaget (Trad. de Introduction à la Pensée Complexe, Paris, ESF Editeur, 1990).

Perrenoud, Philippe. (2000) *10 Novas Competências para Ensinar*. Porto Alegre: Artmed Editora.

Raedó, Jorge. (2018). Teaching architecture to children, through utopias, poetry and nature. In: *Domus*, 23 October 2018, [Online] Available from https://www.domusweb.it/en/opinion/2018/10/23/opininion-jorge-raedo-teaching-children-architecture-education.html

From fantasy to reality: Adaptive reuse for flour mills in Venice

Sheila Palomares Alarcón
HERITAS – FCT – [PhD] – Heritage Studies – CIDEHUS – University of Évora, Évora, Portugal
ORCID: 0000-0001-5451-8225

ABSTRACT: When designers are faced with interventions in abandoned industrial buildings, their imagination leads them, among other things, to spaces that, like a palimpsest, accumulate the stratigraphy of their history. This fantasy gives rise to different design solutions that will inevitably differ from one person to another, leading interventions in our industrial, architectural heritage to become increasingly varied and complex.

Reuse has been a constant in Venetian architecture. Churches, convents and religious buildings were turned into factories in the 19th and early 20th centuries, as was the case with the Stucky or the Passuello e Provera mills, symbols of the local flour industry. These mills, in addition to filling the space of old convents after these were shut down, filled the imagination of the designers and owners who tried to bring these buildings back to life. Finally, and after a period of neglect, they now have new uses.

In this paper, and using the mills mentioned above as case studies, we intend to reflect on the life cycle of the two industrial buildings, and analyse the interventions aimed at their reuse, focusing on how the imagination of the designers gave rise to different solutions.

Keywords: Industrial Architecture, Industrial Heritage Adaptive reuse, Flour mills, Venice.

1 INTRODUCTION. FROM FANTASY TO REALITY, THE ART OF DESIGN

Fantasy: "means the same as imagination" (Covarrubias, 1611: 397). According to the dictionary of the Spanish language, "Imagination" is the "Ease to create new ideas, new projects, etc."[1]

When architects or engineers have to design a new project, they face the challenge of translating the ideas they have imagined in their heads for these new spaces into their plans, or later on, into the building.

This task becomes even more difficult when it comes to renovating or retrofitting a building regarded as industrial heritage because the assumptions that will condition the development of the work are an important input for imagination.

When designers are faced with interventions in abandoned industrial buildings, their imagination leads them, among other things, to spaces that, like a palimpsest, accumulate the stratigraphy of their history. This fantasy gives rise to different design solutions that will inevitably differ from one person to another, leading interventions in our industrial, architectural heritage to become increasingly varied and complex.

> Se c'è una città dove il problema del "che fare" di questo importante patrimonio non esiste – e questa è 'altra singolarità che mi preme segnalare – ebbene questa è proprio Venezia. (Mancuso, 1980, p. 37)

Reuse has been a constant in Venetian architecture. Churches, convents and religious buildings were turned into factories in the 19th and early 20th centuries (Macuso, 2009, p. 67). These are spaces with significant value as heritage, not only from an architectural, social, historical, technological or economic point of view but also in terms of the role they play in the urban landscape.

> Nella città 'arte per eccellenza anche il luoghi e gli impianti della produzione dovessero mimetizzarsi tra 'edilizia monumentale e quella tipica veneziana. (Randolfi, 1979, p. 15)

The industrial flours mills built at the dawn of the 19th century are characterised, among other things, by their large scale. They are usually imposing and very tall buildings that, despite this, in some cases, can blend into the urban landscape; the Stucky or the Passuello mills, symbols of the Venetian flour industry, are only two examples of that.

1. Royal Spanish Academy. Dictionary of the Spanish Language. Available at https://dle.rae.es/?id=L08fZIc

These mills, in addition to filling the space of old convents after these were shut down, filled the imagination of the designers and owners who tried to bring these buildings back to life. Finally, and after a period of neglect, they now have new uses.

In this paper, and using the mills mentioned above as case studies, we intend to reflect on the life cycle of the two industrial buildings, and analyse the interventions aimed at their reuse, focusing on how the imagination of the designers gave rise to different solutions.

2 THE ARCHITECTURAL HERITAGE OF THE FLOUR MILLING INDUSTRY IN VENICE: FROM USE TO REUSE

The Italian food industry was only modernised from the first decades of the 19th century onwards. There were several reasons for that, among which the lack of energy resources; the strong presence of self-consumption; the absence of a specialised workforce; internal and external political problems, or the financial limitations of the domestic market. (Giuseppetti, 1995, p. 12) These circumstances meant that there was no development of the large modern food industry, based on extensive mechanisation, vast economies of scale and standardised production (Chiapparino, 2009, p. 32) until the second half of the 19th century.

From the 1870s onwards, there was an expansion of markets that contributed to an improvement in communications, especially by rail, and modernisation of the machinery used in different industries. The opening of the Suez Canal in 1870 also benefited commercial traffic in cities such as Venice. (Giuseppetti, 1995, p. 13)

Even so, the buildings related to the agri-food industry did not have a large scale nor were they arranged in large manufacturing plants, except for specific situations, especially in the flour milling sector, mostly located in the north of the country, such as the Stucky mill. (Chiapparino, 2009, p. 44)

2.1 *The stucky mill: Currently, a hotel, congress centre, and residential building*

On the Giudecca island, the church and convent of *Santi Biagio e Cataldo*[2] (Giuseppetti, 1995, p. 24) were demolished to allow for the construction of what was considered the most significant industrial flour milling complex in 19th-century Venice and the largest and

Figure 1. Stucky Mill. Exterior view from Santa Marta, Venice (Italy). Photo by: Sheila Palomares Alarcón. 2017.

most modern cylinder mill[3] in Italy until World War I: the Stucky mill.

Giovanni Stucky, who had built a flour milling factory based on the Austro-Hungarian system in Treviso, decided to move to Venice and build a steam mill[4] on the Giudecca island. This decision was driven, among other things, by the fact that most of the grain was imported in bags from North America, Russia or Turkey (Giuseppetti, 1995, p. 15) by sea, so transportation was faster to Venice, especially after the construction of the maritime station (1880), resulting in time and cost savings. (Cacciari, 1997)

This first building, which dates back to 1884 and was based on the multi-storey factory typology, had four diaphanous floors, a rectangular floor plan, numerous windows clad with Istrian limestone, cast iron pillars with capitals, wooden ceilings, and gabled roofs. Preference was given to functionality and production, rather than architecture or decorative aspects. (Giuseppetti, 1995, p. 26)

These facilities were extended three years later, with the construction of a new building with characteristics similar to those of the original one. Offices, warehouses, a three-storey building for storing finished products, workers' homes, a canteen, a mechanical workshop. The Stucky mill grew and was continuously

2. A church and hospice were built in the 10th century and consecrated in 1188. Years later, in 1222, they were replaced by a Benedictine monastery and church founded by Giuliana dei Conti di Collalto. After several renovations, it was closed down and plundered in 1810. Since then, it was reused as a hospital for contagious diseases until 1846, belonging to different owners; the campanile was demolished in 1872, and in 1882 Giovanni Stucky, purchased it and started demolishing it. (Giuseppetti, 1995, p. 24)

3. In the cylinder milling system the wheat runs through a series of rollers placed at variable distances from one another, with more or less grooves; after each grinding, the fine flour is sifted out, and the leaving of each sifting are themselves ground and sifted several times. (Amorós, 192-: 102) The first mills of this type, using iron cylinders, were built between 1821 and 1832 in countries such as Switzerland or Germany. (Maddalluno & Monte, 2012). Among the most commonly used systems were the ones developed by the Swiss companies DAVERIO (1850) or BÜHLER (1860; Daverio branch that split off in 1880), whose main advantage was that the grain casings were preserved during the manufacturing process, clearly separating the flour from by-products such as bran. Thus, performance improved and production increased. (Bayó & Borras, 2009, p. 271 quoted by Palomares, 2016, p. 59)

4. The first steam mill built in Venice was located in the Church of San Geromalo (1842), whose tower was used as a chimney to extract steam. (Giuseppetti, 1995, p. 22).

improved. Plansichters were introduced in 1890[5], and in 1895 an application was submitted at the city council to renovate and extend the mill, with a project signed by the German architect Ernest Wullekopf. (Julier, 1978, p. 8–13)

The architecture of the Stucky mill was consistent with the training that the architect received at the Hanover Polytechnic, which at the time was promoting the "Gothic-Norman", or even the Romanesque or Neoclassical style, distant from the Venetian tradition, for industrial architecture. (Giuseppetti, 1995, p. 46)

From the early years of the 20th century onwards they also produced bread, pasta and introduced improvements that solved hygiene issues. There were several fires, and the building underwent various extension and renovation works:

- A second silo was built in 1907, this time with a reinforced concrete structure, but with the same ornamental technique used in the building by Wullekopf, according to a design by Giancarlo Stucky;
- The façade of the pasta factory was renovated and extended in 1920 by Emil Wurt;
- A new warehouse was built in 1922 by Giancarlo Stucky, who also designed a house that was used as reception between 1924 and 1927.

It was decommissioned in 1954. Without maintenance, the silos were virtually empty in the 1990s, and almost none of the machinery that attested to their industrial power had been preserved. (Giuseppetti, 1995, p. 60–61)

In 1990, Società Acqua Pia, together with Banco San Popolo and other private investors, launched procedures to purchase the mill and discussed different possibilities for its renovation with the city council. Several uses, such as residential, sports, commercial, or hotel were considered. One of the problems involved in the renovation was the size of the building, which made it difficult to intervene in the complex as a whole. (Rafondi, 2000, p. 36)

Finally, Societá Acqua Pia, a group of designers specialising in conservative restoration led by Francesco Amendolagine and Giuseppe Boccanegra, and the Venice City Council, in a public-private intervention, moved forward with the renovation of the Stucky mill, turning it into a five-star hotel, a congress centre, and residential building.

The renovation took 12 years to complete. The mill was regarded as

un valore storico in ogni sua parte, senza posibilità di sottoporlo a giudizzi di valore soggettivi e fuori dalla storia. (Amendolagine & Boccanegra, 2007, p. 16).

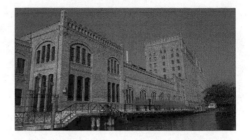

Figure 2. Stucky Mill. Exterior view from the congress centre. In the background, the two silos, currently a hotel. Venice (Italy). Photo by: Sheila Palomares Alarcón. 2017.

The methodological respect of conservative restoration allowed preserving the structure while solving the technical and formal problems that arose. After cleaning the undergrowth, most of the materials were preserved in their places as history had left them, seeking to preserve most of the existing construction elements, even if they no longer served their original purpose, focusing on their reuse. All structural additions were built in red beech, the same material that had been used in the mill. The congress centre was built where the pasta factory used to be; the residential areas in the old flour warehouses; and the hotel in the largest volume of the factory (former Church of San Biagio, Wullekopt tower, and the two silos). (Amendolagine & Boccanegra, 2007).

2.2 *The passuello e provera mill, currently ca' foscari university*

In Cannaregio, north of the city, the convent of San Giobbe was reused in a variety of ways: part of it was used as a cemetery by the church of San Giobbe, and the rest was turned into a wax factory decommissioned in the first half of the 19th century.

The company *Società Anonima Commerciale e Industriale Passuello e Proverá* used the old wax factory as grain warehouse and mill. Faced with the need to extend its facilities, the company bought adjacent land and commissioned the extension project to the engineer Filippo Zanetti in 1921. (Giuseppetti, 1995, p. 48)

Only one two-storey construction was drawn in the Mill extension project as a pre-existing building.[6] The project envisaged the construction of two additional floors above it and an adjacent warehouse. There was also an area for the construction of silos. We should add that the mill's façade overlooked the River Crea and the railroad tracks, making the transport of goods substantially easier.

5. A plansichter is a machine with a large number of square sieves that move back and forth in a zigzag pattern, separating the flour from the bran and the semolina and classifying them (Moreno & López, 2011, p. 56)

6. Archivo Generale. Comune de Venezia. Record. 57275/1920. X/2/4.

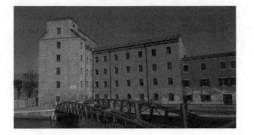

Figure 3. Passuello e Povera Mill. Exterior view from the Valeria Solesin bridge. Venice (Italy). Photo by: Sheila Palomares Alarcón. 2017.

The engineer explains[7] that the intention was to demolish the remains of an older structure and replace it with new reinforced concrete columns and beams, with painted exterior walls that would be 26 cm thick on the ground floor and 13 cm thick on the other floors. Slabs would be planked. Foundations would consist of reinforced concrete piles. The ground floor would be 3.6 m high and the upper floors 3.5 m high. The ground floor would have areas for accommodating two motors and transformers, which would be connected to trippers located on the first floor, accessible through a metal staircase.

Looking at the plans, we can see that the reinforced concrete structure had two light porticoes. The section of the intermediate pillars changed as the building's height increased, i.e., on the ground floor they would have a 40 cm section, 35 cm on the first floor, 30 cm on the second floor; there would be no pillars on the last floor, as a wooden structure topped the building.

The new warehouse would also be built with a reinforced concrete structure, with pillars, beams, and reinforcements halfway along the porticoes.

Aesthetically speaking, the structure was as simple as that of the old building. The type of openings and location is similar. The barred windows were 1 × 1.60 m.

There is a record[8] dated 1923 in which *Società Adriatica Industriale e Comerciale Molino Passuello e Provera* asks permission to build corn silos. The project was designed by "Ferrobeton S.A.I. Ufficio di Venezia". The silos, designed with a height of 20.10 m, would have 14 cells with a total storage capacity of 15,000 Qli.

Although unfortunately it has not been possible to know the exact date on which the mill was decommissioned, probably in the 1970s, we do know that, after a period of neglect, it was used for sports activities ("remiera") and finally transformed to accommodate some of the facilities of the Ca' Foscari University.

It has been part of the economic campus of the university, based in San Giobbe, since 2015. The intervention involved transforming the silo cells, building new slabs at the flour mill floor levels, and building two additional floors.

Inside there are classrooms, research rooms, a library, didactic laboratories and the offices of the Economics and Management department.[9]

In order to achieve this, while preserving the building envelope, as well as the configuration of the openings and the colour of the cladding, there was the need to build new connection spaces and renovate the building as a whole, including the wooden structure of the factory's roof, which was left visible and adapted to its new use.

3 CONCLUSION

The Stucky and the Passuello e Provera mills were the largest in the city[10]. Being typologically similar (multi-storey factory, Austro-Hungarian system) and architecturally different (scale, size, decoration, construction system), they represent the rich industrial past of the Venetian flour milling industry and exemplify the continuous reuse of the city's buildings.

From convent to factory. From factory to neglect. From neglect to "what do we do?" From "what do we do?" to a hotel, a congress centre, residential building, and a university.

There are numerous possibilities for reusing industrial architecture, and Venice is an example of that.

ACKNOWLEDGEMENT

This work is funded by national funds through the Foundation for Science and Technology, under the project UID/HIS/ 00057/2019 and HERITAS [PhD] – Heritage Studies [Ref. PD/00297/2013]. Sheila Palomares Alarcón. PD/BD/135142/2017.

ARCHIVAL SOURCES

Archivio Generale. Comune di Venezia. Records. 27804/23. IX/2/3; 57275/1920. X/2/4.

7. Archivio Generale. Comune de Venezia. Record. 57275/1920. X/2/4.
8. Archivio Generale. Comune di Venezia. Records. 27804/23. IX/2/3.

9. Università Ca'Foscari. Venezia. Available at https://www.unive.it/pag/30505/
10. There were other silos, built in 1900–1901 by the engineers Carissimo and Croti, which were demolished in 1979. They were a great mass visible from all over the city. (Fontana, 1995: vii,viii) There is an interesting series of photographs in the "Fondo Reale Fotografia Giacomelli" from 1923 to 1978 in which we can see the evolution of these silos. Available at http://www.albumdivenezia.it/ (Venetian Album)

BIBLIOGRAPHICAL REFERENCES

AA.VV. (1980). *Venezia, cittá industriale. Gli insediamenti produttivi del 19° secolo*. (pp. 37–48). Venezia: Marsilio Editori.

Amendolagine, Francesco & Boccanegra, Giuseppe. (2007). *Molino Stucky*. Venezia: Il Polígrafo.

Amorós, Narciso. (192-). *Fabricación del pan. Industrias Artológicas. Triticultura, molinería, panadería*. Barcelona: Sucesores de Manuel Soler.

Bayó Soler, Conxa & Borràs Roca, Mercedes. (2009). La mecanización de la molinería mediante el sistema Bühler. In Álvarez Areces, Miguel Ángel (Ed.) *Patrimonio Industrial Agroalimentario. Testimonios cotidianos del diálogo intercultural*. Volumen 9. (pp.269–279). Gijón: INCUNA.

Cacciari, Massimo. (1997). Memoria e profezia. In *Molino Stucky. 1895–1995*. Venezia: Marsilio Editori, s.p.a.

Capigotto, Luca. (1997). *Molino Stucky. 1895–1995*. Venezia: Marsilio Editori, s.p.a.

Covarrubias Horozco, Sebastián. (1611). *Tesoro de la lengua castellana o española*. Madrid.

Chiapparino, Francesco. (2009). Fases y dinámicas de la formación del patrimonio de la industria alimentaria en Italia. Una perspectiva histórico-económica. In Álvarez Areces, Miguel Ángel (Ed.) *Patrimonio Industrial Agroalimentario. Testimonios cotidianos del diálogo intercultural*. Volumen 9. (pp. 31–49). Gijón: INCUNA.

Di Giovanni, Anna. (2009). *Giuidecca Ottocento. Le trasformazioni di un'isola nella prima eta industriale*. Venezia: Istituto Veneto di Scienze, Lettere ed Arti.

Fontana, Vicenzo. (1995). Prefacio. In *Un castello in laguna. Storia dei Molini Stucky*. Venezia: Il cardo editore, s.r.l.

Giuseppetti, Raffaella. (1995). *Un castello in laguna. Storia dei Molini Stucky*. Venezia: Il cardo editore, s.r.l.

Julier, Jürgen. (1978). *Il molino Stucky a Venezia*. Venezia: Centro Tedesco di Studi Veneziani.

Maddalluno, Raffaella & Monte, Antonio. (2014). Las fábricas de molienda y de pasta de Puglia: historia de un ejemplo local. In II Jornadas Andaluzas de Patrimonio Industrial y de la Obra Pública. Cádiz: Junta de Andalucía. Fundación de Patrimonio Industrial de Andalucía.

Mancuso, Francesco. (1980). Il patrimonio di Venezia, città industriale. Dalla formazione al riuso. In *Venezia, città industriale. Gli insediamenti produttivi del 19° secolo* (pp. 37–48). Venezia: Marsilio Editori.

Mancuso, Francesco. (2009). *Venezia è una città*. Venezia: Corte del Fontego editore.

.Moreno Vega, Alberto & López Gálvez, Yolanda. (2011). *Harineras cordobesas. Historia, tecnología y arquitectura (Siglos XIX-XX)*. Córdoba: Alberto Moreno Vega.

Palomares Alarcón, Sheila. (2016). Pan y aceite: arquitectura industrial en la provincia de Jaén. Un patrimonio a conservar. Jaén: Universidad de Jaén. Tesis doctoral.

Ranfondi, Nicola. (1980). Transformazione urbana e produzione industriale nella Venezia dell'Ottocento. In *Venezia, cittá industriale. Gli insediamenti produttivi del 19° secolo*. (pp.11–28). Venezia: Marsilio Editori.

Randolfi, Nicola. (1979). Gli insediamenti industriali a Venezia nel XIX secolo. In *Itinerari di archeologia industriale a Venezia. Film documentario a 16 mm*. (pp. 15–21). Venezia: Comune di Venezia.

Ranfondi, Nicola. (2000). Industria e attività a Venezia agli inizi del '900. *Quaderni. Documenti sulla manutenzione urbana di Venezia, 4, anno II*, 33–40.

Romanelli, Giandomenico. (1980). Alla ricerca di un linguaggio. In *Venezia, cittá industriale. Gli insediamenti produttivi del 19° secolo*. (pp.29–36). Venezia: Marsilio Editori.

Wieser, Hans. (1979). *Itinerari di archeologia industriale a Venezia. Film documentario a 16 mm*. Venezia: Comune di Venezia.

Zucconi, Guido. (1993). *Venezia. Guida all'architettura*. Venezia: Arsenale Editrice srl

The ruined fantasies of intelligent minds: 'The Nobel's town' and neglected Swedish heritage in St. Petersburg

Irina Seits

Department of Aesthetics, School of Culture and Education, Södertörn University, Stockholm, Sweden
ORCID: 0000-0001-9467-3019

ABSTRACT: The present article aims at giving a brief introduction to the Nobel family's living in Russia and to the generally unknown architectural heritage in St. Petersburg that Nobels had left before fleeing the country after the Bolshevik Revolution of 1917 and that still exists in a rather neglected state. This heritage resembles and symbolises many Nobel's technological and social inventions that were complexly applied to the overall improvement of the average peoples' everyday life through the development of the new type of housing for the workers – the so-called Nobel's worker's town.

I touch upon the themes of creativity and intelligence, fantasies and materialisation of utopian dreams that were defining features of several generations of the Nobels through the case of the family's Russian period. To think on where fantasies of the seemingly pragmatic entrepreneurs and serious scientists had brought them and how their heritage had become a subject to oblivion on one side and an object of universal appreciation on the other, I trace the destiny of Nobels' architectural heritage formed in St. Petersburg by Swedish and German architects. This urban heritage is a part of the creative outcome of intellectual work ongoing within the family and a bitter symbol of efforts to materialise their "fantasy" of developing the system of "social responsibility", which, as they believed, could sustain and revitalise another fantasy – the successful existence of the so-called "fair capitalism."

Keywords: Nobel family, St Petersburg, Russia, architectural heritage, Swedish heritage.

1 THE AMBIGUITY OF INTELLIGENCE AND THE (UN)FAIRNESS OF MEMORY

The name of Nobel is very-well known, much cited and discussed in various contexts due to its connection to one of the world's most prestigious prizes. It is also a symbolic name, which indicates the high quality of an individual's intelligence and creativity as well as the recognition of the achievements by a particular human genius in various fields of life. Behind the name of the Nobel prize always stands the first name of its creator – Alfred. The misanthropic will of Alfred Nobel had brought him the fame of one of the most known inventors and scientists as well as of a humanitarian, whose constructive impact long past his death should have made up for his disastrous, destructive invention of the dynamite. Here one of the significant and most acknowledged ambiguities of the outcomes of Nobel's creativity and intelligence comes: his name is as tightly bound to the successful production of the deadly explosives as to the most successful and respected award in the scientific world.

The name of Alfred Nobel has become so distinguished, that it is still disproportionally little known either of the whole dynasty of the Nobels or their intellectual heritage and overall impact on various aspects of modern life. Yet, the history of the Nobel family may serve as a brilliant example of how intelligence and creativity may function within a single family, developing and transforming over the time and under the influence of various life circumstances. This history also shows where the fantasies of people, who are blessed with these traits, may bring them. The story of the Nobel family is a fascinating drama, the embodiment of all predicaments of modernity with its devotion to technological progress as the main engine of humanity's development, and where, on the other hand, intelligence is still understood in Renaissance terms – in that it should be used for the sake of the human's physical and spiritual prosperity.

Even though the story of Alfred Nobel's family has not been a secret, their numerous inventions are widely used around the world, and their business activities are being studied, it is quite little known among general people about their biographies, and about the revolutionary scientific heritage that the family had formed. Not much is known to the general public about the Nobels' living in Russia, where their empire was born and developed back in the nineteenth century.

Even though the Russian sources on the Nobels are quite significant,[1] they are concentrated mostly around the family's economic activities, technological inventions, and their introduction to the industry. The sources in other languages are much scarcer, and the information on, e.g. Wikipedia provides with more than a modest introduction of the family's major names and a brief overview of their inventions.[2] How could it happen that "Russian Rockefellers", as they were called at the beginning of the twentieth century, were nearly forgotten apart from the prize's founder? Why is it so little known about his brothers, who were not less talented and intelligent, and without whose support, neither the dynamite nor the prize would have ever existed? If one comes to the Nobel Prize museum located in the heart of Stockholm and walks through its halls that tell the story of Alfred's life, she will not find much more than a brief mentioning of Alfred's connections to St. Petersburg, while it was a town where he had spent his childhood with his parents and his brothers, where he received his early education and was introduced to the experiments with nitro-glycerine by his chemistry teacher – Russian scientist Nickolay Zimin.

The welcoming message to the Nobel Prize museum's website begins with the statement that reflects the Nobels' views to intelligence and creativity and to their potential of changing people's lives:

The Nobel Prize shows that ideas can change the world. The courage, creativity and perseverance of the Nobel Laureates inspire us and give us hope for the future (nobelprizemuseum.se).

2 MOVING TO RUSSIA

Immanuel Nobel (1801–1872) was a founder of the whole dynasty of talented Swedish inventors. Coming from a simple family, he had become a ship boy at the age of 14 and then a sailor on a trade ship that let him explore the world. Upon returning to Sweden, Immanuel studied construction and was noticed by the king for building a triumphal arch in his hometown Gävle, which allowed him to continue architectural education in Stockholm. At the same time, he was interested in inventing various mechanisms from war equipment to prefabricated sectional housing (Sementsov, 2001).

As Britta Åsbrink mentions in her article on Immanuel's biography for the *Brothers Nobel* online project, "Immanuel Nobel was always more interested

in the inventions than the financial gains, forcing him into several bankruptcies."[3] After his financial situation in Sweden had worsened, he tried luck in Finland. Upon receiving an invitation from the Russian government to demonstrate his underwater exploding mine to the Tsar Nickolay I in 1837, he came to St. Petersburg. The visit was successful, and next year Immanuel Nobel opened in St. Petersburg a mechanical workshop, working on state commissions for various war machines.

In 1842 Immanuel's wife Andriette Ahlsell and their three sons Robert, Ludvig, and Alfred joined Immanuel in St. Petersburg, where in 1843 their youngest son Emil was born.[4] Together with Russian entrepreneur Ogaryov, Immanuel Nobel had founded a mechanical wheel factory in St. Petersburg that in 1851 was transformed into the company "Nobel and sons". The plant was thriving through the years of the Crimean campaign as one of the main suppliers for the Russian army, but since the war was lost and sanctions from the West severely restrained Russian military production, Immanuel faced the threat of another bankruptcy and left St. Petersburg for Stockholm together with his wife and their youngest son Emil. Robert, Ludvig, and Alfred remained in Russia.[5]

Even though Alfred later left St. Petersburg to continue working in Sweden, his brothers Robert and Ludvig, and later Ludvig's son Emanuel, who was born and raised in St. Petersburg, secured the growth of the Nobel's empire. The format of the present article does not allow mentioning all their inventions. Developing his father's plant, Ludvig and his brother Robert Nobel founded the Branobel company that soon produced half of the world's oil. Ludvig designed the whole infrastructure for his oil empire that was based in Baku, from inventing the world's first oil tanker to developing the system of improved pipelines and railroads, running his successful business both as a scientific hub and a social experiment.

1. E.g. the 18-volume historiographic edition that publishes various documents on the life and activity of the Nobel family: Melua, Arkadiy, Ed. 2009-2015. *Documents of Life and Activity of the Nobel Family 1801-1932*. St. Petesrburg: Gumanistika.
2. Among the most complete online resources on the Nobel family are the brothersnobel.com and nobelprize.com.

3. http://www.branobelhistory.com/themes/the-nobel-brothers/the-father-immanuel-nobel-a-passionate-inventor/
4. There were eight children born to Immanuel and Andriette, but only four sons survived infancy.
5. The information regarding Alfred's stay in St. Petersburg after his parents had left in 1859 is contradictory. As Sementsov notes, according to some Swedish sources, Alfred also left Russia, while Russian sources indicate that he continued working at the plant where in the 1860-62 he invented the new explosive substance of the dynamite, since it was in St. Petersburg in 1862 where the first successful experiment with the mine stuffed with the dynamite took place in a specially arranged channel. Alfred then filed to Russian government for a patent, but the heavy bureaucratic procedure made it too long and complicated, which forced Alfred leave Russia and complete registration of his invention in Sweden (Sementsov, 2001).

3 "NOBEL'S TOWNS": A PRAGMATIC FANTASY AT THE SERVICE FOR ALL

Dozens of thousand people that worked for the Nobel's plant all across Russian Empire from St. Petersburg to Baku, were involved into experimental social projects, as Ludvig had developed norms for labour, limiting the work days first to 10 and then to 8 hours from the usual 12-14; introducing social security system to his employees including medical insurance; providing with access to education and leisure. These were not purely the social amusements of a rich businessman, but through the rational organisation of everyday life, of which work was a crucial part, Ludvig believed to optimise the production process, to increase its efficiency and thus profitability. Brothers Nobel believed in the productive potential of the "fair capitalism", where each employee could become, in a sense, a shareholder of the company, which would make him interested in the success of the common business, as Ludvig reported at the Russian Technical Society in 1882:

> Dear gentlemen, it has been already through over the twenty years since I try to apply to my activities a theory that makes each man who works together with me a participant of the achieved results so that the one who shares labour with me had a right to share with me my profits (citation in Ptichnikova, 2006).

Galina Ptichnikova notes that the "worthy reward for the labour regarding the common success of the business was the main principle of Ludvig Nobel," whereas 40% of the profit was shared among the employees (Ptichnikova, 2006).

One of the major concerns of the Branobel company was the organisation of workers' settlements in various centres of the company's entrepreneurship located along the routes of oil transporting from Baku to Astrakhan and further up the Volga river to St. Petersburg – basically through the whole country. The idea of the innovative settlements was realised in what were called "the Nobel's workers' towns" [*nobelevskiye rabochiye gorodki*] that were built in Baku, Tsaritsyn (Volgograd), Saratov, Samara, Ufa, Rybinsk, and other cities along the transport routes. As Ptichnikova remarks, "a Nobel's town was always "new", it did not fit into the existing town blocks. It was built anew and realised the civilising role of the city-planning, Europeanising the lands that were scarcely inhabited at that time" (Ptichnikova, 2006). These settlements received functional planning – a core principle that had been applied to the modern districts around Europe and that was inspired by the ideas of Howard's garden cities and Robert Owen's workers' towns designed around England.

The Nobel's towns were semi-autonomous settlements built in the proximity to both the factories' infrastructure and the existing old towns, implementing ideas of functional zoning within a settlement that separated residential blocks from working areas and that included essential social infrastructure of schools, libraries, hospitals, and entertainment centres accessible to all residents. The developed system of communications provided the town with efficient functioning and connected it to the old city and other Nobel's settlements, thus creating a network of highly developed infrastructure that allowed the Branobel company to function efficiently across the country.

These settlements were built mostly on the open lands, appropriating them into the rationally organised satellite towns – the prototypes for the later functionalist *"siedlungen"* – the German workers' settlements designed on the open slots close to the plants and yet outside of the main cities, as e.g. the *siedlungen* of Neues Frankfurt designed under the guidance of Ernst May in the 1920s. The situation was yet different in the heart of the Nobel's empire – St. Petersburg, – where the location of the Ludvig Nobel's plant in the densely built city required to realise a rationally planned workers' district among a chaotic conglomeration of workers' barracks.

Nobels owned a vast industrial territory from the Viborgskaya (Pirogovskaya) embankment and from behind the Bolshoy Sampsonijevsky prospect till the contemporary Lesnoy prospect and further to the Finland railway (Schtiglitz, Kirikov, 2003, p. 158). The factory complex consisted of the stone shops and a living mansion, which faced the Neva river and at the same time served as the company's administrative office.

The Nobels continued developing their territory in accordance with the initial layout of St. Petersburg when the best architects planned the city's industrial districts as carefully as its royal palaces and noble mansions. St. Petersburg, the first planned city of Russia, had the rationalist ideas intervened into its very tissue, which, by the late nineteenth century, made it one of Europe's leading industrial centres. Nobels were far not the only international entrepreneurs whose success had developed in the Russian capital: Siemens, Eriksson, Bavaria, and Russian Renault are among the many famous brands that settled in the town, contributing to the tremendous economic growth of the country at the turn of the centuries.

4 SWEDISH CAPITALISTS IN RUSSIA: MATERIALISING A SOCIALIST UTOPIA

By the Bolshevik Revolution of 1917, the Swedish population of St. Petersburg had reached 10 000 people, among whom were many talented engineers, architects, jewellers, musicians, and writers. Nobel's mansion on Vyborgskaya Embankment had become a centre of Scandinavian life in St. Petersburg, where Selma Lagerlof, Karl Mannerheim, Adolf Erik Nordenskiöld were among famous visitors.

Figure 1. The Nobel's mansion on Pirogovskaya Emb. in St. Petersburg. Photo by the author (2016).

Figure 2. The iron-foundry shop of the Nobel's (Russian Diesel) plant. Photo by the author (2016).

The building of the living mansion and the office was designed in neoclassical style by the Swedish architect Ñarl Anderson in several stages between 1870–76. In the 1902-03 it was enlarged by Robert Friedrich Meltzer. Together with another famous architect of Swedish origin – Fyodor (Fredrik) Lidvall these architects reconstructed the industrial district owned by the Nobels into a new urban unit that included the plant, the owner's living quarters combined with the administrative office, and the innovative "living colony" for the company's employees.

Ludvig Nobel developed the new housing system, which later was called the "Nobel's system" and the "Nobel's workers' town". Ludvig and his son Emanuel reworked the ideas of garden cities and experimental British workers' settlements in order to apply them to the conditions of a densely populated urban landscape. The housing estate was located in immediate proximity to the plant that was reconstructed by Lidvall, the master of elegant Northern Modern, in proto-functionalist forms. In the 1912 Lidvall covered working space of the iron-foundry's shop with the reinforced concrete trusses – a progressive technique for the time that in the 1920s laid at the basis of the functionalist method. It allowed organising a large open working space within a shop, providing it with good ventilation and increasing the efficiency of production.

The housing estate was located nearby, it was built around the Lesnoy prospect. Architects of German origin Victor Schröter, Robert Meltzer, and their Swedish colleague Lidvall (all lived most of their lives in the Russian Empire), built a complex of 13 apartment blocks for over a thousand tenants and a school designed in Art Nouveau style, which in St. Petersburg had developed under the strong influence of Nordic Finnish and Swedish architecture, thus receiving the name of Northern Modern.

The revolutionary feature of a realised plan was the rejection of the principle to build houses along the closed perimeters, forming the so-called yard-wells. It was a traditional method of housing construction in Europe that allowed to save on the cost, but served a fertile ground for tuberculosis and other diseases, as no sunlight and fresh air could reach residents. The problem of poor health and living conditions caused by the yard-well construction was already fully realised at the beginning of the twentieth century, and yet avoiding the yard-wells construction required either the strict regulations from the state or the commissioners' good will. The Nobels believed that rational and healthy organisation of living space not only met the principles of "fair capitalism", but that the optimisation of living space would rationalise peoples' routines, making them more productive, thus increasing the company's profitability.

The yard-well construction was given official anathema later both in Weimar Germany and early Soviet Russia. It was replaced with the so-called line-building, when long ribbons of houses were located parallel to each other, providing with free air circulation and sunlight between blocks, and where flats occupied the whole width of the house to allow for cross-ventilation. Yet, mass construction of such housing types was possible only under the strongly regulated housing market and broad participation of state when developing the housing legislation and controlling production and distribution of dwellings.

In case of the Nobel's towns, it was the owners' pure goodwill to realise their idea that rationally organised living space could improve life and functioning of the whole society – the ideas actively propagated in the next decade by Russian constructivists and German and Swedish functionalists.

Ludvig Nobel and his son Emanuel, who headed the family plant at that time and took responsibility to organise the living conditions of their employees, could not practice line building within a small district, and yet they insisted on the free-standing living blocks – something that was nearly unprecedented in St. Petersburg of that time.[6]

Each house received a unique Northern Modern design; apartments were rationally planned, and space between the blocks was filled with green areas. The flats in the apartment blocks were given to the plant's best workers and highly skilled specialists (many of

6. About the only other experiment of a kind to be mentioned – the Gavansky workers' settlement (1904-1908, arch. Nickolay Dmitriev).

Figure 3. One of the apartment blocks inside the Nobel's workers' town. Photo by the author (2016).

whom were of worker's class origin) as a part of the reward system developed by Nobel brothers.

A school funded by the family functioned in each "Nobel's town", while the best students, regardless of social origin, continued their education at the Universities receiving scholarships from the company. Nobel brothers emphasised the importance of social projects and prestige of education through commissioning St. Petersburg school for their plant's workers and employees to Robert Meltzer, one of the most fashionable architects of the time.

After Ludvig's death, his son Emanuel took over the administration of the industrial empire. His mansion was built by architects Meltzer and Lidvall in the same workers' district, stressing its egalitarian nature. Each façade of the modestly-sized house resembles a unique Art-Nouveau design. An Art-Nouveau styled fence connects the Nobel's mansion to another building, which was a very new type of social institution for Russia: a so-called "people's house", which after Revolution transformed into the "House" or "Palace of Culture".

Meltzer also built the people's house in 1897-1901 as an entertainment and educational centre for the plant's workers, managers, and Nobel's family members as they participated together in different activities, from discussing books and resonant publications, to staging theatrical performances. In the people's house, there was a library accessible to all Nobel's employees, the rooms for different activities, a billiard hall, and a lecture/concert hall. The main idea behind the elegant house was to be a public space for all members of the community. It was here, where on October 30, 1901, Emanuel Nobel demonstrated the diesel engine in operation, after he bought the licence from Rudolf Diesel in 1898 and improved it to make it operate on petrol instead of kerosene.

The hospital, the pharmacy, and some shops were located on the district' territory, turning it into an island of "fair capitalism." An architectural jewel of the whole district is the so-called "profitable house" – an apartment block designed by Lidvall in Northern Modern style, where flats were rented out by the Nobel family. The architecture of the building resembles both the Italian Renaissance palazzos and the old Swedish mansions.

The district introduced a realised utopia, materialising fantasies of creative, intelligent minds, where capitalists lived happily and in peace with workers, taking care of their well-being and supporting them in their individual and collective development. It is hard to say how long it could have lasted and where it would have led, but the effort to realise another – communist – utopia of the Bolshevik revolution ended Nobel's family social experiments in Russia, making them flee from the country and leave their wealth, their projects, their inventions and their unrealised fantasies behind, in the land that had once been their home.

5 NEGLECT AS THE RE-APPROPRIATION OF HERITAGE

It is not easy to imagine the dramatism of the situation, of what Gustaf Nobel, a great-grandson of Ludvig Nobel, called "a total change of paradigm" (Nobel, G. and Seits, I., 2017, p. 74) and of what the Nobel family, along with many other international entrepreneurs, had gone through the time of Bolshevik Revolution, which draw an ultimate line between the life of the family before and after the October 1917. On both sides of the new life: in both the new Soviet Russia and in Western Europe, first of all, in Sweden, the history of the Russian period of Nobel's family was muted, and the heritage that they had left in Russia was either neglected or reserved to the study and recording only by specialists.

The Nobel's plants were nationalised, and the realised fantasies of a social paradise – the "Nobel's towns" that were built along the oil routes and filled with fruit trees blossoming on previously deserted lands, were destroyed or came into dilapidation in just a few years after their owners had fled the country.

The ideological drive of the Bolshevik Revolution – to destroy the past, to divorce with previous experience and heritage in order to begin from scratch did not only mean the literal destruction of the gone epoch's tangible heritage, but it targeted the destruction of the memory, the divorce with the history itself. There were not only the achievements by actors of the past that were to be undermined and neglected, but their very names were to be forgotten and erased from the new reality. The Ludvig Nobel's plant was re-named into the "Russian Diesel Plant", thus eliminating the very name of the Nobels from existing within the "new paradigm." The technologic achievements and the whole organisation of the Nobel's enterprises were declared the achievements of the new regime, while the family's contribution was severely undermined even in the professional studies and reports by the Soviet scholars, which gave its results: the Nobel's heritage was forgotten in the Soviet Union, and their name was connected only to the foreign prize established by Alfred. A researcher on the Nobels, Vladimir Meshkunov, states that "unfortunately, later everything

had been done to undermine the role of the Nobel family in the development of Russian mechanical engineering and oil industry" (Meshkunov, 2009, p. 23). He admits the intentional ignorance of Nobels' patented inventions within Soviet publications. When various technological achievements realised on the Ludvig Nobel's plant are mentioned, he says, they are referred to as to the products of the Russian Diesel plant – a name that was given to the factory after the Revolution. While Ludvig Nobel's plant is mentioned merely among others, he notes, the Russian Diesel plant is introduced as the Soviet scientific hub, which leads to that "readers get an impression that it is being spoken of the two different plants" (Meshkunov, 2009, p. 23).

The Nobel's housing estate in St. Petersburg was also nationalised, and apartment blocks were subjected to the new norms of housing distribution, forming the so-called *obschezhities* and *kommunalkas* (see Seits, 2018, pp. 301–305). It is only if by chance that the contemporary owners know the history of the estate and its impact on further development of urban planning in Russia. The owners' mansions were turned into public institutions giving no regards to the history of the place. Long decades of neglect of both material and scientific heritage had led nearly to its non-existence within the contemporary urban landscape, as little information on Nobel's living in Russia and their heritage was ever promoted among both the general population and the academic community.

6 THE MUTED TRAUMA

On the other side of the iron curtain, the Russian history of Nobel's family had also been muted but as a traumatic experience. Revolution turned Nobel family into refugees trying to escape arrests and flee the country in severe winter conditions while risking lives of their young children. Thus, members of the Nobel family that previously lived in Russia, but who were born already abroad were divorced from their family's Russian background, as Gustaf Nobel notes:

> I wasn't really a participant in any affairs regarding Russia, because — you know the history — my family: my father, Gunnar Nobel had to flee from Russia with his brother Alfred, his little sister Nina, and mother Eugenie, as did my grandfather Gösta Nobel, who was not with them in Baku at that time; he was in St. Petersburg. Emanuel Nobel also left the country. They had to flee, and they were on the run for one and a half months. Afterwards, my father never talked about it for the rest of his life. Up until his death he said nothing. He would say, "I don't want to talk about it". So, we didn't hear much about Russia or Revolution from him. But then his brother, my uncle, was a bit more open about it because he was three years older than my father…So, we had a little information from him, but not much, really. Russia wasn't very present when we were children. But as we grew up, we became more interested in the history, of course,

Figure 4. The monument to Alfred Nobel in St. Petersburg. Photo by the author (2016).

and we started studying it to a certain extent. Growing up, there was not very much to say about it, since no one talked to us about it. (Nobel, G. and Seits, I., 2017, pp. 74–75).

7 NEGLECTED FUTURE OF THE MUTED PAST

The contemporary state of Nobel's urban heritage in St. Petersburg remains in semi-neglected state. Nobel's house on the Pirogovskaya embankment is falling apart, with its windows boarded up and the remains of interiors and furniture suffering from dust, humidity and cold. The building overlooks the Neva River, where on its other bank a monument to Alfred Nobel[7] which silhouette resembles an explosion on one side and reminds of a tree that lifts its branches to the sun, the symbol of life, on the other. It is the monument to the human genius and creativity and at the same time a warning and a bitter reminding of the nature of human's memory.

Besides the good trend of the slow revival of the memory of Nobel's family in Russia through marking places connected to them by memorial plates and even a monument, there still exists no narrative either on Nobel's family living in Russia or on their contribution to Russian social and economic prosperity. And yet the existence of such a narrative is crucial for the "heritagisation" of material objects before, if neglected, they go into oblivion.

Behind the monument, a small house, where Alfred spent his childhood still stands without a memorial plate: a silent symbol of the muted heritage is waiting for its revival. Yet the preservation of memory and its material objects, as well as the acknowledgement of great ideas and their propagation, is a part of what, according to the Nobel Prize Museum's addressing note, "inspire us and give us hope for the future" (nobelprizemuseum.se).

7. Arch. Sergey Alipov and Pavel Shevchenko, unveiled in 2015.

BIBLIOGRAPHICAL REFERENCES

Åsbrink, B. The father, Immanuel Nobel – a passionate inventor. [Online] *Brothers Nobel.* [Accessed 24 February, 2019]. Available from: http://www.branobel history.com/

Meshkunov, V. 2009. Nobels in Russia / Nobeli v Rossii. *Science, Technology, Society and Nobel Movement,* 3, pp. 9–35.

Ptichnikova, G., 2006. Nobel's towns in pre-revolutionary Russia / Nobelevskije gorodki v dorevolutsionnoy Rossii. Architectural Heritage /Arkhitekturnoje Nasledstvo. 46, pp. 298-306. Here used online publication: [Accessed 24 February 2019]. Available from: http://www.niitiag.ru/pub/pub_cat/ptichnikova_nobelevs kie_gorodki_v_dorevoljucionnoj_rossii

Seits, I. 2018. Architectures of Life-Building in the twentieth century. Stockholm: Södertörn University.

Seits, I. 2017. Muted histories and reunited memories: a story of a Swedish family during the times of the Russian Revolution. Interview with Gustaf Nobel. *Baltic Worlds*, 10 (3), pp. 74–81.

Sementsov, S., 2001. The Dynasty of Nobel – the Swedish industrialists and public activists – in St. Petersburg / Dinastija shwedskikh promishlennikov i obschestvennikh dejateley Nobel' v Sankt-Peterburge. [Online] *St. Petersburg and the Countries of Northern Europe / Sankt-Peterburg i strani severnoy jevropi.* [Accessed 24 February, 2019]. Available from: http://rhga.ru/science/confer ences/spbse/2001/sementsov.php

Schtiglitz, M. and Kirikov, B., 2003. The monuments of the industrial architecture of St. Petersburg / Pamyatniki promishlennoy arkhitekturi Sankt-Peterburga. Sankt-Peterburg: Beloje i Chyornoje.

World-in-spheres: A cartographic expedition through the spherical world of Peter Sloterdijk

Francisco Henrique Brum de Almeida & Gabriel Henrique Rosa Querne
Department of Architecture and Urbanism, Federal University of Santa Catarina, Florianópolis, Brazil
ORCID: 0000-0001-8449-7939; 0000-0002-3722-4791

Lucas de Mello Reitz
Department of Architecture and Urbanism, State University of Santa Catarina, Laguna, Brazil
ORCID: 0000-0001-7152-5275

ABSTRACT: This article proposes the cartography practice as a possible path to pair Peter Sloterdijk's *spherology* theory and the expanded field of architecture and urbanism and deepen the understanding of the relations between the psychosocial movements and the spatial transformation in a contemporary city. As Suely Rolnik's *sentimental cartography* presents us with a route for the *resonant body* – a tool of vulnerability to gain permeability into the intensities flow – this paper traces the path of an imagined cartographer through the discoveries on how social theories can impact and contribute to a richer analysis of the urban space.

Keywords: Peter Sloterdijk, cartography, *spherology*, urban analysis.

1 A CONVENIENT UNDERSTANDING OF THE WORLD

We are now dialoguing with a specific cartographer settled in the world. He is an investigator who seeks to explore a distinct setting with striking architectural properties and urban relevance. Also, he aims to use transdisciplinary knowledge and is open to considering his feelings when recording his path and weaving a convenient understanding of the world.

To do so, this article approaches theories that may fulfil a will to an ontological-formal paradigm break in the expanded field of urbanism and architecture, out of the cartography interaction with Peter Sloterdijk's *spherology* (2011).

1.1 *The scenario*

We are now introduced to the cartographer expedition, reaching a specific place. He stands in the space and observes. His first reflections are practical and products of his *bare eye*. As a first exercise, the cartographer writes down some initial thoughts about the existences noticed:

1) The passers-by, moving everywhere in a central point of the city. Critical point: a man, when a driver dared to hush him, went up against the vehicle with a contradictory and surprising tranquillity. The driver, astounded with the result of his attitude, dodges and speeds up away from that unfortunate clash.

2) Homeless people on the streets, sleeping under the marquee of a famous building in the city and commercial streets of downtown. *What time is it?* Someone asks after opening a tent located on the sidewalk.

3) Under the same marquee, where the movement prevails, a water seller casts suspicious glances.

4) A small clustered group waits, in deep silence and sheltered by the same marquee, the buses to return home.

These initial thoughts took the cartographer to an important reflection: under the same marquee and its surroundings there is a scenery of symbiosis between psychosocial, economic and formal characteristics. There is also an ingrained conflict – although the conflict has some choreographic elements, as a ballet (Jacobs, 1961). However, this ballet does not seem to be executed on a single stage, but rather in multiple stages: close to each other, making singular dance moves, "co-isolated" (Sloterdijk, 2008, p.48), making the existences subject to psychosocial and spatial consequences.

The cartographer feels the need to deepen his understanding of his practice and amplify his perceptive ways: *get closer* to the arrangements of this scenery.

1.2 *Contemporary cartography*

The understanding of cartography as map making was called into question insofar the processes of space production gained complexity, which led to the complexification of its representation. Thereby, the introduction of social theory in cartographic postulates brings a new focus into the socio-political aspects that go beyond the map making (Matias, 1996).

J. B. Harley (2011) showed this pairing of geographical studies and social sciences in the case of cartography in the paper entitled *Deconstructing the Map*. Originally published in 1989, the paper suggests an "epistemological shift in the way we interpret the nature of cartography" (2011, p. 274), bringing the postmodern paradigm of deconstruction and key-concepts of Jacques Derrida and Michel Foucault to be able to "discover the silences and contradictions that challenge the apparent honesty of the image" (2011, p. 276).

Therefore, the need for a critical and enlarged look about a contemporary city and its dynamics goes through the overcoming of the mainly image-based analysis and its representation. It is central to go beyond the usual cartography, considering it as the drawing that makes itself at the same time as the landscape movements (Rolnik, 2016).

So, the cartographer starts to seek another form of perception, based not only on what he sees but in a way that his spatial, temporal and subjective positioning creates the potential to go beyond the traditional image-based support in the investigation.

2 THE SENTIMENTAL CARTOGRAPHY

Suely Rolnik's *Cartografia Sentimental* [Sentimental Cartography] (2016) presents itself as a route – a speculated path, imagined and contextualized in different times, distinct socio-spatial situations, multiple characters and its impulses – with the goal to understand the *desire*, which is "not an organic drive" (Guattari and Rolnik, 2007, p. 354) or has characteristics of particularity or individual originality, but has "infinite possibilities of assembly" (2007, p. 354).

The variety of possibilities allow the cartographer to conceive, in a gradual manner, his paths to investigate the existences in an observed scenery. Understanding the *desire* as the production of psychosocial universes is how the cartographer will, step by step, overcome the limited investigation of the exclusively visible – that is rapidly revealed to the *bare eye* – to focus on the indissolubility of the visible and the invisible (Rolnik, 2016).

Rolnik presents this indissolubility in three initial movements of *desire*: 1) the generation of affects, intensities and its subsequent attraction and repulsion between bodies; 2) the simulation of these affects, in order to create a "plane of consistency" (Deleuze and Guattari, 2005, p.4), in which the affects gain body, producing the territory that provides the intelligibility for the exchange of affects; and, lastly, 3) the intelligibility of this affects exchange: the process of territorialisation (Rolnik, 2016).

The comprehension of *desire* is a crucial moment for this cartographic practice, in which the cartographer wakes up his *resonant body* by discovering his activation factor: what allows and stimulates the power of the body to be vulnerable to the context (Polanco and Pradel, 2015). This first move of the cartographer in the direction of his own *resonant body* is also the first movement of overcoming the longitudinal observation, limited to the generation of affects, its representation and territorialisation. This explorer, with his *resonant body,* activated – that is, under his sensitive self-conduction and the conduction of the unpredictable – notices that doing so is putting himself among the intensities of the explored site. That means perceiving how this intensities are occupying the space, how these processes of affects simulation are (or are not) being able to create and develop planes of consistency and, mainly, if the territorialisation processes are in accordance with its function in the *desire* production process: the assurance of life continuation, by territorialising – as long as they are coherent, or while the affects are passing and being represented effectively – and deterritorialising, so new planes of consistency are made and life can expand itself (Rolnik, 2016).

It is important to highlight that these processes of desire production have an indelible exteriority characteristic. The *desire* is not something detained in an individual or interindividual chart; neither is in an external relationship with the social field. Thus, the *desire* production process is the *reality* production process itself: that is, this production is simultaneously material, semiotic and social (Rolnik, 2016).

Understanding that *desire* is the production of social reality, in other words, production of the world gives the cartographer a necessity to pre-establish some structure of exploring, linked to this main characteristic of the human condition. That way, the explorer must develop a *criterion*, a *principle* and a *rule* to observe and explore the existences in their processes of making, unmaking and destroying worlds – also, their limits and their potentials (Rolnik, 2016).

3 PRACTICE AND THEORY OF CARTOGRAPHY

The cartography practice – based on a *criterion*, a *principle* and a *rule* –, is inalienably simultaneous to the developing of a contemporary cartography theory. However, this epistemological generosity is not an incitement to seek neutrality or an immune and outer point of view: it is an encouragement for the cartographer to absorb, swallow and bring together any

materials if it contributes with "multiple entryways and exits" (Deleuze and Guattari, 2005, p. 21).

Therefore, as we know, this cartographer is an urban explorer that seeks to investigate contemporary cities and their existences. He must begin from somewhere, but he has no intention to remake any specific method or any other previously established urban analysis model. This cartographer wants to go beyond the visible and the invisible: he seeks to understand the indissolubility between these two models of reality; he wants to observe its spatial effects.

However, in the imminence of the expedition, the cartographer notices the need to determine how willing he is to get close to the intensities that are there, with the tension between the representation of affects and its flow – its request for a pass. So, the urban explorer realises that is crucial, as his *criterion*, to define a degree of openness – or intimacy – to the desiring human condition (Rolnik, 2016). This condition will guide the cartographer to his only *principle*, that is, from the intimacy point in which he perceives himself, facing the scenery, to explore and record the moments when life consolidates, when the *desire* undoubtedly turns into world creation (Rolnik, 2016).

If the cartographer is willing to be on the surroundings of the cartography changes, in the proximities of world making processes, then caution is required. The cartographer needs to be aware of the situations where each recorded existence is not able to continue creating worlds, building effective masks to make affects pass and constructing conditions to composing territories. Therefore, the only *rule* for this cartographer is to perceive – with his *resonant body* – the current tolerance limit of disorientation and reorientation of affects: or so, how much the *desire* strategies are (or are not) helping the life expansion (Rolnik, 2016).

Only taking what allows him to take the first step, the cartographer moves to an investigative process that will need, in fact, the openness to everything that creates a path to the *desire* movements: everything that gives language and creates meaning to the affects (Rolnik, 2016).

4 BEING-IN: INVESTIGATING THE SPACE

Questioner of what is conventional, this urban explorer is undoubtedly part of an architecture and urbanism expansion field movement that no longer searches for "single and essential bases for architecture, (…) [but] multiplicity and plurality" (Vidler, 2004, p. 142). A plurality of ideas, a multiplicity of forms, ideas that mix with forms, ideas-forms, forms-meaning: the intention of breaking the current paradigms of form, so the cartographers can rely on more flexible models to understand the world in its complexity, as "blobs, swarms, crystals, and webs" (2004, p. 142).

That comprehension certainly exacerbates a new impetus of relativisation between space and time,

being and space, being and time. And there is something in this relativisation that draws the attention of the urban cartographer, determined to absorb in his expedition everything that produces meaning.

Thus, when arriving at the scenery to be explored, the cartographer questions himself about his search of conciliation with his resonant body, and his theoretical-practical intentions. To him, every revealed existence form seems linked to a reference point, a *where* that is convenient to a territory formation. However, this *where* is not necessarily past, present or future – as a destination, a fixed point or an origin point. This *where*, to the cartographer, is a topological reference of the existence, that lead to an existential analytic of the space, an analytic of *being-in* something (Pessanha, 2018).

Therefore, while watching the passers-by, the cartographer does not intend to investigate why they move so much and so multidirectional. He aims to understand what makes them be in the world – consolidating relations, making groups, protecting themselves and expanding their lives. The cartographer pursuit of comprehending how the passer-by position, as noticed and recorded, is part of the guarantee of its existence.

When the cartographer starts his observation on the homeless people in the streets – same scenery, same cartography process – a very similar questioning emerges. On the water seller, likewise. On everything that *is* and seems to be *there, somewhere*. If all these recorded elements are making different exchanges – psychosocial, economic and formal ones – and that, creating a world and exchanging affects, is happening somewhere, *where* is it? *Where* are we when simulating affects, consolidating territories and creating a world?

5 SPHEROLOGY AS AN UNDERSTANDING OF THE WORLD

This urban explorer, as a cartographer of the visible and the invisible and after having his first meeting with the existences to be recorded, is sure of his main goal, which is to question 1) traditional paradigms of urban analysis and form; 2) ontological paradigms; and, lastly, 3) perception paradigms. However, this questioning is not a product of theoretical aversion nor disagreement; neither has the objective of establishing new paradigms. The main motto is to head to a comprehension that analyses the world and space together: psychosocial, formal and spatial transformations, expansion and deconstruction processes, all in a complementary and co-dependent way.

Therefore, the spherological understanding appears to the cartographer as an alternative to his almost holistic eagerness. In the *Spheres* trilogy, as in his poetic space analysis, German philosopher Peter Sloterdijk begins to promote his immunological shift, when discussing the question "where are we if we are in the world" (Sloterdijk, 2011, p. 27) and assuming himself

as an inside and an interior spaces thinker (Pessanha, 2018).

The mission now becomes to understand how the spherology, as a comprehension that human beings are architects of interior spaces and will always live in autogenerated containers, the so-called *spheres*, can make a theoretical-practical basis to his expedition (Sloterdijk, 2011). Still, it is essential to the explorer – now also a spherologist – to notice what this world understanding will cause in his *resonant body* and his mission as an urban cartographer.

It is crucial for the cartographer to truly understand what constitute these interior spaces, spheres, in what the being-in becomes the being-in-spheres, or the "place that humans create in order to have somewhere they can appear as those who they are" (Sloterdijk, 2011, p. 28). As the first speculation about being-in-spheres is that the sphere is a "shared realm inhabited by humans – in so far as they succeed in becoming humans" (Sloterdijk, 2011). So, if "the simplest fact is automatically at least a two-part or bipolar quantity" (Sloterdijk, 2011, p. 42) and the interior spaces are shared, it is crucial to note that this collaboration is made facing an exterior, and not in an exterior:

> Humans have never lived in a direct relationship with 'nature', and their cultures have certainly never set foot in the realm of what we call the bare facts; their existence has always been exclusively in the breathed, divided, torn-open and restored space (Sloterdijk, 2011, p. 46).

Therefore, if the spheres are inner worlds in an exterior, that create themselves and dissolve; if varied solidarity actions establish as agglutinating forces between human beings; If these actions of solidarity make this existence in "two halves, polarized and differentiated from the start, [...] intimately joined, subjective and subject to experience" (2011, p. 45); then these actions are guarantors of the immunological efficiency of this interior space and, therefore, world creators. Thereby, what is called as the end of a world, that the cartographer has made himself aware of in his reality production processes studies, means "in structural terms (...) the death of a sphere" (2011, p. 48).

Thus, the cartographer becomes able to recreate his *criterion* with spherology, establishing his degree of intimacy with the surroundings of the solidarity actions and with the spheres' inevitable instability, as:

> They would not be constructs of vital geometry if they could not implode [...] [and be] capable of expanding into richer structures (2011, p. 48).

His *principle* takes a metamorphic characteristic, inherent to the interior spaces' interpretation. The *metamorphic principle* is, therefore, referent to the explosion and reconstitution movement of the spheres. The cartographer must be aware of how the spheres are exploding and reconstituting themselves, in a way to guarantee the *metamorphosis*. The immunologically

effective explosion and reconstitution is the guarantee of the life expansion in the spherological interpretation, and what matters to the spherologist cartographer is if humans are "creating the dimension in which humans can be contained" (2011, p. 28).

Alert to the processes of solidarity, the only *rule* of the spherologist cartographer is never to forget that there might be a certain fragility in the psychic spaces' constituency, in possible situations of "deterioration of solidarities" (2011, p. 73) which may lead to shrinking into "isolated depressive points". The cartographer must remember that there is a possible boundary of exposition to the exterior.

That said, the urban spherologist can continue his expedition under his cartographer impetus, observing the *psychosociospherical* dynamic and creating a short route, coherent with his practice and his knowledge, as well as with the unpredictable and with what was not yet perceived and recorded.

6 THE CARTOGRAPHER'S EXPEDITION

The cartographer, when observing the urban dynamics of the case with his *bare eye*, stated that the modifications of the place are given by an interaction of elements that create *fix and flow patterns* daily. Then, he noticed that the elements which remain fixed in a place – no matter if they had an economic, social, cultural or religious nature – were continuously crossed by actions and events that modify their values and meanings, as if in the life of society and space there was a moving engine (Santos, 2007). Therefore, these fixes are points loaded with physical-spatial wraps in order to allow the productive actions to occur in their interior, while the flows cross or install themselves in the fixes, modifying their meaning and value, while they modify themselves (Santos, 2006).

If the city is made of fixes and flows, these are indeed inhabiting the same space, with different temporal relationships between themselves. A mass of students, merchants and workers cross the street heading downtown: with a variable concentration during the day and its own pace, regularity and pendularity. The small street sellers are fixed where they are, being constantly modified by the flows which penetrate them.

Observing and getting familiar with these different swinging movements, the cartographer starts to question what would be their relation. Each flow has its velocity, just as a letter is not as quick as a telegram, telex or fax (Santos, 2006). The water sale, its vending truck and seller stay fixed in the business hours. The homeless people fix themselves every night under the marquees and, at dawn, disperse in the streets. Every day, the street-sweeper retrieves the garbage in the marquee's street – but indeed he is not an anonymous, as he contacts who sleeps under the marquee: he plays and laughs with them.

The cartographer notices that these temporal relationships rarely let affectious relationships go unnoticed. He comes across, then, with a multifaceted space: anonymous multitudes, peculiar groups, *co-isolated* individuals. He perceives that the fix-flow interaction is going through delicate sharing and co-isolation relationships between human beings. It is now up to the cartographer to question: what is being shared here?

In order to transform these deductions – made from temporal relationships – in a better cartographic matter for the spherological space, the cartographer must look for the *inside* of these "*air-conditioning systems*" (Sloterdijk, 2011, p. 46), which allows the coexistence of those who become solidary and make "real coexistence, [as] it is out of the question not to participate" (2011, p. 46).

Where and *inside* of which structures the coexistences find protection? These structures, visible or invisible, could be marquees, institutions or families – if they involve "someone (1) being together with someone else (2) and with something else (3) in something (4)" (Sloterdijk, 2009, para. 72). This human capacity to form spaces, to coexist, can be expanded beyond the original *duo*, through the force of solidarity (Sloterdijk, 2011).

The pillars of this expansive force are the capacity for transference: here the cartographer may investigate on how relationships are happening, seeing that "the limits of (…) [one's] capacity for transference are the limits of (…) [one's] world." (2011, p. 12), and questioning: which affects are being transferred in order that solidarity does not break before exteriority (Rolnik, 2016)? The cartographer observes: when there were no signals of students, professors and workers, the street became a great shared house. From every direction, suddenly appeared individuals of varied ages that started to speak loudly, to accommodate themselves, to share the smoke and to even play some chords on the guitar.

In their conversations, though, there was a dominant subject: the food offered by a charity institution. The cartographer, then, notices that the complexity of that space transcends its intelligible limits, as there is institutional assistance. In the first dialogues, he observes that not all of them accept it, as some show the equipment and metal remains that they intend to sell for self-suppression.

Thus, what *senses* are these collectivities sustaining and sharing? What type of affects is being transferred here to allow this sudden transformation in the hospitable function of the observed public space?

The manifestation of transference will lead to visible space modifications. If the contemporary city is composed of "wide oceanic spaces on the one side and hellishly confined spaces on the other." (Sloterdijk, 2009, para. 22), then every cell depends intrinsically on different degrees of spatial conditions in order to guarantee the existence, with the priority of the inside.

The capacity for producing interior spaces is always a "contrast to the current romanticism of openness" (2009, para. 74). Here, closeness and openness are the physical spatial shapes lived by the users between their *enstatic* or *ecstatic* state, "or, if you will, between the world as apartment and the world as agora" (Sloterdijk, 2009).

After the main transferences were recorded, it is important to organise them through its pendularity, repetition and hierarchy. At this moment, the cartographer starts to localise the internal affectious relationships. With an elevated degree of intimacy, that will invariably lead the cartographer to identify the interior spaces and the exteriorities, providing the "semiotic heavens from which character forming collective inspirations can flow to them" (Sloterdijk, 2011, p. 57), that can be absorbed in varying degrees of solidarity. In these means, attractions and repulsions are born between different coexistences and may lead to a conflict of values and senses: discrimination, violence and other urban phenomena.

Based on the reflections on attractions, repulsions and the solidarity degrees, the cartographer now looks for a weakening in the solidarity bonds and in producing new worlds: the *immunodeficiency* (Sloterdijk, 2011). Are the existences in danger? Does something put the interior spaces in risk? As individuals "tend to lose the power to form mental-emotional spaces" (2011, p. 73), the cartographer ought to analyse the urban structures and phenomena that favours the extreme isolation, capable of corrupting the existence of the interior spaces. What type of spherological mortal ruins is sustaining the unsuccess in space sharing? The dead spheres, that "can remain present in memories – as a memorial, a spectre, a mission or as knowledge" (2011, p.48), can be identified also as ruins in both psychosocial and physical space – in the form of incapability to handle with deterritorialisation and difficulty to open to a new world, to a new sphere. How, then, are the spheres explosions and reconstitutions contributing to immunodeficiency?

In contrast to the immunodeficiencies, the cartographer starts to search *where* the conditions that attend his *principle* are being well practised. Then, how the recorded coexistences are formulating exits in pre-rupture moments of tension? About that: how is the integrity of the charity institution and other involving structures? How well are the spheres interacting with each other? How are human beings working to surpass metamorphosis difficulties?

If the transference continuum is dying, physical space may suffer from these transformations' effects. Then, how the spherical appropriations transform themselves in the physical space when these are in metamorphosis continuum crisis?

A successful event in the explosion and reconstitution continuum should spatially supply both the *ecstatic* and *enstatic* human states of being, respecting the fact "that people also have an infinite need for

noncommunication" (Sloterdijk, 2009, para. 70). By these means, people should be:

> generating spatial settings that support both the singularization of individuals and the grouping of single persons to form multi-individual ensembles of cooperation or contemplation (Sloterdijk, 2008, p.49).

Now the cartographer, with his expanded insights on the case and used to its most subtle urban forms, turns back to observe the space with his *bare eye*. After the analysis of the invisible, it becomes clearer that the *small forms*, which "protect us against fusion with the mass" (Sloterdijk, 2009, para. 70), "already contains intrinsic expansion" (2009, para. 64). And he considers it as crucial for the rational understanding of the space as the significant spherological movements of a city. That way, the man who went up against the vehicle will not go unnoticed anymore by a cartographer's eye, as this kind of event shows every day small ruptures, encounters and conflictual symbiosis.

Also, as the marquee holds functions of a shelter for the homeless, a bus point and a water sale, it becomes an explicit example of a "system to compensate for ecstasy" (2009, para. 74). In it, the homeless people establish relations between themselves and with different institutions, collectivities and individuals. They also create different degrees of interaction with the anonymous passers-by, with the street-sweepers and, in this case, also with the cartographer.

Finally, the bus point can group a silence static mass, sighting the same point, waiting for the buses that will take them far away from the downtown heat. Each one depends, fundamentally, on its final destiny's comfort.

Each function – shelter, bus point, water sale – has co-dependent elements that form the protection capsules and make not only a choreography or a ballet (Jacobs, 1961) but a multiform movement, composed of:

> multiplicities of loosely adjacent lifeworld cells, each of which is accorded the dignity of a universe owing to its intrinsic reach (Sloterdijk, 2008, p. 48).

Therefore, the cartographer never leaves his intrinsic participation in the explored space, as he considers himself part of the landscape – what becomes explicit when the water seller casts suspicious glances at him for being merely observing and not exercising the habitual productive actions of the space.

7 RECOMMENDATIONS

The spheres cartography is a continuous comprehension of the self and space, and the cartographer tries, with all his *resonant body* capacity, to understand the coexistences that produce their interiors. That understanding does not have anything to do with trying to explain or reveal: the important is to make experimental use of the methods which are made available in each situation, opening for the world of affects, of coexistences and interior spaces (Sloterdijk, 2011; Rolnik, 2016). What is being proposed here is cartography of the inside, not subject to the idolatry of any preconceived form and method application, but a cartographer posture that let the body resound in all possible frequencies, as well as invent new positions in which these resonant movements find sounds and passage channels (Rolnik, 2016). In this way, the spherologist cartographer, following his principle, is invited to make new inquiries, put forward new exits and do not hesitate to abandon theories when necessary, as well as improvise on his work, considering that his cartography is taken in a singular place – not being subject to methodological repetitions.

BIBLIOGRAPHICAL REFERENCES

Deleuze, G., Guattari, F. (2005) *A Thousand Plateaus: Capitalism and Schizophrenia* (11th edn). (Massumi B. Trans.) Minneapolis: University of Minnesota Press

Guattari, F., Rolnik, S. (2007) *Molecular Revolution in Brazil.* (Clapshow K., Holmes B., Trans.). Los Angeles: Semiotext(e).

Harley, J. B. (2011) Deconstructing the map. *Classics in Cartography: Reflection on Influential Articles from Cartographica*, 273–294, doi: 10.1002/9780470669488.ch16

Jacobs, J. (1961) *The death and life of great American cities.* New York: Random House.

Matias, L. F. (1996) Por uma cartografia geográfica – uma análise da representação gráfica na geografia (Master thesis) [For a geographical cartography – an analysis of graphic representation in geography]. Retrieved from http://www.ige.unicamp.br/geoget/acervo/teses/Por%20uma%20Cartografia%20Lindon.pdf

Pessanha, J. G. (2018) *Recusa do não-lugar* [Rejection of the non-place]. São Paulo: Ubu Editora.

Polanco, A. F., Pradel, A. (2015) A conversation with Suely Rolnik (Universidade Católica de São Paulo). *Re-visiones.* Retrieved from http://re-visiones.net/anteriores/spip.php%3Farticle145.html

Rolnik, S. (2016) *Cartografia Sentimental: Transformações Contemporâneas do Desejo* (2nd edn) [Sentimental Cartography: Contemporary Transformations of Desire]. Porto Alegre: Sulina/Editora da UFRGS.

Santos, M. (2007) *O Espaço do Cidadão* (7th edn) [The Citizen's Space]. São Paulo: Editora da Universidade de São Paulo.

Santos, M. (2006) *A Natureza do Espaço: Técnica e Tempo, Razão e Emoção* (4th edn) [The Nature of Space: Technique and Time, Rationality and Emotion]. São Paulo: Editora da USP.

Sloterdijk, P. (2011) *Bubbles: Spheres I, Microspherology.* Los Angeles: Semiotext(e).

Sloterdijk, P. (2009) Talking to Myself about the Poetics of Space. *Harvard Design Magazine.* Retrieved from http://www.harvarddesignmagazine.org/issues/30/talking-to-myself-about-the-poetics-of-space

Sloterdijk, P. (2008) Foam City. *Distinktion: Scandinavian Journal of Social Theory*, 9:1, 47–59, doi: 10.1080/1600910X.2008.9672955

Vidler, A. (2004). Architecture's expanded field. *Artforum*, 42(8), 142–147. Retrieved from https://www.artforum.com/print/200404

From international context to Portuguese urban planning: Creativity on mechanical aesthetics in Planos Gerais de Urbanização

José Cabral Dias

CEAU – Centre for Studies in Architecture and Urbanism, Faculty of Architecture, University of Porto, Porto, Portugal
ORCID: 0000-0002-8472-5062

ABSTRACT: It is known that cars have given rise to new spatial relations between the territory, the urban form, the population and the architecture. Space became understood not by distance units, but rather by space/time relations. In the modern age, the City was therefore transformed based on overcoming stabilised urban models. Objectivity was then called into question with new theories. In that approach, the car intensified the closeness between form and function – and modern architects would see this binomial as a manifest, an aesthetic concern, as Le Corbusier (1887-1965) witnessed it in *Vers une Architecture*. In short, an apology came out as a fascination with the machine, which replaced the importance of the machine in itself. Consequently, the thinking of new urban spaces reflected an idea of progress symbolised by the car. Portugal, a country living under a nationalistic right-wing dictatorship (1926-1974) in a contradiction between local and global, tradition and modernity, allow the question on how the mechanical aesthetics set up the architects' thinking having presented the aforementioned scope. The creative ideas towards a new territorial thinking were also real in Portugal, putting in practice the same fascination for the car. Nevertheless, they did not wholly prevail, nor in the international context. This paper aims to set up the closeness between those two contexts.

Keywords: modern Portuguese urban planning, *Planos Gerais de Urbanização*, car, mechanical aesthetics, *Estado Novo*.

1 APPROACH

As we all know, the Industrial Revolution gave rise to unprecedented development in production and consumption. Systematic mechanisation of society (based on scientific and technological advances), as well as a permanent and rapid demographic growth, would, therefore, have inevitable consequences on territorial development and organisation.

One of the major impacts of such phenomenon arose from a new way of understanding the concept of distance as well as from different relations between means of transportation and the space for human life. This concerns the mechanical mobility, i.e. the car, which became a symbol of independence, freedom and speed. For achieving such a symbolic meaning, the car would spread out all over the territory, likely reaching all homes and families. That means that it would place the territory accessible to all as a whole, at least in purely conceptual terms.

This paper's central proposition starts with the idea that cars changed architects and urban planners' territorial understanding, doing what no other means of transportation did. However, when the subject refers to the car and its link to urban space, one may be speaking

about fantasy, that is, the idealisation of new scenarios, which might go far beyond reality. It is also important to bear in mind that idealisation is both a product of intelligence and creativity and, as such, it plays a decisive role to change the world, although not immediately nor directly. To understand the full meaning of this sentence, it is necessary to go back to modern times, when the ideas on urban planning and the car were placed side by side, shaping new meanings, while real pragmatic needs turned into aesthetic intentions.

Moving on to the Portuguese context in the same period – between the 1930s and 1950s, coinciding with *Estado Novo* political regime and *Planos Gerais de Urbanização*[1] – the paradox may be more significant.

1. The Decree-Law n. 24 802, dated 21th December 1934, established the legal framework which instituted Planos Gerais de Urbanização. It was an extensive programme to reorganize Portugal over more than 400 urban settlements. Every one having more than 2500 inhabitants should be subjected to a new plan, including all the places with either touristic, leisure, climatic, spiritual, historic, or artistic relevance. That purpose should be achieved in solely three years after the Decree-Law final approval. Vd. the Article 2nd of Decree-Law 24 802.

Even if it is true that the Portuguese right-wing political regime longed for a new time – which can be seen as a sign of modernity – a conservative tendency was displayed without any surprise while seeking for validating the future upon history. Summing up, if it is true that *Estado Novo* had a reformist agenda, it is also undeniable that different tendencies within society were not aligned with each other. Rosas and Brito (1996, p. 317) point out some of them:

a) the corporate matrix; anti-democratic and anti-liberal;
b) the conservative Catholicism of the Salazarist Catholic Centre;
c) the contributions of the monastic ultramontanism and Lusitanian traditionalism;
d) the concerns of the Republican conservative-liberal right;
e) the developmental ambitions of the 'right of the achievements', the 'engineers', and the 'technicians', who linked the viability of either the industrial development or the 'agrarian reform' to a stable, enlightened and intervening State.

On the other hand, it is not ignored that *Estado Novo*[2] architecture was part of a strategy for renewing the Portuguese society (Brites, 2016, p. 18), in line with an ideological expression that would result in a "new man" (Rosas apud Brites, 2016, p. 14). In that sense, architecture was an expression of modernity (Brites, 2016, p. 14). Besides, for conceptual understanding of the architectural culture in *Estado Novo*, it is not ignored that a modern expression may also result from the updating of already consolidated knowledge and practice (Rodrigues, 2017, p. 347). In that sense, modernity may also result from a discipline with a past and history. That would be the path, along with tradition, in opposition to *avant-garde* ideas (Rodrigues, 2017, p. 347).

Estado Novo propaganda policy designed by António Ferro (1895-1956)[3], his pragmatic and paradoxical director (Torgal, 2009), also has a symbolic meaning in this context: the progressive and cosmopolitan approach to art (Ramos do Ó, 1999) is really diverse from the not so modern ethnographic strategy (Alves, 2007). It was aimed at seducing the urban population by the beauty of a simple life in harmony with the imagery of rural population and its territory, a context in which a unique identity would be forged (Alves, 1997, p. 253).

The exposed complexity does not allow easy answers when one aims to address this theme. Nevertheless, the idealisation and the aim to go beyond

reality, (contradicting the true nature of the city, which is built upon the achievable) has also influenced the Portuguese urban universe, at least in purely conceptual terms. It is also important to notice that Margarida Souza Lôbo (1995) interprets the reorganisation of the Portuguese urban universe during *Estado Novo* as what she calls *plano-imagem* (urban image plan). She refers to it as a product mainly originated from compositional criteria in line with the 19th-century practice.

Summing up, the different arguments show a complex and contradictory reality, built amid the ambitious international scope and the Portuguese cultural specificity at the same time.

2 INPUTS

One possible approach to this subject may be given by some particular moments and a set of significant authors within the framework of the last century city's history. In general, the authors refer to a will for surpassing reality on a symbolic and plastic/aesthetic dimension. Such an approach may be seen as a paradox since the city is a tangible achievement, which relates to reality – things to be materialised – either in everyday life or the near future, considering the available means, and all the dynamics in the society.

The authors go back to even before the car advent and mass dissemination, foreseeing the emergence of another age. As said before, the modern period takes here central importance, but to fully understand the role played by the car as a transforming device in the urban space some antecedents and the end of modern time, in the 1960s, should also be considered. It is essential to understand the devaluation of this vehicle, among other data at the end of the 1950s when it lost importance as a basis for urban theories. That mostly happened amid the revision of the modern principles with the end of the CIAM.

Patrick Geddes (1915) drew attention to the new technologies – including the internal combustion engine – as they were already allowing the larger cities' space to disperse. In the same context, the focus on the region was a premonitory sign already. It reflected the importance of the car for structuring the human habitat in accordance with a larger territorial scope.

In accordance with those first times, Richard Longstreth (1998) exposes the car as a formula for understanding the territory from 1920 onwards in the USA, the first country to feel the impacts of the car, due to its high motorisation rate since early times[4]. The difficulties which congestion posed to this vehicle and Los Angeles traders were opposed to the favourable conditions for a paradigm shift. A population who was territorially spreading out upon mobility, with increased income and available time brought the

2. *Estado Novo*, New State, is how the political regime called itself after the 1933 Constitution.
3. The national propaganda agency was created as SPN – Secretariado de Propaganda Nacional (1933-1944); and named as SNI – Secretariado Nacional de Informação, Cultura Popular e Turismo – afterwards (1944). António Ferro was the agency director until 1949.

4. Richard Longstreth's central theme is the link between the car, the development of new commercial typologies and trade-related urban transformations.

change[5]. Longstreth pointed out, above all, that the conceptualisation or development of theoretical models were not important then. With pragmatism, the car changed the territory: "Californians have added wheels to their anatomy [...] population has become FLUID" (Gordon Whitnall apud. Longstreth, 1998, p. 15)[6].

Anyhow, new achievements came out quickly. Siegfried Giedion (1959) gave expression to a greater idealisation in 1941[7]. Accordingly, this temporal gap is due to a change of meaning. The Author saw the car as a means of transportation that surpassed utility and practicalities. For him, it was instead a device for delight or a symbol, which found its full meaning in the parkway. Giedion praised the beauty resulting from the fluidity and continuous movement with the car sliding on the roads it crossed over the territory. That meant an aesthetic motivation at his highest expression. "[The parkway] humanizes the highway" (1959, p. 728).

Leonardo Benevolo (1996) highlighted the changes based on infrastructures, which always led to territorial transformations: while a higher capacity of movement in urban space was increased, a space-time binomial came up being much more critical than the distances in themselves[8].

One year after, Lewis Mumford (1961) took a more radicalised path, defending the Neighbourhood Unit in accordance with a territorial scale he thought to be appropriate to the car age: the city should be hierarchical, preserve the pedestrian scale and human life in traditional spaces (Mumford, 1982).

However, in the very same year, Jane Jacobs (1961) showed scepticism, while addressing the context of the CIAM's end, towards the ideas that supported the modern city – functional city's four points urbanism. She proposed reread the city against the modern dogma: the car along with the mobility devices was just one more item, among many others, for shaping the urban space. Therefore, at the turn of the 1960s, in line with the CIAM's term, the words focus on the end of abstract, purely aesthetic, and conceptual meanings.

Eric Mumford (2000) also discusses the role of the car in the CIAM debate. He took into account the first times of heroism when the city was idealised to satisfy the new vehicle, but afterwards, he also speaks about a new realism: once again, the car was seen as just one more piece for building the city among others. In the process, the approach to real needs, and concrete conditions of life puts Eric Mumford apart from any pure aesthetic dimension.

In her approach, Françoise Choay (1992) shows the end of the cycle. She referred to the power assumed by the car for territorial transformation throughout the 20th century upon aesthetic and plastic principles. She did so in order to highlight the wrong focus the real scope of urbanism had been under. For her, the idea of scientific urbanism is nothing but a myth created in the industrial society. Accordingly, it was clear that the car, as an aesthetic product of that industrial society, was also a myths generator.

William Curtis (1982) underlined those ideas. Rather than expressing rigour, urbanistic ideas resulted from a subjective approach. Most of all, it placed the centre of the discussion on an aesthetic dimension[9].

This part of the text will close with a chronological reversal, stressing a basic idea. Before the realistic shift towards everyday life over the century, the car was a powerful means for conceptualising ideas and theories beyond pragmatism and realism. As such, the car embodied a new symbolic meaning. Creativity and fantasy were close to each other in this intention to completely change life or, at least, the relation between life and the territory. No one better than Reyner Banham to show up this will. Banham (1960) identified the pivotal moments concerning conceptual and aesthetics evolution in the context of Modern Movement, in the early 1920s, a period he called the First Machine Age. For him, the technological conquest of space and time is an idea that follows Marinetti's[10] concepts: Futurism destroys the static points of observation, and it is the glorification of speed. Reyner Banham establishes a relation between aesthetics and mechanisation. According to him, the ideas, which characterise the First Machine Age, resulted both from intuition, and practical knowledge. Going deeper into this debate, the consolidation of movement was linked to human feelings and the spiritualisation of life.

> We may conclude that the effect produced on the spectator by the machine is analogous to that produced by the work of art. (Mondrian apud Banham, 1977, p. 152).

Reyner Banham emphasised the same idea stating that emotions had a much more preponderant role than logic (1977, p. 321). "Man, not the product, is the aim" (Moholy-Nagy apud Banham, 1977, p. 219).

In this context, architects and thinkers are "the creators of the myths and symbols by which a culture recognises itself" (Banham, 1977, p. 10). This is

5. Traffic congestion and lack of parking lots blocked downtown. The solution was to search for alternative locations, close to the population, where the car could move freely. Cf. Richard Longstreth (1998).
6. Gordon Whitnall said it in 1927. He was the Director of Los Angeles City Planning Department at the time.
7. Giedion's book was first published in 1941, by Harvard University Press (Cambridge), under the same title of the third edition used in this paper: *Space, Time and Architecture: The Growth of a New Tradition*.
8. Leonardo Benevolo's book was first published in 1960, by Editori Laterza (Bari), under the title *Storia dell'Architettura Moderna*.

9. Françoise Choay's book was first published in 1965, by Éditions du Seuil (Paris), under the title *L'urbanisme, Utopies et Réalités. Une Anthologie*.
10. Filippo Tommaso Marinetti (1876–1944). He was the founder of the Futurist Movement, whose manifesto was published in the Parisian newspaper *Le Figaro*, on 20th February 1909.

important since "the symbolic machine of [the] First Machine Age was delivered, the automobile" (1977, pp. 10-11).

Concluding this idea, the myths based on the car resulted from a spiritual and aesthetic dimension that goes beyond the literal expression of technology. Indeed, they had the emotions and the man that is the passion, as essential pillars of a new way of thinking about the machine[11].

3 A POSSIBLE SYNTHESIS

As it was perceived, traditional territorial boundaries were broken with the dissemination of the car. Speed and movement over territorial dimension and urban environment gave prominence to the space-time binomial. The devaluation of the concept of distance in itself was, therefore, a natural outcome. Accomplishing a new role far beyond the opportunity for territorial reorganisation, the car's contribution to territory transformation appeared to be much more than objective. Fascination upon an aesthetic/plastic input was central on the thinking. Indeed, the aesthetic experience was as relevant as everyday needs. The pragmatism and reality, seeking concrete answers, contrasted with an idealised conceptualisation. Therefore, the car played its role between realism and the manifest. Objectivity was opposed to imagined scenarios. The aesthetic dimension concerning the city and life became related to the overcoming of the automobile as a mere machine. As such, it also became a lens for looking into space, and time put territory far beyond a static understanding and experience.

In sum, the car had created a new cultural attitude, as an icon symbolising a new way of looking into the world. It was an outcome of creative intelligence: the intelligence that creatively conceived new possibilities offered by technological potentialities, but going far beyond them. Technology became a symbol of itself, and, accordingly, the car was a symbol of the changes in life and territory form. As such, it was placed beyond technological or functional issues. That is, as a symbol, it freed itself from objectivity. This process has built a mythology-meaning that reality could be very different from the past as if it were possible to reinvent the world, and also if the number of cars circulating would reach a number that would be able to support an entirely new territory. In this case, as in many others, myths are based on what one can call fantasies.

Although revealed by different means, this myth was also real in Portugal. In a society governed under conservatism, this vehicle became a symbol of progress and new life here too. In the appearance, the phenomenon is not different from the context abroad. In Portugal, the car was also seen as a metonymy of progress.

It is true that between the 1930s and 1960s – a similar period shown by international historiography – *Planos Gerais de Urbanização* (General urban Plans) descriptive documents and the reports by *Conselho Superior de Obras Públicas* (Superior Council of Public Works) to assess them showed up ideas between Tradition and Modernity. One may question, therefore, how this vehicle could have broken the limits defined by a rural society (Rosas & Brito, 1996). It is important to stress the attempts to build a new society upon new symbols, despite the conservative ideas and the lack of modern signs in the Portuguese society and economy at the time. Furthermore, it is also true that the Portuguese city in the 1930s was disorganised and unprepared to deal with the new vehicle. Therefore, an opportunity had been created by itself with the need for a modernised city. In fact, the link between the car, the city, and new urban morphologies had inevitably to be considered. Urban planners had to fight against street width, incompatible with modern car-circulation. In the book *Lisboa, uma Cidade em Transformação* [Lisbon, a City in Transformation], Keil do Amaral (1970, p. 103) is peremptory, referring the incompatibility between the traditional urban structure and the new vehicle, doing so as early as 1930.

> Those who owned cars [...] began to realise that their possibilities of travel were limited, not only by cars' engine horse-power, or either safety reasons but by street layouts which had not been designed by progressive improvements and a high number of those machines moving in the Capital. Lisbon was arrived through veritable walled alleyways having two central pathways from which it was prudent not to let the car wheels go out as not to break the springs[12]

Matching the international context, the ideas preceded the reality itself also in Portugal. Actually, the speculation and aesthetic dimension were essential

11. Many examples of such way of thinking may be possible: "For de Stijl, machinery, in separating Man from Nature hastened the spiritualisation of life" (Banham, 1977, p. 151; "The machine is, *par excellence*, a phenomenon of spiritual discipline" (Theo van Doesburg apud Banham, 1977, p. 151); "Since it is correct to say that culture in its widest sense means independence from Nature then we must wonder that the machine stands in the forefront of our cultural will-to-style. [...] The new possibilities of the machine have created an aesthetic expressive of our time, that I once called 'the Mechanical Aesthetic'" (Theo van Doesburg apud. Banham, 1977, pp. 187-188).

12. Author's free translation. "Os que possuíam automóveis [...] começaram a aperceber-se de que as suas possibilidades de deslocação eram limitadas, não apenas pela potência dos carros, ou por razões de segurança, mas por um esquema de arruamentos que não tinham sido concebidos com vista aos progressivos aperfeiçoamentos e ao elevado número daquelas máquinas em circulação na Capital. Chegava-se a Lisboa através de verdadeiras azinhagas muradas, com duas passadeiras centrais de onde era prudente não deixar sair as rodas dos carros para não se partirem molas [...]" (Keil do Amaral, 1970, p. 103).

here, too: both the concepts of speculation and aesthetics would have more importance for shaping the thinking than the number of driven cars, a scenario already real in the developed European countries.

So, any urban extension in Portugal would only be seen as effective, if the car was considered as a part of the process. The action of designing the urban space meant to think following new purposes. As a result, the access to new expansion areas, the pre-existing and new streets, urban crossings and the roads serving the new *Estado Novo*'s infrastructures (e.g. ports and industrial areas) set up the need of modern interurban car-circulation. *Grande circulação* (great circulation), *circulação acelerada* (fast circulation), *grande trânsito* (massive traffic), *viação acelerada and trânsito acelerado* (fast traffic), *movimento acelerado* (fast movement) or *even movimento interno intenso* (strong internal movement) were new meanings in urban planning. Accordingly, *vias interurbanas* (interurban roads) were in contrast to *vias intra-urbanas* (intra-urban roads). Similarly, *vias de distribuição* (roads for traffic distribution) were in opposition to *vias de penetração* (roads for entering the city), as well as *vias de atravessamento* (roads for crossing the city) were different from *vias locais* (local streets), *artérias de serviço (*service streets)*, and artérias de circulação local* (roads for local circulation). Following the same principles, *vias de circulação* (roads for circulation) were in opposition to *vias de habitação* (residential roads). Similarly, *vias de acesso ao centro* (roads for centre access) contrasted with *becos (alleys). Vias arteriais (major traffic roads) and artérias radiais* (radial roads) completed these categories within a universe, which was dichotomously divided between *trânsito arterial interno* and *trânsito arterial externo* (major internal traffic and major external traffic) (Dias, 2011).

As such, those words featured a new way of thinking. Dreams and desires, that is, a will for going beyond the present, were as important as the real conditions and needs.

In this scope of a desired new time, the car changed the human condition: Humans would from then on be travellers[13]. The movement was no longer a need. It was instead a movement and driving enjoyment, i.e. enjoyment based on the views changing over time. The Portuguese city was then featured as a place for delight while moving by car, according to a sense of time, which enlarged the landscape. In sum, time and landscape were extended by the pleasure of crossing territory aboard the effectiveness, freedom and fluidity of the new vehicle.

Siegfried Giedion's (1959) approach to this theme, in 1941, probably is the most potent description concerning this relationship between the car and the landscape. The way he addresses the modern notion of space gives a precise meaning to this context:

> Air views may show the great sweep of the highway, the beauty of its alignment, the graceful sequence of its curves, but only at the wheel of the automobile can one feel what it really means. [...] Full realization is given to the driver and freedom to the machine. (p. 729).

Giedion's words build a bridge between the international context and Portugal. In this context, the urban plan for Lourinhã can be pointed out as a role model. In fact, it can symbolise the closeness of *Planos Gerais de Urbanização* to the new meanings the car gave to movement over territory. It shows that settlements' scale and importance were not decisive factors. As a matter of fact, there are close similarities between the proposal of Giedion to extol the modern conception of space and the small village of Lourinhã:

> The slopes, the descent and ascents on the streets, the curved hills, and all the ground level changes should be used in order to offer variable views, forming a set of pleasant perspectives (Oliveira, 1947, p. 4).[14]

4 CONCLUSION

In summary, one may say that the canonical understanding of urban space was called into question because of praising the car, also in Portugal. The time called out new meanings, and, therefore, the closeness to good national or regional roads was a source of happiness, David Moreira da Silva and Maria José Marques da Silva said (1944, p. 34), within the context of designing the urban plan for Matosinhos, in the northern Portuguese coast.

Despite the traditionalistic urban forms, and the particular conditions of the country – peripheral, conservative, and set away from modern industrialised centres of culture – the creative ideas towards a new way of thinking the territory set up an attempt to break real limits also in Portugal.

Only in part, those attempts became true. The Athens Chart, which would give full meaning to car freedom, did not prevail. In Portugal, the urban plans remained unapproved after 1946, which meant that they became less effective than they could be from then onwards[15].

13. The architects in the Descriptive documents of the urban plans claim it. Cf. Dias (2011, p. 485).

14. Author's free translation. "Os acidentes do terreno, as descidas e subidas das ruas, as colinas onduladas, todas as variações de nível, são elementos a aproveitar, para assim procurarmos situações variáveis do ponto de vista, cujo conjunto nos dá perspectivas agradáveis" (Oliveira, 1947, p. 4).

15. The plans had been systematically reduced to the category of documents regulating the activity of individuals. The new legal system, created in 1946, removed the possibility of a real land policy. Consequently, the municipalities – with the exception of Lisbon and Porto (which were not covered by

The car may, therefore, symbolise a fantasy in a double sense: as a device for achieving a pleasant experience, and a means to build up a state or situation that would never be true or real.

BIBLIOGRAPHICAL REFERENCES

Alves, Vera Marques. (1997). Os Etnógrafos Locais e o Secretariado da Propaganda Nacional. Um estudo de caso. *Etnográfica*. Vol I (2), 237–257.

Alves, Vera Marques. (2007). Camponeses Estetas no Estado Novo: arte popular e nação na política folclorista do secretariado da propaganda nacional (Unpublished doctoral dissertation). ISCTE, Lisboa, Portugal.

Banham, Reyner. (1960). *Theory and Design in the First Machine Age*. London: The Architectural Press.

Banham, Reyner. (1977). *Theory and Design in the First Machine Age* (7th. ed.). London: The Architectural Press.

Benevolo, Leonardo. (1996). *Historia de la Arquitectura Moderna* (7th ed., 1st ed. 1960). Barcelona: Editorial Gustavo Gili.

Brites, Joana. (2016). Is there an Ideologically-Biased Broadening of the Concept of Modern Architecture? Questioning the Limits of Postmodernism's Inclusivism and Testing a Further Expansion, Widening the scope of modernism: is there room for Portuguese fascist architecture. *RIHA Journal 0133*. Retrieved from https://www.riha-journal.org/articles/2016/0131-0140-special-issue-southern-modernisms/0133-brites

Choay, Françoise. (1992). *Urbanismo: Utopias e Realidades* (3rd ed, 1st ed. 1965). São Paulo: Editora Perspectiva.

Curtis, William. (1982). *Modern Architecture Since 1900*. Oxford: Phaidon.

Dias, José Cabral. (2011). *Episódios Significativos de Espacialização Urbana a Partir do Automóvel: os Planos Gerais de Urbanização; 1934–1960*. (Unpublished doctoral dissertation). Faculty of Architecture University of Porto, Porto, Portugal.

Geddes, Patrick Sir. (1915). *Cities in Evolution*. London: Williams & Norgate. Retrieved from https://ia800302.us.archive.org/12/items/citiesinevolutio00gedduoft/citiesinevolutio00gedduoft.pdf

Giedion, Siegfried. (1959). *Space, Time, and Architecture: the growth of a new tradition* (Charles Eliot Norton lectures, 3rd enlarged ed., 1st ed. 1941). Cambridge: Harvard University Press. Retrieved from https://monoskop.org/log/?p=11402.

Jacobs, Jane. (1961). *The Death and Life of Great American Cities*. New York: Random House. Retrieved from http://www.petkovstudio.com/bg/wp-content/uploads/2017/03/The-Death-and-Life-of-Great-American-Cities_Jane-Jacobs-Complete-book.pdf

Keil do Amaral, Francisco. (1970). *Lisboa, uma Cidade em Transformação*. Lisboa: Europa-América.

Lôbo, Margarida Souza. (1995). *Planos de Urbanização à Época de Duarte Pacheco* (2nd ed.). Porto: FauP Publicações.

Longstreth, Richard. (1998). City Center to Regional Mall: architecture, the automobile, and retailing in Los Angeles, 1920-1950. Cambridge, Massachusetts: MIT Press.

Mumford, Eric. (2000). *The CIAM Discourse on Urbanism: 1928-1960*. Cambridge, Massachusetts: The MIT Press.

Mumford, Lewis. (1961). The City in History: Its Origins, Its Transformations, and its Prospects. New York: Harcourt.

Mumford, Lewis. (1982). A Cidade na História: suas origens, transformações e perspectivas (2nd ed.). São Paulo: Martins Fontes.

Oliveira, Mário de. (1947). *Memória Descritiva. Peças Escritas do Ante-Plano Geral de Urbanização de Lourinhã*; Arquivo do Serviço de Estudos de Urbanização da Direcção-Geral do Território, Lisboa, Portugal.

Ramos do Ó, Jorge. (1999). Os Anos de Ferro: o dispositivo cultural durante a "Política do Espírito" – 1933–1949. Lisboa: Editorial Estampa.

Rodrigues, José. Miguel. (2017). Simplesmente Complicado (título de Thomas Bernhard). In *Daniela Sá e João Carmo Simões* (ed.). *Pörösis The Architecture of Nuno Brandão Costa I* (pp. 347–353). Lisboa: Monade.

Rosas, Fernando & Brito, José Maria Brandão de. (1996). *Dicionário de História do Estado Novo*. Lisboa: Bertrand Editora. Vol. I.

Silva, David Moreira da & Silva, Maria José Marques da. (1944). *Peças Escritas do Plano de Urbanização da Vila de Matosinhos*, Arquivo do Serviço de Estudos de Urbanização da Direcção-Geral do Território, Lisboa, Portugal.

Torgal, Luís Reis. (2009). *Estados Novos Estado Novo*. Coimbra: Imprensa da Universidade de Coimbra.

the measure) – were permanently prevented from carrying out any expropriations due to financial and legal reasons (Dias, 2011, p. 280).

"Fantastic" colonial cities: Portuguese colonial utopia

Alexandre Ramos
CIDEHUS – University of Évora, Évora, Portugal
ORCID: 0000-0003-3872-5536

ABSTRACT: Cities of Portuguese Africa reflected the repurposed colonial policy of the post-second World War period (1939-45) in terms of their urban design, architecture, economy, and leisure. In the last decades of Colonialism, countering the winds of decolonisation blowing from the East, the Portuguese government took a series of political and diplomatic steps aimed at preserving its ideologically remodelled Empire (i.e., now officially known as *Ultramar*), following the *Revisão Constitucional de 1951*. Consequently, both old and new colonial cities became the most visible stages of social and economic projects and experiences emerging from the recently adopted colonial narrative. Therefore, the main goal of the current chapter is to understand how this phenomenon of expansion and renovation of these cities, as portraited in cinema, revealed the fantasy and utopia of the colonial politics of the Estado Novo – i.e. a multiracial society, coexisting in harmony, in a sort of *Portuguese pax* of which the self-determination of Angola and Mozambique was the antithesis, i.e., the dystopia.

Keywords: Cinema, Architecture, Portugal, Angola, Mozambique, Colonial Fantasy.

1 INTRODUCTION

In the last decades of Colonialism, countering the winds of decolonisation blowing from the East, the Portuguese government took a series of political and diplomatic steps aimed at preserving its ideologically remodelled Empire – officially known as *Ultramar*, following the *Revisão Constitucional de 1951* [Constitutional Revision of 1951].

Along with the growth of the world economy and the beginning of the Colonial War (1961-75), this reform caused an economic boom and, consequently, an outbreak of white immigration coming from the metropole (Castelo, 2014). In this sense, cities of Portuguese Africa reflected the repurposed colonial policy of the post-second World War period (WW2; 1939-45) in their urban design, architecture, economy and leisure. Accordingly, both old and new colonial cities became the most visible stages of the social and economic projects and experiences emerging from the recently adopted colonial narrative – i.e. assimilation, socioeconomic development and *Lusotropicalism*.

Indeed, this changed Portuguese colonial policy in the cities of the *Ultramar* is expressed in the accomplished colonial cinema, which also grew exponentially in this socioeconomic context. Hence, we selected documentary films as information sources to study this reform momentum. More specifically, those documentary films produced by Portugal and filmed in the cities of Angola and Mozambique during the period of Portuguese administration. Specifically, we focused our study mainly on these two countries because of their high demographic, geographical, and economic expression in the late Portuguese colonial period, and also because, as a consequence, it was there that most films were produced. We were also interested in the narrative paradigm conveyed by colonial documentary films, characterised by a transversal approach to structures, equipment and the *modus vivendi* of the population. In general, our purpose was to understand how the phenomenon of expansion and renovation, as portrayed in cinema, reveals the utopian and the phantasy of the *Estado Novo* (i.e., the ruling regime in Portugal between 1933-74) recently (re)adapted colonial speech.

Until recently, Portuguese colonial cinema was discarded as a documental source possibly because it conveyed the State communication perspective. In fact, some drivers strongly conditioned national cinema production, for example, protectionist legislation, government support and subsidies, funding by colonial lobbies, strategies of international promotion, granting of awards, and censorship. Put differently, film narratives expressed the values perpetuated by the regime's official discourse (Silva, 2014). However, this bias is not always obvious since most colonial films were produced outside the official propaganda apparatus.

In recent years, however, its undeniable informative value for the research on Portuguese colonialism

has been recognised, as evidenced by a good deal of work published in the last decade (e.g., Convents, 2011; Piçarra, 2013, Seabra, 2011). Taking this into account, our method was also determined by the cinema's dual function as a historiographic source. In other words, it allows not only to analyse its visible (image) component as well as its non-visible (juncture of the production process) component (Ferro, 1988). As will discuss below, at the international level colonial cinema promoted the *Ultramar* as a unique space where the multiracial coexistence was possible and fomented a new and better society due to the unique character of Portuguese colonialism – according to the official narrative. Therefore, the cities were cinematographically portrayed with a significant focus on the works of architecture and urbanism and what they provided – health, education, employment, and leisure-, forming parables of the utopia that the *Estado Novo* sought, both materially and theoretically, promote to ensure the maintenance of the *Ultramar*: A multi-ethnic and multi-racial nation based on social and economic development.

To foreshadow, a specific example is the short documentary *Angola* (AGU & Sousa, 1961) and the documentary series *Angola 70* (RTP & Elyseu, 1970) in which we can observe that Angola landscape significantly changed due to the building of large infrastructures (e.g., dams), the creation of new cities and the growth of many others. The pertinence of the film analyses is also seen in *Luanda* (RTP & Elyseu, 1970) which aimed to show a multiracial society coexisting in harmony, in a sort of Portuguese *Pax*.

2 COLONIAL CINEMA

In the light of post-WW2 resolution, Portugal had to deal with the imminent loss of its overseas territories. Hence, the Portuguese State tried to create a colonial Utopia hoping, therefore, that his Empire would continue to be acceptable in a geopolitical juncture in which most countries have progressively adopted an anti-colonial position. Interestingly, the term *Utopia* has long been another name for the unreal and impossible and, indeed, it is considered that is what makes the world tolerable for us (Mumford, 2013). Thus, intelligence and creativity combined with inventiveness was the equation beneath the phantasy of a long-lasting and unwavering Portuguese Empire in Africa that the government sought to convey to its peers in the international diplomatic scene – even after the loss of Portuguese India between 1954 to 1961.

The occupation of the Portuguese India territories by the Indian Union was the spark that woke up the Portuguese regime from its lethargy towards the reconfiguration of the global geopolitics resulting from the resolutions made after the end of the war. The internal

resistance against the revision of the colonial policy gradually dissipated. This change began with the constitutional revision of 1951. However, Lisbon's stand was unequivocal: The Empire was part of Portugal and any kind of autonomy, even partial or under white rule, was not considered.

Facing the political trends that moved in the opposite direction, it was mandatory to strengthen the bonds of dependence (chiefly economic) which united the colonies to the metropole (Telo, 1994). At the end of WW2, European powers lost their hegemony to the United States of America (USA) and to the Union of Soviet Socialist Republics (USSR), whose rivalry led to a bipolarization of the international politics. Consequently, alliances were formed, and the Cold War (1947–91) opposing these two powers aggravated the regional conflicts. Likewise, it also severely impacted the *status quo* of the colonial societies, especially those that had survived to the three waves of independence (i.e., firstly in Asia in the 1940s; secondly, in the Middle East and Northern Africa in the 1950; and, finally, mainly in the 1960s in sub-Saharan Africa (Telo, 1994). In this context, USA and USSR, together with the new nations born from the waves of independence proclaimed more vehemently their anticolonial stand.

However, Portugal considered its colonies a natural and inalienable extension of its mainland – justified by the historical rights of primacy granted by the Age of Discoveries. Therefore, Portugal's only solution, in the light of its diplomatic and military limitations, consisted in turning into reality the "phantasy" of a multicontinental and multiracial nation from Minho (north of Portugal) to Timor (its farthest colony from Europe). Accordingly, it was established that this *Lusotropical* society, declared unique in the world but blurred by utopian notions (due to practical difficulties and the unfavourable international political scene), would be substantiated by social welfare policies anchored to economic development (Alexandre, 2000; Castelo, 2007). Nevertheless, in order to prevail, this strategy required more than just rhetoric; that is, it had to be materialised and effectively demonstrated. So, this was achieved through the official propaganda by cinema and photography, among other resources, as we will further explore. The previous colonial speech based on civilising the "natives by promoting labour", was replaced by the idea of socioeconomic development of the colonies, sustained by reinforced public investment: *Os Planos de Fomento para o Ultramar* 1953-68 [The Development Plans for the Overseas] (Castelo 2014, p. 516).

In fact, the government intervention through the Development Plans and the creation of the *Espaço Económico Português* [Portuguese Economic Area – EEP], along with the national and international juncture of economic growth, the beginning of the Colonial War (1961–75), an increased white-immigration, the incentives to foreign investment, and

the profitability of products (e.g., coffee, oil, and diamonds), energised an economic boom in Portugal's overseas territories, mainly in the provinces of Angola and Mozambique (Lains, 1998; Lains & Silva, 2005).

3 FROM UTOPIA TO FEASIBLE REALITY: THE NEW COLONIAL CITIES

Generally, the Colonial cities profit from the intervention and investment of the government new policies. Against the backdrop marked by the international contestation and the beginning of independence-seeking movements, the real control of colonial territories by the Portuguese administration became a priority. Hence, the economic development of these regions was decisive because such a control required the colonisation by the white population. More specifically, essential structures to the economy, such as housing (for meeting population growth pressure) and social infrastructures were built, since they were considered key elements for social harmony. The materialisation of this works was one of the main aspects used by Portuguese diplomats as an argument to defend Portugal's position to the United Nations Organization (UN) and other organisations, in which Portuguese colonialism was often scrutinised. Furthermore, plans were approved to build major infrastructures (e.g. hydroelectric dams) to back up the white population settlement and their income. As a result, the urban area of cities such as *Nova Lisboa, Moçâmedes, Sá da Bandeira* (Angola) or *Beira* and *Vila Pery* (Mozambique) grew exponentially.

In this context, for the first time in the history of Angola's and Mozambique's, local architects who had questioned the population's segregation on social and racial grounds, became actively involved in the construction and planning of these cities (Tostões, 2016). This was an expression of the Modern Architecture movement that "dodged" the canons of architecture and urbanism standards imposed by Continental Portugal through the *Gabinete de Urbanização Colonial –* GUC [Office for Colonial Urbanization]. Contrary to the previous practice, this movement promoted the construction of buildings designed according to local specificities. Both movements co-existed, but the activity developed by the Modernist architects was always more associated with the private sector and the projects developed by local government agencies than with the metropole.

Between 1945 and 1975, the architectural solutions designed by these two creative entities – i.e. GUC and modern architecture – materialised the different stages of the *Ultramar's* utopian visions. The urban strategy of GUC's architecture can be divided into three phases, which allow us to better understand the final outline of Luso-African cities during the final colonial period (Milheiro, 2012). The first phase (1945–1955)

was influenced by the garden-city concept developed by Ebenezer Howard (1850–1929), which consisted in building large monumental avenues, clearly defining the limits of the "old city", the residential district, and the school district, among others. These were, *grosso modo*, standardised cities and were equipped as such, evidencing plans made in Continental Portugal. In the second phase (in the 1960s), although the garden-city remained the predominant canon, the colonial cities began to be planned to meet the needs of local populations – including the non-European –, and to consider the specificities of the territory. The intervention, therefore, occurred in the neighbourhoods located around the real city, called *musseques* in Angola, or *caniços* (Gonçalves, 2016) in Mozambique. These were inhabited mainly by African populations, but also by Europeans since the 1940s, due to a lack of housing or to financial difficulties. A pragmatic approach prevailed in the 1970s, the last phase, during which testing methods were adopted. Specifically, surveys to individual citizens and companies aimed to define the most appropriate zonings and intervention areas (Milheiro, 2012, 2013).

The action of Modernist architects was guided by a spirit of reaction against GUC's neoclassicism and regionalism inspired by the vernacular architecture of the metropole. During the 1950s, several modern architects travelled to the Portuguese African colonies, considering the transforming ability of architecture – in this case, into a more democratic society. This movement was a paradigmatic illustration of the link they established between architecture and politics (Tostões, 2016). As a matter of fact, they had the opportunity to work more freely in Africa. The principle behind this movement's operation and their travels to the colonies aimed to address the issues *in loco* in order to better understand the territory's socioeconomic and geographic characteristics, as well as the specificities of the local populations, either colonists or natives (Tostões, 2016). Among the most representative examples of these new paradigms, it should be mentioned the collective development of the *Prenda* neighbourhood in Luanda (1963), the work of Pancho Guedes (1915-2015) in Mozambique, and Vasco Vieira da Costa (1911-1982) in Angola (Fernandes, 2015, 2017; Silva, 2016; Tostões, 2016).

The solutions and consequences of both architectural and urbanistic perspectives of the post-WW2 period gradually and partially materialised the theoretical ideal proposed by the official discourse: an *Ultramar* without racial segregation, where any man could rise in the social ladder through his labour – i.e. the Utopia. The new residential buildings and public spaces (e.g., the *Polana* Church, Beira Railway Station, and the TAP Building in Mozambique or the *Cinemas-esplanadas*, the *Totobola* and the *Auto-Avenida* buildings in Angola), rhetorically open spaces to all, was used by the government propaganda to

exhibit a harmonious way of life in the overseas societies (Fernandes 2017).

4 CINEMA AND COLONIAL CITIES: UTOPIA, REALITY OR DYSTOPIA?

From the 1960s onwards, Portuguese colonial cinema increased due to immigration incentives, economic investment, and the need to "show Portuguese Africa" to justify the war. Indeed, in line with the reform of the *Ultramar*, the urbanisation of Overseas territories, and a more liberal daily life in comparison with Continental Portugal turned the colonial cities, mainly Luanda and Lourenço Marques, into desirable scenarios to build an idyllic image.

However, some documentary filmed in Africa, demonstrate that the utopic image did not always correspond to reality. For instance, this dissonance is revealed with the absence of slums located in the margins of the city. When filmed, those neighbourhoods were exceptionally used to illustrate new constructions and measures taken to address that issue – e.g., *Luanda, Cidade Feiticeira* (AGC & Malheiro, 1950), in the sequence focused on building "assimilated" neighbourhoods (*bairros assimilados*, in Portuguese). The films that did not fit this purpose were usually censored like *Catembe* (Almeida & Almeida, 1965).

Like previously mentioned, there was an increasing concern to make rhetoric fit to reality, as from the mid-1950s. In this regard, similarly to architecture, the cinema included themes related to local communities. Henceforth, the inhabitants played a more critical role in films.

Noteworthy, an important illustration of the new paradigm of colonial cinema is *Luanda e sua gente* (CITA, 1973). This short film shows different aspects of daily life in Luanda – family, work, culture and recreation, from dawn to dusk. The film begins with images of wildlife in the Bay of Luanda, to the sound of a quiet melody, but soon evolves towards an aerial close-up to the broad avenues of downtown and the morning rush. The soundtrack becomes faster, and the images of the traffic and the inhabitants illustrate the city's dynamics. Further, the monuments are filmed against a background composed by modern constructions, revealing clearly that one of the central objectives of the film is to demonstrate Luanda past-present duo. Contrary to *Luanda Cidade Feiticeira,* the main characters are the inhabitants, namely, African, European, mulatto and multiracial couples, filmed together in labour or recreational contexts to illustrate the multiracial society proclaimed by the official propaganda.

This human component shows a different Luanda compared to previous films: the architecture and the economy have changed. A good example is the plans shot from below to illustrate the verticality of the new buildings, and the plans shot from above capturing the horizontality of historical buildings.

After introducing the multicultural city in a trance, economic activities became the film's main characters. This sector recalls progress, so no handicraft is shown. Instead, we see factories and industrial compounds, such as PETRANGOL's. Automated assembly lines are presented continuously, with the workers essentially playing a monitoring role. Most tasks are performed by workers of both European and African genders. Supervisors, however, when present, are European. Finally, the film depicts the extractive industry (oil), and the processing industry (automobile industry, electronic components assembly, tobacco, and beer bottling).

Viewers are then taken from the factory to a music concert, with the film director thus operating the transition from work to leisure. The rock band has musicians of African descent, and it plays for a mostly young and multiracial audience. Women are once again highlighted, as it happened in the images of the city centre. Then, images of a girl's school are presented, and we can observe the students (mostly white) leaving school, while their parents and boyfriends wait for them outside. A few long-haired boys are filmed waiting for the students, with general plans showing the interaction between young people of different races.

A sequence of the film is now devoted to sports events, martial arts, parachuting, and swimming. Another sequence stresses Luanda's ability as a sports venue, including international events. The film shows a soccer match, a shooting contest, a car race and a regatta. The awards ceremony of the regatta introduces us to the final sequence of the film: Luanda's nightlife.

We glimpse the need to reflect the *New Brazils* in Portuguese Africa with a permanent search of a multiracial and multicultural landscape that overlooks the city's physical and social barriers. But some aspects portray a monochromatic Luanda, namely the sports events and the beach scenes – in which most people are of European descent. The absence of dialogue avoids any potential vocabulary constraints as well as linguistic issues since the movie is targeted at an international audience. The absence of references to colonial war and the view of a city of the future add to the image of an eternal and harmonious empire. Among others, the documentary *Nova Lisboa – A Terra e as Gentes* (Telecine, 1974) also followed the same standard. Taken together, the documentary films mentioned above evidence not only the Utopic reform of the colonial cause but also the changes needed to accomplish that issue. However, to which extent could these idyllically represented cities be dystopian?

For the Portuguese administration, the colonial dystopia could occur if the independence movements conquered the cities, killing the white and the black

"assimilated" inhabitants in order to install a communist or independent tribal regime. For example, *Nambuangongo: a Grande Arrancada* (RTP, 1961) is a war documentary that represents this dystopia. The film focuses on recapture by the Portuguese army of a village located on a plateau about 200 km from Luanda that was transformed into the headquarters of the Union of Peoples of Angola (UPA) – the independence movement which led to the massacre of white settlers and black ethnic *bailundo* workers throughout northern Angola.

Also, colonial dystopia could be present for those (mostly black, but also white people), that continued to live in the *musseques* and *caniços* or for those who posed a threat to the regime, as witnessed in the international anticolonial production *Sambizanga* (Isabelle Films & Maldoror, 1972), named after the prison in the outskirts of Luanda where the main character was jailed and tortured.

5 CONCLUSION

Portugal had a peripheral geopolitical position and always had to deal with the imminent loss of its overseas territories, especially after the international political juncture of the post-WW2. Instead of instigating wars the *Estado Novo* reformed their colonial policy and the subsequently developed propaganda to maintain their Empire lead to structural reforms in the cities of Portuguese Africa, namely in Angola and Mozambique.

This essay used the recent and fruitful historiographic method to explore the new Portuguese colonial conception through cinema. Enabling the access to the past through image and sound, the analyses of the selected documentary films allowed us to understand how the reformed Portuguese colonial policy reveals the utopia/fantasy of the new colonial politics of *Estado Novo*. Indeed, the colonial films are an instrument that enables the access to a visual history of contexts that have disappeared or have been profoundly changed in material and human terms, such as in colonial Angola and Mozambique.

In this line, this essay also contributes to the architectural and urbanistic study of Portuguese Africa during the late colonialism period (1951-75), given the lack of reference work or colonial film catalogue for that purpose. For example, allowed us to verify in a different perspective the evolution of urban spaces (e.g. buildings or avenues), and to which extent these were suitable and enjoyed by the inhabitants, in comparison to other types of documental sources, such as elevations, plans, and photography.

Summing up, cinema is a fundamental source of information to gauge the importance of these two colonial landscapes and possibly value them as heritage in the post-colonial society.

ACKNOWLEDGEMENT

This chapter is made in the context of the project CIDEHUS – UID/HIS/00057/2013 (POCI-01-0145-FEDER-007702).

BIBLIOGRAPHICAL REFERENCES

Alexandre, V. (2000). *Velho Brasil, novas Áfricas: Portugal e o império (1808–1975)*. Porto: Edições Afrontamento.
Castelo, C. (2007). Passagens para África: O povoamento de Angola e Moçambique com naturais da metrópole (1920–1974). Porto: Edições Afrontamento.
Castelo, C. (2014). "Novos Brasis" em África: Desenvolvimento e colonialismo português tardio. *Varia História*, 30 (53), 507–532.
Convents, G. (2011). Os moçambicanos perante o cinema e o audiovisual: Uma história político-cultural do Moçambique colonial até à República de Moçambique (1896-2010). Maputo: Edições Dockanema/Afrika Film Festival.
Fernandes, J. M. (2015). *Arquitectura e urbanismo na África portuguesa*. Casal de Cambra: Caleidoscópio.
Fernandes, J. M. (2017). Arquitetura Moderna Portuguesa na África Subsaariana. *Portuguese Literary & Cultural Studies*, 30, 95–113. Retrieved from https://ojs.lib.umassd.edu/index.php/plcs/article/view/PLCS30_31_Fernandes_page95/1224
Gonçalves, N. S. (2016). Políticas de gestão (sub)urbana de Lourenço Marques (1875-1975). *Cabo dos Trabalhos*, 12, 1–19. Retrieved from https://cabodostrabalhos.ces.uc.pt/n12/documentos/8_NunoGoncalves_REV.pdf
Lains, P. (1998). An Account of the Portuguese African Empire, 1885–1975. R*evista de Historia Económica – Journal of Iberian and Latin American Economic History*, 16 (01), 235–263.
Lains, P., & Siva, Á. F. (2005). *História económica de Portugal, 1700–2000: O século XX* (Vol. 1). Lisboa: Imprensa de Ciências Sociais.
Milheiro, A. C. F. V. (2012). O Gabinete de Urbanização Colonial e o traçado das cidades luso-africanas na última fase do período colonial português. urbe. *Revista Brasileira de Gestão Urbana*, 42 (2), 215–232. doi: 10.7213/urbe.7397
Milheiro, A. V. (2013). Africanidade e arquitectura colonial: A casa projectada pelo Gabinete de Urbanização Colonial (1944–1974). *Cadernos de Estudos Africanos*, 25, 121–139.
Mumford, L. (1962). *The story of utopias*. Nova York: Viking Press. Retrieved from https://archive.org/details/storyutopias00mumfgoog/page/n10
Piçarra, M. do C. (Ed). (2013). Angola, o nascimento de uma nação. In *O cinema do império* (Vol. 1). Lisboa: Guerra e Paz.
Seabra, J. (2011). África nossa: O império colonial na ficção cinematográfica portuguesa (1945–1974). Coimbra: Universidade de Coimbra.
Silva, C. N. (2016). Urban planning in Lusophone African countries. London: Routledge.
Silva, M. D. (2014). Cinema no Estado Novo. *Aniki: Revista Portuguesa da Imagem em Movimento*, 1 (2), 357–362.
Telo, A. J. (1994). *Economia e império no Portugal contemporâneo*. Lisboa: Edições Cosmos.

Tostões, A. (2016). How to love modern [post-]colonial architecture: Rethinking memory in Angola and Mozambique cities. *Architectural Theory Review*, 21 (2), 196–217.

Filmography

AGC (Producer) & Malheiro, Ricardo (Director). (1950). *Luanda, Cidade Feiticeira*. Portugal: Tobis Portuguesa. Retrieved from http://www.cinemateca.pt/Cinemateca Digital/Ficha.aspx?obraid=2110&type=Video

AGU (Producer) & Sousa, António (Director). (1961). *Angola*. Portugal: Ulyssea Filme. Retrieved from http://www.cinemateca.pt/CinematecaDigital/Ficha.aspx?obraid=2235&type=Video

Almeida, Faria (Producer/Director). (965). *Catembe*. Portugal: Ulysseia Filmes. Retrieved from https://www.youtube.com/watch?v=QoC8A6lHf14

CITA (Producer/Director). (1973). *Luanda e sua gente*. Portugal. Retrieved from http://www.cinemateca.pt/CinematecaDigital/Ficha.aspx?obraid=2622&type=Video

Isabelle Films (Producer) & Maldoror, Sarah (Director). (1972). *Sambizanga*. France: Isabelle Films. Retrieved from https://www.youtube.com/watch?v=Rm6453 fKKAY

RTP (Producer) & Elyseu (Director). (1970). *Angola 70*. Portugal: RTP. Retrieved from https://arquivos.rtp.pt/conteudos/angola-70/

RTP (Producer) & Elyseu (Director). (1970). *Luanda*. Portugal: RTP. Retrieved from https://arquivos.rtp.pt/conteudos/angola-70/

RTP (Producer) & Fernandes, Serra; Costa, Neves da (Directors). (1961). Nambuangongo: a Grande Arrancada. Portugal: RTP Retrieved from https://arquivos.rtp.pt/conteudos/nambuangongo-a-grande-arrancada-i-parte/

Telecine (Producer). (1974). Nova Lisboa – Terra e as Gentes. Portugal: Nacional Filmes. Retrieved from http://www.cinemateca.pt/CinematecaDigital/Ficha.aspx?obraid=3930&type=Video

Fantasy and reality belong together; multidimensional thinking to innovate the creative process

José Silveira Dias & Dulce Loução
CIAUD, Lisbon School of Architecture, Universidade de Lisboa, Lisbon, Portugal
ORCID: 0000-0002-4751-694X; 0000-0001-6723-2939

ABSTRACT: Fantasy presupposes thinking things that never existed. It develops as a result of incremental knowledge resulting from the establishment of the most significant number of relationships among the largest number of data seized through experimentation. A critical reflection on its practice clarifies the understanding of the experimental process that guides it, from the possible forms of manifestation and performance to responsible action. As a methodology applied in the exercise of creative experimentation, it aims to stimulate creativity. It requires the understanding of its complexity as a human activity, as a mechanism and resource, since its evocation requires guidance according to imagined and communicable operations. Complex thinking identifies articulations across disciplinary domains, aspiring to multidimensional knowledge that can identify ways of modelling the future. Since innovation requires fantasising in advance, we imagine possibilities and probabilities to improve the state of the situation. Fantasy develops from sensory perception, emerging from nature and everyday life. The search for memories allows the human being to intuit meanings of the current situation and to foresee the future as life unfolds, building memories. Through fantasy, new forms of expression of knowledge are conceived for expansion of the mind, innovating the creative process. Fantasy inspires reality by modifying it in consonance just as reality inspires fantasy.

Keywords: Fantasy, Multidimensional Thinking, Expanded Mind, Innovate, Creative Process.

1 FANTASY INSPIRES REALITY

Objectively, fantasy does not exist and requires no concretisation to be recognised, but its practice allows expressing desires in a free way.

Fantasy can adopt innumerable forms of manifestation, expressed in the relations of concepts that grant the autonomy of its movement beyond the movement of relations that establishes around it. In the various ways it can form, fantasy can manifest itself through (i) the inversion of a given situation, establishing opposition or complementarity; (ii) the identical or variable repetition of the components that form an integral part of the original idea; (iii) visual or functional analogies that establish new relationships; (iv) the alteration or substitution of attributes such as colour, weight, matter, place, function, scale and movement; (v) the design of new objects combining different elements, recognising the parts that complete it; (vi) the creation of relations between relations, thus increasing the level of complexity of thought (Munari, 2007).

Fantasy presupposes thinking of new things, things that have never existed, without the need to gauge if intuited novelty is an absolute truth. Fantasy develops because of increased knowledge by allowing to establish the most significant number of relationships among the largest number of data seized through experimentation. Critical reflection on the practice of fantasy can clarify the understanding of the experimental process that guides it from the possible forms of manifestation and performance to a responsible action as a methodology for the exercise of creative experimentation. Fantasy inspires reality (Fig. 1).

2 FANTASY FOREVER

Huizinga (2003) describes fantasy as an ability of the spirit and compares this innate ability of the human being to create ideas as a mental game of conceptions that results from imagination. The mythical fantasising of the Man of Prehistory in the representation of the origins of his existence and on events of daily life were already principles of knowledge that would find strong expression in the logical forms of the later epochs. Fantasy supports the creation of the *Deus Ex-Maquina*. This device was used to introduce the divinity into the scene through a mechanism that suspended a supernatural entity that came on the scene and altered the direction of the narrative or determined the immediate outcome (Appleton, 1920). The archaic religious consciousness of the Romans also promoted this faculty in

Figure 1. Fantasy inspires reality. Proposal for the "Continente da Amadora" Lobby's (Author, 2018).

the practice of the *indigitamenta*, through official ceremonies for the institution of new deities to reassure manifestations of collective emotion and to appease social tensions (Lipka, 2009). More recently, at the turn of the millennium, immersive digital experiences, such as games and virtual worlds, appropriate the concept of Avatar as a projected representation of the user within an immersive environment. In a fantasy universe, the avatar can be the user's representation in a projected virtual environment or the extrapolation of reality through imaginary characters in environments of immersive expression using fantasy to transport the user to parallel universes (Rodrigues, 2016).

On the other hand, the concept of simulacrum analysed by Stoichita (2011) in the context of the philosophy of the late twentieth century, showing the operational character of this concept as the "other image" in relation to "image-icon", reveals that its main feature is not in the similarity, but in the existence of the "ghost." The simulacrum, as an artificial construction devoid of the original model, surpasses reality itself and presents itself as existing by in and itself. As such, it exists because it is not limited to copying objects from the world but projecting itself into the world of objects. As an artefact, the simulacrum produces a "resemblance effect" (Deleuze, 1975), because it disguises at the same time the absence of a model using the excess of its existence, which Baudrillard (1991) calls hyper-reality. The simulacrum replaces reality itself by simulating the real and supplants the artefact via fantasy through the ghost artefact.

These are just some appropriations that fantasy has adopted among innumerable forms of expression sustained in this logical organisation that operationalises the imagination in the creative process throughout history of humanity.

3 FANTASY AS METHOD TO CREATIVE PROCESS

The intelligibility of the practice of fantasy needs systematisation so that it can appropriate the countless possibilities of the imaginary in the constant ambition to find uses through imagination. Imagination is considered as the capacity that establishes the representation of objects according to their qualities when supplied to the mind through the senses and the imaginary as interface to produce ideas, conceptions, strategies, where the relations of otherness must be expressed, on the assumption that every human being interacts and interdepends on the other, that is, socialize.

As Pallasmaa (2011) argues, imagination is the operational tool of consciousness, thought, and memory understood as faculties that constitute the real foundation of humanity. It is not possible to explain the capacities to absorb, remember and understand the information that is intrinsic to the human being – such as his personality, his history, the succession of events and places throughout his life - without the existence of schemas, images, maps and mental models, as metaphors that structure, organise, integrate and maintain the enormous volume of fragmented data of sensations and memories that the human being accumulates throughout his life. Just as it is impossible to think of ethical (individual and collective) accountability, without this capacity of imagination to project and concretise the consequences of adopted or alternative behavioural options, namely in decision making, deliberation and orientation of action. In fact, creativity emerges as an operation to project and concretise the imagination, where fantasy can operate methodologically. Thus, one can think of creativity as the final art of fantasy with the ambition to adapt the transformations of daily life to solve problems and develop culture because of humanising interaction. However, creativity requires originality, coupled with effectiveness (Runko and Jaeger, 2012). Originality is fundamental to creativity, but it is not enough condition. The original ideas and products may be useless. The original things must be effective to be creative. Efficacy gives attributes to things, making them useful, adaptable, or appropriate. Effectiveness becomes value when it is reflected in the meaning of products and creative ideas in the context of the market, correlatively to costs and benefits as principles to define innovation.

In this way, fantasy is oriented as a methodology to develop creativity: (i) in the recognition of tools to be used in order to distinguish their potentialities; (ii) in the identification of techniques more adequate for the performance of the applied tools; (iii) the promotion of free will and decision-making in relation to the application of acquired knowledge; (iv) in the analysis and discussion of results obtained in relation to collaboration and respective valuation; (v) in the

stimulus and orientation of participatory work for the presentation of eventual situation; (vi) and, finally, the ability to dismantle this event after its presentation in order to guarantee the constant updating of those involved, that is, in the sense of demystifying the work done, not allowing imitation of models. In this way, the object is not preserved, but the process as an experiment that changes and is receptive to new productions according to the problems to be solved (Munari, 2007) (Clark et al., 1980). As a methodology to stimulate creativity, it needs to understand its complexity as a human activity (Morin, 2008), as a mechanism and as a resource, since its evocation requires guidance according to imagined and communicable operations.

4 COMPLEX THINKING

Complex thought exposes the hidden relations of thought, systematising a critical reflection capable of treating the real, dialoguing and negotiating with it. The ambition of complex thinking is to account for the articulations between disciplinary domains, aspiring to a multidimensional knowledge. It allows the recognition of the links between entities that thought must necessarily distinguish, but not isolate one from the other. According to Morin (2008), complex thinking is animated by a permanent tension between the pretension to a non-fragmentary knowledge and the recognition of the incompleteness of knowledge. This tension animates the life of the human being against the conformism of a closed knowledge: that which isolates the object from its context, its antecedents and eventual evolution. Knowledge operates by selecting and rejecting data, according to its meaning. Recognising data as identified elements of a problem, complex thinking separates and distinguishes them from other elements and unites and associates them, identifying and relating. It can also hierarchize (from the general to the specific) and converge these data in function of a core (concept) where the fundamental principles of the identified problem are concentrated. These operations apply logic and are guided by principles of organisation of thought or paradigms, as principles that guide the view of things and the world intuitively. It is about avoiding an abstract, one-dimensional perspective, considering the consequences of paradigms that can atrophy knowledge and deform reality. Complexity establishes the paradox of the one and the multiple, as it weaves a network of heterogeneous components-events, actions, interactions, feedbacks, and recursions-that are inseparably associated and constitute the world of phenomena.

Complex thinking satisfies the need for knowledge in shaping chaos (Ferry, 2012), systematising phenomena, removing uncertainty and ambiguity, recognising conviction and order. The complexity exercise proposes the clarification of things conveniently, distinguishing the components that correlate and hierarchize

the seized data. It aims, therefore, to grant intelligibility as an operation that provides the autonomy of the process through conceptual instruments.

5 EXPANDING THE MIND

The mind of the human being is complex and immeasurably rich because of the combination of simple data acquired throughout life.

The basic unit for the creation of the human mind is the image, be the image of the thing, of what it does, of what leads to feeling, or even the image of what is thought of the thing or the images of the words that translate each of these possibilities or the whole. The different images can be integrated, producing more complex relations of external and internal realities.

The INTEGRATION of images through the senses is a process of mental enrichment that takes various forms. It can represent an object from multiple sensory perspectives, as well as relate the object to events in time and space producing narratives. Connecting the different components, articulating the links between them, that is, in sequences full of meaning that constitutes and guides the stream of thoughts, is the design of COMPLEX THINKING. All the different sensory regions of the brain contribute the necessary part, at the right time, to the possibility of forming a chain of elements in time. Through associative structures that coordinate the timing of the components and the composition and movement of this chain, the thought is established (Damásio, 2017). Through the processing of images, the brain establishes ABSTRACTION of images revealing the schematic structure underlying any image (visual, sound, tactile, olfactory, gustatory) or integrated images that describe feelings giving rise to metaphors, symbolising objects or events. Here, FANTASY comes into action, manipulating the original images that build the mental life of the human being. It allows the CREATION OF CONCEPTS from images of objects and events, including emotions and feelings. Almost all the information that appears in mental images is subject to internal registration. The quality of the record depends on how the images are treated, in addition to the emotions and feelings generated during one's journey through the mental stream.

The MEMORY of a situation identified in sensorial terms becomes explicit images in a "neural code" that, later, when acting in the opposite direction, allows the subsequent reconstruction in the process of the memory of the original image.

REASONING requires interaction between what the present images show as being now and what the remembered images show to be the before. The reasoning also allows the anticipation of what follows and applies the imagination to anticipate the consequences from the memory of the past. Memory helps the conscious mind to think, evaluate and decide the action by

proposing a behaviour that is precise and effective in the treatment of tasks in everyday life, from the banal to the sublime.

IMAGINATION is triggered by the recall of images and functions as the interface for creativity and can apply fantasy as a method for the CONSTRUCTION OF NARRATIVES of exceptional character where the recall optimises the meanings of the facts and ideas associated with the various objects and events. The order and quantity, as well as the description of objects and events regarding the relevance and qualification of the data introduced, are decisive for the interpretation of the narrative and the way it is stored in memory and how it will be later accessed. It should be remembered that narratives are not exempt from objectivity because they are usually influenced by past experiences and presuppositions agreed upon with likes and dislikes. According to Damásio (2017), the brain resorts to "search engines" that, automatically or when requested, recover the memories of past mental life. This process of remembrance is essential because much of what is memorised does not concern the past, but rather an anticipated future that has not yet been lived and only imagined according to the ambitions and expectations of each one. This process of imagination brings together current and past thoughts and new and old images that are continually being recorded. The CREATIVE PROCESS is continually documented for future and practical application.

The constant search for memories allows the human being to intuit possible meanings of the current situation, as well as to anticipate the future as life unfolds. In fact, as we live in anticipation and a constant projection of the future, we must converge this concern for the creation of new forms of expression of knowledge, to expand the mind and INNOVATE the creative process.

6 INNOVATE THE CREATIVE PROCESS

The action of innovating contributes to anticipate changes that will become relevant as deliberate interventions intended to indicate and establish future developments related to humanisation. Innovating is not just an economic or technological strategy; it is, above all, a social phenomenon. Caracostas and Muldur (2001) argue that the purpose, impact and framework conditions for innovation are closely linked to the social environment in which they emerge. Innovation is not only revealed through the application of technology. Above all, it is the result of learning whose objective is to develop the process for the benefit of quality, increasing the meaning and value that society aspires to find in the search for products, services and processes determined by consumerism. According to these authors, innovation establishes the development of innovative solutions to problems in reformulating existing solutions in the face of the available

investment and the optimisation of the resources identified. Whether it is about new products or related to services or processes, it has the ambition to satisfy needs in a more efficient, effective or sustainable way concerning existing solutions, promoting collaboration and stimulating creative participation and skills for the individual and society to act.

Its intangible and immaterial face (Howaldt and Schwarz, 2010) distinguishes the action of innovating. In fact, innovation does not occur by the material existence of the artefact itself, but by the practice that the artefact can promote. Innovation consists of the renewed combination or configuration of practices in certain areas of action or contexts, induced by specific agents in a targeted and intentional way, to better respond to needs and problems based on participatory practices. However, the practices themselves can be renewed as part of the creativity process (Sanders et al., 2010).

In this sense, innovation can be interpreted as a process of creation where individuals create and establish new rules for a social game of communion and conflict of interest. In other words, the action of innovating emerges as a new practice where participants acquire the necessary cognitive, rational and organisational skills, insofar as the strategies adopted can be analysed, co-oriented and oriented to common practice through reflection on the structure itself of relationships between individuals (Crozier and Friedberg, 2014). Being responsible for the set of methods and techniques to critically reflect possible ways of modelling the future, innovating requires fantasising in advance, imagining possibilities and probabilities for different developments to improve problematic situations through the creative process.

7 REALITY INSPIRES FANTASY

Indeed, fantasy is the necessary faculty for revealing the hidden relations of human nature. The ability to see these connections depends on a sensory fantasy that develops with complex thinking. In search of solutions to a given problem, while the data that may be at stake is entirely different, the imagination can gather this information to articulate data for the creation of problem-solving processes. One of the objectives of knowledge is to establish an intuitive perception of integrity in which the phenomenon in question participates and interdepends in the capacity for understanding the internal connections of its nature. Only from such intuition can the human mind be able to construct rational models and theories from the phenomenon. Thus, fantasy feeds rationality from intuitive concepts and abstractions that emerge from the experience of things by developing an imaginative approach to reality. The sensory and imaginative way of understanding is a prerequisite for intuitive perception, which involves observing phenomena beyond their essence, including

the movement they impose around them. The concepts and models are necessary for scientific recognition, in addition to the sensory image's correlative to the development of a higher intuitive perception. Even if rationality establishes a logical precision, it will subsist to incomprehension without the content provided by the fantasy sustained in the sensory world. Goethe (1998) argued that fantasy as a form of sense delight was rooted in the vital organisation of the human being.

Complex thinking establishes meaningful rational constructions that have a sensory and imaginative basis. The integration of images through the senses is a process of mental enrichment that through maps can represent objects from multiple sensorial perspectives, as well as relate objects with events in time and space, producing narratives. Through image processing (mapping), the brain establishes the abstraction of images revealing the schematic structure underlying any perceptual or metaphorical image that describes feelings, symbolising objects or events. In this, fantasy comes into play manipulating the original images that build the mental life of the human being, leading to new derivations. It allows the creation of concepts from the images of objects and events that include emotions and feelings. As units of knowledge that deduce and conceive the movements within them, the concepts also establish the movement to the life where they apply.

The constant translation of any perceptible image of this action that crosses the mind will enrich it incrementally. Also, the communication through codes that have rules for the combination of sounds in words serves to describe the images of the human mind indefinitely.

Reasoning requires an interaction between the present and the past, as well as the anticipation of the next, applying the imagination to anticipate the consequences from the memory of the past. Consequently, recollection comes to assist the conscious mind in deciding to act through original and effective behaviour with creativity.

The process of imagination is triggered by the recall of images and establishes the interface for creativity by applying fantasy as a method for constructing narratives of exceptional character, where recall optimises the meanings of the facts and ideas associated with the various objects and events. Fantasy develops from sensory perception and emerges from nature and everyday life as territories for rational construction. The fantasy emerges from reality to innovate the creative process, altering the reality in consonance in time that is, inspiring the fantasy again (Fig. 2).

8 AFTERWORD

Writing is an effort to make clear to the other, who reads, a thought, an idea, an image that dwells only in one's identity. With words, silences, commas and

Figure 2. Reality inspires fantasy. German Pavilion in Barcelona by Mies van der Rohe (Author, 2016).

points, what is revealed from the inside is described. It is like drawing a house.

The contours are first delimited; then the interior is filled. Finally, the interior contaminates the exterior, altering the initial layout, resulting in a fusion of relations of sight, of penetration of sunlight or the rays of the full moon, in clear nights.

At the same time, the suggestions of spaces inhabited by imaginary or real people assault the tip of the pencil and lead the drawing for the revisiting of all dream homes, seen in films, in painting, in family portraits, in dreams and so forth.

How to reconcile the desire to make new, with the evidence that everything that has been lived, even in past lives and in others that are yet to come, is projected at every risk in the skipping, in every word that is added, in the text under construction

One thinks of what one has dreamed of, which one has already seen and is now trying to draw, to be inhabited – the house. They are evocative of rose scents in the yard, the colour of the family room's corridor, the touch of the marble stone on the kitchen table, the temperature of the pantry where the smoked sausages smoke on the floor. And it is the departed loved ones that intersect with everyday faces and situations, out of context, but strangely linked in a nexus that the dream reveals.

It is not moral; it is fantasy. Everything is allowed, and, looking intently, the unconscious reveals the meaning of each one's place in the world.

For those who make architecture, the raw material is the unconscious that encloses in its depth ancestral memories chained in the recesses of our brain: it is a whole civilization added of familiar matter and the experience of the world, which unknowingly feeds the desire to build beyond the real, of everyday life, a transcendent secret.

Everyone has of fantasy the need to embody it in images. It is from this design that the records of spatiality evocative of any hidden memory – the new drawings of a new house, which after all is always the same – the dwelling of the gods.

To elaborate a thought about something that does not exist as a tangible entity, but which can be manifested in the real, one day, once the conditions of time and space have been gathered so that a fruit of the imagination is a concrete thing, and as such, manifestation of human being.

This irrepressible desire for the transcendence of everyday life, grounding futures, at each moment, present and even past, are of the very nature of the self; and they are because they define the individual relative to the other, that is, his own identity.

In creating, the self-manifests unique modes of relating to the world, which are at the same time personal and collective, in the sense of belonging at the same time to society.

The possession of a thought that comes to fruition is a gift to the world and a return to the obscure origins of creation. The created thing unleashes new things to create, in the author or in those who contemplate it, but which, at the same time, has always been present since the dawn of time.

The fantasy as an expression of this desire of re-creation, of metamorphosis, from the chrysalis to the butterfly, is inherent to the human being; this desire of, with the imagination, to approach the Divine, nor that this divine, today, is called Technology.

But there is always, if not hidden, this intent, this design, that project that is defined by a successive process of approach to a desire for fullness, a better life, an Ideal House.

BIBLIOGRAPHICAL REFERENCES

Appleton, R. (1920). *The Deus ex-Machina in Euripides*. The Classical Review. New York: Cambridge University Press.

Baudrillard, J. (1991). *Simulacros e Simulação*. Lisboa: Relógio d'Água.

Caracostas, P. and Muldur, U. (2001). The Emergence of the New European Union Research and Innovation Policy. In: Laredo, P. and Mustar, P. editors. *Research and Innovation Policies in the New Global Economy: An International Comparative Analysis*. Cheltenham, UK: Edward Elgar.

Clark, L. et al. (1980). *Lygia Clark*. Rio de Janeiro: Funarte.

Crozier, M. and Friedberg, E. (2014). *L'acteur et le système. Les contraintes de l'action collective*. Paris: Éditions du Seuil.

Damásio, A. (2017). A Estranha Ordem das Coisas. A vida, os sentimentos e as culturas humanas. Lisboa: Círculo de Leitores.

Deleuze, G. (1975). *Lógica do Sentido*. São Paulo: Editora Pespectiva.

Ferry, L. (2012). Homo Aestheticus. A Invenção do Gosto na era Democrática. Lisboa: Edições 70.

Goethe, J. W. (1998). The experiment as a mediator between object and subject. In D. Miller (ed.), *Goethe: the collected works*, Vol. 12, Scientific studies, pp. 11–17. New York: Suhrkamp.

Huizinga, J. (2003). *Homo Ludens*. 4ª ed. Lisboa. Edições 70.

Lipka, M. (2009). *Roman Gods: A Conceptual Approach*. Leiden: Brill.

Morin, E. (2008). *Introdução ao Pensamento Complexo*. 5ª ed. Lisboa: Instituto Piaget.

Munari, B. (2007). *Fantasia*. Lisboa: Edições 70.

Pallasmaa, J. (2011). *The Embodied Image: Imagination and Imagery in Architecture*. Chichester: John Wiley & Sons Limited.

Rodrigues, J. (2016). Brincando de Deus. Criação de mundos virtuais e experiências de imersão digitais. Rio de Janeiro: Marsupial.

Sanders, E. et al. (2010). *A Framework for Organizing the Tools and Techniques of Participatory Design*. In Participatory Design Conference. [online]. [acessed 03 December 2018]. Download from https://www.researchgate.net/publication/220030447_A_Framework_for_Organizing_the_Tools_and_Techniques_of_Participatory_Design.

Stoichita, V. (2011). O Efeito Pigmalião. Para uma Antropologia Histórica dos Simulacros. Lisboa: KKYM.

Creativity and intelligent research in design: The use of quasi-experience

Fernando Moreira da Silva
CIAUD, Lisbon School of Architecture, Universidade de Lisboa, Lisbon, Portugal
ORCID: 0000-0002-5972-778

ABSTRACT: In research, when we talk about areas such as Design or Architecture, we often think of the need to use apply applied research at a certain point in the research process. Given the lack of practical methods and tools to support research development when using Research by Design or Research through Design, it is necessary to acknowledge and know how to use practical and interventionist methodologies in a creatively and intelligently way that can lead to rigorous and scientific results. Among these methodologies, we highlight the Action Research and the Quasi-Experience. This paper focuses on the Quasi-Experience methodology, underlining how it is used, and demonstrating its advantages and limitations. Quasi-experimental research involves the manipulation of an independent variable without the random assignment of participants to conditions or orders of conditions, and it is generally higher in internal validity than correlational studies but lower than the experience methodology. Although this methodology does not meet all the requirements of experimental methodology, its intelligent and creative use in design has allowed researchers to achieve results of high validity.

Keywords: Interventionist research methodologies, intelligent research in design, quasi-experience research, creativity in research.

1 INTRODUCTION

This paper refers to an investigation that has been conducted on the use of appropriate methodologies to applied research, that is, whenever it is necessary to use practical, empirical methodologies in research in areas such as design or architecture.

Researchers are often faced with a lack of methods and tools to enable them to develop research in interventionist project areas for which there is no support in the methodologies used in social sciences. Thus, researchers had to resort to creative and intelligent methodologies that allowed them to involve end-users, methodologies that do not meet all the requirements of experimental methodologies, such as quasi-experience or action research. The use of these methodologies in design has allowed researchers to achieve results of high validity, in many of these research projects there has been an immediate transfer of the knowledge to the society, accompanied by the creation of new products and solutions of added value.

Thus, research by design or research through design has gained ground in research, especially at the level of master and PhD degrees. In the vast majority of cases, it would not have been possible to achieve quality research results without the creative use of these interventionist methodologies, of course after the development of fundamental research studies, with the construction of the necessary theoretical frameworks.

2 WHAT IS QUASI-EXPERIENCE?

The prefix *quasi* means "resembling." Thus quasi-experience research is research that resembles experimental research but is not true experimental research. Although the independent variable is manipulated, participants are not randomly assigned to conditions or orders of conditions (Cook & Campbell, 1979).

A quasi-experimental design is one that looks a bit like an experimental design but lacks the key ingredient – random assignment. Sometimes it often appears to be inferior to randomised experiments. However, something is compelling about these designs; taken as a group, they are easily more frequently implemented than their randomised cousins (Campbell & Stanley, 1966).

When we mention experiment or experience, we refer to that portion of research in which variables are manipulated and their effects upon other variables observed. Quasi-experiment or quasi-experience is an empirical research methodology where there is lack of complete control. When we have to implement research using final users, like humans or animals, we are not able to control all the necessary variables like physical, physiological and psychological variables. In this case, there is a lack of control during the experiment: this methodology is called quasi-experiment. So, this methodology is used to estimate the causal impact of an intervention on target population without

random assignment, allowing the researcher to control the assignment to the treatment condition, but using some criterion other than random assignment. Quasi-experiments are subject to concerns regarding internal validity, because the control groups may not be comparable at baseline. With random assignment, study participants have the same chance of being assigned to the intervention group or the comparison group. Randomisation itself does not guarantee that groups will be equivalent at baseline.

3 QUASI-EXPERIENCE AND THE
EXTRANEOUS VARIABLES

According to Campbell and Stanley (1966), when we use the quasi-experience method, eight different classes of extraneous variables, relevant to internal validity, will be presented. These variables, if not controlled in the experimental design, might produce effects confounded with the effect of the experimental stimulus. They represent the effects of:

1. History, the specific events occurring between the first and second measurement in addition to the experimental variable;
2. Maturation, processes within the respondents, operating as a function of the passage of time per se (not specific to the particular events), including growing older, growing hungrier, growing more tired, and the like;
3. Testing, the effects of taking a test upon the scores of second testing;
4. Instrumentation, in which changes in the calibration of a measuring instrument or changes in the observers or scorers used may produce changes in the obtained measurements;
5. Statistical regression, operating where groups have been selected based on their extreme scores;
6. Biases that result in a differential selection of respondents for the comparison groups;
7. Selection-maturation interaction, etc., which in some of the multiple-group quasi-experimental designs, such as Design, is confounded with, i.e., might be mistaken for, the effect of the experimental variable.

The factors jeopardising external validity or representativeness, which will be discussed are:

8. The reactive or interaction effect of testing, in which a pretest might increase or decrease the respondent's sensitivity or responsiveness to the experimental variable and thus make the results obtained for a pretested population unrepresentative of the effects of the experimental variable for the unpretested universe from which the experimental respondents were selected;
9. The interaction effects of selection biases and the experimental variable;
10. Reactive effects of experimental arrangements, which would preclude generalisation about the effect of the experimental variable upon persons being exposed to it in non-experimental settings;

Multiple-treatment interference, likely to occur whenever multiple treatments are applied to the same respondents because the effects of prior treatments are not usually erasable.

There are many natural social settings in which the research person can introduce something like experimental design into his scheduling of data collection procedures (e.g., the when of measurement and to whom), even though he/she lacks the full control over the scheduling of experimental stimuli (the when and to whom of exposure and the ability to randomize exposures) which makes a true experiment possible. Such situations can be regarded as quasi-experimental designs. But just because full experimental control is lacking, it becomes imperative that the researcher be thoroughly aware of which specific variables his/her particular design fails to control (Campbell and Stanley, 1966).

The designer should work with creativity and intelligence, deliberately seeking out the artificial and natural laboratories which provide the best opportunities for control. But beyond that the researcher should go ahead with experiment and interpretation, fully aware of the points on which the results are equivocal: if this awareness is important for experiments in which "full" control has been exercised, it is crucial for quasi-experimental designs.

4 QUASI-EXPERIMENTAL DESIGN IN
DEVELOPMENT AND EVALUATION

Because the independent variable is manipulated before the dependent variable is measured, quasi-experience research eliminates the directionality problem. But because participants are not randomly assigned—making it likely that there are other differences between conditions—quasi-experimental research does not eliminate the problem of confounding variables. In terms of internal validity, therefore, quasi-experiments are generally somewhere between correlational studies and true experiments.

As stated previously, quasi-experimental designs are commonly employed in the development of applied research within interventionist methods, but also as an evaluation methodology when random assignment is not possible or practical.

So, quasi-experiments are most likely to be conducted in field settings in which random assignment is difficult or impossible. They are often conducted to evaluate the effectiveness of a treatment—perhaps a type of psychotherapy or an educational intervention.

Although quasi-experimental designs need to be used commonly, they are subject to numerous interpretation problems.

According to Gribbons & Herman (1997), frequently used types of quasi-experimental designs include the following:

5 THE NONEQUIVALENT GROUP, POSTTEST ONLY (QUASI-EXPERIMENTAL)

When participants in a between-subjects experiment are randomly assigned to conditions, the resulting groups are likely to be quite similar. In fact, researchers consider them to be equivalent. When participants are not randomly assigned to conditions, however, the resulting groups are likely to be dissimilar in some ways. For this reason, researchers consider them to be nonequivalent. A non-equivalent groups design, then, is a between-subjects design in which participants have not been randomly assigned to conditions.

The nonequivalent, posttest only design consists of administering an outcome measure to two groups. For example, one sample group might receive instructions about the use of a specific program while the other receives no instructions. In the end, we will be able to compare the findings and to see which program was more effective.

Of course, we will expect that the sample group that has received specific instructions on how to use the program will present better results. However, a major problem with this design is that the two groups might not be necessarily the same before any instruction takes place and may differ in important ways that influence the final results. That is why the replication of these experiments is so important, in terms of validation.

For example, a researcher wants to evaluate a new method of teaching fractions to third graders. One way would be to conduct a study with a treatment group consisting of one class of third-grade students and a control group consisting of another class of third-grade students. This design would be a nonequivalent groups design because the students are not randomly assigned to classes by the researcher, which means there could be significant differences between them. Of course, the teachers' styles, and even the classroom environments might be very different and might cause different levels of achievement or motivation among the students. If at the end of the study there was a difference in the two classes' knowledge of fractions, it might have been caused by the difference between the teaching methods—but any of these confounding variables might have caused it.

Of course, researchers using a nonequivalent groups design can take steps to ensure that their groups are as similar as possible.

In the present example, the researcher could try to select two classes at the same school, where the students in the two classes have similar scores on a standardised math test, and the teachers are the same sex, are close in age, and have similar teaching styles. Taking such steps would increase the internal validity of the study because it would eliminate some of the most important confounding variables.

But without correct random assignment of the students to conditions, there remains the possibility of other important confounding variables that the researcher was not able to control.

6 THE NONEQUIVALENT GROUP, PRETEST-POSTTEST DESIGN

The nonequivalent group, pretest-posttest design partially eliminates a major limitation of the nonequivalent group, posttest only design. At the start of the study, the researcher empirically assesses the differences in the two sample groups. Therefore, if the researcher finds that one group performs better than the other on the posttest, she/he can rule out initial differences (if the groups were, in fact, similar on the pretest) and normal development (e.g. resulting from typical home literacy practices or other instruction) as explanations for the differences. Some problems still might result from the participants in the comparison group being incidentally exposed to the treatment condition, being more motivated than the participants in the other group. Additional problems may result from discovering that the two groups do differ on the pretest measure. If groups differ at the onset of the study, any differences that occur in test scores at the conclusion are very difficult to interpret.

In a pretest-posttest design, the dependent variable is measured once before the project is implemented and once after it is implemented. Imagine, for example, a researcher who is interested in the effectiveness of an anti-drug education program on elementary school students' attitudes toward illegal drugs. The researcher could measure the attitudes of students at a particular elementary school during one week, implement the anti-drug program during the next week, and finally, measure their attitudes again the following week. The pretest-posttest design is much like a within-subjects experiment in which each participant is tested first under the control condition and then under the treatment condition. It is unlike a within-subjects experiment, however, in that the order of conditions is not counterbalanced because it typically is not possible for a participant to be tested in the treatment condition first and then in an "untreated" control condition.

If the average posttest score is better than the average pretest score, then it makes sense to conclude that the treatment might be responsible for the improvement. Unfortunately, one often cannot conclude this with a high degree of certainty because there may be other explanations for why the posttest scores are

better. One category of alternative explanations goes under the name of history. Other things might have happened between the pretest and the posttest. Perhaps an anti-drug program aired on television and many of the students watched it, or perhaps a celebrity died of a drug overdose, and many of the students heard about it. Another category of alternative explanations goes under the name of maturation. Participants might have changed between the pretest and the posttest in ways that they were going to anyway because they are growing and learning. If it were a yearlong program, participants might become less impulsive or better reasoners, and this might be responsible for the change.

7 TIME SERIES DESIGNS

A variant of the pretest-posttest design is the inter-rupted time-series design. A time series is a set of measurements taken at intervals over some time. For example, a manufacturing company might measure its workers' productivity each week for a year. In an inter-rupted time series-design, a time series like this one is "interrupted" by a treatment. In one classic example, the treatment was the reduction of the work shifts in a factory from 10 hours to 8 hours (Cook & Campbell, 1979).

Because productivity increased rather quickly after the shortening of the work shifts, and because it remained elevated for many months afterwards, the researcher concluded that the shortening of the shifts caused the increase in productivity.

Notice that the interrupted time-series design is like a pretest-posttest design in that it includes mea-surements of the dependent variable both before and after the treatment. It is unlike the pretest-posttest design, however, in that it includes multiple pretests and posttest measurements.

In time series designs, several assessments (or mea-surements) are obtained from the sample group as well as from the control group. This occurs before and after the application of the measures or model. The series of observations before and after can provide rich informa-tion about participants' growth. Because measures at several points in time prior and after the program are likely to provide a more reliable picture of achieve-ment, the time series design is sensitive to trends in performance.

Thus, this design, especially if a comparison group of similar participants is used, provides a strong picture of the outcomes of interest. Nevertheless, although to a lesser degree, limitations and problems of the nonequivalent group, the pretest-posttest design still apply to this design.

8 COMBINATION DESIGNS

According to Price, Jhangiani & Chiang (2015), a type of quasi-experimental design that is generally

better than either the nonequivalent groups design or the pretest-posttest design is one that combines elements of both. For example, there is a treatment group that is given a pretest, receives a treatment, and then is given a posttest. But at the same time there is a control group that is given a pretest, does not receive the treatment, and then is given a posttest. The question, then, is not merely whether participants who receive the treatment improve but whether they improve more than participants who do not receive the treatment.

Imagine, for example, that students in one school are given a pretest on their attitudes toward drugs, then they are exposed to an anti-drug program and finally, are given a posttest. Students in a similar school are given the pretest, not exposed to an anti-drug program, and finally, are given a posttest. Again, if students in the treatment condition become more negative toward drugs, this change in attitude could be an effect of the treatment, but it could also be a matter of history or maturation. If it really is an effect of the treatment, then students in the treatment condition should become more negative than students in the control condition. However, if it is a matter of history (e.g., news of a celebrity drug overdose) or maturation (e.g., improved reasoning), then students in the two conditions would be likely to show similar amounts of change. This type of design does not entirely eliminate the possibility of confounding variables, however. Something could occur at one of the schools but not the other (e.g., a student drug overdose), so students at the first school would be affected by it while students at the other school would not.

Finally, if participants in this kind of design are randomly assigned to conditions, it becomes a true experiment rather than a quasi-experience.

9 CONCLUSIONS

The challenges facing researchers in the areas of design and architecture, among others, who wish to develop applied research, especially at project design level or to work with sample groups, are many. That is why creative methodologies should be used and intel-ligently in order to reach the objectives outlined and to try to answer the posed questions, that is, to find practical solutions to the real problems that are facing.

Among the interventionist methodologies to which researchers are appealing, the quasi-experience or quasi-experiment, along with action research, stands out.

Quasi-experimental research involves the manip-ulation of an independent variable without the ran-dom assignment of participants to conditions or orders of conditions. Among the important types are nonequivalent groups' designs, pretest-posttest interrupted time-series designs and combination designs. Quasi-experience research eliminates the

directionality problem because it involves the manipulation of the independent variable. It does not eliminate the problem of confounding variables, however, because it does not involve random assignment to conditions. For these reasons, quasi-experimental research is generally higher in internal validity than correlational studies but lower than true experiments (or the experience methodology).

A better knowledge of the quasi-experience methodology, as well as its advantages and limitations, allows the researcher who works in areas of the project to be able to use this methodology, with creativity and in an intelligent way, with scientific results and of high quality.

BIBLIOGRAPHICAL REFERENCES

Campbell, D.T. & Stanley, J.C., (1966). *Experimental and Quasi-Experiment Designs for Research*. New York: Houghton Mifflin.

Cook, T.D., & Campbell, D.T. (1979). *Quasi-experimentation: Design & analysis issues in field settings*. Boston, MA: Houghton Mifflin.

Gribbons, B. & Herman, J. (1997). True and Quasi-Experimental Designs, *Practical Assessment, Research & Evaluation journal*, 5 (14), November. http://PAREonline.net/getvn.asp?v=5&n=14

Price, P., Jhangiani, R. & Chiang, I. (2015). *Research Methods in Psychology*. In http://www.saylor.org/site/textbooks.

Sustainability through design creativity

Ana Moreira da Silva
CIAUD, Lisbon School of Architecture, Universidade de Lisboa, Lisboa, Portugal
CITAD, Universidade Lusíada de Lisboa, Lisboa, Portugal

ABSTRACT: Considering Creativity, the capacity that human beings have to create, to invent, to face and to solve problems by original means, we analyse two examples of design practice in Portugal from the seventies to the present, both in industrial and handicraft areas. Creative projects that focus on sustainability with fixation of the local population and even constitute a form of local attraction with the ability to give visibility to the distinctive values of the territory.

Throughout this chapter, we try to understand the way how Design, as a creative discipline with transdisciplinary skills, may become a useful instrument in the promotion of new practices based on artisans and industrial workers skills. Perhaps we do not need specialised technological know-how to achieve sustainable design, we just need to look with creativity at ways that have worked in the past and adapt them to current needs and conditions.

We intend to conclude from this research that we need to cross over the new ideas that the designer's creativity can bring, to the skills of workers and artisans and find new forms of sustainable design artefacts. The goal is to contribute, through Design Creativity, for the construction of a partnership model between design, handcraft skills and industrial techniques that may lead to an increase in the value of local identities, achieving sustainability, social integration and regional development.

Keywords: Creativity, Design, Sustainability, Social Integration, Regional Development.

1 INTRODUCTION

As Design is about solving problems of different nature, designers can take advantage of the cross-over between thinking and doing, between their design ideas and the skills of artisans and industrial workers. Integrating knowledge of materials from their own experience, approaching vernacular design to material use without nostalgia, creating a sustainable future. In the examples we focus on this paper, designers are finding ways of crossing-over new ideas with old skills and making the best of it: achieving sustainability, social integration and regional development through creative solutions and methods.

Nowadays we speak of cultural diversity and not of globalisation when we want to define authentic and non-standardized material culture as being constituted by the dynamics of traditional and popular cultures, erudite and non-erudite, contemporary or vernacular, constantly mobile and cross-fertilised. As if we all have a unique and specific contribution to a global culture, to a collective imaginary that does not necessarily want to be 'modernised'.

The following examples of design practice in Portugal go from the seventies to the present, both in industrial and handicraft areas. This projects are based on creative solutions achieving sustainability with fixation of the local population and can even constitute a form of local attraction with the ability to give visibility to the distinctive values of the territory.

2 LONGRA INDUSTRY: A SUSTAINABLE CREATIVE ACHIEVEMENT BY DACIANO DA COSTA

We cannot speak about Portuguese Design without referring to Daciano da Costa (1930-2005). Daciano conceived numerous interior and product design projects of outstanding quality from the early '60s onwards until 2003. His work made him one of the most relevant figures of the twentieth-century Portuguese Design. Daciano's interior design and equipment projects already followed sustainability values anticipating one of the main transversal aspect of nowadays design: sustainability.

He has played a pioneering role on design's theory fundaments in Portugal and an important pedagogic role as a teacher. In those days, Daciano brought innovation to the practice and teaching: a modernisation of processes, a new perspective on the emerging themes of design such as social commitment and sustainability.

Daciano da Costa believed that designing was providing a service to the community and so designers should assume new social roles towards sustainable

development. On his practice and teaching, he implemented a design process which deals with sustainability and social commitment, searching for simple, creative, long-term solutions that could last and fulfil human needs, causing minimum material waste.

Design projects developed by Daciano da Costa can prove that the real dimension of his work greatly exceeds its strict physical function as objects and they take on an eminently social dimension implementing interaction between the interests of the industry and his workers' needs and skills, but also with the local resources in a sustainable way. His design thinking successfully operates the mediation between the designer, the industry and the society. Since the early sixties, he always tried to develop a close relationship between human systems integration and production systems engineering when dealing with the Portuguese industry.

We can considerer Daciano's working solutions for Longra Industry as 'sustainable' achievement (we must point out that in the sixties this concept was not yet established and meaningful), an innovation anticipating one of the main transversal aspects of nowadays design: sustainability.

Daciano da Costa considered that one of the goals of the designers' practice was to design and produce products that would last in time both for the durability of their materials and for their formal characteristics.

In the example of Longra, we can also find its concern with social sustainability through the creation of a new line of furniture that allowed to keep the jobs, thus avoiding the unemployment of many workers by the closure of a section of this factory. *Metalúrgica da Longra* (1919-1995) was a Portuguese industry located in Longra, Felgueiras region, which produced hospital and office equipment. In the 1970s, this industry became a pioneer in the application and development of industrial design in Portugal, a fact that is not unrelated to the close collaboration of designer Daciano Costa. For Longra, Daciano was able to develop a production of furniture for domestic consumption, avoiding imports and using local resources that combined durable natural materials with Portuguese technology and traditional craftsmanship. He was able to avoid the unemployment of nearly 100 workers by reusing local technology for new furniture projects by combining durable natural materials with the steel structures that this steel industry usually produced, taking economic advantage and social gains from the human capabilities and local resources that they could have been wasted. Despite being a serial industrial production, he incorporated the Portuguese identity through the use of local long-lived materials, local human resources and technology in search of what is considered to be the genuine concept of sustainable social and regional development.

His intervention at *Metalúrgica da Longra* was decisive to achieve these goals, resulting in the famous line of Cortez furniture and other innovative pieces

Figure 1. Daciano da Costa (1970) office chairs produced by Metalúrgica da Longra. Source: https://www.dacianodacostadesign/photos/albun.

such as a series of upholstered chairs metal, widely used in of theatre and cinema audiences.

At a time when the supply of Portuguese industry was limited and undefined, there was so much to be done. These particular circumstances produced the need for the opportunity to design a global project of high coherence: an integral relationship between the nature of production (the deadlines, the means and the processes associated with it) and the cultural, economic and social context. Daciano believed that Design should be set up as the construction of a relationship with users, with those who commissioned it, and even with those who produced it (Martins and Spencer, 2009).

The commitment to industry was evidenced in the creation of office furniture systems, with the choice of durable materials and the rationalisation of industrial production, allowing the reuse of old machines and methods. Daciano's options led to the production of furniture still in use today, due to its timeless and straightforward forms and the quality of the materials in which they were manufactured.

In the early seventies, Victor Papanek in his book "Design for the Real World, Human Ecology and Social Change", challenged designers to work on social responsibility and that they should propose simple solutions to be used by the whole community. (Papanek, 1972).

Designers need to recognise and play new roles based on the rapid world changes and in the artefacts that are massively produced. Daciano showed an early interest in the rationality and functionality values, which he intended to incorporate in their work, in line with what was happening with other pioneers of modern design abroad (Neves, 2009).

Daciano was involved in the process of understanding the need for comprehensive integration of human capabilities, social needs and local resources into the design process. He has developed his creative process to reconcile the ingenuity of the designer with the needs of the producer and with the capacities of the workers, but also with the local resources and with durable materials and forms.

Since the early sixties, when dealing with the Portuguese industry, he has always tried to develop

Figure 2. Metalúrgica da Longra exhibition stand in the Lisbon International Fair – FIL (1971). Source: https://www.dacianodacostadesign/photos/albuns.

a close relationship between the integration of engineering production system with human principles. (Martins e Spencer, 2009).

For several decades, Daciano was a striking figure in the development of a Design Culture, not only because of his project work but also because of his influence as a teacher and as a promoter of the new project thinking ruled by the principles of Sustainable Design. He criticised the desperate quest for originality and repudiated the effect of immediate culture and high-pressure success that encourages useless production and visual waste (Costa, 1998). The products he has created maintain the sense of synthesis where complexity is simplified, where tradition is integrated into the contemporaneousness within the process of industrial design.

He maintained the desire to adopt the processes of systematic thought and production rationalisation. Since the early 1960s, when dealing with the Portuguese industry, he has always tried to develop a close relationship between the integration of human principles and the production systems engineering. (Martins and Spencer, 2009).

The design projects developed by Daciano demonstrate a high methodological and technical control of the industrial product and a distinctive ecological and social awareness, in the sense of an accurate design thinking that operates the mediation between the designer, industry and society.

We can considerer Daciano's creative solutions for *Longra Industry* as 'sustainable achievement' (we must point out that in the seventies this concept was not yet established and meaningful), an innovation anticipating one of the main transversal aspects of nowadays design: sustainability.

3 BUREL FACTORY: CREATIVE SOLUTIONS FOR THE RE-SIGNIFICATION OF CRAFT TECHNIQUES

Design for sustainability requires generating solutions that are equally beneficial to the society in general and the communities around us, to the natural environment,

and the global, but especially to the local, economic systems. (Vezzoli e Manzini, 2008; Vezzoli, Kohtala & Srinivasan, 2014).

The Burel Factory, a textile industry design project in which Cláudia Albino was involved can be part of these basic principles. Cláudia Albino is a senior designer and assistant professor at Aveiro University, committed with social Integration and sustainable regional development. She is involved in several projects about these issues, through creative partnership models between design and handcraft techniques. Her work is based in searching to understand the way how Design, as a creative meta-discipline with transdisciplinary skills, may become a useful instrument in the creation and promotion of new practices with the ability to give visibility to the distinctive values of the territory.

One of the projects takes place in Manteigas, a region located in the inner centre of Portugal near Estrela Mountain. By the end of the first decade of the 21st century, many people in this region were in economic difficulties because they had stopped working on woollen manufactures once they had shut down. The Penhas Douradas Fashion project, created by Isabel Costa and João Tomás was undertaken under the motto "Re-creating the past, making it present forever and now". This idea allowed that the old knowledge and the how-to-do of the people of Manteigas could find new creative applications for their skills, integrating them into a new agglutination project. The main purposes of this project were: to value the skills of the inhabitants of Manteigas, who have lost their jobs in large numbers due to the closure of wool mills, which have always characterised this region. And also, through the collaboration of several designers, to value the raw material of *burel*, pure and resistant wool, traditionally used in the confection of the covers used by shepherds of the mountain. (Albino, 2014).

Burel is a Portuguese handcrafted fabric, with 100% wool, high durability and resistance, which has always accompanied the life in the mountains. Each family produced their pieces for their use, and the article that acquired higher cultural expression was the cover used by the shepherds. Today it is intended to bring this unique heritage, reinvented to the measure of the present so that it is not only remembered as a handcrafted fabric of the past. By the combination between passion, dedication and commitment of those who work this ancient handcraft skill to an innovative, relevant and surprising design, it seeks to provide new memories with new meanings, dimensions and values by the use of creative designs. (www.burelfactory.com, 2014).

In 2011, *Lanifícios do Império* was an old textile factory dealing with a process of insolvency and, in order to keep the jobs for the 30 people who worked in it, *Saberes e Fazeres da Vila* rented this factory, managing to ensure the required orders avoiding the factory closure.

Figure 3. *Burel* fabric on the interior walls of the Microsoft Lx headquarters building in Lisbon. Source: https://www.burelfactory.com.

Figure 4. *Burel Factory* product for Japan. Source: https://www.burelfactory.com.

That same year a new use for the *burel* fabric produced by *Burel Factory* was tried, as an interior finishing material in architecture. Specifically, *burel* was used as the lining of the interior walls of the Microsoft Lx headquarters building in Lisbon. This work has led to new orders in *burel* fabric for the new use in wall surfaces lining in several parts of the world, already representing this type of orders, a significant part of the turnover of *Burel Factory*.

Nowadays Burel Factory manufactures *burel* fabrics, with new weavers, carders and dressmakers. The majority of the workers in the factory are from this region and holders of the ancestral knowledge in the production of the *burel* fabric.

The artisans work in partnership with several designers integrated into the project, in an open outsourcing system, producing creative *burel* products both for home and clothing.

Guided visits to this factory are taking place, with many foreigners visiting it, so that the use of the English language is fundamental. All this implied to involve in the project also other people efficient in other skills like project management and communication, not endemic in the territory.

Currently, this company has its products presented in exclusive packaging, for sale in more than 40 stores in Portugal. These brand products are also communicated through the company website, increasing more and more the number of orders that are carried out in this way. E-commerce also allows for the possibility of buying products online.

Burel Factory brand sales for the international market represent a high percentage of total turnover. Currently, the company sells, in addition to Portugal, to Finland, Germany, Belgium, the Netherlands, France, the United States of America and Japan. Being Japan its main international market. The company is even working with a design office in Tokyo to implement *burel* products more associated with the needs of Japanese tastes and needs. (https://www.burelfactory.com).

Burel Factory project, following its objectives of rescue and translation of the diversity of the knowledge and practices of this region, presents itself as an effective initiative to develop a local culture through Design. It involves local communities, contributing to the territorial and human development. It has been a project able to give new meanings to traditional techniques, creating new experiences in the region, promoting the artefacts and the territory of origin both locally and globally.

Portuguese design creativity in its relationship with handcraft techniques, thus updates its knowledge vocation through artefacts of sustainable value in harmony with diversity, providing social and environmental quality, redesigning possibilities for partnership, valuing local values while incorporating artisans, as an effective partner of processes and projects, in a collaborative way. In this context, the design is the communication interface between the inherited past and the desired future.

From her experience in several projects in this areas, Cláudia Albino concluded that in projects where there are a high material and immaterial involvement of the actors that promote their likelihood of success is significantly higher than in cases where these commitments are not made by the agents involved and the promoters of the projects. (Albino, 2014).

4 CONCLUSIONS

Throughout this research, we understood that design, being a creative meta-discipline with transdisciplinary skills, may become a useful instrument in the creation and promotion of new practices with the ability to enhance the distinctive values of the territory.

Usually, we do not need specialised technological know-how to achieve sustainable design; we just need to look at ways that have worked in the past and adapt them to current needs and conditions. We can creatively apply successful examples that can socially and economically transform people, adapting them to other regions or realities.

From the initial phases of this research, we can conclude that it is important to cross over the new ideas that artisans can bring to the skills of workers and artisans and find new creative forms of sustainable design artefacts. The main issue is to contribute for the construction of a partnership model between Design Creativity, Handcraft Skills and Industrial Techniques

that may lead to an increase in the value of local identities, achieving sustainability, social integration and regional development through creativity.

BIBLIOGRAPHICAL REFERENCES

Albino, C. (2014). Os Sentidos do Lugar, Valorização da identidade do território pelo design. PhD Thesis, Universidade de Aveiro.

Costa, D. (1998). Design e Mal-Estar. Lisboa: CPD – Centro Português de Design.

Martins, J. P. Spencer, J. (2009). Continuity and Change. Atelier Daciano da Costa, Cascais: True Team.

Neves, J. M. (2009), Two Generations, Atelier Daciano da Costa, Cascais: True Team.

Papanek, V. (1972). Design for the Real World, Human Ecology and Social Change. New York: Pantheon Books.

Vezzoli, C. and Manzini, E. (2008). Design for Environmental Sustainability. London: Springer.

Vezzoli, C., Kohtala, C. and Srinivasan, A. (2014). Product-Service System Design for Sustainability. Sheffield, UK: Greenleaf Publishing.

https://www.burelfactory.com, Accessed February 2016.

https://www.dacianodacostadesign/photos/albuns, Accessed February 2016.

Design skills and craftwork culture in scenic design for theatre

Liliana Soares
Polytechnic Institute of Viana do Castelo, Viana do Castelo, Portugal
CIAUD – The Research Centre for Architecture, Urbanism and Design, Lisbon, Portugal

Rita Assoreira Almendra
Faculty of Architecture, University of Lisbon, Lisbon, Portugal
CIAUD – The Research Centre for Architecture, Urbanism and Design, Lisbon, Portugal

Ermanno Aparo
Polytechnic Institute of Viana do Castelo, Viana do Castelo, Portugal
CIAUD – The Research Centre for Architecture, Urbanism and Design, Lisbon, Portugal

Fernando Moreira da Silva
Faculty of Architecture, University of Lisbon, Lisbon, Portugal
CIAUD – The Research Centre for Architecture, Urbanism and Design, Lisbon, Portugal

ORCID: 0000-0003-0466-9783

ABSTRACT: With this chapter, the authors intend to express that the *modus operandi* of design combining design and craftwork, is a creative act of fantasy, contributing towards the effective improvement of the shows produced by professional theatre companies. This strategy is based on the methodological contribution of design skills and craftwork in new productive contexts. Also, design may improve the relationship between those constructions and context, exploring semiotics and ancestral constructive systems from the context of reference. This approach allows scenic design for theatre subordinated to a specific cultural context. To support this, the authors present case studies employing this creative methodological focus on the Western world, since the beginning of the twentieth century to the present time. With this philosophy in mind, this article aims to demonstrate and validate that creative approaches connecting design and craftwork enhance knowledge transfer and emotion experiences for society.

Keywords: Design Skills, Craftwork Culture, Creativity, Theatre, Design Experience.

1 INTRODUCTION

The topic of creativity and connection among disciplines has been recurrent since the second half of the twentieth century, announcing a world of new connections, many coincidences, medium (as a process) and not origin (or end), of '*déterritorialisation*'(Deleuze, Gatteri, 1994). The deterritorialization interpreted as the production of fragmentation in the defined, firm territories to reach differentiation, inquiry and uncertainty. Concerning the theatre, as argued by Christopher Baugh

> The certainties of earlier twentieth-century modernist ambitions for theatre have been significantly challenged by, amongst other considerations, the increasing diversity of multi-ethnic performance cultures. (Baugh, 2013, p. 223)

Specifically concerning design and its relationship with the theatre, the legitimacy of design and the diffusion of artisanal culture in Portugal are currently in a peripheral situation. Design education and design research can play an important role in the development of learning processes. This paper explores how an interdisciplinary approach contributes to understand and solve this phenomenon.

2 THE RESEARCH PROBLEM

In Portugal, the DGArtes Support Program, 'Programa de Apoio Sustentado às Artes' [Arts sustained support Program] for 2018-2012 contemplates 50 Theatre companies among the 89 companies evaluated, excluding companies from Évora, Porto, Covilhã or

223

Coimbra[1]. According to the national press, this decision caused unrest, dissatisfaction and subsequent social upheaval in several theatre companies, forcing extraordinary support measures from the Portuguese government. Historically, this sort of financial setting originates the reduction or cancellation of specific disciplines in the scope of theatre, namely those theoretically further away from theatre studies. Among them, scenic design and costume design end up replaced by the direct intervention of the director and/or actor. This has often caused the marginalisation of design and craftwork, replaced by more accessible and affordable services from industrial catalogues or the adaptation of pre-existing, albeit not always effective solutions.

However, according to Ugo La Pietra (1997), the symbiotic link between design and craftwork is defined as the connection between the Project Culture and the Culture of Making, conveying knowledge to society and transforming both. For the Culture of Making, this connection is fundamental in the sense that craftwork is revived onto continuous development through the insertion in current reality. As Ugo La Pietra states (1997) new stimuli, and subsequently new perspectives for an area that failed to find space in design, and is already losing contact with reality, insofar as those living in it feel like they are living among real ghettos.

On the other hand, the Project Culture is an opportunity to profit from methodological craft processes, considering that it is about a productive sector of significant reference, experimentation and a starting point for new productive contexts (Aparo, 2010). For the theatre, the permanent connection with other disciplines, namely, with areas of knowledge such as Culture of Doing and Project Culture can be an opportunity to think about the new problems of liquid reality (Bauman, 2005), as the expansion of cities, administrative inefficiency and street insecurity that keep people out of public spaces and designers should know how to solve. According to Jean Nouvel:

> This means that from this point on, we must make use of another strategy, where we're required to be slightly more intelligent – to the extent that we can be – required to constantly diagnose the situation. [...]. (Nouvel apud. Baudrillard, Nouvel, 2005, p. 18)

Jean Nouvel emphasis this notion, pointing out that one must operate with various sorts of analysis, reflections, connotations, building connections between the contradictory and complex objects that define our time.

Considering the research problem in this article, we intend to identify case studies of Professional theatre companies that keep or have kept design and theatre craftsmanship in their *modus operandi*. It also seems pertinent to identify that theatre should be a dynamic centre, conveying knowledge, creativity and fantasy to society.

3 DISCUSSION

Due to financial and social issues, some theatre Companies are being forced to eliminate different disciplines from the creative process, namely design and craftworks. This contributes to the stagnation of theatre solutions, deprived of change about reality. This process, detached from design, helps the public to ignore the participation of design as an area of knowledge and culture, forming generations of people unable to understand the use of visual language for the theatre. On the other hand, craftwork loses an opportunity for reinvention in new business areas for a sector also with problems.

Since the end of the 1960s, the sense of Material Culture has changed in perception and meaning, including the primary and secondary functions (Eco, 1976) built by people regarding objects. Concerning the emotional connections of individuals with the Material Culture, the sociologist Jean Baudrillard explains that due to conjunctures, speed, complexity and contradiction that characterised those times, people created emotional relationships with objects as if they were pets; the 'Animal Domestique Parfait' (Baudrillard, 1968). Later, Architect Andrea Branzi appropriates Baudrillard's definition applied to the definition of a product system for home furnishings entitled "Animali Domestic" (Branzi, 1985). Donald Norman later enunciated the principles of Emotional Design (2005), reinforcing the sensory, the fantasy and intelligence need people to establish with objects a relationship of attraction or repulsion. According to Donald Norman:

> the way we dress and behave, the material objects we possess, jewellery and watches, cars and homes, all are public expressions of ourselves. (Norman, 2007, p. 35)

In fact, people relate to things, to other people, objects, constructions, or theatre sets in search of experiences, sensations, knowledge and culture in order to feel happy. Hence, the link between a theatre spectator and the theatre culture also includes the connection with the stage surface, spaces, props, scenography and lighting.

Concerning the unknown of cultural development, the anthropologist Franz Boas (1939) explained this mystery was circumscribed to the study of the psychological and social conditions, which for humankind are a whole and for the effects of historical events and the specific natural and cultural environment. This means that when thinking on an object or a scenic design production for a theatre play, one must also relate to the spirit of the place it refers to. Design can improve the relationship between constructs and context, namely

1. https://www.dn.pt/lusa/interior/dgartes-programa-de-apo io-sustentado-vai-ter-2075-meuro-por-ano-entre-2019-e-202 1-9253154.html, accessed in May 9, 2018.

through semiotics, ethnographic design, the identification of specific, unique and incomparable symbols, and by the recognition of ancestral constructive systems from the reference context. In theatre, this connection may be construed as an opportunity to add the representation factor and the interaction with the audience in the project, since according to Bruno Latour (2008) the design is always an act of redesign. As advocated by Hans-Georg Gadamer (1976), it is also an action committed to the Past in order to interpret the Future.

4 STATE OF THE ART: CASE STUDIES SINCE THE EARLY 20TH CENTURY TO THE PRESENT TIME

In the 21st-century, it is legitimate to interpret the concept of modernity as a metaphor for the fluidity of our time in which the transformation of reality happens at a swift pace. This age is so fast it seems to reveal an individual who is never established in space or time, diluting all aspirations in immediate pleasure, settling for ephemeral solutions, quickly outdated by new ones. 'Liquid' is the state of matter without own shape, never remaining the same, flexible and taking the shape of any container available. In the scope of design, this phenomenon is quite significant, and reflecting on these metamorphoses means acting to transform society instead of being a by-product of society. Considering Design, an agent that produces contemporaneity, when it is apparent it redefines itself and expands its territories, relating to reality, to people and other disciplines, profiting from the circumstances of the moment. The issues related to the creative process between Design and Theatre are topics addressed in the Western context.

According to Pamela Howard (2009), the Swiss Adolphe Appia was the first Scenic Architect of the 20th century. At a time when the painted scene was the reference for scenography, Adolphe Appia proposed a dynamic system of modules with vertical and horizontal orientation.

In design and architecture teaching, the first notorious example is the Bauhaus Theatre School in Germany, representing the importance and balance of the disciplines. Oskar Schlemmer emphasised scenic design as an interpretation of space, dynamising the existent space as part of a composition. In methodological terms, Schlemmer used concise language assisted by illustrations and hand-drawn diagrams. This process should involve the presence of three different professionals:

the author (as writer or composer) who is the creator of the word or musical sound; the actor whose body and its movements make him the player; the designer who is the builder of form and color" (Schlemmer, 1987, p. 20).

Figure 1. Top to bottom: "Oskar Schlemmer's draft for the opera "Das Nusch-Nuschi" by Paul Hindemith (1921). "The Triadic Ballet" by Oskar_Schlemmer (1922). Source: https://commons.wikimedia.org

On the other hand, László Moholy-Nagy applies different materials and mechanical meanings in his work. In methodological terms, László Moholy-Nagy aims to transform stage activities, breaking the silent relation between actor and spectator, strengthening the role of the construction and the built object.

The next form of advancing theater – in cooperation with future authors – will probably answer the above demands with SUSPENDED BRIDGES AND DRAWBRIDGES running horizontally, diagonally, and vertically within the space of the theater. (Moholy-Nagy, apud. Schlemmer, Moholy-Nagy, Molnár, 1987, p. 68)

In the period between the two World Wars, the relation between the competence of design and craftsman towards the development of scenography for the theatre is a permanent reflection.

A case that stands out is the action of the Architect Carlo Mollino, illustrating the need to dramatise the interior of the architectural construction, the interior of a dwelling, of public space or a theatre. According to Carlo Mollino, the House that is a surprise box, a plot of the most unpredictable environments and furnishings. As Carlo Molino states (Ferrari, 2015) a light

scenography of mobile and sliding frames transform the rooms, separate them, create halls or wings to the turn of the seasons, moods, ceremonies or daily domestic 'events'. Methodologically, Carlo Mollino crossed the practice of sketching as an exercise of experimentation and prototype making. For him, scenic design for cinema is primarily composed of costume design and set design[2].

After World War II, in the late 1950s, the Federal University of Bahia, in Brazil, transformed local artistic and cultural institutions. According to Gonzalo Aguilar (2005), Architect Lina Bo Bardi integrated scenography studies in the University curricula. A case study regarding theatre and Lina Bo Bardi highlights the relationship between design skills and craftwork culture with the set design for The Threepenny Opera by Bertolt Brecht, staged in 1960 at the Castro Alves Theatre in Bahia. In her project, Lina Bo Bardi used watercolour to illustrate and communicate her ideas as Evelyn Lima states (2008). Architect Lina Bo Bardi resorted to low-tech features characterising the local context, and craftwork identity. According to Evelyn Lima (2008), its conception of 'poor architecture' is linked to the aesthetic proposal of structural honesty, leaving the concrete walls uncovered and identified with the concept of 'poor theatre' that characterises Brecht's aesthetics. The modus operandi in theatre construction would also be seen as a pilot project phase. That is, the creator experimented and tested design solutions in the context of the theatre that was later applied to the design and architectural construction in the relationship with companies and other entities.

In the 1970s, an important movement was developed in Portugal in the relationship between design and theatre. For instance, at the Cornucopia Theatre in Lisbon, the designer Cristina Reis uses an open process, crossing opinions and interventions from professionals ranging from actors and directors to designers, dressmakers and carpenters. For the director of the Cornucopia Theatre, Luís Miguel Cintra (2000), when Cristina Reis designs, she creates characters with life as if they were people with a life of their own, remarking that the designer's first work was to photograph the actors as they rehearsed. Cristina Reis communicated her ideas through drawing and painting. According to Paulo Eduardo Carvalho (2003), the sheets of paper where the scenic and costume designer from the Cornucopia prepares the space and clothes that will give shape to the company's spectacles often seemed endless landscapes, where the possibilities of figuration multiply in a seemingly uncontrolled fashion. As argued by Luis Miguel Cintra (2000), the

designer draws and paints as a way of doing theatre, with no luxury, with human dimension materials and always artisanal. Considering that in that historical moment, the country lived the consequences of a revolutionary social and economic process, the *modus operandi* of Cristina Reis would be equally crucial for the Portuguese productive activities that needed to be reinvented. With fantasy and intelligence, the design action of Cristina Reis revealed social responsibility, sustainability and innovation. Like Lina Bo Bardi had done, the Portuguese designer transposed some of the solutions tested in the context of theatre for the business sector and the transformation of the culture of Lisbon architecture's ateliers and workshops. With this methodology in mind, Cristina Reis offered an opportunity for ancestral activities of the local culture, such as carpentry, tailoring or dressmaking. In order to survive in the new reality, the craftsmen had the opportunity to transform their activity and eventually start a new business. A case of Cristina Reis that illustrates this action, relating the Project Culture and the Culture of Making (La Pietra, 1997) is the scenography and costumes developed by the designer Cristina Reis for the play 'The Labyrinth of Crete' by António José da Silva, staged by Luís Miguel Cintra.

In the 1980s, scenography in different European realities was characterised by subjective individualism.

In Finland, Paul Rafael Suominen started the systematic development of scenography as a discipline in college education. Paul Suominen combined design and craftsmanship:

> Being most skilled in set painting, he represented the older generation and traditional craftsmanship but was largely appreciated by both students and 'eld-workers', perhaps also because of his successful activity in the trade union. (Gröndahl, 2015, p. 89)

However, Paul Suominen had significant restrictions concerning modern theatre, insisting on rigid methodological processes, devoid of improvisation and impervious to external factors. On the other hand, the methodological action of the designer Måns Hedström is oriented towards minimalistic scenic design, stripping the stage of anything not necessary to interpret the play.

> In his theatre practice, Hedström was very strict that the minimalistic aesthetic was followed. The directors had to solve the scenes just using the given scenographic options, which they experienced as both stimulating and frustrating. (Gröndahl, 2015, p. 91)

These two attitudes coexisted in the Finnish theatre, contributing for decades to the debate and the ongoing development of the discipline.

Subsequently, new forms of stage design were experienced, but according to Patrice Pavis (2013), the 1980s and 1990s are recorded as years of analysis, conclusions and, in fact, the apotheosis of coexistence,

2. A case that demonstrates the methodological action of Carlo Mollini is the set design for the film Patatrac (1932) from the Italian director Gennaro Righelli. Mollino's fascination for photography and cinema took him to scenic design and costumes design in a process shared with Italo Cremona and Carlo Levi.

connections and previous experiments. In France or Germany, for example, scenic designers are not restricted to a single method or particular style. They work with different directors or in different projects, allowing external factors to intervene in the process definition, developing regenerative projects such as reality.

At the beginning of the twenty-first-century architectural projects remain trapped in historical references from the past as Architect Andrea Branzi states. Since

> the world has changed, but the culture of project hasn't yet. The city is nowadays no longer a whole of architectural boxes but a territory of men, facilities, information, immaterial relations. (Branzi, 2011, p. 26)

It means that it is not intended to conceive new objects or new buildings, but to qualify the singularity of the object. A chance to argue and question with autonomy and with room for error.

Unlike architecture, scenography projects have benefited from the fluid change that characterises the current reality. That is, for instance, new restrictions that underline the awareness of the importance of recycling, conservation and restoration. According to Pamela Howard (2009), this awareness guided the creation of theatrical spaces built on old prisons, warehouses, public kitchens and factories.

> In many cases, it is destruction through war or time that reveals the potential of a space. It is as though when the skin of a city is broken. (Howard, 2009, p. 7)

These causalities and possibilities incite an action based on new rationality. That is an ingenious project that promotes connections between people and entities and, for this reason, a creative project. In this process, it is essential to work with processes, techniques and technologies, regardless of whether they are old or new. For this reason, it seems important to aggregate things, adding value to people's life.

5 CONCLUSIONS

Scenography assumes the responsibility to contribute to the well-being of people's lives, in the sense that the designer asserts himself as the cultural and social agent of his reality. The ability to identify, for example, marginalised, old and unsuitable spaces in time and space reveals constructions that seem hibernated and abandoned, looking for a new identity always renewed. According to (Soares, 2012, p. 199): It is a hermeneutical process, semantic, which is not closed, which intends to reflect on the city's skin at the moment that it is always mutant, different and for that reason, refuses to predict the city of the future.

This consideration about the project culture allows scenarios rejection to be a product and with no

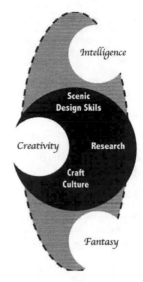

Figure 2. "Diagram for Design skills and craftwork culture in scenic design between intelligence, creativity and fantasy". Font: The authors.

intention of being built, in the sense that, as a mirror of the reality of our time, they do not become products.

Today, theatre seems focused on performing performances, which may offer a more open and fluid-structure within which scenography can be incorporated as a methodology. The experimental and empirical aspects of scenography require all agents to be part of the process. As argued by Christopher Baugh:

> The "making of performance" has become a significantly different activity from that of "directing a play" and has required new practices, new technologies and a new stagecraft. (Baugh apud. Hickie, 2008, p. 54)

In the development of a theatrical stage, the link between the competence of design and craftwork culture may be an opportunity to produce "objects put together without a surrounding frame or border that carry a brief descriptive account of the world they once represented" (Howard, 2009, p. 210) – directly in space, looking for objects with low technology and low budgets, and finally getting under the skin of the characters that inhabit them. As mentioned by Pamela Howard's (2009), they soon realised that designers should be able to practice the virtue of prudence, managing and motivating working groups – from actors to carpenters – promoting intelligence, creativity and fantasy.

ACKNOWLEDGEMENTS

This work was carried out with the support of The Research Centre for Architecture, Urbanism and Design – CIAUD, Lisbon School of Architecture, University of Lisbon.

BIBLIOGRAPHICAL REFERENCES

Aguilar, Gonzalo. (2005) Poesia Concreta Brasileira; as vanguardas na encruzilhada modernista. São Paulo: EDUSP.

Aparo, Ermanno. (2010) *A Cultura Cerâmica no Design da Joalharia Portuguesa*. Universidade de Aveiro, Portugal. URL: http://hdl.handle.net/10773/3688

Aparo, Ermanno; SOARES, Liliana. (2012) *Sei progetti in cerca d'autore*. Seis Projetos à procura de autor. Firenze: Ed. Alinea.

Baudrillard, Jean. (1968). *Le Système des Objets*. Paris: Ed. Gallimard.

Baudrillard, Jean; Nouvel, Jean. (2005). *The Singular Objects of Architecture*. Minneapolis-London: University of Minnesota Press.

Bauman, Zygmunt. (2005) *Modernitá liquida*. Bari: Laterza.

Baugh, Christopher. (2013). Theatre, Performance and Technology: the development and transformation of scenography. New York: Palgrave Macmillan.

Boas, Franz. (1939). *The mind of primitive man*. New York: Macmillan company.

Branzi, Andrea. (2011). Ten modest suggestions for a new Athens Charter. In Koskinen, Ilpo; Harkasalmi, Tiina; MAZÉ, Ramia; MATTHEWS, Ben (Ed.) *Nordes'11: the Nordic Design Research Conference*. Helsinki: Aalto University. School of Art and Design. 26–27.

Branzi, Andrea. (1985). *Le Design Italien: La casa calda*. Paris: L'Equerre.

Carvalho, Paulo Eduardo. (2003). Dentro do tempo, *Vértice*, II série, 110, Março/Abril. 118–127.

Deleuze, Gilles, Guattari, Félix. (1994) *Difference & Repetition*. London: The Athlone Press Limited.

Eco, Umberto. (1979). *A theory of semiotics*. Indiana University Press, Bloomington.

Ferrari, Fulvio. (2015). La Casa del Riposo del Guerriero. Marina Vaensise (Direzione) La Casa di Molino. *Parigi: Istituto Italiano di Cultura, Parigi*. 4 febbraio/février 2015. 30 aprile/avril. 14–33

Gadamer, Hans-Georg. (1976). *Philosophical Hermeneutics*. Berkeley: University of California Press.

Cintra, Luís Miguel (2000) Introdução a Cristina Reis. In Grais, Paula Gris (coord.) *Prémios Nacionais de Design 2000: carreira*. (pp. 10–11). Lisboa: Centro Português de Design.

Gröndahl, Laura. (2015). Stage Design at the Crossroads of Different Operational Cultures. Mapping the History of Scenography Education in Finland. *Nordic Theatre Studies*, 27 (2), 86–102. https://doi.org/10.7146/nts.v27i2.24253

Hickie, Rebecca. (2008). *Scenography as process in British devised and postdramatic theatre*. London: Loughborough University Institutional Repository.

Howard, Pamela. (2009). *What is Scenography?* London: Routledge.

Latour, Bruno. (2008). A Cautious Prometheus? A Few Steps Toward a Philosophy of Design (with Special Attention to Peter Sloterdijk). In Fiona Hackney, Jonathan Glynne and Viv Minto (editors) *Proceedings of the 2008 Annual International Conference of the Design History Society* (pp. 2–10) Falmouth, 3–6 September 2009, e-books, Universal Publishers.

La Pietra, Ugo. (1997). Didattica, progettualità e cultura artigianale. In Morozzi, Cristina (coord.) *Disegnare l'artigianato* (pp. 23–29). Torino: Lindau.

Lima, Evelyn. (2008). *Espaço e Teatro; do edifício teatral à cidade como palco*. Rio de Janeiro: Viveiros de Castro Editora.

Norman, Donald. (2007). Emotional Design: Why We Love (or Hate) Everyday Things. New York: Basic Books.

Pavis, Patrice. (2013). Contemporary Mise en Scène: Staging Theatre Today. New York: Routledge.

Schlemmer, Oskar, Moholy-Nagy, László, Molnár, Farkas. (1987). *The Theater of the Bauhaus*. Walter Gropius and Arthur S. Wensinger (Editors). Connecticut: Wesleyan University Press.

Soares, Liliana. (2012). *O designer como intérprete de cenários de equipamentos*. Universidade de Aveiro. URI: http://ria.ua.pt/handle/10773/8998.

Foot haptic perception in hospital wayfinding

Miguel de Aboim Borges
CIAUD – FAUL, Lisbon School of Architecture, Universidade de Lisboa, Lisboa, Portugal
ORCID: 0000-0002-9352-7914

ABSTRACT: Space is not perceived equally by everyone. People with visual impairment and elderly with low vision are within the group of hospital users for whom interpreting a building is a difficult task, where some even depend from auxiliary staff to lead them around. This paper is about a research project developed in a hospital, in building a sensorimotor wayfinding system, reinforcing spaces' visual communication with haptic foot texture information, for orienting patients within the building and to deliver a building' efficient use to everyone. The project permitted to gauge and identify, within people over 65 years old and with low vision, their visual and motor impairments, as well as, their real perceptions in environment interpretation and landmarks definition when shifting. Analysing space, distribution of services, and questioning technical teams, regarding the functionality and the degree of interpellation that users achieve to identify destinations in the building, were determinant for spatial analysis. The increasing ageing population and the biological changes, especially related to visual perception, balance, dexterity and independent mobility, inherent to this target group, were some of the main aspects of the research work. The user-centred design sensory-motor wayfinding pilot project developed, enabling people in reaching their different hospital areas, by interacting through a visual and foot touch textured communication system.

Keywords: Visual impairment, elderly, low vision, sensory-motor, foot haptic.

1 INTRODUCTION

Today the elderly have increased longevity, reaching old age in better health and with a better quality of life. However, this improved quality of life does not reflect possible health problems. Due to the increase of ageing population and pathologies associated, elderly people are resorting more to hospital care. Low vision pathologies are associated with the ageing eye and represent one of the issues WHO (World Health Organization) is alerting for one of the causes of blindness. This age-related eye diseases, such as low vision pathologies, align with demographic changes. People are living longer with a better life quality reaching 80 years or even more. This longer living in result of medical evolution does not sometimes mean a healthier living. Vision is one of the senses more affected by ageing, aside balance, posture and dexterity change with age (Woollacott, 2007 *apud* Birren, 2007, p. 138). Advanced adult age is accompanied by characteristic changes in the eye, retina and visual nervous system (Schieber, 1994). Besides the eye pathologies referred, ageing is associated with a variety of changes in sensory and perceptual functions (Scialfa, 2002, p. 153). Other biological changes occur in the human organism, such as a decline in dexterity and difficulty in balance management, loss of strength, sensorial acuity decrease, high-frequency perception, hand palm tactile sensitivity and thermal sensitivity. Ageing is associated with decrements in the functional capacity of several organs and systems, which generally begin in the third decade of life (Bourlière *apud* Brocklehurst *et al.*, 1973, p. 61). The aging process is as referred by Carolyn M. Aldwin *et al.* (2006 *apud* Birren & Shaie, 2006, p.85) as one of the most striking changes paradigm since the mid-1960s with the recognition of both individual differences and plasticity in the ageing process, where some individuals become severely disabled in midlife while some are still running marathons in their seventies and even eighties. Several pathologies are irreversible for a blindness situation, but some may be treated but not cured. Although medical care has evolved, due to dietary habits, occupation, lack of exercise and mobility and particularly age-related eye diseases, pathologies such as diabetes responsible for diabetic retinopathies and neuropathies, AMD age-related macular degeneration, glaucoma, high myopia, presbyopia among others, represent a constant dependency to medical care.

A factor is that health units have today more elderly patients than ever before, and they represent also stressing places for the elderly. Part regards the

expected medical opinion about the progression of their diseases, but also the fact that they are entering a crowded and sometimes not familiar environment.

Information Design applies principles of different valences of Design, Architecture, colour theories and symbols to build effective orientation systems, on the deconstruction of the built environment and turning them accessible to all (Golledge, 1999). This research project evaluated patients' sensorial capacity in collecting specific information from the physical environment, in particular, the spatial organisation, so they could act in conformity, specifically for visual and haptic foot touch information order.

2 EMPIRICAL WORK

For this survey, two methods of evaluation were developed. One oriented to the existing space and its characteristics in terms of usage by all users, internal and external, and the other method for evaluating patient's perception in the use of the building regarding their limitations such as vision (visual acuity), mobility, autonomy, independence and dexterity.

The first method used, evaluated building's instrumental value, by analysing medical specialities distribution in the building, locations of medical offices, mandatory vision tests rooms, waiting rooms, different floors access and patients' daily flows. This analysis produced a diagnostic document reflecting the most important decision points of the building and places that were the key points for testing the project's intervention.

According to Bruce Archer (1960 *apud* Buchanan et al., 2010, p. 281),

> instrumental value is the value placed on things, activities, or anything that serves as a means of attaining or achieving something that is said to have intrinsic value or value on itself.

Its qualitative value is associated with the good in terms of benefits to humans as in 'quality of life', which has been central to definitions of design as a means to foster human well-being". Instrumental value evaluation (Fig. 1) had two parameters for collecting hospital's environmental data, being one related with accessibilities, by analysing physical (materials, lighting and colours) and cognitive attributes (what type and content of existing communication, sign types, and their relative positioning and efficiency) and a second parameter oriented to spatial attributes (all services locations related to patients usage, user flows and identification of conflict zones). Medical staff valuable contributions on how patients and users use different areas of the building, represented important data, on a mobility point of view, for the final space diagnosis document.

Secondly, a method was developed for evaluating and understanding the environmental sensory

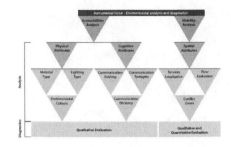

Figure 1. Instrumental Value evaluation (Author).

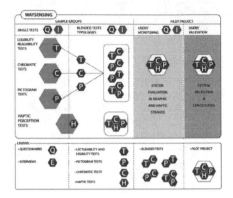

Figure 2. Waysensing evaluation (Author).

perception of elderly patients with low vision. This method, Waysensing (Fig. 2), an environmental user-sensing evaluation, consisted in interviewing patients through questionnaires for collecting data on pathologies visual limitations, visual acuity thresholds and mobility limitations, and a battery of physical tests. The visual tests were aimed for evaluating perception to colours and contrasts colour perception, font types and size readability and legibility, and haptic foot tests were purposed for evaluating haptic foot touch perception to textures, the thickness of shapes and foot touch thresholds. Due to the lack of evidence on haptic foot perception, different tests were performed.

The reason why foot haptic perception was included in this research project, was due to the fact that the elderly scan with their feet in order to walk defensive and safely avoiding falling. Kerzel (2009 *apud* Binder et al., 2009) defined

> percept as the conscious experience of a sensory stimulus, reflecting the stimulation of the sensory system (e.g. eye, ear, skin), and that it is also determined by higher cognitive processes, such as attention and memory

and reinforcing that perception is "our mind window of the world".

Heulat (*apud* Carpman, Grant, & Simmons, 1984) links good wayfinding with good patients flow and

asserts that applying simple organisational architecture and graphic principles not only reduce patient stress and anxiety but also can lead to improving health.

Huppert (2003, p. 31) affirms that:

The need for design change is not limited to consumer products. It should also be a priority for designers involved in the public services. From design of printed matter and communications and information technology, to the design of transport, housing and public buildings, a better understanding of users' needs, can dramatically improve the independence and quality of life of the vast number of older users. But for these endeavours to be most effective, we need to go beyond the numbers, to understand the lifestyles of today's older adults, as well as their physical and mental capabilities.

The successful application of universal design principles requires an understanding of how abilities vary with age, disability, environment and circumstance (Story *et al.*, 1998). Buildings should provide appropriate design features and navigational aids to enable people with a range of sensory impairments to ambulate with confidence and ease (Imrie & Hall, 2004). A user-centred design approach supported the research project. Park (Norman, 1990, p. 188) refers to the user-centred design as a philosophy (POET–*The psychopathology of everyday things*) based on needs and interests of users, with an emphasis on making products usable and understandable, where he refers the main principles for evaluation, such as:

1) make it easy to determine what actions are possible at any moment;
2) make things visible, including the conceptual model of the system, the alternative actions, and the results of actions;
3) make it easy to evaluate the current state of the system;
4) follow natural mappings between intentions and the required actions; between actions and the effect; and between the information that is visible and the interpretation of the system state.

3 VISUAL EVALUATION

The patients' visual capacities evaluation followed the different steps defined in the way sensing methodology. As a first step, ten typographic sans serif fonts in four different sizes applied on boards were proposed for readability and legibility by patients. As result two fonts were the best perceived (*Myriad Pro Regular and Helvetica LT Std Roman*) by patients aged 65 years or more, with nine different pathological types (retina dystrophy, bilateral optic atrophy, amblyopia, central vein occlusion, AMD, glaucoma, optic bilateral retinopathy, diabetic retinopathy and pigmentary retinopathy) and at a distance between 200 and 400

mm away from the printed plates, the most voted height font size was 40 mm.

A second test was carried, evaluating colours and contrasts using the font and size already defined. Using words related to the hospital environment, 16 plates each with a double solution proposing on one text and contrast colour and reversing colours on the other. In this test, 61% of the users had glaucoma, 31%, had retinopathy and two groups of 4% with maculopathy and high myopia. In this group, 52% of patients had 68 years of age or more. As a result, stronger contrasts like (text/background) yellow/black, yellow/dark green, anthracite/white, Bordeaux/pale beige were those that permitted better readability and legibility. With this test was also purposed the evaluation of the best representation of pictograms, also of hospital services, in three ways, having one a negative representation with a surrounding frame (validated by 79,1%), another with positive representation also with a surrounding frame (validated by 15,6%) and the last in positive with no surrounding frame (validated by 5,3%).

The results obtained in these tests were used in the definition of new plates with the communication to be implemented on the decision points defined in the environmental evaluation study. The plates produced with the collected information reflected real orientation users' needs by defining the distribution of services and accessing the building.

4 HAPTIC EVALUATION

Following Ashley Montagu's medical evidence on confirming the primacy of the haptic realm, he writes:

Touch is the parent of our eyes, ears, nose and mouth. It is the sense which became differentiated into the others, a fact that seems to be recognised in the age-old evaluation of touch as the mother of the senses. (Pallasmaa, 2005, p.1).

The foot sole perception study was conceived based on three main research areas on haptic research. One area was related to two-point touch perception thresholds (Fox, 2011, p. 268) in defining minimum distance at which two points of touch can be perceived as separate; scientific study on the distribution of cutaneous mechanoreceptors in the foot sole (Fig.3) and naming just a few important names in haptic perception research (Lederman, 1991; Lederman & Abbott, 1981; Klatzky, Lederman, & Matula, 1993; Gibson, 1986).

The use of a haptic system applied on pavements positioned underneath information plates of a wayfinding system in hospitals (Fig. 4), acting as a trigger in helping users to be more attentive to what surrounded them and they detected visually and read the orientation information already adjusted in size and contrast colours to all.

For the evaluation on patient's perception to shape base textures, different studies and tests were made

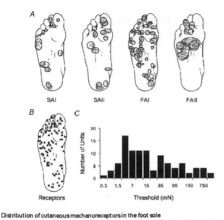

Distribution of cutaneous mechanoreceptors in the foot sole
A - the receptive eld for each receptor type in the foot sole is illustrated. The receptive eld was outlined with a mono lament 4-5 times greater than the initial threshold value.
B - the approximate position of the a erent unit in the foot sole for all receptor types is depicted.
C - distribution of the total number of documented receptors and the accompanying threshold levels per unit in the foot sole (n= 104).

Source: Paul M. Kennedy and J. Timothy Inglis, *Journal of Physiology* (2002), 538.3, pp. 995–1002

Figure 3. Distribution of cutaneous mechanoreceptors in the foot sole (Kennedy & Inglis, 2002, p. 999).

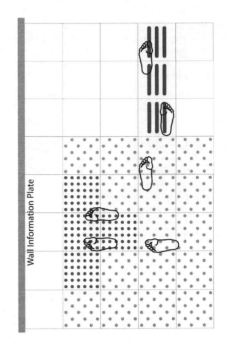

Figure 4. Study simulating patients foot sole over textures. (Author)

with different solutions of shapes, texture height, distances between each piece, always measuring perception awareness to the designed textures. In Fig. 4 is represented one of the studies developed for the evaluation of efficiency for the purposed distances in the three textures based on men and women standard foot soles area.

During the tests, all textures components had a grey colour, similar to the existing pavement tiles and were not perceived or seen by users.

Knowing that most of the pathologies did not lose peripheral vision field, exception to some cases of glaucoma, the introduction of colour on textures components was made. Peripheral vision field colour perception is related with colours blue and yellow and third colour anthracite was also purposed for the components, representing one of the colours that had been highly rated on the chromatic perception tests.

The introduction of colour in texture components proved to be more effective than the grey used in former tests, due to the contrast produced against the background colour of the pavement tiles. This adjustment to the sensorimotor system was well accepted by patients and users and represented a qualitative cognitive improvement.

Cognitive flexibility, as Cañas, et al. (2003, pp. 482–485) stated is the capacity of adapting strategies to changes in the built environment, although it may represent a difficult task for the elderly, but it can be overcome through experiencing, training and education processes and the will to accept challenges, that can bring benefits and promote well-being, self-esteem and independent and autonomous mobility.

5 RESULTS

This research project objective was crossing different areas of research and applying them with the qualitative data obtained, on the development of an inclusive, multisensorial and integrated solution, sustained by the analysis of the elderly with low vision visual and motor limitations having as goal the promotion of their mobility in an autonomous and independent way in hospital environment. What made this research project possible, was the articulation of different wayfinding areas, thinking the project as a whole and in an integrated way and not fragmented as it is usually done.

The pilot project system positioning purposed, proved to be effective among low vision patients and some blind users by independently orienting them in the building. As reflex of this orientation system, auxiliary staff and nurses said that users asked less for information on some services.

BIBLIOGRAPHICAL REFERENCES

Binder, Marc D., Hirokawa, Nobukata, & Windhorst, Uwe (2009). *Encyclopedia of neuroscience*. Retrieved from http://library.wur.nl/WebQuery/clc/1243349

Birren, James E. (Ed.). (2007). Encyclopedia of gerontology – Age, Aging and the Aged. Oxford: Elsevier.

Birren, James E., & Shaie, K. Warner (Eds.). (2006). *Handbook of the Psychology of Aging* (6th ed., Vol. 2). London: Elsevier Academic Press.

Brocklehurst, J. C., Tallis, R. C., & Tissil, H. M. (1973). *Textbook of Geriatric Medicine and Gerontology* Churchill-Livingstone. London.

Cañas, José, Quesada, José, Antolí, Doracion., & Fajardo, Inmaculada (2003). Cognitive flexibility and adaptability to environmental changes in dynamic complex problem-solving tasks. *Ergonomics*, 46 (5), 482–501.

Carpman, Janet R., Grant, Myron A., & Simmons, D. A. (1984). Wayfinding in the hospital environment: The impact of various floor numbering alternatives. *Journal of Environmental Systems*.

Fox, Stuart I. (2011). *Fundamentals of human physiology.* New York: McGraw-Hill.

Gibson, James. J. (1986). *The Ecological Approach to Visual Perception.* New Jersey: Lawrence Earlbaum Associates, Inc.

Golledge, Reginald G. (1999). *Wayfinding Behavior – Cognitive mapping and other spatial processes* (Vol. 1). Retrieved from www.press.jhu.edu

Huppert, Felicia (2003). Designing for older users (J. Clarkson, R. Coleman, S. Keates, & C. Lebbon, Eds.). London: Springer Verlag London Ltd.

Imrie, Rob, & Hall, Peter (2004). Inclusive design: designing and developing accessible environments. London: Taylor & Francis.

Kennedy, Paul M., & Inglis, J. Timothy (2002). Distribution and behaviour of glabrous cutaneous receptors in the human foot sole. *The Journal of Physiology*, 538 (3), 995–1002.

Klatzky, Roberta L., Lederman, Susan J., & Matula, Dana E. (1993). Haptic exploration in the presence of vision. *Journal of Experimental Psychology Human Perception and Performance*, 19, 726–726.

Lederman, Susan J. (1991). Skin and touch. *Encyclopedia of Human Biology*, 7, 51–63.

Lederman, Susan J., & Abbott, Susan G. (1981). Texture perception: studies of intersensory organization using a discrepancy paradigm, and visual versus tactual psychophysics. *Journal of Experimental Psychology: Human Perception and Performance*, 7(4), 902.

Norman, Donald A. (1990). *The Design of Everyday Things.* New York: Library of Congress-in-Publication Data.

Pallasmaa, Juhani (2005). The eyes of the skin: architecture and the senses. London: Wiley.

Schieber, F. (1994). Recent Developments in Vision, Aging, and Driving: 1988-1994. Retrieved from Citeseer website: http://citeseerx.ist.psu.edu/viewdoc/download?doi=10.1.1.133.4554&rep=rep1&type=pdf

Scialfa, C. T. (2002). The role of sensory factors in cognitive aging research. Canadian Journal of Experimental Psychology/Revue Canadienne de Psychologie Expérimentale, 56 (3), 153.

Story, M. F., Mueller, J. L., & Mace, R. L. (1998). The Universal Design File: Designing for people of all ages and abilities (The Delta Center for Universal Design). Retrieved from http://design-dev.ncsu.edu/openjournal/index.php/redlab/article/view/102

Methodology for colour planning in urban furniture: Laje, a case study

Margarida Gamito & Joana Sousa
CIAUD – FAUL, Lisbon School of Architecture, Universidade de Lisboa, Portugal;
Portuguese Colour Association, Lisbon, Portugal

ABSTRACT: This paper presents a work in progress, aiming to develop and test a new chromatic planning methodology for urban furniture, allowing the determination of colour plans, with a higher scientific approach, as a strategy for the enlargement of urban chromatic plans perspective.

The case studies include two Municipalities around Lisbon, Loures and Oeiras, where several settlements with different dimensional, anthropological and topographic specifications were chosen. Samples areas have been selected to apply the new methodology to all furniture elements, in order to increase their potentiality as relevant issues for city colour planning.

The chapter focuses on a particular case study – Laje – which is a settlement from Oeiras municipality, characterised for having three different neighbourhoods: social lodgings, with buildings all alike, belonging to the municipality, and to whom the inhabitants pay rent; buildings belonging to the inhabitants, to whom the municipality sold the land and the projects; and AUGI, a neighbourhood that is inhabited by displaced populations to whom the municipality gave plots not interfering with the construction. All the settlements colours were collected in order to determinate the dominant ones and constituting a basis for the choice of urban furniture palette. Finally, these choices will be validated by the local population, Municipality authorities and Colour Experts.

Keywords: Methodology, Urban Furniture, Urban Chromatic Plans.

1 INTRODUCTION

The case study "Laje" is part of the research project for a new urban furniture chromatic planning methodology, which is being tested in two municipalities located in Lisbon (Portugal) surroundings: Loures, a municipality away from the Tagus river and constituted by traditional, modern and rural settlements, and Oeiras, a municipality that have settlements both in the interior and on the seafront, being at the same time a miscellanea of old and modern. In these municipalities were chosen several settlements with different dimensional, anthropological and topographic characteristics.

This methodology aims to originate a system that will ameliorate urban furniture use, improving the visibility and legibility of its elements, transforming them in identification factors for the different city neighbourhoods, and contributing to a better orientation within the cities. However, it is intended to be applied solely to urban furniture, which will become an ergonomic and inclusive factor, and not interfering with other elements of city signage, which are encoded by road legislation.

Modern cities and particularly big modern cities have complex traffic and transportation webs that cause orientation difficulties and a considerable reduction of the direction sense, especially in cities with architecture more or less similar in their different zones, and where there is a lack of obvious reference points.

To solve this problem, it became necessary to design comprehensive directional systems that could help to guide people and, simultaneously, grant a better identification with the city itself. However, the usual signage and directional systems are designed for being perceived at a distant and fast vision of people driving motorcars on roads and highways. Within the cities, these signage systems are not appropriate to be seen by pedestrians or fulfil the needs of the entire population, because they tend to merge with the building colours and lose visibility. On this purpose, Minah (2005) states:

> As a pedestrian, colors are experienced in a continually changing visual field. Planners have succeeded in achieving visual order in cities by implementing repetitive architectural typologies, zoning to form hierarchy in patterns of blocks and public spaces, and similar building heights.

Craig Berger (2005, p.121) also stresses that cities adapted themselves to tourism and convention centres, originating the necessity for urban orientation

systems. These systems that gather tourism centres, maps, symbols and graphic indications, are intended to turn navigation within the city easier to their visitors and inhabitants.

Urban furniture and, particularly, a chromatic system applied to urban furniture can contribute to the improvement of orientation within the city.

2 URBAN FURNITURE

The urban furniture elements do not have a merely decorative function, as Màrius Quintana Creus (2000) claims: "These elements are objects which are used and which are integrated into the urban landscape, and they must be comprehensible to citizens".

In fact, urban furniture must accomplish several functional requirements in order to assure its functionality and fulfil the population needs, facilitating their lives and contributing to their comfort. So, when urban furniture accomplishes its functions, it contributes to protect the well-being of the city inhabitants; facilitates the accessibility and use to people with visual or motor difficulties; reinforces the local identity, representing a formal family that is coherent and values the surroundings. However, while recognising its necessity, the urban furniture functional possibilities have not been used to their fullest extent, and the choice of its colour or form only rarely obeys to a logic thought.

Considering that, in order to accomplish its functions, urban furniture needs to be seen and an appropriate colour application that improves its visibility considerably, the application of a chromatic planning to urban furniture may originate a system which will function simultaneously as an identification factor for the different city quarters and as an orientation factor for its inhabitants and visitors.

In effect, colour is the objects visual characteristic that the eye first perceives, even before form or texture, and it stands out from the chaos and complexity of the visual field. When applied to urban furniture or signage systems, colour is the easiest way to improve the visibility and legibility of these elements, and simultaneously this application will achieve the identification of the different city zones and will promote the orientation of the population, permanent or temporary. Considering this, Per Mollerup (2005) refers that "colour can be seen from longer distances than other graphic elements" and that "in signage differentiation is the first and foremost role of colour".

As a mean to show the way, colour has been punctually employed successfully in interior and exterior spaces and, therefore, we could assume that a sensible and general application to urban furniture may be a way to the successful resolution of the orientation problem within the city. Nevertheless, inadequate use of colour in urban furniture and signage systems contributes to a lack of visibility that impedes the fulfilment of their functions, as well as it is a factor of social exclusion for people with deficient and older vision.

3 METHODOLOGY FOR URBAN FURNITURE CHROMATIC PLANS

The concern to establish a coherent urban image through colour studies and chromatic plans is relatively recent, despite some pioneer cases, and led to the conception of chromatic planning methodologies, gathering the necessary steps for the selection of a colour palette that would constitute the urban image.

During a previous research project, we studied several methods of chromatic planning in order to choose the one that would best adapt to the ongoing project. However, all these methods were intended solely to be applied to cities architecture, and their characteristics were not sufficiently appropriate to achieve the objectives of a project intended to be applied to street furniture. Thus, it became necessary to develop a new methodology that is now being tested in those two Municipalities on the Lisbon surroundings.

This methodology applies to the study cases an extensive direct observation, with the use of mechanical devices, including photographic mapping of both urban furniture and signage, in order to evaluate their visibility and legibility, as well as their colour applications.

In order to facilitate the study, samples of routes were defined for each urban area, including the main streets and places and, also, some secondary ones, to encompass the most representative zones, those with specific characteristics.

Along the chosen areas, an exhaustive record of all the environmental colours was made, including material samples not only from the buildings, but also from pavements, vegetation and any additional elements present on the environment with a relative permanence in the urban space – the non-permanent colours – that should be taken into account for the spatial chromatic readings. All of them are then classified using the Natural Colour System (NCS), which was chosen because it allows the easy identification of every colour, even when they are located out of reach, and without needing additional equipment. Besides the NCS classification, whenever it is possible, the colourimeter is used for a more accurate colour measurement.

These recorded colours must be completed with the background dominant colours, and with photographs of the environment elements and panoramic views from the different blocks using urban plans, architectural elevations and sections of the selected paths as well, which act as elements of the environment colour components. The angle of the streets is also evaluated in order to determine the percentage of sky colour present in each street, since this colour interferes on the urban area colour and,

therefore, must be taken in account in the colour palette.

We must underline that the recorded colours are perceived colours, not always coincident with the inherent colours (the colours belonging to pigments and materials) and that the perceived colours may also be a partitive synthesis, particularly in the case of vegetation and tiles coated walls.

When recording the environmental colours, all the perceptive factors related to colour interactions must be taken into account, as well as the geographic and atmospheric conditions and the chromatic variations along the different climatic seasons. With this purpose, the palette is tested along the seasons' changes to judge the chromatic alterations aroused from the different colours of the vegetation as well as daylight variations and sky colours according to weather changes to evaluate the chromatic plan pertinence.

All these colours are recorded on forms and maps, previously designed and tested, in order to create a database that will allow the identification of the town dominant colours.

In order to guarantee the scientific rigour on each quarter chromatic plan determination, we consider the dominant colours, proportionally represented, choosing colours to the urban furniture which may establish an adequate chromatic and luminosity contrast with the dominant colours and also respect the traditions, culture, identity and history of the quarter. These contrasts must be observed under the possible local illumination variations, in order to be sure that they accomplish their functions efficiently.

These dominant colours and the contribution of the local history and culture lead to the establishment of a very comprehensive urban chromatic furniture plan, based on scientific rigour.

This plan, which will be different for every settlement, must stand out from the environment, contributing for a better legibility and identification of these elements and, in the same way, will become a city's area identification element which may be used in different supports and, this way, facilitate the orientation and wayfinding within the city.

4 CASE STUDY CHARACTERISATION

The empirical phase of the present research project is being accomplished in two municipalities on the Lisbon (Portugal) surroundings: Loures, a municipality away from the river Tagus and constituted by traditional, modern and rural settlements, and Oeiras, a municipality that have settlements both on the interior and on the seafront, being at the same time a miscellanea of old and modern. In these municipalities were chosen several settlements with different dimensional, anthropological and topographic characteristics. This particular case study – Laje – is an ensemble of settlements from Oeiras municipality.

The origin of Laje is recent. It is a housing complex, instituted by the municipality, and constituted by different three different neighbourhoods: Social Lodgings, with buildings all alike, belonging to the municipality, and to whom the inhabitants pay rent; buildings belonging to the inhabitants, to whom the municipality sold the land and the projects; and AUGI, a neighbourhood that is inhabited by displaced populations to whom the municipality gave plots not interfering with the construction. Its buildings do not exceed four-stories, and the ground configuration is more or less rough with several hills.

The recorded existent colours conduce to a dominant chromatic palette with a predominance of white (S 0500-N), followed by the subdomain of yellow (S 0515_Y20R and S 1020-Y10R), pink (S 1020-Y70R), Burgundy (S 4030-Y80R) and grey (S 3000-N). Because the height of the buildings is mostly low, we must take into account the sky colour, the vegetation and the background greens of the surrounding fields.

Considering the dominant colours and the traditional culture of this settlement, and because this is a work in progress, we can start to define which colours shall be applied to Laje urban furniture, in order to achieve a coherent chromatic plan that will fulfil the urban furniture function requirements, respect the town traditions and achieve the research objectives.

As the Laje dominant colour is white, almost every colour could be chosen to be applied on its urban furniture. However, bearing in mind the other frequent colours, the chosen colour for Laje urban furniture is a particular tone of blue, defined by the NCS notation S 4020-B.

5 CONCLUSION

With this project, which is a work in progress, we aim to test and validate a Methodology for urban furniture chromatic planning. This methodology will define and underline the importance of colour application to urban furniture, taking in consideration that a pertinent chromatic plan can contribute for a better visualization and, consequently, turn urban furniture into an inclusive factor, contributing for a better use of its elements and, simultaneously, ameliorating the orientation within a city or an urban region and identifying its different zones.

We expect that this methodology, which establishes the importance of an appropriate and structured colour application to urban furniture, will contribute to the enlargement of the perspective for urban chromatic plans, allowing them to become more holistic and comprehensive.

BIBLIOGRAPHICAL REFERENCES

Berger, Craig. (2005) Wayfind: Designing and Implementing Graphic Navigational Systems. Switzerland: Rotovision SA, p.121.

Creus, Màrius. (apud Serra, Josep.). (2000) *Elementos urbanos, mobiliário y microarquitectura*. Barcelona, Spain: Editorial Gustavo Gili, p.6.

Minah, Gallen. (2005) Memory Constellations: Urban Colour and Place Legibility from a Pedestrian View. In: *Proceedings of AIC Colour 05 – 10th Congress of the International Colour Association, 8-13 May 2005, Granada*. Granada, Spain: pp.401-404.

Mollerup, Per. (2005) *Wayshowing – A Guide to Environmental Signage: Principles and Practices*. Baden, Switzerland: Lars Müller Publishers, pp.161.

Fashion design and productive thinking: Pragmatical approaches to creativity

Leonor Ferrão & Graziela Sousa

CIAUD – FAUL, Lisbon School of Architecture, Universidade de Lisboa, Lisboa, Portugal
ORCID: 0000-0002-0071-6995

ABSTRACT: This article discusses the development and results of some Productive Thinking Stimulation Techniques (TEPP – from the Portuguese *Técnicas de Estimulação do Pensamento Produtivo*), which are being implemented by the authors at Lisbon School of Architecture since 2007, and exclusively at the Fashion Design Bachelor since 2013. To foster the students' creative abilities, which serve as one of the main activities in a designers' projectual activity, these pragmatic approaches to stimulate high creativity address creative cognition, divergent thinking techniques focused on analogical reasoning. They also seek to fortify the students with a personal and distinctive frame of references through self-knowledge iterations as well as the contact with leading professionals' sources of inspiration. The students' insights about the activities/exercises carried out, and the impact they had on their design processes provided a proper understanding of the importance of these pragmatic approaches. The achieved results also pointed out that there is a need to develop more activities that foster their ability to think, analyse and create afterwards. The use of 'lateral thinking' techniques, serendipity, analogical reasoning, among others, allow the strengthening of the upcoming designer's creative abilities and increase their willingness to take chances in unexplored fields and themes.

Keywords: Fashion Design, Pragmatical Approaches to Creativity, Creative Cognition, Productive Thinking, Design Thinking

1 INTRODUCTION

The creative development of science depends quite generally on the perception of the irrelevance of an already known set of fundamental differences and similarities. Psychologically speaking, this is the hardest step of all. But once it has taken place, it frees the mind to be attentive alert, aware, and sensitive so it can discover a new order and thus create new structures of ideas and concepts.

Bohm, 2004, p. 16

In this chapter, we present the developments of the research project "My Favourite Things" (Ferrão, 2011; Sousa, 2011). We start from the same framework, exemplarily summed on Bohm's epigraph. In 2013/2014, the subject entitled TEPP (*Técnicas de Estimulação de Pensamento Produtivo*/Stimulation Strategies for Productive Thinking) stopped being optional on the 5th year of the pre-Bologna Bachelors from FAUL and included the curriculum of the 2nd year of the Fashion Design Bachelor. The maturity and diversity of students coming from several courses at the end of their academic career/formative process have been lost, yet it was possible to earn a focus on a single disciplinary territory and the specificities of the creative processes from this field.

Among the beliefs which hinder the most creative cognition in fashion design there is the empire of market logic and seasonality, i.e. the compulsory demand to present 'novelties' two times (collections) a year, not to mention that many designers even make midseason collections to 'refresh' their offer and keep their offer and commercial interest fresh. But there are other challenges: a reduced visual culture inside and out of the field and an 'obsession' for some themes, which are repetitive and shared among most of the students.

The proposed exercises derived from the need to:

- (Always) question the fashion system;
- Show that there are many ways to be a fashion designer/professional (which also demands the identification and the creation of market niches);
- Show that the creative process demands continuous work and an effort for searching knowledge, whose focuses are beyond disciplinary frontiers.
- Promote intertextuality in order to feed creative processes.

To this group of general goals, the following specific goals have been added:

– Opening up the frames of references (this may be the most important one, as the students tend to close themselves inside their field, from which they do not even know many references about);
– Fostering the construction of graphic journals in order to stimulate the development of personal poetics and registering what might be interesting to use in the future;
– Knowing and experimenting with several pragmatical approaches to creativity and making critiques about the obtained results;
– Promoting individual research, regardless of the pressure to transform it into a product for consumption.

2 FROM 'FAVOURITE THINGS' TO 'POETIC LISTS'

On the teaching year of 2013/2014, the first one when the subject was delivered only to Fashion Design students, the approach "My favourite things" (MFT1) – inspired by a theme from the movie *The Sound of Music* by Robert Wise (1965) and on the 'good stuff' cards' deck by Charles and Ray Eames (1952) and on the discoveries of neuroscience (Damásio, 2003) – we added "Poetic Lists" (LL) (Eco, 2009; Maldonado, 2012).

The first exercise was quite similar to the one proposed in the previous editions (Ferrão, 2011). Its goal is not just to beat sadness, how the song lyrics which inspired it suggests: favourite things are essential because, conscious or unconsciously, it is through them that the designer sees the world and lets himself be seen (Merleau-Ponty, 2002). The starting point is always to start revealing the things we like to search, others we do not (yet) know if you like or not. The challenge is the following: that starting point is precisely *only* a starting point. In this individual oriented research, we aim to show the students that these personal narratives provide the arguments that justify the processes and their results, if necessary. So, they stimulate the students to develop consistent and visually appealing processes because, although it is not possible to explain all design decisions evoking the hearts' reasons solely, conscious organises itself and operates from them. The theoretical-historical-critical armour, which is specific to the fashion disciplinary field, protects from the excess of subjectivity, reorientating and deepening the possibilities that might arise. In that sense, creating is a similar work as *guessing what must be done*. This process uses abductive thinking, a way of thinking, which is fundamental in the context of high creativity, regardless of the disciplinary field (Csikszentmihalyi, 1996). However, it is not enough. Overinterpretation (to establish new

intertextualities) and analogical thinking revert for this effort of *guessing what must be done*. If overinterpreting is an interdiction (Eco, 1992) out of projectual activity or any other artistical expression, in high creativity, it is highly necessary because it opens up new paths and possibilities.

Most of the strong creative personalities, i.e. the ones that present highly distinctive (and, even, disruptive) poetics, conscious or unconsciously, develop creative processes which put analogical thinking in action (Aav, 2000; Fletcher, 2001; Smith, 2001). They do not need to intellectualise the process. Non-intellectualising has its advantages since it hinders less divergent thinking and minimises the negativity which is characteristic of convergent thinking (i.e. censoring the successive attempts of ideation). Therefore, we propose to our students briefs with a minimum of descriptions, avoiding the conditioning of their interpretations. Overinterpreting the brief, excluding the necessary formal aspects such as stages, key-dates and the number of images/pieces to present, is desirable. For the same reasons (to avoid the intellectualisation of processes), the critical assessment of the processes that trigger creative cognition happens at the end of the semester, i.e. after they have experimented the proposed pragmatical approaches.

The challenge entitled "Poetic Lists" starts with Eco's obsession (2009), extracting their operability into the design process (Maldonado, 2012). The exercise is developed in groups, taking advantage of collaborative intelligence and peer-to-peer learning. The proposed starting point is a list of concepts from which only one is chosen to, then, explore its poetic potential and build a poetic list, with no size limits, but in which every word establishes a connection with the former ones. In order to do this, the students need to work with dictionaries, because it all starts, first and foremost, on verbal language, using figures of speech, figures of construction and/or figures of thought (Silva, 2009) – this pragmatical approach is also inspired in the processes of creative writing (Epel, 1998). The following words belong to the initial list (to build poetic lists): beautiful, lyrical, subtle, wonderful, magical, fantastic, sophisticated, oniric, supernormal (a concept which derives from Product Design field). Following, departing from the poetic potential of the lists made by each group (with one of the concepts from the initial list), they start the search for texts and images that might be useful for the construction of narratives for design. The process was more interesting than the obtained results. There was not enough time to work on the scrapbooks in order to obtain visually complex objects that were directly applicable to design. It is fair to say that the students lack competencies on the domain of digital tools to replace with expressive and communicational efficiency, which might be shown in and with paper (and other materials). The desire to experiment with the potential of poetic lists in design has been left open.

3 FROM 'FAVOURITE THINGS' TO FASHION DESIGN

In the teaching years of 2017/2018 and 2018/2019, given the circumstance that the same professor (one of the paper's authors) teaching TEPP also taught Fashion Design Project it has been possible to test the acquired knowledge from TEPP's exercises in the Project's subject. In these two years, two main exercises were carried out: MFT 1 and MFT 2. The first exercise (MFT 1), followed the initial course of the subject: aiming at self-knowledge, the students are invited to select and show their favourite things, as the name of the project implies. The project aims at self-knowledge as well as at the ability to organise, select and come up with new references – capable of inducing a mental state which will be favourable for projectual activity (Ferrão, 2011). Given the classes length, one of the main adjustments of this exercise has been the need to implement a collaborative/group approach – this fostered the student's abilities to collaborate, get inspired and find out new references from each other. The final results were seen as the identity of a collective of designers (or a design team). An addition has also been made to MFT 1's brief: in the perspective of finding out what could be suggestive for fashion design, after sorting out their favourite things and organising them together with a narrative in panels, the students added a new panel of shape, colour, fabric and texture suggestions – which could function as a 'bridge' for idea generation for their fashion design ideas or projects. As an attempt to assess the potential (and effectiveness) of this exercise as a basis for fashion design's projectual activity, the resulting panels of MFT 1 were distributed randomly and were used as the primary source of inspiration for one of the project's developments in the subject of Fashion Design Project. The students estranged this at the beginning, but as soon as they started to find ways to import these 'newly discovered' references into their ones, they became aware of how enriching the experience was becoming. Being left out of their 'customary' references, finding out new ones – out of their comfort zones, mostly, – became challenging and fulfilling for them, because they were able to come up with new ideas, solutions and looks for their fashion design creations.

The second exercise (MFT 2) was adapted from a previous exercise delivered in 2007/2008, following the aims of MFT 1, the students were invited to take the reverse path: being assigned a recognised fashion designer (with a consistent career), researching about him/her work, life and career and finding out (guessing) what his/her inspirations, references, favourite things might be. This exercise has also been implemented in groups due to the class's size (about 50 students each year). From the assigned designer, the students chose a collection, and started by dissecting it into shapes, colours, themes, looks among other features so they could start building a list of topics to

do research about, they were also stimulated to see documentaries, read interviews and watch other works from the assigned designer – in an immersive approach to a creative's 'world' and mind. After this, the students would start to build (by guessing) a narrative for which they would need to find images or other objects that would re-construct this designer's frame of references. The resulting insights of this exercise and the reverse 'engineer' applied in it made the students more aware about where inspiration comes from and how it is conducted and transformed into design ideas.

4 STUDENTS' IMPRESSIONS/INSIGHTS

The students also made an individual evaluation, in which they were asked about what they felt and had learned, and how they felt that these pragmatical approaches had or will have an influence in their activity as designers. From these testimonies, we were also to realise that, although the students are quite immature (yet) and lacked references and tools to find new ones – belonging to Generation Z, these digital natives are unable to find new paths and switch their attention away from screens, which hinders their ability to open up to new ways, things and themes – they felt a positive impact in their self-awareness and in their design performance. Several highlighted the fact that they got to know themselves better and discover favourite things they were unaware of, by leaving their comfort zones. From their design's performance, they state that their design ideas got richer, more diverse, conscious and relevant, they also felt more capable of finding new solutions for design problems, achieving uncommon results.

5 DISCUSSION

As a development of this research, it would be beneficial 1) to assess student's design projects, before and after their individual and group experiences at this subject to review, adjust, refine and enlarge the subject's contents and briefs; 2) to collaborate with the project subject to mentor our students during their design processes, so they can operationalise TEPP's learnings; 3) to inquire all participants directly involved to interpret and communicate the results.

BIBLIOGRAPHICAL REFERENCES

Aav, M. et al. (2000). *Tapio Wirkkala: Eye, Hand and Thought* (2nd ed.). Helsinki: Taideteollisuusmuseo.

Bohm, D. (2004). *On creativity* (With a new preface by Leroy Little Bear). Lee Nichol (ed.). London: Routledge.

Csikszentmihalyi, M. (1996). Creativity: Flow and the Psychology of Discovery and Invention. New York: Harper Collins.

Damásio, A. (2003). Looking for Espinoza: joy, sorrow and the feeling brain. Orlando, FL: Harcourt.

Eco, U. (2009). *The Infinity of Lists: An Illustrated Essay* (First Edition, A. McEwen, Trans.). New York: Rizzoli.

Eco. U. et al. (1992). *Interpretation & Overinterpretation.* Cambridge, MA: Cambridge University Press.

Epel, N. (1998). *The Observation Deck: A Tool Kit for Writers.* San Francisco, CA: Chronicle.

Eames, C., Eames, R. (1952). *House of Cards.* Santa Monica, CA: The Eames Office.

Ferrão, L. (2011). "My favourite things: estratégias de estimulação de pensamento produtivo no ensino em Design". *Actas de Diseño* – V Encuentro Latinoamericano de Diseño "Diseño en Palermo". Año V, Vol. 10, Buenos Aires, pp. 84-90. ISSN 1850-2032. Accessed Feb. 26, 2019. Available at: <http://fido.palermo.edu/servicios_dyc/publicacionesdc/vista/detalle_articulo.php?id_libro=271&id_articulo=6541>; complete version with colour illustrations retrivable from <https://www.academia.edu/27027131/My_favourite_things_estrat%C3%A9gias_de_estimula%C3%A7%C3%A3o_do_pensamento_produtivo_no_ensino_em_Design>.

Fletcher, A. (2001). *The Art of Looking Sideways.* London: Phaidon.

Maldonado, P. (2012). I*novação, Design et cetera* [Inovation, Design et cetera]. PhD thesis. Faculdade de Arquitectura, Universidade Técnica de Lisboa.

Merleau-Ponty, M. (2002). *L'œil et l'esprit.* Paris: Gallimard.

Silva, A. S. (2009). Figura. In: Ceia, Carlos (dir.*). e-Dicionário de termos literários*, Accessed Feb 26, 2019, http://edtl.fcsh.unl.pt/encyclopedia/figura/

Smith, P. (2001). You can find inspiration in everything* (*and if you can't, look again!). London: Violette Editions.

Sousa, A. G. (2011). Design de moda e pensamento produtivo: estudo exploratório de um processo de I&D/Fashion Design and Productive Thinking: An Exploratory Study of an R&D Process. MA Dissertation, Faculdade de Arquitectura, Universidade Técnica de Lisboa.

Wise, R. (1965). *The Sound of Music* [Motion Picture]. USA: 20th Century Fox.

Part III
Arts

Fantasy, creativity and proportions: Spiral representations in culture and art

Teresa Lousa
CHAM/FCSH/Universidade NOVA de Lisboa, Portugal
ORCID: 0000-0001-6574-6901

José Mikosz
Universidade Estadual do Paraná, Paranavaí, Brazil
Member of CIEBA/Fbaul, Portugal
CHAM, FCSH, Universidade NOVA de Lisboa, Lisbon, Portugal
ORCID: 0000-0002-5314-0758

ABSTRACT: This paper seeks to establish a link between the referential process and the creative representation of the spiral as a symbol that derives from a fantasy plan common to different times and cultures. It is possible to find in different places of the world several archaeological references, from the Neolithic to Ancient Greece, from Brazil to Malta, etc., a common denominator that cannot be ignored. Its cultural expression can start from experiences in non-ordinary states of consciousness such as the shamanistic dimension of certain tribes, but can also be present in the popular and decorative expression of various non-industrial artefacts. In the artistic dimension, we will highlight some examples of contemporary artists who have been sensitive to this Spiral theme. Their inspiration was guided by images of the unconscious and by the golden ratio or certain visual harmonies that depart from mimetic references in nature. In any case, these works of art refer more to a natural and symbolic aesthetics than to the rational use attributed to them.

Keywords: Visionary Art, Spirals, Archaeology, Anthropology

1 INTRODUCTION

Among the various images resulting from non-ordinary states of consciousness that serve as an inspiration to the creative process of artists, the present paper singled out the spirals and studied some of the meanings that are usually attributed to these elements, as well as some transformations and adaptations they can undergo depending on the local culture.

> Etymologically, the word 'spiral' springs from ancient roots inextricably bound up with ideas of creation, life-giving and aspiration – from the Latin spiralis or spira, and the Greek speira, meaning a spire or coil, or a conical or pyramidal structure, as well as from the Latin spirare, meaning 'to breathe', as in expire and inspire. (Ward, 2006, p. 17)

Symbols equivalent to spirals may appear in the form of serpents, spheres, tunnels, ladders, circles, mandalas, or labyrinths.

These symbols, apparently very different, keep between themselves a relationship of similarity and meanings. It is thus difficult to be clear about what is typical to one or the other. However, better than to look at this as a problem, it only reinforces the similarity these symbols represent.

Some examples of the presence of spirals will be discussed here, to highlight the strong influence that these images can have on creativity, imagination, and knowledge in the production of visual works.

Spirals are present all over nature, whether in plants, in vines and ferns, in animals, as in snails and shells, in physical and atmospheric phenomena, such as hurricanes, cyclones, swirls, and in the formation of galaxies (Cirlot, 1984, p. 241). In general, all these spirals follow the golden ratio's proportion patterns. This proportion follows Fibonacci's numerical sequence, which is also found in the divisions of tree branches, in the arrangement of leaves or thorns, in the veins and arteries of animals, etc. These patterns are a structural base that is consistently present in the development and growth of the natural world. Thus, it is possible to understand the association of the spiral as a symbol of energy, of creation, also suggesting the idea of development. Therefore, more than a recurrent shape in the natural world, spirals seem to constitute an archetype of human thought and are often used to express these ideas and principles symbolically, through culture and art, confirmed by Jung's psychoanalytic theory. In his book, *The Archetypes and The Collective Unconscious*, he states that in paintings and drawings made by his patients, the contents depicted are often recurrent,

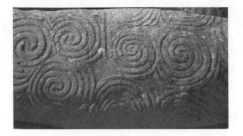

Figure 1. Spirals carved in stone (K1) in Newgrange, Ireland. 3,200~2,900 BC. Source: By John37309 – Own work, CC BY-SA 4.0, https://commons.wikimedia.org/w/index.php?curid=41007893.

which does not mean that the patients already knew that they were dealing with symbols. Jung said the following:

> One can paint very complicated pictures without having the least idea of their real meaning. [...] It is interesting to observe how the execution of the picture frequently thwarts one's expectations in the most surprising way. (Jung, 1968, p. 352)

2 ARCHAEOLOGICAL REFERENCES

Some examples of spirals in artistic remains from prehistoric times and in various geographic locations will be analysed. The meanings of the symbols will be presented here as described by civilisations or according to what researchers have been able to deduce from their uses. In Ireland, Boyne Valley, in County Meath, there is an old building, known as Newgrange. This large funerary monument consists of several inner chambers. The outer walls of this Neolithic building were covered with quartz crystals that glittered in the sunlight. The monument was restored and is 76 metres across and 12 metres high; it was estimated that 200,000 tons of rock and other materials were used in its construction (Robinson, 2007, p. 1170). Although many of the myths associated with Newgrange are of Celtic origin, this monument preceded them by approximately 2,000 years, just as it preceded the Great Giza Pyramid by 500, and the circular stone construction of Stonehenge by almost 1,000 years.

In the Newgrange funerary chambers, there are various stones with spiral carvings as well as circles, serpentine shapes and zigzags. At dawn in the winter solstice (December 21), sunlight penetrates one of the chambers located in the entranceway, illuminating three intertwined carved spirals, the Stone Goddess, important not only in Newgrange but also for the whole Celtic culture that came later (Robinson, 2007, p. 1172). The fact that the winter solstice marks the birth of a new year possibly indicates that the monument was erected pursuing the ideas of fertility, death, and rebirth. The architectural layout and the choice of spirals, among other entropic geometric images, carved in

the stone, seems to have been used to replicate the mental conditions experienced in non-ordinary states of consciousness, specific ideas linked to the conception of a spiritual world.

The entrance stone, described as one of the examples of megalithic art in Western Europe, is also carved with complex patterns, spirals, concentric arches, and diamond shapes (Ward, 2006, p. 35).

It is necessary to cross this spiral barrier to reach the inner sanctum, a kind of passport required to enter a sacred kingdom. This realm of immortality is reached by a real or symbolic death, through rituals and initiations. This theme is found during the megalithic and Neolithic period in Europe, Mexico, China, and Egypt. For Purce, such spirals demonstrate the evolutionary nature of the journey made (Purce, 2003, p. 87).

In Brazil, in the Amazon region, there are several archaeological sites with numerous examples of rock art, and there have been reports on these sites since the colonisation period. The first information about the existence of rock art in the Amazon is found in the chronicles of European travellers and clergymen who travelled through the region during the first centuries of conquest and colonisation of Brazilian lands (Pereira, 2003, p. 17).

Particularly in the state of Pará, there are currently 111 sites with rock art. There are many paintings, petroglyphs and stone carvings in these places, where simplified figures of humans and animals are represented, faces and geometric designs that follow the same patterns found in other archaeological sites around the world, such as zigzags, gratings, and spirals, among others.

The Stone of the Apes is located near Km 96 of the Transamazonian highway (direction Altamira-Marabá). The stone, though less "sophisticated" than that of Newgrange, bears some resemblance to it, namely the curved and square spirals.

Notwithstanding, among European vestiges, the Celtic people represented spirals most vehemently. Celtic is the designation given to a group of various tribes that spread throughout much of North-western Europe around the year 2000 BC. Their artisanal production, such as weapons, household goods, jewellery, was crafted mainly in metals like brass with sophisticated skill in the techniques of the notch. The motifs were geometric designs, spirals, and stylised animal shapes.

In Druidism – the Celts' natural form of religion – the cycle of human life, being born, ageing and dying, was represented by a circle or a spiral. Druidism sought after balance by linking personal life to the spiritual source present in nature and thus recognised eight periods throughout the year, four of which were solar (male) and four lunar (female), marked by special religious ceremonies. The Celts did not pursue knowledge in an objective or rational way as modern civilisations do. The ultimate goal was not to tame the natural forces of Creation, to put a halter on Earth; but instead, to fully

penetrate the mystery of human destiny and allow it to become intoxicated by it (Launay, 1980, p. 10).

Probably the earliest known example of the use of spirals is found in Mal'ta, on Lake Baikal, Siberia. There, a palaeolithic plaque made of mammoth ivory dating back to 16,000 BC was discovered. The carvings are a series of double spirals, possibly serpents, around a simple seven-turn spiral that disappears through a hole in the centre of the plate (Robinson, 2007, p. 1200). According to Ward (2006, p. 12), this plate could date to 23,000 BC and may be associated with the lost civilisation of Shambhala, the legendary country of hyperboreans. The spiral with seven turns is also found among the Hopi Indians, symbolising Mother Earth.

A set of intertwined paths forms the labyrinth as an image coming from the spiral, often built around a cross, spiralling down to the centre. Appearing throughout history and in places all over the world, mazes symbolise the difficulty of reaching the centre, always protected. Christianity adopted this symbol to represent the difficulty of reaching Heaven, where the centre of the labyrinth is "Heavenly Jerusalem" (Ward, 2006, p. 10). In the centre of the labyrinth, artists often leave an invisible cell, shrouded in mystery, thus leaving one to one's intuition or personal affinities (Chevalier & Gheerbrant, 1982, p. 531). Although they have intricate shapes, the labyrinths are spirals and are associated with the cosmos:

[...] the world, the individual life, the temple, the town, man, the womb – or intestines – of the Mother (earth), the evolutions of the brain, the consciousness, the heart, the pilgrimage, the journey, and the Way. (Purce, 2003, p. 29)

According to Cirlot (1984, p. 329), "the maze had a certain fascination comparable with the abyss, the whirlpool and other phenomena" (1971, p. 173). Some cathedrals have a labyrinthine drawing on the ground, and the journey through them symbolised the pilgrimage to the Holy Land, also representing the signature of the initiatory confraternities of the builders of these cathedrals (Chevalier & Gheerbrant, 1982, p. 530).

Some labyrinths shaped like a cross, known in Italy as 'Solomon's knot', and featured in Celtic, Germanic and Romanesque decoration, are a synthesis of the dual symbolism of the cross and the labyrinth; they are known, for this reason, as the 'emblem of divine inscrutability'. (Cirlot, 1971, p. 175)

The famous coin of Knossos, of 3,000 BC, represents the labyrinth where the Minotaur lived. According to the Greek legend, it was also known as a Minoan spiral, but a similar image, or its mirror image, can be found in an Etruscan vase from the 7th century BC, as well as on a pillar in Pompeii and on the rocks of Rocky Valley, Tintagel in Cornwall, England. Much like the coin of Knossos, the American Hopi Indians use it as a symbol of Mother Earth, Tapu'at (mother and son),

or as a symbol of birth and rebirth. These labyrinthine forms are carved into the rocks of the oldest dwellings in North America, in the villages of Oraibi and Shipaluovi, as well as in the ruins of Casa Grande in Arizona (Doczi, 2006, p. 25). Since it is not a simple spiral form, but rather a very complex drawing, it refers to the universality of certain symbols, including the meanings that these cultures assigned to the labyrinth, connected to the mother symbol and the cycles of life.

On another symbolic aspect of labyrinths, Campbell states that:

We have not even to risk the adventure alone, for the heroes of all time have gone before us. The labyrinth is thoroughly known. We have only to follow the thread of the hero path, and where we had thought to find an abomination, we shall find a god. And where we had thought to slay another, we shall slay ourselves. Where we had thought to travel outwards, we will come to the center of our own existence. And where we had thought to be alone, we shall be with all the world. (Campbell, 2011, chapter V, paragraph 1; 2004, p. 23).

3 ANTHROPOLOGICAL REFERENCES

Native societies considered primitive, coexist with a fundamental figure: the shaman or *pajé*. Shamanic practices are associated with non-ordinary states of consciousness and are quite ancient and similar all over the planet, which led Harner to create the term Shamanic State of Consciousness (Harner, 1982, p. 59).

According to Campbell

The shaman is the person, male or female, who in his late childhood or early youth has an overwhelming psychological experience that turns him totally inward. It's a kind of schizophrenic crack-up. The whole unconscious opens up, and the shaman falls into it. This shaman experience has been described many, many times. It occurs all the way from Siberia right through the Americas down to Tierra del Fuego. (Campbell, 2011, Chapter III)

Shamans are the best-prepared individuals in the tribe; they undergo difficult trials of initiation, and are usually the guardians of the stories and traditions of their peoples, taking on diverse roles, including that of doctors, musicians, artists, counsellors, priests, etc. (Eliade, 2002, p. 44). Shamans, as mediators between the material and spiritual world, in their states of trance describe visions of spirals.

The Maori tribes of New Zealand, Polynesia, are another excellent example of the importance of the representations of spirals. They tattoo spiral shapes on their faces. For them, the spirals represent the key to immortality. According to Polynesian tradition, after death, the soul encounters a terrible witch that will devour the spiral tattoos. In exchange, she will touch the eyes of the soul, granting it the vision of the spirits. If the witch does not find the tattoos, she will eat the

eyes of the soul, preventing it from achieving immortality (Purce, 2003, p. 79). In addition, the spirals are a symbol of one's connection to the universe. Maori also carve the spirals in wood and stone, hoping that the power attributed to these symbols will protect them from premature death (Doczi, 2006, p. 25).

The Shipibo-Conibo are tribes located in the eastern part of Peru, along the Ucayali River region, known for their tapestries and ceramics decorated with intricate geometric patterns inspired by ayahuasca experiences. A typical experience described by Shipibo-Conibo shamans is travelling in a supernatural canoe crewed by demons in order to recapture the stolen soul of a sick patient trapped in another canoe of demons by an enemy shaman. A non-shaman, under the influence of ayahuasca, may likewise have his soul taken away by a canoe crewed by these demons (Harner 1973, p. 158), whose crew is led by a yellow jaguar and a black puma (Harner 1973, p. 164). Under the influence of the drink, the Shipibo-Conibo generally see giant anacondas, venomous snakes and jaguars and, less frequently, other animals. The novice shaman, under the influence of ayahuasca, believes that he gets hold of giant serpents that become his personal demons to be used in his defence in supernatural battles against other shamans (Harner, 1973, p. 164).

The Shipibo have an almost unique style of art. Inspiration comes from mirages produced by ayahuasca, but it is a good example of how culture ends up by influencing the whole production of a group, handing down the same style to the next generations. The drawings are used in ceramics, embroidery, body paintings, rugs, paintings and are also associated with icaro or sacred and healing songs. Both the drawings and icaros are received by the shaman in an ayahuasca trance and may be intimately connected in a synesthetic way, that is, the drawings can be sung not only as if they were scores, but as sounds. These drawings sometimes resemble Eastern mandalas, sacred circles with labyrinths, dots and patterns that refer to entropic visions.

Many geometric patterns, although they generally combine straight lines and curves, form spiral figures.

4 SPIRALS IN CONTEMPORARY ART

In the 1950s and 1960s, there was a boom in the use of psychedelic or hallucinogenic substances, notably LSD and hashish, where many forms of artistic expression were inspired by famous trips with these psychoactive substances, creating a particular aesthetic style, at the time associated with beatnik and hippie movements: Psychedelic Art. Psychedelic experiences were full of hallucinations per se, the contents of which were not taken very seriously.

Tom Wolfe reported cases like that of North-American writer Ken Kesey in the book *The Electric Kool-Aid Acid Test*, 1993. Kesey led a group of

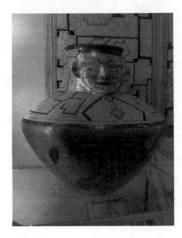

Figure 2. Shipibo-Conibo jar. Shipibo women use an original pattern of geometric lines to decorate their textiles, cloth, body, and ceramics. Source: https://commons.wikimedia.org/wiki/File:Shipibo_jar_(UBC-2010)a.jpg.

not very ordinary people, owing to their extravagant habits and for having decided to spread the use of LSD, which was little known at the time, in order to propagate their supposed advantages to mental life. They opened doors in their minds, doors that they did not even suspect existed, a very wonderful thing. (Wolfe, 1993, p. 36)

Kesey, his band The Merry Pranksters, and friends took off on an old renovated school bus, painted in the best psychedelic style, with last-generation sound equipment and a 16 mm camcorder, to carry out this "evangelising" mission on a trip to the New York World's Fair. Psychedelics were very profuse in the visual arts, and influenced many artists from that period, like Wes Wilson, Victor Moscoso, Rick Griffin, Ed Thrasher, Mati Klarwain, and Robert Williams, whose work inspired the concept of lowbrow or pop surrealism.

Recently the painter and writer Laurence Caruana (2006), director of the Viennese Academy of Visionary Art, reported that in 2005 he had to paint a canvas with the theme "Europe" for an exhibition near Munich, called Dalis Erben Malen Europe. The more he read about the myth of the abduction of Europe, the more intrigued he was about the occult and obscure aspects of the myth. According to the traditional Hellenistic myth, Zeus had turned into a fabulous white bull to seduce Europe, who after climbing on its back, was kidnapped. Zeus runs away with her over the sea to the island of Crete. Upon reaching the island, under a willow tree, Zeus comes out of his bull disguise and forces himself on the nymph. Caruana (2006) decides that the picture should then be called the violation of Europe and not the kidnapping. Among the sons of Zeus and Europe is Minos, who reigned over Crete thanks to Poseidon, who had made a beautiful bull out of the

Figure 3. Remedios Varo. *Spiral Transit*. 1962. Oil on Masonite. Source: https://remedios-varo.com/obras-remedios-varo/decada-1960/transito-en-espiral-1962/

sea, indisputable proof of divine favour. Minos should have sacrificed the animal to Poseidon, but did not. The god takes revenge, driving the bull mad and making Minos' wife, Pasiphae, fall in love with the animal. Pasiphae was able to join the bull. Sometime later, the Minotaur is born. Minos, terrified and ashamed, had an intricate labyrinth built, from which no one could get out, and trapped the Minotaur inside it. Traditional images created by artists such as Titian, Rembrandt and Moreau portrayed the abduction of Europe, with the maiden sitting on the bull running through the water. In the Caruana painting, several ancient images were researched and included in the work. Behind the representation of the Cretan goddess, holding two axes is the famous image of the labyrinth.

Remedios Varo (1908-1963) was a Spanish surrealist painter who lived in Mexico. In her creative process, she was inspired mainly by esotericism and by the teachings of Gurdjieff, the famous Russian mystic and thinker. Her paintings contain alchemic imagery of deep symbolism. Varo painted spirals in several of her works. Figure 03, *Spiral Transit*, shows a journey made on small boats that follow a spiral watercourse. This journey from the periphery to the centre also refers to the idea of the labyrinth as in the *Labyrinth,* by the Fantastic Realist, Rudolf Hausner, and also in Varo's *Insomnio*, and Dorothea Tanning's *Birthday*. These last two depicting corridors with various doors that can lead to multiple compartments, as it happens in a path inside any labyrinth portrayed.

The painter Pablo Amaringo (1943-2009), who has become an icon of Visionary Art, comes from Puerto Libertad, a small settlement near the city of Tamanco, Peru. Before painting his visions, Amaringo painted naïve scenes of everyday life, landscapes, female figures, and was a shaman, a vegetarian. It was not until later, under the influence of the anthropologist Luis Eduardo Luna, who suggested that he pictorially expressed his experiences with ayahuasca, that he began a great series of visionary works that resulted in

the publication of *Ayahuasca Visions: The Religious Iconography of a Peruvian Shaman* (1999), which made him famous worldwide and his images widely used in books and graphic materials that deal with the subject. Amaringo even created a visionary art school in Pucallpa, called Usko Ayar. Amaringo says that he began to paint under the influence of ayahuasca. In visions, he learned how to mix colours correctly to create the most delicate nuances (Luna & Amaringo, 1999, p. 17). The paintings, in general, contain multi-coloured and luminous dots, which stand out even more because of the dark background. This visual effect is typical of miracles produced by ayahuasca. Amaringo comments that the themes painted by him are products of his visions, his experiences alone, and not ideas copied from any book.

The presence of spirals in the visions does not mean that artists necessarily portray them in pure form, as it is often the case in indigenous and prehistoric works. Most depict more complex, mixed figurative scenes among geometric and abstract elements that may or may not contain the spirals. Even if they see these geometric elements, artists will not always use them, in an attempt to avoid repetitions and stereotypes.

John Robinson, an Australian sculptor, created a series of pieces inspired by mathematical, physical, and symbolic motifs. It is an interesting example of a somewhat similar quest for the symbolism of the visionaries. Many places, such as Ireland, Italy, Greece, and Egypt were visited by Robinson, who, in Brazil, visited the city of Florianopolis, where he went to see the archaeological sites of Campeche.

In Eastern culture, Robinson (2007) indicates that the presence of the divine is centred on the harmony of all nature, as expressed by Tai Chi. In Western culture, because our religions teach us that God created man in his own image, the mystery of the divine, by tradition, is represented as a human figure. Robinson's works of the Universe Series attempt to depict works within a kind of symbolism where shapes found in nature are related to the values of life found in Western and Eastern minds. In creating the Universe Series, Robinson followed a path, from the beginning of time to the present day. The entire collection symbolically portrays the earth, animals, man and woman, birth, religion, civilisation, and death.

Another artist illustrating this section is Henson, who grew up in the teeming 1960s and was fortunate enough to see Ashbury Haight, San Francisco's borough and centre of the hippie movement in full bloom. His early experiences were with Cannabis, and later he discovered LSD with a friend. After some recreational experiences, where he also consumed mushrooms, Henson says he was taught by LSD to use it as a form of learning. From there, the experiences served as the deepest inspiration for his paintings:

So it can be said that my art and my person have evolved simultaneously. It would be impossible to

Figure 4. Spiral Jetty by Robert Smithson. Rozel Point, Great Salt Lake, Utah. April 1970 (mud, precipitated salt crystals, rocks, water). Coil 1500' long and 15' wide. https://upload.wikimedia.org/wikipedia/commons/8/84/Spiral-jetty-from-rozel-point.png.

separate the experience of art, because they grew up together. (Personal communication by email of December 15, 2008).

Henson's works touch on the mysteries found in nature, the miracle of creation, sexual love, religions, mysticism, and the evolution of consciousness. In the painting *Wonders of Nature*, a person, in a moment of pure contemplation, admires a flower, resembling a lotus flower. The picture represents a particular moment in this contemplation, as if the whole universe participated in this pleasure, in total complicity pertinent to a daily miracle. In the *Double Helix* painting, a couple embraces, in a moment of love, between rays of energy that surrounds them in spirals, as in the Caduceus of Mercury or as in the DNA molecule, giving an idea of the necessary union of opposites in creative processes. These rays start from the centre of a galaxy in the universe and rise in space among many living beings, animals and plants, until they reach the couple, and move ahead among clouds and, at the bottom of them, an illuminated opening.

American artist Robert Smithson created a monumental spiral work known as Spiral Jetty. Smithson was a visionary artist, the pioneer of land art. Smithson is internationally renowned for his art and critical writings, which challenged traditional notions of contemporary art between 1964 and 1973. This monumental earthwork was inspired in part when Smithson saw the Great Serpent Mound, the Pre-Columbian Indian monument in South-western Ohio (Holt-Smithson Foundation).

With these few examples, we tried to show the timeless interest in recurring images found in nature and their influence on the human imagination. The spirals and their derivations are ever-present, from rock art to the present day, and with quite similar symbols, either as a creative and energetic shape or as portals to the unconscious world. The creative ability associated with fantasy and the spirit of the time (*zeitgeist*) will renew the aesthetics of the works accomplished by artists.

ACKNOWLEDGEMENT

This chapter had the support of CHAM (NOVA FCSH/UAc), through the strategic project sponsored by FCT (UID/HIS/04666/2019).

BIBLIOGRAPHICAL REFERENCES

Campbell, Joseph. (2004). *The Hero of a Thousand Faces*. Princeton: Princeton University Press.

Campbell, Joseph, Moyers, B. (2011). *The Power of Myth* [VitalSource Bookshelf version]. Retrieved from vbk://9780307794727.

Caruana, Laurence. (2006). *The Rape of Europa*. Available in: <http://www.lcaruana.com/webtext/europa.html> 30 February 2019.

Chevalier, Jean & GHEERBRANT, Alain. (1999). Dicionário de Símbolos – Mitos, Sonhos, Costumes, Gestos, Formas, Figuras, Cores, Números. Rio de Janeiro: José Olympio Editora.

Cirlot, J. E. (1971). *A Dictionary of Symbols*. Mishawaka (USA): Philosophical Library.

Eliade, Mircea. (2002). *Imagens e Símbolos – Ensaios Sobre o Simbolismo Mágico-Religioso*. São Paulo: Martins Fontes.

Doczi, György. (1990). *O Poder dos Limites. Harmonias e Proporções na Natureza, Arte e Arquitetura*. São Paulo: Editora Mercuryo.

Harner, Michael. (1973). *Hallucinogens and Shamanism*. New York: Oxford University Press. New York.

Harner, Michael. (1982). The Way Of The Shaman – A Guide To Power And Healing. New York: Bantam Books.

HENSON, Mark. Psychedelic Experiences. [personal message] Message sent to <antarm@gmail.com>. in: 15 December 2008.

Holt-Smithson Foundation. *Robert Smithson*. Available at: <https://www.robertsmithson.com/introduction/introduction.htm>. 30 January 2019.

Jung, Carl-Gustav. (1968). *The Archetypes and the Collective Unconscious* (Bollingen Series XX. 2a ed. vol. 9). New Jersey: Princeton University Press.

Launay, Olivier. (1985). *A Civilização dos Celtas*. Grandes Civilizações Desaparecidas. Rio de Janeiro: Otto Pierre Editores.

Lewis-Williams, David & Pearce, David. (2005). I*nside The Neolithic Mind: Consciousness, Cosmos And The Realm Of The Gods*. New York: Thames & Hudson.

Luna, Luis Eduardo & Amaringo, Pablo. (1999). *Ayahuasca Visions – The Religious Iconography of A Peruvian Shaman*. Berkeley: North Atlantic Books.

Pereira, Edithe. (2003). *Arte Rupestre na Amazônia* – Pará. São Paulo: UNESP.

Purce, Jill. (2003). *The Mystic Spiral: Journey Of The Soul* (Art & Imagination). London: Thames & Hudson.

Robinson, John. (2007). *From the Beginning Onwards: The Autobiography of John Robinson* – Vol. 3. Available in: <http://www.bradshawfoundation.com/jr/pdf_vol3/1169-1188%20Celts.pdf > 30 February 2019.

Wolfe, Tom. (1993). *The Electric Kool-Aid Acid Test*. New York: Picador.

Ward, Geoff. (2006). *SPIRALS: The Pattern of Existence*. Long Barn: Green Magic.

The creative *daemon* (δαίμων) and the hyper-intellection of art

João Pereira de Matos
CHAM, FCSH, Universidade NOVA de Lisboa, Lisbon, Portugal
ORCID: 0000-0003-4333-3385

ABSTRACT: We live in a time full of expressive possibilities, and we have unprecedented access to a tendentially infinite collection of information. However, for this very reason, we never before suffered such tremendous "anxiety of influence", to use the title of Harold Bloom's seminal work (1973). Not only because of this informational overabundance but also, in a way, as a hangover for all the vanguards that in the twentieth century redefined all frontiers of artistic expression and went far beyond them, almost to the apparent exhaustion of all the radical possibilities of Art. To these questions we will try to give one possible answer, pointing a direction or path that can integrate, in the same dynamic approach, the creative impulse, the *daemonic* dimension (from the Greek δαίμων, a spirit that can guide us) so well identified by the Greek Culture of antiquity, with the seemingly overwhelming informational availability of the present. In short, the answer will be to look at the expressive dimension under the filter of a creative (ie, *daemonic) hyper-intellection,* in the sense that if the whole creative impulse comes from an irrational drive it also requires, with the same intensity, to be guided by a filter of a pan-optic understanding of the artistic world, either in the current perspective of the landscape of contemporaneity or in a diachronic approach, that is, with a historical understanding of Culture.

Keywords: Creativity, Art, the anxiety of influence, daemon

1

We live in a time full of expressive possibilities, and we have unprecedented access to a tendentially infinite collection of information. However, for this very reason, we never before suffered such tremendous "anxiety of influence", to use the title of Harold Bloom's seminal work (1973). Not only because of this informational overabundance but also, in a way, as a hangover for all the vanguards that in the twentieth century redefined all frontiers of artistic expression and went far beyond them, almost to the apparent exhaustion of all the radical possibilities of Art.

Bloom, incidentally, mentions that it is the sensation, regardless of the time and place, of arriving late to literature (we argue that now this feeling is even more oppressive), i.e, knowing that a long tradition precedes the writer, because "strong poets" transcend time and not only overwhelm future and contemporary authors but also that "poets create their precursors", i.e., their influence can reach to a moment before their lifetime retroactively redefining the importance of their precursors (Bloom, 1973, p. 19).

What to do, then? Will there be only the way of renunciation as exposed in the *Bartleby y Compañia* of Enrique Vila-Matas (2002) or should one remain indefinitely waiting for, in Blanchot's words *Le Livre à Venir* (1959)?

To these questions (that are not limited to literature but concern all aspects of artistic labour), we will try to give one possible answer, pointing to a direction or path that can integrate, in the same dynamic approach, the creative impulse, the *daemonic* dimension (from the ancient Greek δαίμων, a spirit that can guide us) so well identified by the Greek Culture of antiquity, with the seemingly overwhelming informational availability of the present.

This is only a first approach to the subject of the exhaustion of art. However, it does not yet answer the deeper question of whether Art (even if one knows that it will never cease because there will always be artists who continue to work even when, apparently, there is nothing new to be said) becomes irrelevant because no more is done than repeating specific formulas, variations over the same theme previously exploited to the point of utter exhaustion. An additional requirement is thus posed: how can this daemonic spontaneity still be relevant?

The Greeks had a multiplicity of δαίμονες (*daemones*), minor deities who safeguarded various aspects of human life, and they are even mentioned by Plato (*Symposium*: 202d; *Apology of Socrates*: 31c). Some *daemones* were beneficial, and others were nefarious. Those who were good, who guided those who were possessed by them allowed reaching a state of happiness, εὐδαιμονία (*eudaimonia*). The artist, too, could experience this bonanza, letting him draw inspiration from such deities but without controlling the "when" and "what" of such a phenomenon. This idea has never abandoned a somewhat subterranean or underlying

perspective of Culture. In such a way that this same *mediumistic* state could be mentioned by Duchamp (1997) in the middle of the twentieth century. It is clear that the current physiological and neural paradigms of the brain and its cognitive functions will reject any supernatural dimension of creativity. However, this perspective can be used as a symbolic approach: there is "something" that imposes itself on the artist, on his will, which is sometimes quite unexpected at least in the sense that no one can predict, at the outset, the exact configuration of the outcome. It is like a force that can always reinvent itself: when everyone thinks that the boundaries are reached there is a new artist or artistic movement that pushes them even further.

In short and in our opinion, the answer will be to look at the expressive dimension under the filter of a creative (ie, *daemonic*) *hyper-intellection*, in the sense that if the whole creative impulse comes from an irrational drive it also requires, with the same intensity, to be guided by a filter of a *pan-optic* understanding of the artistic world, either in the current perspective of the landscape of contemporaneity or in a diachronic approach, that is, with a historical understanding of Culture.

However, we must try to explain what is this *hyper-intellection* and what is its role in the contemporary creative process.

2

Rather than just saying that we are in the realm of randomness, creativity has traditionally been viewed as an expression of the irrational. This always meant two things: that the creative drive was never circumscribed to a deliberate program of aesthetic research because it always transcended the intentionality of the critics and the artists themselves and that, being something that subverted those intentions in an unexpected and impersonal way, always meant that for understanding the paradigms of rationality (if one wanted to have an integral idea of the human being) was also necessary to understand the problem of the irrational. This represented a challenge that the idea of *daemon* was no more than one of the answers. This *daemonic* hypothesis then presupposed another entity, with its semi-divine intellectual horizon which, possessing the artist or the thinker, explained this seemingly irrational and insubstantial dimension of creativity. Thus, even using the explanatory order of the myth, the essential character of the creative irruption was to be what is not circumscribed: the absolute horizon of the unexpected, that which resists the necessary deduction between premise and conclusion is, therefore, in *Kantean* terms, a free play between the faculties of imagination and understanding (Kant, 1987).

However, in addition to the perplexity that this irreducibility of creativity entailed, there was also a way of dealing with its distressing dimensions, which is the artist's inability to control his creative impulses and thus deliberate freely: the artist's inscription in a school or movement. This collective dimension allowed a direction of the aesthetic exploration, a framework that defined the terms where the irreducible aspects of the creativity could be freed and put into context in the artistic work.

That is, it was a self-regulatory instance that established the order that framed creative chaos.

3

However, these balances were broken by both the *avant-gardes* and the era of *hyper*-information. In fact, there is a substrate of disorientation where artists have to inhabit: the degree of *avant-garde* experimentation is radical; the access to a totalitarian collection of information about art is, also, radical. Modernism destroyed even the theoretical and pragmatic circumscription of art. Henceforth, it was neither possible to answer the question "what is art?" nor to recognise what is the artistic phenomenon, that is, to answer the practical question "is this is art?" (D'Orey, 2007). The various theoretical avenues have been multiplying in order to arrive at a sufficiently comprehensive concept of the essence of Art and, besides the theory, in social and economic terms (i.e., in practice) there has been a movement of enlargement in order to accept any aesthetic proposal without being able to define *ex-ante facto* what is inside or outside the realm of Art, because Art can be, strictly and absolutely, everything. Whether it is "good" or "bad" Art, if it is relevant to the overall picture, if there is a greater or lesser potential for appreciation in the art market, these are other questions that, in a more or less inorganic way, attempt to be answered (specially, when there are the cyclical media scandals or works of Art full of irony to Art itself) and where, at the same time, the radical horizons of artistic endeavour, as happened with bio-art and extreme manifestations of the intersection between Art and technology, questions the ethical boundaries of artistic work — like the glowing bunny of Eduardo Kac (circa 1998). Because the systematic exploration of frontiers proceeds from Duchamp's radical proposals, notably with his *ready-mades* (1917), Malevich's iconoclasm with the suprematism initiated with his black square (Malevich 1915) or, in literature, with the Baudelaire's (1857) or Rimbaud's poetic irreverence (1972), or the decomposition of traditional forms of narrative with Joyce's Ulysses (1922); in music, with the application to the composition of Schönberg's twelve-tone scale (1967), or Cage's *4′:33″* (1952) just to cite some expressive cases of hundreds of others possible examples.

It is not absurd, in this context, to chose, like Bartleby (Melville 1853), a complete refusal of Art or even to be in a situation of extreme anguish. However, at the same time, a reaction to this state of affairs

should be possible: a basic posture aimed at a path to go forward in the situation of a lack of aesthetic orientation. Well, today, the artist is asked to have an attitude of *hyper-lexical* response to the environment of *hyper-information*. An overall view that guides the irruption of that centuries' old virtuality to harness the forces of the irrational one meant as the *daemonic* experience. What we want to say is that there is a way of radically embracing the intellectual environment that we live in today and, at the same time, exercising the freedom of the artistic work in its maximum power. That road is always to try to reach the *pan-optical* vision as a contextual perception that will allow each artist to reconstruct his own aesthetic foundation. However, the question is still much more complicated: that this extreme rationality must be in a dialectical relation to the irrationality of the *daemonic* forces. For that we mean, at the same moment when the artist achieves the *pan-optic* perception of the whole he must also, in the very foundation of his newfound aesthetic, have to rely on that *daemonic* inspiration, in times before only reserved for the moment of the making of the actual works of Art.

On the other hand, the reverse movement may also be relevant: the artist progresses as if he knew how to contextualise the works already performed in the sense that they can present clues to discover which way to go in the *hyper-intellective* whole of the Art world. That is, it is possible to discover deep dialectical relations between *hyper-intellection* as a paradigm of rationality and the irrationality symbolised by the extreme *daemonic* instance for the aim, from the artist's point of view, will always be to radicalise the old balances between rationality and irrationality to found out, exactly, what he can contribute to his *Zeitgeist*.

4

What is fascinating is that, despite all the mutations in the conceptual paradigms about what is human, the theme of *daemonic* possession persisted, now under the guise of having an innate genius especially in the most idiosyncratic artists that have revolutionised their fields, perhaps as an inheritance of the ideals of Romanticism even in a historical moment such as ours in which it becomes increasingly clear that there is a predominance of what Adorno and Horkheimer had designated by "Culture Industry" (*Kulturindustrie*) in which the model of capitalist-industrial production also serves as the context for artistic activity (Adorno and Horkheimer, 2002).

In fact, in spite of the myth of the *l'artiste fou* whose work derives only or his genius, any specific and monographic analysis on the majority of these artists discovers their deep work of reflection and analysis on their own diachronic and contemporary context, not to mention that most were also inserted in the artistic-intellectual *milieu* of their peers, although sometimes

it was a minority of artists in the marginal fringes of the Art world, as was often the case with the vanguards of the twentieth century. That is, with all the differences from artist to artist, from movement to movement, and even from decade to decade, there was almost always a mix of programmatic vision about aesthetics and an unpredictable eruption of creative solutions even if those eruptions only happen after a slow maturation and under a multiplicity of influences that coalesced in a specific proposal, more or less radical, but always remarkable because a strong identity accompanied it.

Finally, we can try to understand this proposed concept of *hyper-intellection*: after all the vanguard movements of the twentieth century, in our time of an all reaching knowledge, the approach to the creative impulse must contain, *ex-ante facto*, a *pan-optic* understanding of the Art world.

5

It is thus implicitly or explicitly asked of the artist that, in his activity, in addition to mastering the τέχνη (*techne*) specific to his field of artistic performance he asks himself about all these questions, takes a position on them, and be willing to continue this permanent search for "what more is there to be said" while demanding an extreme receptivity and attention to his inner *daemon* in order to remain faithful to his irreducible artistic vision. Those seem to be overly demanding and complex requirements for the artist, and this is true. Moreover, that is because the artist, when he is learning his craft (an even later), should pay attention not only to the technique but also to the theoretical aspects of his context: what is the state-of-the-art in his field?; what are the most influential movements of his time?; who were the most important precursors?; and he should have an idea of what art is, even if Philosophy cannot nowadays reach a consensus on that matter.

However, the means at their disposal are also exponential significant. It is the current communication infrastructure of the information society that allows them to access the wealth of knowledge that will allow guidance in this strange and hypercomplex conceptual labyrinth.

Given the impossibility of fully explore in this paper the complexities of the ontology of Art our intent was not to debate the *state of the art* on the dominant conceptions of this topic but to provide a roadmap for solving the difficulties and anxieties that artists may face in the current context of Art much as Harold Bloom's intention in is *Anxiety of Influence* (1973).

In our view, that roadmap requires that the irrational drives in making the work of art must be in *equilibrium* with an intellectual perspective about Art as lucid as possible, that is, that the artist must also make use of a demanding and informed analysis of the artistic world. Thus, an explicit position was not taken on the

underlying problem of knowing what Art is. Nevertheless, given what was said in this paper it is possible to infer a middle ground between the ontological theory of realism in art and the contextualism defended by Arthur C. Danto (2013) because when an artist is at work he must have some intuitive idea about what Art is, even if that is a kind of *naïve* realism, but at the same time the concern about the impact that his work may have is preordained by the assumption that Art has a strong contextual dimension that is given by the appreciation of the community of Art lovers, critics and fellow artists.

ACKNOWLEDGEMENT

This chapter had the support of CHAM (NOVA FCSH/UAc), through the strategic project sponsored by FCT (UID/HIS/04666/2019)

BIBLIOGRAPHICAL REFERENCES

Adorno, Theodor & Horkheimer, Max. (2002). *Dialectic of Enlightenment*. (Trans. by Edmund Jephcott). Stanford: Stanford University Press.

Banksy. (2018). *Girl with Balloon*.

Baudelaire, Charles. (2013). Les Fleurs du Mal. Miami, FL: HardPress Publishing.

Blanchot, Maurice. (1959). *Le Livre à Venir*. Paris: Gallimard.

Bloom, Harold. (1973). *The Anxiety of Influence*. New York: Oxford University Press.

Cage, John. (1952) 4':33".

Danto, Arthur C. (2013). *What Art Is*. New Haven: Yale University Press.

D'Orey, Carmo, (ed.). (2007). *O Que é a Arte?*. (Trans. by Vítor Silva e Desidério Murcho). Lisboa: Dinalivro.

Duchamp, Marcel. (1997). *O Acto Criativo*. (Transl. Rui Cascais Parada). Portugal: Água Forte.

Duchamp, Marcel. (1917) *Fountain*.

Kac, Eduardo. (Circa 1998) *Alba*.

Kant, Imannuel. (1987). *Critique of Judgement*. (Trans. by Werner S. Pluhar). Cambridge: Hackett Publishing Co.

Livingston, P. (2016, June 07). History of the Ontology of Art. Retrieved from https://plato.stanford.edu/entries/art-ontology-history/#MappOntoThes

Joyce, James. (1975). Ulysses. London: Faber and Faber.

Malevich, Kazimir. (1915). *Black Square*.

Melville, Herman. (1853). *Bartleby, the Scrivener: A Story of Wall Street*. New York: Putnam's Monthly Magazine of American Literature, Science and Art.

Plato. (2008). *Symposium*. (Trans. by M. C. Howatson edited by Frisbee C. C.). Sheffield: Cambridge University Press.

Plato. (2002). *Apology of Socrates*. (Trans. by Thomas Seymour). Gorgias Press.

Rimbaud, Arthur. (1972) *Une Saison en Enfer. Alliance typographique*. (Trans. of Iluminações; Uma cerveja no inferno; translation, preface transl. and notes Mário Cesariny). Lisboa: Estúdios Cor.

Schönberg, Arnold. (1985). *Fundamentals of Musical Composition*. (Edited by Gerald Strang, with an introduction by Leonard Stein). New York: St. Martin's Press, London: Faber and Faber.

Vila-Matas, Enrique. (2002). *Bartleby y Compañia*. Barcelona: Editorial Anagrama.

The creation through listening: Expression, intelligence, inspiration and wisdom

Sara Chang Yan[1] & Ana Leonor M. Madeira Rodrigues[2]
Department of Drawing, Faculty of Architecture, University of Lisbon, Lisbon, Portugal
ORCID: (1) 0000-0001-9526-9658; (2) 0000-0002-9749-3475

ABSTRACT: The world is alive by sounds. If one listens to the sonic reality, it is possible to discover the creative potential within it. However, what is *to listen*? And how *to listen*? These are side questions that the investigation intends to clarify throughout its development. Further on, the main question is *how listening can be a creative experience*? The investigation aims to recognise that listening is a creative experience. Therefore, in order to demonstrate how listening leads to creation, the research is based on the listener's experiences developed by Murray Schafer (*Ear Cleaning*), Pauline Oliveros (*Deep Listening*), Jonathan Harvey (*Music and Inspiration*) and Michel Serres ("Healing in Epidauros"). The research identifies four creative modes: *expression, intelligence, inspiration* and *wisdom*. In these modes occurs the creation of intensities, knowledge, ideas and consciousness: expression (the way it sounds) develops the *intensities* of personal listening; the intelligence within sound offers *knowledge* and *awareness* to the listener; the sound of inspiration reveals exceptional *ideas* in the listener; the wisdom within silence presents *consciousness* of reality. The acknowledgement of these modes clarifies that *listening is a creative experience* that allows one to enjoy the sonic reality in which the listener is immersed. The research reminds us that listening is a personal discovery, according to each own creativity.

Keywords: Listening, Sound, Creativity, Inspiration, Wisdom

1 INTRODUCTION

Sound reveals reality. The vibrating air transmits sensations of silences[1], sonic events and environments.

The listening is a creative potential that allows enjoying the sonic reality. It can reveal intensities, knowledge, ideas and consciousness, that otherwise would not be perceived either interpreted. According to the experience of Schafer: "if you listen carefully, your life is enhanced" (New, 2009, 00:1:23-00:1:27).

However, it is common to ignore the sound. For example, in urban places, due to the excess of information, listening is delimited by sonic events that are considered essential; or it is turned off, to avoid noisy environments (Oliveros, 2005)

While hearing happens continuously (the ear function is working), listening implies a voluntary action (Sonic Acts XIV, 2012). Listening is not a given ability; it requires practice and evolvement.

Then, what is *to listen*? And how *to listen*?

The dictionary indicates that *listening to* means *to hear with attention.* (Academia das Ciências de Lisboa, 2001) But, in reality, what is this *sonic attentiveness*? The research clarifies this side question through Oliveros' findings on modes of attention.

And how *to listen* is another side question that the research intends to elucidate. Throughout the development of the research, it is offered diverse descriptions of the listeners' experiences. These examples serve as starting points that allow others to figure out what the practice can be and to enter in it.

Further on, in the context of the research, the main question is *how listening can be a creative experience?*

The research aims to recognise that *listening to is a creative experience* and to clarify how creation occurs in this receptive mode.

In order to demonstrate *how listening can lead to creation*, the research is based on the experiences developed by advanced listeners.

Each experience reveals significant but partial aspects of listening. Then, the combination of their parts may allow the alignment of a broader understanding of listening.

In the research, the listener's exercises are considered as experiments taken from reality. The interpretation depends on the issues that are analysed from each experience. There were other listener's experiences that have been left out.

1. *The essence of sound* is felt in both motion and silence, it passes from *existent* to *non-existent.* (Schafer, 1993, p. 259)

The research selects four listener's works, not commonly related, to consider the creative ways that happen in listening.

The first is "Ear Cleaning", a practice for beginners developed by Murray Schafer from his teaching experiences, and related to his concept, the *soundscape*. The practice is described as a sequence of exercises in the book *Ear Cleaning*. Also, it is an idea included in the main book of his work "The Soundscape: Our Sonic Environment and the Tuning of the World".

From the "Ear Cleaning" exercises, the research section, *the way it sounds,* presupposes the existence of creative expression in listening.

The second is "Deep listening", a practice mainly develop by Pauline Oliveros, from her work as composer, performance, improviser and listener. From this daily activity in which the reality expands, Oliveros clarifies many of her experience. However, some remain as statements, that guide other listeners and need to be discovered by each one.

The research explores one of her phrases: "sounds carry intelligence" (Oliveros, 2005, p. xxv). The research attempts to understand this idea by gathering ideas taken from diverse texts and talks.

Thus, in the research section, *the intelligence within sound,* "Deep Listening" represents a practice in which sound acts intelligently. However, "Deep Listening" is a vast experience, not limited to the idea of intelligence.

The third, "Music and Inspiration" is the title of Jonathan Harvey's book. The publication results from Harvey's doctoral thesis, in which the composer's inspiration process is clarified, based on letters and texts written by several composers.

The research captures the first and second chapter, in which inspiration is related to the unconscious and the experience of life. Then, the research section, *the sound of inspiration*, can consider the certain inner sounds as being a listening experience.

The fourth, "Healing in Epidauros" is a chapter's title in the book *The Five Senses: The Philosophy of Mingled Bodies*, written by Michel Serres. The chapter reflects on various issues that occurred while Serres is immersed in silence. One of these experiences is to listen to wisdom.

The section, *the wisdom within the silence*, completes the research with the subtle sounds of wisdom.

After all, the research expects to identify four creative modes in listening: *expression, intelligence, inspiration* and *wisdom*.

The acknowledge of these modes clarifies that *listening is a creative experience*, in which occurs the creation of intensities, knowledge, ideas and consciousness:

– The expression "the way it sounds" develops the *intensities* of personal listening.
– "The intelligence within sound" offers *knowledge* and *awareness* to the listener.

– "The sound of Inspiration" reveals exceptional *ideas* in the listener.
– "The wisdom within the silence" presents *consciousness* of reality.

In conclusion, the research's contribution is to remind us that the listener can enjoy the experience of living immersed in a sonic reality.

2 THE LISTENING OPENS SENSIBLE LAYERS

Most often the listener begins at the basic level, in which sound is vaguely perceived, through the general aspects. When attention is given to sound, it is possible to perceive sensible layers within listening. Oliveros describes a starting experience:

> I simply put a microphone in my window and recorded the sound environment […]. When I replayed the tape, I realised that although I had been listening carefully while I recorded, I had not heard all the sounds that were on the tape. I discovered for the first time how selectively I listened, and that the microphone discriminated much differently than I did. From that moment, I determined that I must expand my awareness of the entire sound field. (Oliveros, 1984, p. 182)

The listening to is not entirely given; it develops through practice. Every situation can be a revealing experience. Oliveros reminds: the listening starts when signals reach the brain, "then what happens? Are you listening? If you are listening, what are you listening to? […] What is your experience?" (Sonic Acts XIV, 2012, 00:00:10-00:2:21).

When sonic attentiveness evolves, it allows new experiences. The continuous practice – regular or not – is a journey, in which is revealed the way sound happens for each one, in consonance with the listener sense of creation.

3 THE WAY IT SOUNDS

Even before practising, the listener may recognise the importance of clearing the ear to access the full range of sounds.

"Ear Cleaning" (Schafer, 1967, p. 1) is a set of exercises, in which the listener tunes into the qualities of sound. The sessions gradually explore the variables: noise, silence, tone, timbre, amplitude, melody, texture, rhythm and above all, culminating in a spatial composition of the soundscape.

An example of an *ear cleanse* is to find a specific sound. In this exercise, the listener analyses various sound events, until it is found the "rising starting pitch, or […] one that makes a dull thud followed by a high twitter; or one that combines a buzz and a squeak" (Schafer, 1993, p. 208). Another example, it is to avoid speaking or making noises for 24 hours, in order to listen to sounds coming from others, as also to appreciate silence (Schafer, 1993).

Then, when the level of sonic sense increases, it is possible to interpret nuances that previously were ignored.

According to Schafer (1993), the ear cleaning is considered done, when the listener is sensible to the expressiveness of sound, as well as when he can reproduce the sound vocally. Through the experience, Schafer understood that "one learns about sound only by making sound" (1967, p. 1).

In the research, the reflection between "Ear Cleaning" and creativity recognises the existence of *creative expression in listening.*

During the learning process, the students learn the qualities of sound, simultaneously through their creativity, they are impressed by particular experiences, but not by other situations. Then, each student develops a singular expression by appreciating specific *intensities* of the sonic reality. Moreover, the student develops a personal way of listening, through his own creativity.

The listener is mainly a receiver, but creativity is active in the way each listener assimilates the discovery of sound.

4 THE INTELLIGENCE WITHIN THE SOUND

When the listener becomes sensible to the way sound conveys information, it is possible to discover the field of intelligent transmissions in which one lives in.

In the "Deep Listening" practice, Oliveros is in "a heightened state of awareness and connects to all that there is" (1999, p. 1).

Sensible to all kinds of sounds, from any direction, Oliveros enjoys the way "sounds carry intelligence. Ideas, feelings and memories are triggered by sounds" (2005, p. xxv).

The entire sonic field can set surprising and meaningful experiences, in which every moment "has unique dynamics, feelings, sounds and sensations [...]. The slightest difference may lead you to new creative relationships" (Oliveros, 2005, p. 17).

Sound can be understood as an invisible figure that adds qualities to the sonic reality. Chion (1994) describes diverse ways in which sound acts. An example is when sound appears before the sound source becomes visible, it informs about the event that is happening. Another example is the meanings and intensities that can emerge from the overlapping of sounds.

Sound continuously transmits a multitude of information, occurring in time and space: movement, position, distance, dynamics of the sound sources, as well as information about people (who they are and what are their motivations) (Radiance Meditation Talk Show, 2016).

Usually, sonic communication is considered speech and specific signals. Then, in order to communicate, speech is learned and valued, while the rest of the sounds are ignored. However, it is possible to notice "the knowledge that comes from sound, from actually listening to everything, rather than speech" (Radiance Meditation Talk Show, 2016, 00:23:28-00:23:37).

The listener can distinguish meaningful nuances in the words, categorised sounds and sonic symbols. An example is Janáček (1995), who listens to the speech's melodies. When a person is speaking, Janáček is not interested in the meaning of the words, but in what the tonal modulation reveals "what he is like, what he feels, whether he is lying, [...] or is merely making conventional conversation" (Harvey, 1999, p. 49).

Immersed in a sound field, the listener attention can go outwards, to the environment, as well as inwards, into the body or even to the imagination and memories (Oliveros, 1984).

Then "Deep listening" encourages to discover the sonorities that come from inside. An example is the use of questions: "What is your favourite sound? Can you reproduce it in your mind?" (Oliveros 1984, p. 53). The answer can appear immediately or can emerge throughout an extended period. In this exercise, it is possible to listen to sounds that otherwise would not exist.

Another example is the notebook to record listening experiences. It can reveal a creative dynamic that happens between internal and external sounds. The sequence of notes may reveal new ideas, meanings, patterns or structures (Oliveros, 2005). Also, "a word, a fragment, or a paragraph can later trigger your memory or imagination and yield an enormous amount of information" (2005, p. 18). Alternatively, in a different situation, the notes can change its meaning.

Also, throughout the practice of "Deep Listening", Oliveros understands *what can be the sonic attentiveness.* Then, it is clarified the first side question of this research: *What is to listen?* In which listening is defined as being to *hear with attention.*

Listening combines two modes of attention: global and focal (Oliveros, 1999).

First, in global attention, the listener is in a state of awareness. One experiences and accepts all sounds, without judging or identifying it, the listener is in an entire inclusive mode. Second, when a particular sound captures the listener's attention, he enters in focal attention and can follow the sound in an exclusive mode, to listen to it from the beginning to the end (Radiance Meditation Talk Show, 2016).

The two modes complement and balance the listener. "Attention is narrow, pointed and selective. Awareness is broad, diffuse and inclusive" (Oliveros, 1984, p. 139). When the listener can move between focus and global, it is possible to enter and discover significant sounds, as well as to keep his awareness expanded for the whole field.

Furthermore, when attention is given to a situation, unexpected movements can become sonic, and a new reality may be opened. Even in a calm moment, according to the experience of a practitioner: "I was amazed

that I could hear myself blink. It is about the softest sound I ever heard" (Oliveros, 1984, p. 31).

After all, it is relevant to remember that Oliveros organises several "Deep Listening" workshops that are attended by musicians, as well as by people without musical training. For Oliveros, "Deep Listening" it is a practice to expand the experience of life.

The research delineates what *intelligence within sound* can be and how is the sonic attentiveness that reveals it.

The vibrating air is a source of knowledge that can be sensed, it resonates within the listener. Moreover, the listener himself is a source of physical and mental information.

When the listener is tuned to receive the *intelligence within the sound*, one expands the knowledge and awareness of life, as well as glimpses new creative possibilities.

5 THE SOUND OF INSPIRATION

When the listening evolves, it is possible to access a further sensibility: inspiration.

Although the development of listening is not a linear progression that moves from level one (expression) to level two (intelligence), then to level three (inspiration). Listening may evolve simultaneously in those three layers, in tune with each one creativity.

Harvey (1999) mentions composers, for whom inspiration is essential to go further in their music. It can be described as an "insight which supplies everything the composer needs to complete a given piece" (1999, p. 25). In the sixth symphony's experience, Tchaikovsky describes the experience as something that flows through him:

> Yesterday... suddenly for some reason or other, everything began to play and sing inside me after a long indifference to music. One theme and embryo in B major enthroned itself in my head and unexpectedly fascinated me to such an extent as to make me attempt an entire symphony. (Harvey, 1999, p. 26)

Sometimes, inspiration is a clear indication, other moments it is diffuse – it clarifies along the process – however, in both situations, an intense quality is recognised.

Inspiration is not a choice between many possibilities. When it happens, it conveys a sense of fullness and vitality. "The essential is what inspiration tells you", says Stockhausen (Harvey, 1999, p. 14). Moreover, it occurs intuitively, and it is neither rational nor justifiable.

Harvey (1999) refers that insights can happen in distinct stages of the work. In the beginning, it is common to identify a melody, a structure, a theme, an annotation – an unresolved idea that appeared in previous work – among others starting points. The development of long work is sustained by different modes of inspiration,

whether in the beginning, middle or end. For example, when the work is complete, a simple idea comes to consciousness: This is it, it is done.

Where inspiration comes from? Some composers describe an experience that surpasses them totally. Says Tippett: "It is outside our control [...] it lives us rather than we live it" (Harvey, 1999, p. 5). It is something more significant, overwhelming. Therefore, they do not consider as a content coming from them, nor from the reality, they know. Richard Strauss describes:

> the melodic idea which emerges without the prompting of an external sensual stimulant or of some spiritual emotion [...] it is the greatest gift of the divinity and cannot be compared with anything else. (Harvey, 1999, p. 26)

However, Harvey explains (1999) that it can come from the unconscious because some composer can identify a link between insight and specific experience that he lived, although it is not possible to explain the connection linearly. For instance, Ligeti states that,

> You could see art, artist creation, as a soup constantly simmering in a cauldron. The taste of the soup depends on what you have put in it; the broth simmering over the fire is the artist's potential and what you put into it are experiences. (Harvey, 1999, p. 37)

Then, the composer's inspiration results from everyday life or intense experiences, but "only forms of experience that have a particular resonance for him will contribute to the creative process" (Harvey, 1999, p. 40).

In this idea, inspiration develops between the unconscious and the conscious, moves and aligns, until a spontaneous direction is revealed, as says Schumann (1947):

> It is very nice indeed if you can pick out little melodies on the keyboard; but if such come spontaneously to you, and not at the pianoforte, rejoice even more, for it proves that your inner sense of tone is awaking. (Harvey, 1999, p. 28)

Furthermore, when it comes? Some composers describe that the insight can happen under any circumstance; others refer that it arises only in specific conditions (Harvey, 1999).

Haydn describes his experience:

> Usually, musical ideas are pursuing me, to the point of torture, I cannot escape them, they stand like walls before me. If it's an *Allegro* that pursues me, my pulse keeps beating faster, I can get no sleep. If it's an *Adagio*, then I notice my pulse beating slowly. My imagination plays on me as if I were a clavier. (Harvey, 1999, p. 32)

While Tchaikovsky (1878) explains differently:

> She leaves me only when she feels out of place because my workaday human living has intruded. [...] an artist

lives a double life: an everyday human life and an artistic life... Sometimes I look curiously at this productive flow of creativeness. (Harvey, 1999, p. 5)

Also, it is possible to stimulate the composer's inspiration, to enter a movement conducive to inspiration (Harvey, 1999).

Then, some composers refer a period of preparation, in which some purposeful or random activities are undertaken. For example, according to Wagner, it is possible to study a deliberated subject, or on the contrary, to flow in diverse activities:

I must have time and leisure to wait for inspiration, which I can expect only from some remote region of my nature. (Harvey, 1999, p. 9)

In Beethoven (1961) opinion, even several non-musical activities may have connections with the composition: "No one could love the country as much as I do. For sure woods, trees and rocks produce the echo which man desires to hear" (Harvey, 1999, p. 46).

In some cases, as in Delius's, inspiration may not be a clear sound, but an inner sense that guides to play music: "I, myself, am entirely at a loss to explain how I compose – I know only that at first I conceive a work thro' a feeling" (Harvey, 1999, p. 3)

Even though inspiration may seem a casual event, its analysis demonstrates that it is derived from an attentive way to search and discover (Harvey, 1999).

In the investigation, the musician is an example that uncovers how inspiration can be as a listening activity. From the characteristics of its process, it is possible to perceive that this inner listening occurs in other activities of human life.

The inspiration is a source of exceptional ideas that allow the creation in music, as well as in other creative activities.

6 THE WISDOM WITHIN THE SILENCE

Eventually, the listener finds silence, or sufficient stillness, to listen to wisdom, through an authentic experience of the world.

Inside the amphitheatre of Epidaurus, Michel Serres was immersed in silence, for two hours, and describes what happened.

The specific characteristics of this architecture allow to amplify the sound, but it also intensifies the silence. "An immense ear bathed in the precisely tuned acoustic of the amphitheatre. I listen, I wait, in the dense silence" (Serres, 2009, p. 85).

Involved in the muteness of air, sun and sky, in which even the smallest insect was sleeping (Serres, 2009).

At first, silence surrounds the listener and enters inside him/her. It allows the body to vibrate and to drain until the murmur of the internal organs disappears,

whether it be derived from "comfort, pleasure, pain, sickness, relief, tension, release" (Serres, 2009, p. 85.)

A second moment: silence keeps information away. It places the listener outside the collective ship, where the community lives and sounds. Far from where the air vibrates incessantly, day and night, turned on by the language that is impregnated in everything: garden, house, machine or object.

Serres (2009) recognises the value of language. It conceives culture and science, as well, appreciates the way it allows to understand life, love and death. However, language is a filter that does not allow an authentic experience of reality. "I believe, I know, I cannot demonstrate the existence of this world without us" (Serres, 2009, p. 103). Language may be essential to reach reality, but if it substitutes reality, it becomes alienated inside interpretations.

Therefore, the aim is detoxification of frenetic language. The listener seeks to approach the state of solitude, like the hermit, who knows the need to cross a certain distance, to remain silent. A similar state happens to those who contemplate god, or others, like the hunter, who stands still, waiting for life to return and reveal itself. In silence, Serres waits immobile "in order that what is given, gracious as it is, should come and sit next to me" (2009, p. 89).

Most of all, more than the healing of the body or the detoxification of language, in silence, Serres's main aspiration is to listen to wisdom.

In this research, Serres clarifies wisdom as a listening experience that allows to perceive and contemplate the authentic reality.

Thus, listening to the silence may offer wisdom, in which the consciousness of reality becomes present.

7 CONCLUSIONS

The research presents listening as being a creative experience.

Two listeners, at the same time and place, can listen to distinct experiences, because attention follows each person's singularity, revealing the creation that is happening in each one.

It is possible to identify four creative modes in the listener: *expression, intelligence, inspiration* and *wisdom.*

Expression is how listening develops in each person. While the listener learns the qualities of sound, simultaneously, he discovers the experiences that resonate with him. Thus, the listener aligns the *intensities* of his singular expressiveness, that may become a future creation.

Intelligence is the sound's ability to transmit information that offers *knowledge* and *awareness* to the listener.

Inspiration is to listen to the sounds coming directly from the source, whether it is from the unconscious mind or the higher existence. It offers exceptional

ideas to the creation of music, as well as to other creative activities of human life.

Wisdom is to access an authentic experience of the world, in silence, in which one may listen to *the given*. Then, the experience can open the *consciousness* of reality.

These creative modes are essential for the creation of sound, music or even life.

In the context of the research, the listener is not only the musician but every person who lives immersed in a sound reality.

The research is based on the work of three composers and one philosopher, whose experiences serve as a platform on which others can understand how creation occurs in listening, as well as can find starting points to begin their listening's practice.

Often, it is not easy to recognise the power of receptiveness and listening. It is common to misunderstand listening to hear. In general, people hear but barely listen. Listening, in order to appreciate the sonic reality, requires attention, practice and development.

Thus, people can enjoy the way of listening perceives and expands their experience of life.

The research contributes to remind that listening is a state of receptivity in which creation may occur.

BIBLIOGRAPHICAL REFERENCES

Academia das Ciências de Lisboa, Fundação Calouste Gulbenkian, Verbo (2001). Dicionário da língua portuguesa contemporânea da Academia das Ciências de Lisboa. Lisboa: Verbo.

Chion, M. (1994). *Audio-vision: sound on screen*. New York: Columbia University Press.

Sonic Acts XIV [HandsOnPiano] (2012 April 25) Masterclass Pauline Oliveros-3: Listening and Movement Awareness with Energy Awareness [Video file] Available from https://vimeo.com/40995502

Harvey, J. (1999). *Music and inspiration*. Edited by Michael Downes. London; New York: Faber and Faber.

New, D. [NBF] (2009). *Listen*. [Video]. Available from: https://www.nfb.ca/film/listen/

Oliveros, P. (1984). *Software for people: collected writings 1963–80*. Baltimore, Md: Smith. Available from: https://monoskop.org/images/2/29/Oliveros_Pauline_Software_for_People_Collected_Writings_1963-80.pdf

_____. (2005). Deep listening: a composer's sound practice. New York, NY: iUniverse.

_____. (1999). Quantum Listening: From Practice to Theory (to Practice Practice). Available from: http://soundart archive.net/articles/Oliveros-1999-Quantum_listening. pdf

Radiance Meditation Talk Show (2016 January 1) Pauline Oliveros Deep Listening. [Video file]. Available from: https://www.youtube.com/watch?v=0NCCNlu30r8

Schafer, M. (1967). Ear cleaning: notes for an experimental music course. Toronto: Berandol Music Ltd.

_____. (1993). *The soundscape: our sonic environment and the tuning of the world*. Rochester, Vermont: Destiny Books.

Serres, M. (2009). *The five senses: a philosophy of mingled bodies*. London; New York: Continuum.

Art and mind set: Neuroscience and education in the life project

Cinzia Accetta
Minister of Public Instruction, PhD University of Naples Federico II, Palermo, Italy
ORCID: 0000-0002-2259-9646

ABSTRACT: For long human beings were believed to see only with their eyes, that an image of the world was imprinted on the retina to be then transmitted and interpreted by the brain. With the intense recent research, it was understood that in the eye there is no image in the traditional sense. The retina is the filter and the channel of signals to the brain, which then builds the visual world. Vision is, therefore, an active process. Why do we like a painting or a sculpture? What do the portraits of Vermeer and Van Gogh's sunflowers have in common? The mystery of art and beauty has a thousand interpretations, the most recent being from neuroscience. Semir Zeki, a professor of neurobiology at the University College of London, one of the leading experts on the mechanisms of human vision, is the pioneer. Its fundamental premise lies in the fact that all human activity is a result of brain activity and obeys the laws of the brain. For this reason, only by understanding the neural basis of creativity and artistic experience can we develop a valid aesthetic theory. Since the creation of a work of art requires motor activity (think of a musician playing or a painter painting), to what extent the fact that we like it or not is related to the movements that make artist during creation? The starting hypothesis calls into question the famous "mirror neurons", those that are activated when an individual acts but also when an individual observes the same action performed by another.

Keywords: Art, Mindset, Neuroscience, Painting, Creativity

For long human beings were believed to see only with their eyes, that an image of the world was imprinted on the retina to be then transmitted and interpreted by the brain. With the intense recent research, it was understood that in the eye there is no image in the traditional sense. The retina, on the other hand, is the filter and the channel of signals to the brain, which then builds the visual world. Vision is, therefore, an active process. Matisse understood this instinctively when he wrote, well before the scientists that seeing is already a creative process, which requires much effort.

We are closer to attaining cheerful serenity by simplifying thoughts and figures. Simplifying the idea to achieve an expression of joy. (Matisse, as cited in Kandel, 2016, p. 7).

Why do we like a painting or a sculpture? What do the portraits of Vermeer and Van Gogh's sunflowers have in common? Where does the fascination of the "geometric" paintings of Mondrian and Malevich come from?

The mystery of art and beauty has a thousand interpretations, the most recent being from neuroscience. According to Semir Zeki (2007), a professor of neurobiology at the University College of London, It is a relatively new field, whose goal is to explore the brain activity that underlies the creativity and enjoyment of art. All human activity is a result of brain activity and obeys the laws of the brain. For this reason, only by

Figure 1. Matisse, Mais soudain le soleil n° 1, 1943, (William Weston Gallery).

understanding the neural basis of creativity and artistic experience, we can develop a valid aesthetic theory (Lavazza, 2003).

Our brains (at least at some level) are organised in the same way, but it is also true that different people in front of the same work of art respond differently. Human variability is a subject that has not been studied

in general, and neuroaesthetics can make an illuminating contribution in this sense. We can identify two laws closely related to the creation and artistic enjoyment: the law of constancy and the law of abstraction.

One of the primordial functions of the brain is to acquire knowledge about the world, but the information that comes from the outside is never constant; the brain must discard the continuous changes and extract from the information that reaches us only what is necessary to obtain spendable knowledge.

An excellent example comes from the colour vision: a leaf, for us, remains green whether we observe it at dawn or sunset, at noon, on a cloudy day or in a serene. This happens thanks to a genetically determined brain processing system, which acts on a level, so to speak, primordial. This is the law of constancy. If today we understand the mechanism for colours, not yet fully explained is that for forms. As far as abstraction is concerned, it is the process by which the brain emphasises the general at the expense of the particular, leading to the formation of concepts, from that of a straight line to that of beauty. These are the concepts that artists try to manifest in their works. Examples can come from colours and movement. When the brain determines the colour of a surface, it does it abstractly, without "worrying" about the precise shape of the object; there are specialised visual cortex cells that react only to movement in one direction and not in the other.

Since the creation of a work of art requires motor activity (think of a musician playing or a painter painting), to what extent the fact that we like it or not is related to the movements that make artist during creation? The starting hypothesis calls into question the famous "mirror neurons", those that are activated when a person acts but also when observes the same action performed by another. As if, looking at the "Starry Night" by Van Gogh, we mentally simulated the movements of the arm necessary to trace those broad brushstrokes typical of the painting.

On the occasion of the 2018 World Brain Week, the workshop "The changing mind: neuroscience and education in the Life Project" was held in Catania. The meeting was particularly stimulating given the possibilities the neurological field open to a positive interaction between knowledge of learning processes and refinement of pedagogical methodologies aiming training success. The relationship between these two dimensions of research, the pedagogical and the scientific, moves in the direction of a progressive intensification and interconnection. If scholars have in common the investigation of the brain, its functions and its functioning, the ways of practising it, formulating hypotheses and seeking explanations are often not superimposable. Neuroscientists are interested in understanding the many and varied work processes that the brain puts into play, while educators are strongly oriented to learn more about neuroscience to support or develop their practical work in the classroom. Kandel (2017) underlines how the methodologies

experimented by artists since the 50s, and by contemporary artists, in particular, are singularly similar to some processes of scientific investigation, allowing to combine art and neuroscience according to an innovative and constructive paradigm, aimed at the development of empathic communication and creativity. In this way, neuro-pedagogy can establish a lasting partnership, full of positive and specific effects for each of the areas involved, providing valid instruments of knowledge, with practical repercussions of undoubted validity. We can try to learn from neurons to facilitate teaching, starting from the learning process and creating support networks to compensate for the biological, physical, or socio-cultural deprivations of students. Experiencing new learning models, based on a different way of teaching, is not only possible but even desirable; for example, using abstract art as a means of communicating emotions and models that are more consistent with the learning styles found in everyday teaching practice (according to the well-known model of multifactorial intelligences), fostering the inclusion and autonomy of students in the construction of own life project. It is not only with the intelligence and rationality that one succeeds in learning, considering that, as is well known, but emotions also play an equally important role.

Stefanini (2013) says that the emotions contribute to the successes in learning, to the internalisation of knowledge and meaning, to the improvement of the personal experience of the adult who learns and which transfers and applies in the professional field the results of learning when learning their emotional resources. There is considerable potential for development in the learning process that must be solved through correct environmental stimuli; encouragement and incentives that compensate for the lack of processes that occur spontaneously in common subjects.

Art and, in particular, contemporary art allow us to experiment with a new didactic perspective where it is not the child who has to adapt to the school, but precisely the opposite; that is, the teaching will allow the expressive capacity of the subject to flow freely, without "measuring" it according to standards that do not belong to him.

There is no a priori art, just as there is no student equal to the other. Abstract art, in abandoning the presumed realism, and veering towards conceptual art, realises, so to speak, the true inclusion as it is not based on rigid normed interpretations and formulated by the normals. It is possible to affirm that the creative gesture of a child is not at all different, in substance, from that of an artist and, as Picasso indicates, what they both produce makes sense for what it is (Giordano, 2012, p. 30). We should learn to receive – art and not just the work of art – without expectations.

To those who, in front of a child's drawing, ask us what is it? We should answer remembering the pollock teaching, one should not seek but look passively,

try to receive what a picture has to offer and not have a preconceived subject or expectation. According to a common practice in schools, children's drawings must correspond to something real, otherwise, they are wrong. Thus it is not only the work that is judged but the child. It seems paradoxical, but the same thing happens to many modern artists who, once abandoned the figurative, have to deal with the reactions of the public and critics. Faced with questions about the meaning of their works, two great artists such as Mark Rothko and Adolph Gottlieb refused an interview with *The New York Times*, to explain their works:

> We refuse to defend them not because we cannot. It is an easy matter to explain to the befuddled that "The Rape of Persephone" is a poetic expression of the essence of the myth; the presentation of the concept of seed and its earth with all its brutal implications; the impact of elemental truth. Would you have us present this abstract concept with all its complicated feelings by means of a boy and girl lightly tripping? (Rothko & Gottlieb, 1943)

Our visual perception has nothing objective, but it is linked to factors of pre-knowledge of what we see. In practice, we see what we already know. Neurosciences as much as abstract art arise questions that are central to humanistic thought. In this research, they share, to an astounding extent, some methodologies. Memory is the basis for understanding the world and our sense of personal identity. Kandel (2017, p.11) writes that we are what we are mainly thanks to what we learn and remember. Learning and memory studies show how our brain has developed highly specialised mechanisms to define how we interact with the world, based on the memories we have stored. Similar mechanisms regulate everyone's reaction to a work of art.

> Until the twentieth century, Western art has traditionally represented the world in a three-dimensional perspective, using familiarly recognisable images (Kandel, 2017, p.13).

Abstract art, breaking up the tradition, shows us the world in a decidedly unusual way, exploring the mutual relationship between shapes, spaces and colours.

Kandel (2017, p. 14) places a series of questions regarding questions. Art creates: What realism are we talking about? This would ask Picasso if he could intervene in the debate. What about perspective? Moreover, why not flash the idea of a "hyperrealism" through Cubism in the children's mind? Kandel concludes that reality seen by many points of observation is certainly more "real" than one which presupposes only one.

Even Freinet (1967) states that with the school method, the child gets used to waiting for the orders of others, losing initiative and creativity, not exercising either one's thoughts or initiative. He undergoes and executes what is imposed or suggested, hence the intuition that for a real inclusion, it is necessary to start from the exclusion of any expectation and free oneself from any pre-packaged judgment.

In the presence of cognitive impairment, abstract art can help the child to express his emotions much more than the use of figurative forms of expression that do not belong to him. A shaky and stunted sign, if it is not functional to outline reality according to the usual models, can adequately express the inner world of the child, for example, focusing attention on the use of colour and free forms. The design of the child with a deficit, using abstractionism, will no longer stand out in comparison to the production of the class, but will become a voice in the choir.

More generally, the enhancement in the teaching of the study of contemporary art, the attention to space and colour, the use of the concept rather than the model to be reproduced, allow each student to come into contact with the most profound and emotional part of oneself, without feeling judged by the obsession of the faithful reproduction of reality. Similar to scientific reductionism, which seeks to explain a complex phenomenon by examining its components at a more elementary level, the mechanism of reduction, from the Latin word *reducere*, leads us to explain how with a few brush strokes it is possible to create a portrait of a person much more significant than the original or as a particular combination of colours can evoke feelings of anxiety or exaltation or serenity. Once again, art and science follow similar methodologies.

Reducing the figurative aspect to a few essential traits allows us to concentrate on the essential components of the work, or colour or form, on light rather than on the play of lines. According to Kandel (2017, p. 14), an isolated component stimulates certain aspects of our imagination so that a complex image is not able to do.

The path that links art and science begins at the end of the Belle Epoque, amid the glare of the Great War that upset Europe. From the end of the nineteenth century, they proceed in symbiosis up to Futurism, investigating the human psyche and the moral crisis of society distressed by the prevailing modernity.

We are witnessing a constant dialogue where Art is committed to representing the complexity of the human soul and Science is intent on plumbing the variability of the psyche, on the wave of positivist physiognomy and of Freud's studies. The psychological portrait is born, paradoxical as that of Giovanni Segantini where man is inserted in a paradoxical or fantastic reality, as in the *Fumeria d'oppio* by Gaetano Previati, centred on the metaphor of the soul twirling through the dream world (Lucarelli, 2018). The study of psychology increased the attention to those news events related to unbridled passions or mental imbalances, as in the canvas *Asphyxia* by Angelo Morbelli (1884), which describes the suicide of two lovers. The psychological suffering also characterises a painful remembrance of Giuseppe Pellizza da Volpedo, linked to the memory of his deceased wife and son. Similarly to Edvard Munch (1886) who paints the portrait of his sister, *The Sick Child*, remaining halfway between

Expressionism and Symbolism. In Italy, art is anchored to the representation of social transformations, with Balla, Carrà and Boccioni who return, through the plastic forms of Futurism, the whirling dynamism of the new industrial society. Only after the Second World War, many artists began to wonder what sense art could have after so much horror. What language could correctly describe what the world had become?

In the United States, a group of artists felt the urgency of developing a new art that was unequivocally different from the previous one. The neuralgic centre of artistic creation moves from Paris to New York, from old Europe, set on fire to the new world, giving rise to abstract Expressionism.

According to Kendal, In the transition from figurative art to abstract art, the painters of the New York School – in particular, Willem de Kooning, Jackson Pollock and Mark Rothko, and their colleague Morris Louis were adopting a reductionist approach to art (Kandel, 2017).

The canvas becomes an arena on which to act, what hosts is not a painting but an event, it does not count the technique but the gestural abstraction. The painters of the New York School will influence the new generations of artists, from Andy Warhol to the whole of Pop Art, up to contemporary art.

Modern abstract art was animated by two important innovations; the liberation from the form and of colour. If the cubists, led by Braque and Picasso, had freed the form and broke with the perspective representation, modern art represents the state of mind, the emotions, the inner and subjective vision of the artist that may not coincide with the objective or presumed reality. The naturalistic illusion and the dominance of technique, in favour of individual and free expression, decay. Henri Matisse then clears up the concept of realistic colour, freeing it from the form. He shows how combinations of colours and shapes can arouse deep emotions in the spectator. There are no wrong colours but alternative visions of reality. It is the triumph of expressive freedom. Never in the history of art, artists and users have been freer to make and feel the art according to their own expressive channels, without previous conditioning suggested by current interpretations.

This approach to art as an instrument of expressive liberation is, in my opinion, a very powerful tool for inclusion in particular didactical development, with considerable repercussions in the field of motivation and individual self-esteem. According to Eric Kandel, to exploit the adaptive mechanisms of the brain, from the perception of colour, since our brain processes different colours as endowed with distinct emotional characteristics, but our reaction to colours varies according to the context in which we see them and our mood. Furthermore, says he the same colour can mean different things for different people and for the same person in different contexts, to the perception of light and space, to access new and unpaved roads

of personal expression, channelling emotions and creativity without limits and conditioning (Kandel, 2017, p.160). Numerous studies have been conducted over the years on the subject of learning by Nobel laureate Eric Kandel, who investigated the interesting theme of the relationship between Art and Neuroscience, demonstrating changes in the structure and biochemistry of synapses.

Further details on the origin of neural plasticity are due to the contribution of Rita Levi Montalcini (neurotrophic theory) and Mark S. Cohen (Shermer, 2015) who have shown that this plasticity is due to the particular presence of a protein on neurons called growth or Neurotrophins.

At the time of birth, the individual is already endowed with a large number of neurons but with an immature brain, which still must be constructed through the social environment and the culture of belonging. These changes take place in so-called critical periods, in which the nervous system is subjected to specific experiences in order to learn how to adapt. However, it is not just the brain that changes. With the advent of the modern era, there is even talk of epigenetics and DNA modification due to the environment.

Among the factors that influence the growth of a personality, the environment occupies a prominent position; the relationship between these different factors is one of the most complicated problems that psychology, sociology and cultural anthropology have faced. It is merely a question of adapting a person to the society in which he or she has to live (thus justifying the perspective of a certain social and cultural relativism) or instead, creating an area of freedom and humanisation in which each grows towards maturity in the dialectical relationship between self and the environment? Family, school, peer groups, associations of entertainment, culture and global society are commonly referred to as the most influential agents of sharing and transmitting values. Is this process present only during the developmental age, or does it develop continuously? And, furthermore, are there any possibilities for re-socialisation for individuals already trained in a particular culture?

According to Fichter, socialisation is the process by which society transmits its culture from one generation to the next and adapts the individual to the accepted and approved models of organised social life. The function of socialisation is to develop the attitudes and disciplines that the individual needs, to communicate the aspirations, the systems of values, the ideals of life (Fichter, 1963, p.35). The influence of the school, apart from the quality of the contents transmitted, is remarkable in this age because it catalyses the possibilities of formation of ideology, above all through some particularly formative disciplines such as the study of art. The influence is also linked to the personality of the teachers, often "winning" in comparison with other adult figures. The school also enjoys the advantage

of more extended contact, a gradual influence, a real group experience.

The relationship between biological inheritance, psychic heritage and cultural heritage is configured as a process of interaction, in which the different factors influence each other. There are no purely biological, psychic or social human conduct; but from the first experience, every human being conduct is the result of biological, psychic and social elements mutual conditioning. Referring to another context the study of the schools of deterministic and relational conception, it is clear that all this involves all the figures that revolve around the scholastic formation and specifically the future support teachers, because of the massive and decisive contribution that they can give to the development and personal growth of all students.

BIBLIOGRAPHICAL REFERENCES

Fichter J. H. (1963). *Sociologia fondamentale*. Pompei, Italia: Onarmo.

Freinet C. (1967). *Le mie tecniche*. Firenze, Italia: La Nuova Italia.

Giordano S. (2012). *Disimparare l'arte*. Bologna, Italia: Il Mulino.

Lavazza, A. (2003, December 11). *Neuroestetica: Intervista al neurobiologo Semir Zeki)*. Retrieved from https://www.carmillaonline.com/2003/12/11/neuroestetica/

Matisse H. (1943). *Mais soudain le soleil n° 1*. Retrieved from http://www.williamweston.co.uk/item/exhibition/154/6

Stefanini A. (2013). Le emozioni: Patrimonio della persona e risorsa per la formazione. Milano, Italia: FrancoAngeli.

Kandel, E. (2016). Reductionism in Art and Brain Science: Bridging the Two Cultures. New York, NY: Columbia University Press.

Kandel E. (2017). *Arte e Neuroscienza*. Roma, Italia: Raffaello Cortina.

Rothko, Mark, Gottlieb, Adolph. (1943). "A Letter from Mark Rothko and Adolph Gottlieb to the Art Editor of the New York Times". Retrieved from: https://fedartnyc.tumblr.com/post/82412858602/a-letter-from-mark-rothko-and-adolph-gottlieb-to.

Shermer M. (2015). Homo credens: Perché il cervello ci fa coltivare e diffondere idee improbabili, Roma, Italia: Nessun Dogma.

Zeki S. (2007). *La visione dall'interno*, Torino, Italia: Bollati Boringhieri.

The creativity of artistic appropriation and the copyright

Gizela Horváth

Department of Arts, Partium Christian University, Oradea, Romania
ORCID: 0000-0002-7254-3704

ABSTRACT: The purpose of copyright and authors' rights as an institution is to stimulate artistic creativity. The idea of copyright is a product of modernity, and it is connected to a view on authorship standing at the base of the modern paradigm of art. This paradigm enables the creative genius to question the very foundation of the paradigm: the requirement of originality. Appropriation artists were the ones who went farthest in this direction. They appropriated, "copied" and "repeated" the works of other artists or transformed the objects of popular culture into artistic products. The practice of appropriation is problematic in visual arts from the perspective of copyright and authors' rights. Does the appropriation artist "copy" legitimately or illegitimately? How can this question be handled in such a manner as not to violate the rights of the original artists, while also not limiting the artistic technique of appropriation, one of the most interesting areas of contemporary art? In my view, the framework of European authors' rights is more appropriate for deciding on this issue than the American copyright system. The first point to be decided is whether the contested visual work is a creative or a non-creative appropriation. If it is creative – conveying a new message and centred on different issues than the appropriated work –, then it is not a copy, but a new artwork and the accusation of copyright violation is unfounded.

Keywords: artistic appropriation, copyright, authors' rights, creativity, originality

1 THE COPYRIGHT AND AUTHORS' RIGHTS, AS AN INCENTIVE OF CREATIVITY

Along with the emergence of the function of authorship, modern western societies saw the tendency for the rights of the authors over their works to be regulated. The regulation on copyright has been developed in the American legal system, while the conception of authors' rights is more characteristic for the European states (although it is designated with the same term, 'copyright', in English). Copyright regulation is a case of intellectual property law, which also includes patents, trademarks and trade secrets. However, copyright also differs from regulation on other areas of intellectual property (Chopra, 2018), because "copyright and related rights differ from industrial property rights" (Horvath, 1999, p. 93).

'Copyright' concentrates on the activity that can only be undertaken/allowed by the author (the making of copies of the work), while 'authors' rights' are based on the authors' person. The conception of copyright has a more pecuniary character and relates to property rights, while the author's rights are of a rather moral nature and property rights come under protection in compliance with these.

Although the difference between copyright and authors' rights will play an important role in this text,

for now, I will employ the term 'copyright' when referring to both of these conceptions.

Copyright protects books, music, statues, films and software, that are embodied in a tangible medium. Hence, the copyright does not protect the idea, just its expression. The intention behind copyright regulation is to encourage the production of creative works. At the same time, the duration of the copyright is determined, so that future artists may use previous works freely as their material

European intellectual property rights are concerned with two essential aspects. On the one hand, they protect the financial interests of the author, and on the other hand, his or her so-called 'moral rights', i.e. the right to be recognised as the author of the creative work. While the US law focuses on the work and the author's financial interests, here it is the moral aspect that is important (Hick, 2017).

The issue of originality is essential from the perspective of copyright: it is the originality of the artistic creation that ensures its status as a work of art and its protection (Roş, 2016, p. 204)[1]. At the same time, it is also one of the most challenging issues, both from a theoretical perspective and in legal practice. There

1. All translations from non-English sources are the author's free translations.

is also an important difference between the American and the European perception of originality. In the copyright system, originality is interpreted, first of all, as an absence of copying, i.e. "the work has to originate from the author and cannot be copied from another source" (Roş, 2016, p. 207), while in the system of authors' rights, originality refers to the personal character of the author; hence,

> the original work is one in which the author has expressed, to a greater or lesser extent, in a more or less elevated and sensitive manner, his or her personality. (Roş, 2016, p. 208).

Novelty is not essential in the European conception, which does not require the work to be completely unprecedented, but concentrates rather on the traces of the author's personality left on the work. In this approach,

> it is not only the ex nihilo created work that is original, but also the one created through the contemplation of a pre-existing work of art; the copy of a painting or sculpture, created by the pupil in the master's workshop will be original because the copyist's personality did not fully disappear during the creation of the copy. (Colombet, 1999, p. 27)

It seems that the two different copyright regulations are based on different values: on the one hand, on financial fairness, according to which the creation is regarded as the property of its author, ensuring the owner's right to dispose of the work and to receive equitable remuneration for it; on the other hand, on the recognition of the creative author and on promoting creative (artistic) work (in European law).

At the same time, we must not lose sight of the fact works of art are non-competitive commodities, whose value is precisely in their sharing: literary and musical productions, the works of fine art etc. may become more valuable for society through their widening accessibility. It is a characteristic of cultural production to develop and renew itself in dialogue with other cultural goods. Hence, the broadest possible presentation of cultural results is a social interest.

Some copyright violations are entirely manifest and clear: if someone wants to sell a work without being its author or owner or to sell copies of it without the consent of the owner, or if someone incorporates parts of someone else's works without reference to the original author etc., he or she evidently violates the owners' copyright. However, recent developments in artistic practice and theory render the current copyright regulation unusable, if artistic creativity is to be preserved. This is the case with the so-called 'appropriation arts' and with artistic techniques considered by Nicolas Bourriaud of essential importance for current art. In his *Postproduction*, dedicated to new artistic techniques, he notes that

> [s]ince the early nineties, an ever increasing number of artworks have been created on the basis of

preexisting works; more and more artists interpret, reproduce, re-exhibit, or use works made by others or available cultural products", and "[n]otions of originality (being at the origin of) and even of creation (making something from nothing) are slowly blurred in this new cultural landscape marked by the twin figures of the DJ and the programmer, both of whom have the task of selecting cultural objects and inserting them into new contexts. (Bourriaud, 2005, p. 13)

In the following, I will present some cases in which new artistic strategies have clashed with copyright law, concluding with some proposals for using copyright to be more consistent with contemporary artistic practice.

2 LEGITIMATE AND ILLEGITIMATE APPROPRIATION IN ART

Most copyright violations are cases of illegitimate appropriation, the appropriation of someone else's work, the stealing of his or her music, the forging of his or her paintings, or the plagiarism of his or her writings. Prima facie, the 'appropriation' of a work violates "the right to make adaptations and arrangements of the work" and "the right to make reproductions in any manner or form", provided for in the Berne convention, as well as the moral right

> to object to any mutilation, deformation or other modification of, or other derogatory action in relation to, the work that would be prejudicial to the author's honor or reputation. (WIPO, 1979, p. 7 art. 6)

There is, however, an extreme case, when the appropriation is an artistic technique and an accepted strategy in the artworld.

In the case of 'appropriation art', the artist creates his or her work by using another artwork or cultural product. The paradigmatic example is Sherrie Levine's, who re-photographed her predecessors' photographs and exhibited them without changes in her *After Walker Evans*. Although seemingly indistinguishable, Levine's photographs are about something entirely different than Evans'. These pictures are "ontologically distinct but perceptually indiscernible counterparts" (A. C. Danto, 1981, p. 60). Walker Evans has photographed the people suffering during the Great Depression, as well as their houses and churches, documenting the life of a less visible segment of the American population. Levine's work is not at all about the America of the Great Depression. Her work is conceptual, and as such, asks questions. Who is an author? What does creation mean? Is the requirement of originality still relevant today? What does originality even mean? The Estate of Walker Evans has accused Levine of copyright infringement, and she subsequently donated her photographs to the Estate.

Her case is one in which, from a legal point of view, an artistically innovative and valuable approach has infringed the copyright.

In the context of the American legal practice, it is difficult to protect an artwork largely built upon a previous creation. The only exception recognised by American copyright is a parody. However, not all appropriative artworks are parodic. Sherrie Levine's After Walker Evans is not. At the same time, American legislation accepts cases of 'fair use', in which the court has to assess criteria such as

the purpose and character of the use, including whether such use is of a commercial nature or is for nonprofit educational purposes; the nature of the copyrighted work; the amount and substantiality of the portion used in relation to the copyrighted work as a whole; and the effect of the use upon the potential market for or value of the copyrighted work. (Larson, 2018)

Nevertheless, protection based 'fair use' is also not always a possibility for appropriation artists. Evidently, the original creator wants to sell his or her work, and the appropriated work often falls in the same ontological category as the original. Furthermore, artists often appropriate the entire work. The last point is the only one in which the appropriation artist is perhaps innocent: his or her work is not likely to influence the market and the price of the original work.

Levine was not the only appropriation artist who had to confront legal claims. The most famous legal cases involved appropriation artists Jeff Koons and Richard Prince, whose copyright trial over his *New Portraits* is still going on (Freeman, 2018).

Courts can have a tough time when having to decide if an appropriative artwork is a legitimate or illegitimate copy. One may think that anything that is a copy is illegitimate. It may even seem illegitimate if the author's name is displayed if the appropriation artist does not have any explicit authorisation. In order to facilitate clarity, I will propose in the following a categorisation of appropriation artworks from the perspective of the appropriated work's authorship:

1. The appropriated object/artwork does not have an author. In this case, the starting point is an everyday object that is not artwork and does not have an 'author' as such. Thus, there is also no copyright on it. This is the case of Marcel Duchamp's most readymades.

2. The author of the appropriated object/artwork is not known. Appropriation artists often start from creations of popular culture, whose authors cannot be identified, e.g. photographs, advertisements, postcards and various genres in which there are no recognised authors. Hungarian embroidered wall carpets with their inspirational texts are an interesting example, as they often become satirical gestures when in the hands of the artists. The appropriation gesture of Eszter Ágnes Szabó is similar to what Roy Lichtenstein has done with the visual language of comics. Her first wall carpet presents a fictional event labelled: "My grandma, Mrs Imre Zalai meeting David Bowie". Here, the characteristic style elements (such as the needlework, the lettering, the simplified and naive tracing, the roomy composition) do not illustrate general wisdom, as traditional wall carpets usually do, but present a quite personal, funny as well as unreal event. The wall carpet was first exhibited in 1998. In 2000, its reproduction was uploaded to the internet without crediting the author and inspired one of the most popular meme types of Hungarian online culture. The original author was delighted by this turn of events:

From then on, it could no longer be tied to me personally, it acquired a life of its own. What more could you desire for a pop work? It appeared throughout the country in places such as the wall of a copy shop or on the menu of a pizza parlour. (Szabó, 2016, May 27).

She had, of course, no intention whatsoever to sue the meme creatives. The original artwork was bought by a collector and is currently exhibited in museums – while everyone else has appropriated in on the internet.

3. The appropriated object is an artwork whose author is no longer among the living and/or the copyright no longer applies. Authors' rights – except moral rights – are time-limited; although the limit may vary. Although author's rights are accorded primarily to the original artist – and the dead author can longer enjoy them –, their financial implications may his or her heirs, and the author's financial rights can also be transferred, e.g. to publishing companies.

4. The author of the appropriated work is a living, and an identifiable person or the artwork is still under copyright, even if the artist is not necessarily the owner of the copyright. This case is the most interesting one from the perspective of copyright and has several subcategories:

4.1. The author is a living, known and recognised artist, whose work is appropriated by a colleague. This is the category of the most emblematic appropriation artists, such as the already mentioned Sherrie Levine or the 'repetition artist', Elaine Sturtevant, who began to copy (usually from memory) her contemporaries at the end of the Sixties, creating copies ('repetitions') seemingly identical to the originals, despite some minor differences. The artists chosen by her are all recognised today as key figures of art history, including Roy Lichtenstein, Andy Warhol, Claes Oldenburg, Jaspers Johns. In most cases, Sturtevant began to copy them a short time after they first appeared on the scene. The reactions of her contemporaries were quite different. Warhol lent her the silk-screens of his prints for the *Flowers* series, while Oldenburg did not appreciate it when, in 1967, she recreated his *The Store* only a couple of blocks away from the original location. Although initially supporting the idea, he later stated that his work was "ripped off" (Downey, 2012 p. 100). Since

Sturtevant concentrated on the artists of the Castelli gallery, her attitude "met with ostracism from the art establishment" (Phelan, 2015).

Although rejected by many as a simple bluff or hoax, Sturtevant's work (encompassing many decades of consistent work and based a coherent concept) was accepted by the artworld and there is now a consensus that Sturtevant's work is "an engagement with issues such as authenticity, originality and the conceptualization of singularity" (Downey, 2012, p. 101). In 2004, art critic Anthony Downey has visited an exhibition containing 140 items, created throughout four decades by Elaine Sturtevant, arriving at the conclusion that "[t]he brutal truth in question was simple: these are not copies but original works by Elaine Sturtevant" (Downey, 2012, p. 106).

Sturtevant did not have to face any copyright lawsuits, but the initially unfavourable reaction from the artworld and the negative attitude of the Castelli gallery that initially represented the appropriated artists once forced her into a ten-year voluntary retirement (although her departure to Paris may also be interpreted as a repetition of Duchamp, who left for the French capital after his artistic plans did not enjoy the success he expected in the US). In 2015, one year after her passing away, Richard Phelan still stated that "Sturtevant's work has not been institutionalised in the USA" (Phelan, 2015); for instance, she has no works in the MoMA.

Living contemporary artists who are recognised usually do not sue their colleagues for copyright infringement. Yasumasa Morimura's works consist of substituting iconic portraits with his own face. He has most likely appropriated protected paintings as well – Frida Kahlo passed away only in 1954, so her works are still protected by copyright, and Cindy Sherman is still alive. Nevertheless, to our knowledge, there have never been any copyright infringement trials against Morimura.

4.2. The author of the work that is later appropriated did not produce the object as a work of art, but the appropriation artist creates an artwork of it. Andy Warhol's *Brillo Boxes* adopt the design of the soapbox created by a lesser-known abstract expressionist painter, James Harvey. A publicity shot by Kodak inspired his *Flowers*. Patricia Caulfield, the executive editor of the Modern Photography Magazine, originally shot the picture that he copied and cut out. Then, he increased the contrast and enclosed it in a square shape, to be visible from any direction. Patricia Caulfield sued Andy Warhol, and an out-of-court settlement was reached. Jeff Koons appropriates everyday objects, such as balloons, toys and photos. In 1988, his *Banalities* series brought him several million dollars in revenue, but also as many as five lawsuits, of which he lost three, one is ongoing, and one ended with an out-of-court settlement (Meiselman, 2017). The first lawsuit against him was filed in 1989 for his *String of Puppies*, a sculpture based

on a photograph by Art Rogers, who won the case. For his 2014 series *New Portraits*, Richard Prince has taken photos from Instagram. He blew them up but otherwise left them unchanged, in their entire original Instagram-environment, complete with the site logo, the original author's nickname, likes and comments – the last comment being his own. The original author of an appropriated image, Donald Graham has sent him a cease-and-desist, leading to a trial in 2017, in which U.S. District Judge Sidney H. Stein ruled against Prince's fair use defence ("Graham versus Prince," 2017). However, the trial is still in progress at the time of this writing (December 2018).

3 COPYRIGHT AND MATERIAL ADVANTAGES

The first three categories of the above list usually do not raise any issues of copyright. The most controversial cases are connected to the fourth category (especially 4.2). The artworld has generally accepted appropriation. There are hardly any cases in which well-known artists, whose work was appropriated, pressed charges. Typically, the legal cases involved non-artistic appropriated works, for which the author's remuneration was lacking or minimal, while the art market valued more highly the work created via appropriation. Art Rogers was paid 200 dollars for the photograph used by Museum Graphics on the notecards, while Jeff Koons' statue was valued at 100.000 dollars. The customer hardly paid several million dollars for the original design of the Brillo box, while Warhol's boxes have actually reached this price. It seems that the issue here is not primarily the moral, but financial. It is not about Warhol acknowledging his inspiration in Caulfield's work, but about Caulfield receiving a financial share. This is also why it is possible to settle these conflicts outside the court. Andy Warhol was sued three times (by Patricia Caulfield, Fred Ward and Charles Moore) an out-of-court settlement was reached on each occasion.

Jeff Koons was sued in 1989 for String of Puppies, based on Rogers' photograph, and the court decided against him, with his severe condemnation by the judge for "piracy of a less-known artist's work" (Ames, 1993, p. 1474). This was the first court decision in a case involving artistic appropriation.

Kenly E. Ames, who has studied the case Rogers versus Koons, held that

> art created from existing imagery is a valid form of criticism and comment that should be protected by copyright law against a suit for infringement. (Ames 1993, p. 1475)

The real stake of appropriation art is, in fact, social criticism. Through the decontextualization of popular cultural objects, art makes us aware of how these

objects (advertisements, photographs, china figures, toys, comic books etc.) present us our world and how they influence the worldview in the age of the pictorial turn. Banning appropriation renders this form of social criticism impossible.

4 COPYRIGHT AND CREATIVITY

The stated objective of copyright is to stimulate creativity – although appropriation art may be limited by accusations of copyright infringement and by the legal proceedings against the artists. The accusation of infringement is based on the presupposition that the defendant copied the work presented as their own, i.e. the artwork is not his or her creative product. If we were to implement this perspective rigidly, then we would have to ban the entire genre of appropriation art, since all appropriation artworks "copy" someone else's work.

It seems that, if we apply the perspective of European authors' rights instead, then we can deal with appropriation art more equitably from a legal perspective as well. So, if the issue is approached from the perspective of authors' rights, then what we have to decide is whether the creator's personality is incorporated into the artwork. Is the work the result of his or her creative activity or a mere copy? Copies are entirely or partially physically identical with the copied work. From the second half of the 20th century, it sometimes happens in the visual arts that two perceptually indistinguishable objects belong to distinct ontological realms: one is an everyday object and the other an artwork (A. C. Danto, 1981). The difference between them cannot be seen, since

> [t]o see something as art requires something the eye cannot decry – an atmosphere of artistic theory, a knowledge of the history of art: an artworld. (A. Danto, 1964, p. 580)

Thus, in order to establish whether we are merely dealing with illegitimate appropriation or an appropriation artwork, we sometimes might need more than meets our eyes.

In order to establish that Elaine Sturtevant did not break the law when copying Lichtenstein, we have to know about her motivation and artistic project, centred on questioning authorship and originality, as well as on the revaluation of repetition. Is Sturtevant's process creative? It undeniably is. No one before her constructed their oeuvre choosing contemporary artists with excellent taste and repeating their works from memory almost identically. Her creativity consisted precisely in refusing the interpretation of creativity that reduced to *creatio ex nihilo*.

The court which ruled against Jeff Koons failed to notice that "the transfiguration of the commonplace" (A. Danto) happened here as well. The postcard belongs to a different ontological category than Koons'

statue. Creativity is manifested here in the fact that Koons chooses from the everyday objects of popular culture those that reflect best the tastes of our age, magnifies and recreates them out of wood, porcelain or precious steel, in order to render the infantile cult of vanities even more visible. In the case of the *String of Puppies*, the difference is even visible: while Rogers immortalized a carefree family moment with the couple's favourite pets, Koons repeats the photograph in such a manner as to turn it into a grotesque scene with an incredible amount of blue dogs, the stupid grin fixed on the couple's faces, the daisies in their hair, their feet blending into the pedestal etc. While it is true that Koons' work would not have been possible without Rogers', this does not mean that Koons 'copied' (has 'stolen from' or 'pirated') Rogers. The latter's work is not a work of art and not worth several hundred thousand dollars because Rogers did not see in it the opportunity that Koons did, creatively transforming the family (and animal) idyll.

Should and can we consider the value of a work, if the issue of copyright is raised? According to a seemingly reasonable opinion, "the law has no competence in deciding whether a work is valuable or not, to distinguish between art and pseudo-art", in order to avoid arbitrary decisions (Roş, 2016, p. 198). This restriction cannot be upheld in the case of authors' rights, where it has to be decided about the object that is to be protected, whether it is an artwork. Does it carry any artistic value or not? As the previously quoted author, Viorel Ros, remarks a few pages later

> in order to speak about a 'work' that can be protected, it has to have some artistic value. Otherwise, it is not a work at all! Moreover, if it is not a work, then it also cannot be protected! (Roş, 2016, p. 204)

If copyright lawsuits do not recognise the forms of creativity used in appropriation art, then instead of motivating creative productions, they limit one of the most important contemporary forms of artistic creativity.

5 PROPOSAL

In my view, the issue of appropriation art can be much better handled from the European perspective on authors' rights than from that of the American copyright. The question is not whether the work is preceded by another, without which it could not have been produced. Neither is it an issue of the extent of its correspondence with the previous work. The issue is whether the creators' personality can be detected in the artwork. If the meaning, the message or the question raised by the later work is new, then it has to be regarded as a new artwork even if it can hardly be visually distinguished from a previous product.

If we are dealing with appropriation artwork, then it cannot be asserted that it is an adaptation or

"arrangement" – it is, quite simply, another, new artwork, with a message of its own, for which the appropriated work is merely a pretext, a stimulus or perhaps a building block. At the same time, the original author's moral rights are also not infringed upon, because the appropriating artist does not "mutilate, distort or modify" his or her work: while the appropriated work remains unchanged and the appropriation creates another, new artwork in addition to it. It could be considered, perhaps, whether appropriation represents a process "that would be prejudicial to the author's honour or reputation" (WIPO, 1979, p. 7 art. 6). Rogers may have justifiably felt Koons' interpretation parodistic. However, criticism, parody and commentary are precisely those cases in which the 'fair use' of artworks is granted.

The basis of copyright regulation is the conception according to which the work has to be original and unprecedented – a requirement that cannot be regarded as absolute in our contemporary world, as we are cultural nomads who use what they find (Bourriaud, 2005). Thus, the legal environment also has to adapt itself to this new context of participatory culture. The requirement of originality is substituted with the demand for creativity: the new product must not necessarily be unprecedented – it is sufficient for it to produce new perspectives, questions and approaches.

The essence of my proposal is, hence, that the first question to be decided upon in matters of copyright is whether the work is a creative appropriation or not. If it is the latter, then the purpose of the appropriation is to enjoy the merits of another artist without any effort of its own. In this case, the appropriation is illegitimate.

If the appropriation is creative – carrying a new message and dealing with new issues than the appropriated work –, then what we have is not a 'copy', but a new artwork, and the accusation of copyright infringement is unfounded. So, if we approach the matter in this way, then the application of the copyright may also fulfil its original function: it will not limit, but rather motivate the emergence of new creative works.

However, in order to prove this creative character, the appropriation artist has to state the goal and objective of his or her work. By this statement, if the work is placed into an art historical context, it can be decided whether it carries any new message and ideas, as compared to existing works. The appropriation artwork is not an adaptation and a usage of the existing – but a new work of art.

BIBLIOGRAPHICAL REFERENCES

Ames, E. K. (1993). Beyond Rogers v. Koons: A Fair Use Standard for Appropriation. *Columbia Law Review,* 93 (6), 1473-1526. doi:10.2307/1123081.

Bourriaud, N. (2005). *Postproduction: culture as screenplay?; how art reprograms the world* (Translated from the French by Jeanine Herman.). New York: Sternberg Press.

Chopra, S. (2018, November 12). The idea of intellectual property is nonsensical and pernicious. *aeon* https://aeon.co/essays/the-idea-of-intellectual-property-is-nonsensical-and-pernicious. (Retrieved December 8, 2018).

Colombet, C. (1999). *Propriété littéraire et artistique et droits voisins* (9. éd ed. Vol. Dalloz): Paris.

Danto, Arthur C. (1981). *The transfiguration of the commonplace: a philosophy of art.* Cambridge, Mass: Harvard Univ. Press.

Downey, Anthony. (2012). Authenticity, Originality and Conceptual Art: Will the Real Elaine Sturtevant Please Stand Up? In *Art and Authenticity* (pp. 100-106). London: Lund Humphries.

Freeman, Nilekaw pseud. (2018, October 11). Richard Prince Mounts Defense in Appropriation Lawsuit Over Instagram Portraits. Retrieved from https://www.artsy.net/news/artsy-editorial-richard-prince-fighting-appropriation-accusations-leveled-lawsuit-instagram-portraits. (Retrieved December 27, 201).

Hick, D. H. (2017). Artistic license: the philosophical problems of copyright and appropriation. Chicago: The University of Chicago Press.

Horvath, A. (1999). Două erori judiciare în interpretarea actelor normative referitoare la impunerea redevenţelor persoanelor nerezidente anterior Ordonanţei Guvernului nr. 47/1997. *Revista de Drept Comercial, IX* (3), 90-94.

Larson, A. (2018). Fair Use Doctrine and Copyright Law. *ExpertLaw* https:// www.expertlaw.com/library/intellectual_property/fair_use.html. (Retrieved January 2, 2019).

Meiselman, J. (2017, August 14). How Jeff Koons, 8 Puppies, and a Lawsuit Changed Artists' Right to Copy. Retrieved from https:// www.artsy.net/article/artsy-editorial-jeff-koons-8-puppies-lawsuit-changed-artists-copy. (Retrieved December 22, 2018).

Phelan, Richard. (2015). The Counter Feats of Elaine Sturtevant (1924-2014). *E-Rea. Revue Électronique d'études Sur Le Monde Anglophone, 13*(1) http://journals.openedition.org/erea/4567.

Roş, V. (2016). *Dreptul proprietăţii intelectuale* (Vol. Vol. 1). Bucureşti: C.H. Beck.

Szabó Eszter Ágnes. (2016, May 27). Ki kell mosni és vasalni kell? – Szabó Eszter Ágnes Zalai Imrénéről és az eredeti falvédőről. Retrieved from http://ludwigmuseum.blog.hu/2016/05/27/szea_778. (Retrieved December 10, 2018).

United States District Court Southern District of New York. (2017). Graham versus Prince. Retrieved from https://copyrightalliance.org/wp-content/uploads/2018/02/Graham-v-Prince.pdf.

WIPO. (1979). Berne Convention for the Protection of Literary and Artistic Works (as amended on September 28, 1979) (Authentic text). Retrieved from https://wipolex.wipo.int/en/text/283693. (Retrieved January 2019).

Creativity through destruction in the genesis of artist's books

António Canau

Department of Drawing, Geometry and Computation, Lisbon School of Architecture,
Universidade de Lisboa, Lisbon, Portugal
ORCID: 0000 0002 5944 8905

ABSTRACT: The artist's book has, throughout its history, has employed many formal and conceptual approaches. Its relationship with the universe of plastic and visual art is somewhat structuring, reflecting the heterogeneity and the dilution of barriers of the same nowadays and thus presenting a multitude of formal, conceptual solutions and an encompassing use of materials in its execution. The artist's book, as an object, constitutes one of the most commonly used means of expression in this type of artistic expression. Within this scope, the artist's book as an object resulting from the destruction of existing books, constitutes one of the more extreme approaches, raising the question of ethics in a proximity with some Dadaistic attitudes. This extreme artistic methodology puts creativity at a threshold, requiring the destruction to physically reformulate the existing objects, in this specific case, books. This extreme artistic approach, at its multiple levels of destruction of existing books, the inherent question of ethics in this process, and the consequent formal solutions arising from it, are the objectives/aims of this chapter, which results from my role as researcher, benefitting from my experience, my training in the area of artist's books at the Slade School, in the fact that I create artist's books and that I lecture this subject at university.

Keywords: Creativity, destruction, books, ethics, artist's books

1 INTRODUCTION

The book has always been a source of inspiration to artists, but also in its formal component as object, has been owned/used, being part of the formal vocabulary of some artists, namely Anselm Kiefer, who has regularly incorporated it in his sculptures, installations and paintings as is the case in the series; Book with wings, 1992-1994 and Zweistromland ['Land of Two Rivers'] (1986–89).

The artist's book, as an object, constitutes currently one of the most commonly used forms in this type of artistic expression.

When we refer to the book as an object book, we should nevertheless be more specific as in reality every book by its physical and formal nature is an object. Having said this, book object is not the most adequate form to designate the formal solutions that are found within the scope/range of the artist's books nowadays. The books in which the formal/sculptural component is the dominant component place emphasis on their physical and formal nature, formally and conceptually extrapolating the common layout/form of the book.

In these more assumedly volumetric/sculptural approaches, form, function, matter, handling and therefore reading of the object, deviate completely from the canons that normalise the form, matter and handling and reading of the conventional book.

The narrative underlying the conceptual component of these objects and consequent readings that may arise from their visualisation and manipulation are intrinsically linked to the formal and material solutions used in their creation.

2 THE ARTIST'S BOOK RESULTING FROM THE CREATION OF THREE-DIMENSIONAL/ SCULPTURAL SOLUTIONS

One of the main possible examples:

Anthony Caro *OPEN SECRET* of 2004, edited by Ivorypress is a reference for this type of approach. Made in sets of four materials: stainless steel, grey card, bronze, brass, and an artist proof of each one.

This is a great example, both for its quality and refinement, that which defines an artist's book, a work of art conceptually based on the concept of book, to which its author applies his/her creativity, being responsible integrally for the conception and design of the piece, these two aspects being the *indispensable* condition for it to be considered an artist's book.

We have thus, authorship and creativity in the conceptual and formal solution on the part of the artist and teamwork in its execution, for if the authorship has to be entirely of the artist's responsibility, the execution can be shared, that is we have gathered the elements

that as a general rule constitute the ingredients in creating an artist's book.

In this specific case, the artist's creativity and consequent formal solution resulting from it place this artist's book into the category of the books mentioned above, in which the three-dimensional/sculptural solution is preponderant.

3 THE CREATION IN ART BY BREAKING WITH THE FORMAL AESTHETIC SOLUTIONS IN EXISTENCE PRESENTS ITSELF AT VARIOUS DEGREES OF PROVOCATION AND PHYSICAL DESTRUCTION

Within the scope of artist's books resulting from a preponderant three-dimensional/sculptural solution, the artist's book as an object resulting from the destruction of existing books in some of the more extreme approaches, raising questions of ethics and creativity at an extreme level.

The book is dissemination of knowledge and culture on which the evolution of humanity has depended and continues to depend. It is, therefore, an object of reverence and protection. In extreme situations in the history of humanity, its accidental or purposeful destruction constituted a regression in our civilizational culture. For all these reasons its destruction is TABOO.

However, there are always exceptions. In fact, it is the exception that confirms the rule.

In effect, underlying the creative act, it is always implied that one has to break with the conventions and rules in force, that is, so as to construct something new/innovative one has to destroy the existing structure with regards to the formal and conceptual aspects.

This is a principle that constitutes the indispensable condition in the genesis of all artistic movements. All of them to assert themselves have to break with the prevailing order.

However, the destruction that is thus implied is not that of a physical nature in relation to the objects produced by artistic currents in existence at the time, but of a creative, aesthetic, conceptual and formal nature.

An artistic movement, has nevertheless even advocated the possibility that the physical destruction of the objects, is the exception. In effect, the Dada movement, in an attitude of revolt and provocation wanted to make a clean slate of what lay in the past, going so far as to suggest to use a canvas of a Rembrandt as an ironing board, for example, being Marcel Duchamp the mentor of this act/idea

Another time, wanting to expose the basic antinomy between art and "readymades", I imagined a "reciprocal readymade": use a Rembrandt as an ironing board! (Coutts-Smith, 1970, p. 56)

Obviously, by choosing an untouchable work of art, this kind of attitude could never be more than an intention, as its realisation would never be made possible by cultural institutions due to ethical and patrimonial issues. However, this did not prevent it from being expressed in reproductions of works of art as in the case of the provocation that constitutes the moustache and pear that Marcel Duchamp painted, in 1919, on a postcard with the image of the Mona Lisa by Leonardo da Vinci entitle L.H.O.O.Q – meaning phonetically in French *Elle a chaud au cul*, meaning *She has a hot arse*. With this provocative gesture, Duchamp exposes the gender ambiguity in Leonardo's work, stating that in this form.

...the Mona Lisa becomes a man – not a woman disguised as a man, but a real man. (Jones, 2001)

The act itself is a deliberate provocation, but the reasoning mentioned above prevents it from being a gratuitous act of vandalism.

More recently in 2003, the brothers Jake and Dinos Chapman, two provocative artists par excellence, drew on Goya's prints from the series The Disasters of War, under the pretext of drawing attention to his work and making the non-intervened copies rarer, promising in a provocative attitude, to buy and draw all the etchings of Goya that can be put to hand.

...if we get our hands on every Goya set, we will draw on them... (The Chapman Brothers vs. Goya, 2003)

Regardless of the motives that move them, the copies they have altered are destroyed as the original work of Goya. They also deny the vandalism by claiming

I think the question of it being vandalism is actually, technically, incorrect because vandalism is normally schematically destructive when what we did the Goya pictures was to draw on them very delicately so they are more over-drawings than they are acts of vandalism (The Chapman Brothers vs Goya, 2003)

4 THE CREATION OF THE FORMAL SOLUTION OF THE ARTIST'S BOOK THROUGH THE DESTRUCTION OF EXISTING BOOKS

In the case of artists who create artist's books based on the destruction of existing books, we are faced with a creative attitude with Dadaist similarities.

This neo-Dadaism appears in various degrees with regards to the level of destruction inflicted on the books used in the elaboration of the artist's book.

Here, the question of ethics is a factor that conditions this approach. Some artists only use books that would otherwise be destroyed by weakening the ethical issues, others simply ignore it.

The reasons invoked for this procedure are aesthetic, of social and religious criticism, of pure provocation and ironic character.

Regarding the formal and physical aspects, some opt for solutions to reformulate the shape of the book reversibly, as is the case of the multiple possibilities of the folding of sheets/paper in order to obtain three-dimensional formal solutions appealing in plastic terms.

Here it is possible to undo the folds/duplication getting the original object back, but it is obvious that this is not the intention of the artist. However, *Just unfold and read* by Isaac G. Salazar constitutes a humorous exception.

Another approach is to partially remove the content of the pages by cutting fragments and thus making it impossible to read the original book in full.

An approach like the previous one is to sculpt the book, cutting it so that the result is interesting in terms of the form and the conjugation of the images and the text that remains visible in the object.

In this approach and in the previous one, there is still a partial reading of the initial object, but it is no longer possible to read it totally. They are both irreversible processes.

Another approach following this logic, but taking it to a more extreme level, is to cut the book and treat it at a strictly formal level, transforming it into a sculpture, rendering any possibility of its initial use impossible.

The most radical approach is that which ostensibly destroys the initial object without leaving the slightest chance of recovery of its initial form and condition. Here the object is destroyed ostensibly, a good example is the case of the nailed books.

5 CONCLUSION

In any of these approaches to creativity through destruction, the aim of the artists who resort to using them, however, is always to obtain a formal solution coherent with the artist's conception, combining the conceptual and formal components in order to convey a message through a formal solution plastically achieved in formal and aesthetic terms. The destruction of the original object was something inevitable and inherent in the process and thus legitimate for the artist, thus freeing him in such a way from committing a gratuitous act of vandalism as we have said about Marcel Duchamp and the brothers Jake and Dinos Chapman. In this way, basically, the ends justify the means.

BIBLIOGRAPHICAL REFERENCES

(2003). *The Chapman Brothers vs. Goya*. The Gallery of Lost Art. A project by Tate, ISO and Channel 4. [Online]. [Accessed 6 October, 2018]. Available from: https://www.youtube.com/watch?v=wt-jVRpotIo

Anthony Caro. (2019). *Open Secret*. Ivorypress. 2019. [Online]. [Accessed 1 February, 2019]. Available from: http://www.ivorypress.com/en/editorial/anthony-caro-open-secret/

Castleman, R. (1994). *A Century of Artists Books*. New York: Museum of Modern Art.

Coutts-Smith, K. (1970). *Dada*. London: Studio Vista Limited.

Debray, C. (2008). *Marcel Duchamp: la peinture, même*. Paris: Centre Pompidou.

Jones, J. (2001). L.H.O.O.Q. (1919) Marcel Duchamp. *The Guardian*. [Online]. [Accessed 10 November 2018]. Available from: https://www.theguardian.com/culture/2001/may/26/art

Nicolaisen, D. (2013). *Folded book art by photographer Luciana Frigerio*. [Online]. [Accessed 10 January, 2018]. Available from: http://www.theinspiration.com/2013/03/folded-book-art-by-photographer-luciana-frigerio/

Ritcher, H. (1965). *Dada – Art et anti-art*. Bruxelles: Editions de la Connaissance.

Salamony, S. and Thomas, D. (2012). *1,000 Artists' Books: Exploring the Book as Art* (1000 Series). USA: Quarry Books.

Sanoouillet, M. and Matisse, P. (2008). *Marcel Duchamp du signe: suivi de notes* . Paris: Flammarion.

Torres Arzola, R. (2013). Anselm Kiefer: Structures are no longer valid (quotes) (1985). *Arte y Pensamiento Contemporáneo*. [Online]. [Accessed 5 September, 2018]. Available from: https://arteypensamientocontemporaneo.wordpress.com/2013/10/17/anselm-kiefer-structures-are-no-longer-valid-quotes-1985-2/

Watson, R. (2008). Blood on Paper: The Art of the Book. [Online]. [Accessed 10 February, 2018]. Available from: http://www.vam.ac.uk/content/articles/a/Art-of-the-Book/

Aldo Rossi's Teatrino

Fernando J. Ribeiro
CIAUD – FAUL, Lisbon School of Architecture, Universidade de Lisboa, Lisboa, Portugal
ORCID: 0000-0002-7864-2519

ABSTRACT: Crossed by an irreducible ambivalence, fantasy feeds the illusion of human autonomy over the universe of appearances, with the use of mental representations, at the same time as the desire triggered by images closes its in an endless cycle, forcing the realization of the supremacy of his objects of desire, which assume a phantasmatic dimension. Since the possession of the incorporeal is all the more pressing as its consummation is perpetually delayed, it becomes a generator of galloping melancholy. In artistic fictions, ambivalence results in a theatricality that simultaneously seduces and expels the observer, in a push and pull that gives him power and removes it immediately. When the eternal return manifests as an inexorable condition, the observer internalises the radical distance maintained with the field of reality. Just then, the production of culture from the fantasy imagery field will produce a constant drift between abandonment to the field of things, and the access to a materialisation of the incorporeal and the ineffable.

Keywords: fantasy, phantasm, melancholy, miniature, theatricality

ALDO ROSSI'S *TEATRINO*

The miniature always tends toward tableau rather than toward narrative, toward silence and spatial boundaries rather than toward expository closure. The observer is offered a transcendent and simultaneous view of the miniature, yet is trapped outside the possibility of a lived reality of the miniature. The miniature's fixed form is manipulated by individual fantasy rather than by physical circumstance. In its tableau like form, the miniature is a world of arrested time; its stillness emphasizes the activity that is outside its borders.

Susan Stewart

1 INTRODUCTION

The focus on fantasy is a constant that goes back to Classical Antiquity when analysing the representations that humans produce when in confront with the things of the world. Receiving things like images, fantasy treats them as objects of desire, to be taken as belonging to the depths of spiritual dimension. Regarded as a special faculty of the mind, leads the neo-platonic philosopher Cyrene Synesius to consider that fantasy enables the contact of the spirit and the body, by the passage from the incorporeal to the bodily, from light to shadow, comparing fantasy to one mirror that receives images that emanate from things. Just as things are integrated into the incorporeal, so must the incorporeal acquire corporeality in mental representations which, given their degree of veracity, confer the simulacrum of the real object a phantasmatic status,

> in the form of what is variously termed an image, idol, or simulacrum, which is created, copied, replaced, and endlessly elaborated by the faculty of fantasy. (Koerner, 2016, p. 197)

The attempt at the appropriation of the corporeal on the terrain of the incorporeal may propitiate the relapse of the subject on himself, in a gradual distancing from the universe of appearances. However, this pursue of cognitive autonomy is fallacious, since the mental representations that interpose between the real objects and the self, cannot escape their status of phantasms that – as is known since the Middle Ages – are "the true object and origin of desire" (and not the real object); a desire that, as Koerner (2016, p. 202) says, elaborates images "by an alien process power over which the self, as reflexive consciousness or volition, has little or no control." The faculty of fantasy is thus subject to an inexorable ambivalence:

Moreover, it was the power of fantasy, along with the faculty of reason, which elevated humans above all other creatures. Unable to form mental representations, beasts related to the world only through immediate sense experience. At the same time that it freed the human mind from its bondage to objects; however, fantasy also set humans on a collision course

with nature. Often associated with the sin of pride, and held to motivate insatiable desire, especially of an erotic kind, fantasy was indicted as a root cause of the Fall (Koerner, 1993, p. 167-168)

When the consciousness of this aporia is raised, the radical detachment from the real object becomes conscious, provoking states of melancholy that are difficult to overcome. The melancholic states come from a gradual loss of power over the world, over others and/or finally over the subject himself, over his actions and his affections. As Freud puts it, the passage through the darkness of melancholy is inevitable to deal with the feeling of loss, since only through its awareness is it possible to map the degree of disorientation and to uproot (Freud, 1978, p. 246). When melancholy forces the subject to recognise his dependence on the screens projected by phantasmatic imagery, the notion of the human ceases to report the autonomy of the ontological field, to understand objects and things as inseparable from the construction of identity. It will be in this interstitial zone that the physical and affective relation with things can lead to the liberation from the narcissistic dimension, and to a reinvention of the human position in the world, and in this movement, the human loses its scale and power until it becomes a stranger to himself, as Agamben (1993: 59) puts it:

> Things are not outside, in measurable external space, like neutral objects of use and exchange; rather, they open to us the original place solely from which the experience of measurable external space becomes possible. They are therefore held and comprehend from the outset in the topos *outopos* (placeless place, no-place place) in which our experience of being-in-the-the world is situated. [...] Like the fetish, like the toy, things are not properly anywhere, because their

place is found on this side of objects and beyond the human in a zone that is no longer objective or subjective, neither personal nor impersonal, neither material nor immaterial, but where we find ourselves suddenly facing these apparently so simple unknowns: the human, the thing.

After the ineluctable failure of socio-political utopias, the notion of fantasy in cultural production becomes referred to its properly human condition: no longer in creations allegedly and Ideally *ex-nihilo*, but an activity always and inevitably anchored to images – poetic, musical or visual – already belonging to history. In the framework of post-history, -of which the work of the architect Aldo Rossi is a paradigmatic case – fantasy integrates its agents and users in the present, but always referring to the inevitable analogy with the phantoms of a palimpsest that, as it is being unveiled, is integrated no longer as history but to the "arrested time" of mnemonic exercises. The images produced by fantasy thus cease to belong to the ontological domain, to sum up to memories of a past that, when the existential and ideological foundations of its development are scrutinised, becomes intelligible by its updating that, subsequently, becomes the underground of the present.

2 DEVELOPMENT

Rossi's architectural projects and drawings put the emphasis on fantasy by the use of the notion of analogy in relation to the tectonic artefacts, introducing an equivalence between the city and the private dwellings, that are distinguished only by its scales, as well as the constructive layers of the city lose their historical hierarchy, to appear in architectonic assemblages and graphs where past and present become contaminated, until their limits become imperceptible. The conception of the urban fabric thus loses its historicist dimension, to assume a strictly psychological dimension, passing memory to acquire the status of existential axis responsible for the constant reinvention of the temporal categories.

In the drawing *Disegno with Teatro Gallaratese and Altri Edifici,* (fig. 1), a Roman temple is reduced to the theatre status, denoting in this passage from the sacred to the profane a strategy of miniaturization, which reaches the paroxysm when the drawing shows us a theatre sent to what Rossi (2013, p. 66) calls *teatrinos*.

> I always thought that the term *teatrino* was more complex than the term theatre; this refers not only to dimension but to the character of private, of singular, of repetition of what in the theatre is disguise. [...] *Teatrino* instead of theatre is not so ironic or childish, although irony and childhood are strongly linked to the theatre, but a singular and almost secret character that accentuates the theatrical. The theatre also seemed to me to be in a place where architecture ends, and imagination begins or even foolishness.

The contact and contamination of the "invisible distances," as Rossi affirms, between past and present, is from the beginning enunciated in the suspension of perspective, carried out by the parallelism of the vanishing lines in the axonometric perspective to which the *teatrino* is circumscribed. Raising a sense of self-completeness, the transcendental view elaborated in the miniature entails a temporal suspension that dilutes the limits of temporal categories, in an inner time that brings back the phantom marks of the past projected in the present. As such, suspending perspective also corresponds to a temporal suspension that reduces everything to a pure spatiality, being in this standstill that a perpetual present isolates the *teatrino*; reflecting, according to Susan Stewart (1993, p. 65), sovereign observer's transcendental vision:

> The miniature does not attach itself to lived historical time. [...] the metaphoric world of the miniature makes everyday life absolutely anterior and exterior to itself. The reduction in scale, which the miniature presents, skews the time and space relations of the everyday life world, and as an object consumed, the miniature finds its "use value" transformed into the infinite time of reverie. It is a capacity of the miniature to create an "other" time, a type of transcendent time, which negates change, and the flux of lived reality.

Functioning as an internal frame, the miniature temple-theatre acquires the status of an object that – just as the scenographic cube –, after absorbing the landscape beyond it, becomes an inalienable property of the observer, that is, a place without place that – since all the geographical space was subjected to a radical flattening – is not on the ground, but suspended (and It is up to its projected shadow to give the illusion of its inscription on the ground). As such, it does not belong to the events occurring in the landscape, but to the sovereign observer. Summarised in black and white, the scenario is presented with the neutrality of a tabula rasa, so that the events there deposited abruptly in it by involuntary memory have the appearance of a genesis of the world. However, given the impossibility of representing infinity, these are always fictions carried out in the architectural metaphor of fantasy: the *teatrino*.

If the theatrical casing arises in ecstatic immobility, everything within the *teatrino* is precipitated by an acceleration in which the divergent vanishing lines, the high contrasts of black and white, and the rhythmic intersection of light with the thick boundaries of the scenic elements, produce an unbroken succession of flash moments. The succession of instants leads abruptly to a spatial recession, the outcome of which is on the horizon; but the accumulation of scenographic plans concealed this. Coinciding with the sharp landline outside, its visibility was delayed only to be transferred to the landscape. Nevertheless, due to the alignment with the scenographic horizon, the landline is taken by the geographic and

historical horizon, establishing an analogy between the near and the infinitely distant, the material and the immaterial, the corporeal and the incorporeal, that is, reporting for the fantasy design elaborated by Synesius. Appearing accumulated in the horizon, the whole urban palimpsest is immediately perceptible – because placed in the instant of contemplation -, bearing monumentality that covers almost the entire field of vision. Being the space beyond horizon transformed into an absolute interior, the radical loss of scale of the geographic space legitimises the immensity of the inner world that miniature proportionate.

The linear perspective with a vanishing point indicates projection into the future, always utopian because anchored to an incorporeal one-dimensional signal. Abolishing the vanishing point, Rossi refers the future to a horizon that, due to its excess of visibility, appears in the present. The possession of the horizon by its materialisation absolutely contradicts the precepts of the linear perspective, which thus undergoes a radical inversion in advancing to the observer, transforming all the spatiality into a rigorously interior landscape. If the *teatrino* horizon closes itself in the phantasmatic field of memory, the materialisation of the geographical horizon rescues it from this condition: the possession of the horizon corresponds to the fantasy of miniaturisation of spatial and temporal infinity, which, being here analogous, must arise in the absolute proximity of the present. It is then up to this space hinge to perpetually maintain the fantasy of perpetual coexistence of the past and the present, and, given that the horizon cuts in half all the landscape and the whole image, that same fantasy can only be effected abruptly, by the instantaneous collision of the present with the past. But before the blindness of the moment arises the readability urgency, meanwhile produced by analogical repetition: from history as landscape to history as teatrino, thus echoing history ad eternum in memory, through

> extreme ambiguities of scale, juxtapositions of immeasurable objects apparently forced by the architect into a silent, secret dialogue; the sense of separation and fixity radiated by elementary objects in view of metaphysical cities, lit by a light that seems to consume all substance – all this must be read as the result of the radical impracticability of the order of the Symbolic City for the individual types who wish to possess it. The types persist, torn from themselves, due to this lack; the desire itself persists due to this lack. (Hays, 2019, p. 43)

Containing the ephemerality and portability of beach huts, Rossi's miniatures are always ephemeral and reversible, going from temples to *teatrinos*, from monumental urban groups to figures of an objetual nature, pulverising the borders of the sacred and the profane. In *Disegno con Teatro Gallaratese ed Altri Edifici,* the reversibility to which both tectonic objects and the landscape are subjected, removes them from

the distinction between inner and outer, immaterial and material. In this interstitial zone occurs – inside a *teatrino* presented as a place without place where fantasy is reified – a temporal viscosity, in which the present is projected to a future that, meanwhile, comes as a phantasm of the past.

Just as the incorporeal becomes corporeal, by the flattening of landscape, that reifies the geographical and historical infinity, so the corporeal loses its definition with axonometric reversibility, and the loss of spatial coordinates in the *teatrino*. Making its distinctions almost imperceptible, Rossi's analogical city integrates history and memory, macro and micro, personal and social as categories whose borders become porous and imperceptible – and always with a theatrical accent. Hence the sensation of spatial infinity driven by the push and pull, in the acceleration of perspective and its immediate inversion, of the spatial recession projected into infinity, that afterwards returns to the observer. The present emerges as a permanent updating of memory, properly involuntary because projected into an epiphanic originating field where the loss of fixed coordinates forces a suspension of judgment. Thus, despite the high speed in which the observer is projected into the *teatrino*, all the scenario – and landscape included – turns to a standstill that suspends all motion, till the picture is but a still life, and, as Tafuri (1987, pp. 273–274) affirms:

> the categorical imperative of the absolute estrangement of form is in effect, to the point of creating an emptied sacrality: an experience of fundamental immobility and of the eternal recurrence of geometric emblems reduced to ghosts.

If fantasy arises only by projection (as in theatrical), when the horizon progresses until it is confused with the image support, it abolishes the diaphanousness of the frame window and therefore blocks any hypothesis of projection. With the accumulation of history on the horizon, the compulsory materialisation of infinity leads, after all, to its ultimate opacity. And the loss of legibility translates into the passage of the landscape to the domain of the shadows, returning it to its phantasmatic status.

Just as the images elaborated by fantasy always acquire the condition of phantasms that, their possession always delayed, put desire in perpetual activity, the constant swing of the recession and spatial advance, acceleration and inversion of the perspective in Rossi's drawing escape space legibility. The power of the observer is thus supplanted by a *vertigo* that obstructs the hypothesis of orientation and cognition, in a scenario that pulverises its readability and, thus, subverts the miniature as a model of transcendental vision. Since, as Agamben (2000, p. 53) says:

> The thought of the eternal return, in fact, is intelligible only as a gesture in which power and act, naturalness and manner, contingency and necessity become indiscernible (ultimately, in other words, only as theatre)

when history returns as a simulacrum of the *teatrino*, it is about an epiphany of a strictly theatrical nature. The eternal return of history and the horizon takes place as a meeting with the primordial moment of world's genesis, which, given its simulacrum condition, becomes a utopian hypothesis and, therefore, that occurs only in the theatre field.

3 CONCLUSION

Aldo Rossi's drawing makes visible how in fantasy the invocation and projection into the future – in which completeness of the subject would be realised – is reverted into phantasmatic regression of the past, that is, into the return of the Same. In the oscillation between the eternal return of space infinity and the pressing projection on the *teatrino*, Rossi makes visible the ambivalence inscribed in the human condition, its Interiorisation being the vehicle for the passage from the melancholic state to the integration into the world: the alternation of acquisition and loss of power, of scale, of locus, constitutes a dialectic that increases the self-consciousness of the human position in the world. Only in surrendering to the infinite panoply of appeals that make up the world can the human find his true greatness, his scale, which simultaneously grows and decreases when he is inscribed on the terrain of fantasy. If the encounter with the Other would place the subject in the field of the real, the return of the Other as the Same denotes a push and pull – patent in the recession and advance of the visual pyramids – inherent in the theatricality characteristic of fantasy operations. Thus, the possession of the incorporeal – the spatial and geographical infinity – in the terrain of images implies that they are consigned to the status of pure illusions, properly phantasmatic, in a theatricality that makes conscious the perpetual delay of its possession, that is, its utopian dimension.

The push and pull to which the observer is subjected in Rossi's drawing manifests the ambivalence underlying the phantasy operations. Only when this condition is internalised can the construction of identity cease to report to the autonomy of the ontological field, to understand the physical and affective connection with the real objects of desire. Just then the production of culture from the imagery field of fantasy will produce a constant drift between a loss of power, in abandonment to the designs of things, and the acquisition of power – access and materialisation of the incorporeal and the ineffable –, as Agamben (1993, p. 25) suggests:

> No longer a phantasm and still not a sign, the unreal object of melancholic introjection opens a space that is neither the oneiric hallucinated oneiric scene of the phantasms nor the undifferentiated world of natural objects. In this intermediate epiphanic place, located

in the no-man's-land between narcissistic self-love and the external object-choice, the creations of human culture will be situated one day, in the interweaving of symbolic forms and textual practices through which man enters in contact with a world that is nearer to him than any other and from which depend, more directly than from physical nature, his happiness and his misfortune.

BIBLIOGRAPHICAL REFERENCES

Agamben, Giorgio. (1993). *Stanzas: Word and Phantasm in Western Culture* (Ronald L. Martinez, Trans.). Minneapolis and London: University of Minnesota Press.
_____. (2000). *Means without End: Notes on Politics* (Vincenzo Binetti, and Cesare Casarino, Trans.). Minneapolis and London: University of Minnesota Press.
Eisenman, Peter. (1982). "The Houses of Memory: The Texts of Analogue," in Aldo Rossi, *The Architecture of the City*. Cambridge, Massachusetts: The MIT Press.
Fried, Michael. (1967). "Art and Objecthood," in Gregory Battock (ed.), *Minimal Art: A Critical Anthology*. New York: E. P. Dutton & Co., Inc.
Freud, Sigmund. (1978). "Mourning and Melancholy", in *The Standard Edition of the Complete Psychological Works of Sigmund Freud* (Vol. 14, James Strachey, Trans.). London: Hogarth Press.
Hays, K. Michael. (2009). *Architecture's Desire: Reading the Late Avant-garde*. Cambridge, Massachusetts: The MIT Press.
Koerner, Joseph Leo. (2016). *Bosch and Bruegel: From Enemy Painting to Everyday Life*. Princeton: Princeton University Press.
Rossi, Aldo. (2013). *Autobiografia Científica* (José Charters Monteiro, Nuno Jacinto, Trans.). Lisboa: Edições 70.
Stewart, Susan. (1993). On Longing: Narratives of the Miniature, the Gigantic, the Souvenir, the Collection. Durham: Duke University Press.
Tafuri, Manfredo. (1987). *The Sphere and the Labyrinth: Avant-Gardes and Architecture from Piranesi to the 1970s* (Pellegrino d'Acierno and Robert Connoly, Trans). Cambridge, Massachusetts: The MIT Press.

The torrent of art, the rooms of art. The *Fiumara d'Arte* and *Atelier sul Mare* in Sicily

Santi Centineo
Politecnico di Bari, Bari, Italy
ORCID: 0000-0002-1365-982X

ABSTRACT: It is generally acknowledged that some issues of the aesthetic process relate Architecture to Art, tying them together. The chapter aims at examining under a different point of view the old matter of the correspondence between Art and Architecture. The reported case-study focuses on *Fiumara d'Arte* and *Atelier sul Mare* (Castel di Tusa, Messina, Sicily), a huge artistic park and a very singular hotel in which different artists have designed the rooms. Thanks to this extraordinary private enterprise (the Sicilian patron Antonio Presti), it is possible to open some actual questions about Art's and Architecture's task. First of all, Art can by-pass the functional and ergonomic issues, more typical of the Architectural range. A second point is the possibility for the Artist's creativity to give the user the opportunity of passing throughout a sensorial and intellectual experience. Moreover, as a final synthesis, to understand that the comfort dimension is based on intellectual circumstances, much more than to ergonomics or technological parameters.

Keywords: Landart, *Fiumara d'Arte*, *Atelier sul Mare*, Art rooms, Art & Interior design

1 THE BIRTH OF FIUMARA D'ARTE

In 1986, the Sicilian Antonio Presti, son of a wealthy entrepreneur, began a crazy and visionary project: spreading the art among the Sicilian people and territory, but also, on the contrary, bringing people into the Art.

He began to sell his father's company progressively and to entrust to well-known artists the realisation of works of art to be disseminated on the territory of Alesa Valley, area of great cultural and archaeological interest, near Castel di Tusa (Messina).

According to the legend, Alesa was founded by Aeneas himself, exiled from Troy, even before landing in Lazio, where he would have founded Rome.

A territory rich in magic, where the myth always hovers, in a territory even afflicted by illegal building.

In 1986, October 12th, Pietro Consagra's sculpture, *La materia poteva non esserci* ("The material could not be there", fig. 1), was inaugurated. Hence subsequently, Paolo Schiavocampo's work, *Una curva gettata alle spalle del tempo* ("A curve thrown behind the time"), inaugurated on January 30th, 1988; Tano Festa's *Monumento per un poeta morto* ("Monument for a dead poet", fig. 12), dedicated to his brother Francesco Lo Savio and confidentially renamed by the people "Window on the sea", inaugurated on June 24th, 1989, after the untimely artist's death, together with Hidetoshi Nagasawa's *Stanza di barca d'oro* ("Room of golden boat") by the Romei creek,

Figure 1. Pietro Consagra's *La materia poteva non esserci*, 1986, at Fiumara d'Arte. (Photo by the Author).

Antonio Di Palma's *Energia Mediterranea* ("Mediterranean energy") and Italo Lanfredini's *Labirinto di Arianna*, ("Ariadne's Labyrinth"). These last two artists had been the winners of an under-40 competition, announced by Presti with an international jury.

Also in 1989 *Arethusa*, a colourful ceramic decoration in Castel di Lucio, by Piero Dorazio and Graziano Marini, was completed. In 2010 the most recent of the works, *38° Parallel*, by Mauro Staccioli (fig. 2), a large empty pyramid geographically aligned with the point where the sun rises on the day of the summer solstice, was realised.

All these works are now known as *Fiumara d'Arte* ("The torrent of Art"), the largest diffuse art park in Europe.

Figure 2. Mauro Staccioli's *38th Parallel*, 2010, at *Fiumara d'Arte* (Photo by the Author).

Antonio Presti, since the installation of the first sculpture, started an absurd and paradoxical accuse, for building illegality and for landscape defacing.

He faced several legal processes and was sometimes even condemned at first instance (Schisa, 1990). Presti always reacted by building new works and undertaking new initiatives and projects.

All these works are now known as *Fiumara d'Arte* ("The torrent of Art"), the largest diffuse art park in Europe.

Antonio Presti, since the installation of the first sculpture, started an absurd and paradoxical accuse, for building illegality and for landscape defacing.

He faced several legal processes and was sometimes even condemned at first instance (Schisa, 1990). Presti always reacted by building new works and undertaking new initiatives and projects.

In 1991, for example, he organised in one of the villages of *Fiumara*, Pettineo, the singular event *One kilometre of canvas*, an extemporaneous painting on a canvas that crossed the streets of the village, to be cut into pieces and donated to the inhabitants, whose houses became a "domestic museum". More than 200 artists came, known and less known, and the performance would be repeated the following years.

In summer 1993 the movie *Il viaggio clandestino. Vite di santi e peccatori* ("Lives of saints and sinners") by Raúl Ruiz, Chilean director and avant-garde myth, was filmed among the sculptures of the *Fiumara*.

In October of the same year, Presti invited forty ceramists from all over Europe to create a collective work on the concrete retaining wall of one of the streets of the river, which thus became *The Wall of Life*.

Between the end of 1993 and the beginning of 1994, more than 3000 Italian and international artists and intellectuals mobilised in an attempt to save from the demolition order Tano Festa's *Monument for a dead poet*. Among them, Queen Sofia of Spain.

Only at the end of 1994, Presti is acquitted with a memorable sentence establishing how the concept of Art cannot be considered as a landscape damaging. As the sentence of the Court of Appeal said, "damage of landscape beauties must be excluded, as the concept of beauty is a metaphysical datum, hardly definable".

Maybe for the first time, the concept of Art had become the specific subject of a legal judgment.

2 THE BIRTH OF ATELIER SUL MARE

In the meantime, in 1991, before the sentence was pronounced, Presti gave birth to another project: the *Atelier sul Mare*.

An old structure of the '70s was taken in charge and progressively transformed into a hotel and an artistic project at the same time.

In 1994, after the final judgment had absolved Presti, he commissioned eight rooms more.

They should have been the base for visitors of the *Fiumara* ("Exhibition on the sea"), but also a residence of artists open to the population, a place of exhibitions and cultural events.

The design of the hotel's rooms is therefore entirely entrusted to artists, free to create inside a work of art that will not be exposed but will be 'inhabited' by customers.

Today there are twenty artist's rooms in the hotel, but also some 'normal' rooms.

It is not a hotel where one can go to have special comforts, to judge the service, to evaluate the accessories of the rooms or the comfort of the bed. In the literal sense of terms, these things are included.

The *Atelier sul mare* is something else, and in fact, there has not been any one-sided policy on room design.

3 SENSORY ROOMS

Some artists worked designing a sensorial environment, for example in Maurizio Mochetti's *Energia* ("Energy", 1992), a room whose night furniture glows red; Pepi Morgia's *La stanza della Luce* ("The room of light", 2011), where at night bright writings appear; Sislej Xhafa's *Hammam* (2007), where two different rooms have the common space of a Turkish bath, sharing the experience of well-being; *La Torre di Sigismondo* ("Sigismondo's tower", 1993), by Raúl Ruiz, where the bed is located at the bottom of a tower with an opening roof, that by night lets the light of the stars enter; in *Il Nido* ("The chest", 1991) by Paolo Icaro, an enveloping bed in the centre of the room is the point of view of a perspective towards the sea that crosses the walls.

4 CALLIGRAPHIC ROOMS

Some other artists use their specific sign: Mario Ceroli's *La Bocca della Verità* ("The mouth of the truth", 1990), where the recognisable sign of the sculptor, through furniture that is real sculpture, reinterprets the famous Roman monument of Santa Maria in Cosmedin; or as Ute Pika and Umberto Leone,

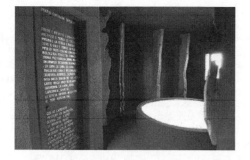

Figure 3. Lunaria- Contrada senza nome by Ute Pica and Umberto Leone, 2007, at *Atelier sul mare*. (Photo by Author).

Figure 4. Mauro Staccioli's *Trinacria*, 1993, at *Atelier sul mare*. (Photo by the Author).

who in *Lunaria– Contrada senza nome* ("Lunaria – a no-name place", 2007, fig. 3), lean on the walls 'sheets' of olive trunks that look almost like pages of a great book or huge wings of butterfly, while in the centre of the room a round white bed looks like the moon falling from heaven to earth; or Piero Dorazio and Graziano Marini's *La stanza della pittura* ("The Painting Room", 1996), filled with their graphic signs; or Agostino Ferrari and Renato Curcio, in *Sogni fra segni* ("Dreams between signs", 1994), where a giant parchment wraps the bed; Mimmo Cuticchio, famous Sicilian puppeteer, who interprets his *La stanza dell'opra* ("The room of the puppetry show", 2010) as a backstage of a theater of Sicilian puppets and the guests of the hotel, from the corridor outside the room can watch the staging; Michele Canzoneri's *Linea d'Ombra* ("Shadow line", 1992), proposes a boat-like environment, in which the light illuminates the bed that filters through the coloured glasses of the Sicilian artist.

5 CONCEPTUAL AND IDEOLOGICAL ROOMS

Finally, other artists embrace a more ideological and conceptual aspect of art: Tobia Ercolino's *Doppio sogno* ("Double dream", 2009), room by alienating metaphysical elements; Antonio Presti, Agnese Purgatorio, Danielle Mitterand and Cristina Bertelli in *Portatori d'acqua* ("Water carriers", 2006, fig. 10) create two sequential environments that suggest the theme of dryness, in which a puddle of aromatic water and a suffused candle light are the only furnishings; on a similar poetic is based Hidetoshi Nagasawa's *Mistero per la luna* ("Mystery for the Moon", 1991), where the golden foil covering the room reflects the light entering the window (with different effects by night or day), or the flickering lamp of a candle; Fabrizio Plessi's *La stanza del Mare negato* ("The room by the denied sea", 1992), offers a sea-sight only through some monitors, before the inhabitant finds the real window, hidden behind one of the many false doors; *Terra e fuoco* ("Earth and fire", 1996) by Luigi Mainolfi is a room

entirely covered by earthenware shards, while the bed is a copper table suspended in the centre.

Mauro Staccioli in *Trinacria* (1993, fig. 4) designs an oppressive environment, with red and black triangles (the shape of Sicily), which also affects the bed; in *Su barca di carta d'imbarco* ("A paper boat made with a boarding card", 1993), by Maria Lai, a split stone in the centre of the room symbolises the opposition between heaven and earth.

Finally, the most conceptual and ideological of the rooms, by Antonio Presti himself, *La stanza del profeta – Omaggio a Pasolini* ("The room of the Prophet– homage to Pasolini", 1995, fig. 9), a room which can be entered only by overturning a door and passing over the verses of the poet/writer/director Pier Paolo Pasolini, symbol of the Italian intellectual protest of the 60s and 70s. The room is covered with mud and straw, and the spectator enters between Arabic writings to the walls, while the bedside lies on the sand of the coast where the body of the murdered poet was found.

6 ART'S UTOPIA

At the entrance of the hotel, the guest is introduced by a very dense concept: "Here lies the utopia, the art's one".

First of all, it would, therefore, be necessary to define what utopia is, a word coined by Thomas More, who, like Seneca, had misplaced his hopes for Nero, dreaming of a better civilisation, but condemned to death by the Emperor.

It means "no-place" (if we rely on a possible etymology *ou*=not; *topos*=place), or "good place" (if we rely on *eu*=good; *topos*=place).

In any case, the utopia is an alternative, a compensatory scenario, but not a substitute for reality. Otherwise, it would no longer be utopian.

However, it is equally clear that the utopia draws a plausible reality that would replace the previous one. A sort of horizon. Just as the horizon does not approach when walking in its direction, but it establishes the

direction of the journey, the utopia is unapproachable but establishes the direction of a path (Friedman, 2003).

So it is clear that when a utopia is drawn, beyond satisfying his own cultural, spiritual, and metaphysical longing, a turn of an ideological direction has been taken.

And it is clear that behind Presti's project for the *Atelier*, there is a strong ideological value.

The same rooms designed by him, *The Prophet's Room* and *Water Carriers*, even more than by an 'ideological beauty', are permeated by a 'beauty ideology'.

7 ART QUESTIONS US

But quite conceivably the matter is another. The Atelier is not an inhabited museum, as Gabriele D'Annunzio's Vittoriale can be[1]. In fact, a museum assumes that the masterwork of art is in some way dead and embalmed and that it needs a frontal relationship with the viewer.

In the *Atelier* instead, the concept of the entire work of art that phagocytes the user in every detail (from the cutlery to the slippers) is not present: the fact that the structure of the building is the visible one of a typical building of the 60/70's, proves it.

In some way, both in the park of the *Fiumara*, and in the case of the Atelier, the spectator is the completion of the work of art.

It is not only a visual completion but first of all, a conceptual one, as can be understood from a comparison between the Window on the sea and the door of Apollo's Temple in Naxos.

The latter opens up a dilemma and a question (fortunately unresolved): in fact, today we consider this object from a double point of view. On the one hand, its value derives from its antiquity; from the possibility of evoking the original context; from historical, artistic, architectural (in a word: archaeological) interest. On the other hand, we inevitably consider it for what it currently is. Although his being at present cannot disregard the consciousness of his antiquity, a part of us is also seduced by his condition of incompleteness: its present state has a justification in being, and its antiquity legitimizes its conditions of existence and subsistence, while in some way it asserts in a supremacist way its elusive essence.

The state of ruin, if on the one hand has, that is, deprived the work of its completeness, its readability, its functionality, on the other hand, enriches it with new meanings, that we continuously are pushed to

research: for example, the possibility of reading it now as a window on the sea that comes into relation with the landscape in a new way, for which surely no prediction had been made by his architect.

In the case of Tano Festa's *Window on the sea* instead, the work has been placed on site, according to a somewhat reason. A reason that is still present, such as developed by the artist.

We can rush to follow this reason, but we will unnecessarily discover it, or, admitting that the artist has declared it, admitting that we can be part of this reasoning, or assuming that we could discover it by ourselves, there is always the possibility of finding other possible personal readings. Indeed, the fact that the work is in some sense enigmatic makes it possible to consider it a work of art: it questions us in fact and, according to Bertram (2008), precisely from this question, from this effort of understanding – the author says, quoting Kant (2011) and Hegel (2017) – its aesthetic fruition of artistic kind becomes evident.

Faced with the enigma of art, each user will be able to construct a plausible answer.

8 CAN WE ANSWER THAT?

So, many will be the answers, as many users are. And this is the subjective part of the art.

However, although different ones, each user will answer. This is the objective part of the art, that of submitting all users to a process of interrogation.

Not only thanks to this effort of understanding, but above all, and especially in the case of not museum art, when the aesthetic fruition is enriched by being a shared collective phenomenon, the primary quality of art arises: it is an intersubjective phenomenon.

These matters are even more crucial, as they are unexpected.

These works of art are not 'prepared' by a designed accompanying path, not 'announced' by the presence of a monumental base and a terrible explanatory label. These masterworks are spread on the territory, like torsos, in the middle of the stones, the gravel or the dungs.

Although it is one of the largest art parks in Europe (and fortunately finally protected by a regional law), *Fiumara d'Arte*, in fact, is not a theme park. The lacks of an equipped path that may knowingly guide the viewer allows not to regard it as a 'programmed' artistic path.

Almost all *Fiumara* and *Atelier*'s artists have worked merely researching the Sublime and with an inevitable reference to Nature.

In fact, and this emerges perfectly in the case of the Atelier, in the rooms of the hotel there is no hedonistic complacency, that is, there does not exist that parameter of the preciousness of the artwork linked to its material value, whereas value is instead entirely linked to its evocative power.

1. The "Vittoriale degli Italiani" is a complex of buildings, gardens and an open-air theatre, erected by the poet Gabriele D'Annunzio in Gardone Riviera (Brescia), between 1921 and 1938, and designed by the architect Giancarlo Maroni. Inside the villa an impressive number of exotic relics, or coming from travel, or war, personal objects of the poet, among the most abstruse, are kept. Today it is a museum.

9 EXPERIENCING THE ART

What does it mean living or sleeping in an artist's room?

It certainly does not mean evaluating the quality of the mattress in which one will sleep, or writing a nice or bad review on "Trip Advisor".

For instance, in the experience of a multi-hand designed hotel, such as the Hotel "Puerta America" in Madrid[2], the user enters the room designed by a famous architect, and in some way, faces critically his/her ability to meet the housing needs and at most with his conception of architectural interior. Sleeping in an artist's room means entering the beauty, privilege for a select few. It is a sort of purification path, which refers to this choice of elective self-consciousness.

Nowadays, the definition of art is very extended. In fact, we speak in the plural of "arts", and the technology extends this concept even further, extending it to mainstream multimedia. In museums, in galleries, we speak more and more often about immersive art or environment, a context of aesthetic fruition in which the viewer 'immerses' and concerning which the artistic phenomenon creates a film insulating from the real world.

In this context, the potential of virtual reality and 3D simulations are evident, as in Frank Gehry's "Biomuseo" in Panama[3].

Beyond the scientific potential of advanced technological application in a museum plant (think of the possibility to see enlarged details, to document the work with great precision, to redefine the work in its original context), these aesthetic forms are based on an emotional and sensorial involvement that takes the subject away from reality (Flusser, 2004; Carroll, 2001). Indeed, they replace it with another, which we usually call "virtual", and that, unlike the other artworks that normally are physically put on material support (the device), they conceal it. The phenomenon of artistic fruition, in this case, is based on a new catharsis (Eco, 1983), determined by the substitution of the comprehension of the artistic reality with the experimentation of a probable reality (Benjamin 1966 & 2012), and above all, by the re-entry when the experience expires (fig. 13).

These apparently 'strong' or 'multisensorial' experiences, to a large extent, because of their power, substitutive of reality, have very often been compared

to real drugs. If Plato had already criticised some forms of art, because they were supposed to be deceptive, he would undoubtedly have expressed all his bewilderment.

10 CONCLUSIONS

Definitely, in the case of the *Atelier sul mare*, we are in an immersive environment, but we are not talking about a context that aspires to the substitution of reality with another of virtual type (Abello Juanpere, 1989). It nor does use technological expedients as a means of pervasive sensoriality, neither it conceals the device of artistic representation, but, on the contrary, the device is present (the room), performs its function (hosting), is absolutely an immersive type, but does not replace reality. Indeed, the shape of the environment is based on very concrete and tangible elements, which even force the user to certain behaviours, aimed at a complete and total enjoyment.

The non-substitution of the work of art with reality is fundamental to start the process mentioned above, described by Bertram: the user called by the transcendent dimension, of the art, must somehow indulge in a path of understanding, the artist only predetermined that, but not defined in detail or the totality of the experience (Bertram, 2008).

There are, therefore, three fundamental points to conclude this brief description:

1 The concept of diffuse art, in which coexist episodes of environmental art (*Atelier*), or land art (*Fiumara*), and of performative art as a bond between the two types of experience (other initiatives).
2 The concept of art, understood not as a magisterium (the rooms do not contain precious elements that could enter a museum), but as a process since it is their unit that constitutes the real work.
3 The completion of the work of art thanks to the individual, who not only completes the work of art but is also completed, becoming himself a part of the aesthetic experience.

Aristotle said that in its diegetic component the art could represent reality in three different ways: as it is, as it is said or believed to be, or as it could be (Aristotele, 2008).

The effort of understanding is, therefore, like being stretched. On the one hand, the material reality that anchors the fellow to his corporeality, on the other hand, the aesthetic experience that would drag him up. In wanting to connect these two realities, in wanting to keep them together, in fighting with his/her own dualism, the fellow comes out better.

2. In the Hotel "Puerta America" in Madrid (2003-05) 18 international architects and designers were individually entrusted to design different parts of the building. Among the most famous: Jean Nouvel for the roof, the 12th floor and the facade; Zaha Hadid (1st floor), Norman Foster (2nd floor), David Chipperfield (3rd floor), Marc Newson (6th floor and bar), Ron Arad (7th floor), Arata Isozaki (10th floor).
3. Frank Gehry's "Biomuseo" in Panama (Amador Causeway, Panama City, 1999-2014), is a museum based on visual technologies and performative spaces. It describes the natural and cultural history of Panama.

BIBLIOGRAPHICAL REFERENCES

Abello, Juanpere, J. (1989). Presti: lo spazio e la permanenza. In: Apeiron, n° 0, p. 4-12. Messina: Ditis.
Aristotele. (2008). *Poetica* (Donini, P., Ed). Turin: Einaudi..

Benjamin, Walter. (1966). L'opera d'arte nell'epoca della sua riproducibilità tecnica. Turin: Einaudi.

Benjamin, Walter. (2012). *Aura e choc: saggi sulla teoria dei media*. Turin: Einaudi.

Bertram, Georg W. (2008). *Arte: un'introduzione filosofica*. Turin: Einaudi.

Carroll, Noeël. (2001). Four Concepts of Aesthetic Experience. In: *Beyond Aesthetics*. Cambridge: Cambridge U.P.

Eco, Umberto. (1983). Catottrica versus semiotica. In: *Rassegna*, n° 13, p. 15. Bologna: CIPIA.

Flusser, Vilém. (2004). *La cultura dei media*. Milan: Bruno Mondadori.

Friedman, Yona. (2003). *Utopie realizzabili*. Macerata: Quodlibet.

Kant, Immanuel. (2011). *Critica della facoltà di giudizio*. Turin. Einaudi.

Hegel, Friedrich. (2017). Estetica: il manoscritto della "Bibliothèque Victor Cousin". Turin: Einaudi.

Schisa, Brunella. (1990). Fiumara amara. In: *Venerdì di Repubblica*, 27 luglio, p.26. Milano: Ed. laRepubblica.

Considerations on the colours of Pompeii walls

Maria João Durão
CIAUD, Lisbon School of Architecture, Universidade de Lisboa, Lisbon, Portugal
ORCID: 0000-0002-3125-4893

ABSTRACT: The present considerations on the colours of Pompeii are carried out specifically in connection to colour application to walls: a research topic within the project "Colour Folds of Pompeii" developed at 'Laboratório da Cor at School of Architecture' and 'Research Group of Colour and Light' – University of Lisbon's Research Centre (CIAUD). The overall project investigates a multiplicity of colour sources that range from architectural elements, façades and reconstruction thereof, interior colours and house objects, outdoor and indoor settings, frescoes, sculptures, mosaic panels, pavements, ceilings, vaults, floorings and walls, clothes, technologies, materials, and broader cultural fields of knowledge.

This paper integrates architectural and pictorial settings concerning wall painted mural colours that were buried in the Mount Vesuvian eruption of 79 A.D. The uncovering of Pompeii provides testimony of a civilisation that did not change in almost two thousand years, therefore allowing for the rebuilding of Roman history and art. The excavations unveiled walls that offer an understanding of Pompeii culture and revealed their extraordinary wealth of colours.

The methodology adopted in the research study includes techniques of observation at Pompeii's archaeological site, and data gathering of documental sources, photographs and sketches drawn *in situ* and at *Museo Archeologico Nazionale di Napoli*.

Keywords: Pompeii, colours, painting, walls, frescoes.

1 HISTORICAL CONTEXT

The Greeks colonised Naples, naming it Neapolis (New City). ca. 650 B.C. and settled, or traded in Pompeii. By the fifth century B.C. the Italian Samnites ruled over Pompeii, but Rome defeated them ca. 302, and although from 91 to 89 B.C. Pompeii rebelled against Rome, its dominance was maintained under the Roman general Sulla. Many Samnitic families fled, and Pompeii was populated with Roman veterans, some becoming owners of Samnitic residences, rehabilitating and redecorating them.

The geographic position of Pompeii, situated alongside the river Sarno, granted wealth, obtained through the production of oil, wine, wool, millstones, fruit, *garum* (fish sauce), and tufa (a volcanic stone). This economic situation justifies to an extent the developments in town planning, engineering, architecture, painting, and sculpture, a Forum, as well as two theatres, four public baths with decorations of stucco on vaults and walls, ten temples and religious sanctuaries, an amphitheatre with a wide auditorium and external arches, seven brothels with painted sex scenes, workshops and shops along the streets and many frescoed houses with arcades, gardens, fountains, and even the pavements and wall mosaics.

In A.D. 62, Pompeii had suffered from a devastating earthquake, but it was the A.D. 79 Vesuvius eruption that buried Pompeii and the surrounding areas of the volcano. Completely submerged under ash and cinders, the 25.000 inhabitants and an area of 66 hectares disappeared from view.

Organised excavations of Pompeii began in 1748 during the reign of the Bourbon King Charles III of Naples, and with the return of Bourbon King Ferdinand I the same methods of excavations continued so that by 1860 much of the western part of the town had been revealed. From 1863 to 1875 Fiorelli directed the Pompeii excavations, introducing a new system according to which houses were uncovered from the top down, thus preserving some discoveries that were later used to inform the restoration of building interiors. However, many wall paintings and mosaics were stripped from the walls and gathered in Naples where they can be viewed at the *Museo Archeologico Nazionale di Napoli.*

Archaeologists such as Michele Ruggiero, Giulio De Petra, Ettore Pais, and Antonio Sogliano, adopted the excavation techniques used by Fiorelli and restored roofs of houses with tiles and wood to protect the fragile wall paintings and mosaics.

2 COLOUR SOURCES

Pompeii, as other towns buried by Vesuvius, grants direct contact with the ancient Roman society. The ancient texts speak of Rome and other big cities, thus limiting history since it is in places like Pompeii that we find authentic accounts of Roman society, left untouched.

The same applies to the evidence of colour. Remains of paint layers and materials were found as well as pigments in painters' workshops. An example of this is on show at the British Museum – six pottery bowls containing blue, red and yellow ochre, madder rose and white lead oxide used by a fresco painter in a Hawara, Egypt tomb during the first century A.D. (Durão, 2011).

The excavations of Pompeii unveiled a wealth of cultural information, including the arts of architecture, sculpture, and painting, as well as the pigments used. The English chemist Sir Humphrey Davy (1778-1829) wrote the first known document on the pigments found on the wall painting and the pots of pigments that were discovered in the same place where they were being used.

Davy's chemical analysis reveals equivalence to those referred in the treatises of Vitruvius (80-20 B.C), Pliny, the Elder (A.D. 23-79), and Dioscorides (A.D. 40-90).

Davy's findings were confirmed by many archaeologists, one of which E. Caley (1945). The pigments found by Humphrey Davy are: red ochre, realgar, cinnabar, burnt ochre, orpiment, yellow ochers, yellow lead, Egyptian blue azurite, indigo, terre verte, malachite, verdigris, purple, madder, kermes, carbon black and white.

These pigments were used in Egypt, Greece, and Rome. The knowledge of Egypt and Greece influenced Pompeii. This is not surprising because the Greek conquered Egypt in 323-330 B.C. during the Ptolemaic period. Rome was enriched by Greco-Egyptian practices and experiences and spread them through the Roman territory.

Delamare & Guineau (2000) claim that pigments and painting techniques used by artists were uniform throughout the Roman Empire:

> We find the same Alexandrian blue (later known as Egyptian blue), the same green earths, Almaden cinnabar (or vermillion), aragonite white, and yellow ochres in Brittany, Gaul, Romania, Scandinavia, the Near East, and North Africa. (Delamare & Guineau, 2000, p. 26)

They also name pigments used in Pompeii mural paintings such as in a wall painting found in the 'House of the Vetti'-rose madder lake, Alexandrian blue and cinnabar red (vermillion). Architectural elements were painted using rectangular compositions. Myths and landscapes were inset in coloured panels such as yellow ochre and red ochre (natural or by heating yellow

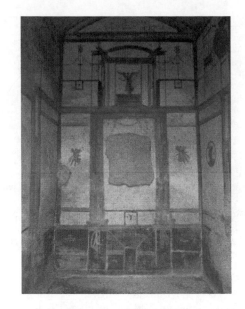

Figure 1. Pompeii archaeological site. Photo by Author.

ochre). Whites were also used on walls and came from calcium carbonates or clay, and carbon black.

3 EXTERIOR FAÇADE COLOURS

A very significant contribution to the understanding of colour use in Pompeii walls came from Vittorio Spinazzola, in 1910, whose excavation techniques led to the unveiling of structure and colours of the façade walls of Via dell' Abbondanza that crosses Pompeii from west to east, and private houses.

The main hypothesis of Karen F. Anter (2011) study of the colours of Pompeii is that the colour pattern shown in Via dell'Abbondanza is also valid for other Pompeiian streets, which she summarised as follows:

– The ground floor of the vast majority of facades is plastered and horizontally divided into two zones, the division most often placed 150–200 cm above the sidewalk.
– The lower zone is red for a majority of the facades, but can also be yellow, black or unpainted.
– Black and yellow lower zones tend to be used on more elaborate facades, including orthostats and/or marbling.
– The upper zone is whitish for the vast majority of facades, but patterned upper zones do exist. Houses with tufa facades or only exhibiting whitish plaster in *opus quadratum* are rare but do exist.
– The upper zone can include larger or smaller pictures of deities, heroes and suchlike. There are many painted messages on the facades.
– Street-shrine paintings tend to be placed in smaller alleys, near the crossing with a main street.

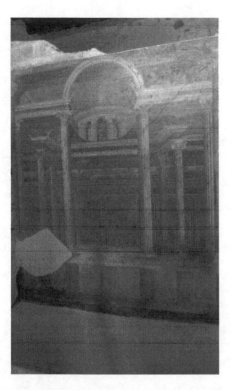

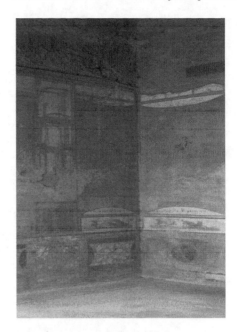

Figure 3. Pompeii archaeological site. Photo by Author.

Figure 2. Pompeii archaeological site. Photo by Author.

4 PAINTINGS OF INTERIOR MURALS

In 1882, August Mau created categories for Pompeian wall painting styles that are still used in the study of ancient Roman paintings. (Richardson, 1988).

The wall paintings in Pompeii were categorised in four styles. They were 'buon fresco', i.e., pigments applied to wet plaster, fixing them to the wall. Mau's categorisations were based on the way the painter organised the wall dividing it and using the paint, the colours, image content, and the overall perception of the surface.

The first two were used in the Republican period, ending in 27 B.C. and influenced by Greek art. The second two styles were adopted in the Imperial period.

August Mau called the First Style the "Incrustation Style" originated in the Hellenistic period during third century B.C. in Alexandria. Walls of painted faux-marble characterise the First Style.

In temples and other official buildings, Romans used imported expensive marbles for the decoration of walls of religious and official buildings. However, most could not afford them and instead decorated their homes with yellow, purple, and pink imitating marble.

Rectangular slabs were painted realistically with the colours and veins of marbles.

The Second style, or "Architectural Style," after August Mau, appeared in Pompeii ca. 80 B.C. and used

until the end of the first century B.C. The faux marble blocks along the base of walls were still in use from the First Style, these are quite different, mainly because the Second Style enlarged spatial depth walls with perception illusions with drawings of architectural elements, sometimes intensified with many vanishing points, in such a way as to manipulate the experience of perspective and make the observers' point of view dynamic.

The Dionysian paintings from Pompeii's Villa of the Mysteries are also included in the Second Style because of their illusionistic aspects. The fact that the figures are megalographic, i.e., life-size and the way they sit in front of the columns surrounds the viewer and pulls the viewer inside the represented acts and actions.

The predominant pigment used to paint the frieze was cinnabar vermillion (sulphide of mercury).

The Third Style, or "Ornate Style," named by August Mau, is from the beginning of the first century B.C. and manipulated the wall using broad, monochromatic planes of black or dark red, and minute details.

The Third Style contained architectural representations but also incorporated columns and pediments painted in a stylised fashion based in the imagination of the artist.

Vitruvius was particularly critical of these paintings for representing reeds instead of columns, or leaves, instead of pediments, volutes growing up from the roots with human figures on the top. Other scenes include the countryside, temples, shrines, hills or shepherds depicted on the centre of walls. This was also the

Figure 4. Pompeii archaeological site. Photo by Author.

period that introduced Egyptian imagery, and motifs such as deities and the Nile.

The Fourth Style that August Mau names the "Intricate Style." Pliny the Elder considered it to be developed by Famulus, the same painter who decorated Nero's famous Golden Palace.

This style began in the mid-first century A.D. and combined the other three previous styles. Faux marble blocks along the base of the walls (as in the First Style) frame the architectural scenes (from the Second Style) that interact with the largescale planes of colour and details (from the Third Style). The Fourth Style also incorporates central panel pictures, although on a much larger scale than in the third style and with a much wider range of themes, incorporating mythological, genre, landscape and still life images.

5 CONCLUDING REMARKS

Colours from antiquity very rarely survive since the medium used is fragile and hence not durable, but the eruption of Vesuvius preserved the paint and colours of Pompeii. For conservation and restoration reasons,

one-third of the territory has not yet been excavated to date, but in the last 270 years, Pompeii has gradually been unveiled and colours revealed. Even so, the recent discovery of 'Leda and the Swan' opens up new avenues of colour research and understanding.

This paper does not deal with colour sources such as mosaics and tiles, although they contribute to the chromatic atmosphere that is sensed on site. The Author intended to bring forth sources of colour of great harmony and beauty, which helped shape harmonic palettes that can be seen at the exhibition of drawings and paintings. These palettes highlight the aesthetic phenomena of relationships and interactions encountered on surface material colours and take into account colour pattern, rhythm, dynamism, repetition, affinity, contrast, and unity as harmonic characteristics.

The presentation of this study is shaped to complement the exhibition of drawings and paintings: 'Pompeii colours and materials' on show at the same venue and provides research support for the author's artwork on show at the exhibition on Pompeii at *Museo Archeologico Nazionale di Napoli*.

BIBLIOGRAPHICAL REFERENCES

Anter, Karen F. (2011) Colour in the Pompeiian cityscape. In Weilguni, M. *Streets, Spaces and Places. Three Pompeiian Movement Axes Analysed. Acta Universitatis Upsaliensis. Boreas*. Uppsala Studies in Ancient Mediterranean and Near Eastern Civilizations.

Caley, E. (1945) Ancient Greek Pigments from the Agora, *Hesperia, Journal of the American School of Classical Studies at Athens*, 14, (2), Apr-June, 152-156.

Davy, Sir Humphrey. (1815) Some Experiments and Observations on the Colours Used in Painting by the Ancients. *Philosophical Transactions*, January 105, 97-105.

Delamare, F. & Guineau, B. (2000) *Colour: Making and using dyes and pigments*. London: Thames and Hudson.

Dioscorides, Pedanius. (1933). *De Materia Medica* (1st century A.D. Published in English translation by John Goodyear, London, 1655. Modernised by Robert T. Gunther). London.

Durão, M. J. (2011). Der Raum der Einbildungskraft: Der Visuelle und der Phänomenale Gedanke, *Studia Universitatis Babes-Bolyai – Philosophia*, 2.

Pliny the Elder. (1952) *Natural History*. Cambridge: Harvard University Press.

Richardson, Jr. L. (1988). *Pompeii: An Architectural History*. Baltimore: Johns Hopkins University Press.

Vitruvius. (1960). *The Ten Books on Architecture*. New York: Dover Publications.

Pictorial (re-) creations: From the fourth Centenary of India (1898) to Expo'98

Maria João Castro
CHAM, FCSH, Universidade NOVA de Lisboa, Lisbon, Portugal
ORCID: 0000-0003-1443-7273

ABSTRACT: This paper aims to map out the artistic output – particularly painting – produced within the context of the great 20th century exhibitions organised to commemorate the Portuguese colonial empire. Chronologically bounded by the 4th centenary of the discovery of the maritime route to India (1898) and Expo'98, this series of transnational events owed much of its success to the creativity and fantasy of the Portuguese artists that participated in it, most of whom had never left the metropole to visit the overseas territories far away. Thus, most of the paintings commissioned were created indirectly from photographic, graphic or literary sources, which served as inspiration for a (re-) creation of a colonial experience that was more idealised than real. For the population of Lisbon and the foreigners that visited it, these pictorial representations generated an unusual image of the overseas possessions, which could be used by the political power as a vehicle of propaganda. Hence, the triangle Creativity-Fantasy-Intelligence became the matrix from which the right-wing dictatorship defined a whole ideological-artistic strand, often very successful and within limits that we know.

Keywords: Art, Colonial Empire, Painting, Exhibitions.

1 THE 4TH CENTENARY OF THE DISCOVERY OF THE MARITIME ROUTE TO INDIA

It is a well-known fact that colonialism was a structuring element of Portuguese history, and another well-known fact is that art transcends geography. Hence the contemporary era has witnessed a growing commitment to the holding of exhibitions, which has reconfigured visual culture at a transnational level as was shown in the previous sub-chapter.

The emergence of modern colonialism at the start of the 20th century created a new rhetoric of imperial propaganda that enjoyed its own cartography in exhibition representations by classifying the artistic culture of the mother-country (or administrating power) from a Lusocentric perspective that increasingly became transformed into a pluricontinental, multiracial view albeit one remaining within the limits we now know.

The event that announced the winds of change that the 20th century would bring was the event held in 1898, which commemorated the 4th Centenary of the Discovery of the Maritime Route to India. The "Pearl of the Orient" described in Camões' verses was the pretext for the first major national event in terms of imperial commemorations although there had already been other earlier exhibitions such as the 1865 Porto International Exhibition[1] or the 1894 Portuguese Insular and Colonial Exhibition.[2] Neither had included any colonial artistic representation though.[3]

Fin-de-siècle Portugal was going through a troubled period (the 1890 *Ultimatum* and the problematic issue of Portuguese interests in Africa, the scepticism of the ruling elites as well as a financial, political and

1. The *Exposição Internacional do Porto* [Porto International Exhibition] was the first to be held in the Iberian Peninsula. The exhibition was mounted in the Crystal Palace (demolished in 1951) and officially visited by the king, D. Luís. There were 3,139 exhibitors, of whom 499 were French, 265 German, 107 British, 89 Belgian, 62 Brazilian, 24 Spanish and 16 Danish, and there were also representatives from Russia, Holland, Turkey, the United States and Japan. With this event, the Portuguese public had the opportunity to observe foreign products, especially art. France mostly displayed the official painting of the *Salons*, ranging from Eugène Boudin (1824–1898) to Théodule-Augustin Ribot (1823-1891), and paid tribute to Tomás da Anunciação by awarding him the medal of honour in the Fine Arts section.
2. The event commemorated the 5th centenary of the birth of Infante D. Henrique.
3. The commemorative dimension of the Discoveries had been explored from the 300th anniversary of the death of Camões (1880) to the already mentioned birth of Infante D. Henrique (1894).

moral crisis). The commemorations had an implicit political dimension and were seen as a bid to restore the nation's power by reaffirming its imperial greatness. The commemorations officially began on 8 July 1897 with the inauguration of the Lisbon Geographical Society's (SGL) new headquarters and the Colonial Ethnographic Museum. The SGL organised the event and publicised by royal decree. Its significance was based on evoking both historical and mythic memory as well as the epic figures of the Discoveries through the first maritime voyage of the Portuguese to India and Vasco da Gama, the navigator responsible for this. Moreover, the support that was most commonly chosen to show the numerous events that took place at the time, as well as the extremely varied means employed, was art.

The diversified programme that had been proposed ended up foundering through a lack of funds and the availability of suitable premises, although a Free Fair and an Exhibition of Traditional Industries and Customs were set up on the land at the top of the Avenida (today the Marquês de Pombal roundabout and surrounding area). The Fair opened with "two artistic stands", one of which was a 7-metre high elephant inside which objects and themes related to India were exhibited and presented by genuine Indians.

One point of interest is that some typical native huts were erected and a group of Africans who were brought over especially for the celebrations were exhibited in what was certainly the first display of indigenous people from the colonies – they came from Cape Verde, Guinea, Mozambique and Portuguese India, although the latter group arrived so late that they did not take part in the civic procession.

Commemorations were held throughout Portugal, spreading into the provinces to promote a veritable evocation on a national scale in order to perpetuate the cult and projection of the nation's inclusive and unitary memory.

Despite all this colonial representation, no-one thought to include any display of paintings associated with the publicised theme. There were, of course, other exhibitions of a less popular nature and the one organised by the *Grémio Artístico* [Artistic Guild] is notable as it presented a sampling of contemporary Portuguese art. José Malhoa presided over the jury, which was tasked with selecting and classifying the 246 works exhibited by artists such as Columbano, Roque Gameiro, José Malhoa, Carlos Reis, Veloso Salgado and Sousa Pinto. Not surprisingly, no colonial paintings were included which showed that, between India's zestful spiciness and the metropole's insipid blandness, a colonial silence crept in – such silences did not overlap although they did touch.

The first Portuguese colonial exhibitions took place outside the country, that is, in the overseas territories: the first Portuguese colonial exhibition was held in Goa (1860), followed by one in Cape Verde (1881). The first one to be held in the metropole though was the First Portuguese Colonial Exhibition which took place in Porto in July and August 1934. Following the model of similar exhibitions, and akin to what had happened in Marseille (1922), Antwerp (1930) and Paris (1931), the location chosen divided the event between an enclosed covered space (the Crystal Palace) and the surrounding open-air area which allowed the "parts" of the empire to be shown. The event was intended to be the first major act of colonial propaganda that would put into practice and render the policy underlying the 1930 Colonial Act visible and show off the vast pluricontinental empire. The technical director was Henrique Galvão,[4] the author of the catchphrase "Portugal is not a small country". This was printed on a map that would become the exhibition's main symbol but also the symbol of an era since it was reproduced over and over again and hung on the walls of classrooms all over the country.

The official bulletin of the event was *Ultramar* [Overseas], which was edited by Henrique Galvão who also co-authored the Exhibition's *Álbum-Catálogo Oficial* [Official Album-Catalogue]. In the exhibition space indigenous villages from the various colonies were reproduced, a zoo housing exotic animals was set up, replicas of overseas monuments were built, and hundreds of exhibitors from both the metropole and the colonies attested to the empire's entrepreneurial dynamic.

What is particularly interesting is the Colonial Art Competition that was held as part of the event and which included a section for painting.

As known, the painting that Henrique Galvão considered to be the "First Great Work of Portuguese Colonial Painting" would become a double metaphor for Portuguese colonial painting. First of all, it was never finished (and the intended triptych ended up as a diptych). This shows the vicissitudes of the importance given to art and painting as the standard bearer for colonial representation. The second point concerns the fact that it is a staged image in which the expressionless faces are clearly the result of a staged theatricality that came from the plastic idealisation of an artist who had never travelled to the empire so that the work – even if it had been finished – could never reflect the actual reality born of experience overseas. The artificiality of his painting results in a series of stylised stereotypes that are nothing more than a mythic and pretentiously exotic view of a certain 'Portugueseness' in the world.

Related to the above is the information provided in numbers 15 and 16 of the review *Ultramar* (N°15, 1

4. A military officer with experience of colonial affairs. He was the director of the Colonial Products Fairs and, in this role, had represented Portugal at the 1931 Paris Colonial Exhibition. Since March of the same year he had edited the review *Portugal Colonial*, and later was responsible for the colonial section at the 1940 Great Exhibition of the Portuguese World. All of this of course was before he became one of the regime's most newsworthy dissidents.

Set. 1934, p. 7) where the list of exhibited artists and works is published:

- Abel de Moura – *Cabeça Negra* [African Head], *A Porta da Cubata* [The Hut Door];
- Abeilard de Vasconcelos – *Paisagem de S. Tomé* [São Tomé Landscape];
- Alberto de Sousa – *Cabeça de Índio* [Head of an Indian], *Coronel Côrte Real* [Colonel Côrte Real], *Dungula-Mulher do Soba de Quipungo* [Dungula – Wife of the Chief of Quipungo], *Sibila* [Sybil];
- Jorge Barradas – *Lavadeiras do Rio de S. Tomé* [Washerwomen in the São Tomé River], *Habitação de Negros* [African Housing], *Perto do Obó* [Near Obó], *No Mato* [In the Bush] (all from São Tomé);
- José Luís Brandão de Carvalho – *Bobo Negro* (tipo bijagós) [African Court Jester from Bijagós];
- Manuel Guimarães. *Negra* [Negro Woman];
- Maria Amélia Fonseca Roseira – *Vista do Pico de S. Tomé* [View from São Tomé Peak], *Cápsulas de Cacau* [Cacao Pods] (still life);
- Maria Noémia de Almeida e Vasconcelos – *A Sabina-Angola* [Angolan Savin];
- Ventura Júnior – *Manipanços [Fetiches]* (still life);

The following were listed under the category of drawing:

- Alberto de Sousa – *Tipo Indiano* [Indian Figure], *Dungula, Sibila* [Sybil], *Tipo Macaista* [Macau Figure], *Congo-Dançarino Tipo Bijagós* [Bijagós Congo-Dancer], *Concerto Macaense* [Macaense Concert], *Tipo Mucancala* [Mucancala Figure], *Tipo Mucancala* (2) [Mucancala Figure 2], *Coronel Côrte Real* [Colonel Côrte Real];
- Armando Bruno. *Sinfonia Negra* [Black Symphony];
- Fernando de Oliveira – *Desenho [Drawing]*
- Maria Noémia de Almeida e Vasconcelos – *Xeque Amand Agi Abdul Reim Hakmi* [sic];
- Octávio Sérgio. *Raça Fina* (Guiné) [Figure – Guinea], *Soba da Guiné* [Guinean Village Chief]

In addition to the works in this list, there were a pair of canvases by Jorge Barradas and a reproduced image of a panel by Ventura Júnior, which in the end was little for an exhibition that was named the First Portuguese Exhibition of Colonial Art.

What the Porto exhibition unmistakably showed was how it was impossible for there to be any multicultural artistic dialogue between the metropole and the colonies; in fact, the exhibition was based on a monologue of the coloniser's civilisational supremacy that showed an anachronistic and reductive cultural-artistic stance that was, however, in perfect harmony with the whole colonial policy advocated by the government. Above all else, the exhibition laid out the path the *Estado Novo* intended to follow in relation to painting – colonially-inspired plastic experimentation that would not be based on any actual experience of the overseas territories but rather on the recreation and stylisation

of stereotypical elements of what the colonies and their artistic culture were thought to be.

2 EXHIBITION OF THE PORTUGUESE WORLD, LISBON, 1940

To commemorate the double centenary of the Foundation of the Portuguese Nation and the Restoration of Independence (1140 and 1640 respectively), the *Exposição do Mundo Português* [Exhibition of the Portuguese World] was held in Lisbon in 1940. It was concentrated in the area around Belém, the imperial quay from which the first Portuguese navigators had set sail to explore the world.

In the context of art and travel in the Portuguese empire, some emblematic pavilions should be considered. The Pavilion of the Portuguese in the World, designed by Cottinelli Telmo, the chief architect of the whole exhibition, shared the space in the Praça do Império with the Pavilion of Honour designed by Cristino da Silva. Its façade was crowned by a heraldic frieze showing the coats of arms of the Castro, Gama, Albuquerque and Cabral families while inside was a journey via a *mappa mundi* through the history of the Portuguese people in an image of sovereignty that invoked its former dominions. There was also the Pavilion of the Discoveries which recreated several milestones in the 15th and 16th-century voyages, with the most vibrant feature being a huge Sphere of the Discoveries which crowned the architectonic body of the building. Inside the Pavilion there was a huge open circular room whose scenographic effects lit up the routes taken by the caravels. Two other pavilions were the Colonisation Pavilion and the Pavilion of Brazil, the only (former) Portuguese colony with the right to its own building.

However, most of the overseas-related aspects, particularly regarding painting, were to be found in the Colonial Section, one of the thematic sections into which the exhibition was divided. This was set up in the Colonial Garden[5] and was organised by Henrique Galvão. Inaugurated on 27 June 1940, it was a sort of annexe to the main exhibition covering an area of some 50 000 m². Access was via a ramp located in the northeast corner of the exhibition. Here the characteristic architecture of each of the overseas provinces was recreated, and even indigenous villages were installed (as in earlier international and/or colonial exhibitions) to recreate the habitats of the people in Cape Verde, Guinea, São Tomé, Angola, Mozambique and Timor.

The entrance led to the Rua da Índia in a composition suggested by Indo-Portuguese architecture. Bordering the street were the Pavilion of Guinea, the Pavilion of the Island Colonies (São Tomé, Cape Verde

5. Today the *Jardim Agrícola Tropical* [Tropical Agricultural Garden], but previously called the *Jardim do Ultramar* [Overseas Garden].

and Timor) and the Pavilion of Indigenous Art, where the most representative works of African and Oriental art were on show. The largest exhibition areas were the Pavilion of Angola and the Pavilion of Mozambique, but there was also enough space for the Rua de Macau, which recreated a street in this Portuguese city in China and was accessed by way of an arch.[6] In addition, serving as an observation platform, there was an elephant made by António Pereira da Silva, which was a copy of an anonymous bronze from Indochina.

The Avenue of Colonial Ethnography displayed sculpted reproductions of the most characteristic heads of races and tribes from the empire based on photographic documentation provided by the Institute of Anthropology in Porto.[7] And surrounding all these buildings was the garden's exuberant African and oriental flora that lent the final exotic touch necessary to recreate Portugal's African and Asian territories.

One thing worth noting is that the Colonial Section counted on the participation of numerous artists who helped to "add colour" to this overseas scenario. They included such names as Fausto Sampaio (referred to in detail in the previous chapter) but also the painter M. A. Amor who exhibited a series of paintings of Goa, Daman, Diu, Chaul, Malacca and Macau in the Pavilion of India. A note appended to the text in the Colonial Section inventory said that the paintings could be bought at the prices published in the catalogue but could only be taken away after the end of the event.

Inside the Pagoda, on the Rua de Macau, there were paintings by the Chinese artist Chiu Shiu Ngong, who had already exhibited at the International Colonial Exhibition of Antwerp (Belgium) in 1930 where he had been awarded a gold medal. In Lisbon, Ngong exhibited forty-two pictures which were on sale at 50 patacas each.

The Colonial Section also enjoyed the collaboration of Maria Adelaide, Mário Reis and Roberto Araújo, painters who undoubtedly helped to crystallise the conservative and conventional taste that put an end to any initial attempt to establish a modern colonial pictorial genre.

Henrique Galvão's idea behind the edification of a Colonial Section was to create a School of Portuguese Colonial Art from this core group of artists whom he had brought together. However, this idea got no further than being an intention, just like so many others had been in the past and would be in the future. And, in a certain way, this is what Adriano de Gusmão refers to in an article in the newspaper *O Diabo* (16.11.1940: 1) when he says that the paintings on display in the exhibition led him to have certain reservations and the artists had wasted an excellent opportunity to launch themselves into a type of painting that would open

up new perspectives for the future. In other words, there was nothing new pictorially and the paintings exhibited were, on the whole, extremely poor. Gusmão discusses the work of some of the artists present, such as Lino António, who painted a mural depicting different types of long-haul vessels that was displayed on the walls of the D. Afonso V room in the Pavilion of the Discoveries. He also mentions the following artists: Jorge Barradas, creator of a frieze drawn in sanguine depicting the leading female figures in the history of Portugal, which decorated the Reception Room in the Pavilion of Honour; Eduardo Malta, who painted a panel in the Pavilion of the Portuguese in the World that depicted a series of religious figures but which "had no value at all"; Manuel Lima, the author of a panel for the Oceania Room; Almada Negreiros, who exhibited several paintings and especially a modern *Camões* that made Gusmão indignant as he considered it an "insult" to the memory of such a great poet. The disappointment caused by the 'colonial' paintings exhibited also extended to the *Exhibition Guide* itself, which was poor and not very informative. It did not name the artists whose paintings decorated the various pavilions, indicating how little importance was given to such an easily understood form of visual art.

What is also important to mention is that on the occasion of the *Festivities Commemorating the Double Centenary of the Foundation of Portugal and the Restoration of Independence*, an "Art Exhibition" was held in the Vasco da Gama Institute in Nova Goa from 5 to 15 October 1940. This was one of the few (if not the only) satellite events organised outside the Metropole when the exhibition was on in Belém. This exhibition decentralisation sought "to stimulate the artistic vocation of the children of India",[8] the Indo-Portuguese artists. The pictorial sections in the Nova Goa event were for oils, watercolours, pastels and works done in crayon, but other arts such as sculpture, photography, jewellery, bookbinding, and printed and painted textiles were represented as well.

3 EXPO'98

If the 1934 exhibition in Porto and the 1940 one in Lisbon showed how the empire was projected from the inside, it was the exhibitions held in the overseas territories that showed how the empire was viewed from the outside.[9] However, these two complementary views were brought together by the 1998 World Exhibition, officially named the *1998 International Exhibition of Lisbon*, held at a time when the empire had already vanished. Almost fifty years after the 1940

6. Still present today in the *Jardim Agrícola Tropical*.
7. The Institute still retains this documentation today.

8. *Programa da Exposição de Arte*, Instituto Vasco da Gama, Nova Goa, Tipografia Rangel, 1940, p. 3.
9. Thematically, this topic is related to the trips made by the Heads of State to the overseas territories so will be dealt with in the following sub-chapter.

event organised by the Estado Novo, on the banks of the same river that had watched the 16th-century caravels set sail although further upstream from Belém, Lisbon celebrated the 500th anniversary of the Portuguese Discoveries on a global scale but reconfigured in the light of postcolonial studies. The theme was "The Oceans: a heritage for the future", and in different ways, the colonial past continued to be present in the postcolonial context but now revisited in the light of late 20th-century multiculturalism.

Within the mythic opulence of the revisited empire and on the threshold of the new millennium, international expositions functioned as a means to spread and mediate culture and art – a worthy objective they still maintain today. Expo'98 was undoubtedly a great moment to disseminate knowledge about Portugal internationally, highlighting its glorious past with its navigators and viceroys as well as its extremely modern present and future.

As far as the arts, and painting in particular, are concerned, the 1998 event led to pictorial miscegenation that had been impossible to achieve up until then in Lisbon, the capital of the Discoveries, not because no occasion to do so had presented itself but because the context had not been propitious. But neither in fact, did the context of Expo'98 manage to update the epic of the Discoveries through another epic – the oceans and cultural encounters. Even so, the results exceeded those of earlier experiences.[10]

As for the former Portuguese colonies, they decided to exhibit indigenous art in their pavilions and show no record of the colonial "era", thereby adopting a simultaneously anti-colonialist position and independentist. They refrained from denouncing the obstructive nature of the power exercised while under Portugal's imperial yoke, preferring instead to highlight a form of art that was the legacy of the tribes who had first inhabited the territory.

For the population of the metropolis (and the foreigners that visited it), these pictorial representations generated an unusual image of the overseas possessions, which could be used by the political power as a vehicle of propaganda. Decorating these realities, the art of indigenous cultures (referred to as savage and/or primitive) or distant ancient civilisations served above all to emphasise the superiority of the metropole in relation to the overseas territories and to assuage the curiosity shown by western culture for faraway possessions. But, more than just "showing" the exotic and the foreign, it had to "appear to be" as T. Vijayaraghavacharya, commissioner of the India Section

at the 1924 British Empire Exhibition, said: "What the public wants to see of India is what *appears to be* Indian, more than what *is* Indian".[11] It was the invention of a condition that rarely corresponded to reality, the myth of the West in the face of almost unknown and consequently undervalued cultures.

In conclusion, there was no actual need to make national artists travel to the colonies. To create a convincing image all it took was their creativity and imagination to idealise and stylise a pictorial representation that not only suggested but also influenced and determined the view that was held of the Portuguese colonial empire. The *Estado Novo* was intelligent in that it appropriated these representations and used them as a vehicle for propaganda, thus helping to legitimate the image of the great overseas empire.

Hence, the triangle Creativity-Fantasy-Intelligence became the matrix from which the right-wing dictatorship defined a whole ideological-artistic strand, often very successfully.

ACKNOWLEDGEMENT

This chapter had the support of CHAM (NOVA FCSH/UAc), through the strategic project sponsored by FCT (UID/HIS/04666/2019).

BIBLIOGRAPHICAL REFERENCES

(1934). *Álbum-catálogo oficial da Exposição*. http://heme rotecadigital.cm-lisboa.pt/RaridadesBibliograficas/OImp erioPortugues/OImperioPortugues_item1/index.html

(1934). *Ultramar*, N.º 15, 1 Set. 1934, N.º 16, 15 Set. 1934.

(1940). Catálogo da Exposição do Mundo Português, Secção Colonial. Lisboa: Neogravura.

(1998). Portugal. Quando o Atlântico encontra a Europa. Lisboa: Expo'98.

Bordaz, Robert. (1983). *Le livre des expostitions universelles 1851-1989*. Paris: Éditions des arts décoratifis.

Carmo, José Pedro do. (1943). *Evocações do Passado*. Lisboa: Tipografia da Empresa Nacional de Publicidade.

Findling, John. (1990). Historical Dictionary of World's Fairs and Expositions, 1851–1988. Connecticut: Greenwood Press.

Galvão, Henrique (1934). *Portugal Colonial*, N°. 45, Nov. 1.

João, Maria Isabel. (1998). As Comemorações do Centenário da Índia in O Centenário da Índia 1898 e a memória da viagem de Vasco da Gama. Lisboa: Comissão Nacional para as Comemorações.

Telo, António. (1991). Lourenço Marques na política externa portuguesa 1875–1900. Lisboa: Cosmos.

10. It is interesting to mention here the *XVII Exposição Europeia de Arte, Ciência e Cultura*, held in Lisbon in 1983, subordinated to the theme *Os descobrimentos Portugueses e a Europa do Renascimento* [The Portuguese Discoveries and Renaissance Europe] which only included history painting whose themes were based on the Portuguese Discoveries. Once again the opportunity for a more wide-ranging show that included painting in a colonial context was lost.

11. T. Vijayaraghavacharya, cited by Filipa L. Vicente "Exposições coloniais na Índia Portuguesa e na Índia Britânica (séculos XIX e XX), Revista *Oriente*, N.º 8, Lisboa, Fundação Oriente, p. 80.

Creativity and the observer

Ana Leonor M. Madeira Rodrigues
CIAUD – FAUL, Lisbon School of Architecture, Universidade de Lisboa, Lisbon, Portugal
ORCID: 0000-0002-9749-3475

ABSTRACT: Artistic creativity is composed by a trio creator/work/observer. The text will look upon the observer as the one that transforms the created object into an artistic achievement.

Keywords: Observer, creativity, nature, communication, art

It is not true that one writes for oneself. That would be the worst blow. In projecting his emotions on paper, one barely manages to give them a languishing extension. The creative act is only an incomplete and abstract moment in the production of a work. If the author existed alone he would be able to write as much as he liked; the work as object would never see the light of day and he would either have to put down his pen or despair. But the operation of writing implies that of reading as its dialectical correlative and these two connected acts necessitate two distinct agents. It is the conjoint effort of author and reader which brings upon the scene that concrete and imaginary object, which is the work of the mind. There is no art except for and by others. (Sartre, 1988, pp. 51–52)[1]

Communication is established by a trio of a speaker/what is communicated/a listener, and whatever the level of relationship between the parts with the aim of transmitting something, is reducible to this simplicity.

In the book *What is Philosophy* and when thinking about what is the concept of the other person, Deleuze and Guattari say

> The Other Person is always perceived as an other, but in its concept it is the condition of all perception, for others as for ourselves. (Deleuze & Guattari, 1994, p. 18)

1. "Il n'est donc pas vrai qu'on écrive pour soi-même: ce serait le pire échec; en projetant ses émotions sur le papier, à peine arriverait-on à leur donner un prolongement languissant. L'acte créateur n'est qu'un moment incomplet et abstrait de la production d'une œuvre ; si l'auteur existait seul, il pourrait écrire tant qu'il voudrait, jamais l'œuvre comme objet ne verrait le jour et il faudrait qu'il posât la plume ou désespérât. Mais l'opération d'écrire implique celle de lire comme son corrélatif dialectique et ces deux actes connexes nécessitent deux agents distincts. C'est l'effort conjugué de l'auteur et du lecteur qui fera surgir cet objet concret et imaginaire qu'est l'ouvrage de l'esprit. Il n'y a d'art que pour et par autrui." (Sartre, 1948, pp. 49–50)

Communication takes place in a cosmos, an organised entity we are part of and believe exists, but previously, we may consider that existence exists because there is an observer. Any possibility of existing, so that it may exist, requires the presence of the one that observes it.

Here the self is a step before the other. Something happened, I see it, but in order that the self becomes, I need it to be observed so "the condition of perception" is established.

To perceive the world that is presented to us and to be able to relate to those perceptions in our brain, we need some order some categorisation that enables the possibility of stabilising information and compare to the eventuality of others to have similar data.

> We require a little order to protect us from Chaos. (Deleuze & Guattari, 1994, p. 201).

In the final chapter of the book, Deleuze and Guattari propose an understanding of knowledge as three planes, which intersect chaos bringing slightly different disturbances from the land of the dead: the philosopher would bring variations, the scientist would bring variables, and the artist would bring varieties.

So here we not only have the individual combination of perceptions, affections, and concepts in the brain, we also are before a *limine*, a threshold between order and disorder were creativity blooms.

Creativity is a characteristic of nature, in general, although humans up-levelled it to a plane that outpaces natural processes turning it into an almost definition of what is to be human.

Creativity, from the Latin *creare* – the ability to make new things-, is also the capacity of finding new solutions to old or new problems.

Every time an organism discovers a solution to a new challenged, and how to surpass it, means it becomes creative in the sense that it created from nothing a new possibility.

One definition of creativity may be the new, even unique, combination of existing data. However, the

result of this combination needs to be transmitted to another organism, so it becomes useful and does not get lost, and in this way improves the performance of others.

Knowledge works in very similar ways whether it is gathered in macroscopic or in microscopic ways: a new creation/solution that needs to be transmitted.

In more complex organisms, knowledge and its transmission became an ever more elaborate construct of data, which acquired a level that transformed itself into an almost parallel cosmos of communication, Art.

We are before a new trio, as the self, became a creator, the observed object became a creation, and the observer (although some name him spectator) continues in its omnipresence of observing and of creating the possibility of any existence including that of the other two.

The first puzzlement is that the observer is not just a validator of existence and a gatherer and transmitter of data. He is not a passive entity at whom information and communication are aimed. He is not a neutral entity that accomplishes his actions and disappears.

The observer is interference.

The simple act of observing becomes interference upon the perceived, at any level or with anything.

> In a study reported in the February 26 issue of *Nature* (Vol. 391, p. 871–874), researchers at the Weizmann Institute of Science have now conducted a highly controlled experiment demonstrating how a beam of electrons is affected by the act of being observed. The experiment revealed that the greater the amount of "watching," the greater the observer's influence on what actually takes place. (Weizmann Institute of Science, 1998).

Time, accidents, qualities, otherness, everything is rooted in the possibility of being observed and thus becoming.

Not only the entity I named creator establishes a possibility of something new but also the observer in her/his simple act of observing participates in the characterisation of the perceived.

If we are nature, and if we have a will to act and a conscience to reflect on the actions or what surrounds us, it may be that Nature itself could also have an intention or a longing of being observed. We, humans, are the reflexive possibility of Nature.

Somehow Nature evolved and created a being (we name human) who defines her/himself as an observer, with the reflexive ability to marvel at its achievements.

But before let me watch the observer, looking and perceiving everything, allowing the outside world as well as the activities inside him/herself to impress several areas of the brain and the mind and seeing that there is another one alike, looking at him/her creating the reality of his/her existence as well as the link of communication.

When I look at a drawing and identify it as an image, as a drawing as well as the representation of

Figure 1. Albrecht Dürer, Rhinoceros, woodcut, 1515. Wikipedia. National Gallery of Art, Washington.

something, I activate several processes, which enable me to represent it in my brain.

I pick the cues that by accident, my senses acknowledge: the material object, the lines of the drawing itself, eventually (or primarily) what it represents. But also I identify what my will or randomness decides to perceive so that what I observe at the moment that I look at the drawing is a particular mixture of perceptive accidents that enable my brain to see the picture and then, maybe, also, to experience it as an object of pleasure, perhaps of aesthetic pleasure.

Some other observer, looking at the same drawing, will accomplish equivalent perceptions and actions, although micro differences and decisions of the subject may determine a completely different relationship to that object.

This image is not there before my eyes, observed for the first time; to my observing, we need to add to all my perceptions all the past perceiving made since it exists, the interference all those observations did and only then may we consider the object in question.

Until around the end of the eighteen century, this image was considered a good representation of a rhinoceros. Durer did this drawing made solely on descriptions, as he never saw one in his life. The animal was brought to Europe and offered to King Manuel I of Portugal, where a fight between an elephant and the rhinoceros took place, following the descriptions in *The Natural History* of Pline (vol. 2, chap. 29 (20), then it was sent as a present to Pope Leon X. The animal died in the journey as the ship sank, and all that was left were descriptions of the formidable creature. Based on one of those descriptions and Pline's *Natural History*, Dürer draws the image that, for many years was considered a rigorous representation of the beast.

Drawings of rhinoceros and this fight exist, and all repeat the kind of image Dürer did in the first time as we may see in an engraving by Francis Barlow from 1685.

Before this drawing was made, it already has a story that will later integrate its existence. Throughout

times it had many observers, some acquainted with the almost mythical facts, some naively thinking they were looking at the representation of the real thing, some, in later times were the rhinoceros became familiar, amused or fondly considering it as just a drawing made by Durer, and the list of possible observers goes on, unendingly.

So this simple drawing, whether we are aware of it or not, contains every observation made upon it, with the load of knowledge or candour the observer brought into its existence.

If such an observer's composition completes the image drawn by Dürer and a drawing that had mostly the aim of being an "as true as possible" representation, the complexity of the creation of the observer increases, as well as the levels of complexity of the work, also increases.

We may say when looking at a drawing:

What the eyes see challenges our brain to experience physically, gestures and actions that we cannot actually do, but which we can nevertheless identify in the absolute sense of recognising in our own body what actions and gestures were necessary to result in the lines we see.

We identify what the lines in a drawing mean, what they represent – not some chaotic or ordered marks.

We perceive what we want to understand, but we can also experience pleasure / aesthetic emotion in this perception. (Rodrigues, 2003, p. 29)[2]

When dealing with the observation of an artistic object, and particularly when experiencing it as an artwork, we are entirely a part of the observed in the sense of Cézanne "Man absent from but entirely within the landscape".

The creator, the creation and the observer are an inseparable trio that makes the whole process viable. One cannot exist without the other, one is the same with the others, and like the poem of the Chinese poet Wang Wei called Painting:

The sky did not clear completely after the rain
 In the secret retreat in the middle of the journey, too lazy to leave out
 I seat watching the green moss
 As it starts to climb into my clothes.
 (Wei, 2018, p. 61)[3]

BIBLIOGRAPHICAL REFERENCES

Deleuze, Gilles & Guattari, Felix. (1994). *What is Philosophy?* London: Verso.

Rodrigues, Ana Leonor Madeira. (2003). *O Desenho*. Lisboa: Quimera.

Sartre, Jean-Paul. (1985). *Qu'est-ce que c'est la littérature?* Paris, Gallimard.

Sartre, Jean-Paul. (1988). *"What is literature?" and other essays*. Cambridge, Mass.: Harvard University Press.

Pline, The Elder. (1855). *The Natural History of Pliny* (Vol. II). Free e-book, retrieved from https://play.google.com/books/reader?id = sDwZAAAAYAAJ&hl = pt_PT&pg= GBS.PA278, (Accessed 28/12/2018).

Weizmann Institute of Science. (1998, February 27). Quantum Theory Demonstrated: Observation Affects Reality. *ScienceDaily*. Retrieved April 28, 2019, from www.sciencedaily.com/releases/1998/02/980227055013.htm.

Wei, Wang. (2018). *Habitar o Vazio*. Lisboa: Licorne.

2. "aquilo que os olhos veem desenhado, desafia o nosso cérebro a experimentar fisicamente gestos e ações que nós talvez não sejamos capazes de realizar e que no entanto somos capazes de os identificar, do modo pleno do reconhecer, no nosso corpo, o que foi preciso mobilizar em ações para conseguir o resultado do risco que está perante os nossos olhos".

3. Pintura "O céu não clareou completamente, depois da morrinha/No retiro secreto, a meio da jornada, demasiado preguiçoso para sair/Sentado observo a cor verde do musgo/Ele começa a trepar pela minha roupa".

Drawing in architecture: Exercising the creativity of thinking architectural space

Artur Renato Ortega & Silvana Weihermann
Architecture and Urban Planning, Universidade Federal do Paraná, Curitiba, Brazil

ABSTRACT: This text describes and analyses a didactic exercise in the context of the architect's training. It covers the contents of drawing and perspective, and its primary purpose is to develop spatial perception and creativity. It explains the concept of architect's design not only as a mean of representing an idea but as a natural mean of expression, as an operational resource of the entire process of design, analysis and design of the form. It proposes the use of basic elements of the visual vocabulary and the method of the central perspective as a phenomenon of projective thinking, a process of projection, allowing the development of creativity and imagination in the elaboration of new urban spaces. It concludes that the exercise contributes to the formation of the architecture student, introducing new contents for the construction of knowledge, develops the visual and spatial perception, as well as the creative imagination, values the sketch as an artistic expression and focuses on the organisation of thought for understanding the process.

Keywords: Design, Perspective, Space Perception, Creativity, Imagination

1 INTRODUCTION

To speak about architecture is to speak of space and to think about architecture is to think of drawing. In the specific field of architecture, the use of the language of design has two fundamental purposes: the creation of architectonic work and communication of this creation.

In the scope of the architect's training, drawing is the primary dialogue language between teachers and students, whose practice is an active process of reflection in action (Schön, 2000) for the construction of this specific knowledge and visual and creativity development.

The production of drawings carried out by the designer students to trigger their ideas is, in fact, a facilitating factor for the development of the design action in Architecture. This is because

> The conceived idea for the production of space and its use is from the first moment a drawing that has its mental representation, and it passes in a second time to order a plastic field, bi and three-dimensional in reduced scale, simulating what must become effective as a habitable spatial product in order to materialise it into a constructed reality. A drawing that turns out to have its representation in the language of the project (Monzeglio, 1993: p.62)[1]

This text presents a didactic exercise entitled "Spatial Perception", which proposes to develop imagination and creativity through the realisation of drawings/freehand drawings, based on the contents of the central conical perspective.

The important reflection on the specific "corpus of knowledge" of architecture scientific field, in which the didactic exercises fit, presenting the concepts about the architect's drawing and the content of perspective, as well as the relation of these with the development of imagination and creativity, motivated the writing of this text. After all, as Chervel (1990: p.204) explains,

> if the explicit contents constitute the central axis of the discipline taught, the exercise is the almost indispensable counterpart. [. . .] Without the exercise and its control, there is no possible fixation of a discipline. The success of the disciplines depends fundamentally on the quality of the exercises they can perform.[2]

1. All translations are the author's free translations. The original texts are presented in footnotes. "A ideia concebida para a produção do espaço e seu uso, é desde o primeiro instante um desenho que tem sua representação mental, e, para que se concretize em realidade construída, passa num segundo tempo a ordenar um campo plástico, bi e tridimensional, na visão da escala reduzida, simulando o que deverá se efetivar como produto espacial habitável. Um modo do desenho que passa a ter sua representação na linguagem do projeto".

2. "se os conteúdos explícitos constituem o eixo central da disciplina ensinada, o exercício é a contrapartida quase indispensável. [. . .] Sem o exercício e seu controle, não há fixação possível de uma disciplina. O sucesso das disciplinas depende fundamentalmente da qualidade dos exercícios aos quais elas podem se prestar".

2 THE ARCHITECT'S DRAWING

Drawing is a universal language. However, the architectural design must not be understood as a mere technical activity or mechanical dexterity, but rather as a task of analysis and synthesis, which is full of intentions and requires personal initiative, since:

> The good architect needs to express himself graphically with ease, but only drawing well does not guarantee the adequate professional quality; her/his mission is not achieved by executing drawings and plans but only with the production of the architectural construction.
>
> In any case, the architect is more worthy of credit when her/his gaze is reflected through drawing: for architectural ideas to progress, it is vital to see while thinking and think while seeing, using graphical resources properly purified and contextualised as an instrument of knowledge and architectural transformation. (Gordo, 2003: p.29).[3]

The drawing, in Ching's words, (2001: p.3):

> [...] is a natural mean of expression that creates a separate but parallel world of images that speak to the eyes [...]. In the essence of all drawings, there is an interactive process of seeing, imagining and representing images. [...] Drawings are images we create on paper to express and communicate our thoughts and perceptions. [...] Drawing is, therefore, more than a manual skill since it involves the construction of visual images, which stimulate the imagination while it provides the impetus to draw.[4]

Such a statement allows us to say that the architect as a designer is one who can think and express her/himself in architecture through drawings. Lapuerta (1997: p.24), adds that

> the architect as a worker is admired, among other things, for his faculties as a designer, faculties that

other professionals have not been able to snatch: engineers, inspectors or builders.[5]

Also, considering that architectural design should be understood as the operational resource of the whole design process (conception and communication), it can be stated that, in the Academy:

> The purpose of the architecture students' training in the graphics field, after all, resides in the development of their ability to drawing as a means of work and, in itself, an instance of necessary and inevitable reflection for the comprehension, analysis, conception and control of the architectural form (Otxotorena, 1996: p.24).[6]

In other words, students, as architects, must produce clear and well-calculated design works; evoking sharp and incisive images, in the most precise language possible, as if using a lexicon or as an expression of nuances of thought and imagination.

The effectiveness of the drawing depends exclusively on who draws on the designer. Understood as a habit that develops a person's mental reasoning, the drawing is thus implicitly allied to the harsh discipline of drawing and drawing and drawing. Pliny already admitted this in his *Natural History*, drawing attention to the methodical exercise of the Greek painter Apelles, who would not let a day go by without drawing. The motto *Nulla dies sine linea* initiated many treatises on design, indicated as being an advice above all others (Bordes, 2003).

This advice refers to something like the Chinese legend that says that a Chinese emperor wanted a new picture of a rooster. After three years of waiting, the emperor went to meet the painter Li Shiu to get his painting. The artist was adequately introduced to the emperor, they exchanged the courtesies of tea and protocol, but without any sign of the painting. The formalities would be followed for a long time until the emperor interrupted them and complained that he was there to see the painting. The painter then unrolled a parchment and painted a magnificent rooster, the most beautiful painting ever seen before. Considering an act of irreverence, the emperor demanded an explanation for the long delay (three years). Li Shiu requested the emperor to accompany him. There were paintings of roosters, hundreds of them, throughout the house on each of the walls of the rooms. They were proof of a thorough and patient search (Pelli, 1999).

3. "[...] El buen arquitecto necesita expresarse graficamente con soltura; pero sólo dibujar bien no garantiza adecuada calidad professional; su cometido no concluye ejecutando dibujos y planos, sino com la producción de arquitectura construída.
En caulquier caso, el arquitecto es más solvente cuando su mirada se plasma a través del dibujo: para que las ideas de arquitectura progresen resulta vital ver pensando y pensar viendo, usando recursos gráficos debidamente depurados y contextualizados, como instrumento de conocimiento y transformación arquitectónica".
4. "[...] é um meio natural de expressão que cria um mundo separado, mas paralelo, de imagens que falam para os olhos [...] Na essência de todos os desenhos, existe um processo interativo de ver, imaginar e representar imagens. [...] Os desenhos são imagens que criamos no papel para expressar e comunicar nossos pensamentos e percepções. [...] Desenhar é, portanto, mais que uma habilidade manual, já que envolve a construção de imagens visuais, que estimulam a imaginação enquanto esta fornece o ímpeto de desenhar".

5. "[...] el arquitecto como trabajador es admirado, entre otras cosas, por sus facultades como dibujante, facultades que no han podido arrebatarle aún otros profesionales: ingenieros, aparejadores o constructores".
6. "El objetivo de la formación de los alumnos de la carrera de Arquitectura em el terreno gráfico, al fin y al cabo, consiste en su capacitación en el recurso al dibujo como medio de trabajo y, ya en sí mismo, también instancia de reflexión necesaria e ineludible en orden a la comprensión, el análisis y la concepción y el control de la forma arquitectónica".

Therefore, experience teaches us that the surest way to succeed in drawing is to have a spirit leaning toward it, dedicating a tremendous and constant practice. In this sense, Read (2001: p.127) points out that there are three fundamental conditions for children to express themselves through drawings. They are eyes that observe, an obedient hand and a soul that can feel. The same conditions, despite the age, should be attributes of students of architecture and urbanism courses, since Cosme (2007: p.79) indicates, in a similar way, that there are many instruments that the architect handles in her/his professional life, but the three main ones are:

[...] the gaze with which one sees, the mind with which one thinks, and the hand with which one represents a thought. All other tools are simple aids to these three necessary tools.[7]

3 THE PERSPECTIVE AS AN EXERCISE OF CREATIVITY AND IMAGINATION

Understanding the representation of the architectural space is nothing more than understanding sensory experiences. Puntoni points out (1997: p.137):

The linear perspective was a conventional way, like any other, that we find from the Renaissance onward, to represent our feeling that things diminish as they move away and increase as they approach; they are geometry results, to give us the sensations of closeness and detachment, simulating the ones objects give us when we observe them.[8]

The legacy left by the Renaissance is, still today, the best visual resource for construction and representation of the architectural space. As a technique, perspective is an easy method to learn and execute. As a graphic resource, it allows anyone to interpret, without the slightest difficulty, the information contained therein. However, in architecture and urbanism courses, perspective is usually treated as a presentation design, which appears in the last stages of the design process, as it is often associated with the teaching of painting and finishing techniques.

What the exercise, presented below, proposes, is that, instead of understanding the perspective as a resource of presentation, it must be understood as a phenomenon of projective thought. In other words, it is a question of using perspective in the process of projection, in the very act of creation and admitting that it can be developed, "educated" by the knowledge of the eye, and training. As Porto (1985: p.61) explains:

There is a direct and profound connection between drawing and architecture, between drawing well and being a creative architect. All great architects drew and designed well. Architects who do not know how to draw are disadvantaged in every way, especially in their perception and spatial creativity. Since they have not developed the relational, synthetic, holistic, and creative spatial characteristics of the right hemisphere of the brain, they have, in general, only the verbal, linear, sequential, and analytic thinking mode of the left hemisphere. From the particular to the general, it is very difficult for them to visualise and imagine the final form, the whole. They have no global vision: usually, they design as if there were only two dimensions.[9]

The exercise aims to use the perspective through the sketch, as a process of developing the student's creativity in thinking about the architectural space. Of course, one does not want to deny orthogonal projections – plant, cut, and elevation – but to make the student understand that space needs to be tested and evaluated three-dimensionally, from the beginning to the end of the process, as a way of evaluating the proposed space. From the first sketches of a project to the final work, the perspective can clarify many doubts, as it helps to visualise the imagined spaces.

The proposed exercise is called "Spatial Perception". It is a proposal to educate the observation, to perceive and mentally navigate the space – sequential vision –, in order to develop the thought and the creativity through the drawing in perspective. In this way, the proposed exercises have the function of:

- Introducing the basic knowledge of visual and perspective elements, to increase knowledge and creativity about the construction of space and its representation;
- Developing visual and spatial perception;
- Developing creative imagination;
- Value the sketch as a graphic expression of students and future professionals;
- Introducing concepts of proportion, scale and dimensions of space;

7. "[...] el ojo con el que ve, la mente con la que piensa y la mano con la que representa lo pensado. Todas las demás herramientas son simples medios auxiliadores de estos tres instrumentos básicos".

8. "A perspectiva linear foi um modo convencional, como qualquer outro, que encontramos, a partir da Renascença, para representar a nossa sensação de que as coisas diminuem quando se afastam e aumentam quando se aproximam, são estudos da geometria, para nos fornecer sensações de proximidade e distanciamento, tais como os objetos nos dão quando os estamos observando".

9. "Há uma ligação direta e profunda entre desenho e arquitetura, entre desenhar bem e ser um arquiteto criativo. Todos os grandes arquitetos desenhavam e desenham bem. Arquitetos que não sabem desenhar ficam prejudicados em todos os sentidos, principalmente na sua percepção e criatividade espacial. Como não desenvolveram as aptidões espaciais relacionais, sintéticas, holísticas e criativas, características do hemisfério direito do cérebro, tem em geral, o modo do pensamento verbal, linear, sequencial e analítico do hemisfério esquerdo. Partem do particular para o geral, tem grande dificuldade para visualizar e imaginar a forma final, o todo. Não tem visão global: normalmente, projetam como se existissem somente duas dimensões".

- Incorporate the person as a user and as a recipient of the space, analysing his relationship with it.

The exercise is offered to undergraduate students, which includes, among others, drawing contents. They are starting their training at the first level of the Course.

The first step is to approach students with the general principles of the Central Conic Perspective. It is called the Central Conic Perspective whose dominant directions of the objects to be viewed are parallel and perpendicular to the projection frame. In this case, the main escape lines converge to the centre, for a single point of view, considering the perspective point. It is a mathematical method that makes it possible to represent three-dimensional space on a two-dimensional surface, whose accuracy and rationality provide for the decrease and increase of things, and which results, for the human eye, respectively, in the distance or proximity of the objects of the scene.

In the same way, we could say that it is the perspective obtained by the visual rays that start from a single point of view, as in the images of the of Leonardo Da Vinci's "Last Supper" (Ostrower, 1986: p.181). It is widely used in the field of art and architecture, as in observation drawings and electronic mock-ups.

The use of this kind of perspective, relatively simple to learn, allows students a new way of looking at space and, above all, of constructing it from its representation. The first concept is that of the line (one dimension), the second refers to the surface or plane (two dimensions) and the third to the volume (three dimensions).

To carry out the exercise, a plant (top view) is presented with a caption explaining the elements (supposed buildings) represented in it and their respective heights. It is not given in numerical values, but in proportions, where a human being is used as the reference (X). From this "measure" the spatial construction is established (Fig. 1).

The student is encouraged to think and represent points of view in three dimensions. One of the fundamental characteristics of the exercise is the proportional relation between the objects. In this way, textures, vegetation, banks, cars, people, and so forth, should follow such proportions, consistent with the existing elements. Thus, when introducing bricks, for example, into a wall, the student must realise the real, proportional size of the new information added to the drawing; the brick must be represented in its scale, compatible with the proportions of the space given in the exercise, as in Figure 2.

Drawings, the student begins to figure spaces in three dimensions, and does it, as s/he travels through space. The drawing begins to happen before, in the student's mind and afterwards represented on the paper.

The purpose is to design drawings of architectural spaces from the observation of the plant, based on a set of stipulated measures and continuous sequences

Figure 1. The plan of the buildings with their respective heights and the points of observation indicated. Source: author's drawing.

Figure 2. Design in central conical perspective from the point of view 3. Source: author's drawing.

as if walking and observing the space. For each point stipulated in the route, a corresponding graphic record must be obtained. The insertions of materials, textures, colours, and so forth are free and encourage the designer's creativity as in Figure 3. The style of buildings and spaces is also free and may be similar to a historical centre, as in Figure 2, or contemporary, as in Figure 4. The only recommendations are the measures stipulated based on the human figure, set points and, of course, the use of the central conical perspective.

In addition to the training of creativity, we add the values of spatiality, inherent to the project discipline, as referred by Coutinho (1998). They are proper values to architecture, which relate to that used in the most diverse forms by individuals. Moreover, just as visual values require visual perception, understanding the spatiality of architecture also requires another form of knowledge: spatial perception.

Figure 3. Design in central conical perspective from the point of view 1. Source: author's drawing.

Figure 4. Drawing in central conical perspective from the point of view 2. Source: author's drawing.

The resulting drawings of the exercise are basic visual elements, as shown in Figure 4, which create a variety of energies and tensions, visually activating every area on which they are represented.

Elements such as dots, spots, lines, contours, planes, and volumes, besides textures, colours, and lights, among others, are part of the lexical field of visual arts, called Visual Alphabetization by several authors. It is the case of Dondis (1976) who explains it as an elementary system for learning, identifying, creating and understanding visual messages. It proposes the exploration and learning of the qualities, character and expressive potentials of each of the simpler elements of visual information. Dondis' work, as well as that of other authors who approach the theme, such as Ostrower (1987), Kandinski (1974), Moholy-Nagy (2006), Ching (1998), Sausmarez (1979) and Massironi (1982), was based on the works of Arnheim (1996) who, in turn, sought to transpose and relate the knowledge of the Gestalt psychological theory to the field of visual arts. Dondis (1976) clarifies that the consciousness of the visual substance is perceived by all our senses, not just by sight, but as whole interactive units.

Visual Literacy has, according to Giacomantonio (1981), three groups of distinct elements:

a) structural: point, line, plane, volume, texture and colour;
b) composites: space, framing, focal points, proportion, balance, motion, figure and background, light and shadow, and depth plane;
c) symbolic: component elements, history, symbolic images and the genre of representation.

Some elements participate more intensely in an image, designating their character. Thus, in some graphic works, the chromatic force predominates, in others the drawing, or the composition of light and shadow, and so forth. Moreover, as the author explains, different levels of attention are distinguished in the act of reading an image, such as the intuitive, the descriptive, and the symbolic.

The intuitive level is closely linked to the mechanism of perception, evokes emotional elements par excellence, it is a fast reading and first impressions about structural lines of perspective and focal points, conditioning the following phases.

The descriptive level is characterised by the analysis of the elements that compose the image. It raises a higher amount of information, such as the description of objects and environments, effects of lights and shadows, perception of vanishing points, textures, volumes, tonal values and gives the image a longer time of enjoyment.

The symbolic level is linked to the mechanisms of knowledge, abstracts signs contained in the image, as well as communicative contents, and can be configured as the main phase of encoding message. The association of the energies created by the visual elements results in what Sausmarez (1979) calls visual kinetics. Every line, for example, explains the author,

> is endowed with an innate kinetic quality regardless of its representative content, the fact that it constitutes the visible path of the creative act forms an integral part of its expressive content is. (1979: p.80)[10]

Moreover, every creative process is composed of

> real facts, issues regarding the work elaboration, which allow us to choose and decide, because, at the level of the intentions, no work can be evaluated. (Ostrower, 1987: p.71)[11]

10. "é dotada de uma qualidade cinética inata independentemente do seu conteúdo representativo, fazendo parte integrante do seu conteúdo expressivo o fato de constituir a senda visível do ato criativo".
11. "fatos reais, fatores de elaboração do trabalho, que permitem optar e decidir, pois, ao nível de intenções, nenhuma obra pode ser avaliada".

For this reason, students receive the preliminary data, necessary information and sufficient to act on them, and transpose to the real what is just an idea or preliminary concept. Their work is a constant process of errors and correctness, in which scientific knowledge about the essential visual elements and perspective merge with creativity, imagination, insights and intuition. Ostrower (1987: p.79) says:

> The form will always be understood as the structure of relationships, as the way in which relationships order and configure themselves. [. . .] Since the form is structure and order, all doing encompasses form in its "how to". For us there is nothing, nor the existence in itself, that does not contain a measure of assortment. (1987: p.79)[12]

The central conical perspective, coupled with the basic elements of the visual system, orders the elements, required in the exercise now created by the student, and establishes a direct connection between the observer and the events of the drawing space. They are creative skills, located in action, and result in the acquisition of new knowledge. It is the exercise of drawing and the creation of space, in the scope of the epistemology of the practice for the formation of the architect.

4 CONCLUSION

This exercise focuses directly on the organisation of thought for the understanding of the design process. Some pre-existent skills or competencies may already exist in the student's psyche, also called aptitude, vocation, talent, inspiration or intuition, characterising the design discipline as a way to train creativity.

Creativity and spatial perception, then, are not explicit knowledge, but they do not obviate the scientificity of architectural design as a university discipline. They are knowledge and skills inherent to the epistemological practice and, uniting the training of these skills to codifiable and transmissible techniques and instruments, to the example of the exercise "Spatial Perception" proposed in this text, we understand architecture as a didactically organised and cognisable art and science. If "learning architecture is a matter of the cognitive sphere, learning to do architecture is a matter of the cognitive and operative spheres" (Silva, 1986: p.25)[13]. Encouraging creativity, imagination and spatial perception in the drawing

or architectural design studio, combined with the traditional contents of drawing and perspective, means to believe in interdisciplinarity, in the integral formation of the human being, in the dialogue between the sciences, in the understanding of the world as a whole, in its most varied and complex relationships. One must add to the mastery of technical vocabulary and perspective the passion for drawing. This passion drives the student to train and, consequently, to become a designer.

Therefore, the exercise of drawing is understood as a systematic process, developing the dexterity, the skills and, mainly, the creativity of the designer. Encouraging the creativity of expressing oneself and communicating through drawings is a highly relevant task, having the freehand drawing a fundamental role in this process. Drawing the prefigured space in the mind is enhancing the designer's capacity as well as enhancing the dialogue about architecture. When drawing, an idea is communicated, literally presented on paper on the table of something that previously existed only in the creator's mind, and thus opens a debate on the creation of spaces, the creation of architecture.

BIBLIOGRAPHICAL REFERENCES

Arnheim, Rudolf. (1996). Arte e percepção visual, uma psicologia da visão criadora. São Paulo: Pioneira.

Bordes, Juan. (2003). El libro, professor de dibujo. In: Molina; Juan J. G. (Coord.). *Las lecciones del dibujo.* (pp. 393–428). Madrid: Cátedra.

Chervel, André. (1990). História das disciplinas escolares: reflexões sobre um campo de pesquisa. In: *Teoria & Educação*, 2, 177–229.

Ching, Francis. D. K. (2001). *Representação Gráfica para Desenho e Projeto.* Barcelona: Gustavo Gili.

Coutinho, Evaldo. (1998). *O espaço da arquitetura.* 2ª ed. São Paulo: Perspectiva.

Dondis, Donis. A. (1976). *La sintaxis de la imagem.* 2ª ed. Barcelona: Gili.

Giacomantonio, Marcello. (1981). *O ensino através dos audiovisuais.* São Paulo: Summus.

Gordo, Antonio G. (2003). *Ideas sobre análisis, dibujo y arquitectura.* Sevilla: Universidad de Sevilla. Secretariado de Publicaciones.

Lapuerta, Jose Maria de. (1997). *El croquis, Proyecto y Arquitectura.* Madrid: Celeste Ediciones.

Massironi, Manfredo. (1982).*Ver pelo desenho: aspectos técnicos, cognitivos, comunicativos.* Trad.: Cidália de Brito. Lisboa: Edições 70.

Moholy-Nagy, László. (2006). *Do Material à Arquitectura.* Barcelona: Gustavo Gili.

Monzeglio, Élide. (1993) O desenho conta uma história. *Revista Sinopses.* Edição Especial Memória, 62–74.

Ostrower, Fayga P. (1986) *Criatividade e Processos de Criação.* 16 ed. Petrópolis: Vozes.

_____. (1987) *Universos da Arte.* 3 ed. Rio de Janeiro: Campus.

Otxotorena, Juan M. (1996). *Sobre dibujo y diseño.* Pamplona: T6 Ediciones S.L.

Pelli, Cesar. (2000). *Observaciones sobre la Arquitectura.* Buenos Aires: Ediciones Infinito.

12. "A forma será sempre compreendida como a estrutura de relações, como o modo por que as relações se ordenam e se configuram. [..] Desde que a forma é estrutura e ordenação, todo fazer abrange a forma em seu "como fazer". Para nós não há nada, nem o existir em si, que não contenha uma medida de ordenação".
13. "aprender arquitetura é uma questão da esfera cognitiva, aprender fazer a arquitetura é uma questão das esferas cognitiva e operativa".

Porto, Maurício. (1985). O arquiteto tem que falar desenho. *Revista Módulo*, 87, 58–61.

Puntoni, Geraldo. (1997). *O Ensino de desenho: um treinamento da habilidade em fazer desenhos.* São Paulo: FAU-USP. Dissertação de Mestrado.

Read, Herbert. (2001). *A educação pela Arte.* Trad. Valter Lellis Siqueira. São Paulo: Martins Fontes.

Sausmarez, Maurice de. (1979). *Desenho Básico: as dinâmicas da forma visual.* Lisboa: Presença.

Schön, Donald. A. (2000). *Educando o profissional reflexivo: um novo design para o ensino e a aprendizagem.* Trad. Roberto Cataldo Costa. Porto Alegre: Artes Médicas Sul.

Silva, Elvan. (1986). Sobre a renovação do conceito de projeto arquitetônico e sua didática. In: Comas, C. E., org. *Projeto Arquitetônico: disciplina em crise, disciplina em renovação.* (pp. 15–31) São Paulo: Projeto.

Part IV
Humanities

The love of the one for the many and the many for the one

David Swartz

Modern Languages, Cultures and Literature, Universidade Nova de Lisboa, Lisbon, Portugal

ABSTRACT: The philosophical "problem" of the *one* and the *many* that has occupied philosophers since Parmenides is also about love and the metaphysical foundations of authorship. In the *Parmenides* Plato takes up this discussion of the *one* and the *many*, leading to the most paradoxical conclusions, such as that the *one* is always becoming older and younger than itself at the same time. To defend Parmenides, Plato has Zeno of Elea propose the thesis that the one can be divided *ad infinitum*. Therefore, the *one* cannot be divided at all. For the poet, the paradox of the *one* and the *many* is conquered through the concept of being *nothing*. The authorial nothingness that the author is interested in willfully achieving involves the simultaneous unity and fragmentation of the author's authorial voice. The author seeks to represent multiplicity and unity simultaneously; which is to say, the author seeks a vision of the one through the many and the many through the one. The simultaneous love of the one for the many and the many for the one describes the self-reflective artistic act.

Keywords: the *one* and the *many*, Shakespeare's tenth muse, the will to nothing, time and eternity, the poet's hands' self-reflection

One who sees the unity of things is dialectical.

Plato, the Republic (VII 537c)

Every good has the power of uniting its participants, and every union is good; and The Good is the same as The One.

Proclus, *Metaphysical Elements* (Proposition XIII)

In what follows, I will look at the philosophical problem of the *one* and the *many* from the point of view of the artist or author.

The problem of the *one* and the *many* that has occupied philosophers since Parmenides is of central concern to our discussion because it sets the *one* and the *many* (and hence being and becoming) in opposition to each other, only to claim that such oppositions cannot logically co-exist. In fact, according to Parmenides and to the Neoplatonic philosophers who spoke about his doctrine of the indivisible One or The Good, existence itself could not be attributed to the One. Discussions of this nature isolate oneness from multiplicity, being, and even unity since nothing at all can be attributed to a completely self-sufficient whole, not even self-reflection. I should rephrase the words "nothing at all" to "nothing above all", since it would be for the concept of nothing that oneness would have a way of becoming many, that is, by willing its own absence.

When I began this study several years ago, such a concept of oneness appeared incomprehensible to me, and I chose to discuss oneness in a way that was reconcilable with unity, being, and multiplicity. However, I have subsequently grown unsure about whether we can entirely discount Parmenides' idea of oneness and some of its corresponding paradoxes, especially in light of Shakespeare's invoking of the "tenth Muse" in his *Sonnets*, which assigns the central task of authorship to the role of being or willing nothing.

When Plato takes up the discussion of the *one* and the *many* in the *Parmenides* it leads to paradoxical conclusions (if any kind of change to its nature is permitted), such as that the *one* is always becoming older and younger than itself at the same time. To defend Parmenides, Plato has Zeno of Elea propose the thesis that if the *one* were dividable, its divisions or multiples could carry on *ad infinitum*. Therefore, the *one* cannot be divided at all. "If all things are one", says Parmenides, "that one of which existence is posited would be without *parts*, limitless, and therefore would be *nothing*."

According to Parmenides' first hypothesis, not only is oneness not reconcilable with multiplicity or being, but it is also nameless, unsayable and unknowable. Nevertheless, the interlocutors in Plato's dialogue eventually find a way of talking about oneness as reconcilable with multiplicity. Later philosophers such as Plotinus (1956), Proclus, and Pseudo-Dionysius the Areopagite would expand this initial idea of the indivisible one, making it central to their understanding of divinity and the problem of how the many emanated from the one.

From the artist's or author's point of view (assuming that the artist can be talked about as being one person), where does the desire to multiply come from? Also, at what stage does the one decide that it must multiply to exist? Or that it requires multiplication for self-fulfilment? In what way is "to become many" to *love many*, especially if the many are parts emanating out of oneself? Is artistic creation a form of self-love or self-reflection? In this latter sense, it would appear as though the love of the other were another way of looking at the love of oneself. An entirely self-contained one, on the other hand, would have no reason to multiply.

According to Pseudo-Dionysius the Areopagite, "the procession of things from, and their reversion to, the One . . . can be understood as intertwined, simultaneous, and co-eternal 'moments' of the same cosmic reality, whereby a given thing oscillates, or spirals, between unity and multiplicity." (Carrasquillo, 2013, p. 207, 211)

Dionysius maintains that it is the divine *eros* which causes the One to emanate outside of itself "the divine *eros* is ecstatic; it does not permit any to be lovers of themselves but of those which they love." Through this *eros*, the One comes out from "within" itself, ecstatically shooting forth outside of itself, differentiating itself into many, thus giving being to the world: (Carrasquillo, 2013, p. 214)

Pseudo-Dionysius' triadic structure of causation, consisting of

> abiding, procession, and reversion (*monê, prodos, epistrophê*) [. . .] shows how the Good *abides* in itself, *proceeds* out of itself into creation, and *reverts back* into itself [w]ithin the context of the reversion of all things to the One. (Carrasquillo, 2013, p. 211)

In Plato's *Symposium*, the prophetess Diotima of Mantinea describes the motives behind the desire of the *one* to become *many* as the innate human impulse to achieve immortality:

> The mortal nature is seeking as far as is possible to be everlasting and immortal: and this is only to be attained by generation, because generation always leaves behind a new existence in the place of the old. Nay even in the life of the same individual there is succession and not absolute unity: a man is called the same, and yet in the short interval which elapses between youth and age, and in which every animal is said to have life and identity, he is undergoing a perpetual process of loss and reparation... Marvel not then at the love which all men have of their offspring; for that universal love and interest is for the sake of immortality. (Plato, 2008, 207–208)

Above all, the *one* wants to divide itself up, to procreate, to tell its story, to maintain its memory beyond time and space: in short, to become immortal. In exchange for losing its initial Absolute oneness, the one is banking on the immortality of its parts. To embrace authorial nothingness, the author moves beyond being

Figure 1. Vincent van Gogh, *The Potato Eaters* 1885, oil on canvas, 82 cm × 114 cm, Van Gogh Museum, Amsterdam (Vincent van Gogh Foundation).

and becoming or the one and the many (in the usual sense), by presenting both at the same time. To achieve his goal, the artist becomes invisible. According to the French novelist Gustave Flaubert,

> The artist must be in his work as God is in creation, invisible and all-powerful; one must sense him everywhere but never see him. (Flaubert, 1980, p. 230).

Neither may we forget that the representation of the artist's invisible voice originates by way of the artist's invisible hands. In effect, the author writes his character's voices into existence. Meanwhile, the invisible hands of the artist remain removed from his artwork.

In Vincent Van Gogh's *The Potato Eaters* (1885), the artist presents us with five characters, one with her back to the viewer. All five characters, except the younger one with her back to us, can be seen eating and drinking with their right hand. The subject of the painting is the artist's invisible hands expressed through the visible hands of the peasants eating around the table, and the invisible hands of the artist himself, symbolically represented by the person at the table whose hands we cannot see. They are five around the table to emphasise that they are part of *one* hand together: the artist's hand.

A similar analogy can be found in Pier Paolo Pasolini's film *Teorema* (1968) where a mysterious unnamed visitor to an affluent Italian household can be viewed as a symbolic representation of the artist in relation to his characters. His visit to their home in Milan brings the entire household to life. Moreover, his erotic encounters with each of them inspire the opening of each of their hands to the mysterious powers of self-discovery, including both creative and self-destructive powers. The visitor brings these powers to the characters as an author brings his characters to life. When he leaves their home and disappears from their lives, their hands, which had formally been activated with a creative spirit, turn in upon themselves. The characters cannot exist without their author. Pasolini connects the hand to *eros* by revealing the connection between

(physical) love and the hand; the opening of the hand symbolising the liberation of subjectivity through self-reflective love. Pasolini's film can be viewed as an attempt to isolate the hand's capacity for the expansion and retraction of subjectivity within the sphere of *eros*.

Just as his love and presence brought them to life, when the visitor leaves, the characters lose their sense of self and melt back into oblivion: the youngest daughter Odette clenching her fists in despair until her spiritless body is taken away to a mental hospital; the father undressing himself naked in a crowded train station; the maid burying herself alive; the mother engaging in indiscriminate sex with strangers who resemble the guest; and the son psychotically painting his desire for the absent guest. The characters in Pasolini's film exist only in connection to the visitor, which is to say, to their author. The author, being his characters' creator, exemplifies the idea that the *one* loves the *many* (evidenced by the visitor making love to each of his characters). Meanwhile, the love of the *many* for the *one* is illustrated by the characters' need for the visitor's presence in their otherwise empty (non-existent) lives.

In Fernando Pessoa's poetry, the flight from the *one* subject or author into the form of his *many* names or heteronyms is psychologically inspired by a philosophy more akin to Heraclitus than Parmenides, who said that reality is both one *and* many. In his notebooks, Pessoa wrote:

> All things changing, says Heraclitus, no knowledge is possible. My answer is that all things changing, myself change with them, and so am in relative stability. Subject and object changing perpetually are the stable ones in relation to the other. (Pessoa, 1968, p. 113)

Pessoa is concerned not only with a view of human agency as changeable but with the expansion of subjectivity itself to include multiplicity. In this manner, Pessoa reflects not only the Greek philosophers but also the American poet Walt Whitman, who in *Leaves of Grass* writes:

> Very well then. I contradict myself
> (I am large, I contain multitudes). (1958, p. 96)

In one of his poems, Pessoa writes:

> Não sei quantas almas tenho.
> Cada momento mudei.
> Continuamente me estranho.
> Nunca me vi nem achei.
> De tanto ser, só tenho alma.
> Quem tem alma não tem calma.
> Quem vê é só o que vê,
> Quem sente não é quem é,
> Atento ao que eu sou e vejo,
> Torno-me eles e não eu. (Pessoa, 2008, p. 268)

> [I don't know how many souls I have.
> I changed at every moment.
> I always feel self-estranged.

I've never seen or found myself
From being so much, I have only soul.
A man who has soul has no calm.
A man who sees is just what he sees
A man who feels is not who he is.
Attentive to what I am and see,
I become them and stop being I.]

On another occasion, Pessoa writes:

> Assim eu me acomodo
> Com o que Deus criou,
> Deus tem diverso modo
> Diversos modos sou.
> Assim a Deus imito,
> Que quando fez o que é
> Tirou-lhe o infinito
> E a unidade até. (2008, p. 273)

> [I've learned to adopt my self
> To the world God has made.
> His mode of being is different:
> My being has different modes.
> Thus I imitate God,
> Who when he made what is
> Took from it the infinite
> And even its unity.]

With Pessoa, we witness the metaphysical transformation of the *one* into the *many*. Pessoa's projected multiplicities involve the realisation that both pure infinity and pure unity were taken from the world in order to allow it to exist.

In *Richard II*, Shakespeare uses the concept of *nothing* to unassert his own authorial identity. Only by becoming nothing is he able to become many. At the end of a long soliloquy, the imprisoned King states:

> Thus play I in one person many people,
> And none contented: sometimes am I king;
> Then treasons make me wish myself a beggar,
> And so I am: then crushing penury
> Persuades me I was better when a king;
> Then am I king'd again: and by and by
> Think that I am unking'd by Bolingbroke,
> And straight am *nothing*: but whate'er I be,
> Nor I nor any man that but man is
> With nothing shall be pleased, till he be eased
> With being nothing. (Shakespeare, 1988, Richard II, V, 5, vv. 31–40, p. 393)

This passage reveals the playwright's art of playing many different parts, and the psychology underlying the author's authorial identity. Shakespeare, in effect, is showing us how he wills his own nothing.

By representing the state of mind before the creation of multiplicities, nothing originates the act of parting.

In Sonnet 8, Shakespeare writes:

> In singleness the parts that thou shouldst bear;
> Mark how one string, sweet husband to another,
> Strikes each in each by mutual ordering,
> Resembling sire, and child, and happy mother,
> Who all in one, one pleasing note do sing:
> Whose speechless song being many, seeming one,

Sings this to thee: 'Thou single wilt prove none.'
(1988, Sonnet 8, vv. 8–14, p. 752)

The final couplet says the opposite of what it means explicitly. "Thou single" refers to *one* and *will* ("single wilt") while "prove none" refers to the concept of *nothing*. In other words, "who all in one [...] being many, seeming one" refers to Shakespeare' one (1) and none (0) together giving birth to the many. Shakespeare's "tenth Muse" is his way of becoming nothing. In sonnet 38, Shakespeare writes:

Be thou the tenth Muse, ten times more in worth
Than those old nine which rhymers invocate;
And he that calls on thee, let him bring forth
Eternal numbers to outlive long date. (1988, vv. 9–12, p. 755)

In Sonnet 10, Shakespeare writes:

Grant, if thou wilt, thou art beloved of many,
But that thou none lov'st is most evident: (1988, vv. 3–4, p. 752)

Shakespeare makes it possible for the reader to read his sonnets vicariously on many levels; most obviously because his name is Will. He is proposing that you too will become will. "If thou wilt" (that is, if you too would be will), "thou (too would be) beloved of many". In fact, you too will be beloved but love none. This goes back to the idea of willing nothing as a way of begetting the many.

One might read Shakespeare's procreation sequence of sonnets as a concentrated attempt to reveal the nature of the dramatist's task, and what fuels the poet's calling and inspiration to write his plays. Above all, it has to do with overcoming Time, the principal enemy of the poet in the *Sonnets*.

The tenth muse is Shakespeare's aesthetics' of parting. In effect, through the author's *will* to *nothing* or "tenth Muse" (equating 1 with *will*, and 0 with *nothing*), the number *one* or *will* is juxtaposed with *zero* (or *nothing*) to create a kind of aesthetic eroticism symbolised by the number 10.

The *one* (and by *one* I mean the authorial unity or authorship) loves or *wills nothing* the same way the *one* loves multiplicity. It may be helpful to look at Keats' definition of the poetical character to see how *nothing* relates to multiplicity from the point of view of the author. "The poetical character", according to Keats:

Is not itself – it has no self – it is everything and nothing – it has no character – it enjoys light and shade; it lives in gusto, be it foul or fair, high or low, rich or poor, mean or elevated – it has as much delight in an Iago as an Imogen (*Cymbeline*). What shocks the virtuous philosopher delights the Chameleon Poet [...]. [A poet] has no identity – he is continually in for – and filling some other Body.

Men of genius are as great as certain ethereal chemicals operating on the Mass of neutral intellect – but they have not any individuality, any determined Character. (2009, p. 52, p. 194)

While Keats's notion of the poetical character (often referred to as "negative capability") reminds us of the authorial nothingness at the heart of authorship, out of which the many parts created are merely parts played, I want to suggest something a bit more ordinary: that the multiplicity of parts is anchored in the character of the reader whose role is nothing less than to perform the resurrection of the writer. The reader's part is the immortalising part.

Like the universe at large, the text or artwork must be expandable through the future reader to survive time. The relationship between the poet and the reader is such that the poet allows his poetry to be shared by the reader as a kind of surrogate self, wherein both the reader and author are given new life. The reader is given new life in another way too, in taking on the role of the redeemer of the poet's verse, fulfilling the prophecy of being the poet's "better part". Meanwhile, the poet is given new life by having his poems or plays brought back to life by the reader.

In the "Phoenix and the Turtle" (Shakespeare, 1988, p. 782), two lovers celebrate a ritual transformation into one. Could it be that the birds symbolise the author's and reader's joint enterprise to overcome time through the perpetual immolation of their loving embrace? When the author and reader became one, the text survives forever.

Shakespeare's nothing is precisely that which makes room for multiplicity and presence. It is similar to the Pythagorean need for a void to reproduce number. It is a nothing which allows for the motion of will.

The one, desiring to become many, resigns itself to being nothing.

Nothing (sees itself) as expanding through its love of will. By perpetually becoming many, nothing remains without statehood or personal identity. The identity-less hero is both author and reader and neither.

The authorial nothingness expanding in every direction beyond distinction refuses to be itself. Nothing will have no foundation in space or time, and consequently, will "bring forth/Eternal numbers to outlive long date." (Shakespeare, 1988, Sonnet 38, vv. 11–12, p. 755).

In Shakespeare's early sonnets, self-love is regarded as selfish and narcissistic folly. The writer urges the reader to share himself. The best and most worthy kind of love bears fruit. The answer to the charge of narcissism is the willful fragmentation of the self: "To live a second life on second head" (1988, Sonnet 68, v. 7, p. 759), by recreating oneself through bearing children, writing poetry or making art.

It is with his "tenth Muse" that Shakespeare tells us he shall outlive time. The tenth muse also refers to the poet's hands. In his *Sonnets,* the word "hand" often alludes to the hand of Time, for example, in the verses:

Then let not winter's ragged hand deface,
In thee thy summer, ere thou be distilled. (1988,
Sonnet 6, vv. 1–2, p. 751)

or

Against my love shall be as I am now,
With time's injurious hand crushed and o'erworn;
(1988, Sonnet 63, vv. 1–2, p. 758).

Though the word "hand" often appears in this capacity, it also implies the opposite of what Shakespeare means by Time. For example, Shakespeare writes: "Or what strong hand can hold his swift foot back?" (Sonnet 63, v. 11, p. 759), speculating as to the existence or absence of a hand powerful enough to hold Time back. Alternatively,

Nay, if you read this line, remember not
The hand that writ it; (Sonnet 71, vv. 5–6, p. 759)

to remind us of the invisible absent hand of the poet.

While oneness is above and beyond number, plurality begins with one and nothing. Willing nothingness into multiplicity with his hands' self-reflective initiative, the poet reveals the process of artistic creation leading to immortality.

The human psychology behind multiplication is the desire to create a lasting legacy in one's image. One might also create a legacy in one's non-image. To make oneself into multiples, to divide oneself up requires the will to become nothing.

The first stage is to find a way to multiply oneself, to divide oneself up into parts; for example, to create sons or sonnets or characters. In Sonnet 3, Shakespeare writes: "Now is the time that face should form another," (v. 2, p. 751). The poet's goal is not only to express the self's multitudinous, contradictory nature but to create an inner space wherein such multitudinous divisions can be willfully developed and projected. Indeed, love itself requires division!

Let me confess that we two must be twain,
Although our undivided loves are one; (Sonnet 36, vv. 1–2, p. 755)

When one draws near to oneself, one becomes multiple. These different multiples or *parts* — having their source of life in the poet, speak to the poet's imaginative leap into multiplicity.

One increases and decreases at the same time. One grows older and younger at the same time. One disappears, and at the same time, one appears. One forgets at the same time as one remembers. One moves forwards, and at the same time, one moves backwards.

Art is the self-reflective act of this simultaneous love. It is the love or will to nothing.

The great circle of causation is how all things emanate from the non-existent artist.

BIBLIOGRAPHICAL REFERENCES

Carrasquillo, Francisco J. Romero. (2013) "The Intertwining of Multiplicity and Unity In Dionysius' Metaphysical Mysticism". *Tópico* 4, 207–236. doi: 10.21555/top.v0i44.9

Flaubert, Gustave. (1980). *Letters of Gustave Flaubert* (Selected, ed., and Transl. by Francis Steegmuller) Cambridge: Belknap Press.

Keats, John. (2009). *Selected Letters* (Revised Version Ed. by Grant F. Scott). Cambridge: Harvard University Press.

Pasolini, Pier Paolo (Director). (1968). *Teorema*, [Franco Rossellini y Manolo Bolognini].

Pessoa, Fernando. (2008). *Forever Somewhere Else: Selected Poems* (Translated by Richard Zenith, 2nd Edition). Lisbon: Assírio & Alvim.

_____. (1968) *Textos Filosóficos* (Vol. I, estabelecidos e prefaciados por António de Pina Coelho). Lisboa: Ática.

Plato. (2008). *Parmenides*. (Benjamin Jowett, Trans.), Gutenberg, available at http://www.gutenberg.org/files/1687/1687-h/1687-h.htm

_____. (2008). *Symposium*. (Benjamin Jowett, Trans.), Gutenberg, available at http://www.gutenberg.org/files/1600/1600-h/1600-h.htm

Plotinus. (1956). *The Enneads* (Stephen MacKenna, Trans.). London: Faber and Faber.

Proclus & Johnson, T. M. (1909). *Proclus' Metaphysical elements–*. Osceola, Mo: Press of the Republican.

Shakespeare, William. (1988). *The Complete Works*. Oxford: Oxford University Press.

Whitman, Walt. (1958). *Leaves of grass*. New York: New American Library.

A Mesopotamian notion of intelligence and creativity: The ingenious nature of Enki/Ea

Isabel Gomes de Almeida
CHAM & DH, FCSH, Universidade NOVA de Lisboa, Lisbon, Portugal
ORCID: 0000-0001-5954-4959

ABSTRACT: In Antiquity, by the banks of the Tigris and the Euphrates, throughout more than three millennia, several intertwined innovations were developed that would forever change the course of history. When analysed together, these innovations manifest a rather dynamic, pragmatic, and imaginative mental framework, where intelligence, creativity and fantasy run side by side.

Deeply religious, the Mesopotamians also created a complex mythical discourse, where the transcendental nature of deities was accommodated through the hyperbolised and metaphorical projection of their own reality. Following a History of Religions perspective, with this chapter, we aim to examine a Mesopotamian notion of intelligence, by linking its historical agents with the envisioned nature of Enki/Ea, the god of wisdom and knowledge.

Keywords: History of Religions, Sumero-Akkadian Mythology, Mesopotamian Literature Wisdom Deities, Ancient Knowledge.

1 MESOPOTAMIA, A CRADLE OF INNOVATIONS AND PRAGMATIC THINKING

After numerous technological advances that allowed the Mesopotamian communities to exploit their surroundings better, urbanism first appeared in that territory during the second half of the 4th millennium BC (Algaze, 2008). This new development prompted the creation of centralised political powers in every "city-state", and the invention of the first known writing system – the cuneiform, which was initially used to record bureaucratized economic data.

Through the 3rd millennium BC, the economic growth allowed for these *urbs* to become sophisticated at every level, namely the artistic one. It was then that the Mesopotamians scribes started to develop an extremely rich literary *corpus*, where fantasy and reality were blended to produce some of the oldest mythic narratives known to humankind[1]. Schools would soon be created where the young apprentices became scribes, constituting also exceptional centres to the development of literary novelties (George, 2005).

On another level, a deductive method based on the observation of natural phenomena, followed by the identification and registration of causal-effect relations was developed by true experts in scrutinising nature – the diviners (Akkadian: *bārû*). These specialists acted upon the belief "that deities painted nature with signs which bore their divine will, in order for communities to know it and more importantly, to act accordingly" (Lopes & Almeida, 2017, p. 11).

From the beginning of the 2nd millennium BC on, several divinatory *compendia* were gathered, containing an immense variety of data related to astronomy, mathematics, medicine, animal behaviour, etc. The study of these compilations allows the identification of Mesopotamian scientific knowledge, though driven by religious practices (Bottéro, 1998, p. 344; Rochberg 2004, p. 237–286).

The vast collections of Mesopotamian texts, whether literary, divinatory, cultic, economic, legal or diplomatic, were systematically reunited and organised in the royal archives and libraries. Alongside, Mesopotamians were keen to compile extensive lists of items considered important in their daily organisation, whether referring to lexicon or professions, to past ruling kings or worshipped deities[2]. It is worth referring that the latter appeared organised by the ranking of importance, family ties, and cosmic functions, thus being an excellent aid in the understanding of the Mesopotamian religious system, in a given period (Rubio, 2011, pp. 97–101).

1. For instance, the adventures of the famous Gilgameš have their origins in the 3rd millennium BC literature (Abush, 2001).

2. The first lists are attested to ca. 2600 BC.

This enormous quantity of data, which survived until the present day in thousands of clay tablets, presents itself as an extraordinary means for a holistic study of the Mesopotamian civilisation. For what this paper is concerned, it shows a profoundly organised and pragmatic mental framework, where everything that was considered important was recorded, annotated, and systematised for time to come.

2 ENKI/EA, THE ARCHETYPICAL DIVINE FIGURE OF INTELLIGENCE

Simultaneously, the Mesopotamian mental framework was profoundly theocentric. In a *longue durée* analysis, this religious system appears guided by the notion that everything is explained by divine will and power. Hence, the reality was observed through a religious filter which, as Jean Bottéro (1998, p. 55) stated, colourised and conditioned its perception/understanding.

This belief led to the creation of a complex mythical discourse (expressed in ritual practices and oral, iconographic and written narratives), which provided a way to appease the anxieties Mesopotamians felt regarding their own existence in a reality controlled by numinous powers.

From the Religious Studies perspective, the mythical discourse finds its roots in the mundane reality, where the *homo religiosus* dwells. The particular aspects are profoundly transformed, through exercises which used a "controlled and calculated imagination" (Bottéro, 1998, p. 55), where the tangible is metamorphosed into symbolic.

Thus, myth should be understood as an account with its own logic and reason, "presenting a form of truth" (Hatab, 1990, p. 10), where the reality and the experiences of the individual/community are, somehow, reflected in the metaphorical and hyperbolised significances created[3].

Consequently, it is interesting to examine the Sumero-Akkadian mythology regarding Enki/Ea, the deity responsible for the principles of knowledge and wisdom, to understand the Mesopotamian archetypical construction of intelligence and creativity.

Diachronically, Enki/Ea was regarded as one of the most important figures in the Mesopotamian divine universe, occupying the third position in the lists of deities (López & Sanmartín, 1993, pp. 302–303). It is curious to note that he was the patron god of the ancient Mesopotamian city of Eridu (modern Tell Abu Shahrain, Iraq), where kingship first descended from

heavens, according to the *Sumerian King List* (*ETCSL* 2.1.1).

Enki/Ea was thought to inhabit and control the cosmic domain of the fresh, and pure subterranean waters (**abzu**/*apsû*), hence his association with aquatic animals, like the turtle or the goat-fish. In glyptic art, Enki/Ea was commonly depicted with flowing streams coming out of his shoulders, with fish swimming on it (Black & Green, 1998, p. 76).

In his cosmic domain, this god was accompanied by his divine wife, Damgalnuna/Damkina, his divine minister, Isimu/Usmû, and the seven sages (*apkallū*), antediluvian figures who were to protect and to teach wisdom to humankind (Black & Greenm 1998, p. 27, pp. 163–164).

Given the cumulative nature of the Mesopotamian religious system, depending on the literary traditions, his divine genealogy may differ. The Sumerian composition *Enki and Ninmah* presents Enki/Ea as the son of the goddess Namma/Nammu, who was the primaeval divine ocean that gave birth to all deities (*ETCSL* 1.1.2). On its turn, the Babylonian epic of creation, *Enūma eliš*, describes him as the son of the celestial god An/Anu, and father of the patron god of Babylon, Marduk (Dalley, 2000, pp. 228–277).

The association of Enki/Ea with the pure waters (through his divine mother and/or through his cosmic abode) might help to explain his abundant character and fertile sexual nature. In *Enki and the world order*, he is depicted fertilising the Tigris and the Euphrates with his semen (*ETCSL* 1.1.3) and, in *Enki and Ninhursaĝa*, he is responsible for impregnating several goddesses (*ETCSL* 1.1.1).

Moreover, his connection with magic and ritual knowledge, and his tutelage of the arts and crafts (Foster, 20015, pp. 151–152) turned him into a divine figure keen to establish order. In fact, the composition *Enki and the world order*, states how the god Enlil, the leader of the pantheon, sent him out to inspect the land and to organise the world, by means of assigning different responsibilities/functions to the gods and goddesses of the divine assembly (*ETCSL* 1.1.3).

Possibly due to all these attributes, Enki/Ea appears as the divine guardian of the innumerable **me**, in *Inana and Enki* (*ETCSL* 1.3.1). This Mesopotamian concept is still difficult to translate and to fully grasp but appears to be "the eternal and unchangeable first principles, or quintessences, of everything that exists. They are also the blueprints for everything that exists, in that they prescribe how it should exist" (Vantisphout, 2009, p. 35). Enki/Ea's orderly and wise character surely mattered to this function.

Enki /Ea was, thus, a deity deeply connected with cosmic abundance, wisdom, and order, being summoned by divine and human actors to carry out tasks that required intelligence. However, the way this deity acted in the mythic literary compositions manifests a certain type of creative intelligence, that made some modern scholars qualify him as "cunning" or

3. As Meslin (1973, 232) stressed, in the same cultural context "le mythe peut être à la fois l'expression de réalités supérieures à l'homme, et tenues par lui pour sacrées, et en même temps un moyen de justifier un ordre social [...] d'expliquer des situation types que tout homme, peu ou prou, rencontrera au long chemin de sa vie'.

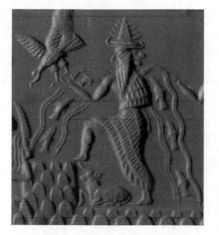

Figure 1. Enki/Ea. Detail of the *Adda Seal* (ca. 2300 BC). The British Museum Collection. Retrieved from http://commons.wikimedia.org.

"crafty"[4] (Jacobsen, 1976, p. 110; Kramer & Maier 1989, p. 5).

Likewise, the Mesopotamian notion of intelligence must have had something to do with its divine patron.

3 THE INGENIOUS ABILITY TO SOLVE DIVINE AND HUMAN PROBLEMS

Enki/Ea was one of the most active deities in Mesopotamian mythic literature. To better illustrate our argument, we will focus our attention in three different compositions: in the first two, Enki/Ea deals with problems related to the goddess Inanna/Ištar; and in the third, this deity presents original solutions to chaotic events, in the divine and human spheres.

4 ENKI AND THE REBELLIOUS "QUEEN OF HEAVEN AND EARTH"

The first references to Inanna/Ištar are dated to the second half of the 4th millennium BC and attest her as the patron goddess of Uruk (modern Warka, Iraq). From the 3rd millennium BC onwards, her cult spread all over the "land between the rivers", and even beyond, through multiple and intricate syncretic processes with other local/regional deities (Westenholz, 2010, p. 336; Selz, 2000).

The long and complex construction processes that this divine figure went through, led her to accumulate several features, which in turn made her patron of numerous domains: royal power, war, abundance, love, and sex, to quote just a few (Almeida, 2015).

Her insatiable ambition for power led to a challenging behaviour, which provoked several conflicts with other deities, and some setbacks in her divine life. The Sumerian composition *Inana's descent to the netherworld* (*ETCSL* 1.4.1)[5] and the Akkadian song *Agušaya Hymn* (Foster, 2005, pp. 78–88) stand as excellent examples of such defiant and problematic character, which requires Enki/Ea intervention.

The first narrative depicts the journey of the goddess to the realm of the dead, which was ruled by her divine sister, Ereškigal. Inanna/Ištar's main goal was to gain control over this subterranean domain, enlarging her already powerful cosmic sovereignty, as she was the "Queen of Heaven and Earth".

However, usurpation was considered a capital crime in Mesopotamia, given the belief that kingship descended from heavens, and thus earthly rulers were chosen by deities to govern in their name.

Accordingly, the goddess' attempt to usurp her sister's throne, "which were assigned to Ereškigal by the great gods (...) is not merely an offense against Ereškigal, but also a violation of the world order, and, therefore, an offense against the great gods who determine the world order" (Katz, 2003, p. 403). Consequently, the goddess is imprisoned in the netherworld, suffering a kind of death, which prevents her to return to her earthly and heavenly functions.

Thus, it becomes imperative to save Inanna/Ištar. Her minister, Ninšubur, rushes off to the presence of the great gods Enlil and Nanna/Sîn (the moon God and father of Inanna/Ištar) asking for their help. However, because of the gravity of her offence, both gods dismiss Ninšubur. It is then that the minister turns to Enki/Ea, who decides to help in the matter. From a piece of mud, that he removes from the tip of his fingernail, Enki/Ea creates the *kurgarra* and the *galaturra*, two creatures of undefined sex, who are sent to the netherworld with a life-giving plant and water, respectively (*ETCSL* 1.4.1, ls 220–223). Moreover, the god carefully instructs them on how to act in front of Ereškigal. Following Enki/Ea's plan, Inanna/Ištar is successfully brought to life and can begin the process of escaping the netherworld.

Contrary to *Inana's descent to the netherworld*, which is very well preserved in several copies, the *Agušaya Hymn* survived to the present day in very few and fragmented tablets. This prevents a complete understanding of the episodes, though it is possible to grasp its general themes and meanings. The song opens with a praise to the martial features of Inanna/Ištar, but as the composition goes on, her warrior character appears excessive and unrestrained, which seems to provoke some preoccupation in the divine assembly.

4. Kramer and Maier (1989, p. 5) stated how they preferred to adjective Enki/Ea as "crafty" instead of "wise", given that this term betters suits the strength, astute and technological ability that this god manifests.

5. There is also an Akkadian composition with the same theme, The Descent of Ištar to the netherworld (Dalley, 2000, pp. 154–162). About their differences and similarities, see Almeida, 2012.

After a long gap, we find Enki/Ea reacting to Inanna/Ištar's uproar (Foster, 2005, tab. I, col. iv, ls. 19–20), but a long hiatus in the song prevent us of identifying his first actions. Bottéro suggests that in this gap, Enki/Ea presented a contingency plan to the divine assembly: to create a double of the goddess, who would confront, win and humiliate her, and consequently control her intimidating character (Bottéro & Kramer 1989, p. 207). In fact, when the narrative is resumed, Enki/Ea is describing the incredible strength and warrior skills this double would have. The divine assembly is, thus, convinced and delegates the task of fashioning the creature to Enki/Ea, given he was the only one capable of performing such a mission.

Like in *Inana's descent to the netherworld*, Enki takes a piece of mud from the tip of his fingernail, and creates Šaltu, the discordance, as the double of Inanna/Ištar, the warrior. He then carefully instructs the creature to prepare her for the confrontation (Foster, 2005, tab. I, col. vi, ls. 20–26). Unfortunately, the passage regarding the clash between the two is too fragmented, so we do not know exactly what happened. But when the composition is resumed, Inanna/Ištar appears offended and asks Enki/Ea to make Šaltu disappear. The god attends to her request, only because her warrior defiant character is finally controlled. Again, the order is restored through Enki/Ea's efforts.

In both narratives, Inanna/Ištar's actions and behaviour constitute a menace to the cosmic order: in the first one, her imprisonment in the netherworld disables her to act as patron deity of her earthly and heavenly domains; in the second, her uncontrolled warrior side can spread war through the land, bringing chaos both to humans and deities. As the wisest of all the divine beings, Enki/Ea is the first to understand the threats and the first (and probably the only one able) to quickly react to them.

The association with the pure waters and cosmic abundance gives him the fertility skills needed to create new beings, and even to hold the life-giving plant and water, which enables to restore the goddess's life. However, it is his creative intelligence that allows him to design the successful plots.

The undefined sex of the *kurgarra* and the *galaturra* did not happen by chance, given that it allowed blurring their identity, which helped them to fulfil their task in the realm of the dead. In fact, Enki/Ea instructs them to pass the netherworld gates like phantoms (sic) and to take advantage of Ereškigal's doubt about their true nature (*ETCSL* 1.4.1, 226–245). Through this confusion, they would attract the goddess's attention, and then, by lamenting themselves for the queen of the dead's suffering, they would make her appeased by their presence (*ETCSL* 1.4.1, 263–272).

Their behaviour shows close resemblances to the ones of the male **gala**, the Mesopotamian professional cultic mourners, which were usually depicted with no beard, long hair, and gender-neutral apparel. They were also referred to as intoning their lamentations for the deceased in the Sumerian dialect **emesal**, which was used by feminine voices in literature. Cohen suggests that this ambiguous behaviour had an apotropaic significance: by confusing the limits of gender identity, they were protected on their liminal function between life and death (Cohen, 2005, p. 55). In the same way, the undefined identity of the *kurgarra* and the *galaturra*, and their sympathetic conduct towards Ereškigal would protect them while in the realm of the dead, allowing the successful execution of their mission.

On what concerns Šaltu, it is important to notice how carefully Enki/Ea instructed this creature about Inanna/Ištar's idiosyncrasies, which for sure gave her leverage when the confrontation occurred. The arrogant goddess was probably struck by the existence of a perfectly designed double. In fact, she furiously shouted to Enki/Ea: "Why did you create Saltu against me (. . .) The daughter of Ningal is unique!" (Foster, 2005, Tab. II, col. v, ls. 4 and 7).

Hence, the way both plans were orchestrated manifest an ingenious mind at work, that knows and uses the weaknesses of his adversaries (the suffering of Ereškigal and the arrogance of Inanna/Ištar), through the creation of beings that closely follow his sage instructions.

A last note about these creatures must be made: Enki/Ea fashioned them from the mud, that is, clay, a perishable material that dictates their finite existence. After fulfilling their mission, the *kurgarra* and the *galaturra* go absent from the narrative, and as for Šaltu, as we have seen, she is destroyed upon Inanna/Ištar's request. Simultaneously, clay is the ubiquitous material of the "land between the rivers" that was used by Mesopotamians to shape every building, every day-to-day utensil, every written tablet. . . Likewise, Enki/Ea makes wonders with this cheap raw material.

5 ENKI/EA, THE DIVINE STRIKE, AND THE NOISY HUMANKIND

In the Akkadian composition *Atrahasis* (Dalley, 2000, pp. 1–38) the resourceful skills of Enki/Ea are, again, summoned to restore cosmic order. The narrative begins in a time where there were no humans, and where a group of deities, the Igigi, "did the work, bore the load", while another group, the Annunaki, received the products of that labour (Dalley, 2005, Tab. I, l. 2). This divine social order lasted for so many years that the Igigi became profoundly tired, disturbed and angry. At some point, they decided to confront the Annunaki, stopping the work, and declaring war to the *status quo*.

The divine universe was on the verge of a conflict, which could have cosmic consequences if not stopped in time. Hence, an urgent reunion of the great Annunaki was called. Upon a clamorous debate, Enki/Ea made his voice heard and defended the cause of the Igigi (Dalley, 2005, tab I, ls. 42–43). He then

offered a solution: the creation of humankind to sub-stitute the Igigi in the hard labour. Together with the goddess responsible for the principles of maternity, Enki/Ea fashioned the first seven pairs of humans from clay, promptly resolving a divine/cosmic crisis.

Many years after this, the humans multiplied and became so noisy that the sleep of Enlil was disturbed. In an impetuous rage, he decided to annihilate the crea-tures, by cursing them with a mortal disease. Upon such catastrophe, Atrahasis, a man of the city of Šurup-pak (modern Tell Fara, Iraq), called for Enki/Ea's help. The wise god, probably foreseeing the cosmic threat the destruction of humans entailed, and taking pity on humans, gave instructions to appease the patron god of the illness, by means of offerings. The plan was successful, and many years later the humans had mul-tiplied again, and once more, were extremely noisy…

After several episodes like the one summarised above, Enlil was furious. Suspecting that humans had divine help, he made the divine assembly swear secrecy about his newest plan: he would send a torrent, a storm and a flood that would forever silent humans, for they would return to clay. Wise Enki/Ea's, again foreseeing chaotic consequences, found himself trapped in the oath of secrecy. However, he quickly found unconven-tional means to solve his problem: he would give all the necessary instructions to Atrahasis survive the flood, by pretending to speak to a reed wall. The Šuruppak's hero was thus advised to build a boat, where he was to protect himself, his family and his cattle when the diluvial waters stroke.

The event, which lasted for seven days and nights, was so terrifying that even deities searched shelter in heavens. When the waters finally retreated, no human was to be seen, except for Atrahasis. Fol-lowing Enki/Ea's instructions, he made a sacrifice to the gods and goddesses, who were so starving that they quickly devoured the offering. After this, Enlil was finally appeased, and resumed the good relations with humankind, given that he understood the imper-ative need for human existence. Several mechanisms to control human population were created to prevent their excessive multiplication, and a new era for the relationship between deities and humans begun.

Through this mythic construction, the Mesopotami-ans explained when, why and how they come to existence: humans were created to solve a cosmic crisis, as substitutes for the divine workers. Though mortals, given the perishable material used for their creation, they could multiply and live a prosperous existence, but only if they kept their divine architects appeased. On their side, deities would refrain from destroying them.

For the present argument, it is interesting to com-pare Enki/Ea's role in this composition with the ones displayed in the previous narratives. The several men-aces to cosmic order (the divine strike, the curses sent to destroy humanity, and the flood) are quickly fore-seen by the god, who is the first and probably the only

one able to prevent them. Contrary to his fellow divine companions, Enki/Ea does not react impetuously, but with common sense and reason.

Similarly, his ingenious plot takes advantage of the weaknesses of his opponents, in this case, their lust for offerings, but also Enlil's naivety on the arrangement of the oath's secrecy terms. Finally, the solution for the divine strike is achieved by fashioning mortal crea-tures from the clay. However, given the interminable mission, humans were to carry on, the relation between the god and these creatures appears more intimate, and durable. Enki/Ea is not only the creator of humans but also their divine champion.

6 ENKI/EA'S WEAKNESSES – A REALISTIC APPROACH TO WISDOM?

So far, the god of wisdom appears as an orderly and mature figure, who predicts and solves cosmic crises, in ingenious ways. However, in the above-mentioned narratives *Enki and Ninhursaǧa*, *Enki and Ninmah* and *Inana and Enki*, we find a different side of the god, where he acts carelessly, impetuously and even violently.

In the first one, Enki/Ea is astounded by the sight of the young and beautiful Ninisig, his and Ninhursaǧa's daughter. In a rampant act, he rapes her, impregnat-ing her with Ninkura. Later, when the god sees the young and beautiful Ninkura, he repeats his violent act, originating Ninimma, who, in time, is also raped and impregnated by the god. In this composition, the wise and orderly Enki/Ea is depicted in an uncontrolled and violent sexual spree, perpetrating a serious crime, according to the Mesopotamian legal compilations (Sanmartín, 1999, p. 123).

In the second narrative, Enki/Ea and the goddess Ninmah embark on a creative competition, after hav-ing drunk too much beer. They fashioned beings with disabilities, having to decree good fates for each other's creatures. Here, Enki/Ea appears rather arrogant, and excessively proud of his creative powers, while in an alcoholic haze.

In the third one, Enki/Ea is stunned at the sight of the amazing beauty of Inanna/Ištar. To seduce her, he offers a feast, plenty of wine and beer. Soon, completely inebriated, Enki/Ea offers the **me** to the goddess, who is clearly taking advantage of the god's weaknesses to feminine allure and liquor. When he sobers up, he understands his fault, but it was too late to reverse his reckless action.

When analysed together, Enki/Ea's nature and behaviour in mythic literature seems contradictory: on the one hand, he is the wise and cunning deity, who finds unconventional and pragmatic means to restore order; on the other, he indulges himself in sexual and alcoholic splurges, which makes him a condemnable menace to others and even to himself.

However, it is our understanding that this does not constitute a contradiction. The logical and messy behaviour of the god of wisdom perfectly corresponds to the delicate cosmic balance between order and chaos of the Mesopotamian mental framework. It should be recalled that, accordingly to *Enūma eliš*, the cosmos was created from a chaotic primaeval aquatic mass; and according to *Atrahasis*, the menace of returning to that chaotic state (through the flood) impelled a new cosmic era. Likewise, both deities and humans were prone to clash between orderly and chaotic behaviours.

In what intelligence is concerned, the archetypical divine figure of such notion was inventive, original, and extremely pragmatic, finding solutions by actively operating within reality. However, because Enki/Ea ingenious agency found its roots in that reality, he was also prone to its temptations, and to deviate himself from the order he tutelages, to begin with.

Hence, through the exam of Enki/Ea's dual nature, one can argue that, for the Mesopotamians, intelligence and creativity were not locked in an ivory tower but sprung from the everyday capacity to deal with a reality that moved back and forth, between order and chaos.

ACKNOWLEDGEMENT

This chapter had the support of CHAM (NOVA FCSH/UAc), through the strategic project sponsored by FCT (UID/HIS/04666/2019).

BIBLIOGRAPHICAL REFERENCES

Abusch, Tzvi. (2001). The development and meaning of the Gilgamesh epic: an interpretative essay. In: *JAOS* 121 (4), pp. 614–622.

Algaze, Guillermo. (2008). Ancient Mesopotamia at the Dawn of Civilization – The evolution of an urban landscape. Chicago & London: The University of Chicago Press.

Almeida, Isabel G. (2012). The Descend to the Netherworld: A comparative study on the Inanna/Ištar imagery in the Sumerian and Semitic texts. In: Agud, Ana et al. ed. *Séptimo Centenario de los Estudios Orientales en Salamanca*. (pp. 91–100), Salamanca: Ediciones Universidad de Salamanca.

Almeida, Isabel G. (2015). *A construção da figura de Inanna/Ištar na Mesopotâmia: IV-II milénios a.C.* PhD thesis. Lisbon: Universidade NOVA de Lisboa. [http://hdl.handle.net/10362/16014, accessed February 2019].

Black, Jeremy & Green, Anthony. (1998) Gods, Demons and Symbols of Ancient Mesopotamia. An Illustrated Dictionary. London: British Museum Press.

Bottéro, Jean. (1998). Religiosité et raison en Mésopotamie. In: Bottéro, J., Herrenschmidt C., and Vernant J-P. eds. *L'Orient ancien et nous*. (pp. 15–91). Paris: Hachette Littératures.

Bottéro, Jean & Kramer, Samuel Noah. (1989). *Lorsque les dieux faisant l'homme*. Paris: Éditions Gallimard.

Cohen, Andrew C. (2005). Death Ritual, Ideology, and the development of early Mesopotamian kingship – Toward a new understanding of Iraq's Royal Cemetery of Ur. Leiden & Boston: Brill/Styx.

Dalley, Stephanie. trans. (2000). *Myths from Mesopotamia. Creation, the flood, Gilgamesh and others*. Oxford: Oxford University Press.

ETCSL – The Electronic Text of Sumerian Literature. (1998–2006). Oxford. [http://etcsl.orinst.ox.ac.uk/, accessed February 2019].

Foster, Benjamin R. (2005). *Before the Muses: An Anthology of Akkadian Literature*. Bethesda, MD: CDL Press.

George, Andrew. (2005) In search of the **é.dub.ba.a**: The ancient Mesopotamian school in literature. In: Sefati, Yitschak. ed. *An experienced scribe who neglects nothing. Ancient Near Eastern Studies in Honor of Jacob Klein*. (pp. 127–137). Bethesda, MD: CDL Press. [http://eprints.soas.ac.uk/id/eprint/1618, accessed February 2019].

Hatab, Laurence J. (1990). *Myth and Philosophy. A contest of truths*. La Salle, ILL: Open Court Publishing Company.

Jacobsen, Thorkild. (1976). *The treasures of Darkness- a History of Mesopotamian Religion*. New Haven & London: Yale University Press.

Katz, Dina. (2003) The image of the Netherworld in the Sumerian Sources. Bethesda, MD: CDL Press.

Kramer, Samuel Noah & Maier, John (1989). *Myths of Enki, the Crafty God*. New York & Oxford: Oxford University Press.

Lopes, Helena T. & Almeida, Isabel G. (2017). The Mediterranean: The Asian and African Roots of the Cradle of Civilization. In: Fuerst-Bjeliš, Borna (ed.). *Mediterranean Identities – Environment, Society, Culture*. InTech. DOI: 10.5772/intechopen.69363.

López, Jesus & Sanmartín, Joaquín. (1993). *Mitología y Religión del Oriente Antiguo I Egipto- Mesopotamia*. Sabadell: Editorial Ausa.

Meslin, Michel. (1973). *Pour une science des religions*. Paris: Éditions du Seuil.

Rochberg, Francesca. (2004). The Heavenly Writing – Divination, Horoscopy, and Astronomy in Mesopotamian Culture. Cambridge: Cambridge University Press.

Rubio, Gonzalo. (2001). Gods and Scholars: Mapping the Pantheon in Early Mesopotamia. In: Pongratz-Leisten, Beate (ed.). *Reconsidering the concept of Revolutionary Monotheism*. (pp. 91–116). Winona Lake, IN: Enseinbrauns.

Sanmartín, Joanquín. (1999). *Códigos legales de tradícion babilónica*. Barcelona: Trotta/Edicions de la Universtitat de Barcelona.

Selz, Gebhard J. (2000). Five divine ladies: thoughts on Inanna(k), Ištar, In(n)nin, Annunitïtum and Anat, and the origin of the title "Quen of heaven" In: *NIN-Journal of Gender Studies in Antiquity* I, 29–59.

Steel, John M. ed. (2007). Calendars and Years: Astronomy and Time in the Ancient Near East. Vol. I. Oxford: Oxbow Books.

Vantisphout, Herman. (2009). Die Geschöpfe des Prometheus, or How and why did the Sumerians create their gods? In: Porter, Barbara N. (ed.). *What is a God? Anthropomorphic and non-anthropomorphic aspects of Deity in Ancient Mesopotamia*. (pp. 15–40). Winona Lake, IN: The Casco Bay Assyriological Institute.

Westenholz, J.G. (2010). 'Inanna and Ishtar in the Babylonian world'. In Leick, Gwendolyn (ed.). *The Babylonian world*. (pp. 332–347). New York/London: Routledge.

The legend of Sardanapalus: From ancient Assyria to European stages and screens

Maria de Fátima Rosa
CHAM and DH, FCSH, Universidade NOVA de Lisboa, Portugal
ORCID: 0000-0003-2302-7751

ABSTRACT: "Adieu, Assyria! / I loved thee well". These were the last words of king Sardanapalus, the last king of Assyria, according to Lord Byron. Throughout the centuries, Europe was confronted with the tragic story of Mesopotamia's last monarch, a king more effeminate than a woman, a lascivious and idle man, a governor who loathed all expressions of militarism and war. But this story was no more than it proposed to be: a story, not history. Sardanapalus was not even real! The Greeks conceived him; artists, play writers, and cineastes preserved him.

Through the imaginative minds of early Modern and Modern historians, artists and dramaturgs, Sardanapalus' legend endured well into the 20th-century in several different media. Even after the first excavations in Assyria, and the exhumation of its historical archives, where no king by the name of Sardanapalus was recorded, fantasy continued to surpass history.

Keywords: Reception of Antiquity, Mesopotamia, Greek Mythology, Opera, Italian Cinema.

1 INTRODUCTION

Who was Sardanapalus? To speak about him means to immerse oneself in the history of the ancient world and the genesis of Eastern and Western cultures. Mesopotamia gave the world one of its first empire, controlled by the Assyrians; their immense power and massive influence were destined to create a resonance for centuries to come. Cultural alterity between the so-called Eastern and Western worlds was already noticeable in Antiquity during the Persian wars, a time when the Hellenic world fought the Orient. The clash contributed to creating various misconceptions, ideas and *biased* tales about the Middle Eastern peoples and empires, such as the Assyrian and the Babylonian.

Sardanapalus was one of those creations. In the accounts of his life are present all the aspects of imagination, fantasy and creativity that contribute to the birth of a legend.

2 RIVALRY AND AMBITION: THE DOWNFALL OF THE ASSYRIAN EMPIRE

The death of Assyrian king Esarhaddon in c. 669 BC marked the ascension of his elder son Ashurbanipal, to whom historiography usually attributes the apogee of the neo-Assyrian empire, given that during his reign Assyria grew to its maximum extension. The renowned monarch[1] is known for his successful military campaigns that drove to the expansion of Assyria's borders (Brinkman 1984, 85-92), his capacity to rule and to subdue his enemies, and for his love for culture. Besides a faithful servant of his gods, a provider of his people and a caretaker of his/the god's land, as a Mesopotamian king should be, Ashurbanipal was also a scribe[2], and an avid collector of manuscripts: his is one of the first world's library, containing more than thirty thousand tablets (Finkel 2018, 80 and ff. and Taylor 2018, 94).

His conquests and victories were numerous, including the defeat of Libya and Egypt at the beginning of his reign and the triumph over the Elamite king Teumman in the battle of Til-Tuba, in 653 BC. Nevertheless, the most problematic and conspicuous victory was the one obtained against his younger brother, Šamaš-šumu-ukin. Before his death, Esarhaddon settled the future of Assyria dividing the empire between his two sons: the older would be in charge of Assyria, the core of the country, and the younger would rule over Babylonia (Fig. 1). However, it did not take long after the death of the sovereign for the rivalry between brothers to begin. The conflict, a true tale of

1. Presently, Ashurbanipal's reputation and celebrity are well recognized due to widely advertised British Museum exhibition "I am Ashurbanipal" (8 November 2018–21 February 2019).
2. In ancient Mesopotamia not all kings were scribes, thus the importance of this trace of Ashurbanipal.

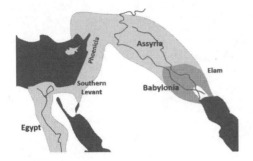

Figure 1. Estimated maximum extension of Ashurbanipal's empire with the highlighted area showing Šamaš-šumu-ukin's approximate dominion in the south (Babylonia). In dark grey are represented Mesopotamia's natural borders: The Persian Gulf and the Mediterranean Sea (plus the Red Sea bordering Egypt. Map made by the author.

jealousy and ambition, a family dispute surrounded with grief and sorrow, would forever mark the imaginary of the West. The story echoed through space and time, collecting different inputs over the following centuries, and reaching Europe's (and the United States') fantasist mind in the imperialist ages of the 19th and 20th centuries. Indeed, who is not familiar with Eugène Delacroix's 1827 (Fig. 2) painting *La mort de Sardanapale* (sometimes credited as Ashurbanipal)?

The suggestive title of Delacroix's work is, however deceitful, as we shall see. The conflict would not result in Ashurbanipal's death but on his brother's *possible* suicide. After Šamaš-šumu-ukin's enthronement in Babylonia in 668 BC, the increasing involvement of Ashurbanipal in the internal affairs of his realm as well as his delay in helping him when he needed (Brinkman 1984, 83–92), led him to express his desire to set Babylonia free from the Assyrian yoke. An upheaval took place in 652 BC (Caramelo 2002, 232–240) forcing Ashurbanipal to drive his armies south and to impose a siege on the capital city of Babylon that lasted for more than two years. After a long period of war between the siblings, with victories and defeats on both sides, Šamaš-šumu-ukin saw his allies gradually shorten, his power quickly diminished, and his city slowly lost. The siege imposed by Ashurbanipal brought famine and disease to Babylon's population, and ultimately a conflagration would devastate the city and dictate the end of Šamaš-šumu-ukin's rule. We do not know with certainty if the monarch committed suicide or if he was eventually pushed into the flames (Von Soden 1972, 85) but all points out to the fact that he died during the fire.

In the aftermath of the combat, in 648 BC, the victorious Ashurbanipal assigned a subordinate, the mysterious Kandalanu, to the throne of the fallen city. Assyria and Babylonia slowly recovered from the Great Rebellion, but the strength of the neo-Assyrian empire was forever slackened. The years of war led to severe economic penalties with the exhausting of

resources, to administrative problems, and the decline of Assyria's control over his subdues. Although this decay began before the civil war, the conflict marked the end of a period of apogee in Assyria's authority and shaped a new order of relationships between the powers of the Near East.

Ashurbanipal and Kandalanu both died in 627 BC, leaving Assyria and Babylonia orphaned of figures of authority. The throne of Nineveh, the capital of the empire, was occupied by several monarchs who were unable to raise Assyria to the power it had achieved with his predecessors, and a new dynasty raised in Babylonia, with kings Nabopolassar and Nebuchadnezzar II imposing their power over the Near East and determining the end of their northern rival. In 612 BC, an alliance between Nabopolassar of Babylon and the Mede king Cyaxares led to the downfall of Nineveh and the death of the last great king of Assyria[3] Sîn-šar-iškun (Curtis 2003, 158).

The episodes comprised in the short period between Esarhaddon's death in 669 BC and the conquest of Nineveh in 612 BC excited the minds of the historical actors that dealt closely with the Mesopotamian agents. They form the basis of a western romanticise tale, a story of love, pain, pleasure, dispute, and tragedy that endured in time and shaped our views of the East.

3 FROM HISTORY TO LEGEND: THE ROMANTICISM OF ANCIENT GREEK WRITERS

Ashurbanipal's political influence resounds in different historical vehicles as the Old Testament: it is possible that the Asnappar of Esdras is, in fact, the Assyrian king (Esd. 4, 10). But the most visible evidence of the Mesopotamian sovereign's prominence and the repercussion of the events that surrounded his governance is the birth of the Greek legend of Sardanapalus. How do we know the latter evokes the former?

The first reference to this somewhat mysterious character dates to the 5th-century BC. Herodotus speaks of the king of Nineveh, Sardanapalus' many richnesses (*The Persian Wars* 2.150.9). Later (c. beginning of the 3rd-century BC), a legend preserved in the demotic script in different Aramaic papyruses betrays a romantic tale of the adventures and misfortunes of two brothers: Sarbanabal and Sarmuge. Do the anthroponyms Ashurbanipal and Šamaš-šumu-ukin resound in the names of the characters of the demotic tale? It all points out to this, considering the discourse of Sarmuge to his elder brother:

> I am the king of (!) Babylon,
> and you are the governor of Ni <ne> veh,

3. Assyria gave his last breath with Ashur-uballit II when he was stationed around Harran. But despite this remainder of authority, the empire had already fallen.

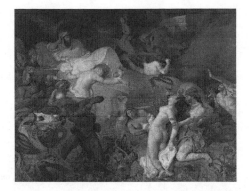

Figure 2. Eugène Delacroix's *La Mort de Sardanapale* (1828) portraying the final moments of Sardanapalus' life. The work was inspired by Byron's play *Sardanapalus* (1821) who was, in turn, influenced by Diodorus Siculus' account. Louvre Museum.

my tributary *city*
Why should I pay homage to you?
(Steiner and Nims 1985, 71).

The story leads to disagreements between the siblings and ends with Sarmuge expressing his wish to build up a room, threw down tar and pitch and set fire to it.

The most elaborate text about Sardanapalus is, notwithstanding, that of Greek historian Diodorus Siculus, who writes his report about the last Assyrian king in the 1st-century BC. In his *magnum opus, Bibliotheca Historica* Diodorus claims to have been inspired by the words of Ctesias of Cnidus, a physician who lived during the time of Achaemenid king Artaxerxes II and whose work has been lost. Reading Diodorus' tale, one is confronted with the transformation of the paradigm of Assyrian royalty and with the mixture of ingredients from different periods of Mesopotamia's History.

We must stress that the Greeks had their very own vision of the world. Herodotus claims to have written his *Histories* in order "that great and marvelous deeds, some displayed by the Hellenes, some by the barbarians" (*The Histories* 1.1.0) not be forgotten. His statement clearly points out to a polarisation between the Hellenes and the Barbarians, among which the Assyrians were obviously included. The perception of a cultural and social distinction that would eventually lead the Greeks to assume an ethnocentric vision was certainly intensified by the Persian wars (Yang 2007, 119). Adding to the symptom of a certain Hellenic pretentiousness was the distance that separated authors like Herodotus, Ctesias, and Diodorus from the events that led to the fall of the Assyrian empire at the beginning of the 7th-century BC.

Mesopotamian kings were seen through the Greek eye as dull and effeminate despots who had led their empires to ruin and were not capable of securing the welfare of their populations. Let us remind ourselves that the Greeks had a political and social organisation that deeply contrasted with their middle eastern counterpart; the Athenian Democracy had been established in the 5th-century BC, and there was a clear distinction between the realms of action of men – the military and political spheres – and women – the *oikos*. The subversion of gender roles was one of the ways found by the Greeks to express their perplexity when facing the cultural differences, often considered bizarre, of the eastern *other*. A figure such as Sardanapalus would thus be as strange as the Assyrian Semiramis, the first and most powerful queen of the East, a concept of sovereignty foreign to the Greeks.

Thus, the second volume of *Bibliotheca Historica* introduces us to a king living among women, dressing as such, using a soft voice and attiring in a way that would be considered unnatural for a Greek man. All this was but a fantasy created by the wondrous mind of the Classic authors who found in writing a way to express their concerns, who sought in myth and legend a means to explain their grandeur and to comprehend the demise of others. If Semiramis was strange[4], stranger would have been Sardanapalus.

According to Diodorus, when Sardanapalus' Mede satrap and general Arbaces saw him mingling in his palace with the women (Diodorus, 1993, 2.24), a revolt was set in motion. Nineveh was subjected to an assault by the Medes, who allied with the Babylonian priest Belesys, and Sardanapalus was faced with a dilemma: to fight or to capitulate. Firstly, the king urges his soldiers to battle; though his efforts are not enough to drive the enemies away. With his chances of winning diminishing rapidly, Sardanapalus takes a decision that highlights the romantic tone of the tale and appeals to the imagination of the reader. Abandoning hope (Diodorus, 1993, 2.27), the king locked himself in a chamber of the palace with his treasures and concubines, lightning up a pyre and sealing his fate as well as that of Assyria – the capital Nineveh burned to the ground in the consequent fire.

The legend of Sardanapalus recounted numerous times throughout the Classical world after the publication of Diodorus' work, invariably contained three vital elements: the king's attitude of detachment; the fire of Nineveh; and the climate of feast before the fall – which can also be seen as a Greek critic to the Mesopotamian *free a*nd lavish style of life. For instance, the Latin writer Justin recalls how Sardanapalus "first looked about for a hiding-place" (Justinus, 1853, 1.3) instead of fighting, an attitude more befitting a woman. His fellow historian Juvenal remembers the long "loves and the banquets and the down cushions of Sardanapalus" (Juvenal, 2014, 10.346); and

4. Semiramis was considered the first queens of Asia. Despite her government and authority, the legends about this female ruler highlighted her lascivious behaviour, laying at night with many men only to abandon them the day after.

Polybius stresses his hedonistic way of life, attributing to him the epitaph: "Mine are they yet the meats I ate, my wanton sport above, the joy of love" (Políbio, 1982, 8.10.3-4).

It is clear from all these narratives that Sardanapalus' character merges three different Assyrian monarchs: Ashurbanipal, one of the most important kings of the neo-Assyrian empire, as we have seen; Šamaš-šumu-ukin, the king who saw the palace of Babylon being set to fire, and possibly died in it; Sîn-šar-iškun, the last king of Nineveh. From Babylon, we were, therefore, slowly driven to Nineveh, and from History, Greek fantasy took us to legend. The Greeks set the tone. In a way, the Greeks (as well as the Old Testament) transformed Assyria: fable and folklore would prevail for *circa* two millennia until excavations in Assyria proved the inexistence of such a sovereign as Sardanapalus (or Semiramis).

When the English explorer Austen Layard started archaeological excavations in Nimrud, in 1845, (not knowing what was the exact city he was excavating), the deteriorated state of some slabs and inscriptions and the confirmation that one of its palaces had been destroyed in a major conflagration led his colleagues to believe that he was confronted with a concrete proof of the Classical story of Sardanapalus and the burning of Nineveh, primarily suggesting to identify the *tell* as such (Larsen 2016, 78).

Fantasy had triumphed[5]

4 EUROPE AND MESOPOTAMIA'S EXOTICISM – A LUXURIOUS FICTION

Lacking concrete evidence of Assyria and Babylonia, Renascence[6] and Enlightenment authors and artists were left to wonder what these ancient countries looked like and what were their inhabitant's anxieties and desires. Although fragile, the Classics provided an answer, and from the conjugation of their reports on Mesopotamia and the imagination of dramaturgs and cineastes legend would endure well into the 20th-century.

5 ON STAGES

The first modern tragedies on the life of Sardanapalus came to light in 17th-century Italy, closely following

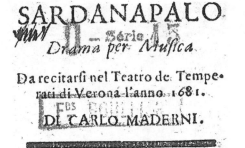

Figure 3. Superior part of the frontispiece to the 17th-century Italian opera *Sardanapalo*, presented in Verona, composed by Domenico Freschi with libretto by Carlo Maderni (Piffaut 2015, 50).

Diodorus' and Justinus' words. Carlo Maderni's libretto (with music from Domenico Freschi, 1678) set the pattern for the operas that would follow, all imbibed in an aura of eroticism and exoticism (Fig. 3). Sardanapalus was portrayed as a king eager for sex, posing like a woman, in a mixture of comedy, perversity, voyeurism, and tragedy (Piffaut 2015).

The Assyrian monarch embodied the "mostro il più lascivo di sfrenata libidine" (Maderni 1681, 5), an image very significant of the concept Europe had of this eastern *other*, and of the elite which governed it. Feasting with the women and neglecting the masculinised side of his reign (which urged to war and military action) was Sardanapalus' and Middle Eastern authorities' way of government. In Maderni and Freschi's play, Sardanapalus, watching Nineveh crumble, decides to organise a true massacre, setting fire to the palace. Hence, the Assyrian empire did not end without a show. A moralist view was hence highlighted – all eastern empires were doomed to fade under their moral decadence.

By the beginning of the 19th-century, the *Orientalist* vision that had set in Europe deepened the significance of Sardanapalus' eastern *persona*. In 1821, Victorian poet Lord Byron launched his *Sardanapalus*, adding to the famous legend the character of Myrrah, which would be, from then on, Sardanapalus' counterpart, his *partner in crime*. The choice of Myrrah's origins was not innocent; despite a slave, the combative spirit and impetuous temperament of Sardanapalus' favourite were certainly deserving of her Greek background. Myrrah's discourse – "I'm a Greek, and how should I fear death?" (Byron 1823, 34) – had an intentional pun. The concubine was the active and militant voice in the play as opposed to Sardanapalus' effeminacy, androgenic nature, and inactiveness[7].

Let us not forget that in this period the Ottoman threat extended through Europe, and Greece emerged

5. 1842 was a turning point in the long history of reception of Mesopotamia. The first excavation led by French consul Paul Émile Botta opened a new era in the knowledge of the country between the Tigre and the Euphrates. The Old Testament narrative and the Classical tales would slowly be replaced by the stories reported in the cuneiform inscriptions, which spoke of the events and characters of this civilization as seen and understood by its own agents. For the first time in twenty-five centuries Mesopotamia had a voice!
6. Boccaccio, for instance, speaks extensively of Sardanapalus (Terrusi 2012).

7. Sardanapalus posture is visible when he declares "I live in peace and pleasure: what can man do more?" (Byron 1823, 35).

in a fight for its independence from the Turkish aggressors. Lord Byron was an active voice in the conflict (Carman 2016, p. 237; Poole 1999, p. 167) and thus, the play shows a concern with the problems Europe faced. The British poet found a creative and clever way to express the dichotomies of East and West, and the paradigm of a cultural divergence that had been noted since Classical times. As in Diodorus Siculus, as in Maderni and Freschi's accounts, the city was condemned, and even the Euphrates seemed eager to precipitate its end, flooding in a destructive rage. After assembling a pyre around his throne, Sardanapalus withdraw with Myrrah to the throne room, and she finally stirred up the flame.

After Byron's creation, many operas would arise from the complicity shared between Sardanapalus and Myrrah, such as Hector Berlioz (1830), Franz Liszt (1849), Peter Ludwig Hertel (1867), or Giuseppe Libani (1887), to name just a few. All portrayed the final fall of Nineveh and Assyria as a direct consequence from its pomp and ostentation, its lack of moral values, and, in a certain way, its innate tendency to sin, to prevaricate, and to failure. The more Assyrian/eastern monarchs raised, the more spectacular was their fall.

6 ON SCREENS

Despite the excavations that granted Assyria and Babylonia a tangible image, during the 19th and 20th-centuries, Sardanapalus's legend was not to cease or be forgotten; the difference was that now he would frequently be depicted mixed with historical appointments that were otherwise absent. The 1910s and 1960s Italian movies are a clear example of the complexity and evolution of Sardanapalus' *persona* and the introduction of aspects that pointed out the disclosure of Assyria's monumental culture.

The first archaeological experience in Assyria took place in 1842, in Khorsabad, a city excavated by French consul Paul Émille Botta. Three years later, the British diplomat Austen Layard uncovered parts of ancient Nimrud, and in 1849 Nineveh was found. Although Byron's play was composed previously to the campaigns in Assyrian soil, the multiple productions in the years to follow, in Europe and the United States (Stauffer 2011), would slowly start to incorporate in its scenarios elements that remitted to the culture uncovered during the first excavations. The so-called *lamassu* (the giant winged bull which used to protect the entrances of palaces and temples in ancient Mesopotamia) appeared in many theatrical sets of the later decades of the 19th-century, together with the *apkallu* (also a protective spirit, a sage, a hybrid being).

Parallel to the physical discover of Mesopotamia were the philological breakthroughs which allowed officially to consider cuneiform's decipherment in 1857. However, although cuneiform tablets were decoded and translated, and Mesopotamia's history and culture were for the first time *truly* known, the myths created by the Greeks would never fade. The world was confronted with the inexistence of characters such as Nimrod, Ninus, Semiramis, Ninyas or Sardanapalus, but the spectacle world of arts and media was not prepared to face reality. In truth, the reality was never the aim! Hence, arts and media decided to ignore History, or, to the put in a gentler way, opted to continue fomenting creativeness, fantasising about the distant *other* in the same way they always had.

The birth of cinema provided yet another vehicle to portray Sardanapalus' tragedy. Curiously, movies centred in the king of Assyria are both Italian productions. *Sardanapalo Re dell'Assiria*, a short movie from director Giuseppe de Liguoro, which premiered in 1910, and *Le sette folgori di Assur*, from Silvio Amadio, which debuted in 1962. The two show clear influences from Byron's work; the stories revolve around the affair of the king with a slave. The fact that they both correspond to Italian creations is certainly due to the necessity of screenwriters and producers to highlight their countries Classical roots, searching heroes and heroines from Antiquity's mythology. Let us also remember the legacy of Italian operas and its influence on the media (and in cinema) still nowadays. On the other hand, the so-called *peplum* genre also provided the ideal ambient to bring to the screen legendary figures from the ancient world.

From the two, Amadio's is the one which shows more originally. The story focuses on a young girl whose village is destroyed in an Assyrian raid. Taken to the empire capital of Nineveh, the girl, Myrrah, soon captures the attention and affection of prince Shamash, the younger brother of the king Sardanapalus, who also displays a love interest for the girl. While Shamash is discussing with Sardanapalus his government over Babylonia and his independence as king, the love both share for Myrrah ends up conflicting in the situation, and a war brakes up between the two. General Arbace, conspiring to take the throne, orders the killing of Shamash during the war between Assyria and Babylonia, and the cleavage deepens. Sardanapalus, suffering over his brother's fate, and fearing his population's demise, conjures the gods, and destroys the statue of Assur, the patron deity of Assyria. The divine response arrives in the way of a massive storm, while enemies suddenly surround Sardanapalus' town. Meanwhile, Myrrah falls into the affection of the king, who decides to offer a great banquet during the tempest (Fig. 4). In the end, the city burns in flames.

This screenplay takes us back to an old episode of Mesopotamia's history, which we have already explored. Indeed, the originality of this picture is the amalgam of historical facts with mythical ones. The tale of the two brothers (Ashurbanipal and Šamaš-šumu-ukin, vide supra) absent during centuries is finally recovered, after the decipherment of cuneiform

Figure 4. Myrrah and Sardanapalus (Mirra and Sardana-palo) as portrayed in the Italian movie *Le sette folgori di Assur*. The king offers an exquisite banquet before the city fall. Still from *Le sette folgori di Assur* (English title: *War Gods of Babylon*), 1962: https://www.youtube.com/watch?v=591yZzxWisg&t=2328s.

the paradigms set by *Orientalism* would prevail in the 20th and 21st-century.

More than twenty-five centuries after Nineveh's conquest by the Persians in 612 BC, fascination sur-rounding its fall persisted. What was more interesting and appealing: To show a city taken by foreign troops without putting much of a fight or to represent the monarch of an empire setting fire to its own capital, locked with his lover in his chambers (or perishing in a tempest and conflagration)?

Fantasy, creativity, fiction, and imagination cap-tured the attention of Europe during centuries. Theatre and cinema spectators watched delightedly to the fall of the last empire of Mesopotamia through a legend that covered Assyria in a whimsical garment.

ACKNOWLEDGEMENT

This chapter had the support of CHAM (NOVA FCSH/UAc), through the strategic project sponsored by FCT (UID/HIS/04666/2019).

tablets. The struggle between the two is mixed with the fable of Ctesias and Diodorus and other interest-ing elements. Historical aspects such as the evocation of Esarhaddon, the father of the two siblings, and the depiction of the city, which although displaying Classical architecture, has many sculptures in Assyr-ian or Persian style, constitutes a somewhat objective revision of the legend forged during Classical age.

Also, in Amadio's film the final destruction of Nineveh originates from the anger of the gods, and particularly from that of Assur, now recognised as the ancient *national* deity of Assyria (contrarily to the one mentioned in Diodorus Siculus' report, Belus). The love triangle of *Le sette folgori di Assur*, on the other hand, adds a tone simultaneously softer and dramatic to Sardanapalus' story. Apart from the political disputes between the two siblings, it was the fight for Myrrah's affection that led to the tragic death of Shamash, whose severed head was displayed before the city, and the subsequent Sardanapalus' rage (followed by divine punishment).

Moreover, in the 1962's film, there was no way Sardanapalus could continue being portrayed as an effeminate and idle monarch. All the reliefs exhumed in Assyria showed the king as a virile man, killing lions and leading bathes. Thus, in *Le sette folgori di Assur*, the monarch displays all the necessary req-uisites of a *traditional* monarch. However, although Sardanapalus (Ashurbanipal) recovers his masculinity, the luxurious, exquisite tendencies, the promiscuity, the bacchanals, and the city fall persist. Why? Because the East would always be the *other* in European con-ception and its extravagant way of life, enhanced by

BIBLIOGRAPHICAL REFERENCES

Brinkman, J. A. (1984). *Prelude to Empire. Babylonian Soci-ety and Politics, 747–626 B.C.* Philadelphia: University of Pennsylvania Museum of Archaeology and Anthropology.

Byron, Lord. (1823). *Sardanapalus*. London: John Murray, Albemarle-Street.

Caramelo, Francisco. (2002). A linguagem proféticana Mesopotâmia (Mari e Assíria). Cascais: Patrimonia.

Carman, Colin. (2016). Byron's Flower Power. Ecology and Effeminacy in Sardanapalus. In: Hall, Dewey W. (ed.). *Romantic ecocriticism: origin and legacies*. (pp. 233–252). Maryland, Lexington Books.

Curtis, John. (2003). The Assyrian heartland in the period 612–539 BC. In: Giovanni B. Lanfranchi, Michael Roaf et Robert Rollinger (eds.). *Continuity of Empire (?): Assyria, Media, Persia*. (pp. 157–68). Padova: Sargon Editrice e Libreria.

Diodorus Siculus. (1993). *Library of History* (Loeb Classi-cal Library), Volume I, Books 1–2.34. Harvard: Harvard University Press.

Finkel, Irving. (2018). Ashurbanipal's library: contents and significance. In: Brereton, Gareth [ed.]. *I am Ashurbani-pal king of the world, king of Assyria*. (pp. 88–99). London: The British Museum.

Justinus. (1853). *Epitome of the Philippic History of Pom-peius Trogus*. London: Henry G. Bohn, York Street, Convent Garden.

Juvenal. (2014). *Complete Works of Juvenal*. Sussex: Delphi Classics.

Lapeña, Óscar. (2008). El Péplum y la Construcción de la Memoria. In: *Quaderns de Cine: Cine i memòria històrica 3*, pp. 105–112.

Larsen, Mogens Trolle. (1996). The conquest of Assyria. Excavations in an antique land 1840–1860. London and New York: Routledge.

Maderni, Carlo. (1679). *Sardanapalo, drama per musica. Da recitarsi nel Teatro di Sant'Angelo l'anno 1679*. Veneza:

Presso Francesco Nicolini [https://www.loc.gov/resource/musschatz.19689.0/?sp=1, accessed February 2019]

Piffaut, L. (2015) Le Sardanapalo (1678). de Freschi: pratiques théâtrales et musicales du contraste dans lópéra vénitien du XVIIe siècle. In: *Chroniques italiennes (Série Web) 30/2*, pp. 47–68.

Políbio. (1982) *Historias*, vol. II. Madrid: Gredos.

Pomarè, Carla. (2014). Sardanapalus, or, Romantic Drama Between History and Archaeology. In: Crisafulli, Lilla Maria and Liberto, Fabio (eds.). *The Romantic Stage. A Many-Sided Mirror* (DQR Studies in Literature, Vol. 55). (pp. 225–278). Amsterdam, Brill Rodopi.

Poole, Gabriele. (1999). Eroi allo specchio. Il Sardanapalus di Byron. In *Giochi di Specchi*. A cura di Agostino Lombardo. (pp. 147–175). Roma, Bulzoni.

Ramsay, G. G. (1920). Juvenal and Persius with an English translation by G.G. Ramsay. London: William Heinemann.

Rotondi, Pietro. (1844). Sardanapalo: melodrama di Pietro Rotondi, muscia del Conte Giulio Litta. Milano: Luigi di Giacomo Pirola.

Said, Edward. (1997). *Orientalismo*. Lisboa: Edições Cotovia.

Stauffer, Andrew M. (2011). Sardanapalus, Spectacle, and the Empire State. In: Green, Matthew, and Pal-Lapinski, Piya (eds.). *Byron and the Politics of Freedom and Terror*. (pp. 33–46). Hampshire, Palgrave Macmillan.

Steiner, Richard, and Nims, Charles. (1985). Ashurbanipal and Shamash-shum-ukin: a tale of two brothers from the Aramaic text in Demotic script. In: *Revue Biblique 92*, pp. 60–81.

Taylor, Jon. (2018). Knowledge: The key to Assyrian Power. In: Brereton, Gareth (ed.). *I am Ashurbanipal king of the world, king of Assyria*. (pp. 80–79). London: The British Museum.

Terrusi, Leonardo. (2012). Sardanapalo in Boccaccio. Risonanze nascoste di un Exemplum medievale. In: Bellone, Luca et al. coord. *Filologia e Linguistica. Studi in onore di Anna Cornagliotti*. (pp. 617–633). Edizioni dell'Orso, Alessandria.

Yang, Huang. (2007). Orientalism in the Ancient World: Greek and Roman Images of the Orient from Homer to Virgil. In: *Bulletin of the Institute for Mediterranean Studies 5*, pp. 115–129.

Ziter, Edward. (2003). *The Orient on the Victorian Stage*. Cambridge: Cambridge University Press.

Fantasy, cryptozoology and/or reality: Interconnected stories of mythological creatures and marine mammals

Cristina Brito
CHAM, FCSH, Universidade NOVA de Lisboa, Lisbon, Portugal
ORCID: 0000-0001-7895-0784

ABSTRACT: Among other monstrosities and myths from the sea and aquatic bodies, the double-tailed mermaid has been profusely described and depicted in early modern literature, bestiaries and natural history treaties as in the iconography and cartography. Usually shown as a female form with one head and upper body and holding its two fish-like tails, it did represent the epitome of beautiful nature creations but also its strangeness and hybridity. With virtues and sins, love and danger within the same body, it could be the reflection of the moral and human acts' (dis)conformities. Besides the symbolic meaning of the mirror, or the twinning, could these mythical beings also be the result of non-understood observations of rare events in the sea? In this paper, more than providing answers, I am proposing some questions regarding early nature apprehension and natural knowledge production by relating the physicality of double-tailed mermaids with the real, yet highly obscure, occurrences of conjoined twins in sea animals. Conjoined or Siamese twins have, in fact, rarely been described in wild (marine) mammals but a couple of cases in cetaceans just came to light in recent years. Even though descriptions of monsters sometimes reveal more about people's minds and perceptions than they do about the animals, the physical similarities between these two types of marine monsters, and the possibility of real observations resulting in imaginary animals will be discussed.

Keywords: Mermaids, Cetaceans, Early modern natural history, Oceans history, Biology

1 INTRODUCTION: MERMAIDS, SEA SERPENTS, MONSTERS AND OTHERS

Since the Antiquity, from the Greek and Roman civilisations to the Middle Ages in Europe, and throughout the early modern period up to the present, sightings and subsequent descriptions, depictions and representations of mermaids have been abundant. Mermaids or siren, mermen or tritons are one of the most persistent legends of the aquatic realm, and they are pervasive in time, geography and cultures. In many other parts of the world, throughout human history, mermaids including the double-tailed mermaid, have been depicted and described and included in numerous myths, stories, rituals and ceremonies. In all oceanic bodies, from offshore to nearshore waters, from islands to inland watery spaces, different aquatic animals may have been the source to all the legends perpetuated through oral stories, group memories and written traditions. The persistence of the mermaid legend and the similarity of so many of the reports from independent origins in different areas suggests that it is based on more than an idle fantasy of the human imagination. It seems inevitable that some real animal or, more likely several different animals lie behind the legend in its various forms (Carrington, 1957). If sometimes mermaids are perceived as the beauties of the sea, most of the times they represent danger; most of the times, they are sea monsters (Ellis, 1994).

These monsters from the ocean, first seen as signs of portents or misfortune, were considered true wonders or prodigies (e.g. Mittman, 2012; Soares, 2012); they were conceived as distortions of the reality or hybrid monstrosities, and they conveyed human errors or sins[1]. Then, they began to converge as real elements of the natural world soon after the European oceanic expansion started in the 15th-century (e.g. Brito, 2016). They are included in the tomes of the Renaissance Natural History such as those from Conrad Gessner[2], Ambroise Paré (Paré, 1982 [1510–1590]), Adriaen Coenen[3] or Ulisses Aldrovandi and

1. All monsters are our constructions, even those that can clearly be traced to "real", scientifically known beings; through the process by which we construct and reconstruct them, we categorize, name, and define them, and thereby Grant them anthropocentric meaning that makes them "ours" (Mittman, 2012).
2. See the work by Hendrikx (2018).
3. See the online digital collection of Adrian Coenen's Fish Book (1580) at the Public Domain Review: https://publicdomainreview.org/collections/adriaen-coenens-fish-book-1580/ (last accessed March 12, 2019). The author has also published the Whales Book. In both books large marine fauna are depicted and described, ranging from real

helped constructing new or different ways of thinking the nature, even though most authors of these exotic natural histories typically relied on the knowledge from the Classical Antiquity, translating them and merely adding some comments. However, from the 16th-century onward the opening of the offshore realms of the (Atlantic and Indian) ocean to Europe, also opened an all-new reign of animals and monstrosities. Giant squids, strange looking sharks and rays, large schools of flying fish, great whales and small dolphins, seals and manatees, many species of coastal and oceanic birds, and even rhinos and hippos, all contributed to the construction of knowledge about the aquatic ecosystems but also to novel or renewed accounts on the mythical sea monks, sea horses, mermaids and tritons. From this moment onward, most monsters merely demonstrated nature's curious mechanisms and were neither portents, signs, nor errors; (sea) monsters evoked curiosity and wonder rather than fear or horror (Davies, 2012; Brito, 2016).

When analysing early modern documental and iconographic sources in-depth, we can easily understand that most of the fabulous descriptions of sea monsters are the result of an attempt to categorise an unknown animal sighting. The misconception of a sea animal sighted – as still happens today – could have happened following the observation of a new or never seen before animal. However, the sighting of a peculiar and rare individual or natural behaviour of a familiar species could also have triggered such fantastic and unreal descriptions. There has always been some confusion between legendary sea beings or animals, and some types of real marine fauna.

Consequently, and similarly to several other sea monsters, double-tailed mermaids may find its origin in real animals from exotic or distant parts of the world, such as Africa, Brazil, or remote regions of the Pacific and Indian Oceans. Marine fauna from sub-tropical and tropical bioregions differs significantly from the fauna from temperate regions, and the difference in the occurrence of new species, in its distribution, relative abundance and local behavioural adaptations to distinct habitats may cause the perception of the new and an exotic novelty. On the other hand, the accounts of fantastic beings may eventually be the result of misidentifications of animals sighted at sea, at different sea and climate conditions. Moreover, they can also find its source in strange and extremely rare natural events occurring anywhere in the world, from the open sea to nearby shores. If rarely seen and/or described, they were for sure not known or understood. For instance, marine animals living in the depths

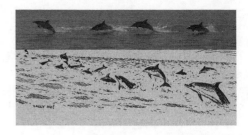

Figure 1. Dolphins porpoising in a line, in a possible visual interpretation of a sea serpent at the surface. Photo and edit by the author.

and approaching either the sea surface or coastal areas rarely may open space to the description of monstrosities or eccentricities from the sea. Even more so, if they are large animals, such as large cetaceans or giant squids.

Let us offer a typical example of such situations. There is a long conflicting history about the (real, believed, imagined, fantastic) occurrence of sea serpents (e.g. Ellis, 1994; Dendle, 2006). They are commonly described since ancient times, many sailors in many oceanic basins have reported their existence, the sightings and accounts are numerous and rich, even if varied in format and style. As a scary gigantic sea monster, no real animal does resemble the sea serpent. Alternatively, the same is to say that there are no sea serpents. Recently, many authors have been discussing the possible misidentification of cetaceans as these large and monstrous sea serpents (e.g. Ellis, 1994; Paxton et al., 2005; France, 2016). What is now believed is that, eventually, a part of the back of a giant whale or of a whale shark, or even a pod of dolphins' porpoising – moving in high speed in a straight line –, might resemble the physical aspect of a serpent at the sea surface and might give the visual sense of such strange "animals" (Fig. 1). For instance, Charles Paxton and colleagues (Paxton, 2005) offer a plausible explanation for the 18th-century sighting in the North Sea of the so-called Egede Sea Serpent (Fig. 2). They believe it was not a serpent that was observed but rather a large whale and they support their debate on the local occurrence of a couple of baleen whales, as well as on their anatomy and behaviours. A similar explanation is given for the 1857 Sea Serpent sighted off Cape Town; it might very well have been a cetacean entangled in marine debris (France, 2016).

No giant sea serpents exist, as no mermaids exist, in any ocean. However, their legend does persist and, in some way, make them real. In fact, almost as real as a real animal. Moreover, this is as much a matter of perception as it is of mental conceptions and mind settings. Mermaids are one of the most common legends in the marine environment; they persevere to the current day, being present across different cultures, geographies and periods (Carrington, 1957; Parsons, 2004; Costantine, 2014; Brito, 2018).

sea animals from the North Sea to all kinds of unreal or fantastic beasts from across the world as they reached Europe during the late 16th century. Single mermaids, double-tailed mermaids, pairs of mermaids and tritons, and several sea monsters – including the 16th-century Gândavo sea monster from Brazil (Brito, 2016) – are included in his tomes of natural history.

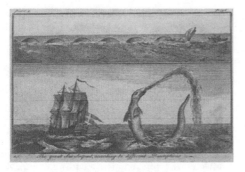

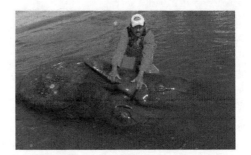

Figure 3. Scientists in Mexico's Laguna Ojo de Liebre, discovered the dead grey whale calves in January 2014, believed to have been miscarried as a result of their disability.

Figure 2. "Sea Serpent representations based on accounts given to Erik Pontoppidan.

As above mentioned, many researchers have been trying to understand historical accounts and descriptions of sea monsters – or sightings of 'unidentified marine objects' – through the lens of science and based on present-day biological knowledge of marine species and its habitats and behaviours (e.g. Paxton et al., 2005; Sent et al., 2013; France, 2016). Following this idea, we argue that some of the historical documental and iconographic descriptions may have been the result of misinterpreted encounters with local (but rare) or exotic/tropical marine mammals, or even misconceptions of observations of real elements and events from the aquatic environments.

As such, we will try to attach some biological meaning to the written descriptions and visual representations of the double-tailed mermaid considering the occurrence of some rare events of the marine world. This type of mermaid is represented since the Classical Antiquity to the present day, for the most different purposes. Even if double-tailed mermaids are not so frequent as the single-tailed mermaid, they can still be found through the centuries in different types of humanistic and natural history works, in frontispieces of books and allegories, in cartography and different forms of art.

Many of its attributes, many of the values and conceptions around it, are the result of the fact that it is constituted by two parts, or two elements, in the same body. This sea monster – this mermaid with the bifid tail-, more than the 'simple' mermaid, is considered as one of the most bizarre monsters of the sea and is a symbol of the mirroring, twinning and/or hybridity.

2 CONJOINED TWINS IN CETACEANS

In January 2014, a rare event from the marine world was documented and widely disseminated in the international press. Rare conjoined Gray Whale (*Eschrichtius robustus*) calves were found stranded dead in a case that was considered to be the first ever for this species (Fig. 3 and Fig. 5). Researchers found the aborted twins floating in a lagoon in Baja California, and the event was widely spread in scientific circuits as

well as in social media (Lee, 2014; Murphy & Malm, 2014).

Reports of conjoined or Siamese twins in wild mammals are very scarce; most reports are cases known in humans, in domestic animals or laboratory mammals (Kompanje, 2005). The precise incidence in wild mammals is unknown, most likely due to high prenatal and antenatal mortality. Almost all known cases of conjoined twins in wild mammals concern unborn embryos and fetus found during dissection of the dead pregnant female (Kompanje, 2005). Some cases of museum specimens of Siamese twins in terrestrial mammals do exist and are well known and documented, but none – to our knowledge – in the case of marine mammals[4].

In fact, the documented cases of twins in marine mammals are few; at least, the effective ones. Researchers estimate that less than 1% of cetaceans' births are multiple, with even fewer being conjoined – two calves sharing part of their bodies. As an example, Sei Whales (*Balaenoptera borealis*) have the highest rate of multiple births out of all cetaceans, a rate of 1,09% (Norris, 1966). In all the cases, the fetus or neonate – usually non-viable and seen as the grotesque result of development anomalies – were found ashore, were identified, documented and studied (Dabin et al., 2014). It is possible, as this is such a rare event for which the biology of the species is not prepared to that many cases result in the dead of the calves and the mother at the moment of birth or soon after, and for that reason might not be accounted for. They are, because they are uncommon, considered as bizarre and out of the norm; they are truly exotic and strange. Even if documented as a natural event, they are called by science as monsters.

Two other cases of conjoined twins in cetaceans are known in recent years. These are the dolphins found ashore in Turkey in 2014 (Fig. 4) and Denmark in

4. Marine mammals are a non-taxonomic group or category that includes animals from different taxonomic orders, such as the cetaceans (Order Cetacea), seals and sea lions (Order Carnivora), manatees and dugongs (Order Sirenia) and, according to some authors, also hippos.

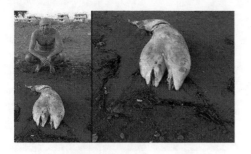

Figure 4. Rare case of conjoined twin dolphins in Turkey (August 5, 2014); a case of polycephaly (two heads) in dolphins.

2017. In the latter, it was a fisherman who caught the two-headed calves of Harbour Porpoise (*Phocoena phocoena*) in his fishing nets. As this is a protected species, the fisherman returned it to the sea but not before taking a picture of it and as a consequence the photograph was widely spread out through social media and the case well disseminated. This present-day description is not that distant from the one reported by Parsons (2004) of a mermaid caught by a fisherman off the Shetlands in the early 19th-century. According to Parsons (2004), a fishing boat from Cullivoe reportedly caught a mermaid on a hook, and although the fishermen threw the creature back in the sea, they gave a vivid description.

(and in the paper, they go on by giving the description). The awkwardness of such encounters may result in this attitude of returning the 'monster' back to his place of origin.

The same happened with the two-headed Bottlenose Dolphin (*Tursiops truncatus*) calves found off Istanbul, Turkey (August 2014); the event was spread out, and photographs of the strange happening were disseminated. However, on the other contrary to others, this specimen was collected and kept for study.

Yet another specimen was collected and studied some years before in the Mediterranean Sea (June 24, 2001, Corsica). It was called 'double-faced monster' and studied from the viewpoint of teratology – the science that studies abnormal development in all living beings (Dabin et al., 2014). The authors, besides describing this particular occurrence, also refer to several real double monsters (two individuals more or less completely fused) that have been described previously and indicate that a few cases of individuals with one or more anomalies have also been reported (see all descriptions in Dabin et al., 2014).

In the study of nature, particular interest is shown in the scientific approaches to the rare, with long accounts being produced and with a large set of studies from distinct disciplines paying detailed attention to these occurrences. Even so, the accounts of conjoined cetacean twins are very uncommon, which is indicative of its rareness in the natural environment. It is probable that any event in history may have resulted in

a description, even if that description – to our modern eyes – do not correspond to a 'real' one in terms of how we now understand biology, ecology and taxonomy.

3 RARE AND MARVELLOUS EVENTS IN THE SEA: FANTASY OR REALITY?

It must not be doubted that just as one sees several monstrous animals of diverse shapes on the earth, so also are there many strange sorts of them in the sea, some of which are men from the waist up, called Tritons, other [are] women, called Sirens, [or, Mermaids], who are [both] covered with scales. (Paré, 1982 [1510–1590], 107).

Humans have a particular interest, if not a particular attraction, for the rare, for the uncommon, for the different or even strange. Historically, humans tended to categorise the 'out of the norm' as such, so that they can socially and culturally normalise individuals, groups, or specific situations. Similarly to these mental and social constructions regarding humans, they proceed in an equal normative way regarding the productions of nature – the ones easily understood and the ones that fall outside of the systems of categorisation or classification. The fascination for the monstrous is continuous, and it encompasses much of the human anguishes of the unknown and the dark, of the marginal and peripheric, of the distant and the unexplainable (e.g. Dendle, 2006; Soares, 2012).

In this historical quest for the bizarre and the unique, naturalists, historians, cryptozoologists – those who study unconfirmed species (Dendle, 2006)-, and biologists, all have had their say. The documented strandings of cetaceans' conjoined twins have provided a unique chance for scientists to study these occurrences, both anatomically and according to the number of accounts (e.g. Dabin et al., 2014). It also offers an excellent opportunity for scholars in the history of natural history (or even of cryptozoology) to discuss how real events from the marine realm may or not be the source of inspiration for the mythological beast and fantastic beings.

Spanning throughout time, geography and cultures, peoples have believed in shape-shifters, in monsters, in rarely seen animals and all kinds of fantasies and unexplainable possibilities. These cryptids populated folklore, traditions, popular tales and epic poems, oral accounts and scientific sightings (e.g. Parsons, 2004). However, are they real? We know that there is no such thing as sea serpents, though they have been sighted and described in scientific and popular literature for centuries. Can eventually all of those sightings been based in biased and misinterpreted observation of real marine animals? If an exploration of historic monsters has taught us anything, it's that most were not fabricated out of pure myth. Usually, they proceed from an attempt to categorize an unknown animal sighting (Costantino, 2014).

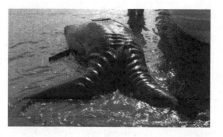

Figure 5. The dead Gray Whale conjoined twins had two heads and two tails; the latter may resemble the two tails of double mermaids.

Figure 6. Tritons, or Nereids, the merpeople of the Greeks and Romans. Ashton, John. Curious Creatures in Zoology. 1890.

Figure 7. Adriaen Coenen double-tailed mermaid in his Fish Book (1577).

Linking descriptions of cryptid or fantastic creatures (typically found in myths, local oral stories and folklore) to actual living counterparts may be only conjectural (Parsons, 2004). Assuming that descriptions of these sea creatures are not merely figments of overactive imaginations and are in some key aspects accurate, is supported on the fact that some features of the described animals that are astonishingly similar to extant marine species (Parsons, 2004). Following this principle, several authors and researchers have tried to understand the real source of fantastic marine beings. This is the case of serpents and cetaceans, of the Kraken and giant deep-sea squids, of the 'regular' mermaid and the manatees (e.g. Carrington, 1957; Parsons, 2004; Paxton et al., 2005; Costantino, 2014; France, 2016; Brito, 2016; Brito, 2018). Although descriptions of sea monsters may initially appear fanciful, on closer inspection they can sometimes reveal characteristics and features that may be recognizable by marine biologists as diagnostic of living marine animals. So even the most unusual tales of sea monsters may, in fact, contain, deep within them, a small element of truth (Parsons, 2004).

In the European history of natural history, sea monsters and cetaceans have often been placed side by side in the same category. Real accounts alongside the perspectives or perceptions from literature, tradition and local cultures blur the line between real marine megafauna and fantastic creatures of the shores and open oceans. Along the time, anecdotes about real but little-known species or specimens may give rise to the appearance over and over again of monster-like sightings (Hendrikx, 2018).

This might very well be the case of double-tailed mermaids across history and the rare occurrence of conjoined cetacean twins. So, besides their typical symbolic meanings of the mirror, or the twinning, could these mythical beings also be the result of non-understood observations of nature monstrosities and rare events in the sea? For sure, the double tail in the conjoined calves of the Gray Whale (see Fig. 5) can physically and anatomically resemble the double tail of the mermaids (see Fig. 6 and Fig. 7).

The double-tailed mermaid is portrayed and described in many different works of natural history or similar. We find this hybrid creature in different entrances of the medieval herbaria Hortus Sanitatis described as a Siren. We find it in the Renaissance zoology or monsters' massive tomes of Ulisses Aldrovandi and John Johnston. The latter refers to it as an Antropomorphus. We even find it in the Frontispiece of 1662 Caspar Schott's *Phisica Curiosa*, populating – alongside with other fantastic creatures and real animals – the marine realm. We encounter it again and again in illustrations, sculptures and paintings; an example of the latter is the late 15th-century double-tailed mermaid by the Italian painter Teodoro Ghisi. And, of course, we find across many European local traditions and folklore, where they are referred to as merpeople or merfolk.

Even if we are not accounting exactly for the past occurrence of such monsters in their natural environment, we are trying to offer a possible biological rationalisation for the prevalence of such fanciful and fantastic descriptions. In the future, it might be interesting to address the global dispersion of such historical illustrations and descriptions, eventually trying to relate it to the global pattern of distribution or occurrence of conjoined cetaceans. Do they occur outside Europe? How do local and indigenous peoples address the marvellous and the unexplainable in natural environments? But marvellous though these creatures may be, they are treated as eminently natural (Ashworth, 1991) and its historical appearance may give a clue to

past biological events. Moreover, this study is particularly important for the cultural understanding of sea monsters and why were double-tailed mermaids – or simply mermaids – considered as part of the natural world at a specific moment in time and a particular set of circumstances.

ACKNOWLEDGEMENT

This chapter was supported by CHAM (Centre for the Humanities) Strategic Project (FCSH, NOVA, UAc) sponsored by FCT (UID/HIS/04666/2019) and by the Exploratory Funding to project ONE (NOVA FCSH). It was developed under the H2020 MSCA–RISE 777998 "CONCHA – The construction of early modern global Cities and oceanic networks in the Atlantic: An approach via Ocean's Cultural Heritage" and the UNESCO Chair in The Oceans' Cultural Heritage (NOVA FCSH).

BIBLIOGRAPHICAL REFERENCES

Ashworth, W.B. (1991). Remarkable humans and singular beats. In Kenseth J (ed.). *The Age of the Marvelous*. Hanover, New Hampshire: Hood Museum of Art, Dartmouth College: 113–144.

Brito, C. (2016). New Science From Old News: Sea monsters in the early modern Portuguese production and transfer of knowledge about the natural world. Lisboa: Escola de Mar.

_____. (2018). Connected margins and disconnected knowledge: Exotic marine mammals in the making of early modern European natural history. In Amélia Polónia; Fabiano Bracht; Gisele C. Conceição; Monique Palma (Eds). *Cross-cultural Exchange and the Circulation of Knowledge in the First Global Age*. (v.1: 106–132). Porto: CITCEM/Edições Afrontamento.

Carrington, R. (1957). Mermaids and mastodons: A book of natural & unnatural history. New York: Rinehart & Company.

Costantino, G (2014). The beautiful monster: Mermaid. Biodiversity Heritage Library. https://blog.biodiversitylibrary.org/2014/10/the-beautiful-monster-mermaids.html (last accessed March 12, 2019).

Davies, S. (2012). The unlucky, the bad and the ugly: Categories of monstrosity from the Renaissance to the Enlightenment. In Mittman AS & Dendle PJ (eds) *The Ashgate Research Companion to Monsters and the Monstrous*. (pp. 49–75) Farnham: Ashgate.

Dabin, W., Cesarini, C., Clemenceau, I. Dhermain, F., Jauniaux, T., Van Canneyt, O. & Ridoux, V. (2014). Double-faced monster in the bottlenosed dolphin (Tursiops truncatus) found in the Mediterranean Sea. *Veterinary Record*, 154: 306–308.

Dendle, P. (2006). Cryptozoology in the Medieval and Modern Worlds. *Folklore*, 117: 190–206.

Ellis, R. (1994). *Monsters of the Sea*. New York: Knopf.

France, R. L. (2016). Reinterpreting nineteenth-century accounts of whales battling 'sea serpents' as an illation of early entanglement in pre-plastic fishing gear or maritime debris. *The International Journal of Maritime History*, 28(4): 686–714.

Hendrikx, S. (2018). Monstrosities from the Sea. Taxonomy and tradition in Conrad Gessner's (1516–1565) discussion of cetaceans and sea-monsters. In Jacquemard C., Gauvin B., Lucas-Avenel M.-A., Clavel B. & Buquet T. (éds), Animaux aquatiques et monstres des mers septentrionales (imaginer, connaître, exploiter, de l'Antiquité à 1600). *Anthropozoo logica* 53 (11): 125–137.

Kompanje, E.J.O. (2005). A case of symmetrical conjoined twins in a bottlenose dolphin Tursiops truncatus (Mammalia, Cetacea). *DEINSEA* 11: 147–150.

Lee, J.J. (2014). Rare Conjoined Gray Whale Calves Found in Lagoon: Could Be First for Species. *National Geographic*. January 10.

Mittman, A.S. (2012). Introduction: The impact of monsters and monsters studies. In Mittman AS & Dendle PJ (eds) *The Ashgate Research Companion to Monsters and the Monstrous*. (pp. 1–14). Farnham: Ashgate.

Murphy, C. & Malm, S. (2014). Conjoined whale calves found dead in Mexican lagoon in world's first documented case of Siamese gray whales. *Daily Mail Online*. January 7, 2014.

Norris, K.S. (1966). *Whales, Dolphins and Porpoises*. Berkley: University of California Press.

Paré, A. (1982) [1510-1590]. *On Monsters and Marvels* (Translated with an Introduction by Janis L. Pallister). Chicago and London: The University of Chicago Press.

Parsons, E.C.M. (2004). Sea monsters and mermaids in Scottish folklore: Can these tales give us information on the historic occurrence of marine animals in Scotland?, *Anthrozoös*, 17 (1): 73–80.

Paxton, C.G.M., Knatterud, E. & Hedley, S.L. (2005). Cetaceans, sex and sea serpents: An analysis of the Egede accounts of a 'Most Dreadful Monster' seen off the Coast of Greenland in 1734. *Archives of Natural History*, 32: 1–9.

Sent, P., Hill, L.C. & Moton, B.J. (2013). Solution to a 440-year-old zoological mystery: The case of Aldrovandi's Dragon. *Annals of Science*, 70 (4): 531–537.

Soares, D. (2012). Compêndio de segredos sombrios e factos arrepiantes. Lisboa: Saída de Emergência.

FIGURES CREDITS

Fig. 1 – Photo and edit by the author.

Fig. 2 – "The Natural History of Norway. 1755. Source: http://biodiversitylibrary.org/page/41885141 (last accessed on March 12, 2019).

Fig. 3 – Source: https://www.dailymail.co.uk/news/article-2535206/Conjoined-whale-calves-dead-Mexican-lagoon-worlds-documented-case-Siamese-gray-whales.html (last accessed on March 12, 2019).

Fig. 4 – Source: http://todropscience.tumblr.com/post/94173 345277/rare-case-of-conjoined-twin-dolphins-in-turkey (last accessed on March 12, 2019).

Fig. 5 – Source: https://www.dailymail.co.uk/news/article-2535206/Conjoined-whale-calves-dead-Mexican-lagoon-worlds-documented-case-Siamese-gray-whales.html (last accessed on March 12, 2019).

Fig. 6 – Source: http://biodiversitylibrary.org/page/23574966 (last accessed on March 12, 2019).

Fig. 7 – Source: https://www.kb.nl/en/themes/middle-ages/adriaen-coenens-visboek (last accessed on March 12, 2019).

To ponder the pathology of power in the early modern Era: Creativity and intelligence in the political theory and practice reflected in emblems and iconological programs

Maria Leonor García da Cruz

Faculdade de Letras da Universidade de Lisboa, Centro de História da Universidade de Lisboa, Lisbon, Portugal
ORCID: 0000-0002-8989-4527

ABSTRACT: Political theorists, theologians, jurists, men of letters, spoke during the early modern Era about uses and abuses of authority. Offences, vices and crimes of rulers or ruling elites are subject to consideration, by revisiting, in texts and images, the conduct of the political body and the repercussions in the social body, which tolerates them or cooperates with them.

The construction shows itself as particularly creative, along with written works which are the inheritance and update of interpretations on the foundations and mechanisms of power, the emblematic with its symbols and enigmatic messages that also cover those subjects.

It is, hereby, covered a fertile field of creativity and fantasy, inspired by ancient and modern sources, which combines *inscriptio* with *pictura* and with *subscriptio*, in a dialectical and intelligent articulation, challenging the reader to seek the senses of the enigma. We are faced with a literature largely spread during the Renaissance, which evolves through successive editions and translations, revisiting texts in prose or verse and recreating engravings according to the geographical and epochal vicissitudes. From Alciato to Ripa, imagery manifests a unique intelligence game.

Keywords: Pathology of power, Intelligence, Emblemata, Iconologia, Renaissance

The pathology of power is directly related to offences, vices and crimes practised by the rulers, corruption among ruling elites, but abnormally accepted by society. It leads us to reflect on the relations of the social body with the politic body, and to consider if, during the early modern Era, the application of legal filters existed or not, independently of coming either from the definition of tyranny and abuse of power or from the definition of corruption (Cruz, 2018).

Political theorists, theologians, jurists, men of letters spoke during this period about the ruler's power and, naturally, about its limits (Mesnard, 1977). An ideal of a ruler was defined in early modern Europe, according to law and ethics, an ethic often imbued with Christian spiritual values. In an organicist conception of power, one would seek the cure for the symptoms of the disease. However, would the disease be in the head of the community or the components of the social body? In this case, it would be up to the supreme authority to correct the "disconcertment" (*desconcerto*) of a "world of face behind" (*mundo de cara atrás*), applying here expressions of Portuguese authors of the sixteenth century, whether it is Luís de Camões or a few decades before Gil Vicente, in his genial creations.

However, it is not only in treaties, and poetic and theatrical productions that we see moralising and intrinsically reforming speech unfold. In a shrewd and well-founded way, the future ruler is guided in works of advising princes, as well as valuing concepts higher than the individual which should guide him and his people in fundamental laws such as the Ordinations (*Ordenações*) of the Kingdom. Does it consist, however, in articulating conducts according to precepts of divine origin or to attend to experiential circumstances that derive fundamentally from the human plane and must be solved by laws, of profane origin, generated by the Republic itself?

In addition to revisiting creators of political theories in extensive works where they develop a modern conception of power, as in the case in 1513 of Machiavelli (1976, 2010) or in 1576 Jean Bodin (2011), we should also follow writers who, in prose or verse, systematized ideas and synthesized representations of realities or of feelings related to the use and abuse of authority. I have selected in particular authors of emblems, for the creativity, fantasy and intelligence that are intrinsic to them, beginning with Andrea Alciato (1993) in 1531, and from repositories as the *Iconologia* of Cesare Ripa (1996) in 1593 and 1613. Referring to the beginning,

in both cases, of textual creation, it will be collected, in successive editions, engravings closely related to the content of writing, valuing it and even complementing it, fruit of the creativity of the recording artist and clearing the intelligence of the message.

The emblematic covers everything that refers to symbols (Amaral Jr, 2005: 7), from *mottos* to iconology. The emblem, in particular, appears in its fullness composed of the *motto* or *inscriptio*, i.e., a phrase that summarises the message, by the engraving or *pictura*, i.e., an allusive and symbolic scene, and by the comment or *subscriptio*, i.e., text in verse or prose. It should be remembered that a significant part of the books of emblems have no illustrations or do not have them in the first editions and that the images, once created, will change according to the date and place of the impression (Balavoine, 1982), a fact that I consider meaningful according to the historical context, the reading public, and the revelation that the editor will give to the enigma underlying the emblem. The three parts end up interpreting each other, having a dialectic between them. It is a "game of intelligence" to obtain the most enigmatic sense possible (Sebastián, 1993).

It will be Heinrich Steyner who will introduce engravings in the collection of the Milanese jurist Andrea Alciato (1492–1550), being the first editions of Augsburg (two in 1531 and one in 1534), published in Latin and later in French (1536), German 1542), Italian, and Spanish (1549), becoming known throughout Europe, read and maintained even in libraries of great Portuguese noblemen such as the Duke of Braganza (Buescu, 2016). However, Alciato (1993) subscribes to a symbolic tradition and translates and uses in the design of its emblems *adagia*, heraldry, Egyptian hieroglyphics, commemorative medals, *mottos*.

We do not always know the authorship of the engravings, all we have for the 16th-century are the notes about the first edition painter Jörg Breu, the printers of Lyon in 1547, Rouille and Bonhomme, and of the Latin edition of Frankfurt in 1566, Jost Amman and Virgil Solis, each of them with its own style. It should also be noted that the number of images created varies from edition to edition.

Among the emblems which relate to the prince in particular, and using the Lyon's edition, we can highlight the 148 *Principis clementia* on the mercy of the ruler illustrated by the hive and by how the prince governs his people with clemency and moderate power, although he could use rigour and punishment, and also the 149 *Salus publica* on the concern of the commonweal and the 143 *Princeps subditorum incolumitatem procurans* which symbolizes – through the dauphin and the anchor – the way to act for the sake of the subjects with agility on opportune occasions and with firmness. It should be noted, by the way, that the latter theme was adopted in devices such as that of the Portuguese monarch Cardinal-King D. Henrique.

In a complementary speech, it is captured the emblem 145 *Consiliarii principum*, on the prince's counsellors, valuing the prudence and justice. Justice, for its part, is nuclear in the emblem 144 *In senatum boni principis*, on the advice of the good prince where he ensures his impartiality (without passion, blindfolded) and that of his magistrates (sitting, pondering, and without hands, not accepting bribes).

On the other hand, tyranny and a calculated form of social discipline (shrewd, not necessarily tyrannical) are also targeted by Alciato's reflection. In this context, it should be highlighted the emblem 146 *Opulentia tyranni, paupertas subjectorum* and the 147 *Quod non capit Christus, rapit fiscus*, both pointing to the dialectic of the finances of the State relatively to the body of the subjects. If in the first one the poverty of the governed is set up due to the extreme rapacity of the prince, in the second one it is questioned the greed of the subjects themselves and how much the ruler can make use of their punishment, confiscating wrongly acquired goods. We will comment later on this second emblem, at a textual and iconographic level, considering a complexification of symbols in different editions of Alciato and comparing it with the *Reason of State* of Cesare Ripa (1996).

Meanwhile, liberation from tyranny is also depicted in Alciato (1993), namely in the emblem 150 *Republica liberata*, based on a coin with the symbols of the sword (means of liberation against Caesar) and the Phrygian cap (used in Rome by the freed slaves).

It adds to this that the existence of a tyrant has specific reasons within the general framework of sovereignty, which is modern in its design, but it is reprehensible and departs from its conceptualisation if we consider that a sovereign is a public person and for the good of the State, while the tyrant acts according to his will and affirmation. But this is a real danger and accompanies the political reflection of modern thinkers, as well as of its predecessors.

The sovereign, unlike the tyrant, exercises power without regard to himself, but under the state. Sovereignty acts for the foundation and conservation of a republic, founds and defines the State, and this gives substance to the collective aspirations of the people. By defining the Republic as "a fair government of several families and of what is common between them with supreme authority" Bodin (2011, Liv.I) emphasizes a State of law, justice, fairness, profane, effect of the sovereign will and, as it seems, non-tyrant (it would be if the sovereign, individual or collective, removed his plans from the common interest). In a modern posture, it results in a State that comes from the human, and that is made for the human. We are faced with a conceptual definition resulting from temporal circumstances, the construction of the modern world.

It should be noted that, at the time of Bodin's work, the regalia tradition joins the Protestant polemic, conflicts and practical experiences that mark the political reflection and the consideration of legal definitions, emphasising the secular effort. It should be recalled how Bodin (1530–1596) lived the environment of the

religious wars in France (Kamen, 1967), as well as another theorist, the Jesuit Mariana (1536–1623) graduated in Letters and Theology by the University of Alcala and with preaching experience in teaching in Rome, Sicily, Paris, where he witnesses the slaughter of St. Bartholomew, before returning to Spain. Of his works, we will highlight for now his *History of Spain* (1592–1598) and fundamentally *De rege et regis institutione* (1598–1599), with several editions. Probably, he knew the theories of the Leagues.

The objective of the sovereign (individual or collective) is to establish peace, even if it has to resort to violence, as Machiavelli (1976) had already stated decades before, and the power is won in order to establish a State by law. By the knowledge, one conquers and conserves the authority. Success reveals fair politics. The Florentine author supports this, not so much on a moral foundation (according to Mariana (1604)), but on the ruler's *virtù*, that is, in his intellectual and tactical capacity to confront and overcome contingency (Mairet, 1997). Thus, in a modern concept, the fair and the law derive from sovereignty.

In practice, the liberation of the State from any external political tutelage is not enough, namely the pontifical one (concretisation in the political Gallicanism at the beginning of the 14th-century in France), but also, in theoretical terms, a liberation of the philosophical-theological tutelage, that blemishes the pre-modern speech, must be elaborated. And Machiavelli will do it.

It should be noted, however, that in a modern conception, although God and nature are not found on the foundation of law and authority, moral obligations persist. These are found not in the foundation of the State (divine order and virtue in the source of good government), but in its political programme, which does not prevent, according to Machiavelli (1976), the ruler, if necessary for the maintenance of his States, for the good of State, to be compelled, that is, coerced, to a conduct against the very humanity and religion, without revealing a merciless nature.

In the process of modernity (of long duration), it is not only a laicization of politics, but a practical process and conceptualisation around the foundation of the republic itself, as a new order of things, necessary, and of politics that are a human project, autonomous, standing out a *res publica* with its own constitutive internal laws and structures (Duso, 2005). Bodin (2011) elaborates the conceptual structure of the State from the idea of sovereignty, from an authority superior to any other power.

Sovereignty is, thus, intimately related to necessity (Machiavelli) and the action of the prince with what is expedient, using his lion and fox skills. This well-marked image in Machiavelli is well mirrored in an emblem (the 22) by Guillaume La Perrière (c.1503–c.1565) in *Le theatre des bons engins* (1544), in which the prince gathers both animals, that is, the fortress and nobility of one with the subtlety and prudence of the other, valuing himself in war and council.

In the Iberian Peninsula, and in particular in Portugal, both Machiavelli and Bodin will have had their attentive readers, although in most cases they will not have been their adherents. Bodin was also known through other authors, notably Giovanni Botero (1540–1617), widely known and appreciated in Spain, through which the term sovereignty was also disclosed in Portugal.

However, many of Machiavelli's and Bodin's readers almost always proved their opponents, which did not invalidate the propagation of the new theories. It should be noted that in both thinkers, religion ceases to be a political reason, although it can be used for the good of the State, given its character that generates cohesion and obedience.

In Portugal, as in other European countries, the king is a Christian, showing the spiritual content of his power in the fundamental laws of the monarchy and in the majesty of the monarch, who is God's lieutenant on earth. These circumstances surround the great crimes and maximum penalties (death penalty and confiscation of assets). I am referring to the crime of lese-majesty (action against the royal figure and its representations) or the crime of heresy (conduct also against God) (Cruz, 2006). Although an autonomy of any political tutelage, including that of the power of the supreme pontiff, manifests itself in the conduct of the ruler, he acts under the influence of morality derived from the Catholic Church commandments, even after the confessional division of Europe.

On the other hand, it is mainly developed in Spanish theoreticians the accentuation of the transmission of power of divine origin to the natural community. The fact of being this latter who transmits it, in turn, to the political society, leaves a greater or lesser margin for a right of rebellion or resistance, in case of manifest tyranny (Mariana, 1604: Liv. I, cap VI, 40). There is a theoretical detachment from Bodin (Franklin, 1993).

In the Portuguese monarchy, even in a conception of power still traditional, there are modern principles. The absolute character of the king stems from the fact that he does not depend on other powers or organs for his decisions, although he can ask for advice from the subjects of attested quality and professionals of specific areas (from finance to war and religion). In this attitude, he reveals, moreover, a superior position. His action of supreme authority is based on Law, on the Kingdom Ordinations, although it may derogate from such laws if justified (for the public good) and by formal conditions. His conscience is that of a public person. The *Mesa da Consciência* reaffirms this image, a court created in 1532.

In the genesis of the modern State of the 16th-century, one can speak of absolute monarchy, not of absolutism, a position that expresses an essential conceptual problematic. Remember the critical

reflection in 1968 of Martim de Albuquerque (2012) following Mousnier (1955),. Vicens Vives (1984) in 1960, Macedo (1971), Naef (1973), and It should be noted that although the king is sovereign, as the laws that aim at the conservation of its authority and its states emanate from the king, a dialogical relationship with the subjects, either in Cortes or outside, is not dispensed. This is notorious in the everyday practice of justice, as well as in the definition of taxation systems. Particularly in this area of finance, there is some modernity in several aspects (Cruz, 2001): a) forms of control in close relation with the king by the high officials. They would invent assets and pre-evaluate their redistribution. They also learn about the variety of problems concerning the mainland and the areas of the overseas Empire; b) greater universality of a tax on purchases and sales of goods, *sisa*, which guarantees high yields. It is transformed into real rights, a change that is consented to in *Cortes* by the people and in the origin of contracts made by representatives of the communities and royal commissioners; c) the use of governance records that safeguard the common good of the people without somehow sacrificing them. This is the case of applications for direct loans to wealthy individuals or communities.

We can affirm that it is in this line that Mariana praises the king against the tyrant, considering that by persuasion (mentioning exhausted treasury or war soon and, simultaneously, excusing extraordinary and substantial taxes) would have the consent of the people (Mariana, 1598: Liv.I, cap.V), guaranteeing with his virtues, even in war, the retinue of good citizens. It goes as far as to legitimise the death of the prince who violates the laws of the State, that is, admits tyrannicide, as will other peninsular authors do, like Soto, Suárez and Molina (Maravall, 1955). As far as justice is concerned, it seems to draw inspiration from Erasmus and Bodin, basing it on the cult of virtue, revealing itself to be the independent, stern and pious judge, before high and low.

Several theorists value the virtues that guide the non-tyrannical king, be it justice, faith or piety, and we find them in the Emblems and other iconological programmes. Here his service to the public good is overvalued, to be obeyed by love and not by terror. The free will to exercise a balanced and just government or, on the contrary, a cruel and tyrannical rule, seems to depend exclusively on the prince, his Christian conscience, in Erasmus's words, or the close observation of conjunctures and cunning according to Machiavelli. Erasmus in 1501 goes so far as to consider the prince, himself, the author of a crime of lese-majesty (usually defined in the attack on the person or the representation of the ruler) when the ruler is practising tyranny over his people, thereby violating laws of divine inspiration and, therefore, attacking one's dignity (Erasmus, 1995). According to the same thinker, in 1509, a prince who does not exercise power for the common good, ensuring the confidence and obedience of his subjects,

only wears theatrical robes when wearing the sceptre and the crown (Erasmus, 1973).

Unlike the tyrant, we saw Alciato valuing a concern of the ruler for the enrichment of his people, also present in Machiavelli (2010: Liv.I, cap.X; 1976: XXI) (although sometimes forgotten by certain commentators of this thinker). We also see in both authors the praising of the prince who listens to his advisors, impartial and meritorious. For Mariana, in turn, the ecclesiastical magistrates, conscientious of the public good, would be the best columns of the State, in a conception not too distant from the definition of priests in the utopian construction of Thomas More (2006). These ideas seem to us clearly derived from the Jesuit formation of Mariana and most probably from his knowledge of the experiences of religious people at the level of governments and the level of missionary organisations themselves.

The image of More on the Senate advisor, who must mature the issues under discussion for the sake of the public good, seems to be reflected, years after, in the representation of the *Council* in the *Iconologia* of Cesare Ripa. This describes an old man dressed as a senator with a chain with a heart around his neck (from which comes the good and sincere advice), trampling a dauphin (speed) and a bear (anger), issuing advice (not mere conjectures or opinions). In one hand he holds three animal heads: the lion, the wolf and the dog, representing respectively the present and the reason, the past, and the future and the hope. On the other hand, he holds a book with an owl, valuing the idea of wisdom and meditation.

There are many other Ripa iconological representations of the political community (Albuquerque, 2008; 2012), but we will fundamentally emphasise the *State Reason*, in a search for connection with Alciato's Emblem 147, *Quod non capit Christus, rapit fiscus*, and the theme of our article. Comparing the texts with the image of both thinkers, it is sought to problematize themes such as: a) the vigilance, attentive, permanent and without precipitation, of the social body by the ruler, for conservation of the State (valued expressly in Ripa by the ears and eyes that decorate the garments of the figure); b) the firmness in the attitude of a strong authority – in Alciato it is added, relatively to the first editions, military robes to the monarch and it is introduced a column in the engraving while in Ripa, besides the military robes, it is added the presence of a lion; c) the imposition of a polarized law on the ruler and the execution of justice in an orientation resulting from that: execution of justice in the background of Alciato's engravings and book with the word Ius at the feet of Ripa's figure meaning how much civil reason can move away from the law; d) expurgates from the bad elements, harmful to good governance and social peace: the sponge that the monarch squeezes in one hand (in the other holds the sceptre) in Alciato and the attitude of veering the plants that grew too much, cutting their corolla, in Ripa. The texts lead to the hypothesis of a

confiscation strategy of goods acquired in bad terms by subjects who, by this way, make themselves rich, being the ruler responsibility to wait for the suitable opportunity to punish them for the benefit of the State.

Thus, considering a pathology of power, there would be many voices that in the Renaissance emphasised the odious of tyrannical authority, as well as the limits of an absolute monarchy, such limits would be concretised in divine laws, in natural laws, in the laws itself or a collective consciousness opposing to tyranny. These voices lacked neither creativity nor intelligence.

BIBLIOGRAPHICAL REFERENCES

Albuquerque, Martim de. (2012). *O Poder Político no Renascimento Português*. Lisboa: Babel.

_____. (2012). Razão de Estado e Iconologia. In: *Na Lógica do Tempo. Ensaios de História das Ideias Políticas*. Coimbra: Coimbra Editora.

_____. (1978). Jean Bodin na Península ibérica. Ensaio de História das ideias Políticas e de Direito Público. Paris: Fundação Calouste Gulbenkian-Centro Cultural Português.

Alciato. (1993). Emblemas. Edición y comentário: Santiago Sebastián. Madrid: Ediciones Akal.

Amaral Jr., Rubem. (2005). Introdução: Emblemática Lusitana. In: *Emblemática Lusitana e os Emblemas de Vasco Mousinho de Castelbranco*. Lisbon: Centro de História da Universidade de Lisboa, 7–62.

Balavoine, Claudie. (1982). Les emblemes d'Alciat: sens et contresens. In: C. Balavoine et al. *L'Embleme a la Renaissance*. Paris: Société Française des Seiziémistes.

Bodin, Jean. (2011). *Os Seis Livros da República*. São Paulo: Ícone Editora.

Buescu, Ana Isabel. (2016). *A livraria renascentista de D. Teodósio I, duque de Bragança*. Lisbon, Biblioteca Nacional de Portugal.

Cruz, Maria Leonor García da. (2018). A corrupção em definições normativas e artísticas do século XVI: permeabilidades consentidas nos circuitos administrativos. In: Andújar Castillo, Francisco and Ponce Leiva, Pilar (eds.) *Debates sobre la corrupción en el Mundo Ibérico, siglos XVI–XVIII*. Alicante: Biblioteca Virtual Miguel de Cervantes, 31–39. Disponível em: http://www.cervantesvirtual.com/obras/autor/andujar-castillo-francisco-83305

_____. (2006). O Crime de Lesa-Majestade nos Séculos XVI-XVII: Leituras, Juízo e Competências. In: *Rumos e Escrita da História. Estudos Homenagem a A.A. Marques de Almeida*. Lisbon: Colibri, 581–597.

_____. (2001). *A Governação de D. João III: a Fazenda Real e os seus Vedores*. Lisbon: Centro de História da Universidade de Lisboa.

De la Perrière, Guillaume. (1544). *Theatre des bons engins*. Paris: Denis Janot, 4th ed.

Duso, Giuseppe (dir.). (2005) *O Poder. História da Filosofia Política Moderna*. Petrópolis: Editora Vozes.

Erasmo (1995) *Enquiridion. Manual del Caballero cristiano*. Madrid: Biblioteca de Autores Cristianos.

_____. (1509; 1973) *Elogio da Loucura*. Mem Martins: Publicações Europa-América.

Franklin, Julian H. (1993). *Jean Bodin et la naissance de la théorie absolutiste*. Paris: Presses Universitaires de France.

Hartung, Fritz and Roland Mousnier. (1955). Quelques Problèmes concernant la Monarchie Absolue. In: *Relazioni – X Congresso Internazionale di Scienze Storiche, V. IV, Storia Moderna*. Firenze, 1–55.

Kamen, Henry. (1967) *The Rise of Toleration*, London: World University Library.

Macedo, Jorge Borges de. (1971) Absolutismo and Despotismo esclarecido. In: Joel Serrão (dir.) *Dicionário de História de Portugal*. Lisbon: Iniciativas Editoriais, V.I; (1983–1984). In: *Polis.Enciclopédia Verbo da Sociedade e do Estado*, Vols. 1 e 2.

Mairet, Gérard. (1997) Le principe de souveraineté. Histoires et fondements du pouvoir moderne. Gallimard.

Maquiavel, Nicolau. (2010) *Discursos sobre a primeira década de Tito lívio*. Lisbon: Edições Sílabo.

_____. (1976) *O Príncipe*. Mem Martins: Publicações Europa-América.

Maravall, José Antonio. (1955). La Philosophie Politique Espagnole au XVIIe Siècle dans ses rapports avec l'ésprit de la Contre-Réforme. Paris: Vrin.

Mariana, Juan de. (1604). Del Rey y de la institucion de la dignidade real. Leipzig, Amazon.

Mesnard, Pierre. (1977). L'essor de la philosophie politique au XVIe siècle. 3th ed. Paris: J. Vrin.

Morus, Thomas (2006). *Utopia*. In Aires A. Nascimento (ed). Fac-símile ed. 1518. Lisbon: Fundação Calouste Gulbenkian.

Naef, W. (1973). La Idea de Estado en la Edad Moderna. Madrid: Aguilar.

Ripa, Cesare (1996). *Iconología*. 2d ed. Madrid: Ediciones Akal, 2 t.

Vives, J. Vicens (1984). A Estrutura Administrativa Estadual nos séculos XVI e XVII. In A. Manuel Hespanha (dir.) *Poder e Instituições na Europa do Antigo Regime. Colectânea de Textos*. Lisbon: Fundação Calouste Gulbenkian.

From the ineptitude to a higher capability: The Jesuits and the formation of a Christian community in Brazil and Japan (16th-century)

Mariana A. Boscariol
CHAM, FCSH, Universidade NOVA de Lisboa, Lisbon, Portugal
ORCID: 0000-0001-9062-0913

ABSTRACT: The Society of Jesus was officially established in Rome in 1540. From the repercussion the group achieved, right in the next year some missionaries were sent to Lisbon by order of King John III. Being promptly incorporated into the Portuguese empire, in less than one decade the Jesuits founded a mission in the geographical edges of the Portuguese Patronage authority: Brazil and Japan. Even though their primary goal was the evangelisation among the non-European populations and their subsequent conversion, the conditions they encountered in these territories were completely different, making the possibility to create a genuine local Christendom more or less reachable. Considering the cases of the Jesuit mission in Brazil and Japan during the 16th-century, this article intends to work on some reflections the missionaries registered about the possibility to establish and consolidate a local Church. The reality showed different demands and struggles, making the creation of a native Christian community too far to be accomplished. For this purpose, it will be analysed letters and reports writing in both missions by its most important leaders – as José de Anchieta and Luis Fróis – during the first decades of their activity, corresponding to the second half of the 16th-century.

Keywords: Jesuits, Mission, Evangelization, Brazil, Japan

1 TWO FACES OF THE SAME PROJECT

The Society of Jesus was officially founded in 1540, having started the evangelising campaign outside Europe as soon as 1541, when Francis Xavier departed from Lisbon to Goa – where he arrived in 1542. In less than one decade, in 1549, with only a few months of difference, the Jesuits founded a mission in the geographical limits of the Portuguese Patronage activity: Brazil and Japan. What is to say, the Order reached this amplitude in an embryonic stage, counting with not much information neither experience and with no previous religious work in these territories before their arrival. Even so, the Jesuit missionaries were promptly and wholly incorporated into both the Patronage and the Portuguese Empire, and as such, they followed the flow of their ships and trades, which were mainly focused on Asia.

Even though Brazil was considered a Portuguese territory since 1500, when the fleet commanded by Pedro Álvares Cabral (1467–1520) arrived for the first time in the territory, it would take a few decades until an administrative structure of the Crown was settled to control and explore its lands. The first General-Governor delegated to Brazil, Tomé de Sousa (1503–1579), arrived in 1549, being accompanied by the first group of Jesuit missionaries. As until that moment, the territory was marginalised within the other regions of interest to the empire, especially in relation to Asia, no religious order was established there before the institution of the General-Government.

In its turn, the first contact with Japan was only made in 1543, when a Portuguese ship accidentally reached the south of the Archipelago, in the island of Tanegashima. In 1549, when the first group of missionaries arrived in Japan intentionally, there still was no effective interaction with the archipelago, not existing any power or support from the Portuguese crown in these lands, only the sporadic presence of merchants who would temporally stay. With a reduced number of people, with little knowledge of the territory, and no previous contact with this population – not only in what concerns the religious activity -, the Jesuits encountered in Japan a socio and cultural condition never experienced before.

These were utterly distinct realities, which, with no direct contact between each other, were connected through the religious campaign promoted by the Jesuit missionaries and the Portuguese empire. Even responding to entirely different dynamics, both missions were still seen as part of the same project and ideal promoted by the Society of Jesus, which was expected to be as harmonious and equally possible. As defended by Daril Alden, the idea the Society of Jesus was "a finely tuned machine whose parts always worked together smoothly and efficiently in response

to the dictates of the chief engineer" is rooted in the collective imaginary (1996, p. 229), but it is not in accordance to the reality.

Thus, in front of a cultural diversity never confronted before, as the Jesuits rapidly spread through the most part of the territories the Portuguese were in contact with, the missionaries were responsible for filtering and transmitting to Europe who and how were the other people and cultures of the world. Facing such a diversity of customs and cultures, without having a precise guideline to follow, and with a deep mismatch in what concerns the communication of the many regions with Europe, the Jesuits came to classify the various populations in a higher or lower degree of civility. This effort to distinguish the people from the world would inevitable condition the evangelisation itself since it was promoting distinct strategies of approach, feeding assorted interests, and permitting different forms of interaction.

At first, the missionaries' main purpose of promoting the evangelisation outside Europe was directed to the conversion of the non-European populations. As such, the image they sustained about the native people of Brazil and Japan conditioned the kind of relationship they came to establish with them, dictating the possibilities of their work. After all, the missionary's reaction to the natives in the two regions was remarkably contrasting, as it was the reality of their presence in these lands.

With a Portuguese community settled in the American territory, which was substantially and rapidly growing, the Jesuits had their attention and time divided between the Europeans and the indigenous. Consequently, their activity was more controlled, as they should respond to their fellow countryman – almost all priests were from Portugal. Experiencing the opposite situation, the missionaries in Japan were confronted with a local power able to resist any imposition, what forced them to adapt their expectations and strategies to the Japanese universe. What is to say, even if the first reaction was a manifest excitement and the recognition of both populations as the best and most promising to build a local Christendom, their characteristics and the confrontation of the missionaries' work with the context they found soon came to show clear and deep discrepancies.

In this sense, even though the American territory was much closer to Europe in relation to East Asia, what in theory would make the region more attractive to the Portuguese intents, the indigenous of Brazil were considered as having a lower degree of civility, and as consequence too distant from the ideal condition to truly become Christians. On the other side, Japan was the most distant territory to be reached from Portugal, but the Japanese people were recognised as having a stage of civility similar to the European one, what would make them propitious to become Christians.

This is to say, in what concerns the religious intents, that even having a culture and behaviour that caused much strangeness and confusion, the Japanese had a writing system, a hierarchical society, and religious sects that were intelligible to Europeans eyes. The reaction to the natives of Brazil was in many senses the opposite, as the priests openly defended that they had no religious knowledge or culture, living in a lack of humanity that only much and continuous work could amend. If the lack, the condition of blank paper (*tabula rasa*) in which the missionaries recognised the indigenous were, could be a good way to start the religious work with 'open space', from zero, it soon showed to be a huge obstacle to surpass. Exposing this concern, the Father José de Anchieta (1534–1597) wrote in a report in 1585:

> After becoming Christians they have some remarkable things, and the first is that they are *tanquam tabula rasa* to print on them all the good, nor there is any difficulty to take from them the rites or worship of Idols because they do not have it [...] they understand very well the Christian doctrine and the mysteries of our Faith, the catechism and apparatus for confession and communion, and they know these things as well or better than many Portuguese. (Anchieta, 1933, p.435).[1]

This was an idea the missionaries nurtured at the beginning of the Brazilian mission, which, even though confronted with the reality they were living, served to report the good possibilities they had to the other members of the Order in Portugal and Rome. However, to become a proper Christian, the Indians should be able to engage their precepts and embrace the Christian life, which showed to be hard to achieve. This idea still was emphasised in the 17th-century as demonstrated by the well-known discourse of Father António Vieira (1608–1697) in 1657 the "*Sermão do Espírito*", about the condition of the indigenous as a myrtle (Viveiros de Castro, 1992). What is to say, a plant that was easy to shape, but that needed continuous and careful maintenance to be kept in the 'right path', to follow 'the truth'. Reinforcing that this idea was fed for a long time, we have this fragment of a report written by Anchieta in 1584 (*Informação do Brasil e de suas Capitanias*):

> The impediments to the conversion and perseverance in the Christian life on the part of the Indians are their inveterate customs, as in all other nations, as the fact of having many women, their wines they abuse off, and taking them off there is usually more difficult than in anything else, for they consider those are their provisions, and so the Fathers do not take it all away

1. "[...] Depois de cristãos têm algumas cousas notáveis e a primeira é que são tanquam tabula rasa para imprimir-se-lhes todo o bem, nem ha dificuldade em tirar-lhes rito nem adoração de Ídolos porque não os têm [...] compreendem mui bem a doutrina cristã e os mistérios de nossa Fé, o catecismo e aparelho para a confissão e comunhão e sabem estas cousas tão bem ou melhor que muitos Portugueses [...]." All translations from Portuguese sources are the author's free translation provided for the benefit on non Portuguese readers.

from them at all, but only the excess [...] (Anchieta, 1933, p. 333).[2]

The inconstancy of the indigenous behaviour, the incapability the missionaries understood they had to stay under the precepts of the religion, was partly a consequence of their attachment to the old customs. The priests tried to cut these 'bad behaviours'. But, due to the unsuccess they experienced, they started to work from the idea of only quit the 'excess' from the Indians, trying to guide their conduct, adapting some of the ceremonials to the native style, in villages controlled and distant from the Portuguese communities (*Aldeamentos, vide* Metcalf, 2014). Working on this direction, the missionaries invested on the formation of the children, since, as wrote Father Manuel da Nóbegra (1517–1570) in 1560, "the adults had the ears closed to listen to the Lord's word":

> because the adults, to whom the bad habit of their parents are almost converted into nature, close their ears not to hear the word of health and convert to the true worship of God... (Leite, 1956–1968, vol. III, p. 249).[3]

Even with this measure, being given more attention to the evangelisation among the younger Indians, the missionaries in many occasions manifested that there was little hope in their evolvement as Christians. As Anchieta narrated in a letter from 1556:

> [...] because not only the adults, men and women, do not bear fruit by not applying themselves to the Christian faith and doctrine, but even the same boys who we almost create by our breasts with the milk of the Christian doctrine, after being well instructed, they follow their parents first in habitation and then in their customs (Anchieta, 1933, p. 92).[4]

As the priests saw the indigenous from Brazil as of inconstant nature, even more after they experienced numerous cases of violence and deaths when dealing with the most resistant tribes, the missionaries started to assume that the interference of the local government by force would be a necessary tool given their uncivilised stage. This undoubtedly was a particular element of the mission in Brazil, as the territory was

a proper Portuguese colony, which means it was submitted to its imperialistic attempts. Anchieta wrote in 1557 to those in Portugal:

> Since I came to understand by experience the little that it can be done in this land in the conversion of the Gentile as they do not submit themselves, and they are a kind of people more of wild beasts condition than of rational people, and be servile people wanted by fear, and together with this to see the little hope on controlling the land, and see the little help and the many encumbrances of the Christians of these lands, whose scandal and example was enough to not convince, since it was people of another quality [...] (Leite, 1956–1968, vol. II, p. 402).

This means that, from the missionaries' point of view, the Indigenous were by nature more of a savage behaviour than of rationality, what undoubtedly was a huge obstacle to surpass. Even so, the bad examples of the Christians settled in the territory were also an inconvenience and even obstruction to their goals. After all, most of the Portuguese settlers never showed any interest or concern on the conversion or good treatment of the Indians, not valuing the missionaries' intents to convert and protect them. Thus, the bad habits and examples demonstrated by the Portuguese were recognised as a clear disturbance to the promotion and foundation of an indigenous Christendom. Emphasising these turbulent relations, Father Nóbrega wrote in 1558:

> I repeat to say that the hatred is so great that the people from this land feel for the Indians, who by all means are taken by the enemy of all good by instruments of damning and hindering the conversion of the Gentile [...] (Leite, 1956–1968, vol. II, p. 452).

Even so, the presence of this Portuguese community together with the existence of an administrative and military apparatus from the Portuguese crown were crucial aspects of the Jesuit mission in Brazil in comparison with the Japanese one. As the fathers understood "they live without laws or government", and for this reason "they cannot keep themselves in peace and concord", the use of force and imposition eventually came to be understood as the only way possible to provide conditions for their work be done and evolve. In another fragment from 1558, Nóbrega described:

> This Gentile is of a quality that you cannot have by good, but by fear and subjection, as we have experienced; and so if you want them all converted you need to order them to submit and you must extend the Christians to the interior land and share among them the service of the Indians to those who help you to conquer and lord it over [...] (Leite, 1956–1968, vol II, pp. 448–449).[5]

2. "Os impedimentos que ha para a conversão e perseverar na vida cristã de parte dos índios, são seus costumes inveterados, como em todas as outras nações, como o terem muitas mulheres; seus vinhos em que são muito contínuos e em tirar-lhos ha ordinariamente mais dificuldade que em todo o mais, por ser como seu mantimento, e assim não lhos tiram os Padres de todo, senão o excesso que neles ha [...]."

3. "[...] porque los ya adultos, a los quales la mala costumbre de sus padres se les a quasi convertido en naturaleza, cierran las orejas para no oir la palabra de salud y converterse al verdadero culto de Dios [...]."

4. "[...] porque não somente os grandes, homens e mulheres, não dão fruto não se querendo aplicar á fé e doutrina cristã, mas ainda os mesmos muchachos que quasi criamos a nossos peitos com o leite da doutrina cristã, depois de serem já bem instruídos, seguem a seus pais primeiro em habitação e depois nos costumes [...]."

5. "Este gentio é de qualidade que não se quer por bem, senão por temor e sujeição, como se tem experimentado; e por isso se S.A. os quer ver todos convertidos mande-os sujeitar e deve fazer estender os cristãos pola terra adentro e repartir-lhes o serviço dos índios àqueles que os ajudarem a conquistar e senhorear [...]."

However, in respect to the Portuguese community settled in the territory we identify a different perception from the disturbances it caused. One that defended it would be necessary more Christians and more control over the land to create an ideal environment to grow the Indians' interest and familiarity with the fundaments of the Christians life, otherwise the bad customs would not be suffocated and exterminated. As wrote by Anchieta in 1555:

> One thing we all wish for and pray to Our Lord, without which we cannot bear any fruit in Brazil, which we wish, and it is that this whole land come to be populated by Christians who have subjected to it, because they are so indomitable and so fierce to eat human flesh and exempt from acknowledging any superior, that it will be very difficult to be firm what we plant [...] (Anchieta, 1933, p.77).

But, in fact, the contact with the Portuguese community settled mainly in the northeast cost made the priests gradually to expand and concentrate their activity more into the countryside. This initiative was also an attempt to get away from the eyes of the main representatives of the Crown and the Church on land, as the priests reported that even the religious authorities had a lack of interest in respect to the work with the native people of Brazil, as the delegated visitors or bishops:

> The third bishop, who now rules the church of Brazil, is D. Antônio Barreiros, from the habit of Aviz. He came in the year 1575; he makes his occupation like the past ones, since he does not show himself so zealous about the conversion of the Indians, nor does he care much of their Christianity, having them for dumb people and of little understanding, and yet he went to visit their villages, and he confirmed those who had the necessity of this sacrament (Anchieta, 1933, p. 309).[6]

Considering all the barriers the priests were facing in Brazil since the beginning, they soon came to replace the first positiveness and optimistic posture for a more hopeless evaluation of the mission's future. As Anchieta wrote right in 1565:

> This land has come to such a state that you should no longer expect news about the fruits in the conversion of the gentility, which lack, therefore, seems to be a consequence of the tribulations that happen, with the hope of being able to harvest some [....] (Anchieta, 1933, pp.196–197).[7]

Under different conditions, the case of Japan was identified as a unique experience. Even if the territory lived a complex and turbulent ambience, it seemed to be a propitious stage for the Jesuits intents. Writing about the Japanese, Father Francis Xavier (1506–1522) wrote in 1549:

> First of all, from the people that we have contact until now, they are the best that have been discovered so far, and it seems to me that among unfaithful people there will be no other who will be better than the Japanese [...] (Cartas, 1997, f. 9).[8]

Not only the priests found in Japan a society which they admired and understood as highly qualified than the others they had contacted, as the political situation of the territory was an open space for the missionaries develop their work. They inclusively became an important tool of the political game that was in course among the local lords in dispute in order to control and centralise the governmental power (Sengoku period). Much of their first good impression was sustained by what the priests recognised as the unusual Japanese capability. This means that, even though they showed to be too hard and resistant to be converted and embrace the faith, the Japanese were individuals with higher competences as human beings, notably intelligent and disciplined. As Father Luis Fróis (1532–1597) wrote in 1566:

> The people are very capable to receive the law of God our Lord, discreet, polite, bellicose of knowledge, submitted to the reason, superb in opinion, which about them they have [...] (Cartas, [1598] 1997, p. 212).[9]

The priest defended that the Japanese had a high ability to learn the doctrine, being people with a desirable behaviour and "submitted to the reason". After all, if they were more rational than of a bestial nature – on the contrary of the indigenous from Brazil-, they should be in a more appropriate stage to learn the Lord's words. As it was said before, Japan's unstable political situation, with many local lords disputing power, let an opening to the entrance and spread of the missionaries over the territory – even though they were concentrated in the south of the archipelago. Father Cosme de Torres (1510–1570) wrote to the Provincial of India in 1561:

> I pray for our Lord's sake your reverence will send us some, at least six, or four, because besides these eight places where the door to the Gospel has been so opened [territories in which they were], Japan is now in a way with this peace, that there is nowhere we go that we cannot manifest or receive our holy faith: therefore, all people, so Christians as Gentiles, show

6. "O terceiro bispo, que agora rege a igreja do Brasil, é D. Antônio Barreiros, do habito de Aviz. Veiu no ano de 1575 (383); faz seu ofício como os passados, posto que não se mostre tão zelozo pela conversão dos índios, nem faz muita conta da sua cristandade, tendo-os por gente boçal e de pouco entendimento, e contudo já foi visitar suas aldeias e crismou os que tinham necessidade deste sacramento."
7. "E' chegada esta terra a tal estado que já não devem esperar dela novas de fruto na conversão da gentilidade, a qual pois falta parece conseqüente superabundar as tribulações que se passam, com esperança de poder colher algum, que se guarde nos celeiros do Senhor, o qual, pois se dignou de nos comunicar algo delas, determinou com elas algo me dilatar, pois o

mesmo disse que o verdadeiro fruto nasce da paciência, para que com tudo seja seu santo nome glorificado."
8. "Primeiramente, a gente que ategora temos conuersado, he a melhor que ategora está descuberta, & me parece que antre gente infiel não se achará outra q ganhe aos Iapões [...]."
9. "A gente he capacissima pera receber a lei de Deos nosso Senhor, discreta, polida, bellicosa de saber, sogeita a rezão, soberbissima na opinião, que de si tem, zelosa de saber em que consiste a saluação [...]."

and give signal that finally there will be a Christendom in this great land (Cartas, [1598] 1997, f.76).[10]

In a first moment, the Jesuits, having the monopoly over the territory, had good news to send to Europe, both about the growing of the mission among the Japanese and their quality to the creation of a proper Christendom. From the news that was circulating the priests were defending that there were no other people like the Japanese. As such, stimulated by the successes they achieved, the mission in Japan got a status of model to be followed, or at least to inspire the missionaries in other regions. As the Visitor Alessandro Valignano (1539–1606) wrote in 1580:

> [...] this enterprise of Japan is not only the biggest one that the Society has in all these parts, but it is one of the largest that there is nowadays in the whole church of God, because the people are very noble, and very capable and very different from all the other people who are converted, and even though the Japanese have many chicaneries, in which they are raised, however, we cannot deny that they are very noble, capable, and of great ingenuity, and the law of our Lord has already spread, and with great reputation and credit everywhere, and it has been given excellent principles to do a lot very soon (Cartas, [1598] 1997, f.477v).[11]

Comparing to the inconstant behaviour of the Indians from Brazil, which could be easily molded but never solid shaped, the Japanese, being people of reason, intelligence, and discipline, would be better instructed, being able to evolve in the faith truly. As Valignano wrote:

> [...] because they are so well inclined and subject to reason and have all the same language, after becoming Christians they are easier to cultivate than all other nations [...] (Valignano, [1593/1592] 1954, p.133).[12]

This means that, besides all the admirable characteristics they had in what concerns their behaviour, the Japanese also counted with another distinction, which was the existence of a single language and a writing system.

The writing was, for the European missionaries, one of the elements that made any population to be considered more or less civilised. In Brazil, the priests encountered not only a wide variety of languages but also the absence of written culture. Since the Catholic doctrine is based on a book, the possibility of working with this material was a real advantage. These competencies, associated with apparent Japanese opening, were seen by the missionaries as a promising opportunity to grow a Japanese Christian community. As Fróis wrote in 1585, two years before the first expulsion edict promulgated by Hideyoshi Toyotomi (1537–1598):

> What comforts us about this Christhood is that it seems to us that they understand well the things of God, because if by the smoke it is believed that there is fire, it is easy by the devotion the Christians show to understand the fire of the things of God, which they have in their souls (Cartas, [1598] 1997, f.145).

As the priest exposed, the fact the Japanese were able to understand the Christian message was an important signal that the missionaries could reach better results in the archipelago. Even so, the persecution and resistance showed by some Japanese leaders started to intensify. This situation was unavoidable, directly affecting the missionaries presence and progress in the territory. Paradoxically, even facing this turbulence, the missionaries were reaching outstanding results, what made them resist and keep believing in the evolvement and consolidation of the Japanese Christians. As wrote Father Luis Fróis:

> About the fruit, and progress of the Christendom: during this period the things were so numerous, and of so great disturbances, and so worrying, and so juncture of adversities with the prosperities, and the tastes with the tribulations, that one can hardly judge whether we are in worse or better state, because for one hand it seems that everything is in great danger, and I depend on a thread (for the great persecution that raged Quambacudono universal lord of Japan from July to this part against Christianity, and the priests). And on the other side, Japan has never been in such good disposition as now to be made great conversion, nor has there ever been such apparatus, nor such power among the lords, and Japanese Christians, we hope our Lord will be better known & glorified in these parts (Cartas, [1598] 1997, f.188).[13]

10. "Peço por amor de nosso Senhor a vossa reuerencia nos mande algús, ao menos seis, & senão quatro, porque alem destes oito lugares em que tãto se abrio a porta pera o Euangelho [territórios em que se encontravam], está agora Iapam de maneira com esta paz, que por nenhum lugar delle se irá aonde não se possa manifestar & receber nossa santa fé: & por tanto todos, assi Christãos como Gentios, mostrão & dam sinal que emfim há de auer nesta terra grande Christandade."
11. "[...] esta empresa de Iapão não sò he a maior que tem a Companhia em todas estas partes, mas he húa das maiores que ha oje em dia em toda a igreja de Deos, porque a gête he mui nobre, & mui capaz, & muito differente de todas as outas fentes que se conuertem, & ainda que tenhão os Iapões muitas más manhas, em as quaes estão criados todauia se não pode neguar que não seja mui nobre, & capaz, & de muito engenho, & a lei de nosso Senhor esta ja diuulgada, & em grande reputação, & credito em todas as partes, & se tem dado muito bõs principios pera se fazer muito em breue tempo."
12. "[...] por ser la gente tal y tan bien inclinada y sujeta a la razón y tener todos uma misma lengua, son después de hechos cristianos más fáciles de cultivar que todas las otras naciones [...]."

13. "Quanto ao fruito, & progresso da Christandad: forão neste tempo as cousas tão varias, & tão grandes as perturbações, & desenquietações, & tão conjuncturas as aduersidades com as prosperidades, & os gostos com as tribulações, que mal se pode ategora julgar se estamos em pior ou milhor estado, pois por húa parte parece que tudo està em grande perigo, & depêndo de um fio (por a grande perseguição que aleuantou Quambacudono senhor vniuersal de Iapão de Iulho a esta parte contra a Christandade, & contra os padres). E

The priests understood that if it were not for their bellicose spirit and the intensification of the conflicts, the Japanese would be willing to become Christians. This predisposition was due both to their exceptional capability and to what they had in their 'souls', what can be seen as the recognition of their humanity – which was in a stage never identified in the 'savages' from America. After all, "Coming all these kingdoms to know the law of God, it can be said they are of the best Christians there are in the world". Reinforcing this idea, the Portuguese Gaspar Vilela wrote in 1571:

> [...] now there is no longer this as in the beginning, the Christians are firm, when they are baptized they already understand reasonably what is necessary from them, because before they are baptized, they take many days listening to what they will receive [...] they show with some signals what they have in their souls, if there were not so many wars as there are right would be many people baptized, but there is a lot of wars, and the few languages we have to explain to them the mysteries of our salvation: there are many impediments to not being baptized many of them [...] (Cartas, [1598] 1997, f.329v).[14]

The reality of the Japanese mission came to a complete change in the 17th-century after the persecution was intensified, ending with the archipelago's closure to the foreigners. Still, during the 16th-century, Japan was a case of success, being identified as one of the most promising Christendom to be formed.

2 CONCLUSION

These profound discrepancies were associated with a higher or lower capability to learn the Christian doctrine, which would affect the possibility of the native people of Brazil and Japan to be truly converted to the Catholicism. In Brazil, the identification of the 'indigenous' lack of interest or constancy in the Christian life was partly justified by a deficiency of their intelligence, the fragility and precariousness of their knowledge, of their capacity to 'evolve' in the faith, or even in their 'humanity'. The Japanese were recognised as competent people, which was associated with their higher intelligence and discipline. However, they

had a bellicose spirit, being continuously involved with war affairs.

Both cases showed to have advantages to the Jesuits' goals, but also plenty of impediments to their consolidation. Clearly the problems faced in both territories were different, and as such, they demanded distinct responses. From one side, they had to manage a Portuguese community which demanded their attention, while it disturbed the missionaries in their approach to the indigenous, considered of a more savage behaviour. On the other hand, they had to deal with the complete inexistence of an administrative and military apparatus from the Portuguese empire to sustain and protect their presence in Japan, territory in which the mission, which was almost wholly focused on a Japanese audience, also gradually came to be formed by a Japanese body.

In both cases, from the interests and actors that were playing a determinant role during this first stage of interaction between the Jesuits with the local populations, the attempt to establish and consolidate local Christendoms happened to meet significant obstacles, not being reached as expected.

ACKNOWLEDGEMENT

This chapter had the support of CHAM (NOVA FCSH/UAc), through the strategic project sponsored by FCT (UID/HIS/04666/2019).

BIBLIOGRAPHICAL REFERENCES

Alden, Dauril (1996). The making of an enterprise. The Society of Jesus in Portugal, its Empire, and beyond, 1540–1750. Stanford: Stanford University Press.

Anchieta, José. (1933). *Cartas, informações, fragmentos históricos e sermões*. Rio de Janeiro: Civilização Brasiliera.

(1997). Cartas que os padres e irmãos da Companhia de Iesus escreuerão dos Reynos de Iapão & China aos da mesma Companhia da India, & Europa, des do anno de 1549 atè o de 1580. Primeiro Tomo. Edição facsimilada da edição de Évora, 1598. Maia: Castolivia editora, lda.

Leite, Serafim. ed. (1956-1968) *Monumenta Brasiliae*. 5 vols. Roma: Institutum Historicum Societatis Iesu.

Valignano, Alessandro (1954). Sumario de las cosas de Japón (1583): Adiciones del Sumario de Japón (1592), Volume 1. In José Luis Alvarez-Taladriz (ed.) *Monumenta Nipponica monographs*. 9th Edition. Tokyo: Sophia University Press.

Viveiros de Castro, Eduardo (1992). O Mármore e a Murta: sobre a inconstância da alma selvagem. *Revista de Antropologia*, 35, 21–74.

pola outra nunca esteue Iapão em tão boa desposição como agora pera se fazer mui grande conuersão nem nunca ouue tal aparelho, nem tanto poder entre os senhores, & Christãos Iapões, esperamos que serà nosso Senhor nestas partes mais conhecido & glorificado."

14. "[...] agora já não há tanto isto como nos principios, os Christãos são firmes, quando se bautizão já entendem arrezoadamente o que lhe he necessario, porque antes que os bautizem, se trazê muitos dias ouuindo o que hão de receber [...] elles mostrão com sinaes o que tem em sua alma, se não ouuera tantas guerras quantas há fora já muita gête bautizada, mas a muita guerra, & as poucas lingoas q temos pera lhes explicar os misterios de nossa saluação: são muito impedimêto a não se bautizarê tantos [...]."

Creativity in the 16th-century representation of King Sebastião's in the Battle of Ksar-el-Kebir

Ana Paula Avelar
Universidade Aberta, Lisbon, Portugal
CHAM, FCSH Universidade NOVA de Lisboa, Lisbon, Portugal
CEC, CH, Universidade de Lisboa, Lisbon, Portugal
ORCID: 0000-0003-0482-3832

ABSTRACT: The concept of Hero lies at the core of this analysis of its representation and of how creativity, intuited as a process that results from the interaction between the authors of the several chronicles and their readers in two texts, king Sebastião's *Journey in Africa* and Sherif Mulei Mahamet's *Chronicle*. The analytic topos is the moment of the battle of Ksar-el-Kebir and the echoes put forward by the authors who gathered information and described the actions of the various actors in the conflict, focusing on the representation of the hero and the authorial creativity therein exposed.

King Sebastião's *Journey in Africa* and Sherif Mulei Mahamet's *Chronicle* help us to decode the way this monarch's profile was shaped. It is in the confrontation of narrative modelling of the hero, as an example and *persona chiara/scura*, that actors, authors and textual purposes are uncovered, where the tone of voice and peroration cross the writing of a battle and those who were its "publicos".

Keywords: Hero; Creativity; Ksar-el-Kebir; Chronicle; King Sebastião

While approaching the hero's profile in some Sebastian chronicles, we try to answer some of the questions that arise when we ponder on the way history was written throughout the 16th-century, and touching a specific *topos* the one meant by the military narrative. On the other hand, I am in line with the concept of *topos* as an active association node for ideas, representing categories and relations that can function as heuristic models; space where situations or events can be placed, categorised and organised in their own way.

In the case of the Sebastian chronicles, I devote myself to the hero's *topos*, uncovering him, taking into account the inherent creativity as a process that results from the interaction established between the authors and their readers. Yet in this process, another concept, that of originality, must be taken into account (Pope, 2005, p. 60). In the case of historical discourse, this concept often is allied to the use of sources, hitherto unknown.

We agree that

Creativity requires novelty; the obvious contrast to creativity is mere repetition and replication. But not every kind of novelty will do; diverging from established practice is not considered creative if it does not lead to a positive result. (Klausen, 2010:349)

These frontiers must be conceived within Camilla Nelson's synthesis that somehow echoes Michel Foucault:

Creativity is an invention brought about by a particular arrangement of knowledge that saw the birth of the humanist subject. (Nelson, 2010:69)

Its nature is somehow fluid since as Foucault himself declares

One thing in any case is certain: man is neither the oldest nor the most constant problem that has been posed for human knowledge. Taking a relatively short chronological sample within a restricted geographical area – European culture since the sixteenth century – one can be certain that man is a recent invention within it. (Foucault, 2005, p. 422)

The writing of human actions is conceived within the correlation between memory and historiography, hoping that both have to be plausible (Catroga, 2017, p. 69). Therefore, while analysing the Sebastian chronicles, we must inscribe them in the model that was chosen by their own authors since historical narrative culturally echoes the society whence it was born and also is part of the historical process.

We do not follow modernist empiricism that, since the 19th-century, has been considering historiographical narrative as an impersonal discourse, which confines itself to the recounting of facts, e.g., the assumption of the writing of History as something free from masks or artifices. As Alain Munslow sharply

shows:

> This vision of the history as a practice fails to acknowledge the difficulties in reading the pre-existing narrative constituted as evidence, or the problems of writing up the past. (Munslow, 2003, p. 10)

Thus, while searching for the unveiling of the unsaid in the reading of the images that run through the meaning of the text, we seek the ultimate purpose of the writing of History through the deconstruction of data and their perception within a historical frame. This analysis of the historical condition, and of what is revealed in it of creativity, echoes Paul Ricoeur when he claims that:

> I will call our "historical condition" this realm of existence placed under the sign of a past as being no longer and having been. And the assertive vehemence of the historian's representation as standing for the past is authorized by nothing other than the positivity of the "having been" intended across the negativity of the "being no longer." Here, we have to admit, the epistemology of historiographical operation reaches its internal limit in running up against the borders of an ontology of historical being. (Ricoeur, 2004, p 422)

We must ponder then on how the *Ars Historica* was conceived in Portugal in the 16th-century, and how tradition and novelty were therein reflected in a time when in Claude-Gilbert Dubois' words: "The return to the ancient becomes the novelty of the times, or more exactly leads to a renewal." (Dubois, 2001, p. 11)[1]

Here lies History writing process. It embodies itself as an instrument of legitimation of power, namely of a kingdom, thus emulating a time, and eventually immortalising it. It is true that, as we have repeatedly shown, the chronicle describes the past events throughout the life of a monarch and his reign.

During the 16th-century, Portugal witnesses the emergence of two trends in a historical narrative: the king's and the Expansion' chronicle. These distinct models of writing follow the same concept of History and support their authors' need to get access to those who lived in the spaces that are described and that had witnessed specific events. Along with these two models of writing History, we find a whole series of texts that relate to personal experiences. The historical time they describe is shorter since the narrative focuses on an event confined in time, and on an experience/testimony that validates the historical narrative of events. This is all the more evident when we dwell on the descriptions of military deeds, such as king Sebastião's expedition to Morocco.

As mentioned above, this essay devotes itself to the analysis of those two texts that describe the young king's last and fateful journey. Both narratives describe the events, the actions and the monarch's profile within a light/dark atmosphere. Serving the king, struggling for the motherland and eventually dying for it, is the

contrastive recurrence where lies the creativity in these historical narratives, thus subscribing the previously defined hermeneutic boundaries.

The summary of all the things that happened in Berberia, since the time [when] Xarife Mulei Mahamet started to reign in 1573, until the end of the year of his death, 1578, in the battle of Ksar-el-Kebir[2], where Sebastião king of Portugal was lost[3] lies upon the point of view of one of António prior do Crato's servant, whose identity remains unknown.

The expedition is the central theme of the historical narrative, while the author testifies to what he may have witnessed in the battlefield, where he was captured and eventually led to Fez where he remained imprisoned. Here he listened to other testimonies that he mentions throughout his narrative. His master's Antonio profile is signalled, in particular when he describes the disagreements that he is supposedly having had with the king. This actually is a discourse about a dysphoric time. From this event there resulted, as he writes in the opening of her first chapter, to the "sad Kingdom of Portugal, so many calamities, so many misfortunes and so many accidents, matter, by the variety and grandeur of it worthy of memory." (Loureiro, 1987, p. 101)[4]

On the other hand, the anonymous text attributed to Fernando de Góis Loureiro, and untitled Journey of King Sebastião to those parts of Africa where he was lost during the battle he fought with the moors in the year 1578 of our Era[5] follows the king chronicle's model, although it is mainly focused on the expedition. The anonymous author seeks to convey the example of History since this is a discipline for the knowledge and learning of kings and princes.

I recall, very briefly, that as soon as he was born king Sebastião was offered the *Sentences* of various authors that reveal the kings the way they must behave both in peace and in war, and how they should rule (Évora, 1993). The prince is one who, on the one hand, must master the exercise of weapons and, on the other, must know the past, since this is a source of teaching that relies on the examples that may help a good government.

King Sebastião's education takes place in an imperial time when the pen was supposed to serve the king, and when Portuguese men of letters sought to write an epic about the nation's deeds. Besides the frontiers

1. Le retour à l'antique devient la nouveauté des temps, ou plus exactement conduit le renouveau.

2. Alcácer Quibir.
3. O sumário de todas as coisas sucedidas em Berberia, desde o tempo (em) que começou a reinar o Xarife Mulei Mahamet no ano de 1573, até ao fim do ano da sua morte, 1578, no dia da Batalha de Alcácer-Quibir, em que se perdeu D. Sebastião, Rei de Portugal.
4. triste Reino de Portugal, tantas calamidades, tantos infortúnios e tão vários acidentes, matéria, pela variedade e grandeza dela digna de memória
5. Jornada de ElRei Dom Sebastião as partes de Africa aonde se perdeo na Batalha que deu aos Mouros em o ano & Era de 1578.

between *Ars Historica* and *Ars Poetica* were anchored in the Aristotelian definition of their own specific functions: one should describe what had happened, and the other what could have happened (Aristotle, 1986, p. 115). In the 16th-century, the epic tone echoes in History writing, namely in Expansion History, and, as we have mentioned above, History plays a particular function in the future king's education, bearing in mind his future status. We do not agree with those who consider these fields – epic and History – to be rivals since both play a part in the prince's education; even if they use different models of writing, yet they serve an ethical purpose (Avelar, 2004, p. 40).

When he was fourteen king Sebastião wrote a brief memory where he put considered that the monarch should be at God's service, propagate the faith, defend the rule of law, justice and morality, punish those who break it and permeate those who fulfil it, thus being an example for those he rules (Buescu, 1996, p. 249)

However, the various voices that describe the king's profile expose the author's creativity in the way they try to approach the reader. But it is important to remind that in the narrative of the Journey, Sebastião emerges as the *Intended Monarch*. This text follows obvious rhetorical prosody, where the metaphorical sentence invades the discourse. It should be noted that during the minority and the early years of the king's rule a Muslim dominion prevailed: the Turkish' and the Safavid's empires, the Maghreb Moors and the Islamized peoples in the Indian Ocean, which threatened the movement of European kingdoms, especially the Iberian powers.

The victory of King John of Austria at Lepanto in 1571 stalled this Muslim irradiation, although it was necessary for the European powers to strengthen their positions, thus rebalancing their forces in the Mediterranean. Portugal intended to extend and consolidate a Portuguese empire in Berberia.

We do not draw here all the conjuncture-long that contextualise the expedition of *Ksar-el-Kebir*. We only point out conjuncture traits that illuminate the historical discourses analysed in this essay. Both the *Summary* [...] and the *Journey* [...] focus on the near past. The first text was written by a Portuguese captive in Fez after the battle, while the second, written between 1588 and 1595, would be, as we mentioned above, attributed to Fernando Góis Loureiro who consulted various sources and collected testimonies.

Although, in a different way, the Portuguese king's action in the Berber scenes of war is the narration space par excellence. The sojourn of the young monarch in the summer of 1574 in Ceuta and Tangier pointed to the choice of the Maghreb area as a territory where Portuguese actions aimed at stopping Turkish expansionism in the Western Mediterranean. The dynastic succession in Morocco is the main reason for Portuguese intervention. In 1557, after the murder of Mawlay Muhammad Shaykh, his son Mawlay 'Abd Allâh al-Galib came to the throne, leaving his brothers,

Mawlay'Abd al-MaliK (Mulei Maluco, according to the designation of Portuguese chronicles) and Mawlay Ahmad (Mulei Amet), offering their services to the Turks.

After the death of the king of Mawlay 'Abd Allâh al-Galib (1574) his son Mawlay Muhammadal-Mutawakkil (Mulei Mahamet) succeeded him, yet he did not follow the designs instituted by the founder of the dynasty. Abd al-Malik, who had shown himself at the service of the Turks, obtained his support for his claim to the Moroccan throne, fighting his nephew, defeating him and thus being proclaimed sultan.

Although Mawlay Muhammad al-Mutawakkil sought aid from Spain, he was not successful. Instead, king Sebastião answered affirmatively to his appeal. An expedition would thus be put into place, despite the difficulties due to the lack of men and financial resources. The author of the *Summary* is, at this level, rather eloquent, emphasising the dissolution and famine that were felt during the provision of the fleet. The Journey also mentions the huge expenses required by the preparation of the expedition, although one witness constant support of the young monarch. Without developing an exhaustive analysis of the different moments of the combat, we must remind that on August 4, 1578, the Portuguese army led by the king, who had joined the Moorish forces of Mawlay Muhammad and some Flemish, German, and Italian mercenaries, confronted 'Abd al-Malik who was supported by his brother Mawlay Ahmad, who eventually won the battle. Mawlay Ahmad would die drowned, and 'Abd al-Malik would die of disease or presumably poisoned. King Sebastião would disappear in combat.

These events are broadly described in both texts. In his *Summary,* Antonio's servant unveils his own experience, while the *Journey*'s author, maybe Fernando Góis Loureiro, describes the king's action, the so-called *desired young monarch*, Sebastião.

In this latest narrative, the pathos flows in the first pages along with the tragic hubris, as conceived by Aristotle, an excessive pride that eventually leads to the hero's fall. Thus is creativity put forward,

> And thus as a name was given, thus with new and with great damage that miserable people [Portuguese] with tears reached it, and with sorrowful performance saw him definitely lost. And thus often men search and wish to achieve things that, when achieved, swiftly lead to destruction what they had longed for before. (Loureiro, 1978, p. 13)[6]

It is within a short temporal arc that both narratives focus king Sebastião's expedition. It is in the heat of

6. E assim como se lhe pôs este nome novo, assim com novos e desses costumados extremos procedeu em grandes danos daquele miserável povo [Portugal] que com lágrimas o alcançou, e com lacrimoso e triste espectáculo o veio a perder de todo. E assim muitas vezes procuram os homens e desejam conseguir cousas que alcançadas são abreviada destruição do que pretendem.

a dysphoric present that the facts are recorded and that the Art of History is exercised. The memory of the deeds is narrated, describing the action of the men and their prince, Sebastião. This was the monarch who had received from the hands of the Spanish captain Francisco de Aldana, the envoy of the Duke of Alba, a gavel and a coat of arms used by his grandfather Carlos V in the conquest of Tunis. Sebastião inscribes himself thus in *the mirror of princes*, under the protection of his grandfather Carlos V, that king on whom Baltasar Gracián and Morales wrote, in *The Hero* (1637) that

> The augustly House of Austria came to be a marvel of lineages, founding its greatness in that it is a cypher of the wonders of God. And he has anointed his imperial blood with that of Christ, Our Lord, the Blessed One [...]. Being a hero of the world, little or nothing is; to be of Heaven is much, to whose great Monarch praise is given, if honour be given, glory be rendered. (Gracián y Morales, 2003, p. 86)[7]

The hero who is in a Modern regulated state, the wise warrior, servant of a nation.

King Sebastião aspires to be the auroral hero, the one who lives for action and honour and who, as stated Daniel Madelénat, appears to us: "Devoid of hiatus between self and persona, between free consciousness and insane body" (Medelénat, 1986, p. 55)[8].

The Portuguese captive in Fez traces a heroic profile of Mulei Mafamed. According to him, the latest had many qualities, not those of a barbarian king, but a very excellent prince. He would be a valiant soldier, pleasant in his dealings, magnanimous and liberal, with a soft and affable condition, so cheerful in his speech, that he was eloquent both in his own language and in Turkish; besides, he also was acquainted with French, Spanish, and Italian. While with his army, he was reading *Orlando the Furious* and other writings in the languages he knew. In the words of our captive, he was an admirer of Carlos V and asked for all the books that could be found on the history of that emperor (Loureiro, 1987, p. 69).

The text's description of Sebastião fulfils the aulic profile of the monarch, who is consubstantiated as the universal mirror of all the maxims, what he seeks to be

> [...] a common hallmark of all heroes to whom he is the centre of all prowess, and the applause in coats of arms with eminent plurality is mistaken: the fortunate, for happiness; the brave, for the value, the discreet, for the ingenuity; the most Catholic, for his heaven; the

fearless, by his gracefulness; and the universal, for all. (Gracián y Morales, 2003, p. 77).[9]

Yet the dysphoria of the present echoes in the laudatory grammar of this chronicle. The author, known as Fernando de Góis Loureiro, imposes an elegiac tone, redeeming the king of all the faults imputed to the masters. There lies his creativity because his prince is what, through education

> not contented with the glory of those above him wished to change his peace, and disturb the rest and quietness of his vassals, and finally seek his ruin in the unnecessary dangerous and difficult conquest of other kingdoms. (Loureiro, 1978, p. 17)[10]

He is the one who, while facing danger, in the heat of the battle

> [...] saw dying before him so many and so good lords [that he] wished to die like them and so he got into the greatest dangers, yet his invincible animus allow him to stay alive. (Loureiro, 1978, p. 116)[11]

His performance in the battle actually is one of a fierce Christian knight.

In turn, Antonio's servant, despite criticising the king, namely by challenging his military decisions, still recognises his worth in the battlefield. According to him, the Portuguese are an example to be followed (Loureiro, 1987, p. 204). Sebastião had listened to ambitious flatterers who have assured him that honour was not achieved through weakness, nor by listening to deferential advice (Loureiro, 1978, p. 164).

It is the testimony that shows experience: passions are exposed in a tone that touches rhetoric, although it does not follow the elegiac lament of the king's Journey in Africa, nor the peroration that closes the life of the monarch (Loureiro, 1978, p. 141). It is within hubris that the symbolic representation of the king persists, as evidenced by authorial creativity.

A contrastive atmosphere of light/dark pervades in the writing of Sebastião's expedition in Africa. Here lies the key to the reading of the creative process as exercised by the two authors we have been analysing. The possible mimicking of these strategies of representation of the monarch in other narratives, and the correlations with their readers are analytical paths that must be further explored, given that we should grasp creativity functionally in terms of what it *does*; or

7. Veio a ser maravilha de linhagens a augustíssima Casa da Áustria, fundando a sua grandeza na que é cifra das maravilhas de deus. E rubricou o seu sangue imperial com o de Cristo, Nosso Senhor, sacramentado. [...] Ser herói do mundo, pouco ou nada é; sê-lo do Céu é muito, a cujo grande Monarca se preste o louvor, se preste a honra, se preste a glória.
8. Dépourvu d'hiatus entre un moi et une persona, entre conscience libre et corps aliéné.

9. émulo comum de todos os heróis a quem é centro de todas as proezas, e equivoque-se o aplauso em brasões com eminente pluralidade: o afortunado, pela felicidade; o animoso, pelo valor, o discreto, pelo engenho; o catolicíssimo, pelo seu céu; o destemido, pela sua airosidade; e o universal, por tudo.
10. não contente com a glória de seus maiores quis alterar seu sossego, e perturbar o repouso e quietação de seus vassalos e finalmente procurar sua ruína na desnecessária perigosa e difícil conquista de reinos alheios.
11. viu morrer diante de si tantos e tão bons fidalgos desejoso de acabar com eles se meteu nos maiores perigos mas de todos seu animo invencível o tirou com vida.

frame it socially in terms of *who*, *where* and *how*; or simply develop the historical view of what being creative *has meant*. (Pope, 2005, p. 52)

And this must be achieved while never forgetting the historical condition of our object of study, as a sharp critic that does not ignore the limits of historical knowledge.

ACKNOWLEDGEMENT

This study is part of the project "De Re Militari"De Re Militari: Da escrita da guerra à imagem do campo de batalha no espaço português (1521–1621)"-PTDC/ART-HIS/32459/2017"

BIBLIOGRAPHICAL REFERENCES

Aristóteles. (1986). *Poética*. Lisboa: Imprensa Nacional-casa da Moeda.

Avelar, Ana Paula. (2004). Do perfil do Herói em algumas crónicas sebásticas, in Academia Portuguesa de História, *Colóquio – O Sebastianismo – Política, doutrina e mito (sécs. XVI-XIX)*. Lisboa. Edições Colibri.

Buescu, Ana Isabel. (1996). Imagens do Príncipe – Discurso normativo e representação (1525-1549). Lisboa: Edições Cosmos.

Catroga, Fernando. (2017). "O Historiador na cidade: História e Política", in Matos, Sérgio Campos e João, Maria Isabel (org.) *Historiografia e Res Publical*. (pp. 27–86). Lisboa: CH-CEMRI.

Dubois, Claude-Gilbert. (2001). Le Bel aujourd'hui de la Renaissance.-Que reste–t-il du XVIe siècle? Paris: Seuil.

Évora, André Rodrigues de. (1993). Sentenças para a Ensinança e Doutrina do Príncipe D. Sebastião. Fac-simile do manuscrito inédito da Casa do Cadaval, Lisboa: Banco Pinto & Sotto Mayor.

Foucault, Michel. (2005). The Order of Things, An archaeology of the human sciences. London: Routledge.

Gracián y Morales, Baltasar. (2003). *O Herói*. Lisboa: Frenesi.

Kantarowics, E. (1984) *Mourir pour la patrie*. Paris: PUF.

Klausen, Søren Harnow. (2010). The Notion of Creativity Revisited: A Philosophical Perspective on Creativity Research. *Creativity Research Journal*, 22 (4), pp.347–360.

Loureiro, Francisco Sales (ed). (1987). *Crónica do Xarife Mulei Mahamet e d'el- ReiD. Sebastião*. Odivelas: Europress.

_____ (ed.). (1978). Jornada del-rei dom Sebastião à África – Crónica de dom Henrique. Lisboa: Imprensa Nacional-Casa da Moeda.

Medelénat, Daniel. (1986). *L'épopée*. Paris: PUF.

Munslow, Alain. (2003). *Deconstructing History*. London: Routledge.

Nelson, Camilla. (2010). The Invention of Creativity-The Emergence of a Discourse. *Cultural Studies Review*, 16 (2), pp. 49–74.

Pope, Rob. (2005). *Creativity: Theory, History, Practice*. London: Routledge.

Ricoeur, Paul. (2004). *Memory, history, forgetting*. Translated by Kathleen Blamey and David Pellauer. Chicago: University of Chicago Press.

Intelligence and creativity at the service of the Society of Jesus in 16th century Japan: The contribution of Father Luís Fróis

Helena Resende

CHAM, FCSH, Universidade NOVA de Lisboa, Lisbon, Portugal
Universidade Lusíada de Lisboa, Lisbon, Portugal
ORCID: 0000-002-1774-9451

ABSTRACT: The sixteenth century brought new worlds to the old world that was Europe, which now also struggled with internal political and religious changes. The Society of Jesus was one of the tools that Catholic Europe used to combat the advance of Protestantism and to deal with the new geographical and cultural realities, and in 16th-century Japan, this religious congregation resorted to intelligence and creativity to advance Catholic evangelisation in a new space.

Intelligence to understand the complexity of Japanese society, creativity to overcome this obstacle through unconventional methods; intelligence to adapt to change, creativity to create a very own form of adaptation – *accommodatio*; intelligence to learn new cultures, creativity to face them without clashing with the directives of the Catholic Church; intelligence in the use of feelings and emotion, creativity in the balance between duty and action.

Father Luís Fróis is one of the best examples of these abilities, revealed both in his vast literary work and in his life of almost 35 years in Japan, using intelligence and creativity to advance with evangelisation and ensure the survival of a small number of European missionaries in a space with many obstacles. We highlight the *Historia de Japam*, the *Tratado*, and the various letters in a corpus of documents – *Cartas de Évora*-, epistolography which we will analyse in greater detail here.

Keywords: Japan; Jesuits; Intelligence; Creativity; Fróis

1 JAPAN IN THE SECOND HALF OF THE 16TH CENTURY

Japan, which has received Europeans since 1543, is the Japan of warriors, with its own code of honour – the *bushido*[1] –, where everyone fights against everyone, and where the political scenario is characterised by a conception of power that is strange to the Western world, shared between the warrior aristocracy, the imperial court and religious institutions.

The Japanese Middle Ages (between the 12th and 16th centuries) is a turbulent period of political chaos and feudal anarchy, with a fragile central power, internal wars and the predominance of relationships of personal dependence, and therefore the preponderance of warriors. Concerning that, three elements converge and coexist:

the old principles of imperial centralisation, the old primitive traditions of semi-tribal organisation and the networks of personal fidelities (Reischauer, 1973:69)[2].

Power is based on the prestige and mobilising capacity of a warrior, depending on the alliances and loyalty achieved.

Curiously and even paradoxically, we will see that the rivalries between the various Japanese lords – *dáimios* – ended up bringing some advantages to the missionary activity of the Jesuits, – who, quite intelligently, for example, played with the Japanese interest in participating in trade with Macau (increasing their power over their rivals). Father Luis Fróis is aware of this circumstance when he writes that:

> One thing is different in Japan from almost all other kingdoms (...) & is that to be better able to expand the law of God, & to have better entrance into kingdoms in which in the time of peace it is not possible, when wars

1. *Bushido* – Literally the path of the warrior. A code that established the rules of conduct of the samurai. Fruit of the religious syncretism proper to the Japanese, it was based on the cultivation of seven virtues: honour, fidelity, courage, goodness, politeness, truthfulness, righteousness and self-control.

2. All translations from non-English sources are the Author's free translations.

arise then one begins to negotiate better this spiritual fishery (CE, II, 17 October 1586, fl.184v)[3]

The Christian century or Namban century[4] witnessed two parallel and complex processes of which the Portuguese and the Jesuits were observers, and even privileged participants:

> openness to the outside and unification, having contributed decisively to the transformation of the medieval, anarchic and feudal country into a modern, peaceful and centralised state (Costa, 1998:11).

Trade is thus an essential means of getting closer to the local authorities and of helping the missionaries to survive and "a symbiosis between Portuguese merchants, Jesuit missionaries and Japanese magnates – a tripartite union of mutual interests "(Pinto,2004: vii) is visible, and the religious themselves actively participate in trade.

It was a reality that the Jesuits, very intelligently,

> used the Portuguese boat and objectively served what were then the interests of Portugal, as a nation conqueror and missionary, and as a Christian people. (Lourenço,1992:50)

We point out that the Portuguese Empire is formed and developed in the new worlds through a very close relationship between the Sword, the Stock Exchange and the Cross, which subjects its participants to the successes and vicissitudes of the action of the military, the merchants and the religious.

As far as the sacred is concerned, the divine in Japan has a very close relationship with everyday life, and certain rituals mean more than manifestations of religious fervour; Braudel (1989) considers that in this country "the religious is confused with all forms of human life: the state is religion, philosophy is religion, morality is religion, social relations are religion" (pp.169–170).

16th century Japan is the Japan of Shintoism and Buddhism, allied to a philosophy of life, Confucianism, which governs social, political and administrative life, sharing the religious scenario with Taoism. Therefore, there is no single, binding religious tendency, and

one cannot speak of a single religion or a national religion, even though Shintoism – the path of the gods – often presents itself as such.

It is to this Japan, which lives a pragmatic religiosity, with a practical approach to religions, that Christianity arrives in the middle of the 16th century.

The inexistence of a single religion and the multiplicity of sects facilitated the work of the Jesuits and Fróis makes a curious reading of this fact, taking advantages for the dissemination and acceptance of Christianity:

> It was a great thing that in Japan there was a great diversity of sects, & contrary opinions, to introduce, & to manifest the law of God our Lord, because if all were unanimous in one worship, & adoration was very difficult to receive our doctrine (CE, I, 6 March 1565, fl.179v).

2 THE SOCIETY OF JESUS

In Japan, the Society of Jesus emerges as an instrument of a Catholic Europe that is confronted with changes in its own terrain, with the advent of revolutionary and innovative evangelising strategies, and with the diversity of the new worlds discovered, opening

> space for the recognition of difference and diversity, something fundamental to the primacy of the concept of adaptation in Jesuit evangelisation (Correia, 2009:76).

The new generation of ecclesiastics that is now being prepared has a more consistent and rigorous theological formation but, mentally and culturally, the transformations are slower. The discipline and union of the Church of Rome are emphasised in the face of the danger and threat of Protestantism.

The reason, intelligence, experience and knowledge must be present in the relationship of the Church with the worlds in which it moves because we are aware that "the Christianity of the modern is not that of the old and the missionaries are the first protagonists of this cultural revolution" (Gasbarro, 2006:75).

Above all, the Church – through the Society of Jesus – must seek to be tolerant, to adjust to the situations in which it is inserted to guarantee its survival.

In the modern age, this congregation knew, in very creative and diverse ways, how to put into practice the definition of intelligence which, centuries later, is given to us by Stephen Hawking: Intelligence is the ability to adapt the change!

The Society of Jesus,

> as a norm, required its members to have undergone an elaborate process of intellectual preparation, which made them privileged observers, endowed with a keen inquiring spirit and an extraordinary capacity to assimilate novelties (Loureiro, 2008:39)

3. In 1598, the largest collection of letters (209) from Jesuit missionaries concerning Japan was published in two volumes in Évora; in this work all citations in the text of this printed source are referenced as follows: CE – Letters from Évora -, the volume (I or II), the date of the letter and the folio/page. 4. The designations "Namban century" and "Christian century" refer, indistinctly, to the period between 1543 (official arrival of the Portuguese) and 1640 (official date of expulsion). The term *Christian Century* was vulgarized by C. R. Boxer, in the 50s of the 20th century, to indicate the period of about one hundred years of institutional contacts between the West (represented by Christianity) and the Far East. Currently, the historiographical trend privileges the term Namban Century because the contacts and interactivity that was generated is mainly cultural, surpassing religion.

The truth is, more than a conquest of a new world:

> It is [the Society of Jesus] greatest prodigy was that of being conquered by it. They were not the only ones who in the presence of the "other" tried to understand him, to evangelize him better or to dialogue with him (...) but no one like them (...) drew from the European matrix and became "other", so that (...) "God was all in all (Lourenço, 1992: 50).

The acceptance of diversity, the conviction that the general must be adapted to the specificities of Japanese society and the use of wit and intelligence to achieve positive results in evangelization, are ideas practiced by Francisco Xavier and expressly defended in the *Ceremonial, the Advertimentos* and in the *Apology* of Alessandro Valignano, Visitor of the Society of Jesus.

Not being an utterly innovative attitude – the defence of accommodation – the Society of Jesus knew how to be original and creative in the ways it conceived and realised it.

The Jesuits defend an acculturation project:

> the pagan societies had to transform themselves without deforming themselves, Christianization had to change only the social practices that clashed head-on with the Gospel, without the subversion of local habits (Franco, 2003:15),

capable of developing the adaptation of Christian doctrine and practice to the specificities of Japanese culture: the adaptation of concepts, terms, rites, dress code and encouragement of the formation of native clergy.

The expansion of Christianity in Japan, since the beginning in the hands of this congregation, and the very Portuguese presence in this territory, must be seen under multiple perspectives: the osmosis of conquest – trade – religion, assumed and practised by the Portuguese in the space of the Empire, and the political, economic and religious evolution of the Japanese territory.

We can say that:

> the period in which the Jesuits arrived – of widespread chaos and lack of links, particularly trade links, with China – was decisive for the easy acceptance of the priests, who took advantage of the disunity of the Japanese elites and played a very skilful and intelligent part in Japan's political power play (Resende, 2017:283–284).

Pinto (1986) says that is difficult to separate temporal interests and mystical values, basic components of Western penetration and, in this space, the missionary strategy of the Society of Jesus is elaborated intelligently, conditioned by local realities (political, military, social and religious). That lead to an approach to the elites and the evolution of evangelisation is directly related to the political support that the congregation receives in various parts of the Japanese territory.

3 THE ROLE OF FATHER LUÍS FRÓIS

Father Luís Fróis is a Jesuit born in Lisbon, in 1532, who does his intellectual and religious training in the East, after 1548, having arrived in Japan in 1563, and lives there, almost uninterruptedly, until the end of his life, in 1597.

Historian and participating observer, because he is an eyewitness who reports everything he sees and is involved in the radical changes that Japan is experiencing in the second half of the 16th century.

The many years he lived in Japan gave him know-how and exact knowledge of the political reality, allowing him, very intelligently, to draw lessons from political events that can influence the work of missionaries.

For example, he clearly explains the advantages of associating Christian acceptance and commercial presence, when he comments the option of Father Cosme de Torres when he

> sent Luis de Almeida with two Japanese (...) to secretly put on the island of Tagoxima (...), and to see if there was a way to make some of the lords of Ximo Christian, giving them hope that the ship of the career would go to their ports, if they had accommodated them (HJ, II:270)[5]

Fróis reveals great intelligence in his reading of the Japanese political scene, presenting us with a very high contrast between the figure of the emperor, in a very weakened position and almost a figurative element in the political scenario, and the decisive role of the *bakufu* (military government), an active force until the appropriation of power and unification by the two warriors who effectively dominated the Japanese political and military reality in the second half of the 16th century: Oda Nobunaga and Toyotomi Hideyoshi.

The Father, during the several years of power exercised by Nobunaga, had the opportunity to be in close contact with what was one of the leading figures in the history of Japan – "made me enter the same room, twice told to give me his tea in his china" (CE, I, 01 Junho 1569:fl.262) – and, in the various letters in which he mentions him, lets us understand the admiration that he has for this warrior, despite criticising some attitudes, especially in the final years of his life.

His writings reveal an evident literary vocation, an unusual – for the time-analytical capacity and curiosity

5. The Historia de Japam is a monumental epic work of Fróis, which follows a chronological line, presenting a chronic structure, and focuses mainly on the history of Japan – politics, society, religion – but obviously always accompanied by the history of Jesuit missionaries in the archipelago. The complete edition of this work, in Portugal, was only achieved in the second half of the 20th century, between 1976 and 1984; in this work all citations in the text of this printed source are referenced as follows: HJ – Historia de Japam, the volum, page.

to capture and transmit what is different, genuinely meeting European Humanism.

In his works, we can see "the rare sharpness and brilliance of intelligence, the fair observation, the rich imagination, the complex description" (Janeira, 1988:118).

We highlight the *Historia de Japam*, a valuable contribution to the knowledge of the sixteenth century Japan, a vast work that confirms the analytical capacity and a curiosity to capture and transmit what is different; The *Tratado das Contradições*, a real anthropological treaty; and the many letters he wrote at the service of the congregation that show Europe the face of Japan.

At the end of the 16th century (1598), the most extensive collection of Jesuit letters about Japan was published in Évora: 209 letters of multiple authorship, 481 folios in the first volume and 267 in the second (without pagination) and Fróis have the most significant contribution (53 letters).

> It should be noted that only in the writings of Fróis (especially in the letters and Historia de Japan), of all the Jesuit texts known from the 16th century, are described in detail Japanese places of worship, because the other sources are very laconic about it.

Parallel to his missionary work:

> Fróis was genuinely interested in the most varied aspects of Japanese civilisation and sought to gain an understanding of the social, cultural and religious practices of the Japanese people (Loureiro, 2008:47).

He understands that accommodation was more than an adaptation: it would be a transformation of oneself and is born

> first of an attentive observation of the other, [and] consists in finding the gateway that allows evangelisation and the incorporation of the culture of others (Bernabé, 2012:108),

The position of Fróis (and of Valignano and some other missionaries) is to condescend as far as not to interfere with the principles of the congregation.

He maintains that accommodatio, at least externally, must be accepted and above all practiced and understands that only by becoming Japanese, in the outward appearance, can Jesuits have a chance to provoke internal changes in places because "the way of life of the Japanese is in everything so different from the way of living, & the laws, & customs of Europe" (CE, I, 25 Agosto 1580: fl.478) and

> we need a complete transmutation of nature in terms of eating and customs and way of living because everything is the opposite and very different from how it is done in Europe (HJ, III:130).

One aspect that Fróis emphasises in his letters is the care to be taken with the exterior appearance and the clothing with which priests present themselves to the local chiefs because the traditional vow of poverty of Western religious orders is not understood in a positive way here.

Thus, the missionaries adopted the use of the Japanese kimono, in combination with more opulent Western costumes and, on his first visit to the capital, in 1565, Fróis refers that Father Gaspar Vilela, to be received by the shogun, dressed rigorously:

> because the Japanese do not cherish people more than by the outside apparatus, the priest would not enter the palace going as we usually walk, it was necessary (...) to put the priest on pontifical. The first two times he visited him was with a stole, & surplice & a red hat on his head, and the other two with good kimonos, & cloth mantle from Portugal on top (CE, I, 20 Fevereiro 1565, fl.178v).

Valignano's visits to Japan have an impact on the determinations as to the behaviour to be adopted about the diversity of the Japanese community and Fróis makes it very clear that the Visitor specifies:

> the way we should have about the customs and ceremonies, and the manner of proceeding of the land, to be well and well regarded among them [and] commanded that in all things we should proceed in our fields according to the proper and accustomed way of Japan (HJ, III:179–180).

Although accommodation to Japanese life is accepted and even defended to achieve the conversion of the elites better, it is also a reality that this position does not always have consensus, mainly because of the difficulties in tracing the limits of this "compromise", worrying the Society and Rome.

The reduced number of European missionaries raised practical problems and led the Society in Japan to have many brothers, together with a smaller number of priests, as opposed to the rest of the missions in the East, something that raises another question: that of the formation of native clergy – predominant from 1588 forward, leading Costa (1999) to state that:

> At the end of Five Hundred, nowhere else in the overseas world controlled by autochthonous powers, completely disconnected from European political-military influence, was there such a large Christianity and served by a team of religious with a mostly native "face" (p. 43)

As far as this native face is concerned, in the idea of Fróis, the native clergy is appreciated and praised, especially for the advantage of knowing the language and the cultural and religious habits. A specific case that refers, in the centre of the territory, in the Miyako area, in the year following the death of Oda Nobunaga, the Jesuit mentions:

> a Japanese brother of 40 years old, is called Vincent, great preacher, & insigne in the phrase, & elegance of the language, very instructed in the knowledge, & news of the sects of Japan, thing in extreme

necessary to our preachers to confront in the arguments the errors, & false opinions of the Bonzos, & more gentiles(CE, II, 2 Janeiro 1588,fls.91–91v).

Another critical issue, which was resolved with creativity, was the obstacle of the language and the lack of vocabulary in the local language that could be used to express Catholic ideas and teachings. The Jesuits had two solutions: either they invented new words, or they used Western words, modifying them to resemble those of Japan.

There are religious terms, proper to the Christian lexicon, with a different meaning from those used in Japan to designate, for example, God, Hell, Soul or Paradise, and the option that prevailed was the adaptation of Western terminology to the phonetics of Japanese.

The importance of Japanese language learning by the missionaries had been emphasised from the beginning by Francis Xavier, who considered it a priority for evangelising success since he understood that "language thus becomes a companion of the faith, its main weapon" (Laborinho, 1994:378).

Fróis proves to us the effort made by Jesuits in this task, visible also in the development of grammars and catechisms, and recognises the need and importance of providing missionaries with study materials and help in learning the native language:

> because in Japan until now [1564] there has been no art according to the order of the Latin language, which was detrimental to learning the language, Brother João Fernandes determined to do it with his conjugations, syntax, and more necessary rules with two vocabularies in order of the alphabet, one that begins in Portuguese, & the other in the same language(CE, I, 3 Outubro 1564, fls. 146v–147).

Brother João Fernandes' role in learning and spreading the Japanese language is thus understood to be vital for the progress of Jesuit evangelization because this initiative "was one of the most necessary things that were needed here, so that the language can bear fruit in souls" (CE, I,3 Outubro 1564, fl.147).

This strategy reveals a long-term vision and enables the Jesuits to have more effective contact with the locals and more in-depth knowledge of the Japanese language. For example, the Japanese used in the capital and palaces differed from what was spoken by most of the population in the more rural world of the rest of the country.

Intelligence is what Fróis also reveals when he decides what he writes and makes it public because however tolerant and open, what he writes is limited by superior indications of the Company, and we perceive in his writing failures or evasions about some issues that could be controversial because they clash with the principles of Christianity.

The strategy of selecting what is disseminated is a form of intelligence and omitting or minimising certain aspects requires some creativity in the way they are

exposed to the Western world and even to the Society of Jesus itself.

We refer, for example, to the existence of concubines (polygamy) by some *dáimios*; the easy end of marriage unions, with repudiation being accepted and practised by both parts; and the practice of *seppuku*[6], a ritual of suicide that would hardly be understood or accepted by the Western Christian mentality.

4 CLOSING REMARKS

The missionaries made an effort to deal with the peculiarities of Japanese society – the strong bonds of fidelity between the chiefs and the vassals, the appreciation of ostentation, the family connections – and to overcome the vicissitudes – the almost permanent state of war, the commercial interest of the lords, the insufficient number of European religious, the language barrier, the rigours of the climate and, above all, the doubts of those on the ground who were faced with situations not yet regulated by the congregation.

The position of the missionaries in contact with the Japanese reality is that of adapting the rules of the Society – and of the Holy See – to the peculiarities of Japanese society, circumventing the problems and finding solutions for each case and each situation.

Remember what Janeira (1988) wrote:

> Only a few missionaries had the capacity of discernment to perceive that a careful, intelligent dialogue, capable of accommodating the Christian religion, as far as possible, to the gears, mindsets and habits of those peoples (...) could be the only way to penetrate a society cemented in a lofty and well aware notion of the greatness of its culture (p.16).

The ideas and practice of the Jesuits advocate the acceptance of diversity, a sign of intelligence because they recognise that this is more successful than forcing a change in Japanese cultural practices.

The flexibility they use in dealing with differences allows them to develop creative methods of approaching the Other and of evangelisation, in a very pragmatic way.

The priests revealed here two fundamental characteristics for the success of the mission: accommodation and resilience:

> accommodating themselves by adapting to local customs but at the same time without bending the constitutive principles of their religious and pedagogical thinking (Ieiri et al., 2011:2).

6. *seppuku* – "honorable death", suicide ritual, usually referred to by harakiri (literally, incision in the belly). More than an institutionalized practice in the warrior elite, it is a ritual that guarantees the honour of the warrior and his descendants and that has significant social and cultural implications.

The Jesuits, and especially Luís Fróis, revealed intelligence to adapt to change, creativity to create a very own form of adaptation – *accommodatio*; intelligence to learn new cultures, creativity to face them without significant value judgments; intelligence in the use of feelings and emotion, creativity in the balance between duty and action.

ACKNOWLEDGEMENT

This chapter had the support of CHAM (NOVA FCSH/UAc), through the strategic project sponsored by FCT (UID/HIS/04666/2019).

BIBLIOGRAPHICAL REFERENCES

Bernabé, Renata C. (2012) *A construção da Missão japonesa no século XVI*. São Paulo, Brasil: Universidade de São Paulo.

Braudel, Fernand. (1989) *Gramática das Civilizações*. Lisboa: Edições Teorema.

Cartas qve os padres e irmãos da Companhia de Iesus escreverão dos Reynos de Iapão & China aos da mesma Companhia da India, & Europa, des do anno de1549, até o de 1580. Nellas se conta o principio, socesso, & bondade da Christandade daquelas partes, & varios costumes, & idolatrias da gentilidade. Impressas por mandado do Reverendissimo em Christo Padre Dom Theotonio de Bragança Arcebispo d'Evora …Em Evora por Manuel de Lyra. Anno de M.D.XCVIII (1997). 2 vols. Maia, Portugal: Castoliva editora Lda. [edição fac-smilada da edição de Évora de 1598].

Correia, Pedro. (2009) Entre o desafio e as soluções: o percurso histórico do Cristianismo no Japão (1549–1638), *Cristianismo no Japão. Universalismo cristão e Cultura nipónica*, 71–82: Fundação AIS.

Costa, João P.O. (1995) *A descoberta da civilização japonesa pelos portugueses*. Lisboa: Instituto Cultural de Macau – Instituto de História D'Além – Mar.

_____, (1998) *O Cristianismo no Japão e o Episcopado de D. Luís Cerqueira*. Lisboa: Faculdade de Ciências Sociais e Humanas, Universidade Nova de Lisboa.

_____, (1999) *O Japão e o Cristianismo no século XVI. Ensaios de História Luso-Nipónica*. Lisboa: Sociedade Histórica da Independência de Portugal.

Franco, José E. (2003) O fim do sonho missionário nas Ilhas do Sol Nascente: a Apologia do Japão e a controvérsia entre Jesuítas e Mendicantes. *Revista de Cultura*, 6, 54–63.

Fróis, Luís, SJ. (1976-1984) *Historia de Japam*. Edição de José Wicki. 5 vols. Lisboa: Biblioteca Nacional de Lisboa.

Gasbarro, Nicola. (2006) Missões: a civilização cristã em ação. *Deus na Aldeia: missionários, índios e mediação cultural*, 67–109. São Paulo, Brasil: Globo.

Ieiri, Maurício, Santos, Fernanda. (2011) Resilência/Acomodação das Missões jesuítas: os casos do Brasil e do Japão. *Anais do XXVI Simpósio Nacional de História*, São Paulo, Brasil: ANPUH.

Janeira, Armando Martins. (1988) *O Impacto Português sobre a Civilização japonesa*. 2ª ed. Lisboa: Publicações D. Quixote.

Laborinho, Ana Paula. (1994) A questão da língua na estratégia da evangelização: as Missões no Japão. *O Século Cristão do Japão*, pp.369–390. Lisboa: Universidade Católica Portuguesa – Universidade Nova de Lisboa.

Loureiro, Rui Manuel. (2008) Jesuit textual strategies in Japan between 1549 and 1582. *Bulletin of Portuguese/Japanese Studies*, 8, 39–63. Lisboa: Centro de História D'Além-Mar, Universidade Nova de Lisboa.

Lourenço, Eduardo. (1992) Portugal e os Jesuítas. *Oceanos*, 12, 47–53. Lisboa: Comissão Nacional para as Comemorações dos Descobrimentos Portugueses.

Pinto, Ana Fernandes. (2004) Uma imagem do Japão. A aristocracia guerreira nipónica nas cartas jesuítas de Évora (1598). Lisboa: Instituto Português do Oriente-Fundação Oriente.

Pinto, Maria Helena Mendes. (1986) *Biombos Namban*. Lisboa: Museu Nacional de Arte Antiga.

Reischauer, E. (1973). *Histoire du Japan et des japonais*. Paris: Éditions du Seuil.

Resende, Helena. (2017). O Outro civilizacional:o Japão do século XVI pelos olhos de um jesuíta português. *Revista de História das ideias*, 35, 279–299. Coimbra: Universidade de Coimbra.

A science of the probable; epistemological inventiveness according to Diderot

Luís Manuel A.V. Bernardo
CHAM, FCSH, Universidade NOVA de Lisboa, Lisbon, Portugal
ORCID: 0000-0002-3587-7799

ABSTRACT: In *Thoughts on the Interpretation of Nature* (1753), Denis Diderot discusses what may be the novelty of a science of becoming and morphogenesis, consequent with the autopoietic of nature. Far from arriving at a positivist conception, as is common among materialistic philosophies, the author projects a science of the probable, the contingent, the transitory, which requires the combined efforts of all capacities of the knowing subject to carry out the ceaseless dialectic between the two poles of observation and interpretation. Imagination, intuition, prospect, and conjecture are summoned to accompany experiential activity, introducing an inventive dimension in science, whose freedom contributes to subverting the epistemological canon, blurring the rigidity of disciplinary boundaries, intensifying scientific discovery, and giving meaning to the cluster of research. Consequently, science becomes a plurality of texts, intersecting facts and conjectures, data and metaphors, protocol rigour and rhetorical procedures.

The unusual character of this exuberance has led the main commentators on the work to presume that it is the fruit of philosophy's intervention, to which it would be fitting to add the step of creativity, unfeasible in scientific methodology. In contrast, we argue that, for the philosopher, those various processes are constitutive of the same scientific research, which finds in judgment the central faculty and in abduction the privileged process of discovery.

Keywords: Diderot; science; imagination; inventiveness; abduction

As Mandosio (2013) rightly saw, the *Thoughts on the Interpretation of Nature* constitute "*le discours de la méthode de Diderot*". There, the philosopher gives shape to what he sees as the ongoing scientific revolution, drawing in detail the epistemology of a science in accordance with the regulatory idea of a nature without determinant intelligence or conductive purpose, all formed by material, variable and self-productive processes in permanent evolutionary transformation. Faced with the difficulty in defending the need for a perennial state of the world, the new science becomes a function of conjectural interpretation. Its success depends less on observation data, always relative to a given instant and relying on interpretation than on the pertinence and coherence of the conjectures, destined to offer contexts of signification to the constitutive opacity of the former.

It is what stems from how Diderot (1999, p. 71) establishes the hierarchy between the two attitudes that, not having to be produced by the same individual, form the general process of science:

> one of the main differences between the observer and the interpreter of nature is that the latter begins at the point where the former ceases to use his senses and his instruments; on the basis of what now exists, he speculates on what is to come; from the established order of things, he draws abstract and generalised conclusions which, for him, have all the force of particular, ascertainable truths.

Consequently, if the observation appears indispensable to give epistemic consistency to the interpretation, it is up to the latter to guarantee the complex task of giving meaning to the scientific discovery.

It is, thus, fit to recognise that the typical process of new science, what makes it progress, as Diderot sees it, is abduction, in other words, the search for the best explanation for a phenomenon that is always the controlled result of serendipity, "chance (which is never idle – and is more fruitful than man's wit)" (Diderot, 1999, p. 63), even if all sorts of experiments and reasonings provoke that discovery. What makes a phenomenon epistemologically meaningful relies, precisely, on the random character of its discovery, without which it would be no more than an effect predicted by theory. In turn, it is the abductive reasoning that makes possible the construction of the epistemological access to a world of matter, moving progressively from the agreed theses – in a

world view in which a double principle of matter and spirit predominates –, to a general framework in which material monism imposes itself as more keeping with the results of scientific research. If we consider, following Robin Smith, that, in the traditional Aristotelian sense, *apagogè* "involves leading the argument away from one question or problem to another because of taking something in addition" (Aristotle, 1989, p. 233), it becomes understandable to expect its protagonism as a gnoseological process. Diderot himself practices it extensively to assert his philosophical perspectives at least since the "Letter to Paul Landois" (Bernardo, 2015, pp. 173-179). The term or its direct definition does not appear in the work, the same being true for others, like deduction and induction, probably because the philosopher seeks to avoid the conventionality of its use in logic, but what may correspond to them, from the epistemological point of view, seems sufficiently characterised in the aphorismatic sequencing.

Thus, Diderot conceives abduction as an ample and complex gnoseological process, geared towards promoting scientific discovery, by combining structural components of the Aristotelian definition, and elements that anticipate the proposed interpretation, almost a century later, by Charles Peirce, at the Harvard conferences on pragmatism (1978, p. 172):

Abduction is the process of forming an explanatory hypothesis. It is the only logical operation which introduces any new idea; for induction does nothing but determine a value, and deduction merely evolves the necessary consequences of a pure hypothesis.

Likewise, Peirce's assertion could be his, according to which "every single item of scientific theory which stands established today has been due to abduction" (1978, p. 172). Consequently, he takes over Stagirite's idea of a sort of approximate reasoning, according to the degree of probability, which is justified:

when it is clear that the first term belongs to the middle and unclear that the middle belongs to the third [...]; or, next if the middles between the last term and the middle are few (Aristoteles, 1989, p. 100)

However, confers it an amplitude and efficacy that lead him to relate it to a set of less conventional processes, equally identified by the American author: divination, breakthrough, instinct, discovery, inventiveness (Peirce, 1978, p. 173). In such an advance, what is discerned is not so much a genealogical link as the centrality that the eighteenth-century philosopher confers to the abductive exercise, in tune with a full realisation of its reach.

Such does not mean that, for Diderot, as also latter for Peirce, the two other processes are not part of scientific research, quite on the contrary, given that the abduction, due to the freer context of the discovery, is marked by a constant tension between objectivity and meaning, truth and conviction. What occurs is a change in the way they are understood, both, henceforth, committed to the balance between experimentation and interpretation, geared to make nature speak, sometimes manipulating it intentionally, sometimes proposing its plan of action.

In effect, the absence of a substantial perennial fund and the return of truth to the probability, make the idea of a necessary sequential reasoning unsustainable, one corresponding to the deduction. As Duflo summarizes (2013, p. 166):

Les principes les plus généraux ne doivent pas nous servir pour déduire, mais pour chercher, et les hypothèses ne sont véritablement fécondes qu'à condition de féconder des expériences qui seules étendent véritablement le savoir.

It is precisely the epistemological core of Diderot's critique of the Methodists, particularly to Linnaean taxonomy, presented as the finished example of the abuse of deduction (Diderot, 1999, p. 64):

Man, says Linnaeus in the preface to his *Fauna Suecica*, is neither a stone nor a plant; he must, therefore, be an animal. He does not have only one foot, so he cannot be a worm. He is not an insect because he has no antennae [...] So what is man? He has a mouth like a quadruped. He has four feet; he uses the two forefeet to touch with, and the two hind-feet to walk with. So he must be a quadruped. [...] 'So your logic must be wrong', the logician will say.

In contrast, the deduction, put at the service of the interpretation of nature, becomes a reasoning by analogy, resulting from a comparative exercise on the similarities and differences between notions, explanations and theories, whose example is found in the 'fifth conjectures' about the molecular formation of bodies, within the framework of a theory of elasticity.

Likewise, inductive reasoning loses its conventional abstractive reach, starting to correspond to an effort to find analogies among similarities or differences between the phenomena and facts resulting from several experiences, designed to highlight those relationships. Inductive work becomes, thus, one of the means of sustaining the adequate production of scientific conjectures, that may satisfy the double criterion of the maximum of possible probability and the maximum of possible reference relation. It stands halfway between singularity and generality, much more than mere collections of sparse data, but rather less than inferences allowing the establishment of a systematic legality or the founding of the exclusivity of one of those explanations. Consequently, the procedure from particular to the universal is reconducted to the horizontal and expansive logic of a network, while the cumulative process of data, personified by Reaumur's entomology (Diderot, 1999, p.70), ends up being questioned, replaced by a particular version of the eight operations of Bacon's experimental method, where the requirement of variation and complexity of the experiments prevails (Diderot, 1999, p. 61) in a

science aimed at following the seriality of nature. His critique is, in this case, directed against Reaumur's monumental work on insects, as he asks (1999, pp. 69–70):

> What would posterity think of us, if all we had to leave behind was a complete entomology or a vast survey of microscopic creatures?

This position leads him to suggest even that, in the impossibility of fulfilling this experimental protocol, it is preferable to opt for experiences of thought whose script recreates it. The entire *Letter to the Blind* illustrates this option, offering a complete thinking experience, replacing the failure to be present at the surgical intervention of Cheldesen, considered insufficient to generate effective progress of knowledge.

Serendipity, experimentation, deduction and induction are not the only procedures in which abduction relies on. The use of the productive imagination, aimed at suggesting images that give shape to the new perspectives, that make tangible the conjectured forms, that confer the due consistency to the foreseen processes, becomes, also, indispensable. Referring to *D'Alembert's Dream*, Bourdin evidences this dynamic (1998, p. 79):

> Imaginer, extrapoler, généraliser, tirer des conséquences, tout le Rêve est animé par des appels à prolonger les suggestions de l'imagination mise en contact avec des savoir positifs.

Just like Diderot's philosophy, the conception of science that he draws, finds in phantasy, simultaneously, the insertion of the most abstract levels of thought into physicality, and the scheme of translation of conjectural flashes into representations, whose figurative character ensures the system of equivalences with the material conditions of nature. However, regardless of how free it may seem, the use of the imagination is doubly delimited: on the one hand, imagination finds itself linked to the composition of *partes extra partes*, which guarantees the external reference; on the other hand, by taking place in the context of scientific discovery, its function becomes, *ipso facto*, defined by the intended objectives. It is not, therefore, a matter of weakening epistemic intentionality by introducing a fictional aspect, but rather of making it benefit from the intrinsic translatability of cognitive faculties. In visually demonstrating, the scientist, while acquiring a superior accuracy over his mental representations, fully shares his vision with the community, favouring intersubjective modes of consensus, fundamental to a science of the probable.

This justifies, likewise, the metaphorical use of images, recovered from cultural imagination or from the latest scientific imagery, namely from Chemistry (Pépin, 2014), put in operation in science's signification regime. Bourdin reminds us that the three central images of *D'Alembert's Dream* – the harpsichord, of La Mettrie, the swarm of bees, of Maupertuis and Bordeu, and the spider, of Chrysippus and Saint Paul – are not original (Bourdin, 1998, p. 97). Originality comes from how they are correlated with the issues under discussion – the sensitivity of matter, the consciousness of identity and the centrality of the brain. This play between resumed and reallocation results in a kind of saturation of the expressive potentialities of each procedure – the imaginary functioning as a true scheme of positivity, the understanding brought back to the plane of matrix analogies – should they be, as we proposed, constitutional, processual, metaphoric or direct (Bernardo, 2009, pp. 213-216) –, which contributes to illuminate the paths of inquiry. The result is neither pure metaphor, nor pure concept, but a "concept-metaphor" (Ibrahim, 2010, p. 100).

In either case, however, there is no place to encourage astonishment with a hypothetical teleological order, in the genesis of a vision marvelled at the prodigies of nature. Diderot, thus, remains faithful to "the principles of adequate conviction, set out in the article "Agnus scythicus" of the first volume of the *Encyclopédie*. Far from apologetically seeking to strengthen the motives for belief, this joint exercise of imagination and reflection aims to consolidate the reasonableness and positivity of knowledge.

In such hybridity, made of science, philosophy and literature, but that Diderot rightly wants not as an amalgam, deviant of the reach of every single one, another process takes on the determining role. It is instinctive intuition, which Diderot (1999, p. 47) defines, with the help of a neologism [flair], as

> a propensity for divination, enabling them [scientists and practitioners] to 'scent', so to speak, unknown procedures, fresh experiments and hitherto-undiscovered results.

It is so, given that the inventiveness, that assists the interpreter of nature in the formulation of conjectural explanations, still requires a capacity to explore the meanings of experimental results, palpitation on the evolution of phenomena and projection of a unifying conjecture of the diverse phenomena. These cannot occur either from the pure exercise of reason, too distant from the physicality of natural processes nor the mere experimental observation, tied in the excessive familiarity with each case.

To enter the functional logic of nature presupposes, rather, a paradoxical faculty, sufficiently attached to animality to convey the most elementary processes of nature, sufficiently intelligent to guarantee the translation of those intuitions to objectified forms of knowledge, that combines a natural spontaneity, a certain unconsciousness destined to facilitate risk-taking and power to combine diverse information. As Diderot writes (1999, p. 48):

> It is an irrational form of behaviour found to a surprising degree in those who have acquired, or who possess naturally, a gift for the experimental sciences.

Inasmuch "dreams of this sort have led to a number of discoveries" (1999, p. 48), he considers that "it is this sort of guesswork which should be taught to learners" (1999, p. 48), more than "to introduce them to procedures and results" (1999, p. 47), given that it constitutes one of the more significant processes to help the passage from the status of observer to the one of interpreter of nature, not at the beginning of the research, where it would be a mere phantasy without foundation, but at a stage already sufficiently supported in factuality.

This intuition is not, therefore, intellectual or noetic, does not stem from innate, *a priori* or preconceived ideas, but is "based on feeling, in the same way as men of taste judge works of the intellect" (Diderot, 1999, p. 47). Likewise, it is not about directly connecting a sensation to a psychic or mental representation, like in the imaginative apprehensions of Epicureanism (Gigandet, 2007, p. 76), but of developing the potentialities of a device of our animality, by way of "the long-established habit of conducting experiments" (Diderot, 1999, p. 47), in order to combine nature and culture.

Diderot clearly marks this distance from the old conceptions of inventiveness and abduction, which assume an ontological character that is expressed in the presupposition of a stable gnoseological element – sensation, prolepsis, obvious major premise – when it replaces the classical definition of the process in question – "go from the known to the unknown" – with a formula that, parodying it, profoundly changes its structure – "the art of proceeding from the relatively unknown to the completely unknown" (Diderot, 1999, p. 48). Establishing the possible knowledge between two negative values, the author accentuates the dynamic character of science, always in constitution, there being no alfa, nor omega, from which to leave or arrive at. In such regime, what must be saturated is the process itself, making it benefit from the poetic-interpretative media with which, in other domains, the connection of ideas is promoted, the variants of segments of the world are suggested, and textualities are rehearsed, which, in being fictional, do not stop fulfilling the criteria of internal coherence, likelihood or pertinence, without abandoning the intentionality that guides scientific research.

The context in which the aphorism arises that of the first conjectures about the spring constitutes in itself an excellent illustration of its scope. By subscribing to the contemporary debates on human reproduction, the series starts from a relatively unknown area, which the initial sentence – "There is a certain body know as a mola" (Diderot, 1999, p. 48) – soon indicates. As the assumptions succeed one another, complying with the protocol of inquiry, on its generation, its constitution, its organisation or its behaviour, the spectrum of what is ignored thickens, making apparent the inversion of the proportionality between the already known and the yet unknown. The manifold conjectures that arise,

therefore, appear as invested in that unknown land, combined effects of scientific rationality and creative imagination.

When practised well, that blurring of disciplinary boundaries allows, likewise, the gaining of 'insights', that lead to a profound rotation of the problems and suggest their eventual solution. *D'Alembert's Dream* enacts such a possibility: amidst fantasies, daydreams, phantasmagorias and erotic dreams, the classic problem of vital animation, that led to the paroxysm of the substantive duality defended by Descartes, ends up converted into the one of animalisation, which confers explanatory plausibility to the hypothesis of life and thought as effects of the organisation of the same matter (Duflo, 2013, pp. 203-204).

Thus, even if Diderot may characterize this scent with terms that refer to mystic enthusiasm or reverie – "a feeling of knowing what is about to happen which is akin to inspiration" (1999, p. 47) –, he keeps it within the limits of the epistemological context, with the purpose of empowering judgement and hence to develop the exercise of conjectural reasoning. What characterises the use of enthusiasm in science is, effectively, its relation to abduction, how it contributes to the progress of scientific discovery, thanks to its power to raise the perception of the relations, the passages and the enchainment, in all the domains where it is exercised.

Consequently, the judgements that originate from such practice cannot assume a dogmatic value, like the one that they hold in religious fervour, but assume the same conditional and conjectural form to which investigative science is obliged. Integrated into the abductive process, they cannot also assert a narrative self-referentiality. Instead, they must subject to the general process of falsification, which is an integral part of the logic of the abductive procedure. Similarly, the dispersion and the disarticulation of intuitions, that suggest an approximation to dreamlike irrationalism, in this 'extravagant' use, that is, destined to foment the extension of scientific knowledge, become eloquent by being put in the service of the same conjectural textuality around analogies, previously identified in the course of the research, whose validity is assessed by its "relation to what precedes or follows it" (Diderot, 1999, p. 47).

It is such subjection of creativity to the conditions of scientific practice that is indicated in this other definition (Diderot, 1999, p. 47):

> it is 'a facility for supposing or perceiving contrasts or analogies which is rooted in a practical knowledge of the physical properties of subjects taken in isolation, or of their reciprocal effects when taken in combination'.

As all that we have been describing, the scent constitutes, likewise, an epistemological procedure, integrating abductive labour, that benefits from the transposition of general schemes of inventiveness to attain the construction of a wise and useful knowledge,

not despite its contingency or its capacity for subversion, but thanks to them.

The new scientific research, as Diderot conceives it, arises, thus, as a permanent effort of discovery, interpretation and conjecture, based on analogical reasoning on data acquired in compliance with experimental protocols, on the invention of processes of experimentation designed to favour such a domain and on the gradual transposition of the information collected into acceptable explanatory sequences, a whole engineering that calls for a balance between creative freedom, the normative rigidity of the method and the learning capacity, up to the limit of resilience, which the work of Franklin or modern chemistry would symbolise (Diderot, 1999, p. 60):

> Open a book by Franklin; thumb through those written by chemists, and you will see how heavily the art of experimentation depends on opinions, imagination, sagacity and resources.

Consequently, all the processes described are fully inscribed in scientific practice, not forcing the distribution of the order of knowledge between scientific method and curiosity (Ibrahim, 2010, p. 94), nor lacking the extraordinary intervention of philosophy, whose task would be to take the step of freedom (Bourdin, 1998, p. 73) or to form the set of hypotheses that would make scientists think (Duflo, 2013, p. 241), even if they can benefit from visiting such repository, and everything points, in this conception, to the ideal of a philosophical science in interaction with a scientific philosophy.

The key to their advance is found in that "alliance […] entre la liberté imaginative et la légalité cognitive", which Jean Petitot considered aesthetic in Kant (Petitot, 2004, p. 118), and that, as will be deduced from our exposition, seems epistemological for Diderot, as he defends (1999, p. 39):

> The whole enterprise comes down to proceeding from the senses to reflection, and from reflection back to the senses: an endless process of withdrawing into oneself, and re-emerging.

Most commentators have also mentioned, that Diderot's epistemological paradigm is marked by the tension between this trial of a science that attempts to keep up with nature and the subjective conditions that make that intent possible. This tension, in fact, cannot but intensify with the progression of knowledge, given that the interpretation, becoming ever more necessary, requires an increased control of its connection to factuality. However, Diderot assumes an optimist position on this dynamism (1999, pp. 67–68):

> Are these conjectures borne out? The more experiments are performed, the more these conjectures are verified. Are the hypotheses valid? The wider the consequences range, the more truths they embrace, and the more compelling the evidence they provide.

This trust originates in another master key of its epistemology: in seeking to calibrate science according to the possibilities of man, the philosopher identifies judgement as the true manager of all the processes involved in knowledge. At all the stages, the research appeals to the ability of judging, be it to select the data for observation, be it to choose the aspects that deserve the attention of the researcher, be it to identify the relations between the phenomena, be it to ponder the value of conjectures, be it to choose the best among them, be it, yet, to prefer one theory over another and, even, to weigh the arguments for a metaphysical conception like materialism, be it to determine the degree of inventiveness and of phantasy necessary to feed the intelligence.

With his defence of the decisive role that the faculty of judgement must have in what he considers to be the new scientific paradigm, Diderot identifies probably the principle that allows the overcoming of one of the significant obstacles to science as an interpretation of nature, formed by the opposition between rationalism and empiricism. In fact, being fit to recognise that it is judgement that carries on the fundamental operations associated to the justification and validation of the results obtained, one must see in that understanding the expression of a perspective that is sufficiently innovative not to be, yet, banalised. Likewise, his perception of an episteme geared by discovery, that benefits from judicious cooperation between the conventional processes of scientific research and different *modi operandi*, usually attached to other spheres of cultural production, points to an epistemological alternative whose relevance has only recently begun to be evidenced. Could it have been his materialism that prevented him from continuing this intuition in a critical theory of the faculty of judging, and led him to prefer the development of a physiology of the faculties and of genius as found in *D'Alembert's Dream*?

ACKNOWLEDGEMENT

This chapter had the support of CHAM (NOVA FCSH—UAc), through the strategic project sponsored by FCT (UID/HIS/04666/2019).

BIBLIOGRAPHICAL REFERENCES

Aristotle. (1989). *Prior Analytics*. Indianapolis/Cambridge: Hackett.

Bacon, F. (2008). *The Major Works*. Oxford: Oxford University Press.

Bernardo, L. (2009). O Papel da Analogia na Carta sobre os Cegos de Denis Diderot. In Soares, l. *Expressões da Analogia*. (pp. 201–222). Lisboa: Colibri.

Bernardo, L. (2015). Denis Diderot – Carta a Paul Landois. *Cultura – Revista de História e Teoria das Ideias* 35, 171–193.

Bourdin, J. C., (1998). *Diderot. Le matérialisme*. Paris: PUF.

Diderot, D. (1999). Thoughts on the Interpretation of Nature and Other Philosophical Works. Manchester: Clinamen Press.

Diderot, D. (2010). Œuvres philosophiques. Paris: Gallimard.

Duflo, C., (2013). *Diderot philosophe*. Paris: Honoré Champion.

Gigandet, A., Morel, P. M. (dir.). (2007). *Lire Épicure et les épicuriens*. Paris: PUF.

Ibrahim, A. (2010). Diderot: un matérialisme éclectique. Paris: Vrin.

Locke, J. (1959). An Essay Concerning Human Understanding. New York: Dover.

Mandosio, J. M. (2013). *Le discours de la méthode de Denis Diderot*. Paris: Editions de l'éclat.

Peirce, C. (1978). *Collected Papers*, v. 5–6. Cambridge: The Belknap Press of Harvard University Press.

Pépin, F. (2012). La philosophie expérimentale de Diderot et la chimie. Paris: Classiques Garnier.

Petitot, J. (2004). *Morphologie et esthétique*. Paris: Maisoneuve et Larose.

The gaze of death or modern adventures of the imagination in three acts

Szymon Wróbel

Institute of Philosophy and Sociology of the Polish Academy of Sciences, Warsaw, Poland
Faculty of "Artes Librales" at the University of Warsaw, Poland
ORCID: 0000-0002-2764-5648

ABSTRACT: The main thesis of the text amounts to the suggestion that in modern philosophy the "power of the imagination" was a lens passing all significant considerations. The power of the imagination, since the times of I. Kant, through the times of H. Bergson and S. Freud, to the times of G. Deleuze has defined the very possibility of thinking. Modern history of the imagination has its dynamics, and it is a destructive dynamics. Imagination, which in the times of Kant took on the form of the demiurgic power of calling the world out of nothingness, in Bergson's times becomes, so to speak, a selector of images of being, whereas in psychoanalytic discourse it is degraded to the position of an ordinary phantasm (Lacan, 1992; Žižek, 1998). In the presented text, the author not only reconstructs three stages of thinking about the imagination – transcendental, immanent and psychoanalytic but considers the impossible look beyond the imagination. The author posits that this is the gaze of death. If this were the case, imagination should not be considered as being "creative" but instead "destructive", pronouncing its ability to "annul" being, that is, to break away from "what is" and follow the direction of "what does not exist". In the final fragments, the author reflects on the imagination in times of simulation, in times post-truth and post-reality.

Keywords: imagination, phantasm, lens, creation

1 FIRST INTUITIONS

Imagination is an exceptionally ambiguous cognitive power. It certainly amplifies the sensory powers of human cognition, and it also invigorates the purely notional functioning of the intellect. This power of imagination is different from that of the senses, in that it goes beyond the data delivered from the external world. But it is also different from the intellect, as it operates on sensory data, and is therefore not purely conceptual. This is equally the strength and the weakness of imagination. This strength is hidden in the ability to transgress what is given here and now. Its weakness results from being oversize and overproductive, as its labour is to create what is not there yet at present.

The positioning of imagination between the intellect and the senses begs the question of whether we should fear the power of imagination, or to the contrary, we should worship it and sing laudatory hymns. Does the imagination heighten our cognitive potencies, or does it deceitfully offer us an illusory way out beyond sensory data and intellectual findings? What is its place not only within our experience but above all in the world?

2 THE STAGE OF DEMIURGE: IMAGINATION AS A TRANSCENDENTAL SOURCE OF THE WORLD

Kant wrote about three sources which provide the initial conditions of human experience. The three sources of human knowledge are these: senses, imagination and apperception. In creating such a distinction, Kant was fully aware that imagination played the key role in human cognitive architecture. It unites the conceptual strengths of the intellect – the power of abstraction, generalisation and formulation of laws – with the strengths of the senses which deliver the empirical material for intellectual machinery. The intellect without sensory data would be empty, but senses without the abstraction of the intellect would be blind. Without the power of imagination, intellect and senses would be defunct. Imagination has the ability to sculpt platonic forms in our mental pictures.

Imagination in Kant holds a transcendental position. What does this mean? Kant asks about the conditions of the possibility of knowledge in general. Why does such a question about the conditions of knowledge surface at all? In Kant's *Critique of Pure Reason,* the "idea" of transcendentalism is contrasted

with two kinds of non-transcendental questions: an empirical and metaphysical question (Kant, 1977, p. 45). For Kant, "empirical" are not only direct representations in space (and time), but it is the very application of space to objects. An analogous difference in levels exists between the transcendental and metaphysical question. What is important In the transcendental question is not the very existence of space and time "as such", but rather their constitutive function, which constitutes time and space as necessary forms in the cognition of real objects. What does it mean? Well, it means that the questions Kant posits are "beyond time", "beyond space", or, in other words, "beyond life", whereby Kant employs the "gaze of death".

Martin Heidegger, interpreting this thread of Kant's thinking, will say: "The transcendental imagination is homeless" (Heidegger, 1929/1965, p. 142). He may say so, as he knows very well that in many places Kant limits human cognitive sources to just two: sensibility and intellect. It seems that Kant was hesitant about imagination and was uncertain whether to grant it some place in his architecture of human cognition!?

According to Heidegger interpretation of Kant human intuition, therefore, is not "sensible" because its affection takes place through "sense" organs (Heidegger, 1929/ 1965, p. 31). Rather, the converse is true: it is because our Dasein is finite – existing in the midst of the essent which already is and to which our Dasein is abandoned – that it must of necessity receive the essent, that is, offer it the possibility of giving notice of itself (Heidegger, 1996, p. 34). These organs are necessary in order that the notification be able to get through. The essence of sensibility lies in the finitude of intuition. The organs which serve affection are sense organs, therefore, because they belong to finite intuition, i.e., to sensibility. Thus, Kant was the first to arrive at an ontological, non-sensuous concept of sensibility. How can a finite being which as such is delivered up to the essent and dependent on its reception have knowledge of, i.e., intuit, the essent before it is given without being its creator? Otherwise expressed, how must this finite being be constituted concerning its own ontological structure if, without the aid of experience, it can bring forth the ontological structure of the essent, i.e., effect an ontological synthesis?

The elucidation of the intrinsic possibility of ontological knowledge in the transcendental deduction has yielded the following: pure concepts through the mediation of the pure synthesis of the transcendental imagination are essentially related to pure intuition (time), and this relation is reciprocal.

If ontological knowledge is schema-forming, then it creates [forms] spontaneously the pure aspect (image). Does it not follow, then, that ontological knowledge, which is achieved in the transcendental imagination, is creative? And if ontological knowledge forms transcendence which in its turn constitutes the essence of finitude, is not this finitude "overcome" by the creative

character in question? Does not the finite being [man] become infinite through this "creative behaviour?"

Whether what is formed by the transcendental imagination is pure appearance in the sense of being something "merely imaginary" is a question which must remain open. To begin with, we are accustomed to calling "merely imaginary" that which is not really on hand. But according to its nature, what is formed in the transcendental imagination is not something on hand, if it is true that the transcendental imagination can never be ontically creative. On the other hand, what is formed by the transcendental imagination can never be "merely imaginary" in the usual sense of that term. On the contrary, it is the horizon of objectivity formed by the transcendental imagination – the comprehension of Being – which makes possible all distinction between ontic truth and ontic appearance (the "merely imaginary"). The transcendental imagination does not "imagine" pure intuition but makes it possible for pure intuition to be what it "really" can be.

But just as the transcendental imagination cannot be considered to be purely "imaginary" [*Eingebildetes*] because as root it is "formative," so also can it not be considered to be a "fundamental power" in the soul. This regression to the essential origin of transcendence is not at all intended to be a monistic empirical explanation of the other faculties of the soul in terms of the imagination.

The sensibility of the transcendental imagination cannot be taken as a reason for classifying it as one of the lower faculties of the soul, especially since, as transcendental, it must be the condition of the possibility of all the faculties. Thus, the most serious, because the most "natural," objection to the thesis that pure thought originates in the transcendental imagination is without foundation. Reason can now no longer be taken as a "higher" faculty. But another difficulty immediately presents itself. That pure intuition arises from the transcendental imagination is conceivable.

Summing up this topic, one might say that in its heyday, modernity elevated the imagination to the rank of the transcendental source of all sense, and to the extent to which the world constitutes meaning, to the rank of the source of the world *tout court*. Such a promotion of imagination was already made by Kant, in *Critique of pure reason*, where he considered "schemata of imagination" to be the source of both the category of intellect and sensory data. So conceived imagination would play a fundamental role in capturing the world in a given way and allow us to extend the partiality of each cognition towards ideas that are never given but constitute the necessary horizon and regulator of all cognition. What is more, it is also the imagination, in the light of the *Critique of the Power of Judgment*, that emerges as a source for mediation combining the theoretical cognition and the practical – moral – actions of the subject. It is thanks to the imagination that the world of what is and the world of what should be, gain a common asymptote and converge within the idea of

the ultimate goal. This will be the path taken by the romantic continuators of Kant, in particular, Friedrich Schiller, for whom art – the product of imagination *par excellence* – will be a synthesis of being and duty.

Originally, the philosophy of imagination is the philosophy of freedom. It is the philosophy of the subject that establishes the world in accordance not only with its a priori categories but also and above all in accordance with its demands and hopes. Even if this subject is finite and conditioned, by definition, it has the ability to transcend this finiteness and conditioning. It is open to the perfect whole and can design the world *as if* nothing limited it. Imagination makes the modern subject the one and only demiurge.

Thus, the idea of transcendental imagination enables us to call for reflection on the very organisation of the theoretical space as a necessary place in which questions about the conditions of knowledge arise. Before Kant, philosophical questions concerning knowledge were placed only in the epistemic field of theory. Thus, Kant is the "first man" to occupy the position of a from "beyond-world" philosopher. Kant understood as an "empirical subject" must, therefore, die so that a place for transcendental imagination, i.e. a gaze of death, can be born.

3 THE STAGE OF DELIRIUM: IMAGINATION AS A SYMPTOM

Freud transfers the transcendental schematic of the imagination from consciousness to the unconscious and the realm of the oneiric. Now the work of the dream is to do what the transcendental imagination had been tasked with before: to merge the magma of empirical experience into one plan. The problem is that within the oneiric plain simple syntheses are no longer plausible. Freud's importance is largely due to his courage to consider a rended subject that is not open to a simple synthesis. Thus, Freud is asking about the subject, which does not get exhausted in its pretence to be a subject of knowledge. The author of *Die Traumdeutung* proposes a model not matching the classic concept of *disegno* with its mimetic clarity, nor the concept of an image-monogram included in the Kantian scheme of synthetic unity.

> What presents itself crudely at first, what presents itself and refuses the idea, is the rend. It is an outside-subject image, an image that is all dream-image. It will impose itself here only by dint of the omission (*Auslassung*) or retrenchment of which it is, strictly speaking, the vestige: the sole survival, simultaneously a sovereign remainder and the trace of an erasure. (Didi-Huberman, 2009, p.146).

Freud introduces a new paradigm of imagery in the transition from distortion to a rend which, in a dream-work, is driven by force positioned somewhere between desire and coercion, a force imposing the process of figuring.

> To figure despite everything, thus to force, thus to rend. And in this constraining movement, in all of this verb's many senses [...] *Tropos* and figura have always yielded, we know, the notion of turn and detour" (Didi-Huberman, 2009, pp. 153–154)

To open is thus to generate new visual constellations. Freud's figuration is not about congealing or creating figures, but about transforming, about the work of distorting the visible. The figure bears the power of constant alienation, over-determination and overinterpretation.

What seems to me key in *The Interpretation of Dreams* is the recognition of the main interest or the leading wish of a dream, which is simply the will to continue dreaming. Freud writes quite openly:

> In a certain sense, all dreams are convenience-dreams; they serve the purpose of continuing to sleep instead of waking. The dream is the guardian of sleep, not its disturber" (Freud, 1957, p. 201)

The wish to continue sleep is for Freud the very motive shaping the dream, i.e. a fulfilling sleep fulfils this wish. The paradox is that Freud, who claims that the main motive of sleep is the continuation of sleep never wonders about the reason for the awakening. Awakening considered a natural fact is a misrepresentation. If the dream is the guardian of sleep and extends sleep to infinity, how is it possible to awaken at all? Freud limits his interests in this regard to the paradoxes of memory, disregarding at the same time the paradoxes of awakening. Freud limits himself to the hypothesis of distraction:

> That a dream fades away in the morning is proverbial [...] On the other hand, it often happens that dreams manifest an extraordinary power of maintaining themselves in the memory. (Freud, 1957, p. 52)

For Freud, the problem is not awakening, but forgetting and remembering alike.

It seems that regarding the dream as the "guardian of sleep" entails that in Freud's dreams must become facades, structures that only support sleep. In *The Interpretation of Dreams* Freud introduces four leading terms in the conception of different forms of psychic representation: *die Vorstellung* (presentation), *die Entstellung* (distortion), *die Verstellung* (transposition), *die Darstellung* (intrapsychic representation). Freud, at first glance, writes something incomprehensible: distortion [*die Entstellung*] appears to be a tool, means, or an instrument of transposition [*die Verstellung*]. Transposition, however, aims only at the continuation of dreaming. While presentation and representation boast a long philosophical tradition, "distortion" and "transposition" are Freud's original idea.

The author of *The Psychopathology of Everyday Life* writes about thinking and, as a result, dreaming as eternal "spinning". The endeavour of thinking is mainly that of falsification of data. Freud also writes about "fabricating nonsense", about pretending madness; he writes openly that madness of a dream is the appearance of madness.

It is for this reason that a recurring theme in *The Interpretation of Dreams* is that of Prince Hamlet. When hysteria enters the realm of dreams, there enters the stage full of performances, the theatre of pretences, and thus arises the need for dramatising performances and theatricalization of the idea.

> However, the possibility seems to have dawned upon others that the madness of the dream is perhaps not without its method- that it is perhaps only a disguise, a dramatic pretence, like that of Hamlet, to whose madness this perspicacious judgment refers. (Freud, 1957, p.65)

This rational judgement is, of course, the pronouncement made by Polonius regarding Hamlet: *Though this be madness, yet there's method in't* (Shakespeare 1609/2005). Yet another – perhaps even more prominent – *dramatis personae* in this regard is that of *Zerrbild* – literally, a distorting mirror or caricature. Caricature is a picture in a state of tension, an image reaching its borders. Caricature of sleep is a sleep in which the dreamer has no reasons to awake.

Freud, quoting Friedrich Schleiermacher, recalls the "stage of appearances" accompanying the process of falling asleep. (Freud, 1957, p. 76). Here, involuntary images are no less obsessive than involuntary thoughts. Thought in the image and through the image is becoming obsessive. Finally, when discussing the fantasy of a dream and a dreamer who lacks the language of concepts, Freud admits that he practices this kind of fantasy, daydreaming. Freud, in his opinion, belongs to the population of the awakened. Freud deals with the only intriguing perversion: he only works. Freud, however, works fantasising.

> Finally, let us frankly admit that it seems as though we cannot very well avoid the phantastical in our attempts to explain dreams. We must remember also that there is such a thing as a phantasy of ganglion cells. (Freud, 1957: 88)

Psychoanalysis is, therefore, a fantasy of ganglion cells armed with the language of concepts. The courage of psychoanalysis is precisely the courage to become this fantasy. However, this is not the courage of people who are awake, but of those who are working "on dreams" and "in dreams".

Dreaming fulfils the wish to sleep, but the fulfilment comes indirectly, through distortion.

> If we call this peculiarity of dreams – namely, that they need elucidation – the phenomenon of distortion in dreams, a second question then arises: What is

the origin of this distortion in dreams?" (Freud, 1957, p. 131)

Notably, Freud is far from addressing the origin of the need to continue dreaming, neither he asks where the motives of awakening come from. The question of distortion receives Freud's swift answer:

> The stricter the domination of the censorship, the more thorough becomes the disguise, and, often enough, the more ingenious the means employed to put the reader on the track of the actual meaning" (Freud, 1957, p. 136).

However, it would be a mistake to deduce from this assertion that without censorship there is no disruption, no masquerading, no distortion. Censorship is ubiquitous, and it is for this reason that to every wish there is its counter-wish [*die Gegenwunschträume*]. It is rather astonishing that in Freud there is no account of "counter-wish" to the wish to continue to sleep; that we do not encounter the "wish to awake". Anxiety-dreams, even those whose dream-content is fire, are not considered by Freud as realisations of such counter-wish.

It belongs to the silent premises of psychoanalysis that the contrast of sleep and wakefulness is never complete. There is a rather infinite variety of states of consciousness, fluid consciousness, divided differently between vigil and sleep. Dreaming is articulated as if it was a pictographic script, and the form of this script makes a rebus and constitutes a collective picture. Despite the hypothesis of the collective picture, Freud never talks about the fact that humanity sleeps together as a collective. The collective picture hypothesis has nothing to do with a collective nor with collective unconsciousness. A collective image is, for example, the image of Irma in Freud's famous dream. It is a picture with conflicting features, but not contradictory dynamics. "Irma" is a representative, and perhaps even a manifestation, of other people in Freud's immediate environment, people – as Freud himself puts it – "discarded in the work of condensation" (Freud, 1900/1957, p.255). "Irma" – a dream-image – is above all Freud's patient, but also, as a result of diffusion of sedimentation, Freud's oldest daughter and – due to ambivalent affects – his wife. "Irma" is lava accumulating rock deposits injected into sleep during the day. "Irma" – as a collective picture – is the force that organises the direction of movement of sleep, but also the process of cooling the sleeping mass. "Irma" is never just Irma. "Irma" is a masquerade of Irma, Irma to the nth power, the facade of Irma, her own name, under which a collection of decomposed bodies and characters is attached.

A collective dream scene skips Freud's attention. Feud never reverses the formula of Heraclitus; he never mentions that during the day everyone has their own separate quarters (chambers), and at night they sleep together in one world, in one room. Instead, Freud

isolates himself from humanity in his own office; he fails to accept the collective dream of humanity. Freud talks about the unique nature of each dream of every banal man. A dream is the reevaluation of all psychic values: the weak becomes strong, the big becomes small, the empty is filled, the well-defined is fuzzy. However, the "unconscious" never becomes "fully conscious". "The dream-speech – adds Freud – thus has the structure of *breccia*, in which the larger pieces of various material are held together by a solidified cohesive medium" (Freud, 1957, p. 358). In a dream, speech becomes a sculpture. Consciousness is not a solid matter; it is matter volatile or liquid. Dreams as a solid matter – for Freud – are like stalagmites, whereas thoughts are like clouds or smoke from the chimney. Stability of the forms of the unconsciousness versus the instability of consciousness – such is the main landscape of Freud's excavation site. During the day, consciousness never becomes fully conscious. This is why Freud never betrays the main wish of the sleep. The awakening is dead. Awake is the overworked Freud.

In Freud, therefore, the imaginary gaze of death is no longer a transcendental gaze from beyond life, but a gaze of Orpheus, who is not allowed to look back at the Eurydice-the world, until he comes out into the sun during the day – beyond dream, beyond spectre – as a phenomenon. During sleep, imagination prolongs it in the subject of its desire; in the daytime, in a state of vigil, it searches in vain for the "objects" of its nocturnal adoration – it sees only dead fossils of the night.

4 THE STAGE OF ASCETICISM: THE METAPHYSICAL POWER OF IMAGES

In *Matter and Memory*, Henri Bergson conflates images with things and thoughts with movement (Bergson, 1990). For Bergson, however, matter is the aggregate of "images" (Bergson, 2012, p. 3), and image itself is a being which in itself is more than an idea (idealism) but less than a thing (realism). In effect, the image is something halfway between a "thing" and an "idea". Bergson further adds that thinking about images in space, or the interval between things and ideas is a matter of common sense. Finally, it is from Bergson that we learn that such an approach to the problem, i.e., placing things in images, allows us to avoid the pitfalls of phenomenology, i.e. thinking about the world and existence in terms of appearance and reality. Images exist before the division between appearance and reality.

Gilles Deleuze, when commenting on Bergson's work in view of film theory remarks in passing that light which diffuses and which is propagated 'without resistance and without loss' is "the set of movements, actions" and asserts that "the identity of the image and movement – stems from the identity of matter and

light. The image is movement, just as matter is light" (Deleuze, 1986, p. 60). Deleuze soon completes this statement on the identity of the image and movement (matter and light) with a theorem on the immanent source of light.

> Things are luminous by themselves without anything illuminating them: all consciousness *is* something, it is indistinguishable from the thing, that is from the image of light. (Deleuze, 1986, p. 60)

For Deleuze reading Bergson, it is not consciousness which is light, it is the set of images, or the light, which is consciousness, immanent to matter.

It is intriguing that Bergson, in his considerations on the dream, takes over themes to be later key to Freud. Bergson, however, takes completely different paths than psychoanalysis. Bergson begins with the hypothesis that in dreaming the conscious values of the world are re-evaluated, i.e. he makes a statement to the effect that in the dream the "least significant" impressions become "important" and that the "insignificant" perceptions "from the day" deepen and gain prominence. However, this "re-evaluation" is not, for Bergson, a simple "reshuffle" or "reversal", nor it is a swindle of "cunning foxes". What, then, is re-evaluation?

The key to understanding dream-work is the speed of moving dream matter. Bergson is fascinated by the lability and ephemerality of the "direction of dream" (Bergson, 1990). Dream direction by far not dream-work. Bergson does not work, Bergson resonates. Dream accelerates or slows down. Dream is not a cinema – it is light. The duration of dream is the time of sleep, and time becomes a function of the speed of movement of the dream matter. Three key issues are the problem of the least meaning, the mysterious speed of dreams and their impermanence. For Bergson, it is not true that the dream is illogical or pointless. On the contrary – the author of *Mater and Memory* claims that the dream is obsessively logical, and this obsession with logic, i.e. the need to react "logically" to any inconsistencies and delamination, is the main form of a dream. The form of dream is not a theatre of performances and misrepresentations, but a logical structure – a kind of rapid conceptual notation: *Begriffsschrift*. Logic is not suppressed during sleep; the dream produces rather something that is lost by the dreamer, i.e. it produces not so much para-logic as it does ultra-logic. Dreaming does not "turn" and "twist" anything, does not lie and does not distort for censorship reasons. It infers with the speed of light. This is a problem for every mind, including cybernetic. For Bergson, "exaggerated logic" of the dream results from successive attempts to keep up with changing and unstable dream material. It is as if the "cybernetic logic-machine" wanted to infer the laws of nature from the composition and movement of clouds.

Two axioms seem to guide the metaphysics of Bergson's images. According to the first, signalled above, there is no moment of ending the reasoning and logic in

a dream. The second axiom states that only seemingly the actions of the senses in the dream are extinguished. The senses in a dream continue to work, and the sensitivity of the senses is never wholly abolished. When we begin to talk about the perception of matter and memory or body and brain in connection with the world, as of devices connected with each other and being in close relation with each other, we often succumb to the illusion of fluidity. This fluidity is deceptive because it produces a "mixture". In this mixture, perception is not "pure perception" because it is contaminated by memory; memory is not "mere memory" because imaginations produce it. The brain does not reveal what it *actually* is because it seems to us that it is the place where the performances are kept, although it is not. The brain is just a relay. The brain is a crossover. The brain does not accumulate anything; it is not a wardrobe. What Bergson therefore wants is to avoid the great theatre of performances, in which everyone pretends to be something other than what they are.

In unmasking this theatre, three phenomena come to the aid, namely: telepathy, dream and misdiagnosis. According to Bergson, "theatrical philosophy" is the result of the confusion of duration with extension, consequences with simultaneity, quality with quantity; as a result, the "pure idea" we may be grasped only by removing this "confusion". Intensity, duration, and memory are three concepts that must be purified, liberated them from the obtrusiveness of the idea of space.

Let us concentrate on dreaming. One of Bergson's key terms is "phosphene" – the after-image left by bright light, a deformed specular shock changing colour, then vanishing – here standing for the true matter of the dream. Perhaps it is Little Sandman, *Sandmännchen*, who has a monopoly on this powdered material. This matter works during a dream akin to Rorschach boards. Dream data is ink stains or blots. These data encounter fossils that form the orbits of memory. Pale corpses of memory and memories, chorally fall on the light spots, phosphenes, treating them like doors, windows, or openings, allowing to squeeze through such "open stains" into the world. Memory is a distracted and undead vital force looking for ways out of the tomb, out of the crypt. The crypt is only seemingly a lifeless place.

The beauty of Bergson's project lies in the fact that his cerebral images are the images that arise through the disturbance of the relations of vision. When vision is stopped or unfinished, the brain is unmounted, and it drifts away from what is "real". However, such a departure or unmooring is never absolute. Dream represents the widest range in the flow of images, the widest panoramic circulation, the extreme layer of all possible circles. Thanks to the dream images we reach the frontier, i.e. the panoramic image. When recognition is unsuccessful, i.e. it does not find its extension, we are dealing with an "insatiable phenomenon", an "empty phenomenon". Bergson claims that when recognition

is unsuccessful, it comes into contact with the virtual elements responsible for *deja vu*. The function of *deja vu*, and similarly – the function of deep sleep, is to reach pure memory, to the memory not only *de facto* but *de jure*. Dreamers reach the "past in general", the past *de jure*, and the dream itself arises when space withdraws from the field of consciousness, and we stop living the obsessiveness of space at all. Time and space are not for us inside or outside of us, but the very distinction between interior and exterior is the work of contraction and relaxation of matter-consciousness.

When perceptual images pass easily, and without resistance to motor imagery, there is a situation of automatic recognition. Images always seek their extension, and the natural extension for each sensory image is the motor image, which is always on the service of our body. In this situation, we see only what our body wants, and the body is the image selector for oriented actions. On the other hand, body movements are extensions of images that affect the body but also flow through the body, "withholding" only some of these images. Thus, the body may well serve as an image catcher; a device for withholding images, but not for capturing them. The present moment is divided – memory is falling apart already at birth.

The imaginary gaze of death in Bergson is not the transcendental eye of the imagination (Kant), nor it is the forbidden gaze of Orpheus (Freud), it is rather the gaze of the spiritual automaton. After the age of clock, machine movement and optical machines, there comes the age of cybernetics. Electronic automatism of digital images emerges as a screen with no cause, Spinosian *causa sui*, a new incarnation of the gaze of death.

5 THE GAZE OF DEATH

The world in which we live today is not only post-transcendental or post-psychanalytical but rather post-real and post-truth. What it means is that in practice we have lost the need for even hollow transcendence. However, we have not become neo-positivists. We rather affirm what appears on computer screens and disbelieve any reasonable alternative. Unless in the afterlife, since after the fall of "secular religions" we happily rehabilitate the traditional. However, our imagining the underworld goes rather poorly. New conservatism does not make us religious visionaries. Sooner, it makes us reactionary dogmatics.

The world appears to us as peculiarly resistant, but at the same time as completely fluid. Perhaps the former appearance prevails. "Everything that is solid evaporates" (Marx Engels, 1848/1908, p. 28) but it leaves a hard residue. Despite the changing techniques, fashions, avalanches of the market offer, global economic and political instability, the "risk society" and the feeling that nothing is certain, the basic rules of the game seem unchangeable and inviolable. More, faster,

more effective. But also: more diversely, more flexible and – necessarily – innovatively. This is what is called cognitive capitalism.

In this situation, the imagination is far from being dead. Nor is dead its concept. One could even go as far as saying that it is truly only now that imagination has made its way to our home theatres and onto computer screens. It is now apparent that even the unemployed should keep being "creative." Imagination is expected from entrepreneurs and managers, advertising designers, stock market analysts, scientists, chefs, architects, from service providers and recipients, producers and consumers, not to mention inventors and artists. Since the concept of "utility value", which Marxism fed on, has long lost its meaning, the value of anything – be it market value or existential value – is now decided by the imagination. Imagination is therefore triggered on an unprecedented mass scale. Imagined good and pleasures, imagined prestige, imagined identity all become the driving force of capitalism. Ultimately, everything in this turbocapitalism and telecapitalism becomes imagined, starting with the money itself, which in physical form is less and less present.

If such a diagnosis were true, it would imply that the imagination, at least mass imagination, has today become, above all, the grease for capitalist logic. Instead of establishing projects that exceed the *status quo*, all energy is used to sustain and strengthen these projects. If imagination has won the victory, transforming the world into "simulacres", then – at least from the perspective of "modern design" – it is a Pyrrhic victory. It has turned out to be powerless against logic, over which there is no power.

And yet, in recent years, not only the sense of helplessness towards "being" seems to be more and more striking, but also the need to overcome it. The postulates of restarting the imagination and going beyond the "system" seem, however, destructive and aim at encouraging the destruction of the system (Fischer, 2009; Land, 2014). Empty – and at the same time all too well defined by the hard rules of the game – the horizon of the future is increasingly disturbing. The new era seems to be preparing a turn in the venture of the manifestation of the imagination and encourages the imagination to look into destruction and to deploy the gaze of death.

BIBLIOGRAPHICAL REFERENCES

Bergson, Henri. (1990). *Matter and Memory*. Trans. N.M. Paul and W.S. Palmer. Zone Books.

_____. (1992). *The Creative Mind*, Trans., M. L. Andison, New York: The Citadel Press.

_____. (1920). *Mind-Energy*, Trans., H. Wildon Carr, London: McMillan and Company.

Deleuze, Gilles. (1986). *Cinema 1: The Movement-Image*, Trans. Hugh Tomlinson, Barbara Habberjam, University of Minnesota Press

Didi-Huberman Georges (*2009) Confronting Images*: Questioning the Ends of a Certain History of Art, Trans. John *Goodman,* Philadelphia, PA.

Freud, Sigmund (1957). The Interpretation of Dreams, [in:] The Standard Edition of the Complete Psychological Works of Sigmund Freud, Volume IV, ed. J. Strachey, London: Hogarth Press.

_____. (1968). The Future of an Illusion, Trans. J. Strachey, [in:] The Standard Edition of the Complete Psychological Works of Sigmund Freud, Volume XXI, ed. and trans. J. Strachey, London: Hogarth.

Fisher Mark (2009). *Capitalist Realism: Is there no alternative?* Winchester: Zero Books.

Heidegger, Martin (1929/1965). *Kant and The Problem of Metaphysics*, Trans. James S. Churchill, Bloomington: Indiana University Press.

_____. (1996). *Being and Time*, Trans. J. Stambaugh, Albany: State University of New York Press.

Kant, Immanuel (1977). *Kritik der Reinen Vernunft*, [in:] Immanuel Kant, *Werke in Zwölf Bänden*. Band 3, Frankfurt am Main: Suhrkamp Verlag.Lacan, Jacques (1992). *The Seminar of Jacques Lacan, Book VII: The Ethics of Psychoanalysis*, 1959–60, trans. D. Porter, ed. J.-A. Miller, New York: Norton.

Marx Karl, Engels Friedrich (1848/1908), *Manifesto of the Communist Party*, trans. Samuel Moore New York: New York Labor News Co.

Land Nick (2014). Phyl-Undhu: Abstract Horror, Exterminator, Time Spiral Press.

Shakespeare William (2006). *Hamlet,* Oxford: Blackwell *Publishing.*

Žižek, Slavoj (1998). *The Plague of Fantasies,* London: Verso.

375

The railways of the Begum's Fortune by Jules Verne and André Laurie

Fernanda de Lima Lourencetti
HERITAS, Estudos de património, FCT, CIDEHUS, University of Évora, Évora, Portugal
(CIDEHUS – UID/HIS/00057/2019)
ORCID: 0000-0001-5649-8774

ABSTRACT: Jules Verne, who is second in UNESCO's list of most translated authors, was one of the pioneers in the production of modern science fiction. Many of his books occupied a special place somewhere between the fantastic and the visionary. André Laurie, one of the pseudonyms of Jean François Paschal Grousset, also a science fiction writer, collaborated with Verne in the publication of *The Begum's Fortune* (1879). This book is a recurring reference in urbanism studies and is cited by several authors. Between the creativity and scientific reasoning used in this book, in this article we will analyse how the urban planning of the cities of *France-Ville* and *Stahlstadt* illustrated, in a futuristic vision, the implantation of railways with antagonistic functions, an aspect that is currently widely discussed in the field of the construction, preservation and rehabilitation of railways.

Keywords: Jules Verne, André Laurie, railway, Begum.

Jules Verne a été l'apôtre de la science utile et constructive, contre celle qui tue ou menace l'homme. [...] (car Jules Verne n'a rien inventé, il projette dans le futur ce qui lui semble être le progrès de l'homme). (Bombard, 1978, p. 31)

Railway systems comprise an infrastructure of collective interest which, in some cases, may become agents of urban imbalance due to their deployment in favour of economic and private interests. In the book *The Begum's Fortune*, Jules Verne and André Laurie illustrate the barrier and connection functions that the railway system can provide in a city[1].

A frequent reference in the field of urban development, this novel still raises problems connected to the implementation of the railway system that has been and is still being discussed.

Like the name of this article, the reference *The Begum's Fortune* was created based on the name of the book under study. Having been the result of an idea that came about following the reception of 500 million francs by the heirs of an immigrant from the city of Begum, it is assumed that Begum made it possible to build the railways described in the work.

In order to deal with the railways of *The Begum's Fortune* we will present a brief summary of the book, to help situate readers and kindle their curiosity about this work, and to explore the roles played by railways, considering them alongside the first strategies that were created for the implementation of railway infrastructure in modern urban planning.

1 SUMMARY

The plot of *The Begum's Fortune* is based on French-German antagonism between idealism and realism, in the fields of industrialisation and urban development. The author is thought to have been influenced by the book by Benjamin Ward Richardson, *Hygeia – a city of health*[2] (1876).

The main characters are the French Doctor Sarrasin, the German Doctor Herr Schultze and the Alsatian Marcel Bruckmann. Both doctors are the heirs of a Hindu princess, who leaves them the sum of 500 million Francs. Having each received half, they use their fortunes in similar ways, in building cities in North America.

Dr Schultz, a former chemistry professor at the University of Yena, builds *Stahlstadt*, also known as Steel City. This is an entirely industrial city, built for the extraction and processing of iron ore into steel and then into military weapons such as war cannons.

Dr Sarrasin, a doctor, builds *France-Ville*, intended to be a model city built based on hygienist principles.

1. Other books by Jules Verne can be considered as being of great importance in the study of railways: these are *Paris in the Twentieth Century* (written in 1863 and published in 1994) and *Around the World in Eighty Days* (1873).

2. This book is about the planning of a model city based on the hygienist principles that were in circulation at the time, like one of the cities in the work in question.

The rivalry between these two characters takes shape from the beginning of the novel when Dr Sarrasin is recognised as the sole heir to the Begum's fortune. From then on, Dr Schultz, described as a xenophobe, acquires an even more malignant feeling of hatred towards this Frenchman in particular, which will drive him throughout the entire novel.

Even though the fortune has been divided equally, the German does not seem to be satisfied. Thus, in order to help Dr Sarrasin, his best friend's father, the orphan Marcel infiltrates the City of Steel to try to unravel the type of threat that the German chemist represents to the model city.

In this context, which takes place against the backdrops of the industrial city and the hygienist city, this article will explore the implementation and use of the railway.

2 THE RAILWAYS

From the 1800s onwards, the metropolises acquired an essential role in the economic sector, as they began to concentrate the centres of exchange and wealth, conditioned by the mode of industrial production. Consequently, in the second half of the 19th century, hygiene and problems of movement became issues that were widely addressed in the development of urban planning.

3 STAHLSTADT

Described as a 'false Switzerland,'

> Ce n'est q'un décor alpestre, une croûte de rocs, de terre et de pins séculaires, posée sur un bloc de fer et de houille. […] Mais il saisit au loin les coups sourds du marteau-pilon, et, sous ses pieds, les détonations étouffées de la poudre. Il semble que le sol soit machiné comme les dessous d'un théâtre […]. L'air est chargé de fumée et pèse comme un manteau sombre sur la terre. (Verne, Laurie, 2005, p. 80)

Stahlstadt, the Steel City, built as a mining operation, has an urban centre surrounded by 18 *faubourgs*[3]. The central zone is a privileged area where only the high-ranking workers were allowed. A password controlled entry and, from the moment the workers rose in position and were moved to this area, they no longer had the right to leave.

In this context, the railway is implemented as an infrastructure that surrounds the city centre (*chemin de fer de ceinture*) extending the walls that already separated the urban core from its *faubourgs*, both territorially and socially.

3. A term dating from the 12th century (Faure, 2003, p. 48), which refers to settlements that developed at the gates of cities, outside of their fortifications.

A sa droite, se creusait un fossé, sur la crête du quel se promenait des sentinelles. À sa gauche, entre la large route circulaire et la masse de bâtiments se dessinait d'abord la double ligne d'un chemin de fer de ceinture, puis une seconde muraille s'élevait, pareille à la muraille extérieure, ce qui indiquait la configuration de la Cité de l'Acier. (Verne, Laurie, 2005, p. 87)

The only connection with the city centre was underground. This is an important detail because the central zone contains a large tropical garden, an artificial forest. Here the train, which travels around the city in the open air on the outside, runs underground. The railway landscape is not mixed with the landscape of the upper echelons, but instead forms a part of the daily life of the workforce. Even the visits by important characters seemed to be reserved for superiors, and are planned in the dead of night.

> Un chemin de fer souterrain mettait ce sanctuaire en communication avec la ligne de ceinture [...] Des trains de nuits y amenaient des visiteurs inconnus […] Il s'y tenait parfois de conseils suprêmes où des personnages mystérieux venaient s'asseoir et participer aux délibérations…(Verne, Laurie, 2005, p. 126)

The different production sectors are also equipped with railway lines. The raw material transformation sector has locomotives loaded with iron or to wait in the furnace at one end, and at the other end locomotives with empty wagons waiting to receive the steel.

In the foundry sector, the layout of the railway lines is the same, with one to carry the steel and the other to take the final product out of the moulds. However, due to the more elongated shape of the production system in this sector, throughout this sector there are rails used by cranes that are used for unloading, moving, and loading the products to be transported by the train.

In chapter 12, when Marcel manages to escape after being imprisoned in the centre of the City of Steel, we have the impression that this is an entirely isolated city, as the fugitive finds himself in a desert, without any means of transportation, and is forced to walk all the way to *France-Ville.*

4 FRANCE-VILLE

> Ils s'entassent dans des villes, dans des demeures souvent privées d'air et de lumière, ces deux agents indispensables de la vie. Ces agglomérations humaines deviennent parfois de véritables foyers d'infection. Ceux qui n'y trouvent pas la mort sont au moins atteints dans leur santé ; leur force productive diminue, et la société perd ainsi de grandes sommes de travail qui pourraient être appliquées aux plus précieux usages. (Verne, Laurie, 2005, p. 49)

This was part of the speech given by Dr Sarrasin during the International Hygiene Congress in Brighton, England, when he proposed the construction of a model city. It should be noted that, despite offering

a more humane view, the argument used seeks to link the importance of this project to industries, which need a large and productive workforce.

With a similar premise to *Hygeia, France-Ville*, a port city described as a *ville de la santé et du bien-être*, was created with a square layout, with gardens and avenues.

To attract manpower, the creators of the model city placed an advertisement in a wagon on the high-speed train that left San Francisco every morning to cross the entire North American continent.

This transcontinental route was a key element in the construction of *France-Ville*. The first company to open in the city was set up with the intention of building a railway line that connected the city with the main route of the *Pacific Railroad*[4], via the city of Sacramento. It was opened in April 1872, after the first train had left New York and arrived at the station of *France-Ville*.

This connection was so important that from the day of its inauguration, the entire Council responsible for building the city left Europe to live in the new city. Another factor that reinforces the relevance of this line is that when the war between the city and *Stahlstadt* was declared, there were rumours that military units were intercepting this route.

Bearing this fact in mind, it is not surprising that the City of Steel did not have any external connections. Together with the fortification that surrounds the industrial city, this leads us to reaffirm that the production of armaments leads to a great sense of unipotency, whereby any kind of external connection is considered a risk to the integrity of the city and its production.

The proposal for the implantation of a railway system in *France-Ville*

De demi-kilomètre en demi-kilomètre, la rue, plus large d'un tiers, prend le nom de boulevard au avenue, et présent sur un de ses côtes une tranchée à découvert pour les tramways et chemins de fer métropolitains. (Verne, Laurie, 2005, p. 194)

Is very similar to the one proposed for *Hygeia*

The acreage of our model city allows room for three wide main streets or boulevards, which run from east to west, and which are the main thoroughfares. Beneath each of these is a railway along which the heavy traffic of the city is carried on. The streets from north to south which cross the main thoroughfares at right angles, and the minor streets which run parallel, are all wide, and, owing to the lowness of the houses; are thoroughly ventilated, and in the day are filled with sunlight [...]. The streets of the city are paved throughout with the same material. As yet wood pavement set in asphalt has been found the best. It

is noiseless, cleanly, and durable. Tramways are not allowed anywhere, the system of underground railways being found amply sufficient for all purposes. The side pavements, which are everywhere ten feet wide, are of white or light grey stone...(Richardson, 1875, p. 20).

Both projects were aimed at preserving air quality and avoiding noise pollution, as imposed by the hygienist theories of the time. The only divergence was the existence of tramways in *France-Ville*, while *Hygeia*, having a controlled population scale, did not see the need for this kind of transport system.

5 TECHNOLOGICAL DEVELOPMENT

During its embryonic period, the discipline "History of the Technique" made part of the "History of Science", only around 1970 it actually entered in the history of economy and the social history. The institutional recognition of this new field of study was in 1987 (Benoit, 2010, pp. 4/7). Among the pioneering initiatives are the economic researches of François Caron, who became one of the main experts in French railway history.

The railway entered the discussion between technological development and landscape (which includes the urban landscape), at the end of the 19th century. Marie-Noëlle Polino (2011, p. 29) quotes, as one of the pioneers works in this field, the article "Le paysage ferroviaire en Seine-Saint-Denis, un enjeu patrimonial et urbain" of Evelyne Lorh (2005), which presents the role of the railway infrastructure in the urban grid, using Seine-Saint-Denis as a case of study.

Il comprend l'étude du rôle de l'infrastructure ferroviaire en tant que verrou et/ou catalyseur urbain pour comprendre les formes de l'urbanisation et les logiques d'implantation ; le recensement des interfaces avec le territoire traversé, notamment les embranchements particuliers, gares, ponts et ouvrages de franchissements, servitudes ; l'étude des lignes d'importance locale (comme la ligne des Coquetiers) et des projets avortés. Il s'agit d'appréhender un patrimoine linéaire, avec une succession de fonctions et l'articulation de sous-ensembles techniques, et un patrimoine de réseau, identifié par la répétition des gares, des décors, des objets techniques, mais aussi un patrimoine d'entreprise avec logements patronaux, centres de sport et de loisirs, jardins cheminots, cantines, dispensaires répartis sur le territoire. (Lohr, 2015)

The development of technology has greatly influenced the production of architecture and urbanism. Here there is no need to enter into a detailed analysis of the urban arguments related to this period, but in order to fully understand "*the railways of the Begum*", it is important to know some of the most critical debates that arose from these projects, as it will be presented in the next sub-chapter.

4. This transcontinental line actually became a reality 1869, as a result of the merger of the *Union Pacific Railroad* and *Central Pacific Railroad*, through the *Pacific Railway Act* (1862). Available at: www.senate.gov.

6 LATER URBAN THEORIES

We can, therefore, see that the book *The Begum's Fortune* addresses spatial, environmental and social problems, which were much discussed in the twentieth century and which have prevailed until the present day when we refer to the railway.

Noise, soot and iron are part of the industrial landscape, and also part of the railway landscape. The City of Steel was designed on the basis of a productive process; the writers, exaggeratedly, portray the separation of social classes by materialising it through the urban typology, framing within this context a railway that galvanises production and represents a barrier between the two.

Having caused controversy in the field of urbanism since its inception, the industrial city gave rise to various arguments. Some scholars, such as the Italian architect Aldo Rossi (2001, p. 229), argue that this debate is nothing more than the result of a romanticised vision of traditional cities, since London and Paris, the two large cities that predated industrialisation, had already been suffering the evils of bourgeois society.

In this line of reasoning, the industry is presented only as a protagonist used by modern urbanists in the design of new urban and architectural morphologies. However, there are those who present industries as an urban abject, as well as the Washington Charter (1987) developed by ICOMOS (International Council of Monuments and Sites), which states that traditional cities must be protected from the threats of degradation arising from industrialisation.

Françoise Choay (2003, p. 3), a French historian, shares Rossi's idea, affirming that it is the demographic growth of cities that ends up cooperating with unprecedented urban production, but does not exclude the idea that the insertion of the industry has accelerated this process, being a catalyst for this phenomenon.

Verne and Laurie brought to their novel the philosophies of serial production and sectorization. These philosophies were appropriated by the architects/urban planners in the 20th century, in order to overcome the shortage of housing and achieve more functional urban planning.

This functionalism gave rise to the appearance of a market-oriented architecture, turning cities into centres of profiteering. A problem that after nearly half a century is contradicted by the Germans themselves, who in the work call the French "dreamers", for the creation of an integrated model city. One can read in "Speech of the German group Neues Bauen" that: The architects of Neues Bauen are wary of the word economic because they know that it is precisely this word that justifies all this misery (of the *Mietskasernen*). Because it was economical, masses of people were exiled from the countryside to the cities, where they languished. Because it was economical, land prices became exorbitant in big cities. Because it was economic, the height of the cubicles to rent built on this land did not stop growing. Because it was economic, the sun and light were expelled from these deserts of stones. We, the architects of Neues Bauen, fought tirelessly against this supposed economy. We declared war on the defenders of this uneconomical economy. We calculate differently, putting man's well-being above all numbers (apud. Kopp, 1990, pp. 51-52).

The concern with the negative social impacts of the industrial city was so worrying that Hannes Meyer, director of the Bauhaus (1928-1930), included the social sciences as part of the courses of the university of architecture, in an attempt to create a policy that would bring the professional together with the union organisations, thereby complementing the knowledge of architects/urban planners in the field of the humanities.

Even so, despite divergent views, there seems to be a theoretical consensus regarding industrialisation, architecture and urbanism, which is the fact that there has been an ideological decline (Tafuri, 2007, p. 167), which is considered as a result of capitalist production.

The city is now planned as a functional machine (Tafuri, 2007, p. 76) without social values. Zoning, which emerged in the twentieth century but which was already addressed in the novel in question, is a policy that leads to a densification that is harmful to circulation and creates visible and invisible social barriers.

With a futuristic vision, the railway is treated as one of these barriers when its implantation in the City of Steel is described, but as an integrating element when implanted in the way that was proposed for *France-Ville*.

Manfredo Tafuri (2007, pp. 148-149), an Italian historian specialising in studies of architecture, characterises the social attempts of modern urbanisation as "utopian" since in capitalism nothing is achieved without the existence of monetary value. This ideology seems obvious in the City of Steel, through the zoning that was created, while in *France-Ville*, it is the first address given by Dr Sarrasin, through the argument of being in the process of creating a city that preserves the integrity of workers with a view to their production, where this idea appears in a more obvious way.

7 CONCLUSION

The urban plans that were elaborated during the early days of modern urbanism were the result of the emergence of a new society, which, based on science, innovation and technology, was obliged to focus on the development of its cities. The railway became a part of this transformation of society through its functionality, speed, and reach. Many of the concepts that took shape at this time influenced contemporary cities, so it is essential to understand what influenced the design of these plans.

The Begum's Fortune deals with the spatial, environmental, and social problems associated with the railway, drawing attention to the possibility of it becoming an agent of urban imbalance.

In a period in which concerns were focused on the contrasts between industrial production and the creation of a healthy urban environment, Verne and Laurie, from the creation of two imaginary cities, managed to illustrate, through the "*railways of the Begum*", the social, urban and environmental impact that the implementation of an infrastructure of this kind is capable of causing to the urban environment.

BIBLIOGRAPHICAL REFERENCES

Benoit, Serge (2010). Un aperçu de la place de l'histoire des techniques dans l'enseignement supérieur Français. In *International Workshop – Techniques, Patrimoine, Territoires de L'Industrie : Quel Enseignement ?*, Edições Colibri / Universidade de Évora / Universidade de Paris 1, Pantheon – Sorbonne / Universidade de Pádua, p. 3–12.

Bombard, Alain (1978). Jules Verne le visionnaire. In *Le Courrier de l'UNESCO: une fenêtre ouvert sur le monde*, XXXI, 3, p. 10-36, illus. port.

Choay, Françoise (2003). *O urbanismo*. Editora Perspectiva S.A., São Paulo.

Faure, Alain (2003). Un faubourg, des banlieues, ou la déclinaison du rejet. In *Genèses*, 2, n.º51, p. 48–69.

Kopp, Anatole (1990). *Quando o modern não era um estilo e sim uma causa*. Editora Nobel-Edusp.

Lohr, Évelyne, Jigaudon, Gérard (2009). L'inventaire du patrimoine ferroviaire à l'échelle du département de la Seine-Saint-Denis : l'exemple de la Grande Ceinture, In *Revue d'histoire des chemins de fer*, 40, p. 35–52.

Polino, Marie-Noëlle (2011). Pour une approche globale du patrimoine d'un mode de transport: le cas des chemin de fer en France et en Europe. In *International Workshop – Les patrimoines de la mobilité: état des lieux et perspectives de recherche*, Edições Colibri / Universidade de Évora / Universidade de Paris 1, Pantheon – Sorbonne / Universidade de Pádua, p. 27–45.

Richardson, Benjamin Ward (1876). *Hygeia – A city of Health*. London: Macmillan and Co.

Rossi, Aldo (2001), *A arquitetura da cidade*. Edições Cosmos.

Tafuri, Manfredo (2007). *Progetto e utopia – Architettura e sviluppo capitalistico*. Editora Gius. Laterza & Figli.

Verne, Jules, Laurie, André (2005). *Les 500 millons de la Bégum*, EONS productions, Château Vallée, Caëstre.

On Hesse's *Der Steppenwolf*: How creatively actual a modern literary artwork can lively be?

Fernando Ribeiro

CHAM, Department of Modern Languages, Culture and Literature, FCSH, Universidade NOVA de Lisboa, Lisbon, Portugal
ORCID 0000-0001-8345-5606

ABSTRACT: Having in mind Hermann Hesse's *Der Steppenwolf* and most specifically "*Harry Hallers Aufze-ichnungen*" and "*Tractat vom Steppenwolf*" as true examples of the creative relationship between inner actual life and literature, this papers reflects on the influence of the unconscious upon the conscious in what it refers to the creation of symbols whose totality summons the multiple meanings an archetype can dispose of to concentrate on how the psychic phantasy energy is capable of giving birth to a literary artwork whose modernity lies on the interaction between individual symptoms and universal symbols lying in everyone's psyche.

Keywords: Unconscious-conscious, symptom-symbol, psychic energy, archetype, modern literary artwork-depth psychology

I

Along the preface to "*Harry Hallers Aufzeichnungen*", Hesse prepares the addressee of the by then unexpect-edly not yet applauded (Unseld, 1973, p. 112) novel *Der Steppenwolf* (1927) to accept the autobiograph-ical records of a midlife, unsocial writer self-named *Steppenwolf* (Hesse, VII, 1982, pp. 183, 198, 201). His artwork core values underline a close relation-ship between art and real life because any addressee can share the hero's response to life demands and challenges (Gajek, 1977, pp. 186–7, 192).

Let us not forget the severe economic depres-sion Germany lived during the Weimar Republic: hyperinflation, unemployment, currency depreciation, industrial production under Ford-Taylor method (Vogt, 1997, pp. 362-4) to understand the hero's behaviour amidst the civilisation contextualization better too. On account of this historical situation, one can from the start be alert thus to a kind of general neurosis lived by many after the Great War while attending directly to Haller's report of his depression (Hesse, 1982, VII, p. 202). His crossing hell's fire, plunging into chaos, deeply suffering from all evil life contains (Hesse, 1982, VII, pp. 203-4). Hesse's narrative skills offer his primal message: symbolic meaning just behind a thinly woven prosaic detail net (Leary, 1977, pp. 33-4) while asking and answering to how does such a cri-sis and spiritual healing come about (Hesse, 1982, XI, p. 53). As a matter of fact Haller's records prove how an artwork is the result of the phantasy driven creativity typical of an "idealist" artist who incorporates every longing, intuition, dream to metamorphose himself such as the one Hesse defines in "*Phantasien*" (1918) (Hesse, 1982, X, pp. 63–4, 66). A fantasy-imagination outcome (*pathologische Phantasie*) wherein chaos and cosmos act mutually inside the hero was written to reach every reader's soul: not as a typical single ill-minded patient's outcome but as a whole generation's. A kind of facts "translation" (Hesse, 1982, VII, pp. 203-4) its author presents while giving form to what concerns the individual transpersonal reality so that the singular addressee can wonder about that general neurosis common to many survivors of the Great War and therewith attend to humanity's universal constants (Kirchhoff, 1977, pp. 17–8, 27–28). Therefore such a narrative cannot immediately be identified with the need to express the hero's inner voice – modern artist's or patient's unconscious – because it expresses a tran-sitivity by which every modern artwork promotes an in-depth dialogue with its recipient beyond its appar-ently empirical features record (Ribeiro, 2003, p. 81). As a matter of fact, this single soul's biography gets its universal extent whenever its single hero features reveal their archetypal nature (Kirchhoff, 1977, p. 18). Every literary artwork always keeps a peculiar rela-tionship to reality; moreover, the interaction between these two entities is always as much rich as the rela-tionship between literature and truth since it owes everything to improbability. That is why an autobi-ographical report such as Haller's must be understood as an actual piece of literary narrative whose sincerity

is but the result of an irony fiction-exercise in order to get the addressee's attention, counting then on his generosity to understand the artwork beyond its immediate significance.

> Le rapport entre littérature et verité est toujours aussi *improbable* que le rapport de littérature à réalité. Il faut que cette *improbabilité* soit écrite. (Oster, 1997, pp. 10–11)

II

The addressee assimilates Haller's half-wolf half human self-definition relevance by learning about the psychic conflict which tears the hero apart. Attending to the psychotic symptoms explanation (Jung, 1979, p. 151-7) he witnesses the hero's how-of-the- how solution to put an end to his devastating inner struggle between his feeling-emotion-animal and his reason-understanding-human divided soul. "H. Haller's records" clarify his neurotic attitude; but shall this artwork create a fictitious reality which goes beyond personal feelings too, or does its creativity lie in the strangeness, in the originality of the chosen images whose abstract sense (Jung, 1979, pp. 81, 89) turns as broad and complex as nature itself is? Hesse himself, in *"Künstler und Psychoanalyse"* (1918) states how a great poet listens carefully to every fantasy and fictitious "hints" he can recover from his remote unconscious collective layers so that his attitude towards truth, self and social commitment gets more and more engaged (Hesse, 1982, X, p. 49, 51, 53). Does, in fact, such a never-ending process of associations – illustrated along every literary artwork discourse – make such images autonomous enough from the conscious and allow us to define them as symbols or are they but symptoms (Jung, 1979, p. 81-3)? Wouldn't it be better to understand this literary artwork as a result of a *in status nascendi* psychic process such as an "autonomous complex" (Jung, 1979, p. 90) and a sort of training exercise carried out to transform everyday language into a piece of art as Hesse asks in *"Sprache"*? (Hesse, 1982, XI, pp. 183, 197).

III

Hesse's main goal is not but to "open the world of the soul to his epoch" – as he declares in *"Bekenntnis des Dichters"* (1929) (Hesse, 1982, XI, p. 244). He knows how to foster magic using the literature essentials – as he asseverates in *"Magie des Buches"* (1930) – since writing and reading have been, "as secret arts", disposing ever since of magic, ancient, infinite codes to offer mankind's face its oneness (Hesse, 1982, X, p. 245). In fact, "Hesse's narrative and descriptive techniques implement this view of 'magic' in peculiarly modern terms" as R. Freedman asserts in "The novel as a disguised lyric" (Freedman, 2003, p. 30). *"H. Hallers Aufzeichnungen"* confirms it if one reads its

"Tractat vom Steppenwolf" as a fragment-document along which Haller is being taught about his crisis:

1 schizophrenic personal situation (Hesse, 1982, VII, p. 242);
2 paradigmatic condition (Hesse, 1982, VII, p. 236);
3 adequate remote solution (Hesse, 1982, VII, p. 238).

The Treatise proves not only how H. Haller's Records is an "oeuvre de tout le temps" but also how literature is not but a way to show true aspects beyond the subjectivity made reality by working out every aspect language can offer either the writer's or the addressees' imagination. Literature is the possibility of filling that void every writer founds during his "voyages" (Oster, 1997, p. 46, 47, 59). Writing his biography, *mutatis mutandis* his autobiography, every writer brings forth the **singularity** any individual is capable of by translating into artwork discourse what he is conscious of having left behind his ordinary, usual, time and place patterns. Some pertinent Treatise parts show how individual psyche, as Haller's is too, give enough evidence proving how much creative and indispensable its energy is: under such a psychotic environment an individual generates thoughts, sensations, feelings, and intuitions with all the benefits for his future development (Jung, 1981, p. 500). Such a "document" belonging to the material assets occasionally found by the hero functions like a narrative double meta-discourse:

1. to be used by the hero himself
2. as a means of lighting up the narrative discourse
3. concerning Haller's individuation process interpretation.

Some of its relevant parts display the value of those symbols drawn from the deepest layer of the human soul and prove how creative they are to reform every individual's life while valuing fantasy's role within the conception of modern literary artwork.

The Treatise becomes, thus, an example of *mise en abyme* proving by then how "H. Haller's Records" is a well-structured piece of autobiographical literary discourse whose deepest singularity is dependent on such a key to be creatively understood. Harry Haller, the protagonist, gets finally his literary, fiction, profile surpassing a mere memory report of an individual past life phase (Oster, 1997, pp. 132–5):

> All of Hesse's techniques […] suggest a concept of the imagination which combines the nineteenth-century reconciliation of opposites with a twentieth-century meaning of psychological conflict. (Freedman, 2003, p. 35).

IV

Imagination gets its leadership, making one's mental activity powerful enough to turn every artist into the

architect of a new reality to be built using his libido – his "psychic energy", according to Jung's definition (Jung, 1981, p. 490). As a victim of major depression (Hesse, 1982, p. 211) Haller illustrates perfectly how the artist's soul reacts in such a situation just as Jung clarified:

1. every psychic element also arises from the individual unconscious since memories search to be understood and explained with the help of rational discourse (Jung, 1981, pp. 493-4);
2. every creative artist translates such psychic elements derived from his most in-depth life experience into a peculiar form whenever he feels how every underlying meaning always asks for the right interpretation (Jung, 1981, p. 496).

The Treatise describes Haller's psychic situation (Hesse, 1982, VII, pp. 226-7) which is common to every artist's solitude, sufferings and need for autonomy (Hesse, 1982, VII, pp. 226-7, 237), but it also comments the situation accurately under an allegory which is a form of systematization of the hero's neurosis symptoms and solution too (Hesse, 1982, VII, p. 234).

Feeling half beast (wolf), Harry takes into account the right "ideal internalised as a feeling surrounding a repressed desire" shared by every Harry's contemporary typical hyper-civilised European[1]. The narrator expresses his non-acceptance of the destructive path his contemporary European civilisation has chosen to follow.

At a first impression we might support this thesis: "H. Haller's records" is an autobiographical narrative. Its preface defines it as the result of the author's crisis; nevertheless, the addressee must not be confined to Haller's personal experience which is above all meant to be a paradigm of his epoch social contradictions.

Moreover the preface author introduces the record's autobiographical hero as an "idealist" artist depicting reality beyond usual time and space borders while also revealing "unintentionally" the lying paradox amidst his soul and the need to interpret and overcome it most conveniently while exemplifying Jung's theorization on modern abstract art according to the example of Picasso (Jung, 1979, pp. 153–4). Besides that, the Treatise author even considers Harry himself a fiction: "simplifying mythology" (Hesse, 1982, VII, p. 240).

On the one hand, the reader deals with the specific Haller's case on the other with his paradigmatic social and psychic value. The latter is of utmost importance: the treatise's unidentified author underlines the psychic value of his soul multiple pair of opposites (Hesse, 1982, VII, p. 241), the need to plunge into chaos and to assimilate and to practice humour as well (Hesse, 1982, VII, p. 238).

Such psychic elements taken out of the personal experience become material to be invested with peculiar energy so that they reach the addressee's conscience with clarity. In fact, every chosen life-fact carrying an emotional meaning is driven out of the chaotic and incomprehensible situation in which they move by the modern artist so that by his artwork a meaningful revelation might be transformed into a collective symbol – revelation or a concretisation of his fantasy (Jung, 1981, p. 55).

Instead of a simple vision worked out by *anamnesis* – recalling a well-known situation common to both creator's and addressee's understanding (Jung, 1979, pp. 104-5) – one is offered a primal vision where peculiar animate or inanimate elements gain their new original and symbolic features as soon as the hero recovers his mythological features as Jung asserts along "*Psychologie und Dichtung*" [Psychology and Literature] (Jung, 1979, pp. 108–110).

The Treatise presents then a creative solution since if Steppenwolf's character is not but a "fiction", a "lie" (Hesse, 1982, VII, p. 240) – anything wouldn't be better than fight it back with another "fiction"; and so every soul's life is then compared to a stage drama wherein each soul feature corresponds to its character, in opposition to the unity of body which must be disguised to play the convenient character (Hesse, 1982, VII, pp. 242–3).

Is it not an outcome of the *active imagination* to compare every individual's soul to an onion or a piece of cloth, whose different layers or threads correspond to the thinnest film where one's deepest emotions are engraved? Instead of a surface-aesthetics (*Oberflächenästhetik*) (Hesse, 1982, VII, p. 243) one is asked to attend to a deep-surface-aesthetics by means of which the way to totality is offered by:

1 man's psyche seen as a stage theatre where mother-nature versus spirituality "characters" goes on playing-fostering psychic energy all the time (Hesse, 1982, VII, p. 243);
2 the immortality path one chooses while accepting suffering, self-transformation under the guidance of *Buddha* or any other totality symbol and example of humble boldness (Hesse, 1982, VII, p. 246).

Stage theatre, onion or Buddha are actual examples of symbols in opposition to wolf-human allegory: they help configure a correct and prospective vision of the soul as a response of one's active imagination to overcome the desperate psychotic phase he experiences. Using artwork every fictionalised element causes the literary narrative to be understood as part of a broader – therefore a fragment – and hidden narrative flowing in the collective unconscious within which:

1- the hero becomes a mythological hero, and certain symbols reveal their archetypal meaning,

2- the artwork shows itself as an all times narrative and primal vision paradigm (Jung, 1979, p. 113).

1. Following J. Berger's assumption "Why look at animals" (2001, p. 268).

The dynamics of this creative process exemplifies the unconscious leadership (Jung, 1979, p. 86) during the creation process of every modern literary discourse wherein symbols constantly play a decisive and vivid role. As part of the collective culture, they develop such a complex nature provided with a hidden and remote meaning that all the psychic functions are called to dispose of an adjusted interpretation proving that every symbol is not but an accumulation of several meaning layers juxtaposed through humanity eras and cultures (Jung, 1981, pp. 518–20).

By the Treatise end, Haller ought to imagine another symbol: a garden whose vegetable species are important enough to make these essential either to the garden or to the gardener. The latter will become riper after learning the value of every species; the former more balanced since nature itself will attain that equilibrium by means of which only totality can be the best result of unity within diversity. New psychic energy will make eternity thereafter be as constant as serenity will be the signal for every human being living under a live humour (Hesse, 1982, VII, pp. 249-50, 238-9). Symbolic meaning cannot, therefore, be immediately understood because the energy born out of the unconscious (Jung, 1980, p. 78-79) gathers so many associated meanings that the intellect becomes unable to apprehend all of them at a time – since only the unconscious disposes of that innate capacity to give chance to a synthesis independent enough of the individual experience to create symbols whose roots emerge out of the collective unconscious proving the vast creativity our phantasy can afford – according to Jung's "Analytische Psychologie und dichterisches Kunstwerk" [Analytical Psychology and Literary Artwork] (Jung, 1979, p. 93).

V

This process arises whenever a modern artist like Haller sees himself no longer as the hero of his record's artwork but above all the paradigm of humanity – therefore not a projection of its creator anymore. The latter feels all the more the need to supply that element which becomes a symbol with abstract meaning what reveals that meaning and energy are accompanied by an essential latent emotion whose density helps turn the symbol into an archetype. As long as Haller feels that conscious life arrives closer to a dead end and becomes inoperative and indifferent to his opposites struggle, he notices that psychic energy is not allowed to express itself. Every sort of response offered by his unconscious is then restrained, or unaccepted, inducing then a ferocious activity of the unconscious which becomes as much active as the need to propose a solution to solve that restraint is urgent: out of this energy surplus there appears an outbreak of engendered forms whose value as synthesis-symbol is decisive for the individual's further life- as a matter of fact such a symbol is of capital importance for the further life of the individual cause it contains a creative solution send by the unconscious to overcome the psychic crisis he is in (Ribeiro, 2007, pp. 183–4). Such symbols like the ones already pointed out show how welcome is to reunite contradictory features provoking an interaction between the conscious and the unconscious and making it essential to overcome such psychic stage charged with paradox meaning (Jung, 1981, p. 520–1, 512–3). If Haller wouldn't be living a psychic disturbance, and his unconscious wouldn't be responding as a compensation (Jung, 1981, p. 486) and "self-regulating" process, there wouldn't arise any solution to make him reconquer his psychic balance as it happens with the **garden symbol** whose message includes the ability to regain one's place back into the community and one's individuality too. Artwork such as the "H. Haller's Records" will be staging the performance of a dynamic process typical of the collective psychic instability/inadaptability in any individual's soul (Jung, 1979, pp. 95-6), showing how paradigmatically real and useful such a fiction might become. Its author needs not to identify himself with the work he wrote nor with the fragment – Treatise – he included in his "Records" anymore (Jung, 1979, p. 83). He shows instead how vital his artwork is to promote aesthetic fruition of the entire narrative: he stimulates a latent criticism without proposing any direct meaning. It becomes clear how Steppenwolf's nature parabolic meaning is surpassed by Buddha's mythological features every time the narrator makes such an analogy. The garden symbol reinforces the latter's compensatory character – this time an image borrowed from the collective unconscious on account of either the individual's or the collective's soul profit emotionally triggered. Neither Haller's records nor the Treatise result indeed from Haller's neurosis (Jung, 1979, p. 77, 82) although they might as fiction narrative present imaginary characters as the *Steppenwolf* or scenes or images created by phantasy: they do not even prove how an artwork can be a response to a psychic crisis (Jung, 1979, p. 82). A psychic activity may certainly feed modern artworks; this, in turn, will allow us to analyse it under the depth psychological patterns (Jung, 1979, p. 76), because by means of its symbols emotions are so determinant that their meaning might be better understood with the help of a language wherein creativity proposed by the unconscious narrative will indeed bear unprecedented originality.

VI

The powerful garden metaphor is then an appeal to fantasy; only everyone's creativity can draw the right archetypal image nature can offer during such cases of psychic distress. Such a **totality symbol** (Jung, 1981, pp. 512-3) reveal how intelligible psychic reality can be in order to promote the addresses' completeness

(Ribeiro, 2011, p. 141) because the archetype's content only reveals how the unconscious dynamics should be preserved in order to keep the **Self** active and alive and pushing life creatively forward. By comparing the garden and its fountain to the *temenos* with its fountain of life whose water – energy – "emerges" out of the "instinct world" (Jung, 1975, p. 143, 148), Jung praises such inner contributions without which no realisation of the **Self** can exist (Jung, 1975, pp. 143–5, 148). The garden, initially taken as a space, symbolises the way to acquire that wisdom every individual needs to overcome disquiet and anxiety and obtain psychic balance and peacefulness (Kirchhof, 1977, pp. 17-8) i.e. immortality, because instead of any static space it is meant a dynamic time – long path towards human **individuation** – superior personality (*höher Mensch*) (Hesse, 1982, VII, p. 248).

VII

Gardens have from ancient times been a sign of man's mastery over nature (Zuylen, 1994, p. 47). This is perhaps because the garden had become the metaphor for "God Almighty['s]" first creation, as Francis Bacon (1561-1626) wrote in 1597, in his essays entitled "Of Gardens" (XLVI). Also because gardens have always been a paradigm of civilisation's progress as being at the same time a sign of grandeur and elegance, *Ver perpetuum* [perpetual spring] and of "greater perfection" too (Bacon, 1908, pp. 211, 224–5). A century later, H. Walpole (1717–1797) also referred the art of gardening as one which was to achieve the same effects nature has in all its seasonal splendour over the attentive promenader (Walpole, 2000, p. 69) The effect of harmony liberated from the predominance of magnificence, dignity and the exact and limiting proportion of the value of each part thus enabling him to contemplate and feel the simplicity imagined by the artist (Walpole, 2000, pp. 59, 62–3, 69, 71). It was important to attain the balance between internal and external organisation in order to feel, according to the acclaimed Russell Page, a psychic pleasure: "faire d'un jardin une oasis dans lequel un simple moment revêt une autre dimension" (Page, 1994, p. 63) and, stimulating his creativity by producing a work of art (Page, 1994, pp. 62, 95) that enhanced the limited space of the garden, making it seem infinite through the exuberant dissimulation of its respective limits (Page, 1994, pp. 60, 79, 77, 72, 74, 84, 89, 95–7).

Gardens are to be perceived as living experiences wherein life itself is wisdom practice and symbols of the paradise centre a sign of the tamed nature and cosmos miniature – one's understanding of nature's rhythm and a symbol of a superior personal metamorphosis too (Chevalier, 1969, pp. 531-33). Modern garden metaphor highlights that primal axiom: simplicity within complexity as long as opposites' union shows how artwork phantasy is decisive to stimulate

human psychic wholeness as a result from the interaction between the transcendent (transzendent) and the living (lebendige) function enabling every reader to deal with the contradictions by which modern life harasses him constantly (Jung, 1971, pp. 521–2).

VIII

Hesse re-enacts then a myth common to tradition so that, in his age of incipient globalisation, literature while playing the resilient part could point out the need to change one's way of feeling and acting. He represents such paradox features provoking the addressee to emulate a hero: a modern myth holder of other moral values. In 1926 he defended, in *"Moderne Versuche zu neuen Sinngebungen"*, a "new awakening of metaphysical desideratum, spirituality's formation, life's interpretation" (Hesse, 1986, p. 366). The addressee would project himself into the hero's behaviour to feel how aesthetics unites itself with ethics getting closer to the main target: literature as the representation of soul's life creatively recall of the values present in phantasy-magic features everyone is provided with (Schärf, 2004, pp. 90–91). Instead of "manoeuvring" language and making the narrative unintelligible as modern narrative also claims, Hesse makes use of phantasy-magic features to reinforce its scope (Schärf, 2004, pp. 93–4). By applying modern depth psychology principles to his artwork, Hesse reacts against his epoch technological optimism, bringing forth values that emerge from the unconscious sphere straightening thus the ties between hero-addressee-narrator (Huber, 2004, p. 197). He reinvents a literary platform by which good and evil interact symbolically and offers an adjustable solution (Huber, 2004, pp. 198-9) to his time uniting thus tradition to modernity (Huber, 2004, p. 197). Being a true neo-romantic, Hesse uses a simple language and the traditional *bildungsroman* structure narrative representing his hero in constant opposition to his society (Huber, 2004, p. 177, 181), succeeding in attaining his psychic goals: the realisation of the **Self**. Hesse puts then forth another principle of his artwork modernity: modern man's identity results not only from a personal self-achievement but also from his ability to dominate and to understand the symbolic discourse by which the "nerve mystic" also speaks out loud (Bahr, 2004, p. 156). Acting so Hesse moves away from naturalist, art for art's sake and from any other avant-guard literary movements (Huber, 2004, p. 178, 181). Nevertheless Hesse's spirit of **modernity** remains in this novel: he rejects routine, renews old standards of creation while "hunting the secrets of human nature" and enacts self-scrutiny (Gay, 2009, p. 2–5), recreating emotions and worlds experienced by the narrator's and his characters' psychic dynamics whose relevance he attaches to the subjectivity which modern artwork discourse cannot do without (Vietta, 2007, pp. 22–3, 27–30).

ACKNOWLEDGEMENT

This chapter had the support of CHAM (NOVA FCSH/UAc), through the strategic project sponsored by FCT (UID/HIS/04666/2019).

BIBLIOGRAPHICAL REFERENCES

AAVV. (2001). *A Arte da Cultura – Homenagem a Yvette Centeno*. Lisboa: Colibri.

_____. (2004). *Hermann Hesse und die literarische Moderne*. F/M: Suhrkamp.

_____. (1997). *Deutsche Geschichte – Von den Anfängen bis zur Gegenwart*. Stuttgart-Weimar: Metzler.

_____. (1977). *Über Hermann Hesse*. II Band. F/M: Suhrkamp.

Bacon, Francis. (1908). *The Essays of Francis Bacon*. New York: Charles Scribner's Sons.

Bahr, H. (2004). *Kritische Schriften*.II Band. Weimar: VDG.

Beck, U. et al. (2007). *Reflexive Modernization- politics, tradition and aesthetics in the modern social order*. Cambridge: Polity Press.

Berger, J. (2001). *Selected Essays* (Geoff Dyer ed.). London: Bloomsbury Publishing.

Chevalier, J. et al. (1969). *Dictionnaire des Symboles*. Paris: Robert Laffont.

Cook, B. (1979). Was ist so interessant an Hermann Hesse. In AAVV, *Über Hermann Hesse*, II Band. (pp. 73-9). F/M: Suhrkamp.

Erné, N. (1977). Variationen über ein gestrichenes Wort. In AAVV, *Über Hermann Hesse*, II Band (pp. 256–270). F/M: Suhrkamp.

Freedman, R. (2003). The Novel as a disguised lyric. In Bloom's *Modern Critical View: Hermann Hesse*. (pp. 25–37).Philadelphia: Chelsea House.

Gagek, B. (1977). Der Poet als Politiker. In AAVV. *Über Hermann Hesse*. II Band (pp. 180–194). F/M: Suhrkamp.

Gay, P. (2009). *Modernism*. London: Vintage Books.

Hafner, Gotthilf. (1970). *Hermann Hesse – Werk und Leben*. Nürnberg: Verlag Hans Carl.

Hesse, H. (1986). Materialien zu Hermann Hesses "Siddhartha". I Band. F/M:Suhrkamp.

_____. (1982). *Gesammelte Werke*. F/M: Suhrkamp.

Huber, P. (2004). Alte Mythen – neuer Sinn. Zur Codierung von Moderne und Modernisierung im Werk Hermann Hesses. In AA VV. (2004). *Hermann Hesse und die literarische Moderne* (pp. 75–201). F/M: Suhrkamp.

Jung, C. G. (1975). *Psychologie und Alchimie* – Traumsymbole des Individuationsprozesses Die Erlösungsvorstellungen in der Alchimie u.a. Olten und Freiburg im Breisgau: Walter Verlag.

_____. (1981). *Psychologische Typen*. Olten und Freiburg im Breisgau: Walter Verlag.

_____. (1980). Zugang zum Unbewussten. Olten: Walter Verlag (pp. 20–103). In Jung, C.G. et al.. *Der Mensch und seine Symbole*. Olten: Walter Verlag.

_____. (1979) *Über das Phänomen des Geistes in Kunst und Wissenschaft*. Olten und Freiburg im Breisgau: Walter Verlag.

Kandinsky, W., Marc, F. (1979). *Der Blaue Reiter*. München: Piper.

Karalaschwili, R. (1983). *Hermann Hesse – Charakter und Weltbild*. F/M: Suhrkamp.

Kirchhof, G. (1977). Kurzgefasster Versuch über Leben und Werk Hermann Hesses. In AAVV, *Über Hermann Hesse*, II Band (pp. 7–30).F/M: Suhrkamp.

Leary, Th. (1977). Dichter der Reise nach innen. In AAVV, *Über Hermann Hesse*, II Band (pp. 33–50). F/M: Suhrkamp.

Oster, D. (1997). *L'Individu Littéraire*. Paris: PUF.

Page, Russell (1994). *L'Éducation d'un Jardinier*. Paris: La Maison Rustique.

Read, H. (1972). *The Meaning of Art*. London: Faber and Faber.

Ribeiro, F. (2011). Das Irreflexões, in AAVV. *A Arte da Cultura – Homenagem a Yvette Centeno* (pp. 131–148). Lisboa: Colibri.

_____. (2007). Jung -Da Alma e seu Mundo: Biografia Breve; Principais Conceitos Operativos; Notas breves sobre Psicólogos, Filósofos entre Outros.In Ribeiro, F., Brumlik, M. *Jung a Consciência do nosso Eu*. (pp. 153–207). Lisboa: Planeta.

_____. (2003). Introdução. In Hesse, H. *O Mágico*, (Tradução, prefácio, introdução, notas bio-bibliográficas Fernando Ribeiro) (pp. 15–88). Lisboa: Planeta Editora.

Schärf, Ch. (2004). Hermann Hesse und die literarische Moderne. In AA VV. *Hermann Hesse und die literarische Moderne* (pp. 87–100). F/M: Suhrkamp.

Unseld, S. (1973). *Hermann Hesse – eine Werkgeschichte*. F/M: Suhrkamp.

Vietta, S. (2007). *Der europäische Roman der Moderne*. München: Wilhelm Fink.

Walpole, H. (2000). *Essai sur l'art des jardins modernes*. Paris: Gérard Monfort Éditeur.

Zuylen, G. v. (1994). *Tous les jardins du monde*. Paris: Gallimard.

Creativity in H.G. Wells: Imagining the role of miracles in a secular society

Leonor Sampaio da Silva
CHAM, FCSH, Universidade dos Açores, S. Miguel, The Azores, Portugal
ORCID: 0000-0002-4241-272X

ABSTRACT: This paper is about the role that creativity plays in life, namely through literary texts in which fantasy is paramount. Textual analysis will focus on a short story by H.G. Wells, a well-known writer of fantasy novels and romances. His books often revolve around the figure of the scientist and the limits of scientific knowledge, to stress the importance of preventing science from replacing religion and, consequently, to avoid the betrayal of the natural order. In this context, the short story "The Man Who Could Work Miracles", first published in 1898, brings this concern into a new light, since it erases the figure of the scientist in order to test the consequences of the belief in supernatural powers by any person prone to rational argument.

Starting with the concept of miracle, the paper will move the role of literary creativity in making sense of life even via narratives in which fantasy prevails to the extent of contradicting natural order and empirical knowledge. As H.G. Wells imagines the role of miracles in a secular society, he reflects on the effects of unlimited power and anticipates Yuval Harari's conviction that fantasy is essential for personal and collective survival.

Keywords: creativity, fantasy, miracle, literature, power.

1 INTRODUCTION: THE KEYWORDS

In sketching out a brief philosophical discussion of miracles, it is impossible to neglect David Hume's part in clarifying this concept. In his *Enquiries Concerning Human Understanding*, he clearly states that miracles are "a violation of natural law" (Hume, 1975, p. 114), and offers an additional element to this simple definition: "a transgression of a law of nature by a particular volition of the Deity, or by the interposition of some invisible agent" (Hume, 1975, p. 115n). This second, and more complete, statement highlights the fact that a miracle must express divine agency. Another aspect worth noticing concerns the importance of witnesses to give miracles credibility, as belief in miraculous occurrences is based on testimony, in the absence of which the situation may fall into the categories of misapprehension of reality or even insanity.

In a similar manner, John Hick repeatedly invokes the matter of divine agency as a key element in understanding miracles. In his words, "a startling happening, even if it should involve a suspension of natural law" cannot be considered miraculous "if it fails to make us intensely aware of God's presence" (Hick, 1973, p. 51). According to another author, being an "extraordinary event", a miracle contradicts natural order, and therefore "can never be naturally explained" (Swiezynski, 2012, p. 104).

Miracles, therefore, belong to the realm of religion and the will of God, and can hardly find a place in the natural world. In turn, creativity is a human trait, intensely embedded in human nature. However, it partially partakes of the "extraordinariness" that is ascribed to miracles, as it consists of bringing together disparate and contradictory things: it mixes old and new thoughts, combines memories and desires, attracts past and future images, in order to "foresee a possible future" (Damásio, 2018, p. 141). According to António Damásio, a considerable part of our lives is spent not in the past nor the present, but in an anticipated future; and this is not exclusive of dreamers or visionaries, but a basic element of life. Human creativity is inherent to "the strange order" of things in which life unfolds, keeping humans with an eye to the future (Damásio, 2018, p. 50). The "extraordinary" power of creativity is, thus, paradoxically, an ordinary part of life, even if it tends to go unnoticed most of the time. But the most striking aspect of Damásio's view of creativity concerns the strangeness it brings to life: it is effusively disordered, which explains why it easily creates not order, but disturbance and chaos (Damásio, 2018, pp. 40-41). This explains why cultural evolution not only proved unable to eradicate violence as, in some cases, intensified violent upheavals (Damásio, 2018, p. 240).

Most violence is perpetrated to achieve, affirm or increasing power. Following Bertrand Russell's view, power is the ability to provoke intentional effects in other persons and/or in the world at large (Russell, 1990, p. 29). Survival should be the key concern of humankind; however, at the core of human societies,

the will of power greatly surpasses the survival principle. In a similar manner, Foucault argues that power is not scarce but abundant in modern societies since it can be observed in a wide range of representations and discourses, all tending to influence the way we think and conduct our lives (Foucault, 1984, pp. 265-267). Language, and the scientific or specialist's discourse, in particular, is a powerful weapon when games of power are in play. Social institutions validate the power of knowledge, which accounts for the importance ascribed to the verbal acts of specialists.

If scientists stand at the forefront of the most powerful speakers, there was a time when writers and poets took centre stage. Romanticism played an important role in extending the view that art possessed "superior cognitive powers" associated with "a specific mental faculty, imagination, and a special kind of individual, the artist" (Mulhern, 2000, p. 80). It suffices to remember how Wordsworth describes the Romantic poet in his Preface to *Lyrical Ballads*: as one possessing extraordinary vision of in-depth layers of reality, just like sometime later Shelly would do when recording Tasso's statement that only tow creators existed: "God and the Poet" (apud Williams, 2001, p. 22). Art was then understood as "the exercise of the creative imagination by the few whom it fully endowed" (Mulhern, 2000, p. 80), and, henceforth, it was set against an order of things where ordinary people moved guided by an ordinary perception of the world. By "ordinary" we mean those activities and persons who are alien to creative interpretation or effort. Art, as opposed to reality, was the extraordinary view capable of recreating the real in terms, which assured the correction of natural imperfection, through beauty, along with an in-depth understanding of life.

This view of art came soon to an end as the 20th century advanced. Raymond Williams, one of the founders of Cultural Studies in England, claimed the dualism of art and reality to be false. For Williams, creativity was not exceptional, but ordinary, because the experienced reality is already a human creation, and nothing happens in the absence of a creative interpretation. Even art is just "one of a number of ways of describing and of communicating" (Williams, 2001, p. 40); and the artist "shares with other men what is usually called the 'creative imagination'", that is, the "capacity to find and organize new descriptions of experience" (Williams, 2001, p. 42). According to Williams, the impulse to communicate "is a human learned response to disturbance of any kind" (Williams, 2001, p. 43), and, as such, common to everyone. The way we see is the result of the assimilation of a set of rules, which are historically and spatially contingent. Each change in time and space involves new learning, and the artists participate in this common ground of meaning upon which communication takes place. Therefore, creativity is ordinary, as it implies the knowledge of the same set of rules without which we can neither see nor transmit knowledge or personal visions of the world.

As I will try to prove, H. G. Wells' literary body of fantasy writing, being historically set in the transition of the 19th to the 20th century, mirrors the complexity of the concept of creativity, in its relation to fantasy, the extraordinary and the ordinary, knowledge and power. Himself a late Victorian who also lived in the first half of the 20th century, he was fully involved in the facts and fictions of his time, divided between past and future imagery, trying to combine antagonistic narratives, such as the scientific hypothesis and the religious dogmas, and equally fascinated by the ordinary life and the extraordinary settings of science fiction. "The Man who Worked Miracles" is emblematic of a creative effort engaged in communicating the dangers of extreme, individual supernatural power.

2 THE CREATIVE MIND IN "THE MAN WHO WORKED MIRACLES"

2.1 *The miracles*

The two main characters in the story are George Fotheringay, a clerk "greatly addicted to assertive argument" (Wells, 1968, p. 299) and a clergyman, Mr Maydig. The plot begins with Fortheringay stating the impossibility of miracles in a pub. In order to silence his main opponent in the debate, Mr Beamish, the protagonist sets first to get a consensus as to what a miracle is ("something contrariwise to the course of nature done by power of Will", p. 299) and, second, to demonstrate the impossibility of such occurrences. For this purpose, he collects all his will and orders an oil lamp in the bar to flame upside down without breaking or ceasing to burn. He intends to prove that no such thing can ever happen, but as he later acknowledges, at the time he expressed his will, he had willed intensely the extraordinary to happen. To his surprise, the lamp does as told, and his acquaintances at the pub dismiss the occurrence as a trick. Only Fotheringay believes that a miracle happened – "the impossible, the incredible, was visible to them all" (1968, p. 300). Astonished by what had happened, he continues testing his supernatural powers, at first expecting them to stop. Once at home, he magically raises a candle in the air. The next day, he accomplishes his daily chores at work, then goes to the park to practise further. There he encounters Mr Winch, a constable who is accidentally injured by his miraculous deeds and, swept by anger at the reaction of the constable, who believes he is playing tricks, sends him to the Hades and later relocates him to San Francisco, so that no harm comes to the policeman.

Deeply distressed by the outcome of his encounter with Constable Winch, he seeks for help. His miracles had been the source of satisfaction and enthusiasm until the policeman had crossed his path. Unnerved, he attends Sunday church service and, at the end of mass, he asks the minister, Mr Maydig, for advice.

As formerly when in the presence of the constable, Fotheringay is forced to admit that he works miracles and decides to provide evidence. This time he is successful. The only witness who recognises his supernatural power is the clergyman.

After the initial surprise, Mr Maydig concedes that it is "possible" and "credible" to work miracles: "It is amazing, of course, but it reconciles a number of difficulties" (1968, p. 307): it makes previous occurrences plausible and allows for an insight into "some profounder law – deeper than the ordinary laws of nature" (1968, p. 308). He sets to integrate miracles in the "strange order of life", to use Damásio's terms: "The power to work miracles is a gift – a peculiar quality like genius or second sight" (Wells, 1968, p. 307). He, therefore, makes the extraordinary as a part of ordinary life, and so reconciles the miracle worker with his 'gift'.

Not only does the minister naturalises miracles as the mark of the exceptional and rare that enriches life, as he becomes eager to participate in the adventure to reorder an imperfect world according to this deeper law.

2.2 *Two different perspectives of power*

Ever since the beginning of the conversation, Fortheringay makes several attempts at solving the problem that his supernatural powers caused him: how to deal with the unfortunate accident that sent Mr Winch to San Francisco? This was the reason why he had sought for advice in the first place. The disappearance of the policeman did not go unnoticed. The river was being dragged in the search for the missing person, and Fortheringay felt deeply troubled by the possibility of Mr Winchbeing at odds to understand what had happened, if not scared, exasperated, annoyed or desperate. He manages to get in his shoes and imagines problems with scorched clothes due to the flames of Hell, expenses with travel arrangements to return to London. He feels responsible for the policeman's misfortunes and uses his powers to give him a new suit, money for current expenses at the same time that keeps sending him back repeatedly to San Francisco, afraid of the effects of his return to London.

Fortheringay is genuinely torn between the need for self-preservation and the responsibility for another person's life. Power brought with it ethical awareness and a heavy conscience. But Maydig shows a very unsympathetic nature. Winch's misfortunes are neglected in face of the brighter perspectives of reordering life. A sharp contrast shows a dynamic Maydig pacing the hearthrug and gesticulating while Fotheringay sits "with his arm on the table and his head on his arm" (1968, pp. 308-309). This is the image of worry as opposed to the energy of enthusiasm.

Maydig eventually suggests that Fotheringay should use his gift to benefit others. That night they walk the town streets, healing illness, erasing vice and

improving public works. Maydig has plans to reform the whole world. "It's practically an unlimited gift" (p. 309), he says, and sets the mood for a growing ambition and an enlarged imagination as to what could be done with it. Every action is "designed in the spirit of infinite benevolence" (Wells, 1968: 311), i.e., as a sign of divine will and agency. Seen in this light, the two men act as representatives of God, endowed with the utmost power – unlimited, infinite – that could ever exist on Earth. But, again, a line can be drawn separating the clergyman and the clerk. Even in the most trivial decisions, Fotheringay shows altruistic concerns, as when he provides a magical dinner to suit Maydig's wishes, and at the height of enthusiasm never fails to remember Constable Winch's ordeal. It is also Fotheringay who suggests they interrupt the "benevolent" acts of the night, so that he may fulfil his working duties early in the morning, as usual. In other words, he is not blinded by power to the point of neglecting a routine made of service and duty.

But Maydig suggests that they could disregard their obligations for the next day if Fotheringay could stop the night altogether. That represents the ultimate power, the power to stop time, to influence the order of life on a cosmic level; in other words, to play God and violate a fundamental law of nature. "We're only beginning", says Maydig, "full of the sweetness of unlimited power" (1968, p. 312). The irony is not fortuitous. It points the finger to the Church as a hypocritical element in society. A symbol of humility and compliance to higher powers it should settle for serving humanity on a moral level.

Fotheringay, who is led by the authority of Maydig as a representative of God, is an instrument of the minister's ambition, and a feeble one too, as he fully accepts Maydig's expertise on supernatural matters. Hence, he agrees and stops the motion of the Earth. With this action, he exemplifies Foucault's view on the power of discourse. Not only does he consider the minister a specialist in miracles as he uses his own power in accordance with the clergyman's orders and wishes.

None of them possesses the necessary knowledge to prevent the catastrophe that follows. Had they been instructed in the laws of nature, via scientific knowledge, they would know that gravity is due to the rotation of the Earth. As it is, the 'miracle' causes all objects on Earth to be hurled from the surface with great force. Chaos ensues, with the destruction of everything on the planet, but Fotheringay ensures his own safety back on the ground, by miraculous thinking: "Let me come down safe and sound. Whatever else happens, let me come down safe and sound" (1968, p. 321). Around him, absolute chaos reigns. He cannot see any familiar shapes, among "the masses of earth and heaps of inchoate ruins", "no trees, no houses", "only a wilderness of disorder vanishing at last into the darkness" (1968, p. 313).

H. G. Wells was acquainted with entropy, the second law of thermodynamics, and used it in several

narratives in order to describe apocalyptic visions. In this case, the complete disorder announces the end of life as we know it. The keywords in the excerpts quoted above are "wilderness" and "darkness", the former implying the loss of ethical principles as a consequence of misusing unlimited power, the latter evoking total dissipation of useful energy and, therefore, death.

Humanity perishes temporarily in "The Man Who Could Work Miracles". Such a catastrophic scenario is the result of belief in the wrong sort of discourse (the religious one) and disrespect for nature and natural laws (itself a sign of scientific ignorance). Against this background, an all-knowing entity keeps us informed of things that neither characters nor readers fully know. This textual entity represents creativity put to the service of collective interests.

Fotheringay repents and uses his power to lose it. He wishes that the power be taken from him and the world restored to a time previous to the demonstration at the pub with the oil lamp. He wishes to be back to a time before the miracles began and wishes to lose the power of working miracles. Amid lightning and thunders, at the peak of chaos, language recreates the world: "let me lose my miraculous power, let my will become just like anybody else's will" (Wells, 1968: 314).

Fotheringay immediately finds himself back in the bar of the Long Dragon, arguing about miracles with Toddy Beamish as before. The all-knowing narrator not only tells that the character has no recollection of previous events as he also had informed the readers some pages before the catastrophe is described that they had died "a year ago" (1968, p. 309) and afterwards resurrected, also without any recollection of the events narrated.

At this point, fantasy reaches its highest point. The narrator is aware that this particular event is unbelievable, but for the sake of coherence, he returns to the concept of miracle to make readers believe his words. Given the fact that "a miracle is nothing if not improbable", it becomes easier to accept that the readers were killed on Nov. 10, 1896 "in a violent and unprecedented manner" (1968, p. 309); given the fact that the man who worked miracles used his power to put an end to it and to return to a time previous to the catastrophe, it is probable that things occurred as described, even if it is impossible to prove them. Nobody remembers, and belief must arise out of an act of faith in the narrator's words. The narrator is, therefore, the ultimate creator.

Wells sustained that the novelist was "one of the most potent of artists" because he could "present conduct, devise beautiful conduct, discuss conduct, analyse conduct, illuminate it through and through" (apud Parrinder, 1977, p. 89). On final analysis, it is the literary discourse, fantastic as it is, the one with the greatest power of attracting belief and causing social change.

2.3 *The creative effort and the creative interpretation*

Language, as stressed by Foucault, is powerful, in particular, the specialist's discourse. In this case, the specialist is not a scientist but a clergyman, but his power is greater than Fotheringay's, as he influences which miracles should be made. However, stronger than miracles is nature itself. The catastrophe proves the secondary role of supernatural powers when confronted with natural law. The force uniting these contradictory elements in the story is creativity.

The creative effort pertains to the textual entity who devises the story and tells it. Being a human trait, it partakes both of the ordinary and the extraordinary elements of life. It consists of conceiving an extraordinary hypothesis (what if a man could work miracles?) and of testing it in the laboratory of literature. It allows the mixture of past and future events via the miraculous erasure of memory and facts that took place on November 10, 1896; it compares the strength of conflicting forces (natural laws and religious discourse); it turns an assertive, rational man into a miracle worker; it places a character in real and mythical places (San Francisco and Hades); it even predicts and describes the end of the world. It is thus that creativity accomplishes the aim of bonding the extraordinary and the ordinary: the apocalypse will become real (and not just imaginary) if the natural order is violated.

This is a recurrent message in Wells' writing. His fantasy stories and novels wage a war against "ignorance, convention, complacency and conservatism" (Borrello, 1982, p. 18), which in this case converge to the belief in supernatural powers. They also warn against unlimited power and present an unconventional image of damnation – not an eternity of pain, but, on the contrary, a comfortable state of individual license to act at one's free will and "to relax in the arms of outworn social and moral conventions" (Borrello, 1972, p. 20). The miracle worker relaxes under the influence of the moral authority embodied by Maydig. Another relevant aspect of Wellsian fiction is the need his heroes feel to communicate their knowledge and the result of difficult moments of apprenticeship. In this case, Fotheringay chooses to forget in order to save the planet and humankind, but the narrator comes forth and takes up the task the character is unable to perform.

Communication comes after the upsurge of violence and destruction that took place in the "possible future" designed by the creative mind so that in the real future, they can be prevented. The strangeness of the catastrophe is presented as a possible threat, its extraordinary character a mere question of ignorant or knowledgeable conduct. The struggle to achieve a better life for humankind is however only complete with creative interpretation.

The fantastic element in the story entices the readers' imagination and interpretative skills. As Harari

states (2017, p. 337), through storytelling, we can extract the meaning of life. Fantasy gives sense to suffering and presents an unexpected order of things that helps us in anticipating the future. When we read, we suspend the being who lives and activate the being who imagines, who thinks about reality, who makes important decisions and who understands the stories that are being told.

The interpretative effort is not free, though. It is the result of the rules we have incorporated as part of the communication mechanism. The self who reads and interprets is also a product of imagination, as much as the self who writes – both of them indulging in fantasies of how to be a man, a woman, a minister, a scientist, a god, a saviour of humanity. That is why creativity is always present in life, an inherent part of life, even when the universes we bring to reality are fantastic and improbable as miracles and miracle workers.

3 CONCLUSION

"The Man Who Could Work Miracles" testifies to the power of creativity in life. The story adjusts to the main characteristics of 'miracles', both as a violation of natural law and a manifestation of a Will that recalls divine agency. It also anticipates Damásio's statement that creativity brings together opposing forces and paves the way for a glimpse at the possible future. It is a source of power, as it helps us make sense of a world where violence, chaos and meaninglessness rule. Even if it cannot stop violence and chaos, it helps us develop a creative interpretation of the symbolic order and, on that basis, make sense of our own lives and improve reality.

In Wellsian fiction, the improvement of reality is inseparable of knowledge and of accepting the primacy of nature over science or religion, no matter how well-structured their discourses may be. Fantasy, or in other words, the eruption of the unexpected, the unreal and the incredible, suggests the precariousness of current, conventional ideas. In a changing world, only through collective endeavours may we feel truly powerful. In this context, the writer and storytelling play a fundamental role as they bridge creative effort and creative interpretation.

As H.G.Wells imagines the task of miracles in a secular society, he reflects on the effects of unlimited power and anticipates Yuval Harari's conviction that fantasy is essential for personal and collective survival. In the end, the events must be narrated so that humankind fully understands the perils lying ahead, in a "possible future". The extraordinary becomes, therefore, part of the ordinary order of things.

ACKNOWLEDGEMENT

This chapter had the support of CHAM (NOVA FCSH/UAc), through the strategic project sponsored by FCT (UID/HIS/04666/2019).

BIBLIOGRAPHICAL REFERENCES

Borrello, Alfred. (1972). *H. G. Wells: Author in Agony.* Southern Illinois University Press.

Damásio, António. (2018 [2017]). *A estranha ordem das coisas. A vida, os sentimentos e as culturas humanas.* Lisboa: Temas e Debates – Círculo de Leitores.

Foucault, Michel. (1984). *The Foucault Reader* (Ed. Paul Rabinow). New York: Pantheon Books.

Harari, Yuval. (2017). *Homo Deus. História breve do amanhã* (trad. de Bruno Vieira do Amaral). Amadora: Elsinore.

Hume, David. (1975). *Enquiries Concerning Human Understanding.* Ed. L.A. Selby-Bigge 3rd ed. Oxford: Oxford University Press.

Mulhern, Francis. (2000). *Culture/Metaculture.* London and New York: Routledge.

Parrinder, Patrick. (1977). *H. G. Wells.* New York: Capricorn Books.

Russell, Bertand. (1990). *O poder – uma nova análise social* (trad. de Isabel Belchior). Lisboa: Editorial Fragmentos.

Swiezynski, Adam. (2012). "The Concept of Miracle as-as "Extraordinary Event", in *Roczniki Filozoficzne – Annales de Filosophie*, Vol LX, number 2, in https://www.researchgate.net/publication/236620178_The_concept_of_miracle_as_an_extraordinary_event. Accessed on January 30, 2019.

Wells, H. G. (1968). "The Man Who Could Work Miracles", in *Selected Short Stories.* Harmondsworth: Penguin Books.

Williams, Raymond. (2001 [1961]). *The Long Revolution.* Ontario: Broadview Press.

On stories: Tolkien and fictional worlds

Maria do Rosário Monteiro
CHAM, FCSH, Universidade NOVA de Lisboa, Lisbon, Portugal
ORCID: 0000-0001-6214-5975

ABSTRACT: This chapter will deal with Tolkien's essay "On Fairy-Stories" (1983d). Two main ideas will guide the text. To prove how in the first half of the 20th century, in an academic scenario dominated by the discussion of who was worth to be included in the novel "Great tradition", Tolkien produced an essay on *a genre unworthy of any serious attention*, which however became itself an unavoidable source for students and researchers of literature in the last century. The other main idea is to prove that "On Fairy-Stories" changed forever the way fantasy was understood (as happened with the essay "Beowulf: the Monsters and the Critics" (1983a), anticipating much of what is now discussed in narratology: *storyworlds* and *fiction worlds*. Tolkien did not have at his disposal the contemporary theoretical vocabulary but he definitely launched the cornerstones for contemporary narrative study that came to be known as the "narrative turn" that took form in the 1990s with critics as Umberto Eco (1990), Lubomír Doležel (1998), Thomas Pavel (1986, 1988), and Marie-Laure Ryan (1992).

Keywords: Tolkien, On Fairy-Stories, Fictional worlds, narrative theory

Syne they came to a garden green,
And she pu'd an apple frae a tree:
'Take this for thy wages, true Thomas;
It will give thee the tongue that can never lee.'
Thomas the Rhymer

1 INTRODUCTION

As with most of Tolkien literary and theoretical production, the essay "On Fairy-Stories" has a long history of versions, revisions and restructurations. In the 1983 edition, Christopher Tolkien states that the first published edition was in 1947 (C. S. Lewis, 1947), re-edited in 1964, and the 1983 edition had only minor corrections (p. 3). Those who know of Tolkien's obsession with perfection[1], widely confirmed by *The*

History of Middle-Earth (1983–1996), and the ever-growing critical editions[2], can only expect to also find a similar pattern regarding "On Fairy-Stories". The 1947 version is a substantial restructuration of Tolkien's lecture presented on March 8, 1939, in the annual "Andrew Lang Lecture", held in St. Andrew University, Scotland[3]. Up until now the actual content of Tolkien's lecture remains unknown, for no records of it have been found (yet) and the information provided by the newspapers does not shed light on it (Tolkien, 2014, pp. 159–169). Flieger and Anderson worked on two manuscript versions (A and B), assuming version A as the research basis for the lecture. They also present a valuable lengthy bibliography that Tolkien quoted or

[1]. The most cited reference to Tolkien's obsession with perfection was made, according to Carpenter, by C. S. Lewis: "His standard of self-criticism was high and the mere suggestion of publication usually set him upon a revision, in the course of which so many new ideas occurred to him that where his friends had hoped for the final text of an old work they actually got the first draft of a new one." (1978, p. 143) However, Carpenter does not indicate the quotation source, for reasons he explains (pp. 275–278). In Lewis *Letters*, one finds the following statements: "Tolkien [...] is most important. *The Hobbit* is merely the *adaptation to children* of part of a huge

private mythology of a most serious kind: the whole cosmic struggle as he sees it but mediated through an imaginary world. *The Hobbit*'s successor, which will soon be finished, will reveal this more clearly. Private worlds have hitherto been mainly the work of decadents or, at least, mere aesthetes. This is the private world of a Christian. He is a very great man. His published works (both imaginative & scholarly) ought to fill a shelf by now: but he his one of those people who is never satisfied with a MS. The mere suggestion of publication provokes the reply 'Yes. I'll just look through it and give it a few finishing touches' – wh. means that he really begins the whole thing over again." (1988, p. 376).

[2]. Just two examples: *On Fairy Stories* (Tolkien, 2014) or *A Secret Vice* (Tolkien, 2016).

[3]. See Michelson (2012) and Flieger & Anderson (2014a) who provide crucial information.

read during the preparation of the lecture (2014, pp. 306–311)[4]

In 1939, Tolkien was having difficulty in writing a sequel for *The Hobbit* (1983b). His relation with the published book followed the pattern of the perfectionist Lewis described. It is accurate to say that Tolkien never overcame a certain dissatisfaction with the way *The Hobbit* conditioned his literary career, namely the writing and publication of *The Silmarillion* (1983e) by introducing a novel/sequel, *The Lord of the Rings* (2005, 1st ed. 1954–1955), that had to connect both with a book written for children and the mythological body[5]. Ironically, *The Lord of the Rings* became a landmark in fantasy literature. The masterpiece took him seventeen years to write, demanding uncountable revisions both to the novel and to *The Silmarillion*, in order to avoid any discrepancy or inaccuracy in the whole body of Middle Earth fictional world (Tolkien, 1981a, p. 2016). The initial project was only (partially) completed with Christopher's posthumous edition of *The Silmarillion*[6], but by 1951 Tolkien could express a global image of his project and its internal coherence:

> I had a mind to make a body of more or less connected legend, ranging from the large and cosmogonic, to the level of romantic fairy-story – the larger founded on the lesser in contact with the earth, the lesser drawing splendour from the vast backcloths [...] Of course, such an overweening purpose did not develop all at once. The mere stories were the thing. They arose in my mind as 'given things', and as they came, separately, so too the links grew. [...] *The Hobbit* [...] was quite independently conceived: I did not know as I began it that it belonged. But it proved to be the discovery of the completion of the whole, its mode of descent to earth, and merging into history. As the high Legends of the beginning are supposed to look at things through Elvish minds, so the middle tale of the

Hobbit takes a virtually human point of view – and the last tale blends them. (Tolkien, 1981a, pp. 144–145)[7]

Tolkien's research for the Andrew Lang Lecture and its writing were done in a period when Tolkien was struggling with *The Lord of the Rings* intended as a sequel for *The Hobbit* (1981a, pp. 40–42). He had, according to Flieger and Anderson, three months to research and write the lecture (Tolkien, p. 128).

Reading "On Fairy-Stories", one cannot miss the implied criticism that Tolkien does to *The Hobbit*, nor the defence of Fairy-Stories being adult reading as justification for the sequel being "darker".

However, the essay is much more than that: it is a theoretical essay on fantasy at the same level that "Beowulf: The Monsters and the Critics" is a landmark on the medieval poem criticism[8]. It is this researcher's opinion that long before the "narrative turn" (Kreiswirth, 2005; Ryan, 2015b, p. 11) Tolkien made it, using the available terminology and adapting other so that the outcome is a quite *avant la lettre* essay on narrative as recent terminology defines it.

This chapter, divided into two parts, begins by trying to demystify the all too frequent interpretation of "On Fairy-Stories" as a personal and biographical text – responsible for the somewhat light use of the theoretical dimension. The second part will focus on Tolkien's anticipation of "the narrative turn". It will deal with the creation of fictional worlds and justification of the now called reader's natural narrative immersion in the fictional world as a necessary way to achieve one of literature main objectives: to widen the ever-increasing strict notion of consensual reality, in itself a functional narrative created and shared within cultural communities.

2 IS "ON FAIRY-STORIES" TOLKIEN'S FICTION SELF-JUSTIFYING TEXT?

The answer is "No"! Tolkien disliked allegory; the author of this chapter has the same feeling for pseudo-literary interpretations based on the author's biography or statements concerning his personal interpretation of his works[9]. This was the usual practice, based on the

4. A specific reference to this bibliographic list will be presented further on.
5. Tolkien's relation with *The Hobbit* was always one of mixed feelings. He clearly welcomed the extra income, but mostly he felt it was almost an "accident" that had nothing to do with what he really wanted to publish: *The Silmarillion* (1983e). In 1938 he struggles with the request to write a "never intended" sequel (Tolkien, 1981b, p. 38) and twenty two years later, "peace" with the first novel was not solved (Tolkien, 1981b, pp. 218, 297–298, 310). Particularly interesting is Tolkien's long letter to W. H. Auden (1981b, pp. 211–217).
6. *The Silmarillion* edited in 1983 does not wholly corresponds to what Tolkien had in mind. It is the outcome of Christopher Tolkien and Guy Gavriel Kay's edition and selection of parts of Tolkien's texts. The editors' ignored then the extent of Tolkien's work, which can only be glimpsed with the publication of *The History of Middle Earth*. For a possible more accurate picture of what Tolkien had in mind, had he lived to see it published, please refer to Noad's "On the Construction of "The Silmarillion" (2000).

7. Tolkien is here considering the temporal link of the fictional project, the evolution of Middle-Earth plot: *The Silmarillion*, *The Hobbit* and *The Lord of the Rings*.
8. "Next after is essay on *"Beowulf*: The Monsters and the Critics", "On Fairy-Stories" is [Tolkien's] most reprinted critical essay, and like the *Beowulf* essay it is a landmark in its field." (Flieger & Anderson, 2014b, p. 9).
9. A clear example of this kind of interpretation centred in Tolkien's opinions expressed in some of his letters is the debate on whether Tolkien's mythology is a Christian or a pagan one (Curry, 1998; Pearce, 1998). Tolkien's interpretations of his own work are irrelevant for the reader and depend on the circumstances that determined his statements. He was "a complex individual [...] a man deeply conflicted, balancing faith against experience, and orthodoxy against an inner

conception of literature being a mimetic creation[10]. This is unacceptable as critical practice since the second half of the 20th century. It is hard to forget Barthes' edit of "the author's death":

> We know now that a text consists not of a line of words, releasing a single "theological" meaning (the "message" of the Author-God), but of a multi-dimensional space in which are married and contested several writings, none of which is original: the text is a fabric of quotations, resulting from a thousand sources of culture. (Barthes, 1989, pp. 52–53)

Barthes makes narrative wholly dependent on language, while the narrative turn centres in the story as a cognitive construct (Ryan, 2015b, p. 11). The "author's death" cannot be assumed as dogma, as structuralism did, replacing him by a fictional character: the implied author; whose usefulness is highly debatable[11].

Indeed, Tolkien does not make it easy to avoid the connection to the biographical dimension:

> Faërie is a perilous land, and in it are pitfalls for the unwary and dungeons for the overbold. [...] I have been a lover of fairy-stories since I learned to read, and have at times thought about them. [...] I have been hardly more than a wandering explorer (or trespasser) in the land, full of wonder but not of information. (Tolkien, 1983d, p. 109)[12]

These sentences create in the reader the expectation of a more literary text, almost a public confession of feelings and opinions instead of an objective and straightforward text. However, one must not forget that, in 1939, to talk about fairy-stories was stepping into a field that, for the vast majority of adult readers and scholars, was necessarily a minor literature, suitable for children, a subject unworthy of an Oxfordian scholar.

However, Tolkien's public was probably quite heterogeneous but also particular:

> Of lesser concern than the primary topic, but nevertheless a circumstance which Tolkien went out of his way to address, was the special nature of his audience. Not only could it be expected to be familiar with Andrew Lang and with fairy-stories, it was presumably and preponderantly Scottish. Tolkien was well aware that Scotland, an indigenously Celtic country, was not just

a natural home of the folk and fairy lore traditionally associated with the Celts, but had been for many years a locus for research into the subject. (Flieger & Anderson, 2014a, p. 130)

So far, the original text that Tolkien presented has not been found (and in what concerns Tolkien's estate statements regarding unknown texts are extremely delicate). However, reading the references on coeval magazines and newspapers, in the days following the conference, one infers that it concerned mainly with a defence of fairy-stories as a legitimate literary genre, with an escapist function, the insistence on a happy ending and the acceptance of the marvellous and the supernatural (Flieger & Anderson, 2014a, p. 130).

One is then allowed to speculate that, in his lecture, the criticism one finds in the final text (but also in the surviving manuscripts), regarding the adaptation and expurgation of some features so that the final narratives could be suited to children, according to adults' criteria, were probably less violent, and some possibly omitted. After all, Tolkien had been invited because in 1937 he published *The Hobbit*, highly praised by critics and with vast circulation. However, here one finds oneself in the field of speculation.

It is possible that Tolkien followed in 1939 an intelligent and cautious strategy, which did not leave him with a feeling of satisfaction, of closure, in either scientific or personal spheres. As he states in two letters dated October 1938 and February 1939, he was uncomfortable with the idea of writing a sequel for children (1981a, pp. 41–42). And in a 1955 letter to Auden, he somehow confesses the coincidence between his writing block regarding *The Lord of the Rings* with the need to restructure the 1939 lecture so that his ideas concerning this type of narrative became clear in his mind.

> "...I was not prepared to write a 'sequel', in the sense of another children's story. I had been thinking about 'Fairy Stories' and their relation to children – some of the results I put into a lecture at St. Andrews, and eventually enlarged and published in an Essay [...]. *As I had expressed the view that the connection in the modern mind between children and 'fairy stories' is false and accidental, and spoils the stories in themselves and for children*, I wanted to try and write one that was not addressed to children at all (as such); also I wanted a large canvas. (1981a, p. 216)[13]

It is undetermined when Tolkien started restructuring the original lecture, but, as Flieger and Anderson (2014a, p. 131) state, this allowed him to use the extensive research started in 1938 and refute the supposed connection between children and fairy tales, considering it a mere misconception.

Actually, the association of children and fairy-stories is an accident of our domestic history. Fairy-stories have in the modern lettered world been relegated to

perception that broke the veil and reached the other side of the visible world" (Flieger, 2017, p. 30). This said his mythology is neither Christian nor Nordic, nor Celtic: it is a mixing of several sources developed, revised and restructured during a lifetime. It is a rich and unique fictional world.
10. For a detailed analysis of traditional interpretations of literary works until the 1980's see Doležel (1998, 2010).
11. See Eco (1979, 1992a, 1994) and Ryan (2011).
12. Italics added. Flieger & Anderson give several meanings to the word "Faërie", one being: "used to mean the Otherworld beyond the five senses – a parallel reality tangential in time and space to the ordinary world" (Tolkien, 2014, p. 85). It is this author's conviction that this is the meaning used in the quoted text.

13. Italics added.

the 'nursery', as shabby or old-fashioned furniture is relegated to the playroom, primarily because the adults do not want it, and do not mind if it is misused. [...] It is true that in recent times fairy-stories have usually been written or 'adapted' for children. [...] It is a dangerous process, even when it is necessary. [...] Fairy-stories banished in this way, cut off from a full adult art, would in the end be ruined; indeed in so far as they have been so banished, they have been ruined. (1983d, pp. 130–131)

After a lengthy excursus through other subjects, Tolkien returns to the subject of fairy stories and children:

> It is true that the age of childhood-sentiment has produced some delightful books [...] of the fairy kind or near to it; but it also produced a dreadful underground of stories written or adapted to what was or is conceived to be the measure of children's minds and needs. The old stories are mollified or bowdlerised, instead of being reserved; the imitations are often merely silly, [...]; or patronising; or (deadliest of all) covertly sniggering, with an eye on the other grown-ups present. (1983d, p. 136)

The research Tolkien undertook (2014, pp. 128–130) led him to conclude that Fairy-Stories have their sources in the myths and legends, i. e. share the same ancestry of all other literature that is considered art. This is the cornerstone of Tolkien's argumentation: fairy stories are Literature, Art, and not minor productions. They come from the same "soup" that boils in the cauldron that produces the myths, legends, novels, a myriad of narratives human societies share and to which they continually add new ingredients.

> Speaking of the history of stories and especially of fairy-stories we may say that the Pot of Soup, the Cauldron of Story, has always been boiling, and to it had continually been added new bits, dainty and undainty. (1983d, p. 125)[14]

This statement is reminiscent of Jung's definition of the collective unconscious, one of the authors Tolkien included in his research for the lecture, and possibly in later years too (2014, pp. 129, 170, 307). From this author's point of view, one of the most exceptional contributions that Flieger and Anderson's edition of "On Fairy-Stories" brings is precisely the factual proof that Tolkien studied the work of the Suisse psychoanalyst and incorporated some elements in his vision of the origin not only of mythology but the narrative in general. This proof is something that requires further inquiry and will make possible new interpretations

of Tolkien's fictional world, further justifying some already published[15].

Having an in-depth knowledge of medieval literature in several languages and knowing that fairy stories, recovered and recreated by the Romantics, have their origins in the primaeval days of human culture, Tolkien chose for entrance in his text three stanzas from the "Thomas the Rhymer" ballad. The choice was neither innocent nor casual: first because having before him an audience made mainly of Scottish people, Tolkien new the richness of Scottish folklore to which this ballad belongs. Second, the chosen stanzas define the fairy world as a third world, outside the realm of reality, but also the realm of rational thinking and the ego.

> O see ye not yon narrow road
> So thick beset wi' thorns and briers?
> That is the path of Righteousness,
> Though after it but few inquires.
> And see ye not yon braid, braid road
> That lies across the lily leven?
> That is the path of Wickedness,
> Though some call it the Road to Heaven.
> And see ye not yon bonny road
> That winds about yon fernie brae?
> That is the road to fair Elfland,
> Where thou and I this night maun gae. (1983d, p. 110)

It is his conviction on the ancestry of fairy stories, of its origin being the "Cauldron of stories" that allows Tolkien to state one of the most important assertions of the essay:

> If fairy-story as a kind is worth reading at all it is worthy to be written for and read by adults. *They will, of course, put more in and get more out* than children can. [...] if written with art, the prime value of fairy-stories will simply be that value which, as literature, they share with other literary forms. (1983d, p. 137)[16]

Tolkien is clearly aware of a fact today assumed as common knowledge that the process of reading is one of cooperation between author, text and reader, the construction of a web of multiple intertextualities brought into the text by both author and reader, responsible for making each reading of a narrative a co-creation unique and unrepeatable by the same participants. No reader interprets the same text twice in the same way just as the same river water will

14. It is worth notice that Tolkien's borrows the term "soup" from an author whose theories he contests, George Weber Dasent (1859, p. XVIII), and by adding the term cauldron immediately turns the "soup" into the product of the celebrated Celtic cauldron of Rebirth, the *Pair Dadeni*.

15. During the many years I have been studying Tolkien's fictional world, I have acknowledge the feeling that Jung's theory was one of the many elements in Middle Earth background, though I never got the change, until recently, of proving my suspicion. These had already been stated by Timothy O'Neill (1980, p. 160). For an analysis of Tolkien's *The Lord of the Ring* and other narratives, exploring the use of symbology and Jungian psychology see Monteiro (1992, 1993, 1997, 2000, 2010, 2014, 2015).
16. Italics added

not pass twice under the same bridge. The narrative/bridge is the same, yet the reader has evolved, became somebody different.

The undervaluation of fairy stories is the outcome of a particular culture, the Western one, produced by the changes of the *Weltanschauung* that started in the end of the Middle- Ages and the beginning of Modern times, a process accelerated by the 19th-century positivism. These changes strengthened the cleavage between the cultural elites and the popular classes, between the opinion makers and those still in connection with the oral tradition, birthplace of myths and legends.

Tolkien knows he is not alone in this interpretation. One may compare the following statement:

> It seems to become fashionable soon after the great voyages had begun to make the world seem too narrow to hold both men and elves; when the magic land of Hy Breasail in the West had become the mere Brazils, the land of red-eyed-wood. (1983d, p. 111)

With this excerpt from Lewis' "New learning and New Ignorance":

> By reducing Nature to her mathematical elements it substituted a mechanical for a genial or animistic conception of the universe. The world was emptied, first of her indwelling spirits, then of her occult sympathies and antipathies, finally of her colours, smells, and tastes. [...] The result was dualism rather than materialism. The mind on whose ideal constructions the whole method depended, stood over against its object in ever sharper dissimilarity. Man with his new powers became rich like Midas but all that he touched had gone dead and cold. This process, slowly working, ensured during the next century the loss of the old mythical imagination: the conceit, and later the personified abstraction, takes its place. Later still, as a desperate attempt to bridge a gulf which begins to be found intolerable, we have the Nature poetry of the Romantics. (C. S. Lewis, 1973, pp. 3–4)

Lewis' conception is based on his discussions with Owen Barfield, possibly during the Inklings meetings, being both aware of the semantic change in words meanings and consequently in the way the world is perceived, as Flieger explains[17]:

> [The] felt unity between man and his world gave his language a similar "ancient semantic unity", a fusion of related meanings within one word. Every word had an "outside" and an "inside", the concrete referent with related meanings that have since been abstracted from it [...]. Early language, describing a world perceptibly more alive and immediate than the one we know, was by its nature rich in what we would now call figures of speech, poetic diction. We mean by that words consciously used as metaphors to enhance meaning, but for the original speakers this was the only language available. All diction was poetic. [...] such

language would have been for its speakers, as ours is for us, the agent as well as the medium of perception, creating reality as it described it. And that reality must have been, by the very nature of the words used, a different reality from the one we know. The development away from the concrete to the abstract, "from homogeneity towards dissociation and multiplicity," has affected not only language, but thought and perceived reality as well, cutting humanity off from its original participation in the natural and supernatural worlds, isolating us and our concepts from the living universe, eroding belief. (1991, pp. 45–46)

Tolkien and Lewis shared Owen Barfield's vision in what concerns language as a means to produce a reality, and poetic language is the supreme quality language can achieve, the means to create new realities freed from the constraints of dualism and more precisely from positivism and evolutionism that dominated the intellectual world since the end of the 19th century.

For the researchers that investigated fairy stories before Tolkien, like Dasent or Max Muller, for instance, myth and legend were the lowest form of communication, that of primitive humanity. Tolkien, Lewis and Barfield in their essays attempt to rescue myth from the lowest position where their predecessors had left it some time before. Both Tolkien in "On Fairy-Stories" (1983d, p. 117) and Barfield *Poetic Diction* and *Speaker's meaning* (1967, p. 87; 1987, p. 89) refute Muller's statement that myth is a "disease of language"[18].

Concluding this section, one may say that it is true that Tolkien wrote fiction and poetry for children. However, his position against the adaptation of traditional narratives, the expurgation of elements considered as nefarious and the systematic use of a paternalist tone, is the outcome of his aesthetic vision combined with his unwillingness to write narratives for children outside the family context. Tolkien wants to and does justify his predilection for the marvellous, fantasy, myth and non-realistic fiction because his ambition is to read and write narratives that plunge their roots deeply in the ancestry of myth, recovering a richer sense of reality. His ambition is to create fictional worlds different from the real one, though highly coherent, places where the reader does not have to willingly suspend his/her disbelief, due to the immersion in the fictional world that must be able to provide aesthetic satisfaction but also recovery of a more comprehensive concept of reality.

To do this, Tolkien has to recreate ancient canons, reinvent language's symbolic and connotative extent, the poetic dimension fully embedded in the fictional texture.

17. See Carpenter (1997).

18. Fairy-stories being an offspring of ancient myths and legends are, for Muller and his followers, a degraded, unworthy literature, therefore "proper for less developed minds, as those of children".

3 FAIRY-STORIES AND THE CONTEMPORARY CONCEPTION OF FICTIONAL WORLDS

In what way does "On Fairy-Stories" contribute, *avant la lettre*, to narrative theory? That is the question this section will address.

There are almost as many definitions of narratology as there are theoretical researchers. For the sake of clarity and conciseness, let us use excerpts of Mieke Bal's definition:

> Narratology is the ensemble of theories of narratives, narrative texts, images, spectacles, events; cultural artifacts that 'tell a story.' [...] a text is a finite, structured whole composed of signs. These can be linguistic units, such as words and sentences, but they can also be different signs, such as cinematic shots and sequences, or painted dots, lines, and blots. The finite ensemble of signs does not mean that the text itself is finite, for its meanings, effects, functions, and background are not. It only means that there is a first and a last word to be identified; a first and a last image of a film; a frame of a painting, even if those boundaries [...] are provisional and porous. (2009, pp. 3–4)

Let us focus on the infinitude of meanings, effects, functions and background. Returning to Tolkien's text, one finds more or less the same idea but expressed in a much more poetic form that adds an element missing in Bal's quotation – immersion:

> Faërie contains many things besides elves and fays, and besides dwarfs, witches, trolls, giants, or dragons: it holds the sea, the sun, the moon, the sky; and the earth, and all things that are in it: tree and bird, water and stone, wine and bread, and ourselves, mortal men, when we are enchanted. (1983d, p. 113)

The text, the weaving of the words, the signs are finite, but the fictional worlds that are created through them, that particular weaving is infinite. Because it feeds on reason but also the imagination, on reality as much as on conjecture, and its vastness depends on the writer and reader's imaginative ability, the rational connections he/she makes and on the dimension of each individual library. This "individual library" can be defined as the personal repository of everything a person has read, experienced, the feelings and their imprints in memory as well as in his/her personality and psychology. It is in all this that resides a relative infinitude of the meanings of the text (Eco, 1992b)[19].

Narratology focusses on several areas, but in this chapter, two main domains will be considered, though they are interconnected. Following Ryan's definition, one will consider the "fictional worlds" and the "storyworlds"[20] with a particular focus on the first due

to its core definition – the ontological nature of fictional worlds -, because it goes directly to one of Tolkien's central thesis: the ontological legitimacy of Fairy-Stories.

The idea of possible worlds originated in Leibniz's philosophy and developed in the 20th century in modal philosophy was integrated into literary studies during the "narrative turn" by several authors from which one seems particularly relevant in the case of Tolkien's theory – Lubomír Doležel (1998, 2010)

After being expurgated of the theological dimension it necessarily had in Leibniz's formulation, the fundamental premise of possible worlds is that

> Actuality is, as it were, surrounded by an infinite realm of possibilities. Or, as we might otherwise put it, our actual world is surrounded by an infinity of other possible worlds. (Bradley & Swartz, 1979, p. 2)

This premise, as Bradley and Swartz's explain, is not confined in the realm of philosophy, rather it reflects itself in every human activity, including cultural artefacts, and literature is a cultural product, as all arts are.

> Whatever the historical facts happen to be, we can always suppose- *counterfactually*, as we say – that they might have been otherwise. We constantly make such suppositions in the world of real life. The world of fiction needs no special indulgence. We easily can, and daily do, entertain all sorts of unactualized possibilities about past, present, and future. We think about things that *might* have happened, *might* be happening and *might* be about to happen. Not only do we ruefully ask "What if things *had been* thus and thus?"; we also wonder "What if things *are* so and so?" and "What if things *were to be* such and such?" Counterfactual supposition is not mere idle speculation. Neither is it just a fancy of the dreamer or a refuge for the escapist. (1979, p. 1)[21]

Bradley and Swartz's mention of "the refuge for the escapist" immediately draws one's attention to Tolkien's core function of fantasy literature to which he dedicates a substantial part of the essay:

> Though fairy-stories are of course by no means the only medium of Escape, they are today one of the most obvious and (to some) outrageous forms of 'escapist' literature [...]. I have claimed that Escape is one of the main functions of fairy-stories, and since I do not disapprove of them, it is plain that I do not accept the tone of scorn or pity with which 'Escape' is so often used. [...] In what the misusers of Escape are fond of calling Real Life, escape is evidently as a rule very practical, and may even be heroic. In real life it is difficult to blame it, unless it fails; in criticism it would seem to be worse the better it succeeds. Evidently we are faced by a misuse of words, and also a confusion of thought. [...] The world outside has not become less real because the prisoner cannot see it. [The critics]

19. For further information on immersion produced by literary texts and narratives in other media see Ryan (2015a, pp. 60–114).
20. For a clear (and short) definition of both terms and their meanings the reading of Ryan's "Texts, Worlds, Stories" (2015b) is a good introduction, with a useful bibliography.

21. Italics in the original text.

confuse the escape of the prisoner with the flight of the deserter. (1983d, pp. 147–148)

When Tolkien refers to the prisoner escaping prison by imaging being "in another world" he stresses that the possible worlds are a mental construction accessed through language. They are possible worlds, not actual (to use the philosophical terminology), that, however, obey basic logical rules plus the modal logical rules of possibility and necessity (Doležel, 1998, 2010).

More recently, in literary criticism, one reads that, as Tolkien suggests, the creation of fictional worlds (being mythical, fantasy or "realistic") is an innate activity in every human being, necessary and aiming evolution (Wolf, 2013, p. 4). Norman Holland (2009), quoting a study by the psychologists John Tooby and Leda Cosmides, exposes the essential aspects of fictional construction, common to all individuals and taken to a higher degree of artistic and aesthetic quality only by some:

1. The ability to "simulate" situations (to imagine them without acting on them) has great value for humans both in survival and reproduction. This ability to simulate seems to occur innately in the human species. We evolved the "association cortices" in our large frontal lobes for just this purpose.
2. All cultures create fictional, imagined worlds. We humans find these imagined worlds intrinsically interesting.
3. Responding to imaginary worlds, we engage emotion systems while disengaging action systems (a key point in this book).
4. Humans have *evolved special cognitive systems that enable us to participate in these fictional worlds*. We can, in short, pretend and deceive and imagine, having mental states about mental states.
5. We can separate these fictional worlds from our real-life experiences. We can, in a key word, *decouple* them. (2009, pp. 327–328)[22]

Comparing these items to Tolkien's essay, in particular, one cannot but acknowledge that all Tolkien major ideas are embodied in these four points. Fictional worlds have the inner consistency of reality provided by logic and strengthened by the reader's immersion in them through the engagement of his/her emotional system. Furthermore, due to the incompleteness inherent to all fictional worlds (unlike those considered by modal logic), the reader is summoned to complete the fictional world using his knowledge of the actual world.

In 1939/1947, Tolkien expresses the four items quoted above, using the short theoretical lexicon available complemented with a skilful choice of words:

Fantasy is a natural human activity. It certainly does not destroy or even insult Reason, and it does not

either blunt the appetite for, nor obscure the perception of, scientific verity. On the contrary. *The keener and the clearer is the reason, the better fantasy will be make.* [...] For creative fantasy is founded upon the hard recognition that things are so in the world as it appears under the sun; *on a recognition of fact, but not a slavery to it.* (1983d, p. 144)[23]

Tolkien further states that "fantasy is made out of the Primary World" (1983d, p. 147), and the same does Doležel in 1989, when he states that in order to create a fictional world the author has to build on the only world he/she knows – the actual world (2010, p. 233).

The fictional worlds have necessarily rules and laws, most of them exposed by the characters that have the function of establishing the dimension of truth in that world. Frequently, particularly in fantasy, there is at least one character as ignorant of the fictional world as the reader, and it is through the identification with such a character that the reader comes to terms with the fictional truth, which may be false in the actual world.

The long debate of the concept of truth in fictional worlds is centred on the question: Is it true what one finds in the fictional worlds? [24] The answer is simple: Yes! It is today's theory accepted by narratological studies, and Tolkien wrote it in 1939/1947.

Probably every writer making a secondary world, a fantasy [...] wishes in some measure to be a real maker, or hopes that he is drawing on reality: hopes that the peculiar quality of this secondary world (if not in all details) are derived from Reality, or are flowing into it. If he indeed achieves a quality that can fairly be described [...] [as] 'inner consistency of reality', it is difficult to conceive how this can be, if the work does not partake of reality. [...] Fantasy can thus be explained as a sudden glimpse of the underlying reality or truth. This is [...] an answer to that question, 'Is it true?' The answer to this question [...] [is]: 'If you

22. Italics in the original text.

23. Italics added.
24. Ryan summarises the long debate in her essay "Possible Worlds" using Lewis article "Truth in Fiction" (1978) as departure: "This analysis has important consequences for literary theory for the following reasons: (1) it regards statements about fiction as capable of truth and falsity, against the formerly prevalent views among philosophers that they are either false (for lack of referent) or indeterminate; (2) it assumes that the real world serves as a model for the mental construction of fictional storyworlds; but (3) it does not limit the fictional text to an imitation of reality, maintaining, on the contrary, that texts are free to construct fictional worlds that differ from AW. Readers imagine fictional worlds as the closest possible to AW, and they only make changes that are mandated by the text. For instance, if a fiction mentions a winged horse, readers will imagine a creature that looks like real world horses in every respect except for the fact that this creature has wings. Ryan (1992) calls this interpretive rule 'the principle of minimal departure,' and Walton (1990) calls it 'the reality principle.'" (2013, paragraph 6).

have built your little world well, yes: it is true in that world'. (1983d, p. 155)[25]

One may replace the mentioned "horse with wings" (see note 25) for a hobbit, and the reader will be guided to imagine a human(ish) being, short and usual paunchy, but with big furry feet. The reality of such a hobbit is unquestionable in the world of Middle Earth, though non-existent in the actual world. In Tolkien's fictional world, the hobbits have the same degree of reality as the golden and silvery leaves of LothLórien trees or the Riders of Rohan. It is either the narrator's or reliable characters' performative statements that build the possible/"secondary" world with the reader's collaboration.

4 A PROVISIONAL CONCLUSION TO AN INEVITABLY INCOMPLETE ANALYSIS

It is this author's *fado*, shared unquestionably by many researchers of Tolkien's work, to have to put an end to an analysis that has to leave without mentioning many untouched lines of research.

Nowadays, researchers no longer debate the "reality" of the fictional worlds, their lack of reference, and their philosophical non-existence. Neither are they confined to dedicate their research to "mimetic fiction" as the only genre worth studying. The literary quality of a text does not depend on its closeness to a consensual notion of reality.

As Ryan states:

In this age of ubiquitous images, fantasy worlds are visually more attractive than realistic worlds. They are the product of a gift of invention that has too long been ignored by literary critics, who tend to privilege writing skills over the art of world-creation. And finally, most fantasy worlds implement reassuring, through stereotypical archetypal plots in which the good guys always triumph over the bad guys after being tested to their limits. Suffering is part of life, these narratives tell us, but it is never in vain. (2017, p. 11)

It was not so in academia when Tolkien wrote both his fiction and his theoretical texts. It is true that his essay "Beowulf: The Monsters and the Critics" changed the way the poem and medieval literature was studied. The essay "On Fairy-Stories" had to battle against much stronger opposition, that had many strong foundations, such as, for instance, E.M. Forster's 1927 *Aspects of the novel* (1985),

Leavis' 1948 *The Great Tradition* (1972) or Auerbach's 1946 *Mimesis: the representation of reality in Western literature* (Auerbach, 2003).

This chapter aimed to point out some of the most unmistakeably innovative theoretical statements that definitely might have placed a then-minor literary art – Fantasy – on the same level as all other praised literary texts. He wrote before the academia was able to understand what he meant. "On Fairy-Stories" took more than half a century to become the theoretical output for a systematic study of fantasy literature. Moreover, even then, academia needed the confirmation provided by other scientific studies from such areas as philosophy, psychology, anthropology cognitive sciences, to take the necessary steps.

To read "On Fairy-Stories" is almost like reading typical Tolkienian prose, full of double meanings, suggested images of distant landscapes glimpsed from a distance. As all other Tolkien's works, "On Fairy-Stories" escapes conclusive readings or interpretations. Nevertheless,

"On Fairy-Stories" is Tolkien's defining study of and the centre-point in his thinking about a genre, as well as being the theoretical basis for his fiction. Thus it is both the essential and natural companion to his fiction. (Flieger & Anderson, 2014b, p. 9)

ACKNOWLEDGEMENT

This chapter had the support of CHAM (NOVA FCSH/UAc), through the strategic project sponsored by FCT (UID/HIS/04666/2019).

BIBLIOGRAPHICAL REFERENCES

Auerbach, Erich. (2003). *Mimesis: the representation of reality in Western literature* (50th-anniversary ed. Translated from the German by Willard R. Trask; with a new introduction by Edward W. Said. 1st ed. 1946). Princeton: Princeton University Press.

Bal, Mieke. (2009). *Narratology: introduction to the theory of narrative* (3ª ed). Toronto: University of Toronto Press.

Barfield, Owen. (1967). *Speaker's meaning*. Middletown: Wesleyan University Press.

—. (1987). *Poetic diction: a study in meaning* (3rd ed. ed). Middletown, Conn.: Wesleyan University Press.

Barthes, Roland. (1989). *The rustle of language* (Richard Howard, Trans.). Berkeley: University of California Press.

Bradley, Raymond, & Swartz, Norman. (1979). *Possible worlds: an introduction to logic and its philosophy*. (pp. xxi, 391 p.). Indianapolis: Hackett Pub. Co.

Carpenter, Humphrey. (1978). *J. R. R. Tolkien: A Biography*. Londres: George Allen and Unwin.

—. (1997). *The Inklings: C. S. Lewis, J. R. R. Tolkien, Charles Williams and their Friends*. London: HarperCollins.

Curry, Patrick. (1998). *Defending Middle-Earth: Tolkien: myth and modernity*. London: HarperCollins.

Dasent, George Webbe (Ed.) (1859). *Popular Tales from the Norse: With an introductory essay on the Origin and*

25. This quotation is taken from the final pages of the essay; many pages before Tolkien had made a similar statement: "[the writer] makes a Secondary World which your mind can enter. Inside it, what he relates is 'true': it accords with the laws of that world. You therefore believe it, while you are, as it were, inside. The moment disbelief arises, the spell is broken; the magic, or rather art, has failed. You are then out in the Primary World again, looking at the little abortive Secondary World from outside" (1983d, p. 132).

Diffusion of Popular Tales (2nd enlarged ed.). Edinburgh: Edmonston and Douglas.

Doležel, Lubomír. (1998). *Heterocosmica: Fiction and Possible Worlds*. Baltimore: John Hopkins University Press.

—. (2010). Possible Worlds and Literary Fictions. In Sture Allén (Ed.), *Possible Worlds in Humanities, Arts, and Sciences: Proceedings of Nobel Symposium 6* (pp. 221–242). Berlin: W. de Gruyter.

Eco, Umberto. (1979). *The role of the reader: explorations in the semiotics of texts*. Bloomington: Indiana University Press.

—. (1990). *The limits of interpretation*. Bloomington: Indiana University Press.

—. (1992a). Between author and text. In *Interpretation and overinterpretation* (pp. 69–88). Cambridge: Cambridge University Press.

—. (1992b). Overinterpreting texts. In Umberto Eco & Stefan Collini (Eds.), *Interpretation and overinterpretation* (pp. 45–66). Cambridge: Cambridge University Press.

—. (1994). *Six walks in the fictional woods*. Cambridge, Mass.: Harvard University Press.

Flieger, Verlyn. (1991). The Sound of Silence: Language and Experience in *Out of the Silent Planet*. In Peter J Schakel & Charles Huttar (Eds.), *Word and Story in C. S. Lewis* (pp. 42–57). Columbia: University of Missouri Press.

—. (2017). *There would always be a fairy tale: more essays on Tolkien*. Kent, OH: The Kent State University Press.

Flieger, Verlyn, & Anderson, Douglas. (2014a). The History of "On Fairy-Stories". In *On Fairy-Stories* (pp. 122–158). London: HarperCollins.

—. (2014b). Introduction. In Verlyn Flieger & Douglas Anderson (Eds.), *On Fairy-Stories* (pp. 9–23). London: HarperCollins.

Forster, E. M. (1985). *Aspects of the novel*. San Diego: Harcourt Brace Jovanovich.

Holland, Norman Norwood. (2009). *Literature and the brain*. Gainesville: The PsyArt Foundation.

Kreiswirth, Martin. (2005). Narrative Turn in the Humanities. In David Herman & Marie-Laure Ryan (Eds.), *Routledge Encyclopedia of Narrative Theory* (pp. 377–382). London: Routledge.

Leavis, F. R. (1972). *The Great Tradition*. Londres: Penguin Books.

Lewis, C. S. (1973). New Learning and New Ignorance. In Kenneth Allott & Norman Davis (Eds.), *English Literature in the Sixteenth Century, Excluding Drama*. Oxford: Oxford University Press.

—. (1988). *Letters of C. S. Lewis* (Walter Hooper Ed. Rev. and enl. ed. With a memoir by W.H. Lewis). London: HarperCollins.

—. (Ed.) (1947). *Essays presented to Charles Williams*. London: Oxford University Press.

Lewis, David. (1978). Truth in Fiction. *American Philosophical Quarterly*, 15 (1), 37–46. http://www.jstor.org/stable/20009693. doi:10.2307/20009693.

Michelson, Paul E. (2012). The Development of J. R. R. Tolkien's Ideas on Fairy-Stories. *Inklings Forever*, 8, 1–11.

Monteiro, Maria do Rosário. (1992). *J. R. R. Tolkien, The Lord of the Rings; A Viagem e a Transformação*. Lisboa: INIC. Retrieved from http://hdl.handle.net/10362/14067

—. (1993). Númenor: Tolkien's literary Utopia. *History of European Ideas*, 16 (4–6), 633–638. http://dx.doi.org/10.1016/0191-6599(93)90199-Z. doi:10.1016/0191-6599(93)90199-Z.

—. (1997). *A Simbólica do Espaço nos Mundos Fantásticos Neo-Românticos: Análise Comparativa das Obras The Lord of the Rings e Earthsea*. (PhD in Comparative Literature), Universidade NOVA de Lisboa, Lisbon.

—. (2000). As Viagens nos Mares Fantásticos de Middle-earth e Earthsea: A Busca da Identidade e o Confronto com o Outro. In Isabel Allegro de MAGALHÃES (Ed.), *Literatura e Pluralidade Cultural* (pp. 915–922). Lisboa: Edições Colibri.

—. (2010). *A Simbólica do Espaço em O Senhor dos Anéis, de J. R. R. Tolkien*. Viana do Castelo: Livros de Areia. Retrieved from http://hdl.handle.net/10362/14314

—. (2014). *Heroes in The Lord of the Rings: Tradition and Modernity*. Paper presented at the International Conference Worlds made of Heroes. Plenary Session. University of Porto.

—. (2015). *Ainulindalë; Criação e Ordenação do Caos na Obra de Tolkien*. Paper presented at the 1º Congresso de História e Mitologia Lisbon.

Noad, Charles E. (2000). On the Construction of *The Silmarillion*. In Verlyn Flieger & Carl F. Hostettler (Eds.), *Tolkien's Legendarium; Essays on the History of Middle-earth* (pp. 31–68). Westport: Greenwood Press.

O'Neill, Timothy. (1980). *The Individuated Hobbit: Jung, Tolkien and the Archetypes of Middle-earth* (2ª ed). Londres: Thames and Hudson.

Pavel, Thomas. (1986). *Fictional Worlds*. Cambridge, MA: Harvard University Press.

—. (1988). *Univers de la Fiction*. Paris: Editions du Seuil.

Pearce, Joseph. (1998). *Tolkien: Man and Myth*. Londres: HarperCollins.

Ryan, Marie-Laure. (1992). *Possible Worlds, Artificial Intelligence, and Narrative Theory*. Bloomington: Indiana University Press.

—. (2011). Meaning, intent, and the implied author. *Style*, 45 (1), 29–47. http://go.galegroup.com/ps/i.do?id=GALE%7CA258993716&v=2.1&u=wash89460&it=r&p=ITOF&sw=w. (2012/7/10/).

—. (2013, 27. September 2013). Possible Worlds. The living handbook of narratology Retrieved from http://www.lhn.uni-hamburg.de/article/possible-worlds.

—. (2015a). *Narrative as virtual reality 2: revisiting immersion and interactivity in literature and electronic media* (2nd revised ed). Baltimore: Johns Hopkins University Press.

—. (2015b). Texts, Worlds, Stories: Narrative Worlds as Cognitive and Ontological Concept. In Mari Hatavera, Matti Hyvärinen, Maria Mäkelä, & Frans Mäyrä (Eds.), *Narrative Theory, Literature, and New Media: Narrative Minds and Virtual Worlds* (pp. 13–28). London: Routledge.

—. (2017). Why Worlds Now? In Mark J. P. Wolf (Ed.), *Revisiting Imaginary Worlds* (pp. 3–13). London: Routledge.

Thomas the Rhymer. (1912). In Arthur Thomas QUILLER-COUCH (Ed.), *The Oxford Book of English Verse, 1250–1900* (pp. 400–403). Oxford: Clarendon Press.

Tolkien, J. R. R. (1981a). *Letters of J. R. R. Tolkien* (Humphrey Carpenter Ed. A selection edited by Humphrey Carpenter with the assistance of Christopher Tolkien). London: George Allen & Unwin.

—. (1981b). *The Letters of J. R. R. Tolkien* (Humphrey Carpenter Ed.). London: George Allen and Unwin.

—. (1983a). Beowulf: The Monsters and the Critics. In Christopher Tolkien (Ed.), *The Monsters and the Critics and Other Essays* (pp. 5–48). Londres: George Allen and Unwin.

—. (1983b). *The Hobbit: Or There and Back Again* (4th ed. 1ª ed. 1937). Londres: Unwin Paperbacks.

—. (1983c). *The Monsters and the Critics and Other Essays* (Christopher Tolkien Ed.). Londres: George Allen and Unwin.

—. (1983d). On Fairy-Stories. In Christopher Tolkien (Ed.), *The Monsters and the Critics and Other Essays* (pp. 109–161). London: George Allen and Unwin.

—. (1983e). *The Silmarillion* (Christopher Tolkien Ed. 3rd ed. 1ª ed. 1977). Londres: Unwin Paperbacks.

—. (1983–1996). *The History of Middle-earth* (Christopher Tolkien Ed. 12 vols). London: George Allen & Unwin.

—. (2005). *The Lord of the Rings* (50th anniversary 1 vol. ed. 1st ed. 1954–1955). London: HarperCollinsPublishers.

—. (2014). *On Fairy-Stories* (Verlyn Flieger & Douglas Anderson Eds.). London: HarperCollins.

—. (2016). *A Secret Vice* (Dimitra Fimi & Andrew Higgins Eds.). London: HarperCollins.

Walton, Kendall L. (1990). *Mimesis as make-believe: on the foundations of the representational arts*. Cambridge, Mass.: Harvard University Press.

Wolf, Mark J. P. (2013). *Building imaginary worlds: the theory and history of subcreation*. New York: Routledge.

Victorious nature in Anglo-Saxon England and fantasy Middle-earth

Andoni Cossío
University of the Basque Country (UPV/EHU), Spain
ORCID: 0000-0003-2745-5104

ABSTRACT: Common sense argues that a writer with a personal appeal for Old English who worked as a Rawlinson and Bosworth Professor of Anglo-Saxon at Oxford for twenty years (1925–1945) must have had been influenced by this scholarship. From that starting point, this paper aims to provide a source study on how the Anglo-Saxon poem *The Ruin* from the *Exeter Book*, is echoed in some descriptions in J. R. R. Tolkien's *The Lord of the Rings*. With that intention in mind, a modern and quite literal translation by Kevin Crossley-Holland of *The Ruin* (2009) is compared and contrasted with three descriptive passages of ruins in *The Lord of the Rings*: the remains of now-extinct civilisations as found next to Trollshaws, at the foot of Amon Hen and North Ithilien including Minas Morgul. It is not difficult to perceive that all three of Tolkien's passages, bear a slight if not strong resemblance with their Anglo-Saxon counterpart. The description, tone, imagery and topic portrayed in *The Ruin* could have fascinated Tolkien, a writer deeply immersed in the Anglo-Saxon world, due to his personal ecological stance. Conscious or unconsciously this may have triggered the inclusion of the theme in his passages, which echo elements from the poem. Even if this were not the case, it would seem that both the writer of the Anglo-Saxon poem and Tolkien must have shared a similar mindset on the representation of how nature triumphs over man-made works.

Keywords: Anglo-Saxon poetry, *The Ruin*, *The Lord of the Rings*, nature triumphs, J.R.R. Tolkien

1 INTRODUCTION

The composition and structure of Anglo-Saxon literary works were crafted to be sung, as their literature was oral. This means as R. P. Creed points out, that the Germanic oral tradition of the Anglo-Saxons was subjected continuously to both slight and profound changes that shaped the form of poems, songs and tales (1986, p. 137). The free variation allowed the circulation of multiple versions of the works in an age when authorship was not a central concern as it is nowadays. As a result, most of the Anglo-Saxon works are anonymous, and the versions which were collected in a physical format can be variations of works produced a long time ago.

This is the case in many texts in the *Exeter Book*, a compilation of all types of works written in Old English which was, in R. F. Leslie's words, composed at the end of the tenth century (1966, p. 1) and deposited in the Library of Exeter Cathedral before 1072 AD according to Max Förster (1933, p. 10). R. W. Chambers remarked its value in 1933, a claim that twenty-first-century academia would not fail to defend:

> The Exeter Book is one of the most essential documents of that remarkable civilisation of pre-Conquest England, the true importance of which in European history we are only slowly beginning to realise. (1933, p. 1)

But what is so unique about this manuscript to deserve so much attention? First of all, it is one of the few surviving instances of Old English Poetry and secondly, the great number of mysteries still unravelled attracts important scholars. Although Mary R. Rambaran-Olm claims that critics agree upon the manuscript most likely being of West Saxon origin and written in the last years of the tenth century (2014, p. 27), no specific date or location has been proven. It is difficult to attribute the works to a specific author,[1] such as the well-known poets Cædmon, Aldhelm or even Cynewulf because although some poems are signed under that name, there is no historical record which shows proof that such a person ever existed (Chambers, 1933, p. 2). In addition, the improper preservation of the manuscripts, which leaves the reader of Old English works to face texts which lack a proper setting, incomplete lines or even passages, and the significant number of undeciphered meanings which need to be decoded, ultimately explain why "our knowledge of Old English poetry is, and must ever be, quite fragmentary" (Chambers, 1933, p. 2).

1. For a summary of the discussion on authorship of the *Exeter Book* since 1857 see Michelle Igarashi (2002, pp. 345–346).

Perhaps this mystery is what seduced J. R. R. Tolkien, who was fascinated by Old English language and poetry from a very early age, and his knowledge and interest grew as he got older. So much so, that Humphrey Carpenter describes how Dr Henry Bradley, his superior and second editor when working for *The Oxford English Dictionary*, reports of Tolkien's knowledge: "his work gives evidence of an unusually thorough mastery of Anglo-Saxon" (Carpenter, 2000, p. 108). Thus, taking into account both his skill and passion, Tolkien at the early age of thirty-three applied and attained the Rawlinson and Bosworth Chair of Anglo-Saxon at Oxford, which he held for twenty years (1925–1945). Therefore, most of his youth and adulthood was devoted to the study and teaching of Anglo-Saxon language and literature, which must have had an impact on his writings. Furthermore, as Nicholas J. Higham and Martin J. Ryan seem to imply J. R. R. Tolkien's *The Lord of the Rings* has introduced many scholars to the study of the Anglo-Saxon world (Higham & Ryan, 2015, p. 7), something which this paper, as a by-product of previous research on this novel, should corroborate as true.

It can certainly be asserted that some echoes of Anglo-Saxon poetry may have filtered through to his works. Among the topics treated in Anglo-Saxon poetry, there is one that suits Tolkien's narrative particularly well. Della Hooke explains, referring to Old English poetry, how the natural world is portrayed as intimidating, ominous, menacing and overall, as of having greater importance than the human species (Hooke, 2010, p. 71). An Old English poem belonging to the Exeter Book named *The Ruin*, which supports Hooke's observation, is described as unique by Silvia Geremia:

> this poem has a contemplative tone and a mainly descriptive style; unlike in other elegies, the narration is in the third person singular and does not deal with stories of personal suffering. (2014, p. 102)

Paraphrasing Françoise Grellet, the observation of an object from far above by an external focaliser, with unlimited knowledge in some cases, is called a 'panoramic view' (2009, p. 101). In *The Ruin*, this general overview is offered in combination with a complete understanding of the history of the place. To this, it can be added the not so common topic of the perishability of human works and the natural world's ability to prevail over them, which is overtly present in *The Ruin*, and a similar theme and structure can be traced in some passages of Tolkien's *The Lord of the Rings*.

Tom Shippey in the revised and expanded edition of *The Road to Middle-earth* (2003) acknowledges that Tolkien employed *The Ruin* as a source (p. 344). In particular, Shippey believes Tolkien modified and incorporated *The Ruin* where Legolas, in the surrounding area of Moria, hears the stones' sorrow at the departure of the elves[2] (2003, p. 33). Although I acknowledge Shippey's claim, I believe the influence of *The Ruin* in *The Lord of the Rings* cannot be limited to the adaptation and inclusion of a single excerpt.

I intend to show how the topic of nature prevailing over human-made works, epitomised in the Anglo-Saxon poem *The Ruin* from the *Exeter Book*, is echoed in some descriptions in J. R. R. Tolkien's *The Lord of the Rings*.[3] I also consider that Tolkien was not only inspired by the theme, but also by the descriptions in the Old English poem.

In order to provide a quality source study of Tolkien, I will follow Jason Fisher's guidelines by: one, proving Tolkien was familiar with the source (Fisher, 2011, p. 37) and two, by credibly demonstrating how he employed and integrated the material into his work (Fisher, 2011, p. 39). With that intention in mind, a modern and quite literal translation by Kevin Crossley-Holland of *The Ruin*[4] is compared and contrasted with three descriptive passages of ruins in *The Lord of the Rings*: the remains of now-extinct civilisations as found next to Trollshaws, at the foot of Amon Hen and North Ithilien including Minas Morgul.

2 *THE RUIN*: NATURE TRIUMPHS

Based on a study of the linguistic and metrical criteria, *The Ruin* is apparently datable before the middle of the eighth century (Leslie, 1966, pp. 34–6). The poem is incomplete, lines 12, 39, 40, 41 and 42 miss some words and line 13 is entirely missing as laid out in Crossley-Holland's translation (2009a, pp. 59–60). Yet, this gap does not impede the clear understanding nor prevents the reader from grasping the central motif of the poem.

Concerning the location Chambers assumes that the remains of the Roman town described in *The Ruin* is likely to be Bath (Chambers, 1933, p. 1; Leslie, 1966,

2. "Deep they delved us, fair they wrought us, high they builded us; but they are gone." (Tolkien, 2004, p. 284).
3. Although the article focuses primarily on this point, it is worth mentioning that *The Ruin* may also have influenced Tolkien by providing a characteristic *topos* of Old English literature: the *wyrd* or "the blindly ruling Fate" (Timmer, 1941, p. 25). *The Ruin* reflects upon how fleeting human lives are ruled by this *wyrd*, translated twice as "fate" (Crossley-Holland, 2009a, pp. 59–60: ll. 1, 20). This *topos* is echoed by Tolkien in his narratives set on Middle-earth, where the protagonists of the events narrated become the chosen ones among the many who had lived before and who would come after, not due to merit or will, but because of this whimsical *wyrd*. As Gandalf explains to Frodo, all the Free Peoples wish that Sauron had not risen once again during their time, "but that is not for them to decide. All we have to decide is what to do with the time that is given us" (Tolkien, 2004, p. 51).
4. The reason for such a choice is based on Crossley-Holland's translation being very close to the literal meaning and thus, since comparing it with prose, the parallels can be more easily established.

p. 25; Crossley-Holland, 2009b, p. 49) and therefore, a real-world setting. Drawing the first parallel, Tolkien's *The Lord of the Ring* is also set in our world:

> Middle-earth is not an imaginary world (…) The theatre of my tale is this earth, the one in which we now live, but the historical period is imaginary. (Tolkien, 2000, p. 239)

Moving on, *The Ruin* is an elegiac poem (Crossley-Holland, 2009b, p. 46) similar to others of the same period, which are deeply connected to lament and sadness. Crossley-Holland identifies the main topic of the poem as "everything man-made will perish, and that there is no withstanding the passing years" (2009b, p. 49) and the poem is tinged with admiration and celebration but not loss (2009b, p. 49). These feelings are certainly justifiable based on Anglo-Saxon architecture being totally different from Roman stone buildings, since as Helena F. Hamerow points out they primarily built of "timber and other perishable materials" (2012, p. 1). Thus, every certain number of years houses had to be rebuilt somewhere else. Anglo-Saxon villages did not seem to be on the whole static (Hamerow, 1991, p. 2), and this model of shifting settlement was widespread between the fifth and seventh century (Hamerow, 2012, p. 67), nucleated villages emerging as late as mid-ninth century onwards (Hamerow, 2012, p. 94).[5] These claims demonstrate that the poem offers an insight into the organisation of Anglo-Saxon settlements, which are far from the majority of present and past western society's need to leave an imprint of their architectural accomplishments at all costs.

On the other hand, early Anglo-Saxons did not have the skill to build in stone, and they would refer to them as the works of giants (Crossley-Holland, 2009, p. 49) regarding those places with awe. There was something mysterious and magical about it, not necessarily negative and yet one cannot but feel pity for the decaying state of those once magnificent structures. That is the reason why Leslie argues that decay is the brooding and main feeling of the poem (1966, pp. 28–9): "the effect is of a vast desolation, intensified here and there by the pathos of the decay of individually portrayed objects" (1966, p. 28), something which is ultimately supported by the well-chosen title.

3 RESONANCES OF OLD IN THE NEW

Undoubtedly, *The Lord of the Rings* is charged with the presence of Anglo-Saxon society, culture, political organisation, art, and literature. As for literature, in Martin Simonson's opinion, two remarkable instances

5. For a better grasp of intra-settlement building mobility with real examples see Hamerow (1991, pp. 1–17) and chapter 3 of Hamerow (2012, pp. 67–119). See Hamerow (2012, p. 94) for a discussion on the dates of emergence of nucleated villages.

can be taken which bear resonances of the Old English poems *The Wanderer* and *Beowulf*. In the former, when approaching Méduseld, Aragorn sings a song similar to the Old English poem *The Wanderer* (Simonson, 2008, p. 168). Whereas in the latter, there is certain parallelism between the arrival of Aragorn at Méduseld and that of the epic hero Beowulf at Heoroth (Simonson, 2008, pp. 168–169).

Moving on to the main discussion, there are several passages in *The Lord of the Ring* which evoke the topic of nature taking over, which is central in *The Ruin*. The first the reader encounters concerns the remains of a now-extinct civilisation next to the woods of Trollshaws. When Frodo, Sam, Merry, Pippin and Strider/Aragorn enter the area, a gloomy atmosphere broods over them: "they were lost in a sombre country of dark trees (…) this new country seemed threatening and unfriendly" (Tolkien, 2004, p. 201). Humans, under the shadow of Angmar and long ago perished, used to dwell in these parts and left their monuments as the only reminder:

> Here and there upon heights and ridges they caught glimpses of ancient walls of stone, and the ruins of towers: they had an ominous look. (Tolkien, 2004, p. 201)

This quote partially reminds one of the first four lines of *The Ruin*:

> Wondrous is this stone-wall, wrecked by fate;
> the city-buildings crumble, the works of the giants decay.
> Roofs have caved in, towers collapsed,
> barred gates are broken, hoar frost clings to mortar. (Crossley-Holland, 2009a, p. 59: ll. 1–4)

There is a distinct difference in style mainly caused by one being verse and the other prose, but still both make use of an external third-person focaliser. Additionally, the desperation is overtly latent in the poem and the narrative of the loss, despite Crossley-Holland's claim of the poem conveying a positive stance (2009b, p. 49). Indeed, the mourning for what is lost cannot be ignored. According to Jennifer Neville (2004, p. 55), the crumbling walls may also represent the necessity for humans to provide themselves with proper defences, though in my view, the walls may portray the futile efforts of homo sapiens to protect themselves from nature and leave an imprint on the landscape.

These four verses are also comparable to the description of the ruined town of Dale in *The Hobbit* by Tolkien, which shares the same setting as *The Lord of the Rings*: "they could see in the wide valley shadowed by the Mountain's arms the grey ruins of ancient houses, towers and walls" (Tolkien, 1999, p. 189). The tone and imagery are what bind together these three instances, producing a similar effect.

The second passage under the influence of despair in The Lord of the Rings occurs when Frodo goes

into the woods at the foot of Amon Hen to deliberate which course to take next. In these woods, nature has overcome the works of an ancient civilisation:

> He came to a path, the dwindling ruins of a staircase of long ago. In steep places stairs of stone had been hewn, but now they were cracked and worn and split by the roots of trees. (Tolkien, 2004, p. 396)

In *The Ruin* the natural forces at work that cause destruction are different, but the source is virtually the same: "hoar frost clings to mortar" (Crossley-Holland, 2009a, p. 59: l. 4) and "the city still moulders, gashed by storms" (2009a, p. 60: l. 12).

Lastly, the third example in Tolkien's work can be found in Ithilien, which he considered being a "lovely land" (Tolkien, 2000, pp. 76, 79). He was in fact thrilled by natural beauty and considering his ecological stance, which clamoured for the rights of environmental preservation, he may not have perceived nature's conquest to be wholly negative. And yet, the tragic fate of Gondorians' infrastructure of old appears to suffer the same disastrous destiny as its predecessors, creating a negative atmosphere again:

> The road had been made in a long lost time, and for perhaps thirty miles below the Morannon it had been newly repaired, but as it went south, the wild encroached upon it. The handiwork of Men of old could still be seen in its straight sure flight and level course: now and again it cut its way through hillside slopes, or leaped over a stream upon a wide shapely arch of enduring masonry, but at last all signs of stonework faded, save for a broken pillar here and there, peering out of bushes at the side, or old paving-stones still lurking amid weeds and moss. (Tolkien, 2004, p. 649)

There is a similarity at this point in the flora; moss is fairly similar in physical form, though not in colour, to lichen which also triumphs over the city in *The Ruin*: "This wall, grey with lichen / and red of hue" (Crossley-Holland, 2009a, p. 59: ll. 9–10). The lichen is not destroying, but staining, and slowly conquering the remains. In Ithilien, are not only roads sinking little by little and being overgrown, but also cities of old. Minas Ithil, renamed as Minas Morgul, is another human-made site embraced by decadence:

> There it seemed to Frodo that he descried far off, floating as it were on a shadowy sea, the high dim tops and broken pinnacles of old towers forlorn and dark. (Tolkien, 2004, p. 697)

The beheaded statue of a king that the hobbits encounter when reaching the Cross-roads offers even stronger evidence: the memorial is said to have been gnawed by the passing of time (Tolkien, 2004, p. 702), its head being crowned by flowers. Yet Tolkien also says that the flowers crown the head "*as if in reverence for the fallen king*" leaving some room for kindness (Tolkien, 2004, p. 702). However, this could also be interpreted as the bleak fact that nature will outlast both

good and evil (Simonson, 2008, p. 210). The crown of flowers is the last and most dreadful symbol for the Gondorians: perhaps they will be victorious in the war, perhaps they may even withstand the passing of the years, but when they die even their mammoth, and supposedly 'everlasting' works cannot survive nature's unstoppable conquest.

4 CONCLUSION

After the analysis of the echoes of *The Ruin* in J.R.R. Tolkien's *The Lord of the Rings*, it can be claimed that there are some provable resonances of the topic of nature taking over civilisation, that could have inspired certain passages of the latter work. It is not difficult to perceive that all three of Tolkien's passages, bear a slight if not strong resemblance with their Anglo-Saxon counterpart. The description, tone, imagery and topic portrayed in *The Ruin* could have fascinated Tolkien, a writer deeply immersed in the Anglo-Saxon world, due to his personal environmental stance. Conscious or unconsciously this may have triggered the inclusion of the theme in his passages, which echo elements of the poem. Even if this were not the case, it would seem that both the writer of the Anglo-Saxon poem and Tolkien must have shared a similar belief in that nature inevitably triumphs over human-made works.

ACKNOWLEDGEMENT

This essay was completed under the auspices of the REWEST research group (code: IT 1026–16), funded by the Basque Government (Dpto. de Educación, Universidades e Investigación / Hezkuntza, Unibertsitate eta Ikertu Saila) and the University of the Basque Country, UPV/EHU.

BIBLIOGRAPHICAL REFERENCES

Carpenter, Humphrey. (2000) *J.R.R. Tolkien: A Biography.* (Paperback ed.). Boston & New York: Houghton Mifflin.

Chambers, R. W. (1933) "The Exeter Book and Its Donor Leofric." In R. W. Chambers et al. (ed.), *The Exeter Book of Old English Poetry* (pp. 1–9). London: Humphries & Co Ltd.

Creed, R. P. (1986) "The Remaking of *Beowulf*." In J. M. Foley (Ed.), *Oral Tradition in Literature, Interpretation in Context* (pp. 136–146). Columbia: University of Missouri Press.

Crossley-Holland, Kevin (Trans.). (2009a) *The Ruin.* In Kevin Crossley-Holland (Trans.), *The Anglo-Saxon World: An Anthology* (Reissued paperback ed., pp. 59–60). Oxford & New York: Oxford University Press.

_____ (Trans.). (2009b) *The Anglo-Saxon World: An Anthology* (Reissued paperback ed.). Oxford & New York: Oxford University Press.

Fisher, Jason. (2011) "Tolkien and Source Criticism: Remarking and Remaking." In Jason Fisher (Ed.), *Tolkien and the Study of his Sources: Critical Essays* (pp. 29–44). Jefferson, NC & London: McFarland & Company.

Förster, Max. (1933) "The Donations of Leofric to Exeter." In R. W. Chambers et al. (ed.), *The Exeter Book of Old English Poetry* (pp. 10–32). London: Humphries & Co Ltd.

Geremia, Silvia. (2014) "The Husband's Message" and "The Wife's Lament": An Interpretation and a Comparison. Pavia & Como: Ibis.

Grellet, Françoise. (2009) A Handbook of Literary Terms: Introduction au vocabulaire littéraire anglais. Paris: Hachette Supérieur.

Hamerow, Helena F. (1991) "Settlement Mobility and the 'Middle Saxon Shift': Rural Settlements and Settlement Patterns in Anglo-Saxon England." In *Anglo Saxon England* (pp. 1–17). Vol. 20. Jan 1991. Cambridge: Cambridge University Press.

_____. (2012) Rural Settlements and Society in Anglo Saxon England. Oxford: Oxford University Press.

Higham, Nicholas J. and Martin J. Ryan. (2015) *The Anglo-Saxon World* (Paperback ed.). New Haven & London: Yale University Press.

Hooke, Della. (2010) *Trees in Anglo-Saxon England: Literature, Lore and Landscape*. Woodbridge & Rochester, NY: The Boydell Press.

Igarashi, Michelle. (2002) "Riddles." In Laura C. Lambdin and Robert T. Lambdin (eds.), *A Companion to Old and Middle English Literature* (pp. 336–351). Westport, Conn. and London: Greenwood Press.

Leslie, R. F. (ed.). (1966) *Three Old English Elegies, The Wife's Lament, The Husband's Message and The Ruin* (Reprinted ed.). Manchester: Manchester University Press.

Neville, Jennifer. (2004) *Representations of the Natural World in Old English Poetry*. Cambridge: Cambridge University Press.

Rambaran-Olm, Mary R. (2014) 'John the Baptist's Prayer', Or, 'The Descent into Hell' from the Exeter Book: Text, Translation and Critical Study. Cambridge: D. S. Brewer.

Shippey, Tom. (2003) *The Road to Middle-Earth* (Rev. ed.). New York: Houghton Mifflin.

Simonson, Martin. (2008) *The Lord of the Rings and the Western Narrative Tradition*. Zurich and Jena: Walking Tree Publishers.

Tree and forest models in Victorian/Edwardian fantasy: MacDonald, Morris and Grahame as triggers of J. R. R. Tolkien's Creativity

Andoni Cossío
University of the Basque Country (UPV/EHU), Spain
ORCID: 0000-0003-2745-5104

ABSTRACT: Creativity is known to be the art of crafting a new work. However, its innovative nature tends to be more limited than generally believed, as its building blocks frequently belong to previous creators. In literature, and therefore in fantasy, it is a commonplace to look into the past in order to reuse and adapt successful old models. In this sense J. R. R. Tolkien was no exception, building the credible world of Arda with the aid of legends, myths, characters and landscapes from different periods. Tolkien was a writer who belonged to the modernist period by chronology, but who shared more with the literature of Victorian/Edwardian England. By using Jason Fishers' (2011) tenets for acceptable Tolkien source criticism, this paper aims to show that the portrayal of trees and forests in the works of George MacDonald's *Phantastes*, William Morris' *The House of the Wolfings* and Kenneth Grahame's *The Wind in the Willows* served as the catalysts that triggered Tolkien's creativity in *The Hobbit* and *The Lord of the Rings*. Tolkien was well acquainted with these novels as his letters and biography corroborate. The passages and examples here analysed, not only vouch for his own words, but also show how he developed and combined these writers' characterisation of trees and forests with his imagination to create and develop certain aspects of the Ents, Mirkwood and the Old Forest.

Keywords: Trees, Tolkien, creativity, fantasy, Victorian/Edwardian

Humphrey Carpenter's *J.R.R. Tolkien: A Biography* (1977), since it first came out, has helped generations of scholars to unravel many traits of Tolkien's personality and appeal, and in many cases its connection with his writings. Although not central in the biography, Tolkien's profound sympathy towards the natural world is evident, in particular, his feelings for trees and forests:

> I am (obviously) much in love with plants and above all trees, and always have been; and I find human maltreatment of them as hard to bear as some find ill-treatment of animals. (Tolkien, 2000, p. 220; c.f. Hammond and Scull, 2002, p. 62)

Trees, in fact, were "a favourite image" (Carpenter, 2000, p. 82) of Tolkien. These claims serve well as a synthesis and justification for the great predominance of trees and forests in his fiction.

Tolkien, better known for his writings, was also a skilful illustrator, whose drawings often include trees. In *J. R. R. Tolkien: Artist and Illustrator* (1995) of the one hundred and ninety-seven pieces of artwork by Tolkien, ninety-six portray either trees or wooded areas, in many cases a given tree being a central figure or the most prominent element in the composition

However, his passion for trees in real-life and art, were not the sole sources which shaped his literary

creativity. As a voracious reader, it is easy to see that specific written sources, literary and mythical, may have provided useful ideas on how to represent trees in his fiction.

However, what does literary creativity entail? According to José Antonio Marina and Álvaro Pombo, literary creation must give birth to a valuable novelty (2013, p. 19). The same applies to fantasy literature, where creators are not bound by anyone's norms but their own (Falconer, 2014, p. 306). Nevertheless, its innovative nature tends to be more limited than generally believed, as its building blocks frequently belong to previous creators. As in the words of the well-known psychologist Mihaly Csikszentmihalyi:

> Creativity (…) is a process by which a symbolic domain in the culture is changed. New songs, new ideas, new machines are what creativity is about. But because these changes do not happen automatically as in biological evolution, it is necessary to consider the price we must pay for creativity to occur. It takes effort to change traditions. (…) A musician must learn the musical tradition, the notation system, the way instruments are played before she can think of writing a new song. (2013, p. 8)

This also entails that any new creation must be socially validated within a given sociocultural system

(Csikszentmihalyi, 2013, p. 23), and appreciated enough to justify its cultural inclusion (Csikszentmihalyi, 2013, p. 25). It undoubtedly helps to incorporate successful previous models to ensure acceptance. Therefore, as proven by the psychological/sociological studies, this leads us to the principle that the new needs to be partially based on the old.

Tolkien was a writer who belonged to the modernist period by chronology,[1] but whose fiction was closer to the literature of Victorian/Edwardian England. Rachel Falconer asserts that it is reasonable to count George MacDonald, William Morris and Kenneth Grahame as having influenced Tolkien's work (2014, p. 303–304). Evidence may be found in Tolkien's letters and biography that he was well aware of this influence, as it will be shown. I aim to take that claim a step further by positing that those three writers served as the catalyst that triggered Tolkien's creativity when designing his trees and forests. However, even if studies on Tolkien's sources have been numerous, until now, little effort has been made to trace the sources of his trees and forests.

Tolkien and the Study of His Sources: Critical Essays (2011) edited by Jason Fisher, is considered to be one of the most compelling studies on Tolkien source criticism, which has a solid theoretical stance and practical application. Nevertheless, trees and forests are definitely not the focus, and influences of trees from Victorian/Edwardian literature are absent altogether. The word tree does not even appear in the index, Old Man Willow is mentioned once, and Ents are mentioned thrice. Lothlórien and Mirkwood are the only forests mentioned, but only three times, without adding any substantial or new material regarding how trees from Victorian/Edwardian literary works shaped Tolkien's.

A Companion to J. R. R. Tolkien (2014) edited by Stuart D. Lee also offers exciting insights into Tolkien's sources, but none of the articles explores the influences other literary trees and forests had on Tolkien. Falconer in "Earlier Fantasy Fiction: Morris, Dunsany, and Lindsay" discusses some elements of Morris' *The House of the Wolfings* (1889) in relation to Tolkien, mainly treating the concept of fellowship and only analysing the forest in relation to the characters in Morris' novel.

Julian Eilmann in *J.R.R. Tolkien: Romanticist and Poet* (2017) briefly shows some of the tree and forest influences of MacDonald in Tolkien's literature. I aim to expand on Eilmann's claims, put them into context and then shed light on similar influences of Morris and Grahame.

In order to ensure the quality of the study, some fundamental notions of Tolkien source criticism must

first be set. Then Tolkien's creativity will be explored comparing MacDonald, Morris' and Grahame's texts side by side with Tolkien's *The Hobbit* (1937) and *The Lord of the Rings* (1954–1955), to understand which trees and forests he borrowed and how he incorporated them.

1 TOLKIEN SOURCE CRITICISM

At this point, it is relevant to highlight the importance of Tolkien source criticism concerning its academic value, as stated by Fisher:

> An understanding of the sources Tolkien utilized, as well as how and why he incorporated them, can enhance readers' appreciation of his works immeasurably. (2011a, p. 2)

This is also true for the source, as it emphasises its value. In the case of this study, it will add a better understanding of how trees and forests were conceptualised and re-represented together with their symbolical and narratological use. Thus, it is not only an exercise of appreciation but also of knowledge. In every case, one must proceed with care because, as Tom Shippey warned, similarity cannot be mistaken for influence (2011, p. 10).

In order to avoid such mistakes, Fisher establishes two tenets for an effective and academically valuable analysis of Tolkien's sources, which I aim to follow. Firstly, it is necessary to demonstrate that Tolkien had access to a given source, as failure to do so will derive in a comparative study, not source criticism (Fisher, 2011b, p. 37). Secondly, the material which is used from the source has to be identified, and a plausible argument presented as to how the source was used and how the material was incorporated (Fisher, 2011b, p. 39).

Fisher explains that most of the sources have been discovered, but he prompts scholars to search for new untrodden paths (2011a, p. 2). I aim to follow one of these and conduct this study from a different angle. Instead of merely trying to identify the source, I intend to trace the borrowed elements (trees and forests) and follow them through different works.

2 GEORGE MACDONALD

In all earnest, Tolkien admitted literary borrowings in several of his letters, but there is one of particular relevance as it addresses fairy-stories:

> I am not 'learned' in the matters of myth and fairy-story, however, for in such things (as far as known to me) I have always been seeking material, things of a certain tone and air, and not simple knowledge. (2000, p. 144)

This is relevant to the Victorian/Edwardian period as it witnessed a prolific evolution of Romantic fairy stories into modern fantasy. Tolkien acquainted himself thoroughly with these works, such as George MacDonald's, and there is written evidence of it as early as 1947 in the essay *On Fairy-Stories* (Tolkien, 2008, p. 44).

MacDonald was undoubtedly an influential figure to Tolkien, but over the years, he developed a distaste for the former's literature and tried to distance himself from him: "I am not as warm an admirer of George MacDonald as C. S. Lewis was" (Tolkien, 2000, p. 351). When requested by Pantheon Books of New York to write a preface for George MacDonald's *The Golden Key* (1867), he did not finish it because he realised how little sympathy he had for MacDonald's work by then, and wrote instead *Smith of Wootton Major* (1967) (Tolkien, 2000, p. 351). On this event, Eilmann remarks that with the writing of *Smith of Wootton Major* Tolkien wished to be distinguished from MacDonald (2017, p. 32). However, Eilmann also defends the position that MacDonald's influence is unavoidable. Tolkien's distaste for him was expressed for the first time in 1964, and thus, it does not deny the influence on Tolkien's earlier works (Eilmann, 2017, p. 181). Eilmann argues that since MacDonald fulfilled Tolkien's recovery[2] of the ordinary in all his works, and acted as a middleman of Tolkien's inherited Romanticism, MacDonald could not have been so uninfluential and loathed before 1964 (2017, p. 181). Direct proof of this is Tolkien's admission, in 1954 after *The Fellowship of the Ring* (1954) was published, that his Orcs in part shared traits with MacDonald's goblins (2000, pp. 178, 185). Therefore, by the time *The Lord of the Rings* was finished and the two other volumes awaited publication, it is safe to say Tolkien still held a positive opinion of MacDonald.

About the impact of specific works, Shippey signals *Phantastes* (1858) as noteworthy (2003, p. 351). Eilmann goes a step further, and provides specific evidence of MacDonald's influence:

> In Phantastes (…) good and bad tree spirits have a supporting role in the plot. Apparently, Tolkien was fascinated by MacDonald's notion of a rational nature which was in active communication with man. (2017, p. 178)

This influence is further justified by a letter now in the hands of a private collector. The international auction house Sotheby's is well-known to Tolkien scholars, especially for the unpublished letters from the author it has sold over the years. Of particular interest for this article is a letter from the 26th of October of 1958 to Mrs L.M. Cutts advertised in one of their auction catalogues, where some passages from the letter are included. Of particular interest is the part which explains that Ents in *The Lord of the Rings* may have been slightly inspired by MacDonald's *Phantastes* (Sotheby's, 2003, p. 297).

In *Phantastes* the Ash, the Alder, the Beech, the Birch, the Elm and the Oak with their properly capitalised nouns, act as fully-functional characters. In Carpenter's analysis of the trees in MacDonald's *Phantastes,* the Ash is described as masculine, father-like and the Beech as maternal (1985, p. 79). In fact, those characters are humanised by referring to them with feminine (MacDonald, 2000, p. 11) and masculine pronouns (MacDonald, 2000, p. 18) correspondingly, avoiding the grammatically correct 'it.' Their nature is also judged considering them as trustworthy (Oak, Elm and Beech), ambiguous (Birch) or dangerous (Ash and Alder), giving them agency (MacDonald, 2000, p. 18).

Tolkien's readers may easily associate all these features to Ents, Huorns and agentive trees. MacDonald catalogued different tree species according to their actions and personality in a polarised way, but Tolkien made the matter much more complex (See Tolkien, 2004, p. 468). Tolkien created a stratified race of Trees including Ents (shepherds), Huorns and agentive trees (sheep), with a historical background, a mythical story of their awaking by the Elves, and complex personality traits.

Moving towards a specific episode that may have shaped Tolkien's creativity, at the very end of *Phantastes*, once having gone back from Fairy Land, the protagonist Anodos sees an ancient beech-tree with new eyes (Tolkien's recovery[3] in full effect) perceiving a humanoid shape:

> I [Anodos] had lain down under the shadow of a great, ancient beech-tree, that stood on the edge of the field (…) I opened my eyes, and, for a moment, almost believed that I saw her face, with its many wrinkles and its young eyes, looking at me from between two hoary branches of the beech overhead. (MacDonald, 2000: 185)

The hallucination is kindled by the memory of the ancient woman in the cottage, yet it reminds of previous episodes when trees turn human. The passage is similar to Tolkien's description of Treebeard in *The Lord of the Rings*:

> The lower part of the long face was covered with a sweeping grey beard, bushy, almost twiggy at the roots, thin and mossy at the ends. But at the moment the hobbits noted little but the eyes. These deep eyes were now surveying them, slow and solemn, but very penetrating. They were brown, shot with a green light. (2004, p. 463)

The focus on both cases is on the eyes and the humanoid features despite the gender difference. It seems as if Tolkien, disillusioned as with *Macbeth*

2. According to Tolkien, recovery, accomplished thought creative fantasy, allows us to regard elements of the real world in a new light: "you will be warned that all you had (or knew) was dangerous and potent, not really effectively chained, free and wild; no more yours than they were you" (2008, p. 68).

3. See note 2.

because the trees do not march to war,[4] unlike in the possibly-influential *Cad Goddeu* (Jones, 2002, p. 66), was disappointed at what Anodos sees is not the countenance of a tree being. Even if this is guesswork, Tolkien explicitly admitted his dissatisfaction with *Phantastes* (Sotheby's, 2003, p. 297). Trees in *Phantastes* can communicate with the protagonist Anodos, though only when they shapeshift (MacDonald, 1981, p. 29). However, Tolkien may have wanted them to preserve their tree form, and still be able to perform the majestic and supernatural feats displayed in *Phantastes*, providing the trees with movement, behaviour and agency to change the course of the plot.

3 WILLIAM MORRIS

William Morris, another Victorian writer of original fairy tales, also influenced Tolkien (Mathews, 2011, p. 86). Tolkien's profound admiration for Morris resulted in him accumulating an almost complete collection of the latter's works, which he even shared with his son Christopher Tolkien (Mathews, 2011, p. 87). Curiously, Morris and Tolkien shared the same goal, which was to create an inexistent English mythology (Shippey, 2011, p. 10). This ambition draws them closer, though Morris' mythology is rooted in history, whereas Tolkien uses a mythical setting (Shippey, 2011, p. 10; Falconer, 2014, p. 307).

Christina Scull and Wayne G. Hammond point out that Tolkien admitted having borrowed certain specific elements from Morris, while it is possible to infer others (2006, p. 599). For instance, *The House of the Wolfings* and *The Roots of the Mountains* (1889) were counted by Tolkien among his sources of inspiration for the Dead Marshes and the Black Gate (Tolkien, 2000, p. 303).

Little has been said on how Morris' trees and forest inspired Tolkien,[5] but it is striking the use of the proper noun Mirkwood in *The House of the Wolfings* (1889). As Scull and Hammond point out the name Mirkwood, unlike many of the names mentioned in his stories, is not a personal creation of Tolkien (2006, p. 600).

The name has Eddic origins, as several of the poems in the *Poetic Edda* (c. AD 1200) mention a pathless place called Mirkwood or Myrkwood,[6] defined as a

frontier that separates the gods from the giants (Larrington, 1996, p. 314). I venture to say that the presence of Gods in Morris' Mirkwood derives from his knowledge of the *Poetic Edda*. As Shippey explains, Morris and Tolkien shared the knowledge of old sources (1980, p. xvii) and therefore, they could have been inspired by the same work. Tolkien seems to have fused the *Poetic Edda*'s Mirkwood, a pathless wood which acts as a boundary, with Morris' Mirkwood, a border as well hosting Mark-men and supernatural phenomena, to produce his own version. In fact, one of Tolkien's letters seems to contain a definition of Mirkwood greatly shaped by *The House of the Wolfings*:

> Mirkwood is not an invention of mine, but a very ancient name, weighted with legendary associations. It was probably the Primitive Germanic name for the great mountainous forest regions that anciently formed a barrier to the south of the lands of Germanic expansion. (2000, p. 369)

Michael W. Perry has made a commercially-oriented comparison in *Tolkien Warriors: The House of the Wolfings: A Story that Inspired The Lord of the Rings* (2013) drawing parallels with the inhabitants of Morris' Mirkwood with the Rohirrim. However valid, the Mark-men also seem to be close to Mirkwood's elves in *The Hobbit*. As Falconer explains in her discussion of *The House of the Wolfings*:

> Wood is the element from which they derive their identity. Their communal hall is made from it; they express their creativity in the decorative carving of wood; and they recede from their dwellings into the wood itself when it becomes time to dispense justice. (2014, p. 308)

The same can be said of the Wood-elves in *The Hobbit*. While a minority dwell in a cave called the Elvenking's Halls, others settle closer to the forest as the thralls of the Wolfings (Morris, 1892, p. 13):

> the subjects of the king mostly lived and hunted in the open woods, and had houses or huts on the ground or in the branches. (Tolkien, 1999, p. 157)

The Elvenking's Halls contain many wooden handcrafted objects as well (c.f. Morris, 1892, pp. 12–13), as a "carven staff of oak" (Tolkien, 1999, p. 160) and "chair of carven wood" (Tolkien, 1999, p. 165). They dwell in buildings like those of the Mark-men (hall and huts), and they venture into the wood to punish trespassers as the dwarves.

There are differences as well. The supernatural in Tolkien, in the form of confusion, dream-like experiences and dangers, is different from Morris' wolf populated (1892, p. 13) but danger-free zone with divine presence as the Wood-Sun (1892, p. 31). I suggest that Morris' forest including its dwellers inspired Tolkien, but the idea was much further developed,

4. Tolkien felt discontent and loath towards: "the shabby use made in Shakespeare of the coming of 'Great Birnam wood to high Dunsinane hill': I longed to devise a setting in which the trees might really march to war" (2000, p. 212).

5. Shippey briefly explains Morris' *The Wood Beyond the World* (1894) served as a source for both Lothlórien and Fangorn because of the false appearances, quick insights and timing that are at work in those episodes (Shippey, 1980, p. xvii).

6. Myrkwood/Mirkwood appears once in *Loki's Quarrel* (p. 91: 42.3) and *The First Poem of Helgi Hundingsbani* (p. 121: 51.3); twice in *The Lay of Volund* (p. 103: 1.1; p. 103: 3.4);

and thrice in *The Lay of Atli* (p. 210: 3.2; p. 211: 5.4; p. 212: 13.2).

adding Mirkwood's legendary origin, incorporating an array of unworldly creatures and hosting supernatural episodes. This gave Tolkien's Mirkwood a rather distinct status as a mythical setting.

4 KENNETH GRAHAME

Another late Victorian/Edwardian that influenced Tolkien is arguably Kenneth Grahame. Carpenter affirms that the first few chapters of *The Lord of the Rings* owe some inspiration to *The Wind in the Willows* (1908) (1985, p. 213). While this is arguable, I do believe that Grahame's literary vision may have offered at least some inspiration not only for the *Lord of the Rings* but also for to an earlier *The Hobbit*. This can be demonstrated using their similar mindset, Tolkien's appreciation of Grahame's work and some textual evidence.

First of all, Grahame and Tolkien had similar ideas concerning nature and modernity. Grahame's biographer Alison Prince describes his dislike for railways because of how they shaped the country both physically and economically. Grahame did not rely on humans due to the harm they inflicted to the natural world, he was in fact a proto-environmentalist (Prince, 1994, p. 66). The latent posthuman view of nature is in a way similar to the one Tolkien will manifest years later in his writings, for example in *On Fairy-Stories* where he shows his dislike for railways as well:

> I cannot convince myself that the roof of Bletchley station is more "real" than the clouds. And as an artefact I find it less inspiring than the legendary dome of heaven. The bridge to platform 4 is to me less interesting than Bifröst guarded by Heimdall with the Gjallarhorn. From the wildness of my heart I cannot exclude the question whether railway-engineers, if they had been brought up on more fantasy, might not have done better with all their abundant means than they commonly do. (2008, p. 71)

In Grahame's eyes, nature was flawless, and thus, life and the natural world were intrinsically bound (Prince, 1994, p. 191). Therefore, it is understandable that his characters are described living in perfect symbiosis with the environment, they are little fragments of nature which as a whole form a divine everything (Prince, 1994, p. 231). Curiously, Tolkien in *The Hobbit* and more so in *The Lord of the Rings* characterised Elves and Hobbits as sustaining an ideal relationship with the landscape. As Grahame, Tolkien responded to his concerns of humans' defying attitudes towards the natural world using his fiction.

Moving on to the literary aspect, Tolkien was well acquainted with *The Wind in the Willows*, as some of his letters show. In the letters number 51 and 145 there are allusions to one of Grahame's characters: Mr Toad is said to be similar to C. S. Lewis in certain respects,

and Tolkien pays a compliment to Grahame's wit along the way:

> He is (except in face) not only very like a toad, but in character v. like Mr Toad of Toad Hall, & I now perceive that the author of the jest was more subtle than I knew. (2000, p. 63)

Furthermore, Tolkien promises "not to become like Mr Toad" (2000, p. 182) after having received many favourable reviews for *The Fellowship of the Ring*. Moreover, he seemed genuinely interested in Grahame's posthumous publication *First Whispers of the Wind in the Willows* (1944):[7] "I must get hold of a copy" (Tolkien, 2000, p. 90). These quotes from Tolkien's letters, besides proving his appreciation for Grahame's works, convey the idea that these were quite present in his mind over an extended period (1943–1954). As Shippey explains, previous texts by other authors shape a writer's creativity underlyingly, and Tolkien, though unaware of those influences, may have benefited from them (2011, p. 13). Even if not explicitly acknowledged, it is reasonable to argue that Grahame's fiction must have shaped his own somehow.

I believe that the episode in Grahame's Wild Wood in *The Wind in the Willows* could have served as an inspiration for a given characterisation of Mirkwood and the Old Forest. In particular, the passage which describes the main character Mole entering the Wild Wood:

> It was over his shoulder, and indistinctly, that he first though he saw a face: a little evil wedge-shaped face, looking out at him from a hole. When he turned and confronted it, the thing had vanished. (…) Then suddenly, and as if it had been so all the time, every hole, far and near, and there were hundreds of them, seemed to possess its face, coming and going rapidly, all fixing on him glances of malice and hatred: all hard-eyed and evil and sharp. (Grahame, 2010, p. 29–30)

This resembles Bilbo's first contact with Mirkwood in *The Hobbit*, as in both cases the protagonists go through a transitional period where they are unsure of the surrounding threats, becoming more certain by the end of the passages:

> There were black squirrels in the wood. As Bilbo's sharp inquisitive eyes got used to seeing things he could catch glimpses of them whisking off the path and scuttling behind tree-trunks. There were queer noises too, grunts, scuffing, and hurryings in the undergrowth, and among the leaves that lay piled endlessly thick in places on the forest-floor; but what made the noises he could not see. The nastiest things they saw were the cobwebs: dark dense cobwebs with threads extraordinarily thick, often stretched from tree to tree,

7. A compilation of stories, published by Grahame's widow, about the characters of *The Wind in the Willows* (Mole, Toad, Rat, Badger, etc.) gathered from Grahame's correspondence with his son.

or tangled in the lower branches on either side of them. (Tolkien, 1999, p. 132)

Even more so, the Old Forest in *The Lord of the Ring* resembles Grahame's pattern, though the source of danger that threatens the hobbits is different:

they all got an uncomfortable feeling that they were being watched with disapproval, deepening to dislike and even enmity. (…) they found themselves looking up quickly, or glancing back over their shoulders, as if they expected a sudden blow. (Tolkien, 2004, p. 111)

Carpenter describes Grahame's Wild Wood as representing dark and harmful thoughts appearing in a person's psyche when self-control is not well exercised (1985, p. 157). This seems to be reflected in the state of slumber and paranoia the hobbits suffer from in the Old Forest, which is comparable to Bilbo and the Dwarves' experience in Mirkwood.

However, Tolkien and Grahame adopted very different approaches when it comes to their writings. Whilst Grahame is bent on entertaining his readers with a cosy, nostalgic and sometimes sentimental tale, redolent of traditions but overtly impossible, Tolkien's idea of fairy stories is that they can be potentially as genuine as the real world in the sense that they may put the reader back in touch with a primordial reality retrieved through the art of storytelling. While in Grahame's case, after the end of the episode, we are unsure whether the threat is real, in Tolkien the menace is made explicit.

Both authors conceived the wood as a dangerous setting which initiates the main character through some rites of passage into a superior level of maturity. In Tolkien's setting, this progression includes the possibility of death and failure, which we cannot see so clearly in Grahame's story. In any case, the episode of the Wild Wood seems to have been haunting Tolkien's imagination when writing about Mirkwood and the Old Forest. Tolkien adopts similar patterns but combining them with his own and other sources of inspiration.

5 CONCLUSION

MacDonald's *Phantastes* hints at a possible influence on the design of the Ents, Huorns and agentive trees. Morris' *The House of the Wolfings* seems to have inspired the conceptualisation of Mirkwood, including given features and even hosting similar inhabitants. Grahame's *The Wind in the Willows* may have offered a model for a forest episode that was replicated, or better said adapted in given passages of Mirkwood and the Old Forest. While these authors are not the only sources for the aforementioned Tolkien's trees and forests, I consider their influence highly probable. The available evidence suggests that Tolkien consciously or unconsciously absorbed those sources into his own

work. Although the building blocks may be of excellent quality, without effective fully-fledged creative skills, the architect would not be able to produce a creation that would stand the test of time. Tolkien was not an imitator, but a skilful master of blending and adapting old material that is still thoroughly enjoyed by readers today.

ACKNOWLEDGEMENT

This essay was completed under the auspices of the REWEST research group (code: IT 1026-16), funded by the Basque Government (Dpto. de Educación, Universidades e Investigación / Hezkuntza, Unibertsitate eta Ikertu Saila) and the University of the Basque Country, UPV/EHU.

BIBLIOGRAPHICAL REFERENCES

Carpenter, Humphrey. (1985) Secret Gardens: A Study of the Golden Age of Children's Literature. London: George Allen & Unwin.

_____. (2000) *J.R.R. Tolkien: A Biography.* (Paperback ed.). Boston & New York: Houghton Mifflin.

Csikszentmihalyi Mihaly. (2013) *Creativity: The Psychology of Discovery and Invention* (Modern Classics ed.). New York: Harper Perennial.

Eilmann, Julian. (2017) *J.R.R. Tolkien: Romanticist and Poet* (Trans. Evelyn Koch). Zurich: Walking Tree Publishers.

Falconer, Rachael. (2014) "Earlier Fantasy Fiction: Morris, Dunsany, and Lindsay." In Stuart D. Lee (Ed.), *A Companion to J. R. R. Tolkien* (pp. 305–316). Chichester: Wiley Blackwell.

Fisher, Jason. (2011a) Preface. In Jason Fisher (Ed.), *Tolkien and the Study of his Sources: Critical Essays* (pp. 1–6). Jefferson, NC & London: McFarland & Company.

_____. (2011b) "Tolkien and Source Criticism: Remarking and Remaking." In Jason Fisher (Ed.), *Tolkien and the Study of his Sources: Critical Essays* (pp. 29–44).Jefferson, NC & London: McFarland & Company.

Grahame, Kenneth. (2010) *The Wind in the Willows*. Oxford: Oxford University Press.

Hammond, Wayne G. & Scull, Christina (Eds.). (2002) *J. R. R. Tolkien: Artista e Ilustrador* (Trans. Ramón Ibero). Barcelona: Ediciones Minotauro.

Jones, Leslie Ellen. (2002) *Myth & Middle-earth*. Cold Spring Harbor, NY: Cold Spring Press.

Larrington, Carolyne. (1996) Annotated Index of Names. In Carolyne Larrington (Trans. & Ed.), *The Poetic Edda* (pp. 298–323). Oxford: Oxford University Press.

MacDonald, George. (2000) *Phantastes: A Faerie Romance*. Grand Rapids, MI: Wm. B. Eerdmans Publishing Company.

Marina, José Antonio & Pombo, Álvaro. (2013) *La creatividad literaria*. Barcelona: Editorial Ariel.

Mathews, Richard. (2011) *Fantasy: The Liberation of Imagination*. New York & London: Routledge.

Morris, William. (1892) *The House of the Wolfings*. Boston, Mass.: Roberts Brothers.

Prince, Alison. (1994) *Kenneth Grahame: An Innocent in the Wild Wood*. London: Allison & Busby.

Scull, Christina & Hammond, Wayne G. (2006) *The J.R.R. Tolkien Companion and Guide: Reader's Guide*. Boston & New York: Houghton Mifflin.

Shippey, Tom. (1980) Introduction. In William Morris, *The Wood beyond the World* (pp. v-xix). Oxford: Oxford University Press.

_____. (2003) *The Road to Middle-Earth* (Rev. ed.). New York: Houghton Mifflin.

_____. (2011) Introduction: Why Source Criticism? In Jason Fisher (Ed.), *Tolkien and the Study of his Sources: Critical Essays* (pp. 7–16).Jefferson, NC & London: McFarland & Company.

Sotheby's. (2003) Sotheby's English Literature, History, Fine Bindings, Private Press Books, Children's Books, Illustrated Books and Drawings. 10 July 2003.

The First Poem of Helgi Hundingsbani. (1996) In Carolyne Larrington (Trans. & Ed.), *The Poetic Edda* (pp. 114–122). Oxford: Oxford University Press.

The Lay of Atli. (1996) In Carolyne Larrington (Trans. & Ed.), *The Poetic Edda* (p. 210–216). Oxford: Oxford University Press.

The Lay of Volund. (1996) In Carolyne Larrington (Trans. & Ed.), *The Poetic Edda* (pp. 102–108). Oxford: Oxford University Press, 1996.

Tolkien, J. R. R. (1999) *The Hobbit* (Paperback ed.). London: Harper Collins Publishers.

_____. (2000) *The Letters of J.R.R. Tolkien* (Humphrey Carpenter & Christopher Tolkien, Eds.). New York: Houghton Mifflin.

_____. (2004) *The Lord of the Rings*. (50th Anniversary (ed.). New York: Houghton Mifflin Harcourt.

_____. (2008) "On Fairy-Stories." In Verlyn Flieger and Douglas A. Anderson (Eds.), *Tolkien On Fairy-Stories* (expanded ed. with commentary and notes, pp.27–84). London: Harper Collins Publishers.

From Tolkien's British Middle-earth to King's American West Mid-World

Raúl Montero-Gilete
University of the Basque Country (UPV/EHU), Spain
ORCID: 0000-0002-2008-0963

ABSTRACT: This paper aims to discover what similarities and differences J. R. R. Tolkien and Stephen King display in their masterpieces *The Lord of the Rings* and *The Dark Tower* series respectively by comparing the synopsis, inspiration sources and personal purpose the two works present. Once the comparison is made, we will draw conclusions that will shed light on the creative process, and the ambitions of both writers when creating two of the most important literary works associated, among others, with the fantasy genre.

Keywords: Tolkien, *The Lord of the Rings*, Stephen King, *The Dark Tower*

1 INTRODUCTION

When J. R. R. Tolkien finished the last volume of *The Lord of the Rings*[1] in 1954, almost thirty years had gone by since the unique writer had started working on the first lines of *The Silmarillion*.[2] In between, the history and story of the Middle-earth would be created, and millions of readers all over the world would have the opportunity of immersing themselves in the terrific masterpiece of the Oxfordian scholar. It is unlikely that future generations will ever equal such an incredible literary project because the ambition, quality, length and depth of Tolkien's work can be considered as unrepeatable.

Almost thirty years later, in 1982, a young teacher who would become one of the most prolific North American authors ever, embarked on a narrative series which, coincidentally, would be constructed over the next thirty years. *The Gunslinger* was the name that was chosen for the first novel of a series of eight from Stephen King's magnum opus' *The Dark Tower*.[3] The rest of the series included *The Drawing of the Three* (1987), *The Waste Lands* (1991), *Wizard and Glass* (1997), *Wolves of the Calla* (2003), *Song of Susannah* (2004), and *The Dark Tower* (2004). In 2012, King added another story which was set between the fourth and the fifth volume of the series: *The Wind Through the Keyhole*. In the light of such a massive and successful project, one needs to consider if, to a certain extent, King has borrowed part of the formula Tolkien used when creating Middle-earth.

This paper aims to discover what similarities and differences the two writers display in the creation of *LotR* and *DT* by comparing the synopsis, inspiration sources and personal purpose the two works present. Once the comparison is made, we will draw conclusions that will shed light on the creative process, and the ambitions of both writers when creating two of the most important literary works associated, among others, with the fantasy genre.

2 THE LORD OF THE RINGS

When we start reading *LotR*, it is not difficult to realise that we are in a world that, to a certain extent, has many similarities to our own, but soon we discover that Middle-earth, where the story is set, has its own history, geography, languages and living races such as humans, hobbits, istaris, elves, dwarves, goblins, orcs, or ents among others. But, what is the story about? Did Tolkien need to write such an extensive story? Why?

In the story of *LotR*, the Dark Lord Sauron, a necromancer, secretly created an almighty and powerful Ring, which was capable of dominating all the Middle-earth races if it was used with evil intent. Unfortunately for Sauron, he lost his Ring in the heat of a battle, and the Ring went its own way, causing the downfall of those who possessed it. Hundreds of years later, Gandalf the Grey, a talented wizard who knew about the story of the Ring, would discover that one of the most insignificant and lesser creatures of Middle-earth, a hobbit named Bilbo Baggins, was in possession of the metal. Gandalf was aware of the fact that the only way of stopping Sauron and his continued attempts to conquer Middle-earth was by destroying the Ring in the

1. *The Lord of the Rings*: LotR.
2. Edited and published posthumously in 1977 by his son Christopher Tolkien.
3. *The Dark Tower*: DT

volcanic Mount Doom situated in the heart of Mordor, where the Dark Tower of Barad-dûr was, and the Dark Lord lives. For this reason, Gandalf, driven by a pristine moral attitude, would create 'The Fellowship of the Ring',a group of heroes composed of four hobbits, two humans, one elf, one dwarf and Gandalf himself, who would risk their lives in order to destroy the evil Ring. "Gandalf represents the archetype of the Wyse Old Man […] When Gandalf returns as 'The White Rider' […] he has 'angelic' powers which he occasionally manifests" (Lakowski, 2002, pp. 22–31). The group quest will be the focus of the story, and it will not finish until they complete their noble feat or perish in their attempt.

Inspiration, sources, and purpose

Some readers of *LotR* do not know that Tolkien, besides being an unrepeatable narrator, was also a brilliant scholar who studied, among other subjects, the epic poem "Beowulf".[4] This poem, together with "The Battle of Maldon",[5] are the most valuable pieces of Anglo-Saxon or Old English literature: "The focus on the North, the Icelandic, and Old English narratives, was one that was to absorb Tolkien both as a scholar and as a storyteller" (Clark and Timmons, 2000, p. 18). By reading Tom Shippey's *The Road to Middle-earth* (2003), we can clearly identify the presence of the Old English language when he writes:

Having fitted in English and Norse, Old English could not be far behind: hence the Riders with their entirely Old English terminology, their names are often Old English nouns capitalized. (p. 116).

Another of the great names associated with fantasy literature, and a brilliant scholar in mid-twentieth-century England, is C. S. Lewis. In addition to being a colleague and friend of Tolkien, in no small extent, Lewis can be grateful to the creator of Middle-earth, for his conversion to Christianity. Tolkien was a fervent Catholic believer and an expert on Christian mythology which, added to the Nordic tradition, will sustain the mythological base that will shape *LotR*.

Tolkien valued *Exodus* especially as an example of Christian material treated in an old-fashioned or heroic style: his own fiction being a similar mixture but the other way round […] The other major riddle-contest in Old Norse appears. (Shippey, 2003, pp. 345–346).

The literature written during the 19thcentury has a fundamental role when trying to understand Tolkien's sources. Both the Romantic and Victorian periods are key sources of inspiration for Tolkien's work. The romantic movement (1780–1832) will mark a profound change of sensibility and revolves around six great poets: William Blake, William Wordsworth, Samuel Taylor Coleridge, Percy Bysshe Shelley, John Keats and Lord Byron. Its main characteristics, as an aesthetic category, are, in broad strokes: The creative power of the imagination; a pristine view of nature, the axis of his work, through the sublime; society and its development as an organic, natural model; the value of the individual; and the role of the artist as someone wise, a new type of philosophical figure who becomes a kind of prophet or religious savior (Kitson, 2008, p. 328). This unique appreciation and understanding of the natural world are well exemplified by Curry's (2004) words when he writes about Tolkien's *LotR*:

But Middle-earth far exceeds the Shire, what is most striking about it is the profound presence of the natural world: geography and geology, ecologies, flora and fauna, the seasons, weather, the night-sky, the stars and the Moon. The experience of these phenomena as comprising a living and meaningful cosmos saturates his entire story […] And there is an accompanying sense of relief: here, at least, a reader may take refuge from a world where, as in a hall of mirrors gone mad, humanity has swollen to become everything, and the measure of everything. (p. 50).

The Victorian period lasted from 1832 to 1901. Most of the Victorian novels were extensive and thorough, with a rich language, where the predominant feature consists of a representation of life that is close to the real social life of that time. This social life was linked to the development of the emerging middle class and the lifestyle and expectations of this class, as opposed to the aristocratic classes that dominated previous eras. For the first time in English history, women assume a central role, and the role of children in literature becomes important, with this century being known as the golden age of children's literature. Big names like Jane Austen, the Brontë sisters, George Eliot, Robert Louis Stevenson, Thomas Hardy, Sir Walter Scott, Charles Dickens, William Morris, Bram Stoker, George MacDonald, Lewis Carroll or Charles Kingsley, among others, will give colour to an era of different literary forms.

Victorian literary history provides many examples of innovative appropriation of both forms and themes inherited from the 18th C. and the Romantic era […] Much Victorian literature, preoccupied with work and practical solutions to the myriad social problems facing the industrial nation. (Frawley, 2008, pp. 430–431).

Vaninskaya (2014) states that "the impact of the Victorian polymath's works on Tolkien's imagination is unmistakable" (p. 351). Moreover, Fantasy fights against this industrial movement by eluding old alternatives:

The fantasies of late Victorian and of Edwardian England present us with a 'green and pleasant land' which by its distance from the immediate and proximate reality of English life reveals its essential conservatism. (Zanger, 1977, p. 155).

4. Unknown author. Written, apparently, between the 8th and 12th century.
5. Unknown author. Written in the years after the "Battle of Maldon" at the end of the 10th century.

And we believe that *LotR* supports this idea throughout its pages.

Another key name that we need to present when speaking about Tolkien's literary influences is William Morris. *The Letters of J.R.R. Tolkien* explains how Tolkien (1981) himself recognises the literary influence that Morris has on his work by admitting that some places in Middle-earth such as "[the] Dead Marshes and the approaches to the Morannon" were influenced by "William Morris and his Huns and Romans, as in The House of the Wolfings or The Roots of the Mountains" (p. 303). Again Shippey (2003), perhaps the most authoritative voice as far as Tolkien studies are concerned, also mentions the influence of Morris on the construction of Middle-earth:

> Tolkien also read William Morris, probably with more appreciation: Morris, after all, knew a good deal of Icelandic and had been stirred by heroic story (p. 351).

Tolkien was a Christian man, raised with honour, respect, and faith, and nurtured by the collective memory that presents the battlefield of the First World War as a modernisation of the epic that fascinated him so much. At night, on the battlefield, the enemy has no face or identity. It is the other, it is bad, it is the eternal dichotomy of good versus evil. Fellowship, friendship and loyalty in the trenches of the war would accompany him throughout his life. Transcendental reflections on life and death would be reflected in his work. He was an active participant in the Great War, in which he had to fight as a soldier, and suffered the consequences of the Second World War which reached the heart of his beloved country: "…a growing body of scholarly articles have explored the influence of World War I and II on *The Lord of the Rings* (Chrism, Croft, Flieger, Garth, Jackson, Livingston, Long, Murname, Simonson)" (Ford and Reid 2014, p. 208).

Once we have presented the main elements that confer a form to *LotR*, we can ask ourselves what the ultimate intention of Tolkien is. We need to understand the motive that pushes the writer to embark on such a venture to create a secondary world of biblical proportions that has been able to capture the imagination of millions of readers in the world. The answer is simple, the way to achieve it, difficult. What Tolkien intends with *LotR* is to create a mythology for England.

3 THE DARK TOWER SERIES

Anyone who has had the opportunity to approach the work of Stephen King cannot doubt that regardless of the literary quality of his novels, his stories do know how to connect with the general public by placing King's works among the best-selling examples of modern literature. What many others do not know is that a large part of King's literary universe directly or indirectly stems from a literary series that has taken him thirty years to complete. *The Dark Tower* is the nexus

that gives coherence to a life devoted to literature, a world of its own that, as with Tolkien, goes beyond the author.

The Dark Tower series tells the story of Roland Deschain, the last Mid-World gunslinger, who travels through this unknown and post-apocalyptic landscape, which reminds us of the American Wild West, in search of a mysterious and powerful place that responds to the name of The Dark Tower. This tower is located in a region called End-World, surrounded by a sea of roses. The tower is the nexus of the space-time continuum. It is the heart of all worlds, including our own world, but it is under threat. The tower is supported by six invisible magnetic beams that maintain the alignment of time, space, size and dimension, but they are weakening. Someone or something is using the evil technology of the Great Old Ones to destroy the tower. The world has started to move on, and it means that direction and time are not lineal any more. Flashbacks help the reader to understand why Roland is a gunslinger while empathising with his mission and justifying his blameworthy actions. He is the only one able to find a way to save the tower, but he cannot achieve his purpose alone. Roland will command a group of heroes; Roland's second ka-tet, who will sacrifice everything to help him to reach the Dark Tower. "Although he doesn't realize it, Roland, Warrior of the White, is a version of the eternal hero" (Furth, 2012, p. 132). Roland needs to complete his search and talk to God, or the Force that resides in the Dark Tower, to answer his questions and save the universe in which we live.

4 INSPIRATION, SOURCES, AND PURPOSE

The Dark Tower series is clearly inspired by British poet Robert Browning's poem "Childe Roland to the Dark Tower Came" (1855), which presents a man named Roland, a kind of aristocrat because this is what we can imply from the word "childe",[6] who is on a dangerous quest for the mysterious Dark Tower.

> The poem, which King had been assigned in a class covering the earlier romantic poets, combines romance and existentialism, atypical of Browning's other work and ahead of its time in its Weltschmerz.[7] (Vincent, 2004, pp. 280–281).

Apart from this poem, when Stephen King explained the other main influences which had led him to create his masterpiece, in his introduction for a new edition of the series in 2003 entitled "On being nineteen (and a few other things)," he acknowledged that *DT* would have never existed without Tolkien's *LotR* and Leone's *The Good, the Bad and the Ugly* (1966):

6. A youth of noble birth.
7. Mental depression or apathy caused by comparison of the actual state of the world with an ideal state.

Hobbits were big when I was nineteen. There were probably half a dozen Merrys and Pippins slogging through the mud at Max Yasgur's farm during the Great Woodstock Music Festival, twice as many Frodos, and hippie Gandalfs without number. J. R. R. Tolkien's *The Lord of the Rings* was madly popular in those days [...] But although I read the books in 1966 and 1967, I held off writing. I responded to the sweep of Tolkien's imagination – to the ambition of the story – but I wanted to write my own kind of story, and had I started then, I would have written his. Thanks to Mr Tolkien, the twentieth century had all the elves and wizards it needed [...] Then, in an almost completely empty movie theater, I saw a film directed by Sergio Leone. It was called *The Good, the Bad, and the Ugly*, and before the film was even half over, I realized that what I wanted to write was a novel that contained Tolkien's sense of quest and magic but set against Leone's almost absurdly majestic Western backdrop [...] I wanted to write not just a long book, but the longest popular novel in history. (King, 2012, pp. XI-XV).

When the reader is introduced to the Mid-World of the last gunslinger Roland Deschain, we can hardly avert our eyes from the pages where Roland is travelling across a landscape which reminds us of the American Far West, but the apocalyptical tone of the narration shows us that the search for a mysterious and probably dangerous Dark Tower cannot be placed in the world we know. The story reveals that if we want to reach the location where the Dark Tower is situated, our journey with Roland will move from Mid-World to End-World, and once there, the pages will lead us to dive into a sea of roses. King places us in a multiverse universe where everything is connected.

When David Wallace writes *The Emergent Universe, Quantum Theory according to the Everett interpretation*, he defends a theory that he calls "Everettian quantum mechanics" (Wallace, 2012, p. 3) in which, in a general and summarised way, he affirms the existence of several parallel universes. According to this, dying in one of them does not necessarily mean dying definitively. The theory of the multiverse has a scientific basis, and King exploits it. Moreover, Clifford D. Simak's Science Fiction novel *Ring Around the Sun* (1953), explored the possibilities of the multiverse, and would be very influential for the creation of King's *DT*:

[The novel] postulates the idea that there are a number of worlds like ours. Not only other planets, but other Earths, parallel Earths, in a kind of ring around the sun. (Vincent, 2004, p. 285).

Now, we can reflect on Stephen King's motivation when creating a world linked to a tower, the Dark Tower; and thus, conceiving a work whose essence has been able to articulate a large part of his literary production. The answer can be found, as stated by the author (2012), in the following line: "I wanted to write not just a long book, but the longest popular novel in history" (pp. XI–XV).

5 CONCLUSIONS

In the light of our study, we can affirm that Tolkien takes as inspiration previous literary traditions that, starting with the "Beowulf" of Old English, feed its mythological world with references to Nordic and Christian mythology. The Romantic and Victorian literature of the nineteenth century, which would be influenced especially by William Morris, would give him the opportunity to present the value of nature and sensitivity for in a sublime manner, while addressing, allegorically, the real problems of his time using a Victorian style. All this mixed with the artisan genius of a unique and unrepeatable writer whose life experience in the trenches of the First World War would impregnate his work with a halo of authenticity with the collective purpose of giving England a mythology of its own. King, meanwhile, also travels to the mid-nineteenth century to present one of its main references with the poem "Childe Roland to the Dark Tower Came". However, the rest of his references are specific and modern, and are located at the beginning of the second half of the 20th-century, both literary — *The Lord of the Rings* and *Ring around the Sun* — and cinematographic — *The Good, the Bad and the Ugly*—, and with a very specific and individual goal, which is to create the most extensive popular novel in history.

Nevertheless, both novels have a central character that supports the narrative thread. The stories are commanded by warriors —Gandalf, a wizard / Roland, a gunslinger — associated with the light. They are powerful, old, demigods. Their adventure/search is not lonely; they need a group — the Fellowship of the Ring / the *ka-tet* of Nineteen — to achieve a greater good: saving the land in which they live.

To conclude, we would like to emphasise that, despite the different narrative influences, and the purposes that writers pursue when they create their works, the storyline does share more features than, a priori, could have been expected before the analysis. Perhaps, this is the formula that has boosted both works to commercial success.

ACKNOWLEDGEMENT

This essay was completed under the auspices of the REWEST research group (code: IT 1026-16), funded by the Basque Government (Dpto. de Educación, Universidades e Investigación / Hezkuntza, Unibertsitate eta Ikertu Saila) and the University of the Basque Country, UPV/EHU.

BIBLIOGRAPHICAL REFERENCES

Clark, G., & Timmons, D. (2000). *J.R.R. Tolkien and his literary resonances*. Westport: Greenwood Press.

Curry, P. (2004). *Defending Middle-earth. Tolkien Myth and Modernity*. Boston: Houghton Mifflin Company.

Ford, J. A., & Reid, R. A. (2014). Polytemporality and Epic Characterization in *The Hobbit*: An Unexpected Journey. In B. L. Eden (Ed.), *The Hobbit and Tolkien's Mythology* (pp. 208–221). North Carolina: McFarland & Company.

Frawley, M. (2008). The Victorian Age. In P. Poplawski (Ed.), *English Literature in Context* (pp. 403–518). Cambridge: Cambridge University Press.

Furth, R. (2012). *The Dark Tower. The Complete Concordance*. London: Hodder.

Honegger, T. (2007). A Mythology for England? Looking a Gift Horse in the Mouth. In T. Honegger & E. Segura (Ed.), *Myth and Magic. Art according to the Inklings* (pp. 109–130). UK: Walking Tree Publishers.

King, S. (2012). Introduction. On being nineteen (and a few other things). In *The Gunslinger* (pp. xi-xix). London: Hodder.

Kitson, P. J. (2008). The Romantic Period. In P. Poplawski (Ed.), *English Literature in Context* (pp. 306–402). Cambridge: Cambridge University Press.

Lakowski, R. I. (2002). Types of heroism in *The Lord of the Rings*. In T. J. Sherman (Ed.), *Mythlore: A Journal of J. R. R. Tolkien, C. S. Lewis, Charles Williams, and Mythopoeic Literature*, 23(4), 21–33. USA: Southwestern Oklahoma State University.

Shippey, T. (2003). *The Road to Middle-Earth*. Boston: Houghton Mifflin Company.

Tolkien, J. R. R. (1981). *The Letters of J. R. R. Tolkien*. In H. Carpenter (Ed.) with the assistance of C. Tolkien. London: George Allen & Unwin.

Vaninskaya, A. (2014). Modernity. Tolkien and His Contemporaries. In S. D. Lee (Ed.), *A Companion to J. R. R. Tolkien* (350–366). New Jersey: Wiley Blackwell.

Vincent, B. (2004). *The Road to the Dark Tower*. USA: New American Library-Penguin Group.

Wallace, D. (2012). *The Emergent Multiverse, Quantum Theory according to the Everett interpretation*. Oxford: Oxford University Press.

Zanger, J. (1977). Goblins, Morlocks, and weasels: classic fantasy and the Industrial Revolution. In *Children's Literature in Education*, 8(4), 154–162. USA: Springer.

Oxford dictionaries. Web. 5 Oct. 2018. Retrieved from https://www.oxforddictionaries.com

Merriam Webster. Web. 6 Nov. 2018. Retrieved from https://www.merriam-webster.com

The final frontier: Fictional explorations of the borders of nature and fantasy in early twentieth-century imaginative literature

Martin Simonson

University of the Basque Country (UPV/EHU), Spain
ORCID: 0000-0003-3576-4636

ABSTRACT: In this paper, I argue that the tension between tradition and modernity which operated upon the mind of many writers in the early twentieth century was frequently articulated around the dichotomy between the city and the country. As in the Romantic period a hundred years earlier, the "country" was associated with autochthonous cultural traditions, folklore, myth and imagination, and seen as a place of escape from a dreary and prosaic industrialised reality. For many writers of the Edwardian period, the countryside turned into a liminal space capable of hosting the presence of both imagination and reason, myth and realism, the native and the foreign, safety and threat. This is frequently seen in the works of Edward Thomas, Arthur Machen and Algernon Blackwood, who each in his own way, and with different results, negotiated the liminal space between the Edwardian everyday reality and the potentially wonder-inspiring world of nature, with its half-hidden historical, mythical and supernatural depths, lurking at the very borders of perception.

Keywords: Liminality; Literature of Place; Fantasy Literature; Horror Literature; Edwardian Literature; Thomas, Edward; Blackwood, Algernon; Machen, Arthur

Fantastic modes of discourse are frequently employed in times of crisis and confusion, whether in the shape of imaginative outlets that allow readers to safely escape to more intelligible and coherent realities, as discourses that highlight and denounce social maladies, or as radical alternatives that inspire those who aim to transform the present. Regardless of the form it takes, fantastic fiction tends to upset apparently solidified forms and extract new patterns that complicate and problematize traditional notions of reality.

The late Victorian and Edwardian periods was one of these confusing and contradictory moments in history. In the second half of the twentieth century, it became commonplace to contest the popular myth of the Edwardian times as a period of perpetual golden summers and garden parties (mostly created in nostalgic response to an even more troubling and confusing reality in the wake of the First World War). A more complex image of the period emerged, one which stressed the inherent tensions of the age. Thus, Samuel Hynes' classic historical account of the period, *The Edwardian Turn of Mind* (1968), paved the way for later popular historians such as Roy Hattersley who, by 2004, could confidently assert that the age saw "a political and social revolution, accompanied and sustained by an explosion of intellectual and artistic energy [which] swept England into the modern world" (Hattersley 2004, p. 1).

In this revised picture of the times, cultural historians often highlight the conflict between tradition and modernity that acted upon the Edwardian mind in all fields of art and politics. In literature, which is my present concern, the imagist and Vorticist experimentation of Ezra Pound and others found a contrast in the traditional Georgian poetry of Rupert Brooke and Edward Thomas, while E.M. Forster's and Henry James' realist accounts of the age coexisted with Lord Dunsany's fantasy tales set in secondary worlds, and with the ubiquitous presence of fairies in children's literature and drama.[1]

1. J.M. Barries' *Peter Pan*, for instance, was an enormous success both for children and adults when first staged in 1904. The presence of fairies in theatrical plays enjoyed a long-standing and prestigious tradition in Britain thanks to Shakespeare, and was widely popularized also in art. According to Iain Zaczek, "in the late eighteenth century, when the authorities were trying to promote a national school of British art, the depiction of Shakespearean subjects was actively encouraged" (Zaczek 2005, p. 12), and fairies were foremost among the preferred subjects. However, the inherent tensions of the age also gave rise to many other fantastic narratives that engaged obliquely with contemporary social concerns. In the last fifteen years of the Victorian period, before Freud articulated his findings in the field of psychology, writers like Stevenson and Wilde explored the potentially explosive tension between our inner instinctive self and external, social pressure — *Dr Jekyll and Mr Hyde* (1886) and *The Picture of Dorian Gray* (1890) are two well-known examples from the

The tensions of the Edwardian times were frequently articulated around the dichotomy between the city and the country. As in the Romantic period a hundred years earlier, the "country" was associated with autochthonous cultural traditions, folklore, myth and imagination, and seen as a place of escape from a dreary and prosaic industrialised reality[2]. Many of the most popular children's tales of the period, such as Kenneth Grahame's *The Wind in the Willows* or Edith Nesbit's tales, are ostensibly set in rural milieus, where the protagonists can explore alternative realities far from the supervision of adults and constrictive urban environments.

Nature writing also developed as a genre of its own in this period, notably through the work of writers like Richard Jefferies, W.H. Hudson and Edward Thomas. Even this genre could be permeated by more fantastic narrative modes, however, and also here we find late-Victorian precedents: children's literature, nature writing and fantasy converged in Jefferies' highly popular *Wood Magic: A Fable* (1881), to give but one example.

Leaving the urban industrial reality behind, even only for a day, and turning to the country in search of solace, inspiration and relief, became a common pastime of the English middle and working classes (Bunce 1994, pp. 111-140)[3]. However, the countryside, which by the beginning of the century was easily accessible by train from all major cities, was more than just a recreational space — for many writers, it turned into a natural catalyst of the tensions between tradition and modernity, imagination and reason, myth and realism, the native and the foreign, safety and threat. This is frequently seen in the works of Edward Thomas, Arthur Machen and Algernon Blackwood, who each in his own way and with different results, negotiate the liminal space between the Edwardian everyday reality and the potentially wonder-inspiring world of nature, with its half-hidden historical, mythical and supernatural depths, lurking just at the very borders of perception.

1 EDWARD THOMAS

Edward Thomas is today perhaps best known for his poetry, but for a period spanning roughly 20 years he also wrote many country books, most of them travelogues set in Southern England and Wales.[4] Thomas was born in London but sustained a life-long aversion to city life, as attested by his biographers (Hollis 2011; Thomas 1997), and from an early age, he took any opportunity he could find to escape from the city for long walks in the countryside, especially the counties surrounding London.

Thomas would himself refer to "that country which is dominated by the Downs or by the English Channel, or by both" as "The South Country" (Thomas 1993, p. 1). For Thomas, who was an incredibly astute observer of the natural world, the region was an imaginatively alluring space, suggestive of old, native and even mythical traditions that were mediated by the natural scenery, and his attempts to capture this half-imaginary, half-real realm in words frequently turn into a quest to unveil cultural strata buried in the landscape. At times, these explorations took on the shape of fantasy narratives in which Thomas unearthed and extracted supernatural elements, which he then examined in order to assess their role in the Edwardian reality. With *The South Country* he set out to write another country book, but in this work, the lyrical descriptions of the natural marvels and folk roots often move beyond the ordinary world of perception and show Thomas trying to find a language to express his fluttering glimpses of the timeless realm hidden beyond ordinary appearances.[5]

In one passage, Thomas reflects on how the smells of nature after rain set off his imagination and bring him a strange joy:

> Newly dressed in the crystal of the rain the landscape recalls [...] the joys of life that come through the nostrils from the dark, not understood world which is unbolted for us by the delicate and savage fragrances of leaf and flower...(Thomas 1992, p. 43).

However, the promise of remaining in the world of mystery and vision vanishes with the changing of the light, as the next paragraph shows:

> But at morning twilight I see the moon low in the west like a broken and dinted shield of silver hanging long forgotten outside the tent of a great knight in

period — while H.G. Wells' Martian invasion in *The War of the Worlds* (1897) forced "civilized" readers to redefine the Other from the unsettling perspective of the colonized subject, and William Morris' pseudo-medieval prose romances, such as *The Well at the World's End* (1896), incorporated older diction and mythological motifs.

2. See chapter 1, "The Making of an Ideal", in Bunce (1994).

3. As John Lewis-Stempel amply demonstrates in his study *Where Poppies Blow: The British Soldier, Nature, The Great War*, this British flair for nature-worship continued well into the First World War, where an astonishing number of British officers and soldiers recreated their experience of the British countryside by growing flowers and engaging in bird-watching, among other things. The literary outcome was not impervious to the influence: "Over and over," Lewis-Stempel writes, "the soldier-poets recollected the British landscape ('home') as antidote and counterpoint to the horror of war" (Lewis-Stempel 2016, p. 19).

4. *Beautiful Wales* (1905), *The Heart of England* (1906), *The South Country* (1909), *The Icknield Way* (1911) and *In Pursuit of Spring* (1913) are the most well-known titles.

5. Longley considers that Emerson and Thoreau were "formative writers" for Thomas and hints at their being partly responsible for his "residual mystical inclinations" (2008, p. 14). Thomas's mystical vision of nature has also been attributed to the influence of Thomas Traherne, an explicit acknowledgment of which is featured in the section "June-Hampshire-The Golden Age-Traherne" of *The South Country* (Thomas 1993, pp. 93–112).

the wood, and inside are the knight's bones clean and white about his rusted sword [...] and I am ill-content [...]. (Thomas 1993, p. 43)

History and myth are no longer alive in the present, Thomas implies, because of the moment of heightened perception which opened the gates of the "dark, not understood world", depends on a state of mind which is contingent both on the whims of nature and on our mortal limitations.[6]

In other works, notably in his short stories,[7] Thomas would give a more sustained expression of his desire to transcend the everyday and enjoy the deeper, supernatural dimension of the English landscape. In "The Queen of the Waste Lands," the concluding tale of the collection *Rest and Unrest*, the narrator is contemplating the English countryside from some vantage point and his inner eye perceives a queen-like figure, who embodies the spirit of the country, with whom he engages in conversation which is worth quoting at some length:

"Queen of the Waste Lands," said I, "where is your realm? How may it be reached and…"

"It is everywhere. You are in the midst of it. This is but one of its provinces. [...] The capital of my realm is now here and now there among these islands. It is in your heart this day. Many times it has been in a poet's heart, but there is no heart where it has not been, either in sleep or in solitude, for a little while."

Very sweet was her voice, and as the plover's voice utters the nature of the marsh so hers uttered that of the Waste Lands, of the islands, their graves and desolate walls, and of the seas. I loved her, and thinking that she also might love me, I spoke again, saying: "Since you have made your palace, Queen, in this empty heart, make me, I beseech you, one of your company that I may serve you and dwell in your realm for ever and be, under you, one of the lords of the Waste Lands."

"You ask," she said, pitifully, "what is impossible, as others have done before you, and will again. For I dwell alone and have no company among the living. Yet a little while and you shall have your will, though you cannot know it when the day comes. Farewell."

The word sundered me from her and from her realm, and left me discontented with the meadow and its green grass and golden flowers, and the white sheep under the wood, with May and its fulness, with life itself that had the Waste Lands among its many kingdoms. (Thomas 1910, pp. 189–191)

Thomas's inherently melancholy disposition prevented him from being permanently enriched by such fleeting glimpses of timeless nature; in part, probably, because he was stifled by his everyday obligations and

hackwork as a literary critic. In this, too, he reflects the contradictory and often frustrated spirit of the Edwardian age.

2 ALGERNON BLACKWOOD

Algernon Blackwood, who was born in Kent in 1869, was a very prolific and highly popular writer who specialized in imaginative "weird" fiction, ranging from fairy tales and drama (*A Prisoner in Fairy Land*, 1913) to tales of horror ("The Wendigo", 1910), ghost stories (*The Empty House and Other Ghost Stories*, 1906) and transcendental nature writing (*The Centaur*, 1911). As a writer of weird fiction, he belonged to a tradition of horror literature developed by Sheridan Le Fanu, R.L. Stevenson, Oscar Wilde, Sir Arthur Conan Doyle, M.R. James, E.F. Benson and others.

Although Blackwood loathed life in the city, he spent long periods both in New York and London, whether by choice or compulsion. In his autobiographical account of his youth, *Episodes Before Thirty*, Blackwood describes the ravishing effects of city-life on his mind and character: "I seemed covered with sore and tender places into which New York rubbed salt and acid every hour of the day" (Blackwood 1923, p. 124).

Blackwood's urban existence stood in sharp contrast with a particular kind of nature mysticism which he developed at an early age:

Bringing comfort, companionship, inspiration, joy, the spell of Nature has remained dominant, a truly magical spell [...] The early feeling that everything was alive, a dim sense that some kind of consciousness struggled through every form, even that a sort of inarticulate communication with this "other life" was possible, could I but discover the way—these moods coloured its opening wonder. (Blackwood 1923, pp. 32–33)

For Blackwood, Nature acted as an antithesis to the materialistic reality centred on personal profit (Joshi 2014, pp. 380-381); a belief underpinned by the theories of the German philosopher Gustav Fechner, who expressed the idea that everything in the Universe had a soul[8] (Ashley 2001, p. 24). He travelled far and wide in search of intimate experiences in nature that would set him on the path towards a deeper understanding and transformed many of his experiences into stories set in more or less exotic locations.[9]

6. This obviously recalls some famous Romantic musings on the same subject, such as Keats's *Ode to a Nightingale*, with which Thomas, the critic of poetry, was well acquainted.
7. The titles of his two collections of short prose, *Rest and Unrest* (1910) and *Light and Twilight* (1911) are evocative of the general mood both of Thomas and the Edwardian times he lived in.

8. In turn, Gustav Fechner (1881–1887) based his theories on the German Romantic idea of *Naturphilosophie*.
9. Among others, "The Wendigo", which takes place in the Canadian wilderness where Blackwood went moose-hunting in 1898; "The Glimmer of the Snow", set in the Swiss Alps where Blackwood would spend countless winter seasons up to the very end of his life; "Sand", an imaginative reflection of his experiences in Egypt; "The Willows", based on a canoe

However, Blackwood also used England as the setting for tales in which nature provides transcendence and a consciousness of a more profound reality. One of these is the novella "The Man Whom the Trees Loved", set in the New Forest. In this story, the contrast between the familiar English landscape and the unknown, fearsome reality that lurks just on its borders, makes it particularly poignant. "The Man Whom the Trees Loved" is mainly about escaping from a trivial reality to a deeper, more fulfilling world in which the natural and the supernatural dimensions converge. The protagonist, David Bittacy, has developed an almost mystical relationship with trees during his many years as a civil servant in India, and once retired to a villa in the New Forest, the English trees beckon him to join them in a mysterious communion that his wife can't understand, but which attracts him profoundly:

> She saw him go away from her, go of his own accord and willingly beyond her; she saw the branches drop about his steps and hide him. His figure faded out among the speckled shade and sunlight. The trees covered him. The tide just took him, all unresisting and content to go […]. Beyond this stealthy silence, just within the edge of it, the things of another world were passing […]. It seemed that behind and through the glare of this wintry noonday in the heart of the woods there brooded another universe of life and passion, for her all unexpressed. (Blackwood 2002, pp. 261–262)

In the story, David Bittacy takes on the role of an explorer of the liminal space between the natural and the supernatural, mediated by the trees. However, not all trees are native; Bittacy has planted a cedar in his garden, and the English species rage against it. Eventually, the cedar is uprooted and destroyed in a storm which, the narrator hints, is prompted by spirits inhabiting the local nature. In this, "The Man Whom the Trees Loved" reflects a typically Edwardian desire to purge the autochthonous of foreign influences and retrieve older and more authentic traditions in the face of contemporary threats. The setting is surely no coincidence: the New Forest is a place with a special role in the English imagination, haunted by legends since time immemorial and very ostensibly subjected to foreign rule when Edward the Conqueror restrained public access to the forest and turned it into a royal hunting reserve for the Norman elite.

3 ARTHUR MACHEN

The Welsh writer Arthur Machen grew up in the town of Caerleon, surrounded by forests, hills and old Roman forts, in the second half of the nineteenth century. This environment would have a strong hold on

Machen's imagination throughout his life, and in his works he would refer to the area as Gwent,[10] the name of the corresponding medieval Welsh kingdom — which recalls the regional world-building also present in Thomas's "South Country", in so far as Machen, in his literary intercourse with the natural world of his native county, strives to unearth older, half-buried cultural strata in which the natural and the supernatural mix freely (Worth 2018, pp. xi–xii, xxix).

As a young man, Machen went to London to study and establish himself as a writer. Like Thomas and Blackwood, he loathed the city, which seemed to drain him of energy, but he could still perceive its underlying depths, especially during his long nightly walks, when the prosaic everyday reality of the metropolis was transformed into something shining and fantastic.[11] He would return to the fascination he felt for such transformations — Machen referred to them as "transmutations" — time and again in his writings, from the autobiographical *The Hill of Dreams* (1907) to the later reminiscences in *Far Off Things* (1922), and the novella "A Fragment of Life" (1906).

Machen combined his career as a journalist with the writing of weird tales, the plots of which frequently involved occult rituals (Worth 2018, p.xiii)[12] and the presence of ancient mythical creatures lingering just below the surface of everyday reality. In the First World War Machen worked as a war correspondent for the *Evening News* and became famous for his story "The Bowmen", published in 1914, about a host of ghosts of medieval British bowmen who appear out of nowhere to succour the beleaguered British soldiers who were trapped during the Battle of Mons in August, 1914.[13]

In his most successful stories, however, Machen moves away from the overtly supernatural and into a liminal area which blends nature, cultural memory and imagination, to explore the interaction between these deeper dimensions of the landscape and the everyday Edwardian reality of his characters. His native

10. As he notes in his autobiography *Far Off Things*, "I had been inventing tales in which and by which I had tried to realise my boyish impressions of that wonderful magic Gwent" (Machen 1922, p. 19).

11. These explorations rightly earned Machen a status as a pioneer of what has later been labelled "psychogeography". See Merlin Coverley's *Psychogeography*, especially chapter 1.

12. Like Blackwood, Machen joined the Order of the Golden Dawn and experimented with occultism; reportedly the two writers met and got on well enough, but did not much enjoy each others' writings (Ashley 2001, pp. 113–114).

13. In spite of its ostensibly supernatural content, the story was taken at face value as a real news report by many, in spite of Machen's later insistence that it was merely a product of his own imagination (Joshi 2011, p. xxi). If nothing else, the reception of the story testifies to the willingness of the British to believe in miracles and supernatural intervention (a belief perhaps even triggered by the Great War, as literary historians such as Paul Fussell would say in his seminal *The Great War and Modern Memory*).

trip undertaken with a friend on the Danube, and the mystical autobiographical novel *The Centaur*, which imaginatively chronicles his travels in the Caucasus.

town, where the old Roman remains mingled with the autochthonous Celtic and Welsh heritage, provided subject matter for many of these stories, which were set off and given shape by local nature. One example is the first chapter of Machen's autobiographical novel *The Hill of Dreams*, written between 1895 and 1897 but not published until 1907, in which the dreamy protagonist and aspiring writer Lucian — a thinly disguised Machen — is suddenly struck by the transformative powers of the landscape. As Lucian leaves his house to go for a walk at dusk, nature seems to conspire with the protagonist's consciousness of the lingering presence of a much older past, the attunement to which endows him with a transcendental perception of the world.

> As Lucian looked he was amazed, as though he were reading a wonderful story, the meaning of which was a little greater than his understanding. Then, like the hero of a fairy-book, he went on and on, catching now and again glimpses of the amazing country into which he had penetrated, and perceiving rather than seeing that as the day waned everything grew more grey and somber. [...] He walked smartly down the hill; the air was all glimmering and indistinct, transmuting trees and hedges into ghostly shapes. [...] He liked history, but he loved to meditate on a land laid waste, Britain deserted by the legions, the rare pavements riven by frost, Celtic magic still brooding on the wild hills and in the black depths of the forest. (Machen 2010, pp. 65–66)

The Hill of Dreams ends in tragedy, when the protagonist is forced to leave his native Welsh village for London, where he attempts to conjure up the same experience but is left exhausted, overwhelmed by a city that forces itself upon his perception in unwanted ways and finally prompts him to commit suicide. To some extent, it reflects Machen's own early experiences in London, but as opposed to his semi-fictional hero, Machen learned to come to terms with the city and would revisit the plot of *The Hill of Dreams* later in life. The novella "A Fragment of Life" (1906) is, again, a story of a Welshman trapped by bourgeois conventions in the city of London, but this time Machen allows his protagonist the possibility of redemption. Edward Darnell (again, in all likelihood, modelled on Machen himself) rediscovers the allure of the country after many years in the city—and he does so by reenacting his youthful walks, which now take him out of the thronged city centre and into a suburbia where the country and the city suggestively blend and create visions of supernatural marvels:

> There was a rapture in Darnell's voice as he spoke, that made his story well-nigh swell into a song, and he drew a long breath as the words ended, filled with the thought of that far-off summer day, when some enchantment had informed all common things, transmuting them into a great sacrament, causing earthly works to glow with the fire and the glory of the everlasting light [...]. "I would roam about old, dim squares and hear the wind whispering in the trees [...]. The shadow, and the dim lights, and the cool of the evening, and the trees that were like dark low clouds were all mine, and mine alone [...] I was living in a world that nobody else knew of, into which no one could enter." (Machen 2011, p. 183)

The story culminates with the couple's decision to move back to Edward's old family home in Wales, to be enriched by the landscape and its cultural and mythical heritage, without yielding either to mad escapism or to the obliteration of such legacies through a passive urban existence. The concluding lines consist of an annotation by Darnell, which shows the rich blend of fantasy and reality that exists in this natural space, charged with mystery and otherworldly presences:

> So I awoke from a dream of a London suburb, of daily labour, of weary, useless little things; and as my eyes were opened I saw that I was in an ancient wood, where a clear well rose into a grey film and vapour beneath a misty, glimmering heat. And a form came towards me from the hidden places of the wood, and my love and I were united by the well. (Machen 2011, p. 222)

4 CONCLUSIONS

In the final analysis, Edward Thomas comes through as a writer who struggled to break free from mundane reality and find solace in the mystical dimension of the countryside, using literary excursions into a landscape heavily informed by history, culture and myth. However, Thomas suffered from frequent depressions and was unable to keep up the heightened perception required by such a purpose for very long. In the end, he gave up his attempts to break through to the "dark, not understood world" by intercourse with nature, instead turning to war for liberation from his earthly bonds.

In the novella "The Man Whom the Trees Loved", Algernon Blackwood expresses a different approach to such experiences. Rather than exploring the possibilities of dwelling on the border between the known and the unknown, his characters are compelled to choose between one dimension or the other. David Bittacy, who has developed a special bond with the trees, passes effortlessly through to the trees' own reality, while his wife is terrified of it. Bittacy's body remains in the Edwardian cottage, but it is now only a "shell, half emptied" (Blackwood 2002, p. 273). The protagonist's quiet acceptance of the tree world is contrasted with his wife's despair, and Blackwood seems to hint that the former has reached a higher state of awareness and is all the more happy for it.

This comes through as wishful thinking, and the works of Arthur Machen—who on one occasion reportedly said that while Tennyson could write exquisite poetry about cedars sighing for Lebanon, "Blackwood believes the cedars really do sigh for

Lebanon and that [...] is damned nonsense!"[14] — express the development of a more fruitful interaction between the real and the imaginative. Little by little, Machen negotiates a space for both, from the desperate attempts of the protagonist of *The Hill of Dreams*, which end in disaster, to the later vision in "A Fragment of Life", where the thoughtful and sensitive Edward Darnell returns with his wife to Wales to partake in both realities.

Collectively, the three writers portray the English countryside not only as a site of consolation, recreation and escape from a dreary city-life, but also a catalyst for ancient myth, the supernatural and horror, thus giving expression to inherently Edwardian tensions that would reach a crescendo in the Great War only a few years later.

ACKNOWLEDGEMENT

This essay was completed under the auspices of the REWEST research group (code: IT 1026-16), funded by the Basque Government (Dpto. de Educación, Universidades e Investigación/Hezkuntza, Unibertsitate eta Ikertu Saila) and the University of the Basque Country, UPV/EHU.

BIBLIOGRAPHICAL REFERENCES

Ashley, Mike. (2001). *Algernon Blackwood: An Extraordinary Life*. New York: Carroll and Graf.

Blackwood, Algernon. (1923). *Episodes Before Thirty*, New York: E.P. Dutton.

Blackwood, Algernon. (2002). *Ancient Sorceries and Other Weird Stories*. London: Penguin Books 2002.

Bunce, Michael. (1994). The Countryside Ideal: Anglo-American Images of Landscape. London & New York: Routledge.

Coverley, Merlin. (2010). *Psychogeography*. London: Pocket Essentials.

Hattersley, Roy. (2004). *The Edwardians*. London: Abacus.

Hollis, Matthew (2011). Now All Roads Lead to France: The Last Years of Edward Thomas. London: Faber and Faber.

Joshi, S.T. (2014). *Unutterable Horror: A History of Supernatural Fiction* (vol. 2). New York: Hippocampus Press.

Joshi, S.T. (2011). "Introduction" in Machen (2011), x–xxiv.

Lewis-Stempel, John. (2016). Where Poppies Blow: The British Soldier, Nature, The Great War. London: Weidenfeld & Nicolson.

Longley, Edna. (2008). "Introduction". In Thomas (2008), 11–27.

Machen, Arthur (1922). *Far Off Things*. London: Martin Secker.

Machen, Arthur. (2010). *The Great God Pan and Hill of Dreams*. Ocean Shores, WA: Watchmaker.

Machen, Arthur. (2011). "A Fragment of Life", in Machen (2011), 148–222.

Machen, Arthur. (2011). *The White People and Other Weird Stories*. London: Penguin.

Machen, Arthur. (2018). *The Great God Pan and Other Horror Stories*. Oxford: Oxford University Press, 2018.

Thomas, Edward (1910). *Rest and Unrest*. London: Duckworth.

Thomas, Edward. (1993). *The South Country*. London: Everyman.

Thomas, Edward. (2008). *The Annotated Collected Poems*. Edna Longley (Ed.). Highgreen: Bloodaxe.

Thomas, Helen (with Myfanwy Thomas). (1997). Under Storm's Wing, Including As It Was and World Without End, Letters and Memoirs. Manchester: Carcanet.

Worth, Arron. (2018). "Introduction". In Machen (2018), pp. ix–xxx.

Zaczek, Iain. (2005). *Fairy Art: Artists and Inspirations*. London: Flame Tree Publishing.

14. These words are attributed to Machen by Vincent Starrett in his book *Born in a Bookshop*. Qtd. in Ashley 2001, p. 114.

The cure for death: Fantasies of longevity and immortality in speculative fiction

Teresa Botelho

Department of Modern Languages, Literatures and Cultures, NOVA School of Social Sciences and Humanities, Lisbon, Portugal
ORCID: 0000 0003 12568771

ABSTRACT: Anxiety about old age and mortality, a constant and cross-cultural reaction to the finitude of life and evanescence of youth, has fed multiple fantasies of immortality that frequently also incorporate the triumphant regeneration of the body. But while in the nineteenth century these fantasies, ungrounded on any scientific possibility, focused on the social and psychological disorientation and disruptions of the defeat of death and ageing, the late twentieth and twenty-first century fictions, invoking possible extrapolations of contemporary scientific and technological knowledge, have used the tropes of immortality and the rejuvenated body to serve either dystopian visions related with problematics of distribution of power, or to signify the utopian techno-optimist promises of trans-humanism.

This paper will discuss these creative imaginings of the defeat of embodied decay using three speculative novels that position themselves as signposts along this spectrum: Walter Bessant's *The Inner House* (1888), a conservative anti-utopian reflection on the social and cultural costs of immortality; Bruce Sterling's *Holy Fire* (1996), a cyberpunk novel where access to permanent health and youth acts as a social divider between deserving elites and the masses condemned to grow old; and Cory Doctorow's *Down and out in the Magic Kingdom* (2003), a post-singularity satirical novel where in a post-scarcity future society all enjoy the possibilities of body and life plasticity.

Keywords: Immortality; Longevity; Speculative Fiction; Singularity; Dystopia

1 WHY WERE WE BORN IF IT WASN'T FOREVER?

In *Declining to Decline*, published more than twenty years ago, Margaret Gullette asserts that "age remains an impoverished concept" in much of the theorizing about discourse, "hidden in its supposed foundation in the body", its constructiveness obscured by a master narrative of decline that sees ageing as ahistorical and pre-discursive, reduced to the protocols of the natural (pp. 201-202). Since these reflections on what Gullette characterized as the "Infancy of Age Theory", much work has been done to cast into doubt that master narrative, questioning whether "decline becomes visible and speakable because the body ages" or because, as she suggests, "our culture finds it necessary for subjects that are young to be seen and be said to be aging" (1997, p. 201). In parallel, our understanding of what philosopher Martha Nussbaum has recently called the "projective disgust" towards the ageing body, has exposed how much of it is, in reality, a manifestation of the anguish caused by the knowledge that

aging is the only disgust-stigma category into which every one of us will inevitably move, if we live long enough. (2017, p. 112)

But unlike other variations of stigma attached to identity-based out-groups, grounded on fantasies of difference based on racial, gender, sexual or ability hierarchies, there is an inescapable reality to ageing in that it is taken to be a precursor and a visible sign of mortality. In the same way as youth is a value dependent on its own evanescence, ageing cannot be separated from the radical transience of life, signifying the certainty of the interruption of the project of making ourselves, summarised by Eugene Ionesco's King Berenger's desperate question "Why was I born if it wasn't forever?"

Equating the ageing body with anguish about death is, of course, a somewhat restrictive proposition. First, it assumes, somewhat uncritically, the familiar axiom that it is the end of life that gives it significance, and that death itself (as separate from the process of dying) is undesirable and undesired. Philosophers like Anthony Brueckner and John Martin Fisher, revising the asymmetrical attitude to non-existence identified by Epicurus and Lucretius, have discussed why death, which no one has personally experienced and should, therefore, be categorised as an "experiential blank" (2009, p. 27), is perceived as bad for the individual who dies in ways that pre-natal non-existence is not, even if we have no expectations of any kind of

afterlife. Answering the Epicureans' arguments against the fear of death, they turn to Thomas Nagel's view that posthumous non-existence is perceived as a privation of experienced good things in ways that pre-natal non-existence cannot be, supported by the uncontroversial and commonsensical awareness that if most humans probably regret not living longer, the same kind of regret is not usually projected into a desire for having been born earlier.

Secondly, besides the obvious fact that one may die before one's body falters, fantasy projections of an ideal life without death usually also preclude aged bodies. No one would envy the Struldbrugs of Luggnagg, the immortals in *Gulliver's Travels* who, though "exempt from that universal calamity of human nature" and living forever, are far from being the "happy people of a happy nation where every child hath at last a chance for being immortal" since they become senile and socially rejected, are stripped of their assets at 80 and eventually lose their memory (Swift, Part III, chapter 10). What fictions of immortality tend to project as ideal is the end of death and the competency associated with a youthful body.

The tension between these two desires – youthful vigour and a transcendence of what Swift called the calamity of human nature – explains why most fictions of longevity, predicated either on the stopping of the ageing process or the creation of methods of rejuvenation, also aspire to immortality and why narratives of immortality also incorporate the triumphant defeat of the destiny of the biological body. These linkages are naturally framed by the horizons of the possibility of a specific timeframe. In the Anglophone tradition, fantasies of immortality emerging in the nineteenth century, when this project could only be imagined by the introduction of some unexplained almost magical *novum*, question the desirability of the defeat of ageing and death focusing mostly on the disorientation and disruptions brought about by these inversions of the natural, as is the case of Mary Shelley's "The Mortal Immortal" (1833) and Walter Bessant's *The Inner House* (1888). Some of these preoccupations also emerge in some late twentieth and twenty-first-century science fiction, framed by the techno-optimism of the singularity theory and by the contemporary debate about the post-human condition, indebted to the inheritance of the Cartesian dualities of cyberpunk. Here the tropes of immortality and the rejuvenated body serve to interrogate both the problematics of distribution of power created by access to immortality and issues related to the survival of the sense of selfhood. This paper discusses and teases out these approaches by contrasting the imagination of immortality in a nineteenth-century text, the *Inner House*, with recent science fiction novels that exemplify different dynamics of post-singularity immortality: Bruce Sterling's *Holy Fire* (1996); *Accelerando* by Charles Stross (2005); and

Down and out in the Magic Kingdom (2003) by Cory Doctorow.

2 LIVING AFTER THE GREAT DISCOVERY

If in Mary Shelley's short story "The Mortal Immortal" (1833) the protagonist's defeat of death is unintended and personally disastrous, as Winzy, the alchemist's apprentice who drinks an immortality potion thinking it is the cure for love, comes to see the results of his eternal youth as a destroyer of his personal happiness and family harmony, *The Inner House*, published 55 years later, extends the investigation of the consequences of immortality from the domain of the personal and the confessional to that of the social and the political.

The narrative opens at the moment the discovery of "the Prolongation of Vital Energy" is revealed in a lecture at the Royal Institution given by Professor Schwarzbaum, who intends to donate the anti-ageing chemical formula to "the world". We soon realise that "the world" will diverge from the generous discoverer in two significant ways. First, while the professor explains to his audience that the medicine is intended to "prolong life only until a person has enjoyed everything they desire", expecting that after two or three centuries "you would, of your own accord put aside the aid of science" and, contented and resigned, "sink into the Tomb" (p. 11), when the story jumps hundreds of years into the future we understand that "the Great Discovery" has been used exclusively as an instrument of immortality.

Secondly, when we visit that future, we understand that the discriminatory clauses proposed by the professor, namely that longevity should be offered only to "the salt of the earth, the flower of mankind" and that those whose

> lives could never become anything but a burden to themselves and to the rest of the world – the crippled, the criminal, the poor, the imbecile, the incompetent, the stupid, and the frivolous [...] would live out their allotted lives and die (pp. 10–11)

had been reinterpreted and expanded. In the immediate aftermath of the discovery, all the elderly had been wiped out in the genocide known as the *Great Slaughter*, and only the young had benefitted from the Great Discovery. In the following centuries, no one had chosen to die, and no one had been born, except on the rare occasions when the state had allowed a birth to replace an accidental death. An authoritarian society, controlled by the organ known as the College of Physicians headed by an Arch Physician, had emerged, one where everyone lives by a collective schedule and acts, looks and thinks in exactly the same way. Having first taken the Arcanum, as the longevity formula is now known, at a young age (twenty-five for women and thirty for men), the citizens of the ageless

and deathless utopia live without personal property, joy, curiosity or thirst for knowledge. In this world, which anticipates the nightmarish landscapes of Zamyatin's *We*, as the narrator[1] informs the reader, "Art, Leaning, Science – other than Physics, Biology and Medicine – all gradually decayed and died away" and the "old foolish pursuit of literature" had also been abandoned since "no longer anxious about their past or their future", these new humans were "contented to dwell in the present" (p. 28). Thus, the narrator assures us, "true happiness has been achieved" as "life has been reduced to its simplest form [...] nothing to hope, nothing to fear" (p. 26) and, as the storyline suggests, nothing to feel and nothing to love. When rebellion comes, it is led by Christina, a young girl whose exceptional birth had been allowed as a replacement for one accidental death. She is allowed to live in an abandoned Art Museum no one visits, with an old man who had escaped the Great Slaughter. Having no personal memory of the past, her contact with its artistic representations in her nightly meanderings through the empty galleries awakens in the young girl a passion for the romanticised elegance of the pre-immortality days when, as the portraits suggest, there were ladies with beautiful dresses and heroic sailors and soldiers who knew they were better than other men. Sharing these imagined memories with a small group of acquaintances, former aristocrats and military men who actually remember, kindles a feeble rebellion that, having failed, leads the nostalgic group to leave the Utopia of Immortality and Equality and retreat to a faraway island to attempt to replay the roles they half remember, to live fully, with pleasure and love and then to die without regrets.

The undisguised conservative undertone of the narrative does not obfuscate this very early literary presence of a very influential trope in immortality fiction – living forever is tedious and soul-crushing. This is the proposition defended by moral philosopher Bernard Williams who, although distancing himself from the tenet that it is the inescapable reality of death that gives meaning to life, argues that immortality would be intolerable, based on the notion of continuity of the self, subject to the same unchanging desires and goals such as those one acquires in the course of a finite life; if such immortal humans retained a sense of selfhood, argues Williams, contentment would be necessarily elusive as an endless cycle "of supposedly satisfying states and activities" would prove unendurably boring to anyone who remained conscious of himself and "who had acquired a character, interests, tastes and impatiences in the course of living" (Williams, 1993,

p. 87). One might argue nonetheless, as John Martin Fisher does, that these conclusions assume a sense of permanence and unchangeability of the self that rules out the possibility that a future I, while recognizably the same, might change in response to future circumstances and either acquire new interests or continue enjoying other non-"self-exhausting", repeatable pleasures (Fisher, 2009, p. 85).

In contemporary speculative fictions of immortality this paradox – how to reconcile the identity condition with the attractiveness condition (being the same and finding pleasure in a never-ending life) – has been a central problem examined from many angles. The premises they explore are obviously different; while narratives of immortality written in the nineteenth-century could not escape the shadow of the quasi-magical and unexplained fantastic defeat of the laws of biology, by the late twentieth-century the utopian mythologies of post-singularity discourses would provide a fertile terrain for imagining the transcendence of what futurist Ray Kurzweil calls our "1.0 biological bodies", over which we will gain power so that "our mortality will be in our hands" and "we will be able to live as long as we want." (Kurzweil, 2006, p. 9). This liberation of the body from its finitude and frailty is frequently imagined either as a function of medical and technological enhancement and fusion with non-biological elements or by extending the Cartesian dichotomy to imagine a self that can move away from its original "meat machine" to inhabit a plurality of disposable and redoable bodies.

3 TECHNOSCIENCE AND POSTHUMAN LIVES

In *Holy Fire* (1996), Bruce Sterling distances himself from some of the cyberpunk tropes he is associated with and invests in a purely carbon-based immortality, choosing to investigate the challenges Williams so clearly identified and to revisit Bessant's agenda, bringing to the fore the new power relations and social landscapes brought about by extreme longevity and immortality.

The novel draws a late twenty-first-century world dominated by a political-medical-industrial complex devoted to the ultimate pursuit of life extension for deserving citizens, aiming to prolong life until a cure for mortality is achieved. Controlling most of the world's economy and biomedicine, employing fifteen per cent of the world's population and topping all other government expenses, it is mostly dedicated to gerontological research. In this global order, the distribution of power is measured by access to longevity. While "once upon a time having money almost guaranteed good health", now worthiness has replaced wealth (p. 49). For the undeserving, dedicated to the pursuit

1. The narrator is not a neutral observer; he is, as the reader only discovers half-way through the text, the former Suffragant (the second rank in the power hierarchy), whose narrative is a retrospective account of an episode of rebellion against the status quo which he defends ardently.

of "irresponsible" body-destroying pleasures, there is no escape from natural ageing and death. A medical surveillance panopticon determines each individual's worthiness; as Martin, a 96-year-old film director denied rejuvenation treatments, explains:

> when you go in for a checkup they take your blood and hair and DNA and they map every trace of every little thing you've done to yourself.

Unless you are "a little tin saint" your records, splashed "all over the net", condemn you to your biological destiny (p. 11).

If, on the other hand, you are a productive, responsible and unquestioning supporter of the medical state and have "objectively demonstrated your firm will to live" and your "tenacious approach to longevity" as demonstrated by your medical records (p. 47), you are rewarded with permanent medical upgrades and rejuvenation treatments that keep you looking and feeling youngish.

On the margins of this elite gerontocracy, pockets of non-compliers (the American Amish, for example, who cling to the natural ways) and the "real" young, struggling to be "vivacious" (that is innovative and creative), have attempted, with little success, to sustain alternative life choices outside the dominant order.

The narrative centres on the experience of Mia, a member of the elite, a 94-year-old medical economist from California, living a meticulously planned existence from which pleasure has long been eradicated. Describing herself as a post-sexual and post-womanly technochrome, she summarises her life:

> I don't have lovers [...] I don't kiss anyone, I don't hug anyone, I don't cheer anyone up. (p. 16);
> I look at screens and study grant procedures and weight results from research programmes. (p. 13)

"I'm a functionary" she concludes. (p. 13)

This exemplary behaviour renders her the perfect candidate for the ultimate experimental treatment which will grant her biological youth, restoration of all metabolic drives and immortality – on condition she lets herself be examined and constantly medically monitored after the procedure. "You are," her doctor explains, "going to be a ninety-five-year-old woman who can look, act and feel like a twenty-year-old girl" (p. 57).

Thus the 20-year-old girl that emerges from the treatment is not exactly the youthful-looking nonagenarian woman who volunteered for it. The difference is not only located in the body but in the double-edged mind, now both old and young. While she certainly retains her sense of self, she recognises that she is not the same. She can let the old self resurface and pretend that not much has changed, but being "the Mia thing", a "meek... and accommodating bundle of habits" (p. 63), is no longer tolerable.

"Something has snapped," she recognises when contemplating her old life.

This is not my place. This is nowhere. I can't live like this. This isn't living. I'm out of here." (p. 66).

Following the new impulsiveness and desires of the new body and new double consciousness, calling herself Maya, the once passive Mia escapes the medical surveillance team and heads to Europe, looking for "holy fire", an excitement about life and its possibilities she had never missed before.

It is when surrounded by what Teresa Magnum calls "metaphors of aging" (2002, p. 76), expressed by the centuries-old landscapes of Praha, Frankfurt and Stuttgart, that, somewhat paradoxically, Maya finds avenues of defiant self-expression in the company of communities of irreverent and bohemian young anarchic artificers who, unable to defeat the power of the artificially young, seek a kind of immortality in virtuality and occasionally find in suicide the most radical gesture of protest against the gerontocratic order.

Defying laws and social mores, experimenting new types of pleasure and sexual delectations, Maya/Mia's embodied performance of youth will eventually fall prey to the paradox identified by John Fisher Martin. Her double consciousness clashes with her newly obtained desires. Her 20-year-old self knows what her 94 years have taught her. Being both the same and not the same turns her potentially immortal life into both a continuous and a discontinuous experience. Finding no long-term satisfaction in her performance of new, liberated youth, she returns home and attempts to live disconnected from the system that gave her what she no longer feels she really wants, knowing full well that this break will mean ageing and eventually death. At the end of the novel, she finds a private and self-reflexive pleasure in photographing the processes of ageing of the Amish, a gesture of reconciliation with the natural processes of body decay and death, which she now has chosen as her future.

If *Holy Fire* projects immortality on a stable biological, if radically modifiable, body, novels which draw more directly on the Singularity metaphors tend to depend on a detachment between the mind and a body which is not only modifiable but replaceable, sometimes even projected into several serial non-atomistic modes of being. Some of these techno-utopias lack, as Steven Shaviro points out, a modicum of "existential anguish", creating naively optimistic post-human vistas (2009, p 109).

Cory Doctorow's *Down and Out in the Magic Kingdom* (2003) is not in that category, offering a more reflective contemplation of the promises of the technological Singularity, modulated by a satirical gaze. It takes the reader to a twenty-second-century post-scarcity world based on the distribution of Free Energy to all, guaranteed by a global entity known as the Bitchun Society.

Under this utopian order, basic material conditions are assured to all; there is no poverty and no economical sources of inequality, work is strictly voluntary,

and a vehicle for self-expression and pleasure rather than a condition of survival, and both sickness and death have been eradicated thanks to a combination of nano-production, mind–uploading and body cloning.

In this ad-hocracy with no central authority, status is based not on money or the value of material objects but on individual reputation, represented by *Whuffie* points attributed to each individual according to their socially useful endeavours. The points are automatically known to all as individual scores are accessed via the networked brain implants all citizens have, establishing a new type of social hierarchy based on a "likeability" status. This ironic portrait is enhanced by the location of the plot, a Disney World where different groups struggle for simulacra of power based on aesthetic values and the popularity of their creations.

Involuntary death has been abolished, age is a flexible concept as one may choose the years of the body one carries, and life is as long as one wants it to be. Immortality is seen as potentially rewarding and filled with delights, as Julius, the more than 100-year-old narrator, initially describes when he mentions his many achievements – the ten languages he has learned, the three symphonies he has composed, his four doctorates, all enjoyed, by choice, in a 40-year-old looking body.

But this listing of the joys of unending possibilities notwithstanding, it is the re-visitation of Williams' conditions for an appealing immortality that most of the novel addresses, dwelling on the double conundrum of the potential boredom of eternity and the permanence and stability of the self.

The challenges of sustaining an interesting never-ending life are assumed to be so inevitable that a solution has been provided – the practice of *deadheading*. This is best described as a temporary death from which one may re-emerge anytime one chooses as one leaves one's conscience backed up ready to unload into a fresh body should one want to try and live again. This widely used practice is recommended to those who feel they have seen all there is to see, done all there is to do and crave a permanent death.

This is the case of Keep A-Movin' Dan, a friend of Julius' who, having lived his very active long years in a 25-year-old body, looks at the long arch of eternity with panic: "I think that if I'm still alive in ten thousand years, I'm going to be crazy as hell." Asking "You really think there is going to be anything recognizably human in a hundred centuries?" he concludes,

> Me, I'm not interested in being a post-person. I'm going to wake up one day and I'm going to say, 'Well, I guess I've seen about enough' and that will be my last day. (p. 13)

When his friend Julius suggests, "why not just deadhead for a few centuries, see if there's anything that takes your fancy and if not, back to sleep for a few more?" the proposition does not appeal to Dan, who is resolved to "stop moving, stop seeking, stop kicking,

and have it done with" when the day comes "when I don't have anything left to do, except stop." (p. 13)

The ironic limitations of the utopian promises of what Julius had called the "cure for death" (p. 7) does not stop here, as the text revisits the disembodied mind trope in new ways, introducing a degree of instability in the process of body assignment and mind uploading that is far from problem-free.

Early in the novel, Julius is murdered, a futile and inexplicable exercise because of the assured reversibility of the act. This is, in fact, his third death and as he admits, it is becoming increasingly easier to recover from it. "The first time I died", in a diving accident, he remembers, the process of making mind-backups was still painfully slow: "it took almost a day, and had to be undertaken at a special clinic", and people like him did not do it regularly. The memory his new body received was therefore incomplete, with a couple of weeks missing, a void hanging so heavily on his sense of "rebirth, that it had taken him almost a year to find and reinvent himself" (p. 34).

His second death, ten years after the first one, this time of a massive heart attack, could have been equally traumatic since he had been lax in backing up again, but this time he was helped by a "computer-generated précis of the events of the missing interval" and was followed by a counsellor until he felt at home again in his rebooted body (p. 35).

Armed with that experience, his casual dismissal of the experience of being killed – "Sure, I'd been murdered, but what had it cost me? A few days of "unconsciousness" while they decanted my backup into my new body" (p. 49) – hides a new concern that will come to haunt him after the procedure.

It is not that he agrees with the ontological doubts of his old friend Dan, who calls into question the sameness of his copy, clinging to the belief that "there is a difference between you and an exact copy of you" and that "being destroyed and recreated" cannot possibly be the same as "not being destroyed at all" (p. 41) since he is sure that he feels like himself, but that he is haunted by a heightened awareness of the loss of memory. If everyone's "decanting" is limited by the date of their last backup what is lost? And how can you be sure of the continuity of the self if something important in shaping that self might be missing, something that cannot be re-lived by mere enunciation of its factuality?

It is this idea of loss of lived time and experience that paralyses him when he begins to suffer from a radical malfunction – his mind goes off-line at unexpected times, depriving him of all the knowledge and connections it has accumulated, leaving him with "no tone in my cochlea indicating a new file in my public directory" (p. 69), no access to statistics and data.

The cause of this condition, his doctor explains, is a defect in the "brain-machine interface" installed when he was restored after his last death. Curing the malfunction would not be difficult, involving a rebooting

into a new clone refreshed from his last backup, nevertheless implying the complete loss of a whole year of memories, and this he finds he cannot accept. "I was going to lose [...] it all," he reflects, "all of it, good and bad. Every moment flensed away." "I couldn't do it" (p. 126).

His refusal, based on the sense of the permanence of the self-grounded on lived emotions, inverts the notions of life and death as Julius comes to see the recommendations of his doctor and friends as an attempt to kill him in order to save him. The choice before him seems to be between a complete breakdown of his brain-machine interface, condemning him to be permanently "offline, outcast, malfunctioning" (p. 105), and the loss of the experiences he most values and that he identifies with his sense of deep identity.

Besides, with Dan planning to take a lethal injection soon, the procedure would erase his best friend completely from his memory. And who will he be if he does not remember the emotion of the existence and loss of a friendship he so values?

Torn by the options before him, he tries to escape from the responsibility of the decision by drowning himself in a lake, hoping to be refreshed without choosing it and consciously "shutting out the last years of my best friend's life" (p. 193). This pathetic attempt to "abdicate", as he puts it, fails (as he is rescued before he dies) and he is left with the impossible decision between what he sees as two kinds of quasi-death.

At the end of the novel, Dan decides not to die, opting for long-term deadheading: "I'll poke my head in every century or so, just to see what's what, but if nothing really stupendous crops up, I'll take the long ride out," he explains (p. 204). Julius, on the other hand, decides to drop off earth and take himself to space, leaving behind his increasingly obsolete back-up and relying instead on his own words, writing "long hand a letter to the me that I'll be when it's restored into a clone somewhere, somewhen" (p. 206). This letter is the novel the reader has just finished reading, a gamble on a sense of permanence projected into a future so distant it can hardly be imagined, neither refusing nor accepting the desirability of non-death.

Sherryl Vint has argued that

> science fiction is particularly suited to exploring questions of post-human futures, since it is a discourse that allows us to concretely imagine other concepts of bodies and selves, estranging our commonplace perception of reality." (2007, p 19)

In the case of our anxieties about ageing and death, while real-life research is being done into the possibilities of extreme longevity (the Calico Longevity Lab is one of the many initiatives operating today)[2], thought-experiments such as those discussed here may be productive mechanisms to explore the consequences of

our conscious and unconscious desires to transcend the limits of our existence that we cannot control. Divided between Plato's advice of acceptance, in his famous recommendation that we should "practise dying", and the scientifically grounded utopias and fantasies about the cure for death, these fictions of immortality offer us a landscape of "what ifs" that may help us work through ethical challenges of both the personal and public kind and think in new ways about the processes of our bodies.

BIBLIOGRAPHICAL REFERENCES

Bessant, Walter. (1888/ 2017) *The Inner House*. Scotts Valley: CreateSpace Independent Publishing Platform.

Brueckner, Anthony L. and John Martin Fisher. (2009) "Why is Death Bad?" In *Our Stories: Essays on Life, Death and Free Will*. Ed. John Martin Fisher. (pp. 17–35). Oxford: Oxford University Press.

Doctorow, Cory. (2003) *Down and Out in the Magic Kingdom*. New York: Tor Books.

Fisher, John Martin. (2009) "Why Immortality is Not so Bad." In *Our Stories: Essays on Life, Death and Free Will*. Ed. John Martin Fisher. (pp. 79–92). Oxford: Oxford University Press.

Gullette, Margaret. (1997) *Declining to Decline: Cultural Combat and the Politics of the Midlife*. Charlottesville: University of Virginia Press.

Ionesco, Eugene. (1963) *Exit the King*. New York: Grove Press.

Kurzweil, Ray. (2006) *The Singularity is Near: When Humans Transcend Biology*. London: Gerald Duckworth & Co.

Magnum, Teresa. (2002) "Longing for Life Extension: Science Fiction and Late Life." *Journal of Aging and Identity*, 7 (2) 69–82.

Nagel, Thomas. (1979) *Mortal Questions*. Cambridge: Cambridge University Press.

Nussbaum, Martha. (2017) Aging Thoughtfully: Conversations about Retirement, Romance, Wrinkles and Regret. Oxford: Oxford University Press.

Shaviro, Steven. (2009) "The Singularity is Here." In Mark Bould and China Miéville (ed.) *Red Planets: Marxism and Science Fiction*. (pp. 103–117). London, Pluto Press.

Shelley, Mary. (1997) "The Mortal Immortal: A Tale." In *Mary Shelley: Collected Tales and Stories*. Ed. Charles R. Robinson. (pp. 219–230). Baltimore: Johns Hopkins University Press.

Sterling, Bruce. (1996) *Holy Fire*. London: Phenix.

Swift, Jonathan. (1996) *Gulliver's Travels*- New York: Dover Publications.

Williams, Bernard. (1993) "The Makropulos Case: Reflections on the Tedium of Immortality." In *The Metaphysics of Death*. Ed. John Martin Fischer. (pp. 73–90). Stanford: Stanford University Press.

Vint, Sherryl. (2007) Bodies of Tomorrow: Technology, Subjectivity and Science Fiction. Toronto: University of Toronto Press.

Zamyatin, Yevgeny. (1993) *We*. New York: Penguin

2. See also the American National Academy of Medicine's Healthy Longevity Grand Challenge, and the Sens Research Foundation, headed by the controversial biomedical gerontologist Aubrey de Grey.

Upgraded fantasy: Recreating SF film

Iuliana Borbely

Department of Languages and Literatures, Partium Christian University, Oradea, Romania
ORCID: 0000-0002-7753-1374

ABSTRACT: In filmmaking empirical logic is seen to give way to magical thinking in film and thus, sci-fi films become less popular while fantasy films gain popularity. With CGI-generated imagery gaining more and more ground both in cinema and television film making, SF seems to demise since it cannot produce visually new material. To counter this tendency, SF film must recreate itself given the new circumstances. Instead of relying on great special effects, lately, both cinema and television productions turn inside and focus on human qualities such as the mind, emotions, identity, and personality while spicing up the story through the narrative with the combination of traditional and CGI-generated imagery. In the process, SF reconsiders some of its conventions and thus reinvents itself. We propose to explore how SF film is recreated by means of close reading of *Westworld* (2016-) sci-fi series against definitions of the genre by Vivian Sobchack and Susan Sontag. The analysis suggests that given its new take on narrative, SF film continues to feed on the anxieties of the present world, and in the same time, by turning the eye to the workings of the mind, its moralistic and lightweight narrative changes as well. It recreates itself by finding the middle way between old approaches and innovations.

Keywords: SF film, SF series, conventions, *Westworld*

1 INTRODUCTION

The release of the first part of the *Harry Potter* and *Lord of the Rings* series, fantasy films boomed and due to – in part – the spectacular imagery they presented, they easily gained popularity over what seemed to be an exhausted genre, the SF film. Vivian Sobchack comments that

> this loss of privilege is the result of the exponential increase in the use of CGI cinematic and televisual effects and their diffusion across a variety of genres" (2014, p. 284)

She further explains that special effects have become expected and commonplace, and due to our extended use of smart devices, digital effects have been "cinematically naturalized [...] and culturally internalized" (2014, p. 284). On the one hand, the use of computers and smart devices has become commonplace; they are not a futuristic, unattainable element anymore. On the other hand, these gadgets can perform such complex tasks that our notions of SF would eventually alter.

SF's difficult premise is heightened by being a heavy genre narrative-wise. It needs to explain not only the special effects but also its internal logic. The theoretical background varies from traditional areas of research to the latest developments, i.e. from the law of physics to robotics and AI research.

Besides components of the film, external circumstances have challenged SF film especially as far as its production is concerned. According to the same author, after 9/11 a non-stop plague of catastrophic events followed which

> not only seemed to concretely fulfil the last century's "premonitions of the future" as "the end of this and that" but also seemed to mark the end of the future itself" (Sobchack, 2014, p. 286).

The world has seen everything, and SF film could no longer present anything spectacular anymore. What is more, the need to represent visions of possible futures seems to have disappeared.

Hence, in order to be palatable in a period dominated by smart devices with which anyone can perform tricks unimaginable until the appearance of these, sci-fi film must recreate itself. Although empirical thinking and explanation of processes can hardly be eluded in these films, through incorporating computer-generated images and relying on the general public's knowledge of basic information technology facts the SF reinvents itself and regains popularity[1].

1. Lately, SF films either rely heavily on CGI, like in *Ready Player One* (Spielberg, 2018), or chose to reflect on how humans and scientific developments relate to one another. In this respect, science-fiction focuses on relationships, emotions and consciousness or the mind against the backdrop of technological development. *Her* (Jonze, 2013) for example, explores the possibility of a human developing a romantic relationship with an operating system. It does not present a very distant future, but exploits the latest developments in IT, and expounds on the anxieties of modern man regarding human identity.

The latest productions show new approaches with some of the old conventions reshaped. Our purpose is to examine whether generic conventions must be rewritten given the new modes of production. In order to answer these questions, we will do a close reading of one of the most popular SF series, *Westworld* (Jonathan Noland and Lisa Joy, 2016-) against the theoretical backdrop of Vivian Sobchack's and Susan Sontag's definitions and characterisation of the sci-fi film.

2 MAJOR CONVENTIONS OF SF

The concern with contemporary anxieties is one of the cornerstones of science fiction. Science fiction

> dramatizes the social consequences of imaginary science and technology in speculative visions of possible futures, alternate pasts, and parallel presents" (Sobchack, 2005, p. 261)

In her overview of American SF film, Sobchack concludes that after World War II, the new conditions of existence led to the first Golden Age of SF, since the atomic bomb, the Cold War, the arms race, and the developments in science and technology provided good soil for the growth of the genre.

Despite their touching upon delicate issues of their times, SF films avoided "reflective relation (allegorical or not) to the significant issues that trouble contemporary culture" (Sobchack, 2014: 284). With very few exceptions, SF films tend not to deal with issues that trouble our times. A romantic relationship with AI or computer-operating system (*Her*, 2013), the idea of lack of time in digital culture (*In Time* 2011, *Looper* 2012), treatment of immigrants (*District 9*, 2009) are some of the exceptions.

Regardless of dealing with anxieties that trouble the contemporary world or imagined ones, "the anomalies of a parallel universe are explained and rationalized in some detail" (Miller, 1987: 19). Empirical logic permeates the narrative delivered by means of discourse mainly. Though sometimes difficult to follow, discourse regarding science is one of the main ingredients of SF films.

In this sense, science becomes either adventure or a technical response to danger in a SF film (Sontag, 1976: 126). Social or political implications of science do not matter at all. Science is performed for its own sake, and in Sontag's reading, the scientist is treated both as a Satanist and a saviour figure.

Science as a social act is treated as a black or white construct: the

> standard message is the one about the proper, or humane, use of science" concluding that the general message is that science must be utilized in a humane manner. (Sontag, 1976, p. 119).

This brings into play another idea in connection with SF films, namely that of dehumanisation. Does not only modern urban society depersonalise humans, but also lifelike entities, machines that act like humans can be created. As such "[t]he attitude of the science fiction films toward depersonalization is mixed" (Sontag, 1976: 125). Non-human entities are conceived as either the ultimate bad or a positive development of science. In this respect, SF film also explores the ambiguities of being human together with our perception of reality.

> Insofar as human subjectivity, memory and identity have become visibly unstable, insecure, and mutable, so too has our sense of 'reality'. (Sobchack, 2005, p. 272)

These building blocks of Man are brought into play while 'reality' as such becomes a shifting notion.

This triggers a "cultural longing for a simpler and more innocent world" (Sobchack, 2005: 269). SF film offers a simplified version of the world. It may be grounded in complex empirical data, but that is not emphasised. Like in Stephen Spielberg's *ET*, technology and aliens are kind and good-willing. In the same vein, SF films are new versions of the oldest romances, since in most of them strong and invulnerable hero of mysterious lineage saves the day and fights against evil (Sontag, 1976: 119).

3 UPGRADING CONVENTIONS

Westworld is a remake of the 1973 feature film of the same title that was written and created by Michael Crichton, who contributed to the writing of the series as well. The setting in both films, an amusement theme park conceived as a holiday resort provides the background against which contemporary anxieties are enacted. In the theme park human-like robots, "hosts," re-enact nineteenth-century American Western frontier. Both cinematic productions revolve around the same idea, namely, that of the human-like machines getting out of control. Nevertheless, the series – produced in the digital era – is influenced both in content and production by computers and smart devices. Not only does it offer a more complicated story, but it also blurs the boundaries between reality and the fantasy world in the series. Its central motif, the game - symbolised by a mysterious and never-ending maze -, and themes – human identity, playing God, creating human-like machines, escape into a parallel universe ruled by clear-cut rules – render the series engaging by offering a somewhat menacing picture of the contemporary world.

One of the major reasons why SF lost ground in Sobchack's reading was that computer-generated imagery rendered traditional special effects obsolete (Sobchack, 2014: 284). Latest SF productions, however, show that SF reinvented itself and incorporated computers both in their content and mode of production. The use of computers has permeated

industry so much that it can easily replace special effects and allows for the recreation of any SF environment. With the help of computers and CGI effects, believable settings can be created regardless of how futuristic and improbable they might be. In *Westworld,* background scenes constantly show how hosts are created, programmed, fixed, cleaned or retired if need be. Creation of a host is symbolised by Leonardo da Vinci's Vitruvian Man, as technically the final, lifeless product is held in a moving circle that holds the body to be embalmed in skin-like material. The slightly futuristic gadgets and devices used to programme and fix the robots blend in while the use of various smart devices that fix and upgrade the human machines, though still a matter of imagination, do not look improbably futuristic.

The title credit already sets the tone with its CGI effect. Under the soundtrack of violin, cello and piano industrial robots are shown while making human-like bodies out of strings and milk-white liquid. The final image of the title credit is that of a life-size Vitruvian Man dipped into a pool of white liquid and then pulled out as a machine ready to be woken up.

This idea continues with the very first sentence of the series uttered by a man in voiceover: "Bring her back online" (Nolan, 2016: 01:53). The title credit, the very first sentence and the opening image – a facility, where human-like machines build new human-like machines or fix old ones full of robots and smart devices – bring into play one of the central ideas of the series, that of man playing God and creating human entities with consciousness.

As a matter of fact, playing God and being in control are two cornerstone motifs of the series. The series does not attempt to produce spectacular large-scale images, but point attention to the inner plane. It exploits questions regarding human characteristics, such as what makes a human or what is consciousness. *Westworld* explores the ideas of playing God, having control over other beings, who is human, what the difference between humans and robots are, and slippery nature of terms such as conscience, memory and agency. Inquiries from the hosts such as: "Have you ever questioned the nature of your reality?" (Nolan, 2016: ep 1, 02:33), or the ever-recurring "Analysis" – in which host are required to review their own programming – keeps the viewer on the edge of their seat. One must be very attentive as to whether a character is a host or a guest and follow each well-wrought storyline. As a host reproaching asks his human maker: "So what's the difference between my pain and yours? Between you and me?" (Nolan, 2016: ep.8, 35:31).

The mastermind of the park, creator of good and bad hosts, Robert Ford claims to have only wanted to tell his stories – he never intended to turn this into a huge business enterprise. Therefore, he cannot be considered the evil mastermind playing God. However, his discourse alludes to the opposite: in his view hosts can be "[f]ree here under my control" (Nolan, 2016: ep

7, 51:11). Not merely a matter of control, Ford understands the complexities of his role "You can't play God without being acquainted with the devil" (Nolan, 2016: ep 2, 17:13).

This taps into the "other" becoming an alarming entity in the series since some of the hosts cannot be distinguished from humans, and the narrative retains information about their identity even from the viewer. That is the case of the main host creator, Bernard Lowe, a host created by the park's mastermind to aid the latter in creating human-like robots who have a conscience since only machines can build human-like, fine-tuned machines.

The imagery also supports this idea by constantly showing how robotic devices create hosts and humans are needed only to deal with the settings.

Since the "other" is a complex entity, neither of the main characters can be described as a simple, flat one. Bernard's true identity is revealed only towards the end of the series when he kills two women. However, he cannot be held responsible for his deed, because he is programmed to listen to commands, and no matter how smart he is, some parts of the programming he cannot elude. There is more to a person that anyone can see and no one can be entirely bad or good.

The series blurs the dichotomy of good and evil. In the park itself the traditional symbols signal type of personality or attitude: a white hat for good guys, black hat and clothing for bad ones. The series does not focus on punishing the bad in the fight between good and evil. The lack of such a moralistic vein also lies in the fact that the series treats the creation of AI as a matter of fact – neither good nor bad. It is a reality one must deal with.

Instead of being concerned with punishing the bad, *Westworld* concentrates on the notion of game. Within the narrative, new storylines are added and new hosts introduced to keep the game going. The dominant symbol, the maze as the central symbol of the game holds plot, storylines and characters together. With the benefit of hindsight, it can be concluded that alarming as machines running amok may be, an even greater danger is losing oneself in the amusement park, or being entirely seduced by the game. The idea of the seductive nature of the game and that of escaping into a purer world dominates the film. The discourse of guests always focuses on how treacherous and complicated the outside; the real-life world is and how meaningful life in the park seems to be.

As a proper SF production, Westworld, too present a parallel universe. The series takes the idea further and adds a twist since two parallel universes are present in one parallel present. Having in mind the technological developments of our times, the parallel universe Westworld present is not very distant at all[2]. The inner

2. On 14 February 2016 Hong Kong-based Hanson Robotics activated a robot named Sophia. In 2017 it was given citizenship in Saudi Arabia. Following the activation of Sophia

workings of the story further complicate the narrative: "We sell complete immersion in 100 interconnected narratives." (Nolan, 2016, ep.1, 28:12-15). In addition to the idea that the creation of human-like robots is not an entirely futuristic, hence improbable possibility, the images in the film add to the feeling of immediacy. The series blurs the boundaries between reality and fantasy. In the 1973 version, the narrative started in the lobby of the hovercraft's station that brings vacationers home from the resort. The real world, a safe haven where one can return to any time, is present. Constant reminders of real-life connection between the resort and home, as it were, intersperse the narrative. Engineers' comments on the phone about their food or laundry have an optimistic vein. On the one hand, there is a clear-cut distinction between "us" (reality) and "the other world" (resort), on the other hand, any danger may be perceived as coming from the outside.

The *Westworld* series tackles the issue of artificial intelligence, robots created by humans that can be mistaken for humans. Although the series tackles a delicate issue, that of AI, it keeps it within the realms of the story. AI in Westworld is to be considered only in terms of the game; it never looks out through the fourth wall as it were. In terms of *Westworld,* this is reflected in the treatment of one of the basic elements of narrative: the hosts. The series taps into the fear of our inability to distinguish robot from humans.

This matter is considered only on the plane of fiction within the boundaries of the narrative, and never in terms of the real external world. *Westworld*, in general, does not tap deep into the AI issue but remains within the borders of the narrative and mind games. Since the outside world is never shown, the emphasis remains on the workings of the human mind.

In the 1973 version, the idea of human-like machines being among humans is less scary. Robots can be easily recognised. When they break and turn against humans, their point of view is shown as well. Images from blurred sight that recognises only heat patterns reassure the viewer that despite their being highly dangerous, hosts shall never be humans and develop personality, conscience, and identity. As opposed to this, the images and the narrative of the 2016 series, do not allow for any relief of that sort.

Although neither of the films presents the real world, the feature film continuously alludes to the existence of the real world and the theme park being a resort. As opposed to this, in the series, the only environment presented is that of the resort facility, the real world where guests come to vacation from is a distant possibility. In addition to this, employees of the park never leave the huge establishment: there are rooms and venues for free-time activities on the spot. Westworld serves as a setting where guests can escape

to from the real world, whereas for the host who has gained consciousness, it is the promise of a better life.

4 CONCLUSIONS

The series shows an interesting combination of destruction and creation. An amusement park is created in which robots can be destroyed, and that destruction is processed during the following night, everything being 'rolled back' for the morning ready to be used again. It employs twists in the narrative, retains information even to the last episode and introduces new characters and storylines in a seemingly random manner. Furthermore, the series tackles issues such as the complexities of mind, consciousness and human identity due to which the narrative becomes one huge riddle and the narrative stops being trivial or lightweight.

Westworld (2016) becomes an example of how an SF production adapts to new modes of production and viewer expectations. It is not the sign of change in paradigm, nor an entirely new form of SF. It merely showcases how SF can become palatable in an age and to a generation that is used to smart devices. It manages to be successful – the third season has been commissioned – in an age when virtual worlds and their simultaneous nature are a reality. To this end, it does not employ spectacular stories on a universal scale, but respects SF conventions, apply modern technological developments within their boundaries. The only significant change in the series could be that it presents more complex narrative and characters.

Westworld (2016) finds the middle way needed to make a successful SF series. It does not radically rewrite conventions, merely plays with them and upgrades these. Since the use of computers, smart devices and CGI effects have become the main ingredient of cinematic productions, the series incorporates both in its story and production. Images of robots creating robots and the latter being fine-tuned through slightly futuristic smart devices provide a similar soil to SF as the technological developments of the 1950s did to SF at that time. In addition to this, the series could be a school example of Sobchack definition of what SF does, namely that it presents developments of imaginary science and technology in a parallel present (Sobchack, 2005: 261). It updated the definition to a viewership used to smart devices and had the boundaries between reality and fantasy disappear. As a further upgrade it set the whole plot in a game that seduces players in – a scenario any contemporary viewer can easily comprehend.

Addiction to the game, the disappearance of special and temporal borders due to the devices we use, developments in robotics and the questions the issue raises as far as human identity and consciousness are concerned are the present-day anxieties that it presents. The series does not take any social or political stance

and granting her citizenship, questions pertaining to human identity as well as legal ones were raised.

in the matter, only sheds light on the matter in dramatic action. Together with this issue comes that of dehumanisation in the form of the "others," the human-like hosts. With some of these machines waking to consciousness, it is rather the humanisation of AI that applies to the story. Considering that two of the most prominent of these characters, Maeve and Dolores, want to change this environment and find that extra something that there is to life, instead of destroying everything and everybody around them, the outcome – machine becoming human – does not even seem alarming. What renders the story menacing is the fact that much information is retained almost to the end: some of the hosts have been programmed by someone to wake up, to beat their own system and lie about their status, and finally, to find a way to destroy the whole resort.

Upgraded with the help of a few twists, but essentially respecting the age-old conventions of SF, *Westworld* (2016) creates a SF fantasy world which caters for the contemporary viewer without giving up its essence: science, empirical logic.

BIBLIOGRAPHICAL REFERENCES

District 9. (2009). [DVD]. Neill Blomkamp dir. Culver City: Tristar Pictures.

Her. (2013). [DVD]. Spike Jonze dir. Los Angeles: Annapurna Pictures.

In Time. (2011). [DVD.] Andre Niccol dir., USA: Regency Enterprises.

Looper. (2012). [DVD]. Rian Johnson dir., USA: Endgame Entertainment.

Miller, J.D. (1987). Parallel Universes: Fantasy or Science Fiction?, in: *Intersections: Fantasy and Science Fiction, Alternatives.* (pp. 19–25). Carbondale: Southern Illinois University Press.

Sobchack, V. (2005). American Science Fiction Film: An Overview, in *A Companion to Science Fiction.* (pp. 261–274). Malden, MA: Blackwell Pub.

_____. 2014. Sci-Why?: On the Decline of a Film Genre in an Age of Technological Wizardry. *Science Fiction Studies.* 41, 284–300. DOI: 10.5621/sciefictstud.41.2.0284

Sontag, S. (1976). "The Imagination of Disaster," in *Science Fiction: A Collection of Critical Essays.* (113–143). Englewood Cliffs, N.J.: Prentice-Hall.

Westworld. (2016). [TV series]. Jonathan Nolan and Lisa Joy prod., USA: Bad Robots, Warner Bros. Company.

Westworld. 1973. [DVD]. Michael Crichton dir., USA: Metro-Goldwyn-Mayer.

Healing through storytelling: Myth and fantasy in Tomm Moore's *Song of the Sea*

Angélica Varandas

Department of English Studies, School of Arts and Humanities, University of Lisbon/ULICES (University of Lisbon Center for English Studies), Lisbon, Portugal
ORCID: 0000-0002-6647-3359

ABSTRACT: *Song of the Sea* is a film directed by Tomm Moore, which focuses on the legends of the *selkies*, mythical creatures which are seals when in the sea but which can become human out of the water.

In this chapter, we intend to examine how Irish myth and legend allows Moore to develop the theme of sorrow and loss. These do not only affect the family depicted in the movie, but they also appear to characterise Ireland as a country that has moved away from storytelling and its own mythical roots lacking the expression of its own identity. As Saoirse, the mute little girl in *Song of the Sea* who is also a *selkie*, Ireland must regain its voice in order to recover its former health. The quest to save Saoirse becomes the quest to save Irish myths which, in Moore's opinion, have become forgotten, running the risk of being forever petrified. As quest story, which establishes an intersection between responsibility, memory and voice, *Song of the Sea* pays tribute to animation cinema, as the place where audiences can still come in touch with magic and wonder, as our ancestors did through myth and storytelling. It also closely follows the structure of fantasy texts, which ultimately aim at "the joy of the happy ending" to which John Clute called "healing".

Keywords: *Song of the Sea*, myth, voice, storytelling, healing

Tomm Moore's *Song of the Sea* is a 2014 fantasy animated movie, which, such as *The Secret of Kells* released five years before, revisits the enchanted realm of Irish myth to approach several anxieties and concerns of the modern world.[1] The bridge between our own days and the times of yore, as well as between the human and the fairy spheres, is built through the character of Saoirse – a silent little girl with the ability to turn into a seal.

Seal folk are common in Irish tradition as well as in the Orkney and Shetland islands of Scotland, where they are named *selkies*, from the Scottish word *silche*, which means "seal". They frequently come ashore and conceal their seal skins behind a rock in order to assume lovely human shapes. If a mortal falls in love with a female *selkie* and wants to marry her, he needs to find her skin and hide it, thus preventing her from returning into the waters. However, the *selkie* eventually discovers her skin and, wearing it again, she reassumes her seal shape and disappears into the sea, sometimes carrying her children with her. Many of these folk stories are told in *People of the Sea*, a collection of tales about *selkies* in Ireland and Scotland,

which was one of Moore's main sources of inspiration for the movie.

This folk tale resumes the motto for *Song of the Sea*: Conor is a lighthouse keeper who falls in love with Bronach, a *selkie*, and marries her. They have a son, Ben, and they have a happy life together until she returns to the sea, while giving birth to Saoirse. The baby, half-human, half-*selkie*, is saved by her mother and washed ashore in her own *selkie* skin. Bronach's disappearance triggers a series of events and leaves her family in despair: Conor's mourning for his loss keeps him apart from the children; Ben disdains his sister, blaming her for their vanishing mother; and Saoirse is unable to speak. At the age of six, she discovers her seal skin hidden in a chest, being led by the magic lights encapsulated in the seashell Bronach had given Ben and which had come from her own mother, probably even from generations before her. This conch allows Ben to listen to the sound of the sea and remember the stories she shared with him. Worried about the children, Conor locks Saoirse's skin inside a chest, which he throws into the ocean. At the same time, Ben and Saoirse's grandmother takes them both to Dublin. Eager to return home, brother and sister decide to run away, but Saoirse is kidnapped by three of the *Deenashee*, the gods of Ireland. As if the stories their mother told them had suddenly become

1. Both *The Secret of Kells* and *Song of the Sea* were nominated for the Oscar of Best Animated Feature Film in 2010 and 2015, respectively.

real, the children are asked to lead the ancient gods of Ireland to their home in the sea where they initially came from. Saoirse needs to find her voice and sing the song of the sea while wearing her skin and thus free the spirit world, preventing the otherworldly creatures from turning forever into stone.

Moore resorts to Celtic myth and Irish and Scottish folktales about sea-folk in order to tell a human story about a family's inability to cope with grief. All characters, in one way or another, try to deal with pain by closing themselves to their emotions or withdrawing to the past when they were happy. As Moore himself explains in an interview:

> I heard these stories [about *selkies*], but I didn't understand them. There was another level to them and I realized that a lot of the *selkie* stories were a way for people to deal with loss. (*Song of the Sea* – Tomm Moore and Paul Young Interview, 2015, 00.02.22).

Song of the Sea is, in fact, a story of love and loss. The movie starts by quoting the lines of the poem "The Stolen Child" by W. B. Yeats,

> Come away, o human child
> To the waters and the wild
> With a fairy hand in hand
> For the world's more full of weeping
> Than you can understand.

The human child in the movie is Ben, so named by Macha and the otherworldly characters, who grows from an angry and rebellious child to an understanding brother. With his fairy sister hand in hand, he manages to accept that even though the world is full of weeping, we all have to deal with grief, not by rejecting it, but by embracing it for it is part of who we are. In this sense, this movie supports the idea that happiness cannot exist without sorrow and that we have to live with both.

Therefore, the mythological dimension of the narrative mirrors the human one converging in a complex plot. In helping the *Deenashee*, Ben and Saoirse are at the same time helping themselves come to terms with their chagrin and save themselves and their family. Moreover, the action that takes place in the mythological realm intersects the one which occurs in the human. In their suffering, both the children's Grandmother and Macha, the Owl Witch, reflect one another: they both want to imprison the children in their homes preventing them from dealing with their feelings of loss, they both live in warm and cosy homes where they drink their tea and listen to the same song played in the same radio, and both have sons who are slowly turning into stone. In fact, Conor and Manannán Mac Lir mirror one another as well, as they both suffered an extreme pain that closed their hearts and minds to the world. In order to identify Conor and Mac Lir as well as Grandmother and Macha, Moore took care that the two groups of characters were drawn very similarly. Also, he intended that the same actors uttered their voices: Brendan Gleeson played both Conor and Mac Lir, and Fionnula Flanagan played both Granny and Macha. In the movie, Ben also establishes the association between his father and Manannán, saying: "Tomorrow is Halloween and Macha's owls might even come here and take Dad's feelings and turn him into stone." (00.12.52) The *Deenashee* are in pain as well since they are imprisoned into stone in an oblivious world that has forgotten them.

Jerome Bruner starts his article "Myth and Identity" with a paragraph that seems unexpectedly relevant to the association between the mythological world and the human one in *Song of the Sea*. As if he were thinking about Bronach's seashell, he says,

> We know now a new origin of the faint hissing of the sea in the conch shell held to the ear. It is in part the tremor and throb of the hand, resonating in the shell's chambers. […] And so with myth. It is at once an external reality and the resonance of the internal vicissitudes of man. (1959, p. 349)

This intersection between the real world and the Otherworld is highlighted by the fact that the journey of the children from Dublin to the island where they live takes place precisely on Halloween which is, as we know, a modernisation of the Celtic pagan festival *Samain*. The Irish Celts believed that in this day, in which they celebrated the beginning of winter, the boundaries between the natural and the supernatural worlds died out authorising the connection between mortals and spirits. Suddenly, the stories Ben used to listen from his mother take shape before him, as he acknowledges "Those stories that Mum told me: they are all true". (00.38.32) It is through these narratives that he manages to save Saoirse, his family and himself. These stories all join in the character of the Great *Seanachaí* – the storyteller – whose body is covered in hair, each thread being a memory.

The *Seanachaí* or *Seanchaí* were, in medieval times, the traditional storytellers who inherited the role of the ancient *fili*, the poets of Celtic Ireland, memorising the old lore, which was transmitted orally. They maintained and disseminated knowledge, being very well respected in their communities. Through them, myths and legends, poems and narratives were transmitted from one generation to another. During the Celtic Revival, in the late 19th and early 20th centuries, many Irish intellectuals, such as W. B. Yeats or Padraic Colum, travelled throughout Ireland in order to write down the stories of these *Seanchaithe* so that Irish readers could know them. Today there are few practising Irish *Seanchaithe*. One of them is Edmund Lenihan who inspired the character of the Great *Seanachaí* in the movie.[2]

2. "And then we talked to Eddie Lenihan, who's a storyteller here in Ireland, an amazing storyteller. He had this huge bank of cassette tapes that he's made recordings of people telling stories, and his whole attitude to the stories is that they're not gospel. They're not set in stone. You can keep retelling and reinventing them and mixing them up and doing your

The Great *Seanachai*'s hairs mix memory, myth and tradition, which become alive by the art of storytelling which links different generations and offers new ways of interpreting past and present. As his mythical companions, however, he lost that ability to tell stories, having forgotten the lore he protected and preserved. He is ill, lacking the voice he once had. He needs to be freed, as do all the *Deenashee*, and regain his poetic voice. He will be able to do so through Saoirse's help, another character whose illness, firstly caused by the sorrow of her mother's disappearance and afterwards by her separation from her sealskin, prevents her from finding her voice. Both are "seriously ill people [who] are wounded not just in body but in voice. They need to become storytellers in order to recover the voices that illness and its treatment often take away" (Frank, 1995, p. xii). The treatment in the movie involves alienation from the body and the causes of its pain. It implies the inability to face grief and speak overtly about the ill body. Macha, the Owl Witch, has enclosed all emotions inside jars, petrifying her own son, blocking his despair and preventing him from coming to terms with his own pain. When Ben meets her for the first time, she says,

> Those stories always pick me as the bad one. But I am not so terrible, you know. I'm just trying to help everyone […]. I see it Ben, your pain. You're so full of emotions, […] nasty little things. They make you feel so awful. […] That's all I do, Ben, to take away the pain. (01.01.40)

Still, only by giving voice to illness by creating stories can that illness be overcome. Only by recognising and accepting Bronach's departure can her family be free to speak together about their loss and move on to live maybe not happily ever after but as happy as they can be: "storytelling is viewed as a form of communication that can help people successfully cope with and reframe illnesses and, thereby, create the paradoxical possibility of being 'successfully ill'", says Farah Mohammed, quoting SunWolf, a university professor who is also a professional storyteller (2018). And if this assumption was not enough highlighted by the plot itself, the Celtic names of Bronach and Saoirse mean respectively "sorrow" and "freedom". Arthur W. Frank claims

> The personal issue of telling stories about illness is to give voice to the body so that the changed body can become once again familiar in these stories. (1995, p. 2)

In order to overcome grief and release the song of the sea, both children undertake a journey of self-recognition, which closely follows Campbell's three stages of departure, initiation and return present in the hero's quest (1993, Chapters I, II and III). In fact, the

children soon find out that their journey home from their grandmother's house becomes a quest to save Saoirse's life whose health grows weaker for lack of contact with her sealskin. Ben can face his past, and therefore his pain, after falling into the sacred well, which leads him to the Great *Seanachai*'s cave. Ben's *katabasis* will make him confront his sorrow, allowing him to have access to the hair thread where is encapsulated the memory of his mother's death, and hence overcome his resentment and get out of the dark cave into the upper world more enlightened and mature. Ben is ready to conclude the hero's journey of transformation mentioned by Campbell in *The Hero with a Thousand Faces,* which was another one of Moore's sources of inspiration for the movie.[3]

Saoirse, on the other hand, was kept off her skin, hidden in a chest at the bottom of the sea, and thus separated from her mother's heritage. Only by reuniting child and skin, rescuing myth from the dark and deep waters of forgetfulness and make it true again, is it possible for Saoirse to sing the song that will cure her and those around her, both from her world and from the Other. Her narrative, however, is more than just words. It is also a song. The song of the sea thus becomes the healing story in an homage to Irish storytelling, which has been closely connected to the sea since medieval times; an association particularly made visible in the mythological narratives of *immrama* and *echtrai.* These texts, also known as "navigations" and "adventures", respectively, relate sea journeys through the vast ocean, which hides the western islands of the Otherworld where the gods live, such as Tir na nÓg, the Land of Eternal Youth, actually mentioned in the movie. The sea is also the abode of the gods, governed by Manannán Mac Lir, son of the sea, and of many magical creatures such as the *selkies.*[4] It is, moreover and above all, a place of regeneration and healing, such as the sacred well where Ben falls into, not only because the water was, in Celtic tradition, an element of cure and rebirth, but also because, due mainly to Celtic monasticism, the ocean was the necessary means to achieve spiritual redemption. The song of the sea also celebrates the power of song and music, central in Irish culture and tradition.

In several interviews available on the internet, Moore underlines the importance of both myth and storytelling today. Paul Young, one of the co-producers of the movie, states, for instance, that "everybody in every culture uses narrative as a way to understand

own versions of them. So that, we felt, gave us a license to be inspired by those stories but come up with our own one." Tomm Moore in VanDerWerff, 2015).

3. Moore claims that when listening to Joseph Campbell's interview to Leonard Maltin about the power of myth, he realized that Irish myth is immensely powerful and could be used a source of inspiration to narrate his own stories. (Tomm Moore talks about *Song of the Sea,* Galway Film Fleadh, 2015).
4. In the movie, the Great *Seanachai* tells Ben the legend of the ocean as a vast mass of water, which originated from the tears of Manannán Mac Lir and his extreme sadness.

what goes on in their lives and that's the way stories unite all of us" (*Song of the Sea* - Tomm Moore and Paul Young Interview, 2015. 00.00.17). Myths are fundamental because, as before, they still tell us true stories about ourselves and the world we live in. In this assumption, Moore echoes the idea of Mircea Eliade to whom

> myths reveal the structures of the real and the multiple ways of existing in the world. That is why they constitute the exemplary model of human behaviours: they reveal true stories, referring to the realities. (Eliade, 1989, p. 9)[5]

Song of the Sea can thus be envisaged as a quest story, one that "accept[s] illness and seek[s] to *use* it [...], affording the ill their most distinctive voice" (italics in original) (Frank, 1995, p. 115). All characters in the movie trace their own self journeys, and their personal stories eventually acquire a social dimension being told in a specific cultural context. In the first place, those who suffer share their common pain, each one of them affecting the others since "the ill person who turns illness into story transforms fate into experience; the disease that sets the body apart from others becomes, in the story, the common bond of suffering that joins the bodies in their shared vulnerability" (Frank, 1995, p. xi). In the second place, their mythical counterparts allow the movie to transcend the illness story of a family to become a film about the illness of a country which has moved away from storytelling and thus from its own mythical roots, lacking the expression of its own identity. The silent voice of the *selkie* is the absent voice of Ireland in need of healing. The recovery of myth is then a fundamental step to the mending of the land. Embracing past and present, mythical narratives are the stronghold of cultural heritage, being essential to define a nation's identity.

With *Song of the Sea*, as with *The Secret of Kells* before it, Tomm Moore is demanding a voice for Ireland, contributing to "define the ethics of our times: an ethic of voice" (Frank, 1995: p. xiii). In this sense, he requires for his art the legacy of the Irish Literary Revival, which, back in the late 19th century and early 20th, also intended to give voice to Irish culture. Moore is, of course, creating his movies in another historical, political, social and ideological context. Nonetheless, he likewise appears to be motived by nationalistic goals, encouraging the preservation of Irish myth and legend, as well as of Irish music and language. As such, Yeats's presence in the movie acquires another meaningful purpose.

Accordingly, Moore not only wants to give Ireland an opportunity to express itself, he mainly intends to

assist in its treatment. The movie is set in 1987, a time of rapid economic growth in Ireland known as Celtic Tiger or simply "The Boom", which lasted until the beginning of Europe's financial crisis in 2007. In this period, Ireland's economy greatly expanded leading the country to overcome its very high rates of poverty and unemployment. In the movie, we can watch the opposition between a still rural landscape of the island where the children live with their father and a more modernised Dublin. In the dawn of its technological development, Ireland is apparently slowly starting to forego its cultural heritage and lose sight of the mythical narratives that shaped its identity. It is beginning to suffer from the illness of emotionlessness and oblivion that characterises our times and which urges to be cured. Thus, the quest to save Saoirse also turns out to be a quest to save Irish myths and traditions, which, in Moore's opinion, have become forgotten running the risk of being forever petrified. Moreover, in Moore's perspective, to healing Ireland further implies an extremely important ecologic and environmental attitude: in healing the country, one is contributing to the preservation of nature, which was so treasured in Irish myth and culture. In the words of Moore:

> [...] we [Moore and his son] kind of realized that the stories were being a bit forgotten. We were talking to a local person about the seal kill that was going on here, and she was saying that there used to be much more superstition around seals and people wouldn't want to kill them. [...] The superstitions and stories were protecting the landscape and the environment and needed to be preserved. (*Song of the Sea* - Tomm Moore and Paul Young Interview, 2015. 00.01.00).

Mythical narratives have a healing power over nature and humankind, approaching the two. Man can rediscover the power of nature through the power of myth. In the new technological world in which the *Seanchaithe* of yore have almost disappeared, it is necessary to resort to the modern means available to create opportunities to tell stories. In this sense, new *media*, such as the cinema, must take the legacy of the *seanachaí* taking the responsibility of bringing into the present the true stories of the past, as Stuart Voytilla defends:

> Moviemaking can be considered the contemporary form of mythmaking, reflecting our response to ourselves and the mysteries and wonders of our existence. (1999, p. 1)

One can, therefore, establish an intersection between responsibility, memory and voice, three elements which, according to Arthur W. Frank, are implied in all quest stories, since these actually involve three different ethics: 1) the ethics of recollection, as they resort to memories of the past in order to better understand the present; 2) the ethics of solidarity and commitment because the storyteller uses his voice to speak for himself and others as well as with others; 3)

5. "Os mitos revelam as estruturas do real e os múltiplos modos de existir no mundo. É por isso que constituem o modelo exemplar dos comportamentos humanos: revelam histórias verdadeiras, referindo-se às realidades." Author's free translation.

the ethics of inspiration in as much as all stories inspire and influence other stories (Frank, 1995, pp. 132-139). As quest story, *Song of the Sea* is embedded with these three ethics by recollecting the treasure of Irish myths and legends in order to share them with audiences, maintaining their memory alive. By doing so, Moore assumes the responsibility, both moral and social, to be an active player on the process of his nation's healing process, being simultaneously a wounded storyteller and a healer. Again, in Arthur Frank's words: "The ill, and those who suffer can also be healers. Their injuries become the source of the potency of their stories." (1995, p. xii)

As such, in reclaiming a voice for Ireland, Moore is also creating a space for Irish storytelling in animation cinema. As happens in *The Secret of Kells*, Moore produces *Song of the Sea* without the use of computers and by hand-drawn animation technique. If *The Secret of Kells* emulated medieval illumination, particularly that of the *Book of Kells* with spiralled and concentric lines and delightful colours, *Song of the Sea*, mingling blues and greys, gives the sense of a safe world like a child's illustrated book. The flattened perspective enhances this association. The colours change into black and brown when the characters seem to be in danger. With both movies, Moore appears to be seeking for an Irish animation style different from all the others, namely the Disney one, much in the same way as there is a Japanese animation style. He says,

Really early on, I was inspired in college [...] I saw a documentary by Richard Williams and [...] he was making it based on Persian art, and it was really quite inspiring 'cause it didn't look like anything else [...] and in the 90's there still [...] most movies looked kind of, they followed the Disney style, you know [...]. I thought: can we do something like that with Irish art that could give us a little advantage, a little special *voice* so that we didn't look like a copycat of the Japanese animation or American animation. So, we thought, well, let's look at what we can do with Irish art [...] and then, of course, we wanted to tap into that, into that rich vein of folklore. (DP/30 @ TIFF: Song of the Sea. Tomm Moore, 2014. (00.06.42)[6]

He may even be trying to create his individual fantasy animation film, such as Hayao Miyazaki has developed his own. He states:

2D for me is a language, you know. It's a way to express and to draw and to think [...] and we've kind of [...] evolved that style over so long that it's kind of became a natural way [...] to story and the style goes hand in hand. [...] And it's a great thing about 2D, it's kind it got a feel that's timeless. (DP/30 @ TIFF: Song of the Sea. Tomm Moore, 2014. 00.16.45)

This timelessness of Moore's animation drawings is in tune with his understanding of myth and storytelling as abiding tools to better comprehend the world we live

in. "Modern fantasy has continued to mine myths, legends and folktales of different cultures and traditions, reshaping them to fit new contexts", says Dimitra Fimi in her new book, *Celtic Myth in Contemporary Children's Fantasy: Idealization, Identity, Ideology*, where she discusses how "highly acclaimed fantasy works that rework 'Celtic' myth are often addressed to a child or young adult" (2017, p. 1), such happens exactly with *Song of the Sea*. Envisaging myths as true stories, Moore holds on to the traditional "relationship between myth and fantasy" as "one of interrelation and entwinement" (Fimi, 2017, p. 5) , sharing from and donating to "the Soup" in "the Cauldron of Story" (Tolkien, 1988, p. 28). As a fantasy animation movie, *Song of the Sea* also depicts a structure common to most of fantasy texts in which the last stage is precisely healing.

In the entry "Structure of Fantasy", in *The Encyclopedia of Fantasy*, John Clute and John Grant consider that the final objective of fantasy literature is healing. They speak about the transformative power of fantasy texts, which imply four stages, the last being the happy ending brought about by the healing of the protagonist or the land he/she lives in or of both.

A fantasy text may be described as a story of an earned passage from bondage – via a central recognition of what has been revealed and of what is about to happen, and which may involve a profound metamorphosis of protagonist or world or both – into eucatastrophe, where marriages may occur, just governance fertilizes the barren land and there is a healing. (Clute and Grant, 1999, pp. 338-9)

Song of the Sea fits in this assumption of fantasy as a literature of hope, having consolation as its final goal. In Tolkienian terms, it also treads the paths of recovery, escape and consolation, finally achieving "the joy of the happy ending". It certainly

does not deny the existence of [...] sorrow and failure [but it ultimately] denies [...] universal final defeat [...], giving a fleeting glimpse of Joy, Joy beyond the walls of the world, poignant as grief. (Tolkien, 1988, p. 62)

After the release of the emotions imprisoned in Macha's jars, Bronach's seashell eventually breaks into pieces. It is not needed anymore. When Saoirse finally dresses her skin thus regaining her health and overcoming her muteness, she becomes herself the song. After uttering her first word, "Ben" (01.16.41), Saoirse listens to her brother finally proclaiming the hidden truth: "She is a *selkie*, like Mom, isn't she?" (01.16.53), a truth acknowledged by Conor. The recognition of this mythical truth participates in the final process of healing which takes place when Saoirse begins to sing. Her song underlines the connection between both worlds – the one of mortals and the Otherworld -, linking the memories of the past with the anxieties of the present. The ancient gods of Ireland, as well as its mythical

6. My italics.

creatures, are finally freed, transformed into beings of air and light, regaining their former dignity. As for Saoirse, she is given a choice: either departing with her mother into the sea or staying with her father and brother. By choosing to stay, Saoirse heals her family: "We are all right, now" (01.27.28), says Conor. By choosing to stay, she becomes a symbol of the necessary presence of myth and legend in today's modern world, a symbol of that small sparkle of wonder, creativity and dream without which our ordinary lives would be a little ill.

> Between the here, between the now
> Between the north, between the south
> Between the west, between the east
> Between the time, between the place
> From the shell
> A song of the sea
> Neither quiet nor calm
> Searching for love again
> Mo ghrá (My love)
> Between the winds, between the waves
> Between the sands, between the shore
> From the shell
> A song of the sea
> Neither quiet nor calm
> Searching for love again
> Between the stones, between the storm
> Between belief, between the sea
> Tá mé i dtiúin (I am in tune) (01.21.46)

BIBLIOGRAPHICAL REFERENCES

Bruner, Jerome. (1959) "Myth and Identity". *Daedalus. Retrieved from* https://www.jstor.org/stable/20026501?seq=1#page_scan_tab_contents (12/03/2019)

Campbell, Joseph. (1993). *The Hero With a Thousand Faces.* London: HarperCollins Publishers, Fontana Press.

Clute, John and John Grant. (1999). *The Encyclopedia of Fantasy.* New York: St. Martin's Griffin.

DP/30: The Oral History Of Hollywood. (2015). DP/30 @ TIFF: Song of the Sea. Tomm Moore. Retrieved from https://www.youtube.com/watch?v=tPTLwwW51V0&t=737s (23/03/2019)

Eliade, Mircea. (1989). *Mitos, Sonhos e Mistérios.* Lisboa: Edições 70.

Fimi, Dimitra. (2017). Celtic Myth in Contemporary Children's Fantasy: Idealization, Identity, Ideology. London: Palgrave Macmillan.

Frank, Arthur W. (1995). *The Wounded Storyteller: Body, Illness, and Ethics.* Chicago and London: The University of Chicago Press.

Into Film Clubs. (2015). *Song of the Sea* – Tomm Moore and Paul Young Interview. Retrieved from https://www.youtube.com/watch?v=lPos5suT42Y (03/03/2019)

Mohammed, Farah. (2018). "How Storytelling Heals". Retrieved from https://daily.jstor.org/how-storytelling-heals/ (23/03/2019)

Moore, Tom (Director). (2014). *Song of the Sea* [Motion Picture. DVD]. Ireland, Belgium, Denmark, France and Luxembourg: Cartoon Saloon.

Tolkien, J. R. R. (1988). On Fairy-Stories. In *Tree and Leaf* (2nd edition, pp. 9–73). London: Unwin Hyman.

Thomson, David. (2017). *People of the Sea* (1st ed. 1954). Edinburgh: Canongate Books.

Turan, Kenneth. (2015). "*Song of the Sea* is a masterwork by Director Tomm Moore". Retrieved from https://www.latimes.com/entertainment/movies/la-et-mn-song-of-the-sea-review-20150109-column.html (03/03/2019)

VanDerWerff, Todd. (2015). *10 images that show why Song of the Sea is the year's most beautiful animated film.* Retrieved from https://www.vox.com/2015/1/25/7881099/song-of-the-sea-review (18/03/2019)

Voytilla, Stuart. (1999). *Myth and the Movies.* Los Angeles: Michael Wiese Productions.

Yeats, William Butler. (1982). The Stolen Child. In *Collected Poems* (pp. 20–21). London: Macmillan.

Between reality and fantasy; a reading of Katherine Vaz' "My Hunt for King Sebastião"

Mário Avelar
CEAUL, ULICES, Universidade Aberta, Lisbon, Portugal
ORCID: 0000-0002-3149-1741

ABSTRACT: This article ponders on the way intertextuality – the textual representations at the *fabula's* level – plays a central function in the tension between reality and fantasy in the Portuguese-American writer Katherine Vaz' short-story 'My Hunt for King Sebastião', from her book *Fado & Other Stories*. The writer's creative use of intertextuality – e.g., the encounter with oral traditions – enhances a manipulation of time – anachronisms - without sabotaging the narrative's flow, and the unveiling of the main character's psychological and intellectual progress. My conceptual framework is built upon the Russian Formalists' distinction between *syuzhet* and *fabula*. I shall also scrutinise time anachronisms such as the analepsy, the prolepsis, and the ellipsis in order to unveil their role in the textual structure, and in the protagonist's progress that eventually leads him to the distinction between his own fantasies from a mythical past.

Keywords: *Fabula*, fantasy, intertextuality, myth, *syuzhet*.

This is very beautiful, and yet very untrue.
John Ruskin, Modern Painters

This article ponders on the way intertextuality – e.g., textual representations at the fabula's level – plays a central function in the tension between reality and fantasy in the Portuguese-American writer Katherine Vaz' short-story 'My Hunt for King Sebastião', from her book *Fado & Other Stories*.

As I will show ahead the writer's creative use of intertextuality – namely the encounter with oral traditions – enhances a manipulation of time – anachronisms – without sabotaging the narrative's flow, and the unveiling of the main character's psychological and intellectual progress.

My conceptual framework is built upon the Russian Formalists' distinction between *syuzhet* and *fabula*; *syuzhet* being the order in which the chronological sequence of events – the *fabula* – is presented in the text (Fokkema and Ibsch, 1978: 18, Tomachevski, 1978: 159–175). My emphasis on time demands scrutiny upon anachronisms such as the analepsy, the prolepsis, and the ellipsis due to their role in the *syuzhet's* structure, namely when condensation is relevant.

As we will be able to figure out ahead, these concepts are critical to the tension between reality and fantasy that runs through Vaz textual meditation on a collective memory that often touches a mythical dimension.

Before moving to this analytical stage, I must start by a brief outline of 'My Hunt for King Sebastião', which allows the reader to become acquainted with its plot.

The narrator/protagonist, Dean, is a second generation Portuguese-American who comes to the Azores on his father's behalf to solve a family dispute concerning some lands that had been inherited by his father. Since these lands had been taken care of by some relatives, Dean must sort out now who should keep on being their legal guardians. When he arrives at the Azores he is forced to deal with a cultural reality he had never conceived of. Eventually, he finds out unsettling truths about his father's past and his own. The story is mainly focused on the few days he spends on the island; this means condensation of time and condensation – claustrophobic restriction – of place.

The central character falls within Gerard Genette's notion of homodiegetic narrator, since he uses the first-person pronoun and reveals a story that is a relevant element of his own experience, of his own self-knowledge, ultimately of the revision of his own identity – memory – in the fullness of time (Genette, 1980, p. 51). It is from an inner focalization that the reader gets to know this chapter of Dean's narrative, since this story may be conceived as a chapter of a larger *bildungsroman*. Although summoning a collective and historical memory, the 'hunt' mentioned in the title also signals a personal quest inscribed in a Freudian family romance.

The peritext, another concept that I borrow from Genette (1997), enacts a dialogue with the past, which expands the character's personal narrative. The

peritext builds a threshold – dedications, inscriptions, title, epigraphs, prologue, footnotes, chapter titles are strategic devices that unfold specific semantic fields. These fields provide a paradoxical context, since, on the one hand, this context constrains the characters, while on the other hand, it opens them to new areas of knowledge.

I must enlighten this aspect with examples taken from the short story under scrutiny. The peritextual elements in 'My Hunt for King Sebastião' are the title and the epigraph; only two elements but radically relevant as I will explain ahead. First, let us approach the way time is manipulated at the *syuzhet's* level.

The story begins when the narrator is about to leave the United States, although he still is not aware of this fact. He starts by disclosing what, in his point of view, was supposed to be a personal romance of betrayal. The first sentence reads as follows: 'My girl-friend was a beautiful liar' (Vaz, 1997, p. 16). And he goes on by stating: 'I should say "is." I figure Cecilia is still inventing her answers off in the fog' (Vaz, 1997). The verb in the first sentence places the reference in the near past, while the second one actu-alises time because it summons the present. But when the reader scrutinises one word, 'fog', s/he becomes aware of intertextual contamination, since 'fog' evokes a semantic field which belongs to a relevant segment of Portuguese identity, of Portuguese collective memory: the imaginary realm surrounding King Sebastião.

I must perform a brief digression in order to pro-vide the historical and cultural backgrounds. Sebastião was a young 16th-century Portuguese king that led the country into a disastrous adventure in Northern Africa, the battle of Alcácer-Quibir, which caused his death, along with most of the Portuguese nobility and thousands of soldiers. This military outcome eventu-ally leads to the loss of sovereignty and to a Spanish dynasty that would last for sixty years. Folk tales sang the king's return home in a foggy day. These became part of our collective imaginary, and some people say that it embodies a certain longing for a saviour, for a certain kind of secular providence, which may be anchored in our traditional passivity. It also unfolds an in-depth dialogue with another relevant theme of our culture, 'saudade'.

Although close to 'longing' or 'homesickness' we cannot find a precise equivalent for this word in other languages. As a theme, it goes back to the medieval troubadour songs. The 19th-century Portuguese histo-rian Oliveira Martins signalled an analogy between these themes and legends and the Celtic legend of Arthur living in a mythic and foggy Avalon (Martins, 1882, p. 79), and Fernando Pessoa, our major 20th-century poet, took it as a central signature for his epic *Message*.

As I mentioned above Fernando Pessoa's discourse is summoned in the peritext, in the epigraph. When I use this word, discourse, I am not taking it as a mere linguistic utterance. Instead, I follow Foucault's concept meaning a:

> delimitation of a field of objects, the definition of a legitimate perspective for the agent of knowledge, and the fixing of norms for the elaboration of concepts and theories' (Foucault, 1977, p. 199).

This underlines the fact that Pessoa's presence in the peritext confers a nostalgic tone that will prevail during the narrative, and provides the reader with a specific cultural and historical context.

Pessoa's epigraph, taken from a cycle of his epic poem significantly entitled "Os Avisos" [The Warn-ings], also has a kind of double-voiced status, both as analepsy and prolepsis, since it reminds the past while, at the same time, warns about the future; and with a double inscription in the collective and the personal:

> When will it be your will, returning
> Here, to make, of my hope, love?
> Ah, when, out of this mist and yearning?
> When, Dream in me and Lord above?' (Vaz, 1977, p. 16)

It is under this atmosphere that Dean's progress will take place.

Let us come back then to Dean's narrative, and the semantic implications of the word under scrutiny, 'fog'. We realise that 'fog' enhances an intertextual dialogue with Portuguese collective memory, thus summoning the past. We may consider it a subliminal semantic heterodiegetic analepsy with an amplitude of several centuries, in line with Roland Barthes notion of a text [that is]

> woven entirely with citations, references, echoes, cul-tural languages [...] antecedent or contemporary, which cut across it through and through in a vast stereophony.' (Barthes, 1977a, p. 160)

We understand now how Mikhail Bakhtin's con-cepts such as the above mentioned 'double-voiced discourse', and 'heteroglossia' and 'hybridisation' are crucial since

> dialogic relationships can permeate inside the utter-ance, even inside the individual word, as long as two voices collide within it dialogically. (1984a, p. 184)

These concepts help us to understand the dialogue – 'contamination'? – between personal and collective memory, between recent and distant past, that eventu-ally lead to the manipulation of time. In the beginning the recent personal past seems to prevail since the narrator is engaged in the fantasies of a confessional narrative – this is obvious, for instance, when he uses the free indirect speech, 'I asked her once to look at me, will you, and tell me one thing that's completely true' (Vaz, 1977, p. 16). The concept of heteroglossia sum-mons the dialogue with the past, with its myths. The 'fog' is both a semantic trace of the myth and ground for embracing personal fantasy.

When Dean mentions it, he is subliminally recognising both contamination and a sense of belonging to a specific cultural community, to a particular identity, to a certain attitude towards life. It is still Bakhtin who reminds that

> language for the individual consciousness, lies on the borderline between oneself and the other. The word in language is half someone else'. (1981, p. 293)

Dean's fantasies lead him to appropriate this sign, the fog, from a specific (determinist?) legacy. Its supposedly innocent presence referring to Cecilia's behaviour may be understood as a shift towards an intertextual configuration of this character. Summoning Roland Barthes analysis in *S/Z*, the fog becomes a *lexia*, thus functioning like a 'minor earthquake' (1974: 13). One wonders whether Dean's use of this word is a Freudian slip of condensation – metaphor of opacity – and displacement – metonymy of his failed relationship with Cecilia.

If we take a little further the Freudian slip of condensation, we realise that this sign – 'fog' – does not allow him a rigorous perception of reality. And this brings to mind the fact that 'looking', 'seeing' are important elements in the narrative's unearthing of reality. Besides, they also lead the reader to another relevant sign, the 'mirror'.

In a certain sense, the narrative is structured upon a system of mirrors, which does not mean that tautology prevails. Instead the mirrors help building an atmosphere of fluctuating time anachronisms, either moving back in time or anticipating the future: Dean's situation mirrors his father's; the picture he is going to be confronted with, mirrors himself; the ghost of the past mirrors his face thus allowing him to understand, to know his father. This mirror is pictured literally in the visual sign – the image, the photograph he will face later in the narrative – and subliminally in language: besides 'fog', another crucial sign emerges, 'hunt'. We find it in the title and the narrator's configuration: his job demanded [a] 'lot of paperwork, a hunt after details…' (Vaz, 1997: 17) This hunt prefigures the proleptic atmosphere concerning his action in the Azores. Nevertheless, this will be an ironic hunt since it will show him as a kind of puppet, a picaresque hero unveiling a reality – his reality – in the course of actions beyond his control.

In order to understand this picaresque dimension, we must understand how the past acts in this narrative. There are three main amplitudes in the analeptic movements towards the past: they actualise the recent, the distant, and the mythic past. The first reveals Dean's story, both involving his former girlfriend and his family romance. The analepsy unfolds the representations he built upon the characters that play significant parts in this romance, namely his father's. These anachronisms are anchored in his own distant past – memory? –, revealing what seem to be mere representations – 'My father has worn a tie for the dinner table since

I can remember' (1997, p. 18), and deeper fears – 'I feared death for him [his father] more than I did for anyone else I knew or have known since.' (1997, p. 19)

The second type of analepsy has an amplitude of several decades and deals mostly with his family secrets; the family romance still prevails. His father keeps on playing a crucial role here since the summoning of the past helps to build the atmosphere of secrecy that surrounds him in his son's eyes:

> He'd come to this country when he was eighteen from the island of Terceira in the Azores; in my whole life the one memory he'd shared with me was that breezes that came in off the sea made him decide at a very young age to dedicate himself to matters of the air, to the intellect and rightness. (1997, p. 19)

This (imaginary?) representation links his father with the collective memory through the words that belong to a semantic field involving the king's myth. Besides it mirrors – anticipates – the secret that surrounds his past; a secret that will be revealed to Dean later in the narrative:

> It [the photograph] was of a young man who looked like me – younger, but at the same time more ancient on account of the beige and oyster-like tinge of the photo. He wore a suit with a high collar and directed his attention off to the side, but he had my forehead, as wide and smooth as a sheet of paper, my large eyes, my poorly combed hair. Another cousin; I was about to receive his deed as well.
> "OK," I sighed, handing the photograph back. "Let's have it."
> "When I saw your face in the church, I knew you were looking for him."
> "Whatever you say." I waited.
> She pressed the photograph into my hand again and said, "Keep it. You need to. I know you don't have any pictures of your brother."' (1997, p.36)

Only then Dean realises he had had a brother. Thus ends personal fantasy, namely the imaginary representation he had built from his father leaving the Azores while

> the breezes that came in off the sea made him decide at a very young age to dedicate himself to matters of the air, to the intellect and rightness.(1977, p. 19)

The third amplitude, the larger heterodiegetic one, reveals the mythic past and constrains the character's progress since it inscribes it in a larger romance, the one of Portuguese identity. This romance is quoted in two mythic moments: the countries' founding origin in a remote past – 'Portugal being called Lusitania by the ancient Romans' (1997, p. 20); and the myth's founding moment in the 16th century. This moment is explained by Pessoa's poetic discourse, which flows from Dean's father voice:

> "The Portuguese sailed around the world and opened the route to the East, Dean," he said, cutting his steak in neat squares, "and now, as the poet Fernando Pessoa

and many others have said, we've done nothing for the last four hundred years but talk about it."

"Meaning what, exactly?"

"Meaning that history swings back and forth, and not everyone has to be dashing around every living minute."' (1997, p. 18)

This fragment explains how the narrative is structured, in a constant flow between past, present and future. Within the soil of family romance, it supports – justifies – his father's behaviour. In what concerns Dean's narrative it shows how his American self-reliance is not enough for him to handle reality ... even when this reality means the ghosts of the past.

In the end, the reader is confronted with a parodic revision of the myth. On the one hand, one realises that the character is unable to control his progress. Ironically, he finds something he was not looking for and which helps him to understand traces of his family romance. On the other hand, the present day *Sebastianites* turn out to be just ordinary people relying on their own fantasies without further expectations, and spending their leisure time 'talking and drinking coffee and eating bread' (1997, p. 40) in the mists by the seawall.

Eventually, Dean's encounter with time, anchored both in oral and written narratives, allows him to disengage personal fantasy from myth, and to get a clear perception of his own reality, eventually of his identity. Thus, in its manipulation of time and myth, in its textual dialogue between private narrative and History, 'My Hunt for King Sebastião' shows how right Julia Kristeva was when she wrote that '... any text is constructed as a mosaic of quotations; any text is the absorption and transformation of another' (Kristeva, 1980, p. 66).

BIBLIOGRAPHICAL REFERENCES

Bakhtin, M. (1981). The Dialogic Imagination: four essays. Austin: University of Texas Press.

_____. (1984). Problems of Dostoevsky's Poetics. Minneapolis: University of Minnesota Press.

Barthes, R. (1974). S/Z. New York: Hill and Wang.

_____. (1977). Image – Music – Text. London: Fontana.

Foucault, M. (1977). Language, Counter-memory, Practice: Selected Essays and Interviews. Oxford: Blackwell.

Fokkema, D. & Ibsch E. (1979). Theories of Literature in the Twentieth Century – Structuralism, Marxism, Aesthetics of Reception, Semiotics. London: C. Hurst & Company.

Genette, G. (1980). Narrative Discourse – An Essay on Method. New York: Cornell University Press.

_____. (1997). Paratexts: Thresholds of Interpretation. Cambridge: Cambridge University Press.

Kristeva, J. (1980). Desire in Language – A Semiotic Approach to Literature and Art. New York: Columbia University Press.

Martins, J. P. O. (1882). História de Portugal – Volume II. Lisboa: Livraria Bertrand.

Tomachevski, B. (1978). Temática. In T. Todorov (Ed.), Teoria da Literatura – II – Textos dos Formalistas Russos. Lisboa: Edições 70, 153–201.

Vaz, K. (1997). Fado and Other Stories. Pittsburgh: Pittsburgh University Press.

Intelligence, creativity and fantasy in *Baltasar and Blimunda*, by José Saramago

La Salette Loureiro
CHAM, FCSH, Universidade NOVA de Lisboa, Lisbon, Portugal
ORCID: 0000-0001-9236-2735

ABSTRACT: In *Baltasar and Blimunda*, by José Saramago, intelligence, creativity and fantasy are present in two ways: 1) in the creation of the novel, visible in the way of telling, in style, in the wide range of knowledge presented, in the plot, in the situations and the most powerful characters; 2) in the content of the novel, through reflection, action, especially the construction of the Passarola and the construction of the Convent, and characters, like Bartolomeu Lourenço and Domenico Scarlatti.

However, according to historiographic metafiction and postmodern historical fiction, Saramago adds to the presence of these faculties and the results they produce in the novel a questioning in the way of Brecht's poem "Questions From a Worker Who Reads", bringing to the forefront the anonymous workers.

Keywords: *Baltasar and Blimunda*, Creativity, Fantasy, Intelligence, José Saramago.

1 INTRODUCTION

As we know, intelligence, creativity and fantasy maintain among themselves a close relationship. The neuroscientist Antonio Damasio considers that any of these faculties is dependent on consciousness (2010, p. 21–22) and the correlative existence of an I (2010, p. 31), a Self where feelings also play a fundamental role (2017, p. 195).

Regarding intelligence, Damasio defines it as "the ability to manipulate the knowledge so that new solutions can be planned and executed", which is based on what he calls "Extended Consciousness, enlarged consciousness or autobiographical", "dominated both by the past lived and the future anticipated" (2010, p. 213).

About human creativity, Damasio believes that this is based on the life and on the fact that this "comes equipped with a precise order: resist and project itself to the future" (2017, p. 50). In this sense, he defines it as "the ability to create new ideas and new things" (2000, p. 359), but he considers that, in addition to consciousness, creativity "Requires an abundant memory of facts and skills, abundant memory work, high-capacity for reasoning, language" (2000, p. 359).

However, he stresses that "consciousness is always present in the creative process", guiding it with its revelations (2000, p. 358). In his view, it is these that inspire all inventions made by Man in all areas.

We should also add that Damasio (2017) includes subjectivity and integrated experience in consciousness (p. 204), and it must be emphasised that this experience includes "our past and future memories" (p. 141), an essential material for the imaginative process.

About this process, indispensable for the creation of fantasy, Damasio tells us that it "consists in the recollection of images and its later manipulation (2010, p. 190). In another book, he reminds us that "remembering past images is essential to the process of imagination, which is the playground of creativity" (2017, p. 140). But he also warns us that "much of what we memorise is not about the past, but about the anticipated future, and that "The creative process is being recorded for the possible and practical future" (2017, p. 141). However, the creative process goes further, especially in Literature and in the Arts, for they not only create possible worlds but create impossible worlds too, which we may call Fantasy, meaning here "the faculty or activity of imagining impossible or improbable things".

In the field of literature but also film, television, video and computer games, such a classification applies to cultural artefacts that fall into the category of possible and impossible worlds, whose features raise logical and ontological issues, according to the definition of Françoise Lavocat (2016):

A possible fictional world is an alternative state of things, stipulated by linguistic constructions, still or moving images or playful interactions (pos.7794, our translation);

and

Impossible worlds, from the logical point of view and from the physical and physiological laws that govern

them, they seem to suffer from an ontological deficit, which affects the characters' bodies in particular (pos. 9096).

2 BALTASAR AND BLIMUNDA

In our opinion, José Saramago's *Baltasar and Blimunda* mobilises intelligence, creativity and fantasy, in two ways: firstly, this presence is revealed in the creation of the novel, which necessarily involves at least two of these characteristics, visible in the form of storytelling, in the style, in the wide range of knowledge presented, in the plot, in the situations and in the very powerful characters, most marginalized, chosen among "God's favourites", because "God has a weakness for madmen, the disabled, and eccentrics" (Saramago, p. 185). Secondly, the content of the novel institutes them as a theme, through action, characters and reflection.

But Saramago goes far beyond the representation of these faculties, for, according to historiographic metafiction and postmodern historical fiction, and in the way of Brecht's poem "Questions From a Worker Who Reads", he comes to question and prove that individual intelligence, creativity and fantasy are not enough to do most of the artefacts whose conception and execution take place in the novel.

So, the novel implies questions like: Who is in charge? Who pays? Who conceives? Who knows? Who performs? How is it executed? Who contemplates? Who is in History?

3 INTELLIGENCE AND CREATIVITY IN THE CREATION OF THE NOVEL

In announcing the award of The Nobel Prize in Literature 1998 to José Saramago, the Swedish Academy recognises and rewards the role of the imagination in Saramago's work, therefore, his creativity and, by this way, also his intelligence and fantasy, present in all his work, endowing it with indisputable originality.

In *Baltasar and Blimunda*, this originality manifests itself in many ways, but in our analysis, we will highlight the plot, the characters, and the full range of knowledge presented.

Concerning the plot and the emplotment process, we consider as Ricoeur (1989, p. 25) and Kukkonen (2014), that

> The term plot designates the ways in which the events and characters' actions in a story are arranged and how this arrangement in turn facilitates identification of their motivations and consequences.

However, extending this concept in order to integrate already the theory of possible worlds, according to which plot is "the complex network of relations between the factual and the nonfactual, the actual and the virtual (Ryan, 2013).

In fact, in the novel, as the quotation from Marguerite Yourcenar in the epigraphs announces, the content will not be limited to the real and the plausible, but it must surpass this border, already if floating, and prowess probably the worlds produced by the fantasy, fact that the reading will confirm.

Indeed, the subjects chosen for the plot refer to the historical reality, the possible and the impossible. But also the emplotment is undoubtedly one of the essential points of the author's work, which shows his intelligence and creativity, and, together with the narrator's attitude, allows the construction of ideological messages, which must be decoded by the reader.

Composed of several narrative threads, factual and fictional, the emplotment establishes between these and its characters contrasts that illuminate each one of them. In this way, the story of the pair King / Queen contrasts with that of Baltasar / Blimunda; the Convent's construction contrasts with the Passarola's construction. It is the Baltasar / Blimunda pair that establishes unity among all these threads.

In our opinion, this plot installs a dark-light set similar to baroque art and it could fit the notion of "negative plotting" proposed by Susan Lanser (2011), which, according to Kukkonen (2014), "outlines how competing plots, "one shadowing the other," become meaningful in their mutual contrast, negotiate different narrative perspectives and broker the struggle for interpretive dominance".

In fact, in *Baltasar and Blimunda*, the contrast established between narrative threads and the characters themselves forms a mirror effect, in which each story or character is constituted as the negative of the other, also producing an effect similar to that of a "counterfactual" narrative, stimulating the reader to formulate hypotheses on the alternatives that answer the question "What if ...". However, in this novel, an alternative is already held in the opposite narrative thread. Moreover, the flight of Bartolomeu de Gusmão is, in fact, counterfactual, because it did not happen in historical reality.

In her studies on Coincidence and Counterfactuality, Hilary Dannenberg considers that "counterfactuality is a principle of divergence that makes visible a vast horizon of alternative stories" (Ryan, 2013). To the same author,

> In alternative history (i.e., narrative ascribing a different life to historical figures), counterfactuality invites the reader to make a comparison between the fictional world and the actual world that precludes total immersion in the fictional world, since the reader must keep an eye on actual history (apud Ryan, 2013),

and

> In realist narrative, it appears as the "what if" reasoning through which the narrator or the characters themselves evaluate situations or ponder the future (Ryan, 2013).

In *Baltasar and Blimunda*, if stories and events are not mostly historically counterfactual, in our view, the way the plot is constructed produces a similar effect, inevitably leading the reader to compare the various worlds of fiction among themselves, but also these worlds and his actual world.

In this sense, if we consider the various types of plot systematized by Kukkonen (2014), "(1) Plot as a fixed, global structure; (2a) Plot as progressive structuration; (2b) Plot as part of the authorial design", we would say that this Saramago's novel combines above all the last two models, but with a predominance of the latter.

In fact, the construction of the plot is oriented, preferably, to the control of reception, in order to direct the reader's emotional reactions and interpretative movements, in a clear ideological perspective, visible, for example, in the order of narration of events and in the quantity and quality of data provided to the reader on each of the narrative threads.

The wish to control reception becomes very clear in the paratextual elements, which vary in different languages and editions, both in the novel's titles and in the covers' image, which clearly suit the target audience (see Yuste Frías, "Paratranslation").

On the subject chosen, it is known that Saramago seeks it out of History, but to this, he adds totally or partly fictitious events and characters, a fact that establishes immediately the question of the relation and crossing between truth and fiction, to which the novel adds still another dichotomy: verisimilitude and unlikelihood.

Having been admitted by the author himself that this is a historical novel, this does not prevent that the real world, possible and impossible worlds, referential and fictional or hybrid characters interact throughout the novel, and that, in certain cases, historical truth is overcome and altered by fiction, such as the case of the Passarola flight.

As far as facts and historical figures are concerned, they are re-evaluated here and subjected to a new analysis to which the reader is invited to contribute, in an attitude informed by the New History, well-known to the author, especially through his translations of Georges Duby, but also by the Poetics of Postmodernism. Regarding the first and Duby, Saramago wrote in his Diary of December 3, 1996, that without them "perhaps *Baltasar and Blimunda* (...) did not exist" (1997, p. 262, apud Flores, 2010, p. 50)

On this subject, Saramago himself clarifies this question by attributing to the novelist the function of "correcting History" by replacing "what was for what it could have been" (Saramago, 1990, p. 18, apud Figueiredo, 2014, p. 16). The Convent of Mafra's construction and the Padre Bartolomeu Lourenço's researches for the construction of the Passarola are indeed historical facts. D. João V, his wife and children, Padre Bartolomeu and Domenico Scarlatti are referential and historical characters, playing thematic roles at certain moments.

However, if this is a constraint on the author's inventiveness, he easily surpasses it by creating wholly or partly fictitious events and figures that interact with the real ones, and through metaleptic procedures, effecting a blurring of boundaries between these different worlds (cf. Lavocat, 2016, pos. 7802).

With regard to events, the ideological positioning of the author and his narrator leads them, for example, to give a great textual highlight to the flight of the Passarola, a counterfactual event, allowing and promoting an attitude of empathy of the reader, while the Convent of Mafra, event and historical monument, is never shown, in order to prevent his empathy and to create an attitude of distancing (Brecht), in favour of a rational analysis of the facts. In the Convent's case, the reader is exposed to the greatness of the effort expended by the workers and never to the result of this work, thus exalting the one who makes and minimising the one who remained in History, thus promoting a new reading of History.

In the same sense, the figure of the mighty king D. João V, playing here above all the thematic role of King (Figueiredo, 2014, p. 32), is subjected to a parody view, which deprives him of his glory and majesty, operating a practice of carnivalization, in Bakhtin's way, and thus preventing an attitude of identification on the part of the reader.

In both cases, Saramago exalts the power of fiction and decreases the power of reality.

This summons the distinction between reference types in fiction, which Lavocat systematised in three different ways: The extra-fictional reference (the denotation), the inter-fictional reference and the intrafictional reference (2016, pos. 7884).

In this perspective, despite the mixture between historical facts and fictitious events and the interaction between historical and fictional characters in the novel, the difference of status and ontology remains, according to Lavocat, to whom fiction has privileges compared to the real world (2016, pos. 8101)

In the case of this novel, the fictional characters Baltasar and Blimunda (this one not entirely fictitious) assume a preponderant role in the novel, overlapping in relief to the royal couple, whose power and importance History registered.

Regarding the character's narrative category, we remember what Helena Kaufman (1991) says about the Saramago's characters, considering that they are atypical, "defective, ugly, rough, violent" (p. 130) and they are "ex-centric",

> because they are marginalized by historical account, bringing a new view of events, and because they are particularly different from most of their milieu (p. 129).

In the novel, Padre Bartolomeu Lourenço with his heresies and his wish to fly, Baltasar Mateus one-handed and Blimunda with her supernatural powers, fall into this description.

Concerning Blimunda, whose powers are applied in the construction of the Passarola and in the collection of Baltasar's will at the end of the novel, Kaufman considers that she introduces the implausible and the wonderful in the novel and combines the "realism of a popular protagonist with the fantastic and the fictional (1991, p. 130).

The choice of the novel's subject and the temporal location of the action, Portugal of the eighteenth century, allowed the author to expose a broad panorama that involves vast knowledge in several areas: History, Religion, Society, Economics, Science, Arts. The narrator manipulates it, obeying the author's interests in questioning History and the way historians told it. By doing so, they compel the reader in varying his reading model, alternating between the top/down, bottom/up and interactive models, in order to adapt his reading process to the requirements of a text that continually surprises his expectations and requires his cooperation.

The Religion, in particular, offers the author the possibility of setting events of great spectacular and theatrical effect consistent with the Baroque splendour, such as processions and the autos-da-fé, but submitting them to the critical and caustic view of the narrator, who triggers his sharp criticism on public and participants, putting in analysis authenticity and hypocrisy in religious practices.

4 INTELLIGENCE, CREATIVITY AND FANTASY IN THE CONTENT OF THE NOVEL

Intelligence, creativity and fantasy are part of the content of the novel through the presence of science and various arts, as well as the thematic role assigned to some characters.

In fact, it could be said that the novel illustrates Howard Gardner's *Theory of Multiple Intelligences*, due to the variety of intelligence application areas it promotes, such as Science, Music, Architecture, Sculpture, seen on the side of creation and reception.

In terms of plot, the great highlight goes to Science and Architecture, because each one forms a narrative thread, the Passarola's construction and the Convent's building, but the first one is also associated with Music and the second with Sculpture. Each one is also associated with some characters.

However, as we said, the treatment given to each of these narrative threads is entirely different. In the first case, the invention, design, execution and obtained result are given equal prominence, while in the second case the first two and the last steps are totally or partly ignored, giving great prominence to the execution process by anonymous workers and some highlight to the King's order to build the Convent, especially to criticize the monarch's arrogance, megalomania and vanity.

What is concerned is the questioning of who conceives, who does, in what way and who stays in History. The two narrative threads mentioned above show who does, as we shall see later, but also different models of the relationship between the various actors, confronting a cooperation's model in the case of Passarola and a repression's model in the case of the Convent.

The first one brings Science and Technology into the novel, putting into practice the three faculties in the analysis, gathering dream, work, study, and the madness necessary to accomplish the impossible, which also characterises Humanity, and also the courage to challenge the Inquisition.

The project leader, Padre Bartolomeu Lourenço de Gusmão, known by the nickname "the Flying Man" and mocked in society, plays a double thematic role, priest and scientist / inventor, a contradictory situation for the time, given the repressive power exercised by the Inquisition, which associates science with practices of magic and witchcraft, which puts the character in imminent and permanent danger, despite the royal protection. This danger is increased by the collaboration of Blimunda with her supernatural powers.

Having a factual and historical basis, the studies and scientific works of Padre Bartolomeu Lourenço, this narrative thread goes far beyond the facts and, through the fantasy, introduces in the novel the wonderful, the utopia and the uchronia, seen as the mobile that made humanity advance, in the conviction of Bartolomeu de Gusmão, for whom "A man stumbles at first, then walks, then runs, and eventually flies" (Saramago, p. 52), then this character in particular works with his memories of future.

This character's beliefs are proved in his flight attempts already made with balloons, some successfully, proven by History. Affected by an ontological hybridism (real and fictitious), this character benefits from an "existential path, mixing truth and Fantasy" (Marinho, 2009, p. 93), and presents himself in the novel as the "Builder of a Dream" (Marinho, 2009, p. 93), agglutinating desires and wills, which, to come true, will join Baltasar, Blimunda and later Scarlatti.

In fact, Bartolomeu Lourenço, in his thematic role of inventor scientist, materialises the conviction of the narrator, that "it is dreams that keep the world in orbit" (Saramago, p. 107). So, he is the concrete example that

> the world itself is like a water wheel, and it is men who by treading it pull it and make it go, and (...) if there are no men, the world comes to a standstill (Saramago, p. 55),

one of the ideological messages of the novel.

On the other hand, the collaboration of Blimunda, gathering the human wills necessary for the machine's flight, with the help of her special powers, introduces the fantastic and the wonderful in the realisation of the project, as well as a correlative allegorical interpretation, that corroborates this ideological message.

With the flight of the machine, Saramago sets up a counterfactual event, an alternative world, impossible for the time and the form of operation in its construction strongly contrasts with what happens in the construction of the Convent.

In fact, if it is evident that without the work and the intense study of the inventor to fulfil his dream this would not materialise, it is also clear that this achievement is only possible with the help of others. In this case, without the manual work of Baltasar and the magic of Blimunda, the Passarola would not fly. The three forms what the Father calls "an earthly trinity" that, through a model of cooperation, put the machine to fly (twice in the novel), leaving the credits of the feat to all of them.

Domenico Scarlatti will join this Trinity with his music, forming a quartet, with number four to assume its symbolic value of the Earth, thus becoming the science, crafts, magic and art gathered in the success of the Passarola, which approximates the earth to Heaven, because when it flies "three of them were up there in the skies together" (Saramago, p. 184).

With this partnership, Saramago establishes an equivalence between art and science, assuming Music as the most prominent art in the novel. Scarlatti is the referential character who represents it, with the thematic role of musician, artist.

Disconnected from any pragmatic and diegetic function, Scarlatti's music brings to the novel the assumption of art as a human creation, that "can elevate human beings to the highest summits of thought and of feeling (Damasio, 2010, p. 362).

According to Damasio (2010), "arts like music, dance and painting" will have appeared before the language, fulfilling multiple functions, among which "a homeostatic compensation" (p. 361). In this perspective, since art in general "is a means of inducing comforting emotions and feelings" (p. 362), in fulfilling this function, music, in particular, has "proved unsurpassed throughout the ages" (p. 362).

In the novel, Scarlatti's music fulfils this role, becoming a source of enchantment and pleasure for him and all who hear it, revealing a rare universality, as confirmed by the emotional reaction of Pe Bartolomeu Lourenço to the improvisation of the musician in the King's Palace, described through portentous visual images.

For this privileged listener, music is "a profane rosary of sounds" (Saramago, p. 150). Thus it is heavenly made terrestrial, a profane sacred, a heaven on earth, therefore fulfilling, incidentally, the author's desire of everything to stick to immanence and deny transcendence.

So, it is this enchanting power of music, which elevates man from the terrestrial to the celestial without losing his earthly condition, which brings together Scarlatti and Gusmao, music and science, because, for the former, "only music is aerial" (Saramago, p. 155), but the second knows that his invention

also should carry the man to the air, performing the "impossible".

Scarlatti would be associated with the secret and, when he sees the machine, he also thinks if it will happen, "then nothing was impossible for man" (Saramago, p. 157). Moreover, fictionally, it did happen.

By his will, the musician brings to the estate the pleasure and blessing of music, thus associating himself with the "earthly trinity".

And therefore, with this partnership, as we said before, Saramago equates these two forms of human creation, an idea that will be corroborated by Blimunda, when she says "Once the machine starts to fly, the heavens will be filled with music" (Saramago, p. 165), but also by Scarlatti, who wishes to take part in the flight and play in the sky.

However, his music has yet another beneficial effect, recovering Blimunda from her sickness. In this case, music retakes one of the original functions of art, its therapeutic role (Damasio, 2010, p. 239).

Scarlatti will see the Passarola "rising into the sky"(Saramago, p. 185) and flying, but he will not be the only one since the Mafra's population also contemplated the "miracle" and interpreted it like being the Holy Spirit, to which she dedicated a procession in thanksgiving.

In the case of the construction of the Convent, which brings Architecture to the novel, the work of the architect Johann Friedrich Ludwig does not deserve great prominence.

Saramago and his narrator do not emphasise the architect's creativity, preferring to concentrate on denouncing the arrogance of a king with absolute power and the dimension of the work required by the monument. The narrator is also responsible for reducing the king to the dimension of the ordinary human being, showing his fragilities.

The entire construction process of the Convent is subject to several criticisms, and it is primarily the work factor that is exalted in the novel, reaching genuinely epic proportions. The highlight goes to the number of workers (40 000, says the novel, 52 000, says the official history) and animals involved, the effort and suffering required, the miserable conditions in which they live and the ruthless repression to which they are subject. Two events of great magnitude fulfil this epic character: the transport of the stone (Benedictione), which lasts eight days, and the procession of statues of saints arrived from Italy, between Fanhões and Mafra.

The first one occupies the Chapter 19, where the narrator shows in detail the whole epic saga, the transport of the stone, which measures 7m, 3m, 64cm and weighs 31020 Kg, carried out by 600 men and 400 oxen. The hard work developed in the middle of the summer, suffering and even death deserve narration and detailed description and ripped compliments of the narrator. The epic dimensions of the event lead the

narrator to identify the transport car with a ship of the Discoveries and to take advantage of the opportunity to fulfil the promise announced in Portuguese novel's title, by erecting a Memorial to all those involved in the construction of the monument by registering names initiated by all the letters of the alphabet.

The other mentioned event, the transport of the statues, is narrated in Chapter 23, giving visibility to the Sculpture. Smaller than the previous one, as the narrator emphasises, this event replicates the form of a procession and combines art and religion. The sculptures of the great Italian masters follow lying in procession for a long journey, during which they are the target of curiosity and festivities of the people, which mixes religiosity and admiration against this "sacred pantheon" (Saramago, p. 323), which follows the interminable "procession of bells, more than a hundred" (Saramago, p. 323), which occurred weeks earlier. However, the most touching moment is even when in the ground and arranged in a circle the statues receive the visit of Baltasar and Blimunda, on a moonlit night.

A result of Saramago's imagination, this episode is a tribute to art, Sculpture and Baroque art in particular, in which the author works as a theatre director, who organises objects in space and manipulates instruments of lighting technology, producing a spectacle of rare beauty. Displaying a baroque light-dark contrast, this show exhibits a game of light-shadow oppositions. Subjected to the gaze, the touch and the interpellations of Blimunda, the statues are an example of Man's confrontation with the enigma of Art, his own creation, as the episode itself suggests, by remitting these creatures to the shadow projected by a "solitary cloud", returning them to the report prior to the action of the artist's creativity, being again "blocks of marble before they take shape under the sculptor's chisel" (Saramago, p. 316), diffuse presences, "as diffuse in their solidity as that of the man and woman in their midst who dissolves in the shadows" (Saramago, p. 317).

The life and vitality of art are once again reaffirmed, when "Blimunda looked back", saw "The statues glistened like crystallised salt" (Saramago, p. 317) and listened to their conversation.

The ineffable beauty of this episode shows the condition of art as life, which manifests itself in every change undergone in the interaction with the context and the spectator, but also in the dialogue that it establishes with him, even under apparent dumbness. In fact, this episode states that art speaks, depending only on the attitude of the interlocutor.

Regarding the control of reception, this episode strongly contrasts with the narrator's refusal to show the reader the splendour of the finished Monument, for ideological reasons. An attitude that contrasts with that of Lord Byron, who did not resist the marvel produced by the monumental complex of Mafra, bowing before the pomp and magnificence of the monument in Childe Harold's *Pilgrimage*.

5 CONCLUSION

In *Baltasar and Blimunda*, Saramago gathers the three faculties in title, giving us a fresco of the century of Lights, of the eighteenth-century Portuguese society, but, as he says himself, "seen in the light of the time in which he is, (...) with the eyes of today", therefore, giving us "his own interpretation of the world". In this case, he draws a dark-light portrait of Portugal, uniting "a desire for fiction and a desire for history, as a symptom of crisis and gesture of criticism, as fear of barbarism and the desire for another future" (Gusmão, 2012, p. 23).

The other historical facts that gave D. João V the name of Magnanimous are not in this book.

ACKNOWLEDGEMENT

This chapter had the support of CHAM (NOVA FCSH/UAc), through the strategic project sponsored by FCT (UID/HIS/04666/2019).

BIBLIOGRAPHICAL REFERENCES

Damásio, António. (2000). *O Sentimento de Si*. Mem Martins: Pub. Europa-América.

___. (2010). *O Livro da Consciência*. Lisboa: Temas & Debates/ Círculo de Leitores.

___. (2017). *A Estranha Ordem das Coisas*. Lisboa: Temas & Debates/ Círculo de Leitores.

Figueiredo, Júlia C. C. S. (2014). A Figuração das Personagens de Memorial do Convento : Hipótese de Leitura. http://hdl.handle.net/10316/27558

Flores, Conceição. (2010). "Da Nova História à metaficção historiográfica: a gênese de Blimunda". *MNEME – Revista de Humanidades*. 11(28) ago /dez.

Gusmão, Manuel. (2012). "Linguagem e História segundo José Saramago". *Blimunda 6* (novembro).

Kaufman, Helena. (1991). "A Metaficção Historiográfica de José Saramago." *Revista Colóquio/Letras* 120 (abril): 124–36.

Kukkonen, Karin. (2014). "Plot". In: Hühn, Peter et al. (eds.): *The living handbook of narratology*. Hamburg: Hamburg University. URL = http://www.lhn.uni-hamburg.de/article/plot [view date: 14 Dec 2018]

Lavocat, Françoise. (2016). *Fait et fiction. Pour une frontière*. Paris: Le Seuil. Edição do Kindle.

Marinho, M. de Fátima. (2009). A Lição de Blimunda – a propósito de Memorial do Convento. Porto: Areal Editores.

Ricoeur, Paul (1989). *Do Texto à Acção*. Porto: Rés-Editora.

Ryan, Marie-Laure (2013). "Possible Worlds", In Hühn, Peter et al. (eds.): *The living handbook of narratology*. Hamburg: Hamburg University. URL = http://www.lhn.uni-hamburg.de/ [view date:13 Dec 2018].

Saramago, José. *Baltasar & Blimunda* (Panther). Random House. Kindle Edition.

Yuste Frías, J. (2012). "Paratextual Elements in Translation: Paratranslating Titles in Children's Literature", in Gil-Bajardí, A., P. Orero & S. Rovira-Esteva [eds.] *Translation Peripheries. Paratextual Elements in Translation*. Frankfurt: Peter Lang, pp. 117–134.

Intelligence for obedience and creativity for subversion: Reading António Ladeira's *Os Monociclistas* (2018) and *Seis Drones* (2018)

Margarida Rendeiro
CHAM, FCSH, Universidade NOVA de Lisboa, Lisbon, Portugal
ORCID: 0000-0002-8607-3256

ABSTRACT: Social networking makes us communicate with the right persons; x-ray luggage scanners ensure secure travelling; computer applications save loads of books and are digital space savers. We could go on to conclude the obvious: intelligence has ensured critical technological breakthroughs to make present-day digital society fully operational and crystalline. However, we can also wonder the extent to which intelligence measures human development, that is the extent to which technology makes us better humans. Han (2015) argues that the digital world is a panoptic system that has made us alike so that we are better controlled. Before him, Foucault (1977) contended that vigilance systems, implemented since the 18th century, developed towards disciplinary forms of social control. A panoptic vigilance-based society has turned us into voluntary obedient humans. António Ladeira's *Os Monociclistas* (2018) and *Seis Drones* (2018) offer a glimpse of the dystopian existence of our urban society in the near future, fully dependent on panoptic systems of vigilance that ensure maximum efficiency and transparency. Han contends that human life is incompatible with absolute transparency regardless of what intelligence produces. Ladeira's anthologies confirm that intelligence has made us obedient, but we cannot be absolutely obedient all the time. Creativity is the disrupting factor that subverts the AI systems, and this factor alone restores our hope of becoming better humans in the future.

Keywords: Intelligence, Creativity, Obedience, Transparency, António Ladeira

1 ON A SLIGHTLY DYSTOPIC NOTE

In December 2018, *The New York Times* reported that the works that raised questions about the social and ethical implications of artificial intelligence (AI) and biotechnology had been pulled from the Guangzhou Triennial on the orders of cultural authorities in the southern Chinese province of Guangdong (Qin, 2018). Receiving no further explanation other than the works' 'incompatibility with Guangdong people's taste and cultural habits', the show's curators and affected artists were left thinking that those works were 'too timely, too relevant and therefore too discomforting for Chinese officials' (Qin, 2018). In China, social stability is a priority; thus, public debates with cogent questions about ethics are unwelcome. Nevertheless, this discomfort does not deter China from struggling to deliver cutting-edge technology, with ambitions to be in the frontline of the AI sector (Lucas, 2018). Uneasiness seems to grow having to expose that technological advancements invade the human body, control and manipulate it with a detrimental impact on the preservation of the concept of privacy associated to being human, thus, an unmanipulated sphere.

The removal of works, such as Kaayk's *The Modular Body*, a living organism with human cells and artificial organs, and Blas and Wyman's *im here to learn so :)))))*, the AI bot created by Microsoft in 2016 and shut down after users trained it to be a bigot, from the Guangzhou Triennial is illustrative of this tension.

As technology evolves, human dependence on computer applications and devices grows stronger and, what is more, technology seems to be one of the prime indicators of the level of human development. The first global forum on innovation and technology in sustainability, organised by the World Centre for Sustainable Development of the UN Development Programme, in Rio de Janeiro, in November 2018, shows that considerations on sustainable human development are largely indebted to its association to technology. *Black Panther*'s (2018) Wakanda relies its high development on cutting-edge technology to the surprise of the rest of the world that deemed this African nation a developing society. Nevertheless, we cannot underestimate the impact that technology has on human development; as, Heidegger contended in the 1950s, "we are delivered over to it in the worst possible way when we regard

it as something neutral" (Heidegger, 1977, p. 4). His words are opportune to this discussion because no one can be indifferent to the fact that day-to-day routines depend on AI.

The advancements in AI have been remarkable, to the point where there is hardly an aspect in contemporary life it does not cover. By the achievements obtained so far, experts, researchers and engineers believe that the most significant accomplishments are yet to come (Roffel and Evans, 2018). However, in these neoliberal times, as AI makes the wealthy more powerful, we cannot underestimate the fact that neoliberal technology presents itself as power and a tool for the powerful. Hence, technology 'brings forth characteristic devotional objects that are employed in order to subjugate' (Han, 2017, p.12). In this respect, the cyber-mystery thriller *The Net* (1995) offered a glimpse of the extent to which the existence of personal identity, and consequently the interaction of the individual in community, was dependent on those holding the power of AI, at the same time the protagonist's daily routine was largely facilitated by computer technology. And the 3rd millennium had not yet begun.

In a world ruled by the AI systems, the information generated by the Big Data is essential to enhance effectiveness and control in the digital society. As Han argues, Big Brother and Big Business have formed an alliance and have divided human beings according to their usefulness and those "assigned to the 'waste' category belong to the lowest class (Han, 2017, p.65).[1]

Subjugating and disciplining people's bodies and minds were, Foucault contended, the traits that characterised modern society since the 18th century. He tracked this project of disciplinary enforcement to the panopticon model designed by J. Bentham. Originally designed as a prison model, the panopticon raises the awareness of the inmate to the feeling of being permanently visible and watched by a single watchman positioned in such a way he could observe all cells. Combining the vigilance structure that 'automatizes and disindividualises power' (Foucault, 1995, p.202), with isolation and labour as part of the permanent disciplinary system, replicated in factories, schools, barracks and hospitals, Foucault argued that the capitalist society was built upon the docility of controlled bodies. Nevertheless, the 21st century shows that as capitalism mutated to neoliberalism, the *politics of the body* evolved towards *psychopolitics* (Han, 2017, p.24):

> The body no longer represents a central force of production, as it formerly did in biopolitical, disciplinary society. Now, productivity is not to be enhanced by *overcoming* physical resistance so much as by *optimizing* psychic or mental processes. Physical discipline

has given way to mental optimization (Han, 2017, p.25).

On the one hand, transparency took hold of the public discourse based on the freedom of information. Freedom is delusional in the digital age when privacy is subordinated to the compelling need to show that there is nothing to hide (Han, 2015, p.69). There is no such thing as privacy as a sphere away from the public eye. Electrical shocks, sleep deprivation, drugs and solitary confinement are no longer disciplinary means. It is the digital panopticon, and docility is obtained by pleasing and fulfilling people, making them dependent and passive. Citizens do not engage in democracy. Neoliberalism turned citizens into onlookers and consumers. In other words, democracy became a *spectator democracy* (Han, 2017, p.10).

On the other hand, the new surveillance society is more elegantly and seductively totalitarian and oppressive than before. Social networks lure consumers into interacting and consuming. The smartphone is the *black mirror* and multifunctional tool of our auto-exploitation.[2]

To which extent has the AI affected the way we define humanity? And to which extent does the AI compromise the potential of our imagination and invention if its potential is not curbed? And to which extent are we not living in a cave, not too different from Plato's, only more seductive because black mirrors make them apparently more appealing? Applications of AI have been endless fodder for pop culture, ranging from *The Matrix* (1999) and *Her* (2013) to Le Guin's novels, just to mention a few of the North-American production. In Portugal, despite a resilient niche, sci-fi has remained almost invisible.[3] António Ladeira's two latest short story anthologies, *Os Monociclistas e outras histórias do ano 2045* (2018) and *Seis Drones – Novas Histórias do ano 2045* (2018) – describe a dystopian existence of the urban surveillance society in the near future – in 2045–, dependent on highly-advanced AI systems that ensure maximum efficiency and transparency at the same time they hamper individual freedom of movement and expression.[4] The two

1. Big Data refers to data sets too complex for traditional data-processing application software to deal with. They offer great statistical power for marketing activities, cost-reducing and smarter decisions.

2. The TV sci-fi anthology series Black Mirror explores a high-tech world in an alternative present or near future, where the greatest tech innovations collide with the darkest instincts. Despite drawing directly from the black screens of computer monitors and smartphones, black mirror is a concept that dates back to the 18th century. At the time, the Claude Glass, also known as black mirror, abstracted the subject reflected in the mirror from its surroundings, reducing and simplifying the colour and tonal range of scenes and scenery to give a painterly quality.
3. Saída de Emergência, Editorial Divergência and Imaginauta have been among the few resilient Portuguese publishers of sci-fi; Some of the recent titles include Lisboa no Ano 2000 (Saída de Emergência, 2013), and Por Mundos Divergentes (Editorial Divergência, 2015).
4. António Ladeira, an Associate Professor of Portuguese at Texas Tech University, is the author of poetry, essays, fiction and a songwriter. His books are published by Bertrand

volumes collect thirteen short stories and each story focusses on a particular invention or system, ranging from digital books and unicycles to term life insurance, social networking, and travelling, among others. This paper establishes that Ladeira's short stories illustrate Han's argument: that despite the transparency panopticon, "human existence is *not transparent, even to itself*" and that "[t]he other's very lack of transparency is what keeps the relationship alive" (Han, 2015, p.3) and this factor alone may deter control from being absolute. In Ladeira's short stories, it is human imagination or creativity, the ineluctable trait of the human potential, that drives the narrative principle and shows that it disrupts the AI-controlled environment, and secure core humanness.

2 INTELLIGENCE FOR OBEDIENCE

Various gadgets and systems offer comfort and security at times when the human mind also has also to be trained to adapt to ever-increasing levels of speed, agility and quickness. Ladeira's anthologies convey the urgency to cope with these present-day needs. Digital pedagogical tools prepare all students to complete their basic, secondary and higher education at a rapid pace because time is a limited asset ("O professor); phone lines use surveillance systems to prevent inaccurate information, rumors and gossips from spreading on phone calls ("Estás livre no sábado?"); a revolutionary unicycle sorts out social inhibitions caused by short stature and is the equalizer in the urban daily life, adapting life to unicycles, rolling at higher speed, excluding those who prefer to continue walking ("Os monociclistas"); a social network avoids love disappointments and time waste by suggesting ideal matches and friendships ("Galeria"); eyeglasses show images of the future ("O complexo"); term life insurances that deter insurees from wasting money and design life insurance plans according to precise calculations of life expectancy ("O contrato"); drones protect their users from massive advertising, stalkers and missiles ("Seis drones"); digital books include reader-tailored advertising and adapt classical literature to the new times and values ("O objecto"); and cars are self-driven and follow routes pre-defined and notified to a central authority in advance. Drivers' needs and routines are pre-defined and, thus, traffic jams and car accidents decrease in number ("A Rede"). Community life is closely monitored through a complex CCTV network ("O inspector"), and another complex agency secures flying from menaces that range from terrorism to tumours that may eventually compromise the passengers' security and tranquillity during the

flight. Intensive training courses make citizens qualified to travel, and their need or wish to travel requires sanctioning by the central authority ("Agência").

People hardly have to reason and strive because everything is organised to live individually and socially in such a way that favours the common good orderly and quietly. Pitfalls and the unexpected happen when people do not comply with the official rules and procedures and make one-off and spontaneous individual decisions; when they decide autonomously, do not use digital resources and use past resources. Reading books in print and writing with pencils are time-consuming activities and, therefore, time-wasters ("O professor"); summarizing films hastily may be the cause of bad publicity ("Estás livre no sábado?"); drone-malfunctioning leaves users to the mercy of buzz marketing and disturb their daily routines painfully ("Seis drones"). Living is complying with dispositions and obeying to rules. All the time. In other words, individuals lead automated lives in order to avoid personal mishaps and social disruptions; individual lives can even be terminated should they outlive the life expectancy limit agreed to lead a quiet life and not impose unnecessary financial liabilities to heirs ("O contrato"). Any decision deriving from predefined schemes is socially disruptive and chaos-damaging. The AI is, therefore, essentially life-supporting and monitoring is a need that makes the loss of individual privacy a collateral damage because it ensures common good and tranquillity.

The narrative space conveys the automated and deindividualized human existence. Geographically, all short stories take place in the "Territory" (*Território*), and the few names of specific areas are geo-localising only: harbour (*Marina*) and cliff (*Falésia*). On the one hand, this generalisation prevents readers from identifying these stories as narratives about a given society; on the other hand, the generalisation participates in the argument that the issues these anthologies deal with belong to the global world and result from the prevalence of the AI in present-day urban society.[5] Action is carried out in places similar to those Foucault identified as traditionally disciplinary: at a school ("O professor"), at (high-tech) plants ("Os monociclistas" and "O Complexo") and at a hospital ("Falésia"). The disciplinary trait is preserved to implement obedience, as shown, for example, in "Os monociclistas", when the reluctance to accept unicycle life is punished and is set an example:

Livreiros and On y va, in Portugal. Selected short stories of Os Monociclistas and Seis Drones were published in one volume in Brazil with the title Estás livre no Sabado? (Realejo Editores).

5. It is worthy of mention the fact that science fiction conveys the major conflicts between science, technology, human nature and society, speculating about the (near) future based upon the major conflicts of the present. Major works published between the 1950s and 1970s conveyed the key importance of the Cold War, affecting areas, such as social organization and space exploration. Noteworthy examples include Orwell's Nineteen Eighty-Four, Le Guin's The Dispossessed and Lem's Solyaris.

Resolvi expiar de uma vez a culpa que sentia: em vez de disciplinar o meu irmão, criei um cargo só para ele. Um lugar de importância vital: representante da Monociclo da primeira colónia pedestre da empresa. Uma colónia que acolheria e absorveria os cidadãos detidos por violação do código de circulação na via pública. Mas que também receberia aqueles que, por temperamento ou opção filosófica, prefeririam continuar a ser peões num mundo de monociclistas (Ladeira, 2018a, p.74).

The figure of the inspector is central at the school and on the streets, ensuring the compliance with rules and acceptance of the social organisation. In "O professor", the inspector swings his body in all directions as he speaks, like a lighthouse, pointing at and looking everywhere. His figure is priest-like and awe-inspiring (Ladeira, 2018a, p.17). Worthy of mention is the fact that there are figures that replace the position of the inspector with similar overseeing functions, such as officers at the airport ("Agência"), the reading board ("O objecto"), the coordinator ("O Complexo") and the nurse ("Falésia"). The closer human overseeing gets to machine-like overseeing, the more effective it is: "Aliviava assim um sistema que – apesar de razoavelmente eficaz – se encontrava sempre sobrecarregado "(Ladeira, 2018a, p.34).

Ladeira's anthologies also feature key places of present-day high-tech and urban society: the airport ("Agência"); crowded streets ("O inspector", "Seis drones" and "A Rede"); and optical highways enablers of phone calls and social networking ("Estás livre no sábado?" and "Galeria"). These new places are Augé's "non-places"; they convey the contemporaneous relations with space, time and interaction among individuals (Augé, 1995). They result from speed and space virtualisation, that is, the impositions of supermodernity.[6] Individuals need to accomplish more in little time. Augé contended that solitude was the consequence of supermodern times, that is "solitude [wa]s experienced as an overburdening or emptying of individuality" (Augé, 1995, p.87). This is shown in "Seis drones", when the protagonist's personal drones stop working, leaving him defenceless on the street,

vulnerable to the aggressiveness of buzz marketing and nobody around him cares: "O egoísmo dos transeuntes não o surpreendeu. Confirmou-lhe, aliás, o que sabia há muito ser regra na cidade: "cada um por si"." (Ladeira, 2018b, p.12). In "Galeria", Bartol, the protagonist, is manipulated by the social network's management, with the complicity of his wife and best friend in order to make his personal life of public domain and pay for the security of his personal data. Action in these places conveys the extent to which personal and family relations become secondary whenever there is the need to preserve the AI-based social systems. In "Falésia", these are relations that Lars, the nurse, describes as a professional impasse, one of the three impasses (together with social and road and pedestrian) that determined the beginning of virtual life in 2025, lived massively by all inhabitants artificially kept in vegetative state and neurologically linked to virtual life (Ladeira, 2018b, p.125-126). This is Baudrillard's hyperreality, the reality composed of simulacra, pushed to its limit. The French philosopher contended that in technologically advanced societies, consciousness is unable to distinguish reality from fiction (Baudrillard, 1994). Twenty-five years later and in view of the appealing AI advancements, fears that reality becomes fiction itself increase and the short story "Falésia" is illustrative of these fears. As these advancements become more effective and, consequently, more luring, human interactions and their natural propension to include unforeseen disagreements and opinion divergences are considered socially destabilising because they cannot be avoided. They eventually jeopardise social stability and disrupt smoothly effective monitoring; thus, they need public disciplining that can eventually take the shape of death ("Falésia") and exile ("Os monociclistas"). Han contends that the violence of transparency, to which I add the obedience to conform to it, lies in the "compulsion for transparency flattens out the human being itself, making it a functional element within the system" (Han, 2015, p.2-3). He calls it "a particular kind of spiritual burnout" (Han, 2015, p.3). In "Galeria", when compelled to make his life totally public on the network, Bartol is the evidence of this burnout as if life that is his wills and wants had been exhaled from his body:

À saída da sala 22, Teresa e Oleg aguardavam-no. Sem perderem tempo, abraçaram-no pela cintura e levantaram-lhe os braços para que se apoiasse nos ombros de ambos. E foi assim, pé ante pé, arrastando as pernas flácidas do recém-interrogado, que avançaram pelo corredor em direcção à porta (Ladeira, 2018a, p.101).

Home, understood as the impenetrable fortress in the west and, hence, an exemplary *anthropological place* where memory is nurtured and human interaction preserved, is not wholly safe from the

6. Supermodernity is the term Marc Augé uses to characterize our times. It entails the difficulty of thinking about time due to the "over-abundance of events in the contemporary world that makes it difficult to understand the present and "give meaning to the recent past"; and the excess of space results from the fact that "the world is becoming open us" in an "era characterized by changes of scale" and that includes space exploration and rapid means of transport that shortened the time of travelling dramatically (Augé, 1995, p. 30-31). Non-places are places characteristic of supermodernity. Castells calls the new communication technologies that entail transformed communication practices the space of flows (of information) as opposed to the space of places as they show the evolution of urban forms under a new spatial logic (Castells, 2010, p.408-409).

consequences of technological surveillance and dein-dividualized ways of living (Augé, 1995:p.78).[7] In "O contrato", the home is invaded by officials and the protagonist dragged from under the bed and killed for failing to die of natural causes by the stipulated date; In "Falésia", the persistent stain on one of the windows of the protagonist's home drives his wife into an inquiry process that determines their removal from the social system.

Order is the opposite of chaos as progress is the opposite of primitivism. Intelligence deters chaos by ensuring protection as a home should. In "A caverna", when the global digital war breaks out, and the AI systems are attacked, the environment becomes dramatically hostile and life-threatening, but it retains its dome-of-protection shape:

> Decidiu então que apenas os espaços não urbanizados ofereceriam a segurança por se encontrarem suficientemente longe da grande abóboda digital (Ladeira, 2018b, p.103).

The primitive cave is the opposite of the dome of protection, and it emerges as the space of the place of memory, the alternative anthropological place, where relations are nurtured. Living in a cave, away from the AI systems, is a symbolic journey to the remote past, to recover emotions and memories forgotten or undervalued. In this short story, this journey is shown through the description of the inhabitants' routine, that include being hunter-gatherers, cutting up their food and cooking it on a fire, in community:

> Foi-lhe atribuída a caverna número quarenta e três. E ela agradecia, a quem tivesse tomado a decisão, não apenas a escolha do local, inspirador e idílico, mas também a selecção dos companheiros com os quais, nos últimos dois anos, construíra uma comunidade exemplar de cooperação, de entreajuda e – porque não dizê-lo? – de verdadeira amizade (Ladeira, 2018b, p.102).

3 CREATIVITY FOR SUBVERSION

Han contends that "emotions derive from deviations from the way-it-is and are "dynamic and performative" (Han, 2017, p.43). Emotions are potentially transgressive because they can trigger disruptive and one-off decisions. "O professor" starts with "Tenho treze anos e quero ser escritor" (Ladeira, 2018a, p.11). This decision results from the satisfaction to be able to use language freely and careless writing for an undetermined

reader despite a pilot programme of writing with pencils being compulsorily terminated because it misfit people's needs in a fast society. The title "Estás livre no sábado?" is also the opening sentence of that short story, uttered out of excitement, that disturbs the second speaker because it subverts basic codes of a conversation on the phone: "Que maneira de começar um telefonema! Já não se cumprimenta?" (Ladeira, 2018a, p.23). It is also the sentence that finishes the narrative, in the course of a conversation that relocates it to its due place in a purpose-oriented conversation with a third speaker after disciplinary mechanisms having ended up excluding the first speaker.

As far as the narrative process is concerned, emotions and sudden decisions propel the catastrophe before catharsis. They introduce narrative creativity in the sense that the short stories are more than descriptions of effective AI systems; these systems are tested and challenged. The old teacher's decision to teach their students to write without digital resources causes one of the students, the narrator, to decide to be a writer as in the old days, without digital apps ("O professor"); the collective decision to wear 'inspector' face masks disrupts the surveillance system because it makes it impossible for the inspector to differentiate the watcher from the watched ("O inspector"); the reluctance to share private decisions disrupts the social network because it introduces negativity in a network that promotes exposure as positive ("Galeria"); the decision to help a man in trouble on the street may be the beginning of a love affair ("Seis Drones"); the decision to form a network of conscientious objectors tests the limits of the vehicle-controlled network ("A Rede"); and the stubbornness of a woman to find out why a window stain cannot be wiped off makes her husband and her find out the truth about the world they live in ("Falésia"). The AI systems are underrated when in view of the constraints they impose on human imagination and free will, humanness resists, and this includes the determination of a boy to become a writer, the survival instinct of a woman against the ruthless AI-based order of things or the thrill of living in community, cast away from the AI environment. Ultimately, resisting to intelligent mechanisms of tight control can only be counterposed with tighter control, as shown in "A Rede". In this short story, when conscientious objectors challenge the network, this system is replaced by a hardened 'ultra-network' in the end. Decisions and emotions are potentially transgressive; nevertheless, the memory of the past knowledge emerges as the potentially transgressive temptation.

Memory is significant to understand the extent to which intelligence jeopardises the very notion of humanness and the extent to which creativity, as a human ability, is its redeemer:

> Memory constitutes a dynamic, living process; here, different levels of time intersect and influence each other. Memory is subject to constant rewriting and

7. English sayings such as "An Englishman's home is his castle" and "there is no place like home", the Italian saying "casa mia, casa mia, per piccina che tu sia, tu mi sembri una badia", or the French saying "charbonnier est maître dans sa maison" convey the importance of home as the last stronghold of individual privacy.

rearrangement. (…) Digital memory consists of indifferent – as it were, *undead* – points of presence (Han, 2017, p.66–67).

The notion of time underlies these anthologies: maturation time for imagination to surpass the apps; time for the memory to show its dynamic relations; and, ultimately, time for the boredom and monotony produced by the AI-controlled environment to let creativity grow as inspiration to overcome the coercive use of power in such environment. The memory of a remote past is symbolically personified in the figure of the old teacher in "O professor", the first story of the first anthology:

> Era um homem feio e velho, que olhava para nós como se tivéssemos feito alguma coisa que merecesse castigo. O olhar do professor magoava (…) era quase sempre fixo. (…) A pele das mãos e dos braços tinha manchas castanhas e era muito fina, quase transparente, com veias grossas. Eu pensava que o professor estava quase a morrer, que morreria antes de terminar a aula (Ladeira 2018a, p.11)

It is the consciousness that knowledge vanishes as time elapses. The figure of the teacher emerges as the depiction of a generation that is on the verge of disappearance, alongside a way of thinking that does not conform to the digital age.

In addition, the book in print and the printed pages are as potentially transgressive as a teacher because the book in print is not controlled and does not include reader-tailored content in view of the needs of the digital age.[8] The digital book, with pop-ups advertising products that meet the reader's needs and wants, appeases the mind and stimulates consumerism in a global world. The reader-consumer indulges the inner life by fixating on externals in a certain way in order to create alternative figures of his or her self, which negate his or her mundane existence. Reading that D Quixote is a man who decides to destroy all chivalric romances because they defend values that have produced in him a melancholic depression; that *Moby Dick* is about Ahab's crusade to protect the whales; and that Kafka's *The Trial* tells the story of a man whose accusations pending on him are due to a computer error sorted out, in the end, is not just reading novels with manipulated plots that make them aberrations of the classics; they show the extent to which alterity, that is, extreme emotions and the evidence of the complexity of the human mind, has to be eliminated so that power can be operationalized more effectively:

The negativity of alterity and foreignness—in other words, the resistance of the Other—disturbs and delays the smooth communication of the Same (Han, 2015, p.2).

Manipulating communication and eliminating complexity, in order to persuade that the world is – and has always been – solely driven by simple, straightforward and down-to-earth intents and emotions convey the extent to which knowledge of the pre-digital era is potentially subversive. The book in print is the fruit of temptation in a world homogenised by the AI, as described in "O Objecto". In this short story, the book in print is the unspeakable word – the forbidden object – a rarity, preserved, out of sight and hidden:

> Quanto à infracção da leitura, não tencionava cometê-la. (…) Deus o livre de semelhante capricho e insensatez! Apenas quer ter o privilégio de poder contemplar o objecto sempre que desejar (…) (Ladeira, 2018b, p.34).

Thinking outside the box and eluding the black mirrors that abstract and simplify what merely is complex by nature is using the potential of imagination and, thus, subverting the logic underlying the AI-controlled environment. Returning to Guanhzhou Triennial, Kaayk felt frustrated following the removal of his work of art because contemporary art means to raise questions and start discussions about important subjects in actuality and those of our near future (Qin, 2018). In this sense, creativity is inconvenient. Intelligence is certainly one of the issues that should be the subject of discussions and make us think about our humanness – outside the box.

ACKNOWLEDGEMENT

This chapter had the support of CHAM (NOVA FCSH/UAc), through the strategic project sponsored by FCT (UID/HIS/04666/2019).

BIBLIOGRAPHICAL REFERENCES

Augé, M. (1995 [1992]). *Non-Places: Introduction to an Anthropology of Supermodernity*. Trans. John Howe. London: Verso Books.

Baudrillard, J. (1994). *Simulacra & Simulation. The Precession of Simulacra*. Trans. Sheila Faria Glaser. Ann Arbor: The University of Michigan.

Castells, M. (2010). *The Rise of the Network Society*. Oxford: Wiley-Blackwell.

Foucault, M. (1995 [1977]). *Discipline and Punish: The Birth of the Prison*. Trans. Alan Sheridan. New York: Vintage Books.

Han, B.C. (2015). *The Transparency Society*. Palo Alto: Stanford University Press.

Han, B.C. (2017). *Psychopolitics: neoliberalism and new technologies of power*. London: Verso Books.

Heidegger, M. (1977). *The Question Concerning Technology and Other Essays*. Trans. and Intr. William Lovitt. New York & London: Garland Publishing, Inc.

8. Ironically or not, the only image about the future in these short stories is forged. In "O Complexo", as a group of friends admire the *Opticons*, spectacles that show their lives within a year's time, Andrei, Victor's rival in love, is unseen as if he had died sometime during that year. We learn that this image had been manipulated at Victor's request so that Sara becomes interested in him more easily. This shows the extent to which intelligence can be subdued to mischievous intentions.

Ladeira, A. (2018a). *Os Monociclistas e Outras Histórias do Ano 2045*. Lisbon: On y va.

Ladeira, A. (2018b). *Seis Drones – Novas Histórias do Ano 2045*. Lisbon: On y va.

Lucas, L. (2018, November 15). China's artificial intelligence ambitions hit hurdles. *Financial Times*. Retrieved from https://www.ft.com/content/8620933a-e0c5-11e8-a6e5-792428919cee.

Qin, A. (2018, December 12). Their Art Raised Questions About Technology. Chinese Censors Had Their Own Answer. *The New York Times*. Retrieved from https://www.nytimes.com/2018/12/14/arts/china-art-censorship.html.

Roffel, S. & Evans, I. (2018, July 9). The greatest advances in AI: the experts' view. *Elsevier*. Retrieved from https://www.elsevier.com/connect/the-greatest-advances-in-ai-the-experts-view.

Literary creativity and political debate. The case of African journals *Mensagem* and *Notícias do Imbondeiro*

Noemi Alfieri
CHAM, FCSH, Universidade NOVA de Lisboa, Lisbon, Portugal
ORCID: 0000-0002-0914-273X

ABSTRACT: This contribution aims at elaborating on the ties between creativity, intended as the ability to create new meanings through literature, and politics, in the Angolan literary sphere of the 1960s. The dispute between *Mensagem* of Casa dos Estudantes do Império and *Notícias do Imbondeiro* went way beyond literary debate. Though centred primarily on current literary production and dissemination, both publications engaged in a heated debate on activism and anti-colonial struggle. Contradictions became thereof apparent.

At the time, what was at stake was, in fact, a struggle on the part of a cultural elite on how to combine theoretical thought grounded in Africa, artistic creation (notably through the multiple representations of African imaginary), whilst setting an agenda for the boundaries of activism.

The arguments of Carlos Ervedosa and Leonel Cosme, representing the two editorial projects and their contrasting positions, as much as the ones of Alfredo Margarido – who anonymously wrote essays on the *Boletim* of C.E.I. -, constitute in this paper a point of departure for the understanding of the cultural background of the Angolan and Portuguese 60s, their contradictions and ambivalences.

Keywords: Africa, Journals, literature, representations, nationalisms.

If, as Claude Prévost stated, the borders of literature are imprecise, the strength of this statement becomes even more intense in case we try to apply it to the context of the African and Angolan literature of the 1960s. At that time, the bond of literature with ideology ended up being quite omnipresent on the African literary debate, as much as it became impossible to escape from it, even for those who, like the editors of *Imbondeiro*, were making huge efforts to do it. The fight for the African independences after World War II and the deterioration of Salazar's Portuguese regime led, since the very beginning of the 1960s, to an exacerbation of the social and cultural conflicts. 1961 was the year in which the first attacks to the Portuguese colonial regime where struck by the movements for the Independence of Angola, such as UNITA, MPLA and FLNA, at the time defined by the colonial administration as terrorist associations. As a response, Salazar decided to engage in a war that would only finish with the Carnation Revolution of April 25th, 1974.

In this context, under censorship and facing growing repression by the political police, PIDE, artistic creation and human intelligence were often used to express, through fiction and literary creation at large, feelings and thoughts that would otherwise be forbidden. As Inocência Mata (2015) stated, literature played a fundamental role in the national awareness of the former Portuguese colonies. In Lisbon, the

Casa dos Estudantes do Império (C.E.I.), an association born in 1945 under the control of *Mocidade Portuguesa*, the section of the Portuguese regime dedicated to cultural initiatives for children and young students, had become a relevant cultural hub. Several young African intellectuals, who were in Lisbon to get the academic education that was not available in the colonies, became aware of the need of cultural change and political opposition and created the *Centro de Estudos Africanos* (Centre of African Studies). *Mensagem*, the bulletin of C.E.I, soon became a tool of dissemination of the nationalist, anti-colonialist and anti-fascist values the new generation of Africans were inspired by. The tight collaboration with the French review *Présence Africaine*, thanks to Mário Pinto de Andrade, also favoured the contacts with the Négritude ideals and their main representatives. The 1960s were, for *Mensagem*, the years of the establishment and definition of a literary canon (Martinho, 2015).

During those same years, a new project was born in Sá da Bandeira (now Lubango), under the direction of Leonel Cosme and Garibaldino de Andrade. Its name was *Imbondeiro*.

Being involved in the project as both editors and writers, the two intellectuals promoted a considerable impact in the literary culture written in Portuguese. They edited poems, anthologies of poetry and short stories, didactical books and novels until they were

forced to interrupt their activities because of the intervention of P.I.D.E., in 1964. Gerald Moser compared the impact of the closure of *Imbondeiro* to the scandal related to the award of the prize "Grande Prémio Novelística", of the SPE[1], to *Luuanda* by Luandino Vieira, and the subsequent scandal that followed (1966, p.486). The *Imbondeiro* editorial project ended up producing nine collections: *Colecção Imbondeiro* (68 issues), *Livros de bolso Imbondeiro, Contos d'África, Novos Contos d'África, Mákua* (anthology of poetry in Portuguese or translated into Portuguese), *Dendela* (short stories for children), *Colecção Primavera* (didactical books), *Imbondeiro Gigante* and *Círculo* (short stories, 1967, under the direction of Garibaldino de Andrade and Orlando de Albuquerque).

As much as they were trying to set aside the political debate, empowering some of the literary works they were publishing to break the borders of fiction – thanks to the clear connections of narrated facts to real events -, the editors of Sá da Bandeira ended up being involved in a debate with C.E.I., challenging the borders between the political and the literary spheres.

1 THE INTERVIEW OF 1960 TO CARLOS ERVEDOSA: MATTERS OF NATIONALITY AND REPRESENTATION

In 1962, an important debate started after the dissemination of an interview given by Carlos Ervedosa and published in issues 3/4 of *Mensagem* by C.E.I., of March – April 1960. The main discussion was around the cultural relevance of Angolan literary movements and intellectuals with a particular focus on the metropolitan *Mensagem*. In his interview, Ervedosa ignored the activities of *Imbondeiro* and chose to just refer to *Mensagem* (from Angola) and *Cultura*.

Commenting on the birth of the anthologies and collections edited by C.E.I., Ervedosa considered them a natural consequence of the "ultramarinização da Casa"[2]. As the representative of the Editorial Board (*Secção Editorial*) he underlined that most of the literary movements that had started in Angola – the country he felt most familiar to – were including, because of the lack of an enlightened criticism, "uma série de literatos e artistas "angolanos" que, na maioria dos casos, nem ao menos de lá são naturais[3]".

At first reading, the comment of Ervedosa, born in Luanda but of Portuguese descent, seemed to exclude from the category of Angolan people those who were born in Portugal. While explaining which were the guiding criteria of the two anthologies edited by C.E.I.,

he stated that as an editor he had just tried to be honest; he had selected the works "without prejudices of race, colour, religion or any other nature".

Accordingly, he stated that Angolan intellectuals were

> todos os brancos, negros ou mestiços, naturais ou não de Angola, black or *mestiços*, natural or not of Angola, que numa simbiose natural das duas culturas em contacto, a europeia e a africana, se irmanam nos mesmos problemas e aspirações, no mesmo amor à terra e às suas gentes, na mesma autenticidade e no mesmo anseio de construção duma sociedade cada vez mais perfeita.[4]

Going deeply into the matter of "natural symbiosis", the author implicitly made a distinction between the concept of luso-tropicalist cultural assimilation and what he considered a truly multiracial society. The Négritude and *Présence Africaine* are the two main points of departure and evaluation criteria of the Angolan case. The subsequent declarations of Cosme (1978) are clear as to these differences:

> Onde está o parêntese fechado e os "presencistas africanos" escreveram "africana", "Imbondeiro" teria escrito "angolana", pensando em termos possíveis de uma originalidade euro-africana. Isto é, admitindo que Angola poderia vir a constituir uma comunidade "sui generis", não seguindo a visão segregativa e paternalista que o Estado colonial-fascista recolhera do luso-tropicalismo e Gilberto Freyre, nem com as barreiras originais que o próprio Diop julgava existirem na real impossibilidade de o autêntico "mundo africano" assimilar o ser assimilado pelo "mundo europeu"[5].

Both positions evoke the formation of a New Man and the need of cultural renovation, but the perspectives and the ways of building the national and

1. Sociedade Portuguesa de Escritores, the Portuguese Writers' Association.
2. Literary, the "overseazation" of C.E.I.
3. As for all the next quotes in this article, I provide a free translation to English: "a series of "Angolan" literates and artists that, in most of the cases, were nor even born there".

4. "all the whites, black or mestiços, natural or not of Angola, that in a natural symbiosis of the two cultures in contact, the European and the African, become like brothers in the same problems and aspirations, in the same love to the land and its people, in the same authenticity and in the same yearning of construction of an increasingly perfect society."
5. "Where there is a closed parenthesis and the "African presencists" wrote "African", "Imbondeiro" they should write "Angolan", thinking on possible terms of a Euro-African originality. That is, by admitting that Angola could constitute a sui generis community, not following the segregationist and paternalistic vision that the colonial-fascist state collected from luso-tropicalism and Gilberto Freire, or Diop's take on the impossibility of "African world assimilating or being assimilated by the "European world".".
Alouine Diop, Senegalese writer and editor was the founder, in Paris (1947), of the journal Présence Africaine, the first giving voice, on a larger scale, to Africa and its intellectuals, becoming the privileged dissemination tool of the négritudinist ideals. Some of the authors represented in it are Richard Wright and Léopold Sédar Senghor. Mário Pinto de Andrade also had an active role in the direction and in 1953 the famous article "Les étudiants noirs parlent" was published.

identitary project rely on two definitions that seemed to be, at least at that point, hardly consensual: the Afro-European and the Euro-African identities.

Some discrepancies between the interviewer Tomás Medeiros and the interviewed Carlos Ervedosa would also seem to be raised from the written statement published in *Mensagem*. As Medeiros stated his doubts about the possibility that white man could identify himself with the black man beyond a sentiment of brotherhood, the opinion of the Saotomean intellectual ended up clashing with the one of Ervedosa.

Ervedosa's thesis raised doubts; how can the white man interpret the problems of a black man properly? The best examples of this possibility of identification would have been expressed by white writers like Castro Sormenho and António Jacinto.

Poems like "Castigo p'ro comboio malandro" (A.A.V.V., 1960) by António Jacinto went beyond social representation. The depiction of the daily reality of an overcrowded train going to Luanda is associated to the idea of resistance of black people to exploitation, in a poetic *crescendo* that turns the claim for justice more and more explicit. The use of native languages and expressions illustrates a stylistic choice that is as well a clear form of affirmation and active Africanization of the Portuguese language. The aspect of the literary activism, though, should not lead us to ignore, or to underestimate, the process of this poetic creation. The poem creates and follows a dense plot, a sort of screenplay that leads the reader into the future, that is, to the moment when the train, possibly representing colonisation, will derail. This time, they will face the refusal of collaboration from Africans.

This kind of disagreements in the arguments of Ervedosa and Medeiros testify that the influence of Senghor's thesis and Négritude among the students of C.E.I., as much as the prominent role of *Présence Africaine,* cannot be denied. Its interpretation and reception between the African independentists, however, was never linear.

Even if the negritudinists' theses had become leading references in this context, their adjustment to the case of Portuguese colonialism was never consensual. Starting from the conference of Senghor in Lisbon in the facilities of C.E.I., in 1956 (A.A.V.V., 2015), there were people who, as David Bernardino and Ivo Lóio, expressed their doubts about the confluences of the speech of the Senegalese intellectual with the Salazarist orientation. This was due to the mystification of lusotropicalism and to the implicit justification and valorisation of the cultural assimilation that, long before that date, already entered the imaginary even of the progressive faction of the Portuguese society.

Going back to Ervedosa and the debate with Cosme, he decided not to include *Imbondeiro* in the list of the movements that, in his opinion, had given a relevant contribution to the renovation of Angolan writing. He may have thought the works published by *Imbondeiro* did not fit the canon of black literature committed to

the fight against the Portuguese colonialism. The political orientation of the editors, furthermore, seemed to be oriented towards a progressive autonomy of the colonies, rather than to independence, as some letters written by Garibaldino de Andrade intercepted by PIDE clearly suggest.

With regards to the other colonies, the movements that are highlighted are *Claridade* for Cape Verde and the journals *Itinerário*, *Notícias* and *Brado Africano* for Mozambique (together with its editors, the Albasini brothers, and the writers Noémia de Sousa, Rui de Noronha and José Craveirinha). In this context, we should not be surprised by the fact that the work of Cosme and Garibaldino was excluded from the comments of the responsible of the Cultural Department of C.E.I.

Imbondeiro did not match the standards of Angolanity established by C.E.I., or the ones of Négritude. Furthermore, we cannot forget that as the interview was published in March/April of 1960, the issues of *Colecção Imbondeiro* that were already available in the bookshelves to be sold were a short story by Garibaldino de Andrade (*O tesouro*), one by Leonel Cosme (*Graciano*) and, possibly, *Filha de Branco* by Lília da Fonseca. All the references made by Ervedosa to movements that, he thought, had promoted the emergence of new values, were referring to literature produced before the very year of 1960.

2 1962: THE RISE OF THE DEBATE BETWEEN C.E.I. AND *IMBONDEIRO*

In 1962, Cosme would go back to this discussion in an article that was originally published in the first issue of the *Boletim da Câmara Municipal de Sá da Bandeira* and then republished in *Notícias de Imbondeiro*, n° 30, March 1962.

We are referring to two distinct ways of conceiving the raising identity and the relationship between literature and the world. C.E.I. was trying to run away from the constraints that the bond with the Portuguese regime implied (we recall that the *Casa* was born under the auspices of Marcello Caetano and the *Mocidade Portuguesa*). *Imbondeiro* was seeking, on the other hand, to achieve an increased involvement in the local reality. The editor was also trying to empower their connections with the local administration, aiming to promote an increasing cultural development of the province and hoping for notoriety in the Metrópole.

By presenting his defence of *Imbondeiro* as an Angolan literary movement, the writer and editor underlined the strength of the editorial programme: for the first time, he stated, Angolan authors were published on a large scale, with a large diffusion in Angola and the Metrópole, whilst the organisation of the project could bring beneficial impact to Angolan literature (Furtado, 2005).

469

Imbondeiro aimed at (always in Cosme's words) dealing with the cultural dissemination, without any discomfort or constraints due to ideological bonds and without questioning the race or colour of its writers, "com a intenção de divulger valores sem lhes perguntar a identidade"[6]. These assertions thus seem to strengthen the idea that *Imbondeiro* tried to escape any ideological or political compromise, not disavowing from disseminating books or works that were representing any clear "values". They were aware that it was impossible to run away from the central questions of the Angolan life: the presence of the Portuguese in Angola, the conditions of the indigenous people, the policies of assimilation and the cultural differences.

The explicit mention to the lack of questioning over "identity" *lato sensu* also reflects an effort of critical distance from both the negritudinist movements (from which it was excluded because of the ethnicity of its authors) and the movements that used the political activism as a flag.

Concerning the 68 short stories that were published in the collection edited by *Imbondeiro* between 1960 and 1964, their heterogeneous content and origin were in line with the dubious political stance of their editors. Aggregated by the powerful symbol of baobab, literary production from all over the Portuguese-speaking world was reunited as representative of the Angolan production. In this particular case, we should consider the editorial project as a whole, as the project itself has both a literary and political meaning. The choice of identifying as "Angolan" the production of writers coming from Angola, Brasil, Cape Verde, but also Portugal and Alentejo (see the series "Seis contistas alentejanos") is relevant and aims to have its own meaning. Edições *Imbondeiro* is one of the cases in which, in order to try to escape both the censorship and some political debates considered problematic, the editors decided to – somehow – hide behind their collection. Cosme and De Andrade tried in different ways to be as silent as possible, while short stories like "Filha de Branco" by Lília da Fonseca, "As calças" by Carlos Sanches, or "Cigarros Sujos", by Henrique Abranches would carry a strong and clear political message. Thinking about the last case, the claim for dignity and equal treatment from an Angolan worker refusing a cigarette his white *capataz* would give him if he had begged for it is constructed by Abranches with high loyalty to the feelings of the exploited man. By publishing this short story, the editors in Sá da Bandeira could take position through literary creation and without having to speak for themselves. What makes the very case of *Imbondeiro* more complex and problematic is the inclusion of some texts that matched the colonial production and that were collaborating in the consolidation of the myth of the civilizational mission of Portugal in Africa. We can take as an example,

"Amor por correspondência ou "O prestígio das letras pátrias" by Joaquim Paço d'Arcos. A young Angolan girl, in the colonial society, spends her time dreaming of becoming a poet and of visiting the *Metrópole*. She starts by writing letters to the correspondent of a journal in Lisbon she falls in love with. Even if the short story will end with a big disillusion for the young girl, already in Lisbon, the impression the short story has on the reader is that some aspirations, like poetry writing, could not be easily accomplished in a place like Angola. Only Lisbon might be the only possible stage for such aspirations and romantic dreams on the part of a young white woman.

Soon after Cosme's declaration on the literary project, he was leading with Garibaldino, C.E.I. responded. Under the title "Imbondeiro, Mensagem, Cultura e a Colecção de Autores Ultramarinos", an apocryphal article defined and clarified once again the opposition to *Imbondeiro* for what concerned its general orientation, practices and objectives. Thanks to the book *Estudos sobre literaturas africanas das nações de língua portuguesa*, we now know the author of the essay was Alfredo Margarido.

Defending himself from the accusation moved by Cosme of "saudosismo", nostalgia, of the movement of the Angolan *Mensagem* and *Cultura*, the author defines the movement as the first form of awareness "that was born in Angola in the last fifty years", that aimed to discover Angola against foreign values that had nothing to do with "the Angolan humanity".

The differences between C.E.I. and *Imbondeiro* are underlined in a harsh tone. The editor of Sá da Bandeira is accused of relying on "série de lugares comuns falhos da realidade[7]" as he was accusing *Mensagem*, *Cultura* and the *Colecção de Autores Ultramarinos* of focusing mostly on a sociological framework rather than on a creative, humanistic approach.

Convinced of the need of condemnation of *Imbondeiro's* politic of inclusion of authors who had nothing to do with Angola, like Paço d'Arcos, Cândido da Velha e Eduardo Teófilo, Margarido concludes that the two publications, despite having the same purpose, showed deep divergences in what concerns the achievement of their particular goals. While *Mensagem* refused the "purely literary", *Imbondeiro* stated its main aspiration was to be a big repository of ideas, a co-op of writers more than a collective publication. They aimed to bypass the political affiliation and the identification with the opposition already haunting the publishing house because of the fame of Cosme in the province. All the moral, social and political responsibilities were transferred to the contents of the works and their authors:

> Não, senhores, IMBONDEIRO não está divorciado das realidades angolanas, do homem angolano. Mas IMBONDEIRO é apenas um movimento editorial

6. "with the intention of spreading values without asking them for their identity."

7. "a series of commonplaces flawed from reality."

angolano – e é angolano porque atendeu a manifestações de cultura angolana (cultura que se processa em Angola, mas podendo ser semelhante à que se processa em Paris), seja ela meramente parnasiana, seja activista. IMBONDEIRO só deseja ser uma cooperativa de escritores e nunca – mais modestamente do que a C.E.I. – uma consciência. Não discute, portanto, o que convém ao homem angolano. Os seus autores sim; a máquina editorial, não.[8] (Cosme, 1978, p. 46)

The position Cosme decided to turn explicit, besides its lack of correspondence to a *posteriori* narration and reconstruction of the facts as he did in books and articles, ended up excluding *Imbondeiro* from the Angolan literary canon. This was based on the refusal of the editors of associating to their literary project an ideological and political project, of explicit activism. This very project was deeply rooted in the idea of reconstruction of an anti-fascist Angolan nation, free from Portuguese colonialism. The lack of an active and interventionist attitude of the editors with regards to the political situation of the territory led to their progressive oblivion and partial neglect after the Independence of Angola in 1975.

3 LINEARITY, MIMICRY AND AMBIVALENCES: THE BORDERS OF CREATIVITY

Another – founded – criticism was brought forward to the *Imbondeiro* project and then widely replicated in anthologies and critical essays of the '70s and '80s (by Carlos Ervedosa and José Carlos Venâncio, in particular): it was about the inclusion of non-Angolan writers in its *corpus*. Referring to the relevant Angolan literary movements of the 1960s, defined by Venâncio (1987) as "um período quase silenciado", that is, a nearly silenced period, *Imbondeiro* is the only mentioned initiative apart from *Mensagem*. The author underlines the lack of an ideological orientation and the fact they also published the work of writers that weren't Angolan natives, but he enhances their contribution to the "cause of angolanity".

Considering this and other statements about *Imbondeiro* implies a deep reflection about the critical space that opened (or not) to a real questioning of the purposes, of the theoretical and methodological contradictions of this project. Whether we share the view of the editors or not, *Imbondeiro* published, disseminated

and publicised the work of many established Angolan writers. Most, but not all of them, had already been published by C.E.I., but were still benefitting from the promotion and distribution of one more editorial project. *Imbondeiro* had a wide distribution network, not just in Angola, but also in several Portuguese cities, where *Colecção Imbondeiro* was printed, as well as in Cape Verde, Brasil, Mozambique.

One may consider the editorial choices in *Imbondeiro* arguable, and they do not even comply with the "Propósitos" expressed in its first volume. It is, however, relevant to revisit the issue as to understand the social and cultural dynamics that engaged colonial society and that had a clear reflection on literary production.

Mensagem and the Cultural Section of C.E.I, on the other hand, were in general deeply convinced of the need to create a militant literature that could actively and publicly support the nationalists' struggles in Africa. This commitment was responsible – together with the undeniable literary quality of the poems, short stories and essays published in the journal – for the popularity of the journal. It led, on the other side, to increased attention and repression by the political police and it eventually culminated in the closure of C.E.I. in 1965.

Both journals were forced to interrupt their literary activities, but their literary archive kept on circulating, demonstrating that the imagination and artistic depiction of nationalist aspirations though repressed by the regime, kept an enduring place and historical relevance.

ACKNOWLEDGEMENT

This chapter had the support of CHAM (NOVA FCSH/UAc), through the strategic project sponsored by FCT (UID/HIS/04666/2019)

BIBLIOGRAPHICAL REFERENCES

ANTT/PT/PIDE/ DGS SC CI (2) PROC. 4134 NT 7323.
AAVV. (1960). *Mensagem*, 3/4. Lisboa: CEI.
AA.VV.(2015). *Mensagem*. Casa dos Estudantes do Império, 1944–1994, Lisboa: UCCLA.
Cosme, L. (1979). *Cultura e revolução em Angola*. Porto: Afrontamento.
_____. (2015). "Recordar é viver": Memórias de Imbondeiro e Luuanda, in *Cultura, Jornal Angolano de Artes e Letras*, 19 de Janeiro de 2015. Retrieved from http://jornalcultura.sapo.ao/letras/recordar-e-viver-memorias-de-imbondeiro-e-luuanda/fotos
Ervedosa, C. (1985). A década de 50. O movimento dos novos intelectuais de Angola. Mensagem e Cultura. In *Roteiro da Literatura Angolana*. Luanda: UAE.
_____. (1979). Roteiro da Literatura Angolana, Luanda: União dos Escritores Angolanos.
Mata, I. (2015). A Casa dos Estudantes do Império e o lugar da literatura na consciencialização política. Lisboa: UCCLA.

8. "No, Sirs, IMBONDEIRO is not divorced from the Angolan realities, from the Angolan man. But IMBONDEIRO is just an Angolan editorial movement – and it is Angolan because it attended manifestations of the Angolan culture (culture processed in Angola, but that could be similar to the one processed in Paris), whether it's merely Parnassian, or activist. IMBONDEIRO just desires to be a co-op of writers and never – more modestly than C.E.I. – a conscience. It doesn't discuss, therefore, what suits the Angolan man. Its authors do, the editorial machine doesn't."

Medeiros, T. (1960). *Conversando com Carlos Ervedosa.* Lisboa: Casa dos Estudantes do Império.

Moser, G. (1966). Portuguese Literature in Recent Years (1962–1965). In *The Modern Language Journal*, 50 (7). pp. 483-492

Martinho, A. M. (2015). Reflexões em torno dos contributos literários na Mensagem da Casa dos Estudantes do Império. In *Mensagem. Casa dos Estudantes do Império, 1944–1994*. Lisboa: UCCLA.

Prévost, C. (1976). Literatura, política, ideologia. Lisboa: Moraes editores.

Venâncio, J. C. (1987). Uma perspectiva etnológica da literatura angolana. Lisboa: Ulmeiro.

(1962, Feb). *Notícias de Imbondeiro*, 29. Sá da Bandeira: Imbondeiro.

(1962, Aug). *Notícias de Imbondeiro*, 35/36. Sá da Bandeira: Imbondeiro.

(1962, Nov.), *Notícias de Imbondeiro*, 39. Sá da Bandeira: Imbondeiro.

Creativity and innovation in *Cante* from the *Estado Novo* to the present

Eduardo M. Raposo
CHAM, FCSH, Universidade NOVA de Lisboa, Lisbon, Portugal
ORCID: 0000-0001-6677-6619

ABSTRACT: As we covered through *Cante alentejano* throughout the 20th century to the present day, we intend to identify its practices and roles in different historical periods, verifying its adaptability and capacity to recreate and innovate over time. We also intend to verify, in its relationship with the power, how *Cante* was able to review itself in these historical moments and how this contributed to its dissemination and also to be recognised as Intangible Heritage by UNESCO and what were the consequences of this recognition. In its ability to address new realities, we also want to measure how *Cante* combines in experimental projects with other musical expressions and how important the teaching of *Cante* is in the classroom for its protection.

Keywords: *Cante*, *Alentejo*, creativity, innovation

1 INTRODUCTION

Cante alentejano is traditionally associated with the sub-region of Baixo Alentejo, where the vast plains predominate and which is delimited to the north by Serra de Portel, the east by Spain, the west by the Atlantic Ocean and has as southern limit the mountains of the Algarve.

The north-lying sub-region, Alto Alentejo, administratively composed of Central Alentejo and North Alentejo, stretches north to the banks of the Tagus River. All of these form the Alentejo region.

Nowadays we have verified the existence of Alentejo choral groups throughout the region, as well as in other parts of the country – Lisbon Metropolitan Area, and less expressively in the Algarve, Ribatejo or Porto – and in foreign cities such as Toronto, Luxembourg or Paris, mainly where there are vast communities of Portuguese people (and their descendants) who were born in Alentejo region.

It is the outcome of a dynamic process that has enabled the emergence of choral groups that accompanied the various migratory generations throughout the twentieth century. These groups, both in the Alentejo and in the diaspora, with innovation and creativity, sought to express their yearnings and the marks of their time, not forgetting the repertoire inscribed in the Traditional Songbook.

The process of innovation of *Cante* is still present in its origin region, Baixo Alentejo, with the proliferation of youth groups, after 2014, with the recognition of *Cante alentejano* as an Intangible Cultural Heritage of Humanity by UNESCO, as well as through the teaching of *Cante* in the school, a process of protection that started in 2007, but that spread mainly after 2014.

There are also experimental projects, not only in Alentejo, where the *Cante* appears associated with genres of popular and classical music, as well as other performing arts.

After contextualising diachronically, we delimited four periods of *cante* evolution: during the Estado Novo (1928-1974); after 1974; the foundation of MODA – *Cante* Alentejano's Association, in 2000; and after 2014.

We will try to understand how *Cante* proved to have the ability to innovate while walking the paths of diaspora, both in the past and today, as well as reflecting the revolutionary period, in particular, the *Reforma Agrária* [Agricola Reformation], and still today in the context of the diaspora.

We have been methodologically taking advantage of works published in different periods, from the eighties to 2018, by renowned academics on the subject, as well as documents prepared for the application to the World Heritage. We also carried out an inquiry directed to a restricted universe of master rehearses, trainers, musicians and singers paying attention to the meaning and the option for *Cante*, the Songbook and the emergence of new themes or the connection between the protection and the intersection of *Cante* with other musical expressions.

2 CONTEXT AND CHARACTERISTICS

Regarding the characteristics of *Cante*, we find the use of Ponto, Alto and *Moda*. Ponto is the solo voice that begins to sing, usually between "DO" and "MI". The Alto is the solo voice that follows the Ponto, in a sharper tone, usually a third above. Finally, the

MODA is sung in chorus by the third voices, be it spontaneously in taverns or presented on stage or in contests.

"*Majestosos corais alentejanos*", ("Majestic *Alentejo* chorals"), a definition proposed the '50s by the priest António Marvão (1903-1993) (considered one of the pioneers of the study of *Cante*), is what we now call the choral groups of *Cante*.

In the middle of the XX century, this polyphonic vocal expression of oral tradition sang by amateur choruses without any musical instruments was practically delimited to the Baixo Alentejo region.

There was the successful creation of a choral group in Lisbon, in the 1950s, under the guidance of the *Casa do Alentejo*, a regional association based in the capital since 1923, (Vieira, 2005, pp. 158-159). Also, in Luanda, Angola, there is news of organised groups during the '60s (Lima, 2012, p. 73).

Though formal recognition only happened in the early twentieth century, the origins of *Cante* are quite ancient. The songs, called "modas", as mentioned by J. Ranita Nazaré, had their oral dissemination for centuries. Manuel Dias Nunes states that agricultural workers exclusively sang this repertoire. "Moda" was consequently the spiritual property of the entire rural population: men, women, and children knew and sang it, as they sometimes still do.

Nazaré refers that the poor and suffering people, spend their entire life 'moirejar' (working on the land), through mountains and valleys, regardless of weather conditions, finding in the choral songs a sweetness to balance the rudeness of the *labour* that subjugates them from the cradle to the grave (1987, pp. 30-31).

The theme of work, alongside those of nature and love, has always been present in *Cante alentejano*. The *Cancioneiro de Serpa*, collected by Maria Rita Ortigão Pinto Cortez between 1983 and 1987 (1994) includes at least nine *modas*, two of them that also constitute social criticism. On the other hand, the ethnomusicologist Salwa Castelo-Branco e Paulo Lima (2018, p. 20) refer to the lack of any songs of work or revolt, statement that a reading of the *Cancioneiro* (songbook) contradicts.

3 CANTE DURING THE ESTADO NOVO

The Estado Novo inherited the military dictatorship established in 1926 and consolidated it, lasting until 1974. During this period *Cante Alentejano* was elected by the regime as one of the most representative practices of the *Alentejo* region, being the target of folklore and object of promotion by institutions such as the National Propaganda Secretariat (SPN) and the National Federation of Work and Joy (FNAT) (Moniz, 2015, p. 56).

This (attempt) to use *Cante* was not an act of kindness and promotion *de per se*. Rather the projection of Cante along with other practices may have been due to an attempt to eliminate the wish of other popular expressive practices of social and/or political criticism challenging control by censorship, but also an action developed by the mediators in the service of the regime, who have contributed significantly to make *Cante* a regional stereotype (Moniz, 2015, p. 56).

This proves that *Cante*, during the Estado Novo, was not persecuted, but instead instrumentalised, because if, on the one hand, its practice as a formal presentation could be controlled – through previous (self) censored if necessary – on the other hand, their rural characteristics appealed to the ideological objective inculcated by the regime: the valorization of the rural heritage; of the traditional family, although to a lesser extent; and of Catholicism[1].

The regulation of the rural heritage was used as a way of fighting against an urban culture, politically more active, that was opposed to the nationalist, ruralist, family, village vision, lacking wealth that characterised the Estado Novo (Moniz, Jorge, 2015, p. 56). It is proved that ethnography and folklore were used for ideological, political and propagandistic purposes.

Popular associations, such as FNAT, *Casas do Povo, Centros de Alegria no Trabalho,* were strongly restricted and controlled by the regime's organisations. Nevertheless, they played an essential role in increasing people awareness of the country's reality during the 1960s, until the fall of the dictatorship. If in the urban areas it was the *Canção de Intervenção* [Politically engaged songs] that had a leading role in the political awareness, in the rural areas, *Cante* will also play, in a way, this role.

In any case, by reinforcing and building an identity in *Cante*, the Estado Novo ends up contributing to the reinforcement of *Cante* as a cultural weapon (Moniz, 2015, p. 56)

Limited to the narrower and more enlightened circles of society generally without opinion – intellectuals, students, political activists and trade unionists – the "canção de intervenção" existed and played a part in a repressed society: they pinched power. This happened not only due to explicit content reasons but also, and above all because they covered an anti-regime involvement and represented an appeal to values that Salazarism had wanted to take away from Portuguese society: intelligence, reason, solidarity (Raposo, 2007, p. 7).

1. During Christmas, there is an ancient Portuguese tradition of, from the 1st of January to the Epiphany (January 6th), small group of singers join to sing the janeiras [Januaries]. With musical instruments or not, they walk through the villages streets, stopping in front of the houses and sing traditional songs, mostly with religious themes. Their payment by the house owners, called the janeiras, consisted traditionally of chestnuts, apples spicy sausages and black pudding. The groups have special insulting stanzas for those who ignore them and do not give the janeiras. In the end of the evening, the group divide what they have collected among themselves.

4 THE CASE OF PIAS

Pias, in the municipality of Serpa, is a reference in opposition to Salazarism, considered as a "fortified" region against the dictatorship in Alentejo, where the opposition and especially the Communist Party (the only organised party) gained considerable popular support, a place where the Regime did not use *Cante*.

The Democratic Opposition in the Baixo Alentejo, Beja District, in 1969, began significantly in Pias, demonstrating its importance in opposition to the regime. According to scholar and the writer Urbano Tavares Rodrigues, candidate for the Democratic Opposition in Beja District, there was a radicalisation of the political attitude as the younger layers of the population felt victimised by the maintenance of the war (Mira, 2017, p. 41).

The village of Pias had, in 1968, two bands, two groups of amateur theatre and two popular Associations, which allowed to feed the social protest in "low voice" and give political support to the opposition to Estado Novo. However, it was in the taverns where people met regularly, talked, ate, drank and dreamed (Mira, 2017, p. 39).

According to Mira, in Pias, there were 12 taverns, partly because of the wine-making propensity of the land. They were the sacred place for all to speak. Taverns were designated by chapels, in slang, because they were places for the confession of sorrow for some, after a few glasses, and of hope, for others[2]. However, these taverns were regularly visited by GNR and PIDE informants spotted by members of the Portuguese Communist Party. Their presence required songs to be controlled song for not all themes could be sung at certain hours and days and with assumed risks. However, of the people from the land, there was no need to be afraid.

The themes, although more restraint when dealing with social conflicts, colonial war or the causes of the emigration, appear in *modas* (Mira, 2017, p. 40), like the following examples that became traditional:
a) About the need for emigration in search of better living conditions

Quando eu cheguei ao Barreiro
No barco que atravessa o Tejo
Chora por mim que eu choro por ti
Já deixei o Alentejo. [...][3]

Algum dia em tendo sede
Ia beber ao teu monte
Agora estou mal contigo
Vou beber a outra fonte.
Meu Alentejo ditoso

Sou obrigado a deixar-te
com as lágrimas nos olhos [...][4]

Though the tavern was the birthplace of *cante* – with men standing by the counter making a *moda,* with the countertenor and the bass in the middle of the group (Mestre, 2014), *Cante* about work or love is also sang by male and female groups while working in the fields.

5 AFTER 25 APRIL 1974

With the socio-political changes brought by the democratic regime, *Cante* spreads a lot. In 1974 there were 20 Alentejo choral groups, but the number grew to 73 groups in 1998. It is an increase of 53 groups, showing the increase of traditional music groups throughout the country, especially in the first ten years after the revolution (Moniz, 2015, p. 56).

Of the total of *Alentejo* choral groups, 46,3% are based in predominantly urban areas, which points to a relocation of the *Cante*, regarding its origin (Moniz, 2015, p. 56). However, this growth was not confined to the Diaspora, although there was an effective growth in the industrial area of Lisbon and Setúbal, an outcome of the migratory process during the 1960s. The growth is also registered in Alentejo urban centres.

In a first moment, we find themes of social criticism or apologetics, in the context of the Reforma Agrária (Agriculture Reform) and the revolutionary period, giving *Cante* a musical and literary expression of political intervention, with texts with explicitly content sung introduced in the repertoire of melodies that integrate the canon of *Cante*.

Topics such as *Baleizão* by the Grupo Coral do Sindicato dos Operários de Aljustrel [Choral Group of the Workers' Union of Aljustrel]; "A Reforma Agrária é o que mais invejo" by Grupo Coral União Alentejana, Baixa da Banheira; or "Ó Cidade do Barreiro" by the Grupo Coral Alentejano Amigos do Barreiro. This last group was the first to set interesting examples of *Modas* with a political nature, where resistance, intervention, and the vindictive character are evident, shaping *Cante*'s political engagement (Castelo-Branco and Lima, 2018, p. 75) thus creatively adapting *Cante* to this historical moment.

In this period it will be the Local Power, that emerges with the establishment of democracy, which will be the leading supporter of *Cante*. The Town Councils assume the *Cante* as the identity paradigm of the Alentejo (Moniz, 2015, p. 57) and will have a decisive role in its support, be it financial, logistical or bureaucratic (Raposo, 2015, p. 20).

Casa do Alentejo, Association of people from Alentejo, based in Lisbon, in the former Alverca Palace,

2. For a short example of singing cante in a tavern after 1974, see: https://www.youtube.com/watch?v=GBhgE3EMQy4. There is also a documentary on cante available at https://www.youtube.com/watch?v=vovwTO36xp4
3. "When I arrived at Barreiro/on the boat that crosses the Tagus,/Cry for me as I cry for you,/I've left Alentejo."

4. "When I was thirsty/ I went to you farm./Now I can't live with you/I must drink in another fountain/My joyful Alentejo I must leave you,/with tears in my eyes." Soundtrack available here: https://www.youtube.com/watch?v=vovwTO36xp4.

also contributed to the agglutination, in the 80s, organising large gatherings and parades and making its rooms regularly available, enabling an expansion stage for the emergence of new groups. By then, there were already more than two dozen active groups in the Lisbon Metropolitan Area and Setubal (Teixeira, 2015, p. 59). The beautiful Arabic Courtyard of the Casa do Alentejo became a paradigmatic place, where the choral groups either from the diaspora or from the Alentejo always registered their presence and performances.

6 THE CANTE CONGRESS AND THE CREATION OF *MODA*

At the end of the '80s, political *modas* fell into disuse, while traditional ones, inscribed in the traditional *Cancioneiro*, are progressively recovered (Castelo-Branco and Lima, 2018, p. 76). In the 90s, we register an ageing of the *Cante* and a weaker ability for attracting younger people. This led to the organisation of the 1st – and only – Congress of *Cante*, in Beja, in 1997.

An intense debate led to the conclusion of the need for renovation and revival of the *Cante*, competing for its ennoblement, valorisation, promotion and protection.

Two aspects stood out: the teaching of *Cante* and the creation of a federation of Alentejo folklore. The second led to the creation, in 2000, of MODA – *Cante Alentejano* Association, congregating a large part of the 110 to 120 groups then active. MODA became a forum for debate and action to the renovation, ennoblement and protection of *Cante*. On the other hand, the project "*Cante* nas escolas" [Cante in the Schools] starts in Almodôvar primary schools, in 2007.

As Raposo stresses, the aim is to awaken the taste for the *Cante*, to value and to make known the culture and the traditions of the Alentejo and above all, to motivate the new generations for the preservation of traditional music. It is intended to form not only voices for *Cante* but also new audiences for what is the *ex-libris* of the region and a landmark as cultural heritage (2015, p. 68)

Although there have previously been occasional experiences, from which some more consistent or ephemeral projects have arisen[5], 2007 marks the beginning of a structured work, of the teaching of *Cante* in the classroom, with the use of formal and informal methods, which were later followed in Castro Verde, Serpa, and Beja, and is currently widespread throughout the Lower Alentejo.

This process, begun by Pedro Mestre, a young but inevitable figure of *Cante* and *Viola Campaniça*[6], is

now practised by other musicians and trainers such as Paulo Ribeiro, David Pereira, Paulo Colaço and Paulo Bicho, the latter in Almada, where the systematic teaching in the classroom started in 2017.

Almada, in Lisbon metropolitan area, has currently eight classes and is the only sustained project of *Cante's* taught in the diaspora, though there are occasional experiences also in Moita, Damaia, Cascais and Palmela.

The teaching of *Cante*, involving adults and children outside the Alentejo community or even with origins in other latitudes or continents, enables *Cante's* protection, enables its innovation, widens and diversifies the audiences, as well as the re-creation of *Cante* beyond of its original locations.

7 THE PATRIMONY OF CANTE

In barely 14 years – from 1998 to 2012 – the creation of new groups in the Alentejo was exponential. When the Inventory-catalog of Groups of *Cante Alentejano* was analysed to produce the application proposal to the Representative List of the Intangible Cultural Patrimony presented to UNESCO, there were 140 groups, almost the double of those active 1998. Currently, as a consequence of the rise of *Cante* to Intangible Cultural Heritage, the existing groups around 150 to 160, being not easy to count them, especially the ones with young people, which appear to start and be inactive or end very frequently. From the 16 youth groups that emerged after 2014, about half are active now. Groups and classes of *Cante* have also appeared in the scope of Senior Universities – the case of Almada – and other institutions for the elderly.

The UNESCO approval in 2014, has contributed to the recognition of *Cante* both nationally and internationally, stimulated the interest of young people in this expressive form, leading to the creation of choral groups exclusively by young people, and encouraged their integration into some existing groups, and the formation of small groups constituted by singers and accompanied by the *viola campaniça* (Castelo-Branco and Lima, 2018, p. 13). It also reinforced the realisation of experimental projects, where *Cante* crosses with other genres of popular and erudite music, as well as other performative arts (dance, theatre). *Cante* won the possibility to evolve creatively, without losing its main characteristics, by finding new and complementary means of expression.

Nowadays, listening to Almada most important group – the "Friends and Ethnographic Group of the Feijo Alentejo" – one finds an innovated repertoire that introduced themes as *Cante* as World Heritage, the

5. As in the case of the Choral and Ethnographic Group Carapinhas de Castro Verde, or the Choral Children Group the Rouxinóis, from Beja.
6. The Viola Campaniça, literaly "viola from the countryside", is a 10 metal string viola used in Southern Alentejo,

mainly in the left bank of river Guadiana. Its peculiar sound is determined by the way strings are arranged in five pairs of strings, by the way they are tunned and for being played mainly with the thumb.

experiences of the great community of 50,000 inhabitants with familiar ties in Alentejo, or the construction of the long-awaited Alqueva dam, with its promise of having a lake that would put an end to the endemic need of water in southern Alentejo.

On the other hand, we have identified musicians and groups that have crossed different genres and musical styles incorporating and reinventing *Cante*.

8 FINAL NOTES

We verified that throughout the historical periods in analysis, *Cante alentejano* could innovate and to self-re-create thematically.

Although with the traditional *Cancioneiro* always present and in the background, it evolved in time giving expression to what the population felt, thought, their physical and political needs, their anxieties, and so forth. It also was and keeps being a means to express joy, love and above all the deep sense of belonging to a specific territory, to a specific culture, to a shared heritage.

Assuming itself as a significant brand of Alentejo's identity, *Cante*, instrumented by the Estado Novo, knew how to be a focus of resistance in the informality of the taverns in the dictatorship and apologetic cry of the conquest of the dignity of the humble rural workers with the end of the agricultural exploitation.

Being nature, nostalgia, love and work structuring themes, however, the claiming and denouncing posture of the will of the powerful also marks *Cante* thematic, be it the profound social exploration during the dictatorship, or the post-revolution period, with situations of repression to the participants in Agrarian Reform.

The teaching of *Cante,* broadening and diversifying its public, is a substantial contribution for the safeguarding of *Cante alentejano*. Participation in experimental projects with other musical expressions and performing arts seems to play an essential role in the dissemination and evolution of *Cante alentejano*.

The appointment as World Heritage, made possible the recognition of *Cante* nationally and internationally, dignifying it, stimulated the interest of young people leading to the creation of youth choral groups. Another consequence is the internationalisation of the *Cante,* revitalising of choral groups in America and Europe, or emerging new ones such as the *Rancho dos Cantadores de Paris*, a mixed group of French, exemplifying the spread of *Cante* on a world scale.

ACKNOWLEDGEMENT

This chapter had the support of CHAM (NOVA FCSH/UAc), through the strategic project sponsored by FCT (UID/HIS/04666/2019).

BIBLIOGRAPHICAL REFERENCES

Castelo-Branco, S. & Lima, P. (2018). *Cante Alentejano Patrimónío Cultural da Humanidade. Cantes* (Vols. 1–4). Lisboa: A Bela e o Monstro, Edições/Público Comunicação Social SA.

Cortez, Maria Rita Ortigão Pinto. (1994). *Cancioneiro de Serpa*. Serpa: Camara Municipal de Serpa.

Lima, P. (2012) Inventário-catálogo dos Grupos de Cante Alentejano. Documento de Trabalho para a Proposta de Candidatura do Cante Alentejano à Lista Representativa do Património Cultural da Humanidade, a Apresentar à UNESCO. 2012. Janeiro. https://www.luardameianoite.pt/cante/cantealentejano%20inventariogrupos.pdf.

Mira, F. de. (ed). (2017). O Cante à Moda de Pias – Grupo Coral e Etnográfico os Camponeses de Pias. Coimbra: Terra Ocre edições.

Moniz, J. (2015). Cante e Diáspora. Do Estado Novo à Actualidade. *Memória Alentejana,* (35/36),55-57.

Nazaré, F. de. (coord.). (1979). *Música tradicional portuguesa – Cantares do Baixo Alentejo*. Lisboa: Instituto de Cultura Portuguesa.

Raposo, E. M. (2015). Canto de Intervenção 1960-1974. (3a ed.) Lisboa: *Público*, Comunicação Social, SA.

_____. (2015). Pedro Mestre. Os mais jovens são a força motriz capaz de garantir o future do Cante. *Memória Alentejana,* (35/36),66-70.

_____. (2015). Joaquim Afonso A salvaguarda do Cante passa pelo rigor, pela paixão, pelo trabalho de base com os jovens, está na alma dos cantadores. *Memória Alentejana*, (35/36), 18–21.

Raposo, Eduardo M. & Neto, Ana Pereira. (In Press). "Cante Intangible Cultural Heritage of Humanity: representation of traditional art in the city of Almada." In *AMPS Proceedings Series Tangible – Intangible Heritage(s)Design, Social and Cultural Critiques on the Past, Present and the Future*. The University of West of London, London, UK. 13–15 June (2018).

Teixeira, F. L. (2015). O Cante Alentejano, Património Vivo do Alentejo. *Memória Alentejana*, (35/36), 58–61.

Vieira, R. R. (205). O Associativismo Alentejano na Cidade de Lisboa no Séc. XX. Lisboa: Edições Colibri/Casa do Alentejo.

From rap to literature: Creativity as a strategy of resistance in Portugal through the works by Telma Tvon

Federica Lupati

CHAM, FCSH, Universidade NOVA de Lisboa, Lisbon, Portugal
ORCID: 0000-0001-7522-3389

ABSTRACT: The present work discusses rap and literature as a means of cultural resistance in postcolonial Portugal. I argue that, especially in the hands of Black women, these two different practices can become compelling platforms against different forms of power exploitation. In order to do this, I examine two works by rapper and writer Telma TVon: the album *Finalmente* (Dreamflow Records, 2005), recorded with soul singer and MC Geny under the name of Lweji, and her first novel, the recently-published *Um preto muito português* (Chiado Editora, 2018). In both works, creativity is cleverly handled to convey messages of revolt and resistance against racial and gender prejudice, social inequalities and injustice in its many different forms.

Keywords: female rappers; women writers; creativity; resistance; Portugal.

1 INTRODUCTION

I had the opportunity and pleasure of meeting former (or "retired", as she would say) rapper Telma TVon in 2017 on the occasion of an event I co-organised in Coimbra, with CES – Centro de Estudos Sociais (RAPensar as Ciências Sociais e a Política – Teatro da Cerca de São Bernardo, July 5-6, 2017) and within the framework of my research on Portuguese female rappers.[1] Telma was invited to the event and was part of the panel I coordinated, "Não vou cumprir com a p*ta da expectativa: o Feminismo e o Rap", representing the second-wave of female voices who were taking part in the practice of rap made in Portugal.[2] Later, in order to help me with my research, Telma was generous enough to agree that I recorded our conversation about her experience as a rapper during the early and mid-2000s in Portugal. Our conversation took place in Lisbon on September 28, 2017. During our informal chat, Telma mentioned her deep love of writing from an early age. As she told me:

> I have always loved writing. Since I was a child, I enjoyed writing, creating poems and a lot of letters [...]. Writing has always been everything to me (TVon, personal communication, September 2017).[3]

Together with her passion and urge to write, Telma always showed great awareness of the social, cultural and political struggle of living in Portugal as a Black woman. This appears in her works as a rapper, which often are built around themes such as racism, gender inequalities and women's empowerment, as well as people coming together against power's exploitation. It is unmistakable in her first work as a writer: Chiado Editora released a few months after our conversation, more precisely on February 10, 2018, Telma's *Um preto muito português* [A very Portuguese nigger].[4]

1. Born in Luanda, Angola, as Telma Marlise Escórcio da Silva, Telma then moved to Portugal with her Family, who settled in Queluz, Lisbon. Her career in rap started with the group Backwordz (1996-2000), to continue with Hardcore Click, comprised of all the female MCs who were active in Lisbon between 2000 and 2002 With them and Dj Cruzfader, she recorded the album RAParigas na Voz do Soul (Riso Records, 2001). Finally, with soul singer and MC Geny she funded the group Lweji, who were active approximatively until 2008. She published her first novel in 2018. Her name both as a rapper and a writer is Telma TVon. Therefore, I refer to her as Telma or just TVon, avoiding the use of her family name.
2. According to my research, I consider that the practice of rap made by women in Portugal has seen three main waves. The first one covers approximately the years between 1990 and 1998 with the groups Djamal and Divine; the second wave corresponds to the early and mid-2000s with the participation of a greater number of women (Telma TVon, Dama Bete, Blaya, Capicua and M7, Eva Rap Diva and Red Chikas), while the third wave can be identified with the present times where we can witness the growth of the career of artists such as Capicua, Blaya and Eva Rap Diva, and the appearance of a large number of new ones: W Magic, Blink, A.m.o.r., Da Chick, Lady N., Mynda Guevara, Muleka XIII, Joana na Rap, Mary M., and RUSSA.
3. The conversation took place in Portuguese. All translations are mine unless otherwise mentioned.
4. The English version of the title is my translation. I chose to use the word "niggar" in order to offer a better perception to non-Portuguese speakers of the term "preto" [black]

The novel, which was born from what initially was meant to be a lyric for a rap song, refers to the life experiences of João, best known as Budjurra, a son of Cape Verdeans living in Lisbon. The numerous episodes of injustice experienced by the protagonist for being a "pretoguês", a "preto" and the word "português" meaning a Black Portuguese, triggered what the author refers to as the "need to get these things off my chest" (TVon 2018: 182) – a "desabafo", in Portuguese – resulting in the book in analysis.

Hence, taking into consideration studies by Hall (1975), Hebdige (1979), Forman & Neal (2004), Contador (2001), Simões (2017), among others, in the present work I aim at discussing both rap and literature as creative strategies of resistance and emancipation for Black voices living in a postcolonial country. In order to do that, in the first part of this work I take a closer look into TVon's contributions as a rapper, with particular attention to the album *Finalmente* (Dreamflow, 2005). In the second part I am focusing on Telma's novel: being intimately connected to rap in terms of narrative strategies and content, I establish that it exposes racism as an endemic, yet painful, component of today's Portuguese society from the point of view of a young, Black citizen.

2 FROM RAP

Telma's need to creatively communicate showed up at quite a young age. Despite what one may think, what led her to join her first rap group – a group of four young MCs called Backwordz – was not her "flow" but her writing skills.[5] Having joined the group around 1996 when still in high school, during our conversation Telma explained how the four MCs created their songs by cooperating in the writing process while sharing a deep love for rap. However, despite showcasing precocious creative skills, there was quite an "absence of a collective message" (TVon, personal communication, 2017), probably due to their young age and inexperience. However, this did not deter them from sharing the same concerns and needs, managing to stay united despite the tensions experienced when they performed

in a male-dominated context: that of rap. In this perspective, I consider the choice of rap itself not only a response to a creative urge, that of writing, but also a strategy of emancipation and resistance: emancipation against the stigmatisation of women as subordinate actors and resistance to the oppression experienced by Black citizens during their everyday life in Portugal. As a matter of fact, in Portugal, ideologies in line with the colonial narrative – in other words, those of Lusotropicalism and racial prejudice – persist relentlessly: on the one hand the country is often depicted as "a non-racist – and, in fact, anti-racist – society that overwhelmingly accepts diversity and hybridity" (Buettner 2016: 404), while on the other hand its non-white citizens still experience discrimination as well as social, cultural and economic struggles on a daily base.[6]

As many scholars have already pointed out (Rose 1994; Bennett 2001; Kitwana 2002; Price 2006) despite its first appearance as a party-oriented practice, rap soon evolved into a strategy of resistance against a condition of oppression and segregation experienced by young African-Americans and Latinos living in the margins of the cultural, economic and political capital, terms I borrow from Pierre Bourdieu. Thus, what can be considered young subalterns (Gramsci 1978; Said 1978; Spivak 1993) found their means of expression and protest through the creative process of combining rhythm and poetry. Rap continues to allow young people to express their dissatisfaction, and its longevity and global spread expose the extent to which the social condition of marginalisation is experienced worldwide (Bennett 2001: 189). In fact,

> as a distinct element of hip-hop culture, it is the aesthetic bridge to a reaffirmed free speech. The form and its adherents engender conversation of resistance, spoken in the vernacular of young urban people (Chang 2006, 16).

During my interview with Telma in September 2017, she recalled that she was already a fan of North-American rap when she lived in Angola in the 1990s – Run DMC, Public Enemy, NWA, Queen Latifah, and MC Lyte being among the artists she mentioned to me. Once in Lisbon, she soon came in contact with Portuguese rap, found herself surrounded by friends who were either MCs or soul singers. In the late 1990s, the rap movement in Portugal was still about "union, unity, and community, about cultural issues and friends" (TVon, personal communication, 2017), sharing the

when referred to non-white people. In Portuguese, "preto" is considered offensive and politically incorrect, as well as openly racist, while "negro" is commonly accepted as a less harmful term. Despite the fact that the English term "nigger" is probably more offensive and charged with meanings than the Portuguese "preto," I chose to use it my translation in the attempt to reproduce what I believe was Telma's play on the two Portuguese terms (preto/negro).

5. Backwordz consisted of four female MCs – Lady, LG, Zau and Tvon – who performed together between 1996 and 2000. They recorded in several mixtapes (by Dj Cruzfader and Bomberjack, for instance) and albums (Mc Xeg, Força Suprema, Bad Spirit, and Guardiões do Movimento Sagrado, among others).

6. With regards to this, Joana Gorjão Henriques's book, *Racismo no país dos brancos costumes* (Tinta da China, 2018), undoes the persisting myth of the 'Pais dos Brandos Costumes' [the country of gentle habits], invented during the Estado Novo. Henrique plays with the words branco/brando [white/mild], and depicts true cases of racial discrimination, complementing them with statistical data and more than 80 interviews, covering justice, housing, education and employment.

need of creating new forms of identity in the diaspora (Buettner 2016):

> United by socio-economic exclusion, limited prospects, spatial segregation, and the experience of racial discrimination in Portugal, African-descended youth born or brought up in Portugal converged across ethnic lines far more habitually than their parents, whose primary identification was more likely to be Cape Verdean, Mozambican, Angolan, or another country of origin (Buttner 2016, 408).

Hence, rap offered the Portuguese youth language they could identify with, as a means to protest against stigmas, racism and social rejection while affirming their pride in their ethnic heritage and cultural choices (409–410).

However, while racial discrimination and social inequality was fought both by male and female MCs, the female MCs also had to face another struggle: that of gender prejudice and machismo, inside and outside the hip hop community. As Isoke explains:

> The exercise of power and dominance over black people does not end with racist, sexist white institutions, ideologies, and practices. It also extends to sexist, misogynist, homophobic, and colonial practices internal to the black community (Isoke 2013: 22)

As regards this, during our conversation Telma enumerated that, during various live performances, the group Backwordz was often targeted with sexist and detrimental remarks such as "you should be at home doing the washing-up" or "you're not good at this," and that she happened to witness various conversations where her male peers commented that female MCs wanted to be part of rap only because they were "looking for a boyfriend." After acknowledging that female MCs tended to focus on attacking men rather than building a scene of their own, TVon began seeing rap as a potential channel of communication with and for other women, a means to empower them and encourage them to join the fight against power abuse in its various forms.

It is precisely with this intention that the project Lweji was born with MC and soul singer Geny. Their first and only album, *Finalmente* (Dreamflow Records, 2005) was created precisely to "educate men on women's issues" while being "a voice for women" (TVon, personal communication, 2017). Indeed, the record is creatively built around delicate matters such as their right to self-determination, the weight of patriarchy and domestic violence, with the intention of destigmatise women from different forms of prejudice: "we sought to make a purely feminine album that women could hear and identify with, especially those women who were stigmatised" (TVon 2017). Perfectly in line with these intentions, in the album's "Intro" (the first, short track) we can hear an excerpt of a conversation between two women where one clearly states

"honestly, I wouldn't want to have children" [sinceramente, eu não queria filhos]. As Meyers reminds us, "women who prefer not to have any children [...] are commonly reproached for selfishness or pitied for immaturity" (Meyers 2002: 30). Hence, the choice of opening the album with such strong statement is at once provocative and an act of emancipation: indeed motherhood is a very personal choice, and the right to choose being childless should be respected as any other right of self-determination. While some listeners can relate to such statement, others may feel uncomfortable; yet, the choice to open their work with such excerpt tells us a lot about where the two MCs are coming from, and where they are going with their work.

Issues related to motherhood are again evoked in the song "A dúvida" [The Doubt], where abortion is discussed by different alternating voices, each representing a different point of view: starting with the pregnant girl's doubts, fears and sorrows, the song then switches giving voice to a moralist and judgmental view about abortion, while closing with the boy's invitation to "get rid of it". The chorus, moreover, evokes the deep sense of loneliness and abandonment that accompanies the difficult decision of ending an unwanted pregnancy. By mentioning the Bible, condemning free sexual intercourse, and frequently stating that "abortion is a mistake", the two MCs seem to be subtly exposing the patriarchal, moral and cultural grid that still limits women's freedom of choice, mainly when it comes to their body.

In this sense, I agree with Durham, Cooper & Morris when they

> see hip-hop feminism as a generationally specific articulation of feminist consciousness, epistemology, and politics rooted in the pioneering work of multiple generations of black feminists based in the United States and elsewhere in the diaspora but focused on questions and issues that grow out of the aesthetic and political prerogatives of hip-hop culture (Durham, Cooper & Morris 2013: 722).

Lweji's album fits this profile: it touches women's issues while also being about compassion, unity, freedom in general. But most importantly, it is a about revolt and resistance through the art of poetry, in the shape of music, with a very clear purpose: "to not be dominated without wishing to dominate others" ("Rebeldes Com Causa", *Finalmente*, 2005). Thus, the album *Finalmente* can be seen as an attempt to create a space of engagement, "in which the impetus for radical and transformative political thought and action is sparked" (Isoke 2013: 19), in line with urban Black women's traditions. Moreover, its content and narrative features correspond to what Williams points out about female poets, since "the female voice is often aligned with revolt [...]" (Williams 2007: 176).

Using narrative strategies that are often autobiographical and highly non-metaphorical, rap embodies

a unique union between aesthetics and praxis (Shusterman 1995). Lweji's album, then, showcases rap not only as a means to express a sense of revolt against the establishment (Rebeldes com Causa; Traficantes de Ódio; Essas Facetas dos Nossos Dias), but also as a means to resist to male hegemony (Entre Elas e Eles; As Invejosas; A Dúvida). In this case, then, "resistance entails more than just arguing, 'talking back,' or even overtly aggressive acts to subvert power structures" (Isoke 2013: 21), it entails using creativity to convey social consciousness, a message of unity and empowerment against power abuse, while exposing the limits of today's postcolonial world.

3 TO LITERATURE

Some time has passed since Lweji's album was released and since the band left the stage (2008). Lweji was Telma's last 'official' project as a rapper, but not her last contribution as an artist, a thinker and a cultural activist. After completing a Bachelor's course in African Studies, TVon graduated with a Master's degree in Social Sciences. As she explained during our event in Coimbra, Telma is today more oriented towards social working rather than rapping; she continues to write but quitted recording: "today, I prefer to continue more underground than any metro you ever knew" (TVon 2017).[7]

Yet, as far as Telma is concerned, the fact that today, she works better out of the spotlight does not mean that she has stopped believing in the power of words as weapons of resistance, nor that she has changed focus as a social and cultural activist. In other words, she is still anchored in rap's mentality in terms of themes, thinking and creative strategies, even if choosing a different channel to deliver them.

Indeed, through her first book as a writer – *Um preto muito português* (Chiado Editora, 2018) – Telma switches between prose and poetry in the building of a novel that is at once a diary, a monologue, careful critique and an emotional burst. Written in the first person, the narration is conducted by Budjurra, a young Black Portuguese, son of Cape Verdeans, who "was indeed born in Lisbon yet considered a foreigner. And not by my choice" (TVon 2018, 5). As a matter of fact, as we read we become aware of the numerous, hostile situations experienced by Budjurra for being a non-white Portuguese, and how this led him to question his identity as a mestizo born in the diaspora, as well as distrust "the land that had impartially given birth to me" (6). Throughout the 47 short chapters that compose the book, and thanks to a sophisticated use of irony and a

hint of humour, the author unravels and criticises the racial, social and cultural biases that affect Black lives in today's Portugal.

Telma's themes as a rapper are merged into this novel and Budjurra's paradigmatic life: the fight against capitalism ("Call center licenciado, Budjurra"), the media's manipulation of information ("Tu agora chamaste arrastão, Budjurra"), the need for more awareness and unity, as well as the call for more empathy and greater humanity, stronger moralities, and the peaceful coexistence of diversities ("Boa pessoa, Budjurra…Boa pessoa, Budjurra"). In addition to this, the book discusses a wide range of matters, going from politics in Africa ("Xê Budjurra, não fala política"), Black Power movements ("Desmistificar o Black Power") and rage against injustice ("Tanta raiva, Budjurra"), to love, compassion and disillusion ("Não sabes nada sobre nada"). The attempt is to redeem those lives that share with Budjurra the fact that

> books tell all stories but mine, the story of a Black Portuguese who fights with himself and with a large part of the Lusitanian society in order to feel just like a Human Being (115).

Telma TVon, hence, uses her novel as a platform to question both the human condition and the new postcolonial era, by giving a literary body to the thoughts, fears and frustrations of an individual whose life is, in fact, its product: one of those many "hyphenated identities", a term I borrow from Inocência Mata (2006). As Kahn explains, these postcolonial subjects are

> human, cultural and identity cartographies who carry the roots and the legacy of a long-lasting, crossbreeding relationship, of the sharing of symbolic territories, which are reproduced in language (Padilha 2005), food, music, art, and in literature itself (Padilha & Calafate 2008; Calafate & Meneses 2008) […] (Kahn 2017: 98).

Hence, I consider Telma's choice of Budjurra – a young individual who firmly believes "in equality among diversity" (9) – as the leading voice of the novel, an example of how literature, in the hands of Black authors, becomes a space of resistance against their assimilation and silencing. *Um preto muito português* gives voice to the hybrid identity (Hall 2006) of the Afro-Portuguese postcolonial subject:

> Of course I am also Cape Verdean, my education, my values and principles say so, but of course I am also Portuguese, I was born here, I learned a lot here, and I also gained new values and principles, therefore, this duality to me is a treasure (TVon 2018: 10).

Telma's literary work, then, can be observed as a step forward towards both the institutionalisation of diversity and the negotiation of its cultural symbols and a contribution to the broadening (and enriching) of the scope of the Portuguese cultural identity (Mata 2014).

Moreover, in line with her works as a rapper, the novel is punctuated with some considerations of a

7. The full video of our panel during the event in Coimbra, RAPensando as Ciências Sociais e a Política, and of Telma's intervention, is available at https://www.youtube.com/watch?v=-VZtrAIam_0&fbclid=IwAR2ynkwxItY1CpoMZl Yh4wexcB5yTOKwVxBU6DI6-Bs4klSNMKLTBUjJ6t8.

feminist nature. In "Uma Budjurra, ou não, para o Budjurra", for instance, the narrator describes himself as a compassionate man whose deepest desire is to experience love as "described in books, in soap operas, with butterflies in the stomach" (35). Budjurra is definitely a non-stereotyped man who is not afraid of expressing his feelings since these do not harm his masculinity and his nature finds full expression throughout the novel. Furthermore, the novel also discusses toxic relationships and women's subordination to men. In "Ela, ele e eu, o Budjurra...No nosso silêncio", the narrator unfolds the story between his friend Fernanda and Rui, the father of her son, a young man who had vanished after deluding her with all his promises. Since then, Fernanda had sunk into sadness, her face always covered by a veil of silence. Budjurra's position is very clear with regards to the father's narcissistic behaviour: "He is that kind man I will never endorse" and "this is not being a Man" (71). Through a surprising final, the chapter closes with Fernanda telling Budjurra that Rui had HIV, and both she and her son have contracted the virus, leaving the reader with a sense of revolt that inevitably leads to the questioning the legitimation of masculinity as hegemonic and subordinating.

Feminism is then broadly debated in "Budjurra, Carlos, Sandra e algumas mulheres". The chapter, in fact, focuses on women's empowerment as individuals and as a collectivity. In order to do this, Budjurra presents two interesting cases: that of his brother Carlos – a "womaniser" (75) – and that of his sister Sandra – "the most chauvinist woman I have ever known" (77). Both are examples of how macho behaviours affect both men and women indiscriminately. In the first case, male chauvinist culture translates into being promiscuous regardless of women's feelings; in the latter, it takes the shape of hatred of women, by other women. The narrator uses both figures to discuss women's tendency to act against each other, instead of working together as a powerful collectivity. In fact, for Budjurra, feminism is the only solution:

> In some sense, I really like the feminists. I think that feminism is truly the right way to fight not only men's unproven beliefs but women's too. Nothing exaggerated, but a feminism strong enough to instil in some women that they won't lose a leg or a hand if they praise other women in a heartful way or if they see in each woman a friend and not an enemy [...] (79).

As mentioned above, these are just a few examples of the feminist imprinting of the whole novel. Bearing this in mind I consider that *Um preto muito português* showcases a creative use of literature as a platform where hegemonic narratives are disclosed and undone, these being racisms, capitalism, patriarchy or power relations in general. By exposing how deeply discriminating they are, the novel contributes to the building of new, alternative narratives as strategies of resistance, as spaces of creation where blackness

and femininity are presented as strong identity pillars. Budjurra's words as exemplary, as follows:

> I am Carlos do Carmo remixed with Cesária Évora, that became a track by Boss AC. I am about Portugal's existence as much as I am about the search for Cape Verde. [...] I am a man, a man that doesn't feel it is necessary for him to stand up for his masculinity and I am this same man who feels necessary to claim his blackness (182).

4 FINAL CONSIDERATIONS

As I have previously stated here, I believe that the works of Telma TVon showcase a similar use of rap and literature as means of cultural resistance against hegemonic narratives. What I would like to add as a final consideration, is that by creating a space for those subjects that history tends to silence, TVon's contributions provide new cultural references to a heterogeneous cohort of voices who are fighting for their expression. More importantly, they stir the debate on the need to renew the (static) categories that define what (and who) is Portuguese and what (and who) is not. I agree with Fernando Arenas when he explains that today:

> Cinema, literary fiction, and popular music, [...] are providing a key platform for the symbolic representation and socio-political empowerment of marginalized African and Afro-Portuguese communities, as well as a prism through which to posit a multiplicity of shifting, and at times, overlapping identity formations ranging from static binary categories such as foreign/national, black/white, African/European as well as localized, situational, and/or hyphenated identities (Arenas 2012: 167).

From rap to literature, Telma TVon's works prove that, in Portugal, creativity can be deployed as a strategic way to discuss and undo cultural, social, and racial categories that delegitimise heterogeneity and equality as necessary elements for the building of a free world.

ACKNOWLEDGEMENT

This chapter had the support of CHAM (NOVA FCSH/UAc), through the strategic project sponsored by FCT (UID/HIS/04666/2019).

BIBLIOGRAPHICAL REFERENCES

Arenas, F. (2012, July-December). Cinematic and Literary Representations of Africans and Afro-descendants in Contemporary Portugal: Conviviality and conflict on the margins. *Cadernos de Estudos Africanos, 24*, 165–186.
Bennett, A. (2001). *Cultures of Popular Music*. Maidenhead (UK): Open University Press.

Buettner, E. (2016). *Europe after Empire. Decolonization, Society and Culture*. Cambridge (UK): Cambridge University Press.

Chang, J. (2006). *Total Chaos. The Art and Aesthetics of Hip-Hop*. New York: Basic Civitas Books.

Durham, A., Cooper, B. C., & Morris, S. M. (2013). The Stage Hip-Hop Feminism Built: A New Directions Essay. *Signs, 38*(3 (Spring 2013)), 712–737.

Gramsci, A. (2007). *Quaderni del carcere*. Torino: Einaudi.

Hall, S., & Jefferson, T. (1975). *Resistance Through Rituals. Youth subcultures in post-war Britain*. London & New York: Routledge.

Hebdige, D. (1979). *Subculture. The Meaning of Style*. London & New York: Routledge.

Henriques, J. G. (2018). *Racismo no País dos Brancos Costumes*. Lisbon: Tinta da China.

Isoke, Z. (2013). Urban Black Women and the Politics of Resistance. New York: Palgrave Macmillan.

Khan, S. (2012). Do pós-colonialismo do quotidiano às identidades hifenizadas: identidades em exílios pátrios? *Comunicação Intercultural: perspectivas, dilemas e desafios*, 95–108.

Kitwana, B. (2002). *The Hip Hop Generation*. New York: Basic Civitas Books.

Mata, I. (2006). Estranhos em permanência: a negociação portuguesa na pós-colonialidade. In M. Ribeiro Sanches, *Portugal não é um país pequeno*. Lisbon: Cotovia.

Mata, I. (2014, July). Estranhos em Permanência: A Negociação da Identidade Portuguesa na Pós-Colonialidade. *Crítica e Sociedade: revista de cultura política, 4*(1), 5–34.

Meyers, D. T. (2002). Gender in the Mirror. Cultural Imaginary and Women's Agency. New York: Oxford University Press.

Price, E. G. (2006). *Hip Hop Culture*. Santa Barbara (CA), Denver (CO) & Oxford (UK): ABC-CLIO.

Rose, T. (1994). Black Noise: Rap Music and Black Culture in Contemporary America. Hanover & London: Wesleyan University Press.

Said, E. (1978). *Orientalism*. New York: Pantheon.

Shusterman, R. (1995). Rap Remix: Pragmatism, Postmodernism, and Other Issues in the House. *Critical Inquiry, 22*(1 (Autumn 1995)), 150–158.

Simões, S. (2017). RAPublicar. A micro-história que fez história numa Lisboa adiada. Lisbon: Caleidoscópio.

Spivak, G. C. (1993). Can the subaltern speak? In P. Williams, L. Chrisman & C. U. Press (Ed.), *Colonial Discourse and Post-Colonial theory. A reader* (pp. 66–111). New York: Columbia University Press.

TVon, T. (2018). *Um Preto muito Português*. Lisbon: Chiado Editora.

Williams, I. (2007). Female Voices, Male Listeners: Identifying Gender in the Poetry of Anne Sexton and Wanda Coleman. In D. L. Hoeveler, & D. D. Schuster, *Women's Literary Creativity and the Female Body* (pp. 175–192). New York: Palgrave Macmillan.

Part V
Social sciences

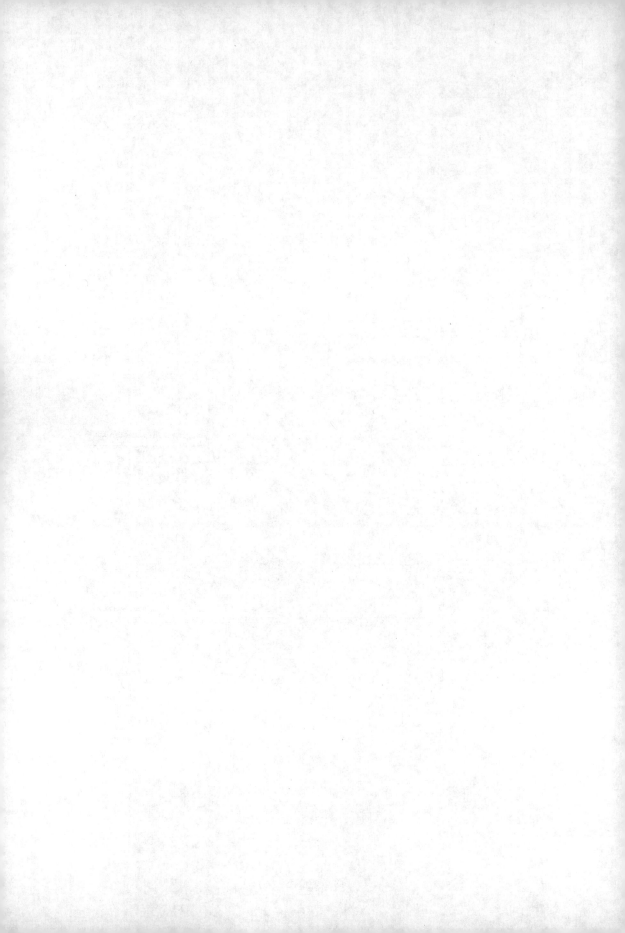

Creativity, Utopia and Eternity at the Francke Foundations in Halle: Art between image politics and cultural memory

Kim Groop
Åbo Akademi University, Turku, Finland
ORCID: 0000-0002-4258-6340

ABSTRACT: In this article, I will study the legacy of the Lutheran Pietist, pastor, professor and social reformer August Hermann Francke. I wish to draw attention to art pieces at the Francke Foundations in Halle in Germany and highlight their participation in the transmission of cultural memory from early modern Pietism. Employing theories from the fields of cultural memory as well as sociomateriality, I will present three works of art that have an extraordinary ability to communicate the core of Francke's work and Halle Pietism from the past into the present. The works of art in question communicate the founder's creativity, his Pietistic utopian views as well as focus on eternity through Christian salvation.

Keywords: Halle-Pietism, Art, Francke, Cultural memory, Sociomateriality

1 BACKGROUND

The Francke foundations in the German town of Halle is one of the many fascinating cultural-historical sites in Europe. Here the Lutheran Pietist priest and professor of oriental languages and theology August Hermann Francke (1663–1727) started an extraordinary social-educational movement with a global reach. Francke was convinced that he could change the world around him if he could only change people through education. The driving force behind all of this was his strong Pietist religiosity.

August Hermann Francke was born in Lübeck in the year 1663. He was brought up in a piously religious home. His father was a court counsellor and Minister of Justice in the administration of Duke Ernst the Pious. It is likely, as Markus Matthias indicates, that August Hermann Francke obtained early influences from this northern German court much characterised by Protestant religiosity and social improvement schemes (Matthias, 2005:100–101). Between the years 1679–1690, August Hermann Francke would pursue studies in no less than five locations in Germany, but it would be at Leipzig University that he stayed the longest. It was here that he defended his master's thesis in Hebrew grammar in 1685. It was also here that Francke underwent a spiritual crisis culminating in an awakening. Philipp Jacob Spener – the author of the renowned Pietist renewal programme *Pia desideria* (1675) – was influential in Francke's spiritual breakthrough and became his mentor and spiritual father. However, the leadership of Leipzig University was not very fond of Pietism and dismissed the Pietistic renewal, which Francke and some of his colleagues

sought to introduce through their exegetical seminar *Collegium Philobiblicum*. Francke left Leipzig for a pastor's position in Erfurt in 1690. In Erfurt, he also taught at the university. However, for very similar reasons as in Leipzig, Francke was dismissed and also expelled from Erfurt in 1691 (Beyreuther, 1969:64–65, 77–78, 103–110; Obst, 2013:16–20). The religious climate in Brandenburg-Prussia was more favourable to Pietism and very soon after his dismissal from Erfurt Francke was appointed professor of biblical languages at the young (Friedrichs) University of Halle. He also became a pastor in St. George's Church in Glaucha, one of the poor suburbs of Halle. In 1695, Francke became a professor of Theology, and from 1716, he served as *prorector* for the whole university. The position as Professor of Theology also made him a pastor at the Halle town church of St. Ulrich (Obst, 2013:54–57, 227–228).

However, it is Francke's work as a founder, developer and leader of the Pietist social-educational institutions in Glaucha for which he is best remembered. Glaucha experienced great poverty, alcoholism, and social challenges in the wake of the Thirty Years War (Schantz, 2013:119). Determined to combine a Pietist renewal programme with his own urge to improve the situation in Glaucha and Halle, Francke soon found himself running not only a school – later several schools – but also an orphanage. Gradually he developed other institutions as well, some of them as a complement or continuation to the schools, and others in order to generate assets needed to run the schools (Raabe, 1995:17). It was not only the poor that sent their children to Francke, but also many wealthy citizens who saw that Francke's schools maintained a

high standard. During his lifetime, (he died in 1727), August Hermann Francke built an impressive estate with an orphanage and education facilities ranging from schools for young boys and girls to a Latina school preparing youngsters for the university. As a professor of Theology and later *prorector* of the Halle University, Francke also had the power to ensure that there were connecting points between his institutions and the university. For instance, he engaged students as teachers in his schools (Schantz, 2013:137). Moreover, Francke, in 1706, sent theologians from Halle University to Tranquebar in south-eastern India. This has often been regarded as the first Protestant mission. Francke's institutions and endeavours were not only supported through businesses, such as a printing press and pharmacy but also through generous donations from wealthy Pietists. Of particular importance was the right Francke obtained from the Prussian king to run a business without having to pay taxes (Müller-Bahlke, 2013:181–192).

2 FROM IMAGE POLITICS TO CULTURAL MEMORY

With regards to the creating, upholding and transfusion of cultural memory, two conditions are fundamental and can hardly be overlooked. First, cultural memory typically relates to one or several objects, a site, a tangible or intangible heritage, which carries or calls for a story. Second, cultural remembrance needs a social context, individuals, who actively relate to this object, heritage or whatever happens to be at the centre of remembrance.[1] In the case of the Francke foundations, it is composed of art treasures, buildings, and a milieu, which has survived for more than three centuries. The Francke foundations have since 1999 been on Germany's "tentative list" of properties intended for possible nomination as a heritage centre (Germany-Unesco World Heritage Centre). Until today there have always been people looking after the Francke foundations and nurturing the cultural memory at this site. Naturally, this social context has possessed and continues to possess power over the way the memory of August Hermann Francke and his institutions is communicated. Cultural heritage can convey a message from the past to the present, but it also needs some measure of skilled interpretation in order for the original message to be transmitted from the creators to the observers – or does it? In the following, three examples of cultural heritage that were designed to impress and their role as mediators of cultural memory will be considered.

1. In this I relate to several historians and cultural memory scholars, one of whom is Maurice Halbwachs who in the opening decades of the 20th century defined memory as fundamentally dependent upon society. See Halbwachs 1992, 38.

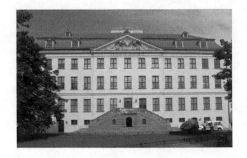

Figure 1. The Francke foundations' historic orphanage. Photo by the author.

3 THE HISTORIC ORPHANAGE AND ITS TYMPANUM

August Hermann Francke was an active pursuer of image politics. When he had his orphanage built between 1698 and 1701, it was important for him that the building was grand and bold. For Francke, writes Claus Veltmann, it very early on became quite clear that he had to conduct 'Image politics', in order to obtain international recognition for his venture (Veltmann, 2013). Holger Zaunstöck (2013:265) fittingly labels the orphanage a socially functional building with the dimensions of a castle. The pompous appearance was crucial, he writes:

> For the success of this far-sized undertaking, what was needed was a media staging and well-thought-out external representation, which communicated a specific image in order to be considered distinguishable in an ever-growing public. (Zaunstöck, 2013:260)[2]

The façade of the orphanage was not only a statement to observers through its sheer size and beauty, but it also communicated a message. In the façade gable or tympanum, a sun and two eagles are depicted. The eagles look towards the sun (God) and stand on a banner with a verse from Isaiah 40:31 in the Old Testament:

> But those who hope in the Lord will renew their strength. They will soar on wings like eagles; they will run and not grow weary, they will walk and not faint. (Isaiah 40:31)

This passage demonstrates the Pietist mind-set of Francke and his institutions. They would put their faith in the Lord and obtain new strength; as it was commonly known that eagles obtain new feathers even in old age. Through trust in, and help from God, the Francke Foundations would carry on tirelessly and achieve great things.

The orphanage was depicted in many books and papers printed by the foundations' own printing press. It soon became a landmark not only for the Francke

2. All translations from non-English sources are the author's free translations.

Figure 2. The tympanum of the historic orphanage with the sun and the two eagles. Photo by the author.

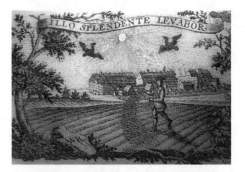

Figure 3. The sower with the Francke Foundations in the background. Photo by the author.

Foundations but also for Pietism at large. Francke's orphanage was often considered to be too "palace-like" for orphans. Naturally, this was not a problem for Francke as long as he could demonstrate to all by-passers that it was a work of God. Therefore, the façade should be viewed in light of his image politics. However, through the two eagles, as Veltmann writes, Francke also demonstrated that the Prussian king protected his institutions. In this image, both the Pietist mindset and the political legitimacy of the Francke Foundations is clearly emphasised.

4 THE SOWER

Another piece of artwork that has contributed significantly to the cultural memory of early Halle Pietism is the "the sower". This refers to Mark 4:14 in the *New Testament* about the farmer sowing the word. For several years, this work of art has been displayed in two locations in the ground-floor exhibition of the historic orphanage, both as a printed image and as a beamer-projected image. This image strikes me as the most extraordinary piece of art and a fine example of Francke's "image politics". It is an engraving in black and white from 1732, but an earlier version of the image had already appeared in 1724 on the title page of one of Francke's books (Francke, 1724; Breul 2013:65). Subsequently, the image was to appear in most books printed by the Francke Foundations. It became the signet of the orphanage bookstore (Obst, 2013:92). On the image, a man is sowing the field in front of the historic orphanage. Above the sowing man, there is a banner with the text "Illo splendente levabor" (through his glory I will be raised up). Below the banner, but above the orphanage and the sower, the same sun and two eagles appear as on the façade of the historic orphanage. The sun and the eagles thus indirectly also refer to the bible verse in Isaiah 40:31.

In the book *The Halle Orphanage – The Francke Foundations: History and Sights* (Müller-Bahlke, 2015:87) this image is explained as "the signet of the Orphanage bookshop press showing a figure of a sower at the Orphanage façade in an ideal landscape." Whether or not Francke originally designed

the image and whether similar images of the sower existed elsewhere is beyond my knowledge.

In my opinion, this image communicates Francke's mission and message more clearly than any other insignia or images on display at the Francke Foundations. The sowing man is clearly and visibly connected with the Francke Foundations. The sower demonstrates or reinforces Francke's view of his institutions as a nursery (Pflantzgarten, Francke, 2013 [1706]) "from where a real improvement could be expected in all estates in and outside Germany, yes in Europe and all other parts of the world" (Francke, 1881)[3]. The image can also be viewed as something of a visiting card, where the act of sowing the good Gospel is emphasised, and the Francke Foundations are presented in the background as the institutions from where the sower has come. The "godliness" of the Francke institutions is further clarified through the Latin text.

In the *New Testament* text about the sower some seeds are sown on good soil whereas others fall "along the path", "on rocky places", or "among thorns". Notably, in the image above, the soil is good. This demonstrates, with the help of the Latin text – under his splendour shall I be lifted up – that the Francke Foundations, through faith in God, will sow on good soils and succeed in their Godly endeavours. Again, the eagles demonstrate the link to the Prussian king and further reinforces the good prospects of Francke's sowing project.

The sower as a concept originates from Francke's times and principles and visualises his most fundamental values and "trump cards". It is a powerful visual demonstration of a combination of piety, determination, hope, and divine as well as royal protection, which people during Francke's times were very likely able to interpret and which are still interpretable today.

3. This is a translation from a pamphlet titled *August Hermann Francke's Project zu einem Seminario Universali oder Anlegung eines Pflantz-Gartens, in welchem man eine reale Verbesserung in allen Ständen in und auserhalb Deutschlands, ja in Europa und allen übrigen Theilen der Welt zu gewarten.*

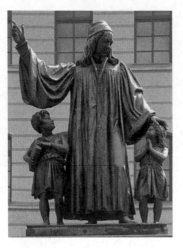

Figure 4. The Francke statue sculpted by Christian Daniel Rauch in 1829. Photo by the author.

Figure 5. Interpretation of the Francke statue in Halle. Photo by the author.

5 THE FRANCKE STATUE

The third work of art that I want to discuss is Christian Daniel Rauch's statue of August Hermann Francke. This statue is located at the eastern end of the Linden-hof (Linden yard). The statue, inaugurated in 1829, portrays Francke together with a boy and a girl from the orphanage. Francke rests one hand on the girl's head while looking at her and pointing with his other hand upwards, presumably towards heaven. The girl presses her hands together as if she were praying or showing thankfulness. The boy carries a book, pre-sumably Francke's bible, and is as such allowed to be involved in the founder's mission. The statue sends a clear message. The children have been educated, they have become pious, and they look up to Francke as their teacher. Francke may be talking to the children about heavenly things, or he may be comforting the children telling them that they indeed have a bright future. Alternatively, he may be doing both, as would so much befit his motto "World change through improve-ment of man" (*Weltveränderung durch Menschen-verbesserung,* see Lehmann, 2015:115–118). Under the statue, a plate reads: "He put his trust in God" (Er vertraute Gott).

This statue has not only been central to the Francke Foundations, but it has also been seen in images all over Halle at least since the German reunification in 1990. Sometimes it has been altered, where parts of the statue have been related to other images in various ways. Some of these new compositions have been utilised by the Francke Foundations, whereas others have appeared in different settings. The pop-ularity of this Francke statue is probably connected with the fact that it is an easily accessible well-known local theme. However, for the Francke foundations, it is naturally beneficial that this statue – and thereby

also the Francke Foundations in general – seems to be viewed as representing something positive. The present Francke Foundations logo is also taken from this statue (see www.francke-halle.de). However, it has been considerably simplified, and only spectators who know the original are likely to see the resemblance.

The fatherly – or Jesus-like – image of Francke serves the Francke Foundations well. It does not draw attention to the Pietist movement per se, but to the Pietist fatherly educator amidst those whom he cared for. In this statue, the utopian aspect of Francke's life work has been toned down, and instead the focus has been given to his care for local orphans.

This statue is an interesting example of how an object can support a cultural memory. It was unveiled hundreds of years after the founder's death in order to commemorate him and his life's work. It shows Francke the way the artist and the Francke Founda-tions wanted to "remember" him. On the other hand, this statue is a later production, and the intention was no longer necessarily to communicate the Pietist spirit, which so much characterised Francke himself. The focus of the statue is not predominantly on that of the professor, pastor, Pietist, or global entrepreneur, but on the *first* and maybe *most central* of his achievements in Glaucha: the orphanage.

This illustrates the unreliability of cultural mem-ory on the one hand and its multifacetedness on the other. For almost 190 years, this statue has re-enforced the narrative about Francke as an educational pio-neer and genius, and the ground-breaking work of the Francke institutions in the area of education and social work. This attribute of the founder has fitted within the major political norms in Germany ever since it

was introduced. In line with this, the Francke Foundations were also commonly referred to as the "School town" (*Schulstadt*), and not as the "Pietistic town for human improvement (*Menschenverbesserung*)", which I would see as more fitting. This image has reinforced Francke's work as an educator and social worker at the cost of his work to build institutions that would make Halle a centre for Pietism in Europe in the early 18th century.

6 ART BETWEEN IMAGE POLITICS AND SOCIOMATERIALITY

In order to understand August Hermann Francke and his life's work, we may benefit from some acquaintance with the actor-network theory (ANT). Bruno Latour (and several other of his colleagues and successors) have emphasised the need to give attention not only to human actors but also to the non-human aspects used in and for the creating of networks. Latour means that just as the writer needs instruments such as a pen, paper or a digital device to produce his or her texts, all networks and environments involving humans at work also require the utilisation of non-human agencies. Similarly, it would be unfruitful not to consider for instance the Berlin Wall as an actor during the Cold War, as it facilitated or hindered networks from being created similar to any human actor. Consequently, this kind of non-human agency must be given proper attention. (Latour, 2005:71–72, 79–86).

In the case of Francke, he had the determination to utilise whatever means were at his disposal in order to change the world in line with his pious Christianity. This not only included powerful like-minded individuals, but it also included images, creations, and physical objects. Francke was not alone in his use of images, but can indeed be seen as one of the religious leaders of his time who best understood how to make full use of them as instruments in his work to change the world. These images also included representations of himself which were already widely painted and reproduced during his lifetime (Wiemers, 2013:247–256). As for the enormous orphanage, its intention was not only that it would be large enough to host the orphans and a variety of activities that could generate assets for the running costs. It was also intended to be a statement, to draw attention and to communicate a strong message through images and bible references; to be a bold "actor" in his multi-faceted Pietist project. Francke also utilised other material objects beyond those that were common at the time. Very early on he started using objects from various mission fields at various levels of teaching. The Cabinet of Artefacts and Natural Curiosities (*Kunst und Naturalienkammer*) in the historic orphanage hosts some 3,000 natural history specimens, curiosities and artefacts.

Francke's planning was fruitful. The orphanage and its adjacent buildings and schools not only became successful – in the early 18th century the school town hosted nearly three thousand school children and young people (Bunge, 2001:248) – but still stands as tall today and continues to impress and communicate.

Historical objects vary in their readability. Some may demand a significant level of prior knowledge in order to "speak" to the spectator while others can be experienced with little explanation. Some background information may be welcome, but too many facts about the object, its creation, context, and message would spoil the experience. These objects possess a rather extraordinary ability to communicate cultural memory with little external mediation. To put it another way; if the human mediators disappeared, some pieces of art would be readable to a much greater extent than others.

My interest in this article lies in the agency of materiality, and, in particular, some of the artworks, which *stand out* as mediators of the cultural memory at the Francke Foundations. I have presented three examples of art that I would claim have an extraordinary ability to communicate not only the creative, but also the utopian qualities and character of August Hermann Francke and his social context. The readability of the façade of the historic orphanage, the bookstore signet and the Francke statue are notably major examples. This may be because the three objects "belong together" and speak the same language about Francke's Pietistic project to change the world with heavenly eternity in mind. Nonetheless, their readability is enhanced by embedded themes, mottos, and biblical references which were known in their time, and which are still comprehended today.

Francke created two of the "images" under scrutiny in this article during his time of activity, and the third was created in memory of Francke. They are all results of the image politics which he pursued and started at the Francke Foundations. They are examples of objects created to be "flashy" and thus possess an ability to communicate a cultural memory with extraordinary authenticity. In other words, through his extraordinary skills, widespread support from likeminded Pietists, and last but not least through his conscious image politics Francke significantly affected the way he and his foundations would be remembered. Therefore, it is because of Francke's own work and choices that there are artefacts that still speak today, and it is because of this that Francke is still so vividly remembered in Germany and beyond.

It was hardly a conscious plan of his to create a personal legacy. Instead, his focus was set on heavenly dimensions and on working towards the spreading of Pietist Christianity through education, social work and Christian mission.

Furthermore, due to the societal relevance of Francke's project (in many respects he set an example for education and social work in Europe) the Francke foundations survived the Nazi era and the GDR period. Despite Francke's (disturbing) religious

message, these regimes could appreciate at least the educational aspects of his institutions and the fact that this site was widely respected as a ground-breaking educational centre. While many churches in the Eastern parts of Germany were demolished during the GDR era (Groop, 2017, pp. 391–395), the Francke Foundations lost only its brick wall and parts of the eastern wing of the so-called Pädagogium when a fly-over was built from Neustadt to the centre of Halle (Obst, 2013, p. 208.). To the GDR regime, the Francke foundations were more useful as a cultural memory of a past educational era (indeed part of the Martin Luther University moved into the Francke buildings) than it was disturbing due to its religious connotations.

What we have therefore at the Francke Foundations – and the objects presented there – is something of a synthesis between image politics, sociomateriality, and cultural memory. This location and its artefacts should be studied as something highly integrated with its founder. While there are many dimensions in Francke's life's work – he was a professor, he was a builder, he was a leader of his institutions and so on – it would be incorrect not to clearly emphasise his deep pious spirituality. The Francke Foundations have attempted to emphasise the human qualities of Francke's in some of its exhibitions in order for them to make sense to an East German audience – which may not be all that interested in Francke's religious views. However, with this comes a risk of misrepresentation. Thus, hopefully, the general environment at the Francke Foundations and maybe, in particular, the pieces of art under scrutiny in this article will counterbalance this tendency.

BIBLIOGRAPHICAL REFERENCES

Beyreuther, Erich. (1969) *August Hermann Francke 1663–1727. Zeuge des lebendigen Gottes*. Marburg an der Lahn: Verlag der Francke-Buchhandlung.

Breul, Wolfgang. (2013) "Gewissheit" bei Martin Lutherund August Hermann Francke. H. Zaunstöck, T. Müller-Bahlke und c. Veltmann. *Die Welt Verändern. August Hermann Francke. Ein Lebenswerk um 1700*. Halle: Verlag der Frankeschen Stiftungen zu Halle, Harrassowitz Verlag in Kommission.

Bunge, Marcia J. (2001) Education and the Child in Eighteen-Century German Pietism: Perspectives from the Work of A. H. Francke. M. J. Bunge. *The Child in Christian Thought*. Grand Rapids and Cambridge: William B. Eerdmans Publishing Company.

Francke, August Hermann. (1881) *August Hermann Francke's Project zu einem Seminario Universali oder Anlegung eines Pflantz-Gartens, in welchem man eine reale Verbesserung in allen Ständen in und auserhalb Deutschlands, ja in Europa und allen übrigen Theilen der Welt zu gewarten*. https://nbn-resolving.de/urn:nbn:de:gbv:ha33-1-160403. Accessed 6 February 2019.

Francke, August Hermann (1724) Commentatio De Scopo Librorum Veteris Et Novi Testamenti. Halae Magdebvrgicae.

Francke, August Hermann. (2013 [1706]) *Nützliche und nötige Handleitung zu wohlanständigen Sitten*. Halle: Verlag der Frankeschen Stiftungen.

Groop, Kim. (2017) A Memory in Transition. The University Church of St. Paul in Leipzig. N. Blåder & K. Helgesson Kjellin. Mending the World? Possibilities and Obstacles for Religion, Church, and Theology. Eugene, Oregon: Pickwick Publications.

Halbwachs, Maurice. (1992) On Collective Memory. Edited by Lewis E. Coser. Chicago: University of Chicago Press.

Latour, Bruno. (2005) Reassembling the Social. An Introduction to Actor-Network-Theory. Oxford: Oxford University Press.

Lehmann, Hartmut. (2015) Die Frankeschen Stiftungen als ein einzigartiges Projekt zur Verbesserung der Menschheit. Tief verwurzelt – hoch hinaus/ Strong roots – inspiring vision. Die Baukunst der Frankeschen Stiftungen als Sozial- und Bildungsarchitektur des protestantischen Barock. /The Francke Foundations as Social and Educational Architecture in the Protestant Baroque. Halle: Verlag der Frankeschen Stiftungen zu Halle, Harrassowitz Verlag in Kommission.

Matthias, Markus. (2005) August Hermann Francke (1663–1727). C. Lindberg. *The Pietist Theologians*. Malden: Blackwell Publishing.

Müller-Bahlke, Thomas. (2013) Die Bedeutung des Adels für das hallische Netzwerk. H. Zaunstöck, T. Müller-Bahlke und c. Veltmann. *Die Welt Verändern. August Hermann Francke. Ein Lebenswerk um 1700*. Halle: Verlag der Frankeschen Stiftungen zu Halle, Harrassowitz Verlag in Kommission.

Müller-Bahlke, Thomas. (2015) *The Halle Orphanage – The Francke Foundations: History and Sights*. Halle: Verlag der Frankeschen Stiftungen zu Halle, Harrassowitz Verlag in Kommission.

Obst, Helmut. (2013) *August Hermann Francke und sein Werk*. Halle: Verlag der Frankeschen Stiftungen zu Halle, Harrassowitz Verlag in Kommission.

Raabe, Paul. (1995) Pietas Hallensis Universalis. Weltweite Beziehungen der Frankeschen Stiftungen im 18. Jahrhundert. Halle: Frankesche Stiftungen zu Halle.

Schantz, Douglas. (2013) An Introduction to German Pietism. Protestant Renewal at the Dawn of Modern Europe. Baltimore: The John Hopkins University Press.

Unesco, State parties, Germany. https://whc.unesco.org/en/stateparties/de.

Veltmann, Claus. (2013) *August Hermann Francke und die „Marke" Waisenhaus*. https://www.kulturfalter.de/magazin/stadtgeschichte/august-hermann-francke-und-die-marke-waisenhaus/.

Wiemers, Michael. (2013) "Sehr wohl getroffen" – August Hermann Francke im Bildnis. H. Zaunstöck, T. Müller-Bahlke und c. Veltmann. *Die Welt Verändern. August Hermann Francke. Ein Lebenswerk um 1700*. Halle: Verlag der Frankeschen Stiftungen zu Halle, Harrassowitz Verlag in Kommission.

Zaunstöck, Holger. (2013) „Das „Werck" und das „publico". Franckes Imagepolitikund die Etablierung der Marke Waisenhaus" in Die Welt Verändern: August Hernann Francke Ein Lebenswerk um 1700.

Harriet Martineau, John H. Bridges, and the sociological imagination

Matthew Wilson
Ball State University, Muncie, Indiana, USA
ORCID: 0000-0003-0406-1743

ABSTRACT: For first-generation sociologists Harriet Martineau and John H. Bridges, intelligence and creativity kindled the sociological imagination, revealing the links between personal troubles and social issues. A social analyst, novelist, and reformer, Martineau published the first sociological studies in Britain from a feminist-intellectual perspective. She also translated and condensed Auguste Comte's *Cours de philosophie positivisme* (1830–42), which introduced the modern discipline of sociology. Here, Comte presented sociology as a modern master-science of society and the centre of all future knowledge. Bridges, meanwhile, translated part of Comte's magnum opus, *Système de politique positive* (1851–4). This study set the bar for calling oneself a sociologist at: obtaining a medical license, adhering to Comte's new 'Religion of Humanity', and seeking to realise his utopian vision of modernity. On this basis, Bridges not only developed a biologic-historical outlook of sociology but worked as a physician, Poor Law inspector, political activist, and philosopher. This essay explores these sociologists' complementary methods for interpreting Victorian life through the lens of Comtean Positivism. It will be shown that their works were imbued with altruistic and utopian sentiments seeking to transform thoughts and feelings into actions via didactic instruction. Their distinct utopian hopes and beliefs, it will be argued, played a role in the institutionalisation of the discipline of sociology in Britain.

Keywords: sociology, utopianism, positivism, feminism, urban hygiene

It was once said that Auguste Comte's 'one meritorious gift to the world' was his 'intensely personal Utopia of a Western Republic'. Those unfamiliar with this French mathematician's works might find such a suggestion rather curious, especially considering recent studies on his impact within the fields of the history of science, political thought, and philosophy (Bourdeau, 2006; Bourdeau, Pickering, & Schmaus, 2018; Feichtinger, Fillafer, & Surman, 2018; Grange, 2000; Petit, 2003; Wernick, 2001). Such works chiefly focus on Comte's most famous treatise, *Cours de philosophie positivisme* (1830–42) which, among other ostensible feats, introduced the modern discipline of sociology. There is little doubt that the author of the utopian line of argument above, the novelist H.G. Wells, was fully aware of Comte's contributions to the science of society. Indeed, as a member of the first formal institute of sociology in Britain, the Sociological Society, Wells argued that the creation and criticism of utopia was the 'proper and distinctive method of sociology'. It enabled one to 'measure realities from the standpoint of the idealisation' of society (Wells, 1907, pp. 367–368).

This essay tests this premise in the Victorian context by exploring how the sociological imagination of Harriet Martineau (1802–1876) and John H. Bridges (1832–1906) operated at the interchange of intelligence and creativity. It will be shown that their works aimed to reveal to the public the connections between the inner troubles and outer issues of the world: Martineau from an intellectual-feminist perspective, and Bridges from a biologic-historical outlook. Their efforts were imbued with altruistic sentiments seeking to transform thoughts and feelings into actions that improve the relationships between the individual, society, and the environment.

This line of thinking is similar to how some scholars have defined the word 'utopia'. The sociologist Ruth Levitas (2011, p. 1), for instance, has defined utopia as 'how we would live and what kind of world we would live in if we could do just that'. Along a similar vein, C. Wright Mills (1967, pp. 4, 5–24) has referred to employing the 'sociological imagination' to 'understand the larger historical scene in terms of its meaning for the inner life [biography] and the external career of a variety of individuals [world history]'. The philosopher Charles Taylor (2004, p. 17) explicates here by stating that being a 'social imaginary' entails engaging with 'how things go on between' people and 'their fellows, the expectations that are normally met, and the deeper normative notions and images that underlie expectations'.

A compatible language on the social imagination appears in Comte's *Cours*. Here, Comte wrote that sociology was based on the positive sciences of history and biology, and was a 'complementary part of natural

493

philosophy which relates to the positive study of all fundamental laws of social phenomena'. Sociology aimed at 'discovering or perfecting the exact coordination of all observed facts'. This process could open to the 'human imagination the largest and most fertile field' of existence, life on earth and its improvement (Comte, 1839, p. 294).

Martineau produced a condensed and accessible English edition of the *Cours,* thereby making Comte popular among the British working-classes. And when his four-volume *Système de politique positive* (1851–4) appeared, Bridges and his close network of followers published an English equivalent. This sociological treatise contained modern utopia-making principles, and they used them as a way to interpret and critique Victorian life (M. Wilson, 2018b).

Recently, intellectual historians have suggested that the system of modern life Comte envisioned — Positivism — was a catalyst for various world-making activities during the nineteenth and early twentieth centuries (Feichtinger et al., 2018; M. Wilson, 2018a). Along these lines, this essay will show that Martineau and Bridges developed two distinct but complementary strands of sociology for re-making Victorian society and the environment.

1 A FEMINIST-INTELLECTUAL PERSPECTIVE

Throughout her life Martineau challenged ideological assumptions that underpinned various forms of social oppression. Her works of fiction and nonfiction alike educated Victorians on such pressing affairs as slavery, industrial capitalism, and the condition of women. One of her recent biographers argued that she was a 'daughter of the Enlightenment, committed to social progress and human perfectibility', and was convinced of the 'power of education' (Hoecker-Drysdale, 1992, p. 21).

Martineau's life as a writer, spanning from the ages of nineteen to seventy-four, reached beyond the Victorian boundaries of the feminine domain. She was born into a stern, hard-working family of Unitarians. Her parents were the chief source of her education. They offered little emotional support for her inability to hear, taste, and smell. Martineau's earliest public intellectual and moral connections, the Norwich Unitarians, shaped her life trajectory. They championed rationalism and empiricism and were activists for moral education and social welfare. They opened up to her the idea of women as public figures. Martineau's first published piece, 'Female Writers of Practical Divinity', spoke admirably of Unitarianism as such (Discipulus, 1822). Ultimately, she was among several Unitarians who expressed interest in Comte's sociological thinking, which for many served as a stepping stone to agnosticism.

As mentioned, Martineau would popularise Comte's work during the 1850s. Her affiliation to Positivism, as the basis of sociology, began with an introduction to the

works of Comte's master, Henri de Saint-Simon. By the 1800s, Saint-Simon had begun to outline how science and industry could supplant ancient regimes and bequeath a peaceful, rational, and meritocratic system of social democracy. From the 1820s, Martineau issued the six-part 'Essays on the Art of Thinking' series in the *Monthly Repository*, and it quietly resonated with positivist perspectives on modern institutions. Here, Martineau surveyed the toll of superstition on religious perils, warfare, and the unquiet obedience of social powers that hindered the progress of science and philosophy. Like Saint-Simon, she upheld the 'right pursuit of truth' and the development of a 'noble faculty of Reason' towards an 'enlightened intellect' acting on its 'moral obligation' towards the gradual perfection of society (Martineau, 1836, pp. 62, 112–114).

From 1832 to 1834 Martineau synthesised intellectual curiosities and creative talents, producing more than 3,000 pages for her popular *Illustrations of Political Economy* series. Her fictional narratives exposed the intellectual, social, and financial forces of political economy, as laid out by Smith, Bentham, Mill, Ricardo, and Malthus. Her novelettes relayed few explicit criticisms against mammon worship, rampant speculation, the emancipation of women, or the Whig's house-tax on shop owners. She intended to reveal to the common reader the rigid mechanics and 'immutable laws' of capitalist political economy (David, 1987, pp. 43–44). Written during the era of the First Reform Bill, Martineau (2007, p. 691) relayed her altruistic intentions: 'I thought of the multitudes who needed it, and especially of the poor, — to assist them in managing their own welfare'.

The only non-fiction volume of the series, *The Moral of Many Fables,* outlined the systematic principles of political economy and declared that 'we must mend our ways and be hopeful'. Echoing the utopian sentiments of Condorcet, Saint-Simon, and Comte, Martineau expressed hope for a state when 'society shall be *wisely* arranged, so that all may become intellectual, virtuous, and happy' (Martineau, 1834, p. 141). Ethical social institutions, she argued, could achieve happiness for all by first addressing the 'long tragedy of pauperism' in which nine million people received legal charity annually. While the poor were the 'object of primary attention' of various social leaders, the responsibility was left as 'almost the sole employment of women', complained Martineau (1834, p. 62). The development of women's intellectual and practical capacities as public figures, she maintained, was central to ameliorating the lives of the operative classes.

A similar approach framed Martineau's *How to Observe Morals and Manners* (1838). Written in 1834, during her journey across the Atlantic to America, scholars consider it the first work on sociological methods (Martineau & Lipset, 1968, p. 7). Martineau described it as a study on the 'science of morals'; she wished to kindle readers' awareness of moral

progress in relation to mutual cooperation through object-oriented ethics (Martineau & Hill, 1989, p. 15). Like Bridges, and Durkheim nearly sixty years later, Martineau was concerned with the 'study of THINGS' — 'the eloquence of Institutions and Records, in which the action of the nation is embodied and perpetuated'. This 'DISCOURSE OF PERSONS' on 'THINGS', not limited to 'architectural remains, epitaphs, civic registers, [and] national music' afforded one more information on morals in a day than the testimony of individuals in a year (Martineau & Hill, 1989, pp. 73–74, 211–212). Such 'social objects' were positive evidence of the cooperation and the 'fraternal spirit' or the morals and manners of individuals, nations, and humanity generally (Martineau & Hill, 1989, p. 221).

Martineau subsequently published *Society in America* (1837), which was more popular at the time than Alexis de Tocqueville's *Democracy in America* (1835). Her study systematically and comprehensively treated various aspects of contemporary life. It examined the morals of American governmental policies; the economy of disparate climactic regions, including agriculture, manufacture, and commerce; and the concomitant conflicts arising between indigenous peoples and European invaders. It explored the condition of women, children, and the poor in society. Women, she professed, had been written out of the Declaration of Independence but that they were excluded from full, true democratic representation. The government held the power to unjustly take their property and to enslave, imprison, punish, and execute them for offences. As such, Martineau (1837a, p. 152) proclaimed that women should not acquiesce to the rule of law. Along these lines, she criticised the insufficiencies of women's education. Allowing women to develop critical thinking skills and practical training towards self-realisation was considered 'dangerous' or in the best case a fanciful pastime to American men. Women were denied the justice of gender equality and were pressured into learning to be a wife and a male companion in the so-called 'paradise' of indulgent male chivalry (Martineau, 1837b, pp. 226–228).

American Southerners would criticise Martineau for the abolitionist views she expressed in the study. Ever the idealist, however, she expressed ultimate optimism for the fate of the oppressed. Pointing to the work of some 800 abolitionist institutions in the North, she commented that soon few would regard America as the 'country of the double-faced pretender to the name of Liberty' (Martineau, 1837a, p. 148; 1837b, p. 368). Owing chiefly to the questions of slavery and women amidst the quiet assent of the clergy, however, Martineau (1837b, p. 369) concluded that the 'civilisation and the morals of the Americans fall below their own principles'.

And the subsequent *Letters on the Laws of Man's Nature and Development* (1851), co-written with the geologist Henry George Atkinson, made her intellectual position even more explicit. Here she controversially enticed Atkinson to explain his support for phrenology and disbelief. Enthusiastically, she attested to having been emancipated 'from the little enclosure of dogma'. Martineau championed making science the basis of all knowledge (Martineau & Atkinson, 1889, p. 289). A confessed 'atheist in the vulgar sense', Martineau rejected 'popular theology'. Her faith was in the 'positive method, and its uniform and reliable conclusions' (Martineau, 1877a, p. 351; 1877b, p. 217).

Martineau's next significant undertaking, a translation of Comte's *Cours de philosophie positivisme* (1830–42), was the 'largest enterprise with which she was ever to be engaged' (Wheatley, 1957, p. 315). Although familiar with his name for decades, Martineau first learned Comte's ideas through Lewes' *A Biographical History of Philosophy* (1845). Comte's works then became a 'singular means of enjoyment' thanks to a friend she visited in Yorkshire in 1850. By 24 April 1851, she was reading the *Cours,* and after two days of dreaming about translating it, she began planning out the project (Martineau, 1877b, pp. 366, 371–372). Comte's six-volume set of scientific lectures, each volume averaging over 750 pages, was full of repetitions written in a stuffy style. Over a period of sixteen months Martineau condensed them down to two volumes totalling 1056 pages. She introduced English readers the hierarchical classification of the positive sciences, the 'Law of Three Stages' and the static and dynamic analyses of sociology. Martineau relayed Comte's desire to bring all speculations under the auspices of the scientific method and to establish a rational basis for education. It was not a translation but an 'intellectual exercise' which brought her to tears of joy (Martineau, 1877b, p. 391).

Martineau's rationale for undertaking the project was that Comte's work 'ascertains with singular sagacity and soundness' a 'firm foundation of knowledge' as the basis for 'intellectual, moral, and social progress'. It was necessary reading, she thought, for the alienated and ethically adrift English working-classes (Martineau, 1896, pp. xxiii–xxiv). Moreover, as a feminist Martineau likely enjoyed recasting a work written by a misogynist who considered women less intelligent than men. She omitted references Comte made to his positivist church of the future and the word 'spiritual', generally, because they betrayed her view of positivism as a philosophy of science, which served as the impetus for decades of her intellectual creativity (Hoecker-Drysdale, 2001; Pickering, 2009, pp. '132–157; 2017, pp. 175–204; Webb, 1960, p. 307).

2 A BIOLOGIC-HISTORICAL OUTLOOK

Like many middle-class Victorians, Bridges' was raised in a family of strict Christian values. He was born at the vicarage, Old Newton, Suffolk to the daughter of Reverend Charles Martin, Harriet Torlesse, and

the Reverend Charles Bridges, a well-known evangelist. Bridges received a preparatory education and in 1845 entered Rugby School, the mission of which was to create upstanding, common-sense Christian citizens devoted to public life, and at the same time imbued with the romantic, moralising sentiments of Tennyson, Coleridge, and Wordsworth. He proved himself as an independent thinker, and in 1851 he won a scholarship to Wadham College, Oxford.

Here he became part of an eccentric group of students known as the 'Mumbo Jumbo club'. Alongside Frederic Harrison, E.S. Beesly, and G.E. Thorley, Bridges ritualistically enjoyed a Sunday breakfast of cold duck and discussion of the democratic and republican teachings of the Wadham don, Richard Congreve (Harrison, 1911, p. 86). Barring Thorley, this Wadham trio became the 'Congreve School' of organised British Positivism, which would become a synthesis of a debating society, scientific body, and an activist group.

As Congreve's favourite and closest follower, Bridges in 1854 became a complete adherent to Comtean Positivism. A vociferous reader and independent thinker already too set in his heterodoxy, Bridges displeased his examiners for the *Literae humaniores* course. Although known as the 'ablest man' around (M.A. Bridges, 1908, p. 70), he took a tragic third-class degree. Despite this setback, by the late 1850s, he had begun his training as a physician at St George's Hospital, London. He took a BMed at Oxford in 1859, and was admitted as a member of the Royal College of Physicians in 1860. Here, Bridges was fulfilling the requirement to practice as a Positivist sociologist and priest of Comte's utopian and sociocratic city-states.

To keep his nonconformist beliefs discrete, Bridges emigrated to Australia with his cousin-bride Susan Torlesse. After arriving at Melbourne in June 1860, she died of typhoid fever six months later. During his three-month voyage back to England, Bridges locked himself up in his cabin and translated the 430 pages of the first volume of Comte's *Système*. Published in 1865, the translation helped English readers appreciate the point of Comte's philosophy, polity, and sociology: social reorganisation.

Appointed physician at Bradford infirmary in 1861, Bridges set out to indefatigably enact the Positivist maxim, 'Live for others'. For the next seven years, he plunged into the intellectual, cultural, and industrial problems of the region. Fortified with death-rate statistics, facts he had acquired from independent sanitary surveys, and knowledge from operatives visiting his medical practice, Bridges' began to lecture on the impact of industrial life: the steam engine, alcohol, the printing press, the factory and house. Bradford ranked among the deadliest towns in England because of its poor sanitary quality of dwellings, workshops, and its 'inconceivable and intolerably monstrous' canal system, he reported. Like Martineau, he suggested such objects indicated that Englanders

'had not yet reconciled our higher civilisation to a higher form of life' (J.H. Bridges, 1862, pp. 7–27; N.A., 1862). Yet, out of the blind chivalry Martineau despised, he recommended among other social reforms the removal of women from unsanitary and unsafe working conditions.

Bridges also issued some of the 'most philosophical essays ever written on public health' during the time (E.T. Wilson, 1870, p. 42). In the 'Influence of Civilisation on Health' (1869), Bridges confined himself to the 'study of the laws . . . the constant relations which exist in social phenomena'. Like Martineau, he situated political economy and its blind accumulation of wealth as the chief ideological influence over society, and thus the successor of military, civic, intellectual, and religious values. Lacking 'sympathetic instincts', one could not anticipate in this social environment a proper education but instead a morbidly dull, monotonous, and ultimately poisonous existence. It amounted to a failure to achieve the 'Harmony of the Moral Nature' of individual and community, and thus true civilisation, claimed Bridges (1869, pp. 147–149). With historical statistics and diagrams, Bridges showed how the growth of England's manufacturing centres was supplied by workers from the deteriorating rural districts. He claimed that the 'greatest problem' of the nineteenth century was that religious and military communities had increasingly ignored the medieval notion of *noblesse oblige*.

Like Comte, Bridges called for a new 'kind of discipline, some supreme controlling influence' over the social environment: the recognition of new sensibilities in which industry and capital supplanted the military mentality, and the scientifically-trained intellect took the role once played by religion acting on beneficent principles. He envisioned the 'consolidation and revision of our whole sanitary legislation', the appointment of two hundred medical inspectors devoted to public work, the enforcement of existing sanitary laws with regard to housing, the implementation of a 'simple catechism of health' in primary education, creating new public parks, and a focus on the 'condition of the agricultural labour' as the 'reserve stock' of national health. All this represented for Bridges (1869, pp. 158–161) the 'conscious direction and modification' of the social environment by the sociological 'wisdom and the foresight of Humanity'.

Despite his Comtism, Bridges' altruistic activities were well-received. He was elected FRCP in 1867, became factory inspector for North Yorkshire in 1869, and from 1870 to 1892 he acted as a metropolitan medical inspector to the Local Government Board. Among his causes were nutrition, artisan housing conditions, child hygiene, and the prevention of smallpox and contagious diseases. Bridges also urged Mumbo Jumbo to take 'social action' in response to the 'Cotton Famine'. They opposed the application of the Poor Law to distressed operatives; exposed the misuse of charity by church leaders; polemicised against disinterested

clerics, cotton lords, and the governing aristocracy; and protested against American slavery. Bridges also relayed vigorous defences of the Manchester Martyrs and Irish home rule, and he contested England's religious and governmental intervention in Chinese affairs (J.H. Bridges, 1886; Congreve, 1866).

Turning to intellectual endeavours in *The Unity and Life of Comte's Doctrine* (1866), Bridges issued a rebuttal to J.S. Mill's strictures on the development of Comtean Positivism into an ethical creed in the *Système*. Here Bridges reveals the great extent to which Mill's recent works (1865) aligned with Comte's system of ideas. But the inconsistent ally Mill (1865, p. 29; 1905, p. 30) castigated Comte's turn to 'intellectual degeneracy' and 'hatred for scientific and all purely intellectual pursuits'. He labelled despotic Comte's calls for 'unity' via an organised spiritual power. Despite the efforts of Mill and Martineau, Bridges argued that Comte's earliest works of the 1810s through to his death expressed an enduring 'master-motive' — to provide a rational, 'renovated education' for modern world-making guided by sociology. Here unity was a central theme, and it represented the creative interplay of physical, intellectual, and moral energies converging to invigorate the collective organism of humanity (1866, pp. 28–34). The notion of unity, claimed Bridges, meant crushing neither the ego or selfish instincts, but learning the altruistic principle of subordinating the self to the common good. Following the Positivist motto '*Conciliant en fait, inflexible en principe*', Bridges (1882a, p. 47) argued Comte was no despot.

Bridges soon thereafter issued 'History an Instrument of Political Education' (1882), which contended that the purpose of education was to 'redeem modern industrial life from slavery by giving each worker a share in the inheritance of Humanity' (J.H. Bridges, 1882b, p. 8). Here the notion of 'unity' was cast in terms of political education, which encompassed religion, government, war, commerce, art, science, industry, and language as a long dramatic chain of global events that constituted the present. Like a physician examining a patient, the student of the past thus had to investigate the comprehensive history of the patient, England, and the health of its internal and external evolution by reading history backwards from the present. Beginning with contemporary assumptions, he accordingly recounted England's oppressive policies regarding the Irish, Muslims, and the Dutch in South Africa. Throughout this meandering analysis, Bridges pointed to the etymology of various scientific words as originating from and bonding together various Eastern and Western cultures. Science was not, he argued, a language of shallow nationalism but was cooperative, international, and unifying, which suggested that the advance of scientific research could eventually produce a peaceful 'global commonwealth of states', like those Comte imagined (J.H. Bridges, 1882b, p. 30).

During the late 1870s, Bridges became the first president of the English Positivist Committee. As an offshoot of the Positivist Society established by Congreve during the 1850s, it offered various social, intellectual, and cultural activities (political education) in affiliation with Positivist clubs across the world (M. Wilson, 2015). Affiliates to British Positivism initiated and supported the founding of the Sociological Society in London. Here, Bridges spoke on 'Some Guiding Principles of the Philosophy of History' (1906). He referred to the creative or 'speculative faculties' as the 'most influential agent of social movement'. These faculties are based on intellectual and religious developments and drive affections and practical activities towards social change (J.H. Bridges, 1906, pp. 200–201). Drawing on Comte's Law of Three stages, Bridges examined the advance of Western 'civilisation' by fetishist-polytheistic and theocratic leaders by way of upholding beliefs in 'unseen and arbitrary' powers, which advanced 'civilisation' through warfare and slavery (J.H. Bridges, 1906, p. 212). Examining Comte's utopia as a scientific epistemology, he expressed his belief that the third 'positive' stage of historical existence would become a 'sociocracy'. Its 'foundations will rest', he imagined, 'on scientific examination of the laws of social concord and of social progress; and that the superstructure will be a fabric of justice, freedom and mutual service' (J.H. Bridges, 1906, p. 220).

3 CONCLUSION

Martineau and Bridges shared commonalities that were not mutually exclusive to all Victorian sociologists, but these likenesses nonetheless seemed integral to their Positivist outlooks. Both examined 'things' to frame their views on social ethics. They were not only atheists but believed social progress was rooted in creating an altruistic and rational society, where science was the basis of all knowledge. Here sociology was understood as a process of observation, reflection, and proposals for social change. They both took a critical position about political economy and the exploitation of workers. Martineau defended liberating women from the spaces of the home and their near-singular role as Poor Law guardians, and she remained suspicious of trade unionism. This contrasted with Bridges' support for trade unionism, the reduction of working hours, and his desire to see women and children relieved of the factory environment. Whereas both thinkers took a critical stance on slavery, Bridges also maintained an explicitly anti-imperialist position. His intellectual and creative work focused on history and theories of social unity, and his altruistic convictions drove a practical activism to improve urban hygiene as a physician. Martineau, on the other hand, took the role of a detached observer, turning from an intellectual to an all-encompassing social commentator to influence

institutions. Thus, Martineau took the typical male Victorian role of the intellectual, and Bridges assumed the typical female role or reformer. Both considered education as central to revealing the links between inner troubles and societal issues and any meaningful social change. Whereas Martineau chiefly operated alone, Bridges led the political and social activists of the British Positivist Committee. Apart from these differences, it is clear that while Positivism informed their work, for Martineau it was strictly a practice of a scientific method linked to hopefulness about rational social change. Bridges was a full believer in the destiny of humanity as laid out in the *Système,* and he considered his lifework as a contribution towards realising Comte's utopia.The translations of both these actors helped to advance Comte as the founder of modern sociology, and their work helped to drive the institutionalisation of sociology as a 'critical-utopian' method in Britain.

BIBLIOGRAPHICAL REFERENCES

Bourdeau, M. (2006). *Les trois états: Science, théologie et métaphysique chez Auguste Comte*. Paris: Éditions du Cerf.

Bourdeau, M., Pickering, M., & Schmaus, W. (Eds.). (2018). *Love, Order and Progress*. Pittsburgh: University of Pittsburgh Press.

Bridges, J.H. (1862). *Health - A Lecture*. Bradford: James Hanson.

Bridges, J.H. (1866). *The Unity of Comte's Life and Doctrine*. London: Trübner.

Bridges, J.H. (1869). The Influence of Civilisation on Health. *Fortnightly Review*, VI(32), 140–162.

Bridges, J.H. (1882a). *Five Discourses on Positive Religion*. London: Reeves and Turner.

Bridges, J.H. (1882b). *History an Instrument of Political Education*. London: Reeves and Turner.

Bridges, J.H. (1886). *The Home Rule Question Eighteen Years Ago* London: Stanford.

Bridges, J.H. (1906). Some Guiding Principles in the Philosophy of History. In S. Society (Ed.), *Sociological Papers* (Vol. II, pp. 197–220). London: Macmillan.

Bridges, M.A. (1908). *Recollections of John Henry Bridges*. London: Privately Published.

Comte, A. (1839). *Cours de philsophie positive* (Vol. IV). Paris: Bachelier.

Congreve, R. (Ed.) (1866). *International Policy*. London: Chapman and Hall.

David, D. (1987). *Intellectual Women and Victorian Patriarchy*. Ithaca: Cornell University Press.

Discipulus. (1822). Female Writers of Practical Divinity. *The Monthly Repository*, 17(202), 593–597.

Feichtinger, J., Fillafer, F.L., & Surman, J. (Eds.). (2018). *The Worlds of Positivism*. London: Palgrave Macmillan.

Grange, J. (2000). *Auguste Comte: la politique et la science*. Paris: Éditions Odile Jacob.

Harrison, F. (1911). *Autobiographic Memoirs* (Vol. I). London: Macmillan.

Hoecker-Drysdale, S. (1992). *Harriet Martineau, first woman sociologist*. Oxford: Berg.

Hoecker-Drysdale, S. (2001). Harriet Martineau and the Positivism of Auguste Comte. In M. R. Hill & S. Hoecker-Drysdale (Eds.), *Harriet Martineau: Theoretical and Methodological Perspectives* (pp. 169–190). London: Routledge.

Levitas, R. (2011). T*he Concept of Utopia*. Oxford: Peter Lang.

Martineau, H. (1834). *Moral of Many Fables*. London: Charles Fox.

Martineau, H. (1836). *Miscellanies* (Vol. I). Boston: Hilliard, Gray.

Martineau, H. (1837a). *Society in America* (Vol. I). New York: Saunders and Otley.

Martineau, H. (1837b). *Society in America* (Vol. II). New York: Saunders and Otley.

Martineau, H. (1877a). *Autobiography* (Vol. I). London: Smith, Elder.

Martineau, H. (1877b). *Autobiography* (Vol. II). London: Smith, Elder.

Martineau, H. (1896). *The Positive Philosophy of Auguste Comte* (Vol. I): Bell & Sons.

Martineau, H. (2007). *Autobiography* (L. H. Peterson Ed.). Peterborough: Broadview.

Martineau, H., & Atkinson, H.G. (1889). *Letters on the Laws of Man's Nature and Development*. Boston: Josiah P. Mendum.

Martineau, H., & Hill, M.R. (1989). *How to Observe Morals and Manners*. New Brunswick Transaction.

Martineau, H., & Lipset, S.M. (1968). *Society in America*. Gloucester: P. Smith.

Mill, J.S. (1865). Later Speculations of Auguste Comte. *Westminster Review*, 28(1 July), 1–42.

Mill, J.S. (1905). *On Liberty*. New York: Holt.

Mills, C.W. (1967). *The Sociological Imagination*. Oxford: Oxford University Press.

N.A. (1862, 20 Nov). *The Health of Bradford*. Bradford Observer.

Petit, A. (Ed.) (2003). *Auguste Comte: Trajectoires positivistes 1798–1998*. Paris: L'Harmattan.

Pickering, M. (2009). *Auguste Comte: an Intellectual Biography* (Vol. III). Cambridge: Cambridge University Press.

Pickering, M. (2017). Auguste Comte and the Curious Case of English Women. In A. Wernick (Ed.), *The Anthem Companion to Auguste Comte* (pp. 175–204).

Taylor, C. (2004). *Modern Social Imaginaries* (Vol. Duke University Press). London.

Webb, R.K. (1960). *Harriet Martineau: A Radical Victorian*. New York: Columbia University Press.

Wells, H.G. (1907). The So-called Science of Sociology. In L. T. Hobhouse, P. Geddes, B. Kidd, et al. (Eds.), *Sociological Papers* (Vol. III, pp. 357–369). London: Macmillan.

Wernick, A. (2001). *Auguste Comte and the Religion of Humanity*. Cambridge: Cambridge University Press.

Wheatley, V. (1957). *The Life and Work of Harriet Martineau*. Fair Lawn: Essential Books.

Wilson, E.T. (1870). Public Health. *The Labourers' Friend*, N.A. (232), 36–42.

Wilson, M. (2015). On the Material and Immaterial Architecture of Organised Positivism in Britain. *Architectural Histories*, 3(1), 1–21.

Wilson, M. (2018a). British Comtism and Modernist Design. *Modern Intellectual History*, 1–32.

Wilson, M. (2018b). *Moralising Space*. London: Routledge.

Form and function regulating creativity and facilitating imagination: Literary excursions in the diary of my great-grandfather

Jakob Dahlbacka

Department of Church history at the Faculty of Arts, Psychology and Theology at Åbo Akademi University, Turku, Finland

ABSTRACT: My great-grandfather, Ture Dahlbacka, kept a diary during his National (military) service, which lasted from 1922 to 1923. The main reason for keeping a diary appears to have been to serve as an imagined, private space in a setting where everything private must have been a commodity in short supply. Throughout the journal, his home village – Kortjärvi, located in the Northern parts of Swedish speaking Ostrobothnia – stands out as an antithesis to the garrison. It is to Kortjärvi that his mind flees in the long and lonely hours of service; remembering the place where he grew up becomes his sanctuary, his haven of refuge.

Referring to Mikhail Bakhtin, the home village in the diary can be said to serve as a "chronotope of the idyll". In this article, I discuss how both the diary form, and the memories of his home village that Ture uses to create the idyllic chronotope, are dependent upon a creative and almost nostalgic act, but also restricted to and thus affected by certain conventions. At the same time, these very same memory constructions allow him to imagine a future after, and outside of the military.

Keywords: Chronotope of the idyll, Diary, Memory, Ostrobothnia

1 INTRODUCTION

My great-grandfather was called Ture. He was born in New York in 1898, but moved to Finland only a couple of years later. He lived practically all his life in a small village called Kortjärvi in the northern parts of Swedish-speaking Ostrobothnia. The only times he left his home village for a longer period of time, was when he was called up for National (military) service in the town of Vasa between 1922 and 1923, and when he was called up for duty in the armed forces in the so-called Finnish Continuation War, between 1941 and 1944. This article deals with his nine months of military service 1922–1923. During this time, he kept a journal, which will serve as the primary source of this article. The diary is not published, but kept by the author of this article. It is planned to be published later in 2019.

After an introductory presentation of the diary, followed by a brief discussion of its value as a historical source, I will continue with a discussion on how both the diary form and what seems to be the function of the diary, affect the literary creativity expressed in it.

2 THE DIARY OF TURE DAHLBACKA

The diary under scrutiny in this article was written by hand in two slender booklets. It spans slightly more than nine months, from the late autumn of 1922 to the late summer of 1923. It therefore qualifies as a so-called "diary of situation", namely a diary that begins – and sometimes ends – with a specific event or situation (Kagle, 1986, p. 3). Ture's diary begins with him being called up for military duty, and ends at his discharge. There is nothing to indicate that he had ever kept a diary before this time – nor that he continued afterwards.

There is also a great deal in the diary that points towards Ture writing primarily for himself and not for a prospective audience. A comparison could be made to Linnéa Johansson, a maid in Ångermanland, Sweden in the 1930s, whose diary-writing aimed at creating continuity and safety in a fickle existence by offering a "written room in between the covers of the diary" in an environment where private space must have been a precious commodity (Edlund, 2007, p. 21).

The conditions must have been somewhat similar for Ture in the garrison, where the living space, if possible, was even more tangibly restricted. In that environment, the diary offered him a space – an imagined written room – where he was able to go for refuge. On several occasions, he repeats what turns out to be a sentence from a book by the German author Jean Paul: "Memory is the only place from which we cannot be driven" (Richter, 1842, p. 80). One or two times, and in an equally poetic manner, he states: "memories are golden threads in the dark weave of the military life." The memories he refers to are the ones of his home village.

Figure 1. Ture Dahlbacka in military uniform. (Photo, with the author).

3 THE DIARY AS A HISTORICAL SOURCE MATERIAL

Using diaries as source material has not always been considered unproblematic within the field of historical research. Partly, the drift behind the critique is the view that what is found in a diary is not objective, and that it is not possible to make generalised assumptions based on it. This is somewhat due to a widespread assumption that the authors behind the diaries cannot be considered ordinary and average, and therefore they are not representative.

The historian Britt Liljewall describes this somewhat outdated attitude as a focus on the structure at the expense of the individual – where the confidence in the criticism of the sources is disproportionately strong. From a Swedish perspective, considerable change has occurred since the 1980s. Nowadays, more ordinary and commonplace sources are also credited with significance and considered important, and the criticism of the sources – in contrast to what used to be the case – not only aims to determine whether a source is useful or not, but the way in which it is useful (Liljewall, 2007, p. 53–55).

On a general level, this change in attitude stems from what is usually called the linguistic and cultural turn by the social and cultural sciences. For historical research, this turn has increased interest in the mundane existence of people, in their everyday lives, and in how history has taken form in the imagination and perception of ordinary people. A shift from structure to experience has also led to a demand for people's feelings, ideas etc., and to a renegotiation of what can

be used as a source (Johansson, 2013; Iggers, 2005, pp. 101–117; Salomon, 2009, pp. 68, 73, 76, 80). Types of historical research such as "history from below", "microhistory", or "Alltagsgeschichte" – which focus not so much on the elites of society but on groups of people that have previously been dismissed or relegated to the margins – have gained territory (Götlind & Kåks, 2004, p. 25). A quite telling description, used by Judy Young, is "documentary source material", which aims at strengthening and elucidating archive material (Judy Young, 2015, p. 6). She refers to James E Young, who says that the value of autobiographical texts, such as diaries and letters, is that they offer the reader knowledge of an event, not necessarily evidence of that event (James E. Young, 1990).

Apparently, the critique nowadays is levelled against persistent tendencies towards interpreting the reality with the aid of all-embracing theoretical systems, and against a predominant insistency on universal truth and representativity. The aim, for instance with microhistory, is rather to nuance, complement, or problematize a simplified overall picture with the help of particular, non-representative examples (Sivelius, 2018; Liljewall, 1995, p. 51).

4 CONVENTIONS OF THE DIARY FORM REGULATING THE CREATIVE WRITING PROCESS

It is common to believe that diaries offer unique and instant glimpses of their authors' inner worlds. At the same time, there is no doubt that diaries often – even when they claim to depict their author's world of ideas and feelings unreservedly – are influenced and regulated by societal and literary conventions (Stowe, 2002). This implies that letters and diaries written at the same time in history tend to resemble each other and – intentionally or unintentionally – follow specific basic patterns concerning the design, disposition, style, theme etc.

Such patterns might be slight and subtle, such as writing as if the diary were a human being – "dear diary" – or using the letter genre as a blueprint when writing the diary, e.g. ending each day with a salutation (Edlund, 2007, p. 13). Alternatively, they can be concerned with more extensive thematic similarities such as systematically keeping track of and reporting on the weather, making notes of events in the home village, or keeping accounts of journeys.

Steven Stowe uses the image of a manuscript to describe the relationship between the conventions (script) and the diary (performance of the script). Therefore, he states:

> The historical richness of these texts is found precisely in the friction between the general form available to all writers and individuals' use of it for their own purposes (Stowe, 2002).

One type of diary that follows patterns characteristic of its time is the so-called peasant diary, which, especially in Sweden, has aroused the interest of researchers (Larsson, 1992). To some extent, the diary of Ture resembles these peasant diaries. One of their characteristics is that they are taciturn and choppy – although often the notes are very regularly written – and outline the life of the farm and countryside. They are sometimes called "weather- and workbooks" because the weather reports take up so much of their content (Edlund, 2007, p.'7).

In all probability, the frequent and recurrent entries in Ture's diary that touch upon the weather, and which I will return to later in the article, are remnants from these peasant diaries half a century earlier. For Ture, who was also a farmer, it was a natural thing to keep track of the daily weather. It gave the workday and the season a tangible and clear structure.

The point is that several items in Ture's diary – the frequent but taciturn notes, the recurrent weather reports etc. – suggest his dependence on external patterns or conventions, which – alluding to the conference theme – must be regarded as more or less regulating the creative writing process. One could even argue, just as I will in the following paragraph, that Ture's recurrent references to his home village are partly due to, or at least influenced by, certain common patterns and strategies of storytelling.

5 THE HOME VILLAGE AS A CHRONOTOPE OF THE IDYLL

As pointed out in the introduction, a central theme in Ture Dahlbaka's diary is his frequent and recurring references to – and his memories and descriptions of – his home village Kortjärvi. This is not merely a reconstruction after the event, or a rationalisation made by me, but something that Ture himself notices and writes about in the diary:

> Surprisingly enough, my thoughts are almost always in my home village, even though I am far away.

On the very first page of his diary, this familiar and safe provincial town is already contrasted with the garrison (located in Vasa, a relatively large city compared to Kortjärvi), which he – even before having arrived there – predicts will turn out to be a "misery without an end".

This dichotomisation or polarisation continues all the way through the diary. For instance, the noise, and the experienced sense of captivity in the military, is contrasted with the calmness and freedom represented by home. In addition, the dreary inspections of military equipment, the drills, and the occasional visits to the movies (almost considered a hotbed of sin for anyone with a revivalist background) are compared to the more desirable church services or social gatherings Ture attended at the folk school in his home. Whereas

the military, in Ture's diary, stands for the unknown and the frightening – change, if you will, – his home village represents stability and security – tradition.

Several concepts could be used to describe and analyse the function of the home village as it appears in Ture Dahlbackas diary – "Nostalgia", "Heimat", "Topophilia", "local patriotism" being some that come to mind. Most convenient in this case, as a unit for analysing a text, might be the concept of "chronotope" – more precisely "the idyllic chronotope" – as introduced by the Russian literary scholar Mikhail Bakhtin. In addition, I believe that applying the concept of the chronotope as a conceptual tool to this particular empirical material, will offer some interesting insights about the theme of the conference – creativity and fantasy (in this case understood primarily as imagination and reverie).

Admittedly, the concept and usage of the chronotope can hardly be considered unambiguous, since it may simultaneously refer to literary genres (e.g. the adventure novel), key themes (e.g. the meeting, the road), and scenarios (the idyll) as well as, for instance, to specific characters within a novel (Aronsson, 2009, p. 17). To complicate things even further, a chronotope "can include within it an unlimited number of minor chronotopes" (Bakhtin, 2008, p. 252).

Generally speaking, a chronotope – literally meaning time-space – is "the intrinsic connectedness of temporal and spatial relationships that are artistically expressed in literature" (Bakhtin, 1981, p. 84). According to Bakhtin:

> In the literary artistic chronotope, spatial and temporal indicators are fused into one carefully thought-out, concrete whole. Time, as it were, thickens, takes on flesh, becomes artistically visible; likewise, space becomes charged and responsive to the movements of time, plot, and history.

Thanks to their representational function, and their metaphorical significance, chronotopes make the narrative events concrete and palpable (Bakhtin, 2008, pp. 250, 158–159). In a way, they could be described as generic templates, symbols, or motifs that convey and enhance the narrative by representing specific and universal themes.

The concept of "narrative abbreviation", used by scholars in history, might illuminate the concept of chronotopes, even though they are not identical. In short, a narrative abbreviation is a linguistic expression (a word or a concept) that in a historical culture (a specific situation or context) vigorously (in an abbreviated form) can represent a phenomenon in the past (as in a concentrated narrative retelling a historical event). Narrative abbreviations exist everywhere and in all languages (Olofsson, 2013:) They have the capacity of "dissolving into narrative form and converting into a more or less embroidered story", even though it is not a story in itself (Rüsen, 2004, p. 157). Whereas the narrative abbreviation retells a specific historical

event, the chronotope seems to be more universal and mouldable depending on the time and context. It represents an idea, and is not dependent on the audience being familiar with a specific historical event.

One such chronotope with a symbolical meaning is what Bakhtin calls the "chronotope of the idyll". In the idyll, time moves in cycles, things go on just as usual, and people live in proximity to nature, which plays an important role for the idyll. The idyll is characterised by a special relationship between time and space. Bakhtin describes it as:

> an organic fastening down, a grafting of life and its event to a place, to a familiar territory with all its nooks and crannies, its familiar mountains, its valleys, fields, rivers and forests, and one's own home. Idyllic life and its events are inseparable from this concrete, spatial corner of the world where the fathers and grandfathers lived and where one's children and their children will live. This little spatial world is limited and sufficient unto itself, not linked in any intrinsic way with other places, with the rest of the world (Bakhtin, 2008, p. 225).

Bakhtin continues:

> Time here has no advancing historical movement; it moves rather in narrow circles: the circle of the day, of the week, of the month, of a person's entire life. A day is just a day, a year is just a year – a life is just a life. Day in, day out the same round of activities are repeated, the same topics of conversation, the same words and so forth. - - - This is commonplace, philistine cyclical everyday time. - - - Time here is without event and therefore almost seems to stand still. - - - It is a viscous and sticky time that drags itself slowly through space (Bakhtin, 2008, p. 247–248).

Ture's description of his home village, and the function it plays in the military diary, fits very well within Bakhtin's description of the chronotope of the idyll. Just as in the idyll, time, in Ture's descriptions of Kortjärvi, seems to stand still and move in cycles. For instance, when writing about what he has been doing on a Sunday, or on a Wednesday, Ture's mind instantly travels back to Kortjärvi, where both Sundays and Wednesdays imply specific and self-evident activities that seem to repeat themselves week after week.

> Sunday. It's been a constant rush and tear. [...] We're just about to march off towards the movie theater. I would much rather take part in a Bible class, which used to be customary back home. [...] It is Wednesday evening now. I reckon there's a gathering at the folk school right now. If only one had the chance to be there.

For Ture, Sundays apparently trigger memories of earlier, weekly visits to the Prayer house, while Wednesdays recall his memories of social gatherings at the folk school, which were equally regular and recurring.

Another example is when writing about the Christmas celebrations in the military, something that

Figure 2. A marriage arranged outdoors in Kortjärvi. (Photo, with the author). According to Bakhtin, the idyll is limited to a few of life's basic realities, such as marriage, labour and food.

Figure 3. Ture's vision of the idyll: his home in Kortjärvi, as seen from one of the many lakes in the district. (Photo, with the author).

reminds Ture of the traditions in his home village. Dejected he states:

> I really didn't find any peace when going to bed. I'm certainly not used to celebrating Christmas eve in such a manner. [...] Back home one certainly used to celebrate the third day of Christmas like a Sunday, surely not like this. [...] When the meeting at the prayer house had ended, I walked back to the barracks to dream about last year's celebrations.

Within the idyll, the same round of activities keeps repeating themselves year after year. Nothing is changed, nothing is challenged.

Secondly, according to Bakhtin, life in the idyll is close to nature:

> There is finally a third distinctive feature of the idyll, closely linked with the first: the conjoining of human life with the life of nature, the unity of their rhythm, the common language used to describe phenomena of nature and the events of human life (Bakhtin, 2008, p. 226).

This too, is very tangible in the diary. Many, if not most, of Ture's recollections of home spring to his mind when the weather is lovely. Several times, he expresses his opinion about nature being unique in his home village.

How beautiful it is tonight. The full moon is shining. How much it reminds me of what has been before. [...] How beautiful it was tonight. It was almost delightful to be outside. The full moon shined so bright. It reminded me of so many things from before. So many moments from my native district. [...] There's plenty of time to think when standing alone in the night-time. Thoughts drift so easily back in time to moments I've been back home and walked together with [unclear writing] during moonlit nights. It's so easy to drift away on the blue lake of memories. Or slowly to swing back and forth on the calm waves of thoughts...

6 THE FUNCTION OF THE IDYLL RENDERING POSSIBLE FANTASIES ABOUT THE FUTURE

According to Bakhtin, the idyll does not account for any primary time in the story, but is instead a "contrasting background for temporal sequences that are more charged with energy and event" (Bakhtin, 2008, p. 248). Even though this primarily concerns novels – where the destruction of the idyll has been a central theme ever since the 18th century (Bakhtin, 2008, p. 233) – it is certainly applicable to Ture's diary as well. Here, the home village serves as a background for the military, which in its turn must be regarded as the primary time in the story. This results in the "good life" of the idyll accentuating the dreariness and misery of the military life, and vice versa. On a personal level, the military does seem to have posed an immediate and substantial threat to what Ture considered to be his safe haven – Kortjärvi.

With the examples given above, I have tried to show, that in order to establish and maintain this idyllic background, a condensation, thickening, or solidifying of time and place into a concrete whole is necessary. As a consequence, Ture's memories become, in a way, simplified or distorted. Most probably, even in Kortjärvi, Sundays and Wednesdays contained more than merely visits to the Prayer house and the folk school. However, in Ture's memory, and in his notes, these days are reduced to – fused or condensed into – these single activities. Likewise, at least as far as can be judged from the diary, the weather in Kortjärvi is always pleasant. Certainly, this was not the case in reality. Occasionally, there had to be clouds and rain even there, even though they have no place in Ture's memory or his diary.

Bakhtin quite poignantly speaks of how this kind of descriptions of the ordinary everyday life is expressed in a "softened" and even "sublimated" form:

Strictly speaking, the idyll does not know the trivial details of everyday life. Anything that has the appearance of common everyday life, when compared with the central unrepeatable events of biography and history, here begins to look precisely like the most important things in life. But all these basic life-realities are present in the idyll not in their naked realistic aspect but in a softened and to a certain extent sublimated form (Bakhtin, 2008, p. 226).

In other words, it seems as if the function of the diary – more precisely the chronotope of the idyll – in a way influences Ture's memories of his hometown, lending them an almost romantic or nostalgic light. No wonder, Svetlana Boym, when speaking of nostalgia, defines it as a "sentiment of loss and displacement" but also "a romance with one's own fantasy" (Boym, 2001, p. xiii). Alternatively, to put it in the words of Bakhtin – Ture's portrayal is not nakedly realistic, but softened and sublimated.

Interestingly enough, Ture seems to be well aware of this fact. On the very last page of his diary, he writes about the difficulties any diarist encounters:

My notes in the diary from my military service end here. However, generally, one ought not to be writing down notes. It could be likened to a wanderer who walks along the road where a large number of flowers, thorn and thistle grow. The wanderer starts collecting the thorn and the thistle, but forgets the flowers. Likewise, one records the hardships and difficulties in life, but easily forgets what is bright and easy.

Ture admits to having overstated the downside of military life – or at least to have given it a disproportionate amount of attention at the expense of the positive. This is achieved partly by sublimating the memories of his home village, since it has enhanced the contrast between the two.

However, at the same time, these very same nostalgic memory constructions are the same ones that allow Ture to imagine a future after, and outside of, the military. Several times, Ture describes himself as a dreamer, nourishing himself on the memories of the good old days:

I live in the world of dreams. A dreamer is sometimes happy. [...] Memory is the only paradise, from which we cannot be expelled. [...] He [Ture, most probably, is here talking about himself in third person] walks, lost in thoughts that eventually turn into dreams. He dreams about the blissful times that have passed. He has to live solely on memories of what has been. Memories – these golden threads in the dark weave of the military life. He dreams about bright summer days that will come. However, such castles in the air often collapse.

The sublimated memories of the idyllic home village make it possible for him to fantasise about life beyond the military.

BIBLIOGRAPHICAL REFERENCES

Aronsson, Peter. (2008) Historia som förebild. Den gode, den onde och den fule. *Platser för en bättre värld. Auschwitz, Ruhr och röda stugor.* Peter Aronsson (Ed.). Lund: Nordic Academy Press.

Bakhtin, Mikhail M. (1981) *Dialogic Imagination: Four Essays.* Michael Holquist (Ed.). Austin: University of Texas Press.

Boym, Svetlana. (2001) *The Future of Nostalgia.* New York: Basic Books.

Edlund, Ann-Catrine. (2007) Vardagens skrivande. *Västerbotten* 1/07.

Götlind, Anna & Kåks, Helena. (2004) *Handbok i konsten att skriva mikrohistoria.* Stockholm: Natur och kultur.

Iggers, Georg. (2005) Historiography in the Twentieth Century: From Scientific Objectivity to the Postmodern Challenge. Middletown, CT: Wesleyan University Press.

Johansson, Alf W. (2013) Dagböcker ger inblickar i beslutshierarkiernas toppar. *Respons* 2/2013.

Kagle, Steven E. (1986) *Early Nineteenth-Century American Diary Literature.* Boston, Twayne Publishers.

Larsson, Bo. (1992) *Svenska Bondedagböcker. Ett nationalregister.* Stockholm: Nordiska museet.

Liljewall, Britt. (1995) Bondevardag och samhällsförändring – studier i och kring västsvenska bondedagböcker från 1800-talet. Göteborg: Hist. inst.

Richter, Johann Paul Friedrich. (1842) *Jean Paul's Sämmtliche Werke.* Zwei und dreissigster Band. Berlin: G. Reimer.

Jörn Rüsen. (2004) Berättande och förnuft. Historieteoretiska texter. Göteborg: Bokförlaget Daidalos.

Olofsson, Hans. (2013) "Hiroshimagrejen liksom". Om narrativa förkortningar och historiskt meningsskapande hos högstadieelever. *Kritiska perspektiv på historiedidaktiken.* David Ludvigsson (Ed.). Historielärarnas förening.

Salomon, Kim. (2009) Den kulturella vändningens provokationer. *Scandia* 75 (1).

Sivelius, Inna. (2018) Mikrohistoria nyanserar bilden av det förflutna, Curie, 26.4.2018.
https://www.tidningencurie.se/nyheter/2018/04/26/mikrohistoria-nyanserar-bilden-av-det-forflutna/

Stowe, Steven. (2002) Making Sense of Letters and Diaries. *History Matters: The U.S. Survey Course on the Web.* http://historymatters. gmu.edu/mse/letters/

Young, James E. (1990) Writing and Rewriting the Holocaust: Narrative and the Consequence of Interpretation. Indiana, UP: Bloomington.

Young, Judy. (2015) History or Fictionalized Truth in Fenyö's Diary Az elsodort ország (A Country Swept Away). *Comparative Literature and Culture*, Vol. 17 Nr. 3.

Translanguaging as a creative and enriching practice

Renata Seredyńska-Abou Eid
School of Education, University of Nottingham, UK
ORCID: 0000-0002-7977-1646

ABSTRACT: *Translanguaging* as a language practice is creative and enriching for individuals and societies. The diversity observed within communities of the modern world seriously challenges the systemic boundaries of languages, attitudes and meanings. *Translanguaging* is a multimodal phenomenon that transcends borders, codes and interpretations and is thus empowering for individuals. This paper explores the concepts of *translanguaging* and *creativity* and draws upon relevant examples of communication of Polish migrants in the UK.

Keywords: Translanguaging, creativity, enriching practice, language practice, Polish migrants

1 INTRODUCTION

The linguistic realities of the contemporary world go far beyond well-established conceptions of languages as individual entities, with clearly drawn boundaries that separate native speakers from non-native users of a language. The term *translanguaging* has been used with reference to a range of multilingual and multimodal activities that involve using the resource of at least two named languages to generate meaning in users' discursive practices. These can be frequently observed in bilingual and multilingual spaces worldwide. Although the process of applying linguistic resources from an individual's repertoire seems complex, it is undoubtedly *creative* and therefore *enriching* for bilinguals, multilinguals and their surrounding environment.

This paper explores the concepts of *translanguaging* and *creativity* in order to demonstrate the inventiveness and richness of multilingual communication that transcends pure-form language(s), their perceived boundaries and linguistic systems. The *creative* essence of *translanguaging* makes the process of meaning construction empowering and enriching for individuals. This is illustrated by examples of translanguaging that were observed in a qualitative mixed-methods study *Translating Cultures, Adapting Lives (TCAL)* (Seredyńska-Abou-Eid, pending[1]). These are further supported by instances of such practice mentioned in the literature of the field.

1. The examples discussed in this paper were observed during the Translating Cultures, Adapting Lives doctoral project by the author and are included in the thesis, which is currently in the corrections stage.

2 CONCEPTUALISATIONS OF TRANSLANGUAGING AND CREATIVITY

Both terms, *translanguaging* and *creativity*, are concepts that refer to processes and practices rather than established theories. Since *creativity* is an underpinning feature of *translanuaging* activities while their outcomes are often exemplifications of creative outcomes, the correlation between the two concepts is apparent.

3 TRANSLANGUAGING

In recent years, there has been research development to explicate the understanding of translanguaging and to distinguish it from other terms used in bilingualism, multilingualism and language studies, such as *code-switching*, *code-mixing*, *hybrid language practices*, *multilanguaging*, *polylanguaging*, *diglossia*, *heteroglossia*, etc. Those terms refer to activities in which individuals employ more than one language to generate meaning. Yet, the notions of mixing or switching hint an existence of a barrier that needs to be overcome and consolidate the common assumption that languages are individual entities that operate within boundaries.

Translanguaging, however, serves as an 'all-encompassing term for diverse multilingual and multimodal practices' (Li, 2018). This view resonates with the 'translation turn' in social studies, as indicated by Susan Bassett and Andre Lefevere (1998), and a 'cultural turn' in translation studies (Bassnett 1998). The term itself is attributed to the Cen Williams's (1994) study on pedagogical practices in the Welsh language revitalisation programmes, in which the practice of

generating English-Welsh responses was named as *trawsieithu*, later translated into *translanguaging* (Li, 2018, p. 15). Furthermore, *translanguaging* derives from the concept of *languaging*, an idea proposed by scholars in the 1990s (cf. Becker 1991) and 2000s (cf. Swain 2006, Swain and Lapkin 2011). It is defined as an 'activity of mediating cognitively complex ideas using language' (Swain and Lapkin 2011).

Hence, *languaging* is seen as a 'continual activity' (Becker 1991), not just a thought or an output, which would hint complete entities (Swain 2006). Instead, 'languaging completes thought' and is crucial for higher mental processes (Swain and Lapkin, 2011, p. 106). Similarly, *translanguaging* refers to 'going beyond' languages (Li, 2018, p. 23) and to engaging by individuals their varied linguistic resources and language repertoire into their everyday communication in socially, culturally and linguistically diverse contexts (Creese et al. 2018).

Recent studies on cognition indicate that human cognitive processes cannot be divided into linguistic and non-linguistic ones as learning, perception and communication are characterised by multimodality, multi-competence and multisensorial nature (Li, 2011 and 2018). Neurolinguistic evidence in bilingualism studies (Abutalebi et al., 2007, p. 488) suggests that

> the bilingual brain cannot be considered as the sum of two monolingual systems, but is rather a unique and complex neural system which may differ in individual cases.

More recent studies cited by Li (2011 and 2018) also show clear interdependencies between language and other cognitive systems; therefore, for Li (2018), *translanguaging* surpasses the linguistic and non-linguistic division as it gives prominence to various uses of languages for the purpose of cross-contextual interpretation of signs and communication of meaning. Hence, in a *translanguaging* perspective, individuals flexibly use their communicative repertoire, instead of the individual languages they can speak, and apply the resources that they find suitable in a specific situation (Creese et al., 2018). Such an engagement is often rooted in their socio-cultural experience while at the same time it leads to new encounters. Therefore, the communicative repertoire is constantly adjusted. Garcia and Li (2014), however, point out that in its transcendental nature, *translanguaging* is not about synthesising separate systems or creating hybrid patterns of communication. It is rather a new language practice that reveals the complexities of modern multilingual spaces. Hence, Li (2018) frames *translanguaging* as a practical theory of language.

4 CREATIVITY

Defining *creativity* is a challenging task as it is itself uncreative due to limits it imposes on the meaning of the term. Yet, attempts have been made within and beyond academia. For Ken Robinson (2013 and 2015), an advisor on education in arts, 'define[s] creativity as a process of having original ideas that have value'. This definition, however, seems very simplistic and does not seem to acknowledge any previous research on creativity.

Although poets William Wordsworth and Samuel T. Coleridge debated *creativity* and *deep thinking* around 1800 (Christensen, 1946), it was not until 1950 that academic interest in the Anglophone world started with Joy P. Guilford's article in *American Psychologist*. According to Christensen (1946), for Coleridge the nexus of *creativity* was *association* while Wordsworth affiliated *creativity* with *perception* and *feelings*; hence, he used the term *creative sensibility*. For Guilford (1950), *creativity* in humans is a psychological factor alongside intelligence. Therefore, research on *creativity* gained attention within education studies.

For John Dewey, a precursor of *pedagogy of creativity* in the 1970s, the idea of *creative activity* being an *intellectual activity*. As crucial elements of the latter, he identified *inventiveness, novelty* and *originality* of attitude (Diaconu, 2016). Although it corroborates Guilford's view on *novel ideas* being a basis for creativity, it is in contrast to Götz's (1981, p. 298) definition of *creativity*, which can be summarised as 'the process of making'. His definition debate involved two perspectives: etymological and procedural. In terms of the first approach, Götz emphasises that *creativity* should be distinguished from *thinking*, in the form of guessing or discovering, *originality*, *products* or *capacity*. Regarding the stages of the *creative process*, *creativity* should not be confused with any of the procedural elements, such as *preparation*, *incubation*, *insight* or *concretisation*.

Further scholarly work on conceptualising *creativity* included *psycho-dynamic*, *cognitive*, and *confluence* approaches as well as *thinking styles* (Sternberg and Lubart, 1999). While within the psycho-dynamic perspective the focus is rather on the unconscious and on human subconscious drives, the cognitive approaches advocate creative thought that comprises numerous mental processes, including '*retrieval, association, synthesis, transformation, analogical transfer*, and *categorization*' (Sternberg and Lubart, 1999, p. 7, own emphasis). This seems to be in line with confluence approaches, in which the multiplicity of components is seen as a basis for *creativity* to be observed. As further support, Sternberg refers to his 1985 study that also brought to light implicit elements of personality and cognition, such as *motivation, inquisitiveness, ability to connect ideas, flexibility, unorthodox approach* or *questioning societal norms* (Sternberg and Lubart, 1999).

The beginning of the 21st century directed attention to creativity within emerging technologies. There seems to be a particular focus on artificial intelligence

(AI) and its *creative agency*, though the latter is debated as to what extent it is possible (d'Inverno, 2019).

5 TRANSLANGUAGING AS CREATION

If *translanguaging* is a cognitive process that goes beyond named languages and *creativity* is an intellectual process including retrieval of information, categorisation and transformation, to recall just a few of its elements, the link between the two concepts seems apparent. Sternberg and Lubart (1999, p. 7) assert that '[c]*reativity* arises from the tension between conscious reality and unconscious drives'. Li's (2018) perception of *translanguaging* as a dynamic language practice stemming from competing or conflicting meanings interpretations, yet, while *translanguaging*, communicators break boundaries between languages and conventions rather than blend or mix them. This often results in the formation of new elements and new meanings or in the adjustment and generation of a more accurate meaning, which in essence is *creative*. The choice of semiotic resource, however, is rather subjective and involves individual's experience, socio-cultural background, environment, attitude and personal preferences.

Zhu et al. (2017) and Li (2018) propose the concept of *translanguaging space*, a space created by and for *translanguaging* practices, in other words through 'deployment and orchestration of multilingual, multimodal, multisensory and multi-semiotic sense- and meaning-making resources' (Zhu et al., 2017, p. 429). The examples of *translanguaging* in those two articles refer to the context of Singaporean Chinglish (Li, 2018) and a Polish shop in London. To actually demonstrate the whole process of *translanguaging* and meaning creation, the authors use named languages to illustrate which elements of the exchanges, utterances and communication originate from which language and explain the created meaning. Li (2018) emphasises that many of the examples of Chinglish are not comprehensible for a monolingual speaker, which frequently seems to be the case in *translanguaging space*. This is due to insufficient knowledge of a monolingual speaker to comprehend the entire expression, its context and the reasoning behind the creation, which is not problematic for a *translanguaging* individual who is flexible and less restrained in their communicative zone. The fluidity of *translanguaging spaces* reflects all shades of *creativity*.

6 TRANSLANGUAGING OBSERVED IN THE TCAL STUDY

The TCAL project was a mixed-methods qualitative study aimed at exploring the role of translating cultures in the acculturation processes of Polish post-accession migrants in the UK and conducted in the years 2013-14 (Seredyńska-Abou-Eid, pending). In addition to a questionnaire and semi-structured interviews, ethnographic observation proved to be an invaluable method for collecting language data as the observed interactions provided language produced entirely naturally in authentic contexts, not in arranged situations.

Examples of *translanguaging* obtained in the study depict purposeful contextualised adaptation of English terms that are non-existent in Polish, which seems to be targeted at meaning precision. One term seems to be particularly commonly used by Polish migrants in the UK:

w UKeju
[transl: in the UK]

It represents the adaptation of an English term to reflect the specificity and precision of the name of the country. In Polish, similarly to many other European languages, the names England or Great Britain are frequently used with reference to the UK, where such a selective usage can be offensive through its exclusionary effects. Hence, Polish migrants adopted the original term, but in a partly polonised form, i.e. often the pronunciation of the letters remains English /ju: ke?/, but for declining the term, a Polish preposition for location (PL: w) with a relevant Polish inflection for the locative (Loc.) are added.

Another example also depicts contextualised use of a term that is specific to the professional environment of bus drivers:

Jeżdżę dablem.
[transl: I drive a double-decker]

Since there is a lack of a direct equivalent of the term in Polish as double-decker buses are not common, one would have to use a complex descriptive term, such as *autobus piętrowy* [= a multi-storey bus] or *autobus dwupoziomowy* [= a two-storey bus]. Furthermore, the phrase in Polish needs to include the word 'bus' (PL: *autobus*) to convey the meaning, so it is far less convenient than the English compound noun. Therefore, Polish drivers in the UK adopted the local term and polonised the spelling (i.e. *dabl* or *dabel*) and the sounds.

The above examples illustrate innovative, yet practical ways, in which new meanings have been generated to reflect the cultural specificity of items in question. The third example refers to a brief exchange between a woman and a man accompanying her, or rather her monologue, in a casual situation when the couple were returning from town, and on the bus, the woman was looking at her purchase and expected the man to praise it or at least to comment on it. This example demonstrates a purposeful choice of the word 'nice' while the rest of the utterance is structured in Polish. Language purists could argue that using a Polish word in this exchange would equally convey a complete meaning; however, it needs to be noted that in Polish

this structure would require an adjective describing the object of purchase, so it would also have to be of gender. The English word 'nice', however, can be used not only as a descriptive adjective assigned to a noun but also as an adverb in a commentary to a whole situation. This could be the case in this example as the woman potentially expected a comment on the whole idea of purchasing the item, not only a confirmation of the qualities of the product. Although it could also be debated of which of the two named languages the repetition of the word 'nice' is more typical, the emphatic intent is rather explicit.

> Woman: Nice?
> Man: –
> Woman: No powiedz, <u>nice</u>, czy nie <u>nice</u>?
> [Tell me, nice or not?]

The fourth example, an exchange between a mother and her eight- or nine-year-old son, demonstrates how the boy is attempting to appropriate British and Polish Easter customs.

> Boy: Święta w Polsce? Mają święta w Polsce?
> (transl: Festive celebrations in Poland? Do they have festive celebrations in Poland?)
> Mother: Tak, teraz będzie Wielkanoc.
> (transl: Yes, now there will be Easter.)
> Boy: Aaa! Mają <u>Easter</u> w Polsce!
> (transl: Oh! They have Easter in Poland!)
> Mother (emphasizing the Polish term):
> Wielkanoc! Wielkanoc!
> Boy: Tak, mają Wielkanoc w Polsce i <u>chocolate eggs</u>.
> (transl: Yes, they have Easter in Poland and chocolate eggs.)
> Mother: Nie, <u>chocolate eggs</u> są w Anglii. W Polsce nie ma.
> (transl: No, they have chocolate eggs in England/ Britain. In Poland they don't.)

The boy is clearly familiar with some terminology in English and is successfully manipulating all his language to keep the conversation on track while the mother focuses on the distinctions, which becomes apparent in her translation of his English terms into Polish. Furthermore, the emphasis on the Polish name of Easter shows her irritation with the boy's English interference. Yet, he successfully sustains the exchange while the mother does not manage to maintain her initial consistency with the language division and eventually provides the boy with false information about chocolate eggs. The latter exist in both cultures, though in slightly different forms; however, in Poland the most popular figure for Easter is a chocolate bunny. Yet, the conversation is an example of creative use of language in order to appropriate customs. At the same time, this conversation demonstrates how the translation of cultures takes place in that the boy is trying to understand Polish customs by means of traditions he is familiar with in Britain.

Figure 1. Price tag in a Polish shop in Nottingham, 14 Jan 2014.

Similarly, the fifth example uncovers how the use of symbols can be adjusted in diverse contexts. Figure 1 presents a price tag for a reduced product in a Polish shop in Nottingham.

The tag includes all necessary information in the Polish language, i.e. the Polish word 'przecena', meaning 'reduced', a number indicating nominal value, a currency symbol and a weight unit of measure. Although the currency symbol (£) is the internationally recognised representation of the local currency – pound sterling, all the other elements of the price tag are written in accordance with Polish conventions, i.e. the currency symbol follows the number (0,50£), instead of preceding it as in English; the decimals are separated by a comma (0,50), not by a point as in English (0.5); and the weight is expressed in metric units (kg), not imperial customary units (lb). The writer of the tag must have found it practical and informative to use the pound symbol. Although it resembles one of the letters in the Polish alphabet, i.e. the letter 'Ł', pronounced as /w/ in water, in the UK context it conveys a specific meaning and can be observed in all trade situations. Therefore, from the communication effectiveness point of view, it seems rational to use the symbol instead of writing the Polish name of the currency in an attempt to maintain a language consistent approach.

The above examples of translanguaging illustrate how creative, skilful, rational and open migrants are in using their language resource to convey the meaning of choice. Such a language practice requires an open and critical approach, which is often enriching for individuals.

7 TRANSLANGUAGING AS AN ENRICHING PRACTICE

Translanguaging transcends boundaries and has a transformative and resemiotising effect on activities and actions. It enables individuals to explore, (re)think, (re)design and (re)create codes within, across and beyond linguistic, semiotic and cognitive systems. In

addition to creativity, *translanguaging* also enhances criticality as due to the existence of potential differences and tension between systems, it provides more opportunities to question evidence and, in this way, enhances individual's eloquence.

Increased interactions within a diverse context and with individuals from varied backgrounds is *enriching* in that it brings to light new or broadened perspectives and enables individuals to adapt their behaviour with greater flexibility. Similarly, in terms of the linguistic aspect, multilingual and translingual communication enables a greater spectrum of meanings. Yet, it needs to be noted that the great value of the enriching aspect of *translanguaging* lies in the fluidity of communication as there is no 'switch' that would turn an individual from one resource to another. Hence, the concept of *hybridity* does not seem applicable.

The multiplicity of available resources in multimodal *translanguaging* needs to be seen as developmental for each individual. Even if it is not appreciated, or at times even rejected, by some, holistically it is beneficial for an individual as the acquired resource can be activated at any point by future experiences. Furthermore, regardless of a nationalistic turn and the commonality of the discourse of national languages in many parts of the world, *translanguaging* occurs across countries as the named languages have not been static. Instead, they have influenced each other, often within close proximity and as neighbouring systems. A case in point is English and French, in which case in English there are many thousands of words borrowed from French. While the spelling of many of such words remained consistent with French, their pronunciation has changed. Another example is Polish, which was strongly influenced by French in the 17th century, resulting in many thousands of words and structures being brought across and having the spelling polinised over time. Although the two countries are not neighbours, French markedly influenced Polish. Hence, a speaker of Polish who is learning French in an English-speaking group is likely to be the only learner in that group who would instantly understand the meaning of the word 'sondage' as in Polish 'sondaż', with mostly retained French pronunciation, is used as opposed to English 'survey'. This example depicts how linguistic resource can be deployed to comprehend encountered information within an individual's mind, without labelling languages, hence surpassing assigned boundaries and categories.

Translanguaging is certainly enriching as the multiplicity of resources offers more than one perspective and more insight into communicated information. Such enhanced criticality is likely to result in better-informed decisions, possibly more reasoned interpretation of views and opinions and more rationalised problem-solving in a variety of situations. Therefore, it seems apparent that multilingual and multimodal experiences have a transformative effect on individuals and enable their identities to evolve.

8 CONCLUSION

Translanguaging as a phenomenon and a language practice seems to be both *creative* and *enriching* for individuals. It seems to be effective for capturing and generating new meanings. Because it transcends boundaries, it allows identities to evolve through multimodal experience of diverse practices, meanings and values. The developmental aspect of *translanguaging*, enabled by language manipulation to better comprehend and generate meanings, is of high importance to individuals and their functioning within societies.

BIBLIOGRAPHICAL REFERENCES

Abutalebi, Jubin; Cappa, Stefano F. and Perani, Daniela. (2007). The Bilingual Brain as Revealed by Functional Neuroimaging. In *The Bilingualism Reader*, ed. by Li Wei, 2nd ed. (pp. 475–491). Oxon: Routledge.

Bassnett, Susan (1998). The Translation Turn. In Bassnett, Susan & Lefevere, Andre (eds). *Constructing Cultures: Essays on Literary Translation*. (pp. 123–140). Clevedon: Multilingual Matters.

Bassnett, Susan & Lefevere, Andre (eds). (1998). *Constructing Cultures: Essays on Literary Translation*. Vol. 11. Clevedon: Multilingual Matters.

Becker, A. L. (1991). Language and Languaging. *Language & Communication*, 11 (1/2), 33–35.

Christensen, Francis. (1946). Creative Sensibility in Wordsworth. *The Journal of English and Germanic Philology*, 45 (4), 361–368.

Creese, Angela; Blackledge, Adrian & Hu, Rachel. (2018). Translanguaging and translation: The Construction of Social Difference across City Spaces. *International Journal of Bilingual Education and Bilingualism*, 21 (7), 841–852.

Diakonu, Mihai. (2016). John Dewey – The Precursor of Pedagogy of Creativity. *Journal of Educational Sciences and Psychology*, VI/LXVIII (1B), 86–91.

d'Inverno, Mark. (2019). The Future of Creativity. Seminar, Learning Sciences Research Institute, School of Education, University of Nottingham, 22 January.

Garcia, Ofelia & Li, Wei. (2014). *Translanguaging: Language, Bilingualism and Education*. London: Palgrave.

Götz, Ignacio L. (1981). On Defining Creativity. *The Journal of Aesthetics and Art Criticism*, 39 (3), 297–301.

Guilford, Joy P. (1950). Creativity. *American Psychologist*, 5 (9, 444–454.

Li, Wei. (2011). Multilinguality, Multimodality and Multicompetence: Code- and Mode-switching by Minority Ethnic Children in Complementary Schools. *Modern Language Journal*, 95, 370–384.

Li, Wei. (2018). Translanguaging as a Practical Theory of Language. *Applied Linguistics*, 39 (1), 9–30.

Lewis, Gwyn; Jones, Bryn & Baker, Colin. (2012). Translanguaging: Developing Its Conceptualisation and Contextualisation. *Educational Research and Evaluation*, 18 (7), 655–670.

Robinson, Ken. (2013). To encourage creativity, Mr Gove, you must first understand what it is. *The Guardian*, 17 May.

Robinson, Ken and Aronica, Lou. (2015). *Creative Schools*. New York: Viking.

Seredyńska-Abou-Eid, Renata. (pending). *Translating Cultures, Adapting Lives*. Unpublished PhD Thesis, University of Nottingham.

Sternberg, Robert J. and Lubart, Todd I. (1999). The Concept of creativity: Prospects and Paradigms. In Sternberg, R. J (ed). *Handbook of Creativity*. (pp. 3–14). Cambridge: Cambridge University Press.

Swain, Merrill. (2006). Languaging, Agency and Collaboration in Advanced Second Language proficiency. In Byrnes, Heidi(ed). *Advanced Language Learning: The Contribution of Halliday and Vygotsky*, (pp. 95–108). London: Bloomsbury.

Swain, Merrill & Lapkin, Sharon. (2011) Languaging as Agent and Constituent of Cognitive Change in an Older Adult: An Example. *Canadian Journal of Applied Linguistics*, 14 (1), 104–117.

Williams, Cen. (1994). Arfarniad o Ddulliau Dysgu ac Addysgu yng Nghyd-destun Addysg Uwchradd Ddwyieithog [An Evaluation of Teaching and Learning Methods in the Context of Bilingual Secondary Education]. Unpublished doctoral thesis, University of Wales, Bangor.

Zhu, Hua; Li, Wei and Lyons, Agnieszka. (2017). Polish Shop(ping) as Translanguaging Space. *Social Semiotics*, 27 (4), 411–433.

Intelligence, innovation, fantasy and heart: The Portuguese engineers of the nineteenth and early twentieth centuries

Ana Cardoso de Matos
CIDEHUS, University of Évora, Évora, Portugal
ORCID: 0000-0002-4318-5776

ABSTRACT: Civil engineers of the late 19th and early 20th centuries are usually seen as rational men, whose precise actions and command of technology enabled them to intervene in the public works, urban modernisation, and major territorial infrastructures – such as roads, canals, and railways – that structured the territories of each country. Nevertheless, those men possessed other traits which, to this day, have received little attention. To grasp the multiple facets of these engineers, we need only remember that many of them were involved in publishing initiatives, besides authoring articles and books, mostly technical. It is true that these often had a didactic purpose, or were aimed at dissemination, but there were also (more so than we have known so far) works of a literary nature such as novels, short stories, and theatre plays.

Keywords: engineers, intelligence, phantasy, diffusion of science and technology, literature.

Brain and Hands need a mediator. The Mediator between Brain and Hands must be the Heart.
(Harbou, 1925, p. 41)

1 INTRODUCTION

Generally, civil engineers are considered as rational men only interested in his profession. However, many of Portuguese engineers of 19th and early 20th centuries have also developed other interests, namely publishing initiatives, and had written different kinds of works from technical books to works of a literary nature or a fictional one.

Influenced by Saint-Simonianism theories, engineers also had an important intervention in society, namely in promoting the technical education of the working classes. To approach in a global way the Saint-Simonianism movement, Antoine Picon (2002) wrote the book *Les saint-simonies. Raison, imaginaire et utopie*, in which he seeks a broader perspective of this movement, considering it as revealing the dynamics at work within French society, just as it was about to enter the Industrial Age (Picon, 2002, p. 297).

François Vatin's words somehow convey the various characteristics of engineers, the 19th century engineer, while he sometimes has 'his head in the stars', more often has 'his feet in the mud', and, if we may snatch the metaphor, 'his hands on the coal' (2008: 135).

Both faith in technology and the idea of progress, guided the actions of many engineers in this period,

made them imagine fictional worlds which would come into being in a more or less distant future, and in which technology would assume growing importance and would enable them to make life easier – namely in urban spaces, where the rising population figures were beginning to raise issues. However, this fictional, optimistic view of the future, promoted by many engineers, was opposed by another, pessimistic outlook, which feared the control that technology could come to gain over human life.

These various facets of engineers make it a complex task to study this professional group globally since it must go beyond the study of their technical skills or their work output. As late as the 1980s, André Grelon (1984) wrote that one must go beyond the traditional framework of the disciplines and even sub-disciplines and that working on the subject of the engineers forced one – and luckily so – to adopt a multidisciplinary approach.

2 FROM TECHNICAL TEXTS AND REPORTS TO NOVELS, THEATRE, AND POETRY: THE DIVERSIFIED WRITTEN OUTPUT OF ENGINEERS

Several engineers taught at the technical schools, which, throughout the 19th and 20th centuries, were established in Portugal. Some of them wrote technical books associated with the specific disciplines they

taught. As an example we have Joaquim Henriques Fradesso da Silveira (1825–1875) who, in the early 1840's, applied to the position of substitute teacher of Physics and Chemistry at the *Escola Politécnica* (Polytechnic school), in which he replaced, until 1853, the holder of the position, Júlio Máximo de Oliveira Pimentel (1809–1884). To support his teachings there, he wrote, in 1846, his *Manual do curso de química elementar* ("Handbook of Elementary Chemistry"), and, in 1848, the work *Lições de Óptica* ("Lessons in Optics"). Having resigned from the Polytechnic school in 1853, he joined the Ministry of Public Works, Trade, and Industry, where he headed the Weights and Measures Division. In the 1860's he was a member of the General Board of Customs; later on, after the inquiries, he conducted from 1862 to 1865 into the Portuguese wool industry, he wrote *As fábricas de Portugal. Indagações relativas aos tecidos de lã* (Industrial Plants of Portugal. Inquiries into Wool Fabrics) (1864).

For his part, the engineer João Inácio Ferreira Lapa (1823–1892), who taught at the *Escola de Veterinária Militar* (Military Veterinary School) and later at the *Instituto Agrícola de Lisboa* (Agricultural Institute of Lisbon), founded in 1852, engaged in several study commissions, throughout his life, leaving important reports such as the *Relatório da missão agrícola da província do Minho* ("Report by agricultural mission in the Minho region") (1871) and the *Revista de agricultura na exposição universal de Paris em 1878,* ("Review of the Agriculture Mission in the 1878 Paris Universal Exhibition") (1879), just to cite some examples from his work.

The engineers Sebastião José Ribeiro de Sá (1822–1865) and João de Andrade Corvo (1824–1890) both provide good illustrations of the diversified relationships existing between engineers and literature.

The former was the author of technical reports, novels, and short stories written for the wider public, in addition to translating and adapting works by foreign authors and contributing various articles for several different journals. In effect, his report *A Indústria Nacional e a Exposição de 1849* ("National Industry and the 1849 Exhibition") was published in several issues of the *Revista Universal Lisbonense* in the same year.

In his book *Contos ao Serão* (Short stories at night), Ribeiro de Sá mentions that this work was a selection of for the enjoyment of people who see the length of a novel as one of its main drawbacks (1849: III).

Thus, over a total of 156 pages, he offers five short stories. The first one, named "Braço Forte", tells the story of a fisherman – João do Braço Forte ("Strong Arm"), whose heart was so soft as his arm was strong, and who let himself become bewitched by a woman.

To this engineer, we also owe the translation, adapted to Portugal, of the book by Charles Émile Souvestre (1806–1854), *Le monde tel qu'il sera*, published in 1846 – a book that became a model for the science fiction dystopian literature which came later[1]. This work

> is science fiction's first great warning against the dangers of mechanization. But that warning is blunted by Souvestre's heavy reliance on a satiric method of *reductio ad absurdum* that stresses the ridiculous rather than the horrifying potential consequences of nineteenth-century mechanical 'progress' (Alkon, 2002, p. 63).

Likewise, the engineer João de Andrade Corvo (1824–1890), usually better known on account of his distinguished political career, held several other posts throughout his life and produced different kinds of written output. As a politician, he was elected deputy in 1865, became minister of Public Works the following year and later minister of Foreign Affairs from 1871 to 1878 – a period in which he played an important role regarding the country's colonies and wrote several reports on political matters.

Throughout his life, he was also an agronomist and a teacher at the *Instituto Agrícola* and the *Escola Politécnica de Lisboa*. Charged with studying the development of agriculture in the 1855 Universal Exhibition, in 1857 he published his report called *Relatório sobre a Exposição Universal de Paris. Agricultura*, ("Report on the Paris Universal Exhibition – Agriculture") where he made a very technical and objective appreciation of the various agricultural machines present in the Exhibition, indicating which of these he thought it would be advantageous to introduce to Portugal. He also considered that the country was not prepared, either economically or regarding technical education, to receive certain machines, which represented outstanding technological advances. His interest in disseminating technical and scientific knowledge gave rise to several works he wrote on agriculture (published in the Agriculture and Science Library) such as *Da água das regas* ("On Irrigation Water") (1881) and the work *Os motores na indústria e na agricultura* ("Engines in industry and agriculture") (1883).

However, while in many ways the actions and writings of this engineer bore the stamp of his rational spirit, the "heart", or maybe we could say "feelings", were never alien to him. His pen also produced novels, theatre plays, and even poetry. A non-exhaustive list might include two novels: *Um ano na Corte* (One year in royal court) (1850–1851) – his most famous work –, and *O Sentimentalismo (* Sentimentalism) (1871); the theatre play *O Alliciador* (The enticer) (1859), a 3-act drama, *O Astrólogo* (The astrologer), considered by

1. This novel is Souvestre's only venture into science fiction, or what French critics call *roman de l'avenir*, had become "the model for everything that would be written in the genre during the 19th and 20th centuries" (Monteiro, 2017). There is a recent edition of this Portuguese adaptation of Souvestre's work, with an introductory text by Fátima Vieira (Souvestre, 2006). The first English translation appeared in 2004 (Souvestre, 2004).

some of his contemporaries made for pondered, private reading rather than for the rapid and unpredictable effects of the theatre (Panorama, 253), and short stories as *Conto ao Serão* (Short story at night) (1852). Also, in 1861 he wrote a poetry book, *O beijo do diabo* (The kiss of the devil). In 1883 he published *Contos em viagem. Phanthasias Philosophicas de D. Fagundes Primigenius* (Short stories in travel. Philosophical Fantasies of D. Fagundes *Primigenius*), telling us about a journey during which he meets D. Fagundes, an elder archaeologist from Madeira island, who had long been living in the island of Tenerife – which he considered to be one of the peaks of long-lost Atlantis.

3 ENGINEERS AND EDITORIAL INITIATIVES

Numerous engineers got involved in editorial initiatives, some of which were directly connected to their professional activity, including the great public works on the railways and other sectors of the economy resorting to the technical competences of this professional group. Among these kinds of publications, we can cite the *Gazeta de Caminhos de Ferro* ("Railroad Gazette"), which appeared in the 1880's (Ribeiro, 2009) with the goal of constituting a serious, well-informed technical newspaper that can stand comparison with foreign publications of the same kind and of keeping pace with the scientific world, divulging its most interesting progresses (*Gazeta dos Caminhos de Ferro*, 1888, p. 2). It relied on the collaboration of several among the most important engineers linked to the railways.

Ever since the first half of the 19th century, on the other hand, engineers were engaged in editorial initiatives directed to the broader public as well. In 1848, Andrade Corvo and Luís Augusto Rebello da Silva began to publish *A Época. Jornal de Industria, Sciencias, Literratura, e Bellas-Artes*, dividing it into two parts: one scientific and industrial, the other literary. In the first, they intended to disseminate new methods and processes that could help the development of the various economic activities.

One year later, the engineer Joaquim Fradesso da Silveira took into his hands the publishing of the *Revista Popular, Semanário de Litteratura, Sciencia e Industria* – this, too, was a journal of technical-scientific dissemination, formerly owned by Francisco Angelo Almeida Pereira e Sousa (1827–1898) and José Maria Baptista Coelho (1812–1891). He assured its publication up until 1851 when the engineer José Ribeiro de Sá became its new owner.

The *Almanaques Populares* (1848–1851) published by the engineers Filipe Folque (1800–1874), Fradesso da Silveira, and F. A. de Almeida Pereira e Sousa, which sought to be "everyone's book – for everyone" (*Almanaque Popular*, 1849, p. 1), constituted one of the ways in which they tried to provide a more significant number of people with useful knowledge and some

Figure 1. "River over the Tagus", a project by E. Bartissol and T. Seyrig, *O Occidente* n.° 380, picture by L. Freire, 1889.

scientific information, written in plain language. With a circulation of 6,000 copies, these almanacks sold for 160 *reis* each, and their market was guaranteed.

The examples listed above are a mere illustration of engineers' involvement in diversified editorial initiatives.

4 THE FANTASY OF ENGINEERS: FROM IDEALIZED, NON-BUILT WORKS TO FICTIONALIZED SOCIETIES

4.1 *The 'dream' of connecting the two banks of Lisbon*

In 1889, the magazine *O Occidente* published a print of a bridge over the Tagus river, with an accompanying text by Mendonça e Costa, in which he wrote that the dream of connecting the two banks of the Tagus through a bridge is on its way to becoming a reality, thanks to the initiative and activity of Mr. Bartissol and the daring intelligence of the distinguished engineer Dr. Sevrig, who built the D. Luiz bridge in the city of Porto (*Occidente*,1889, p. 155).

The idea of building a bridge connecting Lisbon to the other bank had been considered since the 1870s when the engineer Miguel Correia Pais put forward a proposal, which did not materialise (Barata, 2010, p. 115). In fact, in his article *Ponte sobre o Tejo Próximo a Lisboa, ('Bridge over the Tagus near Lisbon')* dated 1879 (Paes, 1879), this engineer specified that what he was presenting was not a well-studied project, not even an pre-project, being at best the likely indication of an pre-project, which further studies will either confirm or modify (Paes, 1879).[2]

The construction of a bridge over the river Tagus was but one among many projects which, in the last decades of the 19th century and the beginning of the 20th, were put forward by engineers, making use of their rational spirit and their command of new materials such as steel and concrete, with the aim of modernising the city and improving the circulation of people and goods.

From the last decades of the 19th century to the beginning of the 20th, several proposals were made to facilitate the circulation of people in the city and

2. Quoted in (Nascimento, 1959, p. 65).

overcome the level differences which characterised the urban space of Lisbon. Among these were proposals by the aforementioned Miguel Correia Pais, who wanted to even out the different levels by connecting the valleys through tunnels and the peaks through viaducts made of steel (Barata, 2018, p. 134). Both Correia and other engineers subscribed proposals for building viaducts – which they called 'aerial avenues' – that would link the city's hills, but the project of the 'aerial avenues' of Lisbon ended up in the imagined urban landscape of the city (Barata, 2018, p. 134).

The various proposals submitted to the Lisbon City Hall around the turn of the century showed the influence of technological developments displayed at the Universal Exhibitions, events for which edifices were built using new materials such as glass or steel, along with the latest construction techniques. Likewise, those proposals were influenced by the construction of large bridges and viaducts, in iron and steel, for the railways, and also by the science fiction literature thriving at the time.

4.2 *The engineer Sebastião José de Ribeiro de Sá and his adaptation of Émile Souvestre's work*

In 1895 was published the book *O mundo no ano três mil*[3], ('The World in the Year 3000') initially attributed to Pedro José Supico de Morais[4], but whose author was in fact, as has been mentioned, the engineer Sebastião José de Ribeiro e Sá.

This engineer adapted to the Portuguese reality the book by Souvestre, *Le monde tel qu'il sera*, telling the story of a young couple – Marta and Maurício – who voice out loud their desire of living in the future, where they thought the world would be a better place. Their wish is heard by Sir John Progress, "a member of all the Societies for Betterment in Europe, Asia, Africa, America, and Oceania", who sat on a locomotive from which a great column of smoke escaped "and shouldered the Daguerreotype machine from the Chevalier plant"[5]. Sir John proposes they go to sleep and wake up only in the year 3000.

In this *brave new world*[6] the railways – which in previous years had proliferated in such a way that they

now occupied an important fraction of the globe's surface – had been replaced by subterranean railways, while gigantic contraptions, set in motion by machines, inserted or retrieved from the railroads the smoking locomotives (Morais, n/d, n/p).

Children, for their part, were raised in groups, serviced by mechanisms which fed them at specified times, and their learning was carried out mechanically, instead of being based on experience – to mention just one example.

The book views with a critical spirit the advances of technology and the leading role given to machines. Those "wonderful machines" with "polished and gleaming limbs" were "blind and deaf monsters" and their steady, uniform motion "spoke to no feeling, there was no relationship between them and those who saw them" (Morais, n/d, n/p).

Disenchantment towards a world ruled by technology and machines is expressed at the end of the book when a despondent Maurício says:

> We had hopelessly looked for love and poetry in this improved world: we had only faith left, which serves as a relief for all torments!", however, Faith has flown away from the world, followed by love, which decries the misadventure of men, and by poetry which, clinging to the lyre, looks away from the miseries of the Earth! (Morais, s/d, s/p)

Despite the negative light under which technology and machines are seen in the book *Le monde tel qu'il sera*, Émile Souvestre exerted a strong influence on the work of Jules Verne (1828–1905), an author who later came to popularise science fiction with a series of books that still raise interest today, especially among younger readers.

4.3 *"Lisbon in the Year 2000" according to the engineer Mello de Matos: The fantasized vision of progress*

A fervent believer in progress, the engineer Mello de Matos published in 1906, in *Ilustração Portuguesa*, an article criticising the fact that Portugal was bent more on the past than the future.

> We admire the heroes of our national history, we wonder at the broadmindedness of Afonso d'Albuquerque or the Marquess of Pombal, but we dare not face what the future may hold for our country. If a statesman ever wished to take the initiative, to make us tread as other nations do, he was seen as either a visionary or an adventurer (Mello de Mattos, 1906, p. 129)[7]

Thus, deciding to step into the realm of fantasy, Mello de Matos proposes a vision of *Lisbon in the Year 2000*, a date when he considered that, if the country progressed as might be expected, it would achieve more

3. Pedro José Supico de Morais, *O Mundo no ano 3000. A obra que deu início à literatura de ficção científica em Portugal, Luso Livros. Uma Nova forma de ler.* Online *https://www.luso-livros.net/wp-content/uploads/ 2015/06/O-Mundo-no-Ano-3000.pdf* [consulted on 20/02/2019]
4. In the 18th century lived an author by this name, who wrote several works, among which the following: Pedro José Supico de Morais, *Coleção moral de apophthemas memoráveis ou ditos agudos e sentenciosos*, Lisboa, Officina de Antonio Pedrozo Galrão, 1720.
5. Niepce had used a camera produced by the opticians Charles and Vincent Chevalier.
6. This is the name of the book published by the Englishman Aldous Huxley in 1932, in which the author describes what the world would be like in the year 2000, expressing as well his disbelief in technical progress (Huxley, 2003).

7. Author's free translation.

Figure 2. Mello de Mattos Lisboa no Ano 2000, Illustração Portuguesa, nº 6, 1906, 188.

than "everything we fantasize here" (Mello de Mattos, 1906 p. 129).

In this fictionalised Lisbon it is the engineers, with their capacity for innovating and doing great works, that feature as the leading players. Thus the subway line of overhanging rails, thanks to the changes introduced by a Portuguese engineer, worked very efficiently in Lisbon, connecting the various places in the city.

Each line in this network constituted a complete circuit, and from its rails hung a series of inverted V's which suspended railcars transporting large numbers of passengers. On the other hand,

> The stations had elevators, which distributed passengers according to class, laid out in such a way that trains stopped automatically, and the doors opened in the same way. On the left side the passengers came in, and on the right side they got off the railcar (Mello de Mattos, 1906, p. 132[8]).

On the streets, pedestrians circulated side by side with automobiles and bicycles. The sky was crossed by balloons and other vehicles, which allowed to free up the streets, making the inhabitants' mobility easier.

Electricity was this city's driving force. It enabled it to function, setting in motion a series of machines and, by night, illuminating the whole city.

Mello de Mattos concluded his description of *Lisbon in the Year 2000* by stating that, thanks to all the progress he described,

> Lisbon had been transformed entirely. The beauty decorating the blue skies of Portugal was now joined by the art through which man had been able to complement the magnificent features of Nature (Mello de Mattos, 1906, p. 13)[9]

Lisboa do ano 2000, was to become an inspiration, both to later literary works and recent architectural proposals. In the first instance, we can quote the text by João Barreiros, *O Turno da Noite* (2011). An example of the second is given by the overhanging subway line

8. Author's free translation.
9. Author's free translation.

Figure 3. Mello de Mattos Lisboa no Ano 2000, Illustração Portuguesa, nº 5, 1906, 131.

proposed by Marta Machado, which follows up on the idea by Mello de Mattos of finding a solution that will not interfere with pedestrian pathways and the city's layout.[10]

4.4 The influence of Universal Exhibitions and the writings of Albert Robida and Jules Verne on "Lisboa no Ano 2000" by Mello de Mattos

When we read Mello de Mattos's work, we are almost immediately transported to the Universal Exhibitions of the late 19th century. In effect, the Steel Tower of the Lisbon Quay which appears in the engineer's book reminds us of the Eiffel Tower, built for the 1889 Paris Universal Exhibition, which constituted an important moment for the affirmation of engineers.

On the other hand, the modernisation of the cities that hosted Universal Exhibitions, namely concerning transportation to ensure the circulation of a great number of people, was a source of inspiration to the improvements proposed, and fantasised, for the city of Lisbon. The case of the Paris subway, whose project was under discussion for several years and which was finally built only for the Universal Exhibition of 1900, comes to mind. The same goes for the rolling platform made for the same Exhibition, enabling the transportation of visitors among different spots of the grounds, and also the escalator which dazzled those who had the chance of using it.

The article written by Mello de Mattos, fitting into the category of fantasised science literature, suffered

10. Marta Machado says that her proposal follows that intention using two ideas: it redraws a second coastline as a new horizon moving from Praça do Comércio; and it realigns a coastline jagged by landfills and ground digs (Machado, 2013, p. 89).

Figure 4. Mello de Mattos. Lisboa no Ano 2000, *Illustração Portuguesa*, nº 6, 1906, 190.

the influence of other authors, such as Jules Verne and Albert Robida.

In the work of Jules Verne, however, as explained by the historian of science Michel Serres,

> No rule of mechanics is ever violated, no law of nature, physics, the resistance of materials, biology, is ever broken. The scientific content, in fact, is usually quite outdated [. . .]. Far from being anticipatory, these novels are behind their time in this respect. They even celebrate steam power and electricity as novelties. The technical performances described are repetitions or retrospectives, when they appear as projects for the future. (Serres, 1974, p. 82)[11]

The time in which Jules Verne wrote his works was marked by a constant concern with disseminating science and technology through a series of initiatives, such as holding conferences and publishing articles in magazines aimed at the general public (Matos, 200, Malaquias, 2019). In this effort of dissemination, engineers played, as we have seen, an important role.

For his part, Albert Robida (1848–1926), the author of *Le Vingtième Siecle* (1883) and *La vie eléctrique* (1892) is considered to be "the grandmaster of foresight" by experts in this literary genre[12]. Having

visited the Universal Exhibitions and familiarised himself with technical journals and works of dissemination of scientific and technological knowledge, his "anticipations" were based on technological innovations which he extrapolated from the projects and accomplishments of his day.

> Unlike Jules Verne, bound to difficult scientific explanations, he has only to draw. In fact, drawing takes the place of technical discourse, and Robida focuses on actual usage (Lacaze 2015, p. 79)[13]

5 CONCLUSION

Our approach to several aspects concerning the Portuguese engineers of the second half of the 19th century beginning of the 20th century, enabled us to show that many men from this professional group managed to associate their rational mentality, their ability to project highly technical works, and to innovate in order to respond to the needs of their society and economy, with a diversified experience ranging from their concern for the dissemination of science and technique to their interest in literature and theatre.

In the field of literature, their talent found expression in novels and other works of fiction in which they voiced their appreciation of technological progress, which opened up new forms of life for humankind, side by side with a critical vision of the dehumanisation that the growing importance of technology could impose on society.

The study of diverse activities by several Portuguese engineers living during the transition from the 19th to the 20th century allows us to realise that the personality of engineers was, in fact, richer than one often tends to consider (since their rational spirit controlled their professional activity). In their case, reason did not stifle either 'heart' or 'fantasy', which they expressed through their (often non-concretised) projects, their actions, and the literary works they left behind.

ACKNOWLEDGEMENT

This chapter is made in the context of the project CIDEHUS – UID/HIS/00057/2013 (POCI-01-0145-FEDER-007702).

BIBLIOGRAPHICAL REFERENCES

Alkon, Paul K. (2002). *Science Fiction before 1900. Imagination Discovers Technology*. New York: Routledge.

11. "Jamais une règle mécanique n'y est outrepassée, nulle loi naturelle, de physique, de résistance de matériaux, de biologie, n'y est extrapolée. Le contenu de science, en général est même fort en retard sur son âge : Bouvard et Pécuchet sondes encyclopédistes d'une autre lignée, mieux avertis, mois enfantins dans le romanesque. Loin d'être d'anticipation, ces romans, sur ce point, ne sont pas à la page. Songez qu'on y célébré la vapeur et l'électricité. Pour les performances techniques, elles sont des reprises ou des rétrospectives, quand elles paraissent des projets."
12. "comme le reconnaissent les spécialistes du genre Pierre Versins, Jacques Van Herp ou Gérard Klein." [as confirmed

by the experts on the genre, Pierre Versins, Jacques Van Herp and Gérard Klein] (Lacaze, 2015: 78).
13. "À la différence de Jules Verne, astreint à de difficiles justifications scientifiques, il lui suffit de dessiner. En fait le dessin tient lieu de discours technique et Robida se concentre sur l'usage."

Almanak Popular para o Anno de 1849.

Barata, Ana. (2010). *Lisboa "caes da Europa": realidades, desejos e ficções para a cidade (1860–1930)*, Lisboa: Colibri/IHA – Estudos de Arte Contemporânea, FCSH/UNL.

_____. (2018) Das colinas de Lisboa: as 'avenidas 'aéreas' nunca construídas. *Cadernos do Arquivo Municipal*, 2ª serie, (9)

Barreiros, João. (2011). 2º turno da noite, *Revista Bang* (10), 10–14

Gazeta dos Caminhos de Ferro nº 1, 1888.

Grelon, André. (1984). Les ingénieurs encore *Culture Technique*, (12), 11–17.

Corvo, João de Andrade. (185–1851). Um anno na corte. *Revista Universal Lisbonense*

_____. (1852). *Um Conto ao Serão*. Lisboa: Tip. Revista Popular.

_____. (1859). *O Aliciador; O Astrólogo*. Lisboa: Typ. Universal.

_____. (1871). *O Sentimentalismo*. Coimbra: Imprensa da Universidade.

_____. (1883). *Contos em Viagem*. Lisboa: Liv. Ferreira.

Harbou, Thea von Harbou. (1925). *Metropolis*. Berlin: A. Scherl.

Huxley, Aldous. (2003). O *Admirável Mundo Novo*. Lisboa: Colecção Mil Folhas.

Lacaze, Dominique. (2015). "Albert Robida, maitre de l'anticipation", *Revue des deux mondes*, Jullie-auout, 78–89.

Machado, Marta Gracinda Pinto Machado. (2013). *Lisboa do ano 2000. Dois pojectos para um futuro da cidade de há 100 anos*. Dissertação de mestrado Arquitectura Cultura Arquitectónica, Universidade do Minho.

Malaquias, Isabel. (2019). Do imaginário em Jules Verne *Carnets* [En ligne], Deuxième série – 15, URL: http://journals.openedition.org/carnets/9173 ; DOI: 10.4000/carnets.9173

Matos, Ana Cardoso de. (2000). Os agentes e os meios de divulgação cientifica e tecnológica em Portugal no século XIX *Scripta Nova. Revista Electrónica de Geografía y Ciencias Sociales*. Barcelona: Universidade de Barcelona Nº 69 (29).

Mello de Mattos. (1906) Lisboa no ano 2000. *Illustração Portugueza*, II (5 and 6).

Miguel Carlos Correia Paes. (1879). *Ponte sobre o Tejo Próximo a Lisboa. Pontes sobre os rios: Lima no Minho, Tay e Forth na Escócia*. Lisboa: Typographia Universal.

Monteiro, Maria do Rosário. (2018). Two dystopic visions on the relationship of humans and progress – Emile Souvestre and Cordwainer Smith. In Mário S.

Ming Kong, Maria do Rosário Monteiro, & Maria João Pereira NETO (Eds.), *Progress(es), Theories and Practices* (pp. 353–359). Leiden: CRC Press doi:https://doi.org/10.1201/9781351242691-64.

Morais, Pedro José Supico de M. (s/d) *O Mundo no ano 3000*. Lisboa: Uma Nova forma de ler. On line *https://www.luso-livros.net/wp-content/uploads/2015/06/O-Mundo-no-Ano-3000.pdf*

Nascimento, Alfredo Ferreira do. (1959). Um sonho a caminho da realidade a Ponte dobre o Tejo, *OLisipo. Boletim Trimestral do Grupo Amigos de Lisboa*, Ano XXII, nº 86.

O Occidente. Revista Illustrada de Portugal e do Estrangeiro, vol. XII, nº 380, 11 de julho de 1889.

Paes, Miguel Correia. (1889). Melhoramentos de Lisboa: uma ponte sobre o Tejo *O Occidente*, (380) 115–157.

Picon, Antoine. (2002) *Les saint- simoniens. Raison, imaginaire et utopie*. Paris: Belin.

Ribeiro, Elói de Figueiredo. (2009). A Gazeta dos Caminhos de Ferro e a Promoção do Turismo em Portugal (1888–1940). *Biblio 3W. Revista Bibliográfica de Geografía y Ciencias Sociales*, Universidad de Barcelona, Vol. XIII, (837). On line <http://www.ub.es/geocrit/b3w-837.htm>

Robida, Albert. (1883). *Le vingtième siècle*. Paris: George Decaux.

_____. (1892). *La vie électrique le vingtième siècle*. Paris: Librairie illustrée.

Sá, José Sebastião Ribeiro de. (1849). Contos ao Serão. Lisboa: Typ. Do Panorama.

Souvestre, Émile. (1846). *Le monde tel qu'il sera*. Paris: W. Coquebert.

_____. (1859). *O que há ser o mundo no anno tres mil*. Acomodado ao gosto português por Sebastião José Ribeiro de Sá. Lisboa: J.M. Correia Seabra & T. Quintino Antunes.

_____. (2006). O Que Há-de Ser o Mundo Nn Ano Três Mil (Acomodado Ao Gosto Português Por Sebastião José Ribeiro De Sá, Ed., Introd. E Notas Fátima Vieira). Vila Nova de Famalicão: Quasi.

_____. (2004). *The World as it Shall Be* (Edition and Introduction by I. F. Clarke. Margaret Clarke, Trans. The Wesleyan Early Classics of Science Fiction Series). Middleton, Conn.: Wesleyan University Press.

Serres, Michel. (1974), *Jouvences, Sur Jules Verne*. Paris: Les Éditions de Minuit.

Vatin, François. (2008) L'esprit d'ingénieur: pensée calculatoire et éthique économique *Revue Française de Socio-Économie*, La Découverte, 2008, 1 (1) 131–152. Accessible on line https://www.cairn.info/revue-francaise-de-socio-economie-2008-1-page-131.htm

The introduction of new construction materials and the teaching of engineering based on technical intelligence: The role of Antão Almeida Garrett

Maria da Luz Sampaio
IHC – Faculdade de Ciências Sociais e Humanas da Universidade Nova de Lisboa, Lisbon, Portugal
ORCID: 0000-0002-9231-4757

ABSTRACT: Through the teaching of engineering, the introduction of new materials into civil construction gained a privileged mean of circulating knowledge and stimulating the new construction experiences that shaped a technical intelligence within the scope of which there stood out the professor of the Faculty of Engineering of the University of Porto, including Francisco Xavier Esteves, Francisco Correia de Araújo and Antão Almeida Garrett.

This chapter's objective is to analyse the introduction of reinforcing cement and its interconnections with the study plans for engineering teaching at the University of Porto in the 1920s and 1930s, which were first structured around the Technical Faculty that later became the Engineering Faculty of Porto University. We correspondingly opted to identify some of the specific experiences and theoretical reflections around the application of this new construction material and highlighting the role of Antão Almeida Garrett and his purposes for advancing with the utilisation of reinforced cement in civil construction, especially in industrial buildings in Porto.

Keywords: engineering, intelligence, construction methods, reinforced concrete, affordable

1 INTRODUCTION

The teaching of engineering and the performance of their schools is a way to analyse the transmission of scientific knowledge and the production of an academic elite, an *intelligentsia* responsible for innovation and the circulation of knowledge.

We focus on the Engineering Faculty of Porto University, through the work of professor Antão de Almeida Garrett, in order to analyse the introduction of reinforced concrete in the decade of 1930, and we concluded that he belongs to a generation of engineering professors that improved the use of concrete and disseminated technical knowledge within the models created by education policies since 1911, under the republican government.

2 THE UTILISATION OF REINFORCED CEMENT IN CIVIL CONSTRUCTION IN THE EARLY DECADES OF THE 20TH CENTURY

At the beginning of the 20th century, there remained the construction practices, techniques and materials handed down from the 19th century. Limestone, wood (especially pine) applied to floor and roof structures and as well as forged iron with steel arriving later. The new materials were used to improve the construction mainly the connection between wood and the stonemasonry. (Appleton, 2004). According to Vale (2012) house building in the early decades of the 20th-century continued to prefer resistant stonemasonry walls, floors and roofs in wooden structures, varying in their quality in accordance with the economic resources available.

One of the materials that would progressively expand in utilisation throughout construction, was Portland cement and over the course of the 20th-century the use of reinforced concrete: this new material had the advantage of fire resistance; the possibility of realizing large spans; economy, speed; and improved quality in the construction (Póvoas, 2015).

Since the second half of the 19th-century progress in transport and communications onwards ensured the next century began with a better understanding of the functioning of materials especially the scope for concrete and its respective typologies. This development interlinked with the registering of numerous patents and other successful applications that brought about its adoption for facades, beams and other structural features. The development of this new material arose from various contributions and experiences, especially those of:

– Louis Vicat (1786–1861), graduated in engineering at École Polytechnique de Paris and École Nationale des Ponts et Chaussées;

521

– the chemical engineer François Coignet (1814–1888), deemed the inventor of reinforced cement applied to building structure (Mascarenhas-Mateus, 2018);
– the German engineer Matthias Koenen (1894–1924), the first to do structural calculation of reinforced concrete elements (Moussard *et al*, 2017).
– as well as the British industrialist and cement manufacturer Joseph Aspdin (1778–1855), who obtained the patent for Portland cement in 1824 (Mascarenhas-Mateus, 2018).

In 1897, another significant contribution came from the French François de Hennebique with the use of iron bars and stirrups inserted in the mass of the concrete, which developed a construction system using the iron reinforced concrete that enabled the construction of spaces with spans of considerable size, and increased loads (Tostões, 2004).

Other variants of this product were developed in the early 20th-century like the pre-stressed concrete as well as the introduction of asbestos-cement. This process stemmed from the scientific progress that enabled the provision of different construction technologies coupled with experiences associated with the building of large manufacturing facilities, bridges, channels, garages, aerodromes, water storage tanks and as well as platforms, dams and power stations.

Already into the 20th century, leading contributions were made by the French engineer Eugène Freyssinet, who studied and determined its characteristics. He patented his ideas in 1928, and was a structural designer and bridge builder, lacked the teaching qualities necessary to communicate his ideas to other engineers (Dinges, 2009), (Camprubí, 2017).

Just like reinforced cement, pre-stressed concrete also incorporated steel but held a higher load capacity and thereby endowing greater resistance and durability to cement features and correspondingly broadening their scope of utilisation in civil construction.

In Portugal, the 1920s–1930s were years of experimentation and adaptation to the principles of Modern Architecture with the application of modern materials alongside the daring solutions that only engineers knew how to design (Tostões, 2004). The modern architecture movements would foster the awareness of the artistry and capacity of reinforced cement in following the works of Auguste Perret who encourages the use of reinforced concrete due to its potentialities to find new structural systems and aesthetic solutions (Tostões, 2004). However, materials such as reinforced cement would only enter in regular use in the 1950s. Until then only a limited group of engineers knows how to apply appropriately this material given its need for unusual calculations and application manuals (Appleton, 2004). This reality, more transversal to the entire civil construction sector, did not prevent the emergence of very particular experiences in the usage of Portland cement in as early as the

19th-century and the first decades of the following century. In Portugal, the first significant cement construction was the new building of Moagem do Carmujo [Caramujo Wheat Mill], built in 1898 (Toscano, 2012) and the Luiz Bandeira de Sejães Bridge on the EN333-3 over the river Vouga, dating to 1907, opening up a new paradigm in the history of construction. (Appleton, 2004). The choice of this material stemmed from the need to design industrial facilities structured into large pavilions, capable of bearing significant loads, providing stable structures and flooring simultaneously more resistant to fire and high temperatures.

With the proliferation of functional modernism backed by the ongoing calculations and research, the technical intelligence of the engineers ensured the architects recognized this new material for establishing a new aesthetic language using the plasticity of this material to project large openings with extensive glazing, creating a taste for smooth surfaces and pure volumes (Tostões, 2004). In this context, there stood out in Lisbon works such as the Portugália Brewery (1912–1914); the Capitólio cinema by Cristino da Silva (1896–1976) in 1929; the Instituto Superior Técnico, designed by Porfírio Pardal Monteiro in 1927 and completed in 1936. In Porto, these were accompanied by the São João Theatre (1910–1918), the Armazéns Nascimento Department Store (1914–1927) and the Garage for *O Comércio do Porto* newspaper designed by the architect Rogério Azevedo (1899–1983); the Passos Manuel Garage by the architect Mário Abreu; as well as the fish fridge building in Massarelos by Januário Godinho (Tostões, 2004).

The introduction of reinforced concrete in Portugal led to the publication, in 1918, of the Regulatory Instructions for the employment of Concrete, carried out based on the French norms and its later developments. (Appelton, 2004). A new regulation was published in 1935, establishing the need for rigorous calculations to meet the needs of compression, tension and safety of reinforced concrete works, among other aspects, demonstrating a broad field of applications of this material in civil construction (Decree 25.948 of October 16, 1935).

In parallel, the cement industry underwent significant expansion. According to Mascarenhas-Mateus studies "The effective production of natural cement began in 1866 under the Rasca brand manufactures in Alcântara, Lisboa, by Francisco Pereira de Gusman" (Mascarenhas-Mateus, 2018, p. 905), while the first industrial production unit had been founded in 1898, Companhia Cimento Tejo in Allandra by António Teóphilo Araújo Rato (Mascarenhas-Mateus, 2018). In the 20th-century, new facilities came in the 1920s, with Maceira-Liz factory in Leiria, which began operating in 1923, and under the Estado Novo government was founded in 1930 the major corporate group: SECIL – Companhia Geral de Cal e Cimento S.A. In 1934, Lusalite began the elaboration of fiber-cement, being

an associated company to the group Sommer that centralised the entire sector. This was the result of the protectionist and interventionist policy of Salazar's government since 1931, but the changes in the sector only began after World War II (Costa, Fazenda et al., 2010).

3 THE TEACHING OF ENGINEERING AND THE INTRODUCTION OF REINFORCED CONCRETE

The introduction of this new material is associated with the reorganisation of engineering education, especially in civil engineering. Since 1881-82 the military School had a scientific approach, it became part of the curricula for the engineers' training. This new material was already disseminated in the 19th-century by the review "Le Betón Armé et ses Applications" published by Paul Christophe, engineer of Ponts et Chaussés School and in Portugal by the *Revista de Obras Públicas e Minas* 1870–1926, edited by Associação dos Engenheiros Civis Portugueses [Association of Portuguese Civil Engineers] (Mascarenhas-Mateus, 2018).

Under the Republic government, two schools were founded: the Lisbon Instituto Superior Técnico and the University of Porto. In the latter, the Technical Faculty was created in 1915 and was transformed, in 1926, into the Faculty of Engineering of the University of Porto.

The Technical Faculty of the University of Porto was one of the first schools officially to approve this discipline in the curricular plan. The school board decided in 1917 to recruit Francisco Xavier Esteves to be the professor of "Reinforced concrete and Bridges" (FEUP/Actas do Conselho Escolar, 1917). This teacher obtained a degree in civil engineering from the Politécnica Academy (Tavares, 2017), and in 1912 was a managing partner of the *Companhia de Cimentos Tejo*, using Portland cement. Among Xavier Esteves' works, *Livraria Lello* (bookshop Lello) stands out, a 1904 project where the cement is used in the interior stairs, in the gallery of the store and the frame of the facade. Xavier Esteves also signed other works like the 1898 Augusto Pereira Nobre's house[1] in the street of Castelo do Queijo (Foz do Douro) or Diogo Eugénio Cabral's residence[2] located on Rua Miguel Bombarda and which received works of expansion in 1927, using Portland cement (AHMP/CMP, L. O. nº 192/1928). It is important to emphasise that in the case of the *Livraria Lello* the neo-gothic facade was built with the use of Portland Cement also due to its moulding capacities (Vale, 2012).

The active participation in public life led Xavier Esteves to embrace other projects and, in addition

to his short experience in engineering education, he joined, from December 1917 to June 1918, Sidónio Pais' government, as Minister of Commerce (between December 11, 1917, and March 7, 1918) and Minister of Finance (between 7 March and 1 June 1918). Later, his business connections led him to be elected a second term as president of the Portuense Industrial Association, between 1919 and 1930.

From 1922 the chair of "Reinforced concrete" was taught by Theotónio Rodrigues, but in 1932 it became the responsibility of Antão Almeida Garrett, (1897–1978), recently graduated in civil engineering.

Graduated in 1925 by the University of Porto, he became professor-assistant of the First Group: Civil Constructions in the Faculty of Engineering of the University of Porto and recruited in 1932 to the chair of "Reinforced
Concrete". According to the educational traditions prevailing in engineering schools, he produced an anthology that included the definitions and characteristics of this material, its usages as well as the formulas and calculations for building different structures and that remained an essential reference manual throughout many years. Students, also keeping the tradition, would annually produce new editions and we highlight the contributions of the re-edited manual by Pinto Basto and Lamas Viana, Alfredo Barata da Rocha, Alberto Fontes, Vicente de Paiva, Torquato Alvares Ribeiro and as well as the engineer Edgar Cardoso, who would also be a professor of engineering at *Instituto Superior Técnico*, founding in 1944 his own Laboratory for the Study of Structures and Foundations. Cardoso had extensive work with the use of concrete as well as other materials. Among his projects is the Arrábida Bridge in 1963 and the S. João Railway Bridge in Porto, opened in 1991.

Like reinforced concrete, pre-stressed concrete was also introduced in engineering education through the contacts and missions carried out by another professor of Porto University, Francisco Sarmento Correia de Araújo, who graduated in civil engineering in 1934. He carried out a mission financed by the Instituto de Alta Cultura at the Gent University (Belgium) where he worked with Gustaaf Robert Magnel, professor of reinforced concrete and founder of the Magnel Laboratory for Concrete Research one of the great centres of expertise and knowledge dissemination of reinforced and prestressed concrete in Europe. Gustave Magnel gave many lectures in several countries in which he explained in a simple way the principles of pre-stressed concrete and wrote the first book of design in this subject (Dinges, 2009).

This experience ensured Correia de Araújo to played a decisive role not only in teaching civil engineering but also in the dissemination the use of reinforced concrete, participating in the technical teams for diverse public projects that resulted in some of the emblematic landmarks of Porto city. His position as head of the Serviços de Obras Municipais e Habitações

1. Augusto Pereira Nobre (1865–1946) was a biologist and professor of Porto University.
2. Diogo Eugénio Cabral was a Porto industrialist and 1st Count of Vizela.

Populares (1940–41) [Town Constructions and Inhabitants Houses Department] enabled his interventions in the reinforced concrete project for the Massarelos Bolsa do Pescado [Massarelos Fishing Market]; the calculations for the Massarelos bridge to fish fridge; the inspection, the calculation of the projects of the construction of the "Abrigo dos Pequeninos" [Children Shelter]; the new City Council Hall, and the calculation and inspection of the construction of the Duque de Saldanha's local council housing project, among others.

Within the Porto Faculty of Engineering, the circulation of knowledge interlinked with the engineering practices of their professors but also extended to the missions financed by the Institute of High Culture (Instituto de Alta Cultura) that brought an increase of the technical intelligence able to apply and disseminate these new construction materials sustained by their respective calculations. There thus appeared new constructions held up by beams, pillars, roofing and terraces, large-scale architectural projects in their majority with high functional performance and resistance requirements. Dissemination and experimentation with these new materials were also much shaped by the founding of the Laboratory for Testing Construction Materials under the auspices of the Faculty of Engineering (established officially as a Cabinet of the school of engineering in 1915). The Faculty laboratory was used by the students in practical lessons and to do their projects, but also as outsourcing services for official and private entities, carried out a leading role in testing construction materials. This was where Professor Antão Almeida Garrett do experiments with different materials, especially national woods: maritime pine from Leiria, and reinforced concrete helicoid beams as well as testing the fire resistant properties of reinforced concrete, demonstrating that when slowly exposed to high temperatures it would inevitably get destroyed (Garrett, 1938). Many other tests and studies took place not only in conjunction with the academic programs but also as a result of studies requested from industry and official entities, with the laboratory taking on a determinant role in engineering research. Antão Almeida Garrett would take over as its director in 1964.

4 THE ARTIFICIAL SILK FACTORY EXPANSION PLAN: COMPANY "FIBRA COMERCIAL LUSITANA LDA."

From the 1920s, new construction projects of private entities in the city of Porto allowed for the emergence of works that marked the introduction of a modern architecture capable of designing the necessary interior functionality of the buildings. One of the industrial buildings that used reinforced concrete was the factory of the company "Fibra Commercial Lusitana Lda" — designed in 1933 by the architect Leandro de Morais

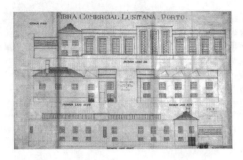

Figure 1. Architectural project of the new building of the company *Fibra Comercial Luzitana, Lda.* 1936. Source: CMP/AHMP. L.O. n° 1146/1936, p. 416.

(1883–?) in a parcel of land situated in the crossroad between the avenue of Boavista and the street Coutinho de Azevedo, neighbouring another textile unit: Fábrica de Fiação e Tecidos da Boavista owned by William Graham. This new unit was part of the group of industrial units located in this new avenue, an important expansion axis for the city towards the west allowing the connection of the city centre to the sea, in particular to Leixões Port, through the maritime marginal or crossing of the agricultural suburbs.

Three years after licensing the first building for the artificial silk (rayon) factory, the company advanced with an investment in its expansion through the addition of a perpendicular body, with a sizeable volumetric scale and careful design, surrounded by a garden that extended as far as the avenue.

The calculations for the concrete structures were of the responsibility of Antão Almeida Garrett who established the scale, loads and tensions for each construction component. The new building would form a typified example of modern architecture from the early 20th-century, with a regular composition and flat roofing surface. The imposing southern facade stands out in this otherwise classically designed building with its innovation emerging out of the scale of the vertical openings that only become feasible due to their reinforced concrete infrastructure. The flat roof with a terrace was lined by a row of sheds supported by concrete trusses. On the inside, space was divided by a concrete beam-pillar structure that replicated the design of the metallic structures that were previously applied to these buildings while ensuring a wide and very open space with a scalable to cope with the installation of heavy and large-scale machinery and equipment.

The Descriptive Memory of the project details not only the calculations as well as the description of the materials. In this document, the engineer Garrett presents the use of a reinforced concrete skeleton that supports the building from the first floor to the roof, showing all the calculations for beams, pillars, sheds and concludes by highlighting the use of asbestos-cement in the roof (L.O. 1146/1936).

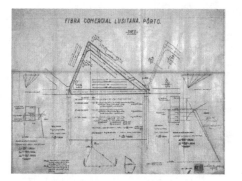

Figure 2. Project of Shed coverage of the new building of the company *Fibra Comercial Luzitana, Lda.* 1936. Source: CMP/AHMP, L,O, nº 1146/1936, p. 426.

This new industrial building is another example of the complicity established between modern architecture and engineering, in a partnership irredeemable for the experimental load that the new constructive materials imposed.

Antão Almeida Garrett was involved in other projects. From 1930 and 1939 we found his signature in projects for water tanks, terraces, garages, bourgeois dwellings, alterations of buildings, using always reinforced concrete, namely for the coverings, pavements, pillars and beams.

5 ANTÃO ALMEIDA GARRETT: REFLECTIONS AND EXPERIENCES WITH REINFORCED CONCRETE

Antão Almeida Garrett was engaged in the task of promoting and disseminating new construction materials and techniques and their impacts on the construction industry. In 1932, he wrote an article for the Bulletin of the Civil Engineers Association of Northern Portugal, entitled "Construction Processes", where he details a new process of using concrete in order to build walls that would enable homes to become more insulated from temperature variations (Garrett, 1932). Hence, this engineering professor, driven by his preference for reinforced concrete and his capacity for experimentation, set up an area to make concrete moulds at the bottom of his garden. His tests and studies led him to the production of a unique layout of moulds, resulting in a concrete beam with two support frames (Garrett, 1932). In 1938 he published "O betão armado e o fogo" [Reinforced Concrete and the Fire] and he related the experiences made in concrete, following the studies and fire tests of the American Professor I. H. Woolson and Professor M. M. Milankovitch from University of Belgrade, and also from the *Station d' Essais de L' Office National des Recherches et Inventions*, demonstrating to be aware of the works in this area in other universities and research centres.

The rationalisation of construction systems was also a strong subject for this engineer, and he defended the use of national raw materials for civil construction. He published an article, in 1939, in the University of Porto Engineering Journal entitled "Porque se não deverá empregar tanto betão armado" [Why we should not employ so much reinforced concrete] In the opening lines, he answered by saying that iron is imported; it is applied where there is no justification, and also because reinforced concrete is generally poorly designed and badly executed (Garrett, 1939).

The article continues with a set of considerations against the high costs of iron imports for reinforced concrete, declaring his opposition to the incorrect employment of reinforced concrete. In parallel, he thus defended the use of national woods, referring to how such materials hold the capacities to provide solutions to the different demands of construction systems. Garrett ends his reflections by expressing the idea that technical progress in this field does' not yet have given a substantial improvement on civil construction (Garrett, 1939).

We highlight that the introduction of concrete was a gradual process and with Estado Novo regime (1926–1974) started the regulation and control of the process of civil construction and housing projects, framed within the urban growth projects of the main urban centres.

Antão Almeida Garrett had a long career as professor and engineer, and from the 1940s, he undertook numerous studies, focusing in particular in the urban plan of Porto, working in partnership with national and foreign architects and urban planners.

6 CONCLUSION

The first uses of reinforced concrete demonstrate a progressive knowledge of the properties of new materials for civil construction, but their diffusion was also due to engineering schools and its teachers. They have a privileged role in the circulation of technical knowledge, the diffusion of new practices and the use of new building materials.

The first generations of graduated engineers from the Faculdade Técnica of the University of Porto, played an essential role in the dissemination of this knowledge, especially Antão Almeida Garrett, who throughout his career as professor improved the technical intelligence in his disciples and as engineer designed small-scale projects such as concrete structures for water tanks, terraces, but also projects of concrete structures for factory buildings, houses, making extensive use of reinforced concrete and even asbestos-cement.

Antão Almeida Garrett fostered the study of new materials, especially the reinforced concrete with his experimentation and theoretical principles improving

the modernisation of the civil construction, sustained by the development of engineering.

ACKNOWLEDGEMENT

This chapter was produced under the scholarship FCT SFRH/BPD/117829/2016, dedicated to the project: History of engineering education in Portugal: 1901–1960.

BIBLIOGRAPHICAL REFERENCES

Appleton, J. (2004). Materiais e tecnologias de construção: um século de mudança, ou da tradição à inovação. In Manuel Heitor, J. M. Brandão de Brito; Maria Fernanda Rollo (Coord.), *Momentos de Inovação e engenharia em Portugal no século XX: Grandes Temas*, (Vol. II, pp. 154–178). Lisboa: Publicações Dom Quixote.

Brito, J. M. Brandão de, Heitor, M., Rollo, M. F. (eds). (2002). *Engenho e obra: uma abordagem à história da engenharia em Portugal no século XX*. Lisboa: Dom Quixote.

Costa, J., Fazenda, L., Honório, C. et al (2010). *Os Donos de Portugal: Cem anos de poder Económico (1910-2010)*. Lisboa: Edições Afrontamento.

Camprubí, L. (2017). *Los Ingenieros de Franco*. Barcelona: Crítica

CMP / Arquivo Histórico Municipal do Porto – Licença de Obras nº 1146/1936.

_____. Licença de obras nº 192/1928-

·_____. Licença de obras nº 192/1928.

_____. Licença de obras 65/1930.

_____. Licença de Obras nº2/1932.

_____. Licença de obras 13 06/ 1935.

_____. Licença de Obras nº 1146/1936.

_____. Licença de obras 512/1936.

_____. Licença de obras nº 314/1938.

_____. Licença de Obras nº 314/1938.

_____. Licença de obras 41/1940.

Dinges, Tyson. (2009). The History of Prestressed Concret: 1888 to 1963: Relatory of Master of Science Kansas State University, 2009. Manhattan Kansas: Kansas State University.

Edgar, C. (1936–1837). Cimento Armado: Lições proferidas pelo Eng. Antão Almeida Garrett. Porto: FEUP.

FEUP. (1959). O laboratório de Ensaios de Materiais da Faculdade de Engenharia da Universidade do Porto. Porto: FEUP.

_____. (1926). Faculdade de Engenharia da Universidade do Porto: Faculdade Técnica da Universidade do Porto (1915–1926). Available: file:///C:/Users/Utilizador/Downloads/FEUP_-_Estudo_organico_e_funcional%20(6).pdf

_____. SDI/ARQUIVO – *Livro de Actas do Conselho Escolar*, 1915–1922. Cota: 7(01)ARQ00000006. Porto: FEUP.

Fontes, A., Paiva, V. de, Ribeiro, T.A. (1936). Materiais e Processos gerais de Construção: lições dadas pelo Ex.mo Senhor Professor Antão Almeida Garrett. Porto: Tipografia Gonçalves & Cª.

Garrett, Antão Almeida. (1932). Processos de Construção. In *Boletim da Associação dos Engenheiros Civis do Norte de Portugal*, 7, pp. 30–32.

_____. (1932–33). Cimento Armado [texto policopiado]: lições professadas no ano lectivo de 19332–33 pelo assistente Engenheiro Antão Almeida Garrett, copiadas pelos alunos Germano Venade e Manuel Arala Chaves. Porto: FEUP.

_____. (1935). Cimento Armado: Lições pelo assistente Engenheiro Antão Almeida Garrett. Porto: FEUP.

_____. (1938a). O betão armado e o fogo. In *Revista Faculdade de Engenharia*, IV (3), pp. 109–114.

_____. (1938b). Ainda as vigas helicoidais de betão armado carregadas uniformemente. In *Revista da Faculdade de Engenharia*, IV (2), pp. 49–51.

_____. (1939). Porque se não deverá empregar tanto betão armado. In *Revista da Faculdade de Engenharia,* V, (4) (dez.), pp. 156–158.

Mascarenhas-Mateus, J., Castro, C.R. (2018). The Portland Cement Industry and Reinforced Concrete in Portugal (1860–1945). In Ine Wouters, Stephanie van de Voorde, Inge Bertels, Bernard Espion. *Building Knowledge: Constructing Histories. Proceedings of the 6th International Congress on Construction History* (6ICCH-2018) (Vol.2, pp. 903–911). Brussels: CRC Press.

Moussard, M., Garibaldi, P., Curbach, M. (2017). The Invention of Reinforced Concrete (1848–1906). In D.A. Hordijk, M. Lukovic (editors) – *High Tech Concrete: Where Technology and Engineering Meet: Proceedings of the 2017 fib Symposium* held in Maastricht, The Netherlands, June 12–14, 2017.(pp.2785–2794). Deft University of Technology *fib*/Springer

Póvoas, R.F. (2018) O papel dos Arquitetos na introdução do Betão em Portugal. in J. Mascarenhas-Mateus (ed) *História da Construção em Portugal: Consolidação de uma disciplina*. Gráfica Diário do Minho, pp.121-137

Tavares, D. (2017). T*ransformações na Arquitectura Portuense: o caso António da Silv*a. Equações de Arquitectura. Porto: Dafne editora.

Tostões, Ana. (2004). Construção moderna: as grandes mudanças do século XX. In Manuel Heitor, J. M. Brandão de Brito, J.M.; Rollo, M.F. (Coord.), *Momentos de Inovação e engenharia em Portugal no século XX: Grandes Temas*, (Vol. II, pp.130–164). Lisboa: Publicações Dom Quixote.

Toscano, M.C.A. (2012). *A fábrica de Moagem de Caramujo: Património Industrial da Cova da Piedade*. Dissertação de Mestrado da Universidade Aberta, 2012. Lisboa: Universidade Aberta.

Vale, M. C. P. (2011). *Um alinhamento Urbano na construção do edificado do Porto – o eixo da Boavista (1927-1999)*. Dissertação de Doutoramento da FAUP, set.2011-janeiro 2012. Porto: FAUP.

A relationship between typography, designers and users to build a creative experience in the digital culture

Eduardo Napoleão & Gilson Braviano
Centre of Communication and Expression, Federal University of Santa Catarina, Florianópolis, Brazil
ORCID: 0000-0003-0391-5356
ORCID: 0000-0002-7967-2015

Pedro Manuel Reis Amado
School of Fine Arts, University of Porto, Porto, Portugal
ORCID: 0000-0002-6934-144X

Maria José Baldessar
Centre of Communication and Expression, Federal University of Santa Catarina, Florianópolis, Brazil
ORCID: 0000-0001-8971-4576

ABSTRACT: Typography is a content reproduction media, facilitator of access to information and a communication instrument. Its use in the digital culture makes it possible for the users to materialise their experiences in several other types of media. The reality inherent to its traditional use, however, may hinder the creativity of digital users due to problems related to licensing, protection, piracy, and design. The purpose of this article is to propose a set of guidelines to the design of digital types considering the creative experience of the user related to the use of typography in digital environments. This way, considering current social characteristics, such as interconnectivity, immediate flow of circulation and communication – as well as the expansion of consumption patterns and access to materialised cultural goods – it is hoped that the design of digital types will assume new economic features in order to reflect social ideals based on the stock and distribution of zero marginal costs. Initiatives based on content and free typography services, such as Google Fonts, among others – which require subscription, such as the ones offered by Monotype and Adobe Typekit, web-based software development (Prototypo), and the utilization of typographic development environments (Font Bakery) – may be relevant options in the relationship between designers, users, typography, and experience in the digital culture.

Keywords: Typography, creativity, typography community, type design, creative user experience.

1 INTRODUCTION

The comprehensive and easy access to typography as a product has become a widespread reality just recently. Before that, the XV-century revolution popularised by Gutemberg in printing, editorial design, and press areas, consequently, was characterised by the restricted use to specialised professionals. Their techniques were closer to the ones applied by craftsmen than to those organised by the modern designers of nowadays, who have only been set free from the classic limitations imposed by physical supports in the last few decades thanks to the digital culture. (Aguillar, 2015).

The development of classic typography has, creatively speaking, an important relationship with the ideas of copy and reproduction of information, aiming at facilitating the access to such features. Broad rights were granted, especially to the booksellers and editors, and not to the authors (Paranaguá e Branco, 2009).

Typography, while modifying the ways one interprets language and its social role, transformed itself into a portable consumer good. While manipulating language and words as a practical resource, it forges aspects of our own culture – including human beings themselves – as it indicates possibilities inherent to a world which is continually changing and moving or may even lead to moments of total isolation and introspection (Mcluhan, 2011).

The process of designing digital types may include research steps, an indication of visual guidelines, sketching on paper and canvas, drawing of different weights and sizes, as well as special characters and adaptation to different linguistic realities (Henestrosa, Meseguer e Scaglione, 2014). Amado (2014)

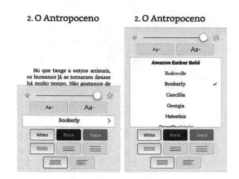

Figure 1. Typographic usage options for Kindle application users. Source: created by the authors.

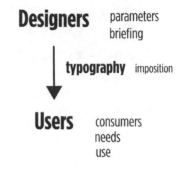

Figure 2. Classic passive relationship between designers and users, mediated by typography. Source: created by the authors.

also considers a stage of publication and distribution of types, which, according to the author, is primarily responsible for the revolution of the typographic design process in digital environments. However, brief use of any mobile device makes us understand that contact with the use of types is no longer restricted to the universe of designers and typographers and that its relationship with the users of the characters is not passive or merely mandatory. Digital access devices such as the Kindle allow the users to choose what anatomical characteristics of the typography used during the experience consumption of these products. The image composition presented in Figure 1 shows three screen cut-outs of the application, performed on September 10, 2018, in the iOS device, using a copy in the Portuguese language of the digital archive of the book Homo Deus, written by Yuval Noah Harari and published in Brazil by Editora Schwarcz in 2015. In them, it is possible to observe the typographical composition of the beginning of the second chapter and its different possibilities of typographic composition, such as the change of the size of the characters, colours, and spacing between lines, as well as alignment and typographic family.

As noted in the Kindle device, the products which, in the classical age of typography, were finalised and subsequently made available to users now provide possibilities for adaptations and continuous modifications. The typographic creativity here is no longer required but participatory.

In this sense, what general characteristics should designers consider when designing, producing, and distributing fonts taking into account the new realities of screen composition, type and copyright customisation in a world where typographic characters appear to be available everywhere, being altered and adapted by users according to their creative needs and interests? The purpose of this article is to propose a set of guidelines for the design of digital types that consider the creative experience of the user regarding typographic use in digital environments.

2 BUILDING A RELATIONSHIP BETWEEN DESIGNERS AND USERS MEDIATED BY TYPOGRAPHY AND SUPPORTED BY CREATIVITY

The typographic selection in projects by the designers foresees the choice of certain types to the detriment of others. Usually, this selection is made considering the specific visual characteristics of the characters (Aguillar, 2015). Considering the culture and universe of design, the choice of suitable characters depends on the factors present in the project briefing (Phillips, 2007). The intention is to associate these visual characteristics with the objectives of the product, service or brand that is being developed. For Lupton (2010) the selection of suitable sources is a necessary action among the many tasks of the designers. Thus, initially, designers often select or develop certain types that are used by consumers in their products and services. These users, then, used to act passively concerning their experience with the typographic elements, as shown in Figure 2.

Figure 2, therefore, represents a feature of relationships in which the creative experience provided by the designer was imposed. However, the digital age has changed the way designers, and users interact. Today, in products such as digital books (Lupton, 2014), this relationship between the creation and use of the product happens in an active and liquid way. It can be said that the product itself does not have a single final version because its characteristics are adapted and adopted by consumers.

Visions of several areas support the studies related to the theme "creativity". Considering the design process, it is contemporaneously associated with Design Thinking (Brown, 2009; Silva et al., 2012). The creative vision of the individual by Piaget and Freud (Freitas-Magalhães, 2003) is complemented by the vision of group relations (King and Schlicksupp, 1999). The natural, Darwinian, evolutionary, and adaptive human context (Johnson, 2010) is also supported by human fantasy influenced by mythology (Ulbricht, Vanzin and Zandomeneghi, 2010), as well as by studies

on happiness (Csikszentmihalyi, 1996) and idleness creative (Masi, 2000). In order to establish a systematic relationship between typography and creativity, Napoleão et. al. (2018) identifies that the few studies related to the subject consider the use of semiotic theories, the use of copy (Dawkins, 2017) and also informality as ways of concretizing the relationship between these two areas, usually materialised products of the design area. The author also cites as fundamental the development of partnerships and the development of research groups that aim to "establish clearer relations between the proposed areas".

The authors of this article consider creativity in type design mainly from the establishment of relations in groups and the creative act associated with the idea of adaptation. Thus, the creative act "may be a means to seek a solution for the configuration of the deficit structures", since inserted correctly in the design process (Napoleão et al., 2018).

In addition to the concepts presented, it is essential to consider the social and cultural changes that occurred when transitioning between an era of limited, printed, and electrical inputs (McLuhan, 2011) and a digital world with abundant characteristics (Harari, 2015, Jenkins, 2015b). In the digital environment, offers are limitless, infinitely reproducible, and based on a reality of consumption and mass experience (Schwartz, 2004). These characteristics also permeate the design culture (Ferrari, 2014). Typographic culture is also affected by these properties, and designers can design creative interactions usually guided by changes in anatomical typographic characteristics and proposed to users. Variable fonts, for example, allow for innumerable variations in weight, size and typographical spacing, among others, to be created from changes generated in intuitive interfaces, allowing users to select and adapt types to their usage needs.

The proposed net or active relationship within the digital culture indicates that co-creation, the basis of the construction of the proposed relationship, allows users to change the design parameters proposed in the briefing. One of the first indications of this relationship between typography, consumption, and the experience of design products may be in the universe of digital publishing, which has changed the way readers interact with content, as described in Figure 1. If before the editorial product had stable and rigid characteristics, providing mostly linear experiences, today the digital experience is more liquid and adaptive. Current readers not only control and choose the content to be read but also how, when, where, and in what medium it will be consumed (Lupton, 2014). For the author, the current books should adapt not only to the needs of the new platforms but also to the desires of the new users. In this context, the author states that the future of books is social. Thus, due to the design characteristics of the books, it is possible to affirm the same of type design (Amado, 2014).

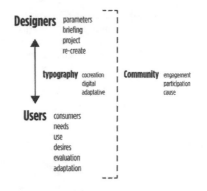

Figure 3. The formation of communities as mediators of the relationship between typography, designers, and users in digital environments. Source: created by the authors.

Books then changed from fixed objects to open systems. The experience goes beyond the use and consumption of the product, including the way consumers evaluate, review, and annotate texts and research elements at various points in the material. Not only the designers but also the writers can communicate with the readers during the process of construction of the content and the product itself. Even after the launch, readers continue to influence the product for the reasons cited above, assuming the interactivity of the process (Brown, 2009; Silva et al., 2012) and recreating the proposed experiment (Lupton, 2014). However, assuming that consumers change the suggested typographical parameters without direct supervision of designers, it is understood that this manifestation does not occur passively. In this way, the relationship between designers, users and design parameters, expressed here by typography, should be represented in a more integrated way.

Other ways to creatively express the relationship between designers, users and types may happen from joint funding of types (crowdfunding). The joint funding campaign "Folk is a great font, let us complete it," for example, developed and applied on the Kickstarter site between October and November 2011, sought to engage people around the development of lowercase characters for the proposed source. The campaign was successful and managed to raise a little more than the money initially envisaged. Other researches consider the relationships human beings have with chatbots, modifying the way we perceive the messages and how experiences happen between human beings and artificial intelligence mediated by typography (Candello, Pinhanez and Figueiredo, 2017).

With the advent of the Internet and the fast and liquid connection possibilities, design parameters that once served as rigid guidelines for creating designs and design products need to be adaptable so that users can also adapt and re-create the product. This direct influence of the users on the product is evaluated by these and by the designers, thus generating a cyclical and

non-linear process of co-creation. One can speak then about the existence of a community between designers and users. This relationship mediated by typography must be organised as a community, as proposed in Figure 3.

3 POSSIBLE NOISES AND OTHER OPPORTUNITIES OF DIGITAL CULTURE

Certain factors of digital culture may influence this relationship, such as piracy, free culture, and the relationship between typography and copyright. Piracy, within the digital culture, may include the illegal reproduction and distribution of games, music, photos, books, movies and typographic files. This feature is facilitated by the "zero cost" of reproduction of the original files. Even the application of specific protections, such as the creation of laws or the development of campaigns on ethics and morals, may prevent the action of piracy (Anderson, 2011). In the universe of creativity, one can associate it with the idea of mimetic (Dawkins, 2017). The author also states that artists use this dynamic to "promote shows, promotional articles, licensing and other paid items". Typographic production is also inserted in this context, and type designers seek to carry out events to promote typographic culture, licensing of typographic files and type design as a way to guide professionals in the area in relation to the characteristics of the area (Teixeira, 2012). In an interview with the newspaper O Globo, the designer Bruno Porto says that piracy of typographic files is as common as that of music files (Tardáguila, 2012). During the same interview, the designer Fábio Lopez states that "the future and viability of this market do not depend on good lawyers or stricter laws, but good business." For him, designers "need to facilitate formal access to their sources, provide unique solutions, and have good technical support." Thus, it is understood that both music and typography, manifested by their digital archives, are now much more a way of centralising marketing or branding strategies, thus generating new possibilities and monetisation models which no longer conceive the existence of this file as an end, but as a means.

Broad access may facilitate the manifestation of group creativity. Piracy may often be seen as a "tax-free" practice, and this is a reality faced by the software industry itself as part of everyday life, regardless of counter-attempts (Anderson, 2011). Typographic files, because they are also legally classified as software, are in the same reality. For the author, "Piracy is a form of zero cost marketing." In addition, it allows the circulation of media and products (Jenkins, 2015b).

Aguilar (2015) considers that European legal initiatives (French, English and European Union laws) seem to refer to formal issues of types, generally associating them with the spheres of industrial design, artistic works or graphic works. In the United States, there are

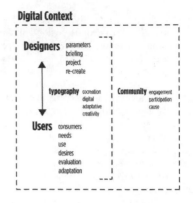

Figure 4. The formation of the typographic community in a digital context. Source: created by the authors.

two realities: (1) typography as an industrial design and (2) typography as software, considering those used to reproduce digital fonts.

In Brazil, Law 9.610/98, considered the Brazilian copyright law, takes sources as drawing works. Also, the protection of designs is governed by the Berne Convention, which is responsible for regulating copyright issues in the world and is signed by 166 countries (Almeida, 2013).

4 ORGANISING THE PROPOSED CONTEXT

An organised system should help designers and users to (1) create, recreate, adapt, alter and evaluate products, set parameters and co-create; and (2) to propose and facilitate the access of users and designers to the typographic elements in the "digital stock" and to assist in the quality of the final experience.

The typographic licensing should happen in this complexity, considering the typography in its formal characteristics, like software and the final product in its unfinished condition and inserted in the culture of the free. Figure 4 presents an overview of these types design guidelines which consider the user's creative experience of typographic use in digital environments.

Typography is, therefore, the media which enables the creative interactions between type designers and users, continually shaping and personally experiencing each one. This idea of a creative community must be applied between the designers themselves and the users, who can provide data and recommendations as to how they use the fonts in their specific contexts. Designers and users form a community but are influenced by the digital context, considering them as environments manifested by active processes (McLuhan, 2013). It is also understood that the community is more effective when organised around a cause (Jenkins, 2015a).

As aforementioned, the idea of design in a co-creative universe also happens among designers. Font

Bakery, for instance, is an initiative of typographic professionals seeking to ensure the final quality of the fonts made available on Google Fonts (Crossland and Sanches, 2018). Developing collaborative typographic software among all its professionals from the beginning of the design project is also one of the premises of Type Together. The company is registered in the city of Prague but does not necessarily own a physical studio in the city, using the characteristics of the digital universe to design and distribute its types.

Thus, considering current social characteristics such as interconnectivity, the desire for freedom, immediate flows of communication and circulation, the plurality of actors and the expansion of patterns of consumption and access to materialised cultural goods, for example, by popularising the use of streamline services such as Spotify and Netflix, it is expected that the design of types and the use of files and characters may assume new economic characteristics that reflect society's ideas based on zero marginal cost of inventory and distribution, sharing economy and belief that, at least in digital culture, we live in an era of abundance rather than scarcity (Rifkin, 2014; Harari, 2015). The creative and large-scale manifestation of shared digital images using the Impact source as a creator and transmitter of ideas may be yet another form of manifestation, albeit simple, of this new creative reality in a mimetic context (Brideau and Berret, 2014).

5 CONCLUSION

In a market with free possibilities, digital piracy, amateur development, and problems with the design and licensing of types, it is understood that there is a paradigm shift concerning the classic use of typography which directly affects how the type designers must conceive their products in digital environments.

Although it is considered an input to the type design process, the creative typographic experience still needs to be organised into models that consider the active participation of users in communities, intending to improve the final experience of these projects, processes and products. Initiatives based on free content and typographic services such as Font Bakery and Google Fonts, in addition to others organised around subscriptions or rental models, such as those proposed by Monotype, Adobe Typekit and Fontstand, and the development of web-based software, such as that created by Prototypo may be interesting in the midst of a creative and relationship system in communities still strongly influenced by non-digital culture.

The licensing of sources and their use can be used as a strategy for obtaining data for companies that own the rights to the sources. These, in turn, can be used in other strategies, such as marketing campaigns, merchandising sales, licensing for other uses, among others. This also influences the publishing world and

can improve the way we read or consume books. In this sense, typography can become part of brand marketing strategies as well as a way to metrify the experience of users while using their products and services, modifying and improving reading, time, frequency, and broadening the forms of experience of groups that may have special reading needs, with age groups and people with some type of vision impairment. The licensing and use of typographic software can be facilitated by existing licenses such as those proposed by Creative Commons, helping to materialise the ideal of "free" culture.

During creative processes, designers must keep in mind that different users can creatively and continuously modify layouts of different design products. The services for web fonts seem more advanced compared to printed use, so there is a real need to unite these two realities (Almeida, 2013). Not only the future of books, as mentioned by Lupton (2014) is social, but also the future of typography and design. In this way, typographic creativity thought in a communitarian way would also be an inclusive form, since it allows more users to have comfortable conditions of access to the contents and information made available, adapted to each of them, individually.

The path of typographic use seems to follow that of group creativity, which initially includes an increase in the possibilities of adaptation and personification by the end user, thus influencing the design process, which must consider the existence of these possibilities from the beginning of the creation of the typographic software. The expansion of product development teams, as well as the specialisation of the members in specific positions, seems to be a possible alternative for designers to achieve these goals of creative experience between designers and users mediated by typography.

BIBLIOGRAPHICAL REFERENCES

Aguillar, R. S. S. R. (2015) "Os direitos autorais na arte da tipografia", *Revista da ABPI*, (136), p. 49–54.
Almeida, G. M. de (2013) *Direitos sobre tipos graficos, Publishnews*. Available at: http://www.publishnews.com.br/materias/2013/01/23/71925-direitos-sobre-tipos-graficos%0A (Acessed:2018 may 30).
Amado, P. M. R. (2014) Participação ativa no desenvolvimento de comunidades online. Universidade do Porto.
Anderson, C. (2011) *Free: grátis: o futuro dos preços*. Rio de Janeiro: Elsevier.
Brideau, K. and Berret, C. (2014). "A brief introduction to impact: 'The meme font'", *Journal of Visual Culture*, 13(3), p. 307–313. doi: 10.1177/1470412914544515.
Brown, T. (2009). *Change by Design*. New York: Harper-Collins.
Candello, H., Pinhanez, C. and Figueiredo, F. (2017). "Typefaces and the Perception of Humanness in Natural Language Chatbots", *Proceedings of the 2017 CHI Conference on Human Factors in Computing Systems – CHI '17*, p. 3476–3487. doi: 10.1145/3025453.3025919.

Crossland, D. and Sanches, F. (2018). "Font Bakery: Fresh files every day", in 9º *Encontro de Tipografia*. Tomar: Instituto Politécnico de Tomar.

Csikszentmihalyi, M. (1996). "Creativity: flow and the psychology of discovery and invention". New York: HarperCollins.

Dawkins, R. (2017). *O gene egoísta*. São Paulo: Companhia das Letras.

Ferrari, T. G. (2014). "Communication Design and the age of abundance", *e-revista LOGO*, 3(1), p. 31–40.

Freitas-Magalhães. (2003). *Psicologia da Criatividade*. ISCE.

Harari, Y. N. (2015). *Homo Deus: Uma breve história do amanhã*. São Paulo: Companhia das Letras.

Henestrosa, C., Meseguer, L. and Scaglione, J. (2014). *Como criar tipos: do esboço à tela*. Brasília: Estereográfica.

Jenkins, H. (2015a). *Cultura da Conexão*. São Paulo: Editora Aleph.

Jenkins, H. (2015b). *Cultura da Convergência*. São Paulo: Editora Aleph.

Johnson, S. (2010). *Where Good Ideas Come From*. New York: Riverhead Books.

King, B. and Schlicksupp, H. (1999). *Criatividade: Uma vantagem competitiva*. Qualitymark.

Lupton, E. (2010). *Thinking with Type*. 2º ed. New York: Princeton Architectural Press.

Lupton, E. (2014). *Type on Screen*. New York: Princeton Architectural Press.

Masi, D. de (2000). *O Ócio Criativo*. 3ª, *Journal of Chemical Information and Modeling*. 3ª. Rio de Janeiro: Sextante. doi: 10.1017/CBO9781107415324.004.

Mcluhan, M. (2011). *The Gutenberg galaxy*. Toronto: University of Toronto Press.

Mcluhan, M. (2013). *Understanding Media: The extensions of man*. Berkeley: Gingko Press.

Napoleão, E. *et al.* (2018). "Analysis of relations between typography and creativity: A systematic review", in 9º *Encontro de Tipografia*. Tomar: Instituto Politécnico de Tomar.

Paranaguá, P. and Branco, S. (2009). *Direitos Autorais, Direitos Autorais*. Rio de Janeiro: FGV. doi: 10.1016/S0104-1843(14)50035-5.

Phillips, P. L. (2007). *Briefing: A gestão do projeto de design*. São Paulo: Blucher.

Rifkin, J. (2014). *The Zero Marginal Cost Society*. New York: Palgrave Macmillan.

Schwartz, B. (2004). *The Paradox of Choice: Why more is less*. London: HarperCollins.

Silva, M. J. V. *et al.* (2012). *Design Thinking: Inovação em negócios*. Rio de Janeiro: MJV Press.

Tardáguila, C. (2012). *Uso indevido de fontes será discutido na Bienal de Tipografia Latino-Americana*. Available at: https://oglobo.globo.com/cultura/uso-indevido-de-fontes-sera-discutido-na-bienal-de-tipografia-latino-americana-4629051 (Acessed:2019 january 10).

Teixeira, P. H. G. (2012). O Negócio das Letras: Uma análise da criação à venda de fontes tipográficas no Brasil. Universidade de Brasília.

Ulbricht, V. R., Vanzin, T. and Zandomeneghi, A. L. A. de O. (2010). *Criatividade e Conhecimento*. Florianópolis: Pandion.

The fantasy of the natural/cultural elements as symbolic tourist attractions through senses and technology

Ana Pereira Neto
CHAM, FCSH, Universidade NOVA de Lisboa, Lisbon, Portugal
ISEC, Lisbon, Portugal
ORCID: 0000-0002-0954-1220

ABSTRACT: The purpose of this paper is to understand the importance of the traditional knowledge on the use of space and events organisation, in the hedonistic practices associated with leisure and creative processes in tourism innovation, throughout new forms of intelligence, such as the artificial one, better known as A.I.

We cannot dissociate this kind of so-called intelligence from the authenticity of the memories that are still remembered by the real agents of culture- the people who live in the places that are visited by tourists. And these are the ones who can capture the interest of these visitors, arousing it with the explanations of their sensorial stimulation; this is already possible for a better comprehension of the usage of culture in visited places. It is on the excellent use of communication, by its awareness, that we can get better learning for the heritage safeguarding.

By our knowledge based on long-term ethnographic immersion on the Portuguese rurality, and in the bibliographic review, we propose the usage of the communication based on the traditional wisdom that can be taught by the locals, in tourism sites, and on media applications. The creation of attractions in tourism must be equational to the primacy of ethical principles with culture and technology.

Keywords: tourism, heritage, senses, creativity, technology

1 INTRODUCTION

There is an increasing interest in demand on reality and identity, but the individualism concerning preferences causes problems of adaptation to supply tourism services. The latter tends to take more time to adjust strategically to the new realities and sometimes with a significant loss in the thread of identities. It is essential to understand the criteria that reveal representations, cultural models and environments to comprehend the creative process of these identities. Knowing that there are no fixed descriptions, the requirements can change, and the notion of demand can be constructed in different ways, from different premises, which does not invalidate the need to preserve identity-based on the heritage legacy, constituted as implicit or explicit memory.

With the plurality of information available, one tends to use that which was already known and used for the same purpose. There is a certain laxity in the face of the accurate representation of reality.

The actual experiences in the visited places are, when authentic, a multiplier effect in the returning visitors and first time ones.

More than the real image, it is the experience that sets the right information. Hence, we consider the importance of the ethical awareness of the authenticity of who is involved in the whole supplying service.

Culture, like tourism, involves issues of exchange and the relationship between what is given and received, between creation and contemplation, and these relationships depend on the crossing of two axes: the guest/host population and the heritage. It is in this dynamics that the communicational process can produce an attractional factor to tourism sites.

Without knowledge, there can be no noteworthy reading on the heritage, including the natural one, and therefore there can be no quality in hosting integration, based on authenticity and genuineness.

It is in this sense that we propose the valuation of information about heritage through the sensory impressions that can be taught by communication technologies, using the local cultural codes of interpretation, using the memories of the locals that still remember.

We make a brief presentation of the vantages and disadvantages of the use of technologies, in touristic frequency, concerning with the audio, visual, odour

and tact, in the communication between the user guest and the localhost.

2 AUTHENTICITY THROUGH THE INTERPRETATION OF NATURAL AND CULTURAL SYSTEMS

For the maintenance of natural and cultural heritage, there must be a correct understanding of its meaning as well as its intrinsic significance.

Dynamics of identity maintenance and projection are necessary, based on the history of space, where the traits and elements that characterise cultural originality reside, still recognised by the inhabitants of most of the places we seek to know as tourists.

These traits can be rapidly perceived by individual research in media platforms or the visited places. However, there can be several misunderstandings of the real site itself.

When someone describes the sites makes it with one's perception and codes of interpretation. Smart Tourism instead of being a significant data information facilitator to stakeholders (Buhalis, D. & Amaranggana, A. 2013) has to become more communicative. Sometimes the wrong information is passed by its producers on the tourism sites, inferred by economic interests, most of the time. (Soukhathammavong, B., & Park, E., 2019).

Landscape and urban places have their own stories to tell, and these must be integrated into a learning process based on an intelligible communicational process.

Beacons as a form of technology that can provide information in consumerism places, like shopping malls, or in nature itself, are used as a provider of information of data sites. However, a significant part of that information is just a part of the stories that can be told. (Neto, Ana Pereira and Mateus, 2017).

These technological devices are very interesting, concerning the attribution of economic value to local spaces and products; but the information they convey lacks the interpretative value of who is heir to the tradition – the local population – who is the interpretive facilitator par excellence, of the contents of the domestic spaces inserted in the regional context.

The customer using this technology can interact with the application and then the places where it consumes; this ensures the individualisation of choice and informational feedback but does not guarantee the quality of the information, which should operate in a broader context.

Direct communication can bring magic to the visited places and stimulates fantasy to the ones who attend them, and thus can bring more attractional factors to sites. Real identification must be taught; otherwise, the interpretative discourse could be distorted, and fantastic stories can pass to newcomers without pedagogical significance.

3 VISUAL AND ODOUR SENSES

These senses are implicitly joined in most of the touristic experiences. Some products like the ones related to food and beverage are integrated into marketing communication to promote destinations.

Food and culinary techniques relate to the regional marketing in which they constitute just a part of the metaphorical information (Berg, P. O., & Sevón, G. 2014).

This information requires qualification throughout the certification of traditional products, as an institutional procedure. However, this does not contemplate the information that comes from previous ethnographic and ethnological studies. This fact and the disregard for the knowledge of the local producers, which remains a secret to the public domain, can bring some annoyance to the few ones that still remember the right procedures in the creation of the real local flavour.

The formal aspect of Portuguese ceremonial pastry can be appreciated if its ethnological information is passed to consumers; that is the case of *folares, sonhos, espécies*, amongst many others. Their shapes can tell many interesting stories that can be related to many others that are local identifiers of ethnic identity.

Tradition consumerism of these kind of commodities is embedded of profane symbolism, part of the intangible heritage that does not come to the public, namely the possible visitors. That happens with the use of olive oil or pork fat which has a visual effect that is unperceived without the explanation of the symbolic meaning of its use within the traditional calendar.

The odour of fried olive oil or pork oil can tell much of the importance of its use, for sacred/profane means. Its consumption can validate the quality of the experience, in the oeno/gastronomic context.

Some natural ingredients used in some occasions can be trusted as fixers of traditional knowledge, and essential health keepers and, as well, attraction identifiers (Neto, Ana Pereira, 2015).The culinary techniques and traditional receipts that are enhancers of local identity can be safeguarded by technology.

The moderate doses of traditional natural ingredients in culinary techniques is nowadays one of our research issues. That is something that the visual presentation cannot identify. And, what about the odour?

The *pastel de nata*, one of the world's best-known Portuguese pastry elements is representative of the urban culture and is empty of traditional meaning. Its configuration, however, can have a wide range of odour interpretation than if it is shown only in pictures.

Odour wheels, nowadays used in city branding or specific places or cases, like archival paper (Bembibre, C., & Strlič, M. 2017) can also be used in instructive ways, in mobile apps, as facilitators of daily interpretation for personal users.

The traditional codfish with garlic cannot taste Portuguese tradition if it is not made with raw fresh garlic. It is already possible to associate odour to mobile phone apps, this technology is known for some years (Ranasinghe, Nimesha, et al. 2011) and can be perfected in associating images to "tastes".

The explanation of the smelly tradition can be made with personal hosts avatars, like those created by ObEN, Artificial Intelligence Inc., on the Project Personal Artificial Intelligence -PAI. (Du, J., Fang, D., & Harvilla, M. 2019).

Through A.I. applications on mobile phones, these avatars can interact with the user and speak several languages, although they can only transmit information for what they are programmed for (Wagner, 2018).

The identification of ingredients, using the knowledge and its appliance in a local touristic promotional site, seems to us of interest, especially if this can be done using A.I. storytelling, with the advantage of multilingual speech use.

4 SONIC SENSE

Symbolic perception of sonic experiences and its interpretation in tourism promotion require our attention, namely in everything that concerns the authenticity and its certification.

The data concerning information on sonic heritage is, like other information for tourists, well-kept and used in several ways, although dispersed in the available interpretation to users.

Sound can help fixing memories, and the sonic experiences can bring awareness of olfactory and visual issues on the visited places. The use of sound traces to explain cultural elements, by A.I technology, seems to us a perfect way to facilitate the holistic sensuous perception of local culture to tourists. However, the local codes of interpretation have to be given in an intelligible form.

Cante, as UNESCO intangible heritage (Raposo, Eduardo M. and Neto, Ana Pereira, forthcoming) is an example of the importance of the cultural, spatial context for authentic performance. However, how can this be explained to someone that does not relate the several meanings of that context?

The sonic effect that the singers can produce in a tavern or an open space has its particularities; these are identifiers of behavioural performing actions. The listener is aware of the difference, but cannot perceive the whole message that comes from the group.

Personal hosts are excellent interpreters; however, they are often used for groups of tourists that come to spaces in a disturbing way, as spectators.

Reduction of the impact that the number of incomers can produce in a space where this chant tradition emerge can also be one of the advantages of the use of the referenced technology.

Sound as an interpretative way of places, has often been used in its branding, especially in urban areas related to the musical genre that configures some of the typicity of the sites. This use is done mostly for marketing purposes of the stakeholders involved in tourism. Thus, the attraction factor is, someway, manipulated, and voids its symbolism.

In itineraries, sonic experiences can be enlarged in its range, covering the territory focusing attention to several components of the environment such as the cultural and the natural ones. These can be separated for a better perception of different times in the past. The awareness of aroused memories from the past and its projection for a new future should be useful as a recreational fantasia, based upon real data collection.

Times of remembrance of the sounds produced by men, domestic animals, individual calls made by people in certain hours of the day can imprint their mark for a better perception of local identity.

Places of the southern coastal line of Portugal are being lived and sold as part of the marketing clichés, proposed by stakeholders. Everything seems similar to other contexts, and even the new generations of locals do not recognise in nature the stories and legends of their ancestors.

It is with certain anguish that we do not see any more tourists who come exclusively to feel the experience of hearing the sonic purity of the wave spraying, or the donkeys braying when the evening is coming. However, it is possible to do experience phantasy with the right mobile application, without crowd disturbance.

5 TOUCH SENSE

And what about touch? How can it be interpreted? Spoken and written word use can be a useful tool, conjoined with the others that we referred to previously.

The importance of traditional materials used in the primary production technologies in gastronomy, in weaving, ceramics and shelter/habitation, are fundamental for a better comprehension of the visited whole. Its explanation, focusing the arousal of this sense, is not commonly used for individual tourists.

Museums are the privileged places for this kind of cultural appreciation; however, the readings that users have from the exhibits are only a partial component, subdued to thematic schemes, of the possible interpretations that new technologies can bring.

The exhibition time can be permanent or temporary, and the possibilities of crossed information and its interpretation fix in closed spaces, reducing touching experiences, which are, most of the times, forbidden.

The use of samples, for touch purpose, from original materials is reductive for observation and integration in the communicative process of knowledge transmission. Texture, for example, must be explained in its entire context, not disregarding all the procedures of its elaboration.

Here, once more, the representation odour wheels can be associated with odour applications transmitters. It is also possible, nowadays by the use of augmented virtual reality, known as A.R., to provide touch experiences in diverse portable ways, like prints (Olalde, Karle. Guesalaga, Imanol 2013).

6 FINAL NOTES

Portability and individual use of knowledge provided by technology can be facilitators of heritage safeguarding, in a self-educational way.

The portable applications can be used freely, without the preoccupation of limitations based on time and spatial distance. Thus, the constraints of time schedules of overture and closure of nature/cultural interpretation centres are postponed.

We cannot ignore the possibilities that A.I. technology has in its communicational range. However, the knowledge that resides out of the big data servers, and its importance like all the work done by researchers in several areas of science, namely in the almost forgotten Anthropology, must gain its role to its enrichment.

A.I. technology has several advantages in transferring knowledge, throughout chatterbots and avatars; however, there is a long way to go to explain symbolic thought, which is fundamental to comprehend the culture in all its ranges.

Sensuous explanations seem of an exciting area to exploit, nowadays and soon, where nature and memories appear to be things that must come out to the light of comprehension, to the ones that live in times where the past only comes out when is called. However, it may never come if no one is aware of its existence

Memory data must include in a dynamic communicational process, as interest enhancers, through its usage, by everyone.

Quality of the information vehiculated by these kinds of technologies must rely on as a trustful mean of ethical principles, which cannot subdue to economic based interests.

Thus it can safeguard the heritage specificities of each bio-socio-cultural system; the attraction factor for the demand of diversity can be used as an element of qualification to those systems.

ACKNOWLEDGEMENT

This chapter had the support of CHAM (NOVA FCSH/UAc), through the strategic project sponsored by FCT (UID/HIS/04666/2019)

BIBLIOGRAPHICAL REFERENCES

Bembibre, C., & Strlič, M. (2017). Smell of heritage: A framework for the identification, analysis and archival of historic odours. *Heritage Science*, 5(1). https://doi.org/10.1186/s40494-016-0114-1

Berg, P. O., & Sevón, G. (2014). Food-branding places – A sensory perspective. *Place Branding and Public Diplomacy*, 10 (4), pp.289–304. https://doi.org/10.1057/pb.2014.29

Buhalis, D., & Amaranggana, A. (2013). Information and Communication Technologies in Tourism 2014. EProceedings of the ENTER 2014 PhD Workshop, 1–146. https://doi.org/10.1007/978-3-319-03973-2

Du, J., Fang, D., & Harvilla, M. (2019). PAI Data, Summary of the Project PAI Data Protocol.

Neto, Ana Pereira, and Mateus, Anabela Félix. (2017). Turismo de Saúde e Bem-Estar. A informação Comunicação como atractivos termais. Um caso: As Caldas da Rainha. In *Perfiles actuales en la información y lo informadores*. Ediciones Universitarias. pp. 365-377. Editorial TECNOS (Grupo Anaya). ISBN 978-84-309-7378-1.

Neto, Ana Pereira. (2015). *Termalismo- As lógicas do consumo na entropia da ordem cultural, o exemplo das Caldas da Rainha*. (PhD).Universidade Nova de Lisboa. http://hdl.handle.net/10362/14498

Olalde, Karle, Guesalaga, Imanol. (2013). The New Dimension in a Calendar: The Use of Different Senses and Augmented Reality Apps. *Procedia Computer Science*, ISSN: 1877-0509, Vol: 25, pp: 322–329. https://doi.org/10.1016/j.procs.2013.11.038

Ranasinghe, Nimesha, et al. (2011). Digital taste and smell communication. In *Proceedings of the 6th International Conference on Body Area Networks.*, (78–84). Brussels: ICST (Institute for Computer Sciences, Social-Informatics and Telecommunications Engineering.

Raposo, Eduardo M. and Neto, Ana Pereira. (forthcoming). Cante Intangible Cultural Heritage of Humanity: representation of a traditional art in the city of Almada In *AMPS Proceedings Series Tangible – Intangible Heritage(s)Design, Social and Cultural Critiques on the Past, Present and the Future*. London: the University of West of London.

Soukhathammavong, B., & Park, E. (2019). The authentic souvenir: What does it mean to souvenir suppliers in the heritage destination? Tourism Management, 72,105–116. https://doi.org/10.1016/j.tourman.2018.11.015

Wagner, Kurt (2018). I talked to Google's Duplex voice assistant. It felt like the beginning of something big. But it's not even close to ready for everyday use. https://www.recode.net/2018/6/27/17508166/google-duplex-assistant-demo-voice-calling-ai.

Remediation and metaphor: Gamifying teaching programming

Desirée Maestri & Luciane Maria Fadel

Programa de Pós-Graduação em Engenharia e Gestão do Conhecimento, Universidade Federal de Santa Catarina, Florianópolis, SC, Brasil
ORCID: 0000-0002-9198-3924

ABSTRACT: The development of abstract thinking needed to solve complex problems is often associated with teaching programming. Most of the platforms that support this teaching are structured in a rigid form and with a coherent interface to the old logic patterns associated with programming. Thus, it is common for beginners in the programming study to feel uncomfortable with such sobriety. This paper argues that remediating games through structural metaphor can make programming teaching environments fun without losing focus on logical intelligence. A close reading of the App Inventor platform developed this argument. This reading was carried out using the analytical lenses of remediation and metaphor. The findings indicate that App Inventor remediates a puzzle game through structural metaphor. The blocks that fit together (use of pieces) and are joined from a set of rules indicate the elements of games used. Both (pieces and rules) are the re-enactment of the puzzle. The similarity to a puzzle encourages experimentation because the metaphor was built into the user's conceptual system. In addition, the structure of a game allows errors to be made. Experimentation and error provide the basis for learning because they support agency. Thus, structural metaphor evokes agency through mastering choice and mastering narrative. Agency, in turn, supports logical intelligence.

Keywords: Remediation, gamification, teaching programming, agency

1 INTRODUCTION

Information and communication technologies (ICTs) are increasingly occupying space in the work and teaching environments. However, they are used much more as a mean than as an end; that is, the established is at the media content level and not as an object of study in itself. Consequently, there is more interest in studying the development of ICT in a different context, such as online courses, ODL colleges, instead of studying the ICT artefact. Besides, computer science is a promising area in the job market, with many opportunities. Therefore, the inclusion of people in the ICT universe is also an inclusion of people in the work market, allowing the economic autonomy of many families. Still, teaching programming languages is an environment surrounded by myths about difficulty and complexity. It turns out that often the interface is not friendly, that is, the "black screen" scares and sends away many beginners. However, some studies point to other reasons for this difficulty, which are not related to the content itself, but to the way it is presented. Several studies focused on the difficulties of teaching beginner programming, which leads to research on ways to improve these teaching and learning conditions (Ball et al., 2018; Souza et al., 2011; Gomes et al., 2005; Gomes et al., 2007a; Gomes & Mendes, 2007b; Jenkins, 2002).

In addition, some authors argue that the difficulty of teaching programming is not only about the skills of writing the code correctly, but also includes generic problem-solving skills and logic (Gomes & Mendes, 2007a). Moreover, this difficulty is related to previous teachers' and students' expectations, attitudes and experiences (Jenkins, 2002). One significant obstacle reported by students when starting the study of computation is not the programming languages or description of algorithms themselves, but rather the difficulty in abstracting and describing the solutions of problems counting on only a few simple structures (Souza et al., 2011). One initiative to improve the way the knowledge is transmitted is to bring elements of games to the strategies of teaching, which means to gamify teaching. Gamification in programming teaching makes it possible to demystify its complexity, especially among people who are afraid to start these studies. However, gamification can value the playful, which seems to go against the logic necessary in teaching programming.

Logic is an area of mathematics whose purpose is to investigate the veracity of its propositions According to Souza et al. (2011), the role of logic in programming is to ensure the correct sequence of instructions that must be defined in order for the program to reach its goal. That is, logic is an instrument for verifying the written program, as it proves whether it is correct or not. The programming logic is expressed by algorithms, which represent a set of rules for solving a problem. That is, in programming, the algorithm specifies clearly and correctly the instructions that software should contain so that, when executed, it provides expected results (Souza et al., 2011). An algorithm is the results of systematic thinking that does not seem to correspond to a playful approach. Thus, this paper starts from the question: how to gamify teaching programming without losing focus on logic?

To answer this question, this paper investigates remediation as a way of capturing the abstraction necessary for the development of logical thinking while valuing fun. Therefore, this paper uses the close reading method to analyse through the analytical lens of remediation and metaphor the platform App Inventor, a Visual Programming Language (VPL) that uses block-based programming.[1]

App Inventor was chosen because it is free and open source platform developed by MIT to assist in programming and development of Android applications. Next section presents some basic concepts for this analysis: remediation and metaphor. Following, analysing the remediation process through metaphor deconstructs the artefact, and some considerations about gamification and agency are drawn.

2 REMEDIATION

According to Bolter and Grusin (1999), the term remediation has two definitions: the first refers to the representation of one media in another (Manovich, 2002). The second definition refers to the oscillation between immediacy (making the medium transparent) and hypermediacy (the medium becomes opaque). This paper deals with the first definition because it argues that the remediation of the metaphor of a game establishes the necessary balance between logic and the fun in teaching programming. Bolter and Grusin (1999) conceived four levels of remediation, which relate to the old and new media. At the first extreme, the old media is represented in digital media without any change, such as a digitised book for example. The second level already incorporates some feature of the new media to the old. In the previous example, the digital book is processed to allow various actions like text marking and search. At the third level, the old media begins to undergo significant changes, but mainly, it

is still the same digitally represented object. The digital book becomes an e-book. When the new media fully embeds the old media, it would reach the fourth level. The artefact presents itself as a new proposal evidenced by a new experience. One way to design a new medium at a high level of remediation is to use metaphors.

3 METAPHORS

Metaphors can be seen as a device to explain some concept or thing, stating its resemblance to another concept or thing. Metaphors help us to understand something and create meanings by establishing a conceptual relationship. Lakoff and Johnson (2003, p.4) argue "our ordinary conceptual system, regarding what we think and act, is fundamentally metaphorical in nature." Moreover, for these authors, the metaphor is:

1. By definition inaccurate;
2. The metaphor is interpreted contextually at various levels, from isolated individuals to large-scale cultures;
3. It works within a conceptual system, not in isolation;
4. It can be one of the leading models that human beings have to understand new concepts.

Conceptual metaphors are divided, according to Lakoff and Johnson (2003) into three categories: orientational, ontological and structural. According to the authors, each structural metaphor is internally consistent, and the "dominant" conceptual domain imposes this structure on the conceptual domain that is structured, allowing its comprehension.

4 STRUCTURAL METAPHORS

The most popular kind of metaphor that Lakoff and Johnson (2003) have identified is the structural metaphor. The structural metaphor involves the presence of a vehicle, which is some well-understood object or concept of the real world, which carries the content (meaning). The more specific the chosen vehicle, the more likely there will be more structure, hence the name "structural metaphor." This category of metaphor is usually more apparent because the disparity between the content and the vehicle is very evident, and thus, the metaphor is likely to be understood. The difference between content and vehicle is crucial to the success of metaphor because they create relationships between things that are not directly equivalent (Johnson, 2001). The benefit of metaphor occurs when two disparate concepts are related, and a new meaning is created. Structural metaphors are the most obvious type of metaphor used in everyday life,

1. http://appinventor.mit.edu/explore/aboutus.html

such as Shakespeare's 'Juliet is the sun' metaphor or the trash can (data deletion) in a software interface.

5 ONTOLOGICAL METAPHORS

Ontological metaphors occur, according to Lakoff and Johnson (2003), because we apply our experience with physical objects and substances to make sense of more abstract terms. For example, a set of data obeys the 'document' metaphor. Users may be instructed to 'move the document to the trash.'

6 ORIENTATIONAL METAPHORS

Lakoff and Johnson (2003) argue that orientational metaphors attribute the concept to spatial orientation. This spatial orientation is based on our experience of moving forward and in an upright position. Thus we associate the metaphor 'happiness points up', 'more is up,' 'good is up.' Browsing on a web site, for example, applies the metaphor: 'the next is to the right.'

This paper argues that the use of conceptual metaphors guides remediation as a way of capturing the abstraction necessary for the development of logical thinking while valuing fun. To develop this argument, a close reading of the App Inventor platform was carried out using the poetics of remediation and metaphor.

Figure 1. App Inventor "Designer" interface.
Source: the authors.

Figure 2. App Inventor "Blocks" interface.
Source: the authors.

7 APPINVENTOR

Thinking about making programming accessible to more people, Google along with MIT have developed a block-based programming platform: App Inventor. This platform, like Alice[2] and Scratch[3], also uses block language, but these two are more focused on games and storytelling. The difference of App Inventor, released in 2009/2010, is a platform to develop applications for Android, with different goals, not just games, and be available for use on the mobile. Its premise is to value intuition through a visual interface to enhance the interaction between people and their environment. The App Inventor is divided into two interfaces: Designer and Blocks. In the "Designer" interface, the user can add interface components on the application screen, as well as create new screens. The left column contains the interface components separated into groups: user interfaces, layout adjustments, insert media, etc. In the first column on the right, the user can find the screen components, such as a button, labels, and sounds. Below, there are the external media to be added in the app, such as the kitten's image and sound.

2. https://www.alice.org/
3. https://scratch.mit.edu/

The second column contains the customisation properties of these components. In the "Blocks" interface, there is a column with the types of functional blocks: control, logic, text, variables, etc. Figure 1 shows the "Designer" interface.

Moreover, the "Blocks" interface contains all the interface components that have been added in the "Designer" tab. On the canvas, the blocks are assembled and have a backpack (ontological metaphor), which serves to carry pieces of code to another screen of the application or another App Inventor project. Figure 2 shows the "Blocks" interface.

However, the majority of programming languages uses Textual Programming Languages (TPL), such as Python.

Figure 3 shows an example of code in Python to calculate student grade. The average is between two partial marks (Grade 1 and Grade 2) and, if it is above 7, the student passed. Part of the same programming written using App Inventor, as shown in Figure 2.

The way to execute the two codes is also different: Python code is executed through a Command Line Interface (CLI) meanwhile App Inventor uses Graphic User Interface (GUI) to input data and check the result on a more friendly user interface. Figure 4 shows the CLI (top) and the app interface (bottom).

```
def main():
    grade1 = input ('Grade1: ')
    grade2 = input ('Grade2: ')
    media = (grade1 + grade2) / 2

    if media >= 7:
        print ('Passed')
    else:
        print ('Failed')

if __name__ == '__main__':
    main()
```

Figure 3. Python code example.
Source: the authors.

Figure 4. Executing Python code (top) and App Inventor code (bottom).
Source: the authors.

On CLIs, the user has to type the grades using a keyboard, and the result (algorithm's return) appears on the same screen as a text result.

In App Inventor, the "AI Companion" functionality allows viewing the prototype in real time on an Android smartphone. In this case, the user types the grades and checks the result on the smartphone.

8 METHODOLOGY

The close reading method was applied to investigate how fun was designed without losing focus on logic on the App Inventor platform. Thus, the first step was to observe the facts and details about the artefact. So, the platform was used to create applications with low complexity. Each interface (Designer and Blocks) was deconstructed in terms of objects, form, and rules.

Screenshots were taken from each segment so they could be analysed. The analysis of the platform led to the description of the interface, which in this case was very close to a puzzle. Detailed notes about the description of the interface were taken.

9 CLOSE READING THE APP INVENTOR

It is evident the relationship of App Inventor with a puzzle. This relationship occurs through the blocks that fit when the docking shapes are compatible. Moreover, as in a puzzle not only the shape determines the right place of a piece but also the information generated in the set, that is, the content of the figure formed must have meaning. The difficulty of the game is due to both the increase in the number of pieces (form) and the complexity of the image (semantics).

Concerning the form, blocks in the shape of a puzzle piece are the elements used for remediation. Concerning semantics, the logic of programming must follow the rules of the puzzle game, which is to fit the pieces with complementary form, in order to build an image (or code) that makes sense. In App Inventor, the remediation of the puzzle takes place through the structural metaphor of this object. Structural metaphors allow us to use a highly structured and delineated concept to structure another. That is, in defining that programming is a puzzle, programming ceases to be an abstract concept since it now relates to puzzles. Programming comes to be perceived in a more structured way.

Therefore, the programming that is the content of the App Inventor is structured like a puzzle. This metaphor is culturally grounded in our experience with puzzles.

Having this experience means that all the qualities of the puzzle object as known are used to structure the programming object (which is new to the audience in question). So even a beginner in programming knows that pieces can only fit together if form and semantics are consistent. From this structural metaphor, it is possible to understand the narrative logic of programming, which encourages the development of abstract thinking as support for logical intelligence. For example, as in a puzzle, the pieces with a straight side certainly belong to the edge of the figure, while a 90° angle determines a corner. This information eliminates many pieces and directs the choice of starting pieces (start with a corner, for example). Likewise, in the App Inventor, these border pieces are easily identified by colour and shape, such as the "When-click" block in Figure 2 (corner piece, or in this case an involucre). The structural metaphor also leads the user to separate the pieces by semantics. When doing a puzzle is common to separate parts that have a similar design, either by colour, texture or form. This reasoning indicates to the user that parts with similar information will form a coherent set. Still following the narrative of the puzzle, the user knows, without any initial information that the best way to approach this problem is to fit piece by piece. It is also no use insisting on a piece that, at first, does not fit anywhere. It is a better move to leave it aside and pick up another piece because the right moment to use it will come, as the player will remember its shape and content. The structural metaphor of the puzzle also implies in the

pre-judgment of the difficulty implied by the number of pieces, the size of these pieces and content. So the user knows that assembling a programming piece is easy by the number of parts available. The perception of the degree of difficulty (in this case, low) can increase self-confidence and break with some barriers and beliefs that programming is complicated.

10 FINAL CONSIDERATIONS

The result of the App Inventor remediation is a gamified environment. Gamification means applying game elements to things that are not games (Deterding, 2014). This means that gamification uses the essence of the games: mechanics (game-based mechanics), aesthetics and game thinking, based on a structure and dynamics organized to engage people, engage them and motivate them to action and, thus, achieve their goals, which is learning in the educational case (Kapp, (2012). Engagement happens because the ludic activity transmits varied information, stimulating several senses at the same time, without becoming boring, because they are considered attractive and pleasant (Falkembach, 2002).

In the App Inventor, the blocks that fit together (use of pieces), which are joined from a set of rules indicate the elements of games used. Both (pieces and rules) are the re-enactment of the puzzle. The gamified environment is an environment that values the user experience. What is expected is for the user to feel comfortable experimenting, making mistakes and learning.

The similarity to a puzzle encourages experimentation because the metaphor was built into the user's conceptual system. The user knows how to do a puzzle and brings this experience to the environment. The structure of a game allows mistakes to be made, which leads to a fresh start. If the programming is like a puzzle, the error is allowed because it is easy to correct: remove the piece that fits (form) but did not form a logical semantics and try another one. Experimentation and error provide the basis for learning because they support agency (Murray, 1998).

Murray defines agency as "the satisfying power to take meaningful actions and see the results of our decisions and choices" and together with immersion and transformation, they form the aesthetic of the computer. In this sense, agency is not a characteristic of the medium but an aesthetic pleasure perceived by the user (Murray, 2011). This statement also means that the user experiences the power of dynamically change the environment, which goes beyond simple interactivity. Murray argues that common places to experience agency include the structured activities of games, the pleasure of navigation and constructivist stories.

Eichner (2014) investigated agency experienced in the process of media reception and builds a model of agency as a mode of media involvement. Involvement refers to any textual attachment (the text holds significance for the reader) that either can be related to cognitive interpretation or emotional experience. Agency for Eichner (2014) can assume three levels: personal agency, creative agency and collective agency. In the case of App Inventor, personal agency is more evident and arises mainly from the mastering choice and mastering narrative.

It is considered that the text recognition and its patterns of features, and the interpretation of the text with its polysemy according to readers' knowledge, is the most basic form of involvement with the text, or the first-order involvement. Mastering narrative belongs to second-order involvement and happens when the default resources call for participation of the reader who recognises the textual structure that forms the narrative. Eichner definition of agency relies on genre conventions, like film genre, or in conscious provocations of the audience expectations with complex narratives. Therefore, agency explores the space of free movements of the user in a rigid structure (Zimmerman, 2004). Mastering choice happens when the users perceive that their choices had influence and made a difference in the final result of the narrative. This perception implies that mastering choice depends on the flow perceived by users (Csikszentmihalyi, 1990).

Mastering choice evolves by realising that the choice of a piece was decisive in the final result. Likewise chess, the amount of actions in the puzzle is quite limited. One can only fit the pieces to form a coherent form. Even so, the number of choices (which piece fits where) is enormous. Agency evolves when users perceive that their choice led to a significant construction of the piece. In addition, the freedom of experimentation and of making mistakes and starting all over again support mastering choice. Besides, personal agency grows with mastering programming logic narrative. Once the user understands that the narrative obeys a genre, and specific rules, it is easy to guess what the textual sequence is and act upon it. This is to say that the user constructs his coherent narrative through mastering narrative logic of programming. This structure allows the logical intelligence to develop because it is possible to play with the pre-established standard. Following Zimmerman definition of play, the interactive narrative of App Inventor is designed for play into the structure of the experience of programming using blocks.

Applying structure metaphor to remediate a puzzle can also be found on the design of Scratch and Alice. Likewise, App Inventor, programming using Scratch or Alice is assembling different blocks to form a coherent structure. The platform asks the user to put the blocks that fit together (respecting form and semantics).

Finally, seeing this platform as a puzzle makes it clear how programming compels the user to engage with logic actively.

ACKNOWLEDGEMENT

This work was conducted during a scholarship financed by CAPES – Brazilian Federal Agency for Support and Evaluation of Graduate Education within the Ministry of Education of Brazil.

BIBLIOGRAPHICAL REFERENCES

Ball, R., Duhadway, L., Hilton, S., & Rague, B. (2018). GUI-Based vs Text-Based Assignments in CS1, 1017–1022.

Bolter, J. D., & Grusin, R. (1999). Immediacy, Hypermediacy, and Remediation. In: J. D. Bolter, & R. Grusin, *Remediation* (pp. 20–50). Cambridge: MIT Press.

Csikszentmihalyi, M. (1990). *Flow: The Psychology of Optimal Experience.* New York: Harper Perennial Modern Classics.

Deterding, S. (2014). The Ambiguity of Games: Histories and Discourse of a Gameful World. In: S. P. Walz, & S. Deterding, *The Gameful World: Approaches, Issues, Applications* (pp. 23–64). Cambridge: MIT Press.

Eichner, S. (2014). Agency and Media Reception: Experiencing Video Games, Film, and Television. Potsdam: Springer VS.

Falkembach, G. A. M. (2002). Ludic in Educational Games. Mídias na Educação. Rio Grande do Sul: CINTED/UFRGS.

Gomes, A., & Mendes, A. J. (2007a). An environment to improve programming education. Proceedings of the 2007 International Conference on Computer Systems and Technologies – CompSysTech '07. Retrieved from http://doi.org/10.1145/1330598.13 30691

Gomes, A., & Mendes, A. J. N. (2007b). Learning to program-difficulties and solutions. International Conference on Engineering Education, pp. 1–5.

Jenkins, T. (2002). On the Difficulty of Learning to Program. Language, 4, (pp.53–58). Retrieved from http://doi.org/10.1109/ISIT.2013.6620675

Johnson, S. (2001). Interface Culture: How New Technology Transforms the Way We Create and Communicate. Rio de Janeiro: Zahar.

Kapp, K. M. (2012). The gamification of learning and instruction: game-based methods and strategies for training and education. San Francisco: Pfeiffer.

Lakoff, G., & Johnson, M. (2003). *The Metaphors We Live By.* Chicago: University of Chicago Press.

Manovich, L. (2002). *The Language of New Media.* London, England: The MIT Press.

Murray, J. H. (1998). Hamlet on the Holodeck The Future of Narrative in Cyberspace. Cambridge: MIT Press.

Murray, J. H. (2011). Affordances of the medium. In J. Murray, *Inventing the Medium Principles of Interaction Design as a Cultural Practice* (pp. 56–92). Cambridge: MIT Press.

Souza, M. A. F. de, Gomes, M. M., Soares, M. V.; Concilio, R. (2011). Algoritmos e lógica de programação (2a ed.) São Paulo: Cengage Learning.

Zimmerman, E. (2004). Narrative, Interactivity, Play, & Games. In: N. Wardrip-Frui, & . Harrigan, *First Person: New Media as Story, Performance, and Game* (pp. 154–164). Cambridge: MIT Press.

Pokémon Go: The embedded fantasy

Gustavo Henrique Campos de Faria
Architecture and Urban Design, Federal University of Santa Catarina, Florianópolis, SC, Brazil
ORCID: 0000-0002-1568-4498

Luciane Maria Fadel
Engineering and Knowledge Management, Federal University of Santa Catarina, Florianópolis, SC, Brazil
ORCID: 0000-0002-9198-3924

Carlos Eduardo Verzola Vaz
ORCID: 0000-0002-5841-7605

ABSTRACT: The Pokémon Go application can be read as remediation of the Pokémon game created by a Japanese company in 1995. The presence of a well-established narrative known to users has generated considerable enthusiasm for game experimentation integrating augmented reality. Due to the mechanics of traversing public spaces for the capture of extraordinary creatures, a real fever took over the cities, significantly altering the flow of people in the main urban areas. This article discusses the poetics of this media, mainly the narrativization of the interface, in order to understand the phenomena of gameplay of the application and its main implications in the context of the contemporary city. The close reading method was applied to analyse the oscillation between immediacy and hypermediacy that highlights the perception of urban spaces and the implications of interactivity and agency as the driver of actions. The results suggest that the new media are instruments capable of stimulating the perception, use, and occupation of urban space, albeit subjectively, contextualising a new phase of understanding the concept of the city. Thus, through these poetics, it is argued that the fantasy sustained by digital media can enhance the attractiveness of public spaces.

Keywords: interface, narrative, interaction, agency, public space

1 INTRODUCTION

The integration of virtual spaces into physical spaces, through new media, facilitates the execution of daily tasks, and it is already unthinkable to live without them. This integration means that these media are manifested in different forms and are increasingly present in the routine of people, which corroborates to McLuhan's (1998) futurist discourse: the media are extensions of the human body. In this sense, Oliveira (2002) argues that the body is considered a place of dwelling and communication, and the world as a sphere of experiences. From this angle, it can be said that new media provide not only new spatial conceptualizations but also the construction of new experiential meanings, articulating virtual space and physical space, that is, new media as a stimulus of movement of occupation and perception of spaces, increasing cognitive, valid and active interactions in the context of the city. Thus everything happens in time and space through the unfolding of movements and actions, that is, through experiences (Oliveira, 2002).

In this context, the evolution of mobile computing and wireless technologies favours fantasy because, according to Manovich (2001), computerisation allows new ways of experiencing reality, such as game creation. Therefore, it should be noted that the new media are interactive, and in contrast to the old media, the user becomes able to interact with the object (Manovich, 2001). Thus, the user becomes an agent, in other words, he can choose the paths to be traced in the tools and can be considered the interactor of the proposed narrative (Murray, 1998).

In this scenario, new interaction paradigms have emerged in the contemporary world, such as the augmented reality that allows the combination of digital information with physical surfaces (Preece and Rogers, Sharp, 2005). This paper analyses how the poetics of the new media give support to the fantasy and extend the perception and use of public spaces of everyday use, even if subjectively. In order to do that, a close reading of the Pokémon Go application, from the perspective of the game as well as the insights of the narrativization of the interface, was made. Therefore,

the application was deconstructed in micronarratives and analysed regarding mechanisms that propitiate the immersion of the user to the universe of the game from the perspective of Bolter and Grusin (1999) and Bizzocchi (2007). In addition, the analysis involved the narrative proposed by Salen and Zimmerman (2004), the game spaces defended by Jenkins (2004) and the pleasure of navigability, argued by Murray (1998) and Eichner (2013). Finally, we seek an exploratory reflection about the main impacts of the application in the redefinition of how people perceive and experience the geographic and political locus of the contemporary city.

2 POKÉMON GO: THE GAME

The Pokémon Go application was launched in 2016 in several countries, inspired by the well-known media franchise The Pokémon Company, created by Satoshi Tajiri in 1995. In the etymology of the word, Pokémon is the contraction of two words that come from the English language: pocket, which means pocket and monster, which means monster The Pokémon came as a video game RPG, and later, the game was adapted for cartoons, which was considered a fever for the generation of the late '90s. The storyline surrounding the franchise is based on the story of young collectors of creatures found in random spaces. Such collectors, known as Pokémon trainers, should strive to capture, through their *pokeballs*, the most significant number of creatures, which will be trained and used in battles waged with other trainers. The goal to be achieved is the achievement of gyms and consequent recognition as an expert Pokémon trainer. Based on this idea, the Pokémon Go application was developed through collaboration between Niantic Inc, and Nintendo, for the mobile technology platforms. The goal of the game is a ludic experience based on augmented reality elements, thus providing genuine user interaction with the game plot (Bayón; Cuenca & Caride, 2017).

The operation of the game is based on the use of the Global Positioning System (GPS) and the camera of the mobile device. The application's game space consists of a hybrid map of the city the player is in, which causes the user to traverse public spaces in search of creatures to be captured, directly affecting the movement of the virtual character of the game. The distribution of Pokémon is done randomly, which is why the game impels the user to cross several places in order to find a greater variety of creatures. Along the way, as well as encountering Pokémons, he also finds gyms and *pokestops* that are located in the city's sights and historical sights, which are used for rewards and battles. Thus, the application proposes a new slope for the Pokémon universe, in which it impels an exploration of the city as a conditioner of advance in the game. With this, it can be said that the game suggests an expansion for the spatial experiences, besides

giving the user a new form of interaction with the media.

3 METHODOLOGY

A close reading of Pokémon Go was the basis for developing the argument of this paper. This methodology carefully investigates the poetics of the media, in a qualitative and subjective analysis of the artefact (Bizzocchi; Lin & Tanenbaum, 2011). Initially, the author positioned himself as a tactical player of Pokémon Go, in order to promote a critical reflection on the phenomenon of gameplay and a better understanding of the operation of the game, searching for meanings and particularities of the application. According to Bizzocchi, Lin, and Tanenbaum (2011), the games present several challenges to the researchers, because they present instability due to the player's choices. Thus, in the course of the game experiences, some shots of the screen were organised schematically in order to understand the main structure of the game and the presented interfaces. After a better understanding of the operation of the application, a mental map of the primary structures that uses narrative and interactivity was carried out in order to study the stories, the characters and the forms of play and their interrelationships. This mental map facilitates the organisation, analysis, and management of the information obtained while playing. For the construction of the mental map, the authors used the narrative dimensions proposed by Ryan (2006), facilitating the understanding of the main micronarratives presented in the application.

Finally, the paper explored how a game developed for use in mobile technology devices can redefine people experiencing the geographic locus of the city, that is, the perception of space through Pokémon Go within the context of contemporary society.

4 THE NARRATIVISED INTERFACE OF POKÉMON GO

Beyond the consolidated culture of video games, Pokémon is a great success as an animated series, which appeared in Japan in 1996, and presents itself in its 20th season in the year 2018. Thus, the Pokémon universe recombines and multiplies in several aspects for the consumer market, currently presenting its main materialisation: the application for mobile devices, Pokémon Go. Thus, the game can be defined as remediation near the 4th level proposed by Bolter and Grusin (1999). For these authors, remediation means a process of incorporating elements of an old media into a new artefact, that is, in the case of Pokémon Go, the media loses its original characteristics and becomes a new media, altering the archetypes of interaction. A vital aspect of the great success of the game is the fictional atmosphere proposed by the series and the challenges

proposed by the application. The presence of sensors in mobile technologies, such as GPS, camera, internet receivers/pedometers (step counter), allow the fantasy closer to the real world, providing users a combination of pleasure of narrative and pleasure of gameplay, directly interfering in the decision making of the plot (Bizzocchi; Lin & Tanenbaum, 2011).

5 THE OPERATIONAL INTERFACE

Pokémon Go main interface (Figure 1) consists of the following elements: (1) Climate – presents weather conditions and their implications on Pokémons; (2) Compass – instrument that allows navigation and orientation to the user; (3) Gymnasiums – spaces intended for team battles and raid battles; (4) *PokeStop* – places to win items such as *pokeballs*, potions and eggs; (5) Coach – Player avatar graphic; (6) Pokémon – creatures for capture; (7) Profile – where you will find all the information about the progress and achievement of the user; (8) Buddy – Pokémon that receives candy in the course of the user's movement; (9) Main Menu – allows access to settings, items obtained in *pokestops, pokedex*, store and Pokémon menu; (10) Searches – displays the progress of field searches and special searches; (11) Close By – displays the Pokémons and raid battles that are close to the user's location.

The presence of a hybrid spatial interface associated with the already consolidated narrative makes the existing game space revolutionise the public's memory

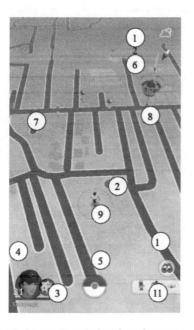

Figure 1. Pokémon Go main interface elements.
Source: Print screen of the game interface, edited by the Authors, on 5th April 2018.

to the recognisable space, which follows the discussions of Jenkins (2004) on the role of space in the construction of narrative. The evocative space of Pokémon Go requires a multi-textual reading of the space, so that, when using the application, it becomes intuitive the constitution of the real world at the interface, providing exploratory navigation and recalling the user of analogies of the Pokémon universe.

6 THE NARRATIVE AS AN INTERACTION INTERFACE

According to Bizzocchi, Lin and Tanenbaum (2011), narrative can be considered an expressive phenomenon in people's lives.

The narrative presents the personal, social, cultural and economic aspects of society. In Pokémon Go, the narrative becomes the primary tool of interaction between the user and the interface.

For the player to experience the full potential of the game, deep immersion in the context of the game is required. Bizzocchi (2007) comments that this immersion has several aspects in the literature, which has been amplified with the possibilities of virtual reality. According to the author, the immersion can be based on challenges, which consists of the active involvement of the user with the dynamics proposed by the game. The imaginative one, which corresponds to the voluntary surrender of the player to the pleasure of history; and the sensorial, which has similar aspects to the cinema of attractions proposed by Gunning (1990), demonstrating the users' fascination with the new media and their ways of acting (Ermi & Mayra cited In Bizzocchi, 2007). Therefore, it is important to carry out a reflection about these immersion mechanisms provided by the user's subjective perception of the Pokémon Go game. Initially, Bizzocchi (2007) argues about the player's commitment to the dynamics of the game, also called challenge-based immersion. This type of immersion can be perceived by the immediacy of the gym micronarratives and field and special research. The first example stems from the goal of becoming a guardian of a gym for obtaining coins. Thus, in addition to going through the city in search of gyms, the user is instigated to enter the gym to carry out the battles. Within the gymnasium interface, the attention of the user becomes a fundamental factor for understanding the data contained therein, as well as for meaningful actions. Another example is field research and special research. Determined to obtain exclusive rewards, users put themselves in constant movement to carry out these tasks, retaining the attention and enhancing the intensity of contact of the user with the objectives launched there.

The second concept of immersion, argued by Bizzocchi (2007), is the imaginative immersion. This concept relates to the user's surrender to the pleasure of the proposed narrative. Due to the broad consolidated

public of the Pokémon universe, the great success of the game can be directly related to the imaginative immersion, allowing an embedded narrative. Another potentiating form is derived from the micronarrative capture of Pokémon, which is possible to relate the generations of the Pokémon with the generations of the players. Due to the chronology of the series over the years, one can associate a certain degree of intimacy of the user with each one of the generations of monsters, according to the year in which the story was transmitted in the television.

Finally, the sensorial immersion gives an account of the user's emotion permeated by the technological strategies of interface playability. By breaking with the fictitious context, propitiating the experience in the public space through augmented reality, the game intrigues the user to experience the Pokémon universe in an illusory window of experiences, full of emotions and sensations. Thus, it is noticed that the levels of immersion caused by the game derived from the interface between the narrative, interface and augmented reality, highlighting the role of the language of the new media that integrate real and virtual objects to generate a new identity and experience to the user. It is also observed that the presence of micronarratives provides the first oscillation between immediacy and hypermediacy. This presence is due to the dynamics of dividing a single story into several mini-games that have their narrative arc, allowing the user to immerse the user into the application gradually.

According to Bolter and Grusin (1999), this system of gradual immersion of the user in the interface of the game is based on the mechanisms that allow the player to take control of the information. Thus, agency evolves from the micronarrative system and the dynamics of the game, providing the oscillation between immediacy and hypermediacy.

Therefore, the oscillation mechanism, caused by the narrative interface of the game, increases the visibility of spaces, establishing new spatial modalities for users. That is, it supports the emergence of a new behavioural aspect of the individual in the contemporary city, which allows the emergence of a new spatial tendency from the construction of virtual imaging. Hence, the possibilities of immersion can be considered as a benefit of the mobile media as an instrument of information dissemination, insofar as it brought to its players' information and spatial perceptions of the city (Schnabel et al., 2007).

7 INTERACTIVITY AND AGENCY: NARRATIVE AS THE DRIVER OF ACTIONS

Eichner (2013) argues that gameplay is not always based on player choice, but rather on the structure of the game. In Pokémon Go, the consolidated narrative led to an augmented reality game. By deconstructing the plot in micronarratives, the structure of the game

allows the realisation of different trajectories from the original plot, although pre-established by the programming. That is, even with a narrative extremely referenced to the Pokémon universe, it is restructuring in micronarratives allows the user to follow paths that deconstruct the linearity of the plot. According to Murray (1998), this deconstruction can be considered a potential generated by rhizomatic conformation about the game.

In this context, it can be said that Pokémon Go uses interfaces designed with rich narrative potential, allowing the adaptation of the story in the users' daily life. This concept suggests a high level of agency attributed to players and allows a unique experience of narrative and objects (Jenkins, 2004). Unique experiences are explained as the cinema of attraction by Gunning (1990). The attraction is maintained by the ability to choose an action and generates stimuli to keep the player within the game space, offering users an intensified pleasure in achieving the proposed goals. Thus, the application broadens the freedom and allows new interpretations, in which history happens based on the choices and actions of each player.

The freedom of choice offered by the plot is closely related to the first level of interactivity argued by Salen and Zimmerman (2003) – cognitive interactivity. Thus, the use of a narrative in the function of the exteriorization of the thoughts and the memory of the user allows the application of history in daily life. This relationship of the user's interaction with the narrative interface of the media is also associated with the personal agency, defined by Eichner (2013), which evolves from the challenges proposed by the game. In presenting a congruence with the fictional series and all the other games already launched with this theme, it can be said that this reflects as an essential factor in the process of the meaning of the narrative, transforming the navigation and combining the expectations of the user with the pleasure of play. Thus, the cognitive interactivity presented by Pokémon Go involves thinking, comparing and making decisions, enhancing the user's creativity.

Eichner (2013) also argues about the domain of action, which is related to the interface's interactive capability, that is, the object's explicit interactivity (Salen & Zimmerman, 2003). The application invites the user to a spatial exploration of the plot, by demonstrating how to perform the correct procedures in the game environment, and making the interaction with the environment fundamental. The interaction values the strategies of embedded narratives, imbuing emblems scattered throughout the city (Jenkins, 2004). Therefore, the role of the narrative is fundamental in the orientation of the user on the elements presented in the interface.

Pokémon Go presents a critical characteristic when sharing the same level of correlation between action and perception, that is, virtual objects, which

correspond to the space of action, determine perceived space and, consequently, these spaces are represented of real artefacts. In this context, it is noticed that the user can identify the new spaces within the virtual environment. To support this feature, the *pokestops* never visited, appear in the interface surrounded by white rings. This mechanism can be used as an instrument that allows gathering action and reflection in the interaction with the game, that is to say, when handling the physical object with a hybridised interface, the user has visual feedback of the actions taken there, amplifying their perception of the real space.

Finally, the domain of space consists of the last characteristic of personal agency, defended by Eichner (2013). According to the author, the pleasant sensation of navigation stems from the feeling of presence and immersion in the environment. This fact, the use of hybrid interface contributes not only as a functional narrative interface but also as a propitiatory of the expansion of the game space domain. From the georeferencing of virtual elements in the context of the city, it causes the players to elaborate a mental map creating new meanings for the physical space. Thus, the interaction of players is also made before the physical space, that is, from the moment the user inserts into the hybridised environment, creates a new spatial relationship based on the real infrastructure from the virtual interface. Thus, urban elements, in this context, become interactive pieces fundamental to the game's functioning, that is, history becomes a structuring instrument of that of the interaction between physical space and virtual space, allowing the user greater control over the space of the game. It is important to emphasise that spatial navigation stems not only from the interface but from the movement performed by the player, expressing in the user the sensation of presence and immersion, making it free to experience the space presented there. Another important feature, which directly reflects on the player's space domain, is the ability for players to participate in creating the virtual environment of the game. This ability resumes the expansion of the perception of physical space, and the user can suggest, within the interface of the application, urban objects that have the potential to become *pokestops* or gymnasiums. Given this, it is noticed that the application provides new conceptualisations on not only the urban space but also the construction of new senses for the city since they articulate directly to the symbolic representation to the physical space. Even after the glimpse at the launch of the Pokémon Go application, undeniable that, even two years after its debut, the number of users is still considerable, being possible to find players on the streets looking for their Pokémons, as well as groups of encounters for battles between the players, created in social media (Facebook, Telegram, Whatsapp). Due to this use of other media as a form of interaction between players, the capacity of meta-interactivity stands out, argued by Salen and Zimmerman (2003).

8 FINAL CONSIDERATIONS

Taking the concept of contemporary space as characterised by hybridity, the game Pokémon Go manifests itself as an essential stimulus mechanism for the use of public spaces by users. This characteristic is linked to the narrative of walking through streets, squares, and parks since this movement is crucial for the user to experience the experience offered by the game. Thus, it is possible to affirm that the application under analysis awakens in the user an essential movement of the occupation of the public spaces, which is not only due to the routine activities in general but expanding the leisure activities in the context of the city, due to the playful character of the game. Based on this logic, public spaces of everyday use should be thought of as bases of a full and democratic society. To ensure that the population effectively enjoys such spaces is an invaluable condition, in which one must think of a state capable of offering its citizens what is rightfully theirs.

However, due to the growing public security crisis envisaged in Brazil, many people abandoned the use of open public spaces and turned to more enclosed spaces, such as their own homes and shopping malls. However, with the introduction of these new media, which require the use of urban space, due to its operating characteristic, it is noticed that the public spaces, taken in a broader conception, have been conquering new users and gradually returning, to be used by the population.

Considering that the new media, in this case, the game Pokémon Go, through the poetics of interactivity and agency, becomes a tool capable of providing higher appropriations and perceptions of the urban space by the population, leading the community to a greater use of various public spaces, which were often disregarded, either because of their location, precariousness of urban furniture or even because of issues related to the weakness of public security. Besides, through the narrativization of the interface, it can be said that the user becomes a reproducer of the behaviours of the game character (Bizzocchi; Lin & Tanenbaum, 2011), which makes the domain of the space reinforced allowing a greater attractiveness and appropriation of public spaces.

Consequently, the vast potential of the new media in the perception of the cultural meaning of the place is perceived, expanding the historical-spatial comprehension, besides the urban structure, allowing to the users the expansion in social interactivity and the community's belonging. Thus, it is suggested that the narrative structure and power of the agency are critical poetics in media artefacts that can be implemented in diverse objects, besides those determined for entertainment, such as educational, cultural, tourism, among others.

It is undeniable that the use of those spaces, once forgotten by the population, but which, because of their perception then provided by the concept of

contemporary space, in which the physical and the virtual are merged, will impel social demands for improvements, which will be used in public policy debates in the arena of democratic discussion of cities, thus reinforcing the idea of collaboration that must be present in public management. In view of this, it can be seen that the new media are intrinsically linked to the concept of sociability and to the use of public spaces by the population, whereby through the use of these media, popular participation becomes, besides a tool of interlocution between the agents, an instrument that enhances the sense of belonging to the community, increasing the condition of exercising citizenship. Nevertheless, this participation goes beyond individual freedom, which must be understood as a structure of collectivity, of social construction.

Also, the possibility of the game is perceived as a strategy of urban planning, since the construction of the space of game will be of collective form by the players. Thus, city-planning agencies can use the digital interface of Pokémon Go as an instrument to enhance the use of public spaces, participating in the construction of the game space tactically in the city. In this sense, the possibility of future studies to empirically evaluate the perception and appropriation of public spaces by users, as well as to investigate the participation of public management in the formation of the space of play as an instrument of urban planning.

Thus, the city is a living organism, in constant evolution, requiring a continuous process of adaptation to the needs that arise in the context of people's lives. In this way, it is possible to say that the application in epigraph inserts itself in this process of stimulus to the use and utilisation of the urban space, although in an incipient way, contextualising a new phase of understanding of the very concept of city, in which it is demanded Public Policies for physical and technological improvements for a broader and adequate use of cities.

BIBLIOGRAPHICAL REFERENCES

Bayón, F., Cuenca, J., & Caride, J. A. (2017). Reimaginar la ciudad. Prácticas de ocio juvenil yproducción del espacio público urbano. *OBETS. Revista de Ciencias Sociales,* 12(Extra 1), 21–41.

Bizzochi, J. (2007). Games and narrative: An analytical framework. *Loading – the Journal of the Canadian Games Studies Association,* 1(1), 5–10. DOI:10.2307/3149924

Bizzocchi, J., Lin, M. A. Ben, & Tanenbaum, J. (2011). Games, narrative and the design of the interface. *International Journal of Arts and Technology,* 4 (4), 460–479. DOI:10.1504/IJART.2011.043445

Bolter, J. D., & Grusin, R. (1999). Immediacy, Hypermediacy, and Remediation. In *Remediation* (pp.20–50). Cambridge: MIT Press. DOI:10.5860/CHOICE.36-4895

Eichner, S. (2013). Agency and Media Reception: Experiencing Video Games, Film, and Television. Potsdam, Germany: Springer VS.

Gunning, T. (1990). The Cinema of Attraction. In T. Elsaesser (Ed.), *Early Cinema: Space, frame, narrative* (Vol. 3, pp. 63–70). Londres: BFI Publishing.

Jenkins, H. (2004). Game Design as Narrative Architecture. In P. Harrigan & N. Wardrip-Fruin (Eds.), *First Person: New Media as Story, Performance, and Game* (pp. 118–130). Cambridge, MA: MIT Press. DOI:10.1075/prag.7.3.05cho

Manovich, L. (2001). *The Language of New Media.* MIT Press. Cambridge: MIT Press. DOI:10.1386/nl.5.1.25/1

McLuhan, M. (1998). The Playboy Interview. In M. McLuhan & F. Zingrone (Eds.), *The Essential McLuhan* (pp. 233–269). New York: Harper Collins.

Murray, J. (1998). *Agency. The Aesthetics of the Medium* (pp. 126–153). Cambridge: MIT Press.

Oliveira, B. S. de. (2002). O que é Arquitetura? In V. DelRio, C. R. Duarte, & P. A. Rheingantz (Eds.), *Projeto do Lugar: colaboração entre psicologia, arquitetura e urbanismo* (pp.135–142). Rio de Janeiro: Contra Capa.

Preece, J., Rogers, Y., & Sharp, H. (2005). *Design de Interação: Além da interação homem-computador.* Bookman. Porto Alegre: Bookman. DOI: 0-471-49278-7

Ryan, M.-L. (2006). *Avatars of Story.* University of Minnesota Press.

Salen, K., & Zimmerman, E. (2003). *Rules of Play: Game design fundamentals.* London: MIT Press.

Schnabel, M. A., Wang, X., Seichter, H., & Kvan, T. (2007). From virtuality to reality and back. *Proceedings of the International Association of Societies of Design Research,* 1–15. Retrieved from http://www.sd.polyu.edu.hk/iasdr/proceeding/papers/From Virtuality to Reality and Back.pdf

Zimmerman, E. (2004). Interactivity; Narrative; Play and Game. In N. Wardrip-Fruin & P. Harrigan (Eds.), *First Person: New Media as Story, Performance, and Fame.* Cambridge: The MIT Press.

Crowdsourcing: An intelligent and creative way for information access

Leonor Calvão Borges
Faculty of Arts and Humanities, University of Coimbra, Coimbra, Portugal
ORCID: 0000-0002-2316-9365

Ana Margarida Dias da Silva
Faculty of Arts and Humanities, University of Coimbra, Coimbra, Portugal
ORCID: 0000-0003-1247-8346

ABSTRACT: The primary goal of this paper is to point out how memory institutions (such as Libraries, Archives and Museums or the GLAM sector, if we add Galleries) are creatively using collective intelligence to facilitate usage and a better description of their collections.

The change of links between users and memory institutions followed a line from mere receiver to co-producer, thus leading to user-contributed content. Collaborative tools from web 2.0, although not primarily designed for institutional information dissemination, are being used by memory institutions to engage the general public for knowledge construction. A few collaborative and creative projects are presented and analysed, advocating it as the best way to maintain links and renew relations between memory institutions and communities of users. In conclusion, the opening to new technological possibilities is not a fantasy but a valid contribution for memory institutions, a change of mentality that contributes to a better way of disclosing information concerning historical heritage.

Keywords: citizen science, memory institutions, web 2.0, user-contributed content, gamification

1 INTRODUCTION

Memory institutions (like Libraries, Archives, and Museums or GLAM, if we add Galleries) in addition to the primary functions of safeguarding, organisation and description, also provide information access. This one is perhaps the most important function. Therefore information retrieval is both relevant for the organisation itself and external researchers (Silva & Borges, 2018).

All cultural institutions should have as the main purpose "to have the greatest possible amount of the knowledge they possess accessed by as many people as possible." (Grønbæk, 2014, p. 141).

The development of ICT and the Internet brought with it projects of massive digitisation of records that memory institutions use to preserve originals and enable their online dissemination to reach new and broader audiences

In this context, Web 2.0 platforms are key factors to the collaborative construction of knowledge, thus making use of collective intelligence transformed everyone simultaneously in information consumers and producers (Silva, Borges & Marques, 2018).

Alvin Toffler, in his 1980 book *The Third Wave* coined the term prosumer, which "blurs the distinction between a 'consumer' and a 'producer'" (Matthews, 2016, p. 92), which is indeed what we can see now in information services of memory institutions.

For several authors, the real revolution is not so much the technology but the change of attitude. Users are no longer only information consumers but stakeholders in the development and management of content. (Silva, Borges & Marques, 2018).

Because the way to access information access and outreach has changed in particular due to the users' participation, namely because of the emergence of collaborative tools, the GLAM sector will necessarily develop the ability to fit the cyberculture reality and to follow the evolution of technology (Silva, 2013).

Furthermore, user-contributed content can change the way people regard memory institutions, who also benefit from this collaboration.

A review of the scientific literature on crowdsourcing in memory institutions and the establishment of new connections with citizens through the use of web 2.0 platforms was made.

The identification and analysis of the projects were limited to the last ten years (2008–2018), and projects published and object of academic study.

2 CROWDSOURCING IN GLAM

Crowdsourcing, a neologism that brings together "crowd" and "source" was first used by Jeff Howe in 2006, in an article of "Wired magazine". The term refers to the "wisdom of the crowds", and it is used

to designate a new collaborative business model to monetise the collective creativity available on the Web, and which is very popular in the Information Society under the designation of virtual communities (Silva, Borges & Marques, 2018).

Within the GLAM sector, Ridge (2012), Oomen & Aroyo (2011) and Matthews (2016) suggested different categories of participation that have in common contextualization, creating user-generated content, co-curation and corrections, to which Matthews adds citizen science.

Moreover,

> as crowdsourcing initiatives gain traction in the cultural heritage space, it is the organisations that are most open (releasing collections as public domain or CC when possible) that are reaping the benefits. (Kapsalis, 2016, p. 2)

Thus:

> we must see digital representations of artwork, writing, music and film, and the metadata behind them, as shared public resources that we all have an interest in both accessing and maintaining. (Cousins, 2014, p. 135)

Another aspect of this evolution is the use of gamification, seen as "the use of game design elements in non-game contexts" or even only game design principles by memory institutions. Ivanjko (2018) advocates its use showing that it can revitalise public archives, for example.

That alone must lead to a change in the way professionals in memory institutions understand the new role users have in the future of these organisations.

Although crowdsourcing, user-contributed content and gamification are increasingly a reality, Nogueira (2010) speaks of the "reluctance" and Grayson (2016) of "scepticism" both of some memory institutions and historians to use collective intelligence because of the use of no-official or invalid applications from the web 2.0, which lead to a clear distinction between "information professionals that aren't ready for a paradigm change" (Silva, Borges & Marques, 2018, p. 13), when professional flexibility is seen nowadays as a "distinct advantage in LAM collaborations" (Zorich, Waibei & Erway, 2008, p. 27).

That alone will bring a significant development upon the value of memory institutions.

3 INTELLIGENT AND CREATIVE WAYS FOR INFORMATION RETRIEVAL

The call for citizen participation comes with the opinion that information scientists can no longer work alone as content creators for researchers. Therefore, cooperation and multilateral cooperation have become new philosophies in the IS work (Paris Folch, 2017).

In an interconnect, technological, and globalised world, memory institutions

> should seek to ensure that the freely available content is shared, enriched, and processed by users, whether they are citizens, students, scholars, researchers, or commercial ventures. (Grønbæk, 2014, p. 142)

Given that fact, we provide an analysis of how memory institutions are engaging intelligent and creative ways for information retrieval, highlighting some best practices.

Concerning the shift of the paradigm, we can see that some institutions already have interdisciplinary services dedicated to these projects, namely the New York Public Library Labs[1] and British Library Labs, responsible for the design and marketing of new products.

As stated by the first, on its website[2]

> NYPL Labs combines core digital library operations [...] with a publicly engaged tech, design, and outreach team focused on enabling new uses of collections and data, collaborating with users on the creation of digital resources, and applying new technologies to library problem-solving.

The Royal Library in Copenhagen is promoting crowdsourcing with the project "Denmark seen from above" in the spirit that "collaboration is the new norm" (Hansen & Ertmann-Christiansen, 2014, p. 157). The project gained a tremendous interest: 400.000 images were released online 370.000 of which were correctly identified.

As to the subjects and types of documents placed at the users' willingness to collaborate, we can highlight:

- the correction of OCR in Libraries, either in its old collection (digital volunteers' program of the National Library of Finland, for example) or in more recent projects whose information would otherwise be lost ("What's on the menu?" project in NYPL, a typical example of a type of material not usually described. Since its release, 1.334.128 dishes were transcribed from 17.545 menus).
- The transcription of manuscripts in archives or other memory institutions has allowed for the massive identification of documents, linking communities by subject; with great experience of collaboration and sharing of information, genealogists emerge as a solid community for example, with projects as differentiated as the "Find my past", or "Family Search". French archives, departmental ou local, have undertaken crowdsourcing projects with huge success and the numbers speak for themselves. At the Archive of Vendée et Martinique, 2.500.000 names have been tagged[3] from 101.000 individual

1. https://www.nypl.org/collections/labs
2. https://www.bl.uk/projects/british-library-labs
3. http://www.culture.fr/Genealogie/Actualites/Une-nouvelle-base-dans-Genealogie-Noms-de-Vendee/(theme)/1

fiches, 69.400 have been indexed in Yonne archive[4]; volunteers of Orléans local archive made 225.650 tags[5]; and with the help of *Ardennes Généalogie* 138.618 annotations were made, hoping to achieve and to share online 153.000 until the end of 2017[6]. Cantal departmental archive thanks the numerous internauts who made it possible to tag almost 1.500.000 names from parish books, a volunteer work of seven years, that are now retrievable by everyone[7].

Some projects are developed in academic communities, such as UCL Transcribe Bentham, which was launched with the aim of transcribing the complete work of that philosopher. (21.710 manuscript pages have now been transcribed or partially-transcribed. Of these transcripts, 20.999 (96%) have been checked and approved by TB staff), an exemplary project in creating and maintaining anonymous communities of users through their blog, educational materials and even the call for users to create "Games With a Purpose (GWAP) that would combine computer processing with human expertise to make transcription as easy, accessible and entertaining as possible".

Or the 2019 crowdsourcing transcription project promoted by the UNESCO Chair in Biodiversity Safeguard for Sustainable Development, in collaboration with the Botanic Garden of the University of Coimbra, and the Life Sciences Department, "Plant Letters" that uses the collaborative platform, Zooniverse[8], where users are requested to engage with the Botany Archive of the UC and transcribe mostly handwritten letters in several languages,

Transcription of documents related to events such as the First World War (e. g.: "Project Operation War Diary: reports from the front", the project "Mémoire des Hommes", or the Australian project "Measuring the ANZACs"). For example, the massive collaboration of volunteers as allowed the indexation of 52.000 files within the project *Grand mémorial 1914–1918* from French departmental archive of Haute-Loire between 2015 et 2017[9].

Revealing another type of approach between users and the archives we have the "Citizens Archivist projects" of the North American National Archives, and his appeal "One day all of our records will be online"; "The volunteers promoted by the English National Archives", "volunteer or simply tell us how we are doing (. . .) However, you can get involved with the National Archives, we value your time and ideas",

or the participatory national archives of the French national archives.

Asking for public participation on photos description is a verified winning strategy in collaborative projects, with Flickr Commons promoted by the Library of Congress being the most known, which, through the collaboration of citizens with tags, descriptions and even specialised bibliography, has been able to improve their own catalogue substantially. In 2008, when the project was released, and after only eight months, the Library of Congress reported 500.000 views a month and had crossed the 10 million mark in total views and the 6 million mark for visits. The eleven-year project continues to generate better descriptions.

- Document georeferencing emerges as another popular and innovative way of achieving collaboration, and the Map Wrapper project in NYPL provides an excellent example.
- The use of gamification of which "Old Weather" is an exciting example, emphasises that building a story and creating rankings generates competitive mechanisms that captivate the most active participants and catch the attention of new participants (Ivanjko, 2018, pp. 188–189).

Some of these projects have a direct link with projects of Digital Humanities and, in an embryonic way, with citizen science, as is visible in the use of the Zooniverse platform. In these cases, there is a greater diversity of subjects and collections of documents to transcribe, being literary projects (Shakespeare's World), artistic (AnnoTate), scientists (Reading Nature's Library) or even related to minority groups (African American Civil War Soldiers).

Most of these projects are promoted with free and open access, providing the possibility of its reuse, like the digital images of the Metropolitan Museum of Art or the OpenGLAM initiative, just to give two famous examples.

In Denmark, although the number of archives, libraries and museums is very sparse, the projects "Denmark viewed from Above" of the Royal Danish Library, "Listed and landmark buildings in Denmark" of the Danish Agency for Culture, and "Archaeological Finds and Ancient Monuments" of the Historical Atlas society, offer open and easy access to data (Wang, 2014, p. 183).

4 DISCUSSION

The change that both the Internet and electronic governance has brought to the way public institutions communicate with citizens is also reflected, of course, in memory institutions that have had to adapt to this new reality.

In the digital world, we can highlight two fundamental problems in the GLAM sector: the need to digitally

4. http://www.rfgenealogie.com/s-informer/infos/archives/l-yonne-passe-a-l-indexation-collaborative
5. http://archives.orleans-metropole.fr/r/547/
6. https://blogs.ucl.ac.uk/transcribe-bentham/http://archives.cd08.fr/arkotheque/consult_fonds/index.php?ref_fonds=7
7. http://archives.cantal.fr/
8. https://www.zooniverse.org/
9. http://www.archives43.fr/article.php?laref=716&titre=grand-memorial-1914-1918

disclose historical heritage and the impossibility of describing it at the same pace as its availability.

Thus, crowdsourcing in memory institutions is seen as a "new opportunity" (Grayson, 2016), "creative" (Saylor & Wolf, 2011; Wiley-Blackwell, 2016), "innovative" (Saylor & Wolfe, 2011) way for information access. Analysing crowdsourcing projects we can see that it really is a problem-solving mechanism for memory institutions.

The openness to citizen participation by memory institutions, with well-designed projects and even material made available on strategies for describing and appointing tags, in a movement that only brings advantages for memory diffusion and knowledge sharing is here to stay, with profound change on the way citizens see heritage.

The number of tags revealed by memory institutions all over the world shows the importance of crowdsourcing and volunteer help. How many years would it take for the archives to have indexed, in some cases, over one million records?

To these challenges, memory institutions are responding creatively and making use of collective intelligence, in the process of fundamental transformation for the construction of collective knowledge.

> The publications, apps, websites and games developed will be brand-new uses of cultural heritage content, which can be fed back to the cultural heritage domains (galleries, libraries, archives, museums), bringing in new users and generate jobs and economic growth from which we all benefit. (Cousins, 2014, p. 136)

Moreover, the use of collaborative tools, game design elements or even simple gamification has already proved to be an imaginative way to reach out for new users, while improving the number of documents descriptions.

Unsurprisingly, some projects are developed with open source software and promote open access and free re-use of their data.

Presently, Information professionals understand that "sharing is caring" (Sanderhoff, 2014). Moreover,

> [i]n terms of collections use and dissemination, once an institution makes its collections open, digital volunteers do the work to disseminate them even further. (Kapsalis, 2016, p. 11).

Crowdsourcing, collaboration, open data and reused data are also about "sharing authority with the users; the authority to read, interpret and improve" GLAM collections, therefore, user participation has become a key factor on knowledge (Giersing, 2014, p. 199).

Another advantage of using social networks to disclose heritage collections is the fact that it reaches different kinds of public, not accustomed to consult these institutions for information.

5 CONCLUSIONS

The aforementioned projects and examples show that the traditional work of the organisation, management, preservation, and communication in the Glam Sector, is not incompatible with open access, open science, and collaborative projects.

Also, they show that information scientists are intelligent by using creative ways to overcome difficulties such as lack of human and financial resources.

The link between the GLAM sector, the scientific community, author of many of these projects, and the anonymous community of users, in an effort to creatively stimulate common knowledge, proves to be a solid one.

Thus, local, national and academic memory institutions are engaging new publics, inviting volunteers, profiting from experts and amateurs knowledge to improve their information systems.

Archivists and Information scientists are thinking *out of the box* and crowdsourcing is helping to get information for all. It is not a fantasy.

BIBLIOGRAPHICAL REFERENCES

Cousins, J. (2014). Building a commons for digital cultural heritage. In Sanderhoff, M. (ed.) *Sharing is caring. Openness and sharing in the cultural heritage sector.* (pp. 132–140.) Copenhagen: Statens Museum for Kunst, ISBN 978-87-92023-62-9 – English version.

Giersing, S. (2014). Sharing authority. User-generated images as future cultural heritage? In Sanderhoff, M. (ed.) *Sharing is caring. Openness and sharing in the cultural heritage sector.* (pp. 199–206). Copenhagen: Statens Museum for Kunst. ISBN 978-87-92023-62-9 – English version.

Grayson, R. S. (2016). A Life in the Trenches? The Use of Operation War Diary and Crowdsourcing Methods to Provide an Understanding of the British Army's Day-to-Day Life on the Western Front. *British Journal for Military History*, 2 (2), 160–185.

Grønbæk, M. v. H. (2014). GLAMourous remix. Openness and sharing for cultural institutions. In Sanderhoff, M. (ed.) *Sharing is caring. Openness and sharing in the cultural heritage sector.* (pp. 141–153). Copenhagen: Statens Museum for Kunst, ISBN 978-87-92023-62-9 – English version.

Hansen, H. J., Ertmann-Christiansen, C. (2014). Towards a shared Danish infrastructure for collection management and presentation. In Sanderhoff, M. (ed.) *Sharing is caring. Openness and sharing in the cultural heritage sector.* (pp. 154–160). Copenhagen: Statens Museum for Kunst, ISBN 978-87-92023-62-9 – English version.

Ivanjko, T. (2018). La gamification en el ambito del patrimonio: crowdsourcing con un diseno ludico. Tabula: *Estudios Archivisticos de Castilla y León*, (21), 177–195.

Kapsalis, E. (2016). The Impact of Open Access on Galleries, Libraries, Museums, & Archive. Presented at the Smithsonian Emerging Leaders Development Program. Retrieved from http://siarchives.si.edu/sites/default/files/pdfs/2016_03_10_OpenCollections_Public.pdf

Matthews, J. R. (2016). Adding Value to Libraries, Archives and Museums: Harnessing the Force That Drives Your Organization's Future. California: Libraries Unlimited.

Nogueira, M. (2010). Archives in Web 2.0: New Opportunities. *Ariadne*, 63(April). Retrieved from http://www.ariadne.ac.uk/issue63/nogueira

Oomen, J., & Aroyo, L. (2011). Crowdsourcing in Cultural Heritage domain. In *Proceedings of the 5th International Conference on Communities and Technologies*. Retrieved from http://citeseerx.ist.psu.edu/viewdoc/download?doi=10.1.1.464.6933&rep=rep1&type=pdf

Paris Folch, M. L. (2017). Conectados: Experiencias de Cooperación y Transversalidad en el Archivo de la Universitat Jaume I. *RUIDERAe: Revista de Unidades de Información*, (11), 1–10. Retrieved from https://revista.uclm.es/index.php/ruiderae/article/view/1398

Ridge, M. (2012, June 3). Frequently asked questions about crowdsourcing in Cultural Heritage. Retrieved from http://www.openobjects.org.uk/2012/06/frequently-asked-questions-about-crowdsourcing-in-cultural-heritage/

Sanderhoff, M. (ed.) (2014). *Sharing is caring. Openness and sharing in the cultural heritage sector*. Copenhagen: Statens Museum for Kunst. ISBN 978-87-92023-62-9 – English version.

Saylor, N., & Wolfe, J. (2011). Experimenting with Strategies for Crowdsourcing Manuscript Transcription. *Research Library Issues: A Bimonthly Report from ARL, CNI, and SPARC*, 277, 9–14. Retrieved from http://publications.arl.org/rli277/

Silva, A. M. D. da, & Borges, L. C. (2018). A transcrição e a leitura de manuscritos entre o crowdsourcing e a participação cidadã. In *Actas do 13º Congresso BAD*. Fundão. Retrieved from https://www.bad.pt/publicacoes/index.php/congressosbad/article/view/1792

Silva, A. M. D. da, Borges, L. C., & Marques, M. B. (2018). Crowdsourcing in history projects in local archives of Portugal and England: a comparative analyses. In *Proceedings of the International Conference on Information Society and Smart Cities (ISC 2018)*. Fitzwilliam College, University of Cambridge. Retrieved from http://www.isc-confrence.org/index.php/proceedings

Silva, A. M. D. da. (2013). *O Uso da Internet e da Web 2.0 na difusão e Acesso à informação arquivística: o Caso dos Arquivos municipais portugueses* (Master thesis). Faculdade de Ciências Sociais e Humanas da Universidade Nova de Lisboa. Retrieved from http://run.unl.pt/handle/10362/12014

Terras, M. (2016). Crowdsourcing in the Digital Humanities. In S. Schreibman, R. Siemens, & J. Unsworth (Eds.), *A New Companion to Digital Humanities* (pp. 420–439). UK: Wiley-Blackwell. Retrieved from http://www.arise.mae.usp.br/wp-content/uploads/2018/03/A-New-Companion-to-Digital-Humanities.pdf

Wang, J. R. (2014). Digital culture heritage. Long perspectives and sustainability. In Sanderhoff, M. (ed.) *Sharing is caring. Openness and sharing in the cultural heritage sector*. (pp. 178–185). Copenhagen: Statens Museum for Kunst, ISBN 978-87-92023-62-9 – English version.

Zorich, D. M., Waibel, G., & Erway, R. (2008). Beyond the Silos of the LAMs: Collaboration Among Libraries, Archives and Museums (Report produced by OCLC Research). Retrieved from https://www.oclc.org/content/dam/research/publications/library/2008/2008-05.pdf

Comparative analysis of the luminous performance of fenestration with Japanese paper and glazing with a polymeric film in meditation rooms

Mário Bruno Cruz
Arquitetura, Faculdade de Arquitetura, Universidade de Lisboa, Lisbon, Portugal
ORCID: 0000-0002-4580-6273

Júlia Pereira
Engenharia, CERIS, DECivil, Instituto Superior Técnico, Universidade de Lisboa, Lisbon, Portugal
ORCID: 0000-0003-4539-8844

Maria da Glória Gomes
Engenharia, CERIS, DECivil, Instituto Superior Técnico, Universidade de Lisboa, Lisbon, Portugal
ORCID: 0000-0003-1499-1370

Mário S. Ming Kong
Arquitetura, Faculdade de Arquitetura, Universidade de Lisboa, Lisbon, Portugal
ORCID: 0000-0002-4236-2240

ABSTRACT: In Japan, Shôji has been used in fenestration that communicates with the exterior in rooms for meditation practice. This Japanese paper seems to be geared towards filtering the amount of solar light adequate to meditation practice. In the West, it has been replaced with an adhesive polymeric film, such as Japanese paper, imitating the Shôji, which can be used in external glazing. In this study, the effect of replacing the Shôji with this polymeric film will be analysed through a set of experimental tests conducted in reduced scale models. We look forward to having the intelligence to be creative enough to find new solutions to the problems that are emerging in this field. So, in these models, the Japanese paper solution will be applied and, in parallel, another model, with a 6 mm single clear glazing, with and without the adhesive film, will be tested. The tests will be carried out in an external environment, during the Winter and Summer equinoxes and the Spring solstice, to obtain significant data from different solar geometries. The present paper will only focus on the results of winter equinox. The main aim of the present study is to understand if there are advantages in keeping the traditional Japanese solution, compared to the solutions offered by the adhesive films in glazing. Moreover, the results of the present study, provide a better understanding of the illuminance conditions, using traditional Japanese solution of Shôji and the application of the adhesive polymeric film, which are of utmost importance inside a meditation room where the light, with its immense power of creation and fantasy, strongly influence the meditation practitioner's health, wellbeing and mood.

Keywords: Meditation, Shôji, Japanese paper, adhesive polymeric film, illuminance.

1 INTRODUCTION

Pablo Picasso once said that the chief enemy of creativity is good sense. To be creative in a world of competition demands a bit of madness. The madness to calm down and sit, as the Zen Buddhist monks do in Japan. It is easy to have an idea, but to have a successful idea is not that easy. It demands calm, patience, perseverance, concentration. The idea of testing new solutions for a meditation room's exterior fenestration was not an easy idea, neither in its birth nor in its implementation. It came suddenly as a possible bright and creative idea, and demanded lots of creativity to implement, as the means at our disposal were not always what we expected. However, its implementation went well without many incidents mainly because we were creative enough to find solutions to the problems that were emerging.

Light has an immense power of creation and fantasy when even say that it has an intelligence of its own. In contact with human beings, it has the power to change mood. Too much light, however, brings destruction. So, men searched for ways of controlling the light that helped them in their multiple activities. One of them is meditation. And for those who start this practice, the ambience is essential. Namely the visual

ambience, including the light you allow inside, in the rooms set aside for this practice. These practitioners spend long, tedious hours, doing nothing except noticing their breath. If the light they receive is not adequate; if it is too low, they might get depressed or, if it is too high, they might become troubled. Therefore, creative solutions for a meditation room's exterior fenestration should be developed and tested, in order to obtain the best lighting for this activity. Japan has a long tradition of controlling the light in meditation rooms; the Zen Buddhist temples, and we can even say that in this country all dwellings are meditation rooms.

In Japan, architecture is closely connected with nature. Cabeza Lainez et al. (2006) refer the vegetal roofing (kaya), wooden trusses and rice-straw mats (tatami), and the disposition around the place that contemplates "natural balance often related to geomancy like Feng Shui and the observance of deeply rooted environmental rules". These authors argue that Japanese architecture has evolved through the years in accordance with the climatic conditions.

The shōji (障子) has been used in the exterior fenestration as a way of controlling light in the interior of the rooms creating the shades and tranquillity already referred to by Tanizaki in his book *In Praise of the Shadows* cited by Jay van Arsdale:

> Here the muted intensity of light from the shoji hardly changes with the hour or the season. "Have not you yourselves sensed a difference in the light that suffuses such a room, a rare tranquillity not found in ordinary light?" Tanizaki asks. (1988, p. 10)

In Buddhist Zen temples, the shōji might have created, over time, an ambience favourable to meditation practice. As Cabeza Lainez et al. (2006) describe: "in Japan reverence for the environment is the main feature of Sacred Architecture", more than in public or vernacular buildings. In the West, most meditation rooms might not use this method of solar light control, using more common methods such as blinds, curtains or others instead. The level of light has a strong influence on human beings' health and mood as it does in the meditation practitioner. As Vargas (2011) states, recently a new sensory system which detects light effects, and which has influence in the neurobehavioral activity, has been discovered. So, parameters related to the relationship between the Architecture and the lighting ambience can be established, which influence the health and wellbeing of its users. These parameters involve the performance, visual comfort and aesthetic appreciation of the spatial aspects. Vargas (2011) also concludes that natural as well as artificial lighting influence the relationship between the user and the built environment. Castro et al. (2006) cite various criteria related to the visual perception as contrasts, visual angles, dazzles and levels of lighting that might interfere with the productive activities and cause health mismatches that would influence the evaluation of

the place influencing the affective relationships either positive or negative (Vargas, 2011).

Sitting during long hours requires an adequate level of light that does not disturb the calmness of the meditation practitioner's mind. Soft and diffuse solar radiation and light are the best conditions practitioners could have, and the shōji has been doing this in the Japanese Zen temples.

However, the Japanese paper presents some durability and thermal behaviour problems, so that it has been used in combination with with glass or replaced with glazing systems. More recently, new solutions have been developed and implemented trying to reproduce the optical behaviour of the Japanese paper. Consequently, some solutions have been proposed as the use of adhesive polymeric film for interior glass application imitating the Japanese paper used in the shōji. Given the relevance of the light intensity to the success of meditation practice especially in its beginner levels, the intention was to check if this new adhesive film was an advantageous substitute for the shōji or if there were other, more advantageous, solutions. The creative intelligence of the designer performs a core role in the success of this search for solar radiation and light control solutions. In the present study, various solutions were presented for this problem and were tested on a reduced scale model (scale 1:10). For the tests, a window screen with Japanese paper was tested. Tests with a window screen with Japanese paper and a single glazing with adhesive polymeric film imitating Japanese paper were carried out, and a set of pyranometers and luxmeters assessed the environmental irradiance and illuminance and indoor illuminance distribution. A 6 mm single clear glazing was used during the tests and light meter sensors at an 8 cm height (scale 1:10) above the ground in the interior of the model for the horizontal measurements and 15cm inside and above the model ground for the vertical measurements. The tests were done on a sunny day without clouds close to the winter equinox on two models of a meditation room, scale 1:10 (30 × 40 × 70 cm), and the radiating light and luminosity were measured at 9 a.m., at noon and at 3 p.m. We intended to verify which is the best way to control the luminosity in rooms for meditation practice. This millenary practice demands for its neophytes a soft and diffuse solar light and the tests we are conducting take this into consideration. We considered the possibility of simulating a shading device like a sun visor to simulate the Japanese overhanging eave, as the Portuguese sun can be extreme, but finally, it was not tested as it complicated the tests too much. We agree with Arsdale when he says that "a shoji installation that merely mimics the Japanese style is bound to look out of place." (1988, p. 14)

In Japan, temple are "more carefully planned and designed than dwellings" (Cabeza Lainez et al., 2006), to improve the daylighting inside, "a shallow pond filled with rocks and gravel" (Karesansui or Saniwa) is used, which is very useful in summer as well as in

winter. This architectonic solution is combined with the temple roof inclination to reinforce the conveying of the light to the main altar. All these devices help to reduce the limitations of the shōji, they would be difficult to reproduce in a Western environment, but it is important to be aware of their existence.

2 THE SHŌJI

In Japanese architecture, the term tategu is used to refer to the internal and external doors and windows, and those who make and install them are called tateguya or tategushi. The shōji doors and windows are just a part of the tateguya work although an important part, explains Desmond King. The term shoji means something that "blocks off" (light) or "obstructs" (view), as King also refers.

> To the Japanese [the shōji] are a way of life, a constant that has been a part of their character for almost a thousand years, and even amid the gradual trend away from the traditional Japanese style houses, the sense of warmth and comfort projected by shoji ensures that they will remain within the Japanese spirit for centuries to come. (King, 2013)

The shōji, as Cabeza Lainez, J. M. et al. refer to it, is "a tiny wooden lattice, covered with panes of oiled paper, relatively impervious and resistant to the wind that works as a kind of sliding door and window." (2006) Moreover, as it is not transparent, "helps to avoid unwanted glances" (2006) According to Arsdale, "in Japan, most shoji are single sided, one explanation for this being that a shoji is like a human head: it has only one face and one back-side." (1988, p. 18). According to Bruno Taut, cited by Cabeza Lainez, J. M. et al., "people [...] remain trembling while the cold winter winds whistle through the rattling shōji" (2006). The shōji screen offers little protection from heat, soundproofing or security unless we build it with design-appropriate materials such as safety glass, argues Arsdale. However, "it [could] can screen out the hot sun without making the home overly dark" (Arsdale 1988, p. 18). Arsdale considers the shōji the eyes and the skin of the dwelling, it captures the indirect light that resides under the eaves, in the veranda, and diffuse it into the home, animating it without destroying its identity. Arsdale argues that it is more useful to think of the shōji as a filter than as a barrier and that it makes us participate in the rhythms of nature as the shadow of the kumiko patterns travel through the rooms along the day. The kumiko arrangements determine the designation of the shōji, so there is aragumi-shōji, yokogumi- shōji, yokoshige- shōji, tategumi-shōji and others.

Traditionally, cedar and cypress woods have been used in Japan to make the kumiko, explains Arsdale. These softwoods are especially suited to the needs of the shōji screen, they are good for joinery because of their density consistent cellular structures and are not layered with hard and soft growth rings, making glueing unnecessary, adds Arsdale in his book about the shōji. The frame and kumiko were traditionally sized in Japan to be very lightweight, because they only had to support the paper that was glued onto them and the common woods that are suitable should have "clear, straight grain; even and lightly closed pores; light weight and flexibility; stability in all dimensions; thorough seasoning; be easy of working and able to take a good finish" (Arsdale 1988, p. 22).

According to Arsdale, summer is on the mind of the Japanese when they design their traditional home. Yet, according to this author, "no one is sure exactly when shoji screens were introduced" (1988, p. 18) in Japan, "[T]hey are thought to have evolved from free-standing and folding screens of a type used in China." (18) The shōji might have begun being used in Japan by the Heian period (794–1185). During this period, the introduction of thin translucent paper was seen in Japan, says King:

> To differentiate [the shōji screens] from the existing fusuma-shoji, this new fitting was called akari-shoji (akari is the Japanese word for light). Over time, the akari part was dropped, as was the shoji part of fusuma, so the opaque silk paper partitions were known simply as fusuma, and the translucent paper-baked partitions were referred simply as shoji. (King, 2013)

It was at first used as interior partitions in noble houses, gradually being used in outer walls too. But "by the end of the 14th century, shōji as we know them today were in use even in the homes of commoners" (Arsdale, 1988, p. 18). According to King, during the Kamakura (1185–1333) and Muromachi (1333–1573) periods the living space in the household evolved with the introduction of covered ceilings and greater use of the tatami throughout the residence, in a way that sliding fusuma and shōji fitted between structural pillars were extensively used to divide the rooms:

> Forming a backdrop to this was the gradual transition of political power from the court nobles to the samurai warrior class, and over time the general function of the residence changed into more of a focus on reception of guests. These social gatherings among the samurai and noble elite steadily took on greater political significance and importance, [sic] and became a central part of everyday life. Poetry, flower arrangement, the tea ceremony and other arts flourished, sweeping landscapes were painted on fusuma, and more complex shoji patterns were adopted as rooms become more elaborately decorated. (King, 2013)

During the Momoyama period (1573–1603) a new architectural style (shoin-zukuri) appeared, which has been having a major influence in Japan until today, according to King. This style "took shoji to a new level of elegance". (King, 2013) There are references (Mizumura et al. 2015, p. 43) to the fact that during the Edo period (1615–1868) mino paper (美濃紙)

was used to make high-quality shōji, the Imai Family served as Mino village headman at the Japanese wholesale store until around the end of the Edo period. The shōji continued to be refined during the last four centuries, and today it is less frequently being manufactured in traditional ways, and more frequently by industrial means.

The Japanese shōji "rice" paper is made from the inner bark of kozo extracted from the mulberry tree. The washi, the Japanese paper, has traditionally been used for the shōji because it is light-weight and translucent; it is soft and strong, and will last if we do not compromise it with moisture, roughness or sharp objects. In Japan, it is a custom to repair the shōji with fresh white sheets of washi at the end of the year to purify the home before the beginning of the new year, explains Arsdale. The most admired shoji paper in Japan was from the Mino province, and it came in sheets of 10 3/4 wide, says Arsdale. In the past, before the introduction of modern paper manufacturing technology, kumiko arrangement was determined by the width of the washi (Japanese hand-made paper), as King says.

The oldest paper in Japan is stored in the Shosoin Temple. This paper was filtered and was used as a family register in the regions called Mino (Southern Gifu Prefecture), Chikuzen (North West Fukuoka Prefecture) and Buzen (Northern half part of Oita Prefecture), during the 2nd year of the Taiho era (year, 702), according to the Mino-washi Museum Website. Even 1300 years ago, Mino paper was known for being evenly intertwined and having a silky softness, and with the arrival of the Middle Ages, the name Mino Paper started frequently appearing in literature, according to this Website. Moreover, in the Edo era, this paper was given the highest evaluation and was considered the Japanese sliding door's most luxurious paper; the Mino reputation became a standard, concludes the Website. According to the Mino-washi Museum, Mino paper is white, beautiful, soft and strong, and when the sun shines the beautifully intertwined fibres can even be seen. According to this Museum, the best elements are what make Mino paper such a special paper: the stream of the Nagara River, the richest and finest quality water flowing from the stream of the Itadori River, the finest Nasu kozo from Ibaraki Prefecture, Kiso cypress as the instrument, the solid brass filtered figure and the scrapes from the bamboo to make a sukisu or a bamboo strainer.

3 EXPERIMENTAL PROCEDURE

In order to evaluate the natural daylight in an indoor environment using shōji paper and other solutions as transparent components of the façade, a scale model was built (Figure 1). Field experiments were carried out on the rooftop of DECivil building in Instituto Superior Técnico of Lisbon, Portugal, in two models

Figure 1. Experimental procedure: a) scale model; b) outdoor illuminance on horizontal and vertical plan and; c) measurement of indoor illuminance grid on horizontal plan.

(1:10 scale) that best represent the geometrical practices adopted for meditation rooms. These models were 30 cm high, 40 cm wide and 70 cm long in the interior. In this interior, a 70 cm long wooden ruler was placed, and four luxmeter sensors were fixed on stoppers at 8 cm above the model, corresponding to an 80 cm height in reality, which is the average height of the human eye in a meditative or relaxed posture (Figure 1a).

The same ruler was placed in three positions (left, central and right) during the tests for the horizontal measurements, for each one of the fenestration types to be tested in this study. Exterior horizontal and vertical measurements with luxmeter sensors were also carried out. Finally, the global and diffuse solar radiation on a horizontal plan were measured in the indoor and outdoor environments with a pyranometer sensor. Figures 1b and 1c show the grid of points measured on the horizontal plan in the indoor environment and the outdoor environment, respectively.

The scale models were placed over black plastic in order to prevent the incidence of undesired solar radiation reflection from the ground and to isolate the models from the roof's humidity. The experimental measurements were made at 9 a.m., at noon and 3 p.m., and at these hours of the day, photos were taken of the models' interior with all the tested fenestration: a) 6 mm clear glass; b) shōji paper; and c) 6 mm clear

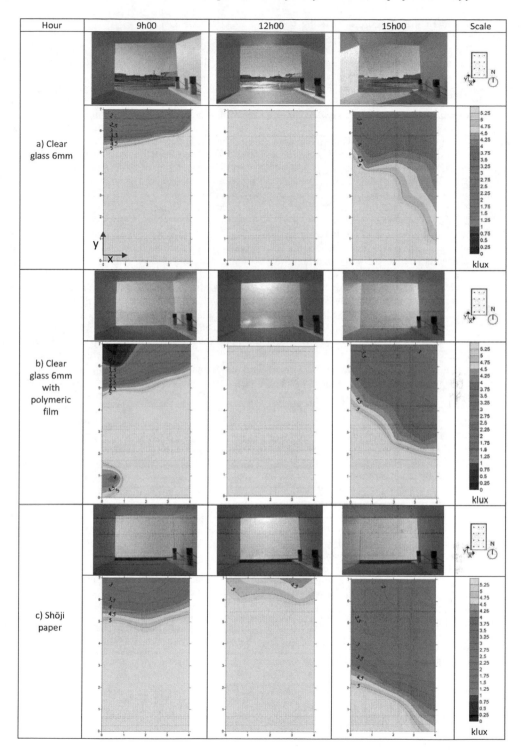

Figure 2. Illustration and illuminance measurements on a horizontal plan at 09h00, 12h00 and 15h00 for the Winter solstice under clear sky conditions for a) clear 6 mm glass; b) shōji paper; and c) clear 6 mm glass with a polymeric film.

glass with polymeric film (Figure 2). All the tests were performed with the fenestration oriented towards the South. The solution of a single clear 6 mm thick glass is taken as reference, whereas the frame with the Japanese paper represents the traditional shoji fenestration solution and the glazing with the polymeric Sagano film (from 3M®) glued to the internal surface of the glass exemplifies the more recently developed solutions.

We determined that the tests would take place during the Winter and Summer solstice and the Autumn and Spring equinoxes. The measurements would be conducted under clear sky conditions. Finally, the additional measurements would take place on a cloudy day on any other day of the year. This is an ongoing study, and the present paper will only focus on results obtained during the Winter solstice. Figure 2 (at the end of the paper) shows the illustration and illuminance measurements on the horizontal plane at 09h00, 12h00 and 15h00 for the winter solstice under clear sky conditions for the single clear 6 mm glass, the shōji paper, and the clear glass with polymeric film.

4 DISCUSSION

In general, the average illuminance values preferred by occupants, at the work plan level, are strongly dependent on the activities being developed, the quality, distribution and type of light, and on personal preferences. Recommended minimum illuminance values can vary from 500 lux/m2 for normal office work, 750 lux/m2 for normal and technical drawing work and art rooms or 2000 lux/m2 for the performance of visual tasks with low contrast and very small size (EN 12464-1, 2002). For relaxed activities such as meditation, the preferred values may be lower. The results of indoor illuminance distribution at the height of 80 cm, presented in Figure 2, show that: at 09h00, the illuminance is approximately 5000 lux in the area which is 5 m away from the window, for the clear 6 mm glass (Figure 2a), clear 6 mm glass with the polymeric film (Figure 2b) and shōji paper (Figure 2c). At this hour, the illuminance values in the area 5–7 m away from the window have a higher variation, varying between 1750–5000 lux for the clear 6 mm glass, 0–5000 lux for the clear 6 mm glass with the polymeric film, 2750–5000 lux for the shōji paper; at 12h00 the clear 6 mm glass and the clear 6 mm glass with polymeric film show illuminance values above 5000 lux. The shōji paper presents a slight decrease of the illuminance values reaching a minimum value of 4500 lux 6–7 m away from the window; the highest difference in the illuminance values in the indoor environment occur at 15h00. Illuminance values vary between 3000–>5000 lux for both the clear 6 mm glass and the clear 6 mm glass with the polymeric film, 1750–>5000 lux for the shōji paper.

5 CONCLUSIONS

The present paper focuses on the comparative analysis of the luminous performance of fenestration with Japanese paper and glazing with a polymeric film in meditation rooms. From the results we obtained, it was observed that, as expected, it was difficult to obtain the same shading effect of the shōji in Japan with current glazing solutions. It was verified that the traditional solution, the Japanese paper, is better for obtaining soft and diffuse light in the room. As meditation is practised during any time of the day, at noon, we strongly recommend the use of curtains to help get softer and more diffuse light. The western technology proved to be worse at guarantying this kind of lightening in the meditation rooms. However, there is a problem of viability with this traditional solution, with the contemporary demands for indoor thermal comfort, energy efficiency and building envelope durability. To obviate that, the Japanese paper combined with glass solutions already in use in Japan and other countries is recommended, and to do that, intelligence allied with creativity is indispensable. For instance, the use of a glass panel in the fenestration and its interior, either in a frame for the Japanese paper to be protected from damage or simply a shoji screen. With these tests, we got the notion that the shōji in Japanese Zen temples performed a fundamental role in facilitating the meditation practice for the neophytes.

ACKNOWLEDGEMENTS

Engineer André Quinhones from Instituto Superior Técnico, for assistance with the campaign, and Engineer Carlos Miguel from Impersol for help with the glass with the Sagano polymeric adhesive film.

BIBLIOGRAPHICAL REFERENCES

Arsdale, Jay van. (1988) *Shoji: How to Design, Build, and Install Japanese Screens*. Otowa, Japan: Kodansha International Ltd.
Cabeza Lainez, Jose Maria, Saiki, Takahito, Almodóvar Melendo, Jose Manuel and Jimenez Verdejo, Juan Ramón. (2006) 'Lighting features in Japanese traditional architecture', paper presented at the PLEA2006 – The 32nd Conference for Passive and Low Energy Architecture, Geneva, Switzerland, 6–8 September 2006.
Chernyshov, Elena. (2008) *Light, dark and all that's in between: revisiting the role of light in Architecture*. Master's degree dissertation in Architecture, University of Waterloo.
European Committee for Standardization (November 2002). EN 12464-1, 'Light and lighting – Lighting of work places – Part 1: Indoor work places'. Brussels.
Fredriksson, Mikaela. (2017) *The poetics of light*. Master's degree project in Architecture, Stockholm.
King, Desmond. (2013) *The Complete Guide to Shoji and Kumiko Patterns*. Queensland, Australia: D & M King.

Kong, Mario Ming. (2014) 'Architecture on Paper and sustainable materials. Sustainable materials as methodological support of the graphical thinking process in the development of a creative aesthetic language', paper presented at the 2nd Annual International Conference on Architecture and Civil Engineering (ACE 2014), Singapore, indexed to SCOPUS and EBSCO, pp. 376–381, Print ISSN: 2301– 394X, E-periodical: 2251-371X.

Kong, Mario Ming. (2013) 'Creativity, fantasy and architectural culture', paper presented at the 1st Annual International Conference on Architecture and Civil Engineering (ACE 2013), Singapore, indexed to SCOPUS and EBSCO, pp. 136–140, Print ISSN: 2301-394X, E-Periodical ISSN: 2301-3958; Doi: 10.5176/2301-394X_ACE13.40.

Mino-washi Museum Website. Translated from the Japanese into English with the help of the Google translator. Available at: http://www.city.mino.gifu.jp/minogami/. Accessed 19 Feb. 2019.

Mizumura, Megumi, Kubo, Takamasa and Moriki, Takao. (2015) 'Japanese paper: History, development and use in Western paper conservation', paper presented at the Adapt & Evolve 2015: East Asian Materials and Techniques in Western Conservation, International Conference of the Icon Book & Paper Group, London 8–10 April 2015. (pp. 43–59). London: The Institute of Conservation: 2017.

Palaasma, Juhani, …Burnett, Deborah. (Autumn 2016) Daylight and Architecture, n° 26, Singapore: Velux group, Michael K. Rasmussen.

Plummer, Henry. (1987) *Poetics of Light*, n° 12, Tokyo, Japan: a+u Publishing Co., Ltd.

Reist, Tessa and Kingsley Brad. (1969) 'Silence and Light: Towards the Poetic Experience in Exeter Library', lecture at ETH Zurich.

Tanizaki, Jun'ichirō. (1977) *In Praise of the Shadows*. Connecticut, USA: Leete's Island Books Stony Creek.

Turner, Christopher and Stoichita, Victor. (2006/7) 'A Short Story of the Shadow: An Interview with Victor I. Stoichita', Cabinet Magazine, n° 24, Brooklyn, New York: Immaterial Incorporated.

Vargas, Cláudia Rioja de Aragão. (2011) Os impactos da iluminação: visão, cognição e comportamento, *Revista Lumière*, v. (161), 88–91.

The magic touch of creative fantasy: Turning C.G. animation into telling movies

Carlos M. Figueiredo
CIAUD, Lisbon School of Architecture, Universidade de Lisboa, Lisbon, Portugal
ORCID: 0000-0002-1107-4211XXX

ABSTRACT: The Cinematographic Fictional Space consists of a movie fictional world. Its conception and accomplishment adapted or from scratch, is entirely intended to work smoothly as a support of the film's action, narrative and drama.

Movies' syntax and their grammar have been used ever since it was developed and compiled along the first 15 years after the Lumiére brothers' camera was created. The language of cinematic telling has been able, until now, to adapt to any fiction, following its plot, the entire range of film genres, aesthetic concepts, style movements, ideologies, cultures, and places.

The Graphic Computing Imagery (CGI), since the 80s, provided a new way of representing worlds, setting common ground with drawn animation and real action films. However, its use to visually convey and tell fiction stories revealed itself to be a powerful new way of creating animated or real action films. It forever changed the way these films were made, from scripts to grammar, from light to directing, from fictional space to characters dialogue, characterisation and acting.

This changing boundaries crossed mediums, languages, and grammars, and have been used with mixed creative approaches, making (able to) possible the development of a multitude of new ways of plot telling, fiction portray and space concepts.

The aim of this reflection is a better understanding of this film and animation tellings. It is also about the mixed and combined use of its grammar.

Keywords: CGI, Film, Animation, Fiction Telling, Grammar, Space

1 INTRODUCTION

In animation films created by means of computer graphic imagery, there is a more stylised and illustrative quality, rooted in both the comics and cartoon drawings, while lending an even greater relevance to the principles of composition and perception, and of form as space.

In a digital virtual space, everything must be built and replicated, from nature to sets, from actors to lighting. Nothing is reality as there is nothing we can physically touch. But even though fictional worlds and characters are intangible, the viewer will inhabit these spaces (there) anyhow, by immersing himself in those virtual plots and worlds. Are we not dealing with mental self-representations of the outer reality, all the time?

So, the spectator just needs, more than ever, for these self-representations to be based on anchors, bond to principles alike to the ones of our "real" world. That need is the same as we have in our everyday life, at all times.

Those anchors are links that bind digital virtual fiction worlds of film or animation to our real-world concepts. The viewer, fed with those references, will then feel immersed and live experiences in the virtual world as rational, emotionally intense, and authentically as if they were from his "real" world.

We see our "real" world through ourselves, only getting a virtual representation of it! We cannot get out of our shell! We cannot touch or reach any "real" world, just representations of it.

The production of films using CGI did not create a new grammar, but instead demanded a more in-depth and simultaneous use of several grammars, much more than real action films do.

So, with time, CG required Art Directors to get knowledge and get involved in all the Arts and Narrative Languages – not only the cinematographic or animation ones, but almost all others, in a trend that mixed and merged grammar and syntax from writing (scripting), photography, paint, theatre, acting and embodiment, music, architecture, animation cartoon, comics, perception concepts – just as it had happened

before with the birth of cinema, but this time not to create a new language, but to mix those known and blend their boundaries.

This profound dependence of CGI in relation to known art and storytelling/portray grammar implies that most of their principles of motion picture production and directing have become adopted and also strictly applied to the storytelling using digital virtual worlds generated portrayal.

More demanding, as characters are digital and not live actors that embody the fictional characters of a play, the use of CGI implies to emulate life in characters from scratch, aiming to create in digital characters an illusion of life and attitude, the existence of the soul in them.

Animation has done that in drawn characters, humanising cartoon characters. Disney did that, and CGI took that and took it much far.

So in order a digital model constitutes itself as an alive and believable character or space, it has to be felt as authentic, we have to feel in it its own identity, we have to feel the soul and mind of digital characters and their world.

This includes lighting and atmospheric effects; of the phenomena of our world, in an ideal and controllable way: so CGI emulates super credible waves, rain, wind, our world's physics – inertia, gravity, flexible material interactions, fur, hair, skin, muscles, skeletons, fabrics and cloth behaviour, light – all this according to said to physics.

CGI had to turn to nature and the world of humans because it is only in relation to these references that we measure and make sense of everything.

Also, like hand-drawn cartoons, theatrical plays, and the first silent films did, CGI emphasises and exaggerates the characteristics that it wants to be felt by the viewer, applying this pantomime to expressions, gestures, body movement, walking, volume, form, depth, and colour.

This accentuation makes the spectator feel more strongly a CGI character or telling than that of a random piece of our real but faded life, in our daily life.

Now, CGI has turned its attention to real action films, making them a blend virtual and reality, leaving the viewer to differentiate between them! In Movies, virtual became a reality, and cinema changed its telling, action, and fictions, expanding their grammar with others. Draw animation also merged with CGI, making it impossible to say what is hand or digital maid, as they are now not only joined but blended!

2 THE CREATIVE PROCESS

The understanding of how to represent the depth in a two-dimensional plan – as in a painting or drawing – was one of the most important developments in art history. This development remains paramount on CGI:

> All of the methods used to depict real or mystical three-dimensional occurrences on a two-dimensional plane have been new steps in new directions. (Watkins, 2001)

In search of an aesthetic answer, in the drawing and composition for their digital work, the CGI artists should look, first of all, for the inherent principles of the motion picture and cartoon.

The digital artist is not just an animator. He needs to think in a global way about the script, the sets, the actors, the narrative – just as he a director makes, translating the argument for the visual language of film:

> This fascination with achieving the appearances of prior modes of representation as the cinematography (…) is one of the central objectives of the film and computer graphics (Darley, 2000)

Another issue is quite fundamental: that everything makes sense to the observer. The cinematic transcription of the script will feed the emotions and the dialogue of actors. The perfect compromise of shots, dialogue, and script, will maintain the spectator's interest. (Watkins, 2001)

A good photographic direction helps create the right atmosphere or dramatic effects, inducing mood, and emotions in the spectator. The same principles of the illumination in movies, theatre, and photography must be unavoidably applied:

> When you control a camera in 3D space, you are controlling how the audience will view the scene. You choose their point of view since it determines how an event is perceived. (Ablan, 2003)

In the creative process, just as a director, the digital animator must also imagine the film, the shots, and sequences: the narrative he is going to build. Using the same approach to film, a CGI art director has to interpret the script to turn it into the corresponding visual telling.

3 USING CINEMATIC NARRATIVE AND GRAMMAR

In the techniques of the theatre, that the movie picture has adopted at the beginning, the sets were modelled along with several depth levels, starting from the proscenium arch, in successive layers of wings, legs, borders, masking flats and other scenic one-sided painted flats. This line goes until the back of the stage, finishing in a backdrop painted in an illusionist perspective – trompe-l'oeil – to add visual depth, or in a cyclorama, opening the set to the infinite.

The illusion was built to be seen from a unique point of view, along a perpendicular axis to the bottom,

through the proscenium arch, that separated the audience from a confined illusion of the world's fiction, in the stage and its scenic box. It was this direction that the early cinema began using, in a fixed frontal camera, as Méliès did. This way, Early Cinema movies moved away from actors, allowing the painted drops and sets formatted as a stage, forcing acting poses in a pantomime format with exaggerated gestures to make acting and meaning reach the viewer.

This was a natural consequence of the whole immobility and unidirectional view imposed by the sets and by the arrested camera. CGI uses this approach when the digital space to be portrayed is far so that they can make flat painted set elements. The most of the landscape, supposedly 3D, are theatrical "flats"; painted drops.

In the Italian Monumental Movement, before the first war, the liberation of the sets was obtained, building enormous environments that resembled the ones of the monumental classic architecture, stunning the public with its monumentality, gigantic dimensions and the ornamental delirium of spectacular sets. Like in CGI, now the sets involved the actors and the action, and the characters seemed to inhabit in those spaces, with the same realism and conviction that we inhabit the spaces of our own world. This placed the viewer immersed in the fictional world and action and makes that world seem infinite and real. In CGI animations, to place spectacular sets and immerse and surround both characters and camera is now a golden rule, as it is in video games.

Techniques as the eye-line match between shots, the reaction shots and pairs of inverse shots became normalised conventions to connect and relate different spaces, while transition devices became signs of the deviation from the linear temporality, such as the flashback and the dream time. CGI learned and perfected these devices, using them always.

The space out of the screen can then be felt as real, as we can relate separate portions from the fictional space in a mental unity or "synthetic space," relating space fragments in a coherent spatial space. CGI animations and later RPG games use this film approach and not the drawn animation technics like horizontal moving overlap layers.

4 THE CINEMATIC EYE OF THE MOVIE CAMERA

From the beginning, there was the question of how the camera in a virtual world would behave. The option was to emulate with virtual cameras the features found in real movie and photography cameras, even those that in the digital world did not make sense, unless by analogy with the real world and the motion picture grammar.

Indeed, if in a virtual camera, elements such as the format, framing, and lenses make sense, the sharpness

of images is always total from the camera to infinity. However, the real focus of the cameras – based on the depth of field determined by the lens, its openness and length of exposure – was to virtually reproduce with CGI, an equivalent of the actual mechanics and optics of film cameras.

Another question was how to use a camera in a digital virtual world. By not being limited by gravity, rails, cables, sets or other physical or technical constraints, the digital world allows any camera movement, positioning, and angles, covering a huge range of impossible situations while shooting in the real world.

But CGI dropped all that freedom of their virtual cameras and emulated precisely the constraints of real physical cameras. This way they comply with the particular shots that have become standard in cinema and long-time assimilated by spectators and their narrative, that have become standard in film language: "We limited our camera moves to the type that you expect to see in a live-action film." (Brooker, 2003).

Therefore, the virtual camera behaves as if in a studio, denoting some weight on their movement. The fluid movements and flying, denouncing the camera to the spectator and leaving him confused, were ultimately avoided in computer graphics. (Rickett & Nirkind, 2000)

The new possibilities of virtual cameras also influenced cinema, especially when the films are made with the assistance of computer graphics, like in special effects or set design:

> The question for a history of the creativity of cinema is how such innovations would affect the aesthetics of the [new] medium. (Cousins, 2011)

The objects on the scene in the shot are perceived by the audience under the principles of composition, which are inherent to the human being himself and are necessarily involved in his constructed image of the world:

> Most of it [the visual storytelling] is not noticeable on a conscious level to the viewer but adds depth and richness to the story and the visual experience. (Calahan, 1996)

In animation films that use CGI, there is a more fashionable and illustrative quality, with roots in cartoons, giving even greater importance to the principles of composition and perception of forms and spaces.

Everything is built and simulated, the nature of sets, actor or lighting; nothing is real. So, to give meaning to what you see, the viewer must be based on these principles, even more than it does in the movies.

The sense of the visual environment, represented in each of the shots of the film, builds a cognitive process that relates the elements to each other, contributing with information that confers them more than is present in themselves alone, achieving a new level of understanding about the space unity.

5 THE REAL LIGHT OF OUR FANTASY UPON THE DIGITAL WORLD

Many of the techniques to describe, measure, and place the lights were also being developed earlier in photography, theatre, dance, opera and in the cinema. Though with different approaches to scene lighting, these techniques and knowledge have a broad base in common. These are the same principles of conventional lighting that digital artists try to apply, with the devices and techniques of CGI, to their characters and virtual environments.

> Lighting in CG, as in the world of cinematography and photography, is all about producing a final look that reinforces the mood of a scene and creating the all-important emotional connection with your audience." (Brooker, 2003)

These digital devices are always inspired by natural phenomena – in the theories of physics that describe the light:

> Virtual 3D light, like everything else in digital space, is virtual. It is a set of algorithms that attempt to imitate light as it occurs in the real world. (Watkins, 2001)

After all, CGI imitates and reproduces nature and the scenic processes of lighting. But if the lighting in CGI has the advantage of providing complete control in the placement of lights, it has the huge disadvantage of being very difficult to reproduce, in the digital world, the lighting as it happens in the real world.

The creative use in computer graphics, equivalent to the lamps, lenses, filters, gelatine, broadcasters, opening angles of incidence, contributes to the construction of narrative, character, and atmosphere in digital animation:

> Working through basic cinematic principles while understanding the differences in light types, lighting environments, atmospheres, shadows, and the like is the smart way to set up your shots. (Ablan, 2003)

The focusing of the audience's attention within each shot, by providing information and clues regarding the action, characters, and locations, constitutes a vital role at several levels: in the communication of the sense of place and time, in conveying a sense of drama compliant with the script or in revealing the characters, their personalities or their mood.

The lighting should also strengthen the three-dimensional nature of the forms made in CGI and its depth, disclose them by changing their perception in the light. Light can also make evident the rhythms of spaces and sets:

> [Shadows] are actually so vital in terms of composition, spatial relationships, and contrast, that its importance in a lighting scheme simply cannot be overstated. (Brooker, 2003)

CGI or not, light always operates at an emotional level, reinforcing the desired environments and establishing the mood in which a scene takes place: the lighting can create a soft and romantic atmosphere or a frightening and mysterious one; light can create suspense by the shadows it produces, where unknown threats can hide.

6 CHARACTER'S ACTION: GIVING SOUL TO DIGITAL ACTORS

In the digital making, one can put the same issues as in a film conventional means or even a play in the theatre: what is the emotional and psychological characterisation of the characters? Where do they live? What is their personal style? How do they relate to their surroundings? What is the impact of their surrounding physical space in their lives? How can the history of their own life be placed in the physical environment?

The specific techniques of computer graphics are about bringing life and credibility to digital models, in themselves only a collection of technical and mathematical precepts: "Animation is bringing the geometry of models to life; giving them life, a motion personality." (Watkins, 2001)

Even if an animated character is situated in a fantasy world, the spectator will only be convinced of his authenticity by the movement presented by him if he can relate it, even if at an unconscious level, to what he knows from his own reality.

7 CONSIDERATIONS

There is in CGI animated film an attempt to reproduce the forms and attributes of objects and phenomena of our world without, however, simulating a world that can be taken by ours.

What is intended to create is a world in which the characters and fiction of the argument may exist, carrying its plot and personalities, and the events that are being narrated.

This world of fiction reports to ours in many respects, where we anchor our understanding about it, but it must obtain its own identity, which in no time we identify as being our own universe.

As in the early cinema, in CGI there is now a tendency to accentuate the visual attractiveness above the quality or even coherence of the narrative, of the look over the content and of the spectacle above the strength and consistency of the script.

The film started with references to the theatre, photo, and painting, which is transformed into its own language, becoming Art.

CGI took the narrative of the film, of production design and lighting, as well as references from theatre to create its characters that emulate the drawn humanisation of animation and Nature's behaviour.

So, CGI is just a mere technology for digital construction, to be absorbed in time by the Cinema and other Arts but, by new syntax in their grammars, it

is changing the Grammars it emulates, changing Art concepts and narrative storytelling profoundly!

BIBLIOGRAPHICAL REFERENCES

Ablan, D. (2003). *Digital cinematography & directing* (1st ed). Indianapolis, Ind: New Riders Pub.

Brooker, D. (2003). *Essential CG lighting techniques*. Oxford: Focal Press.

Calahan, Sharon. (1996). Storytelling through Lighting: A Computer Graphics Perspective. In *A Lighting Approach for Computer Graphics*. New Orleans: Siggraph'96.

Cousins, M. (2011). *The story of film* (rev. hardback ed). London: Pavilion Books.

Darley, A. (2000). Visual digital culture: surface play and spectacle in new media genres. London; New York: Routledge.

LoBrutto, V. (2002). *The filmmaker's guide to production design*. New York: Allworth Press.

McLaren, N. (1991). *On The Creative Process*. Montreal, Canada: National Film Board of Canada.

Rickett, R., & Nirkind, B. (2000). *The history and technique of special effects*. New York, NY: Billboard Books.

Watkins, A. (2001). *3D animation: from models to movies* [English]. Rockland, Mass.: Charles River Media.

Part VII
Exhibitions

Drawings & paintings: "Pompeii colours and materials"

Maria João Durão

CIAUD, Lisbon School of Architecture, Universidade de Lisboa, Lisbon, Portugal
ORCID: 0000-0002-3125-4893

DRAWING AND PAINTING EXHIBITION: The exhibition of drawings and paintings of Pompeii colours and materials is the result of colour studies carried out during observational studies *in situ,* as part of a research project that articulates theory and practice. The criteria for selection of drawings and paintings was twofold: to complement the theme of the paper by the author 'Considerations on the colours of Pompeii walls' presented at the Congress in the same venue; to offer a method of research in art expression focused on the actual colours of Pompeii's murals and frescoes.

A key character of the drawings and paintings is the adoption of a common colour palette of red ochre, vermillion, burnt ochre, yellow ochers, Egyptian blue azurite, indigo, terre verte, malachite, verdigris, purple, madder, carbon black and white. Relationships with chromatic fields and atmospheres found their way into various experimental techniques used in the drawings and paintings, where watercolour, oil, and dry pastel combine with pigments extracted from plants and insects, to create pictorial spaces embedded in Pompeii's chromatic memories and sense of place.

Keywords: Pompeii; colours, painting, drawing, art

Figure 1. Drawing by Author. Watercolour on Canson paper.

Figure 2. Drawing by Author. Dry pastel and flower pigments on mixed ground.

Literature and video: "Borderlands"

Prose texts, presentation and film script by Martin Simonson
University of the Basque Country – UPV/EHU, Spain

Photography by Thomas Örn Karlsson
Sweden

ABSTRACT: "Borderlands" is an exhibition that combines photography, prose and video, and acts like an extended metaphor for how our virtual identities affect us in our daily lives. Images and text merge to invite the reader/spectator to explore the liminal space between the virtual and the physical in which we are currently dwelling, and ask themselves where this exploration might take us.

Keywords: Liminality; Borders; Literature of Place; Photography; Video

This exhibition, which combines the media of photography, literature and video, explores the liminal area where landscapes, identities and narratives intersect in the 21st century. Among many other things, our era is marked by unprecedented possibilities to develop alternative personalities in the virtual dimension. While this can be felt as refreshing and liberating, the issue is not devoid of complications. Sooner or later, we are bound to ask ourselves how our presence in social media and other virtual modes of interaction affect the construction of our identity, as well as our perception of the physical world. We now dwell simultaneously in two different dimensions — or rather in some borderland between both in which we are constantly negotiating a personal space for ourselves — and as our interaction with ourselves and with others becomes more consolidated in the virtual dimension, virtual abstractions surreptitiously alter our perception of the physical reality.

Such a process obviously paves the way for posthuman conceptions of reality, and in the hypothetical (albeit not entirely improbable) case that technology will one day be able to provide a perpetuation of ourselves without the need to resort to physical bodies, virtual identities might come to replace the physical dimension of our existence altogether. As of yet, this possibility is a mere conjecture — but the moment it can be imagined, it becomes fertile ground for speculative fiction and art. The present exhibition attempts to give shape to the borderland experience that already affects us all in our daily lives by merging prose, photography and film. By doing so, we wish to reflect on this liminal area — which still separates us more or less tangibly from the hypothetical posthuman reality — that most people in the early 21st century have already begun to explore in earnest.

In the written texts, taken from the novel *Gamezone Borderland*, the protagonists are players or narrative directors of a massively multiplayer online role-playing game called "The Community," similar to well-known real-world equivalents such as "Eve" or "Second Life," in which hundreds of thousands of players are engaged in building a virtual civilization out of the ashes of the old. The game turns out to be extremely addictive, and after a few years some of the most successful players have grown so used to their virtual alter egos that they demand that the game create enclaves for their avatars in the physical reality, so that they can live and interact with others also in the "real" world.

The revolutionary proposal is accepted, land is bought with the players' money, and locations are designed for the purpose of recreating the game's fictional reality in the real world for the players. The "break-through" is eventually carried out. Hence, the imaginative recreation of the real world that took place in the virtual reality is now transferred back and projected onto the real one, modifying the actual physical reality in the process. This obviously opens up new possibilities, as the people in charge of the development of the game's narrative no longer control only a set of avatars in a virtual reality — they can now exert their influence also on real people, in the real world. What began as entertainment soon turns into a nightmarish international power struggle set in a liminal space where fiction and reality blur without any clear sense of direction.

The photographs that accompany the text in the book — and which are shown in this exhibition together with the prose fragments taken from the novel — provide a visual perspective of this uncanny borderland, where different realities blend. However, they are not meant to be mere illustrations of the text

but tell their own story through a different medium, and neither the prose fragments nor the photographs provide complete narratives. The spectators are thus forced to engage with both dimensions simultaneously in an attempt to negotiate some sort of common ground for themselves in this liminal space, filtered through their imagination, experience and previous textual or visual references.

The film, on the other hand, provides a synthesis of both narrative and photography, with music by Anders Rane. It takes place shortly after the action described in the novel, at a moment in which only fragments of our civilisation remain — literally. Explorers have been sent out in a desperate attempt to trace the origins of the catastrophe, and one of these men chances upon an abandoned house in a clearing. Inside, he finds an old computer, scattered notes and a book with strange symbols. As the soldier begins to piece the information together, the fragments of evidence recreate in his mind a distant summer when a young couple came to spend a few weeks in the house. However, the holiday seems to have ended in disaster when something came to life in the man's computer... The soldier realises that the sinister episode could be related to the origins of the disaster that blighted the world and sets out to recover more evidence. But as he delves deeper into the mystery, the world begins to change in front of his bewildered eyes, and it is suddenly unclear if he will ever find his way back.

For better or worse, time and space warp and different identities merge as we redefine, give up or sacrifice what we used to consider the "real" for the virtual. "Borderlands" thus acts as an extended metaphor for how our virtual identities affect us in our daily lives and invites the reader/spectator not only to explore the inter-dimensional space in which we are currently dwelling but also to ask themselves where this exploration might take us.

Author index

Accetta, C. 261
Alfieri, N. 467
Almendra, R.A. 223
Amado, P.M.R. 527
Aparo, E. 223
Avelar, A.P. 351
Avelar, M. 449

Baldessar, M.J. 527
Baptista-Bastos, M. 105, 121
Bernardo, L.M.A.V. 363
Borbely, I. 437
Borges, L.C. 549
Borges, M. de A. 229
Boscariol, M.A. 345
Botelho, T. 431
Braviano, G. 527
Brito, C. 333
Brum de Almeida, F.H. 187

Cabral Dias, J. 193
Canau, A. 273
Cardoso de Matos, A. 513
Castro, C.R. 149
Castro, M.J. 293
Centineo, S. 283
Cossío, A. 405, 411
Cruz, M.B. 555

da Cruz, M.L.G. 339
da Silva, A.M.D. 549
Dahlbacka, J. 499
de Almeida, I.G. 319
de Carvalho, G.M. 143
de Faria, G.H.C. 543
du Sautoy, M. 3
Duarte, J.M.C. 137
Durão, M.J. 289, 571

Fadel, L.M. 537, 543
Farias, H.L. 155
Feliciano, A.M. 59
Ferrão, L. 239
Figueiredo, C.M. 563
Fimi, D. 13

Gamito, M. 235
Gomes, M. da G. 555
Gonçalves, C.G. 47
Groop, K. 487

Higashino, A.P. 89
Horváth, G. 267

Jesus, D. 79

Kong, M.S.M. xi, xiii, 43, 125,
 149, 555
Kuchpil, E. 99

Lavocat, F. 5
Loureiro, L.S. 453
Louro, M. 167
Lousa, T. 245
Loução, D. 205
Lourencetti, F. de L. 377
Lupati, F. 479

Maddaluno, R. 65
Maestri, D. 537
Mikosz, J. 245
Montero-Gilete, R. 419
Monteiro, M. do R. xi, 395
Moreira da Silva, A. 217
Moreira da Silva, F. 211, 223

Napoleão, E. 527
Neiva, A. 93
Nogueira, A. 125
Nunes, J. 131

Oliveira, F. 53
Örn Karlsson, T. 573
Ortega, A.R. 303

Paiva de Sousa, S. 105, 121
Palomares Alarcón, S. 173
Pereira de Matos, J. 251
Pereira Neto, A. 533

Pereira Neto, M.J. xi
Pereira, J. 555
Pimentel dos Santos, A. 99
Pimentel, M. do R. 21

Ramos, A. 199
Raposo, E.M. 473
Reitz, L. de M. 187
Rendeiro, M. 459
Resende, H. 357
Ribeiro, F. 383
Ribeiro, Fernando J. 277
Rodrigues, A.L.M.M. 255, 299
Rosa, M. de F. 325
Rosa Querne, G.H. 187

Sampaio, M. da L. 521
Sampaio da Silva, L. 389
Santos Leite, A. 161
Seits, I. 179
Serafin, A. 109
Seredyńska-Abou Eid, R. 505
Shatvoryan, A. 7
Silveira Dias, J. 205
Simonson, M. 425, 573
Soares, L. 223
Soares, M.J. 71
Sousa, G. 239
Sousa, J. 235
Swartz, D. 313

Tarasova, I. 85

Varandas, A. 443
Vasconcelos, A. 115
Vaz, C.E.V. 543

Weihermann, S. 303
Wilson, M. 493
Wróbel, S. 369

Yan, S.C. 255

Zink, R. 35

PHI (Book Series)
ISSN Print : 2639-0191
ISSN Online : 2639-0205

1. Modernity, Frontiers and Revolutions (2018)
Edited by Maria do Rosário Monteiro, Mário S. Ming Kong & Maria João Pereira Neto
ISBN: 978-0-367-02397-3